History
of **Art** for
Young
People

H. W. Janson and
Anthony F. Janson

History
of Art for
Young
People

Fifth Edition

Harry N. Abrams, Inc., Publishers

Project director: Julia Moore
Editor: Elaine Banks Stainton
Assistant editor: Monica Mehta
Designer: Lydia Gershey, with Yonah Schurink of Communigraph
Photo editor: Uta Hoffmann
Illustrator: John McKenna

Library of Congress
Cataloging-in-Publication Data

Janson, H.W. (Horst Woldemar), 1913–
 History of art for young people/
 H.W. Janson and Anthony F. Janson.—5th ed.
 p. cm.
 Includes bibliographical references and index.
 ISBN 0–8109–4150–3
 1. Art—History. I. Janson, Anthony F. II. Title
N5300.J33 1997
709—dc20 96–22361
 CIP

On part-opener pages 28–29: Trilithons, Stonehenge, Salisbury Plain, Wiltshire, England, c. 2000 B.C.; 124–27: detail of fig. 154; 234–35: detail of fig. 264; 406–09: detail of fig. 530

Published in 1997 by Harry N. Abrams, Incorporated, New York
A Times Mirror Company

This book is also published by Prentice Hall/Abrams under the title *A Basic History of Art*

The original edition of *History of Art for Young People* was written by H. W. Janson with Samuel Cauman

Printed and bound in Japan

Brief Contents

Contents

Preface and Acknowledgments to the Fifth Edition

This edition of H. W. Janson's *History of Art for Young People* continues the evolution of broad change that was inaugurated in the previous edition. As before, this edition both reflects changes incorporated in the current version of Janson's *History of Art* and previews others that will be introduced in the next edition. Readers familiar with earlier editions will note some significant changes in emphasis. Whereas the fourth edition concentrated on art from Mannerism forward, I have focused in this fifth edition on art before 1520. I have brought the scholarship on ancient art up-to-date. In this I had the benefit of numerous suggestions made by Prof. Andrew Stewart and Dr. Mary Ellen Soles. In several instances, however, I have followed an independent approach to ongoing controversies. Some of them are relatively minor: for example, which battle the *Nike of Samothrace* commemorates. The most important contention is the vexing question of the debt of Roman painting to Greek art, to which I devoted a year's study before siding with those specialists who see it as essentially Roman in character. I have also rethought a good deal of medieval art. This has resulted in a major reorganization that now places Constantine and the beginnings of Christianity under Early Christian art. I am indebted to the helpful comments of Prof. Dale Kinney, who served as a reader. Thus, I examined afresh the contribution of Abbot Suger in the formation of Gothic architecture, which has been undergoing a major reevaluation of late, although again I have taken a different stand on the issue. I have also emphasized what I regard as the critical role of the Byzantines in preserving the heritage of early Christian art and transmitting it to the Latin world, where it provided the foundation for the revolution in Gothic painting and sculpture. Finally, I reorganized the historical background in the Introduction to Part Two and included additional background information within each chapter.

So far as the Renaissance is concerned, I have included more iconography than before, such as the inspiration of Poliziano in Botticelli's *Birth of Venus* and Raphael's *Galatea*, and the symbolism of Giorgione's *The Tempest*. The presentation of High Renaissance art has been altered, particularly in the case of Michelangelo, and more subtly with Leonardo and Raphael. In the same vein, the account of Jan van Eyck's *Arnolfini-Cenami Portrait* takes advantage of recent scholarship.

Perhaps the biggest change to the book has been the incorporation of new sections on the history of music and theater. They are frankly experimental, for although books on other disciplines have often included material on art, art history surveys have not reciprocated the honor. Despite misgivings about such an interdisciplinary approach, I decided to add them so as to suggest the larger cultural context in which the visual arts have been created. I have done so out of my own deep love for music and drama. However, my account is necessarily slanted to those aspects that illuminate the main content of this book. As this is not intended to be a general humanities book, I have placed less emphasis on the history of literature and philosophy, which are vast subjects in themselves, except in some instances where they are directly relevant.

I confess that I have tried to advocate modern music and theater, because I appreciate the resistance that most people will feel toward them, just as they do to modern art. I, too, have felt that resistance—to modern art, as well as the rest of modern culture, and I am more than sympathetic to the plight of many readers. From my own experience, I can attest that the only way to come to terms with these demanding art forms is to immerse oneself in them fully, however forbidding that may seem. The rewards are more than worth the effort.

This book has been completely redesigned to provide more space for new features that make art history more accessible: marginal glosses, labeled drawings, and chronologies. Julia Moore of Harry N. Abrams, Inc., who understands the book probably better than anyone else, served as the most sympathetic and creative project director one could ask for. To her is owed the considerate idea of including supplemental information that could not otherwise be incorporated into the text, collaborating with me in writing a good number of the individual pieces. These boxes and glosses offer access to such material as classical gods, the Greek concept of ethos and arete, biblical iconography, monasticism, "vexed" terms that have undergone changes in meaning, and the like. These annotative excursions have been introduced as judiciously as possible to avoid disrupting the flow of the narrative.

I owe a special debt of gratitude to Elaine Banks Stainton, whose role far exceeded that of manuscript editor and became one of collaborator. A well-qualified art historian and teacher in her own right, she not only tracked down vital information on short notice but contributed numerous insights and acted as a sounding board for new ideas. Besides managing and writing new terms for the glossary, assistant editor Monica Mehta held the team together with graced competence. As always, Uta Hoffmann was tireless in procuring new and better photographs. And again, I have been privileged to have Lydia Gershey and Yonah Schurink as designers. Their understanding of the interdependence of design and text is matchless. So is their care in the details of all they do.

One of the pleasures of writing books is the opportunity to acknowledge close friendships. And so this volume is dedicated to Bill and Elaine Anlyan, who have given so much more than they have received. I have tried to write this book with an ideal family in mind, one very similar to the Anlyans (including Sully, Katy, and Matthew): educated, but of different ages and, hence, varying interests in art. No matter how private and individual a pursuit of art may be, it is still best when shared with like-minded people.

AFJ, 1996

Introduction

Art and the Artist

"What is art?" Few questions provoke such heated debate and provide so few satisfactory answers. If we cannot come to any definitive conclusions, there is still quite a lot we can say. *Art* is first of all a *word*, one that acknowledges both the idea and the fact of art. Without the word, we might well ask whether art exists in the first place. The term, after all, is not found in the vocabulary of every society. Yet art is *made* everywhere. Art, therefore, is also an object, but not just any kind of object. Art is an *aesthetic object.* It is meant to be looked at and appreciated for its intrinsic value. Its special qualities set art apart, so that it is often placed away from everyday life, in museums, churches, or caves. What do we mean by aesthetic? By definition, aesthetic is "that which concerns the beautiful." Of course, not all art is beautiful to our eyes, but it is art nonetheless.

People the world over make much the same fundamental judgments. Our brains and nervous systems are the same, because, according to recent theory, we all descend from one woman in Africa who lived about a quarter-million years ago. Taste, however, is conditioned by culture, which is so varied that it is impossible to reduce art to any one set of laws. It would seem, therefore, that absolute qualities in art must elude us, and that we cannot escape viewing works of art in the context of time and circumstance, whether past or present.

Imagination

We all dream. That is imagination at work. To imagine means simply to make an image—a picture—in our minds. Human beings are not the only creatures who have imagination. Even animals dream. There is, however, a profound difference between human and animal imagination. Humans are the only creatures who can tell one another about imagination in stories or pictures. The imagination is one of our most mysterious facets. It can be regarded as the connector between the conscious and the subconscious, where most of our brain activity takes place. It is the very

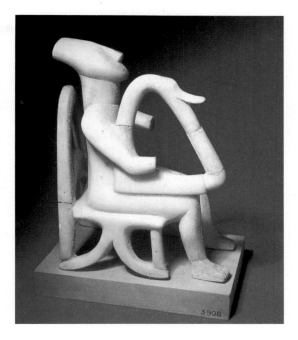

1. *Harpist,* so-called *Orpheus,* from Amorgos in the Cyclades. Latter part of the 3rd millennium B.C. Marble, height 8$1/2$" (21.6 cm). National Archaeological Museum, Athens

glue that holds our personality, intellect, and spirituality together. Because the imagination responds to all three, it acts in lawful, if unpredictable, ways that are determined by the psyche and the mind.

The imagination is important, as it allows us to conceive of all kinds of possibilities in the future and to understand the past in a way that has real survival value. It is a fundamental part of our makeup, though we share it with other creatures. By contrast, the urge to make art is unique to us. It separates us from all other creatures across an unbridgeable evolutionary gap. The ability to make art must have been acquired relatively recently in the course of evolution. Human creatures have been walking upright on Earth for some 4.4 million years, but the oldest prehistoric art that we know of was made only about 35,000 years ago. It was undoubtedly the culmination of a long development no longer traceable, since the record of the earliest art is lost to us.

Who were the first artists? In all likelihood, they were shamans, individuals believed to have divine powers of inspiration and the ability to enter the underworld of the subconscious in a deathlike trance, but, unlike ordinary mortals,

able to return to the realm of the living. Just such a figure seems to be represented by our *Harpist* (fig. 1) from about four thousand years ago. A work of unprecedented complexity for its time, it was carved by a remarkably gifted artist who makes us feel the visionary rapture of a poet as he sings his legend. With the rare ability to penetrate the unknown and to express it through art, the artist-shaman seemed to gain control over the forces hidden in human beings and nature. Even today the artist remains a magician whose work can mystify and move us—an embarrassing fact to many of us, who do not readily relinquish our rational control.

Art plays a special role in human personality. Like science and religion, art fulfills a universal urge to comprehend ourselves and the universe. This function makes art especially significant and, hence, worthy of our attention. Art has the power to reach the core of our being, which recognizes itself in the creative act. For that reason, art represents its creators' deepest understanding and highest aspirations. At the same time, artists often act as the articulators of shared beliefs and values, which they express through an ongoing tradition to us, their audience.

Creativity

What do we mean by *making*? If we concentrate on the visual arts, we might say that a work of art must be a tangible thing shaped by human hands. This definition at least eliminates the confusion of treating as works of art such natural phenomena as flowers, seashells, or sunsets. It is a far from sufficient definition, to be sure, since human beings make many things other than works of art. Still, it will serve as a starting point. Now let us look at the striking *Bull's Head* by Pablo Picasso (fig. 2), which seems to consist of nothing but the seat and handlebars of an old bicycle. How meaningful is our definition here? Of course the materials Picasso used are fabricated, but it would be absurd to insist that he must share the credit with the manufacturer, since the seat and handlebars in themselves are not works of art.

While we feel a certain jolt when we first recognize the ingredients of this visual pun, we also sense that it was a stroke of genius to put them together in this unique way, and we cannot very well deny that it is a work of art. Nevertheless, the

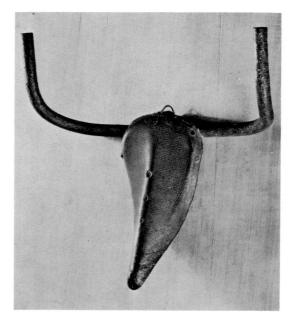

2. Pablo Picasso. *Bull's Head*. 1943. Bronze cast bicycle parts, height 16¹/₈" (41 cm). Galerie Louise Leiris, Paris

actual handiwork of mounting the seat on the handlebars is ridiculously simple. What is far from simple is the leap of the imagination by which Picasso recognized a bull's head in these unlikely objects. The leap of the imagination is sometimes experienced as a flash of inspiration, but only rarely does a new idea emerge full-blown like Athena from the head of Zeus. Instead, it is usually preceded by a long gestation period in which all the hard work is done without finding the key to the solution to the problem. At the critical point, the imagination makes connections between seemingly unrelated parts and recombines them.

Our *Bull's Head* is, of course, an ideally simple case, involving only one major connection and a manual act in response to it. Once the seat had been properly placed on the handlebars and then cast in bronze, the job was done. Ordinarily, artists do not work with ready-made parts but with materials that have little or no shape of their own. The creative process generally consists of a long series of leaps of the imagination and the artist's attempts to give them form by shaping the material accordingly. In this way, by a constant flow of impulses back and forth between the mind and the partly shaped material, the artist gradually

defines more and more of the image, until at last all of it has been given visible form. Needless to say, artistic creation is too subtle and intimate an experience to permit an exact step-by-step description. Only artists can observe it fully, but they are so absorbed by it that they have great difficulty explaining it to us.

The creative process has been likened to birth, a metaphor that comes closer to the truth than would a description cast in terms of a transfer or projection of the image from the artist's mind. The making of a work of art is both joyous and painful, and full of surprises. We have, moreover, ample testimony that artists themselves tend to look upon their creations as living things. Perhaps that is why creativity was once a concept reserved for God, as the only one who could give material form to an idea. Indeed, the artist's labors are much like the Creation told in the Bible.

This divine ability was not realized until Michelangelo, who described the anguish and glory of the creative experience when he spoke of "liberating the figure from the marble that imprisons it." We may translate this to mean that he started the process of carving a statue by trying to visualize a figure in the rough, rectilinear block as it came to him from the quarry. It seems fair to assume that at first Michelangelo did not see the figure any more clearly than one can see an unborn child inside the womb, but we may believe that he could see isolated "signs of life" within the marble. Once he started carving, every stroke of the chisel would commit him more and more to a specific conception of the figure hidden in the block, and the marble would permit him to free the figure whole only if his guess as to its shape was correct. Sometimes he did not guess well enough, and the stone refused to give up some essential part of its prisoner. Michelangelo, defeated, left the work unfinished, as he did with *Saint Matthew* (fig. 3, page 14), whose very gesture seems to record the vain struggle for liberation. Looking at the block, we may get some inkling of Michelangelo's difficulties here. But could he not have finished the statue in *some* fashion? Surely there is enough material left for that. He probably could have, but perhaps not in the way he wanted. In that case the defeat would have been even more stinging.

Clearly, then, the making of a work of art has little in common with what we ordinarily mean by "making." It is a strange and risky business in which the makers never quite know what they are making until it has actually been made: or, to put it another way, it is a game of find-and-seek in which the seekers are not fully sure what they are looking for until they have found it. In the case of the *Bull's Head* it is the bold "finding" that impresses us most; in the *Saint Matthew*, the strenuous "seeking." To the nonartist, it seems hard to believe that this uncertainty, this need to take a chance, should be the essence of the artist's work. We all tend to think of "making" in terms of artisans or manufacturers who know exactly what they want to produce from the very outset. There is thus comparatively little risk, but also little adventure, in such handiwork, which as a consequence tends to become routine. Whereas the artisan attempts only what is known to be possible, the artist is always driven to attempt the impossible, at least the improbable or unimaginable. No wonder the artist's way of working is so resistant to any set rules, while the craftsperson's encourages standardization and regularity. We acknowledge this difference when we speak of the artist as *creating* instead of merely *making* something. Clearly, then, we must be careful not to confuse the making of a work of art with manual skill or craftsmanship. Some works of art may demand a great deal of technical discipline; others do not. Even the most painstaking piece of craft does not deserve to be called a work of art unless it involves a leap of the imagination.

Needless to say, there have always been many more craftspeople than artists among us, since our need for the familiar and expected far exceeds our capacity to absorb the original but often deeply unsettling experiences we get from works of art. The urge to discover unknown realms, to achieve something original, may be felt by every one of us now and then. What sets the real artist apart is not so much the desire to *seek*, but that mysterious ability to *find*, which we call talent. We also speak of it as a "gift," implying that it is a sort of present from some higher power; or as "genius," a term which originally meant a higher power (a kind of "good demon") that inhabits and acts through the artist.

Originality and Tradition

Originality, then, ultimately distinguishes art from craft. We may say, therefore, that it is the

3. Michelangelo. *Saint Matthew* (foreground). 1506. Marble, height 8'11" (2.72 m). Galleria dell'Accademia, Florence

yardstick of artistic greatness or importance. Unfortunately, it is also very hard to define. The usual synonyms—uniqueness, novelty, freshness—do not help us very much, and the dictionaries tell us only that an original work must not be a copy. But no work of art can be entirely original. Each one is linked in a chain of relationships that arises somewhere out of the distant past and continues into the future. If it is true that "no man is an island," the same can be said of works of art. The sum total of these chains makes a web in which every work of art occupies its own specific place. We call this web *tradition*. Without tradition (the word means "that which has been handed

down to us") no originality would be possible. It provides, as it were, the firm platform from which the artist makes a leap of the imagination. The place where he or she lands will in turn become part of the web and serve as a point of departure for further leaps. And for us, too, the fabric of tradition is equally essential. Whether we are aware of it or not, tradition is the framework within which we inevitably form our opinions of works of art and assess their degree of originality.

Meaning and Style

Why do we create art? Surely one reason is an irresistible urge to adorn ourselves and to decorate the world around us. Both impulses are part of a larger desire, not to remake the world in our image but to recast ourselves and our environment in *ideal* form. Art is, however, much more than decoration, for it is laden with meaning, even if that content is sometimes slender or obscure. Art enables us to communicate our understanding in ways that cannot be expressed otherwise. Truly a painting (or any work of art) is worth a thousand words, not only in its descriptive value but also in its symbolic significance. In art, as in language, we are above all inventors of symbols that convey complex thoughts in new ways. However, we must think of art in terms not of everyday prose but of poetry, which is free to rearrange conventional vocabulary and syntax in order to convey new, often multiple, meanings and moods. A work of art likewise suggests much more than it states. It communicates partly by implying meanings through pose, facial expression, allegory, and the like. As in poetry, the value of art lies equally in what it says and how it says it.

But what is the *meaning* of art—its iconography? What is it trying to say? Artists often provide no clear explanation, since the work is the statement itself. Nonetheless, even the most private artistic statements can be understood on some level, even if only an intuitive one. The meaning, or content, of art is inseparable from its formal qualities, its *style*. The word *style* is derived from *stilus*, the writing instrument of the ancient Romans. Originally, it referred to distinctive ways of writing: the shape of the letters as well as the choice of words. In the visual arts, style means the particular way in which the forms that make up any given work of art are chosen and fitted together. To art historians the study of styles is of central importance. It not only enables them to find out, by means of careful analysis and comparison, when, where, and often by whom a given work was produced, but it also leads them to understand the artist's intention as expressed through the style of the work. This intention depends on both the artist's personality and the context of time and place. Accordingly, we speak of "period styles." Thus art, like language, requires that we learn the style and outlook of a country, period, and artist if we are to understand it properly.

Nevertheless, our faith in the very existence of period styles has been severely shaken, even though we keep referring to them as a convenient way of discussing the past. They seem to be a matter of perspective: the more remote or alien the period, the more clear-cut the period style— and the more limited our knowledge and understanding. The nearer we come to the present, the more apt we are to see diversity rather than unity. Yet we cannot deny that works of art created at the same time and in the same place do have something in common. What they share is a social and cultural environment, which must have affected artist and patron alike to some degree. We have also come to realize, however, that these environmental factors often do not influence all the arts in the same way or to the same extent. Nor can artistic developments be fully understood as direct responses to such factors. Insofar as "art comes from art," its history is directed by the force of its own traditions, which tend to resist the pressure of external events or circumstances.

Self-Expression and Audience

Many of us are familiar with the Greek myth of the sculptor Pygmalion, who carved such a beautiful statue of the nymph Galatea that he actually fell in love with it and embraced her when Venus made his sculpture come to life. The birth of a work of art is indeed an intensely private experience, so much so that many artists can work only when completely alone and refuse to show their unfinished pieces to anyone. Yet it must, as a final step, be shared by the public in order for the birth to be successful. Artists do not create merely for their own satisfaction, but want their work validated by others. In fact, the creative process is not complete until the work has found an audience.

In the end, most works of art exist in order to be liked rather than to be debated.

Perhaps we can resolve this seeming paradox once we understand what artists mean by "public." They are concerned not with *the* public as a statistical entity but with their particular public, their audience. Quality rather than wide approval is what matters to them. The audience whose approval is so important to artists is often a limited and special one. Its members may be other artists as well as patrons, friends, critics, and interested beholders. The one quality they all have in common is an informed love of works of art, an attitude at once discriminating and enthusiastic that lends particular weight to their judgments. They are, in a word, experts, people whose authority rests on experience rather than theoretical knowledge. In reality, there is no sharp break, no difference in kind, between the expert and the public at large, only a difference in degree.

Tastes

Deciding what *is* art and rating a work of art are two separate problems. If we had an absolute method for distinguishing art from non-art, it would not necessarily enable us to measure quality. People tend to compound the two problems into one. Quite often when they ask, "Why is that art?" they mean, "Why is that *good* art?" Since the experts do not post exact rules, people are apt to fall back on the defense: "Well, I don't know anything about art, but I know what I like." It is a formidable roadblock, this stock phrase, in the path of understanding. Let us examine the roadblock and the various unspoken assumptions that buttress it.

Are there really people who know nothing about art? No, for art is so much a part of the fabric of human living that we encounter it all the time, even if our contacts with it are limited to magazine covers, advertising posters, war memorials, television, and the buildings where we live, work, and worship. The statement "I know what I like" may really mean "I like what I know (and I reject whatever fails to match the things I am familiar with)." Such likes are not in truth ours at all, for they have been imposed by habit and culture without any personal choice.

Why should so many of us cherish the illusion of having made a personal choice in art when in fact we have not? There is another unspoken assumption at work here: something must be wrong with a work of art if it takes an expert to appreciate it. But if experts appreciate art more than the uninformed, why should we not emulate them? The road to expertness is clear and wide, and it invites anyone with an open mind and a capacity to absorb new experiences. As our understanding grows, we find ourselves liking a great many more things than we had thought possible at the start. We gradually acquire the courage of our own convictions, until we are able to say, with some justice, that we know what we like.

Looking at Art

The Visual Elements

We live in a sea of images conveying the culture and learning of modern civilization. Fostered by an unprecedented media explosion, this "visual background noise" has become so much a part of our daily lives that we take it for granted. In the process, we have become desensitized to art as well. Anyone can buy cheap paintings and reproductions to decorate a room, where they often hang virtually unnoticed, perhaps deservedly so. It is small wonder that we look at the art in museums with equal casualness. We pass rapidly from one object to another, sampling them like dishes in a smorgasbord. We may pause briefly before a famous masterpiece that we have been told we are supposed to admire, then ignore the gallery full of equally beautiful and important works around it. We will have seen the art but not really looked at it. Indeed, looking at great art is not an easy task, for art rarely reveals its secrets readily. While the experience of a work can be immediately electrifying, we sometimes do not realize its impact until time has let it filter through the recesses of our imaginations. It even happens that something that at first repelled or confounded us emerges only many years later as one of the most important artistic events of our lives.

Understanding a work of art begins with a sensitive appreciation of its appearance. Art may be approached and appreciated for its purely visual elements: line, color, light, composition, form, and space. These may be shared by any work of art; their effects, however, vary widely according to medium (the physical materials of

which the artwork is made) and technique, which together help determine the possibilities and limitations of what the artist can achieve. For that reason, our discussion is merged with an introduction to four major arts: graphic arts, painting, sculpture, and architecture. (The technical aspects of the major mediums are treated in separate sections within the main body of the text and in the glossary at the back of the book.) Just because line is discussed with drawing, however, does not mean that it is not equally important in painting and sculpture. And while form is introduced with sculpture, it is just as essential to painting, drawing, and architecture.

Visual analysis can help us appreciate the beauty of a masterpiece, but we must be careful not to trivialize it with a formulaic approach. Every aesthetic "law" advanced so far has proven of dubious value and usually gets in the way of our understanding. Even if a valid "law" were to be found—and none has yet been discovered—it would probably be so elementary as to prove useless in the face of art's complexity. We must also bear in mind that art appreciation is more than mere enjoyment of aesthetics. It is learning to understand the meaning (or iconography) of a work of art. Finally, let us remember that no work can be understood outside its historical context.

Line Line may be regarded as the most basic visual element. A majority of art is initially conceived in terms of contour lines, and their presence is often implied even when they are not actually used to describe form. Because children generally start out by scribbling, line is often considered the most rudimentary component of art, although as anyone knows who has watched a young child struggle to make a stick figure, drawing is by no means as easy as it seems. Line has traditionally been admired for its descriptive value, so that its expressive potential is easily overlooked, but line is capable of creating a broad range of effects.

Line drawings—as opposed to wash drawings and other works on paper that emphasize tone rather than contour—represent line in its purest form. The appreciation of drawings as works of art dates from the Renaissance, when the artist's creative genius first came to be valued and paper began to be made in quantity. Drawing style can be as personal as handwriting. In fact, the term *graphic art*, which designates drawings and prints,

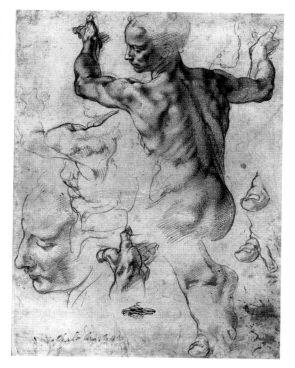

4. Michelangelo. Study for the *Libyan Sibyl*. c. 1511. Red chalk on paper, 11³/₈ x 8³/₈" (28.9 x 21.3 cm). The Metropolitan Museum of Art, New York
Purchase, Joseph Pulitzer Bequest, 1924

comes from the Greek word for writing, *graphos*. Collectors treasure drawings because they seem to reveal the artist's inspiration with unmatched freshness. Their role as records of artistic thought also makes drawings uniquely valuable to art historians, for they help in documenting the evolution of a work from its inception to the finished piece.

Artists themselves commonly treat drawings as a form of note-taking. Some of these notes are discarded as fruitless, while others are tucked away to form a storehouse of motifs and studies for later use. Once a basic idea is established, an artist may develop it into a more complete study. Michelangelo's study for the *Libyan Sibyl* (fig. 4) painted on the Sistine Chapel ceiling is a drawing of compelling beauty. For this sheet, he chose the softer medium of red chalk over the scratchy line of pen and ink that he used in rough sketches. His chalk approximates the texture of flesh and captures the play of light and dark over the nude form, giving the figure a greater sensuousness. The emphatic outline that defines each part of the form is so

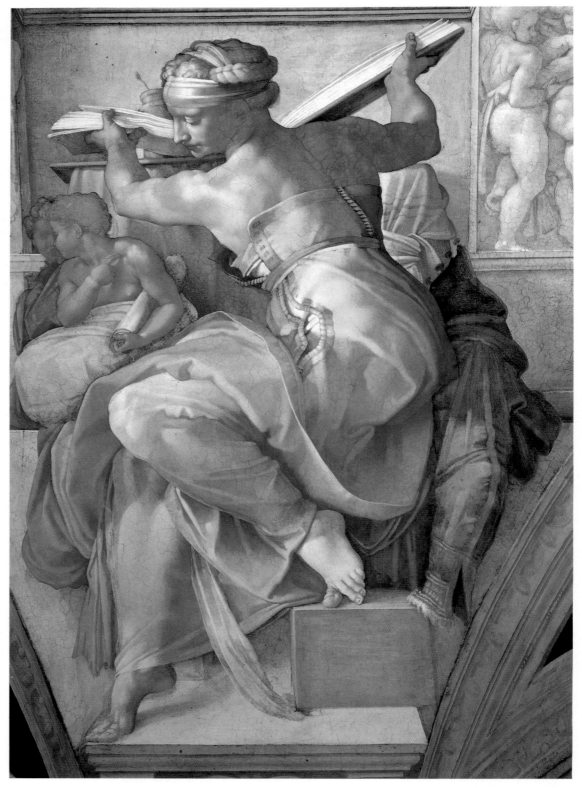

5. Michelangelo. *Libyan Sibyl*, detail of the Sistine Ceiling. 1508–12. Fresco. Sistine Chapel, The Vatican, Rome

fundamental to the conceptual genesis and design process in all of Michelangelo's paintings and drawings that ever since his time line has been closely associated with the "intellectual" side of art.

It was Michelangelo's habit to base his female figures on male nudes drawn from life. To him, only the heroic male nude possessed the physical monumentality necessary to express the awesome power of figures such as this mythical prophetess. As in other sheets like this by Michelangelo, his focus here is on the torso; he studied the musculature at length before turning his attention to details such as the hand and toes. Since there is no sign of hesitation in the pose, we can be sure that the artist already had the conception firmly in mind; probably he established it in a preliminary drawing. Why did he go to so much trouble when the finished sibyl is mostly clothed and must be viewed from a considerable distance below? Evidently Michelangelo believed that only by describing the anatomy completely could he be certain that the figure would be convincing. In the final painting (fig. 5) the sibyl communicates a superhuman strength, lifting her massive book of prophecies with the greatest ease.

Color The world around us is alive with color. Whereas color is an adjunct element to graphics and sometimes sculpture, it is indispensable to virtually all forms of painting. This is true even of tonalism, which emphasizes dark, neutral hues like gray and brown. Of all the visual elements, color is undoubtedly the most expressive, as well as the most recalcitrant. Perhaps for that reason, it has attracted the wide attention of researchers and theorists since the mid-nineteenth century. We often read that red seems to advance, while blue recedes; or that the former is a violent or passionate color, the latter a sad one. Like a recalcitrant child, however, color in art refuses to be governed by any rules. They work only when the painter consciously applies them. Moreover, the emotional effects produced by their interaction are often subtle and nearly impossible to translate into words.

Notwithstanding the large body of theory regarding color in art, its role rests primarily on its sensuous and emotive appeal, in contrast to the more cerebral quality generally associated with line. The merits of line versus color have been the subject of an ongoing debate that first arose between partisans of Michelangelo and of Titian, his great contemporary in Venice. Titian himself

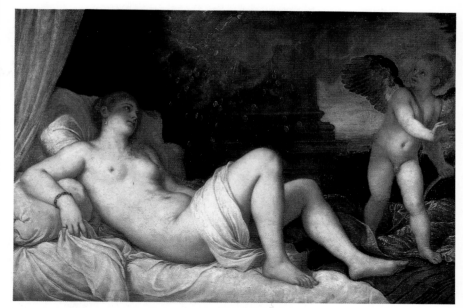

6. Titian. *Danaë*. c. 1544–46. Oil on canvas, 3'11³/₄" x 5'7³/₄" (1.20 x 1.72 m). Museo e Gallerie Nazionali di Capodimonte, Naples, Italy

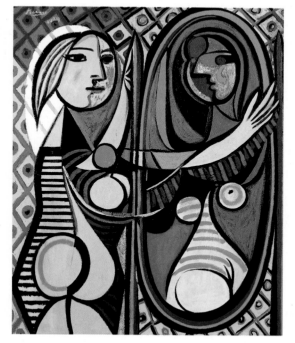

7. Pablo Picasso. *Girl before a Mirror*. March 1932. Oil on canvas, 5'4" x 4'3¹/₄" (1.63 x 1.3 m). The Museum of Modern Art, New York
Gift of Mrs. Simon Guggenheim

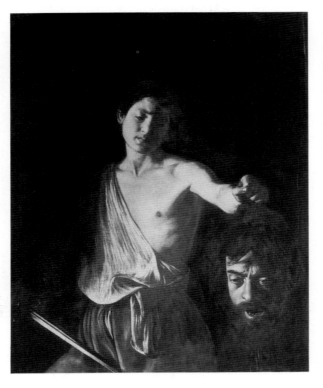

8. Caravaggio. *David with the Head of Goliath*. 1607 or 1609/10. Oil on canvas, 49¼ x 39⅜" (125.1 x 100 cm). Galleria Borghese, Rome

was a fine draftsman and absorbed the influence of Michelangelo. He nevertheless stands at the head of the coloristic tradition that descends through Rubens and van Gogh to the Abstract Expressionists of the twentieth century. *Danaë* (fig. 6, page 19), executed toward the end of Titian's long career, shows the painterly application of sonorous color that is characteristic of his style. Though he no doubt worked out the essential features of the composition in preliminary drawings, none have survived. Nor evidently did he transfer the design onto the canvas but worked directly on the surface, making numerous changes as he went along. By varying the consistency of his paints, the artist was able to capture the texture of Danaë's flesh with uncanny accuracy, while distinguishing it clearly from her drapery and bedclothes and the mysterious cloud hovering over her bed that represents Jupiter in disguise. To convey these tactile qualities, Titian built up the surface of the painting in thin coats, known as glazes. The inter-action between these layers produces unrivaled richness and complexity of color; the medium is so filmy as to become nearly translucent as the cloud trails off into the gossamer sky.

Color is so potent that it does not need a system to work its magic in art. From the heavy outlines, it is apparent that Picasso must have originally conceived *Girl before a Mirror* (fig. 7, page 19) in terms of form; yet the picture makes no sense in black and white. Picasso has treated his shapes much like the enclosed, flat panes of a stained-glass window to create a lively decorative pattern. The motif of a young woman contem-plating her beauty goes all the way back to antiq-uity (see, for example, *The Toilet of Venus* by the French Baroque artist Simon Vouet, fig. 322), but rarely has it been depicted with such disturbing overtones. Picasso's girl is anything but serene. On the contrary, her face is divided into two parts, one with a somber expression, the other with a masklike appearance whose color suggests pas-sionate feeling. She reaches out to touch the image in the mirror with a gesture of longing and apprehension. Now, we all feel a jolt when we unexpectedly see ourselves in a mirror, which often gives back a reflection that upsets our self-conception. Picasso here suggests this visionary truth in several ways. Much as a real mirror intro-duces changes of its own and does not merely give back the simple truth, so this one alters the way the girl looks, revealing a deeper reality. She seems not so much to be examining her physical appear-ance as exploring her sexuality. The mirror is a sea of conflicting emotions signified above all by the color scheme of her reflection. Framed by strong blue, purple, and green hues, her features stare back at her with fiery intensity. Clearly discernible is a tear on her cheek. But it is the masterstroke of the green spot, shining like a beacon in the middle of her forehead, that conveys the anguish of the girl's confrontation with her inner self. Picasso was no doubt aware of the theory that red and green are complementary colors which inten-sify each other. However, this "law" can hardly have dictated his choice of green to stand for the girl's psyche. That was surely determined as a matter of pictorial and expressive necessity.

Light Except for modern light installations such as laser displays, art is concerned with reflected light effects rather than with radiant light. Artists have several ways of representing radiant light. Divine light, for example, is sometimes indicated by golden rays, at other times by a halo or aura. A candle or torch may be depicted as the source of light in a dark interior or night scene. The most common method is not to show radiant light

directly but to suggest its presence through a change in the value of reflected light from dark to light. Sharp contrast (known as *chiaroscuro,* the Italian word for light-dark) is identified with the Baroque artist Caravaggio, who made it the cornerstone of his style. In *David with the Head of Goliath* (fig. 8), he employed it to heighten the drama. An intense raking light from an unseen source at the left is used to model forms and create textures. The selective highlighting endows the lifesize figure of David and the gruesome head with a startling presence. Light here serves as a device to create the convincing illusion that David is standing before us. The pictorial space, with its indeterminate depth, becomes continuous with ours, despite the fact that the frame cuts off the figure. Thus, the foreshortened arm with Goliath's head seems to extend out to the viewer from the dark background. For all its obvious theatricality, the painting is surprisingly muted: David seems to contemplate Goliath with a mixture of sadness and pity. According to contemporary sources, the severed head is a self-portrait, but although we may doubt the identification, this disturbing image communicates a tragic vision that was soon fulfilled. Not long after the David was painted, Caravaggio killed a man in a duel, which forced him to spend the rest of his short life on the run.

Composition All art requires order. Otherwise its message would emerge as visually garbled. To accomplish this, the artist must control space within the framework of a unified composition. Moreover, pictorial space must work across the picture plane, as well as behind it. Since the Early Renaissance, viewers have become accustomed to experiencing paintings as windows onto separate illusionistic realities. The Renaissance invention of one-point perspective (also called linear or scientific perspective) provided a geometric system for the convincing representation of architectural and open-air settings. By having the orthogonals (shown as diagonal lines) converge at a vanishing point on the horizon, the artist was able to gain command over every aspect of composition, including the rate of recession and placement of figures.

Artists usually dispense with aids like perspective and rely on their own eyes. This does not mean that they merely transcribe optical reality.

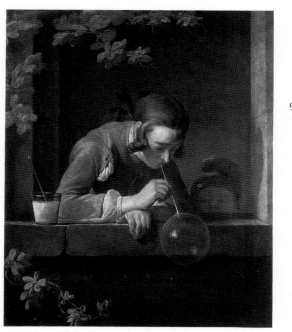

9. Jean-Baptiste-Siméon Chardin. *Blowing Bubbles.* c. 1745. Oil on canvas, 36⁵/₈ x 29³/₈" (93 x 74.6 cm). The National Gallery of Art, Washington, D.C.
Gift of Mrs. John Simpson

Blowing Bubbles by the French painter Jean-Baptiste-Siméon Chardin (fig. 9) depends in good measure on the satisfying composition for its success. The motif had been popular in earlier Dutch genre scenes, where bubbles symbolized life's brevity and, hence, the vanity of all earthly things. This meaning still resonates in Chardin's picture, however simple it at first appears. But much of its interest also lies in the sense of enchantment imparted by the children's rapt attention to the moment. We know from a contemporary source that Chardin painted the youth "carefully from life and . . . tried hard to give him an ingenuous air." The results are anything but artless, however. The triangular shape of the boy leaning on the ledge gives stability to the painting, which helps suspend the fleeting instant in time. To fill out the composition, the artist includes the toddler peering intently over the ledge at the bubble, which is about the same size as his head. Chardin has carefully thought out every aspect of his arrangement. The honeysuckle in the upper left-hand corner, for example, echoes the contour of the adolescent's back, while the two straws are virtually parallel to each other. Even the crack in the stone ledge has a purpose: to draw attention to the glass of soap by setting it slightly apart.

Often artists paint not what they see but what they imagine. Pictorial space, however, need not conform to either conceptual or visual reality. El

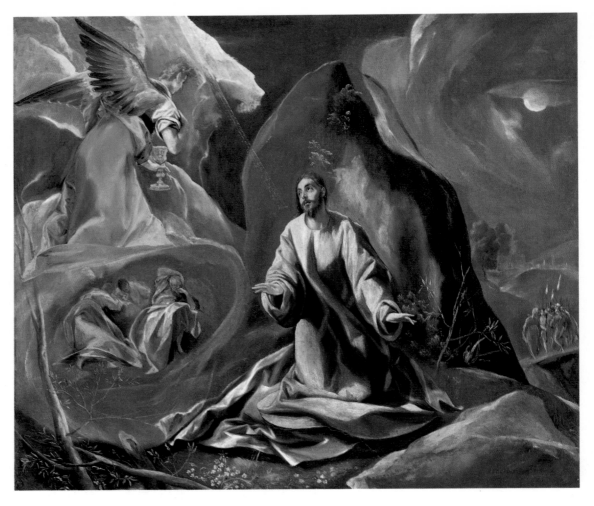

10. El Greco. *The Agony in the Garden*. 1597–1600. Oil on canvas, 40¼ x 44¾" (102.2 x 113.7 cm). The Toledo Museum of Art, Ohio

Gift of Edward Drummond Libbey

Greco's *The Agony in the Garden* (fig. 10) uses contradictory, irrational space to help conjure up a mystical vision that represents a spiritual reality. Christ, isolated against a large rock that echoes his shape, is comforted by the angel bearing a golden cup, symbol of the Passion. The angel appears to kneel on a mysterious oval cloud, which envelops the sleeping disciples. In the distance to the right we see Judas and the soldiers coming to arrest the Lord. The composition is balanced by two giant clouds on either side. The entire landscape resounds with Christ's agitation, represented by the sweep of supernatural forces. The elongated forms, eerie moonlight, and expressive colors—all hallmarks of El Greco's style—help heighten our sense of identification with Christ's suffering.

Form Every two-dimensional shape that we encounter in art is the counterpart to a three-dimensional form. There is nevertheless a vast difference between drawing or painting forms and sculpting them. The one transcribes, the other embodies them, as it were. They require fundamentally different talents and attitudes toward material as well as subject matter. Although numerous artists have been competent in both painting and sculpture, only a handful have managed to bridge the gap between them with complete success.

Sculpture is categorized according to whether it is carved or modeled and whether it is a relief or freestanding. Relief remains tied to the background, from which it only partially emerges, in contrast to freestanding sculpture, which is fully liberated from it. A further distinction is made between low (*bas*) relief and high relief, depending on how much the carving projects. However, since scale as well as depth must be taken into account, there is no single guideline, so that a third category, middle relief, is sometimes cited.

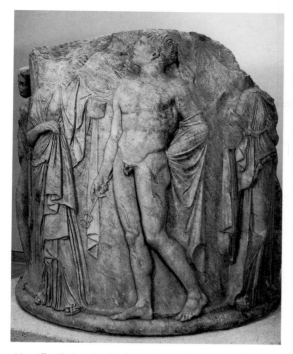

11. *Alkestis Leaving Hades.* Lower column drum from the Temple of Artemis, Ephesus. c. 340 B.C. Marble, height 5'11" (1.8 m). The British Museum, London

Low reliefs often share characteristics with painting. In Egypt, where low-relief carving attained unsurpassed subtlety, many reliefs were originally painted and included elaborate settings. High reliefs largely preclude this kind of pictorialism. The figures on a column drum from a Greek temple (fig. 11) are so detached from the background that the addition of landscape or architecture elements would have been both unnecessary and unconvincing. The neutral setting, moreover, is in keeping with the mythological subject, which occurs in an indeterminate time and place. In compensation, the sculptor has treated the limited free space atmospherically, although the figures nonetheless remain imprisoned in stone.

Freestanding sculpture—that is, sculpture that is carved or modeled fully in the round—is generally made by either of two methods. One is carving. It is a subtractive process that starts with a solid block, usually stone, which is highly resistant to the sculptor's chisel. The brittleness of stone and the difficulty of cutting it tend to result in the compact, "closed" forms evident, for example, in Michelangelo's *Saint Matthew* (see fig.

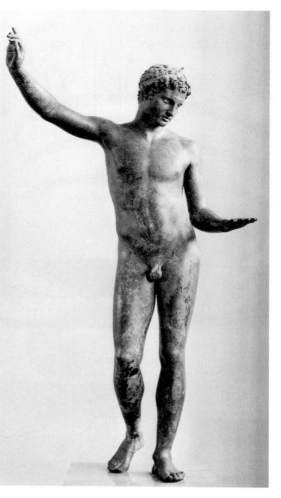

12. Praxiteles (attributed to). *Standing Youth,* found in the sea off Marathon. c. 350–325 B.C. Bronze, height 51" (129.5 cm). National Archaeological Museum, Athens

3). Modeling is the very opposite of carving. It is an additive process using soft materials such as plaster, clay, or wax. Since these materials are not very durable, they are usually cast in a more lasting medium: anything that can be poured, including molten metal, cement, even plastic. Modeling encourages "open" forms created with the aid of metal armatures to support their extension into space. This technique and the development of lightweight hollow-bronze casting enabled the Greeks to experiment with daring poses in monumental sculpture before attempting them in marble. In contrast to the figure of Hades on the column drum (see fig. 11), the bronze *Standing Youth* (fig. 12) is free to move about, which lends him a lifelike presence that is

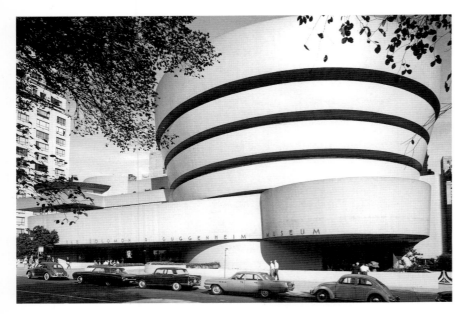

13. Frank Lloyd Wright. Solomon R. Guggenheim Museum, New York. 1956–59

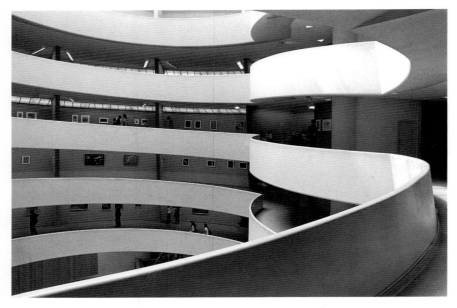

14. Interior, Solomon R. Guggenheim Museum

Space Architecture is the principal means of organizing space. Of all the arts, it is also the most practical. The parameters of architecture are defined by utilitarian function and structural system, but there is almost always an aesthetic component as well, even when it consists of nothing more than a decorative veneer. A building proclaims the architect's concerns by the way in which these elements are woven into a coherent program.

Architecture becomes memorable only when it expresses a transcendent vision, whether personal, social, or spiritual. Such buildings are almost always important public places that require the marshaling of significant resources and serve the purpose of bringing people together to share goals, pursuits, and values. An extreme case is the Solomon R. Guggenheim Museum in New York by Frank Lloyd Wright. Scorned when it was erected in the late 1950s, it is a brilliant, if idiosyncratic, creation by one of the most original architectural minds of the century. The sculptural exterior (fig. 13) announces that this is a museum, for it is self-consciously a work of art in its own right. As a piece of design, the Guggenheim Museum is remarkably willful. In shape it is as defiantly individual as the architect himself and refuses to conform to the boxlike apartments around it. From the outside, the structure looks like a gigantic snail, reflecting Wright's interest in organic shapes. The office area forming the "head" (to the left in our photograph) is connected by a narrow passageway to the "shell" containing the main body of the museum.

The outside gives us some idea of what to expect inside (fig. 14), yet nothing quite prepares us for the extraordinary sensation of light and air in the main hall after we have been ushered through the unassuming entrance. The radical design makes it clear that Wright had completely rethought the purpose of an art museum. The exhibition area is a kind of inverted dome with a huge glass-covered eye at the top. The vast, fluid space creates an atmosphere of quiet harmony while actively shaping our experience by determining how art shall be displayed. After taking an elevator to the top of the building, we begin a leisurely descent down the gently sloping ramp. The continuous spiral provides for uninterrupted viewing, conducive to studying art. At the same time, the narrow confines of the galleries prevent

further enhanced by his dancing pose. His inlaid eyes and soft patina, accentuated by oxidation and corrosion (he was found in the Aegean Sea off the coast of Marathon), make him even more credible in a way that marble statues, with their seemingly cold and smooth finish, rarely equal, despite their more natural color.

us from becoming passive observers by forcing us into a direct confrontation with the works of art. Sculpture takes on a heightened physical presence which demands that we look at it. Even paintings acquire a new prominence by protruding slightly from the curved walls, instead of receding into them. Viewing exhibitions at the Guggenheim is like being conducted through a predetermined stream of consciousness, where everything merges into a total unity. Whether one agrees with this approach or not, the building testifies to the strength of Wright's vision by precluding any other way of seeing the art.

Meaning

Art has been called a visual dialogue, for though the object itself is mute, it expresses its creator's intention just as surely as if the artist were speaking to us. For there to be a dialogue, however, our active participation is required. Although we cannot literally talk to a work of art, we can learn how to respond to it and question it in order to try to fathom its meaning, despite what are sometimes enormous cultural barriers. Finding the right answers usually involves asking the right questions. Even if we aren't sure which questions to ask, we can always start with, "What would happen if the artist had done it another way?" And when we are through, we must question our explanation according to the same test of adequate proof that applies to any investigation: have we taken into account *all* the available evidence, and arranged it in a logical and coherent way? There is, alas, no step-by-step method to guide us, but this does not mean the process is entirely mysterious. We can illustrate it by looking at some examples together. The demonstration will help us gain courage to try the same analysis the next time we enter a museum.

The great Dutch painter Jan Vermeer has been called the Sphinx of Delft, and with good reason, for all his paintings have a degree of mystery. In *Woman Holding a Balance* (fig. 15, page 26), a young woman, richly dressed in at-home wear of the day and with strings of pearls and gold coins spread out on the table before her, is contemplating a balance in her hand. The canvas is painted entirely in gradations of cool, neutral tones, except for a bit of the red dress visible beneath her jacket. The soft light from the partly open window is concentrated on her face and the cap framing it. Other beads of light reflect from the pearls and her right hand. The serene atmosphere is sustained throughout the stable composition. Vermeer places us at an intimate distance within the relatively shallow space, which has been molded around the figure. The underlying grid of horizontals and verticals is modulated by the gentle curves of the woman's form and the heap of blue drapery, as well as by the oblique angles of the mirror. The design is so perfect that we cannot move a single element without upsetting the delicate balance.

The composition is controlled in part by perspective. The vanishing point of the diagonals formed by the top of the mirror and the right side of the table lies at the juncture of the woman's little finger and the picture frame. If we look carefully at the bottom of the frame, we see that it is actually lower on the right than on the left, where it lies just below her hand. The effect is so carefully calculated that the artist must have wanted to guide our eye to the painting in the background. Though difficult to read at first, it depicts Christ at the Last Judgment, when every soul is weighed. The parallel of this subject to the woman's activity tells us that, contrary to our initial impression, this cannot be simply a scene of everyday life. The painting, then, is testimony to the artist's faith, for he was a Catholic living in Protestant Holland, where his religion was officially banned, although worship in private houses was tolerated.

The meaning is nevertheless far from clear. Because Vermeer treated forms as beads of light, it was assumed until recently that the balance holds items of jewelry and that the woman is weighing the worthlessness of earthly possessions in the face of death; hence, the painting was generally called *The Pearl Weigher* or *The Gold Weigher*. If we look closely, however, we can see that the pans contain nothing. This is confirmed by infra-red photography, which also reveals that Vermeer changed the position of the balance: to make the composition more harmonious, he placed it parallel to the picture plane instead of allowing it to recede into space.

What, then, is she doing? If she is weighing temporal against spiritual values, it can be only in a symbolic sense, because nothing about the figure or the setting betrays a sense of conflict.

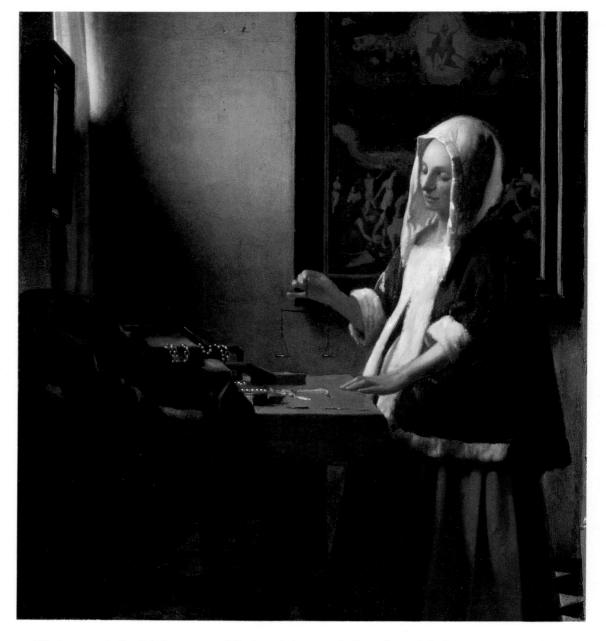

15. Jan Vermeer. *Woman Holding a Balance.* c. 1664. Oil on canvas, 16³/₄ x 15" (42.5 x 38.1 cm). The National Galley of Art, Washington, D.C.
Widener Collection, 1942

What accounts for this inner peace? Perhaps it is self-knowledge, symbolized here by the mirror. It may also be the promise of salvation through her faith. In *Woman Holding a Balance,* as in Caravaggio's *The Calling of Saint Matthew* (see fig. 284), light might therefore serve not only to illuminate the scene but also to represent religious revelation. In the end, we cannot be sure, because Vermeer's approach to his subject proves as subtle as his pictorial treatment. He avoids any anecdote or symbolism that might limit us to a single interpretation. There can be no doubt, however, about his fascination with light. Vermeer's mastery of light's expressive qualities elevates his concern for the reality of appearance to the level of poetry and subsumes its visual and symbolic possibilities. Here, then, we have found the real "meaning" of Vermeer's art.

The ambiguity in *Woman Holding a Balance* serves to heighten our interest and pleasure, while

the carefully organized composition expresses the artist's underlying concept with singular clarity. But what are we to do when a work deliberately seems devoid of ostensible meaning? Modern artists can pose a gap between their intentions and the viewer's understanding. The gap is, however, often more apparent than real, for the meaning is usually intelligible to the imagination at some level. Still, we feel we must comprehend intellectually what we perceive intuitively. We can partially solve the personal code in Jasper Johns' *Target with Four Faces* (fig. 16) by treating it somewhat like a rebus. Where did he begin? Surely with the target, which stands alone as an object, unlike the long box at the top, particularly when its hinged door is closed. Why a target in the first place? The size, texture, and colors inform us that this is not to be interpreted as a real target. The design is nevertheless attractive in its own right, and Johns must have chosen it for that reason. When the wooden door is up, the assemblage is transformed from a neutral into a loaded image, bringing out the nascent connotations of the target. Johns has used the same plaster cast four times, which lends the faces a curious anonymity. He then cut them off at the eyes, "the windows of the soul," rendering them even more enigmatic. Finally, he crammed them into their compartments, so that they seem to press urgently out toward us. The results are disquieting, aesthetically as well as expressively.

Something so disturbing cannot be without significance. We may be reminded of prisoners trying to look out from small cell windows, or perhaps "blindfolded" targets of execution. Whatever our impression, the claustrophobic image radiates an aura of menacing danger. Unlike Picasso's joining of a bicycle seat and handlebars to form a bull's head, *Target with Four Faces* combines two disparate components in an open conflict that we cannot reconcile, no matter how hard we try. The intrusion of this ominous meaning creates an extraordinary tension with the dispassionate investigation of the target's formal qualities.

How can one be certain? After all, this is merely our personal interpretation, so we turn to the critics for help. We find them divided about the meaning of *Target with Four Faces,* although they agree it must have one. Johns, on the other hand, has insisted that there is none! Whom are we to be-

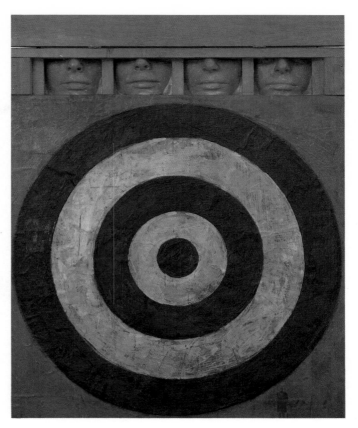

16. Jasper Johns. *Target with Four Faces.* 1955. Assemblage: encaustic on newspaper and cloth over canvas, 26 x 26" (66 x 66 cm), surmounted by four tinted plaster faces in wood box with hinged front. Box, closed $3^3/4$ x 26 x $3^1/2$" (9.5 x 66 x 8.9 cm); overall dimensions with box open, $33^5/8$ x 26 x 3" (85.4 x 66 x 7.6 cm). The Museum of Modern Art, New York.
Gift of Mr. and Mrs. Robert C. Scull

lieve, the critics or the artist himself? The more we think about it, the more likely it seems that both sides may be right. Artists are not always aware of why they have made a work. That does not mean there were no reasons, only that they were unconscious ones. Under these circumstances, critics may well know artists' minds better than the artists do and may therefore explain their creations more clearly. We can now understand that to Johns his leap of imagination in *Target with Four Faces* remains as mysterious as it first seemed to us. Our account reconciles the artist's aesthetic concerns and the critics' search for meaning, and while we realize that no ultimate solution is possible, we have arrived at a satisfactory explanation by looking and thinking for ourselves.

Part One
The Ancient World

Art history is more than a stream of art objects created over time. It is intimately related to history itself, that is, to the recorded evidence of human events. For that reason, we must consider the *concept* of history, which, we are often told, begins with the invention of writing some 5,000 years ago. And indeed, the development of a system of writing was an early accomplishment of the "historic" civilizations of Mesopotamia and Egypt. Without writing, civilization as we know it would be impossible. We do not know the earliest phases of its development, but writing must have been several hundred years in the making—between 3300 and 3000 B.C., roughly speaking, with Mesopotamia in the lead—after the new societies there had already emerged. Thus, "history" was well under way by the time writing could be used to record events.

The invention of writing makes a convenient landmark, for the absence of written records is a key difference between prehistoric and historic societies. But as soon as we ask why this is so, we face some intriguing problems. First of all, how valid is the distinction between prehistoric and historic periods? Does the distinction we make merely reflect a difference in our *knowledge* of the past? (Because of the invention of writing, we know a great deal

more about history than about prehistory.) Or was there a genuine change in the way things happened—and in the kinds of things that happened—after history began? Obviously, prehistory was far from uneventful. Yet changes in the human condition before this landmark, decisive though they are, seem incredibly slow-paced and gradual when measured against the events of the last 5,000 years. The beginning of history, then, means a sudden increase in the speed of events, a shifting from low gear into high gear, as it were. It also means a change in the *kinds* of events. Historic societies quite literally make history. They not only bring forth "great individuals and great deeds"—to cite one traditional definition—by demanding human effort on a large scale, but they make these achievements *memorable* as well. And for an event to be memorable, it must be more than "worth remembering"; it must also be accomplished quickly enough to be grasped by human memory, not spread over many centuries. Collectively, memorable events have caused the ever-quickening pace of change during the past five millenniums, which begin with what we call the ancient world.

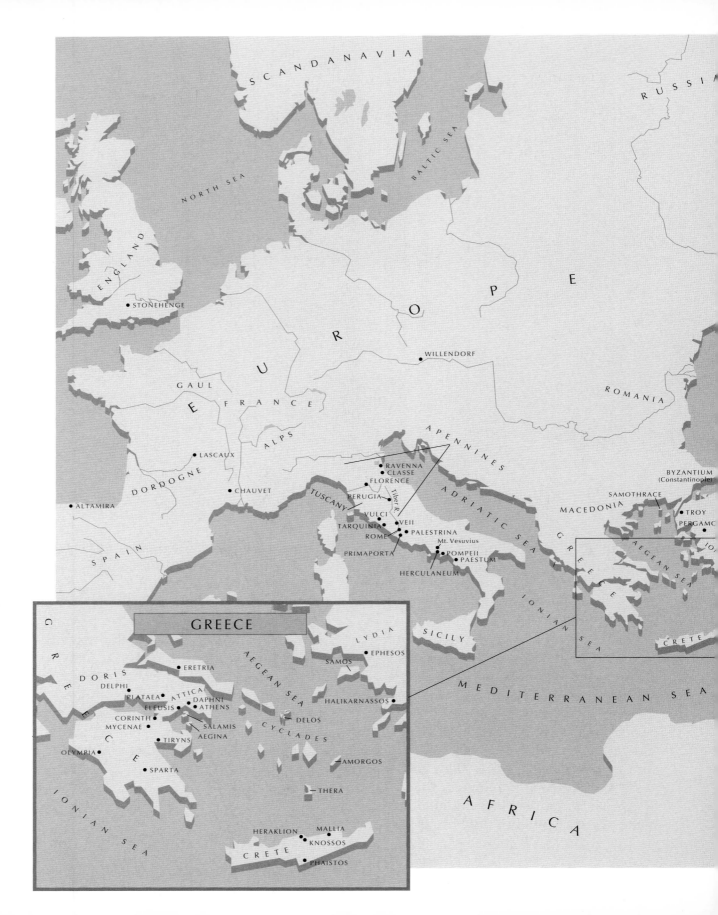

SCANDANAVIA

RUSSIA

NORTH SEA

BALTIC SEA

ENGLAND

E U R O P E

• STONEHENGE

GAUL

• WILLENDORF

FRANCE

ROMANIA

ALPS

APENNINES

• LASCAUX

• RAVENNA
• CLASSE
• FLORENCE

BYZANTIUM
(Constantinople)

DORDOGNE

• CHAUVET

TUSCANY

ADRIATIC SEA

MACEDONIA

SAMOTHRACE

• TROY

PERUGIA
Tiber R.

• ALTAMIRA

• VULCI

PERGAMON

• VEII

TARQUINIA
ROME

• PALESTRINA

G R E E C E

AEGEAN SEA

SPAIN

Mt. Vesuvius

PRIMAPORTA

• POMPEII
• PAESTUM

CRETE

HERCULANEUM

IONIAN SEA

SICILY

MEDITERRANEAN SEA

GREECE

G
R
E
E
C
E

LYDIA

DORIS

• ERETRIA

AEGEAN SEA

SAMOS

• EPHESOS

DELPHI

PLATAEA
ELEUSIS

ATTICA
DAPHNI
• ATHENS

HALIKARNASSOS

CORINTH
MYCENAE

SALAMIS
AEGINA

• DELOS

TIRYNS

CYCLADES

OLYMPIA •

• SPARTA

AMORGOS

IONIAN SEA

THERA

AFRICA

HERAKLION

MALLIA

KNOSSOS

CRETE

PHAISTOS

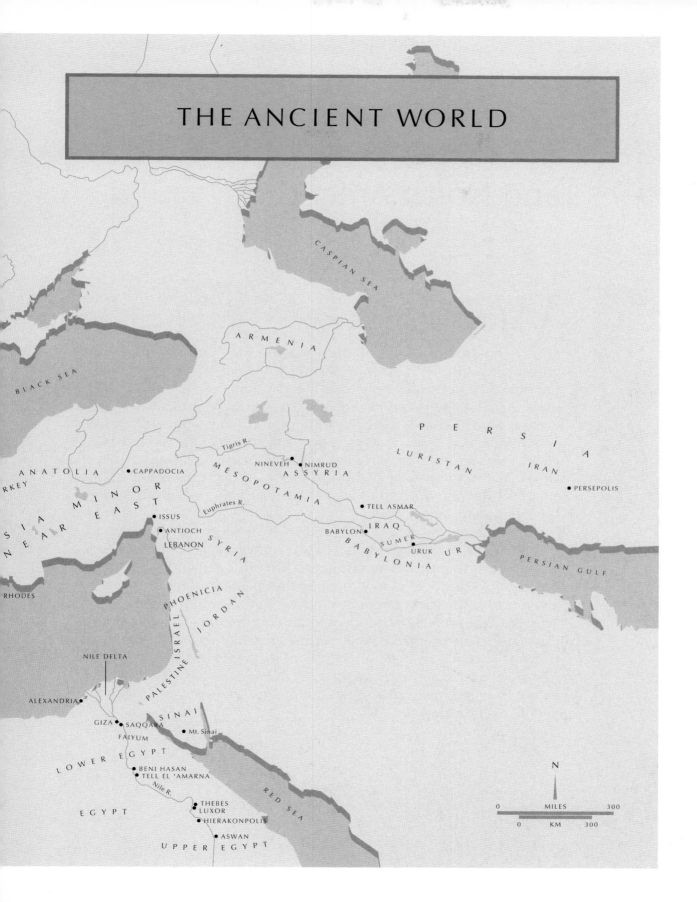

THE ANCIENT WORLD

CASPIAN SEA

ARMENIA

BLACK SEA

PERSIA

Tigris R.

ANATOLIA CAPPADOCIA NINEVEH NIMRUD LURISTAN IRAN

MESOPOTAMIA ASSYRIA PERSEPOLIS

RKEY

ASIA MINOR Euphrates R. TELL ASMAR

NEAR EAST ISSUS IRAQ

ANTIOCH BABYLON SUMER

LEBANON SYRIA BABYLONIA URUK UR

PERSIAN GULF

RHODES PHOENICIA

JORDAN

NILE DELTA PALESTINE ISRAEL

ALEXANDRIA SINAI

GIZA SAQQARA

FAIYUM Mt. Sinai

LOWER EGYPT N

BENI HASAN RED SEA

TELL EL 'AMARNA

Nile R. 0 MILES 300

EGYPT THEBES 0 KM 300

LUXOR

HIERAKONPOLIS

ASWAN

UPPER EGYPT

Prehistoric Art in Europe and North America

When did human beings start creating works of art? What prompted them to do so? What did these earliest works of art look like? Every history of art must begin with these questions—and with the admission that we cannot answer them. Our earliest known ancestors began to walk on two feet about 4 million years ago, but how they were using their hands remains unknown to us. Not until more than 2 million years later do we meet the earliest evidence of tool-making. Humans must have been *using* tools all along, however. After all, apes will pick up a stick to knock down a fruit or a stone to throw at an enemy. The *making* of tools is a more complex matter. It demands first of all the ability to think of sticks or stones as "fruit knockers" or "bone crackers," not only when they are needed for such purposes but at other times as well.

Once our ancestors were able to think that way, they gradually discovered that some sticks or stones had a handier shape than other ones, and they put them aside for future use. They selected and "appointed" certain sticks or stones as tools because they had begun to connect *form* and *function*. The sticks have not survived, but a few of the stones have. They are large pebbles or chunks of rock that show the marks of repeated use for the same operation, whatever that may have been. The next step was to try chipping away at these tools-by-appointment in order to improve their shape. This is the first craft of which we have evidence, and with it we enter a phase of human development known as the Paleolithic period, or Old Stone Age.

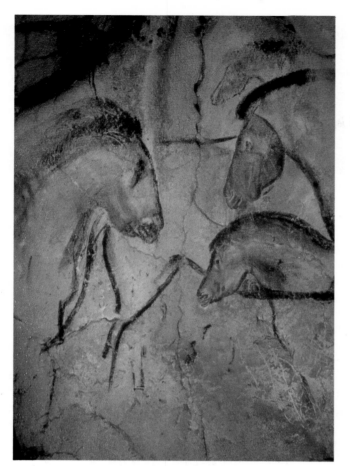

17. Cave paintings, Chauvet cave, Vallon-pont-d'Arc, Ardèche gorge, France. c. 28,000 B.C.

This 30,000-year-old image of an owl in Chauvet cave was made by pressing a flat-ended tool of some kind into the soft limestone surface of the cave wall, a process called incising. Most prehistoric incising produced chiseled lines that are narrower than those of this owl, but the process is the same.

The Old Stone Age

At the time of the last Ice Age in Europe, from about 70,000 to 8000 B.C., the climate between the Alps and Scandinavia resembled that of present-day Siberia or Alaska. (There had been at least three previous ice ages, alternating with periods of subtropical warmth, at intervals of about 25,000 years.) Huge herds of reindeer and other large herbivores roamed the plains and valleys and were preyed upon by the ferocious ancestors of today's lions and tigers, as well as by humans.

Cave Art

These people liked to live in caves or in the shelter of overhanging rocks wherever they could find them. Many such sites have been discovered, mostly in Spain and in southern France.

Chauvet The most striking works of Paleolithic art are the images of animals **incised** (cut into the stone), painted, or carved on the rock surfaces of caves. In the recently discovered Chauvet cave in southeastern France, we meet the earliest works of art known to us: paintings dating from about 30,000 years ago, near the dawn of the Paleolithic. Ferocious panthers, lions, rhinos, bears, and mammoths are depicted with extraordinary vividness, along with bison, bulls, horses, birds, and human handprints. These paintings already show an assurance and refinement far removed from any humble beginnings. The vivid, lifelike image of horses (fig. 17) amazes us not only by the keen observation and the confident, vigorous outlines but perhaps even more by the power and expressiveness of these creatures. Unless we are to believe that images such as this came into being in a single, sudden burst, we must assume that they were preceded by thousands of years of development about which we know nothing at all.

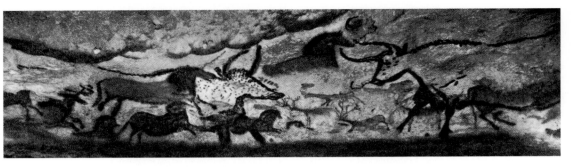

18. Cave paintings, Lascaux, Dordogne, France. c. 15,000–10,000 B.C.

Lascaux At Lascaux, in the Dordogne region of France, bison, deer, horses, and cattle race, as they do at Chauvet, across walls and ceiling in wild profusion (fig. 18). Some of them are simply outlined in black and others are filled in with bright earth colors, but all show the same uncanny sense of life. No less important, the style remains essentially the same as that at Chauvet, despite the gap of thousands of years—testimony to the remarkable stability of Paleolithic culture. Gone from Lascaux, as from all later cave paintings, however, are the fiercest of beasts.

How did this extraordinary art happen to survive intact over so many thousands of years? The question can be answered easily enough. The pictures never occur near the mouth of a cave, where they would be open to easy view and destruction, but are found only in the darkest recesses, as far from the entrance as possible (fig. 19). Some can be reached only by crawling on hands and knees, and the route is so intricate that one would soon get lost without an expert guide. In fact, the cave at Lascaux was discovered purely by chance in 1940 by some neighborhood boys whose dog fell into a hole that led to the underground chamber.

What purpose did these images serve? Hidden underground to protect them from the casual intruder, they must have been considered far more serious than decoration. There can be little doubt that they were produced as part of a magic ritual. But what kind? The traditional explanation is that their origin lies in hunting magic. According to this theory, in "killing" the image of an animal, people of the Old Stone Age thought they had killed its vital spirit; this custom seems later to have evolved into fertility magic, also practiced deep within the caves.

But how are we to account for the presence at Chauvet of lions and other dangerous creatures that we know were not hunted? Perhaps initially the people using the cave assumed the identity of lions and bears to aid in the hunt. Although it cannot be disproved, this suggestion is not completely satisfying. In addition to being highly speculative, it fails to explain many curious features of cave art. There is a growing consensus that cave paintings must incorporate a very early form of religion. If so, the creatures found in them embody a spiritual meaning that makes them the distant ancestors of the animal divinities and their half-human cousins we shall meet throughout the Near East and the Aegean. Indeed, how else are we to account for the emergence of these later figures? Moreover, such a hypothesis accords as well with the belief that nature is filled with spirits, which was universal in the isolated preliterate societies that survived intact until recently.

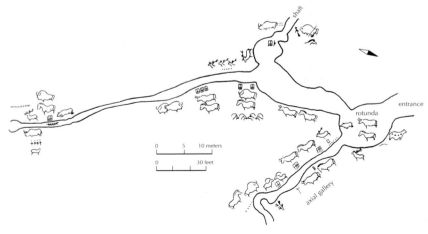

19. Plan of Lascaux caves

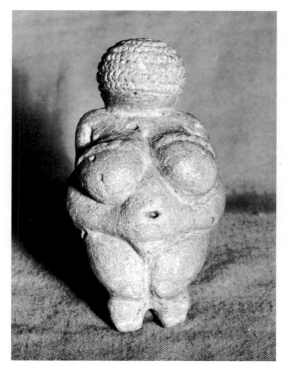

20. *Woman of Willendorf*, from Austria.
c. 25,000–20,000 B.C. Limestone, height 4 3/8"
(11.1 cm). Naturhistorisches Museum, Vienna

Portable Objects

Besides large-scale cave art, the people of the Upper Paleolithic era—the period of roughly 40,000– 8000 B.C.—also produced small, hand-size drawings, carvings, and beads in bone, horn, and stone, skillfully cut by flint tools. Some of these carvings suggest that the objects may have originated with the recognition and elaboration of a chance resemblance to something of importance to the carvers. Earlier Stone Age people, it seems, collected pebbles in whose natural shape they saw something that rendered them "magic." Echoes of this approach can sometimes be felt in later, more fully worked pieces. The *Woman of Willendorf* (fig. 20), one of many such female figurines, has a bulbous roundness of form that recalls an egg-shaped "sacred pebble." Her navel, the central point of the design, is a natural cavity in the stone. She and like carvings are often considered fertility figures, based on the spiritual beliefs of "preliterate" societies of modern times, but although the idea is tempting, we cannot be certain that such parallels existed in the Old Stone Age.

The New Stone Age

The art of the Old Stone Age in Europe as we know it today marks the highest achievements of a way of life that began to decline soon afterward. Adapted almost perfectly to the special conditions of the receding Ice Age, that way of life could not survive beyond then. What brought the Old Stone Age to a close has been termed the Neolithic Revolution. And a revolution it was indeed, although its course extended over several thousand years. It began in the Near East—an area encompassing the modern countries of Turkey, Iraq, Iran, Jordan, Israel, Lebanon, and Syria—sometime about 8000 B.C., with the first successful attempts to domesticate animals and food grains. Domestication of food sources was one of the truly epoch-making achievements of human history. People in Paleolithic societies had led the unsettled life of the hunter and food gatherer, reaping where nature sowed and at the mercy of forces that they could neither understand nor control. But now, having learned how to assure a food supply by their own efforts, they settled down in permanent village communities. A new discipline and order also entered their lives.

There is, then, a very basic difference between the New Stone Age, or Neolithic period, and the Old Stone Age, or Paleolithic period, despite the fact that people still depended on stone as the material of their main tools and weapons. Long before the earliest appearance of metals, the new mode of life brought forth a number of important utilitarian inventions and the techniques for making them: pottery, weaving, and spinning, as well as basic methods of construction in wood, brick, and stone.

We know of these beginnings from the tangible remains of Neolithic settlements that have been uncovered by excavation. Unfortunately, these remains tell us very little, as a rule, about the spiritual condition of Neolithic culture. They include stone implements of ever greater technical refinement and beauty of shape, as well as a seemingly infinite variety of clay vessels

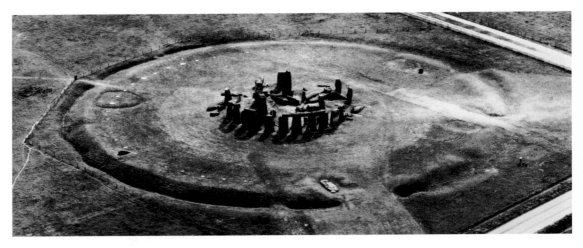

21. Stonehenge, Salisbury Plain, Wiltshire, England. c. 2000 B.C. Diameter of circle 97' (29.6 m)

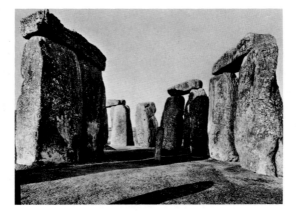

22. Stonehenge

covered with abstract ornamental patterns, but hardly anything is comparable to the painting and sculpture of the Paleolithic. Nevertheless, the changeover from hunting to husbandry must have been accompanied by profound changes in the people's view of themselves and the world, and it seems impossible that these transformations did not find expression in art. There may be a vast chapter in the development of art that is largely lost to us simply because Neolithic artists worked in wood or other impermanent materials. Or perhaps new excavations in the future will help fill the gap.

One exception to this generalization is the great stone circle at Stonehenge in southern England (figs. 21, 22), the best preserved of several such megalithic, or large stone, monu-ments. Its purpose was religious. Apparently the sustained effort required to build Stonehenge could be compelled only by faith—faith that almost literally demanded the moving of mountains. The entire structure is oriented toward the exact point where the sun rises on the longest day of the year, and therefore it most likely served a sun-worshiping ritual. Even today, Stonehenge has an awe-inspiring, super-human quality, as if it were the work of giants.

Whether a monument such as Stonehenge should be classified as architecture is a matter of definition. Nowadays, we tend to think of architecture in terms of enclosed interiors, but we also have landscape architects, who design gardens, parks, and playgrounds. Nor would we want to deny the status of architecture to open-air theaters or sports stadiums. To the ancient Greeks, who coined the term, *architecture* meant something higher (*archi-*) than ordinary build-ing (*tecture*), much as an archbishop ranks above a bishop. Thus, architecture is a structure dis-tinguished from the practical, everyday kind by its scale, order, permanence, or solemnity of purpose. A Greek would certainly have acknowl-edged Stonehenge as architecture. We, too, shall have no difficulty in doing so once we under-stand that it is not necessary to *enclose* space in order to define or articulate it. If architecture is "the art of shaping space to human needs and aspirations," then Stonehenge more than meets the test.

23. Great Serpent Mound, Adams County, Ohio. c. 600 B.C.–A.D. 200

Neolithic North America

The "earth art" of the prehistoric peoples of North America, the so-called Mound Builders, is comparable to the megalithic monuments of Europe in the effort involved in building them. The term *earth art* is misleading, since these mounds vary greatly in shape and purpose as well as in date, ranging from about 2000 B.C. to the time of the Europeans' arrival in the late fifteenth century A.D. Of particular interest are the "effigy mounds" in the shape of animals, presumably the totems, or symbolic representatives, of the peoples who produced them. The most spectacular is Great Serpent Mound (fig. 23), a raised-earth snake some 1,400 feet long that slithers along the crest of a ridge by a small river in southern Ohio. The huge head, its center marked by a heap of stones that may once have been an altar, occupies the highest point. Evidently, it was the natural formation of the terrain that inspired this extraordinary work of landscape architecture, as mysterious and moving in its way as Stonehenge.

Chapter 2
Egyptian Art

The road from hunting to husbandry is long and arduous. The problems and pressures faced by historic societies are very different from those that confronted peoples in the Paleolithic or Neolithic eras. Prehistory was a phase of evolution during which humans learned how to maintain themselves against a hostile environment. Their achievements were responses to threats of physical extinction. With the domestication of animals and edible plants, people won a decisive victory in this battle, assuring our survival on this planet. But the Neolithic Revolution placed us on a level at which we might well have remained indefinitely: the forces of nature—at least during that geological era—would never again challenge men and women as they had Paleolithic peoples.

In a few places, however, the Neolithic balance between humans and nature was upset by a new threat, posed not by nature but by people themselves, so that they began to build fortifications. What was the source of the human conflict that made these defenses necessary? Competition for grazing land among groups of herders or for arable soil among farming communities? The basic cause, we suspect, was that the Neolithic Revolution had been *too* successful, permitting population groups to grow beyond the available food supply. This situation might have been resolved in a number of ways. Constant warfare could have reduced the population; or the people could have united in larger and more disciplined social units for the sake of ambitious group efforts that no loosely organized society would have been able to achieve. Such conflicts generated enough pressure to produce a new kind of society, very much more complex and efficient than had ever existed before.

From Prehistoric to Historic

First in Egypt and ▼MESOPOTAMIA and somewhat later in neighboring areas, as well as in the INDUS VALLEY in India and along the YELLOW RIVER in China, people were to live in a more dynamic world, where their capacity to survive was challenged not only by the forces of nature but also by human forces—by tensions and conflicts arising either within society or as the result of competition between societies. These efforts to cope with human environment have proved a far greater challenge than the earlier struggle with nature. They also spurred the development of new technologies—the first in human history—in what we designate the Bronze Age and the Iron Age. Like the Neolithic, the Bronze and Iron ages are not distinct eras but stages. People first began to cast bronze, an alloy of copper and tin, in the Middle East around 3500 B.C., the same time when the earliest cities arose in Egypt and Mesopotamia. The smelting and forging of iron was invented about 2,000–1,500 B.C. by the Hittites, an ▼INDO-EUROPEAN-speaking people who settled in Cappadocia (today's east central Turkey), a high plateau with abundant copper and iron ore. Indeed, it was the competition for mineral resources that helped create the conflicts that beset civilizations everywhere.

The Old Kingdom

Egyptian civilization has long been regarded as the most rigid and conservative ever. The fourth-century B.C. Greek philosopher Plato said that Egyptian art had not changed in 10,000 years. Perhaps "enduring" and "continuous" are better descriptions of it, although at first glance all Egyptian art between 3000 and 500 B.C. does tend to have a certain sameness. In fact, the basic model of Egyptian institutions, beliefs, and artistic ideas was formed during the first few centuries of that vast span of time and kept reasserting itself until the very end. We shall see, however, that over the years this pattern went through ever more severe crises that challenged its ability to survive. Had

it been as inflexible as some suppose, it would have succumbed long before it finally did. Egyptian art alternates between conservatism and innovation but is never static. Some of its great achievements had a decisive influence on Greek and Roman art, and thus we can see how Western art is still linked to the Egypt of 5,000 years ago by a continuous, living tradition.

Dynasties

The history of Egypt is divided into dynasties, or families, of rulers, in accordance with ancient Egyptian practice, beginning with Dynasty 1, shortly after 3000 B.C. (The dates of the earliest rulers are difficult to pin down exactly in our calendar; the dating system used in this book is that of French Egyptologist Nicolas Grimal.) The transition from prehistory to Dynasty 1 is referred to as the Predynastic period. The next major period, known as the Old Kingdom, lasted from about 2700 B.C. until about 2190 B.C., with the end of Dynasty 6. This method of counting historic time by dynasties conveys at once the strong Egyptian sense of continuity and the overwhelming importance of the pharaoh (king), who was not only the supreme ruler but was also revered as a god. The pharaoh transcended all people, for his kingship was not a duty or privilege derived from a superhuman source but was absolute, divine. This belief remained the key feature of Egyptian civilization and largely determined the character of Egyptian art. We do not know exactly the steps by which the early pharaohs established their claim to divinity, but we do know their historic achievements: molding the Nile Valley from the First Cataract (falls) at Aswan to the Delta into a single, effective state and increasing its fertility by regulating the river waters through dams and canals.

Tombs and Religion

Of the vast public works along the Nile nothing remains today, and very little has survived of ancient Egyptian palaces and cities. Our knowledge of early Egyptian civilization rests almost entirely on tombs and their contents. Their

▼ Apparently independent of one another, the earliest civilizations arose in four places, beginning after 4000 B.C. Egyptian civilization is found in the northeast corner of the continent of Africa, nourished by the Nile River. MESOPOTAMIA is the area encompassed by present-day Iraq, Iran, eastern Turkey, and the deserts of Syria drained by the Tigris and Euphrates rivers. In roughly what is Pakistan today, drained by the Indus River, were the INDUS VALLEY civilizations, and in west-central China, civilizations arose along the YELLOW RIVER.

▼ INDO-EUROPEAN describes the world's largest language group, or linguistic family, and takes its name from the area where the original language arose sometime before 2000 B.C.: that encompassed by Europe and India and the lands in between. The term *Indo-European* describes only a linguistic group, not ethnic or cultural divisions, and not all peoples living in this area speak an Indo-European language. Vocabulary and grammar structure are the common elements among the subfamilies, which include Anatolian, Baltic, Celtic, Germanic, Greek, Indo-Iranian, Italic, Slavic, and several other smaller language groups.

Speaking of

king, kingship, kingdom, dynasty, and *pharaoh*

Egyptian kings were believed to combine divine and mortal qualities. Kingship passed from father to son or to near kin. Dynasties were groupings of kings linked by kinship and were first devised in the early third century B.C. by the priest Manetho, who designated clusters of dynasties into kingdoms and "Intermediate Periods." Three main Kingdoms—the Old, Middle, and New—comprise clusters through Dynasty 20. Manetho recognized thirty dynasties to 343 B.C., after which ancient Egypt continued another 700 or so years. The word *pharaoh* has been used synonymously with *king* by modern writers. *Pharaoh* derives from the Egyptian word for "royal palace" and was used by the Egyptians to mean "king" only beginning in Dynasty 18.

▼ Before Egypt was united by King Menes (Narmer) about 3200 B.C., there were two kingdoms, that of UPPER EGYPT (the Nile Valley southward from Memphis to Aswan) and that of LOWER EGYPT (the Nile Delta north from Memphis to the Mediterranean Sea).

white crown
Upper Egypt

red crown
Lower Egypt

double crown
unified Egypt

▼ HIEROGLYPHS were used in two ways: as ideographs and as phonetic signs.

amulet

In this Dynasty 12 amulet, the stylized papyrus clump on the left is an ideograph for "around" or "behind." The *ankh* in the center is a symbol for life, and the *sa* on the right is a symbol of protection. The basket (*nebet*) means variously "all," "lord," or "master." Thus, this ideographic amulet is read "All life and protection are around [the master, king, lord]."

cartouche

The phonetic reading of this hieroglyph is, from top to bottom: *sha* (for the stand of lotus) *ba* (Egyptian for "ram") *ka* (upraised arms meaning "spirit" or "soul"). Because the signs are enclosed by the lozenge-form rope, called a cartouche, we know that this hieroglyph means "King Shabaka."

Steadied by a local expedition worker, pioneering American Egyptologist James Henry Breasted copies a long hieroglyphic inscription at Wadi Halfa, January 1906.

survival is no accident, since the tombs were built to last forever. Yet we must not make the mistake of concluding that the Egyptians viewed life on this earth mainly as a road to the grave. Their preoccupation with the cult of the dead is a link with the Neolithic past, but the meaning they gave it was quite new and different: the dark fear of the spirits of the dead that dominates early ancestor cults seems entirely absent. Instead, the Egyptian attitude was that each person must provide for his or her own happy afterlife. The ancient Egyptians equipped tombs as a kind of shadowy replica of their daily environment for their spirit (*ka*) to enjoy and to make sure that the *ka* had a body to dwell in (the individual's own mummified corpse or, if that should be destroyed, a statue of the person).

There is a curious blurring of the sharp line between life and death here, and perhaps that was the essential impulse behind these mock households. People who believed that their *kas*, after death, would enjoy the same pleasures they now did and who had provided these pleasures for their *kas* could look forward to active and happy lives without being haunted by fear of the great unknown. In a sense, then, the Egyptian tomb was a kind of life insurance, an investment in peace of mind. Such, at least, is the impression one gains of Old Kingdom tombs. Later on, the serenity of this concept of death was disturbed by a tendency to subdivide the spirit or soul into two or more separate identities and by the introduction of a sort of judgment, a weighing of souls. Only then do we also find expressions of the fear of death.

Sculpture

Palette of King Narmer At the threshold of Egyptian history stands a work of art that is also a historic document: a carved slate ceremonial palette, or slab (fig. 24). This palette—celebrating the victory of Menes (Narmer), king of ▼UPPER EGYPT, over LOWER EGYPT—is the oldest known image of a historic personage identified by name. It already shows most of the features characteristic of Egyptian art. But before we concern ourselves with these, let us first "read" the

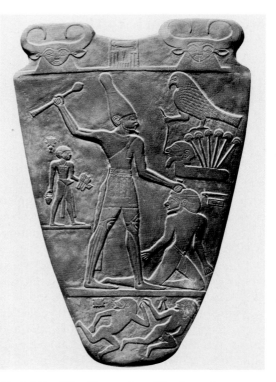

24. *Palette of King Narmer*, from Hierakonpolis. c. 3150–3125 B.C. Slate, height 25" (63.5 cm). Egyptian Museum, Cairo

scene. The fact that we are able to do so is another indication that we have left prehistoric art behind. The meaning of these **reliefs** (sculpture in which the image stands out from a flat background) is made clear and explicit not only by means of ▼HIEROGLYPHIC labels but also through the use of a broad range of visual symbols conveying precise messages to the beholder and—most important of all—through the disciplined, rational orderliness of the design.

In figure 24, Narmer has seized a fallen enemy by the hair and is about to slay him with a mace. Two other defeated enemies are placed in the bottom compartment. (The small rectangular shape next to the man on the left stands for a fortified town or citadel.) Facing the king in the upper right is a complex bit of picture writing: a falcon standing above a clump of papyrus plants holds a tether attached to a human head that seems to grow from the same

25. *Ti Watching a Hippopotamus Hunt*, Tomb of Ti, Saqqara. c. 2510–2460 B.C. Painted limestone relief, height approx. 45" (114.3 cm)

clarity, not illusion, and therefore picked the most telling view of their subjects. But they imposed a strict rule on themselves: when the angle of vision changes, it must be by 90 degrees, as if sighting along the edges of a cube. As a consequence, only three views are possible: full face, strict profile, and vertically from above. Any intermediate position is an embarrassment. (Note the oddly rubberlike figures of the fallen enemies.) Moreover, the standing human figure does not have a single main profile but two competing profiles, so that, for the sake of clarity, these views must be combined. The method of doing this (which was to survive unchanged for 2,500 years) is clearly shown in the large figure of Narmer (see fig. 24): eye and shoulders in frontal view, head and legs in profile. Apparently this formula was worked out so as to show the pharaoh (and all persons of significance who move in the aura of his divinity) in the most complete way possible. And since the scenes depict solemn and, as it were, timeless rituals, our artist did not have to deal with the fact that this method of representing the human body made almost any kind of movement or action practically impossible. In fact, the frozen quality of the image would seem especially suited to the divine nature of the pharaoh. Ordinary mortals *act;* he simply *is.*

The Egyptian style of representing the human figure, then, seems to have been created specifically for the purpose of conveying in visual form the majesty of the divine king. It must have originated among the artists working for the royal court. And it never lost its ceremonial, sacred flavor, even when, in later times, it had to serve other purposes as well.

Tomb of Ti The style used to depict Narmer in the ceremonial palette was soon adopted for nonroyal tombs in the Old Kingdom. The hippopotamus hunt in figure 25, from the offering chambers of the architectural overseer Ti at Saqqara, is of special interest because of its landscape setting. A papyrus thicket is represented in the background of the relief. The stems of the plants make a regular, rippling pattern that erupts in the top zone into an agitated scene of nesting birds menaced by small

Most figures were represented like the long-haired woman: eyes and shoulders seen frontally and everything else rendered in profile. Figures that are drawn more naturalistically—like the short-haired woman—are always of commoners and slaves.

Open papyrus in a stylized representation

soil as the plants. This composite image actually repeats the main scene on a symbolic level. The head and papyrus plant stand for Lower Egypt, while the victorious falcon is Horus, the local god of Upper Egypt. The parallel is plain. Horus and Narmer are the same; a god triumphs over human foes. Hence, Narmer's gesture must not be taken as representing a real fight. The enemy is helpless from the very start, and the slaying is a ritual rather than a physical effort. We gather the ritualistic aspect from the fact that Narmer has taken off his sandals (the court official behind him carries them in his right hand), an indication that he is standing on holy ground. The same notion recurs in the Old Testament, perhaps as the result of Egyptian influence, when the Lord commands Moses to remove his shoes before appearing to Moses in the burning bush.

The inner logic of the Narmer palette's style is readily apparent. Egyptian artists strove for

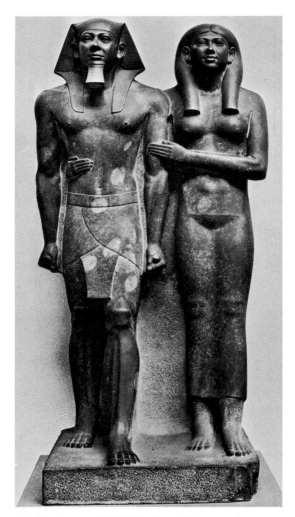

26. *Menkaure and His Wife, Queen Khamerernebty*, from Giza. c. 2515 B.C. Slate, height 54½" (138.4 cm). Museum of Fine Arts, Boston

His size also lifts him out of the context of the hunt. He neither directs nor supervises it but simply observes. His passive role is characteristic of the representations of the deceased in all such scenes from the Old Kingdom. It seems to be a subtle way of conveying that the body is dead but the spirit is alive and aware of the pleasures of this world, though the man can no longer participate in them directly. We should also note that these scenes of daily life do not represent the dead man's favorite pastimes. If they did, he would be looking back, and such nostalgia is quite alien to the spirit of Old Kingdom tombs. It has been shown, in fact, that these scenes form a seasonal cycle, a sort of perpetual calendar of recurrent human activities for the spirit of the deceased to watch year in and year out. On the other hand, such scenes offered artists a welcome opportunity to widen their powers of observation, so that in details we often find astounding bits of realism.

Portraits The "cubic" approach to the human form can be observed most strikingly in Egyptian **sculpture in the round**, such as the splendid group of the king Menkaure and his queen, Khamerernebty (fig. 26). After marking the faces of the rectangular block with a grid, the artist drew the front, top, and side views of the statue on each side, then worked inward until these views met. This approach also encouraged the development of systematic proportions. Only in this way could the artist have achieved figures of such overpowering three-dimensional firmness and immobility—magnificent vessels for the *kas* to inhabit. Both have the left foot placed forward, yet there is no hint of a forward movement. The pair also affords an interesting comparison of male and female beauty as interpreted by a fine sculptor, who knew not only how to contrast the structure of the two bodies but also how to emphasize the soft, swelling form of the queen through a thin, close-fitting gown. Like other Old Kingdom statues, the group originally must have been vividly colored and thus strikingly lifelike in appearance. Unfortunately, coloring has survived completely intact in only a few instances. According to the standard conven-

predators. The water in the bottom zone, marked by a zigzag pattern, is equally crowded with struggling hippopotamuses and fish. All these, as well as the hunters in the first boat, are acutely observed and full of action. Only Ti himself, standing in the second boat, is immobile, as if he belonged to a different world. His pose is that of funerary portrait reliefs and statues (compare fig. 26), and he towers above the other men because he is more important than they.

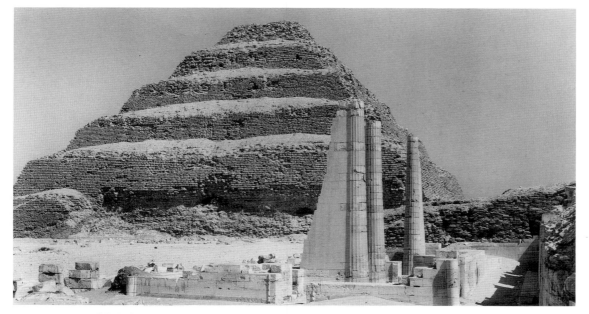

27. Imhotep. Step pyramid of King Djoser, Saqqara. Dynasty 3, c. 2681–2662 B.C.

tion of Egyptian art, the king would have had a darker body color than the queen. Their eyes, too, would have been painted, and perhaps inlaid with shining quartz, to make them look as alive as possible and to emphasize the individuality of the faces.

Architecture

When we speak of the Egyptians' attitude toward death and afterlife as expressed in their tombs, we must be careful to make it clear that we do not mean the attitude of the average Egyptian but only that of the small aristocratic caste clustered around the royal court. The tombs of the members of this class of high officials, who were often relatives of the royal family, are usually found in the immediate neighborhood of the pharaohs' tombs. Their shape and contents reflect, or are related to, the funerary monuments of the divine kings. We still have a great deal to learn about the origin and significance of Egyptian tombs, but there is reason to believe that the concept of the afterlife expressed in the so-called private tombs did not apply to ordinary mortals but

only to the privileged few because of their association with the immortal pharaohs. The standard form of these tombs was the **mastaba**, a squarish mound faced with brick or stone, above the burial chamber, which was deep underground and linked to the mound by a shaft. Inside the mastaba is a chapel for offerings to the *ka* and a secret cubicle for the statue of the deceased.

Pyramids Royal mastabas grew to conspicuous size and soon developed into step pyramids. The earliest is probably that of King Djoser (fig. 27), a step pyramid suggestive of a stack of mastabas, in contrast to the smooth-sided later examples at Giza (see fig. 29). Pyramids were not isolated structures in the middle of the desert but rather were part of vast funerary districts, with temples and other buildings that were the scene of great religious celebrations during the pharaoh's lifetime as well as after. The most elaborate of these funerary districts surrounds the step pyramid of King Djoser. Enough of its architecture has survived to enable us to understand why its creator, Imhotep, came to be deified in later Egyptian tradition.

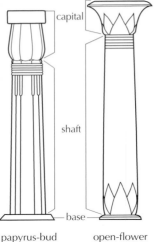

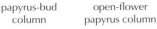

papyrus-bud open-flower
column papyrus column

The Egyptians devised columns of three parts—base, shaft, and capital—the same parts found in two of the three main Greek classical orders, which were to come later. The papyrus, both open and closed, was a favorite motif of Egyptian capitals. The shafts of columns were frequently decorated with brightly painted hieroglyphic writing in shallow relief or sunken relief.

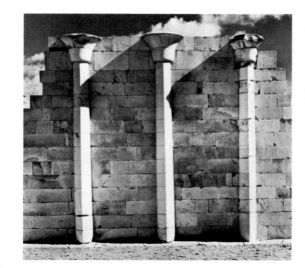

28. Papyrus half-columns, North Palace, funerary district of King Djoser, Saqqara

He is the first artist whose name has been recorded in history, and deservedly so. His achievement remains impressive not only for its scale but also for its unity, which embodies the concept of the pharaoh to perfection. Imhotep must have possessed remarkable intellect as well as outstanding ability. His work set an important precedent for all the great architects who followed in his footsteps. Even today, their designs respond to the important ideas and issues of the times in which we live.

Columns Egyptian architecture had begun with structures made of mud bricks, wood, reeds, and other light materials. Although Imhotep used cut-stone masonry, his repertory of architectural forms still reflected shapes or devices developed for less enduring materials. Thus, we find **columns** of several kinds— always **engaged** (set into the wall, rather than **freestanding**)—which echo the bundles of reeds or the wooden supports that used to be set into mud-brick walls in order to strengthen them. But the very fact that these members no longer had their original functional purpose made it possible for Imhotep and his fellow architects to redesign them so as to make them serve a new, *expressive* purpose. The notion that

architectural forms can express anything may seem difficult to grasp at first. Today we tend to assume that unless these forms have a clear-cut structural service to perform (such as supporting or enclosing), they are mere surface decoration. But let us look at the slender, tapering, fluted columns in figure 27 or the papyrus-shaped half-columns in figure 28. These columns do not simply decorate the walls to which they are attached but interpret them and give them life. Their proportions, the feeling of strength or resilience they convey, their spacing, the degree to which they project—all share in this task.

Giza Djoser's successors soon developed the step pyramid into its familiar smooth-sided form. The most **monumental** examples were built during Dynasty 4 in the famous triad of Great Pyramids at Giza (fig. 29). These pyramids originally had an outer casing of carefully **dressed stone**, which has disappeared except near the top of the pyramid of Khafre. According to recent theory, the three are arranged in the same configuration as the stars in the constellation Orion, which was identified with the god Osiris, the mythical founder of Egypt. The hypothesis, though controversial, is tantalizing, for it helps to explain this and many other puzzling features of the pyramids in terms of Egyptian cosmology, which equated the pharaoh with Horus as the son of Osiris and his consort, Isis. Clustered around the three Great Pyramids are several smaller ones and a large number of mastabas for members of the royal family and high officials, but the unified funerary district of Djoser has given way to a simpler arrangement (fig. 30). Adjoining each of the Great Pyramids to the east is a funerary temple, from which a processional causeway leads to a second temple at a lower level, in the Nile Valley, at a distance of about a third of a mile. This new arrangement represents the decisive final step in the evolution of kingship in Egypt. It links the pharaoh to the eternal cosmic order by connecting him physically and ritually to the Nile River, whose annual cycles give life and dictate its rhythm in Egypt to this very day.

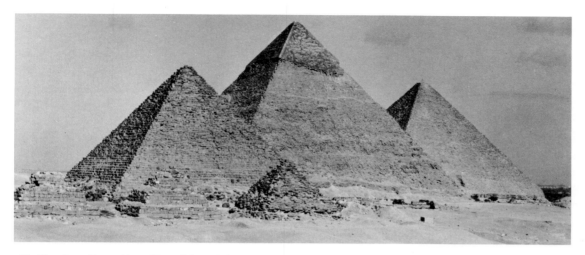

29. The Great Pyramids at Giza of (from left) Menkaure, Khafre, and Khufu. Dynasty 4, c. 2601–2515 B.C.

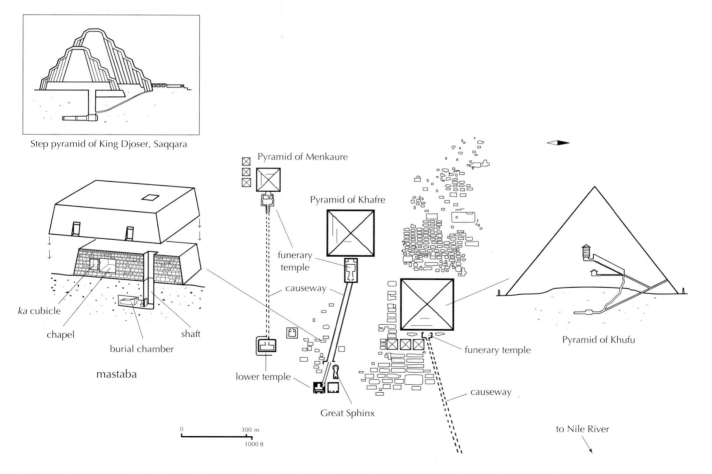

Step pyramid of King Djoser, Saqqara

Pyramid of Menkaure

Pyramid of Khafre

funerary temple

causeway

lower temple

Great Sphinx

funerary temple

causeway

Pyramid of Khufu

to Nile River

ka cubicle

chapel

burial chamber

shaft

mastaba

0 300 m

1000 ft

30. Plan of funerary district at Giza with sections of Pyramid of Khufu and mastaba, and with inset of section of step pyramid of King Djoser at Saqqara

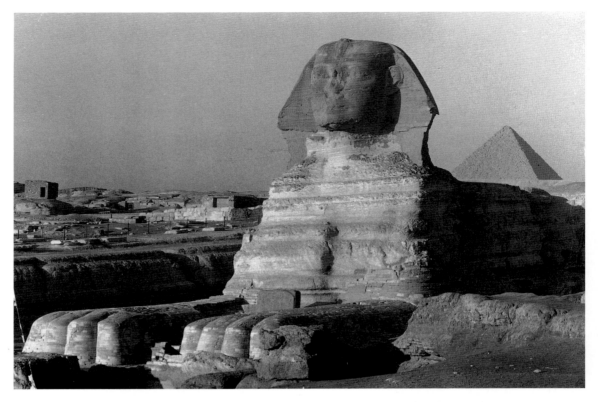

31. The Great Sphinx, Giza. c. 2570–2544 B.C. Sandstone, height 65' (19.8 m)

Next to the valley temple of the pyramid of Khafre stands the Great Sphinx, carved from the live rock (fig. 31). It is, if anything, an even more impressive embodiment of divine kingship than the pyramids themselves. The royal head rising from the body of a lion towers to a height of 65 feet and once bore, in all probability, the features of Khafre (damage inflicted upon it during Islamic times has obscured the details of the face). Its awesome majesty is such that a thousand years later it could be regarded as an image of the sun god.

The Great Pyramids at Giza mark the high point of pharaonic power. After the end of Dynasty 4, less than two centuries later, enterprises of this huge scale were never attempted again, although much more modest pyramids continued to be built. The world has always marveled at the sheer size of the Great Pyramids as well as at the technical accomplishment they

represent. They have also come to be regarded as symbols of slave labor, with thousands of men cruelly forced to serve the aggrandizement of absolute rulers. Such a picture may well be unjust. Certain records indicate that the labor was paid for, so we are probably nearer the truth if we regard these monuments as vast public works providing economic security for a good part of the population.

The Middle Kingdom

After the collapse of centralized pharaonic power at the end of Dynasty 6, Egypt entered a period of political disturbances and ill fortune that was to last almost 700 years. During most of this time, effective authority lay in the hands of local or regional overlords, who revived the old rivalry of the Upper and Lower Egypts. Many dynasties followed one another in rapid

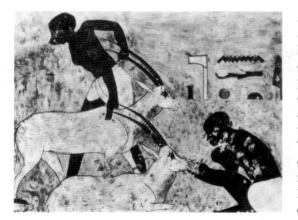

32. *Feeding the Oryxes*. Modern copy of an original of Dynasty 12, c. 1928–1895 B.C. at the Tomb of Khnumhotep, Beni Hasan

succession, but only two, Dynasties 11 and 12, are worthy of note. These two occurred during the Middle Kingdom (2040–1674 B.C.), when a series of able rulers managed to reassert themselves against the provincial nobility. However, the spell of divine kingship, having once been broken, never regained its old effectiveness, and the authority of the Middle Kingdom pharaohs tended to be personal rather than institutional. Soon after the close of Dynasty 12, the weakened country was invaded by the Hyksos, a western Asian people of somewhat mysterious origin, who seized the Delta area and ruled it for 150 years until their expulsion by the princes of Thebes about 1552 B.C.

Tomb Decorations

A loosening of established rules is felt in Middle Kingdom painting and relief, leading to all sorts of interesting departures from convention. These deviations occur most conspicuously in the decoration of the tombs of local princes at Beni Hasan, which have survived destruction better than most Middle Kingdom monuments because they are carved into the living rock. The **mural** *Feeding the Oryxes* (fig. 32) comes from one of these rock-cut tombs, that of Khnumhotep. (As the emblem of the prince's domain, the oryx antelope seems to have been a sort of honored pet in his household.)

According to the standards of Old Kingdom art, all the figures ought to share the same **groundline**, or else the second oryx and its attendant ought to be placed above the first. Instead, the painter has introduced a secondary groundline only slightly higher than the primary one, and as a result the two groups are related in a way that closely approximates normal appearances. The artist's interest in exploring spatial effects can also be seen in the awkward but quite bold **foreshortening** of the attendant's shoulders. Foreshortening is a method of drawing that creates a convincing illusion of projection. If we cover up the hieroglyphic signs, which emphasize the flatness of the wall, we can "read" the forms in depth with surprising ease.

The New Kingdom

The New Kingdom, comprising Dynasties 18, 19, and 20, was a third golden age of Egypt. The country, once more united under strong and efficient kings, extended its frontiers far to the northeast, into present-day Palestine, Israel, and Syria; hence, this period is also known as the Empire. New Kingdom art covers a vast range of styles and quality, from rigid conservatism to brilliant inventiveness, from oppressively massive ostentation to the most delicate refinement. As with the art of imperial Rome 1,500 years later, it is almost impossible to summarize in terms of a representative sampling. Different strands are interwoven into a fabric so complex that any choice of monuments is bound to seem arbitrary. All we can hope to accomplish is to convey some of the flavor of its variety.

Architecture

The divine kingship of the pharaohs was now asserted in a new way: by association with the god Amun, whose identity had been fused with that of the sun god Ra and who became the supreme deity, ruling the lesser gods much as the pharaoh towered above the provincial nobility. During the climactic period of power and prosperity, between about 1500 B.C. and the end of the reign of Ramesses III in 1145 B.C.,

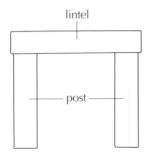

The simplest space-spanning construction device is the post-and-lintel combination. The wider the distance spanned (and the less the "give" of the spanning material), the closer the uprights (posts) have to be. Egyptians used stone columns for posts; the weight of the rigid stone lintels forced the builders to place the columns close together.

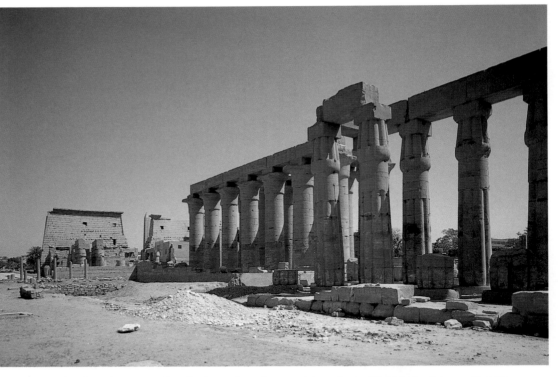

33. Court and pylon of Ramesses II and colonnade and court of Amenhotep III, Temple of Amun-Mut-Khonsu, Luxor. Dynasty 19, c. 1279–1212 B.C.

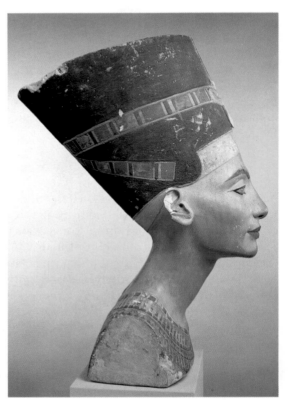

34. *Akhenaten* (*Amenhotep IV*). Dynasty 18, c. 1348–1336/5 B.C. Limestone, height 3¹/₈" (7.9 cm). Staatliche Museen zu Berlin, Preussischer Kulturbesitz, Ägyptisches Museum

35. *Queen Nefertiti*. Dynasty 18, c. 1348–1336/5 B.C. Limestone, height 19" (48.3 cm). Staatliche Museen zu Berlin, Preussischer Kulturbesitz, Ägyptisches Museum

vast architectural energies were devoted to building huge temples dedicated to Amun under royal sponsorship. The complex at Luxor (fig. 33) is characteristic of the general pattern of later Egyptian temples. The **facade** (the side that faces a public way, at the far left in our illustration) consists of two massive walls, with sloping sides, that flank the entrance. This gateway, or **pylon**, leads to a series of courts and pillared halls, beyond which is the temple proper. The entire sequence was enclosed by high walls that shut off the outside world. Except for the pylon, such a structure is designed to be experienced from within. Ordinary worshipers were confined to the courts and could but marvel at the forest of columns that screened the dark recesses of the sanctuary. The columns had to be closely spaced, for they supported the stone **lintels**, or horizontal members, of the ceiling; the lintels had to be short to keep them from breaking under their own weight. Yet the architect has consciously exploited this condition by making the columns far heavier than they need be. As a result, the beholder feels almost crushed by their sheer mass. The effect is certainly impressive, but it is also rather coarse when measured against earlier great works of Egyptian architecture. We need only compare the papyrus columns of the colonnade of Amenhotep III with their remote ancestors in Djoser's North Palace (see fig. 28) in order to realize how little of the genius of Imhotep has survived at Luxor.

Akhenaten and Tutankhamun

The growth of the Amun cult produced an unexpected threat to royal authority: the priests of Amun grew into a caste of such wealth and power that the pharaoh could maintain his position only with their consent. Amenhotep IV, the most remarkable figure of Dynasty 18, tried to defeat them by proclaiming his faith in a single god, the sun disk Aten. He changed his name to Akhenaten, closed the Amun temples, and moved the capital to central Egypt, near the modern Tell el'Amarna. His attempt to place himself at the head of a new monotheistic faith, however, did not outlast his reign

(1348–1336/5 B.C.), and under his successors the Amun cult was speedily restored. During the long decline that began about 1000 B.C., the country became increasingly priest-ridden, until, under Greek and Roman rule, Egyptian civilization came to an end in a welter of esoteric religious doctrines.

Of the great projects built by Akhenaten hardly anything remains above ground. He must have been a revolutionary not only in his religious beliefs but in his artistic tastes as well, consciously fostering a new style and a new ideal of beauty in his choice of artists. The contrast with the past becomes strikingly evident in a portrait of Akhenaten (fig. 34). Compared with works in a traditional style (see figs. 24, 25), this profile seems at first glance like a brutal caricature, with its oddly haggard features and overemphatic, undulating outlines. The head of Akhenaten is indeed an extreme statement of the new ideal. Still, we can perceive its kinship with the justly famous bust of Akhenaten's queen, Nefertiti (fig. 35), one of the masterpieces of the so-called Amarna style. What distinguishes this style is not greater realism so much as a new sense of form that seeks to unfreeze the traditional immobility of Egyptian art. Not only the contours but the plastic shapes, too, seem more pliable and relaxed, antigeometric in fact.

Although the old religious tradition was quickly restored after Akhenaten's death, the artistic innovations he encouraged could be felt in Egyptian art for some time to come. Even the face of Akhenaten's successor, Tutankhamun, as it appears on his gold coffin cover (fig. 36), betrays an echo of the Amarna style. Tutankhamun, who died at the age of eighteen, owes his fame entirely to the accident that his is the only pharaonic tomb discovered in our times with most of its contents undisturbed. The sheer material value of the tomb (Tutankhamun's gold coffin alone weighs 250 pounds) makes it understandable that grave robbing has been practiced in Egypt ever since the Old Kingdom. To us, the exquisite artistry of the coffin cover, with the rich play of colored inlays against the polished gold surfaces, is even more impressive.

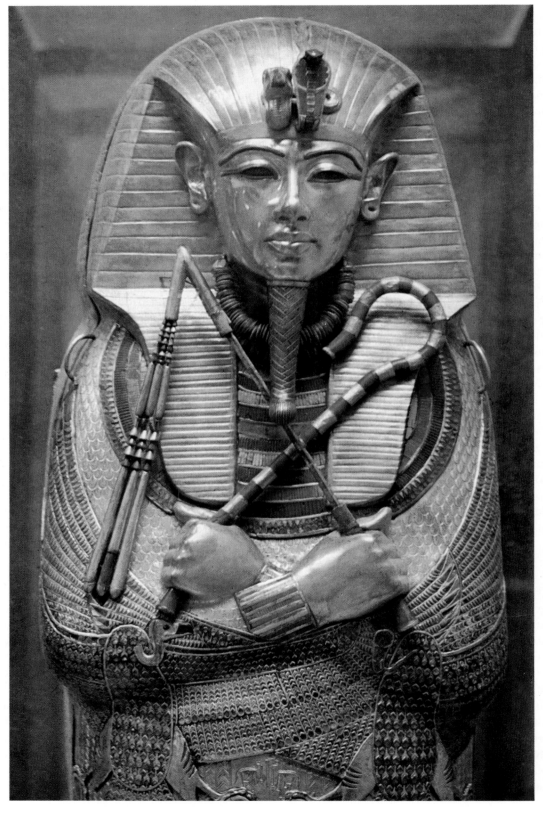

36. Cover of the coffin of
Tutankhamun. Dynasty 18,
c. 1327 B.C. Gold inlaid
with enamel and semi-
precious stones, height
6'7/8" (1.85 m). Egyptian
Museum, Cairo

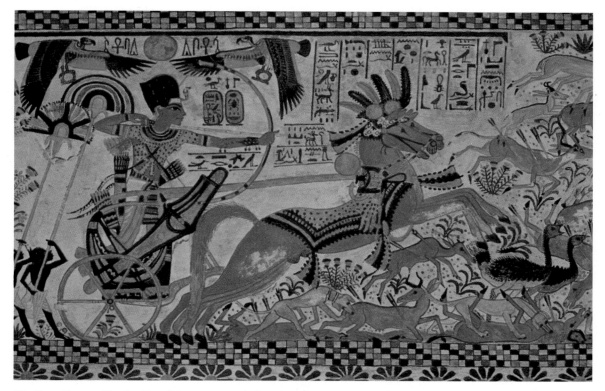

37. *Tutankhamun Hunting*. Detail from a painted chest found in the king's tomb, Thebes. c. 1336/5–1327 B.C. Length of scene approx. 20' (20.7 cm). Egyptian Museum, Cairo

As unique as the gold coffin is a painted chest from the same tomb, showing the youthful king in battle and hunting scenes (fig. 37). These subjects, which were intended to glorify Tutankhamun (hunting was of primarily ritual significance), had been traditional since the late years of the Old Kingdom, but here they are done with astonishing freshness, at least so far as the animals are concerned. While the king and his horse-drawn chariot remain frozen against the usual blank background filled with hieroglyphs, the same background in the right-hand half of the scene suddenly turns into a desert. The surface is covered with stippled dots to suggest sand, desert plants of considerable variety are strewn across it, and the animals stampede over it helter-skelter, without any groundlines to impede their flight.

Here is an aspect of Egyptian painting rarely seen on the walls of tombs. Perhaps this lively scattering of forms against a landscape background existed only on the miniature scale of the scenes on Tutankhamun's chest, and even there it became possible only as a result of the Amarna style. How these animals-in-landscape endured in later Egyptian painting we do not know, but they must have survived somehow; their resemblance to Assyrian reliefs done nearly 700 years later is far too striking to be ignored.

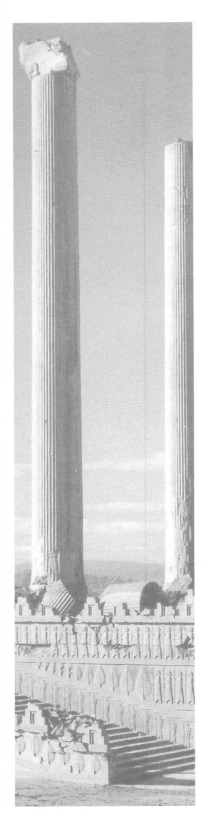

Chapter 3
Ancient Near Eastern Art

It is an astonishing fact that human civilization emerged into the light of history in two separate areas of the Near East at just about the same time. Between 3500 and 3000 B.C., when Egypt was being united under the rule of kings, another great civilization arose in Mesopotamia, the "land between the rivers." And for close to 3,000 years, the two rival centers retained their distinct characters, even though they had contact with each other from their earliest beginnings and their destinies were interwoven in many ways. The pressures that forced the inhabitants of both regions to abandon the pattern of Neolithic village life may well have been the same. But the valley of the Tigris and Euphrates rivers, unlike that of the Nile, is not a narrow fertile strip protected by deserts on each side. It resembles a wide, shallow trough with few natural defenses, crisscrossed by two great rivers and their tributaries, and easily encroached upon from any direction. As a result, over its history Mesopotamia was repeatedly invaded and settled by a succession of peoples of diverse ethnic origin.

These upheavals tended to discourage the unification of the entire area under a single ruler. As a consequence, the political history of ancient Mesopotamia has no underlying theme of the sort that divine kingship provides for Egypt. Local rivalries, foreign incursions, the sudden upsurge and equally sudden collapse of military power—these are its substance. Against such a chaotic background, the continuity of cultural and artistic traditions seems all the more remarkable. This common heritage is very largely the creation of the founders of Mesopotamian civilization, called Sumerians after the region of Sumer, which they inhabited, near the confluence of the Tigris and Euphrates.

Sumerian Art

The origin of the Sumerians remains obscure. Their language is unrelated to any other known tongue. Sometime before 4000 B.C., they came to southern Mesopotamia from Persia, and there, within the next thousand years, they founded a number of city-states and developed their distinctive form of writing in cuneiform (wedge-shaped) characters on clay tablets. Unfortunately, the tangible remains of Sumerian civilization are extremely scanty compared with those of ancient Egypt. Since building stone was unavailable in Mesopotamia, the Sumerians used mud bricks and wood, so that almost nothing is left of their architecture except the foundations. Nor did they share the Egyptians' concern with the hereafter, although some richly endowed tombs—in the shape of vaulted chambers below ground—of the Egyptian early dynastic period (c. 3150–2700 B.C.) have been found in the city of Ur. Yet we have learned enough to form a general picture of the achievements of this vigorous, inventive, and disciplined people.

Each Sumerian city-state had its own local god, who was regarded as its "king" and owner. It also had a human ruler, the steward of the divine sovereign, who led the people in serving the deity. The local gods, in return, were expected to plead the cause of their subjects among their fellow deities who controlled the forces of nature such as wind and weather, water, fertility, and the heavenly bodies. Nor was the idea of divine ownership treated as a mere pious fiction. The gods were quite literally believed to own not only the territory of their city-states but also the labor power of the population and its products. All these were subject to the gods' commands, transmitted to the people by their human steward. The result was an economic system that has been dubbed theocratic socialism, a planned society whose administrative center was the temple. The temple controlled the pooling of labor and resources for communal enterprises, such as the building of dikes or irrigation ditches, and it collected and distributed a considerable part of the harvest. All this required the keeping of detailed written records. Hence we are not surprised to find that the texts of early Sumerian inscriptions deal very largely with economic and administrative rather than religious matters, although writing was a priestly privilege.

Architecture

The temple had a dominant role as the center of both spiritual and physical existence in Sumerian cities. Houses were clustered around a sacred area that was a vast architectural complex embracing not only shrines but workshops, storehouses, and scribes' quarters as well. In their midst, on a raised platform, stood the temple of the local god. These platforms, known as **ziggurats**, soon reached great heights and were comparable to the pyramids of Egypt in the immensity of effort required for construction and in their effect as great landmarks that tower above the featureless plain.

The most famous ziggurat, the biblical Tower of Babel, has been completely destroyed, but a much earlier example, built shortly before 3000 B.C. and thus several centuries older than the first of the pyramids, survives at Warka, in present-day Iraq, the site of the Sumerian city of Uruk (called Erech in the Bible). The mound, its sloping sides reinforced by solid brick masonry, rises to a height of 40 feet. Stairs and ramps lead up to the platform on which stands the sanctuary, called the White Temple because of its whitewashed brick exterior (figs. 38, 39). Its heavy walls, articulated by regularly spaced projections and recesses, are sufficiently well preserved to suggest something of the original appearance of the structure. The main room, or **cella**, where sacrifices were offered before the statue of the god, is a narrow hall that runs the entire length of the temple and is flanked by a series of smaller chambers. But the main entrance to the cella is on the southwest side, rather than on the side facing the stairs or on one of the narrow sides of the temple, as one might expect. In order to understand the reason for this arrangement, we must view the ziggurat and temple as a whole. The entire complex is planned in such a way that the worshiper,

The stylus, usually fashioned from a reed, was shaped on both ends. One end was a wedge form; the other end was either pointed, rounded, or flat-tipped. Cuneiform characters were made by pressing an edge (not the end) of the stylus into damp clay. The pointed end was used to draw lines and make punch marks. The tablets were sun-dried or baked.

This c. 1750 B.C. Babylonian deed of sale graphically shows the impressions made by the stylus in the soft clay. Department of Western Asiastic Antiquities, No. 33236. The British Museum, London

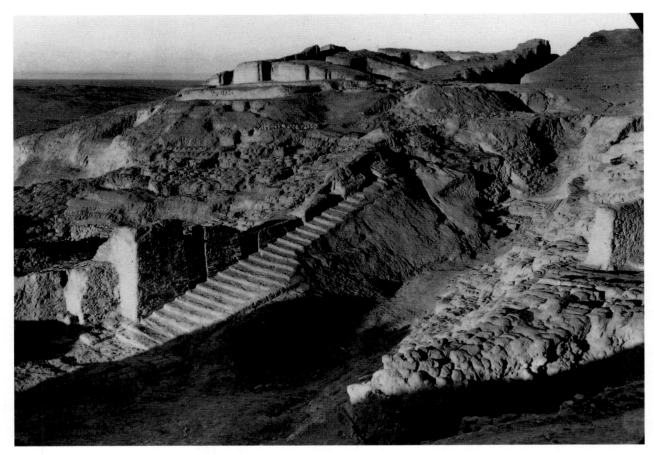

38. The White Temple on its ziggurat, Uruk (Warka), Iraq. c. 3500–3000 B.C.

starting at the bottom of the stairs on the east side, is forced to go around as many corners as possible before reaching the cella. The processional path, in other words, resembles a sort of angular spiral. This "bent-axis approach" is a fundamental characteristic of Mesopotamian religious architecture, in contrast to the straight, single axis of Egyptian temples (see fig. 33).

Sculpture

The image of the god to whom the White Temple was dedicated is lost—it was probably Anu, the god of the sky—but excavations of

39. Plan of the White Temple and its ziggurat (after H. Frankfort)

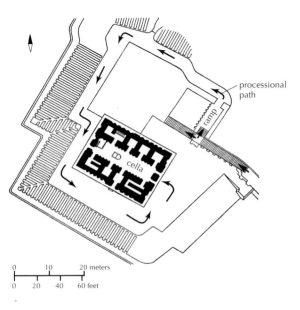

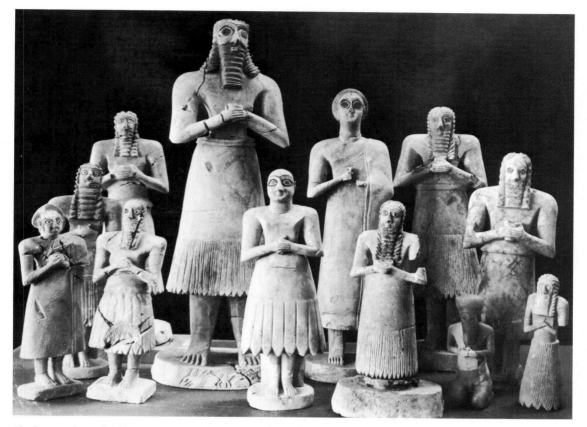

40. Statues, from the Abu Temple, Tell Asmar, Iraq. c. 2700–2500 B.C. Limestone, alabaster, and gypsum, height of tallest figure approx. 30" (76.2 cm). Iraq Museum, Baghdad, and The Oriental Institute Museum of The University of Chicago

other temples have yielded stone statuary. A group of figures from Tell Asmar, in modern Iraq (fig. 40), contemporary with the pyramid of King Djoser, shows the geometric and expressive aspects of sculpture from Egypt's Early Dynastic period. Although the two tallest figures have traditionally been considered Abu, the god of vegetation, and a mother goddess, it is likely that all are **votive** statues representing priests and worshipers. Despite the disparity in size, each has the same pose of humble worship, save for the kneeling figure to the lower right. The eyes of all the figures are enormous, communicating a sense of awe entirely appropriate before the often-terrifying deities they worshiped. Their insistent stare is emphasized by colored inlays, which are still in place. The entire group must have stood in the cella of the

Abu Temple, the priests and worshipers communicating with the god through their eyes.

The term *representation* has a very direct meaning here: the gods were believed to be present in their images, and the statues of the worshipers served as stand-ins for the persons they portrayed, offering prayers or transmitting messages to the deity in their stead. Yet none of them indicates any attempt to achieve a real likeness. The bodies as well as the faces are rigorously simplified and schematic, in order to avoid distracting attention from the eyes, "the windows of the soul." If the Egyptian sculptor's sense of form was essentially cubic, that of the Sumerian was based on the cone and cylinder. Arms and legs have the roundness of pipes, and the long skirts worn by all these figures are as smoothly curved as if they

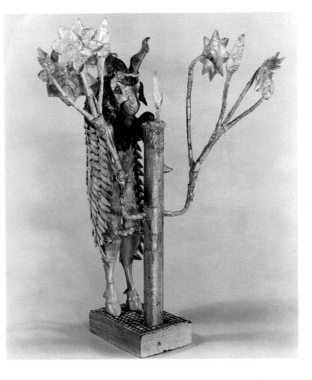

41. *Ram and Tree*. Offering stand from Ur (Muqaiyir), Iraq. c. 2600 B.C. Wood, gold, and lapis lazuli, height 20" (50.8 cm). University of Pennsylvania Museum, Philadelphia

had been turned on a lathe. Even in later times, when Mesopotamian sculpture had acquired a far richer repertory of shapes, this quality asserted itself again and again.

The conic-cylindrical simplification of the Tell Asmar statues is characteristic of a carver, who works by cutting forms out of a solid block. A far more flexible and realistic style prevails among the Sumerian sculpture that was made by addition rather than subtraction (that is, either **modeled** in soft materials for **casting** in bronze or put together by combining such varied substances as wood, gold leaf, and lapis lazuli). Some sculpture of the latter kind, roughly contemporary with the Tell Asmar figures, have been found in tombs at Ur. They include the fascinating object shown in figure 41, an offering stand in the shape of a ram rearing up against a flowering tree. The animal, marvelously alive and energetic, has an almost demonic power of expression as it gazes at us from between the branches of the symbolic tree. And well it might, for it is sacred to the god Tammuz and thus embodies the male principle in nature.

Such an association of animals with deities is a carryover from prehistoric times. We find it not only in Mesopotamia but in Egypt as well

(see the falcon of Horus in fig. 24). What distinguishes the sacred animals of the Sumerians is the active part they play in mythology. Much of this lore, unfortunately, has not come down to us in written form, but tantalizing glimpses of it can be caught in pictorial representations such as those on an inlaid panel from a harp (fig. 42) that was recovered together with the offering stand at Ur. The hero embracing two human-headed bulls in the top compartment was so popular a subject that its design has become a rigidly symmetrical, decorative formula. The other sections, however, show animals performing a variety of human tasks in surprisingly lively and precise fashion. The wolf and the lion carry food and drink to an unseen banquet, while the ass, bear, and deer provide musical entertainment. (The bull-headed harp is the same type as the instrument to which the inlaid panel was attached.) At the bottom, a scorpion-man and a goat carry some objects they have taken from a large vessel.

The skillful artist who created these scenes was far less constrained by rules than Egyptian artists were. Even though these figures, too, are placed on **groundlines**, there is no fear of overlapping forms or **foreshortened** shoulders. We

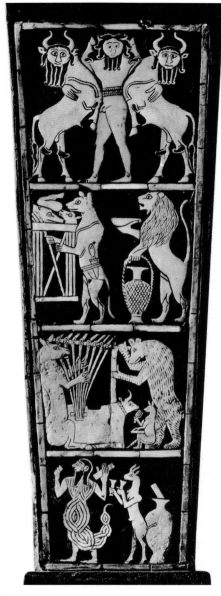

42. Inlay panel from the sound box of a lyre, from Ur (Muqaiyir), Iraq. c. 2600 B.C. Shell and bitumen, 12¼ x 4½" (31.1 x 11.4 cm). University of Pennsylvania Museum, Philadelphia

must be careful, however, not to misinterpret the intent. We simply do not know the context in which these actors play their roles, and what strikes the modern eye as delightfully humorous was probably meant to be viewed with perfect seriousness. The animals, which in all likelihood descend from tribal totems or worshipers wearing masks, presumably repre-

sent deities engaged in familiar human activities. Detached from their original meaning, they eventually were assimilated into folklore and literature. Thus, we can regard them as the earliest known ancestors of the animal ▼FABLE that flourished in the West from AESOP to LA FONTAINE. At least one of them, the ass with the harp, survived as a fixed image in medieval sculpture.

Babylon

Toward the end of its early dynastic period, the theocratic socialism of the Sumerian city-states began to decay. The local "stewards of the god" had in practice become reigning monarchs, and the more ambitious among them attempted to enlarge their domain by conquering their neighbors. At the same time, the Semitic-speaking inhabitants of northern Mesopotamia drifted south in ever larger waves, until they outnumbered the Sumerian peoples in many places. These newer arrivals had adopted many features of Sumerian civilization but were less bound to the tradition of the city-state. It was they who produced the first Mesopotamian rulers who openly called themselves kings and proclaimed their ambition to rule their neighbors. Few of them succeeded; the second millennium B.C. was a time of almost continuous turmoil. Central power was held by native rulers only from about 1760 to 1600 B.C. Hammurabi (ruled c. 1792–1750 B.C.), the best-known king of the Babylonian dynasty, is by far the greatest figure of the age. Combining military prowess with a deep respect for Sumerian tradition, he saw himself as "the favorite shepherd" of the sun god Shamash whose mission was "to cause justice to prevail in the land." Under him and his successors, Babylon became the cultural center of Sumer. The city was to retain this prestige for more than a thousand years after its political power had waned.

Hammurabi's most memorable achievement is his law code, justly famous as the region's most complete surviving body of laws, which are amazingly rational and humane in conception. He had it engraved on a tall **stela**, or stone slab, whose top shows Hammurabi

Major Civilizations in the Ancient Near East

c. 4000–2340	Sumerian
c. 1792–1750	Babylonian
c. 1000–612	Assyrian
c. 612–539	Neo-Babylonian
c. 559–331	Persian

▼ The FABLE is a very old literary form in which animals play human characters. Fables may be in verse or in narrative, but either way they are moralizing allegorical commentaries on human behavior and are often highly satirical. The two greatest fabulists are thought to be AESOP, a semilegendary Greek said by Herodotos to have lived in the sixth century B.C., and JEAN DE LA FONTAINE, a seventeenth-century French writer of twelve books of 230 fables, many of which derive from Aesop's. The word *fabulous* derives from *fable*, meaning "of an astonishing or exaggerated nature."

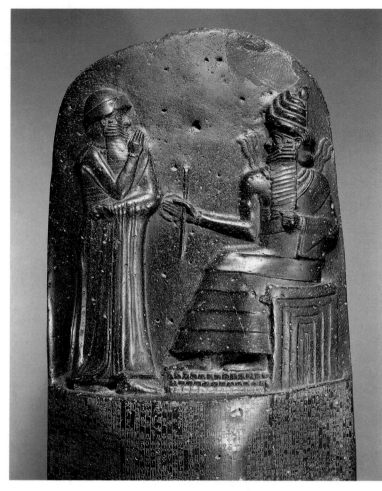

43. Upper part of stela inscribed with the Law Code of Hammurabi, from Susa (Shush), Iran. c. 1760 B.C. Diorite, height of stela approx. 7' (2.13 m); height of relief 28" (71.1 cm). Musée du Louvre, Paris

Assyria

The most copious archeological finds date from the third major phase of Mesopotamian history, between about 1000 and 500 B.C., which was dominated by the Assyrians until the last hundred years. Under a series of able rulers, the Assyrian domain gradually expanded until it embraced not only Mesopotamia proper but the surrounding regions as well. At the height of its power, from about 1000 to 612 B.C., the Assyrian Empire stretched from the Sinai peninsula to Armenia. Even Lower Egypt was successfully invaded around 670 B.C.

Assyrian civilization drew on the achievements of the Sumerians but reinterpreted them to fit its own distinctive character. Much of Assyrian art is devoted to glorifying the power of the king, either by detailed depictions of his military conquests or by showing the sovereign as the killer of lions. As in Egypt, whence they derive (see fig. 37), royal hunts were more in the nature of ceremonial contests than actual hunts: the animals were released from cages into a square formed by troops with shields for the king to kill. (Presumably, at a much earlier time, the hunting of lions in the field had been an important duty of Mesopotamian rulers as the "shepherds" of the communal flocks.) In an extraordinary Assyrian relief sculpture from the Palace of Ashurnasirpal II (d. 860? B.C.) at Calah (Nimrud), the lion attacking the royal chariot from the rear is clearly the hero of the scene (fig. 44). Of magnificent strength and courage, the wounded animal seems to embody all the dramatic emotion of combat. The dying lion on the right is equally impressive in its agony—so different from the way the Egyptian artist had interpreted a hippopotamus hunt (see fig. 25).

The Neo-Babylonians

The Assyrian Empire came to an end in 612 B.C., when Nineveh fell before the successive onslaught of ▾SCYTHIANS, MEDES, and Babylonians from the east. At that time the commander of the Assyrian army in southern Mesopotamia made himself king of Babylon. Under him and his successors the ancient city

confronting the sun god (fig. 43). The ruler's right arm is raised in a speaking gesture, as if he were reporting his work of codification to the divine king. The relief here is so high that the two figures almost give the impression of statues sliced in half. As a result, the sculptor has been able to render the eyes in the round, so that Hammurabi and Shamash gaze at each other with a force and directness unique in representations of this kind. They make us recall the statues from Tell Asmar, whose enormous eyes indicate an attempt to establish the same relationships between humans and gods in an earlier phase of Sumerian civilization.

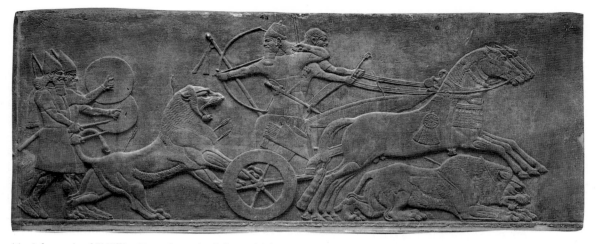

44. *Ashurnasirpal II Killing Lions*, from the Palace of Ashurnasirpal II, Calah (Nimrud), Iraq. c. 850 B.C. Limestone, 3'3" x 8'4" (99.1 cm x 2.54 m). The British Museum, London

had a final brief flowering between 612 and 539 B.C., before it was conquered by the Persians. The best known of these Neo-Babylonian rulers was Nebuchadnezzar II (d. 562 B.C.), the builder of the Tower of Babel.

Whereas the Assyrians had used carved stone slabs, the Neo-Babylonians (who were farther removed from the sources of such slabs) substituted baked and **glazed** brick. This technique, too, had been developed in Assyria, but now it was used on a far larger scale, both for surface ornament and for architectural reliefs. Its distinctive effect is evident in the Ishtar Gate of Nebuchadnezzar's sacred precinct in Babylon, which has been rebuilt from the thousands of individual glazed bricks that covered its surface (fig. 45). The stately procession of bulls, dragons, and other animals of molded brick within a framework of vividly colored ornamental bands has a grace and gaiety that remind us again of that special genius of ancient Mesopotamian art for the portrayal of animals, which we noted in early dynastic times.

Persian Art

Persia, the mountain-fringed high plateau to the east of Mesopotamia, takes its name from the people who occupied Babylon in 539 B.C. and became the heirs of what had been the Assyrian Empire. Today the country is called Iran, its older and more suitable name, since the Persians who put that area on the map of

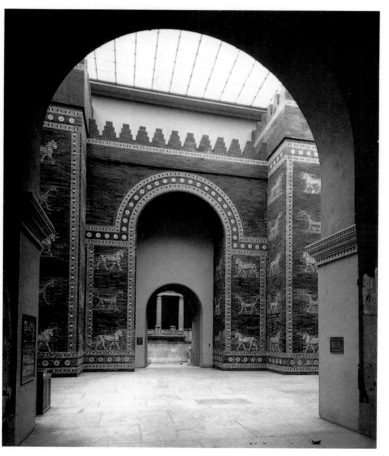

45. Ishtar Gate (restored), from Babylon, Iraq. c. 575 B.C. Glazed brick. Staatliche Museen zu Berlin, Preussischer Kulturbesitz, Vorderasiatisches Museum

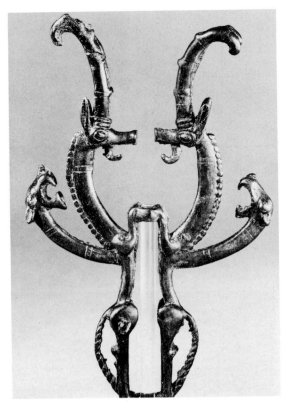

46. Pole-top ornament, from western Iran. 10th–7th century B.C. Bronze, height 7¹/₂" (19.1 cm). The British Museum, London

cles of adornment, cups, bowls, and the like. These objects have been found over a vast area, from Siberia to central Europe, from Iran to Scandinavia. They have in common not only a jewel-like concentration of ornamental design but also a repertory of forms known as the animal style. Its main feature, as the name suggests, is the decorative use of animal motifs in a rather abstract and imaginative manner. And one of the sources of the **animal style** appears to be ancient Iran. We find the style in small bronzes of the tenth to seventh century B.C. from western Iran. The pole-top ornament (fig. 46) is nomad's gear of a particularly resourceful kind. It consists of a symmetrical pair of rearing ibex that originally may have been pursued by a pair of lions; but the bodies of the attackers have been absorbed into those of their prey, whose necks and horns have been elongated to a dragonlike slenderness.

The Achaemenids

After conquering Babylon in 539 B.C., the Persian king Cyrus II (c. 600–529 B.C.) of the Achaemenid dynasty assumed the title King of Babylon along with the ambitions of the earlier Assyrian rulers. The empire he founded continued to expand under his successors. Egypt as well as Asia Minor fell to them, and Greece escaped the same fate only by the narrowest margin. At its high tide, under the Achaemenid kings Darius I (c. 550–486 B.C.) and Xerxes (519–465 B.C.), the Persian Empire was far larger than its Egyptian and Assyrian predecessors together. Moreover, this huge Achaemenid domain endured for two centuries—it was toppled by Alexander the Great (356–323 B.C.) in 331 B.C.—and during most of its existence it was ruled both efficiently and humanely. For an obscure group of nomads to have achieved all this is little short of miraculous. Within a single generation, the Persians not only mastered the complex machinery of imperial administration but also evolved a monumental art of remarkable originality to express the grandeur of their rule.

Despite their genius for adaptation, the Persians retained their own religious beliefs, drawn from the prophecies of ▼ZOROASTER.

world history were latecomers who had arrived on the scene only a few centuries before they began their epochal conquests. Inhabited continuously since prehistoric times, Iran seems always to have been a gateway for migratory groups from the Asian steppes to the north as well as from India to the east. The new arrivals would settle down for a while, dominating or intermingling with the local population, until they in turn were forced to move on—to Mesopotamia, to Asia Minor (roughly Asian Turkey), to southern Russia—by the next wave of migrants. These movements are a shadowy area of historical knowledge; available information is vague and uncertain.

Animal Style

Since nomads leave no permanent monuments or written records, we can trace their wanderings only by a careful study of the objects they buried with their dead. Such articles, of wood, bone, or metal, represent a distinct kind of portable art called the nomad's gear: weapons, bridles for horses, buckles, clasps and other arti-

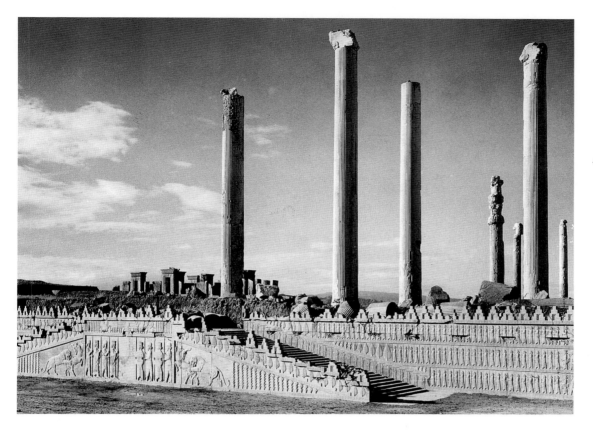

47. Audience Hall of Darius and Xerxes, Persepolis, Iran. c. 500 B.C.

This faith was based on the dualism of Good and Evil, embodied in Ahura Mazda (Light) and Ahriman (Darkness). Since the cult of Ahura Mazda centered on fire altars in the open air, the Persians had no religious architecture. Their palaces, on the other hand, were huge and impressive structures.

The most ambitious palace, at Persepolis, was begun by Darius I in 518 B.C. Assyrian traditions are the strongest single element throughout the vast complex. Yet they do not determine the character of the building, for they have been combined with influences from every corner of the empire in such a way that the result is a new, uniquely Persian style. Thus, at Persepolis columns are used on a grand scale. The Audience Hall of Darius, a room 250 feet square, had a wooden ceiling supported by thirty-six columns 40 feet tall, a few of which are still standing (fig. 47). Such a massing of columns suggests Egyptian architecture (see fig. 33)—and Egyptian influence does indeed appear in the ornamental detail of the bases and capitals—but the slender, fluted shaft of the Persepolis columns is derived from the

Ionian Greeks in Asia Minor, who are known to have furnished artists to the Persian court.

The double stairway leading up to the Audience Hall is decorated with long rows of solemnly marching figures in low relief. Their repetitive, ceremonial character emphasizes a subservience to the architectural setting that is typical of all Persian sculpture. Even here, however, we discover that the Assyrian-Babylonian heritage has been enriched by innovations stemming from the Ionian Greeks, who had created such figures in the course of the sixth century B.C., so that the style of the Persian carvings is a softer and more refined echo of the Mesopotamian tradition.

Persian art under the Achaemenids, then, is a remarkable synthesis of many diverse elements. Yet it lacked a capacity for growth. The style formulated under Darius I about 500 B.C. continued without significant change until the end of the empire. The main reason for this stasis, it seems, was the Persians' preoccupation with decorative effects regardless of scale, a carryover from their nomadic past that they never discarded.

Chapter 4
Aegean Art

If we sail from the Nile Delta northwestward across the Mediterranean, our first glimpse of Europe will be the eastern tip of the island of Crete. Beyond it, we find a scattered group of small islands, the Cyclades, and, a little farther on, the mainland of Greece, facing the coast of Asia Minor across the Aegean Sea. To archeologists, *Aegean* is not merely a geographical term. They have adopted it to designate the civilizations that flourished in this area during the third and second millenniums B.C., before the development of Greek civilization proper. There are three of these cultures, closely interrelated yet distinct from each other: that of the small islands north of Crete, known as Cycladic; that of Crete, called Minoan after the legendary Cretan King Minos; and that of the Greek mainland, called Helladic, which includes Mycenaean civilization. Each of them has in turn been divided into three phases: Early, Middle, and Late, which correspond, very roughly, to the Old, Middle, and New Kingdoms in Egypt. The most important remains, and the greatest artistic achievements, date from the latter part of the Middle phase and from the Late phase.

Aegean civilization was long known only from two epic poems by Homer (eighth century B.C.) and from Greek legends centering on Crete. Since then, a great amount of fascinating material has been brought to light—far more than the literary sources would lead us to expect—but knowledge of Aegean civilization even now is very much more limited than knowledge of Egypt or the ancient Near East. We thus lack a great deal of the background knowledge necessary for an understanding of Aegean art. Its forms, although linked both to Egypt and the Near East on the one hand and to later Greek art on the other, are no mere transition between these two worlds. They have a haunting beauty of their own that belongs to neither. Among the many special qualities of Aegean art, and perhaps the most puzzling, is its air of freshness and spontaneity, which makes us forget how little we know of its meaning.

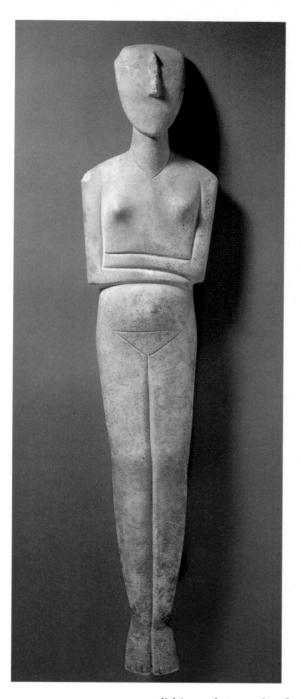

48. Figure, from
Amorgos, Cyclades.
c. 2500 B.C. Marble,
height 30" (76.2 cm).
Ashmolean Museum,
Oxford

Cycladic Art

After about 2800 B.C., the people who inhabited the Cycladic islands often buried their dead with marble sculptures of a peculiarly impressive kind. Almost all of them represent a nude female with arms folded across the chest. They also share a distinctive shape, which at first glance recalls the angular, abstract qualities of Paleolithic and Neo-

lithic sculpture: the flat, wedge shape of the body; the strong, columnar neck; and the tilted, oval shield of the face, featureless except for the long, ridgelike nose. Within this narrowly defined and stable type, however, the figures show wide variations in scale as well as form, so that they possess surprising individuality.

The best of these Cycladic figures, such as the one seen in figure 48, represent a late, highly

developed phase of around 2500–2400 B.C. The longer we study this piece, the more we realize that its qualities can only be defined as elegance and sophistication. What an extraordinary feeling for the organic structure of the body there is in the delicate curves of the outline, in the hints of roundness marking the knees and abdomen. Even if we discount its deceptively modern look, the figure seems a bold departure from anything we have seen before. There is no dearth of earlier female figures, but almost all of them betray their descent from the bulbous, heavy-bodied type of the Old Stone Age (see fig. 20). In fact, the earliest Cycladic figurines, too, were of that kind. No one knows what led the Cycladic sculptors to adopt the lithe, "girlish" ideal of figure 48. The transformation was presumably related to a change in religious beliefs and practices *away* from the mother and fertility goddess known to us from Asia Minor and the ancient Near East, whose ancestry reaches far back to the Old Stone Age. The largest figures were probably cult statues to a female divinity who may have been identified with the sun in the great cycle of life and death, while the smaller ones might have been displayed in household shrines or even used as **votive** offerings. (Traces of color indicate that facial and anatomical features were painted in.) Although their meaning and function remain far from clear, their purpose was not simply funereal. Rather, they were important objects that were included in graves with others from everyday life, as either offerings to the deity or provisions for the afterlife. Rarely were they freestanding. Most have been found in a reclining position, but they may also have been propped upright during normal use.

Minoan Art

Minoan civilization is by far the richest, as well as the strangest, of the Aegean world. What sets it apart from the civilizations of Egypt and the Near East, and also from that of Greece which was to follow, is a lack of continuity that appears to have been caused by archeological accident. The different phases appear and disappear so abruptly that their fate must have

been determined by sudden violent changes affecting the entire island. Yet the character of Minoan art, which is gay, even playful, and full of rhythmic motion, conveys no hint of such threats. The first of these unexpected shifts occurred about 2000 B.C. Until that time, during the thousand years of the Early Minoan era, the Cretans had not advanced much beyond the Neolithic level of village life, even though they seem to have engaged in some overseas trade that brought them into contact with Egypt. Then they created not only their own system of writing but an urban civilization as well, centering on several great palaces. At least three of them—at Knossos, Phaistos, and Mallia—were built in short order. Little is left today of this sudden spurt of large-scale building activity. The three palaces, as well as several lesser ones, were all destroyed at the same time, about 1628 B.C. These palaces, it seems, were demolished by a catastrophic earthquake following the eruption of a volcano on the island of Thera. Contrary to popular belief, the eruption did not mean the end of Minoan civilization, although it destroyed everything on Thera. After a short interval, new and even larger structures began to appear on the same sites in Crete, except at Phaistos, only to suffer destruction, in their turn, about 1450 B.C. by another earthquake. These sites were abandoned, except for the palace at Knossos, which was occupied by the Mycenaeans, who took over the island almost immediately after the earthquake.

Architecture

These "new" palaces are our main source of information on Minoan architecture. The one at Knossos, called the Palace of Minos, was the most ambitious, covering a large territory and composed of so many rooms that it survived in Greek legend as the ▼LABYRINTH of the MINOTAUR. It has been carefully excavated and partly restored. We cannot recapture the appearance of the building as a whole, but we can assume that the exterior probably did not look impressive compared with Assyrian or Persian palaces (see fig. 47). There was no striving

▼ In Greek myth, the LABYRINTH was a maze of rooms beneath the palace of King Minos at Knossos, on the island of Crete. So complex was it that one could not enter it without getting lost. Within the Labyrinth lived the MINOTAUR, half-man and half-bull, who ate human flesh. After losing a war with Crete, Athens was compelled to send fourteen young men and women to Crete each year to feed the monster. The Athenian prince Theseus put an end to the carnage by killing the Minotaur and escaping from the Labyrinth with the help of the Cretan princess Ariadne.

for unified, monumental effect. The individual units are generally rather small and the ceilings low (fig. 49, page 66), so that even those parts of the structure that were several stories high could not have seemed very tall.

Nevertheless, the numerous **porticoes** (roofed entranceways), staircases, and air shafts must have given the palace a pleasantly open, airy quality. Some of the interiors, with their richly decorated walls, still have an atmosphere of intimate elegance to this day. The masonry construction of Minoan palaces is excellent throughout, but the **columns** were always of wood. Although none has survived, their characteristic form (the smooth **shaft** tapering downward, topped by a wide, cushion-shaped **capital**) is known from representations in painting and sculpture. About the origins of this type of column, which in some contexts could also serve as a religious symbol, or about its possible links with Egyptian architecture, archeologists are just beginning to theorize.

Sculpture

The religious life of Minoan Crete is even harder to define than the political or social order. It centered on certain sacred places, such as caves or groves, and its chief deity (or deities?) was female, akin to the mother and fertility goddesses we have encountered before. Since the Minoans had no temples, we are not surprised to find that they lacked large cult statues as well, but even on a small scale, religious subjects in Minoan art are few and of uncertain significance. Several statuettes of about 1650 B.C. from Knossos must represent the goddess in one of her several identities, or perhaps some of her priestesses, although the costumes endow them with a secular, "fashionable" air. One of them shows her with three long snakes wound around her arms, body, and headdress. The meaning is clear: snakes are associated with earth deities and male fertility in many ancient religions, just as the bared breasts of this statuette suggest female fertility (fig. 50, page 66). Only the style of the statuette hints at a possible foreign source: the emphatically conical quality of the figure and the large

eyes and heavy, arched eyebrows suggest a kinship—remote and indirect, perhaps through Asia Minor—with Mesopotamian art.

Painting

After the catastrophes that had wiped out the earlier palaces, there was what seems to our eyes an explosive increase in wealth and an equally remarkable outpouring of creative energy. The most surprising aspect of this sudden blossoming, however, is its great achievement in painting. Unfortunately, these paintings have survived only in small fragments, so that we hardly ever have a complete composition, let alone the design of an entire wall. A great many of them were scenes from nature showing animals and birds among luxuriant vegetation, or they depicted creatures of the sea.

Marine life (as seen in the fish and dolphin wall painting in figure 49) was a favorite subject of Minoan painting, and the marine feeling pervades all Minoan art. We sense it even in *"The Toreador Fresco,"* the most dynamic Minoan wall painting recovered so far (fig. 51, page 67). The darker patches are the original fragments on which the restoration is based. The conventional title should not mislead us: what we see here is not a bullfight but a ritual game in which the performers vault over the back of the animal. Two of the slim-waisted athletes are girls, differentiated (as in Egyptian art) mainly by their lighter skin color. That the bull was a sacred animal, and that bull vaulting played an important role in Minoan religious life, are beyond doubt. Scenes such as this still echo in the Greek legend of the youths and maidens sacrificed to the Minotaur. If we try, however, to "read" the scene as a description of what actually went on during these performances, we find it strangely ambiguous. Do the three figures show successive phases of the same action? How did the youth in the center get onto the back of the bull, and in what direction is he moving? Scholars have even consulted rodeo experts without getting clear answers to these questions. All of which does not mean that the Minoan artist was deficient—it would be absurd to find fault for failing to accomplish what was

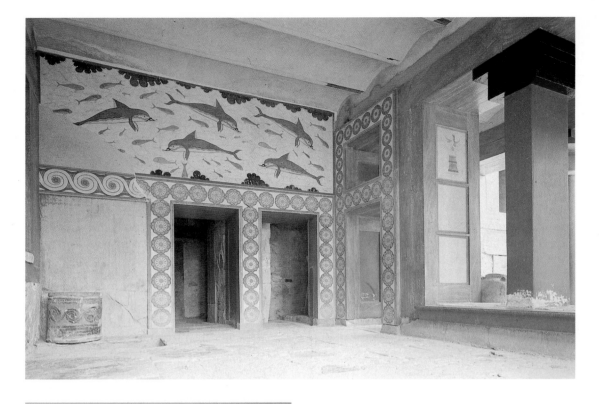

49. The Queen's Megaron,
Palace of Minos, Knossos,
Crete. c. 1700–1300 B.C.

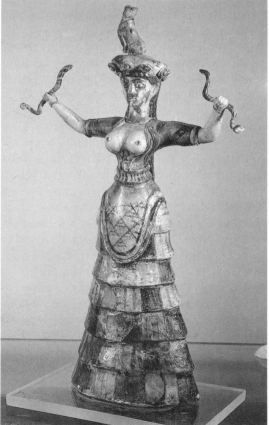

never intended in the first place—but that fluid, effortless ease of movement was more important to the artist than factual precision or dramatic power. The artist has, as it were, idealized the ritual by stressing its harmonious, playful aspect to the point that the participants behave like dolphins gamboling in the sea.

Mycenaean Art

Along the southeastern shores of the Greek mainland there were during Late Helladic times (c. 1600–1100 B.C.) a number of settlements that corresponded in many ways to those of Minoan Crete. They, too, for example, were grouped around palaces. Their inhabitants have come to be called Mycenaeans, after Mycenae, the most important of these settlements. Since the works of art unearthed there by excavation often showed a strikingly Min-

50. *Goddess with Snakes*, from the palace complex, Knossos. c. 1650 B.C. Faience, height 11⁵/₈" (29.5 cm). Archeological Museum, Iraklion, Crete

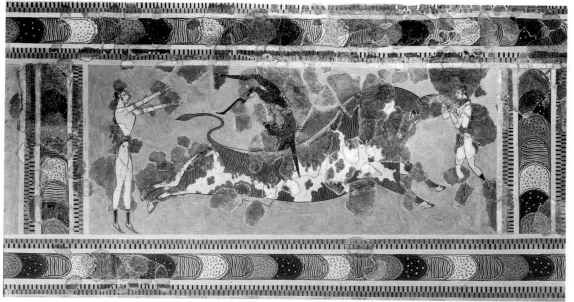

51. *"The Toreador Fresco,"* from the palace complex, Knossos. c. 1500 B.C. Height including upper border approx. 24¹/₂" (62.2 cm). Archeological Museum, Iraklion, Crete

Major Civilizations in the Aegean

c. 2800–1600	Cycladic
c. 3000–1450	Minoan
c. 1600–1100	Mycenaean

Corbeling as a space-spanning device relies on the downward pressure of overlapped layers of stone to lock in the projecting ends.

corbel arch

corbel vault

oan character, the Mycenaeans were at first regarded as having come from Crete, but it is now agreed that they were the descendants of the earliest Greek clans, who had entered the country sometime after 3000 B.C.

For centuries, these people led an inconspicuous pastoral existence in their new homeland. Their modest tombs have yielded only simple pottery and a few bronze weapons. Toward 1600 B.C., however, they suddenly began to bury their dead in deep graves reached by a well-like passageway (shaft grave) and, a little later, in conical stone chambers, known as beehive tombs. This development reached its height toward 1300 B.C. in such impressive structures as the one shown in figure 52, built of concentric layers of precisely cut stone blocks that taper inward toward the highest point. (This method for spanning space is called **corbeling**.) Its discoverer thought it far too ambitious for a tomb and gave it the misleading name Treasury of ▼ATREUS. Burial places as elaborate as this can be matched only in Egypt during the same period.

Apart from such details as the shape of the

52. Interior, "Treasury of Atreus," Mycenae. c. 1300–1250 B.C.

columns or decorative motifs of various sorts, Mycenaean architecture owes little to the Minoan tradition. The palaces on the mainland were hilltop fortresses surrounded by defensive walls of huge stone blocks, a type of construction quite unknown in Crete. The Lioness Gate

▼ In Greek legend, ATREUS was the father of Menelaus—whose wife Helen's abduction caused the Trojan War—and Agamemnon, the leader of the Greek armies that besieged Troy. Through Agamemnon (often addressed as "Son of Atreus" in Homer's *Iliad)*, Atreus became the ancestor of the royal family of Mycenae.

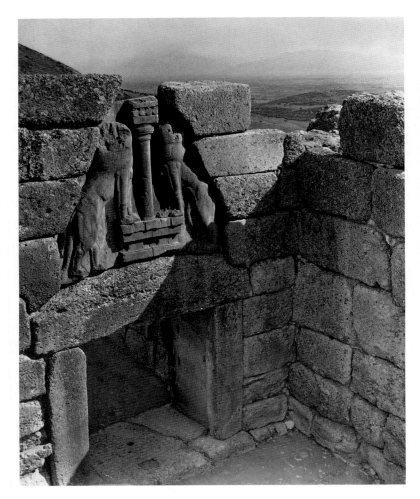

53. The Lioness Gate, Mycenae. 1250 B.C.

majesty. Their function as guardians of the gate, their tense, muscular bodies, and their symmetrical design again suggest an influence from the ancient Near East. Homer's ▼*ILIAD* and *ODYSSEY* recount the events of the TROJAN WAR, which brought the Mycenaeans to Asia Minor soon after 1200 B.C. It seems likely, however, that they began to sally eastward across the Aegean, for trade or war, much earlier than that.

Mycenae in the sixteenth century B.C. thus presents a strange picture. What appears to be an Egyptian influence on burial customs is combined with a strong artistic influence from Crete and with an extraordinary material wealth as expressed in the lavish use of gold. What we need is a triangular explanation that involves the Mycenaeans with Egypt as well as Crete about a century before the destruction of the new palaces. Such a theory—fascinating and imaginative, if hard to confirm in detail—runs about as follows: between 1700 and 1580 B.C., the Egyptians were trying to rid themselves of the Hyksos, who had seized the Nile Delta (see page 47). For this they gained the aid of warriors from Mycenae, who returned home laden with gold (of which Egypt alone had an ample supply) and deeply impressed with Egyptian funerary customs. The Minoans, not renowned as soldiers but famous as sailors, ferried the Mycenaeans back and forth, so that they, too, had a new and closer contact with Egypt. This role as ferriers may help to account for their sudden prosperity toward 1600 B.C., as well as for the rapid development of naturalistic wall painting at that time. In fact, such a theory is supported by the discovery of a large group of Minoan paintings in Egypt. The close relations between Crete and Mycenae, once established, were to last a long time.

▼ The TROJAN WAR was a half-legendary conflict fought between a number of the Greek city-states and Troy, a city on the coast of Asia Minor (modern Turkey). Homer's epic poem the *ILIAD* describes events that took place during the last year of the war, while his *ODYSSEY* recounts the ten-year homeward voyage of one of the Greek generals, Odysseus (Roman, Ulysses), after the conflict. These poems—part history and part myth—developed gradually within the oral tradition of Greek poetry passed down for centuries from one generation of poets to another before there was a written Greek language. Recent archeological discoveries have confirmed the accuracy of many of the details of Homer's narrative.

at Mycenae (fig. 53) is the most impressive remnant of these massive ramparts, which inspired such awe in the Greeks of later times that they were regarded as the work of the Cyclopes (a mythical race of one-eyed giants). Even the "Treasury of Atreus," although built of smaller and more precisely shaped blocks, has a Cyclopean **lintel** (see fig. 52).

Another aspect of the Lioness Gate foreign to the Minoan tradition is the great stone relief over the doorway. The two lionesses flanking a symbolic Minoan column have a grim, **heraldic**

Chapter 5
Greek Art

To most people living in Western countries, the works of art we have come to know so far seem like fascinating strangers, because of their "alien" background and the "language difficulties" they present. Greek architecture, sculpture, and painting, by contrast, appear not as strangers but as relatives, older members of a family that is immediately recognizable. However, we shall find that Greek art was indebted in countless ways to the art of a number of cultures that preceded it, so that we may consider those cultures, too, among the direct ancestors of Western civilization. In addition, we should be aware that the continuous tradition since the ancient Greeks can be a handicap as well as an advantage—especially in looking at Greek originals, whose contribution is sometimes obscured by our familiarity with later imitations.

The Mycenaeans and other clans described by Homer were the first Greek-speaking people to wander into the peninsula now called Greece. This was during the third millennium B.C. Then, sometime between 1250 and 1100 B.C., others came, overwhelming and absorbing those who were already there. Among these late arrivals, three groups stand out. First were the Dorians, whose invasion of Mycenaean territory may account for the fall of that civilization. The Dorians populated southern Greece, including the Cyclades. The Ionians colonized central Greece, most of the islands in the Aegean Sea, and the central coast of nearby Asia Minor, called Ionia. The last were the Aeolians, who moved into the northern mainland and settled the coast of Asia Minor as far north as Troy. In the eighth century B.C., the Greeks spread westward, founding important settlements in Sicily and southern Italy. By 500 B.C., Greek colonies and cities were established as far west as modern Spain, in northern Africa, and along the coastline of the Black Sea. Although the Greeks were united by language and religious beliefs, old loyalties continued to divide them into city-states. The intense rivalry among these city-states for power, wealth, and status stimulated the growth of ideas and institutions. In the end, they paid dearly for their inability to compromise: they engaged in almost continuous warfare. The Peloponnesian War (431–404 B.C.), in which the Spartans and their allies defeated the Athenians, was only the most notable among the series of conflicts that left Greece so weak that it was easily defeated by Alexander the Great in the late fourth century B.C.

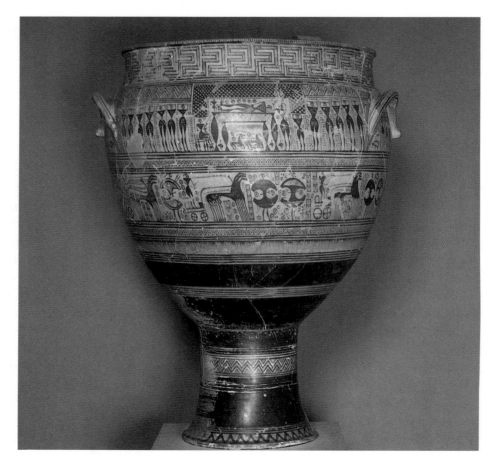

54. Vase, called the *Dipylon Vase*, from the Dipylon cemetery, Athens. 8th century B.C. Height 40¹/₂" (102.9 cm). The Metropolitan Museum of Art, New York

Rogers Fund, 1914

Painting

The formative phase of Greek civilization embraces about 400 years, from about 1100 to about 700 B.C. Yet we know very little about the first three centuries. The Dorians, Ionians, and Aeolians left very little archeological evidence; all written language died out; and the population of the Greek mainland and islands declined to about one-tenth of what it had been in Mycenaean times. Only after about 800 B.C., about the time when Homer wrote the *Iliad* and the *Odyssey*, did the Greeks emerge into the full light of history. The earliest specific dates that have come down to us are from that time: 776 B.C., the founding of the ▼OLYMPIAN GAMES and the starting point of Greek chronology, as well as several slightly later dates recording the founding of various cities. That time also saw the full development of the oldest characteristically Greek style in art, the so-called Geometric. We know it only from painted pottery and small-scale sculpture, for monumental architecture and sculpture in stone did not appear until the seventh century B.C.

Geometric Style

At first, pottery was decorated only with **abstract** designs—triangles, checkers, concentric circles—but toward 800 B.C. human and animal figures began to appear within the geometric framework, and in the most mature examples these figures could form elaborate scenes. A vase from the Dipylon cemetery in Athens, for example (fig. 54), belongs to a group of very large vessels that functioned as grave monuments. Its bottom has holes through which liquid offerings could filter down to the dead in the ground below. On the body of the vase, we see the deceased lying in state, flanked by figures with their arms raised in a gesture of mourning, and, below, a funeral procession of chariots and warriors on foot.

The most remarkable thing about this scene is that it contains no reference to an afterlife. Its purpose is purely commemorative. Here lies a worthy man, it tells us, who was mourned by many and had a splendid funeral. Did the Greeks, then, have no conception of a hereafter? They did, but the realm of the dead to them was a colorless, ill-defined region where the souls, or shades, led a feeble and passive existence without making any demands on the living.

Orientalizing Style

Narrative (the depiction of an event or story), entirely absent from the Dipylon vase, demands greater scope than the conservative tradition of the Geometric style could provide. The dam finally burst toward 725 B.C., when Greek art entered another phase, called the Orientalizing style, and new forms came flooding in. As its name implies, the new style reflects powerful influences from Egypt and the Near East, stimulated by increasing trade with these regions. Between about 725 and 650 B.C., Greek art absorbed a host of Oriental motifs and ideas, and it was profoundly transformed in the process. The change becomes very evident if we compare the large amphora (a vase for storing wine or oil) from Eleusis (fig. 55) with the Dipylon vase of a hundred years earlier.

Geometric ornament has not disappeared from this vase altogether, but it is confined to the peripheral zones: the foot, the handles, and the lip. New, curvilinear motifs—such as spirals, interlacing bands, palmettes, and rosettes—are conspicuous everywhere. On the shoulder of the vessel we see a band of fighting animals, derived from the repertory of Near Eastern art. The major areas, however, are given over to narrative, which has become the dominant element. Ornament of any sort now belongs to a separate and lesser realm, clearly distinguishable from that of representation, so that the decorative patterns scattered among the figures can no longer interfere with their actions.

Narrative painting tapped a nearly inexhaustible source of subjects from Greek myths and legends (see "The Greek Gods and Goddesses," page 72)—a fact that also helps explain

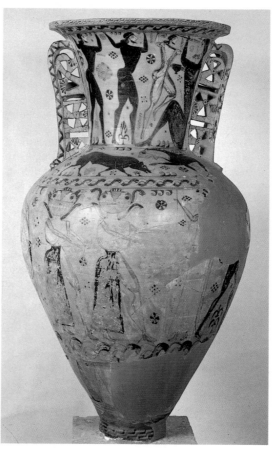

55. *The Blinding of Polyphemos and Gorgons,* on an amphora. c. 675–650 B.C. Height 56" (142.2 cm). Archeological Museum, Eleusis, Greece

the strong appeal exerted on the Greek imagination by Oriental lions and monsters. These terrifying creatures embodied the unknown forces of life faced by the hero. This fascination is clearly seen on the Eleusis amphora. The figures are a far cry from the conventionalized forms of the Geometric style. They have gained greatly in both size and descriptive precision. As a result, the Homeric tale of the blinding of the giant, one-eyed Cyclops Polyphemos by Odysseus and his companions—whom the Cyclops had imprisoned—is enacted with memorable directness and dramatic force in a scene on the neck of the amphora. If these figures lack the beauty we will later expect of epic heroes in art, their movements have an expressive vigor that makes them seem thoroughly alive. The slaying of another monstrous creature is depicted on the body of the vase, the

Used almost continuously throughout Western art, the Greek vocabulary of ornamental motifs is vast, highly adaptable, and very durable.

spirals made of interlacing bands

palmette

rosette

acanthus

meander

egg-and-dart

The Greek Gods and Goddesses

All early civilizations and preliterate contemporary cultures have creation myths to explain the origin of the universe and humanity's place in it. Over time, these myths have been elaborated into complex cycles that represent a comprehensive attempt to understand the world. The Greek stories of the gods and heroes—the myths and legends—were the result of the absorption of local Doric and Ionic deities and folktales into the family of Olympian gods. (The Greeks believed that the major gods, or pantheon—meaning "all the gods"—dwelled on Mount Olympus and therefore called them Olympian gods. The twelve main gods—six male and six female—were Zeus, Hera, Apollo, Artemis, Athena, Ares, Aphrodite, Demeter, Hephaistos, Poseidon, Hermes, and Hestia.) Greek myths came from many sources, reflecting the successive waves of immigration that brought them to Greece. Just as one culture was displaced by another on the peninsula, one generation of gods was threatened and overthrown by another. In these Greek tales, the behavior of the gods and goddesses was very human. They led civilized lives, but they also quarreled, waged war, and had children with each other's spouses and often with mortals as well—which made for a most complex array of relationships.

The Greeks believed that the Olympians were the third generation of divinities. The first two generations are called TITANS, who included ATLAS (who was credited with holding up the earth), HEKATE (an underworld goddess), SELENE (goddess of the moon), HELIOS (a god of the sun, sometimes identified with Apollo), and PROMETHEUS (a demigod, who gave humanity the gift of fire and was therefore severely punished). The first king and queen of heaven were URANUS (the sky) and his wife GAIA (the earth), who were overthrown in the second generation by their son KRONOS and his sister and wife, RHEA. Kronos, hearing a prophecy that he, too, would be overthrown by one of his children, took the precaution of swallowing them as soon as they were born. Finally, Rhea—not wanting to lose another of her offspring—hid her newborn son ZEUS (the Roman Jupiter) from his father. Zeus later tricked Kronos into disgorging his siblings, who then overthrew him with the help of their grandmother, Gaia. Like his father and grandfather before him, Zeus became god of the sky and king of his generation of gods, the Olympians. After the defeat of Kronos, Zeus divided the universe by lot with his brothers POSEIDON (Neptune), who ruled the sea, and HADES (Pluto), who became lord of the underworld but was not among the twelve main Olympian gods.

Zeus, like his father, married one of his sisters, HERA (Juno), goddess of marriage and fruitfulness. Two of their children were ARES (Mars), the god of war, and HEPHAISTOS (Vulcan), the god of metalworking and the forge. Zeus also fathered numerous other children through his many love affairs with goddesses and mortal women. With Leto he became the father of APOLLO (also Apollo to the Romans), the god of reason and civilization, and ARTEMIS (Diana), goddess of the hunt and sometimes considered a moon goddess along with Selene.

One of Zeus's most illustrious children was ATHENA (Minerva), goddess of war. While Zeus's consort Metis was pregnant with Athena, Zeus swallowed her alive because he had been told he would toppled by a son born to Metis. Athena was eventually born, fully grown and armed, from Zeus's head. Although a female counterpart to the war god Ares, Athena was also the goddess of peace, a protector of heroes, a patron of arts and crafts (especially spinning and weaving) and, later, of wisdom. She became the patron goddess of Athens, an honor she won in a contest with Poseidon. Athena's gift to the city was the olive tree, with all its useful benefits, while Poseidon's present was a useless saltwater spring.

Zeus fathered APHRODITE (Venus), the goddess of love, beauty, and fertility. She became the wife of Hephaistos and a lover of Ares, by whom she bore children, among them EROS (Cupid), the god of erotic passion. She and the Trojan prince Anchises were the parents of AENEAS, a hero of Homer's *Iliad* who later became the legendary progenitor of the Roman people. Another of Zeus's children was HERMES (Mercury), the messenger of the gods, conductor of souls to the underworld, and the god of travelers and commerce. He was sometimes credited with inventing the lyre and shepherd's flute. HESTIA (Vesta) was goddess of the hearth. DEMETER (Ceres) governed agriculture, especially grains.

Two gods are especially important to our study of Greek art. The main god of civilization (including art, music, poetry, law, and philosophy) was Zeus's son Apollo, who was also the god of prophecy and medicine, flocks, and herds. Opposite in temperament to Apollo was the god DIONYSOS (Bacchus), said to be the son of Zeus and either PERSEPHONE (Proserpina), queen of the underworld, or the earth goddess SEMELE. Dionysos's followers were half-man, half-goat satyrs (the oldest of whom is SILENOS, the tutor of Dionysos) and their female companions, nymphs and women known as maenads (bacchantes), who worshiped him by entering into ecstatic states in which they hoped to be united with the spirit of Dionysos himself. As the god of fertility, Dionysos was also a divinity of vegetation (he was credited with the invention of wine making), as well as of peace, of hospitality, and of the civilized arts.

In its inspiration and grandeur, Greek civilization represented a fusion of contrasting sensibilities—the rational Apollonian and the intuitive Dionysian. An example of this coalescence is Classical tragedy, which originated in Dionysiac rites and was transformed in an Apollonian spirit in the plays of such great fifth-century B.C. dramatists as Aeschylos, Sophocles, and Euripides.

main part of which has been badly damaged, so that only two figures have survived intact. They are ▼GORGONS, the sisters of the snake-haired, terrible-faced MEDUSA, whom PERSEUS killed with the aid of the gods. Even here we notice an interest in the articulation of the body far beyond the limits of the Geometric style.

Archaic Style

The Orientalizing phase of Greek art was a period of experiment and transition, in contrast to the stable and consistent Geometric style. Once the new elements from the Near East had been fully assimilated, there emerged another style, as well defined as the Geometric but infinitely greater in range: the Archaic, which lasted from the later seventh century to about 480 B.C., the time of the famous Greek victories over the Persians. During the Archaic period, we witness the unfolding of the artistic genius of Greece not only in vase painting but also in monumental architecture and sculpture. While Archaic art lacks the balance and sense of perfection of the Classical style of the later fifth century B.C., it has such freshness that many people consider it the most vital phase of Greek art.

Black-Figure Style The difference between Orientalizing and Archaic vase painting is one of artistic discipline. Toward the end of the seventh century, Attic vase painters—those from the Athens region—resolved these inconsistencies by adopting the "black-figure" style, which means that the entire design is painted in silhouette in black against the reddish clay. Internal details are scratched in with a needle, or incised, and white and purple may be added on top of the black to make certain areas stand out—a procedure that favors a decorative, two-dimensional effect. The scene of Herakles killing the Nemean lion (see "The Hero in Greek Legend," below), on an amphora attributed to the painter Psiax (fig. 56), is all grimness and violence. The two heavy bodies almost seem united forever in their struggle. Incised line and touches of colored detail have been kept to a minimum so as not to break up the compact black mass. Yet both figures show such a wealth of anatomical knowledge and skillful use of foreshortening that they give an illusion of existing in the round. The work of Psiax is the direct outgrowth of the forceful Orientalizing style of the blinding of Polyphemos in the Eleusis amphora. Herakles in his struggle reminds us of the hero on the soundbox of the harp from Ur (see fig. 42). Both show a hero facing the unknown forces of life embodied by terrifying mythical creatures. The Nemean lion likewise serves to underscore the hero's might and courage.

Major Periods of Greek Art

c. 900–725	Geometric
c. 725–650	Orientalizing
c. 650–480	Archaic
c. 480–400	Classical
c. 400–325	Fourth Century
c. 320–30	Hellenistic

▼ In Greek myth, MEDUSA and her sister GORGONS were so powerful that anyone looking directly at their faces would be turned to stone. PERSEUS, a favorite mythical hero, is most often shown in art as the one who beheaded Medusa.

The Hero in Greek Legend

The early Greeks grasped the meaning of events in terms of destiny and human character rather than as accidents of history. Heroes were a class of quasi-divine mortals, rather than true gods, who functioned as models of character—personalities whose fascination has lasted into our time. The Greeks' poetry and religious festivals reflect their belief that the accomplishments and qualities of their legendary heroes and heroines were incomparably greater than those of contemporary men and women. Most of these heroic personalities were believed to have descended from gods who had children with mortals, and this divine lineage helped explain their great strength or other superior qualities. The hero's or heroine's very excellence (called *arete* by the Greeks) could in excess lead to overweening pride (*hubris*) and sometimes consequently to a serious error or wrongdoing (*hamartia*) with disastrous results. Greek tragedies—including the surviving examples by Sophocles, Aeschylos, and Euripides—were religious plays relating the stories of the downfall of essentially virtuous heroes and heroines, destroyed by terrible fate or their own personal flaws.

Perhaps because of this cultural preoccupation with the consequences of *hubris* and *hamartia*, moderation was a Greek ideal. Personifying this ideal was the god of reason, Apollo, the patron of art and civilized life. As Greek society developed, the idea of *arete* came to be identified with such personal and civic virtues as modesty and piety.

The best known of all heroes was HERAKLES (Hercules to Romans). The son of Zeus and the Greek princess Alcmene, Herakles undertook twelve exploits—the so-called Labors of Herakles—so difficult that he was rewarded with acceptance into the company of the Olympian gods upon his death. The phrase *Herculean effort* recalls Herakles' extreme exertion in performing his twelve labors, the first of which was killing the lion at Nemea.

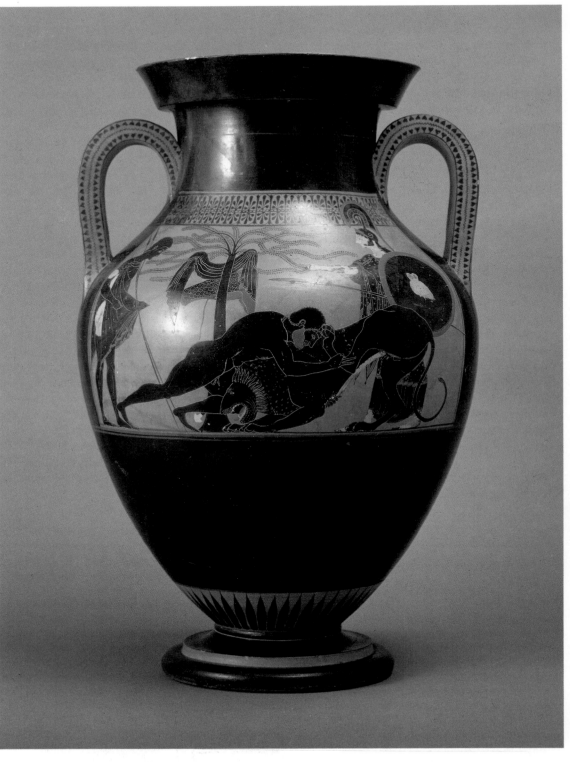

Speaking of

Classical, classical,
and *classic*

In art history, *Classical* spelled
with a capital *C* refers specifically
to Greek civilization between
about 480 and 325 B.C. The term
classical refers to the entire ancient
Greek and Roman period and its
creations. In the Western tradition,
classical has also come to mean
that which is moderate, balanced,
excellent, and enduring. It is prob-
ably for this reason that serious
European music is called "classical
music." The word *classic* is used
to describe and signify something
of traditional excellence, such
as Dickens's novel *A Tale of Two
Cities* or a predictably fine sporting
event—like a golf classic.

56. Psiax. *Herakles Strangling the Nemean ▯*
Height 19 1/2" (49.5 cm). Museo Civico dell'Età Cristiana, Brescia, Italy

74 Greek Art

Red-Figure Style Vase painters must have felt that the silhouettelike black-figure technique made the study of foreshortening unduly difficult, for in some of their vases they tried the reverse procedure, leaving the figures red and filling in the background. This red-figure technique gradually replaced the older method toward 510 B.C. Its advantages are well shown in figure 57, a krater (wine mixer) by Euphronios of about 510 B.C. showing Herakles wrestling Antaios. The details are freely drawn with a brush, rather than laboriously incised, so the picture depends far less on the profile view than before. Instead, the artist exploits the internal lines that permit him to show boldly foreshortened and overlapping limbs, precise details of costume (note the pleated dresses of the giant's two sisters), and intense facial expressions. The painter is so fascinated by all these new effects that he has made the figures as large as possible. They almost seem to burst from the field of the vase.

Classical Style

According to literary sources, Greek painters of the Classical period, which began around 480 B.C., achieved a great breakthrough in mastering **illusionistic** space. Unhappily, we have very few **murals** or panels to verify that claim, and vase painting by its very nature could echo the new concept of **pictorial space** only in rudimentary fashion. From the mid-fifth century B.C. on, the impact of monumental painting gradually transformed vase painting as a whole into a satellite practical art that tried to reproduce large-scale compositions in a kind of shorthand dictated by its own limited technique and the fact that vessels were made in large volume and sold cheaply. We can get some idea of what Greek wall painting looked like from later copies and imitations, although their relation to the originals is extremely

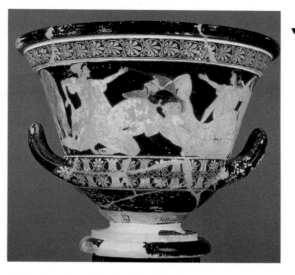

57. Euphronios. *Herakles Wrestling Antaios*, on an Attic red-figure krater. c. 510 B.C. Height 19" (48 cm). Musée du Louvre, Paris

problematic (see page 117). According to the first-century A.D. Roman writer ▼PLINY, Philoxenos of Eretria in the late fourth century B.C. painted the victory of ▼ALEXANDER THE GREAT (356–323 B.C.) over Persian King Darius III (d. 330 B.C.) at Issus in Asia Minor. An echo of that work may survive in a famous third-century B.C. Pompeian mosaic (fig. 58), which follows the four-color scheme (yellow, red, black, and white) that is known to have been widely used in Philoxenos's time. The scene is far more complicated and dramatic than anything from earlier Greek art in the crowding, the air of

58. *The Battle of Issus* or *The Battle of Alexander and the Persians*. Mosaic copy from Pompeii of a Hellenistic painting of c. 300 B.C. 8'11" x 16'9½" (2.78 x 5.12 m). Museo Archeològico Nazionale, Naples

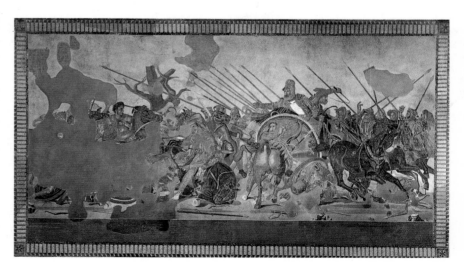

▼ There were two Plinys: Pliny the Elder (A.D. 23/24–79) and his nephew and adopted son, Pliny the Younger (A.D. c. 61–c. 112). PLINY THE ELDER was a renowned equestrian and served several Roman emperors as a military officer. In midlife, he took up writing. Of the thirty-one books mentioned by PLINY THE YOUNGER, only the encyclopedic *Historia naturalis (Natural History)* survives. Pliny the Younger's literary distinction is in his letters, including one that poignantly describes watching his uncle from a boat as he suffocated to death on the shore of the Roman seaside resort of Pompeii while it was being consumed by volcanic mud and steam from Mount Vesuvius.

▼ Already an accomplished general at age eighteen, ALEXANDER THE GREAT (356–323 B.C.) became king of Macedon—the modern Macedonian region—in 336, when he was twenty years old. Within ten years he conquered various Persian and Near Eastern peoples as he created an empire that reached from the west across Mesopotamia to the Indus Valley. He encouraged Greek culture in the peoples he ruled, while not suppressing local beliefs or traditions. After surviving staggering military perils, he died suddenly in the city of Babylon when he was just thirty-three.

frantic excitement, the precisely cast shadows, and the powerfully modeled and foreshortened forms. And for the first time, we have a depiction of something that actually happened, without the symbolic overtones of *Herakles Strangling the Nemean Lion.* In character and even in appearance, it is close to later Roman reliefs commemorating specific historic events (see figs. 97, 98). Yet, there can be little doubt that the mosaic was executed by a Greek, as this technique originated in Hellenistic times and remained a specialty of Greek artists to the end.

Temples

Orders and Plans

In architecture, the Greek achievement has been identified since ancient Roman times with the creation of the three classical architectural **orders**: Doric, Ionic, and Corinthian. Strictly speaking, there are only two, because the Corinthian is a variant of the Ionic. The **Doric order** (named for its home region on the Greek mainland) may well claim to be the basic order, since it is older and more sharply defined than the Ionic, which developed on the Aegean islands and the coast of Asia Minor.

What do we mean by *architectural order*? By common agreement, the term is used only for Greek architecture and its descendants; and rightly so, for none of the other architectural systems known to us produced anything like it. Perhaps the simplest way to make clear the unique character of the Greek orders is this: there is no such thing as "*the* Egyptian temple" or "*the* Gothic church." Individual buildings, however much they may have in common, are so varied that we cannot distill a generalized type from them. But "*the* Doric temple" is a real entity that inevitably forms in our minds as we examine the monuments themselves. We must be careful not to think of this abstraction as an ideal that permits us to measure the degree of perfection of any given Doric temple. It simply means that the elements of which a Doric temple is composed are extraordinarily constant in number, in kind, and in their relation to one another. As a result of this narrowly cir-

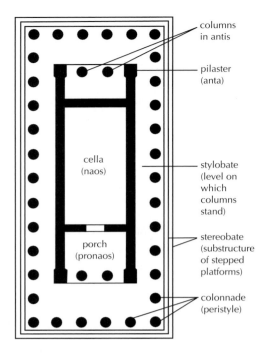

59. Ground plan of a typical Greek peripteral temple

cumscribed repertory of forms, Doric temples all belong to the same clearly recognizable family. They show an internal consistency, a mutual adjustment of parts, that gives them a unique quality of wholeness and organic unity.

Temple Plans

The **plans** of Greek temples are not directly linked to the orders, which concern only the **elevation**, or a side view. (A third type of architectural drawing is the **section**.) They may vary according to the size of the building or regional preferences, but their basic features are so much alike that it is useful to study them from a generalized "typical" plan (fig. 59). The nucleus is the **cella**, or naos (the room in which the image of the deity is placed), and the porch (pronaos) with its two columns (columns in antis) flanked by **pilasters** (antae). Often we find a second porch added behind the cella, to make the design more symmetrical. In larger temples, the central unit is surrounded by a **colonnade**, called the **peristyle**, and the structure is then known as peripteral. The very largest temples of Ionian Greece may even have a double colonnade.

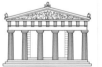

A plan, or ground plan, depicts a building as if sliced horizontally about 3 feet above the ground, usually showing solid parts in a darker tone than openings (doors and windows) and open spaces. Lines may indicate changes of level, such as steps. This plan shows a Doric temple.

An elevation shows one exterior side seen straight on, with the parts drawn to scale. This elevation is of the main entrance end of the Doric temple seen in the plan above.

A section reveals the inside of a structure as if sliced clean through.

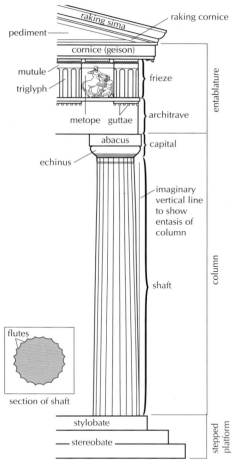

raking sima

raking cornice

pediment

cornice (geison)

mutule

triglyph

frieze

metope guttae

architrave

abacus

capital

echinus

imaginary
vertical line
to show
entasis of
column

shaft

entablature

column

flutes

section of shaft

stylobate

stereobate

stepped
platform

60. Greek Doric order

Doric Order

The term *Doric order* refers to the standard parts, and their sequence, constituting the exterior of any Doric temple. Let us first look at the three main divisions: the stepped platform (incorporating the stylobate and stereobate), the columns, and the **entablature** (fig. 60). The Doric **column** consists of the **shaft**, marked by shallow vertical grooves known as **flutes**, and the **capital**, which is made up of the flaring, cushionlike **echinus** and a square tablet called the **abacus**. The entablature, which includes all the horizontal elements that rest on the columns, is the most complex of the three major units. It is subdivided into the **architrave**, a row of stone blocks directly supported by the columns; the **frieze**, made up of grooved **triglyphs** and flat or sculpted **metopes**; and a projecting horizontal **cornice**, or geison, which

may include a gutter (sima). The entablature in turn supports the triangular **pediment** and the roof elements (raking geison and raking sima).

How did the Doric order originate? Its essential features were already well established about 600 B.C., but how they developed and why they became fixed so rapidly as a system remain a puzzle to which we have few reliable clues. The notion that temples ought to be built of stone, with large numbers of columns, must have come from Egypt; the fluted half-columns at Saqqara (see fig. 28) strongly suggest the Doric column. Egyptian temples, it is true, are designed to be experienced from the inside, while the Greek temple is arranged so that the exterior matters most (religious ceremonies usually took place out of doors, in front of the temple facade). But might not a Doric temple be interpreted as the columned hall of an Egyptian sanctuary turned inside out? The Greeks also owed something to the Mycenaeans. We have seen an elementary kind of pediment in the Lioness Gate (see fig. 53), and the capital of a Mycenaean column is rather like a Doric capital. There is, however, a third factor: to what extent can the Doric order be understood as a reflection of wooden structures? Our answer to this thorny question will depend on whether we believe that architectural form follows function and technique, or whether we accept the striving for beauty as a motivating intention. The truth may well lie in a combination of both these approaches. At the start, Doric architects certainly imitated in stone some features of wooden temples, if only because these features served to identify the building as a temple. Thus, the triglyphs were derived from the ends of ceiling beams that had been decorated with three grooves and secured with wooden pegs, whose shape is abstractly echoed in the **guttae**. Metopes evolved out of boards that filled the gaps between the beams as protection against the elements. Likewise, **mutules** reflect the rafter ends of wooden roofs. But when those characteristics became enshrined in the Doric order, it was not from blind conservatism. By then, the wooden forms had been so thoroughly transformed that they were an organic part of the stone structure.

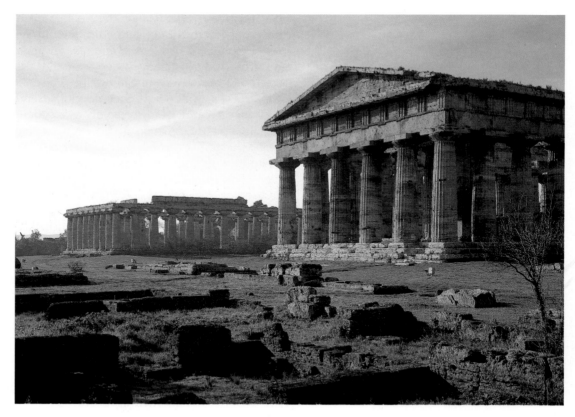

61. The "Basilica," c. 550 B.C., and the "Temple of Poseidon," c. 460 B.C., Paestum, Italy

Paestum We can see the evolution of temples in two examples near the southern Italian town of Paestum, where a Greek colony flourished during the Archaic period. The older is the "Basilica" (fig. 61, background); the "Temple of Poseidon" (it was probably dedicated to Hera, wife of Poseidon, the god of the sea) was erected about a hundred years later (fig. 61, foreground). How do the two temples differ? The "Basilica" looks low and sprawling—and not only because its roof is lost—while the "Temple of Poseidon," by comparison, appears tall and compact. The difference is partly psychological, produced by the outline of the columns, which in the "Basilica" are more strongly curved and are tapered to a relatively narrow top. This swelling effect, known as **entasis**, makes one feel that the columns bulge with the strain of supporting the superstructure and that the slender tops, even though aided by the widely flaring cushionlike capitals, are

just barely up to the task. The sense of strain has been explained on the grounds that Archaic architects were not fully familiar with their new materials and engineering procedures. Such a view, however, judges the building by the standards of later temples—and overlooks the expressive vitality of the building, the vitality we also sense in a living body.

In the "Temple of Poseidon" the exaggerated curvatures have been modified. This change, combined with a closer spacing of the columns, literally as well as expressively brings the stresses between supports and weight into more harmonious balance. Perhaps because the architect took fewer risks, the building is better preserved than the "Basilica." Its air of self-contained repose parallels developments in the field of Greek sculpture.

The Parthenon In 480 B.C., shortly before a decisive defeat by the Greeks, the Persians had

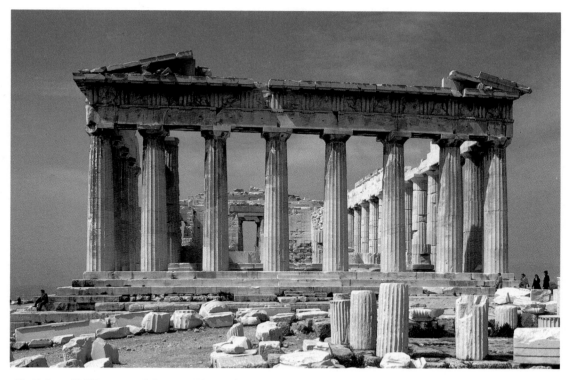

62. Iktinos, Kallikrates, and Karpion. The Parthenon (view from the west), Acropolis, Athens. 448–432 B.C.

destroyed the temple and statues on the Acropolis, the sacred hill above Athens, which had been a fortified site since Mycenaean times. The rebuilding of the Acropolis under the leadership of ▼PERIKLES during the later fifth century B.C., when Athens was at the height of its power, was the most ambitious enterprise in the history of Greek architecture, as well as its artistic climax. Individually and collectively, these structures represent the Classical phase of Greek art in full maturity. The inspiration for such a complex may well have come from Egypt. So must Perikles' idea of treating it as a vast public works project, for which he spared no expense.

The greatest temple, and the only one to be completed before the Peloponnesian War began in 431 B.C., is the Parthenon (fig. 62), dedicated to the virgin goddess Athena, the patron deity in whose honor Athens was named. The architects Iktinos, Kallikrates, and Karpion erected it in 448–432 B.C., an amazingly brief span of time for a project of this size. Built of gleaming white marble on the most prominent site along the southern flank of the Acropolis, it dominates the entire city and the surrounding countryside, a brilliant landmark against the backdrop of mountains to the north of it.

As the perfect embodiment of Classical Doric architecture, the Parthenon makes an instructive contrast with the "Temple of Poseidon" (see fig. 61). Despite its greater size, the Parthenon seems far less massive. Rather, the dominant impression it creates is one of festive, balanced grace within the austere scheme of the Doric order. This effect has been achieved by a general lightening and readjustment of the proportions. The entablature is lower in relation to its width and to the height of the columns than in the "Temple of Poseidon," and the cornice projects less. The columns

▼ *The* preeminent leader of Classical Greece was the Athenian PERIKLES (c. 495–429 B.C.; romanized to Pericles). During his thirty-three-year rule, from 462 to 429 B.C., Athens became the center of a wealthy empire, a highly progressive democratic society, and an astonishingly vibrant center of art and architecture.

themselves are a good deal more slender, their tapering and entasis less pronounced, and the capitals are smaller and less flaring; yet the spacing of the columns is wider. We might say that the load carried by the Parthenon columns has decreased, and as a consequence the supports can fulfill their task with a new sense of ease.

These intentional departures from the strict geometric regularity of the design for aesthetic reasons are features of the Classical Doric style that can be observed in the Parthenon better than anywhere else. Thus, the stepped platform and the entablature are not absolutely straight but are slightly curved, so that the center is a bit higher than the ends; the columns lean inward; and the interval between the corner column and its neighbors is smaller than the standard interval adopted for the colonnade as a whole. Such adjustments give us visual reassurance that the points of greatest stress are supported and are provided with a counter-stress as well.

These refinements nevertheless fail to account fully for the Parthenon's remarkable persuasiveness, which has never been surpassed. The Roman architect ▼VITRUVIUS records that Iktinos based his design on carefully considered proportions. But accurate measurements reveal them to be anything but simple or rigid. They, too, are replete with subtle adjustments, which lend the temple its surprisingly organic quality. In this respect the Parthenon closely parallels the underlying principles of Classical sculpture (see pages 85–87). Indeed, with its sculpture in place the Parthenon must have seemed animated with the same inner life that informs the pediment figures, such as the *Three Goddesses* (see fig. 73).

The Propylaia Immediately after the completion of the Parthenon, Perikles commissioned another splendid and expensive edifice, the monumental entry gate at the western end of the Acropolis, called the Propylaia (fig. 63, left and center). It was begun in 437 B.C. under the architect Mnesikles, who completed the main part in five years; the remainder had to be abandoned because of the Peloponnesian War. Again, the entire structure was built of marble

▼ During his lifetime, Marcus VITRU-VIUS Pollio (active 46–27 B.C.) was an architect for the Roman emperor Hadrian. His lasting fame, however, rests on the fact that his ten-book treatise on classical architecture, *De architectura,* is the only such work to survive from antiquity. From the fifteenth to the twentieth century, architects have pored over the rough translations of Vitruvius's books to learn about classical principles of proportion, orders, theory, and other matters of theory and practice—often interpreting them with wide latitude.

and included refinements comparable to those of the Parthenon. It is fascinating to see how the familiar elements of a Doric temple have here been adapted to a totally different task and difficult terrain. Mnesikles' design not only fits the irregular and steeply rising hillside but also transforms it from a rough passage among rocks into a splendid overture to the sacred precinct above.

Ionic Order

Next to the Propylaia is the small and elegant Temple of Athena Nike (fig. 63, right), which displays the slenderer proportions and the scroll capitals of the **Ionic order**. The previous development of the order is known only in very fragmentary fashion. Of the huge Ionic temples that were erected in Archaic times on the island of Samos and at Ephesos, little has survived except the plans. The Ionic vocabulary, however, seems to have remained fairly fluid, with strong affinities to the Near East, and it did not really become an order in the strict sense until the Classical period. Even then, it continued to be rather more flexible than the Doric order. Its most striking features are the continuous frieze, which lacks the alternating triglyphs and metopes of the Doric order, and the Ionic column, which differs from the Doric not only in body but also, as it were, in spirit (see fig. 60). The Ionic column rests on an ornately profiled base of its own, perhaps used initially as protection from rain. The shaft is slenderer, and there is less tapering and entasis. The capital shows a large double scroll, or **volute**, below the abacus, which projects strongly beyond the width of the shaft.

That these details add up to an entity very distinct from the Doric column becomes clear as soon as we turn from the diagram (opposite) to an actual building, such as the Temple of Athena Nike. How shall we define it? The Ionic column is lighter and more graceful than its mainland cousin. It lacks the latter's muscular quality. Instead, it evokes a growing plant, something like a formalized palm tree. This vegetal analogy is not sheer fancy, for early ancestors, or relatives, of the Ionic capital bear

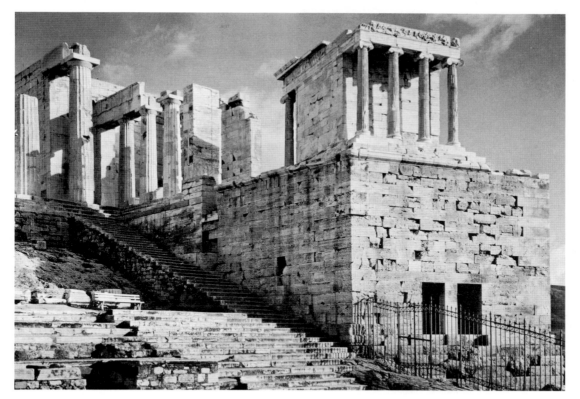

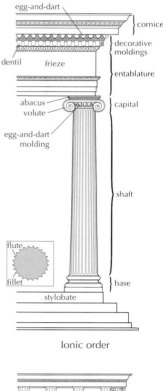

Ionic order

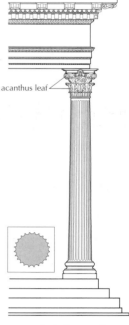

Corinthian order

The third major classical order, the Corinthian is the most elaborate and elongated. The acanthus leaf motif is distinctive of the Corinthian capital.

63. Mnesikles. The Propylaia, 437–432 B.C.; the Temple of Athena Nike, 427–424 B.C., Acropolis (view from the west), Athens

it out. If we were to pursue these plantlike columns all the way back to their point of origin, we would eventually find ourselves at Saqqara, where we encounter not only "proto-Doric" supports but also the wonderfully graceful papyrus half-columns of figure 28, with their curved, flaring capitals. It may well be, then, that the Ionic column, too, had its ultimate source in Egypt, but instead of reaching Greece by sea, as the proto-Doric column supposedly did, it traveled a slow and tortuous path by land through Syria and Asia Minor.

In the end, the greatest achievement of Greek architecture was much more than just beautiful buildings. Greek temples are governed by a structural logic that makes them look stable because of the precise arrangement of their parts. The Greeks tried to regulate their temples in accordance with nature's harmony

by constructing them of measured units that were so proportioned that they would all be in perfect agreement. ("Perfect" was as significant an idea to the Greeks as "forever" was to the Egyptians.) Now architects could create organic unities, not by copying nature, not by divine inspiration, but by design. Thus, their temples seem to be almost alive. They achieved this triumph chiefly by expressing the structural forces active in buildings. In the Classical period, expressions of force and counterforce in both Doric and Ionic temples were proportioned so exactly that their opposition produced the effect of a perfect balancing of forces and a harmonizing of sizes and shapes. This is the real reason why, in so many periods of Western history, the orders have been considered the only true basis for beautiful architecture. They are so perfect that they could not be surpassed, only equaled.

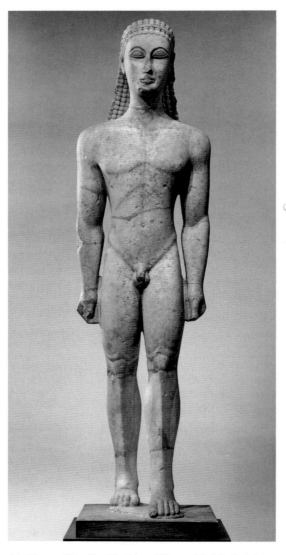

64. *Kouros (Standing Youth)*. c. 600 B.C. Marble, height 6'1½" (1.88 m). The Metropolitan Museum of Art, New York

Fletcher Fund, 1932

Sculpture

While enough examples of metalwork and ivory carvings of Near Eastern and Egyptian origin have been found on Greek soil to account for their influence on Greek vase painting, the origins of monumental sculpture and architecture in Greece are a different matter. To see such things, the Greeks had to go to Egypt or Mesopotamia. There is no doubt that they did so (we know that there were small colonies of Greeks in Egypt at the time). But

this does not explain why the Greeks should have developed a sudden desire during the seventh century B.C., and not before, to create such things for themselves. The mystery may never be cleared up, for the oldest existing examples of Greek stone sculpture and architecture show that Egyptian tradition had already been well assimilated and that the skill to match was not long in developing.

Archaic Style

Let us compare a very early Greek statue of a nude youth of about 600 B.C., called a **kouros** (fig. 64), with the Egyptian statue of Menkaure (see fig. 26). The similarities are certainly striking: we note the block-conscious, cubic character of both sculpture; the slim, broad-shouldered silhouette of the figures; the position of their arms, their clenched fists, the way they stand with the left leg forward, the emphatic rendering of the kneecaps. The formalized, wiglike treatment of the hair is a further point of resemblance. Judged by Egyptian standards, the Archaic statue seems somewhat rigid, oversimplified, awkward, and less close to nature. But the Greek statue also has virtues of its own that cannot be measured in Egyptian terms. First of all, it is truly freestanding—the earliest large stone image of the human form in the entire history of art of which this can be said. The Egyptian carver had never dared to liberate such figures completely from the stone. They remain immersed in it to some degree, so that the empty spaces between the legs and between the arms and the torso (or between two figures in a double statue, as in fig. 26) always remain partly filled. There are never any holes in Egyptian stone figures. In that sense, they do not rank as sculpture in the round but as an extreme case of high relief. The Greek carver, on the contrary, does not mind holes in the least. That sculptor separates the arms from the torso and the legs from each other, and goes to great lengths to cut away every bit of dead material. (The only exceptions are the tiny bridges between the fists and the thighs.) Apparently it now is of the greatest importance that a statue consist only of stone that has representa-

tional meaning within an organic whole. The stone must be transformed. It cannot be permitted to remain inert, neutral matter.

This is not a question of technique but of artistic intention. The act of liberation achieved in the kouros endows the figure with a spirit basically different from that of any Egyptian statues. While the latter seem becalmed by a spell that has released them from every strain for all time to come, the Greek image is tense, full of hidden life. The direct stare of his huge eyes offers the most telling contrast to the gentle, faraway gaze of the Egyptian figures.

The **kore**, as the Greek female statue type is called, shows more variations than the kouros. A clothed figure by definition, it poses a different problem: how to relate body and drapery. It is also likely to reflect changing habits or local differences of dress. The kore of figure 65 was carved almost a century after our kouros. She, too, is blocklike, with a strongly accented waist. The heavy cloth of her outer garment, called a peplos, forms a distinct, separate layer over the body, covering but not concealing the solidly rounded shapes beneath. As compared with the rigid wig of the kouros, the treatment of the hair, which falls over the shoulders in soft, curly strands, is more organic. Most noteworthy of all is the full, round face with its enchantingly merry expression, often called the Archaic smile.

Whom do these figures represent? The general names of *kore* ("maiden") and *kouros* ("youth") are noncommittal terms that gloss over the difficulty of identifying them further. Nor can we explain why the kouros is always nude while the kore is clothed. Whatever the reason, both types were produced in large numbers throughout the Archaic era, and their general outlines remained extraordinarily stable, paralleling the consistency we have noted in Doric temple architecture. Some are inscribed with the names of artists ("So-and-so made me") or with dedications to various deities. The figures with dedications, then, were votive offerings (the left hand of our kore originally was extended forward, proffering a gift of some sort). But whether they represent the donor, the deity, or a divinely favored person such as

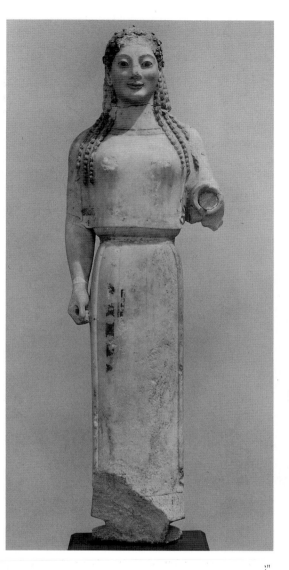

a victor in athletic games remains uncertain in most cases. Other figures were placed on graves, yet they can be viewed as representations of the deceased only in the broadest (and a completely impersonal) sense. This odd lack of differentiation seems part of the essential character of the figures. They are neither gods nor mortals but something in between, an ideal of physical perfection and vitality shared by mortal and immortal alike, just as the heroes of the Homeric epics dwell in the realms of both history and mythology.

Architectural Sculpture When the Greeks began to build their temples in stone, they also fell heir to the age-old tradition of architectural sculpture. The Egyptians had been covering the walls and even the columns of their buildings with reliefs since the time of the Old Kingdom, but these carvings were so shallow (see, for example, fig. 25) that they left the continuity of the wall surface undisturbed. They had no weight or volume of their own, so that they were related to their architectural setting only in the same limited sense as Egyptian wall paintings, with which they were, in practice, interchangeable. This characteristic is also true of the reliefs on Assyrian, Babylonian, and Persian buildings (see, for example, figs. 43, 44). There existed, however, another kind of architectural sculpture in the ancient Near East: great guardian monsters protruding from the blocks that framed the gateways of fortresses or palaces. This tradition may have inspired, albeit indirectly, the carving over the Lionness Gate at Mycenae (see fig. 53). We must nevertheless note one important feature that distinguishes the Mycenaean guardian figures from their predecessors. Although they are carved in high relief on a huge slab, this slab is thin and light compared with the enormously heavy, Cyclopean blocks around it. In building the gate, the Mycenaean architect left an empty triangular space above the lintel, for fear that the weight of the wall above would crush it, and then filled the hole with the comparatively lightweight relief panel. Here, then, we have a new kind of architectural sculpture: a work integrated with the structure yet also a separate entity rather than a modified wall surface or block.

The Greeks followed the Mycenaean example. In their temples, stone sculpture is confined to the pediment, between the ceiling and the sloping sides of the roof, and to the zone immediately below it (the frieze). However, the Greeks retained the narrative wealth of Egyptian reliefs. The *Battle of the Gods and Giants* (fig. 66), part of a frieze from the ▼TREASURY OF

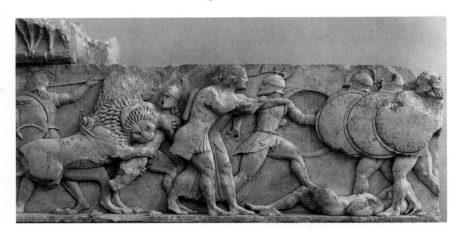

66. *Battle of the Gods and Giants*, from the north frieze of the Treasury of the Siphnians, Delphi. c. 530 B.C. Marble, height 26" (66 cm). Archeological Museum, Delphi

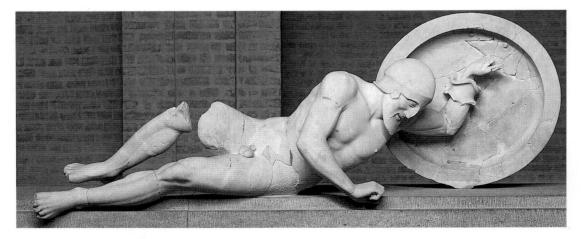

67. *Fallen Warrior*, from the east pediment of the Temple of Aphaia, Aegina. c. 490 B.C. Marble, length 6' (1.83 m). Staatliche Antikensammlungen und Glyptothek, Munich

THE SIPHNIANS at DELPHI, is executed in very high relief, with deep undercutting. The sculptor has taken full advantage of the spatial possibilities offered by this technique. The projecting ledge at the bottom of the frieze is used as a stage on which figures can be placed in depth. The arms and legs of those nearest the beholder are carved completely in the round. In the second and third layer, the forms become shallower. Yet even those farthest removed from us are never permitted to merge with the background. The result is a limited and condensed but very convincing space that permits a dramatic relationship between the figures such as we have never seen before in narrative reliefs. Any comparison with older examples (such as figs. 25, 44) will show us that Archaic art has indeed conquered a new dimension here, not only in the physical but also in the expressive sense.

Meanwhile, in pedimental sculpture, relief has been abandoned altogether. Instead, we find separate statues placed side by side in complex dramatic sequences designed to fit the triangular frame. The most ambitious ensemble of this kind, that of the east pediment of the Temple of Aphaia at Aegina, was created about 490 B.C. and thus brings us to the final stage in the evolution of Archaic sculpture. Among the most impressive figures is the fallen warrior from the left-hand corner (fig. 67), whose lean, muscular body seems marvelously functional and organic. That in itself, however, does not explain his great beauty, much as we may admire the artist's command of the human form in action. What really moves us is his nobility of spirit in the agony of dying. This man, we sense, is suffering—or carrying out—what fate has decreed with tremendous dignity and resolve. And this communicates itself to us in the very feel of the magnificently firm shapes of which he is composed.

Classical Style

Sometimes things that seem simple are the hardest to achieve. Greek sculptors of the late Archaic period were adept at representing battle scenes full of struggling, running figures in reliefs. To infuse the same freedom of move-

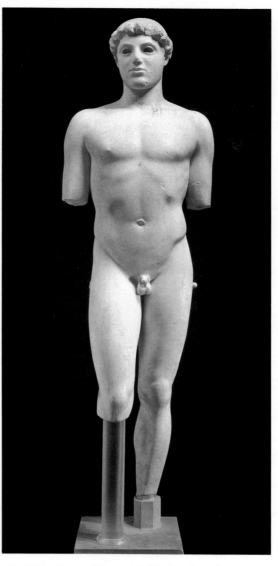

68. *Kritios Boy*. C. 480 B.C. Marble, height 46" (116.7 cm). Acropolis Museum, Athens

▼ The TREASURY OF THE SIPHNIANS is one of twenty treasure vaults built by various Greek cities within the walls of the sacred precinct at DELPHI, an important sanctuary dedicated to the god Apollo. These small, rectangular buildings, fronted with two columns and often decorated with sculpture, were commissioned by cities as offerings to the sanctuary god, as well as being a safe place to keep the offerings sent by their states. The only other buildings inside the sacred precincts were altars and temples. In the sixth century B.C., when this treasury was built, Siphnos, an island in the Cyclades chain, was extremely rich from its gold and silver mines.

ment into freestanding statues was a far greater challenge. Not only did it run counter to an age-old tradition that denied mobility to these figures, but also the unfreezing had to be done in such a way as to safeguard their all-around balance and self-sufficiency.

Early Greek statues have an unintentional military air, as if they are soldiers standing at attention. It took more than a century after our kouros was made before the Greeks discovered the secret to making a figure stand "at ease." *Kritios Boy* (fig. 68), named after the Athenian sculptor to whom it has been attributed, is the

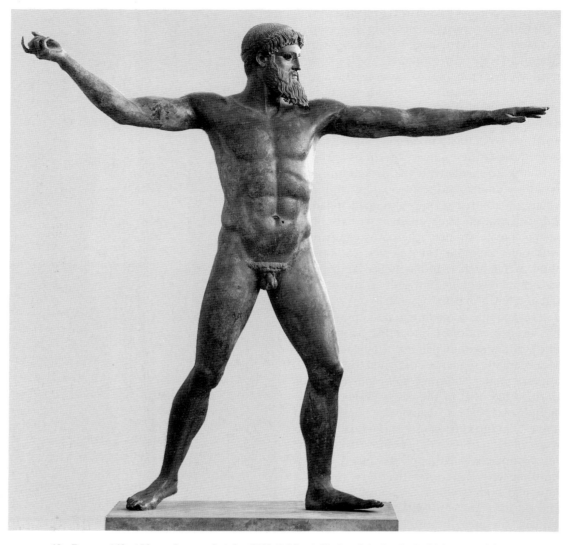

69. *Zeus.* c. 460–450 B.C. Bronze, height 6'10" (2.08 m). National Archeological Museum, Athens

first known statue that "stands" in the full sense of the term. Just as in military drill, this is simply a matter of allowing the weight of the body to shift from equal distribution on both legs (as is the case with the kouros, even though one foot is in front of the other) to one leg. The resulting stance—called **contrapposto** (or counterpoise)—brings about all kinds of subtle curvatures: the bending of the "free" knee results in a slight swiveling of the pelvis, a compensating curvature of the spine, and an adjusting tilt of the shoulders. Like the refined details of the Parthenon, these variations have nothing to do with the statue's ability to maintain itself erect but greatly enhance its lifelike impression. In repose, it will still seem capable of movement; in motion, of maintaining its stability. Life now suffuses the entire figure. Hence, the Archaic smile, the "sign of life," is no longer needed and has given way to a serious, pensive expression. To put it another way, once the Greek statue was free to move, as it were, it became free to think, not merely to act. The two are inseparable aspects of Greek Classicism. The

forms, moreover, have a new naturalism and harmonious proportion that together provided the basis for the strong idealization characteristic of all subsequent Greek art.

Once the concept of contrapposto had been established, the solution to showing large, freestanding statues in motion no longer presented serious difficulties. Such figures are the most important achievement of the early phase of Classicism known as the Severe style. The finest one of this kind (fig. 69) was recovered from the sea near the coast of Greece: a magnificent nude bronze Zeus, almost 7 feet tall, in the act of hurling his thunderbolt. Here, stability in the midst of action becomes outright grandeur. The pose is that of an athlete, yet it is not so much the arrested moment in a continuous motion as an awe-inspiring gesture that reveals the power of the god. Hurling a weapon thus becomes a divine attribute rather than an act aimed at a specific foe in the heat of battle.

The new articulation of the body that appears in the *Kritios Boy* was to reach its full development within half a century in the mature Classical style of the Periklean era. The most famous kouros of that time, the *Doryphoros (Spear Bearer)* by Polykleitos (fig. 70), is known to us only through Roman copies, whose hard, dry forms must convey little of the beauty of the original. Still, it makes an instructive comparison with the *Kritios Boy.* Everything is a harmony of complementary opposites. The contrapposto has now become much more emphatic. The differentiation between the left and right halves of the body can be seen in every muscle, and the turn of the head, barely hinted at in the *Kritios Boy*, is equally pronounced. The "working" left arm is balanced by the "engaged" right leg in the forward position, and the relaxed right arm by the "free" left leg. This studied poise, the precise (if in our copy overexplicit) anatomical details, and above all the harmonious proportions of the figure made the *Doryphoros* renowned as the standard embodiment of the Classical ideal of beauty. The ideal here must be understood in a dual sense as perfect model and universal prototype. According to one ancient writer, the statue was known simply as the *kanon* (canon, "rule" or "measure"). But the

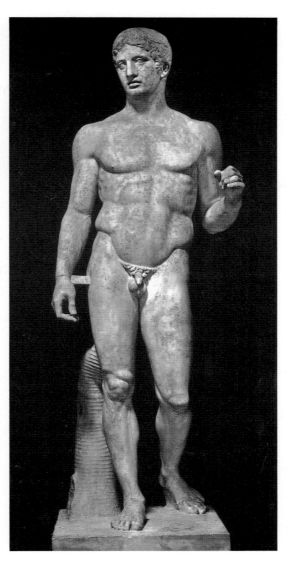

70. *Doryphoros (Spear Bearer).* Roman copy after an original of c. 450–440 B.C. by Polykleitos. Marble, height 6'6" (2 m). Museo Archeològico Nazionale, Naples

Doryphoros was not simply an exercise in abstract geometry. Polykleitos's faith in numbers had a moral dimension: he equated beauty with the good. Rather than being opposed to naturalism, this elevated conception was inseparably linked to a more careful treatment of form. Classical Greek sculpture appeals equally to the mind and the eye, so that human and divine beauty fully become one. It is no wonder that figures of victorious athletes have sometimes been mistaken for gods.

Speaking of

canon

Kanon (canon) in ancient Greek meant "rule" or "law." In art history, *the canon* has come to mean the large body of artworks that, taken together, have been proclaimed as definitive of the Western tradition. (This book is centered on that canon.) The term *canon* also means a norm or ideal ratio of proportions, usually based on a unit of measure. It is in this sense that the Greeks originally called Polykleitos's *Doryphoros* the *Kanon.* (However, the Egyptian canons of proportion for the human body were not the same as the Greek canon.) *Canon* means different things in the fields of music, religion, and law, in the Catholic Church, and in cultural fields that parallel art history, such as literature.

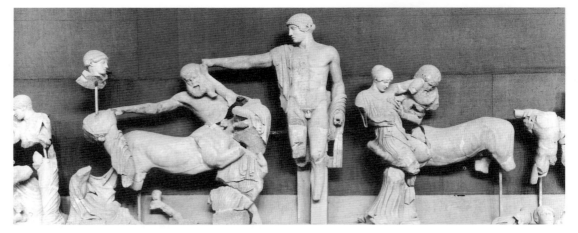

71. *Battle of the Lapiths and Centaurs*, from the west pediment of the Temple of Zeus, Olympia. c. 460 B.C. Marble, slightly over lifesize. Archeological Museum, Olympia

▼ The mythical story of the LAPITHS' fight with CENTAURS is recounted in Homer's *Iliad* and *Odyssey:* a king of the Lapiths invited the Centaurs (half-man, half-horse creatures who were crazy for wine, quite wild, and lustful) to his wedding, where the drunken Centaurs attempted to violate the bride and the female guests. In the ensuing battle, the Lapiths defeated the Centaurs—in Greek thinking, a metaphoric lesson on the need for the rational side of human nature to prevail over the irrational side. Centaurs appear in other myths, including an attack on Herakles.

Architectural Sculpture The conquest of movement in a freestanding statue exerted a liberating influence on pedimental sculpture as well, endowing it with a new spaciousness, fluidity, and balance. The greatest sculptural ensemble of the Severe style is the pair of pediments of the Temple of Zeus at Olympia, carved about 460 B.C. and now reassembled in the local museum. In the west pediment, the more mature of the two, we see the victory of the ▼LAPITHS over the CENTAURS under the aegis of Apollo, who is at the center of the composition (fig. 71). His commanding figure is part of the drama and yet above it. The outstretched right arm and the strong turn of the head show his active intervention. He *wills* the victory but, as befits a god, does not physically help to achieve it. Nevertheless, there is a tenseness, a gathering of forces, in this powerful body that makes its outward calm doubly impressive. The forms themselves are massive and simple, with soft contours and undulating, continuous surfaces. Apollo's glance is directed at a Centaur who has seized Hippodamia, bride of the king of the Lapiths (fig. 71, to the right of Apollo). Here we witness another achievement of the Severe style: passionate struggle expressed not only through action and gesture but through the emotions mirrored in the faces. The Centaur's pain and desperate effort contrast vividly with the stoic, calm face of the young woman.

To the Greeks, pose and expression signify character and feeling, which revealed the inner person and, with it, *arete* (excellence or virtue). There is a clear moral distinction in the con-

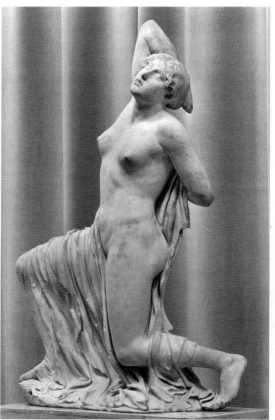

72. *Dying Niobid*. c. 450–440 B.C. Marble, height 59" (149.9 cm). Museo delle Terme, Rome

trast between the bestial Centaurs and the human protagonists, who partake of Apollo's nobility. Thus it is Apollo, as the god of music and poetry, who emerges as the real hero by ensuring the triumph of humanity's rational and moral sides over its animal nature. More specifically, however, it refers to military inva-

sions by the Persians under Darius I, which had been repulsed by Athenian troops at Marathon, outside of Athens, in 490 B.C., and then again in 480, when Darius's son Xerxes I (519?–465 B.C.) routed the Greek navy.

No Archaic artist would have known how to combine the two figures of Hippodamia and the Centaur into a group so compact, so full of interlocking movements. Strenuous action had already been investigated in pedimental sculpture of the late Archaic period (see figs. 66, 67). However, such figures, although technically carved in the round, are not freestanding. They represent, rather, a kind of super-relief, because they are designed to be seen against a background and from one direction only.

The *Dying Niobid* (fig. 72), a work of the 440s B.C., was carved for the pediment of a

Music, Poetry, and Theater in Ancient Greece

Although the earliest surviving evidence of Greek culture can be dated to the eighth century B.C., these fragmentary remains show such sophistication that they must have been preceded by at least 400 years now lost to us. In the eighth century, we find the oldest remnants of Greek sculpture, painting, and architecture, the beginnings of Greek philosophy, and above all the *Iliad* and the *Odyssey*, the two great epic poems attributed to the legendary poet HOMER (see page 68).

Music was of great importance in ancient Greece. The word *music* derives from *muse*, the personifications and inspiring spirits of the nine branches of art and learning. Thus, an educated person was a "musical" person. Greek music was organized in a system of five basic MODES that were the forerunners of today's SCALES. Each mode had certain rhythms, meters, and melodies associated with it that lent it a distinctive character (ethos), but that can only be guessed at, since very little remains of Greek music.

Early Greek vocal music was accompanied by lyres (harps) having only a few strings or by a primitive form of the aulos, an oboelike reed instrument that was always played in pairs. Like other poets of his time, Homer would have chanted his verses to the accompaniment of a lyre (hence, LYRIC POETRY). Indeed to the Greeks, all poems, like dances, were set to music, and the unity of word and music was to be a constant feature of Greek poetry. The lyric poets SAPPHO (early sixth century B.C.) and ANACREON (c. 570–c. 485 B.C.) sang their words, as did PINDAR (518?–c. 438 B.C.), the noted composer of ODES (poetry meant to be sung by a chorus). Instrumental music gradually became independent of singing. The first piper's contest *(agones)* was held in 586 B.C. Music gradually developed increasingly novel, complex forms. It also underwent a change in character toward the ecstatic, serpentine music still found in the Near East. By the mid-fifth century B.C., the emphasis on virtuosity inevitably influenced vocal music as well.

Music and philosophy were closely linked, thanks in part to the philosopher and mathematician PYTHAGORAS (c. 582–c. 507 B.C., see page 301), who is generally credited with discovering that an octave is exactly one half the length of the next octave lower on a lyre string. This and other discoveries in the field of mathematics provided the basis for the aesthetic system based on harmonious proportion expounded by the philosopher PLATO (427?–347 B.C.) Moreover, beauty was regarded by Plato and his successor ARISTOTLE (384–322 B.C.), the teacher of Alexander the Great, as having inherent ethical associations and educative functions. This concept, too, was rooted in music. The concept of musical ethos reached its height in the second century A.D. with the Greco-Egyptian astronomer Ptolemy, whose system of cosmic proportions was founded very much on his belief in the "tuning" of the soul.

In the theater, Greek tragedy ("goat song") combined words, music, and dance, reflecting its origins in ecstatic songs performed for the god Dionysos. At first, tragic dramas were improvised, but in the early sixth century B.C., the poet ARION of Corinth—the city that claimed to have invented COMEDY—began to set down his verses in literary form. In 534 B.C., the Athenians reorganized the Dionysian festival and held the first drama contest, which was won by Thespis (whose name survives in the term *thespian*, meaning "actor").

Our understanding of Greek tragedy is largely formed by the *Poetics* of Aristotle. With his inquisitive mind, everything became the subject of systematic philosophical thought. Aristotle believed that tragedy is the highest form of drama and that *Oedipus Rex* by SOPHOCLES is its greatest representative. His theory is based on the complex idea of imitation, by which he means "not of men but of life, an action," which is conveyed by plot, words, song, costumes, and scenery.

Comedy was represented by the bawdy satyr play, the distant ancestor of modern BURLESQUE theater, which was apparently invented by Pratinas in the late sixth century B.C. The only surviving examples are EURIPIDES' *Cyclops* and a fragment from Sophocles' *The Trackers*, which are parodies of tragic dramas. Entirely different in character and perhaps origin are the comic plays of ARISTOPHANES (c. 448–c. 388 B.C.), which are commentaries on the contemporary scene: society, politics, war, literature—nothing was too sacred for his irreverent satire. Later Greek comedy, of which nothing remains, centered on the daily life of the middle class. Only about thirty-one plays by four playwrights survive, of the approximately 1,000 plays that are mentioned. Although all date to the fifth century B.C., the characteristics of the works of the four dramatists vary considerably.

The visual arts contributed little to Greek theater, which made sparse use of scenery. (The term *scenery* is derived from *skene*, the hut where actors changed their costumes.) However, music and theater were of vital importance to art: during the fifth century B.C., Greek sculptors sought to infuse their work with strong philosophical connotations by investing it with *rhythmos* (composed movement) and *symmetria* (proportion), terms taken from music and dance.

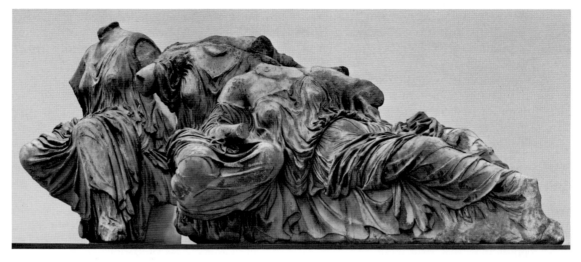

73. *Three Goddesses*, from the east pediment of the Parthenon. c. 438–432 B.C. Marble, over lifesize. The British Museum, London

Doric temple but is so richly three-dimensional and so self-contained that we hardly suspect her original context. Niobe, according to legend, had declared herself superior to the mother of Apollo and Artemis because of her larger family—she had seven sons and seven daughters—whereupon the two gods killed all of Niobe's children. Our *Niobid* ("child of Niobe") has been shot in the back while running. Her strength broken, she sinks to the ground while trying to extract the fatal arrow. The violent movement of her arms has made her garment slip off. Her nudity is thus a dramatic device rather than a necessary part of the story. The *Niobid* is the earliest known large female nude in Greek art. The artist's primary motive in devising it was to display a beautiful female body in the kind of strenuous action hitherto reserved for the male nude. Still, we must not misread the intent. It was not a detached interest in the physical aspect of the event alone but the desire to unite motion and emotion and thus to make the beholder experience the suffering of this victim of a cruel fate. Looking at the face of the Niobid, we feel that here, for the first time, human emotion is expressed as eloquently in the features as in the rest of the figure.

A brief glance backward at the wounded warrior from Aegina (see fig. 67) will show us how very differently the agony of death had been conceived only half a century earlier. What separates the *Niobid* from the world of Archaic art is a quality summed up in the Greek word *pathos*, which means "suffering," but particularly suffering conveyed with nobility and restraint so that it touches rather than horrifies us. Late Archaic art may approach it now and then, yet the full force of pathos can be felt only in Classical works such as the *Dying Niobid.*

The largest, as well as the greatest, group of Classical sculpture at our disposal consists of the remains of the marble decoration of the Parthenon, most of them, unfortunately, in battered and fragmentary condition. The east pediment represents various deities witnessing the birth of Athena from the head of Zeus (fig. 73). Here we marvel at the spaciousness, the complete ease of movement even in repose. There is neither violence nor pathos in them— indeed, no specific action of any kind, only a deeply felt poetry of being. We find it in the soft fullness of the *Three Goddesses*, enveloped in thin drapery that seems to share the qualities of a liquid substance as it flows and eddies around the forms underneath. The figures are so freely

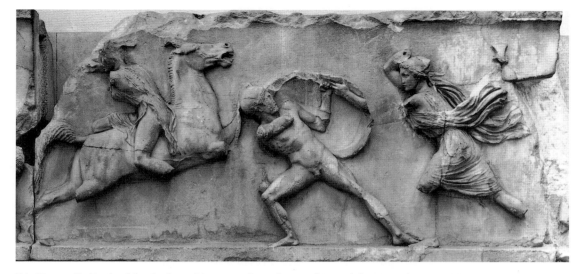

74. Skopas (?). *Battle of the Greeks and Amazons*, from the east frieze of the Mausoleum, Halikarnassos. 359–351 B.C. Marble, height 35" (88.9 cm). The British Museum, London

conceived in depth that they create their own aura of space. Though all are seated or half-reclining, the turning of the bodies under the elaborate folds of their costumes makes them seem anything but static. The "wet" drapery unites them in one continuous action, so that they seem in the process of arising. In fact, it is hard to imagine them "shelved" upon the pediment. Evidently the sculptors who achieved such lifelike figures also found this incongruous. The sculptural decoration of later buildings tended to be placed in areas where the figures would seem less boxed in and be more readily visible.

Fourth-Century Sculpture

The Athenian style, so harmonious in both feeling and form, did not long survive the defeat of Athens by Sparta in the Peloponnesian War. Building and sculpture continued in the same tradition for another three centuries, but without the subtleties of the Classical age, whose achievements we have just discussed. There is, unfortunately, no single word, like *Archaic* or *Classical*, that we can use to designate the final phase in the development of Greek art. The seventy-five-year span between the end of the Peloponnesian War and the rise of Alexander the Great used to be labeled *Late Classical*, and the remaining two and a half centuries *Hellenistic*, a term meant to convey the spread of Greek civilization southeastward to Asia Minor and Mesopotamia, Egypt, and the borders of India. However, the history of style is not always in tune with political history. We have come to realize that there was no decisive break in the tradition of Greek art at the end of the fourth century and that Hellenistic art was the direct outgrowth of developments that occurred well before the time of Alexander. The art of the years 400–325 B.C. nevertheless can be better understood if we view it as pre-Hellenistic rather than as Late Classical.

The contrast between Classical and pre-Hellenistic art is strikingly demonstrated by the only project of the fourth century that corresponds to the Parthenon in size and ambition. It is not a temple but a huge tomb erected about 350 B.C. at Halikarnassos in Asia Minor by Mausolos, ruler of the area, from whose name comes the term *mausoleum*, used for outsized funerary monuments. Skopas, who was very probably the sculptor of the main frieze, showing the Greeks battling the ▼AMAZONS (fig. 74), was familiar with the figure style of the Parthenon,

▼ AMAZONS, who comprised a mythical nation of powerful women warriors, were said to live somewhere in Asia Minor. In legend, they repeatedly engaged the Greeks in battle but always lost to them. From very early, these battles were popular subjects in Greek art and are seen from the seventh century B.C. on through the Hellenistic era.

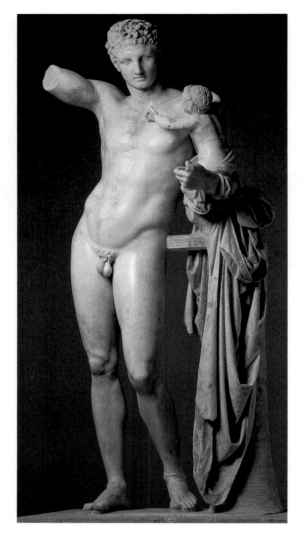

75. Praxiteles. *Hermes.* c. 330–320 B.C. (or later copy of c. 300–250 B.C.). Marble, height 7'1" (2.16 m). Archeological Museum, Olympia

but he has rejected its rhythmic harmony, its flow of action from one figure to the next. His sweeping, impulsive gestures require a lot of elbow room. What the composition lacks in continuity, it more than makes up for in bold innovation (note, for instance, the Amazon seated backward on her horse) and heightened expressiveness. In a sense, Skopas turned back as well to the scenes of violent action so popular in the Archaic period. We recognize its ancestor in the Siphnian *Battle of the Gods and Giants* (see fig. 66).

In most instances, unfortunately, the best-known works of the Greek sculptors of the fifth and fourth centuries B.C. have been lost, and only copies are preserved. The famous *Hermes* found at Olympia (fig. 75) is of such high quality that it was long regarded as an original work by the renowned fourth-century sculptor Praxiteles. However, the disturbing strut and the unfinished back have convinced most scholars now that it is a very fine later Greek copy. The *Hermes* nevertheless exemplifies perfectly the qualities for which Praxiteles was admired in his own day. We also find many refinements that are ordinarily lost in a copy. The sensuousness, the lithe proportions, the sinuous curve of the torso, the play of gentle

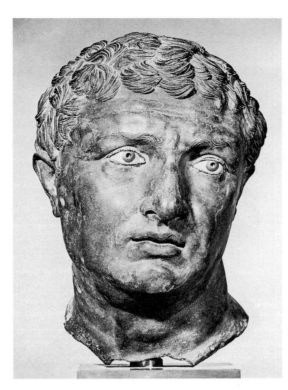

76. Portrait head, from
Delos. c. 80 B.C.
Bronze, height
12³/₄" (32.4 cm).
National Archeolog-
ical Museum,
Athens

curves, the sense of complete relaxation (en-
hanced by the use of an outside support for the
figure to lean against)—all these are quite the
opposite of Skopas's energetic innovations. The
lyrical charm of the *Hermes* is further enhanced
by the caressing treatment of the marble: the
faint smile, the meltingly soft, "veiled" mod-
eling of the features, and even the hair, left
comparatively rough for contrast, all share a
misty, silken feel. Here, for the first time, there
is an attempt to modify the stony look of a
statue by giving to it an illusion of an envelop-
ing atmosphere.

Hellenistic Style

Compared to Classical statues, the sculpture
of the Hellenistic age often has a more pro-
nounced realism and expressiveness, as well as a
greater experimentation with drapery and pose,
which often shows considerable twisting. These
changes should be seen as a valid, even neces-
sary, attempt to extend the subject matter and
dynamic range of Greek art in accordance with

a new temperament and outlook. The difference
in psychology is suggested by the portrait head
in figure 76. The serenity of Praxiteles' *Hermes* is
replaced by a troubled look. And for the first
time, this is an individual portrait—something
that was inconceivable in earlier Greek art,
which emphasized ideal, heroic types. It was not
made as a bust but rather, in accordance with
Greek custom, as part of a full-length statue. The
identity of the sitter is unknown. Whoever he
was, we get an intensely private view of him: the
fluid modeling of the somewhat flabby features,
the uncertain, plaintive mouth, and the un-
happy eyes under furrowed brows reveal an
individual beset by doubts and anxieties, an ex-
tremely human, unheroic personality. There are
echoes of noble pathos in these features, but it is
a pathos translated into psychological terms.
People of such inner turmoil certainly existed
earlier in the Greek world, just as they do today.
Yet it is significant that such complexity could
be conveyed in art only when Greek inde-
pendence, culturally as well as politically, was
about to come to an end.

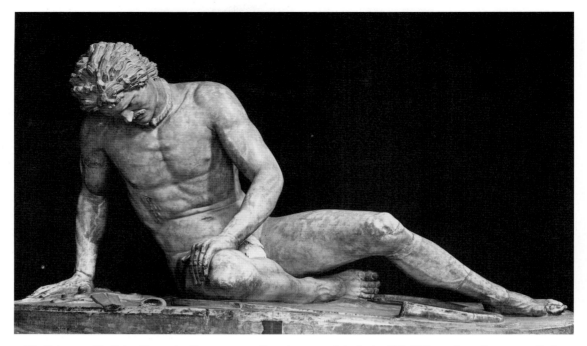

77. Epigonos (?). *Dying Trumpeter*. Roman copy after a bronze original of c. 230–220 B.C., from Pergamon, Turkey. Marble, lifesize. Museo Capitolino, Rome

▼ The CELTS were a widespread people, first found in the second millennium B.C. in southwestern Germany and eastern France, called Gaul by the Romans. They spoke Indo-European dialects, were skilled in the art of smelting iron, and used their iron weapons to raid and conquer other peoples in Europe and Asia Minor well into the fourth century B.C., when they were displaced in much of Europe by Germanic peoples. Clearly, they dominated Iron Age culture in Europe. The Greeks noted that Celtic warriors were tall, light-skinned, and well-muscled.

This more human conception is found again in the *Dying Trumpeter* (fig. 77), from a Roman copy in marble of the bronze groups dedicated by Attalos I of Pergamon (a city in northwestern Asia Minor) shortly before 200 B.C. to commemorate his victory over the invading ▼CELTS, who kept raiding the Greek states from Galatia, the area around present-day Ankara, Turkey, until Attalos forced them to settle down. Epigonos of Pergamon, the sculptor who probably conceived the figure, must have known the Celts well, for the ethnic type in the facial structure and in the bristly shock of hair has been carefully rendered. The torque worn at the neck is another character-istically Celtic feature. Otherwise, the figure shares the heroic nudity of Greek warriors, such as those on the Aegina pediments (see fig. 67). If his agony seems infinitely more real-istic in comparison, it also has considerable dignity and pathos. Clearly, the Celts were considered worthy foes. "They know how to die, even if they are barbarians" is the idea the artist communicated in this statue. Yet we also sense something else, a brute quality that had never before been part of Greek images of men. Death, as we witness it here, is a very concrete physical process: no longer able to move his legs, the Trumpeter puts all his waning strength into his arms, as if to prevent some tremendous invisible weight from crushing him against the ground.

Several decades later, we find a second sculptural style flourishing at Pergamon. Around 166–156 B.C., Eumenes II, the son and successor of Attalos I, had a mighty altar erected on a hill above the city to commemorate the victories of Rome and its allies over Antiochos the Great of

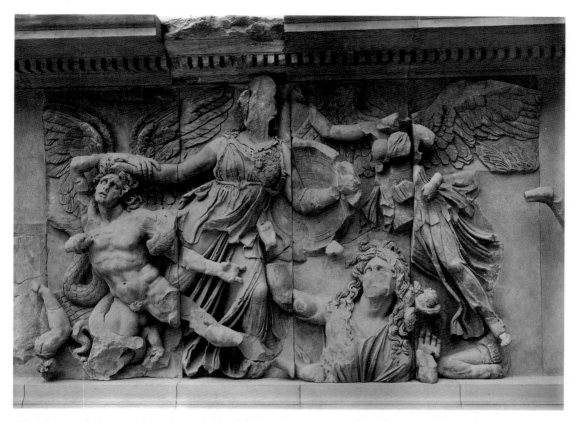

78. *Athena and Alcyoneus*, from the east side of the Great Frieze of the Great Pergamon Altar at Pergamon. c. 166–156 B.C. Marble, height 7'6" (2.29 m). Staatliche Museen zu Berlin, Preussischer Kulturbesitz, Pergamonmuseum

Syria. Much of the sculptural decoration has been recovered by excavation, and the entire west front of the Great Pergamon Altar has been reconstructed. The subject of the frieze covering the base (fig. 78), the battle of the gods and giants, is traditional for Ionic friezes; we saw it before on the Siphnian treasury (compare fig. 66). At Pergamon, however, it has a novel significance, since the victory of the gods is meant to symbolize the victories of Eumenes II. Such a translation of history into mythology had been an established device in Greek art for a long time: victories over the Persians were habitually represented in terms of Lapiths battling Centaurs or Greeks fighting Amazons. But to place Eumenes II in analogy with the gods themselves implies an exaltation of the ruler that is Oriental rather than Greek in origin. Since the time of Mausolos, who may have

been the first to introduce it on Greek soil, the idea of divine kingship had been adopted by Alexander the Great and it continued to flourish among the lesser sovereigns who divided his realm, such as the rulers of Pergamon. The huge figures, cut to such a depth that they are almost detached from the background, have the scale and weight of pedimental statues without the confining triangular frame—a unique compound of two separate traditions that represents a thundering climax in the development of Greek architectural sculpture. The carving of the frieze, though not very subtle in detail, has tremendous dramatic force. The heavy, muscular bodies rush at each other, and the high relief creates strong accents of light and dark, while the beating wings and wind-blown garments are almost overwhelming in their dynamism. A writhing movement

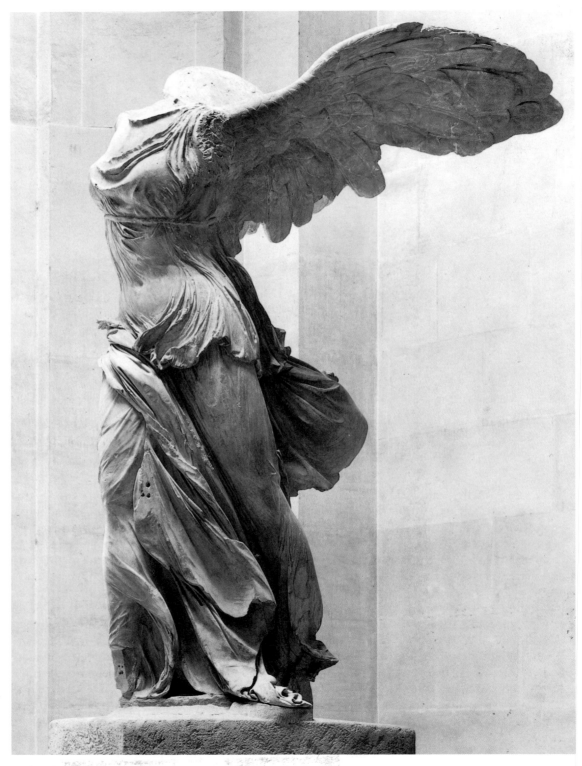

79. Pythokritos of Rhodes (?). *Nike of Samothrace*. c. 200–190 B.C. Marble, height 8' (2.44 m). Musée du Louvre, Paris

pervades the entire design, down to the last lock of hair, linking the victors and the vanquished in a single continuous rhythm. This sense of unity disciplines the physical and emotional violence of the struggle and thus keeps it—but just barely—from exploding its architectural frame.

Equally dramatic in its impact is the great victory monument *Nike of Samothrace* (fig. 79). This winged personification of Victory, named after the island where she was discovered, perhaps commemorates the naval victory in 190 B.C. over Antiochos the Great by Eudamos of Rhodes, although some scholars would date it to the mid-third century B.C. for purely historical rather than artistic reasons. The style is late Rhodian, and the statue may well have been carved by the island's leading sculptor, Pythokritos. The goddess has just descended to the prow of a ship. Her great wings spread wide, she is still partly airborne by the powerful head wind against which she advances. The invisible force of onrushing air here becomes a tangible reality. It not only balances the forward movement of the figure but also shapes every fold of the wonderfully animated drapery. As a result, there is an active relationship—indeed, an interdependence—between the statue and the space that envelops it, such as we have never seen before. By comparison, all earlier examples of active drapery seem inert. This is true even of the *Three Goddesses* from the Parthenon (see fig. 73), whose wet drapery responds not to the atmosphere around it but to an inner impulse independent of all motion. Nor shall we see it again for a long time to come. The *Nike of Samothrace* deserves all of her fame as the greatest work of Hellenistic sculpture.

Chapter 6
Etruscan Art

We know surprisingly little about the early Etruscans. According to the fifth-century B.C. Greek historian Herodotos, they had left their homeland of Lydia in western Asia Minor sometime during the twelfth century B.C. and settled in the area in Italy between Florence and Rome, which to this day is known as Tuscany. According to some scholars, however, they were descended from different people called Villanovans (after the town of Villanova, near Bologna), who brought the Iron Age from central Europe to the Italian peninsula about 1100 B.C.

But their presence on Italian soil may go back much further: other historians believe the Etruscans were an indigenous people. If so, the sudden flowering of Etruscan civilization from about 700 B.C. onward could have resulted from a fusion of this native stock with small but powerful groups of seafaring invaders from Lydia in Asia Minor during the course of the eighth century B.C.

The Etruscans were strongly linked with Asia Minor and the ancient Near East culturally and artistically, yet they also show many traits for which no parallels can be found anywhere. For example, the Etruscans borrowed their alphabet from the Greeks, but their language, of which our understanding is still very limited, has no apparent relation to any known tongue, for it was not Italic. The only Etruscan writings that have come down to us are brief funerary inscriptions and a few somewhat longer texts relating to religious ritual, though Roman authors tell us that a rich Etruscan literature once existed.

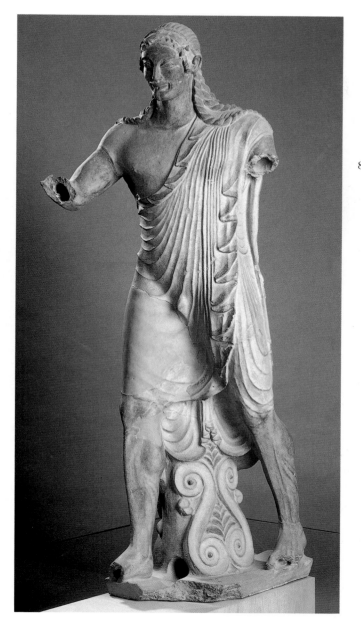

80. *Apollo*, from Veii. c. 510 B.C. Terracotta, height 5'9" (1.7 m). Museo Nazionale di Villa Giulia, Rome

Modeled sculpture is additive in the sense that the basic form is built up from a base material, such as clay (left), and then finished by carving and smoothing the details (right).

The Etruscans and Rome

The ancient Romans believed that their city had been founded in 753 B.C. by the descendants of refugees from Troy in Asia Minor. In fact, the earliest Greeks did begin to settle along the southern shores of Italy and in Sicily during the eighth century B.C., whether or not they were related to the Trojans. The seventh and sixth centuries B.C. saw the Etruscans at the height of their power. Their cities rivaled those of the Greeks; their fleet dominated the western Mediterranean and protected a vast commercial empire competing with the Greeks and Phoenicians; and their territory extended as far as Naples in the south and the lower Po Valley in the north. Rome itself was ruled by Etruscan kings for about a century, until the establishment of the ▼ROMAN REPUBLIC in 510 B.C. The kings threw the first defensive wall

▼ Rome arose on the east bank of the Tiber River from a cluster of hilly settlements of several early Italic peoples, including Etruscans. By 510 B.C., united Romans overthrew the "foreign" rule of the Tarquins, an Etruscan royal house, and established the ROMAN REPUBLIC. Under generations of elected leaders (not kings), the Roman Republic extended its direct and indirect dominion throughout the Mediterranean basin, including North Africa, much of Asia Minor, and Europe to the North Sea. The Roman Empire dates from 27 B.C., when Octavian was named emperor (*imperator*, meaning "commander") and received the honorary name Augustus ("revered"). The Roman Empire reached its greatest geographical extent, which was almost the entire known Western world, under Emperor Trajan (ruled A.D. 98–117), then declined gradually. In A.D. 395, the Empire split into Eastern and Western dominions. From then on, the Western Empire rapidly weakened until its fall in 476, when the last Roman emperor was deposed by a Germanic king.

Cast-metal sculpture was traditionally made by the lost-wax process.

First, a core of clay is shaped into the basic form of the intended metal sculpture. The clay core is covered with a layer of wax about the thickness of the final sculpture. The details of the sculpture are carefully carved in the wax. A heavy outer layer of clay is applied over the wax and secured to the inner core with metal pegs. Then the mold is heated enough to melt the wax, which runs out. The space left by the "lost wax" is filled with molten metal, usually bronze. The outer and inner molds are broken, leaving a shell of metal that is the metal sculpture. The sculptor finishes the piece by chiseling and polishing details.

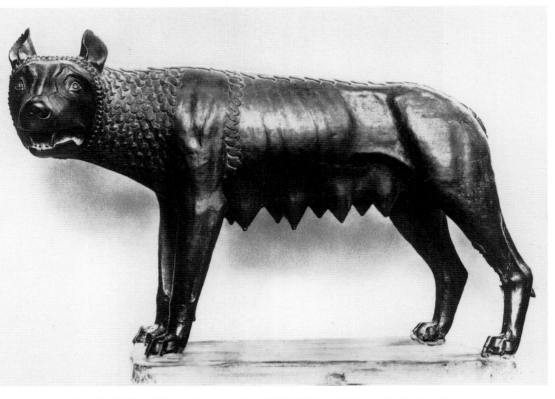

81. *She-Wolf*. c. 500 B.C. Bronze, height 33½" (85.1 cm). Museo Capitolino, Rome

▼ The FORUM was a square or rectangular market- and meeting-place in the heart of cities and towns built under Etruscan and Roman rule. The first Roman forum was laid out in a marshy valley between two of Rome's seven hills: the Palatine and the CAPITOLINE (Capitol). The Capitoline was the highest of the hills and was the religious center of the city from earliest times.

around Rome's seven hills, drained the swampy plain of the ▼FORUM, and built the original temple on the CAPITOLINE HILL, thus making a city out of what had before been little more than a group of villages.

But the Etruscans, like the Greeks, never formed a unified nation. They were no more than a loose federation of individual city-states given to quarreling among themselves and slow to unite against a common enemy. During the fifth and fourth centuries B.C., one Etruscan city after another succumbed to the Romans. By the end of the third century B.C., all of them

had lost their independence; many continued to prosper, however, if we are to judge by the richness of their tombs during the period of political decline.

Sculpture

The flowering of Etruscan civilization coincides with the Archaic age in Greece. During this period, especially near the end of the sixth and early in the fifth century B.C., Greek Archaic influence had displaced Orientalizing tendencies. But Etruscan artists did not simply imitate their

Hellenic models. Working in a very different cultural setting, they retained their own clear-cut identity, as we can see from the **modeled** clay *Apollo* in figure 80, which has long been acknowledged as the crowning piece of Etruscan Archaic sculpture. His massive body, completely revealed beneath the ornamental striations of the drapery; the sinewy, muscular legs; the hurried, purposeful stride—all these betray an expressive power that has no counterpart in freestanding Greek statues of the same date.

The cast-bronze figure of the she-wolf that nourished Romulus and Remus, the legendary founders of Rome (fig. 81; the two babies are Renaissance additions), has the same wonderful ferocity of expression, the physical power of the body and legs, and the awesome quality we sense in the *Apollo*.

Tombs and Their Decoration

We do not know precisely what ideas the Archaic Etruscans held about the afterlife. They seem to have regarded the tomb as an abode not only for the body but for the soul (in contrast to the Egyptians, who thought of the soul as roaming freely and whose funerary sculpture therefore remained "inanimate"). Perhaps the most astonishing painted images are found in the Tomb of Hunting and Fishing at Tarquinia of c. 520 B.C. Figure 82 shows the great marine panorama at one end of the low chamber: a vast, continuous expanse of water and sky in which the fisherman and the hunter with his slingshot play only an incidental part. The free, rhythmic movement of birds and dolphins is strangely reminiscent of Minoan painting of a thousand years earlier (see fig. 49), although the weightless, floating quality of Cretan art is absent. Could the mural have been inspired by Egyptian scenes of hunting in the marshes, such as the one in figure 25, which seem to be the most convincing precedents for the general conception of the subject? If so, the Etruscan artist's addition has been to bring the scene to life.

A somewhat later example, from the Tomb of the Lionesses in Tarquinia (fig. 83), shows a pair of ecstatic dancers. As in the *Apollo*, the passionate energy of their movements strikes us as uniquely Etruscan rather than Greek in spirit. Of particular interest is the transparent garment of the woman, which lets the body shine through. The contrasting body color of the two figures continues a practice introduced by the Egyptians more than 2,000 years earlier. In Greece, this differentiation had appeared only a few years earlier, during the final phase of Archaic vase painting. Since nothing of the sort has survived in Greek territory, such paintings are important, not only as an Etruscan achievement but also as a possible reflection of Greek wall painting.

During the fifth century B.C., the Etruscan view of the hereafter must have become a good deal more complex and less festive. The change is reflected by the group in figure 84, a cinerary (cremated ash) container carved of soft local stone soon after 400 B.C. A woman sits at the foot of the couch, but she is not the wife of the young man. Her wings indicate that she is the demon of death, and the scroll in her left hand records the fate of the deceased. The young man is pointing to it as if to say, "Behold, my time has come." The thoughtful, melancholy air of the two figures may be due to some extent to the influence of Classical Greek art, which pervades the style of this group. At the same time, however, a new mood of uncertainty and regret is felt: human destiny is in the hands of inexorable supernatural forces, and death is the great divide rather than a continuation, albeit on a different plane, of life on earth. In later tombs, death gains an even more fearful aspect. Other, more terrifying demons enter the scene, often battling against benevolent spirits for possession of the soul of the deceased.

Architecture

According to Roman writers, the Etruscans were superb architectural engineers, as well as town planners and surveyors. The Etruscans must also have taught the Romans how to

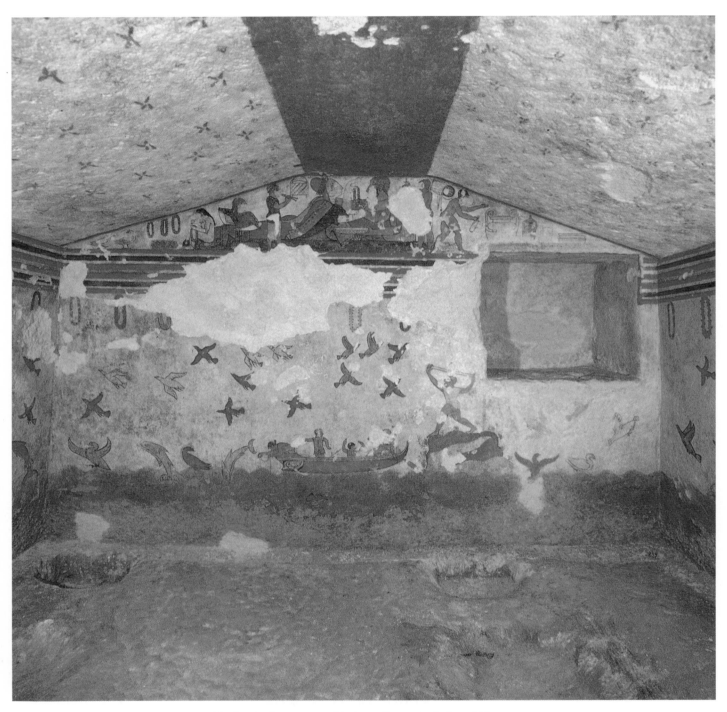

82. Tomb of Hunting and Fishing, Tarquinia, Italy. c. 520 B.C.

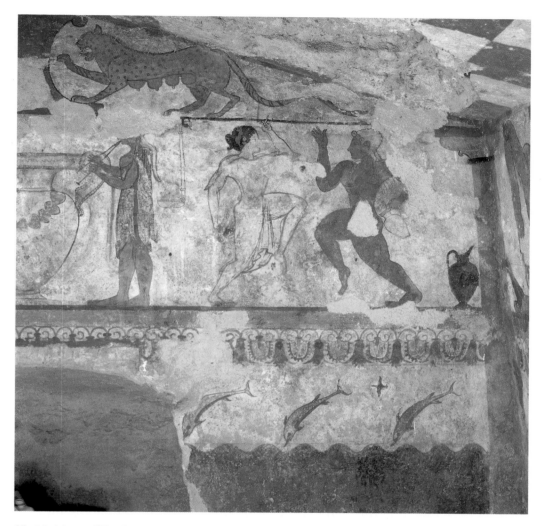

83. *Musician and Two Dancers*. Detail of a wall painting, Tomb of the Lionesses, Tarquinia. c. 480–470 B.C.

build fortifications, bridges, drainage systems, and aqueducts, although very little remains of their vast construction enterprises. That the Romans learned a good deal from them can hardly be doubted, but exactly how much the Etruscans contributed to Roman architecture is difficult to say, since hardly anything of Etruscan or early Roman architecture remains standing above ground.

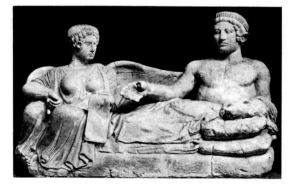

84. *Youth and Demon of Death*. Cinerary container. Early 4th century B.C. Stone, length 47" (119.4 cm). Museo Archeològico Nazionale, Florence

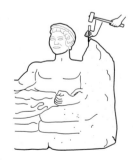

Carved sculpture is subtractive in the sense that the sculptor begins with a block of material, such as stone, that is larger than the finished sculpture and carves away what is not needed for the form of the final piece.

Chapter 7
Roman Art

Of all the civilizations of the ancient world, that of the Romans is far more accessible to us than any other. They have left a vast literary legacy that permits us to trace their history with a wealth of detail that continues to amaze us. Yet, paradoxically, there are few questions more difficult to answer than "What is Roman art?" The Roman genius, so clearly recognizable in every other sphere of human activity, becomes elusive when we ask whether there was a characteristic Roman style in the fine arts, particularly painting and sculpture. Why is this so? The most obvious reason is the great admiration the Romans had for Greek art of every period and variety. They imported originals of earlier times by the thousands and had them copied in even greater numbers. In addition, the Romans' own production was clearly based on Greek sources, and many of their artists, from Republican times (510–27 B.C.) to the end of the Western Empire (27 B.C.–A.D. 395), were of Greek origin. Roman subject matter differed from that of the Greeks, but even beyond that, the fact remains that, as a whole, the art produced under Roman auspices does look distinctly different from Greek art and has positive un-Greek qualities expressing different intentions. Thus, we must not insist on evaluating Roman art by the standards of Greek art. The Roman Empire was an extraordinarily complex and open society, which absorbed national or regional traits into a common all-Roman framework that was homogeneous and diverse at the same time. The "Romanness" of Roman art must be found in this complex pattern rather than in a single and consistent quality of form.

85. Sanctuary of Fortuna Primigenia, Praeneste (Palestrina). Early 1st century B.C.

Architecture

If the originality of Roman sculpture and painting has been questioned, Roman architecture is a creative feat of such magnitude as to silence all doubts about its being a Roman distinction. Its growth from the very start reflected a specifically Roman way of public and private life, so that whatever elements had been borrowed from the Etruscans or Greeks were soon marked with an unmistakable Roman stamp. Greek models, though much admired, no longer sufficed to accommodate the sheer numbers of people in large public buildings necessitated by the Empire. And when it came to supplying the citizenry with everything it needed, from water to entertainment on a vast scale, radical new forms had to be invented, and cheaper materials and quicker construction methods had to be used.

From the beginning, the growth of the capital, Rome, is hardly thinkable without the **arch** and the vaulting systems derived from it: the **barrel vault**, a half cylinder; the **groin vault**, which consists of two barrel vaults intersecting each other at right angles; and the **dome**. True arches are constructed of wedge-shaped blocks, called **voussoirs**, each pointing toward the center of the semicircular opening. Such an arch is strong and self-sustaining, in contrast to the "false" arch composed of horizontal courses of masonry or brickwork (like the opening above the lintel of the Lioness Gate at Mycenae, fig. 53). The true arch, and its extension, the barrel vault, had been invented in Egypt as early as about 2700 B.C., but the Egyptians had used it mainly in underground tomb structures and in utilitarian buildings, never in temples. Apparently they thought it unsuited to monumental architecture. In Mesopotamia, the true arch was used for city gates (see fig. 45) and perhaps elsewhere as well; to what extent we cannot determine for lack of preserved examples. The Greeks knew the principle from the fifth century B.C. on, but they confined the use of the true arch to underground structures or to simple gateways, because they refused to combine it with the elements of the architectural orders.

No less vital to Roman architecture was concrete, a mixture of mortar and gravel with rubble (small pieces of building stone and brick). Concrete construction had been invented in the Near East more than a thousand years earlier, but the Romans developed its potential until it became their chief building technique. The advantages of concrete are obvious: strong, cheap, and flexible, it alone made possible the vast architectural enterprises that are still the chief reminders of "the grandeur that was Rome." The Romans knew how to hide the unattractive concrete surface by adding a facing of brick, stone, or marble or by covering it with smooth plaster. Today, this decorative skin has disappeared from the remains of most Roman buildings, leaving the concrete core exposed and thus depriving these ruins of the appeal that Greek ruins have for us. They speak to us in other ways, through massive size and boldness of conception.

Sanctuary of Fortuna Primigenia The oldest monument in which the qualities of size and boldness are fully in evidence is the Sanctuary of Fortuna Primigenia at Palestrina (fig. 85), in

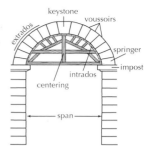

Arches were constructed of stone or brick over a temporary wooden scaffold, called centering. Roman arches have round tops, as opposed to later Gothic arches, which are pointed. In building the arch, the last stone laid is the keystone, which locks in the other arch stones (voussoirs) before the centering can be removed. The outside curve of the arch is the extrados, the inside curve the intrados.

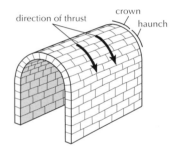

Built on the principle of the round arch, the barrel, or tunnel, vault may be thought of as a series of pressed-together arches. This vaulting is very heavy and exerts enormous pressure (thrust) downward and outward. Barrel vaulting, therefore, is usually supported by heavy walls.

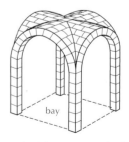

Also called the square vault, the groin vault was much favored in Roman architecture. The area enclosed within the four corner pillars is called a bay.

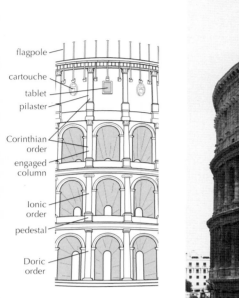

flagpole

cartouche

tablet

pilaster

Corinthian
order

engaged
column

Ionic
order

pedestal

Doric
order

The first three levels of the Colos-
seum facade have engaged
columns flanking the open ends
of barrel vaults. The highest level is
decorated with pilasters, between
which once hung cartouches and
tablets with inscriptions.

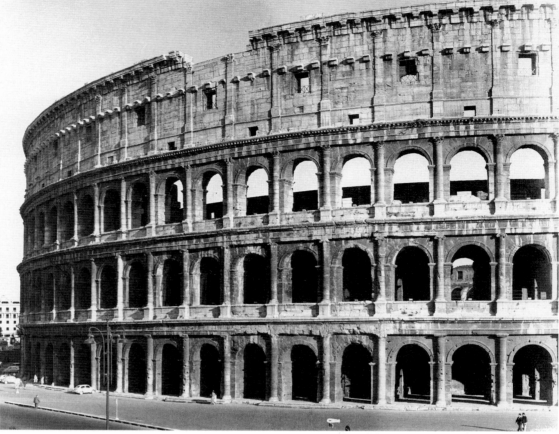

the foothills of the Apennines east of Rome. Here, in what was once an important Etruscan stronghold, a cult had been established since early times, dedicated to Fortuna (Fate) as a mother deity and combined with a famous oracle, a person through whom the deity was believed to have spoken. The Roman sanctuary dates from the early first century B.C. (The semicircular edifice on the top of the sanctuary is of much later date.)

A series of ramps leads up to a broad colonnaded terrace, from which a flight of steps ascends to the great colonnaded court that crowned the entire structure. Arched openings, framed by engaged columns and architraves, played an important part in the second terrace, just as semicircular recesses did in the first. These openings were covered by barrel vaults, another characteristic feature of the Roman architectural vocabulary. Except for one niche with the columns and entablature on the lower terrace, all the surfaces now visible are of concrete. Indeed, it is hard to imagine how a complex as enormous as this could have been constructed otherwise.

What makes the sanctuary at Palestrina so imposing, however, is not merely its scale but also the superb way it fits the site. An entire hillside, comparable to the Acropolis of Athens in its commanding position, has been transformed and articulated so that the architectural forms seem to grow out of the rock, as if human beings had simply completed a design laid out by nature itself. Such a molding of great open spaces had never been possible, or even desired, in the Classical Greek world. (The only compa-

rable projects are found in Egypt.) Nor was it compatible with the spirit of the Roman Republic. Significantly enough, the Palestrina sanctuary dates from the time of Sulla, whose absolute dictatorship (82–79 B.C.) marked the transition from Republican government to the one-man rule of Julius Caesar and his imperial successors.

Colosseum The arch and vault, encountered at Palestrina as an essential part of Roman monumental architecture, testify not only to the high quality of Roman engineering but also to the sense of order and permanence that inspired such efforts. These virtues impress us again in the Colosseum, the enormous amphitheater for gladiatorial games in the center of Rome (fig. 86). Completed in A.D. 80, it is, in terms of sheer mass, one of the largest single buildings anywhere; when intact, it accommodated more than 50,000 spectators. The concrete core, with its miles of stairways and barrel- and groin-vaulted corridors, is an outstanding work of engineering efficiency devised to ensure the smooth flow of traffic to and from the arena. The exterior, dignified and monumental, reflects the interior articulation of the structure but clothes and accentuates it in cut stone. There is a fine balance between vertical and horizontal elements in the framework of engaged columns and entablatures that contains the endless series of arches. The three classical orders are superimposed according to their intrinsic "weight": Doric, the oldest and most severe, on the ground floor, followed by Ionic and Corinthian. The lightening of the proportions, however, is barely noticeable, for the orders in their Roman adaptation are almost alike. Structurally, they have become ghosts, yet their aesthetic function continues unimpaired. It is through them that this enormous facade is related to human scale.

Arches, vaults, and concrete permitted the Romans to create vast interior spaces for the first time in the history of architecture. These were explored especially in the *thermae*, or great baths, which had become important centers of social life in imperial Rome. The experience gained there could then be applied to other,

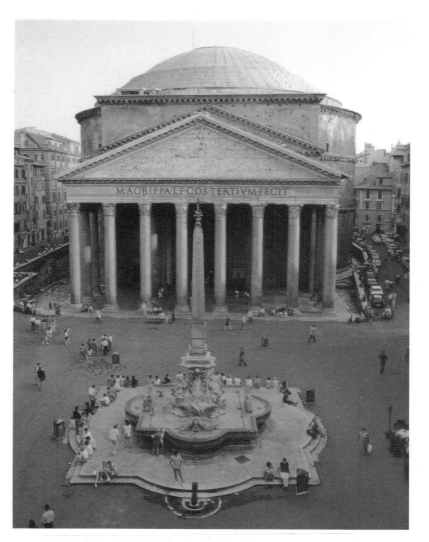

more traditional types of buildings, sometimes with revolutionary results.

Pantheon Perhaps the most striking example of these new applications is the famous Pantheon in Rome, a very large round temple of the early second century A.D. whose interior is the best preserved, as well as the most impressive, of any surviving Roman structure (fig. 87). There had been round temples long before this time, but their shape is so different from that of the Pantheon that the latter could not possibly have been derived from them. On the outside, the cella of the Pantheon appears as an

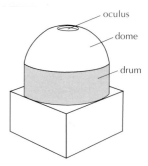

In dome-on-drum construction, the hemispheric dome sits on a thick circular band of masonry. An opening at the top of the dome (the oculus, meaning "eye") admits light.

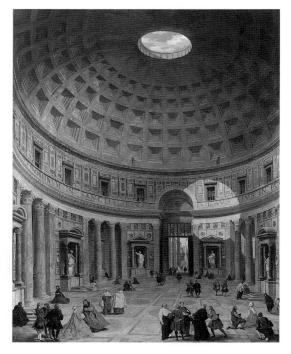

88. Giovanni Paolo Pannini. *The Interior of the Pantheon.* c. 1740. Oil on canvas, 50¹/₂ x 39" (128.3 x 99.1 cm). National Gallery of Art, Washington, D.C.

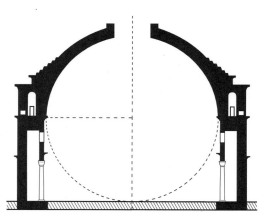

89. Section of the Pantheon

unadorned cylindrical **drum**, surmounted by a gently curved dome. The entrance is emphasized by a deep porch of a type standard to Roman temples. The junction of these two elements seems rather abrupt, but we no longer see the building raised on a high podium, as it was meant to be seen. Today, the level of the surrounding streets is a good deal higher than it was in antiquity.

That the architects did not have an easy time with the engineering problems of supporting the huge hemisphere of a dome may be deduced from the heavy plainness of the exterior wall. Nothing on the outside, however, gives any hint of the airiness and elegance of the interior; photographs fail to capture it, and even the painting (fig. 88) that we use to illustrate it does not do it justice. The height from the floor to the opening of the dome (called the oculus, or eye) is exactly that of the diameter of the dome's base, thus giving the proportions perfect balance (fig. 89). The weight of the dome is concentrated on the eight solid sections of wall. Between them, with graceful columns in front, niches are daringly hollowed out of the massive concrete, and these, while not connected with each other, give the effect of an open space behind the supports, making us feel that the walls are less thick and the dome much lighter than is actually the case. The multicolored marble panels and paving stones are still essentially as they were, but originally the dome was gilded, or overlaid with a thin layer of gold.

As its name suggests, the Pantheon was dedicated to all the gods or, more precisely, to the seven planetary gods. (There are seven niches for their statues.) It seems reasonable, therefore, to assume that the golden dome had a symbolic meaning, that it represented the Dome of Heaven. Yet this solemn and splendid structure grew from rather humble antecedents. The Roman architect Vitruvius, writing more than a century earlier, describes the domed steam chamber of a bathing establishment that anticipates (undoubtedly on a very much smaller scale) the essential features of the Pantheon: a hemispherical dome, a proportional relationship of height and width, and the circular opening in the center (which could be closed by a bronze shutter on chains to adjust the temperature of the steam room).

Basilica of Constantine The Basilica of Constantine, from the early fourth century A.D., is a more direct example of transforming *thermae* applications. **Basilicas**, long halls serving a

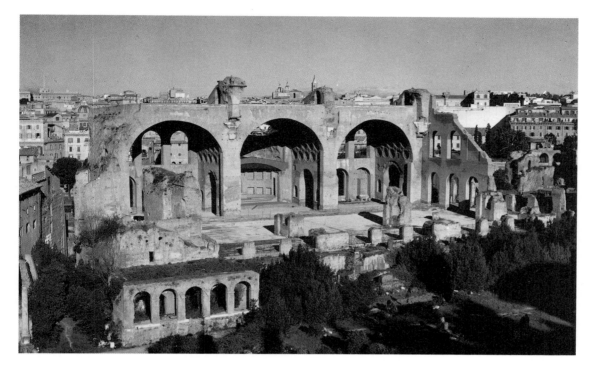

90. The Basilica of Constantine, Rome. c. A.D. 307–20

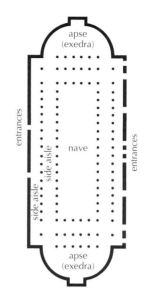

There was no standard form for the Roman basilica. This basilica plan shows two apses, or exedrae; most have only one apse.

variety of civic purposes, had first been developed in Hellenistic Greece. Under the Romans, they became a standard feature of every major town, where one of their chief functions was to provide a dignified setting for the courts of law that dispensed justice in the name of the emperor. Unlike other basilicas, the Basilica of Constantine (it was actually begun by his predecessor, Maxentius) derives its shape from the main hall of the public baths built by two earlier emperors, Caracalla and Diocletian. But it is built on an even grander scale. It must have been the largest roofed interior in all of Rome. Today, only the north **aisle**, consisting of three huge barrel-vaulted compartments, is still standing (fig. 90). The upper walls of the center tract, or **nave**, were pierced by a row of large windows (called the **clerestory**), so that the interior of the basilica must have had a light and airy quality despite its enormous size (fig. 91). We meet its echoes in many later buildings, from churches to railway stations. The Basilica of Constantine was entered through the **narthex** at the east end and terminated in a semicircular **apse**, where the colossal statue of

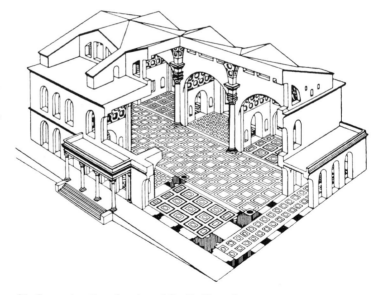

91. Reconstruction drawing of the Basilica of Constantine (after Huelsen)

Constantine stood (see fig. 96). Perhaps to accommodate his cult statue, Constantine modified the building by adding a second entrance to the south and a second apse opposite it where he could sit as emperor.

Sculpture

The dispute over the question "Is there such a thing as a Roman style?" has centered largely on the field of sculpture, for understandable reasons. Even if we discount the wholesale importing and copying of Greek originals, the reputation of the Romans as imitators seems borne out by large quantities of works that are most probably adaptations and variants of Greek models of every period. While the Roman demand for sculpture was tremendous, much of it may be attributed to a taste for antiquities and for sumptuous interior decoration. On the other hand, there can be no doubt that some kinds of sculpture had serious and important functions in ancient Rome. They represent the living sculptural tradition. We shall concern ourselves here with those aspects of Roman sculpture that are most conspicuously rooted in Roman society: portraiture and narrative relief.

Portraits

We know from literary accounts that, from early Republican times on, meritorious political or military leaders were honored by having their statues put on public display. The habit was to continue until the end of the Empire, a thousand years later. Unfortunately, the first 400 years of this Roman tradition are a closed book to us. Not a single Roman portrait has yet come to light that can be dated before the first century B.C. with any degree of confidence. Apparently, however, the creation of a monumental, unmistakably Roman portrait style was achieved only in the time of Sulla, when Roman architecture, too, came of age (see pages 105–7). It arose from a patriarchal Roman custom of considerable antiquity. Upon the death of the male head of the family, a wax image was made of his face, which was then preserved in a special shrine or family altar. At funerals, these ancestral images were carried in the procession. The patrician families of Rome clung tenaciously to this kind of ancestor worship well into imperial times. The desire to have these perishable wax records duplicated in marble perhaps came about because the

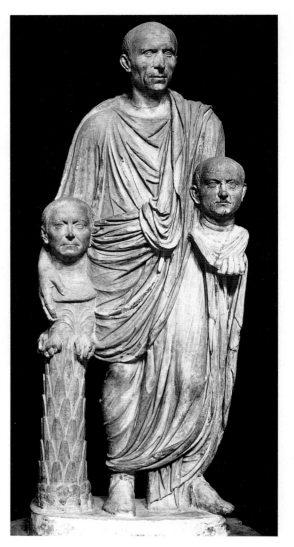

92. *A Roman Patrician with Busts of His Ancestors.* Late 1st century B.C. Marble, lifesize. Museo Capitolino, Rome

patricians—the Roman upper class—feeling their traditional position of leadership endangered, wanted to make a greater public display of their ancestors as a way of emphasizing their ancient lineage.

Ancestor Portraits Display of ancestors certainly is the purpose of the statue in figure 92. It shows an unknown Roman holding two busts of his ancestors, presumably his father and grandfather. The impressive heads of the two ancestors are copies of the lost originals. (Differences in style and in the shape of the bust indicate that the original of the head on the left

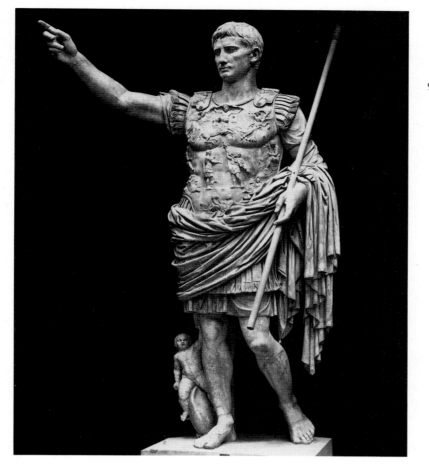

93. *Augustus of Primaporta*. Roman copy c. A.D. 20 of a Roman original of c. 15 B.C. Marble, height 6'8" (2.03 m). Musei Vaticani, Braccio Nuovo, Città del Vaticano, Rome

is about thirty years older than that of its companion.) The somber face and grave demeanor of this dutiful Roman are strangely affecting and indeed seem to project a spirit of patriarchal dignity not present in the heads of the ancestors. The process of translating ancestor portraits into marble not only made the ancestral images permanent but monumentalized them in the spiritual sense as well.

Nevertheless, what mattered was only the facial "text," not the "handwriting" of the artist who recorded it. For that reason, these portraits are characterized by a serious, prosaically factual quality. The term *uninspired* suggests itself—not as a criticism but as a way to describe the basic attitude of the Roman artist in contrast to the attitude of Greek or even Etruscan portraitists. That seriousness was consciously intended as a positive value becomes clear when we compare the right-hand ancestral head in our group with the fine Hellenistic portrait from Delos in figure 76. A more telling contrast

could hardly be imagined. Both are extremely persuasive likenesses, yet they seem worlds apart. Whereas the Hellenistic head impresses us with its subtle grasp of the sitter's psychology, the Roman may strike us at first glance as nothing but a detailed record of facial topography—the sitter's character emerges only incidentally, as it were. And yet this is not really the case. The features are true to life, no doubt, but the carver has treated them with a selective emphasis designed to bring out a specifically Roman personality—stern, rugged, iron-willed in its devotion to duty. It is a "father image" of frightening authority, and the minutely observed facial details are like individual biographical data that differentiate it from others.

Augustus of Primaporta As we approach the reign of the emperor Augustus (27 B.C.–A.D.14), we find a new trend in Roman portraiture that reaches its climax in the splendid statue *Augustus of Primaporta* (fig. 93). At first glance, we may

Rome's Republic and Empires

Roman Republic	510–27 B.C.
Roman Empire	27 B.C.–A.D. 395
Western Empire	A.D. 395–476
Eastern Empire	A.D. 395–1453

Major Roman Emperors

Augustus	27 B.C.–A.D. 14
Titus	79–81
Trajan	98–117
Hadrian	117–138
Marcus Aurelius	161–180
Caracalla	211–217
Diocletian	284–305
Constantine	306–337

tury B.C. Alexander the Great made it his own, as did his successors. They, in turn, transmitted it to Julius Caesar and the Roman emperors.

The idea of attributing superhuman stature to the emperor, thereby enhancing his authority, became official policy, and while Augustus did not carry it as far as later emperors, the Primaporta statue clearly shows him enveloped in an air of divinity. (He also was the chief priest of the state religion.) Still, despite its heroic, idealized body, the statue has an unmistakably Roman flavor. The costume, including the rich allegorical program on the breastplate, has a concreteness of surface texture that conveys the actual touch of cloth, metal, and leather. The head is idealized, or, better perhaps, "Hellenized." Small physiognomic details are suppressed, and the focusing of attention on the eyes gives it something of an "inspired" look. Nevertheless, the face is a definite likeness, elevated but clearly individual, as we know by comparison with the numerous other portraits of Augustus.

The output of portraits was vast, and the diversity of types and styles mirrors the ever more complex character of Roman society. If we regard the Republican ancestral tradition and the Greek-inspired *Augustus of Primaporta* as standing at opposite ends of a stylistic scale, we can find almost any combination in between. Augustus still conformed to age-old Roman custom by being clean-shaven. His successors, in contrast, adopted the Greek fashion of wearing beards as an outward sign of admiration for the Hellenic heritage. It is not surprising, therefore, to find a strong classicistic trend, often of a peculiarly cool, formal sort, in the sculpture of the second century A.D., especially during the reigns of Hadrian and Marcus Aurelius, both of them private men deeply interested in Greek philosophy.

Equestrian Monuments We can sense his introspective quality in the statue of Marcus Aurelius on horseback (fig. 94), which is remarkable not only as the sole survivor of many imperial equestrian monuments but as one of the few Roman statues that remained on public view throughout the Middle Ages. The image showing the mounted emperor as the all-conquering lord of

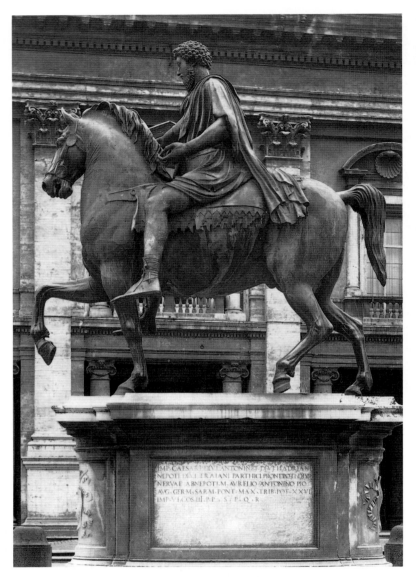

94. *Marcus Aurelius*. A.D. 161–80. Bronze, over lifesize. Piazza del Campidoglio, Rome

be uncertain of whether it represents a god or a human being. This doubt is entirely appropriate, for the figure is meant to be both. In fact, the statue is probably a later copy of a lost original: the bare feet indicate that the emperor has been deified, so the sculpture was certainly made after his death. Here, on Roman soil, we meet a concept familiar to us from Egypt and the ancient Near East: that of the divine ruler. It had entered the Greek world in the fourth cen-

the earth had been a firmly established tradition ever since Julius Caesar permitted such a statue of himself to be erected in the forum that he built. As depicted here, Marcus Aurelius, too, was meant to been seen as ever victorious, for beneath the right front leg of the horse (according to medieval accounts) there once crouched a small figure of a bound barbarian chieftain. The wonderfully spirited and powerful steed expresses this martial spirit. But the emperor himself, without weapons or armor, presents a picture of stoic detachment. He is a bringer of peace rather than a military hero, for so he indeed saw himself and his reign (A.D. 161–80).

Portrait Heads The late second century A.D. was the calm before the storm, for the third century saw the Roman Empire in almost perpetual crisis. Barbarians endangered its far-flung frontiers while internal conflicts undermined the authority of the imperial office. To retain the throne became a matter of naked force, succession by murder a regular habit. The "soldier emperors," who were mercenaries from the outlying provinces of the realm, followed one another at brief intervals. The portraits of some of these men, such as Philippus the Arab (fig. 95), who reigned from A.D. 244 to 249, are among the most powerful likenesses in all of art. Their facial realism is as uncompromising as that of Republican portraiture, but its aim is expressive rather than documentary. All the dark passions of the human mind—fear, suspicion, cruelty—suddenly stand revealed here, with a directness that is almost unbelievable. The face of Philippus mirrors all the violence of the time. Yet in a strange way it moves us to pity. There is a psychological nakedness about it that recalls a brute creature, cornered and doomed.

The results will remind us of the head from Delos (see fig. 76). Let us note, however, the new means through which the impact of the Roman portrait is achieved. We are struck, first of all, by the way expression centers on the eyes, which seem to gaze at some unseen but powerful threat. The engraved outline of the iris and the hollowed-out pupils, devices alien to earlier portraits, serve to fix the direction of the glance. The hair, too, is rendered in thoroughly un-Classical

95. *Philippus the Arab.* A.D. 244–49. Marble, lifesize. Musei Vaticani, Braccio Nuovo, Città del Vaticano, Rome

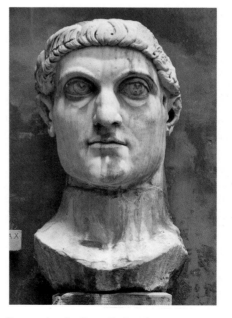

96. *Constantine the Great.* Early 4th century A.D. Marble, height 8' (2.44 m). Palazzo dei Conservatori, Rome

fashion as a close-fitting, textured cap. The face has been given a peculiar unshaven look that results from roughing up the surfaces around the jaw and mouth with short chisel strokes.

Clearly, the agony of the Roman world was

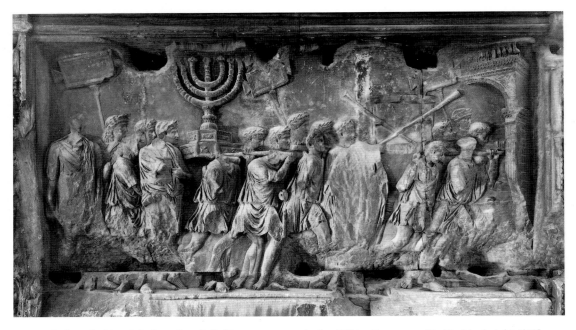

97. *Spoils from the Temple in Jerusalem*. Relief in passageway, Arch of Titus, Rome. A.D. 81. Marble, height 7'10"
(2.39 m)

spiritual as well as physical. So, too, were the glories of its dwindling years—or so they must have seemed to Constantine the Great (fig. 96), reorganizer of the Roman state and the first Christian emperor (see page 124). No mere bust, this head is one of several remaining fragments of a colossal statue (the head alone is more than 8 feet tall) that once stood in front of the apse of Constantine's gigantic basilica (see fig. 90). Although other late imperial sculpture continued to show the ruler standing, this one probably depicted him seated nude in the manner of Jupiter, with a mantle draped across his legs. It is probably the large statue mentioned by Bishop Eusebius, Constantine's friend and biographer, that held a cross-scepter, called a labarum, in its right hand. Under Constantine, this imperial device, originally a Roman military standard, became Christianized through the addition of the chi rho insignia with a wreath.

Thus, the colossal statue represented Constantine as a Christian ruler of the world. (The other hand most likely held an orb.) At the same time, it served as a cult statue to the emperor himself. In this head everything is so out of proportion to the scale of ordinary humans that we feel crushed by its immensity. The impression of being in the presence of some unimaginable power was deliberate, we may be sure, and we may call it superhuman, not only because of its enormous size but even more so perhaps as an image of imperial majesty. The impression is reinforced by the massive, immobile features of the head, out of which the huge, radiant eyes stare with hypnotic intensity. All in all, the sculpture tells us less about the way Constantine looked than about his view of himself and his exalted office.

Reliefs

Imperial art was not confined to portraiture. The emperors also commemorated their outstanding achievements in narrative reliefs on ▼MONUMENTAL ALTARS, TRIUMPHAL ARCHES, and columns. Similar scenes are familiar to us from Egypt and the ancient Near East (see figs. 24, 43, 44) but not from Greece. Historic events—that

is, events that occurred only once, at a specific time and in a particular place—had not been dealt with in Classical Greek sculpture. If a victory over the Persians was to be commemorated, it was represented indirectly, as a mythical event outside any space-time context: a combat of Lapiths and Centaurs or Greeks and Amazons. Even in the Hellenistic era, this attitude persisted, although not quite as absolutely as before. When the kings of Pergamon celebrated their victories over the Celts, the latter were represented faithfully (see fig. 77) but in typical poses of defeat rather than in the framework of a particular battle.

Greek painters, on the other hand, had depicted historic subjects. As we have seen, the mosaic from Pompeii showing *The Battle of Issus* (see fig. 58) probably reflects a famous Greek painting of about 315 B.C. depicting the defeat of the Persian king Darius by Alexander the Great. In Rome, too, historic events had been painted from the third century B.C. on. Rendered on panels, these pictures seem to have had the fleeting nature of posters advertising a hero's triumphs. Sometime during the late years of the Republic, the temporary representations of such events began to assume more monumental and permanent form by being carved and attached to structures intended to last indefinitely. They were thus a ready tool for the glorification of imperial rule, and the emperors did not hesitate to use them on a large scale.

Arch of Titus Roman relief carving reached its greatest development in the two large narrative panels on the triumphal arch erected in A.D. 81 to commemorate the victories of the emperor Titus. One of them (fig. 97) shows part of the triumphal procession celebrating the conquest of Jerusalem. The booty displayed includes the seven-branched menorah, or candlestick, and other sacred objects. Despite the mutilated surface, the movement of a crowd of figures in depth is still conveyed with striking success. On the right, the procession turns away from us and disappears through a triumphal arch placed obliquely to the background plane so that only the nearer half actually emerges from the background—a radical but effective device.

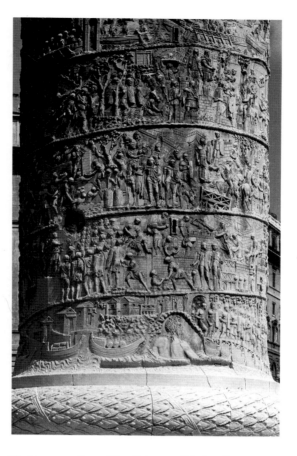

98. Lower portion of the Column of Trajan, Rome. A.D. 106–13. Marble, height of relief band c. 50" (127 cm)

Column of Trajan The purposes of imperial art, narrative or symbolic, were sometimes incompatible with a realistic treatment of space. In terms of the number of figures and the density of the narrative, the continuous spiral band of relief covering the Column of Trajan (fig. 98), erected in A.D. 106–13 to celebrate that emperor's victorious campaigns against the Dacians (the ancient inhabitants of Romania), is by far the most ambitious **frieze** composition attempted up to that time. It is also the most frustrating, for viewers must "run around in circles" to follow the narrative and can hardly see anything above the fourth or fifth turn without binoculars.

The spiral frieze was a new and demanding framework for historic narrative that imposed

a number of difficult conditions upon the sculptor. Since there could be no clarifying inscriptions, the pictorial account had to be as self-sufficient and explicit as possible, which meant that the spatial setting of each episode had to be worked out with great care. Visual continuity had to be preserved without destroying the inner coherence of the individual scenes. And the actual depth of the carving had to be much shallower than in reliefs such as those on the Arch of Titus. Otherwise, the shadows cast by the projecting parts would make the scenes unreadable from below.

Our artist has solved these problems with great success but at the cost of sacrificing all except the barest remnants of illusionistic spatial depth. Landscape and architecture are reduced to abbreviated "stage sets," and the ground on which the figures stand is tilted upward. The scenes in our detail are a fair sampling of the events depicted on the column. Among the more than 150 separate episodes, actual combat occurs only rarely, while the geographic, logistic, and political aspects of the campaign receive detailed attention, much as they do in Julius Caesar's famous account of his conquest of Gaul.

Painting

We know infinitely less about Roman painting than we do about Roman architecture or sculpture. Almost all of the surviving examples consist of wall paintings, and the great majority of these come from Pompeii, Herculaneum, and other settlements buried by the eruption of Mount Vesuvius in A.D. 79, or from Rome and its environs. Their dates cover a span of less than 200 years, from the end of the second century B.C. to the late first century A.D. What happened before that time remains largely a matter of guesswork, but Roman painting seems to have stagnated thereafter.

Roman Illusionism

The style that prevailed at the time of the eruption of Mount Vesuvius can be seen in the painting that adorned a corner of the Ixion Room in the House of the Vettii at Pompeii (fig. 99). It combines imitation marble paneling, conspicuously framed mythological scenes intended to give the effect of panel pictures set into the wall, and fantastic architectural vistas seen through make-believe windows, creating the effect of a somewhat disjointed compilation of **motifs** from various sources. The architecture, too, has a strangely unreal and picturesque quality that is believed to reflect the architectural backdrops of the theaters of the time. The illusion of surface textures and distant views has an extraordinary degree of three-dimensional reality, but as soon as we try to analyze the relationship of the parts to each other, we quickly realize that the Roman painter has no systematic grasp of spatial depth, that the perspective is haphazard and inconsistent within itself. Apparently this artist never intended us to enter the space created. Like a promised land, it remains forever beyond us.

When landscape takes the place of architectural vistas, exact foreshortening becomes less important, and the virtues of the Roman painter's approach outweigh the limitations. This is most strikingly demonstrated by the famous *Odyssey Landscapes*, a continuous stretch of landscape subdivided into eight compartments by a framework of pilasters. Each section illustrates an episode of the adventures of Odysseus (Ulysses). In the adventure with the Laestrygonians reproduced in figure 100 on page 118, the airy, bluish tones create a wonderful feeling of atmospheric, light-filled space that envelops and binds together all the forms within this warm Mediterranean fairyland, where the human figures seem to play no more than an incidental role. Only upon further reflection do we realize how frail the illusion of coherence is. If we were to try mapping this landscape, we would find it as ambiguous as the architectural perspective just discussed. Its unity is not structural but poetic

Villa of the Mysteries There exists one monument whose sweeping grandeur of design and coherence of style are unique in Roman painting: the great cycle of paintings in one of the rooms in the Villa of the Mysteries, just outside Pompeii (fig. 101). The artist has placed the fig-

Theater, Music, and Art in Ancient Rome

According to contemporary sources, the Romans adopted Greek music, including its system of modes, with little modification. Roman theater, by contrast, was in many respects very different from Greek theater, because it was derived primarily from Etruscan rather than Greek sources. Tarquin the Elder, the Etruscan king of Rome between about 616 and 578 B.C., introduced to Rome the Etruscan taste for lavish spectacles when he built the first Circus Maximus for horse races and other athletic events. Tarquin also established religious festivals known as *ludi Romani* (Roman games) to honor Jupiter each September. The Roman historian Livy (59 B.C.–A.D. 17) recorded that the first theatrical performances were held in 364 B.C., when musicians and dancers were imported from Etruria to placate the gods during a plague. Thereafter, theater, too, became a part of religious festivals.

Much Roman theater resembled modern carnival or circus acts, called *mimus*, or mime. In 22 B.C., PANTOMIME ("all mime") was introduced from Greece. This was a form of popular theater in which a single dancer acted out all the roles of a play with gestures, changing to a new mask for each part. Serious Roman drama began with LIVIUS ANDRONICUS, a freed slave of Greek origin from south Italy, who in 240 B.C. produced a Latin translation of two Greek plays for the *ludi Romani*. Livius Andronicus and other writers continued to write and produce Latin dramas in the Greek manner, which were always performed at religious festivals. Because these plays reflected the stringent moral values of Republican Rome, they gradually died out during the Empire.

Roman sources tell us that the greatest author of comedies was Caecilius Statius (c. 219–168 B.C.), but, as with Livius Andronicus, none of his works has survived. During the first century B.C., Roman comic theater was dominated by the *fabula Atellana* (named for a town near Naples), a coarse variety of farce that relied for its appeal on stock subjects, happy endings, and musical accompaniment.

All that remains of Roman theater are twenty-one comedies by PLAUTUS (c. 254–184 B.C.), six comedies by the freed African slave TERENCE (190–156 B.C.), and nine tragedies by SENECA (4 B.C.–A.D. 65), the philosopher and teacher of the emperor Nero. Seneca's plays, which were evidently written for private banquets, may never have been performed in public. All of these writers exercised enormous influence on English Renaissance theater by providing models of plot and style that were used by William Shakespeare and Christopher Marlowe (see page 333). Roman playwrights have fallen into undeserved neglect today, especially Seneca, whose plays—far from being dry imitations of Greek prototypes—are powerful dramas with penetrating characterizations revealed in soliloquies fully the equal of Shakespeare's.

The architect and historian VITRUVIUS (see page 80), writing in the late first century B.C., has left us a detailed account of Roman theater practices, which suggests that Roman architectural backdrops and painted scenery were considerably more elaborate than those of the Greeks. We can get a good idea of their probable appearance from the illusionistic treatment of architecture in Roman wall paintings (see fig. 99).

ures on a narrow ledge of green against a regular pattern of red panels separated by strips of black, a kind of running stage on which they enact their strange and solemn ritual. Who are they, and what is the meaning of the cycle? Many details remain puzzling, but the program as a whole represents various rites of the Dionysiac Mysteries, a semisecret cult of very ancient origin that had been brought to Italy from Greece. The sacred rituals are performed, perhaps as part of an initiation into womanhood or marriage, in the presence of Dionysos and Ariadne, with their train of satyrs and sileni. Human and mythical reality tend to merge into one. We sense the blending of these two spheres in the qualities all the figures have in common: their dignity of bearing and expression, the wonderful firmness of body and drapery, the rapt intensity with which they participate in the drama of the ritual. Many of the poses and gestures are taken from the repertory of Classical Greek art, yet they lack the studied and self-conscious quality called classicism. An artist of exceptional greatness of vision has filled these forms with new life. Whatever the relation to the famous Greek artists whose works are lost to us forever, our painter was their legitimate heir in the same sense that the finest Latin poets of the Augustan age were the legitimate heirs to the Greek poetic tradition.

Greek Sources

Since we have so few Classical Greek or Hellenistic wall murals on Greek soil and no panels whatsoever, the problem of singling out the Roman element as against the Greek is far more difficult in painting than in sculpture or architecture. Despite the fact that the characters'

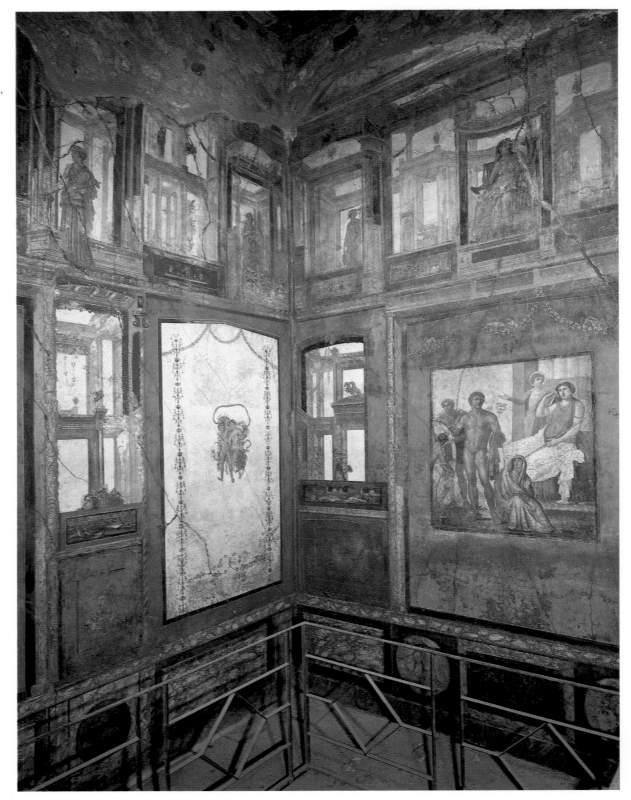

99. The Ixion Room,
House of the
Vettii, Pompeii.
A.D. 63–79

100. *The Laestrygonians Hurling Rocks at the Fleet of Odysseus*. Wall painting from the *Odyssey Landscapes* series in a house on the Esquiline Hill, Rome. Late 1st century B.C. Musei Vaticani, Biblioteca Apostolica, Città del Vaticano, Rome

101. Scenes of a Dionysiac Mystery cult. Fresco mural, Villa of the Mysteries, Pompeii. c. 50 B.C.

names are given in Greek, there is no doubt that Greek designs were copied, Greek paintings were imported, and Greek painters came to work in Roman cities. It is tempting to link Roman paintings with lost works recorded by Pliny, Vitruvius, and others. But *The Battle of Issus* (see fig. 58) is one of the rare instances where this can be convincingly done.

For the most part, Roman painting appears to have been a specifically Roman development. There is no need to assume a Greek origin for the *Odyssey Landscapes*. On the contrary, the illusionistic tendencies that gained the upper hand in Roman murals during the first century B.C. represent a dramatic breakthrough without precedent in Greek painting.

The issue is more complex when it comes to narrative painting. Although not a trace of it exists, we can hardly doubt that Greek painting continued to evolve after the Classical era. Narrative painting seems to have undergone a decline in the late Hellenistic era and was revived, so Pliny tells us, around the middle of the first century B.C. by Timomachus of Byzantium, who "restored its ancient dignity to the art of painting." This is the same time as the ▼FRESCOES in the Villa of the Mysteries. Like them, Roman painting as a whole shows the same genius for adapting Greek examples to Roman needs as do sculpture and architecture. This is true even of seemingly reproductive or imitative works. The mythological panels that occur like islands within an elaborate architectural framework (see fig. 99) sometimes give the impression of relatively straightforward copies after Hellenistic originals. In several cases, however, we possess more than one variant of the same composition derived ultimately from the same, presumably Greek, source, and the divergences attest to how readily the original was copied and changed. Moreover, a closer reading shows that such panels, too, underwent a clear-cut evolution that reflects the changing taste of Roman artists and their patrons. Figures were freely altered, rearranged, and recombined, often within very different settings. Thus, whatever the relation to the famous paintings of Greece that are lost to us forever, scenes like those in the Ixion Room represent a uniquely

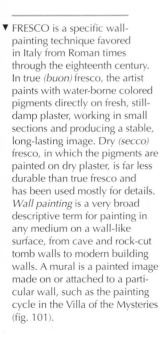

▼ FRESCO is a specific wall-painting technique favored in Italy from Roman times through the eighteenth century. In true *(buon)* fresco, the artist paints with water-borne colored pigments directly on fresh, still-damp plaster, working in small sections and producing a stable, long-lasting image. Dry *(secco)* fresco, in which the pigments are painted on dry plaster, is far less durable than true fresco and has been used mostly for details. *Wall painting* is a very broad descriptive term for painting in any medium on a wall-like surface, from cave and rock-cut tomb walls to modern building walls. A mural is a painted image made on or attached to a particular wall, such as the painting cycle in the Villa of the Mysteries (fig. 101).

102. Portrait of a boy, from Faiyum, Lower Egypt. 2nd century A.D. Encaustic on panel, 15 3/8 x 7 1/2" (39 x 19 cm). The Metropolitan Museum of Art, New York

Gift of Edward S. Harkness, 1918

Roman approach to painting, and it is likely that most were newly painted at the time Pompeii was destroyed.

Portraits

We know from Pliny that portrait painting was an established custom in Republican Rome. None of these panels has survived, and the few portraits found on the walls of Roman houses in Pompeii may well derive from a different, specifically Hellenistic, tradition. The only coherent group of painted Roman portraits at our disposal comes instead from the Faiyum district in Lower Egypt. We owe them to the survival (or revival) of an ancient Egyptian custom, that of attaching a portrait of the deceased to the wrapped, mummified body. The amazing freshness of their color is due to the fact that they were done in a medium of great durability called **encaustic**, which means that the pigments are suspended in hot wax. The mixture can be opaque and creamy, like oil paint, or thin and translucent. At their best, such as the very fine and well-preserved wooden panel reproduced in figure 102, these portraits have an immediacy and sureness of touch that have rarely been surpassed, thanks to the need to work quickly before the hot wax set. Our dark-haired boy is as solid, sparkling, and lifelike a piece of reality as anyone might wish. The artist has emphasized certain features, for example, the eyes. But in this happy instance, the stylization has been made with the intention only of recalling the attractive personality of a beloved child. This way of painting was revived four centuries later in the earliest Byzantine icons, which were "portraits" of the Madonna and Child.

CHRONOLOGICAL CHART 1

	Political History	Religion and Literature	Science and Technology
B.C.			
4000	Sumerians settle in lower Mesopotamia	Pictographic writing, Sumer, c. 3500	Wheeled carts, Sumer, c. 3500–3000 Sailboats used on Nile c. 3500 Potter's wheel, Sumer, c. 3250
3000	Early Dynastic, Old Kingdom, Egypt (Dynasties 1–6), c. 3150–2190 Early dynastic period, Sumer, c. 4000–2340; Akkadian kings 2340–2180	Hieroglyphic writing, Egypt, c. 3100 Cuneiform writing, Sumer, c. 2900 Divine kingship of the pharaoh Theocratic socialism in Sumer	First bronze tools and weapons, Sumer
2000	Middle Kingdom, Egypt, 2040–1674 Hammurabi founds Babylonian dynasty c. 1760 Flowering of Minoan civilization c. 1700–1450 New Kingdom, Egypt, c. 1552–1069	Code of Hammurabi c. 1760 Monotheism of Akhenaten (ruled 1348–1336/5) *Book of the Dead*, first papyrus books, Dynasty 18	Bronze tools and weapons in Egypt Canal from Nile to Red Sea Mathematics and astronomy flourish in Babylon under Hammurabi Hyksos bring horses and wheeled vehicles to Egypt c. 1725
1000	Jerusalem capital of Palestine; rule of David; of Solomon (died 926) Assyrian Empire c. 1000–612 Persians conquer Babylon 539; Egypt 525 Romans revolt against Etruscans, set up republic 510	Hebrews accept monotheism Phoenicians develop alphabetic writing c. 1000; Greeks adopt it c. 800 First Olympian games 776 Homer (active c. 750–700), *Iliad* and *Odyssey* Zoroaster, Persian prophet (born c. 660) Aeschylus, Greek playwright (525–456)	Coinage invented in Lydia (Asia Minor) c. 700–650; soon adopted by Greeks Pythagoras, Greek philosopher (active c. 520)
500	Persian Wars in Greece 499–478 Periklean Age in Athens c. 460–429 Peloponnesian War, Sparta against Athens, 431–404 Alexander the Great (356–323) occupies Egypt 333; defeats Persian 331; conquers Near East	Sophocles, Greek playwright (496–406) Euripides, Greek playwright (died 406) Socrates, philosopher (died 399) Plato, philosopher (427–347); founds Academy 386 Aristotle, philosopher (384–322)	Travels of Herodotos, Greek historian, c. 460–440 Hippokrates, Greek physician (born 469) Euclid's books on geometry (active c. 300–280) Archimedes, physicist and inventor (287–212)
200	Rome dominates Asia Minor and Egypt, annexes Macedonia (and thereby Greece) 147		Invention of paper, China
100	Julius Caesar dictator of Rome 49–44 Emperor Augustus (ruled 27 B.C.–14 A.D.)	Golden Age of Roman literature: Cicero, Catullus, Vergil, Horace, Ovid, Livy	Vitruvius' *De architectura*
A.D.			
1	Jewish rebellion against Rome 66–70; destruction of Jerusalem Eruption of Mt. Vesuvius buries Pompeii, Herculaneum 79	Crucifixion of Jesus c. 30 Paul (died c. 65) spreads Christianity to Asia Minor and Greece	Pliny the Elder *(Natural History)* dies in Pompeii 79 Seneca, Roman statesman
100	Emperor Trajan (ruled 98–117) rules Roman Empire at its largest extent Emperor Marcus Aurelius (ruled 161–80)		Ptolemy, geographer and astronomer (died 160)
200	Shapur I (ruled 242–72), Sassanian king of Persia Emperor Diocletian (ruled 284–305) divides Empire	Persecution of Christians in Roman Empire 250–302	
300	Constantine the Great (ruled 324–37)	Christianity legalized by Edict of Milan 313; state religion 395 Augustine of Hippo (354–430), Jerome (c. 347–420)	Silk cultivation brought to eastern Mediterranean from China

Architecture	Sculpture	Painting
"White Temple" and ziggurat, Uruk (38, 39)		
Step pyramid and funerary district of Zoser, Saqqara, by Imhotep (27, 28) Sphinx, Giza (31) Pyramids at Giza (29)	Palette of Narmer (24) Statues from Abu Temple, Tell Asmar (40) Offering stand and harp from Ur (41, 42) *Mycerinus and Queen Khamerernebty (26)* Cycladic female figures from Amorgos (48)	
Stonehenge, England (21, 22) Palace of Minos, Knossos, Crete (49) Temple of Amun-Mut-Khonsu, Luxor (33) Treasury of Atreus, Mycenae (52)	Stela of Hammurabi (43) Heads of Akhenaten and Nefertiti (34, 35) Coffin of Tutankhamun (36) Lionness Gate, Mycenae (53)	The "Toreador Fresco" (51)
Ishtar Gate, Babylon (45) "Basilica," Paestum (61)	Pole-top ornament from western Iran (46) Relief from Nimrud (44) *Kouros (64)* *Kore in Dorian Peplos (65)* North frieze from Treasury of the Siphnians, Delphi (66) *Apollo from Veii (80)*	Dipylon vase (54) Black-figure amphora by Psiax (56)
Palace, Persepolis (47) Temple of Poseidon, Paestum (61) Temples on Acropolis, Athens: Parthenon (62); Propylaia and Temple of Athena Nike (63)	*She-Wolf* from Rome (81) East pediment from Aegina (67) *Kritios Boy (68)* *Zeus (69)* East pediment from the Parthenon (73) East frieze from the Mausoleum, Halikarnassos (74) Cinerary container (84) *Dying Trumpeter (77)*	*Herakles Wrestling Antaios*, red-figure krater (57) Tomb of Lionesses, Tarquinia (83) *The Battle of Issus (58)*
	Nike of Samothrace (79)	
	Roman Patrician (92) *Portrait Head* from Delos (76)	*Odyssey Landscapes (100)* Villa of the Mysteries, Pompeii (101)
Colosseum, Rome (86)	Arch of Titus, Rome (95)	House of the Vettii, Pompeii (99)
Pantheon, Rome (87, 88)	Column of Trajan, Rome (98) Equestrian statue of Marcus Aurelius, Rome (94)	*Portrait of a Boy*, Faiyum (102)
	Philippus the Arab (95)	
Basilica of Constantine, Rome (90, 91)	Colossal statue of Constantine the Great (96)	

NOTE: Figure numbers are in *italics*.

The Middle Ages

When we think of great civilizations of the past, we tend to do so in terms of visible monuments that have come to symbolize the distinctive character of each: the pyramids of Egypt, the ziggurats of Babylon, the Parthenon of Athens, the Colosseum of Rome, and Hagia Sophia in Constantinople. The Middle Ages, in such a review of climactic achievements, would be represented by a Gothic cathedral—Nôtre-Dame in Paris, perhaps, or the cathedral of Chartres in France, or Salisbury Cathedral in England. We have many to choose from, but whichever one we pick, it will be well north of the Alps (although in territory that formerly belonged to the Roman Empire). And if we were to spill a bucket of water in front of the cathedral of our choice, this water would eventually make its way to the English Channel rather than to the Mediterranean Sea. Here, then, we have perhaps the most important single fact about the Middle Ages: the center of gravity of European civilization has shifted to what had been the northern boundaries of the Roman world. The Mediterranean,

for so many centuries the great highway of commercial and cultural exchange binding together all the lands along its shores, has become a barrier, a border zone.

How did this dramatic shift come about? In A.D. 323 Constantine the Great made a fateful decision, the consequences of which are still felt today. He resolved to move the capital of the Roman Empire to the Greek city of Byzantium, which came to be known then as Constantinople and today as Istanbul. Seven years later, after an energetic building campaign, the transfer was officially completed. In taking this step, the emperor acknowledged the growing strategic and economic importance of the eastern provinces, a development that had been evolving for some time. The new capital also symbolized the new Christian basis of the Roman state, since it was in the heart of the most thoroughly Christianized region of the Empire.

Constantine could hardly have foreseen that shifting the seat of imperial power would result in splitting the realm. In 395, less than a seventy-five years after the capital was relocated in the East, the

division of the Roman Empire into the Eastern and Western empires was official and permanent. That separation eventually led to a religious split as well.

By the end of the fifth century, the bishop of Rome, who derived his authority from Saint Peter, regained independence from the emperor and reasserted his claim as the acknowledged head—the pope—of the Christian Church. His claim to pre-eminence, however, soon came to be disputed by the Eastern counterpart to the pope, the patriarch of Constantinople. Differences in doctrine began to develop, and eventually the division of Christendom into a Western, or Catholic, and an Eastern, or Orthodox, Church became all but final. Institutionally, the differences between them went very deep. Roman Catholicism maintained its autonomy from imperial or any other state authority and became an international institution, reflecting its character as the universal church. The Orthodox Church, on the other hand, was based on the union of spiritual and secular authority in the person of the emperor, who appointed the patriarch. It thus remained dependent on the power of the State, exacting a double allegiance from the faithful and sharing the vicissitudes of political power. (This tradition did not die even with the fall of Constantinople to the Ottoman Turks in 1453. The czars of Russia claimed the mantle of the Byzantine emperors, Moscow became "the third Rome," and the Russian Orthodox Church was as closely tied to the State as was its Byzantine parent body.)

Under Justinian (ruled 527–65), the Eastern (or Byzantine) Empire reached new power and stability after riots in 532 nearly deposed him. In contrast, the Latin West soon fell prey to invading Germanic peoples: Visigoths, Vandals, Ostrogoths, Lombards. By the end of the sixth century, the last vestige of centralized authority had disappeared, even though the emperors at Constantinople did not relinquish their claim to the western provinces. Yet these invaders, once they had settled in their new environment, accepted the framework of late Roman, Christian civilization, however imperfectly. The local kingdoms they founded—the Vandals in North Africa, the

Visigoths in Spain, the Franks in Gaul, the Ostrogoths and Lombards in Italy—were all Mediterranean-oriented, provincial states on the periphery of the Byzantine Empire, subject to the pull of its military, commercial, and cultural power. As late as 630, after the Byzantine armies had recovered Syria, Palestine, and Egypt from the Sassanid Persians, the reconquest of the lost western provinces remained a serious possibility. Ten years later, the chance had ceased to exist, for a tremendous and completely unforeseen new force had made itself felt in the East: Islam.

With the rise of Islam, a hundred years later the African and Near Eastern parts of the Empire were overrun by conquering Arabs. By 732, a century after Muhammad's death, the Arabs had absorbed Spain as well and threatened to add southwestern France to their conquests. In the eleventh century, the Turks occupied a large part of Asia Minor, while the last Byzantine possessions in the West (in southern Italy) fell to the Normans, from northwestern France. The Eastern Empire, with its domain reduced to the Balkan Peninsula, including Greece, held on until 1453, when the Turks finally conquered Constantinople itself.

Islam had created a new civilization stretching to the Indus Valley (now Pakistan) in the East, a civilization that reached its highest point far more rapidly than did that of the medieval West. Baghdad, on the Tigris, the most important city of Islam in the eighth century, rivaled the splendor of Constantinople. Islamic art, learning, and crafts were to have a far-ranging influence on the European Middle Ages, from arabesque ornament, the manufacture of paper, and Arabic numerals to the transmission of Greek philosophy and science through the writings of Arab scholars. (The English language records this debt in such words of Arabic origin as *algebra* and *alcohol*.)

It would be difficult to exaggerate the impact of the lightninglike advance of Islam on the Christian world. The Byzantine Empire, deprived of its western Mediterranean bases, concentrated all its efforts on keeping Islam at bay in the East. The Byzantine Empire's impotence in the West, where it retained only a precarious foothold on Italian soil, left the European shore of the Mediterranean, from the Pyrenees to Naples, exposed to Arabic raiders from North Africa and Spain. Western Europe was thus forced to develop its own resources—political, economic, and spiritual.

The process was slow and difficult, however. The early medieval world, beset by unremitting upheaval, presents a con-

stantly shifting picture. Not even the Frankish kingdom, ruled by the Merovingian dynasty from about 500 to 751, was capable of imposing more than temporary order. As the only international organization of any sort, Christianity was to play a critical role in promoting a measure of stability. Yet it, too, was divided between the papacy, whose influence was limited, and the monastic orders that spread quickly throughout Europe but remained largely independent of the Church in Rome.

This expansion suggests an important aspect of Christianity: like Islam, its diffusion cannot be explained simply in institutional terms, for the Church was at best an imperfect embodiment of Christian ideals. Moreover, its success was hardly guaranteed. In fact, its position was often precarious under Constantine's Latin successors. Instead, it must have exercised an extraordinarily persuasive appeal, spiritual as well as moral, on the masses of people who heard its message.

Church and State gradually discovered that cooperation worked to their mutual advantage and that, in fact, they could not live without each other. What was needed, however, was an alliance between a strong central secular authority and a united church. This link was forged when the Catholic Church, which had now gained the allegiance of the religious orders, broke its last ties with the East and turned for support to the Germanic north, where the energetic leadership of Charlemagne and his heirs—the Carolingian dynasty—made the Frankish kingdom into the leading power during the second half of the eighth century after overturning the Merovingian dynasty. In the year 800, the pope solemnized the new order of things by bestowing the title of emperor upon Charlemagne. In placing himself and all of Western Christianity under the protection of the king of the Franks and Lombards, the pope nevertheless did not subordinate himself to the newly created Catholic emperor, whose legitimacy depended on the pope. (Formerly it had been the other way around: the emperor in Constantinople had ratified the newly elected pope.) This interdependent dualism of spiritual and political authority, of Church and State, was to distinguish the West from both the Orthodox East and the Islamic South. Its outward symbol was the fact that though the emperor had to be crowned in Rome, he did not reside there. Charlemagne built his capital at the center of his effective power, in Aachen, located, on the present-day map of Europe, in Germany and close to France, Belgium, and the Netherlands.

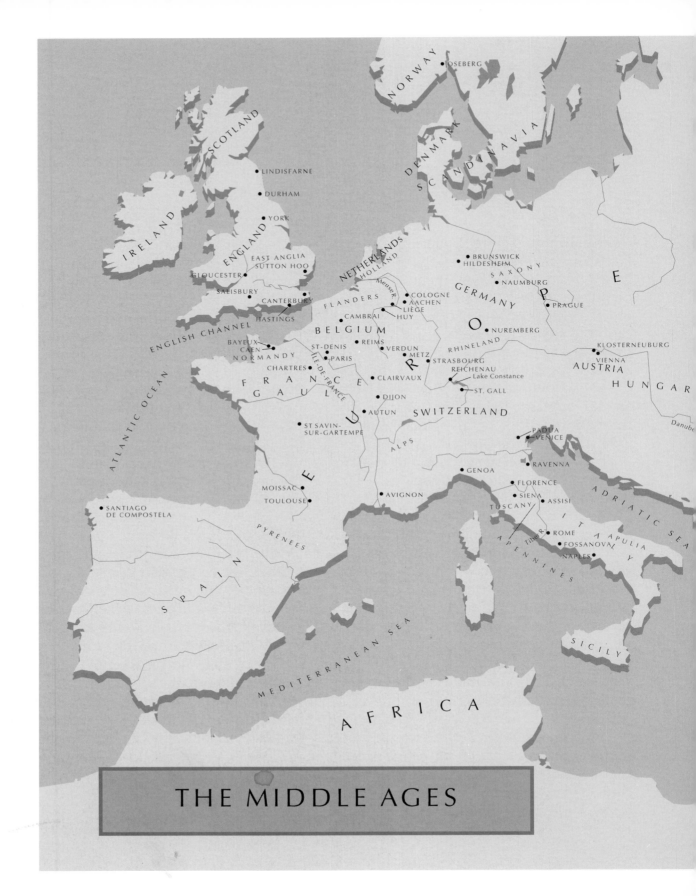

NORWAY
OSEBERG
SCOTLAND
SCANDINAVIA
DENMARK
LINDISFARNE
IRELAND
DURHAM
ENGLAND
YORK
EAST ANGLIA
SUTTON HOO
NETHERLANDS
BRUNSWICK
HILDESHEIM
SAXONY
GLOUCESTER
HOLLAND
NAUMBURG
GERMANY
SALISBURY
Meuse R.
CANTERBURY
FLANDERS
COLOGNE
E
AACHEN
PRAGUE
HASTINGS
CAMBRAI
LIÈGE
P
ENGLISH CHANNEL
BELGIUM
HUY
O
NUREMBERG
BAYEUX
ST-DENIS
REIMS
R
KLOSTERNEUBURG
CAEN
VERDUN
RHINELAND
ATLANTIC OCEAN
NORMANDY
PARIS
METZ
VIENNA
CHARTRES
ILE-DE-FRANCE
U
STRASBOURG
AUSTRIA
F R A N C E
CLAIRVAUX
REICHENAU
HUNGARY
G A U L
Lake Constance
ST. GALL
DIJON
Danube
AUTUN
SWITZERLAND
ST SAVIN-
E
SUR-GARTEMPE
PADUA
VENICE
ALPS
RAVENNA
GENOA
ADRIATIC SEA
MOISSAC
FLORENCE
TOULOUSE
AVIGNON
SIENA
ASSISI
SANTIAGO
TUSCANY
I T A L Y
DE COMPOSTELA
APULIA
PYRENEES
Tiber R.
ROME
FOSSANOVA
APENNINES
NAPLES
S P A I N
MEDITERRANEAN SEA
SICILY

AFRICA

THE MIDDLE AGES

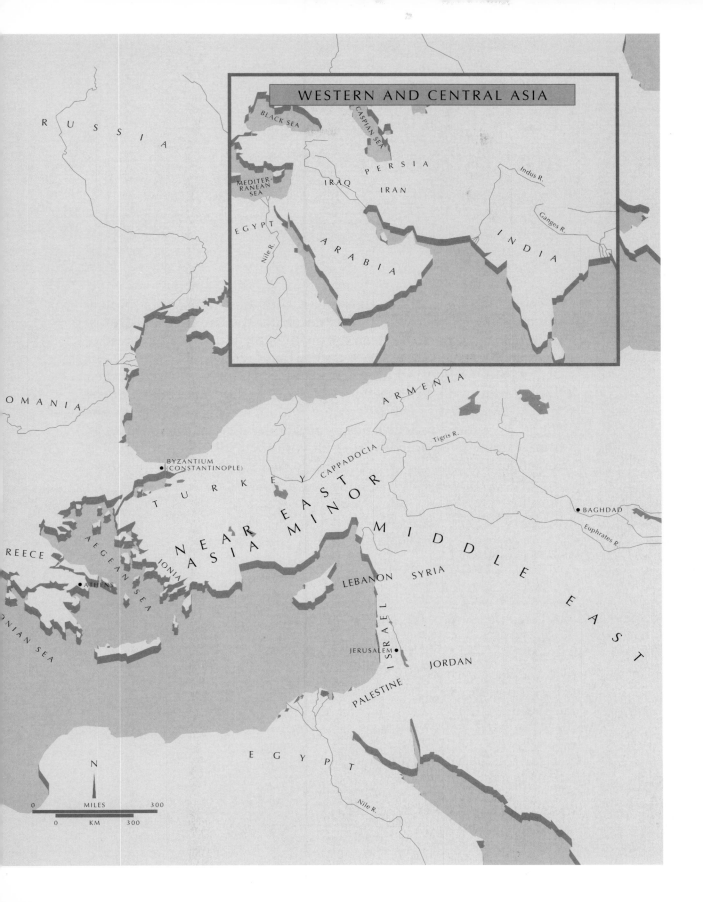

WESTERN AND CENTRAL ASIA

RUSSIA

BLACK SEA

CASPIAN SEA

PERSIA

IRAQ

IRAN

Indus R.

MEDITER-
RANEAN
SEA

EGYPT

Nile R.

ARABIA

Ganges R.

INDIA

ROMANIA

ARMENIA

Tigris R.

BYZANTIUM
(CONSTANTINOPLE)

TURKEY

CAPPADOCIA

NEAR EAST

ASIA MINOR

MIDDLE EAST

BAGHDAD

Euphrates R.

GREECE

AEGEAN SEA

IONIA

ATHENS

LEBANON

SYRIA

CYPRUS

IONIAN SEA

ISRAEL

JERUSALEM

JORDAN

PALESTINE

EGYPT

Nile R.

N

MILES
0 300

KM
0 300

Chapter 8
Early Christian Art and Byzantine Art

In the third century A.D., the Roman world was gripped by a spiritual crisis that reflected broad social turmoil as the Empire gradually disintegrated. Characteristic of the mood of the times was the spread of Oriental Mystery religions. They were of various origins—Egyptian, Persian, Semitic—and their early development naturally centered in their home territory, the southeastern provinces and border regions of the Roman Empire. Although based on traditions in effect long before the conquest of these ancient lands by Alexander the Great, the cults had been strongly influenced by Greek ideas during the Hellenistic period. It was, in fact, to this fusion of Oriental and Greek elements that they owed their vitality and appeal.

Religions under Roman Rule

In the first three centuries after the birth of Jesus, the Near East was a vast religious and cultural melting pot where all of the many competing faiths (including ▼JUDAISM, CHRISTIANITY, MITHRAISM, MANICHAEISM, GNOSTICISM, and many more) tended to influence each other, so that they had a number of things in common, whatever their differences of origin, ritual, or nomenclature. Most of them shared such features as an emphasis on revealed truth, the hope of salvation, a chief prophet or messiah, the dichotomy of good and evil, a ritual of purification or initiation (baptism), and the duty to seek converts among "unbelievers." The last and, in the Near East, the most successful development of this period was ▼ISLAM, which still dominates the area to this day.

The growth of the Graeco-Oriental religions under Roman rule is difficult to trace, since many of them were underground movements that have left few tangible remains. This is true of Christianity as well. The Gospels of Mark, Matthew, Luke, and John (their probable chronological order) were written in the later first century and present somewhat varying pictures of Jesus and his teachings; in part, these reflect doctrinal differences between Peter, the first bishop of Rome, and Paul, a tireless proselytizer and the most important of the early converts. For the first three centuries after Christ, congregations were disinclined to worship in public. Instead, their simple services, held at best at portable altars with a minimum of implements or vestments (garments worn while conducting services), were conducted in the houses of the wealthier members. The new faith spread first to the Greek-speaking communities, notably Alexandria, then to the Latin world by the end of the second century. Even before it was declared a lawful religion in 261 by the emperor Gallienus, Christianity was rarely persecuted. It suffered chiefly under Diocletian, whose successor, Galerius, issued an edict of toleration in 309. Nevertheless, it had little standing until the conversion of Constantine the Great in 312, despite the fact that nearly one-third of Rome was by then Christian. According to

Bishop Eusebius of Caesarea, based on Constantine's own account late in life, on the eve of the decisive battle against his rival Maxentius at the Milvian Bridge over the Tiber River in Rome there appeared in the sky the sign of the cross with the inscription "In this sign, conquer." The next night, Christ came to Constantine in a dream with the sign (undoubtedly the chi rho monogram of Christ—the labarum) and commanded him to copy it, whereupon he had it emblazoned on his helmet and the military standards of his soldiers. Following his victory, Constantine accepted the faith, if he had not done so already, although he was baptized only on his deathbed. The following year, he and his fellow emperor, Licinius, promulgated the Edict of Milan, which proclaimed freedom of religion throughout the Empire. Constantine never declared Christianity the official state religion. Still, it enjoyed special status under his patronage. The emperor championed its cause and played an active role in shaping its theological program, partly in an effort to settle doctrinal disputes. Unlike his pagan predecessors, Constantine could no longer command the status of a deity, but he did claim that his authority was granted directly from God. Thus, he retained a unique and exalted role by placing himself at the head of the Church as well as of the State. We recognize this claim as the adaptation of an ancient heritage: the divine kingship of Egypt and the Near East. Although the sincerity of Constantine's faith is not to be doubted, he set a pattern for future Christian rulers in using religion for personal and imperial ends, for example, by continuing to promote the cult of the emperor.

Early Christian Art

Little is known for certain about Christian art until the reign of Constantine the Great. The painted decorations of the Roman **catacombs**, the underground burial places of Christians, provide the only sizable and coherent body of material, but these are merely one among various possible kinds of Christian art. Before that time, Rome was not the only center of faith. Older and larger Christian communities existed

The chi rho sign, a monogram of Christ, is composed of the first two Greek letters of *Christos: chi* (*x*) and *rho* (*p*). It is also called *Chrismon* and *Christogram.*

▼ MITHRAISM, MANICHAEISM, and GNOSTICISM had as a common element a dualistic struggle between forces of good and evil. All three were Mystery religions in the sense that all involved elaborate and secret initiations. All were monotheistic (one god) religions, as were JUDAISM and CHRISTIANITY.

▼ ISLAM is practiced by Muslims. Islam has but one god, Allah, who revealed himself in the seventh century A.D. to a historical figure, the prophet Muhammad. (Muslims regard Old Testament prophets and Jesus as predecessors to Muhammad.) The Koran is the text of God's revelations to Muhammad. Because it forbids the representation of people and animals, Islamic art is highly decorative and incorporates much calligraphy into designs.

Speaking of

pagans, infidels, heathens, and heretics

To early Christians and Muslims, all believers in polytheistic religions were called infidels, or unbelievers. In Early Christian Rome and during the Middle Ages, unbelievers were called either pagans ("unenlightened ones," from the Latin *paganus,* "country dweller,") or heathens (those who were not Christian, Jewish, or Muslim). Although, strictly speaking, the words *pagan* and *heathen* are synonyms, the former is often—including in this book—reserved for classical antiquity, the latter for Northern Europe. Heretics, by contrast, are the faithful who hold opinions contrary to orthodox doctrine.

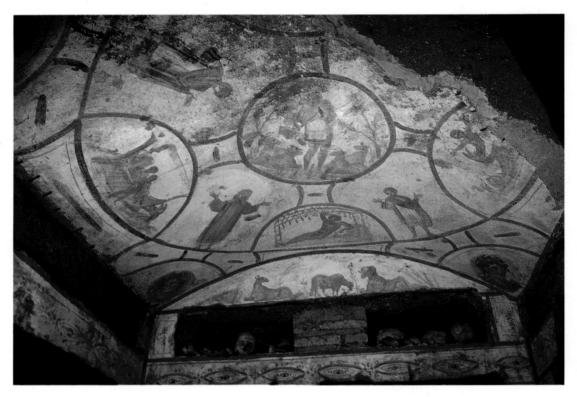

103. Painted ceiling, Catacomb of SS. Pietro e Marcellino, Rome. 4th century

in the great cities of North Africa and the Near East, such as Alexandria and Antioch. They had probably developed separate artistic traditions of their own, but few traces of them survive. If the dearth of material from the eastern provinces of the Empire makes it difficult to trace the early development of Christian art, the catacomb paintings nevertheless tell us a good deal about the spirit of the communities that sponsored them.

Catacombs

Burial rites and the safeguarding of tombs were of vital concern to early Christians, whose faith rested on the hope of eternal life in paradise. In the painted ceiling in figure 103, the imagery of the catacombs clearly expresses this outlook, although the forms are in essence still those of pre-Christian mural decoration. The division of the ceiling into compartments is a late and highly simplified echo of the illusionistic architectural schemes in Pompeian painting. The

modeling of the figures, as well as the landscape settings, betrays their descent from the same Roman idiom, which here has become debased in the hands of an artist of very modest ability. But the catacomb painter has used this traditional vocabulary to convey a new, symbolic content, and the original meaning of the forms is of little interest here. Even the geometric framework shares in this task, for the great circle suggests the Dome of Heaven, inscribed with the cross, the basic symbol of the faith. In the central medallion, or circle, we see a youthful shepherd, with a sheep on his shoulders, in a pose that can be traced back as far as Greek Archaic art. He stands for Christ the Savior, the Good Shepherd who gives his life for his flock.

The semicircular compartments tell the story of Jonah. On the left he is cast from the ship, on the right he emerges from the whale, and at the bottom he is safe again on dry land, meditating upon the mercy of the Lord. This Old Testament miracle, often juxtaposed with

Architecture

Constantine's decision to sanction Christianity as a legal religion of the Roman Empire had a profound impact on Christian art. Now, almost overnight, an impressive architectural setting had to be created for the newly approved faith so that the Church might be visible to all. Constantine himself devoted the full resources of his office to this task, and within a few years an astonishing number of large, imperially sponsored churches arose, not only in Rome but also in Constantinople, the Holy Land, and other important sites.

S. Apollinare in Classe The structures built under Constantine were a new type—the Early Christian basilica—and they provided the basic model for the development of church architecture in western Europe. The Early Christian basilica, as seen in the sixth-century Church of S. Apollinare in Classe, near Ravenna (figs. 104, 105), is a synthesis of assembly hall, temple, and private house. It also has the qualities of an original creation that cannot be wholly explained in terms of its sources. It owes to the imperial basilicas the long **nave** flanked by aisles and lit by **clerestory** windows, the **apse**, and the wooden roof. Our view, taken from the west, shows the entrance hall (**narthex**) but not the **colonnaded** court (**atrium**), which was torn down a long time ago; the round bell tower, or **campanile**, is a medieval addition. (Many basilican churches also include a **transept**, a separate compartment of space placed at right angles to the nave and aisles forming a cross plan, though this feature is frequently omitted, as here.) The Roman basilica was by no means unique to Christianity. It had already been employed by early cults and by Judaism. It was nevertheless a suitable model for Constantinian churches, since it combined the spacious interior demanded by Christian ritual (see "The Liturgy of the Mass," page 134) with imperial associations that proclaimed the privileged status of Christianity. But a church had to be more than an assembly hall. In addition to enclosing the community of the faithful, it was the sacred House of God, the

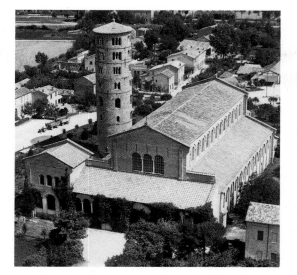

104. S. Apollinare in Classe, near Ravenna, Italy. 533–49

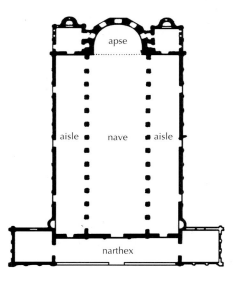

105. Plan of S. Apollinare in Classe (after De Angelis d'Ossat)

New Testament miracles, enjoyed great favor in Early Christian art as proof of the Lord's power to rescue the faithful from the jaws of death. The standing figures may represent members of the Christian Church, with their hands raised in prayer, pleading for divine help. The entire scheme, though small in scale and unimpressive in execution, has a consistency and clarity that set it apart from its non-Christian ancestors.

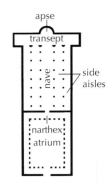

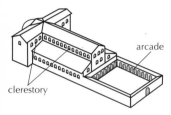

This Early Christian basilica plan has two features not present in S. Apollinare in Classe (fig. 105): a transept and an atrium forecourt.

The oblique view shows clearly the rows of clerestory windows in the transept and nave and reveals the open arches (arcades) around the inside of the atrium.

Christian successor to the temples of old.

In order to express this function, the design of the basilica had to be given a new focus, the altar, which was placed in front of the apse at the eastern end of the nave, while the entrances, which in earlier basilicas had usually been on the flanks (compare the Roman basilica plan on page 109), were shifted to the western end. The Christian basilica was thus oriented along a single, longitudinal axis that is curiously similar to the layout of Egyptian temples (compare fig. 33).

S. Apollinare in Classe shows another essential aspect of Early Christian religious architecture: the contrast between exterior and interior. The plain brick exterior remains conspicuously unadorned. It is merely a shell whose shape reflects the interior space it encloses—the exact opposite of the classical temple. This ascetic, anti-monumental treatment of the exterior gives way to the utmost richness (fig. 106) as we enter the church proper. Having left the everyday world behind, we find ourselves in a shimmering realm of light and color where precious marble surfaces and the brilliant glitter of **mosaics** evoke the spiritual splendor of the Kingdom of God. The steady rhythm of the nave arcade pulls us toward the great arch at the eastern end, which frames the altar and the vaulted apse beyond.

Mosaics

The rapid growth of Christian architecture on a large scale had a revolutionary effect on the development of Early Christian painting. All of a sudden, huge wall surfaces had to be covered with images worthy of their monumental framework. The heritage of the past, however, was not only absorbed but also transformed to make it fit its new physical and spiritual environment. In the process, a great new art form emerged, the Early Christian wall mosaic, which to a large extent replaced the older and cheaper medium of **mural** painting. The Hellenistic Greeks and the Romans had produced mostly floor mosaics. The vast and intricate wall mosaics of Early Christian art thus are essentially without precedent. The same is true of their material, for they consist of small cubes of colored glass known as **tesserae**. These offered colors, including gold, of far greater range and intensity than the marble employed in *The Battle of Issus* (see fig. 58) but lacked the fine gradations in tone necessary for imitating painted pictures. The shiny (and slightly irregular) faces of glass tesserae act as tiny reflectors, so that the overall effect is that of a glittering, immaterial screen rather than of a solid, continuous surface. All these qualities made glass mosaic the ideal complement of the new architectural aesthetic in Early Christian basilicas. The brilliant color, the light-filled, transparent brightness of gold, the severe geometric order of the images in a mosaic complex such as that of S. Apollinare in Classe fit the spirit of these interiors to perfection. One might say, in fact, that Early Christian and Byzantine churches

The Liturgy of the Mass

The central rite of many Christian churches is the EUCHARIST or COMMUNION service, a ritual meal that reenacts Jesus' Last Supper. In the Catholic Church and in a few Protestant churches as well, this service is known as the MASS (from the Latin words *Ite, missa est,* "Go, [the congregation] is dismissed" at the end of the Latin service). The Mass was first codified by Pope Gregory the Great around 600. Each Mass consists of the "ordinary"—those prayers and hymns that are the same in all masses—and the "proper," the parts that vary, depending on the occasion. In addition to a number of specific prayers, the "ordinary" consists of five hymns: the *Kyrie Eleison* (Greek for "Lord have mercy on us"); the *Gloria in Excelsis* (Latin for "Glory in the highest"); *Credo* (Latin for "I believe," a statement of faith also called the Creed); *Sanctus* (Latin for "Holy"); and *Agnus Dei* (Latin for "Lamb of God"). The "proper" of the Mass consists of prayers, two readings from the New Testament (one from the Epistles and one from the Gospels); a homily, or sermon, on these texts; and hymns, all chosen specifically for the day.

Musical settings for the five "ordinary" hymns, also called a mass, have been a major compositional form from 1400 into the twentieth century, although they follow no set tradition and have considerable variety. Many of the greatest composers have written masses, including Josquin Des Prés, Bach, Haydn, Mozart, Beethoven, Verdi, Stravinsky, and Bernstein. These often depart rather freely from liturgical requirements of the Mass, as they were written for special occasions, such as the Requiem Mass for the dead, the Nuptial Mass for weddings, and the Coronation Mass.

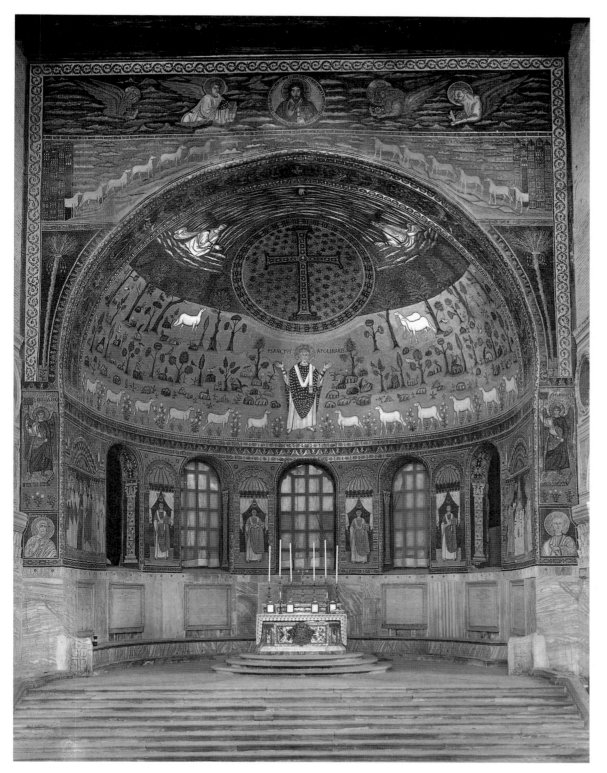

106. Interior (view toward the apse), S. Apollinare in Classe

107. *The Parting of Lot and Abraham.* Mosaic in Sta. Maria Maggiore, Rome. c. 430

Speaking of

saints

In English, the abbreviations for *Saint* and *Saints* are *St.* and *Sts.* Saints in Italy are *S.* (*San,* male saint), *Sta.* (*Santa,* female saint), and *SS.* (*Santi,* male or male and female saints. It is quite permissible to use simply *S.* for any category.) In French, *Saint* is expressed without a period and always hyphenated with the name of the saint, as in St-Denis: *St-* (*Saint,* male), *Ste-* (*Sainte,* female), and *Sts-* (*Saints,* all plural forms).

The veneration of saints is a Catholic practice, and a person can be declared a saint only after death. The pope acknowledges sainthood by canonization, a complex process based on meeting rigid criteria of authentic miracles and beatitude, or blessed character. At the same time, the pope ordains a public cult of the new saint throughout the Church. In this book, a historical figure being discussed before death is referred to without the word *saint* preceding the Christian name.

demand mosaics the way Greek temples demand architectural sculpture.

In Early Christian mosaics the flatness of the wall surface is denied, not in order to suggest a reality beyond the surface of the wall as in Roman mural painting, but for the purpose of achieving an "illusion of unreality," a luminous realm populated by celestial beings or symbols. In narrative scenes, too, we see the illusionistic tradition of ancient painting being transformed by new content. Long sequences of scenes, selected from the Old and New Testaments, adorned the nave walls of Early Christian basilicas.

The Parting of Lot and Abraham (fig. 107) is a scene from the oldest and most important surviving cycle of this kind, executed about 430 in the Church of Sta. Maria Maggiore in Rome. Abraham, his son Isaac, and the rest of his family occupy the left half of the composition as they depart for the land of Canaan; Lot and his clan, including his two small daughters, turn toward the city of Sodom on the right. The task of the artist who designed our panel is comparable to that faced by the sculptors of the Column of Trajan (see fig. 98): how to con-

dense complex actions into a visual form that would permit them to be read at a distance. In fact, many of the same "shorthand" devices are employed, such as the abbreviative formulas for house, tree, and city or the trick of showing a crowd of people as a "grape-cluster of heads" behind the foreground figures. But in the Trajanic reliefs, these devices could be used only to the extent that they were compatible with the realistic aim of the scenes, which re-create actual historic events. The mosaics in Sta. Maria Maggiore, on the other hand, depict the history of salvation, beginning with Old Testament scenes along the nave. The scheme constitutes not only a historic cycle but, above all, a unified symbolic program that presents a higher reality—the Word of God. The reality they illustrate is the living word of the Scripture (in this instance, Genesis 13), which is a *present* reality shared by artist and beholder alike, rather than something that happened only once in the space-and-time context of the external world. Hence, there was no need to clothe the scene with the concrete details of historic narrative. Glances and gestures are more important here than dramatic movement or three-dimensional form. The symmetrical composition, with its cleavage in the center, makes clear the significance of this parting: the way of righteousness, represented by Abraham, as against the way of evil, signified by the city of Sodom, which was destroyed by the Lord.

Roll, Book, and Illustration

From what source did the designers of narrative mosaic cycles such as that of Sta. Maria Maggiore derive their compositions? They were certainly not the first to illustrate scenes from the Bible in extensive fashion (see "Versions of the Bible," page 138). For certain subjects, they could have found models among the catacomb murals, but some prototypes may have come from illustrated manuscripts. Because of their portability, such manuscripts have played an important role in spreading religious imagery. In certain well-identified cases, manuscript illustrations unquestionably served as models for wall paintings, while in others it is apparent

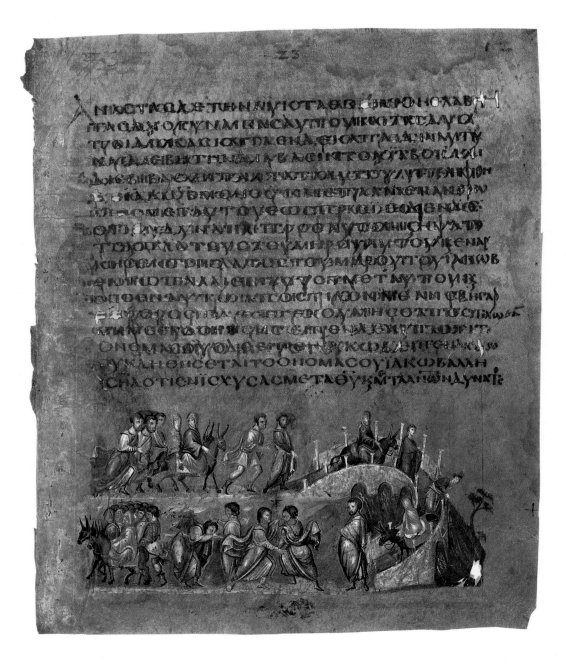

108. Page with *Jacob Wrestling the Angel*, from the *Vienna Genesis*. Early 6th century. Tempera and silver on dyed vellum, 13¼ x 9½" (33.7 x 24.1 cm). Österreichische Nationalbibliothek, Vienna

that manuscript "illuminations" (as they are also called) must have been derived from frescoes. But in many more instances than have been acknowledged, the similarities between two pictures point to a common source that was probably a lost mural, not a manuscript.

As a scriptural religion, founded on the Word of God as revealed in Holy Writ, the early Christian Church must have sponsored the duplicating of the sacred text on a large scale.

Every copy of it was handled with a reverence quite unlike the treatment of any book in Graeco-Roman civilization. But when did these copies become works of pictorial art as well? And what did the earliest Bible illustration look like?

Books, unfortunately, are frail things. Thus, their history in the ancient world is known to us largely from indirect evidence. It begins in Egypt (we do not know exactly when) with the

Versions of the Bible

The word *bible* is derived from the Greek word for "books," since it was originally a compilation of a number of sacred texts. Over time, the books of the Bible came to be regarded as a unit, and thus the Bible is now generally considered a single book.

There is considerable disagreement between Christians and Jews, and among various Christian and Jewish sects, over which books should be considered "canonical"— that is, accepted as legitimate parts of the "biblical canon," the standard list of authentic texts. However, every version of the Bible includes the Hebrew TORAH, or "the Law" (also called the PENTATEUCH, or Books of Moses), as the first five books. Also universally accepted by both Jews and Christians are the books known as "the Prophets" (which include texts of Jewish history as well as prophecy). There are also a number of other books known simply as "the Writings," which include history, poetry (the Psalms and the Song of Songs), prophecy, and even folktales, some universally accepted, some accepted by one group, and some accepted virtually by no one.

Books of doubtful authenticity are known as APOCRYPHAL BOOKS, or simply, Apocrypha, from a Greek word meaning "obscure." The Jewish Bible or Hebrew Canon—the books which are accepted as authentic Jewish Scripture—was agreed upon by Jewish scholars sometime before the beginning of the Christian era.

The Christian Bible is divided into two major sections, the OLD TESTAMENT and the NEW TESTAMENT. The Old Testament contains many, but not all, of the Jewish Scripture, while the New Testament, originally written in Greek, is specifically Christian. It contains four GOSPELS—each written in the first century A.D. by one of the early Christian missionaries known as the four EVANGELISTS, Mark, Matthew, Luke, and John. The Gospels tell, from slightly different points of view, the story of the life and teachings of Jesus of Nazareth. The Gospels are followed by the EPISTLES, letters written by Paul and a few other Christian missionaries to various congregations of the church. The final book is the APOCALYPSE, by John the Divine, also called the Book of Revelation, which foretells the end of the world.

Jerome (342–420), the foremost scholar of the early Church, selected the books considered canonical for the Christian Bible from a large body of early Christian writings. It was due to his energetic advocacy that the Church accepted the Hebrew scriptures as representing the Word of God as much as the Christian texts, and therefore worthy to be included in the Bible. Jerome then translated the books he had chosen from Hebrew and Greek into Latin, the spoken language of Italy in his time. This Latin translation of the Bible was—and is—known as the VULGATE, because it was written in the vernacular (Latin *vulgaris*) language. The Vulgate remained the Church's primary text for the Bible for more than a thousand years. It was regarded with such reverence that when in the fourteenth century early humanists first translated it into the vernacular languages of their time, they were sometimes suspected of heresy for doing so. The writings rejected for inclusion in the Bible by Jerome are known as Christian Apocrypha. Although not canonical, some of these books, such as the *Life of Mary* and the *Gospel of James*, were nevertheless used by artists and playwrights during the Middle Ages as sources for stories to illustrate and dramatize.

discovery of a suitable material, paperlike but rather more brittle, made from the papyrus plant (see page 41). Books of papyrus were made in the form of rolls throughout antiquity. Not until late Hellenistic times did a better substance become available: parchment, or **vellum** (thin, bleached animal hide), which is far more durable than papyrus. It was strong enough to be creased without breaking, and it thus made possible the kind of bound book we know today, technically called a codex.

Between the first and the fourth century A.D., the vellum codex gradually replaced the roll, whether vellum or papyrus. This change must have had an important effect on the growth of book illustration. As long as the roll form prevailed, illustrations seem to have been mostly line drawings, since the layers of pigment would soon have cracked and come off in the process of rolling and unrolling. Only the vellum codex permitted the use of rich colors, including gold, that was to make manuscript illumination the small-scale counterpart of murals, mosaics, and panel pictures. There are still unsettled problems: when, where, and at what pace the development of pictorial book illumination took place; whether biblical, mythological, or historical subjects were primarily depicted; how much of a carryover there might have been from roll to codex; and especially their relation to murals and role in spreading religious imagery. There can be little question, however, that the earliest illuminations, whether Christian, Jewish, or classical, were done in a style strongly influenced by the illusionism of Hellenistic-Roman painting of the sort we met at Pompeii.

Vienna Genesis One of the oldest extant examples of an Old Testament book, the *Vienna Gen-*

esis, a Greek translation written in silver (now turned black) on purple vellum, was adorned with brilliantly colored **miniatures**—or small color illustrations—that achieve a sumptuous effect not unlike that of the mosaics we have seen. Figure 108 shows several scenes from the story of Jacob. In the foreground, we see him wrestling with the angel and receiving the angel's benediction. The picture thus does not show a single event but a whole sequence, strung out along a single U-shaped path, so that progression in space becomes progression in time. This method, known as continuous narration, may reflect earlier illustrations made for books in roll form. For manuscript illustration, the continuous method offers the advantage of spatial economy. It permits the painter to pack a maximum of narrative content into the available area. Our artist apparently thought of this picture as a running account to be read like lines of text, rather than as a window demanding a frame. The painted forms are placed directly on the purple background that holds the letters, emphasizing the importance of the page as a unified field.

Sculpture

Compared to painting and architecture, sculpture played a secondary role in Early Christian art. The biblical prohibition of graven (carved) images in the Second Commandment was thought to apply with particular force to large cult statues, the idols worshiped in pagan temples. If religious sculpture was to avoid the taint of idolatry, it had to eschew lifesize representations of the human figure. It thus developed from the very start in an antimonumental direction: away from the spatial depth and massive scale of Graeco-Roman sculpture toward shallow, small-scale forms and lacelike surface decoration. The earliest works of Christian sculpture are marble **sarcophagi**, or coffins, which were produced from the middle of the third century on for the more important members of the Church. Before the time of Constantine, their decoration consisted mostly of the same limited repertory of themes familiar from catacomb murals—the Good Shepherd, Jonah and the Whale, and so forth—but within a framework clearly borrowed from secular sarcophagi. Not until a century later do we find a significantly broader range of subject matter and form.

Sarcophagus of Junius Bassus A key Christian sarcophagus is the richly carved *Sarcophagus of Junius Bassus*, made for a high official of Rome who died in 359 (fig. 109). Its colonnaded front, divided into ten square compartments, shows a mixture of Old and New Testament scenes. In the upper row are (left to right), the Sacrifice of Isaac, Peter Taken Prisoner, Christ Enthroned between Saints Peter and Paul, and Jesus before Pontius Pilate (two compartments); in the lower row are the Misery of Job, the Fall of Man (the Temptation of Adam and Eve), Jesus' Entry into Jerusalem, Daniel in the Lions' Den, and Paul Led to His Martyrdom. This choice, somewhat strange to the modern beholder, is characteristic of the Early Christian way of thinking, which stresses the divine rather than the human nature of Jesus. Hence his suffering and death are merely hinted at (see "The Life of Jesus," page 142). He appears before Pilate as a youthful philosopher expounding the True Wisdom (note the scroll), and the martyrdom of the two apostles is represented in the same discreet, nonviolent fashion. The two central scenes are also devoted to Christ. Enthroned above Jupiter as the personification of the heavens, he dispenses the Law to Saints Peter and Paul; below, he enters Jerusalem as Savior. Adam and Eve, the original sinners, denote the burden of guilt redeemed by Christ, the Sacrifice of Isaac is an Old Testament prefiguration of Jesus' sacrificial death and resurrection, while Job and Daniel carry the same message as Jonah in the catacomb painting (see fig. 103): they fortify the hope of salvation. The figures in their deeply recessed niches still recall the statuesque dignity of the Greek and Roman tradition. Yet beneath this superimposed classicism we sense an oddly becalmed, passive air in the scenes calling for dramatic action. The events and personages confronting us are no longer intended to tell their own story, physically or emotionally, but to call to our minds a higher, symbolic meaning that binds them together.

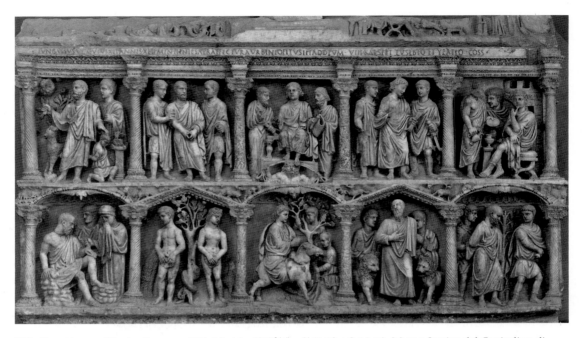

109. *Sarcophagus of Junius Bassus.* c. 359. Marble, 3'10½" x 8' (1.18 x 2.44 m). Museo Storico del Capitolino di S. Pietro, Rome

Classicism Classicizing tendencies of the sort found in the *Sarcophagus of Junius Bassus* seem to have been a recurrent phenomenon in Early Christian sculpture from the mid-fourth to the early sixth century. Their causes have been explained in various ways. During this period paganism still had many important adherents, who may have fostered such revivals as a kind of rear-guard action. Recent converts (including Junius Bassus himself, who was not baptized until shortly before his death) often kept their allegiance to values of the past, artistic and otherwise. There were also important leaders of the Church who favored a reconciliation of Christianity with the heritage of classical antiquity, and with good reason: early Christian theology depended a great deal on Greek and Roman philosophers, not only more recent thinkers such as Plotinus but also Plato, Aristotle, and their predecessors. The emperors, too, both East and West, always remained aware of their institutional links with pre-Christian times and thus their imperial capitals could become centers for revivalist impulses. Whatever its roots in any given instance, clas-

sicism was of great importance during this age of transition.

Ivory Diptychs The continuing importance of classicism held true particularly for a category of objects whose artistic importance far exceeds their physical size: ivory panels and other small-scale reliefs in precious materials. Designed for private ownership and meant to be enjoyed at close range, they often mirror a collector's taste, a refined aesthetic sensibility not found among the large, official enterprises sponsored by Church or State. The ivory panel (fig. 110) done soon after 500 in the Eastern Roman Empire is just such a piece. It shows a classicism that has become an eloquent vehicle of Christian content. The majestic archangel is a descendant of the winged victories of Graeco-Roman art, down to the richly articulated drapery (see fig. 79). Yet the power he heralds is not of this world, nor does he inhabit an earthly space. The architectural niche against which he appears has lost all three-dimensional reality. Its relationship to him is purely symbolic and ornamental, so that he

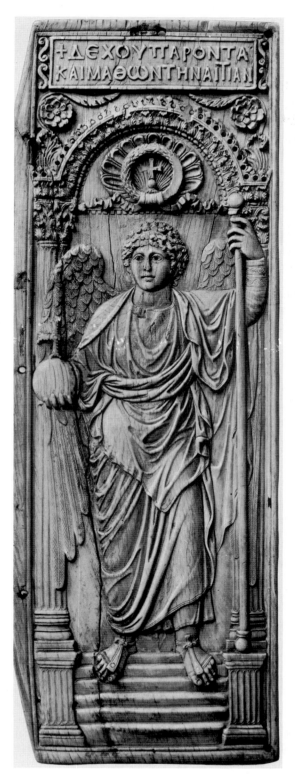

110. *The Archangel Michael*. Panel of a diptych.
Early 6th century. Ivory, 17 x 5¹/₂" (43.2 x 14 cm).
The British Museum, London

seems to hover rather than to stand. (Notice the position of the feet on the steps.) It is this disembodied quality, conveyed through harmonious forms, that gives him so compelling a presence.

Byzantine and Early Christian Art

It is the religious, even more than the political, separation of East and West that makes it impossible to discuss the development of Christian art in the Roman Empire under a single heading. *Early Christian* does not, strictly speaking, designate a style. It refers, rather, to any work of art produced by or for Christians during the time prior to the first splitting off of the Orthodox Church—roughly, the first five centuries of our era. *Byzantine*, on the other hand, designates not only the art of the Eastern Roman Empire but a specific culture and a quality of style as well. Hence, the terms are by no means equivalents. Nevertheless, there is no sharp dividing line between Early Christian and Byzantine art, since the latter grew out of certain tendencies that can be traced back to the time of Constantine in the early fourth century or even earlier. Justinian himself, who ruled the Eastern Empire from 527 to 565, was a man of strongly Latin orientation, and he almost succeeded in reuniting the Constantinian domain. The monuments he sponsored, especially those on Italian soil, may be viewed as either Early Christian or Byzantine, depending on which frame of reference we select.

The political and religious cleavage between East and West became an artistic cleavage as well. In western Europe, Celtic and Germanic peoples fell heir to the civilization of late antiquity, of which Early Christian art had been a part, and transformed it into that of the Middle Ages. The East, in contrast, experienced no such break. Late antiquity lived on in the Byzantine Empire, although the Greek and Oriental elements came increasingly to the fore at the expense of the Roman heritage. The same sense of tradition, of continuity with the past, played an important role in the development of Byzantine art.

Major Dates in the Early Christian and Byzantine Periods

c. 1st–6th century	Early Christian period
330	Constantine relocates capital to Constantinople
395	Roman Empire permanently divided
526–726	Early Byzantine period
c. late 9th–11th century	Middle Byzantine period
1054	Christian Church split into Eastern (Orthodox) and Western (Catholic) Churches
c. 12th–15th century	Late Byzantine period
1453	Byzantine Empire ends when Turks capture Constantinople

The Life of Jesus

From his birth through his ascension to heaven, events in the life of Jesus are traditionally grouped in "cycles," each with numerous episodes. The scenes most frequently depicted in European art are presented here.

INCARNATION CYCLE AND THE CHILDHOOD OF JESUS

These episodes concern Jesus' conception, infancy, and youth.

ANNUNCIATION. The archangel Gabriel tells Mary that she will bear God's son. The Holy Spirit, shown usually as a dove, represents the Incarnation, the miraculous conception.

VISITATION. The pregnant Mary visits her older cousin, Elizabeth, who is to bear John the Baptist and who is the first to recognize the divine nature of the baby Mary is carrying.

NATIVITY. Just after the birth of Jesus, the Holy Family is usually depicted in a stable or, in Byzantine representations, in a cave.

ANNUNCIATION TO THE SHEPHERDS AND ADORATION OF THE SHEPHERDS. An angel announces the night birth of Jesus to shepherds in the field. They then appear at the birthplace.

ADORATION OF THE MAGI. Wise men from the East (called the Three Kings in the Middle Ages), the Magi follow bright star for twelve days until they find the Holy Family and present their precious gifts to the infant Jesus.

PRESENTATION IN THE TEMPLE. Mary and Joseph take the baby Jesus to the Temple in Jerusalem, where Simeon, a high priest, and Anna, a prophetess, foresee Jesus' messianic (savior's) mission and martyr's death.

MASSACRE OF THE INNOCENTS and FLIGHT INTO EGYPT. King Herod orders all babies murdered to preclude his being murdered by a rival newborn king. The Holy Family flees to Egypt.

PUBLIC MINISTRY CYCLE

BAPTISM. John the Baptist baptizes Jesus in the Jordan River, recognizing Jesus' incarnation as the Son of God and marking the beginning of his ministry.

CALLING OF MATTHEW. A tax collector, Matthew, becomes Jesus' first disciple (apostle) when Jesus calls to him, "Follow me."

JESUS WALKING ON THE WATER. During a storm, Jesus walks on the water to reach his apostles in a little boat.

RAISING OF LAZARUS. Jesus brings his friend Lazarus back to life four days after Lazarus's death and burial.

DELIVERY OF THE KEYS TO PETER. Jesus names the apostle Peter his successor by giving him the keys to the kingdom of heaven.

TRANSFIGURATION. As Jesus' closest disciples watch, God transforms Jesus into a dazzling vision and proclaims him to be his own son.

CLEANSING THE TEMPLE. Enraged, Jesus clears the Temple of money changers and animal traders.

PASSION CYCLE

The Passion (from *passio*, Latin for "suffering") cycle relates Jesus' death, resurrection from the dead, and ascension to heaven.

ENTRY INTO JERUSALEM. Welcomed by crowds as the Messiah, Jesus rides an ass into Jerusalem.

LAST SUPPER. At the Passover seder, Jesus tells his disciples of his impending death and lays the foundation for the Christian rite of Eucharist: the taking of bread and wine in remembrance of Christ. (Jesus is called Jesus until he leaves his earthly physical form, after which point he is called Christ.)

JESUS WASHING THE DISCIPLES' FEET. Following the Last Supper, Jesus washes the feet of his disciples to demonstrate humility.

AGONY IN THE GARDEN. In Gethsemane, the disciples sleep while Jesus wrestles with his mortal dread of suffering and dying.

BETRAYAL (ARREST). Disciple Judas Iscariot takes money to identify Jesus to Roman soldiers. Jesus is arrested.

DENIAL OF PETER. As Jesus predicted, Peter denies knowing Jesus three times when questioned in the presence of the high priest Caiaphas.

JESUS BEFORE PILATE. Jesus is charged with treason by the Roman governor, Pontius Pilate, for calling himself King of the Jews.

FLAGELLATION (SCOURGING). Jesus is whipped by Romans.

JESUS CROWNED WITH THORNS (MOCKING). Pilate's soldiers make fun of Jesus by dressing him in robes, crowning him with thorns, and calling him King of the Jews.

CARRYING OF THE CROSS (ROAD TO CALVARY). Jesus carries the wooden cross on which he will be executed from Pilate's house to the hill of Golgatha, "the place of the skull."

CRUCIFIXION. Jesus is nailed to the cross by hands and feet and dies after much physical suffering.

DESCENT FROM THE CROSS (DEPOSITION). Jesus' followers lower his body from the Cross and wrap it for burial. Also present are the Virgin, the apostle John, and sometimes Mary Magdalen.

LAMENTATION (*PIETÀ* OR *VESPERBILD*). The grief-struck followers gather around Jesus' body. In the Pietà, Jesus' body lies across the lap of the Virgin.

ENTOMBMENT. The Virgin and others place the wrapped body in a sarcophagus, a rock tomb.

DESCENT INTO LIMBO (HARROWING OF HELL). Christ descends to hell, or limbo, to free deserving souls.

RESURRECTION (ANASTASIS). Christ rises from the dead on the third day after his entombment.

THE MARYS AT THE TOMB. As terrified soliders look on, Christ's female followers (the Virgin Mary, Mary Magdalen, and Mary, mother of the apostle James) discover the empty tomb.

NOLI ME TANGERE, SUPPER AT EMMAUS, DOUBTING OF THOMAS. In three episodes during the forty days between his resurrection and ascent into heaven, Christ tells Mary Magdalen to not to touch him ("Noli me tangere"); shares a supper with his disciples at Emmaus; and invites the apostle Thomas to touch the lance wound in his side.

ASCENSION. As his disciples watch, Christ is taken into heaven from the Mount of Olives.

Biblical, Church, and Celestial Beings

Much of Western art deals with biblical persons and celestial beings. Their names appear in titles of paintings and sculpture and in discussions of subject matter. Following is a brief guide to some of the most commonly encountered persons and beings in Christian art.

PATRIARCHS. Literally, "head of a family," "ruler of a tribe." Old Testament patriarchs are Abraham, Isaac, Jacob, and Jacob's twelve sons. *Patriarch* also refers to the bishops of the five chief bishoprics of Christendom: Alexandria, Antioch, Constantinople, Jerusalem, and Rome.

PROPHETS. In Christian art, *prophets* usually means the Old Testament figures whose writings were seen to foretell the coming of Christ. The so-called Major Prophets are Isaiah, Jeremiah, and Ezekiel. The Minor Prophets are Hosea, Joel, Amos, Obadiah, Jonah, Micah, Nahum, Habakkuk, Zephaniah, Haggai, Zechariah, and Malachi.

TRINITY. Central to Christian belief is the doctrine that One God exists in Three Persons: Father, Son (Jesus Christ), and Holy Spirit. The Holy Spirit is often represented as a dove.

HOLY FAMILY. The infant Jesus, his mother Mary, and his foster father Joseph constitute the Holy Family.

JOHN THE BAPTIST. The precursor of Jesus Christ, John is regarded by Christians as the last prophet before the coming of the Messiah, Jesus. John was an ascetic who baptized his disciples in the name of the coming Messiah; he recognized Jesus as that Messiah when he saw the Holy Spirit descend on Jesus at the moment of baptism.

EVANGELISTS. There are four: Matthew, John, Mark, and Luke—each an author of one of the Gospels. The first two were among Jesus' Twelve Apostles. The latter two wrote in the second half of the first century.

APOSTLES. The apostles are the twelve disciples Jesus asked to convert nations to his faith. They are Peter (Simon Peter), Andrew, James the Greater, John, Philip, Bartholomew, Matthew, Thomas, James the Less, Jude (or Thaddaeus), Simon the Canaanite, and Judas Iscariot. After Judas betrayed Jesus, his place was taken by Matthias.

DISCIPLES. See APOSTLES.

ANGELS AND ARCHANGELS. Beings of a spiritual nature, angels are spoken of in the Old and New Testaments as being created by God to be heavenly messengers between God and human beings, heaven and earth. Spoken of first by the apostle Paul, archangels, unlike angels, have names: Michael, Gabriel, Tobias, and Raphael.

CHERUBIM AND SERAPHIM. The celestial hierarchy devised by Pseudo-Dionysios about A.D. 500 (see page 190) had cherubim (with six wings) and seraphim (four wings) at the peak, encircling the throne of God and the Ark of the Covenant. After the Middle Ages, a cherub came to be represented as a rosy-cheeked, plump, and winged child.

SAINTS. See page 136.

MARTYRS. Originally, *martyrs* referred to all the apostles. Later, it signified those persecuted for their faith. Still later, the term was reserved for those who died in the name of Christ.

POPE. Meaning "father," the term refers to the bishop of Rome, the spiritual head of the Roman Catholic Church. The pope dwells in and heads an independent state, Vatican City, within the city of Rome. His chief attribute is a shepherd's staff; he dresses in white.

CARDINALS. Priests or higher religious officials chosen to help the pope administer the Church. They are of two types: those who live in Rome (the Curia), and those who remain in their dioceses. Together, they constitute the Sacred College. One of their duties is to elect a pope after the death or removal of a sitting pope. They dress in red garments and wear broad-brimmed hats tied under the chin.

DIOCESE. A territorial unit administered in the Western Church by a BISHOP and the Eastern Church by a PATRIARCH. A Cathedral is the diocese church and the seat of the bishop.

BISHOPS AND ARCHBISHOPS. A bishop is the highest order of minister in the Catholic Church, with his administrative territory being the diocese. Bishops are ordained by archbishops, who also have the authority to consecrate kings. Bishops carry an elaborately curved staff called a crozier and wear a three-pointed hat.

PRIESTS AND PARISHES. Priests did not exist in the early Church, because only bishops were authorized to offer the Eucharist and receive confession. As the Church grew, church officials called presbyters were designated by bishops to perform the Eucharist and ablution in smaller administrative units, called parishes, and they became priests.

ABBOTS AND ABBESSES. Heads of large monasteries (called abbeys) and convents (nunneries).

MONKS AND NUNS. Men and women living in religious communities who have taken vows of poverty, chastity, and obedience to the rules of their orders.

CANONS AND CANONESSES. Men and women who live in religious communities but under less rigorous rules than monks and nuns.

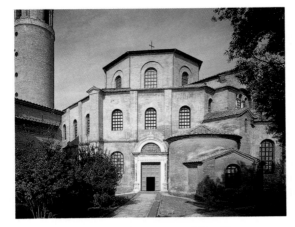

111. S. Vitale, Ravenna. 526–47

capital as well. Justinian himself was an art patron on a scale unmatched since Constantine's day. The works he sponsored or promoted have an imperial grandeur that fully justifies the acclaim of those who have termed his era a golden age. They also display an inner unity of style that links them more strongly with the future development of Byzantine art than with the art of the preceding centuries. The richest array of early Byzantine monuments (A.D. 526–726) survives today not in Constantinople (where much has been destroyed) but in the Adriatic port of Ravenna, which, under Justinian, was the main stronghold of Byzantine rule in Italy.

Early Byzantine Art

There is, as we noted, no clear-cut demarcation between Early Christian and Byzantine art before the reign of Justinian, when Constantinople not only asserted its political dominance over the West but became the undisputed artistic

S. Vitale, Ravenna The most important church of that time, S. Vitale (fig. 111), was begun by Bishop Ecclesius in 526, just before the Ostrogothic king Theodoric's death, but was built chiefly in 540–47 under Archbishop Maximian, who also consecrated S. Apollinare in Classe

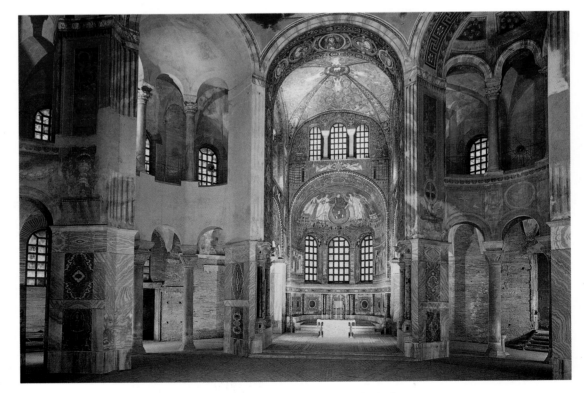

112. Interior (view from the apse), S. Vitale

two years later (see figs. 104–6). The structure has an octagonal plan, with a domed central core, that marks it as the descendant of the elaborate Roman baths. The design of the Pantheon (see fig. 87) was derived from that source as well, but the intervening development seems to have taken place in the East. S. Vitale is notable for the richness of its spatial effect. Below the clerestory, the central space opens into a series of semicircular niches that penetrate into the surrounding aisle, or **ambulatory**, and thus link it to the nave in a new and intricate way. The ambulatory itself has been given a second story: the **galleries**, which may have been reserved for women. A new economy in the construction of the vaulting permits large windows on every level, which flood the interior with light. The complexity of the exterior is matched by the spatial richness of the interior (fig. 112), with its lavish decoration.

Remembering S. Apollinare in Classe (see fig. 104), built in Ravenna at the same time, we are particularly struck by the different character of S. Vitale. We find only the merest remnants of the longitudinal axis of the Early Christian basilica. Toward the east is a cross-vaulted compartment for the altar, backed by an apse; on the other side is a narthex, whose odd, non-symmetrical placement has never been fully accounted for. From the time of Justinian, domed **central-plan churches** were to dominate the world of Orthodox Christianity as thoroughly as the basilica plan dominated the architecture of the medieval West. How did it happen that the East favored a type of church building (as distinct from baptisteries and mausoleums) so radically different from the basilica? After all, the design of the basilica had been backed by the authority of Constantine himself. Many different reasons have been suggested—practical, religious, political. All of them may be relevant, yet they fall short of a really persuasive explanation.

S. Vitale's link with the Byzantine court is manifested by the famous mosaics flanking the altar, which depict Justinian (fig. 113) and his empress, Theodora, accompanied by officials, the local clergy, and ladies-in-waiting. Although they did not attend the actual ceremonies, the royal couple is shown as present at the consecration of S. Vitale to demonstrate their authority over Church and State, as well as their support for their archbishop, Maximian, who was initially unpopular with the citizens of Ravenna. In these large panels, we find an ideal of human beauty quite different from the squat, large-headed figures we encountered in the art of the fourth and fifth centuries. We have caught a glimpse of this emerging new ideal occasionally (see figs. 103, 110), but only now do we see it complete: extraordinarily tall, slim figures with tiny feet; small, almond-shaped faces dominated by their huge, staring eyes; and bodies that seem to be capable only of slow ceremonial gestures and the display of magnificently patterned costumes. Every hint of movement or change is carefully excluded—the dimensions of time and earthly space have given way to an eternal present amid the golden translucency of heaven, and the solemn, frontal images in the mosaics seem to present a celestial rather than a secular court. This union of political and spiritual authority accurately reflects the "divine kingship" of the Byzantine emperor. We are invited to see Justinian as analogous to Christ. He is flanked by twelve companions (six are soldiers, crowded behind a shield with the monogram of Christ)—the imperial equivalent of the Twelve Apostles.

Justinian, Theodora, and his immediate neighbors were surely intended to be individual likenesses, and their features are indeed differentiated to a degree (those of the archbishop, Maximian, and Julianus Argentarius, the banker who underwrote the building, more so than the rest), but the ideal has molded the faces as well as the bodies, so that they all have a curious family resemblance. The same large, dark eyes under curved brows, the same small mouths and long, narrow, slightly aquiline noses became the standard type from now on in Byzantine art.

If we turn from these mosaics to the interior space of the church, we discover that it, too, shares the quality of dematerialized, soaring slenderness that endows the figures with their air of mute exaltation.

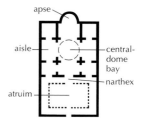

A central-plan church may be a square, like this generalized plan of an Early Christian structure, a polygon, or in the form of a Greek cross, with its four "arms" intersecting at the crossing. The dome sits over the central bay.

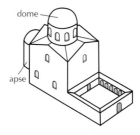

The vertical axiality of central-plan buildings is distinctive. Otherwise, central-plan churches share elements with basilica-plan churches: narthex, nave, aisles, crossing (under the dome), and apse. Not every Early Christian and Byzantine church had an atrium.

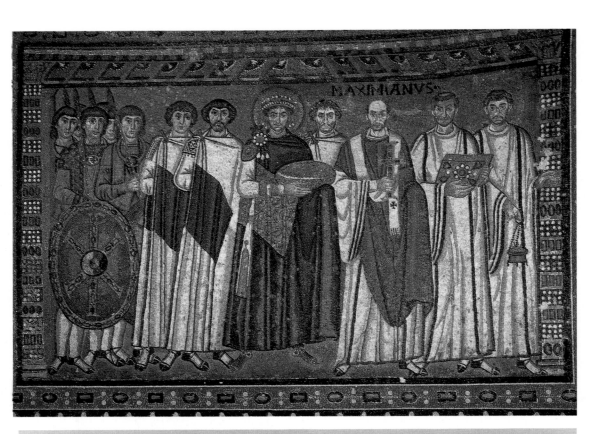

113. *Emperor Justinian and His Attendants*. Mosaic in S. Vitale. c. 547

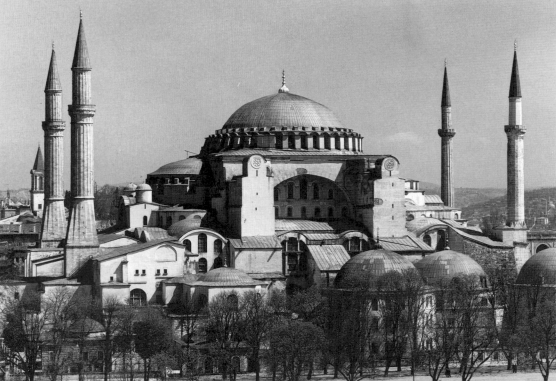

114. Anthemius of Tralles and Isidorus of Miletus. Hagia Sophia, now Istanbul, Turkey. 532–37

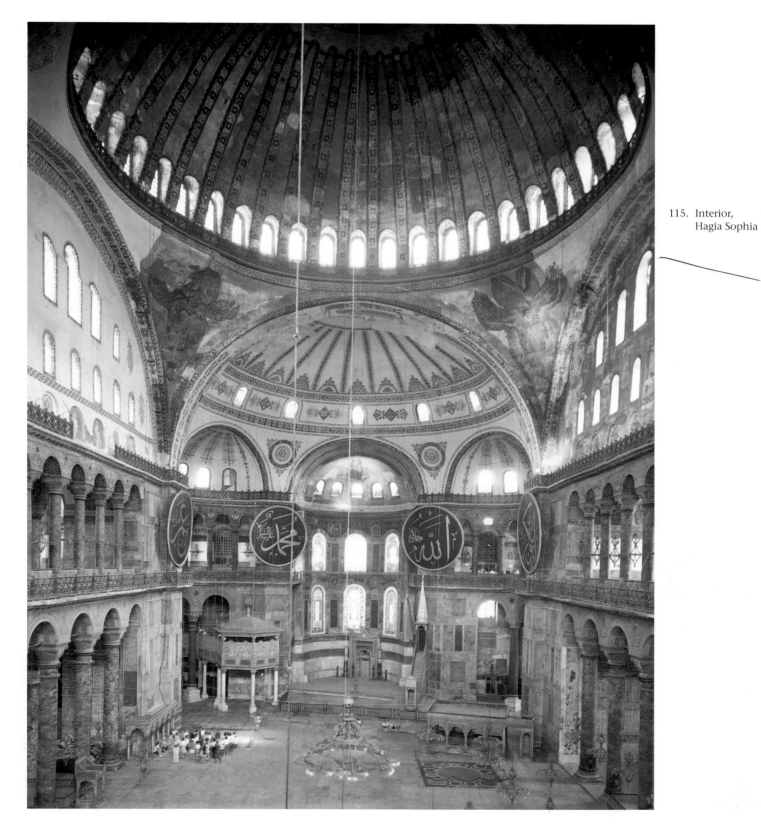

115. Interior, Hagia Sophia

Hagia Sophia, Constantinople Among the surviving monuments of Justinian's reign in Constantinople, the most important by far is Hagia Sophia (the Church of Holy Wisdom), the architectural masterpiece of that era and one of the great creative triumphs of any age (figs. 114, 115). A previous church, begun by Constantine and finished in 360, was destroyed, along with several other monuments, in the riots of 532 that almost deposed Justinian, who immediately rebuilt it. Completed in only five years, Hagia Sophia achieved such fame that the names of the architects, too, were remembered: Anthemius of Tralles, an expert in geometry and the theory of statics and kinetics, and Isidorus of Miletus, who taught physics and wrote on vaulting techniques.

The design of Hagia Sophia presents a unique combination of elements. It has the longitudinal axis of an Early Christian basilica, but the central feature of the nave is a square compartment crowned by a huge dome and abutted at each end by half domes, so that the nave becomes a great ellipse. Below these half domes are semicircular niches with open arcades, similar to those in S. Vitale. One might say, then, that the dome of Hagia Sophia has been inserted between the two halves of a central-plan church. The dome rests on four arches that carry its weight to the great **piers** at the corners of the square, so that the walls below the arches have no supporting function at all. The transition from the square formed by these arches to the circular rim of the dome is achieved by spherical triangles called **pendentives**. This device permits the construction of taller, lighter, and more economical domes than the older method (as seen in the Pantheon and S. Vitale) of placing the dome on a round or polygonal base. The plan, the buttressing of the main piers, and the huge scale of the whole recall the Basilica of Constantine (see fig. 90), the most ambitious achievement of imperial Roman vaulted architecture and the greatest monument associated with a ruler for whom Justinian had particular admiration. Hagia Sophia thus unites East and West, past and future, in a single overpowering synthesis. The four minarets were

added after the Turkish conquest in 1453, when the church became a mosque.

Once we are inside, all sense of weight disappears, as if the material, solid aspects of the structure had been banished to the outside. Nothing remains but an expanding space that inflates, like so many sails, the apsidal recesses, the pendentives, and the dome itself. Here the architectural aesthetic we saw taking shape in S. Apollinare in Classe (see fig. 106) has achieved a new, magnificent dimension. Even more than previously, light plays a key role: the dome seems to float—"like the radiant heavens," according to a contemporary description of the building—because it rests upon a closely spaced ring of windows, and the nave walls are pierced by so many openings that they have the transparency of lace curtains. The golden glitter of the mosaics must have completed the "illusion of unreality."

Icons In the late sixth century, **icons**—"portraits" of Christ, the Madonna, or saints—came to vie with relics as objects of veneration. Among the chief arguments in their favor were the claim that Christ himself had permitted Luke to paint his portrait and that other portraits of Christ or of the Virgin had miraculously appeared on earth by divine fiat. These original, "true" sacred images were supposedly the source for the later, human-made ones. Such pictures had developed in Early Christian times out of Graeco-Roman portrait panels (such as the one in fig. 102). Little is known about their origins, for examples painted before the early eighth century are extremely scarce.

Of the few discovered so far, perhaps the most revealing is the *Virgin and Child Enthroned between Saints Theodore and George and Angels* (fig. 116). Like late Roman murals (see page 118), it is a compilation painted in several styles at once. Its link with Graeco-Roman portraiture is evident not only from the use of encaustic, a medium that went out of use after the Iconoclastic Controversy, but also from the fine gradations of light and shade in the Virgin's face, which is similar in treatment to that of the little boy in our Faiyum portrait (see fig. 102). She is flanked by the warrior-saints

Pendentives are the curved triangular sections of vaulting that arc up from the corners of a square area to form a rounded base from which a dome springs. Such a construction is called "pendentive dome" or "dome on pendentives."

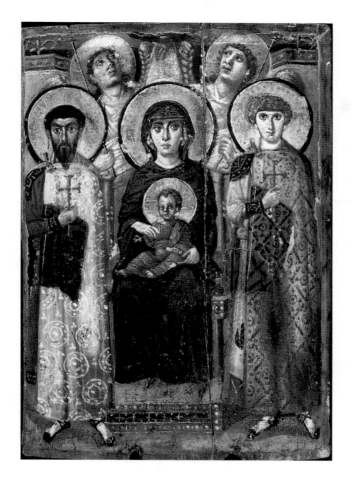

116. *Virgin and Child Enthroned between Saints Theodore and George and Angels.* Late 6th century. Encaustic on wood panel, 27 x 19³/₈" (69 x 50 cm). Monastery of St. Catherine, Mount Sinai, Egypt

Theodore on the left and George on the right, who recall the stiff mannequins accompanying Justinian in S. Vitale (see fig. 113). Typical of early icons, however, their heads are too massive for their doll-like bodies. Behind them are two angels who come closest in character to Roman art, although their features show that classicism is no longer a living tradition (compare fig. 96). Clearly these figures are quotations from different sources, so that the painting marks an early stage in the development of icons. Yet it is typical of the conservative icon tradition that the unknown artist has tried to remain as faithful as possible to sources, in order to preserve the likenesses of these holy figures. While hardly an impressive achievement in itself, it is worthy of our attention: this is the earliest known representation of the Madonna and Child. We shall encounter its descendants again and again in the history of art.

Middle Byzantine Art

The development of Byzantine painting and sculpture after the age of Justinian was disrupted by the Iconoclastic Controversy, which began with an imperial edict of 726 prohibiting religious images as idolatrous and raged for more than a hundred years. The roots of the conflict went very deep. On the plane of theology they involved the basic issue of the relationship of the human and the divine in the person of Christ. Socially and politically, they reflected a power struggle between State and Church and between the Western and Eastern provinces. The controversy also caused an irrevocable break between Catholicism and the Orthodox faith, although the two churches remained officially united until 1054. The edict did succeed in reducing the production of sacred images very greatly but failed to wipe

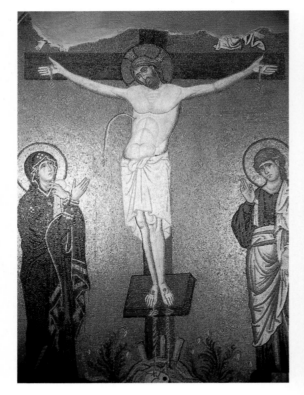

117. *Crucifixion*. Mosaic in Monastery Church, Daphni, Greece. 11th century

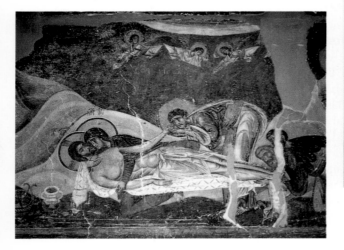

118. *Lamentation over the Dead Christ*. Fresco in the Church of St. Panteleimon, Nerezi, Republic of Macedonia. c. 1164

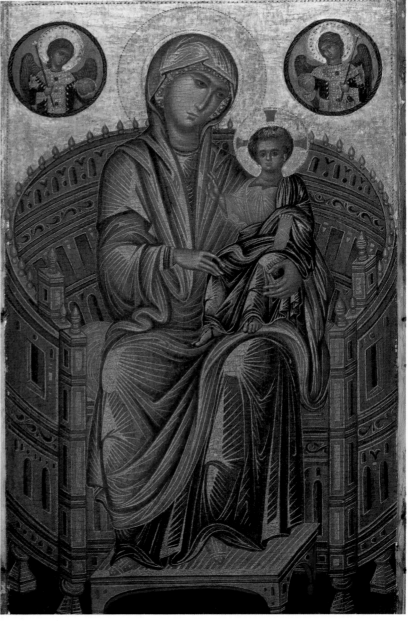

119. *Madonna Enthroned*. Late 13th century. Tempera on wood panel, 32 1/8 x 19 3/8" (81.6 x 49.2 cm). National Gallery of Art, Washington, D.C.

Andrew W. Mellon Collection

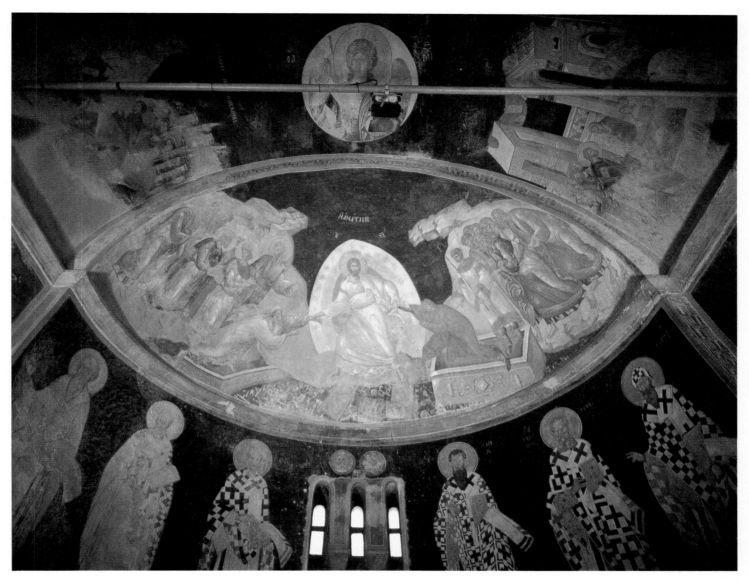

120. *Anastasis*. Fresco in Kariye Camii (Church of the Savior in Chora), Istanbul. c. 1310–20

it out altogether, so that after the victory of the Iconophiles in 843 under the empress Theodora there was a fairly rapid recovery. Spearheaded by Basil I the Macedonian, this resurgence, known simply as Middle Byzantine art, lasted from the late ninth to the eleventh century. While we know little for certain about how the Byzantine artistic tradition managed to survive from the early eighth to the mid-ninth century, Iconoclasm seems to have brought about a renewed interest in secular art, which was not affected by the ban. This interest may help to explain the astonishing reappearance of late classical motifs.

Mosaics The finest works of the period show a classicism that has been harmoniously merged with the spiritualized ideal of beauty we encountered in the art of Justinian's reign. Among these, the *Crucifixion* mosaic at Daphni, Greece (fig. 117), enjoys special fame. Its classical qualities are deeply felt yet are also completely

Christian. There is no attempt to re-create a realistic spatial setting, but the composition has a balance and clarity that are truly monumental. Classical, too, is the statuesque dignity of the figures, which seem extraordinarily organic and graceful compared to those of the Justinian mosaics at S. Vitale (see fig. 113).

The most important aspect of these figures' classical heritage, however, is emotional rather than physical. The gestures and facial expressions convey a restrained and noble suffering of the kind we first met in Greek art of the fifth century B.C. (see pages 86–90). Early Christian art had been quite devoid of this quality. Its view of Christ stressed the Savior's divine wisdom, and power remained important. Alongside wisdom and power we now find a new emphasis on the human Christ of the **Passion** that exercises a powerful appeal to the emotions of the beholder. When and where this human interpretation of the Savior made its first appearance we cannot say, but it seems to have developed primarily in the wake of the Iconoclastic Controversy. There are, to be sure, a few earlier examples of it, but none of them has so powerful an appeal to the emotions of the beholder as the Daphni *Crucifixion*. To have introduced this compassionate quality into sacred art was perhaps the greatest achievement of the Middle Byzantine period, even though its full possibilities were to be exploited not in the Byzantine Empire but in the medieval West at a later date.

The emphasis on human content reaches its climax in the paintings at the Church of St. Panteleimon in Nerezi, Macedonia. It was built by members of the Byzantine royal family and decorated by a team of artists summoned from Constantinople. From the beginning of Byzantine art, mural painting had served as a less expensive alternative to mosaic, which was preferred whenever possible. The best painters nevertheless participated fully in the new style; in some cases, they even felt free to introduce innovations of their own. The artist responsible for *Lamentation over the Dead Christ* (fig. 118) was a great artist who amplified on the latest advances. The gentle sadness of the Daphni *Crucifixion* has been replaced by a grief of almost unbearable intensity. The style remains the same, but its expressive qualities have been emphasized by subtle adjustments in the proportions and features. The subject seems to have been recently invented, for it is otherwise unknown in earlier Byzantine art. Even more than the Daphni *Crucifixion*, its origins lie in classical art. Yet nothing prepares us for the Virgin's anguish as she clasps her dead son or the deep sorrow of John holding Jesus' lifeless hand. We have entered a new realm of intensity of religious feeling that was to be further explored in Western art.

Late Byzantine Painting

In 1204, the Eastern Empire sustained an almost fatal defeat when the armies of the Fourth Crusade, instead of warring against the Turks, assaulted and took the city of Constantinople. For more than fifty years, the core of the Eastern Empire remained in Western hands. The Byzantines, however, survived this catastrophe. In 1261, it once more regained its sovereignty, and the fourteenth century saw a last flowering of Byzantine painting, with a distinct and original flavor of its own, before the Turkish conquest in 1453.

Because of the veneration in which they were held, icons had to conform to strict formal rules, with fixed patterns repeated over and over again. As a consequence, the majority of them are more conspicuous for exacting craft than for artistic inventiveness. The *Madonna Enthroned* (fig. 119) shows this conservatism. Although painted in the late thirteenth century, it reflects a much earlier type. Echoes of Middle Byzantine art abound: the graceful pose, the rich play of drapery folds, the tender melancholy of the Virgin's face, the elaborate architectural perspective of the throne (which looks rather like a miniature replica of the Colosseum). But all these elements have become oddly abstract. The throne, despite its foreshortening, no longer functions as a three-dimensional object, and the highlights on the drapery resemble ornamental sunbursts, in strange contrast to the soft shading of hands and faces. The total effect is neither flat nor spa-

tial but transluscent—somewhat like that of a colored-glass window; the shapes look as if they were lit from behind. Indeed, the highly reflective gold background against which they are set and the gold highlights are so brilliant that even the shadows never seem wholly opaque. This all-pervading celestial radiance, we will recall, is a quality first encountered in Early Christian mosaics. Panels such as ours, therefore, should be viewed as the aesthetic equivalent, on a smaller scale, of mosaics, and not simply as the descendants of the ancient panel painting tradition. In fact, some of the most precious Byzantine icons are miniature mosaics done on panels, rather than paintings.

Because of the impoverished state of the greatly shrunken Eastern Empire, murals often took the place of mosaics, but at Kariye Camii in Constantinople (the former Church of the Savior in Chora) they exist on an even footing. Most impressive is the painting of the *Anastasis* (Greek for "resurrection") in the mortuary chapel attached to the church. The scene depicts the traditional Byzantine image of this subject, an event before Christ's Resurrection on earth that Western Christians call Christ's Descent into Limbo, or the Harrowing of Hell (fig. 120). Surrounded by a radiant **mandorla**, the Savior has vanquished Satan and battered down the gates of hell and is raising Adam and Eve from the dead. (Note the bound Satan at Christ's feet, in the midst of an incredible profusion of hardware.) What amazes us about this central group is its dramatic force, a quality we would hardly expect to find on the basis of what we have seen of Byzantine art so far. Christ here moves with extraordinary physical energy, tearing Adam and Eve from their graves, so that they appear to fly through the air—a magnificently expressive image of divine triumph. Such dynamism had been unknown in the earlier Byzantine tradition. Coming in the fourteenth century, it shows that, almost 800 years after Justinian, Byzantine art still had its creative powers.

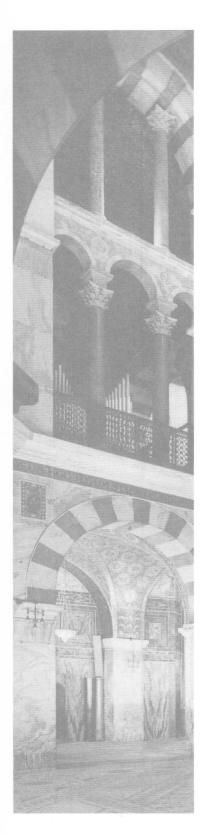

Chapter 9

Early
Medieval
Art

The labels used for historical periods tend to be like the nicknames of people. Once established, they are almost impossible to change, even though they may no longer be suitable. Those who coined the term *Middle Ages* thought of the entire thousand years from the fifth to the fifteenth century as an age of darkness, an empty interval between classical antiquity and its rebirth, the Renaissance in Europe. Since then, our view of the Middle Ages has changed completely. We no longer think of the period as "benighted" but as a time of great cultural change and considerable creative activity. During the 200-year interval between the death of Justinian and the unifying reign of the first Holy Roman Emperor, Charlemagne, as we have already pointed out, the center of gravity of European civilization shifted northward from the Mediterranean Sea. It remained there in the Early Middle Ages until well into the eleventh century. The economic, political, and spiritual framework of the Middle Ages took shape in those eight centuries. We shall now see that the same centuries also gave rise to some important artistic achievements.

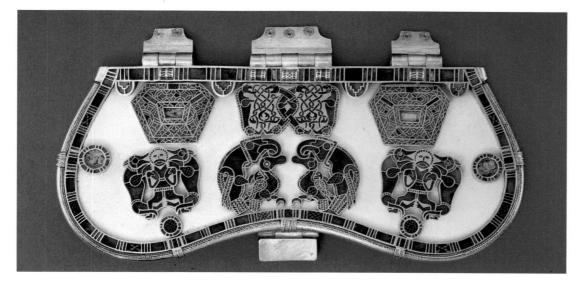

121. Purse cover, from the Sutton Hoo ship burial. 625–33. Gold, with garnets and enamels, length 8" (20.3 cm). The British Museum, London

Celtic-Germanic Style

The Celtic-Germanic style was a result of widespread migrations after the fall of the Roman Empire. The Celts, who had settled the area later known to the Romans as Gaul (in southwest Germany and eastern France) during the second millennium B.C., spread across much of Europe and into Asia Minor, where they battled the Greeks (see page 94). Pressed by neighboring Germanic peoples, who originated in the Baltic region, they crossed the English Channel in the fourth century B.C. and colonized Britain and Ireland, where they were joined in the fifth century A.D. by the Angles and Saxons from today's Denmark and northern Germany. In 376, the Huns, who had pressed beyond the Black Sea from Central Asia, became a serious threat to Europe, first pushing the Visigoths westward into the Roman Empire from the Danube River, and then under Attila (d. 454) invading Gaul in 451 before attacking Rome a year later. These Germanic peoples from the East carried with them, in the form of nomads' gear, an ancient and widespread artistic tradition, the so-called **animal style** (see page 60).

This style, with its combination of abstract and organic shapes, of formal discipline and imaginative freedom, merged with the intricate ornamental metalwork of the Celts to create Celtic-Germanic art. An excellent example of this "heathen" style is the gold-and-enamel purse cover (fig. 121) from the grave, at Sutton Hoo, of an East Anglian king who died between 625 and 633. On it are four pairs of symmetrical **motifs**. Each has its own distinctive character, an indication that the motifs reflect four different traditions. One motif, the standing man between confronted animals at the lower left and lower right, has a very long history indeed—we first saw it in Sumerian art more than 3,000 years earlier (see fig. 42). The eagles pouncing on ducks, the two figures in the lower center, also date back a long way, to similar pairings of carnivore and victim. The design above them, on the other hand, is of more recent origin. It consists of fighting animals whose tails, legs, and jaws are elongated into bands forming a complex interlacing pattern. The fourth motif, interlacing bands as an ornamental device, on the top left and right, occur in Roman and Early Christian art, especially along the southern shore of the Mediterranean. However, their combination with the animal style, as shown here, seems to be an invention of Celtic-Germanic art that arose not much before the date of our purse cover.

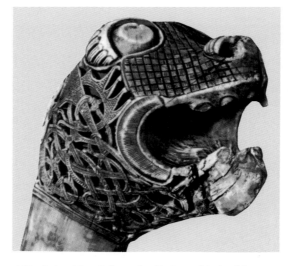

122. Animal head, from the Oseberg ship burial. c. 825. Wood, height approx. 5" (12.7 cm). Institute for Art History and Classical Archaeology, University of Oslo, Norway

Metalwork, in a variety of materials and techniques and often of exquisitely refined execution, had been the principal medium of the animal style. Such metal objects—small, durable, and eagerly sought after—account for the rapid diffusion of this style's repertory of forms. These forms migrated not only in the geographic sense but also, technically and artistically, in the mediums used: from metal into wood, stone, and even pigment in manuscript painting. Wooden specimens, as we might expect, have not survived in large numbers. Most of them come from Scandinavia, where the animal style flourished longer than anywhere else. The splendid animal head in figure 122, of the early ninth century, is the terminal, or decorated end, of a post that was found, along with much other equipment, in a buried Viking ship at Oseberg in southern Norway. Like the motifs on the Sutton Hoo purse cover, it shows a peculiarly composite quality. The basic shape of the head is surprisingly realistic, as are certain details (teeth, gums, nostrils). But the surface has been spun over with interlacing and geometric patterns that betray their derivation from metalwork. Snarling monsters such as this used to rise from the prows of Viking ships, which endowed them with the character of mythical sea dragons.

Hiberno-Saxon Style

The earliest Christian works of art made north of the Alps also reflected the pagan Germanic version of the animal style. They were made by the Irish (Hibernians), who assumed the spiritual and cultural leadership of western Europe during the Early Middle Ages. The period 600–800 deserves, in fact, to be called the golden age of Ireland. Unlike their English neighbors, the Irish had never been part of the Roman Empire. Thus, the missionaries who carried the Gospel to them from England in the fifth century found a Celtic society entirely barbarian by Roman standards. The Irish readily accepted Christianity, which brought them into contact with Mediterranean civilization, but they did not become Rome-oriented. Rather, they adapted what they had received in a spirit of vigorous local independence.

The institutional framework of the Roman Church, being essentially urban, was ill suited to the rural character of Irish life. Irish Christians preferred to follow the example of the desert saints of Egypt and the Near East who had left the temptations of the city to seek spiritual perfection in the solitude of the wilderness. Groups of such hermits, sharing the ideal of ascetic discipline, had founded the earliest "monasteries" in Egypt and now did so in Ireland. By the fifth century, monasteries had spread as far north as western Britain, but only in Ireland did monasteries take over the leadership of the Church from the bishops.

Irish monasteries, unlike their Egyptian prototypes, soon became seats of learning and the arts. They developed a missionary fervor that sent Irish monks to preach to the heathen and to found monasteries not only in northern Britain but also on the European mainland, from present-day France to Austria. These Irish monks speeded the conversion to Christianity of Scotland, northern France, the Netherlands, and Germany. Further, they established the monastery as a cultural center throughout the European countryside. Although their Continental foundations were taken over before long by the monks of the Benedictine order, who were advancing north from Italy during the

seventh and eighth centuries, Irish influence was to be felt within medieval civilization for several hundred years to come.

Manuscripts

In order to spread the Gospel, the Irish monasteries had to produce copies of the Bible and other Christian books in large numbers. Their scriptoria (writing workshops) also became centers of artistic endeavor, for a manuscript containing the Word of God was looked upon as a sacred object whose visual beauty should reflect the importance of its contents. Irish monks must have known Early Christian illuminated manuscripts, but here, as in so many other respects, they developed an independent tradition instead of simply copying their models. While pictures illustrating biblical events held little interest for them, they devoted great effort to decorative embellishment. The finest of these manuscripts belong to the Hiberno-Saxon style, that Christian form which evolved from heathen Celtic-Germanic art and flourished in the monasteries founded by the Irish in Saxon England.

The Cross page in the *Lindisfarne Gospels* (fig. 123) is an imaginative creation of breathtaking complexity. The miniaturist, working with a jeweler's precision, has poured into the compartments of the geometric frame an animal interlace so dense and yet so full of controlled movement that the fighting beasts on the Sutton Hoo purse cover seem simple in comparison. It is as if these biting and clawing monsters had suddenly been subdued by the power of the Cross. In order to achieve this effect, our artist had to work within an extremely severe discipline, following "rules of the game" that demand, for instance, that organic and geometric shapes be kept separate, as well as that within the animal compartments every line turn out to be part of an animal's body, if we take the trouble to trace it back to its point of origin. There are other rules, too complex to go into here, concerning symmetry, mirror-image effects, and repetitions of shapes and colors. Only by working these out for ourselves by intense observation can we hope to enter into the spirit of this very different, mazelike world.

Of the representational images they found in Early Christian manuscripts, the Hiberno-Saxon illuminators generally retained only the symbols of the four Evangelists—Matthew, Mark, Luke, and John—since these could be translated into their ornamental idiom without much difficulty. On the other hand, Celtic and Germanic artists showed little interest in the human figure for a long time. The bronze plaque of the Crucifixion (fig. 124), probably made for a book cover, shows a continuing concentration on flat patterns, even when faced with the image of a man. Although the composition is Early Christian in origin, the artist nevertheless has conceived the human frame as a series of ornamental compartments, so that the figure of Jesus is disembodied in the most literal sense: the head, arms, and feet are all separate elements joined to a central pattern of whorls, zigzags, and interlacing bands. Clearly, there is a wide gulf between the Celtic-Germanic and the Mediterranean traditions, a gulf that the Irish artist who modeled the *Crucifixion* saw no need to bridge. Much the same situation prevailed elsewhere during the Early Middle Ages; even the French and the Lombards, on Italian soil, did not know what to do with human images. The problem was finally solved by Carolingian artists drawing on the Byzantine tradition, with its roots in classical art.

Carolingian Art

Although Charlemagne's empire did not endure, the cultural achievements of his reign have proved far more lasting. This very page would look different without them, for it is printed in letters whose shapes derive from the script in Carolingian manuscripts. The fact that these letters are known today as Roman rather than Carolingian recalls an important aspect of the cultural reforms sponsored by Charlemagne: the collecting and copying of ancient Roman literature. The oldest surviving texts of a great many classical Latin authors are to be found in Carolingian manuscripts, which, until not very long ago, were mistakenly regarded

Matthew, a man

Mark, a lion

Luke, an ox

John, an eagle

Each of the Four Evangelists has a symbol, or icon. Their identities were immediately recognizable by Christians until comparatively recent times—though their appearance varied greatly according to period. Often but not always the symbols were winged. These are 15th-century examples from Dinant, in present-day Belgium, that were originally made as lecterns (reading stands) for a church.

123. Cross page from the *Lindisfarne Gospels*. c. 700. Tempera on vellum, 13¹/₂ x 9¹/₄" (34.3 x 23.5 cm). The British Library, London

Architecture

The achievement of Charlemagne's Palace Chapel (fig. 125) is all the more spectacular seen in this light. On his visits to Italy, the emperor had become familiar with the architectural monuments of the Constantinian era in Rome and with those of the reign of Justinian in Ravenna. Charlemagne's own capital at Aachen was designed to convey the majesty of the Empire through buildings of an equally impressive kind. The Palace Chapel was inspired by S. Vitale in Ravenna (see fig. 112). To erect such a structure on Northern soil was a difficult enterprise. Columns and bronze gratings had to be imported from Italy, and expert stonemasons must have been hard to find. The design, by Odo of Metz (probably the earliest architect north of the Alps known to us by name), is by no means a mere echo of S. Vitale but a vigorous reinterpretation, with **piers** and

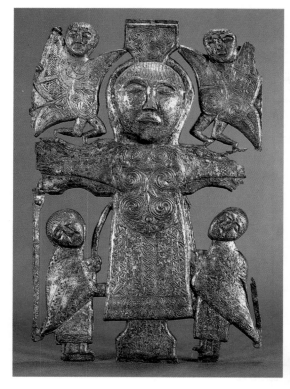

124. *Crucifixion.* Plaque from a book cover (?). 8th century. Bronze, height 8¼" (21 cm). National Museum of Ireland, Dublin

as Roman; hence their lettering, too, was called Roman.

This interest in preserving the classics was part of an ambitious attempt to restore ancient Roman civilization, along with the title *emperor.* Toward that end, Charlemagne established a court school, headed by Alcuin of York, who assembled a glittering array of the best minds from around the realm. The emperor himself took an active hand in this revival, through which he expected to implant the cultural traditions of a glorious past in the minds of the elite of his realm. To an astonishing extent, he succeeded. Thus, the "Carolingian revival" may be termed the first, and in some ways the most important, phase of a genuine fusion of the Celtic-Germanic spirit with that of the Mediterranean world.

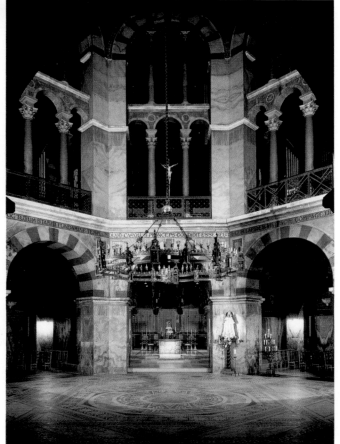

125. Odo of Metz. Interior, Palace Chapel of Charlemagne, Aachen, Germany. 792–805

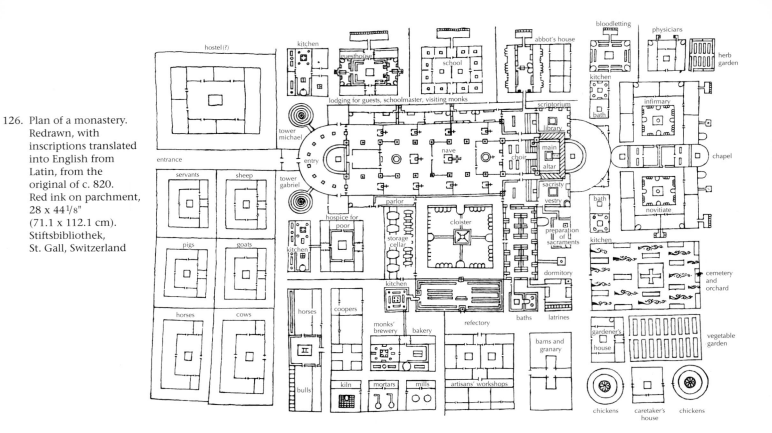

126. Plan of a monastery. Redrawn, with inscriptions translated into English from Latin, from the original of c. 820. Red ink on parchment, 28 x 44 1/8" (71.1 x 112.1 cm). Stiftsbibliothek, St. Gall, Switzerland

vaults of Roman massiveness and a geometric clarity of the spatial units very different from the fluid space of the earlier structure.

Monastery Plan The importance of monasteries and their close link with the imperial court are vividly suggested by a unique document of the period, the large drawing on five sheets of **vellum** of a plan for a monastery preserved in the Benedictine Abbey library at St. Gall in Switzerland (fig. 126). Its basic features seem to have been determined at a council held near Aachen in 816–17 that established the Benedictines as the official order under the Carolingians (see "Monasticism and Christian Monastic Orders," page 172). This plan was then sent by Abbot Haito of Reichenau to Gozbert, the abbot of St. Gall, for "you to study only" in rebuilding the monastery. We may regard it, therefore, as a standard plan, intended to be modified according to local needs.

The monastery plan shows a complex, self-contained unit, filling a rectangle about 500 by 700 feet. The main path of entrance, from the west, passes between stables and a hostelry toward a gate that admits the visitor to a **colonnaded** semicircular **portico** flanked by two round towers—an early instance of a monumental western church front, or **westwork**—that loom impressively above the low outer buildings. The plan emphasizes the church as the center of the monastic community. The church is a **basilica**, with a **transept** and **choir** in the east but an **apse** and altar at either end. The nave and aisles, containing numerous other altars, do not form a single continuous space but are subdivided into compartments by screens. There are numerous entrances: two beside the western apse, others on the north and south flanks.

This entire arrangement reflects the functions of a monastery church, designed for the liturgical needs of the monks rather than for a lay congregation. Adjoining the church to the south is an **arcaded** cloister, around which are grouped the monks' dormitory (on the east

What Is an Architect and Who Is a Master

During the Middle Ages, the word *architect* (which derives from the Greek word for "master builder" and was defined in the modern sense of designer and theoretician by the first century A.D. Roman writer Vitruvius) came to have different meanings. During the eighth century, the distinction between design and construction, theory and practice, became increasingly blurred. As a result, the term *architect* nearly disappeared in the North by the tenth century and was replaced by a new vocabulary, in part because the building trades were strictly separated under the guild system. When it was used, *architect* could apply not only to masons, carpenters, and even roofers but also to the person who commissioned or supervised a building. In some instances, the abbot (leader) of a community of monks was the actual designer. As a result, the design of churches became increasingly subordinate to liturgical (public worship) and practical considerations.

Not until about 1260 did Thomas Aquinas revive Aristotle's definition of *architect* as the person of intellect who leads or conducts, as opposed to the artisan who makes. Within a century the humanist Petrarch used the term to designate the *artist* in charge of a project and thus acknowledged what had already become established practice in Florence, where first the painter Giotto, then the sculptors Andrea Pisano and Francesco Talenti, were placed in charge of the construction of Florence Cathedral (see pages 201–2).

In the Middle Ages, the word *master* (Latin, *magister*) was a title conferred by a trade organization, or **guild**, signifying a member who had achieved the highest level of skill in the guild's profession or craft. In each city, trade guilds virtually controlled commercial life by establishing quality standards, setting prices, defining the limits of each guild's activity, and overseeing the admission of new members. The earliest guilds were formed in the eleventh century by merchants; but craftsmen, too, soon organized themselves in similar professional societies, whose power continued well into the sixteenth century. Most guilds admitted only men, but some, such as the painters' guild of Bruges, occasionally admitted women also. Guild membership established a certain level of social status for townspeople, who were neither nobility, clerics (people in religious life), nor peasantry.

A boy would begin as an apprentice to a master in his chosen guild, and after many years might advance to the rank of journeyman. In most guilds this meant that he was then a full member of the organization, capable of working without direction, and entitled to receive full wages for his work. Once he became a master, the highest rank, he could direct the work of apprentices and manage his own workshop, hiring journeymen to work with him.

In architecture, the master mason (sometimes called master builder) generally designed the building, that is, acted in the role of architect. In church-building campaigns, teams of carpenters (joiners), metalworkers, and glaziers (glassworkers) labored under the direction of the master builder.

side), a refectory (dining hall) and kitchen (on the south side), and a cellar. The three large buildings north of the church are a guesthouse, a school, and the abbot's house. To the east are the infirmary, a chapel and quarters for novices (new members of the religious community), the cemetery (marked by a large cross), a garden, and coops for chickens and geese. The south side is occupied by workshops, barns, and other service buildings. There is, needless to say, no monastery exactly like this plan anywhere—even in St. Gall the design was not carried out as drawn—yet its layout conveys an excellent notion of such establishments throughout the Middle Ages.

Manuscripts and Book Covers

The visual arts played an important role in Charlemagne's cultural program from the very start. We know from literary sources that Carolingian churches contained **murals**, **mosaics**, and **relief** sculpture, but these have disappeared almost entirely. **Illuminated** manuscripts, carved ivory panels, and goldsmiths' work, on the other hand, have survived in considerable numbers. They demonstrate the impact of the Carolingian revival even more strikingly than the architectural remains of the period. As we look at the picture of Saint Matthew in a Gospel Book said to have been found in the tomb of Charlemagne and, in any event, closely linked with his court at Aachen (fig. 127), we find it hard to believe that such a work could have been executed in northern Europe about the year 800. If it was not for the large golden **halo**, the Evangelist Matthew might almost be mistaken for a classical author's portrait. Whether Byzantine, Italian, or Frankish, the artist plainly was fully conversant with the Roman tradition of painting, down to the acanthus ornament on the wide frame, which emphasizes the "window" treatment of the picture.

This *Saint Matthew* represents the initial and most conservative phase of the Carolingian revival. It is the visual counterpart of copying

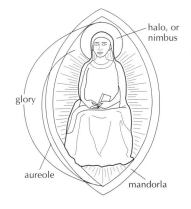

The halo (also nimbus) represents light radiating around the head of a saint or divinity. The aureole is light around the body, and the glory is all the light—both the halo and aureole. The mandorla is the almond-shaped form that encloses the image of a saint and is also symbolic of the radiant light of holiness.

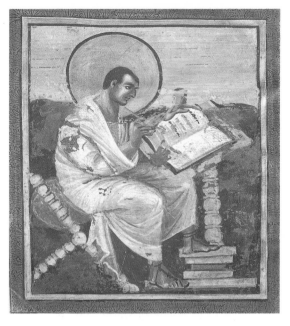

127. *Saint Matthew*, from the *Gospel Book of Charlemagne*. c. 800–10. Ink and colors on vellum, 13 x 10" (33 x 25.4 cm). Kunsthistorisches Museum, Vienna

128. *Saint Mark*, from the *Gospel Book of Archbishop Ebbo of Reims*. Ink and colors on vellum, 10¼ x 8³/₁₆" (26 x 20.8 cm) 816–35. Bibliothèque Municipale, Épernay, France

the text of a classical work of literature. More typical is a slightly later **miniature** for the *Gospel Book of Archbishop Ebbo of Reims* (fig. 128) that shows the classical model translated into a Carolingian idiom. The *Saint Mark* will remind us of the Enthroned Christ from the *Sarcophagus of Junius Bassus* (see fig. 109, top center), made about 475 years earlier, in the seated "stance" with one foot advanced, the diagonal drape of the upper part of the toga, and the square outline of the face. The hands, too, are similar, with one holding a scroll or codex, the other a quill pen that is added to what must once have been an expository gesture. And the throne on which Christ is seated in the earlier sculpture has exactly the same kind of animal legs as Saint Mark's seat. But now the entire picture is filled with a vibrant energy that sets everything in motion. The drapery swirls about the figure, the hills heave upward, the vegetation seems to be tossed about by a whirlwind, and even the acanthus pattern on the frame assumes a strange, flamelike character. The Evangelist himself has been transformed from a Roman author setting down his own thoughts into a man seized with the frenzy of divine inspiration, an instrument for recording the Word of God. His gaze is fixed not upon his book but upon his symbol (the winged lion with a scroll), which acts as the transmitter of the Sacred Text. This dependence on the Word, so powerfully expressed here, characterizes the contrast between classical and medieval images of humanity. But the *means* of expression—the dynamism of line that distinguishes our miniature from its predecessor—recalls the passionate movement in the ornamentation of Irish manuscripts (see fig. 123).

The style of the Reims school can still be felt in the reliefs of the jeweled front cover of the *Lindau Gospels* (fig. 129), a work of the third quarter of the ninth century. This masterpiece of the goldsmith's art shows how splendidly the Celtic-Germanic metalwork tradition could be adapted to the Carolingian revival. The clusters of semiprecious stones are not mounted directly on the gold ground but are raised on claw feet or arcaded turrets so that light can

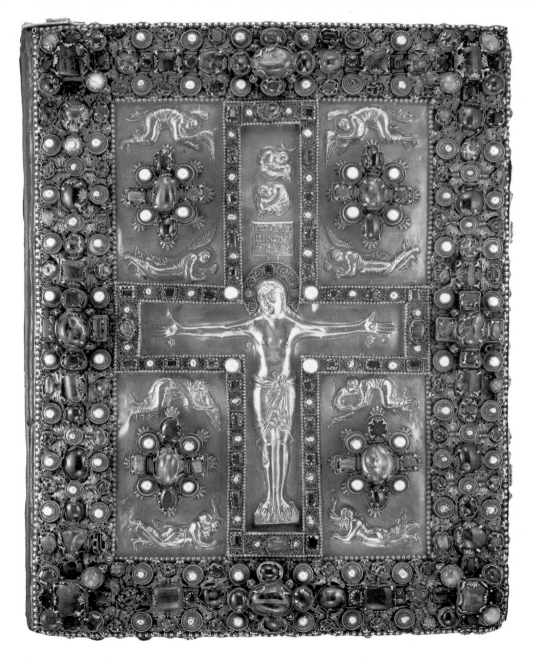

129. Front cover of binding, *Lindau Gospels*. c. 870. Gold and jewels, 13¾ x 10½" (34.9 x 26.7 cm). The Pierpont Morgan Library, New York

penetrate beneath them to bring out their full brilliance. Interestingly enough, the crucified Jesus betrays no hint of pain or death. He seems to stand rather than to hang, his arms spread out in a solemn gesture. To endow him with the signs of human suffering was not yet conceivable, even though the means were at hand, as we can see from the eloquent expressions of grief among the small figures in the adjoining compartments.

Ottonian Art

After the death of Charlemagne's son Louis I, the empire built by Charlemagne was divided in 843 into three parts by his grandsons:

130. *Gero Crucifix*. c. 975–1000. Wood, height 6'2" (1.88 m). Cologne Cathedral, Germany

Charles the Bald, the West Frankish king, who established the French Carolingian dynasty; Louis the German, the East Frankish king, whose domain corresponded roughly to the Germany of today; and Lothair I, who inherited the middle kingdom and the title of Holy Roman Emperor. By dividing the king's domain among his heirs, the Carolingian dynasty made the same fatal mistake as its predecessors, the Merovingians. The Carolingians' power became so weak that continental Europe once again lay exposed to attack. In the south, the Muslims resumed their depredations; Slavs and Magyars advanced from the east; and Vikings from Scandinavia ravaged the north and west.

The Vikings (the Norse ancestors of today's Danes and Norwegians) had been raiding Ireland and Britain by sea from the late eighth century on. Now they invaded northwestern France as well and occupied the area that ever since has been called Normandy. Once established there, they soon adopted Christianity and Carolingian civilization, and from 911 on their leaders were recognized as dukes nominally subject to the authority of the king of France. During the eleventh century, the Normans assumed a role of major importance in shaping the political and cultural destiny of Europe, with William the Conqueror becoming king of England, while other Norman nobles expelled the Arabs from Sicily and the Byzantines from southern Italy.

In Germany, meanwhile, after the death of the last Carolingian monarch in 911, the center of political power had shifted north to Saxony. The Saxon kings (919–1024) reestablished an effective central government, and the greatest of them, Otto I, also revived the imperial ambitions of Charlemagne. After marrying the widow of a Lombard king, he extended his rule over most of Italy and had himself crowned emperor by the pope in 962. From then on the Holy Roman Empire was to be a German institution—or perhaps we ought to call it a German dream, for Otto's successors never managed to consolidate their claim to sovereignty south of the Alps. Yet this claim had momentous consequences, since it led the German emperors into centuries of conflict with the papacy and local Italian rulers, linking North and South in a love-hate relationship whose echoes can be felt to the present day.

Sculpture

During the Ottonian period, from the mid-tenth century to the beginning of the eleventh, Germany was the leading region of Europe, artistically as well as politically. German achievements in both areas began as revivals of Carolingian traditions but soon developed new and original traits. The change of outlook is impressively brought home to us if we compare the Jesus on the cover of the *Lindau Gospels* with the *Gero Crucifix* (fig. 130) in the Cologne Cathedral. The two works are separated by little more than a hundred-year interval, but the contrast between them suggests a far greater span. In the *Gero Crucifix*, we meet an image of the crucified Savior new to Western art: monumental in scale, carved in powerfully rounded forms, and filled with a deep concern for the sufferings of the Lord. Particularly striking is the forward bulge of the heavy body, which makes the physical strain on arms and shoulders seem almost unbearably real. The face, with its deeply incised, angular features, has turned into a mask of agony, from which all life has fled.

How did the Ottonian sculptor arrive at this startlingly bold conception? The *Gero Crucifix* was clearly influenced by Middle Byzan-tine art, which, we will recall, had created the compassionate view of Jesus on the Cross (see fig. 117). Byzantine influence was strong in Germany at the time, for Otto II had married a Byzantine princess, Theophano, establishing a direct link between the two imperial courts. It remained for the Ottonian artist to translate the Byzantine image into large-scale sculptural terms and to replace its gentle melancholy with an expressive realism that has been the main strength of German art ever since.

Architecture

St. Michael's, Hildesheim Judged in terms of surviving works, however, the most ambitious patron of architecture and art in the Ottonian age was Bernward, who became bishop of Hildesheim after having been court chaplain and one of the tutors of Otto III during the regency of the empress Theophano. It was under Bernward that the Benedictine Abbey Church of St. Michael, later designated Hildesheim Cathedral (figs. 131, 132), was built. The plan, with its two choirs and lateral entrances, recalls the monastery church of the St. Gall plan (see fig. 126). But in St. Michael's the symmetry is carried much further. Not only are there two identical transepts, with crossing towers and stair turrets, but the supports of the nave arcade, instead of being uniform, consist of pairs of columns separated by square piers. This alternating system divides the arcade into three equal units, called **bays**, of three openings each. Moreover, the first and third units are correlated with the entrances, thus echoing the axis of the transepts. And since the aisles and nave are unusually wide in relation to their length, the architect's intention must have been to achieve a harmonious balance between the longitudinal and transverse axes throughout the structure. The Bernwardian western choir was raised above the level of the rest of the church to accommodate a half-subterranean basement chapel, or **crypt**, apparently a special sanctuary of St. Michael's, which could be entered both from the transept and from the west. The crypt was covered by **groin vaults** resting on two rows of columns, and its walls

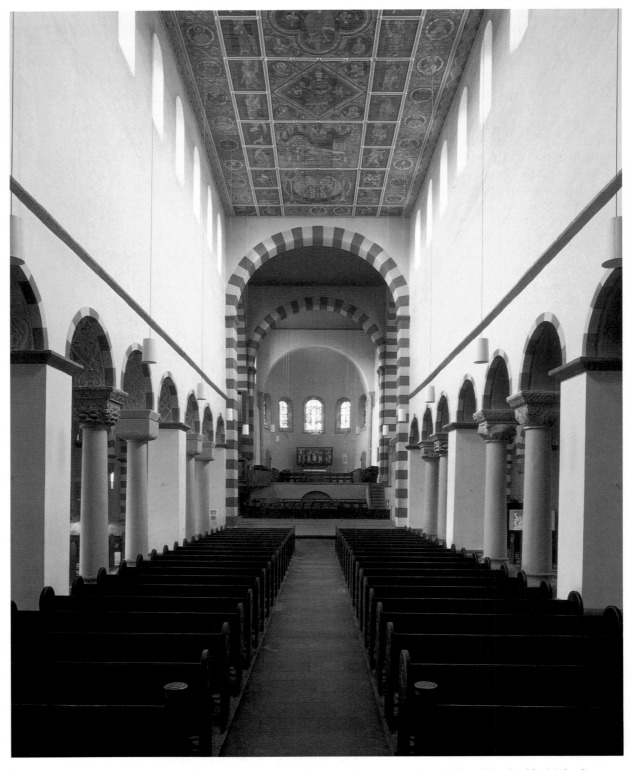

131. Interior (view toward the west, after restoration of 1950–60), Hildesheim Cathedral (Abbey Church of St. Michael), Germany. 1001–33

132. Reconstructed plan, Hildesheim Cathedral

were pierced by arched openings that linked it with the U-shaped corridor, or **ambulatory**, wrapped around it. This ambulatory must have been visible above ground, enriching the exterior of the western choir, since there were windows in its outer wall. Such crypts with ambulatories, usually housing the venerated tomb of a saint, had been introduced into the repertory of Western church architecture during Carolingian times. But the Bernwardian design stands out for its large scale and its carefully

planned, successful integration with the rest of the building.

Metalwork

How much importance Bernward himself attached to the crypt at St. Michael's can be gathered from the fact that he commissioned a pair of richly sculptured bronze doors that may have been meant for the two entrances leading from the transept to the ambulatory. (They were finished in 1015, the year the crypt was consecrated.) Bernward, according to his biographer, Thangmar of Heidelberg, excelled in the arts and crafts. The idea for the doors may have come to him as a result of his visit to Rome, where he could see ancient Roman (and perhaps Byzantine) bronze doors. The Bernwardian doors, however, differ from their predecessors. They are divided into broad horizontal fields rather than vertical panels, and each field contains a biblical scene in high relief.

Our detail (fig. 133) shows Adam and Eve after the Fall. Below it, in inlaid letters remarkable for their classical Roman character, is part of the dedicatory inscription, with the date and Bernward's name. In these figures, we find

133. *Adam and Eve Reproached by the Lord*, from the Doors of Bishop Bernward, Hildesheim Cathedral. 1015. Bronze, approx. 23 x 43" (58.4 x 109.2 cm)

134. *Christ Washing the Feet of Peter*, from the *Gospel Book of Otto III*. c. 1000. Tempera on vellum, 13 x 9³/₈"
(33 x 23.9 cm). Staatsbibliothek, Munich

nothing of the monumental spirit of the *Gero Crucifix*. They seem far smaller than they actually are, so that one might easily mistake them for a piece of goldsmith's work such as the *Lindau Gospels* cover (compare fig. 129). The composition must have been derived ultimately from an illuminated manuscript, since very similar scenes are found in medieval Bibles. Even the oddly stylized bits of vegetation have a good deal of the twisting, turning movement we recall from Irish miniatures. Yet this is no slavish imitation, for the story is conveyed with splendid directness and expressive force. The accusing finger of the Lord, seen against a great void of blank surface, is the focal point of the drama. It points to a cringing Adam, who passes the blame to his mate, while Eve, in turn, passes it to the serpent at her feet.

Manuscripts

The same intensity of glance and of gesture found in the Bernwardian bronze doors characterizes Ottonian manuscript painting, which blends Carolingian and Byzantine elements into a new style of extraordinary scope and power. The most important center of manuscript illumination at that time was the Reichenau Monastery, on an island in Lake Constance, on the borders of modern-day Germany, Switzerland, and Austria. Perhaps its finest achievement—and one of the great works of medieval art—is the *Gospel Book of Otto III*. The scene of Jesus washing the feet of Peter (fig. 134) contains notable echoes of ancient painting, transmitted through Byzantine art. The soft pastel hues of the background recall the illusionism of Graeco-Roman landscapes (see fig. 100), and the architectural frame around Jesus is a late descendant of the kind of architectural perspectives we saw in the House of the Vettii (see fig. 99). These elements have been reformulated by the Ottonian artist, who has put them to a new use: what was once an architectural vista now becomes the Heavenly City, the House of the Lord filled with golden celestial space set against the atmospheric earthly space without. The figures have undergone a similar transformation. In ancient art, this composition had been used to represent a doctor treating a patient. Now Peter takes the place of the sufferer, and Jesus that of the physician. (Note that Jesus is still the beardless young philosopher type here.) As a consequence, the emphasis has shifted from physical to spiritual action, and this new kind of action not only is conveyed through glances and gestures but also governs the scale of things. Jesus and Saint Peter, the most active figures, are larger than the rest; Jesus' "active" arm is longer than his "passive" one; and the eight disciples, who merely watch, have been compressed into a tiny space, so that we see little more than their eyes and hands. Even the Early Christian crowd cluster from which this derives (see fig. 107) is not quite so literally disembodied. The scene straddles two eras. On the one hand, the nearly perfect synthesis of Western and Byzantine elements represents the culmination of the early medieval manuscript tradition; on the other, the expressive distortions look forward to Romanesque art, which incorporated them in heightened form to telling effect.

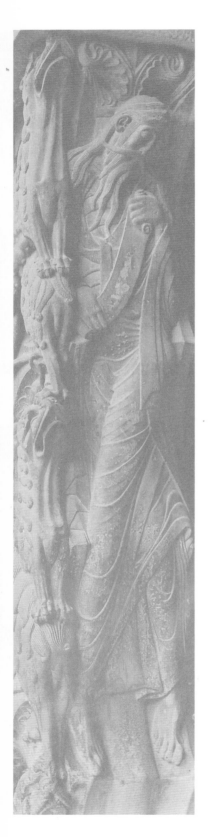

Chapter 10
Romanesque Art

L ooking back over the ground we have covered in this book so far, a thoughtful reader will be struck by the fact that almost all our chapter headings and subheadings might serve equally well for a general history of civilization. Some are based on technology (for example, "The Old Stone Age"), others on geography or religion. Whatever the source, they have been borrowed from other fields, even though in our context they may also designate artistic styles. There are only two important exceptions to this rule: *archaic* and *classical* are primarily terms of style. They refer to qualities of form rather than to the setting in which these forms were created. Why don't we have more terms of this sort? We do, as we shall see—but only for the art of the past 900 years.

Those who first conceived the idea of viewing the history of art as an evolution of styles started out with the conviction that art in the ancient world developed toward a single climax: Greek art from the age of Perikles to that of Alexander the Great. This style they called Classical (that is, perfect). Everything that came before was labeled Archaic, to indicate that it was still old-fashioned and tradition-bound, not yet Classical but striving in the right direction, while the style of post-Classical times did not deserve a special term since it had no positive qualities of its own, being merely an echo or a decadence of Classical art.

The early historians of medieval art followed a similar pattern. To them, the great climax was the Gothic style, from the thirteenth century to the fifteenth. For whatever was not yet Gothic they adopted the label *Romanesque*. In doing so, they were thinking mainly of architecture. Pre-Gothic churches, they noted, were round-arched, solid, and heavy, in comparison with the pointed arches and the soaring lightness of Gothic structures. It was rather like the ancient Roman style of building, and the term *Romanesque* was meant to convey just that. In this sense, all of medieval art before 1200, insofar as it shows any link with the Mediterranean tradition, could be called Romanesque.

The Ascendancy of Christianity

Carolingian art, we will recall, was brought into being by Charlemagne and his circle, as part of a conscious revival policy, and even after his death, it remained strongly linked with his imperial court. Ottonian art, too, had this sponsorship and a correspondingly narrow base. Romanesque art proper (that is, medieval art from about 1050 to 1200), in contrast, sprang up all over western Europe at about the same time. It consists of a large variety of regional styles, distinct yet closely related in many ways and without a central source. In this respect, it resembles the art of the Early Middle Ages rather than the court styles that had preceded it, although it includes that tradition along with a good many other, less clearly traceable ones, such as Late Classical, Early Christian, and Byzantine elements, some Islamic influence, and the Celtic-Germanic heritage.

What welded all these different components into a coherent style during the second half of the eleventh century was not any single force but a variety of factors that made for a new burgeoning of vitality throughout the West. The first millennium came and went without the Apocalypse (described in the New Testament Book of Revelation; see "Versions of the Bible," page 138) that many had predicted. Christianity had triumphed everywhere in Europe. The Vikings, still largely non-Christian in the ninth and tenth centuries when their raids terrorized the British Isles and the Continent, had entered the Catholic fold, not only in Normandy but in Scandinavia as well. The Muslim threat subsided after 1031. And the Magyars settled down in Hungary.

In many respects, western Europe between 1050 and 1200 became a great deal more "Roman-esque" than it had been since the sixth century, recapturing some of the international trade patterns, the urban quality, and the military strength of ancient imperial times. The central political authority was lacking, to be sure. Even the empire of Otto I did not extend much farther west than modern Germany does. But the central authority of the Church, which emerged as the single greatest force in Europe, took its place to a considerable extent. The monasteries of the Cistercians and Benedictines rivaled the wealth and power of secular rulers (see "Monasticism and Christian Monastic Orders," page 172). Indeed, it was now the pope who sought to unite Europe into a single Christian realm. The international army that responded to Urban II's call in 1095 for the First ▼CRUSADE to liberate the Holy Land from Muslim rule was more powerful than anything a secular ruler could have raised for the purpose.

The pope's authority was spiritual, not just temporal, as he sought to combat the "heresies" that mushroomed throughout the Catholic realm. Papal assertion of dogmatic supremacy led to the final break with the Byzantine Orthodox Church in 1054. The Crusades, although ultimately unsuccessful, did result in the substantial retreat of Islam from western Europe. The reopening of Mediterranean trade routes by the navies of Venice, Genoa, and Pisa led to the revival of trade and travel, which united Europe commercially and culturally, with consequent growth of urban life. During the turmoil of the Early Middle Ages, the towns of what had once been the Western Roman Empire had shrunk greatly in size. (The population of Rome, about 1 million in A.D. 300, fell to less than 50,000 at one point.) Some cities were deserted altogether. From the eleventh century on, they began to regain their former importance. New towns sprang up everywhere and, like the cities, gained their independence thanks to a middle class of artisans and merchants that established itself between the peasantry and the landed nobility as an important factor in medieval society.

Architecture

The greatest difference between Romanesque architecture and that of the preceding centuries is the amazing increase in building activity. An eleventh-century monk, Raoul Glaber, summed it up well when he triumphantly exclaimed that the world was putting on a "white mantle of churches." These churches were not only more numerous than those of the Early Middle Ages, they were also generally larger, more richly artic-

▼ Between 1095 and 1291, seven different armies were raised in Europe to undertake campaigns, called CRUSADES, to the Holy Land in the name of "freeing" Jerusalem from Muslim control. In fact, the Church's broad call was for war against all of its perceived opponents: political, heretical, and schismatic. In responding to the call, however, the nobles who volunteered themselves and their loyal soldiers believed they were accumulating merit by waging a "holy war" to reclaim the lands where Jesus had lived. The Crusades combined aspects of the PILGRIMAGE as well, with Crusaders making stops at holy sites along the way from their homes to their various destinations in Syria, Palestine, and Egypt.

Monasticism and Christian Monastic Orders

People of many times, places, and religious faiths have renounced the world and wholly devoted themselves to a spiritual way of life. Some have chosen to live alone as hermits, often in isolated places, where they have led harsh ascetic existences. Others have come together in MONASTERIES—religious communities—to share their faith and religious observance. Hermits have been especially characteristic of Hinduism, while the monastic life has been more common in Buddhism, and Islam. Among the Jews of the first century B.C., there were both hermits, or ANCHORITES (John the Baptist was one of these), and a form of monasticism practiced by a sect known as the Essenes.

The earliest renunciation practiced by Christians was the hermit's life. Chosen by a number of pious men and women who lived alone in the Egyptian desert in the second and third centuries A.D., this way of life was to remain fundamental to the Eastern Church. But early on, communities emerged when colonies of disciples—both men and women—gathered around the most revered of the hermits.

Eastern monasticism was founded by Basil the Great (c. 330–379), bishop of Caesaria in Asia Minor. Basil's rules for this life established the basic characteristics of Christian monasticism. They emphasized prayer, scriptural reading, temperance, chastity, and humility. His rule also emphasized work, not only within the monastery but also for the good of laypeople in the world beyond its walls. In the fourth and fifth centuries, monasticism spread to many parts of the Western Empire, including to North Africa, France, and Ireland. The most important figure in Western monasticism was Benedict of Nursia (c. 480–c. 553), the founder of the abbey at Monte Cassino in southern Italy. His rule, which was patterned after Basil's,

divided the monk's day into periods of private prayer, communal ritual, and labor, and also mandated the rules governing communal life. This was the beginning of the BENEDICTINE order, the first of the great monastic orders (or societies) of the Western Church. The Benedictines thrived with the strong support of Pope Gregory the Great, himself a former monk, who codified the Western liturgy and the forms of Gregorian chant (see "Medieval Music, Theater, and Art," page 196).

Monasteries (including communities for women, which are often called convents or nunneries) assumed great importance in medieval life. Their organization and continuity made them ideal seats of learning and administration under the Frankish kings of the eighth century, and they were even more strongly supported by Charlemagne and his heirs, who gave them land, money, and royal protection. As a result, they became rich and powerful, even exercising influence on international affairs. Monasteries and convents provided a place for the younger children of the nobility, and also talented members of the lower classes, to pursue challenging, creative, and useful lives as teachers, nurses, writers, and artists, opportunities that generally would have been closed to them in secular life (see "Hildegard of Bingen," page 184).

Besides the Benedictines, the other important monastic orders of the West included the Cluniacs, the Cistercians, the Dominicans, the Franciscans, and the Carthusians. The CLUNIAC order (named after its original monastery at Cluny, in France) was founded in 909 by Berno of Baume as a renewal of the original Benedictine rule. By the late eleventh century, however, the Cluniacs had become enormously rich and so powerful in Church affairs that many churchmen considered them too worldly. Partly in reaction to the wealth and secular power of the Cluniac order and other

Church institutions, the CISTERCIAN order was founded in 1098 by Robert of Molesme as a return to the Benedictine rule. Cistercian monasteries were deliberately sited in remote places, where the monks would come into minimal contact with the outside world, and the rules of daily life were particularly strict. In keeping with this austerity, the order developed an architectural style known as Cistercian Gothic, recognizable by its simplicity and lack of ornamentation.

The FRANCISCAN order was founded in 1209 by Francis of Assisi (c. 1181–1226) as a preaching community. Francis insisted on a life of complete poverty, not only for the members personally, but for the order as a whole. Thus, Franciscan monks and nuns were originally MENDICANT—that is, they begged for a living—however, this rule was revised in the fourteenth century. The DOMINICAN order was also founded as a mendicant preaching community, by Dominic, a Spanish monk, in 1220. Besides preaching, the Dominicans devoted themselves to the study of theology and the combat of heresy. They were considered the most intellectual of the religious orders in the late Middle Ages and the early Renaissance.

The CARTHUSIAN order was founded by Bruno of Cologne (c. 1030–1101) in 1084. Carthusians are in effect hermits, each monk or nun living alone in a separate cell, vowed to silence and devoted to prayer and meditation. The members of each house come together only for religious services and for communal meals several times a year. Because of the extreme austerity and piety of this order, several powerful dukes in the fourteenth and fifteenth centuries established Carthusian houses ("charterhouses"; French, *chartreuses*), so that the monks could pray perpetually for the souls of the dukes after they died. The most famous of these was the Chartreuse de Champmol, built in 1385 near Dijon, France, by Philip the Bold of Burgundy (see pages 210–11).

ulated, and more "Roman-looking." Their naves now had **vaults** instead of wooden roofs, and their exteriors, unlike those of Early Christian, Byzantine, Carolingian, and Ottonian churches, were decorated with architectural ornament and sculpture. Geographically, Romanesque monuments of the first importance are distributed over an area that might well have represented the

world—the Catholic world, that is—to Raoul Glaber: from northern Spain to the Rhineland, from the Scottish-English border to central Italy. The richest examples, the greatest variety of regional types, and the most adventurous ideas are to be found in France, but throughout Europe we are presented with a wealth of architectural invention unparalleled by any previous era.

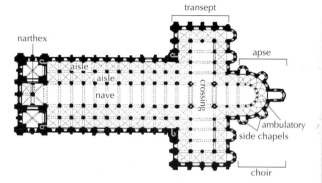

135. Plan of St-Sernin, Toulouse, France

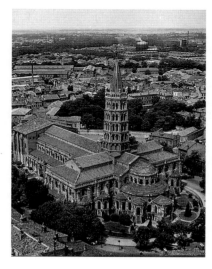

136. St-Sernin. c. 1080–1120

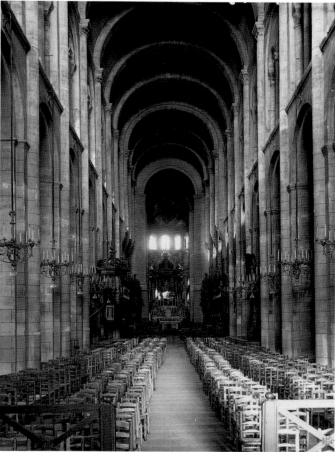

137. Nave and choir, St-Sernin

Southwestern France

We begin our sampling of Romanesque churches with St-Sernin, in the southern French town of Toulouse (figs. 135–37), one of a group of great churches of the pilgrimage type, so called because they were built along the roads leading to the pilgrimage center of Santiago de Compostela in northwestern Spain. The plan immediately strikes us as much more complex and more fully integrated than the designs of earlier structures such as St. Michael's at Hildesheim (see fig. 132). It is an emphatic **Latin cross**, with the center of gravity at the eastern end reinforced by the crossing tower. Clearly this church was designed to serve not only a monastic community but also large crowds of lay worshipers in its long nave and transept.

The nave is flanked by two aisles on each side. The inner aisle continues around the arms of the transept and the apse, thus forming a complete ambulatory circuit anchored to the two towers of the west facade. The ambulatory, we will recall, had developed as a feature of the crypts of such earlier churches as St. Michael's (see fig. 132). Now it has emerged above ground and is linked with the aisles of nave and transept, where it is enriched with apsidal chapels that seem to radiate from the apse and continue along the eastern face of the transept. (Apse, ambulatory, and radiating chapels form a unit known as the pilgrimage **choir**.) The plan also shows that the aisles of St-Sernin are **groin-vaulted** throughout. In conjunction with the features already noted, this vaulting imposes a high degree of regularity upon the

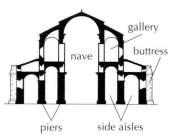

Seen in section, the physics of St-Sernin are quite apparent. The walls of the nave and the aisles transfer the weight downward through the piers and outward to the lowest side walls, where it is buttressed.

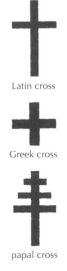

Latin cross

Greek cross

papal cross

Tau, Egyptian,
or Saint Anthony's
cross

Celtic cross

entire design. The aisles are made up of square **bays**, which serve as a basic module for the other dimensions, so that the nave and transept bays equal two such units, the **crossing** and the facade towers four units. The spirit of harmony conveyed by the repetition of these units is perhaps the most striking achievement of the pilgrimage church.

The exterior is marked by an equally rich articulation, or interrelationship of elements. The different roof levels set off the nave and transept against the inner and outer aisles, the apse, the ambulatory, and the radiating chapels. This effect is enhanced by the **buttresses** reinforcing the walls between the windows to contain the outward **thrust** of the vaults. The windows and **portals** are further emphasized by decorative framing. The great crossing tower was completed later, in Gothic times, and is taller than originally intended. The two facade towers, unfortunately, have remained stumps.

As we enter the nave, we are impressed with its tall proportions, the elaboration of the nave walls, and the dim, indirect lighting, all of which creates a sensation very different from the ample and serene interior of St. Michael's, with its simple and clearly separated blocks of space (see fig. 131). If the nave walls of St. Michael's look Early Christian (see fig. 106), those of St-Sernin seem more akin to structures such as the Colosseum (see fig. 86). The syntax of ancient Roman architecture—vaults, arches, **engaged columns**, and **pilasters** firmly knit together into a coherent order—has indeed been recaptured here to a remarkable degree. Yet the forces whose interaction is expressed in the nave of St-Sernin are no longer the physical, muscular forces of Graeco-Roman architecture but spiritual forces of the kind we have seen governing the human body in Carolingian and Ottonian **miniatures**. The half-columns running the entire height of the nave wall would appear just as unnaturally drawn out to an ancient Roman beholder as the arm of Jesus in figure 134. The columns seem to be driven upward by some tremendous, unseen pressure, hastening to meet the transverse arches that subdivide the **barrel vault** of the nave. Their insistently repeated rhythm propels

us toward the eastern end of the church, with its light-filled apse and ambulatory (now, unfortunately, obscured by a huge altar of later date).

In thus describing our experience we do not mean to suggest that the architect consciously set out to achieve this effect. Beauty and engineering were inseparable. Vaulting the nave to eliminate the fire hazard of a wooden roof not only was a practical aim but also provided a challenge to make the House of the Lord grander and more impressive. Since a vault becomes more difficult to sustain the farther it is from the ground, every resource had to be strained to make the nave as tall as possible. However, the **clerestory** was sacrificed for safety's sake. Instead, **galleries** were built over the inner aisles to abut the lateral pressure of the nave vault in the hope that enough light would filter through them into the central space. St-Sernin serves to remind us that architecture, like politics, is "the art of the possible" and that its success, here as elsewhere, is measured by the degree to which the architect has explored the limits of what seemed possible under those particular circumstances, structurally and aesthetically.

Burgundy and Western France

The builders of St-Sernin would have been the first to admit that their answer to the problem of the nave vault was not a final one, impressive though it is on its own terms. The architects of Burgundy arrived at a more elegant solution, as evidenced by the Church of St-Lazare—later the Autun Cathedral (fig. 138)—where the galleries are replaced by a **blind arcade** (called a **triforium**, since it often has three openings per bay) and a clerestory. What made this three-story elevation possible was the use of the pointed arch for the nave vault.

The pointed arch may have reached France from Islamic architecture, where it had been employed for some time. (For reasons of harmony, it also typically appears in the nave arcade, where it is not needed for additional support.) By eliminating the part of the round arch that responds the most to the pull of gravity, the two halves of a pointed arch brace

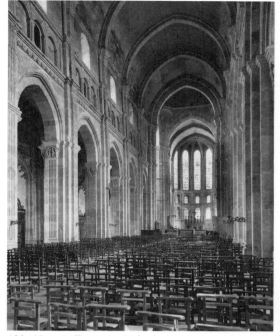

138. Nave wall, Autun Cathedral, France. c. 1120–32

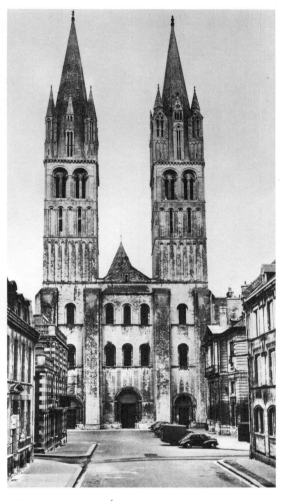

139. West facade, St-Étienne, Caen, France. Begun 1068

each other. The pointed arch thus exerts less outward pressure than the semicircular arch and can be made as steep as possible. The potential for engineering advances that grew out of this discovery were to make possible the soaring churches of the Gothic period (Chapter 11). Like St-Sernin, Autun comes close to straining the limits of the possible. The upper part of the nave wall shows a slight but perceptible outward lean under the pressure of the vault, a warning against any further attempts to increase the height of the clerestory or to enlarge the windows.

Normandy and England

A major development in architecture took place in Normandy, farther north—and for good reason. Although Christianity came late to Normandy, it was enthusiastically supported by the Norman dukes and barons, who played an active role in monastic reform and established numerous abbeys. Normandy soon became a cultural center of international importance. The architecture of southern France was assimilated and merged with local traditions to produce a distinctive Norman school that evolved in an entirely different direction. On the west facade of the Abbey Church of St-Étienne at Caen in Normandy (fig. 139), founded by William the Conqueror a year or two after his invasion of England (see page 164), decoration is kept to a minimum. Four huge buttresses divide the front of the church into three vertical sections, and the vertical impetus continues energetically upward in the two splendid towers, whose height would be impressive enough without the tall Early Gothic helmets that cap the towers. St-Étienne is cool and composed: a structure of refined proportions to be appreciated by the mind rather than the eye.

the rest of the nave, following the same pattern, was finished by 1130. This vault is of great interest, for it represents the earliest systematic use of a pointed-rib groin vault over a three-story nave and thus marks a basic advance beyond the solution we saw at Autun. The aisles, which we can glimpse through the arcade, consist of the usual groin-vaulted compartments closely approaching a square, while the bays of the nave, separated by strong transverse arches, are decidedly oblong and groin-vaulted in such a way that the **ribs** form a double-X design, dividing the vault into seven sections rather than the conventional four. Since the nave bays are twice as long as the aisle bays, the transverse arches occur only at the odd-numbered **piers** of the nave arcade, and the piers therefore alternate in size, the larger ones being of compound shape (that is, bundles of column and pilaster **shafts** attached to a square or oblong core), the others cylindrical.

Perhaps the easiest way to visualize the origin of this system is to imagine that the architect started out by designing a barrel-vaulted nave, with galleries over the aisles and without a clerestory, as at St-Sernin. The realization suddenly dawned that putting groin vaults over the nave as well as the aisles would gain a semicircular area at the ends of each transverse vault that could be broken through to make a clerestory, because it had no essential supporting functions (fig. 141, left). Each nave bay is intersected by two transverse barrel vaults of *oval* shape, so that it contains a pair of Siamese-twin groin vaults that divide it into seven compartments. The outward thrust and weight of the whole vault is concentrated at six securely anchored points on the gallery level. While the transverse arches at the crossing are round, those to the west of it are slightly pointed, indicating a continuous search for improvements.

Ribs provided a stable skeleton for the groin vault, so that the curved surfaces between them could be filled with masonry of minimum thickness, thus reducing both weight and thrust. We do not know whether this ingenious scheme was actually invented at Durham, but it could not have been created much earlier, for it

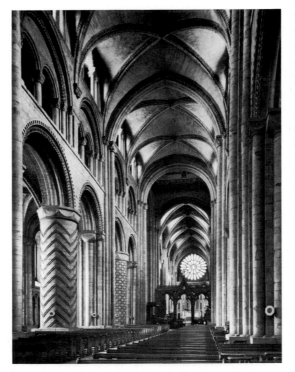

140. Nave (looking east), Durham Cathedral, England. 1093–1130

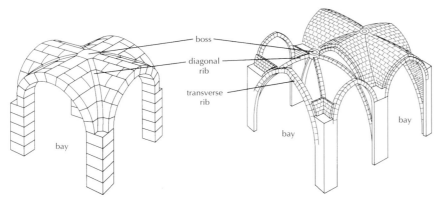

boss
diagonal rib
transverse rib
bay
bay
bay

141. Rib vaults (after Acland)

The thinking that went into Norman architecture is responsible for the next great breakthrough in structural engineering, which took place in England, where William started to build as well. Durham Cathedral (fig. 140), begun in 1093, is among the largest churches of medieval Europe. Despite its great width, the nave may have been designed to be vaulted from the start. The vault over its eastern end had been completed by 1107, a remarkably short time, and

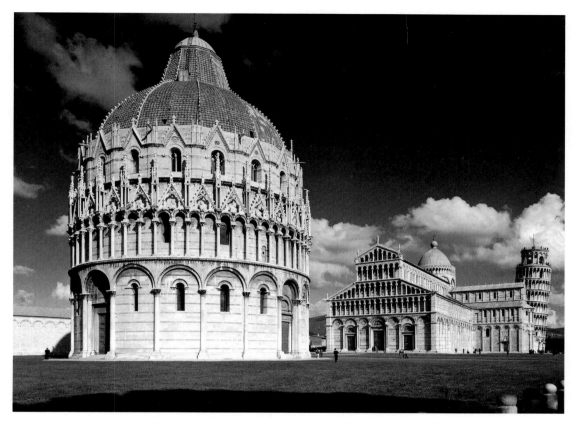

142. Pisa Baptistery, Cathedral, and Campanile (view from the west), Italy. 1053–1272

is still in an experimental stage. Aesthetically, the nave at Durham is among the finest in all Romanesque architecture: the wonderful sturdiness of the alternating piers makes a splendid contrast with the dramatically lighted, sail-like surfaces of the vault. In addition to being relatively lightweight, this flexible system for covering broad expanses of great height with fireproof vaulting without sacrificing the ample lighting of a clerestory marks the culmination of the Romanesque and the dawn of the Gothic.

Italy

We might have expected central Italy, which had been part of the heartland of the original Roman Empire, to have produced the noblest Romanesque architecture of all, since surviving classical originals were close at hand. Such was not the case, however. All of the rulers having ambitions to revive "the grandeur that was Rome," with themselves in the role of emperor, were in the north of Europe. The spiritual authority of the pope, reinforced by his considerable territorial holdings, made imperial ambitions in Italy difficult to achieve. New centers of prosperity, whether arising from seaborne commerce or local industries, tended to consolidate a number of small principalities, which competed among themselves or aligned themselves from time to time, if it seemed politically profitable, with the pope or the German emperor. Lacking the urge to re-create the old Empire, and furthermore having Early Christian church buildings as readily accessible as classical Roman architecture, the Tuscans were content to continue what are basically Early Christian forms, but they enlivened them with decorative features inspired by earlier architecture.

If we take one of the best-preserved Tuscan Romanesque examples, the cathedral complex of Pisa (fig. 142), and compare it on the one

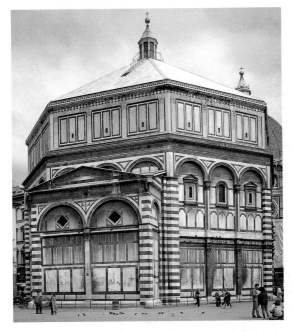

143. Baptistery of S. Giovanni, Florence. c. 1060–1150

to emulate such marble inlay in the Baptistery in Florence (fig. 143), whose green and white marble paneling follows severely geometric lines. The blind arcades, too, are eminently classical in proportion and detail. The entire building, in fact, exudes such an air of classicism that the Florentines themselves came to believe a few years later that it had originally been a temple of Mars, the Roman god of war.

Sculpture

The revival of **monumental** stone sculpture is even more surprising than the architectural achievements of the Romanesque era, since neither Carolingian nor Ottonian art had shown any tendencies in this direction. Freestanding statues, we will recall, all but disappeared from Western art after the fifth century. Stone **relief** survived only in the form of architectural ornament or surface decoration, with the depth of the carving reduced to a minimum. Thus, the only continuous sculptural tradition in early medieval art was that of sculpture-in-miniature: small reliefs, and occasional statuettes, in metal or ivory. Ottonian art, in works such as the bronze doors of Bishop Bernward (see fig. 133), had enlarged the scale of this tradition but not its spirit. Moreover, its truly large-scale sculptural efforts, represented by the impressive *Gero Crucifix* (see fig. 130), were limited almost entirely to wood.

Southwestern France

Just when and where the revival of stone sculpture began we cannot say with certainty, but the earliest surviving examples are found along the pilgrimage roads, in southwestern France and northern Spain, leading to Santiago de Compostela. As did Romanesque architecture, the rapid development of stone sculpture shortly before 1100 coincides with the growth of religious fervor among the general population in the decades before the First Crusade. Architectural sculpture, especially when applied to the exterior of a church, is meant to appeal to the lay worshiper rather than to the members of a closed monastic community.

hand with S. Apollinare in Ravenna and on the other with St-Sernin in Toulouse (see figs. 104, 136), we are left in little doubt as to which is its closer relation. True, the Pisa Cathedral has grown taller than its ancestor, and a large transept has altered the plan to form a Latin cross, with the consequent addition of the tall **lantern** rising above the intersection. Also, a detached bell tower (**campanile**) has been added: the famous Leaning Tower of Pisa, which was not planned that way but soon began to tilt because of weak foundations. But the essential features of the earlier basilica type, with its rows of flat arcades, still continue much as we see them in S. Apollinare.

The only deliberate revival of the antique Roman style in Tuscan architecture was the most unclassical use of multicolored marble inlays—which the Romans had used for interior decoration but the Tuscans now put on the exteriors of churches. (Early Christian examples tended to leave the outsides plain.) Little of this inlaid marble is left in Rome, a great deal of it having literally been "lifted" for the embellishment of later structures. But the interior of the Pantheon (see fig. 88) still gives us some idea of it, and we can recognize the desire

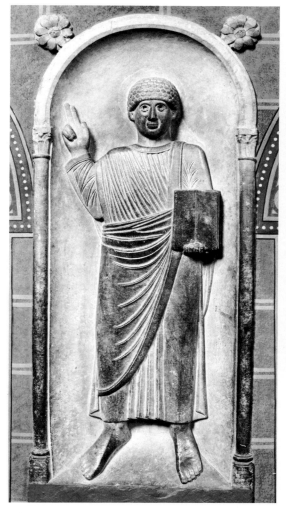

144. *Apostle*. c. 1090. Stone. St-Sernin, Toulouse

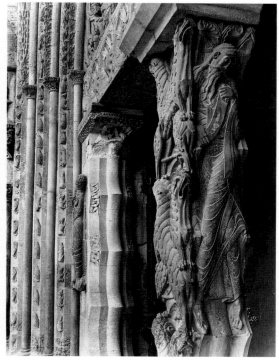

145. Portion of south portal, St-Pierre, Moissac, France. Early 12th century

St-Sernin at Toulouse contains several important examples probably carved about 1090. The original location of the *Apostle* (fig. 144) within the church remains uncertain; perhaps it decorated the front of an altar. Where have we seen its like before? The solidity of the forms has a strongly classical air, indicating that our artist must have had a close look at late Roman sculpture, of which there are considerable remains in southern France. But the solemn frontality of the figure and its placement in the architectural frame shows that the design as a whole must derive from a Byzantine source, in all likelihood an ivory panel descended from the *Archangel Michael* in figure 110. In enlarging such a miniature, the carver of our relief has also reinflated it.

The niche is a real cavity, the hair a round, close-fitting cap, the body severe and blocklike. Our *Apostle* has, in fact, much the same dignity and directness as the sculpture of Archaic Greece.

The figure (which is somewhat more than half lifesize) was not intended for viewing at close range only. Its impressive bulk and weight "carry" over a considerable distance. This emphasis on massive volume hints at what may well have been the main impulse behind the revival of large-scale sculpture: a carved-stone image, being tangible and three-dimensional, is far more "real" than a painted one. To the mind of the cleric steeped in the abstractions of theology, this might seem irrelevant, or even dangerous. For the unsophisticated laity, however, any large piece of sculpture inevitably had something of the quality of an idol, and it was this very fact that gave it such great appeal.

Another important early center of Romanesque sculpture is at the abbey at Moissac, some distance north of Toulouse. The south portal of its church (fig. 145), carved a generation later

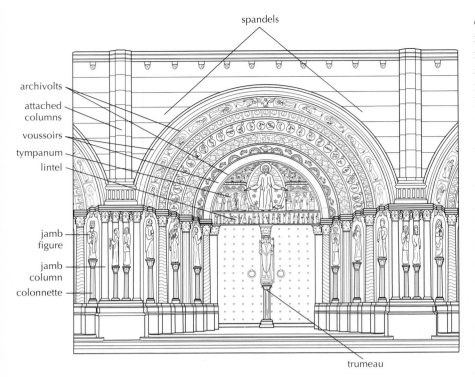

archivolts

attached
columns

voussoirs

tympanum

lintel

jamb
figure

jamb
column

colonnette

spandels

trumeau

146. Romanesque portal ensemble (composite)

than the *Apostle* from St-Sernin, displays a remarkable richness of invention. (The parts of typical medieval portals are shown in figure 146.) In figure 145 we see the magnificent **trumeau** (the center post supporting the lintel) and the western **jamb** (the side of the doorway). Both have a scalloped profile, and the shafts of the half-columns applied to jambs and *trumeau* follow this scalloped pattern, as if they had been squeezed from a giant pastry tube. Human and animal forms are treated with the same flexibility, so that the spidery prophet on the side of the *trumeau* seems perfectly adapted to his precarious perch. (Notice how he, too, has been fitted into the scalloped outline.) He even remains free to cross his legs in a dance-like movement and to turn his head toward the interior of the church as he unfurls his scroll.

But what of the crossed lions that form a symmetrical zigzag on the face of the *trumeau*—do they have a meaning? So far as we know, they simply "animate" the shaft, just as the interlacing beasts of Irish miniatures (whose

descendants they are) animate the compartments assigned to them. In manuscript illumination, this tradition had never died out. Our sculpture has undoubtedly been influenced by it, just as the agitated movement of the prophet has its ultimate origin in miniature painting (see fig. 128). The crossed lions reflect another source as well. They can be traced back through textiles to Persian metalwork, to the confronted animals of ancient Near Eastern and Aegean art (see figs. 42, 53). Yet we cannot fully account for the presence of the crossed lions at Moissac in terms of their effectiveness as ornament. They belong to an extensive family of savage or monstrous creatures in Romanesque art that retain their demoniacal vitality even though they are compelled, like our lions, to perform a supporting function. Their purpose is thus not merely decorative but expressive as well. They embody dark forces that have been domesticated into guardian figures or banished to a position that holds them fixed for all eternity, however much they may snarl in protest.

The south portal at Moissac displays the same richness of invention that Bernard of Clairvaux condemned in his famous letter of 1127 to Abbot William of St-Thierry about the sculpture of Cluny:

In the cloister under the eyes of the brethren who read there, what profit is there in those ridiculous monsters, in that marvellous and deformed beauty, in that beautiful deformity? . . . So many and so marvellous are the varieties of shapes on every hand, that we are more tempted to read in the marble than in our books, and to spend the whole day wondering at these things rather than in meditating on the law of God. For God's sake, if men are not ashamed of these follies, why at least do they not shrink from the expense?

Although he does not object specifically to the role of art in teaching the unlettered, he had little use for church decoration, and would surely have disapproved of the Moissac portal's excesses, which were clearly meant to appeal to

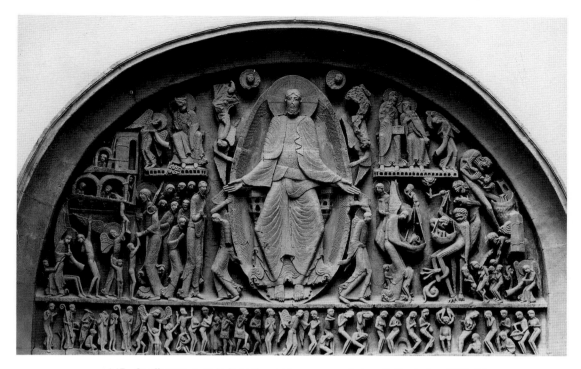

147. Giselbertus. *Last Judgment*, west tympanum, Autun Cathedral. c. 1130–35

the eye—as Bernard's begrudging admiration for the cloister at Cluny so eloquently attests.

Burgundy

The **tympanum** (the half-round panel above the lintel) of the main portal of Romanesque churches is usually given over to a composition centered on the Enthroned Christ, most often the Apocalyptic Vision, or the Last Judgment, the most awesome scene of Christian art. At Autun, this subject has been visualized with singularly expressive force by the sculptor Giselbertus (fig. 147), who probably based his imagery on a contemporary account rather than relying on the Book of Revelation of John. The apostles at the left of Christ observe the weighing of souls to his right as four angels in the corners sound the trumpets of the Apocalypse. At the bottom, the dead rise from their graves in fear and trembling; some are already beset by snakes or gripped by huge, clawlike hands. Above, their fate quite literally hangs in the balance, with devils yanking at one end of the scales and angels

at the other. The saved souls cling like children to the angels for protection before their ascent to the Heavenly Jerusalem (far left), while the condemned are seized by grinning devils and cast into the mouth of Hell (far right). These devils betray the same nightmarish imagination we observed in the Romanesque animal world. They are composite creatures, human in general outline but with spidery, birdlike legs, furry thighs, tails, pointed ears, and enormous, savage mouths. Their violence, unlike that of the animal monsters, is unchecked, and they enjoy themselves to the full in their grim occupation. No visitor, having "read in the marble" here (to speak with Bernard of Clairvaux), could fail to enter the church in a chastened spirit.

The emergence of distinct artistic personalities in the twelfth century is a phenomenon that is rarely acknowledged, perhaps because it contradicts the widespread notion that all medieval art is anonymous. Giselbertus is not an isolated case, however. He cannot even claim to be the earliest. He is among a number of Romanesque

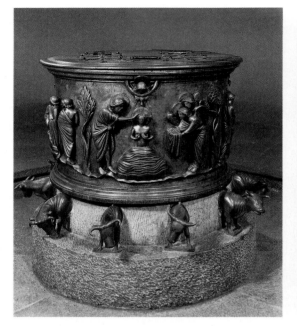

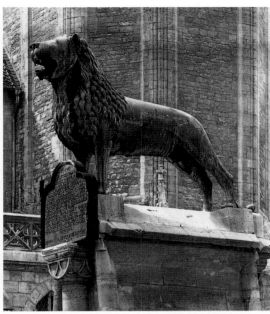

148. Renier of Huy. Baptismal font. 1107–18. Bronze, height 25" (63.5 cm). St-Barthélemy, Liège, Belgium

149. Lion. 1166. Bronze, length approx. 6' (1.83 m). Cathedral Square, Brunswick, Germany

sculptors who are known to us by name—not accidentally. Their highly individual styles made theirs the first identities worthy of being recorded since Anthemius of Tralles and Isidorus of Miletus a half millennium earlier.

The Meuse Valley

The revival of individuality is found, in addition to Burgundy, in one particular region of the north, the valley of the Meuse River, which runs from northeastern France into Belgium and Holland. This region had been the home of the classicizing Reims style in Carolingian times (see figs. 128, 129), and an awareness of classical sources still characterizes its art during the Romanesque period. Here again, interestingly enough, the revival of individuality is linked with the influence of ancient art, although this influence did not produce works on a monumental scale.

Mosan sculptors excelled in metalwork, such as the splendid baptismal font of 1107–18 in Liège (fig. 148). The masterpiece of the earliest among the individually known artists of this region, Renier of Huy, the vessel rests on

twelve oxen (symbols of the Twelve Apostles), like Solomon's basin in the Temple at Jerusalem as described in the Bible. The reliefs make an instructive contrast with those of Bernward's doors (see fig. 133), since they are about the same height. Instead of the rough expressive power of the Ottonian panel, we find here a harmonious balance of design, a subtle control of the sculptured surfaces, and an understanding of organic structure that, in medieval terms, are amazingly classical. The figure seen from the back (beyond the tree on the left in our picture), with its graceful turning movement and Greek-looking drapery, might almost be taken for an ancient work.

Germany

The one monumental freestanding statue of Romanesque art—perhaps not the only one made, but the only one that has survived—is that of an animal, and in a secular rather than a religious context: the lifesize bronze lion on top of a tall shaft that Duke Henry the Lion of Saxony had placed in front of his palace at Brunswick in 1166 (fig. 149). The wonderfully

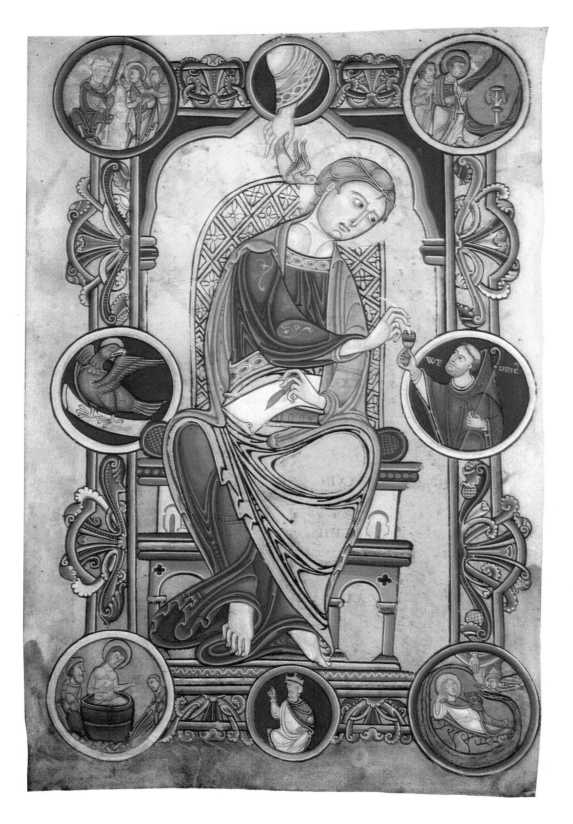

150. *Saint John the Evangelist,* from the *Gospel Book of Abbot Wedricus.* Tempera on vellum, 14 x 9¹/₂" (35.5 x 24 cm). c. 1147. Société Archéologique et Historique, Avesnes-sur-Helpe, France

Hildegard of Bingen

The late tenth through the twelfth century witnessed an unprecedented surge of influential women, first as patrons of art and then, especially in Germany, as artists. This remarkable chapter began with the Ottonian dynasty, which forged an alliance with the Church by placing members of the family in prominent positions. Mathilde, Otto I's granddaughter, became abbess of the Holy Trinity convent at Essen in 974; later, the sister, daughters, and granddaughter of Otto II served as abbesses of major convents. Hardly less important, though not of royal blood, were Hrosvitha, canoness at a monastery in Gandersheim, who was the first woman dramatist we know of, and two abbesses at Niedermünster, both named Uota. Such women, in turn, paved the way for Herrad of Hohenberg (d. 1195), author of *The Garden of Delights*, a compilation of religious knowledge that presented a complete medieval worldview for the education of her nuns.

Most remarkable of all was the Benedictine abbess Hildegard of Bingen (1098–1179). One of the most brilliant women in history, she was in close correspondence with Europe's foremost political and ecclesiastical leaders. In addition to composing a musical drama in Latin, the *Ordo virtutum (Order of the Virtues)*, about the struggle between the forces of good and evil, she composed more than seventy highly original vocal works that rank with the finest medieval music. She also wrote some thirteen books on theology, medicine, and science. She is known above all for the three books of her visions, which made her one of the great spiritual voices of her day. The first of them, *Scivias (To Know the Ways of God)*, is now known only in facsimile (it was destroyed in 1945) and the last, *Liber divinorum operum (The Book of Divine Works)*, in a later reproduction. It seems likely that the originals were illustrated under Hildegard's direct supervision by nuns in her convent on the Rhine River in Germany or by monks at the abbey of St. Eucharius at Trier. That there were women artists in the twelfth century is certain, although we know only a few of their names. In one instance, an illuminated initial includes a nun bearing a scroll inscribed, "Guda, the sinful woman, wrote and illuminated this book," while another book depicts one Claricia, evidently a lay artist, swinging as carefree as any child from the letter *Q* she has decorated.

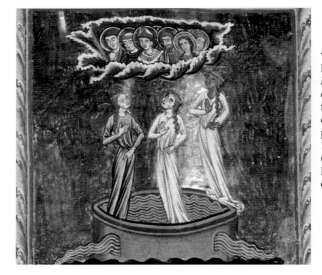

"The Fountain of Life," detail from *Liber divinorum operum*, Vision 8, fol. 132r. 13th century. Temperaon vellum, 13 1/8 x 5 5/8" (33.3 x 14.4 cm). Biblioteca Statale di Lucca, Italy

This detail, from Vision 8 of *The Book of Divine Works,* illustrates Hildegard's vision of the fountain of life: "I also saw . . . three figures, two of whom were standing in a fountain of great purity, which was surrounded by a round stone, pierced with holes. . . . One was clad in purple, the other in white. . . . The third, however, was standing out of the fountain, on the stone. . . . and her face shone with such radiance that my face flinched from it. And the blessed ranks of saints appeared like clouds before them and they gazed intently upon them."

Fiona Bowie and Oliver Davies, eds. *Hildegard of Bingen: Mystical Writings*. New York: Crossroads, 1993. page 99

ferocious beast personifies the duke, or at least that aspect of his personality that earned him his nickname. It will remind us in a curious way of the Etruscan bronze she-wolf of Rome (see fig. 81). Perhaps the resemblance is not entirely coincidental, since the she-wolf was on public view in Rome at that time and must have had a strong appeal for Romanesque artists.

Painting and Metalwork

Unlike architecture and sculpture, Romanesque painting shows no sudden revolutionary developments that set it apart immediately from Carolingian or Ottonian. Nor does it look more "Roman" than Carolingian or Ottonian painting. This does not mean, however, that in the eleventh and twelfth centuries painting was any less important than it had been during the earlier Middle Ages. The absence of dramatic change merely emphasizes the greater continuity of the pictorial tradition, especially in manuscript illumination. Nevertheless, soon after the year 1000 we find the beginnings of a painting style that corresponds to—and often anticipates—the monumental qualities of Romanesque sculpture.

The Channel Region

Although Romanesque painting, like architecture and sculpture, developed a wide variety of regional styles throughout western Europe, its greatest achievements emerged from the monastic scriptoria of northern France, Belgium, and southern England. The works produced in this area are so closely related in style that it is at times impossible to be sure on which side of the English Channel a given manuscript originated. Thus, the style of the wonderful miniature of Saint John (fig. 150) has been linked with both Cambrai, France, and Canterbury, England. Here the abstract linear drafting of early medieval manuscripts (see fig. 128) has been influenced by Byzantine style (note the ropelike loops of drapery, whose origin can be traced back to such works as the Crucifixion at Daphni in figure 117 and even further, to the ivory panel in figure 110), but without losing its energetic rhythm. It is the precisely controlled dynamics of every contour, both in the main figure and in the frame, that unite the varied elements of the composition into a coherent whole. This quality of line still betrays its ultimate source in the Celtic-Germanic heritage. If we compare our miniature with the *Lindisfarne Gospels* (see fig. 123), we see how much the interlacing patterns of the Early Middle Ages have contributed to the design of the Saint John page. The drapery folds and the clusters of floral ornament have an impulsive yet disciplined aliveness that echoes the intertwined snakelike monsters of the animal style, even though the foliage is derived from the classical acanthus and the human figures are based on Carolingian and Byzantine models. The unity of the entire page, however, is conveyed not only by the forms but by the content as well. The Evangelist "inhabits" the frame in such a way that we could not remove him from it without cutting off his ink supply (proffered by the donor of the manuscript, Abbot Wedricus), his source of inspiration (the dove of the Holy Spirit in the hand of God), or his identifying symbol (the eagle). The other medallions, less directly linked with the main figure, show scenes from the life of Saint John.

The linearity and the simple, closed contours of this painting style lend themselves readily to other mediums and to changes in scale (murals, tapestries, **stained-glass** windows, sculptured reliefs). The so-called *Bayeux Tapestry* is an embroidered **frieze** 230 feet long, illustrating William the Conqueror's invasion of England. In our detail (fig. 151, page 186) portraying the Battle of Hastings, the main scene is enclosed by two border strips that perform a framing function. The upper tier with birds and animals is purely decorative, but the lower strip is full of dead warriors and horses and thus forms part of the story. Although told in a direct style devoid of such pictorial devices of classical painting as foreshortening and overlapping (see fig. 58), the tapestry gives us an astonishingly vivid and detailed account of warfare in the eleventh century. The massed forms of the Graeco-Roman scene are gone, replaced by a new kind of individualism that makes of each combatant a potential hero, whether by force or cunning. (Observe how the soldier who has fallen from the horse that is somersaulting with its hind legs in the air is, in turn, toppling his adversary by yanking at the saddle girth of his mount.)

Southwestern France

The firm outlines and strong sense of pattern found in the Channel region are equally characteristic of Romanesque wall painting in southwestern France. *The Building of the Tower of Babel* (fig. 152, page 186) is part of the most impressive surviving cycle, on the nave vault of the church at St-Savin-sur-Gartempe. It is an intensely dramatic design, crowded with strenuous action. The Lord himself, on the far left, participates directly in the narrative as he addresses the builders of the colossal structure. He is counterbalanced, on the right, by the giant Nimrod, the leader of the enterprise, who frantically hands blocks of stone to the masons atop the tower, so that the entire scene becomes a great test of strength between God and human. The heavy dark contours and the emphatic play of gestures make the composition eminently readable from a distance; yet

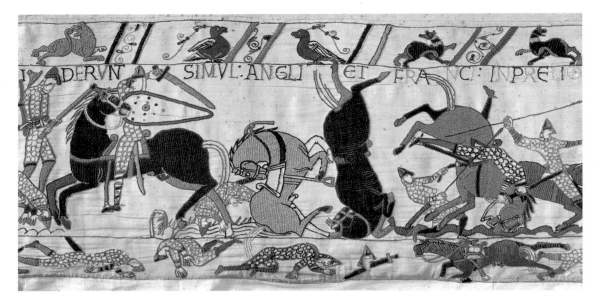

151. *The Battle of Hastings*. Detail of the *Bayeux Tapestry*. c. 1073–83. Wool embroidery on linen, height 20"
(50.8 cm). Centre Guillaume le Conquérant, Bayeux, France

152. *The Building of the Tower of Babel*. Detail of painting on the nave vault, St-Savin-sur-Gartempe, France.
Early 12th century

the same qualities occur in the illuminated manuscripts of the region, which can be equally monumental despite their small scale.

The Meuse Valley

Soon after the middle of the twelfth century, an important change of style began to make itself felt in Romanesque painting on both sides of the English Channel. *The Crossing of the Red Sea* (fig. 153), one of many enamel plaques that make up a large ▼ALTARPIECE at Klosterneuburg by Nicholas of Verdun, shows that lines have suddenly regained their ability to describe three-dimensional forms instead of abstract patterns. Indeed, the figures, clothed in rippling, "wet" draperies familiar to us from countless classical statues, exhibit a high degree of organic body structure and freedom of movement. Here we meet the pictorial counterpart of the classicism that we saw earlier in the baptismal font of Renier of Huy at Liège (see fig. 148). That the new style should have had its origin in metalwork (which includes not only **casting** and **embossing** but also **engraving**, **enameling**, and goldsmithing) is not as strange as it might seem, for its essential qualities are sculptural rather than pictorial. Moreover, metalwork had been a highly developed art in the Meuse Valley area since Carolingian times. In these "pictures on metal," Nicholas straddles the division between sculpture and painting, as well as that between Romanesque and Gothic art. Although the *Klosterneuburg Altarpiece* was completed well before the end of the twelfth century, there is an understandable inclination to rank it as a harbinger of the style to come, rather than the culmination of a style that had been. Indeed, this altarpiece was to have a profound impact on the painting and sculpture of the next fifty years.

No less revolutionary than this stylistic innovation is the new expressiveness that unites

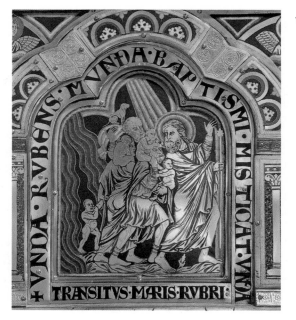

153. Nicholas of Verdun. *The Crossing of the Red Sea*, from the *Klosterneuburg Altarpiece*. 1181. Enamel on gold plaques, height 5¹/₂" (14 cm). Klosterneuburg Abbey, Austria

all the figures, even the little dog perched on the bag carried by one of the men, through the exchange of glances and gestures within the tightly knit composition. Since late Roman times we have seen such concentrated drama only in Middle Byzantine art, and indeed its intensity is uniquely medieval. The astonishing humanity of Nicholas of Verdun's art must be understood against the background of a general reawakening of interest in human beings and the natural world throughout northwestern Europe. This attitude could express itself in various ways: as a new regard for classical literature and mythology, as an appreciation of the beauty of ancient works of art, or simply as a greater readiness to acknowledge the enjoyment of sensuous experience.

▼ ALTARS are tables or sometimes low stones that are the focal point of religious worship, often the site of sacrificial rites. Altars have been found at most Neolithic sites and are virtually universal. The Christian altar traditionally is a narrow stone "table" that contains bone fragments of a martyr within it (Protestants do not have this requirement) and a prescribed set of liturgical objects used in the rite of Eucharist on the top surface (the mensa). The altar frontal (antependium) may be plain or decorated. An ALTARPIECE is not an altar but is an independent unit, invariably bearing images, that stands on or just behind an altar. Early altarpieces were wingless, with painted or carved images in the shrine section and more images in the predella zone below the shrine. In its simplicity, this altarpiece is typically Romanesque, with a single panel above a lower tier, called a predella. Winged altarpieces were developed in the twelfth century. Wings allow the imagery to change according to the church calendar.

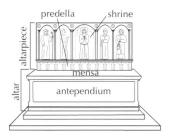

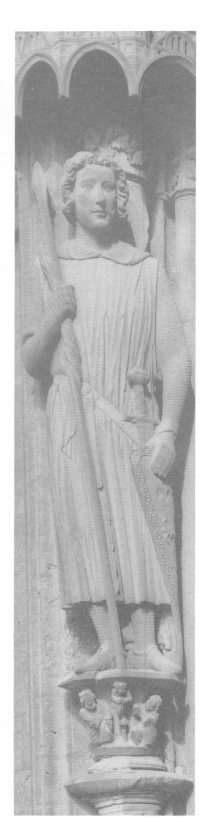

Chapter 11
Gothic Art

The term *Gothic* was first coined for architecture, and it is in architecture that the characteristics of the style are most easily recognized. For a century—from about 1150 to 1250, during the age of the great cathedrals—architecture retained its dominant role. Gothic sculpture was at first severely architectural in spirit but became less and less so after 1200; its greatest achievements occurred between the years 1220 and 1420. Painting, in turn, reached a climax of creative endeavor between 1300 and 1350 in central Italy. North of the Alps, painting became the leading art after about 1400. We thus find, in surveying the Gothic era as a whole, a gradual shift of emphasis from architecture to painting—or, better perhaps, from architectural to pictorial qualities.

Overlying this broad pattern is another one: international diffusion rather than regional independence. Starting as a local development in the Île-de-France region surrounding Paris, Gothic art radiated from there to the rest of France and to all Europe, where it came to be known as *opus modernum* or *opus francigenum* ("modern work" or "French work"). In the course of the thirteenth century, the new style gradually lost its imported flavor, and regional variety began to reassert itself. Toward the middle of the fourteenth century, we notice a growing tendency for these regional achievements to influence each other until, about 1400, a surprisingly homogeneous "International Style" prevails almost everywhere. Shortly thereafter, this unity broke apart. Italy, with Florence in the lead, created a radically new art, that of the Early Italian Renaissance, while north of the Alps, Flanders assumed an equally commanding position in the development of "Late Gothic" painting and sculpture. A century later, the Italian Renaissance became the basis of another style that is international. This development roughly parallels what happened in the political arena. Supported by shifting alliances with the papacy, the kings of France and England emerged as the leading powers at the expense of the Germans in the early thirteenth century, which was generally a time of peace and prosperity. Under these supportive conditions, the new Franciscan and Dominican orders were established and Catholicism found Thomas Aquinas, its greatest intellect since Saint Augustine and Saint Jerome some 850 years earlier. After 1290, however, the balance of power quickly broke down, resulting in the exile of the papacy to Avignon, France, in 1305 for more than seventy years.

Architecture

France

Abbey Church of St-Denis We can pinpoint the origin of no previous style as exactly as that of Gothic. It was born between 1137 and 1144 in the rebuilding by Abbot Suger of the royal Abbey Church of St-Denis just outside the city of Paris. If we are to understand how Gothic architecture happened to come into being at this particular spot, we must first acquaint ourselves with the special relationship between St-Denis, Suger, and the French monarchy. The kings of France derived their claim to authority from the Carolingian tradition, although they belonged to the Capetian line (founded by Hugh Capet after the death of the last Carolingian in 987). But their power was eclipsed by that of the nobles who, in theory, were their vassals. The only area the kings ruled directly was the Île-de-France, and they often found their authority challenged even there. Not until the early twelfth century did the royal power begin to expand, and Suger, as chief adviser to Louis VI, played a key role in this process. It was he who forged the alliance between the monarchy and the Church, which brought the bishops of France (and the cities under their authority) to the king's side, while the king, in turn, supported the papacy in its struggle against the German emperors.

Suger championed the monarchy not only in practical politics but in "spiritual politics." By investing the royal office with religious significance and glorifying it as the strong right arm of justice, he sought to rally the nation behind the king. His architectural plans for the Abbey Church of St-Denis must be understood in this context, for the church, founded in the late eighth century, enjoyed a dual prestige that made it ideally suitable for Suger's purpose. It was the shrine of Saint Denis (d. c. A.D. 250), the Apostle of France and special protector of the realm, as well as the chief memorial of the Carolingian dynasty. Both Charlemagne and his father, Pepin, had been consecrated kings there, and it was also the burial place of Charles Martel, Pepin, and Charles the Bald. Suger wanted to make the abbey church the spiritual

154. Ambulatory, Abbey Church of St-Denis, Île-de France. 1140–44

center of France, a pilgrimage church to outshine the splendor of all the others, the focal point of religious as well as patriotic emotion. But in order to become the visible embodiment of such a goal, the old edifice had to be enlarged and rebuilt. The great abbot himself has described the campaign in considerable detail. Unfortunately, the west **facade** and its sculpture are sadly mutilated today, and the **choir** at the east end, which Suger regarded as the most important part of the church, retains its original appearance only in the **ambulatory** (fig. 154).

The ambulatory and radiating chapels surrounding the **arcaded apse** are familiar elements from the Romanesque pilgrimage choir (compare fig. 135), yet they have been integrated in strikingly novel fashion. The **chapels**, instead of remaining separate entities, are merged so as to form, in effect, a second ambulatory, and ribbed **groin vaulting** based on the pointed arch is employed throughout. (In the Romanesque pilgrimage choir, only the ambulatory had been groin-vaulted.) As a result, the entire plan is held together by a new kind of geometric order. It consists of seven nearly identical wedge-shaped units fanning out from the center of the apse. (The central chapel, dedicated to the Virgin, and its neighbors on each side are slightly larger, pre-

sumably because of their greater importance.) We experience this double ambulatory not as a series of separate compartments but as a continuous (though articulated) space, whose shape is outlined for us by the network of slender **arches**, **ribs**, and **columns** that sustains the **vaults**.

What distinguishes this interior immediately from its predecessors is its lightness, in both senses. The architectural forms seem graceful, almost weightless when compared with the massive solidity of the Romanesque, and the windows have been enlarged to the point that they are no longer openings cut into a wall—they fill the entire wall area, so that they themselves become translucent walls, making possible an abundance of light. The outward pressure of the vaults is contained by heavy **buttresses** jutting out between the chapels. The main weight of the masonry construction is concentrated there, visible only from the outside. No wonder, then, that the interior appears so amazingly airy and weightless, since the heaviest members of the structural skeleton are beyond our view. The same impression would be even more striking if we could see all of Suger's choir, for the upper part of the apse, rising above the double ambulatory, had very large, tall windows. The effect, from the nave, must have been similar to that of the somewhat later choir of Nôtre-Dame in Paris (see fig. 156).

Suger and Gothic Architecture In describing Suger's choir, we have also described the essentials of Gothic architecture. Yet none of the individual elements that entered into its design is really new. The pilgrimage choir plan, the pointed arch, and the ribbed groined vault can be found in various regional schools of the French and Anglo-Norman Romanesque, even though we never encounter them all combined in the same building until St-Denis. The Île-de-France had failed to develop a Romanesque tradition of its own, so that Suger (as he himself tells us) had to bring together artisans from many different regions for his project. We must not conclude from Suger's process, however, that Gothic architecture originated as no more than a synthesis of Romanesque traits. If it were only that, we would be hard pressed to explain the new spirit that strikes us so forcibly at St-Denis: the emphasis on geometric planning and the quest for luminosity.

Suger's account of the rebuilding of his church insistently stresses both of these as the highest values achieved in the new structure. Harmony (that is, the perfect relationship among parts in terms of mathematical proportions or ratios) is the source of all beauty, since it exemplifies the laws according to which Divine Reason has constructed the universe. Thus, it is suggested, the "miraculous" light that floods the choir through the "most sacred" windows becomes the Light Divine, a revelation of the spirit of God.

Suger was not a scholar but a man of action who was conventional in his thinking. It is probable that he consulted the contemporary theologian Hugh of St-Victor, who was steeped in Pseudo-Dionysian thought, for the most obscure part of his program at the west end of the church. This does not mean that Suger's own writings are little more than a justification after the fact. On the contrary, he clearly knew his own mind. What, then, was he trying to achieve? Like the three blind men trying to describe an elephant from different parts, scholars have come to surprisingly little agree-

ment. For Suger, the material realm was the stepping-stone for spiritual contemplation. Thus, the actual experience of dark, jewel-like light that disembodies the material world lies at the heart of Suger's mystical intent, which was to be transported to "some strange region of the universe which neither exists entirely in the slime of earth nor entirely in the purity of Heaven."

Suger and the Medieval Architect The success of the choir design at St-Denis is proved not only by its inherent design qualities but also by its extraordinary impact. Every visitor, it seems, was overwhelmed by the achievement, and within a few decades the new style had spread far beyond the confines of the Île-de-France. The how and why of its success are a good deal more difficult to explain. Here we encounter a debate we have met several times before—that of form versus function. To the advocates of the functionalist approach, Gothic architecture has seemed the result of advances in architectural engineering, which made it possible to build more efficient vaults, to concentrate their **thrust** at a few critical points, and thus to eliminate the solid walls of the Romanesque structure. Suger, they would argue, was fortunate in securing the services of an architect who evidently understood the principles of ribbed groin vaulting better than anybody else at that time. If the abbot chose to interpret the resulting structure as symbolic of Pseudo-Dionysian theology, he was simply expressing his enthusiasm over it in the abstract language of the cleric, so that his account does not help us to understand the origin of the new style.

As the careful integration of its components suggests, the choir of St-Denis is more rationally planned and constructed than any Romanesque church. The pointed arch (which can be "stretched" to reach any desired height regardless of the width of its base) has now become an integral part of the ribbed groin vault. As a result, these vaults are no longer restricted to square or near-square compartments. They have gained a flexibility that permits them to cover areas of almost any shape (such as the trapezoids and pentagons of the ambulatory). The buttressing of the vaults, too, is more fully understood than before.

It is difficult to see how the ideas of Suger could have led to these technical advances unless we are willing to assume that he was a professionally trained architect. If we grant that he was not, can he claim any credit at all for the style of what he so proudly calls "his" new church? Oddly enough, there is no contradiction here. As we have seen (see "What Is an Architect and What Is a Master," page 161), the term *architect* was understood in a very different way from the modern sense, which derives from Greece and Rome by way of the Italian Renaissance. To the medieval mind, Suger was the overall leader of the project, not the master builder responsible for its construction—as his account makes abundantly clear, which is why he remains so silent about his helper. Furthermore, professional architectural training as we know it did not exist at the time.

Perhaps the question poses a false alternative, somewhat like the conundrum of the chicken and the egg. The function of a church, after all, is not merely to enclose a maximum of space with a minimum of material but to communicate the great religious ideas that lie behind it. For the builder who constructed the choir of St-Denis, the technical problems of vaulting must have been inextricably bound up with such ideas, as well as considerations of form—of beauty, harmony, fitness, and so forth. As a matter of fact, the design includes various elements that express function without actually performing it, such as the slender shafts (called responds) that seem to carry the weight of the vaults to the church floor.

But in order to know what concepts to convey, the medieval architect needed the guidance of ecclesiastical authority. At a minimum, such guidance might be a simple directive to follow some established model, but in the case of Suger, it amounted to a more active role. It seems that he began with one builder at the west end but was disappointed in the results and had it torn down. This not only indicates Suger's participation in the design process but also confirms his position as the architect of St-Denis in the medieval sense. Suger's views no doubt helped to determine his choice of a second builder of Norman background to translate them into the kind of structure he wanted,

not simply as a matter of design preference. This great artist must have been singularly responsive to the abbot's objectives. Together, they created the Gothic. We have seen this kind of close collaboration between patron and architect before: it existed between Djoser and Imhotep, Perikles and Phidias, just as it does today.

Nôtre-Dame, Paris Although St-Denis was an abbey just north of Paris, the future of Gothic architecture lay in the towns rather than in rural monastic communities. There had been a vigorous revival of urban life, we will recall, since the early eleventh century. This movement continued at an accelerated pace, and the growing size of the cities was felt not only economically and politically but in countless other ways as well. Bishops and the city clergy rose to new importance. That is why the Gothic era is known as the great age of cathedrals. (A cathedral is the principal church of the territory presided over by a bishop, usually in the leading city of his jurisdiction.) Cathedral schools and universities took the place of monasteries as centers of learning, while the artistic efforts of the age culminated in the great cathedrals.

Nôtre-Dame ("Our Lady," the Virgin Mary) at Paris, begun in 1163, reflects the salient features of Suger's church at St-Denis more directly than does any other cathedral. The plan (fig. 155), with its emphasis on the longitudinal axis, is extraordinarily compact and unified compared to that of major Romanesque churches. The double ambulatory of the choir continues directly into the aisles, and the short transept barely exceeds the width of the facade. The sexpartite (six-part) nave vaults over squarish bays, although not identical to the groin vaulting in Durham Cathedral (see fig. 140), nevertheless continue the kind of structural experimentation that was begun by Norman Romanesque builders. Inside (fig. 156), we find other echoes of that style in the galleries above the inner aisles and the columns used in the nave arcade. Here, too, the pointed ribbed arches, which were pioneered in the western bays of the nave at Durham, are continued systematically throughout the building. Yet the large clerestory windows and the lightness and

155. Plan of Nôtre-Dame, Paris. 1163–c. 1250

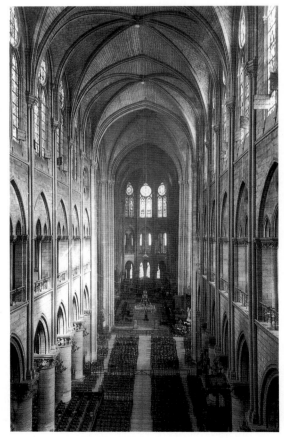

156. Nave and choir, Nôtre-Dame, Paris

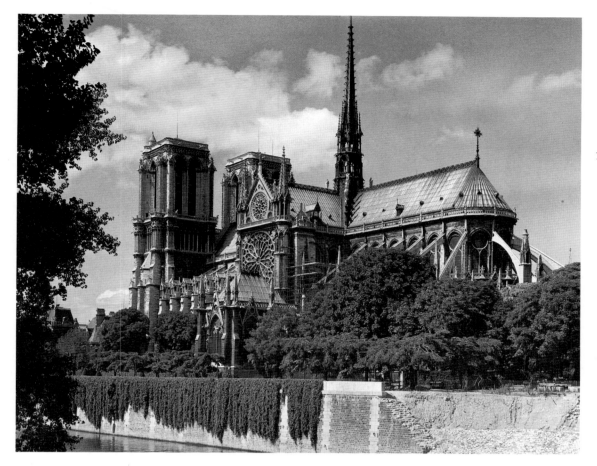

157. Nôtre-Dame, Paris
(view from the southeast)

slenderness of the forms create the "weightless" effect that we associate with Gothic interiors and make the nave walls seem thin. Gothic, too, is the verticality of the interior space. This vertical sense depends less on the actual proportions of the nave—some Romanesque naves are equally tall, relative to their width—than on the constant accenting of the verticals and on the soaring ease with which the sense of height is attained. Romanesque interiors (such as that in fig. 137), by contrast, emphasize the great effort required in supporting the weight of the vaults.

In Nôtre-Dame, as in Suger's choir, the buttresses (the "heavy bones" of the structural skeleton) are not visible from the inside. The plan shows them as massive blocks of masonry that project from the building like a row of teeth. Above the aisles, these piers turn into **flying buttresses**—arched bridges that reach upward to the critical spots between the clerestory windows where the outward thrust of the nave vault is concentrated (figs. 157, 158). This

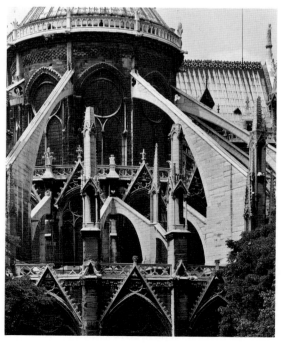

158. Flying buttresses, Nôtre-Dame, Paris

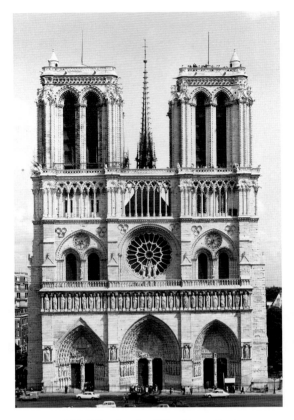

159. West facade, Nôtre-Dame, Paris

three main parts, the placing of the portals, and the three-story arrangement. The rich sculptural decoration, however, recalls the facades of southwestern France and the elaborately carved portals of Burgundy (see fig. 145).

Much more important than these resemblances are the qualities that distinguish the facade of Nôtre-Dame from its Romanesque ancestors. Foremost among these is the way all the details have been integrated into a wonderfully balanced and coherent whole. The meaning of Suger's emphasis on harmony, geometric order, and proportion becomes evident here even more strikingly than in St-Denis itself. This formal discipline also embraces the sculpture, which is no longer permitted the spontaneous growth so characteristic of the Romanesque but has been assigned a precisely defined role within the architectural framework. At the same time, the cubic solidity of the facade of St-Étienne at Caen has been transformed into its very opposite. Lacelike arcades, huge portals, and windows dissolve the continuity of the wall surfaces, so that the total effect approximates that of a weightless openwork screen. How rapidly this tendency advanced during the first half of the thirteenth century can be seen by comparing the west front of Nôtre-Dame with the somewhat later facade of the south transept, visible in the center of figure 157. In the west facade, the **rose window** in the center is still deeply recessed and, as a result, the stone **tracery** that subdivides the opening is clearly set off against the surrounding wall surface. On the transept facade, in contrast, we can no longer distinguish the rose window from its frame, as a single network of tracery covers the entire area.

Chartres Cathedral Alone among all major Gothic cathedrals, Chartres still retains most of its more than 180 original stained-glass windows. The magic of the colored light streaming down from the clerestory through the large windows is unforgettable to anyone who has experienced their intense, jewel-like hues (fig. 160). The windows admit far less light than one might expect. They act mainly as multicolored diffusing filters that change the *quality* of

method of anchoring vaults, a characteristic feature of Gothic architecture, certainly owed its origin to functional considerations. Even the flying buttress, however, soon became aesthetically important, and its shape could express support (apart from actually providing it) in a variety of ways, according to the designer's sense of style.

The most monumental aspect of the exterior of Nôtre-Dame is the west facade (fig. 159). Except for its sculpture, which suffered greatly during the French Revolution and is for the most part restored, it retains its original appearance. The design reflects the general disposition of the facade of St-Denis, which in turn had been derived from Norman Romanesque facades such as that of St-Étienne at Caen (see fig. 139). Comparing the latter with Nôtre-Dame, we note the persistence of some basic features: the pier buttresses that reinforce the corners of the towers and divide the front into

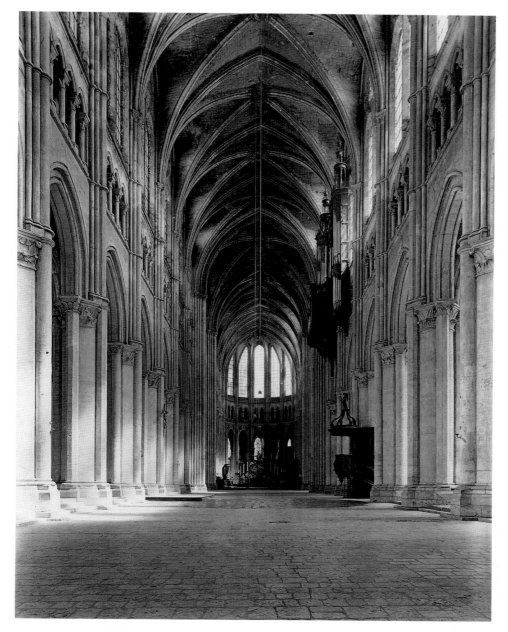

160. Nave and choir, Chartres Cathedral, France. 1145–1220

ordinary daylight, endowing it with the poetic and symbolic values—the "miraculous light"—so highly praised by Abbot Suger. The sensation of ethereal light, which dissolves the physical solidity of the church and, hence, the distinction between the temporal and the divine realms, creates the intensely mystical experience that lies at the heart of Gothic spirituality.

The High Gothic style defined at Chartres reaches its climax a generation later. Breathtaking height becomes the dominant aim, both technically and aesthetically. Skeletal construction is carried to its most precarious limits. The inner logic of the system forcefully asserts itself in the shape of the vaults, taut and thin as membranes, and in the expanded window area, so that the entire wall above the nave arcade becomes a clerestory.

Medieval Music and Theater

As in ancient Greece, music and theater were intimately connected during the Middle Ages. Indeed, medieval theater was in large part a direct outgrowth of musical performance. The only musical texts that survive from the Middle Ages before the late eleventh century are religious, and these, like Early Christian visual art, bring together Roman, Greek, Jewish, and Syrian elements. These early medieval pieces, or CHANTS, were in the form of PLAINSONG, a single, unaccompanied line of melody in free rhythm. Plainsong continued many of the features of the ancient Greek modes (see page 89), but in altered form, because the early medieval writers seem to have partially misunderstood the Greek music theory.

One of the most important early medieval composers was Ambrose, a fourth-century bishop of Milan, who introduced an early variety of plainsong now known as AMBROSIAN CHANT. Over the next two centuries, Ambrosian chant was developed further, especially by the choir of the papal chapel in Rome. Around 600, Pope Gregory the Great (papacy 590–604) codified the Church's liturgy (the prescribed form for various worship services and other rites), including the music to be sung in each kind of service. The plainsong style in use in Rome at this time, and which is still sung in many Catholic services even today, is known as GREGORIAN CHANT.

At first, medieval chant was sung in unison, one word to a note, but gradually more notes were added for some syllables. Eventually some of these multinote passages were elaborated into long musical phrases (MELISMAS), until there were so many notes for each word that additional, often unrelated texts could be inserted into the work. These interpolated texts (TROPES, from the Latin *tropus*, for "added melody") ultimately developed into medieval drama. The introduction of dramatic elements was also eased by the interplay between two choruses (ANTIPHONS), or between a soloist and a choir (RESPONSES).

The burgeoning complexity of medieval music stimulated the gradual evolution of music theory—an organized code of rules comparable to the grammar of a spoken language—that culminated in the thirteenth century, when a system for musical notation was perfected. The development of this body of theory may be compared to the gradual evolution of architectural principles during the Romanesque and Gothic eras, as musicians sought a comprehensive structure for their work. New centers of chant grew up, the most important of which was the Cathedral of Nôtre-Dame in Paris, where a new type of POLYPHONIC MUSIC (music in parts), called ORGANUM, developed from the ninth to the thirteenth century. Organum might have two or more voices, which sang the same words and melody a given interval apart, sometimes with a plainsong underpinning (*cantus firmus*). These pieces became gradually more complex, until around 1200 each voice was assigned its own text and melodic line. The resulting multivoiced composition, sometimes with instrumental accompaniment, was called a MOTET (from French *mot*, "word"). The motet was such an appealing form that it was quickly secularized, when vernacular verses, chiefly love poems, were substituted for religious texts.

Like Gothic architecture, the Nôtre-Dame style quickly spread throughout Europe, and lasted until about 1400. It was gradually replaced after 1325 by a new musical style, called *ars nova* (new art), which featured polyphonic singing of ever-greater complexity and subtlety, especially in its elaborate rhythms. The greatest exponent of *ars nova* was Guillaume de Machaut (c. 1300–77), a cleric who served the kings of Bohemia and France and was also considered the finest poet of his day—a perfect blend of religious and secular talents characteristic of the Gothic era as a whole. Guillaume de Machaut represented a new figure in European culture: the professional composer. During the twelfth and thirteenth centuries, courtly music had been composed by aristocratic amateurs (called *trouvères*, *troubadours*, or *Minnesingers*), who wrote songs chiefly on the theme of courtly love, but often left the actual performance to minstrels, or *jongleurs*. Because of its sophistication, however, *ars nova* increasingly required professional musicians to compose and play it. In its elaboration, *ars nova* paralleled the complexly ornamented late phase of Gothic architecture. It may also be seen as a musical counterpart to late medieval scholasticism, which presented an equally complex blend of theology and philosophy.

Although theater, too, came eventually to rely on vernacular texts, it remained associated with religious life for a long time. Plays were performed at the great religious feasts, such as Christmas and Easter, and liturgical drama flourished at many of the same monasteries and churches that contributed to the development of medieval art and music, such as St. Gall in Switzerland. Not surprisingly, theater and music shared many of the same subjects, such as the Passion cycle. The close affiliation between them is illustrated by the career of such composer-playwrights as Hildegard of Bingen (see page 184). Another link of the two performing arts to religious life was architectural: music and drama were presented exclusively inside churches before 1200. Religious plays, acted by the priests and choirboys, often involved intricate self-contained architectural sets, called mansions. In the early thirteenth century, performances were moved outdoors to the churchyards. At the same time, secular plays and farces illustrating moral lessons began to develop out of religious drama.

During the late Middle Ages, theater flourished as towns grew prosperous and the major guilds began to shoulder the costs of staging religious pageants. The dramas best known today—such as the vast Corpus Christi cycle performed at York, England, the great Passion plays, and morality plays like *Everyman*—date from the fourteenth century and later. These were community affairs, mounted in town squares, in which guild members assumed all the roles, so that there was no clear distinction between religious and popular theater. The medieval tradition of music and theater continued into the Renaissance, especially in the North. The most important figure in this tradition was Hans Sachs (1494–1576), the head of the shoemakers' guild in Nuremberg. A *Meistersinger* (master singer) and composer immortalized by Richard Wagner in a nineteenth-century German opera, Sachs wrote thousands of songs, fables, verses, religious plays, and secular farces.

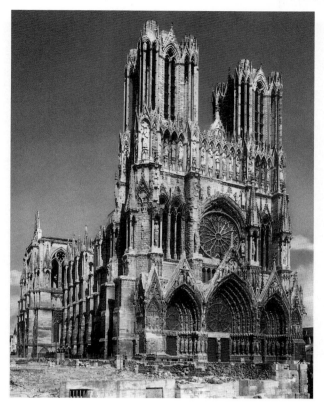

161. West facade, Reims Cathedral, France. c. 1225–99

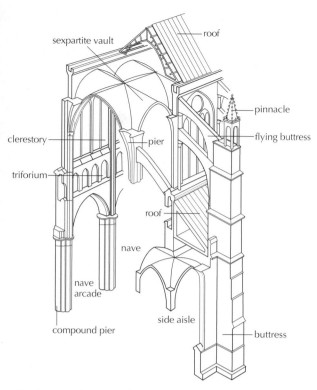

162. Cutaway drawing of a High Gothic cathedral (after Acland)

Reims Cathedral The same emphasis on verticality and translucency found in the nave can be traced in the development of the High Gothic facade. The most famous of these facades, at Reims Cathedral (fig. 161), makes an instructive contrast with the west facade of Nôtre-Dame in Paris, even though its basic design was conceived only about thirty years later. Many elements are common to both, but in the younger structure they have been reshaped into a very different ensemble. The portals, instead of being recessed, are projected forward as **gabled** porches, with windows in place of **tympanums** above the doorways. The gallery of royal statues, which in Paris forms an incisive horizontal band between the first and second stories, has been raised until it merges with the third-story arcade. Every detail except the rose window has become taller and narrower than before. A multitude of pinnacles further accentuates the restless upward-pointing movement. The sculptural decoration, by far the most lavish of its kind, no longer remains in clearly marked-off zones. It

has now spread to so many hitherto unaccustomed places, not only on the facade but on the flanks as well, that the exterior of the cathedral begins to look like a decorated cake. The progression toward verticality in French Gothic cathedral architecture occurred relatively swiftly; figure 162 explains how vast height and large expanses of window were achieved toward the end of this development.

International Gothic Architecture

The High Gothic cathedrals of France represent a concentrated expenditure of effort such as the world has rarely seen before or since. They are truly national monuments, whose immense cost was borne by donations collected all over the country and from all classes of society—the tangible expression of that merging of religious and patriotic fervor that had been the goal of Abbot Suger. Among the astonishing things about Gothic art is the enthusiastic response this royal French style of the Paris region

Speaking of

Early Gothic, High Gothic, Classic High Gothic, International Gothic, International Style

The first three of these terms are descriptive of styles, not time periods (the points of difference between styles can be readily inferred from the text). High Gothic and Classic High Gothic creations can and do appear in the same place and at the same time, as do a number of other overlapping styles. International Gothic refers to the spread of French High Gothic style sensibilities outward from the Île-de-France to all of Europe, and International Style (see page 227) describes the lyrical, courtly style of painting and sculpture that flourished around 1400 throughout Europe.

Gothic Art **197**

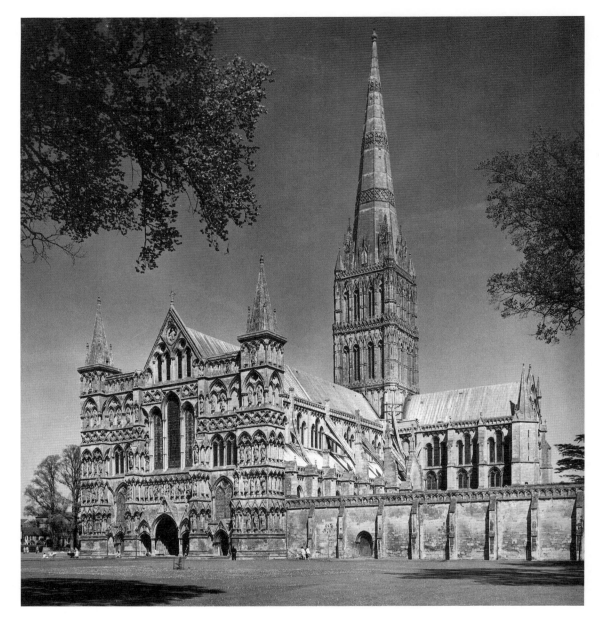

163. Salisbury Cathedral,
England. 1220–70

evoked abroad. Even more remarkable was its
ability to acclimate itself to a variety of local
conditions—so much so, in fact, that the
Gothic monuments of England and Germany
have become objects of intense national pride
in modern times, and critics in both countries
have acclaimed Gothic as a peculiarly "native"
style. A number of factors contributed to the
rapid spread of Gothic art: the superior skill of
French architects and stone carvers; the great
intellectual prestige of French centers of learn-
ing; and the influence of the Cistercians, the
reformed monastic order founded by Bernard
of Clairvaux, which promulgated an austere
version of the Gothic throughout western
Europe. The ultimate reason for the interna-
tional victory of Gothic art, however, seems to
have been the extraordinary persuasive power
of the style itself, its ability to kindle the imag-
ination and to arouse religious feeling even
among people far removed from the cultural
climate of the Île-de-France.

England

That England should have proved particularly receptive to the new style is hardly surprising. Yet English Gothic did not grow directly from Anglo-Norman Romanesque but rather from the Gothic of the Île-de-France, introduced in 1175 by the French architect who rebuilt the choir of Canterbury Cathedral, and from the architecture of the Cistercians. Within less than fifty years, English Gothic developed a well-defined character of its own, known as the Early English style, which is best exemplified in Salisbury Cathedral (fig. 163). We realize immediately how different the exterior is from its counterparts in France—and how futile it would be to judge it by French Gothic standards. Compactness and verticality have given way to a long, low, sprawling look. (The great crossing tower and spire, which provide a dramatic unifying accent, were built a century later than the rest and are much taller than originally planned.) There is no straining after height, and flying buttresses have been introduced only as an afterthought. The west facade has become a screen wall, wider than the church itself and stratified by emphatic horizontal bands of ornament and statuary, while the towers have shrunk to stubby turrets.

English Gothic rapidly developed toward a more pronounced verticality. The choir of Gloucester Cathedral (fig. 164) is a striking example of the English Late Gothic, also called the Perpendicular style. The name certainly fits, since we now find the dominant vertical accent that is so conspicuously absent in the Early English style. (Note the responds running in an unbroken line from the vault to the floor.) In this respect, Perpendicular Gothic is much more akin to French sources, yet it includes so many features we have come to know as English that it would look very much out of place on the Continent. The repetition of small uniform tracery panels recalls the bands of statuary on the west facade at Salisbury. The square end simulates the apses of earlier English churches, and the upward curve of the vault is as steep as in those buildings. The ribs of the vaults, on the other hand, have assumed an

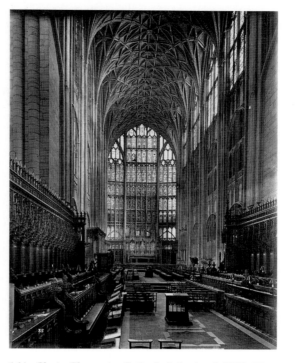

164. Choir, Gloucester Cathedral, England. 1332–57

altogether new role—they have been multiplied until they form an ornamental network that screens the boundaries between the bays and thus makes the entire vault look like one continuous surface. This, in turn, has the effect of emphasizing the unity of the interior space. Such decorative elaboration of the "classic" four-part vault is characteristic of the so-called Flamboyant style on the Continent as well, but the English started it earlier and carried it to greater lengths.

Germany

In Germany, Gothic architecture took root a good deal more slowly than in England. Until the mid-thirteenth century, the Romanesque tradition, with its persistent Ottonian reminiscences, remained dominant, despite the growing acceptance of Early Gothic features. From about 1250 on, however, the High Gothic of the Île-de-France had a strong impact on the Rhineland. Especially characteristic of German Gothic is the *Hallenkirche,* or hall church, with aisles and nave of the same height. In the large hall choir added in 1361–72 to the Church of St. Sebald in

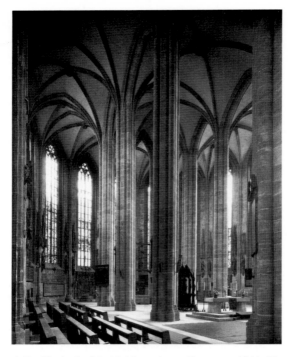

165. Choir, St. Sebald, Nuremberg, Germany. 1361–72

Nuremberg (fig. 165), the space has a fluidity and expansiveness that enfold us as if we were standing under a huge canopy. There is no pressure, no directional command to prescribe our path. And the unbroken lines of the pillars, formed by bundles of shafts that gradually diverge as they turn into ribs, seem to echo the continuous movement we feel in the space itself.

Italy

Italian Gothic architecture stands apart from that of the rest of Europe. Judged by the formal criteria of the Île-de-France, most of it hardly deserves to be called Gothic at all. Yet the Gothic in Italy produced structures of singular beauty and impressiveness that cannot be understood as continuations of the local Romanesque. We must be careful, therefore, to avoid too rigid or technical a standard in approaching these monuments, lest we fail to do justice to their unique blend of Gothic qualities and Mediterranean tradition. It was the Cistercians, rather than the cathedral builders of the Île-de-France, who provided the chief exemplars on which Italian architects based their conception of the Gothic style. As early

as the end of the twelfth century, Cistercian abbeys sprang up in both northern and central Italy, their designs patterned directly after those of the French abbeys of the order.

Abbey Church, Fossanova One of the finest Italian Gothic buildings, at Fossanova, some sixty miles south of Rome, was consecrated in 1208 (fig. 166). Without knowing its location, we would be hard put to decide where to place it on a map—it might as well be Burgundian or English. The plan looks like a simplified version of Salisbury, and the finely proportioned interior bears a strong family resemblance to all Cistercian abbeys of the Romanesque and Gothic eras. There are no facade towers, only a lantern over the crossing, as befits the Cistercian ideal of austerity prescribed by Bernard of Clairvaux. The groin vaults, although based on the pointed arch, have no diagonal ribs; the windows are small; and the architectural detail retains a good deal of Romanesque solidity. Nevertheless, the flavor of the whole is unmistakably Gothic.

Cistercian churches made a deep impression upon the Franciscans, the monastic order founded by Francis of Assisi in the early thirteenth century. As mendicant friars dedicated to poverty, simplicity, and humility, the Franciscans were the spiritual kin of Bernard of Clairvaux, and the severe beauty of Cistercian Gothic must have seemed to them to express an ideal closely related to theirs. From the first, the Franciscans' churches reflected Cistercian influence and thus played a leading role in establishing Gothic architecture in Italy.

Sta. Croce, Florence Sta. Croce in Florence may well claim to be the greatest of all Franciscan structures (fig. 167). It is also an outstanding example of Gothic architecture, even though it has wooden ceilings instead of groin vaults except in the apse. There can be no doubt that this was a matter of deliberate choice, rather than of technical or economic necessity. The choice was made not only on the basis of local practice. (Wooden ceilings had been a feature of the Tuscan Romanesque.) It also sprang perhaps from a desire to evoke the simplicity of Early Christian basilicas and, in doing so, to link Fran-

ciscan poverty with the traditions of the early Church. Since the wooden ceilings do not require buttresses, there are none. This allows the walls to remain intact as continuous surfaces.

Why, then, do we speak of Sta. Croce as Gothic? Surely the use of the pointed arch is not sufficient to justify the term. A glance at the interior will dispel our misgivings, for we sense immediately that this space creates an effect fundamentally different from that of either Early Christian or Romanesque architecture. The nave walls have the weightless, "transparent" quality we saw in northern Gothic churches, and the dramatic massing of windows at the eastern end conveys the dominant role of light as forcefully as Abbot Suger's choir at St-Denis. Judged in terms of its emotional impact, Sta. Croce is Gothic beyond doubt. It is also profoundly Franciscan—and Florentine—in the monumental simplicity of the means by which this impact has been achieved.

Florence Cathedral If in Sta. Croce the architect's main concern was an impressive interior,

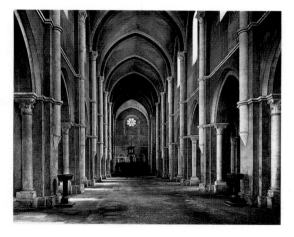

166. Interior, Abbey Church of Fossanova, Italy. Consecrated 1208

Florence Cathedral was planned as a monumental landmark to civic pride towering above the entire city (fig. 168). The original design, by the sculptor Arnolfo di Cambio, dates from 1296, about the same time construction was begun at Sta. Croce. Although somewhat smaller than the present building, Arnolfo di Cambio's design probably showed the same basic

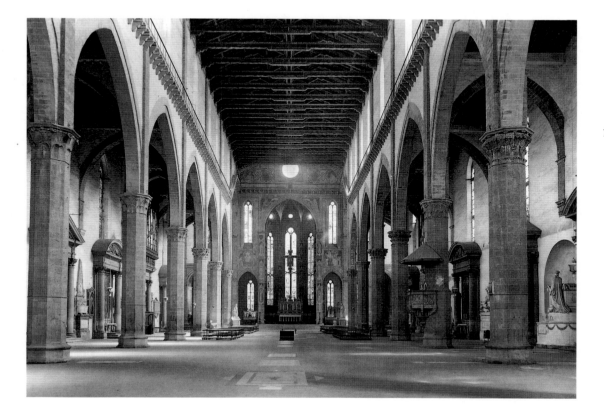

167. Nave and choir, Sta. Croce, Florence. Begun c. 1295

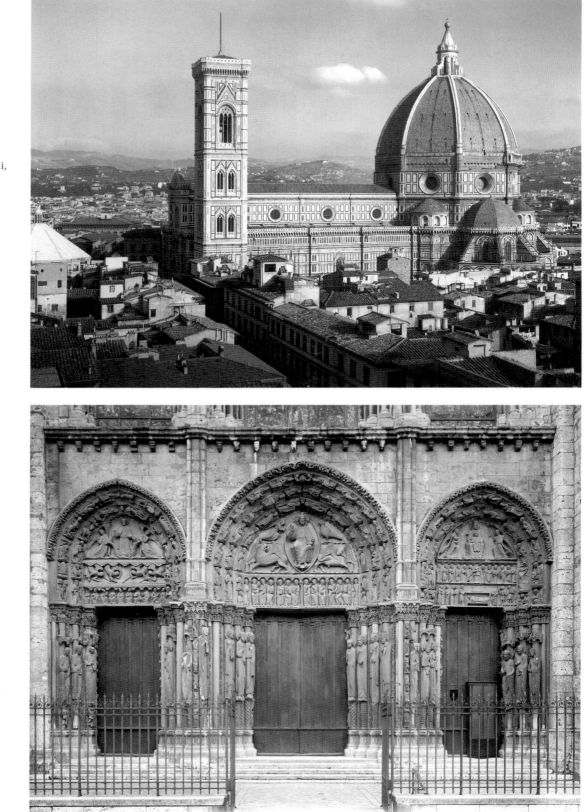

168. Florence Cathedral (Sta. Maria del Fiore). Begun by Arnolfo di Cambio, 1296; dome by Filippo Brunelleschi, 1420–36

169. West portal, Chartres Cathedral. c. 1145–70

plan. Most of the building as we know it, however, is based on a design by Francesco Talenti, who took over around 1343. The most striking feature is the great dome with its subsidiary half-domes. It forms a huge central pool of space that makes the nave look like an afterthought. The basic characteristics of the dome were set by a committee of leading painters and sculptors in 1367; however, its actual design and construction belong to the early fifteenth century (see pages 292–3).

Apart from the windows and the doorways, there is almost nothing Gothic about the exterior of Florence Cathedral. A freestanding **campanile**, or bell tower, takes the place of the facade towers familiar to us in northern Gothic churches. The campanile was begun by the great painter Giotto, who managed to finish only the first story, and continued by the sculptor Andrea Pisano, who was responsible for two zones with shallow niches. The rest represents the work of Talenti, who completed it by about 1360.

Sculpture

France

Although Abbot Suger's story of the rebuilding of St-Denis does not deal at length with the sculptural decoration of the church, he must have attached considerable importance to this aspect of the enterprise. The three portals of his west facade were far larger and more richly carved than those of Norman Romanesque churches. Unhappily, their condition today is so poor that they do not tell us a great deal about Suger's ideas of the role of sculpture within the total context of the structure he had envisioned.

Chartres Cathedral Suger's ideas paved the way for the admirable west portal of Chartres Cathedral (fig. 169), begun about 1145 under the influence of St-Denis, but even more ambitious. The west portal probably represent the oldest full-fledged example of Early Gothic sculpture. Comparing them with a Romanesque portal, we are impressed first of all with a new sense of order, as if all the figures had suddenly come to atten-

tion, conscious of their responsibility to the architectural framework. The dense crowding and the frantic movement of Romanesque sculpture have given way to an emphasis on symmetry and clarity. The figures on the lintels, **archivolts**, and tympanums are no longer entangled with each other but stand out as separate entities, so that the entire design can be seen much farther than that of previous portals.

Particularly striking in this respect is the novel treatment of the jambs (fig. 170), which

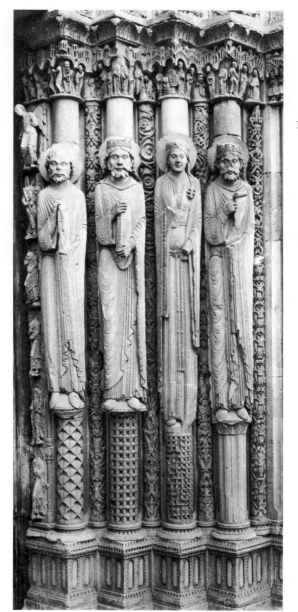

170. Jamb statues, west portal, Chartres Cathedral. c. 1145–55

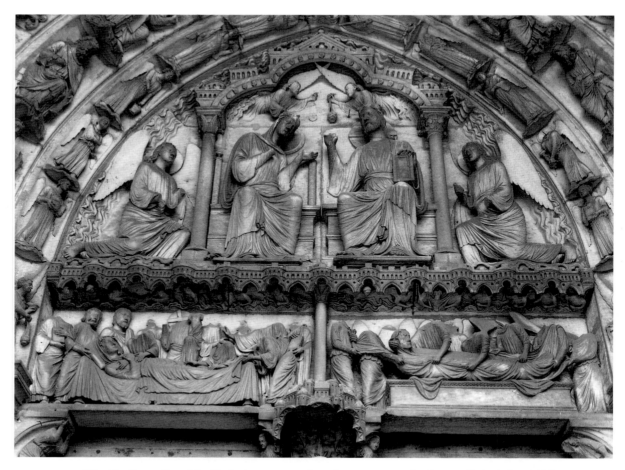

171. *The Coronation of the Virgin*, tympanum of north transept portal, Chartres Cathedral. c. 1230

are lined with tall figures attached to columns. Instead of being treated essentially as reliefs carved into—or protruding from—the masonry of the doorway, the Chartres jamb figures are essentially statues, each with its own axis. They could, in theory at least, be detached from their supports. Here, then, we witness a development of truly revolutionary importance: the first basic step toward the reconquest of monumental sculpture in the round since the end of classical antiquity. Apparently, this step could be taken only by borrowing the rigid cylindrical shape of the column for the human figure, with the result that these statues seem more abstract than their Romanesque predecessors. Yet they will not retain their immobility and unnatural proportions for long. The very fact that they are

round endows them with a more emphatic presence than anything in Romanesque sculpture, and their heads show a gentle, human quality that betokens the fundamentally realistic trend of Gothic sculpture.

Realism is a relative term whose meaning varies greatly according to circumstances. On the Chartres west portals, realism may appear to be a reaction against the fantastic and demoniacal aspects of Romanesque art. This response may be seen not only in the calm, solemn spirit of the figures and their increased physical bulk but also in the rational discipline of the theological program underlying the entire scheme. While the subtler aspects of this program are accessible only to those fully conversant with the theology of the Chartres Cathedral school,

its main elements can be readily understood.

The jamb statues form a continuous sequence linking all three portals. Together they represent the prophets, kings, and queens of the Bible. Their purpose is both to acclaim the rulers of France as the spiritual descendants of Old Testament royalty and to stress the harmony of secular and spiritual rule, of priests (or bishops) and kings—ideals insistently put forward by Abbot Suger. Christ himself appears enthroned above the main doorway as Judge and Ruler of the Universe, flanked by the symbols of the four Evangelists, with the apostles assembled below and the twenty-four elders of the Apocalypse in the archivolts. The right-hand tympanum shows Jesus' Incarnation: the Birth, the Presentation in the Temple, and the Infant Christ on the lap of the Virgin, who also stands for the Church. In the archivolts, slightly below the Infant Jesus are the personifications and representatives of the liberal arts as human wisdom paying homage to the divine wisdom of Jesus. Finally, in the left-hand tympanum, we see the timeless Heavenly Christ (the Christ of the Ascension) framed by the ever-repeating cycle of the year: the signs of the zodiac and their earthly counterparts, the labors of the twelve months.

When Chartres Cathedral was rebuilt after the fire of 1195, the so-called Royal Portals of the west facade must have seemed rather small and old-fashioned in relation to the rest of the new edifice. Perhaps for that reason, the two transept facades each received three large and lavishly carved portals preceded by deep porches. The north transept is devoted to the Virgin (fig. 171). She had already appeared over the right portal of the west facade in her traditional guise as the Mother of God seated on the Throne of Divine Wisdom. Her new prominence reflects the growing importance of the cult of the Virgin, which had been actively promoted by the Church since the Romanesque period. The growth of Mariology, as it is known, was linked to a new emphasis on divine love, which was enthusiastically embraced by the faithful as part of the more human view that became increasingly popular throughout the Gothic era. The cult of the Virgin received spe-

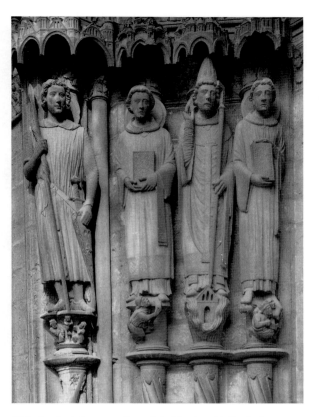

172. Jamb statues, south portal, Chartres Cathedral. c. 1215–20

cial emphasis when Chartres, which is dedicated to her, received the head of her mother, Saint Anne, as a relic in 1204. Our tympanum depicts events associated with the Feast of the Assumption (celebrated on August 15), when Mary was transported to heaven: the Death (Dormition), Assumption, and Coronation of the Virgin, which, with the Annunciation (fig. 174), were to become the most characteristic subjects relating her life. The appearance of all three here is extraordinary. It identifies Mary with the Church as the Bride of Christ and the Gateway to Heaven, in addition to her old role as divine intercessor. More important, it stresses her equality with Christ. Like him, she is transported to heaven, where she becomes not only his companion (the Triumph of the Virgin) but also his queen. Unlike earlier representations, which rely on Byzantine prototypes, the compositions are of Western invention. The figures

The reverse S-curve is slight, yet it animates the figure.

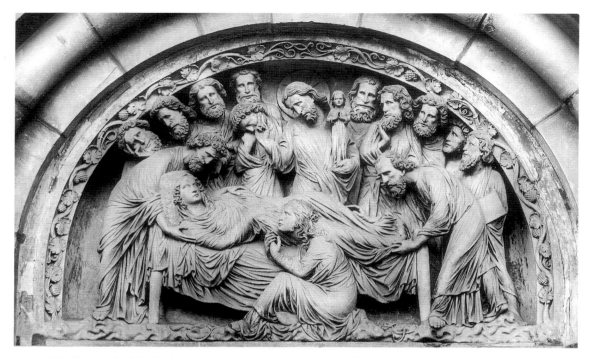

173. *The Death of the Virgin*, tympanum of south transept portal, Strasbourg Cathedral, France. c. 1220

have a monumentality quite unprecedented in medieval sculpture, while the treatment is so pictorial that the scenes are virtually independent of the architectural setting into which they have been crammed.

Gothic Classicism *The Coronation of the Virgin* (fig. 171) exemplifies an early phase of High Gothic sculpture. The jamb statues of the Chartres portals, such as the group of about 1215–20 shown in figure 172, show a similar evolution. By now, the symbiosis of statue and column had also begun to dissolve. The columns are quite literally put in the shade by the greater width of the figures, by the strongly projecting canopies above, and by the elaborately carved bases of the statues.

In the three saints on the right, we still find echoes of the rigid cylindrical shape of Early Gothic jamb statues, but even here the heads are no longer strictly in line with the central axis of the body. Saint Theodore, the knight on the left, already stands at ease, in a semblance of classical **contrapposto**. His feet rest on a hor-

izontal platform, rather than on a sloping shelf as before, and the axis of his body, instead of being straight, describes a slight but perceptible reverse S-curve. Even more astonishing is the abundance of precisely observed detail in the weapons, the texture of the tunic and chain mail. Above all, there is the organic structure of the body. Not since imperial Roman times have we seen a figure as thoroughly alive as this. Yet the most impressive quality of the statue is not its realism. It is, rather, the serene, balanced image that this realism conveys. In this ideal portrait of the Christian Soldier, the spirit of the Crusades has been cast into its most elevated form.

The style of the *Saint Theodore* could not have evolved directly from the elongated columnar statues of Chartres's west facade. It incorporates another, equally important tradition: the classicism of the Meuse Valley, which we traced in the previous chapter from Renier of Huy to Nicholas of Verdun (compare figs. 148, 153). At the end of the twelfth century, this trend, hitherto confined to metalwork and

miniatures, began to appear in monumental stone sculpture as well, transforming it from Early Gothic to Classic High Gothic. The link with Nicholas of Verdun is striking in *The Death of the Virgin* (fig. 173), a tympanum at Strasbourg Cathedral slightly later than the Chartres north transept portal. Here the draperies, the facial types, and the movements and gestures have a classical flavor that immediately recalls the *Klosterneuburg Altarpiece* (see fig. 153).

What marks the Strasbourg tympanum as Gothic rather than Romanesque, however, is the deeply felt tenderness pervading the entire scene. We sense a bond of shared emotion among the figures, an ability to communicate by glance and gesture that surpasses even the *Klosterneuburg Altarpiece*. This quality, too, has a long heritage reaching back to antiquity. We recall that it entered Byzantine art during the eleventh century as part of a renewed classicism (see figs. 116, 117). Gothic expressiveness is unthinkable without such examples. But how much warmer and more eloquent it is at Strasbourg than at Chartres. What appears as merely one episode within the larger doctrinal statement of the earlier work now becomes the sole focus of attention—and the vehicle for an outpouring of emotion such as had never been seen in the art of Latin Christendom.

The climax of Gothic classicism is reached in some of the statues at Reims Cathedral. The most famous of them is the *Visitation* group (fig. 174, right). To have a pair of jamb figures enact a narrative scene such as this would have been unthinkable in Early Gothic sculpture. The fact that they can do so now shows how far the sustaining column has receded into the background. Now the S-curve, resulting from the pronounced contrapposto, dominates the side view as well as the front view. The physical bulk of the body is further emphasized by horizontal folds pulled across the abdomen. The relationship of the two women shows the same human warmth and sympathy we found in the Strasbourg tympanum, but their classicism is of a far more monumental kind. They make us wonder if the artist was inspired directly by large-scale Roman sculpture.

The vast scale of the sculptural program for

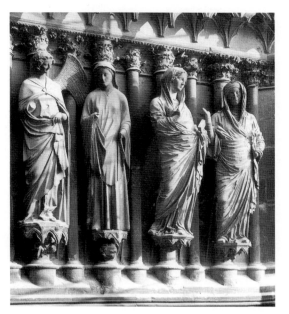

174. *Annunciation* and *Visitation*, west portal, Reims Cathedral. c. 1225–45

Reims Cathedral made it necessary to call upon the services of masters and workshops from various other building sites, and so we encounter several distinct styles among the Reims sculpture. Two of these styles, both clearly different from the classicism of the *Visitation,* appear in the *Annunciation* group (fig. 174, left). The Virgin exhibits a severe manner, with a rigidly vertical body axis and straight, tubular folds meeting at sharp angles, a style probably invented about 1220 by the sculptors of the west portals of Nôtre-Dame in Paris. The angel, in contrast, is conspicuously graceful. We note the tiny, round face framed by curly locks, the emphatic smile, the strong S-curve of the slender body, the ample, richly accented drapery. This "elegant style," created around 1240 by Parisian sculptors working for the royal court, was to spread far and wide during the following decades. It soon became, in fact, the standard formula for High Gothic sculpture.

A half century later, every trace of classicism has disappeared from Gothic sculpture. The human figure itself now becomes strangely abstract. Thus, the famous *Virgin of Paris*

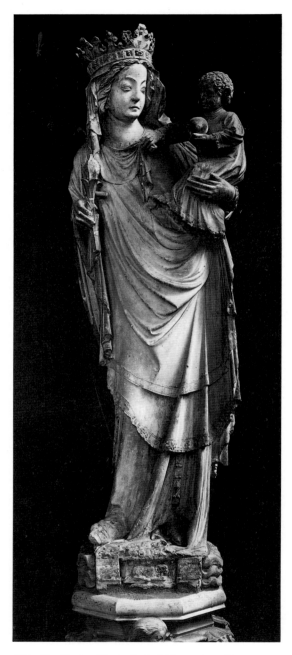

175. *The Virgin of Paris*. Early 14th century. Stone. Nôtre-Dame, Paris

(fig. 175) in Nôtre-Dame Cathedral consists largely of hollows, the projections having been reduced to the point where they are seen as lines rather than volumes. The statue is quite literally disembodied—its swaying stance no longer bears any relationship to the classical contrapposto. Compared to such unearthly grace, the angel of the Reims *Annunciation* seems solid and tangible indeed. Yet it contains the seed of the very qualities so strikingly expressed in *The Virgin of Paris*.

When we look back over the century and a half that separates *The Virgin of Paris* from the Chartres west portals, we cannot help wondering what gave rise to this graceful manner. The new style was certainly encouraged by the royal court of France and thus had special authority, but elegant attenuated forms and smoothly flowing, calligraphic lines came to dominate Gothic art, not just in France but throughout northern Europe, from about 1250 to 1400. It is clear, moreover, that the style of *The Virgin of Paris* represents neither a return to the Romanesque nor a complete repudiation of the earlier realistic trend.

Gothic realism was never of the allembracing, systematic sort. In general, it focused on specific details rather than on the overall structure of the visible world. This intimate kind of realism survives even within the abstract formal framework of *The Virgin of Paris*. We see it in the Infant Jesus, who appears here not as the Savior-in-miniature austerely facing the beholder but as a thoroughly human child playing with his mother's veil. Our statue thus retains an emotional appeal that links it to the Strasbourg *Death of the Virgin* and to the Reims *Visitation*. It is this appeal, not realism or classicism as such, that is the essence of Gothic art.

Germany

The spread of the Gothic style in sculpture beyond the borders of France began only toward 1200—the style of the Chartres west portals had hardly any echoes abroad—but, once under way, it proceeded at an astonishingly rapid pace. England may well have led the way, as it did in evolving its own version of Gothic architecture. Unfortunately, so much English Gothic sculpture was destroyed during the Reformation that we can study its development only with difficulty. In Germany, the growth of Gothic sculpture can be traced more easily. From the 1220s on, German sculptors

trained in the workshops of the great French cathedrals transplanted the new style to their homeland, although German architecture at that time was still predominantly Romanesque. Even after the middle of the century, however, Germany failed to emulate the large statuary cycles of France. As a consequence, German Gothic sculpture tended to be less closely linked with its architectural setting. (The finest work was often done for the interiors rather than the exteriors of churches.) This, in turn, permitted it to develop an individuality and expressive freedom greater than that of its French models.

The Naumburg Master The qualities of individuality and expressive freedom are strikingly evident in the style of the Naumburg Master, an artist of real genius whose best-known work is the magnificent series of statues and reliefs of about 1240–50 for Naumburg Cathedral. The *Crucifixion* (fig. 176) forms the central feature of the **choir screen**; flanking it are statues of the Virgin and John the Evangelist. Enclosed by a deep, gabled porch, the three figures frame the opening that links the nave with the sanctuary. Rather than placing the group above the screen, in accordance with the usual practice, our sculptor has brought the sacred subject down to earth both physically and emotionally. The suffering of Jesus becomes a human reality because of the emphasis on the weight and volume of the Savior's body. Mary and John, pleading with the beholder, now convey their grief more eloquently than ever before. The emotions communicated by these figures are heroic and dramatic, in comparison to the lyricism of the Strasbourg tympanum or the Reims *Visitation* (see figs. 173, 174).

The Pietà Gothic sculpture, as we have come to know it so far, reflects a desire to endow the traditional themes of Christian art with an ever greater emotional appeal. Toward the end of the thirteenth century, this tendency gave rise to a new kind of religious image, designed to serve private devotion. It is often referred to by the German term *Andachtsbild* ("contemplation image"), since Germany played a leading part

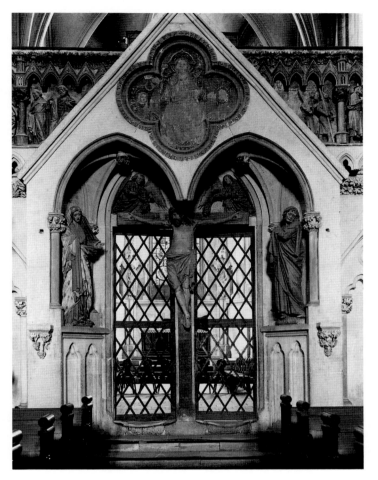

176. Naumburg Master. *Crucifixion*, on the choir screen, Naumburg Cathedral, Germany. c. 1240–50

in its development. The most characteristic and widespread type of *Andachtsbild* was the Pietà (the Italian term *Pietà* was derived from the Latin *pietas*, the root word for both "pity" and "piety"): a representation of the Virgin grieving over the dead Jesus. No such scene occurs in the scriptural account of the Passion. The Pietà conflates two iconic types: the Madonna and Child and the Crucifixion, which were often paired as objects of veneration once they became familiar to Europeans following the conquest of Constantinople by the Fourth Crusade in 1204. Exactly where or when the Pietà was invented we do not know, but it represents one of the Seven Sorrows of the Virgin, a tragic counterpart to the familiar motif of the Madonna and Child, which depicts one of her Seven Joys.

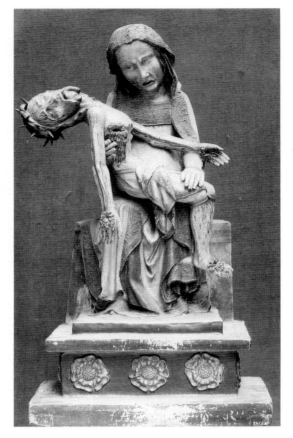

The example reproduced in figure 177 is of carved wood, with a vividly painted surface. Like most such groups, this large cult statue was meant to be placed on an altar. The style, like the subject itself, responds to the emotional fervor of lay religiosity, which emphasized a personal relationship with the deity as part of the tide of mysticism that swept the fourteenth century. Realism here has become purely a vehicle of expression to enhance its impact. The Virgin's agonized face conveys almost unbearable pain and grief, while the blood-encrusted wounds of Jesus are enlarged and elaborated to an almost grotesque degree. The bodies and limbs have become puppetlike in their thinness and rigidity. The purpose of the work, clearly, is to arouse so overwhelming a sense of horror and pity that the faithful will share completely in Jesus' suffering and identify their own feelings with those of the grief-stricken Mother of God. The ultimate goal of this emotional bond is a spiritual transformation that comprehends the central mystery of God in human form through compassion (which means "to suffer with").

At a glance, our Pietà would seem to have little in common with *The Virgin of Paris* (see fig. 175), which dates from the same period. Yet they share both a lean, "deflated" quality of form and a strong emotional appeal to the viewer that characterize the art of northern Europe from the late thirteenth century to the mid-fourteenth. Only after 1350 do we again find an interest in weight and volume, coupled with a renewed impulse to explore tangible reality as part of a larger change in religious sensibility.

International Style Sculpture in the North

The climax of the new trend toward realism came around 1400, during the period of the International Style (see pages 237–41). Its greatest exponent was Claus Sluter, a sculptor of Netherlandish origin working at Dijon for the king's brother, Philip the Bold, the duke of Burgundy. In the *Moses Well* (fig. 178), a symbolic well surrounded by statues of Old Testament prophets and once surmounted by a crucifix, he explores sculptural style in two new directions. In the majestic Moses, to the right in our picture, soft, lavishly draped garments envelop the heavyset body like an ample shell, and the swelling forms seem to reach out into the surrounding space, determined to capture as much of it as possible. (Note the outward curve of the scroll, which reads: "The children of Israel do not listen to me."). The effect must have been enhanced greatly by the **polychromy**, which has largely disappeared. At first glance, Moses seems a startling premonition of the Renaissance. Only upon closer inspection do we realize that in his vocabulary Sluter remains firmly allied to the Gothic. In the Isaiah, facing left in our illustration, these aspects of our artist's style are less pronounced. What strikes us, rather, is the precise and authoritative realism of every detail, from the minutiae of the costume to the texture of the wrinkled skin. The head, unlike that of Moses, has all the individuality of a portrait. Nor is this impression deceiving, for the sculptural development that culminated in Claus Sluter produced the first genuine portraits since late antiquity, including splendid examples by Sluter

himself. This attachment to the tangible and specific distinguishes his realism from that of the thirteenth century.

Italy

We have left a discussion of Italian Gothic sculpture to the last, for here, as in Gothic architecture, Italy stands apart from the rest of Europe. The earliest Gothic sculpture on Italian soil was probably produced in the extreme south, in Apulia and Sicily, the domain of the thirteenth-century German emperor Frederick II, who employed French, German, and native artists at his court. Of the works he sponsored, little has survived, but there is evidence that his taste favored a strongly classical style derived from the *Visitation* group at Reims (see fig. 174).

Nicola Pisano Such was the background of Nicola Pisano (c. 1220–78/84) not related to Andrea Pisano), who went to Tuscany from southern Italy about 1250 (the year of Frederick II's death). His work has been well defined as that of "the greatest—and in a sense the last— of medieval classicists." In 1260, he completed the marble pulpit in the Baptistery of Pisa Cathedral, which is covered with reliefs of narrative scenes such as the *Nativity* (fig. 179). The classical flavor is so strong that the Gothic elements are hard to detect at first glance. They are there nonetheless. Most striking, perhaps, is the Gothic quality of human feeling in the figures. The dense crowding, on the other hand, has no counterpart in northern Gothic sculpture. Aside from the Nativity, the panel also shows the Annunciation and the shepherds in the fields receiving the glad tidings of the birth of Jesus. This treatment of the relief as a shallow box filled almost to bursting with solid, convex shapes tells us that Nicola Pisano must have been thoroughly familiar with Roman sarcophagi (compare fig. 109).

Giovanni Pisano Half a century later, Nicola's son Giovanni (1245/50–after 1314), who was an equally gifted sculptor, carved a marble pulpit for Pisa Cathedral. It, too, includes a Nativity (fig. 180). Both panels have a good many things

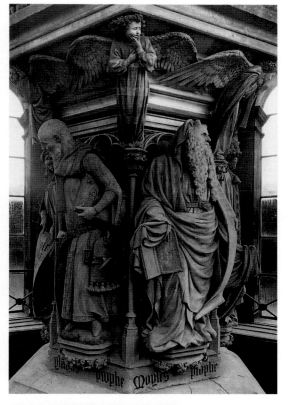

178. Claus Sluter. *Moses Well.* 1395–1406. Stone, height of figures approx. 6' (1.88 m). Chartreuse de Champmol, Dijon, France

179. Nicola Pisano. *Nativity.* Detail of pulpit, Baptistery, Pisa. 1259–60. Marble, 33 1/2 x 44 1/2" (85.1 x 113 cm)

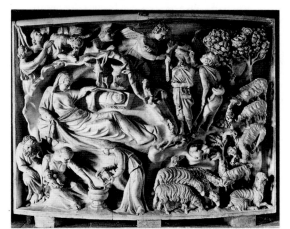

180. Giovanni Pisano. *Nativity.* Detail of pulpit, Pisa Cathedral. 1302–10. Marble, 34 3/8 x 43" (87.2 x 109.2)

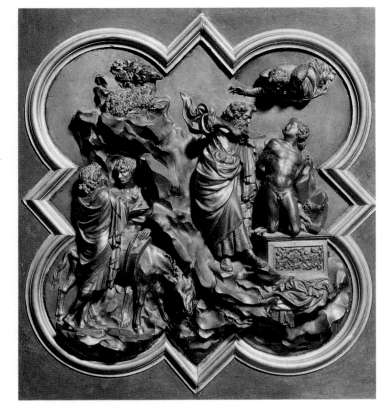

181. Lorenzo Ghiberti. *The Sacrifice of Isaac*. 1401–2. Gilt bronze, 21 x 17" (53.3 x 43.2 cm). Museo Nazionale del Bargello, Florence

in common, as we might well expect, yet they also offer a sharp—and instructive—contrast. Giovanni's slender, swaying figures, with their smoothly flowing draperies, recall neither classical antiquity nor the *Visitation* group at Reims (see fig. 174). Instead, they reflect the elegant style of the royal court at Paris that had become the standard Gothic formula during the later thirteenth century. And with this change there has come about a new treatment of relief: to Giovanni Pisano, space is as important as **plastic** form. The figures are no longer tightly packed together. They are now spaced far enough apart to let us see the landscape setting that contains them, and each figure has been allotted its own pocket of space. If Nicola's *Nativity* strikes us as essentially a sequence of bulging, rounded masses, Giovanni's appears to be made up mainly of cavities and shadows. Giovanni Pisano, then, follows the same trend toward "disembodiment" that we encountered north of the Alps around 1300, only he does so in a more limited way

International Style Sculpture in the South

By about 1400, French influence had been thoroughly assimilated by artists in Italy. The International Style's foremost representative was Lorenzo Ghiberti (c. 1381–1455), a Florentine who as a youth must have had close contact with French art. We first encounter him in 1401–2, when he won a competition for a pair of richly decorated bronze doors for the Baptistery of S. Giovanni in Florence. (It took him more than two decades to complete these doors, on the north portal of the building.) Each of the competing artists had to submit a trial relief, in a Gothic **quatrefoil** (four-lobed) frame, representing the Sacrifice of Isaac. Ghiberti's panel (fig. 181) strikes us first of all with the perfection of its craft, which reflects his training as a goldsmith. The silky shimmer of the surfaces and the wealth of beautifully articulated detail make it easy to understand why this entry was awarded the prize. If the compo-

sition seems somewhat lacking in dramatic force, that is characteristic of Ghiberti's calm, lyrical temper, which was very much to the taste of the period. Indeed, his figures, in their softly draped, ample garments, retain an air of courtly elegance even when they enact scenes of violence.

However much his work may owe to French influence, Ghiberti proves himself thoroughly Italian in one respect: his admiration for ancient sculpture, as evidenced by the beautiful nude torso of Isaac. Here our artist revives a tradition of classicism that had reached its highest point in Nicola Pisano but had gradually died out during the fourteenth century. But Ghiberti is also the heir of Giovanni Pisano. In Giovanni's *Nativity* panel (see fig. 180) we noted a bold new emphasis on the spatial setting. Ghiberti's trial relief carries this same tendency a good deal further, achieving a heightened sense of the atmosphere around the figures. For the first time since classical antiquity, we experience the background of a panel not as a flat surface but as empty space from which the sculpted forms emerge toward the beholder, so that the angel in the upper right-hand corner seems to hover in mid-air. This pictorial quality relates Ghiberti's work to the painting of the International Style, where we find a similar concern with spatial depth and atmosphere (see pages 227–31). While not a revolutionary himself, he prepares the ground for the great revolution that will mark the second decade of the fifteenth century in Florentine art called the Early Renaissance.

Painting

Stained Glass

Although Gothic architecture and sculpture began dramatically at St-Denis and Chartres, Gothic painting developed at a rather slow pace in its early stages. The innovative architectural style sponsored by Abbot Suger gave birth to a new conception of monumental sculpture almost at once but did not demand any radical change of style in painting. Suger's account of the rebuilding of his church, to be sure, places a great deal of emphasis on the miraculous effect of stained-glass windows, whose "continuous light" flooded the interior. Stained glass was thus an integral element of Gothic architecture from the very beginning. Yet the technique of stained-glass painting had already been perfected in Romanesque times, and the style of stained-glass designs (especially single figures) in some places remained Romanesque for nearly another hundred years.

Nevertheless, the "many masters from different regions" whom Suger assembled to do the choir windows at St-Denis faced a larger task and a more complex pictorial program than before. During the next half century, as Gothic structures became ever more skeletal and clerestory windows grew to huge size, stained glass displaced manuscript illumination as the leading form of painting. Because the production of stained glass was so intimately linked with the great cathedral workshops, the designers came to be influenced more and more by architectural sculpture. The majestic *Nôtre Dame de la Belle Verrière* (fig. 182) at Chartres Cathedral, the finest early example of this process, lacks some of the sculptural qualities of its relief counterpart on the west portals of the church (see fig. 169) and still betrays its Byzantine ancestry. The stained glass dissolves the group into a weightless mass that hovers effortlessly in indeterminate space.

The window consists not of large panes but of hundreds of small pieces of tinted glass bound together by strips of lead. The maximum size of these pieces was severely limited by the existing methods of medieval glass manufacture, so that the design could not simply be "painted on glass." Rather, the window was painted *with* glass, by assembling it somewhat the way one would a mosaic or a jigsaw puzzle, out of odd-shaped fragments cut to fit the contours of the forms. Only the finer details, such as eyes, hair, and drapery folds, were added by actually painting—or, better perhaps, drawing—in black or gray on the glass surfaces. This process encourages an abstract, ornamental style, which tends to resist any attempt to render three-dimensional effects. Only in the

STAINED GLASS got its colors from being heated with different metal oxides.

The stained-glass artist first drew the design on a large flat surface, then cut pieces of colored glass to match the drawn sections.

The individual pieces of glass were enclosed by channeled strips of lead.

The lead strips (cames) between the individual glass pieces were always an important part of the design.

hands of a great artist could the maze of lead strips resolve itself into figures having such monumentality.

Apart from the peculiar demands of their medium, the stained-glass workers who filled the windows of the great Gothic cathedrals also had to face the difficulties arising from the enormous scale of their work. No Romanesque painter had ever been called upon to cover areas so vast or so firmly bound into an architectural framework. The task required a technique of orderly planning for which the medieval painting tradition could offer no precedent. Only architects and stonemasons knew how to deal with this problem, and it was their methods that the stained-glass workers borrowed in mapping out their own compositions. Gothic architectural design, as we recall from our discussion of the choir of St-Denis (see pages 189–90), uses a system of geometric relationships to establish numerical harmony. The same rules could be used to control the design of stained-glass windows, through which shines the Light Divine.

The period 1200–50 might be termed the golden age of stained glass. After that, as architectural activity declined and the demand for stained glass began to slacken, manuscript illumination gradually recaptured its former position of leadership. By then, however, miniature painting had been thoroughly affected by the influence of both stained glass and stone sculpture, the artistic pacemakers of the first half of the century.

Illuminated Manuscripts

The influence of stained glass and stone sculpture can be seen in figure 183, which shows a page from a Psalter done about 1260 for King Louis IX (Saint Louis) of France. The scene illustrates 1 Samuel 11:2, in which Nahash the Ammonite threatens the Jews at Jabesh. We notice, first of all, the careful symmetry of the framework, which consists of flat, ornamented panels—very much like those in the *Belle Ver-*

183. *Nahash the Ammonite Threatening the Jews at Jabesh*, from the *Psalter of Saint Louis*. c. 1260. 5 x 3 1/2" (12.7 x 8.9 cm). Bibliothèque Nationale, Paris

rière window—and of an architectural setting remarkably similar to the choir screen by the Naumburg Master (see fig. 176). Against this emphatically two-dimensional background, the figures are "relieved" by smooth and skillful modeling. But their sculptural quality stops short at the outer contours, which are defined by heavy dark lines rather like the lead strips in stained-glass windows. The figures themselves show all the characteristics of the elegant style that originated about twenty years earlier in the work of the sculptors of the royal court: graceful gestures, swaying poses, smiling faces, neatly waved strands of hair. Of the expressive energy of Romanesque painting we find no trace (see fig. 150). Our miniature exemplifies the subtle and refined taste that made the court art of Paris the standard for all Europe.

Italian Painting

At the end of the thirteenth century, Italian painting produced an explosion of creative energy as spectacular—and as far-reaching in its impact on the future—as the rise of the Gothic cathedral in France. As we inquire into the conditions that made it possible, we find that it arose from the same "old-fashioned" attitudes we met in Italian Gothic architecture and sculpture. Medieval Italy, although strongly

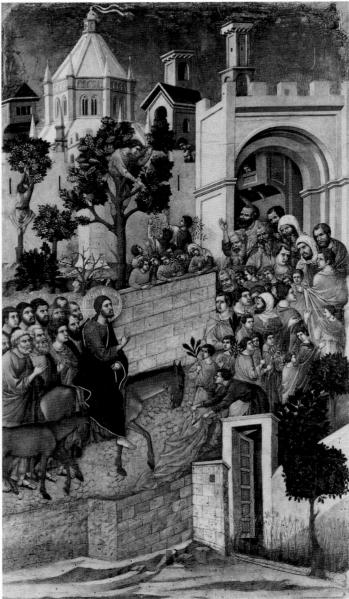

184. Duccio. *Christ Entering Jerusalem*, from the back of the *Maestà Altarpiece*. 1308–11. Tempera on panel, 40¹/₂ x 21¹/₈" (102.9 x 53.7 cm). Museo dell'Opera del Duomo, Siena, Italy

influenced by Northern art from Carolingian times on, had always maintained contact with Byzantine civilization. As a result, panel painting, mosaic, and mural painting—mediums that had never taken firm root north of the Alps—were kept alive on Italian soil. Indeed, a new wave of Byzantine influence overwhelmed the lingering Romanesque elements in Italian painting at the very time when stained glass became the dominant pictorial art in France.

There is a certain irony in the fact that this neo-Byzantine style made its appearance soon after the conquest of Constantinople by the armies of the Fourth Crusade in 1204. (One thinks of the way Greek art had once captured the taste of the victorious Roman armies of old.) In any event, this "Greek manner," as the Italians called the neo-Byzantine style, prevailed almost until the end of the thirteenth century. The Byzantine tradition had preserved

Early Christian narrative art virtually intact. When transmitted to the West, it led to a remarkable eruption of subjects and compositions that had been essentially lost for nearly 700 years, although some of them had been available all along in the mosaic cycles of Rome and Ravenna, and there had been successive waves of Byzantine influence throughout the Early Middle Ages and Romanesque. Nevertheless, they lay dormant, so to speak, until interest in them was reawakened through closer relations with Constantinople, which enabled Italian painters to absorb Byzantine art far more thoroughly than ever before. During this same period, we recall, Italian architects and sculptors followed a very different course; untouched by the Greek manner, they were assimilating the Gothic style. Eventually, toward 1300, Gothic influence spilled over into painting as well, and the interaction of this element with the neo-Byzantine produced the revolutionary new style.

Duccio Among the painters of the Greek manner, the most important was Duccio (Duccio di Buoninsegna, c. 1255–before 1319), of Siena. His great altarpiece for Siena Cathedral, the *Maestà* ("Majesty"), includes many small compartments with scenes from the lives of Jesus and the Virgin. Among these panels, the most mature works of Duccio's career, is *Christ Entering Jerusalem* (fig. 184). Here, the cross-fertilization of Gothic and Byzantine elements has given rise to a development of fundamental importance: a new kind of picture space. In Duccio's hands, the Greek manner has become unfrozen. The rigid, angular draperies have given way to an undulating softness. The abstract shading-in-reverse with lines of gold (compare fig. 117) is reduced to a minimum. The bodies, faces, and hands are beginning to swell with a subtle three-dimensional life. Clearly, the heritage of Hellenistic-Roman illusionism that had always been part of the Byzantine tradition, however dormant or submerged, is asserting itself once more. But there is also a half-hidden Gothic element here. We sense it in the fluency of the drapery folds, the appealing naturalness of the figures, and the tender glances by which they

communicate with each other. The chief source of this Gothic influence must have been Giovanni Pisano, who was in Siena from 1285 to 1295 as the sculptor-architect in charge of the cathedral facade.

Christ Entering Jerusalem shows us something we have never seen before in the history of painting: Duccio's figures inhabit a space that is created and defined by the architecture. Northern Gothic painters, too, had tried to reproduce architectural settings, but they could do so only by flattening them out completely (as in the *Psalter of Saint Louis*; see fig. 183). The Italian painters of Duccio's generation, trained as they were in the Greek manner, had acquired enough of the devices of Hellenistic-Roman illusionism to let them render such a framework without draining it of its three-dimensional qualities (see fig. 97). In *Christ Entering Jerusalem*, the architecture keeps its space-creating function. The diagonal movement into depth is conveyed not by the figures, which have the same scale throughout, but by the walls on each side of the road leading to the city, by the gate that frames the welcoming crowd, and by the structures beyond. Whatever the shortcomings of Duccio's perspective, his architecture demonstrates its capacity to contain and enclose, and, for that very reason, it strikes us as more intelligible than similar vistas in ancient art.

Giotto Turning from Duccio to Giotto (Giotto di Bondone, 1267?–1336/7), we meet an artist of far bolder and more dramatic temper. Ten to fifteen years younger, Giotto was less close to the Greek manner from the start, and by instinct he was a wall painter rather than a panel painter. Of his surviving murals, those in the Arena Chapel in Padua, done in 1305–6, are the best preserved as well as the most characteristic. The decorations are devoted principally to scenes from the life of Jesus, set forth in a carefully arranged program consisting of three tiers of narrative scenes (fig. 185). Giotto depicts many of the same subjects that we find on the reverse of Duccio's *Maestà*, including *Christ Entering Jerusalem* (fig. 186). A single glance at Giotto's painting will convince us that we are

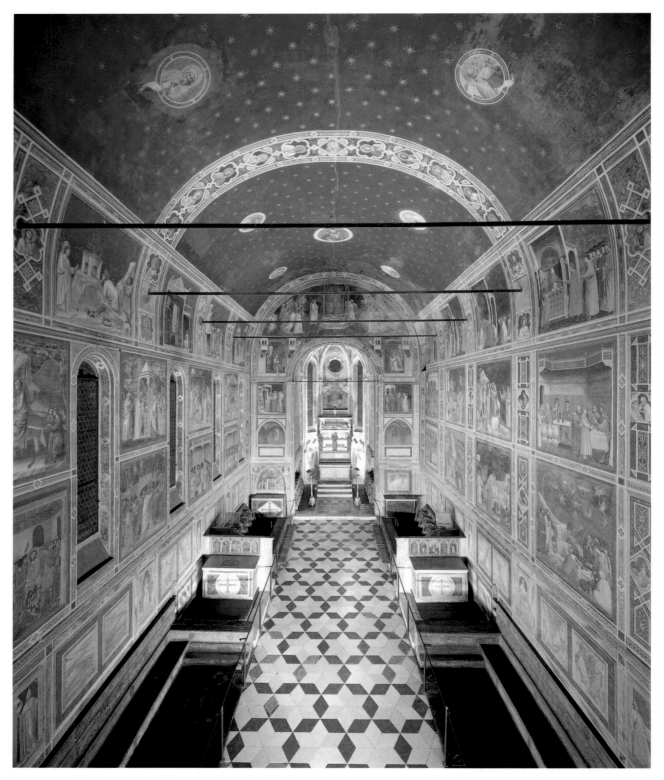

185. Giotto. Frescoes in the Arena (Scrovegni) Chapel, Padua, Italy. 1305–6

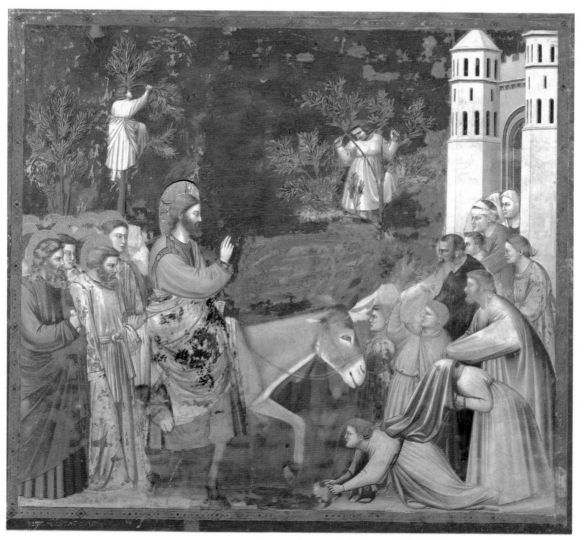

186. Giotto. *Christ Entering Jerusalem*. Fresco in the Arena Chapel. 1305–6

faced with a truly revolutionary development. How, we wonder, could a work of such intense dramatic power be conceived by a contemporary of Duccio? To be sure, the two versions have many elements in common, since they both ultimately derive from the same Byzantine source. But where Duccio has enriched the traditional scheme, spatially as well as in narrative detail, Giotto subjects it to a radical simplification. The action proceeds parallel to the **picture plane**. Landscape, architecture, and figures have been reduced to the essential minimum. The sober medium of **fresco** painting (water-based paint applied to the freshly plastered wall), with its limited range and intensity of tones, further emphasizes the austerity of Giotto's art, compared to the jewel-like brilliance of Duccio's picture, which is executed in **tempera** (egg mixed with water) on gold ground. Yet Giotto's work has by far the more powerful impact of the two: it makes us feel so close to the event that we have a sense of being participants rather than distant observers.

How does the artist achieve this extraordinary effect? He does so, first of all, by having the entire scene take place in the foreground. Even more important, he presents it in such a way that the beholder's eye-level falls within the lower half of the picture. Thus, we can imagine ourselves standing on the same **ground plane** (the surface upon which figures and objects stand in a picture or relief) as these painted figures, even though we see them from well below, whereas Duccio makes us survey the scene from above, in bird's-eye perspective. The consequences of this choice of viewpoint are truly epoch-making. *Choice* implies conscious awareness—in this case, awareness of a relationship in space between the beholder and the picture—and Giotto may well claim to be the first to have established such a relationship. Duccio, certainly, does not yet conceive his picture space as continuous with the beholder's space. Hence, we have the sensation of vaguely floating above the scene rather than of knowing where we stand. Even ancient painting at its most illusionistic provides no more than a pseudo-continuity in this respect (see fig. 99). Giotto, on the other hand, tells us where we

stand. Above all, he also endows his forms with a three-dimensional reality so forceful that they seem as solid and tangible as sculpture in the round.

With Giotto it is the figures, rather than the architectural framework, that create the picture space. As a result, this space is more limited than Duccio's—its depth extends no farther than the combined volumes of the overlapping bodies in the picture—but within its limits it is very much more persuasive. To Giotto's contemporaries, the tactile quality of his art must have seemed a near-miracle. It was this quality that made them praise him as equal, or even superior, to the greatest of the ancient painters, because his forms looked so lifelike that they could be mistaken for reality itself. Equally significant are the stories linking Giotto with the claim that painting is superior to sculpture. This was not an idle boast, as it turned out, for Giotto does indeed mark the start of what might be called the era of painting in Western art. The symbolic turning point is the year 1334, when he was appointed the head of the Florence Cathedral workshop, an honor and responsibility hitherto reserved for architects or sculptors.

Giotto's aim was not simply to translate Gothic statuary into painting. By creating a radically new kind of picture space, he had also sharpened his awareness of the picture surface. When we look at a work by Duccio (or his ancient and medieval predecessors), we tend to do so in installments, as it were. Our glance travels from detail to detail at a leisurely pace until we have surveyed the entire area. Giotto, on the contrary, invites us to see the whole at one glance. His large, simple forms, the strong grouping of his figures, the limited depth of his "stage"—all these factors help endow his scenes with an inner coherence such as we have never found before. Notice how dramatically the massed verticals of the "block" of apostles on the left are contrasted with the upward slope formed by the welcoming crowd on the right, and how Jesus, alone in the center, bridges the gulf between the two groups. The more we study the composition, the more we come to realize its majestic firmness and clarity.

Thus, the artist has rephrased the traditional pattern of Jesus' entry into Jerusalem to stress the solemnity of the event as the triumphal procession of the Prince of Peace.

The art of Giotto is so daringly original that its sources are far more difficult to trace than those of Duccio's style. Apart from his Florentine background in the Greek manner, the young Giotto seems to have been familiar with the more monumental, neo-Byzantine style practiced by painters in Rome, partly under the influence of ancient Roman and Early Christian mural decorations, and it is likely that he became acquainted with such older monuments as well. Classical sculpture, too, seems to have left an impression on him. More fundamental than any of these, however, was the influence of certain late-medieval Italian sculptors, including Nicola and Giovanni Pisano. They were the chief intermediaries through whom Giotto first came in contact with the world of Northern Gothic art, which remains the most important of all the elements that entered into Giotto's style. Indeed, Northern works such as that illustrated in figure 171 are almost certainly the ultimate source of Giotto's powerful emotional impact.

Simone Martini There are few artists in the entire history of art who equal the stature of Giotto as a radical innovator. His very greatness, however, tended to dwarf the next generation of Florentine painters, which produced only followers rather than new leaders. Their contemporaries in Siena were more fortunate in this respect, because Duccio never had the same overpowering impact. As a consequence, it was they, not the Florentines, who took the next decisive step in the development of Italian Gothic painting. Simone Martini (c. 1284–1344) may well claim to be the most distinguished of Duccio's disciples. He spent the last years of his life in Avignon, the town in southern France that served as the residence-in-exile of the popes during most of the fourteenth century. *The Road to Calvary* (fig. 187), originally part of a small altar, was probably done there about 1340, as it was commissioned by Philip the Bold of Burgundy for the Char-treuse de Champmol. In its sparkling colors, and especially in the architectural background, our tiny but intense panel still echoes the art of Duccio (see fig. 184). The vigorous modeling of the figures, on the other hand, as well as their dramatic gestures and expressions, betray the influence of Giotto. While Simone Martini is not much concerned with spatial clarity, he proves to be an extraordinarily acute observer. The sheer variety of costumes and physical types and the wealth of human incident create a sense of down-to-earth reality very different from both the lyricism of Duccio and the grandeur of Giotto.

The Lorenzettis The closeness to everyday life seen in the paintings of Simone Martini also appears in the work of the brothers Pietro and Ambrogio Lorenzetti (both died 1348?), but on a more monumental scale and coupled with a keen interest in problems of space. The boldest spatial experiment is Pietro's 1342 **triptych** (a work with three panels; see page 250), *The Birth of the Virgin* (fig. 188), where the painted architecture has been correlated with the real architecture of the frame in such a way that the two are seen as a single system. Moreover, the vaulted chamber where the birth takes place occupies two panels. It continues unbroken behind the column that divides the center from the right wing. The left wing represents an anteroom that leads to a large and only partially glimpsed architectural space suggesting the interior of a Gothic church. What Pietro Lorenzetti achieved here is the outcome of a development that began three decades earlier in the work of Duccio: the conquest of **pictorial space**. Only now, however, does the picture surface assume the quality of a transparent window through which—not *on* which—we perceive the same kind of space we know from daily experience. Duccio's work alone is not sufficient to explain Pietro's astonishing breakthrough. It became possible, rather, through a combination of the *architectural* picture space of Duccio and the *sculptural* picture space of Giotto.

The same procedure enabled Ambrogio Lorenzetti to unfold a comprehensive view of the entire town before our eyes in his frescoes

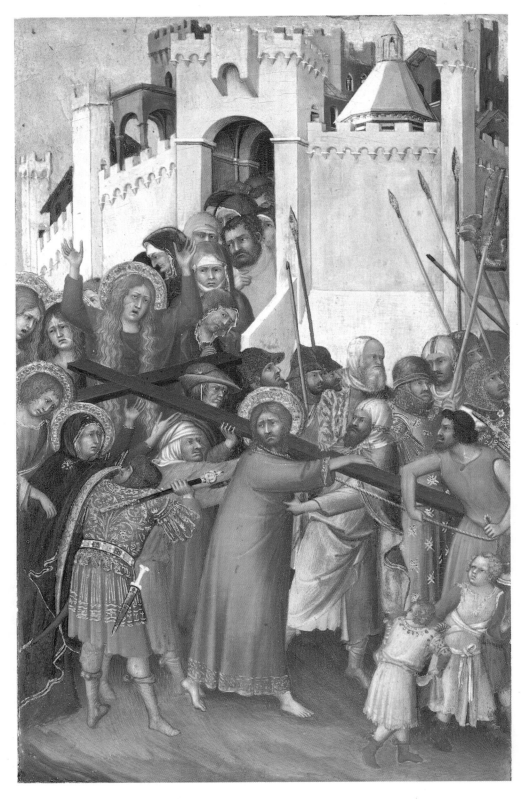

187. Simone Martini. *The Road to Calvary*. c. 1340. Tempera on panel, 9⁷/₈ x 6¹/₈" (25.1 x 15.6 cm). Musée du Louvre, Paris

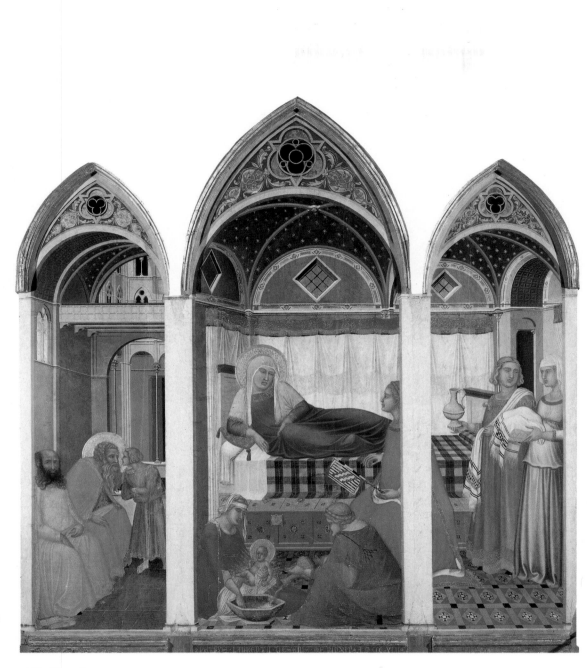

188. Pietro Lorenzetti. *The Birth of the Virgin*. 1342. Tempera on panel, 6'1¹/₂" x 5'11¹/₂" (1.88 x 1.82 m).
Museo dell'Opera del Duomo, Siena

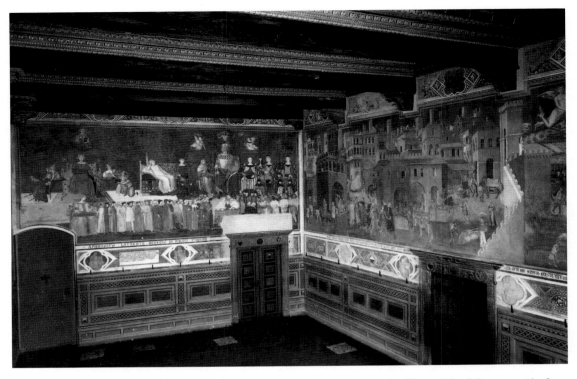

189. Ambrogio Lorenzetti. *The Commune of Siena* (left), *Good Government in the City* and *Good Government in the Country* (right). Frescoes in the Sala della Pace, Palazzo Pubblico, Siena. 1338–40

of 1338–40 in the Siena city hall (fig. 189). (On the right, beyond the margin of figure 189, the *Good Government* fresco provides a view of the Sienese countryside.) We marvel at the distance that separates this precisely articulated "portrait" of Siena from Duccio's Jerusalem (see fig. 184). Ambrogio's mural forms part of an elaborate allegorical program depicting the contrast between good and bad government. To the right on the far wall of figure 189, we see the Commune of Siena guided by Faith, Hope, and Charity and flanked by a host of other symbolic figures. The artist, in order to show the life of a well-ordered city-state, had to fill the streets and houses with teeming activity. The bustling crowd gives the architectural vista its striking reality by introducing the human scale.

The Black Death The first four decades of the fourteenth century in Florence and Siena had been a period of political stability and eco-

nomic expansion as well as of great artistic achievement. In the 1340s, both cities suffered a series of catastrophes whose echoes were to be felt for many years. Banks and merchants went bankrupt by the score, internal upheavals shook the government, there were repeated crop failures, and in 1348 the epidemic of bubonic plague—the Black Death—that spread throughout Europe wiped out more than half of the urban population of Florence and Siena. Many people regarded these events as signs of divine wrath, warnings to a sinful humanity to forsake the pleasures of this earth; to others, the fear of sudden death merely intensified the desire to enjoy life while there was yet time. These conflicting attitudes are reflected in the pictorial theme of the Triumph of Death.

Francesco Traini The most impressive treatment in art of the subject of the Triumph of Death—unfortunately destroyed during World

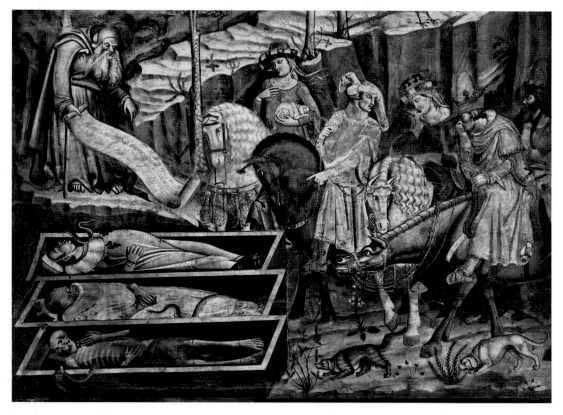

190. Francesco Traini. *The Triumph of Death*. Detail of fresco, Camposanto, Pisa. c. 1325–50

War II—was an enormous fresco, attributed to the Pisan master Francesco Traini (documented c. 1321–63), in the Camposanto, the cemetery building next to Pisa Cathedral. In a particularly dramatic detail from this work (fig. 190), the elegantly costumed men and women on horseback have suddenly come upon three decaying corpses in open coffins. Even the animals are terrified by the sight and smell of rotting flesh. Only the hermit, having renounced all earthly pleasures, calmly points out the lesson of the scene. But will the living accept the lesson, or will they turn away from the shocking spectacle more determined than ever to pursue their own hedonistic ways? The artist's own sympathies seem curiously divided. His style is far from being otherworldly, and it recalls the realism of Ambrogio Lorenzetti, although the forms are harsher, more expressive.

Traini retains a strong link with the great artists of the second quarter of the century. The

Tuscan painters who reached maturity after the Black Death, around the 1350s, cannot compare with the earlier artists whose work we have discussed. Their style, in comparison, seems dry and formula-ridden, although they were capable at their best of expressing the somber mood of the time with memorable intensity.

Painting North of the Alps

We are now in a position to turn once more to Gothic painting north of the Alps. What happened there during the latter half of the fourteenth century was determined in large measure by the influence of the great Italians. Toward the middle years of the fourteenth century, Italian influence becomes ever more important in Northern Gothic painting. Sometimes this influence was transmitted by Italian artists working on Northern soil; an example is Simone Martini.

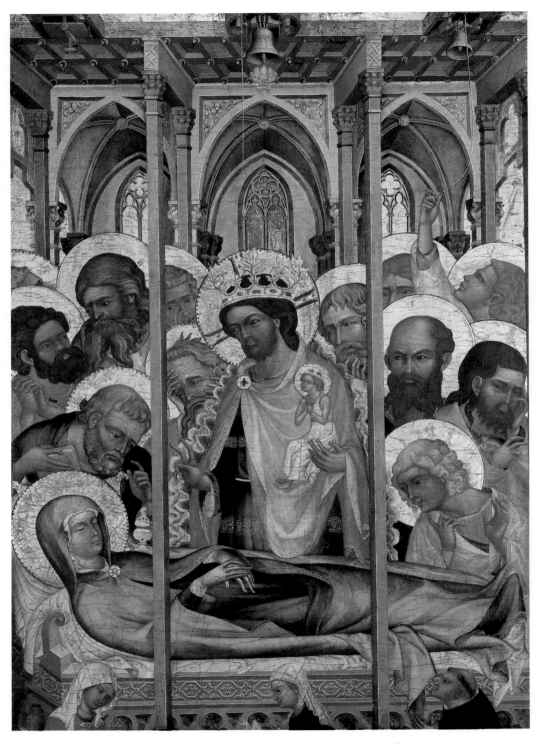

191. Bohemian Master. *The Death of the Virgin*. 1350–60. Tempera on panel, 39 3/8 x 28" (100 x 71.1 cm).
Museum of Fine Arts, Boston

William Francis Warden Fund; Seth K. Sweetser Fund; the Henry C. and Martha B. Angell Collection, Juliana Cheney Edwards Collection, Gift of Martin Brimmer, and Gift of Reverend and Mrs. Frederick Frothingham; by exchange

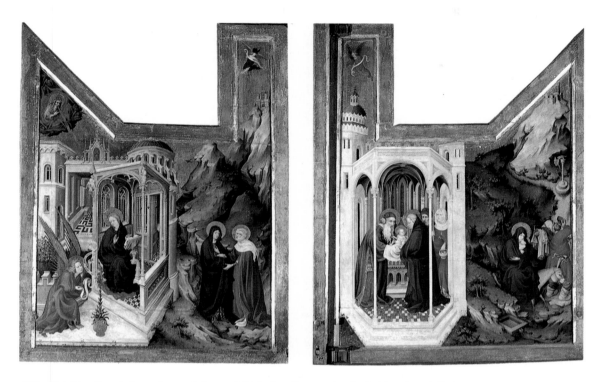

192. Melchior Broederlam. *Annunciation* and *Visitation; Presentation in the Temple* and *Flight into Egypt.* 1394–99. Tempera (?) on wood panel, 53³/₄ x 49¹/₄" (136.5 x 125.1 cm). Musée des Beaux-Arts, Dijon

One gateway of Italian influence was the city of Prague, the capital of Bohemia, thanks to Emperor Charles IV (1316–78), the most remarkable ruler since Charlemagne. After receiving an excellent education in Paris at the court of Charles IV, whose daughter he married and in whose honor he changed his name from Wenceslaus, he returned to Prague and eventually succeeded his father as king of Bohemia in 1346. As a result of his alliance with Pope Clement VI, who resided at Avignon during the papal exile, Prague became an independent archbishopric. It was also through Clement's intervention that Charles was elevated to Holy Roman Emperor at Aachen in 1349. In ex-

change, Charles supported Pope Urban V's return to Rome in 1367. Like Charlemagne before him, Charles sought to make his capital a center of learning, and in 1348 established a university along the lines of that in Paris. He also became an active patron of the arts, which he supported by founding an artist's guild. Prague rapidly developed into an international cultural center second only to Paris itself. Charles was nevertheless impressed most by the art he saw during his two visits to Italy. Thus, *The Death of the Virgin* (fig. 191), made by an unknown Bohemian master about 1355–60, brings to mind the achievements of the great Sienese painters. Its glowing richness of color

recalls Simone Martini (see fig. 187), who, it will be remembered, had worked at Avignon. The carefully articulated architectural interior further betrays its descent from such works as Pietro Lorenzetti's *The Birth of the Virgin* (see fig. 188) although it lacks the spaciousness of its Italian models. Italian, too, is the vigorous modeling of the heads and the overlapping of figures, which reinforce the three-dimensional quality of the design but raise the awkward question of what to do with the halos. Still, the Bohemian artist's picture is not just an echo of Italian painting. The gestures and facial expressions convey an intensity of emotion that represents the finest heritage of Northern Gothic art. In this respect, our panel is far more akin to *The Death of the Virgin* at Strasbourg Cathedral (see fig. 173) than to any Italian work.

International Style Painting

Toward the year 1400, the merging of Northern and Italian traditions gave rise to a single dominant style throughout western Europe. This International Style was not confined to painting—we have used the same term for the sculpture of the period—but painters clearly played the main role in its development.

Melchior Broederlam Among the most important painters in the development of the International Style was Melchior Broederlam (active c. 1387–1409) from Flanders, who worked for the court of the duke of Burgundy in Dijon. Figure 192 shows his only known work: the panels of a pair of movable wings for an altar shrine that he did in 1394–99 for the Chartreuse de Champmol, where he would have known Simone Martini's *The Road to Calvary* (see fig. 187). (The interior consists of an elaborately carved relief by one Jacques de Baerze showing the Adoration of the Magi, the Crucifixion, and the Entombment.) Each wing is really two scenes within one frame. As a result, landscape and architecture stand abruptly side by side, even though the artist has made a half-hearted effort to persuade us that the scene extends around the building. Compared with the treatment of space in paintings by Pietro

Lorenzetti and Simone Martini, Broederlam's picture space still strikes us as naive in many ways: the architecture looks like a doll's house, and the details of the landscape are quite out of scale with the figures. Yet the panels convey a far stronger feeling of depth than we have found in any previous Northern work. The reason for this is the subtlety of the modeling. The softly rounded shapes and the dark, velvety shadows create a sense of light and air that more than makes up for any shortcomings of scale or perspective. This soft, pictorial quality is a hallmark of the International Style. It appears as well in the ample, loosely draped garments with their fluid curvilinear patterns of folds, which remind us of Sluter and Ghiberti (see figs. 178, 181).

Our panels also exemplify another characteristic of the International Style: its "realism of particulars." It is the same kind of realism we encountered first in Gothic sculpture. We find it in the carefully rendered foliage and flowers, in the delightful donkey (obviously drawn from life), and in the rustic figure of Joseph, who looks and behaves like a simple peasant and thus helps emphasize the delicate, aristocratic beauty of the Virgin. This painstaking concentration on detail gives Broederlam's work the flavor of an enlarged miniature rather than of a large-scale painting, even though the panels are more than 4 feet tall.

The expansion of subject matter during the International Style fostered a comparable growth in symbolism. In the left panel, for example, the enclosed garden next to Mary signifies her virginity, as does the lily, while the contrasting Romanesque and Gothic architecture stands for the old and new dispensations of God. This important development paves the way for the dramatic elaboration of symbolic meaning that occurs a mere twenty-five years later under the Master of Flémalle (see page 241).

The Limbourg Brothers Book **illumination** remained the leading form of painting in northern Europe at the time of the International Style, despite the growing importance of panel painting. The International Style reached its most advanced phase in the luxurious Book

of Hours known as *Les Très Riches Heures (The Very Rich Hours)*, produced for the duke of Berry, the brother of the king of France and the most lavish art patron of his day. The artists were Pol de Limbourg and his two brothers, three Flemings introduced to the French court by their uncle, painter Jean Malouel. Like Sluter and Broederlam, the Limbourg brothers had settled in France early in the fifteenth century. They must have visited Italy as well, for their work includes numerous motifs and whole compositions borrowed from great artists of Tuscany.

The most remarkable pages of *Les Très Riches Heures* are those of the calendar, with their elaborate depiction of the life of humanity and nature throughout the months of the year. Such cycles, originally consisting of twelve single figures each performing an appropriate seasonal activity, had long been an established tradition in medieval art. The Limbourg brothers, however, integrated all these elements into a series of panoramas of human life *in* nature.

Figure 193 shows the sowing of winter grain during the month of October. Landscape and architecture are harmoniously united in deep, atmospheric space. It is a bright, sunny day, and the figures—for the first time since classical antiquity—cast visible shadows on the ground. We marvel at the wealth of realistic detail, such as the scarecrow in the middle distance and the footprints of the sower in the soil of the freshly plowed field. The sower is memorable in other ways as well. His tattered clothing, his unhappy air, go beyond mere description. Although peasants were often caricatured in Gothic art, the portrayal here is surprisingly sympathetic, as it is throughout *Les Très Riches Heures*. He is meant to be a pathetic figure and to arouse our awareness of the miserable lot of the peasantry in contrast to the life of the aristocracy, as symbolized by the splendid castle on the far bank of the river. (The castle is a "portrait" of the Louvre Palace in the late fourteenth century, the most lavish structure of its kind at that time. Here, then, Gothic art transcends its realism of particulars to an encompassing vision of life that reflects the Limbourg brothers' knowledge of Italian art, as a glance at Ambrogio Lorenzetti's *Good Government* frescoes (fig. 189) attests.

Gentile da Fabriano From the *Très Riches Heures* it is but a step to the altarpiece with the Three Magi and their train (fig. 194) by Gentile da Fabriano (c. 1370–1427), the greatest Italian painter of the International Style, who surely knew the work of the Limbourg brothers. The costumes here are as colorful, the draperies as ample and softly rounded, as in Northern painting. The Holy Family, on the left, almost seems in danger of being overwhelmed by the festive pageant pouring down upon it from the hills in the distance. The foreground includes more than a dozen marvelously well observed animals, not only the familiar ones but also hunting leopards, camels, and monkeys. (Such creatures were eagerly collected by the princes of the period, many of whom kept private zoos.) The Eastern background of the Magi is further emphasized by the Asian facial cast of some of their companions. It is not these exotic touches, however, that mark our picture as the work of an Italian painter but something else— a greater sense of weight, of physical substance, than we could hope to find among the Northern representatives of the International Style. Despite his love of fine detail, Gentile at heart is obviously a painter used to working on a large scale, rather than a manuscript illuminator. The panels decorating the base, or **predella**, of the altarpiece have a monumentality that belies their small size. He was thoroughly familiar with Sienese art. Thus, *The Flight into Egypt* in the center panel is indebted to Ambrogio Lorenzetti's frescoes in the Siena city hall (see fig. 189), while *The Presentation in the Temple* to the right is based on another scene by the same artist. They nevertheless show that Gentile, too, commanded the delicate pictorial effects of a miniaturist. Though he was not the first artist to depict it, the nocturne in the *Nativity* at the left, partly based on the vision received by the fourteenth-century Swedish princess Bridget in Bethlehem, had an unprecedented poetic intimacy. Yet the new world of artistic possibilities it opened up were not to be fully explored until two centuries later—characteristically enough, by Northern artists.

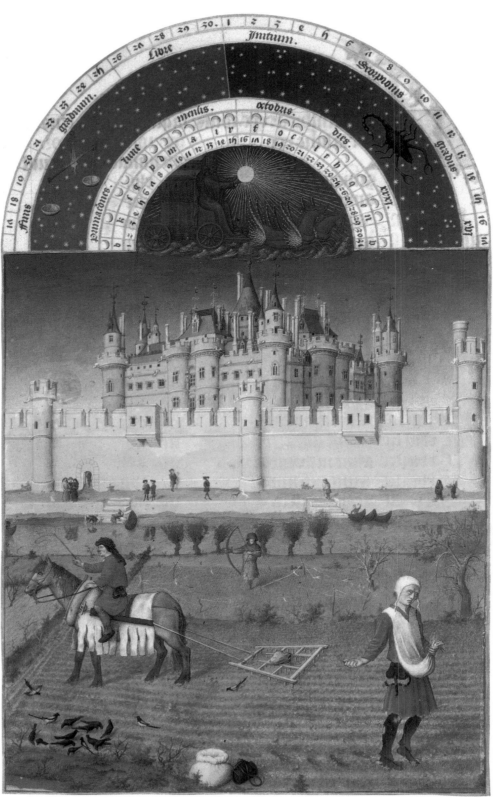

193. The Limbourg Brothers. *October*, from *Les Très Riches Heures du Duc de Berry.*1413–16. 8⁷/₈ x 5³/₈" (22.5 x 13.7 cm). Musée Condé, Chantilly, France

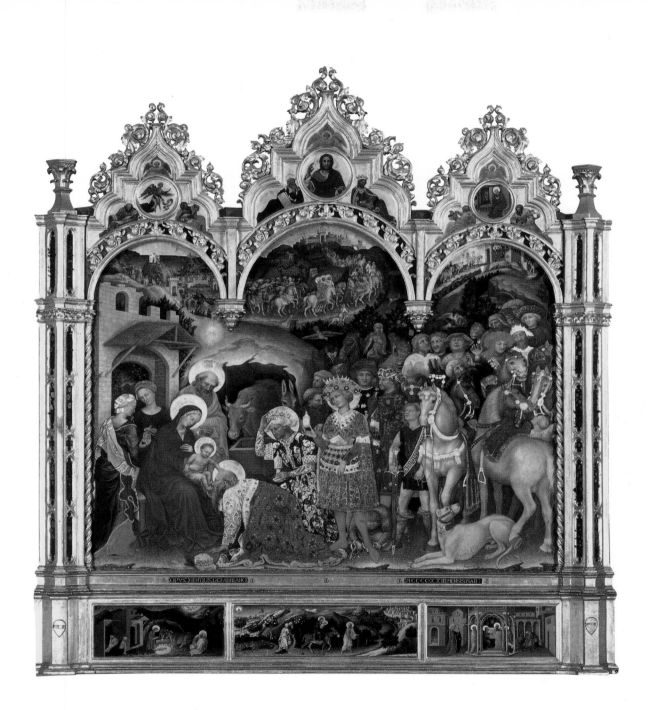

194. Gentile da Fabriano. *The Adoration of the Magi*. 1423. Oil on panel, 9'10¹/8" x 9'3" (3 x 2.88 m).
Galleria degli Uffizi, Florence

CHRONOLOGICAL CHART 2

	Political History	Religion and Literature	Science and Technology
400	Roman Empire split into Eastern and Western branches 395 Rome sacked by Visigoths 410 Fall of Western Roman Empire 476 "Golden Age" of Justinian 527–65	Patrick (d. c. 461) founds Church in Ireland 432 Split between Eastern and Western Churches begins 451	
600	Muhammad (570–632) Byzantium loses Near Eastern and African provinces to Muslims (642–732) Muslims invade Spain 711–18; defeated by Franks, Battle of Tours, 732 Independent Muslim state established in Spain 756	Isidore of Seville, encyclopedist (d. 636) Koran 652 *Beowulf*, English epic, early 8th cent. Iconoclastic Controversy 726–843	Papermaking introduced into Near East from China Stirrup introduced into Western Europe c. 600
800	Charlemagne (ruled 768–814) crowned Holy Roman Emperor 800 Alfred the Great (ruled 871–99?), Anglo-Saxon king of England	Carolingian revival of Latin classics Earliest printed book, China, 868	Earliest documented church organ, Aachen, 822 Horse collar adopted in Western Europe, makes horses efficient draft animals
900	Otto I crowned Holy Roman Emperor 962 Otto II (ruled 973–83) defeated by Muslims in southern Italy	Cluniac monastic order founded 910 Conversion of Russia to Orthodox Church c. 990	Earliest application of waterpower to industry
1000	Normans arrive in Italy 1016 William the Conqueror defeats Harold at Battle of Hastings 1066 Reconquest of Spain from Muslims begins 1085 First Crusade (1095–99) takes Jerusalem	College of Cardinals formed to elect pope 1059 Cistercian order founded 1098 *Chanson de Roland,* French epic, c. 1098	Leif Ericsson sails to North America 1002
1100	King Henry II founds Plantagenet line in England 1154 Frederick Barbarossa (ruled 1155–90) titles himself "Holy Roman Emperor," tries to dominate Italy	Rise of universities (Bologna, Paris, Oxford); faculties of law, medicine, theology Pierre Abélard, French philosopher and teacher (1079–1142) Flowering of French vernacular literature (epics, fables, *chansons*); age of the troubadours	Earliest manufacture of paper in Europe, by Muslims in Spain Earliest use of magnetic compass for navigation Earliest documented windmill in Europe 1180
1200	Fourth Crusade (1202–4) conquers Constantinople Magna Carta limits power of English kings 1215 Louis IX (ruled 1226–70), king of France Philip IV (ruled 1285–1314), king of France	St. Dominic (1170–1221) founds Dominican order; Inquisition established to combat heresy St. Francis of Assisi (d. 1226) St. Thomas Aquinas, Italian scholastic philosopher (d. 1274) Dante Alighieri, Italian poet (1265–1321)	Marco Polo travels to China and India c. 1275–93 Arabic (actually Indian) numerals introduced in Europe First documented use of spinning wheel in Europe 1298, replaces distaff and spindle
1300	Exile of papacy in Avignon 1309–76 Hundred Years' War between England and France begins 1337 Black Death throughout Europe 1347–50	John Wycliffe (d. 1384) challenges Church doctrine; translates Bible into English Petrarch, first humanist (1304–1374) *Canterbury Tales* by Chaucer c. 1387 *Decameron* by Boccaccio 1387	First large-scale production of paper in Italy and Germany Large-scale production of gunpowder; earliest known use of cannon 1326 Earliest cast iron in Europe
1400	Great Papal Schism (since 1378) settled 1417; pope returns to Rome	Jan Hus, Czech reformer, burned at stake for heresy 1415; Joan of Arc burned at stake for heresy and sorcery 1431	Gutenberg credited with invention of printing with movable type 1446–50

Architecture	Sculpture	Painting
S. Vitale, Ravenna *(111, 112)* Hagia Sophia, Istanbul *(114, 115)* S. Apollinare in Classe, Ravenna *(104, 105)*	*Sarcophagus of Junius Bassus,* Rome *(109)* *Archangel Michael,* diptych leaf *(110)*	Catacomb of SS. Pietro e Marcellino, Rome *(103)* Mosaics, Sta. Maria Maggiore, Rome *(107)* *Vienna Genesis (108)* Mosaics, S. Apollinare in Classe and S. Vitale, Ravenna *(106, 113)*
	Sutton Hoo ship-burial treasure *(121)* *Crucifixion* (plaque from a book cover?) *(124)*	*Lindisfarne Gospels (123)*
Palace Chapel of Charlemagne, Aachen *(121)* Monastery plan, St. Gall *(126)*	Oseberg ship-burial *(122)* Crucifixion relief, cover of *Lindau Gospels (129)*	*Gospel Book of Charlemagne (127)* *Gospel Book of Archbishop Ebbo of Reims (128)*
	Gero Crucifix, Cologne Cathedral *(130)*	
St. Michael's, Hildesheim *(131, 132)* Pisa Cathedral complex *(142)* Baptistery, Florence *(143)* St-Étienne, Caen *(139)* St-Sernin, Toulouse *(135, 136, 137)* Durham Cathedral *(140)*	Bronze doors of Bishop Bernward, Hildesheim *(133)* *Apostle,* St-Sernin, Toulouse *(144)*	*Gospel Book of Otto III (134)* Mosaics, Daphne *(117)* *Bayeux Tapestry (151)*
St-Denis, Paris *(154)* Nôtre-Dame, Paris *(155–159)* Chartres Cathedral *(160)* Reims Cathedral *(161)*	South portal, St-Pierre, Moissac *(145)* Baptismal font, St-Barthélemy, Liège, by Renier of Huy *(148)* *Last Judgment* tympanum, Autun Cathedral *(147)* West portals, Chartres Cathedral *(169, 170)* *Klosterneuburg Altarpiece,* by Nicholas of Verdun *(153)*	Nave vault murals, St-Savin-sur-Gartempe *(152)* *Gospel Book of Abbot Wedricus (150)*
Salisbury Cathedral *(163)* Sta. Croce, Florence *(167)* Florence Cathedral *(168)*	West portal, Reims Cathedral *(174)* Choir screen, Naumburg Cathedral *(176)* Pulpit, Baptistery, Pisa, by Nicola Pisano *(179)*	Stained glass *Nôtre Dame de la Belle Verrière,* Chartres Cathedral *(182)* *Psalter of Saint Louis (183)* *Madonna Enthroned,* icon *(119)*
Gloucester Cathedral *(164)*	*Pietà,* Bonn *(177)* Pulpit, Pisa Cathedral, by Giovanni Pisano *(180)* *Moses Well,* Dijon, by Claus Sluter *(178)*	Arena Chapel frescoes, Padua, by Giotto *(185, 186)* *Maestà Altarpiece,* Siena, by Duccio *(184)* *Good Government* fresco, Palazzo Pubblico, Siena, by Ambrogio Lorenzetti *(189)* *Road to Calvary,* by Simone Martini *(187)* *Birth of the Virgin* triptych, Siena, by Pietro Lorenzetti *(188)* *Death of the Virgin,* by Bohemian Master *(191)* Altar wings, Dijon, by Melchior Broederlam *(192)*
	Competition relief for Baptistery doors, Florence, by Ghiberti *(181)*	*Les Très Riches Heures du Duc de Berry,* by Limbourg Brothers *(193)* *Adoration of the Magi* altarpiece, by Gentile da Fabriano *(194)*

NOTE: Figure numbers are in *italics*.

Part Three
The Renaissance

In discussing the transition from classical antiquity to the Middle Ages, we were able to point to the rise of Islam as a major event marking the separation between the two eras. No comparable event sets off the Middle Ages from the Renaissance. The fifteenth and sixteenth centuries did witness far-reaching developments: the deep spiritual crisis of the Reformation and Counter-Reformation, the fall of Constantinople and the Turkish conquest of southeastern Europe, and the journeys of exploration that led to the founding of overseas empires in the New World, in Africa, and in Asia, with the subsequent rivalry of Spain and England as the foremost colonial powers.

None of these events, however great their effects, can be said to have produced the new era. By the time they happened, the Renaissance was well under way. Even if we disregard the minority of scholars who would deny the existence of the period altogether, we are left with an extraordinary diversity of views on the Renaissance. Perhaps the only essential point on which most experts agree is that the Renaissance had begun when people realized they were no longer living in the Middle Ages.

This statement is not as simpleminded as it sounds. It brings out the undeniable fact that the Renaissance was the first period in history to be aware of its own existence and to coin a label for itself. Medieval people did not think they belonged to an age distinct from classical

antiquity. The past, to them, consisted simply of the era "under the Law" (that is, of the Old Testament) and the era "of Grace" (that is, after the birth of Jesus): B.C. meaning "before Christ" and A.D. for "anno Domini" ("in the year of the Lord"). From their point of view, then, history was made in heaven rather than on earth. The Renaissance, by contrast, divided the past not according to the divine plan of salvation but on the basis of human achievements. It saw classical antiquity as the era when civilization had reached the peak of its creative powers, an era brought to a sudden end by the "barbarian" invasions that destroyed the Roman Empire. During the thousand-year interval of "darkness" that followed, little was accomplished, but now,

at last, this "time in-between" or "Middle Age" had been superseded by a revival of all those arts and sciences that flourished in classical antiquity. The present, the "New Age," could thus be fittingly labeled a "rebirth": *rinascita* in Italian (from the Latin *renascere*, "to be reborn"), *renaissance* in French, and by adoption, in English.

The origin of humanism—this revolutionary view of history—can be traced back to the 1330s in the writings of the Italian poet Francesco Petrarca. Petrarch, as we call him, thought of the new era mainly as a "revival of the classics," limited to the restoration of Latin and Greek to their former purity and the return to the original texts of ancient authors—a process that was already well under way.

During the next two centuries, this concept of the rebirth of antiquity grew to embrace almost the entire range of cultural endeavor, including the visual arts. The latter, in fact, came to play a particularly important part in shaping the Renaissance, for reasons that we shall explore later.

Individualism—a new self-awareness and self-assurance—enabled Petrarch to proclaim, against all established authority, his own conviction that the "age of faith" was actually an era of darkness, while the "benighted pagans" of antiquity really represented the most enlightened stage of history. Such readiness to question traditional beliefs and practices was to become profoundly characteristic of the Renaissance as a whole. Humanism, to Petrarch, meant a belief in the importance of what we still call the humanities or humane letters, rather than divine letters or the study of Scripture: the pursuit of learning in languages, literature, history, and philosophy for its own end, in a secular rather than a religious framework.

We must not assume, however, that Petrarch and his successors wanted to revive classical antiquity lock, stock, and barrel. By interposing the concept of "a thousand years of darkness" between themselves and the ancients, they acknowledged (unlike the medieval classicists) that the Graeco-Roman world was irretrievably dead. Its glories could be revived only in the mind, by nostalgic and admiring contemplation across the barrier of the "dark ages," by rediscovering the full greatness of ancient achievements in art and thought, and by endeavoring to compete with these achievements on an ideal plane.

The aim of the Renaissance was not to duplicate the works of antiquity but to equal and, if possible, to surpass them. In practice, this meant that the authority granted to the ancient models was far from unlimited. Writers strove to express themselves with eloquence and precision, but not necessarily in Latin. Architects continued to build the churches demanded by Christian ritual, but not to duplicate pagan temples. Rather, their churches were designed *all'antica*, "in the manner of the ancients," using an architectural vocabulary based on the study of classical structures. The humanists, however great their enthusiasm for classical philosophy, did not become neopagans but went to great lengths trying to reconcile the heritage of the ancient thinkers with Christianity.

The people of the Renaissance, then, found themselves in the position of the legendary sorcerer's apprentice who set out to emulate his master's achievements and in the process released far greater energies than he had bargained for. Since their master was dead, rather than merely absent, they had to cope with these unfamiliar powers as best they could until they became masters in their own right. This process of forced growth was replete with crises and tensions. The Renaissance must have been an uncomfortable, though intensely exciting, time in which to live. Yet these very tensions, it seems, called forth an astonishing outpouring of creative energy. Indeed, the desire to return to the classics, based on a rejection of the Middle Ages, brought to the new era not the rebirth of antiquity but the birth of modern civilization.

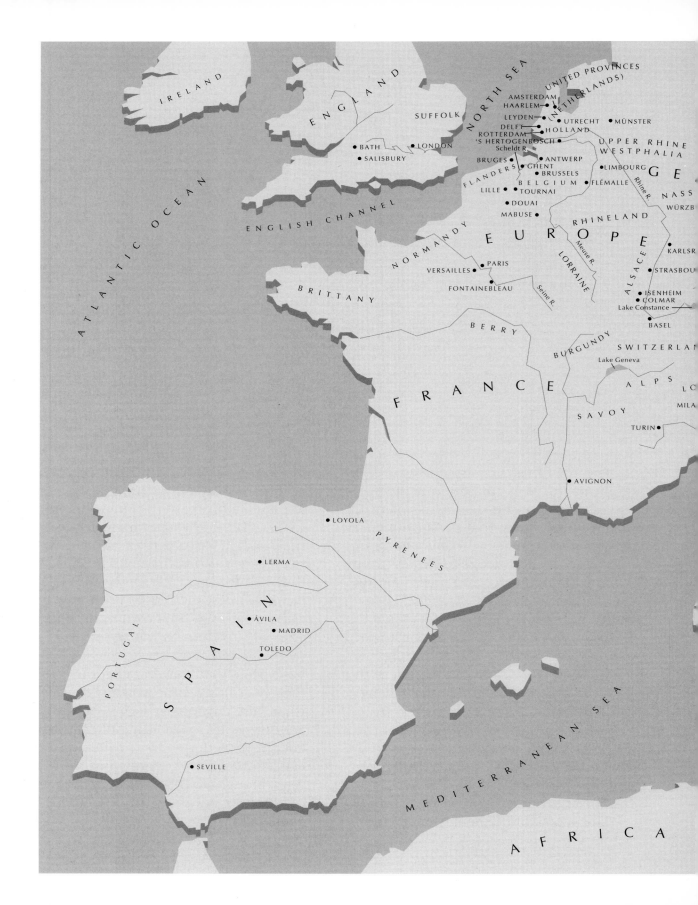

IRELAND

ENGLAND

NORTH SEA

SUFFOLK

UNITED PROVINCES

AMSTERDAM
HAARLEM
LEYDEN · UTRECHT · MÜNSTER
DELFT · (NETHERLANDS)
ROTTERDAM · HOLLAND
'S HERTOGENBOSCH

· BATH · LONDON

UPPER RHINE
WESTPHALIA

Scheldt R.

· SALISBURY

BRUGES · · ANTWERP · LIMBOURG
GHENT
· BRUSSELS

G E

ATLANTIC OCEAN

FLANDERS
BELGIUM · FLÉMALLE
LILLE · · TOURNAI

NASS

WÜRZB

· DOUAI
MABUSE

RHINELAND

Rhine R.

ENGLISH CHANNEL

E U R O P E

KARLSR

Meuse R.

NORMANDY

· PARIS

LORRAINE

ALSACE

· STRASBOU

VERSAILLES ·
· FONTAINEBLEAU

Seine R.

· ISENHEIM
· COLMAR

BRITTANY

Lake Constance —

· BASEL

BERRY

SWITZERLAN

BURGUNDY

Lake Geneva

F R A N C E

A L P S

LO

SAVOY

MILA

· TURIN

· AVIGNON

· LOYOLA

P Y R E N E E S

· LERMA

PORTUGAL

S P A I N

· ÁVILA
· MADRID

· TOLEDO

MEDITERRANEAN SEA

· SEVILLE

A F R I C A

238

THE RENAISSANCE

● BERLIN

● TENBERG

AXONY

MANY

● NUREMBERG

● AUGSBURG

AUSTRIA

YROL

RUSSIA

ARDY
TRENT ● VERONA
RESCIA ● VICENZA
ARAVAGGIO ● VENICE
● MANTUA PADUA
● PARMA

Danube R.

PRATO ● FLORENCE
VINCI ● URBINO
● AREZZO
● PERUGIA
TUSCANY ● ASSISI
UMBRIA

ADRIATIC SEA

Tiber R. ● ROME

APENNINES

ITALY

APULIA

● NAPLES

GREECE

AEGEAN SEA

● ATHENS

STRAIT OF MESSINA

IONIAN SEA

SICILY

CRETE

N

0 MILES 200

0 KM 200

Chapter 12
"Late Gothic" Painting, Sculpture, and Graphic Arts

As we narrow our focus from the Renaissance as a whole to the Renaissance in the fine arts, we are faced with many questions. When did Renaissance art start? Did it, like Gothic art, originate in a specific center, or did it arise in several places at the same time? Should we think of it as one coherent style or as a new "Renaissance-conscious" attitude that might be embodied in more than one style? "Renaissance consciousness" was an Italian idea, and there can be no doubt that Italy played the leading role in the development of Renaissance art, at least until the early sixteenth century. This fact does not necessarily mean, however, that the Renaissance was confined to the South. So far as architecture and sculpture are concerned, modern scholarship agrees with the traditional view, first expressed more than 500 years ago, that the Renaissance began soon after 1400. For painting, however, an even older tradition argues that the new era began with Giotto. Scholars hesitate to accept such a claim at face value, for they must then assume that the Renaissance in painting dawned about 1300, a full generation before Petrarch. Similarly, as we have seen, Giotto himself did not reject the past.

195. Master of Flémalle
(Robert Campin?).
Mérode Altarpiece.
c. 1425–30. Oil on
wood panels,
center 25 3/16 x 24 7/8"
(64 x 63.2 cm),
each wing
approx. 25 3/8 x 10 7/8"
(64.5 x 27.6 cm).
The Metropolitan
Museum of Art,
New York

Cloisters Collection, 1956

Renaissance versus "Late Gothic" Painting

Renaissance art was born of a second revolution, a century after Giotto, which began simultaneously and independently in Italy and in ▼FLANDERS about 1420. We must think, therefore, of two events, linked by a common aim—the conquest of the visible world—but sharply divided in almost every other respect. The Italian, or Southern, revolution was the more systematic and, in the long run, the more fundamental, since it included architecture and sculpture as well as painting. The movement that originated in Florence is called the Early Renaissance. The same term is not generally applied to the new style that emerged in the NETHERLANDS. There is, in fact, no satisfactory name to designate the Northern branch of the revolution. Art historians are still of two minds about its scope and significance in relation to the Renaissance as a whole.

For the new Northern style, we shall use the label *"Late Gothic,"* with quotation marks to indicate its doubtful status. The term hardly does justice to the special character of Northern fifteenth-century painting, but it has some justification. It indicates, for instance, that the creators of the new style, unlike their Italian contemporaries, did not entirely reject the International Style. Rather, they took it as their point of departure, so that the break with the past was less abrupt in the North than in the South. Moreover,

their artistic environment was clearly "Late Gothic." Fifteenth-century architecture outside Italy remained firmly rooted in the Gothic tradition. How could they create a genuinely postmedieval style in such a setting, one wonders. Would it not be more reasonable to regard their work, despite its great importance, as the final phase of Gothic painting? Italian Renaissance art, after all, made very little impression north of the Alps before 1500. Furthermore, humanism did not begin to play an important role in Northern thought until the final decades of the fifteenth century, so that there was an essential continuity of worldview with the late Middle Ages.

If we treat Northern painters of this time as the counterpart of the Early Renaissance, it is because the great Flemish artists whose work we are about to examine had an impact that went far beyond their own region. In Italy, they were admired as greatly as the leading Italian artists of the period. Their intense realism had a conspicuous influence on Early Renaissance painting, for the Italians themselves associated the exact imitation of nature in painting with a return to the classics. To their eyes, "Late Gothic" painting appeared definitely postmedieval.

Netherlandish Painting

The Master of Flémalle The first, and perhaps the decisive, phase of the pictorial revolution in Flanders is represented by an artist whose

▼ Originally a county (ruled by counts), FLANDERS was a cultural and political entity for many centuries (its original lands are now parts of Belgium, France, and the Netherlands). It was fought over and controlled by a succession of counts, dukes, and kings of France, Burgundy, and Flanders itself. Ghent and Bruges were two of its most important cities. HOLLAND was a county to the north of Flanders, whose history parallels that of Flanders in being subject to outside rule for much of its history. Holland was absorbed into the NETHERLANDS when it was officially formed as a kingdom in 1648. BELGIUM is a relatively modern entity, a kingdom created in 1839.

name we do not know for certain. He is called the Master of Flémalle (after the fragments of a large altarpiece from Flémalle), but he was probably Robert Campin, the foremost painter of Tournai, whose career we can trace in documents from 1406 to his death in 1444. His finest work is the *Mérode Altarpiece* (fig. 195), which he must have done soon after 1425. Comparing it with one of its relatives among the Franco-Flemish pictures of the International Style (see fig. 192), we see that it falls within that tradition. Yet we recognize in it a new pictorial experience.

Here, almost for the first time, we have the sensation of actually looking *through* the surface of the panel into a spatial world that has all the essential qualities of everyday reality: unlimited depth, stability, continuity, and completeness. The painters of the International Style, even at their most adventurous, had never aimed at such consistency, and their commitment to reality was far from absolute. The pictures they created have the enchanting quality of fairy tales, where the scale and relationship of things can be shifted at will, where fact and fancy mingle without conflict. The Master of Flémalle, in contrast, has undertaken to tell the truth, the whole truth, and nothing but the truth. To be sure, he does not yet do it with total ease. His objects, overly **foreshortened**, tend to jostle each other in space. But with almost obsessive determination, he defines every last detail of every object to give it maximum concreteness: its individual shape and size; its color, material, and surface textures; its degree of rigidity and way of responding to illumination. The artist even distinguishes between the diffused light creating soft shadows and delicate gradations of brightness, and the direct light entering through the two round windows, which produces the twin shadows sharply outlined in the upper part of the center panel and the twin reflections on the brass vessel and candlestick.

The *Mérode Altarpiece* transports us from the aristocratic world of the International Style to the household of a Flemish burgher. The Master of Flémalle was no court painter but a city dweller catering to the tastes of such well-to-do fellow citizens as the two donors piously kneeling outside the Virgin's chamber. This is the earliest Annunciation in panel painting that occurs in a fully equipped domestic interior (compare fig. 188), as well as the first to honor Joseph, the humble carpenter, by showing him at work next door.

This bold departure from tradition forced upon our artist a problem no one had faced before: how to transfer supernatural events from symbolic settings to an everyday environment without making them look either trivial or incongruous. The Master of Flémalle has met this challenge by the method sometimes called disguised symbolism, which means that almost any detail within the picture, however casual it may seem, may carry a symbolic message. We saw its beginnings during the International Style in the *Annunciation* by Melchior Broederlam (see fig. 192), but his symbolism seems rudimentary in comparison with the profusion of hidden meanings in the *Mérode Altarpiece*. Thus, the flowers in the left wing and the center panel are associated with the Virgin: the roses denote her charity, the violets her humility, and the lilies her chastity. The shiny water basin and the towel on its rack are not ordinary household equipment but further tributes to Mary as the "vessel most clean" and the "well of living waters."

The significance of these well-established symbols would have been readily understood by the artist's patrons. Clearly, an entire wealth of medieval symbolism survives in our picture, but it is so completely immersed in the world of everyday appearances that we are often left to doubt whether a given detail demands symbolic interpretation. Perhaps the most intriguing symbol of this sort is the candle next to the vase of lilies. It was extinguished only moments before, as we can tell from the glowing wick and the curl of smoke. But why had it been lit in broad daylight, and what made the flame go out? Has the divine radiance of the Lord's presence overcome the material light? Or did the flame of the candle itself represent the divine light, now extinguished to show that God has become human, that in Jesus "the Word was made flesh"? Equally mystifying to the modern

eye is the little boxlike object on Joseph's workbench and a similar one on the ledge outside the open window. They have been identified as mousetraps intended to convey a specific theological message. According to ▼AUGUSTINE, God had to appear on earth in human form so as to fool Satan: "the Cross of the Lord was the devil's mousetrap."

The freshly extinguished candle and the mousetrap are unusual symbols that the Master of Flémalle himself introduced into the visual arts. He must have either been unusually well educated or had contact with theologians and other scholars who could supply him with references that suggested the symbolic meanings of everyday things. Our artist, then, did not merely continue the symbolic tradition of medieval art within the framework of the new realistic style. He expanded and enriched it by his own efforts.

Why, we wonder, did he pursue simultaneously what are customarily regarded as two opposite goals: realism and symbolism? To him, apparently, the two were interdependent, rather than in conflict. For him to paint everyday reality, he had to "sanctify" it with a maximum of spiritual significance. This deeply reverential attitude toward the physical universe as a mirror of divine truths helps us understand why in the *Mérode* panels the smallest and least-conspicuous details are rendered with the same concentrated attention as the sacred figures. Potentially at least, everything is a symbol and thus merits an equally exacting scrutiny. The disguised symbolism of the Master of Flémalle and his successors was not an external device grafted onto the new realistic style but was ingrained in the creative process. Their Italian contemporaries must have sensed this, for they praised both the miraculous realism and the "piety" of the Flemish painters.

If we compare the *Mérode* Annunciation with an earlier panel painting (see fig. 192), we see that, all other differences aside, the Master of Flémalle's picture stands out for its distinctive **tonality**. The jewel-like brightness of the older work, with its patterns of brilliant hues and lavish use of gold, has given way to a color scheme that is far less decorative but much more flexible and differentiated. The subdued palette of muted greens and bluish or brownish gray tints shows a new subtlety, and the scale of intermediate shades is smoother and has a wider range. All these effects are essential to the realistic style of the Master of Flémalle. They were made possible by the use of oil, the medium he was among the first to exploit.

Tempera and Oil Techniques The basic medium of medieval panel painting had been **tempera**, in which the finely ground pigments were mixed (tempered) with diluted egg yolk to produce a tough, quick-drying coat of colors that cannot be blended smoothly. Oil, a viscous, slow-drying medium, could produce a vast variety of effects, from thin, translucent films (called **glazes**) to a thick layer of creamy, heavy-bodied paint (called **impasto**). The ▼TONES could also yield a continuous scale of HUES necessary for rendering three-dimensional effects, including rich, velvety dark shades previously unknown. **Oil painting** offers a unique advantage over using egg tempera, **encaustic**, and **fresco**: oils give artists the unprecedented ability to change their minds almost at will. Without oil, the Flemish artists' conquest of visible reality would have been much more limited. Although oil was not unfamiliar to medieval artists, it was the Master of Flémalle and his contemporaries who discovered its artistic possibilities. Thus, from the technical point of view, too, they deserve to be called the founders of modern painting, for oil has been the painter's basic medium ever since.

Jan and Hubert van Eyck The full range of effects made possible by oil was not discovered all at once, nor by any one individual. The actual "invention" of oil painting was long credited to Jan van Eyck, a somewhat younger and much more famous artist than the Master of Flémalle. A good deal is known about Jan's life and career. Born about 1390, he worked in Holland from 1422 to 1424, in Lille (now in northern France) from 1425 to 1429, and thereafter in Bruges (now in Belgium), where he died in 1441. He was both a townsperson and a

▼ AUGUSTINE of Hippo (in present-day Algeria) is regarded as the greatest theologian of the Roman Catholic Church. Born in 354, he was a Manichaean for some time, then a Neoplatonist (see page 251); he was converted to Christianity under the influence of fellow theologian Ambrose at age thirty-two in Milan. Augustine's powerful autobiographical *Confessions,* covering his life to 387, is a Christian classic. He returned to Africa and in 395 was named bishop of Hippo. Before his death in 430, Augustine wrote his immensely influential *City of God.* Augustine is the patron saint of printers and theologians.

▼ The vocabulary of color includes the terms *TONE, HUE, tint, shade,* and *intensity. Hue* refers to the name of a color—green, for example. *Tint* refers to a color resulting from the mixture of white with a given hue (light green), and *shade* is the hue darkened by the addition of black (dark green). *Intensity* is the degree of a hue's purity or saturation. *Tone* and *tonality* describe the impression given by a color or a range of colors, which can range from soft to garish.

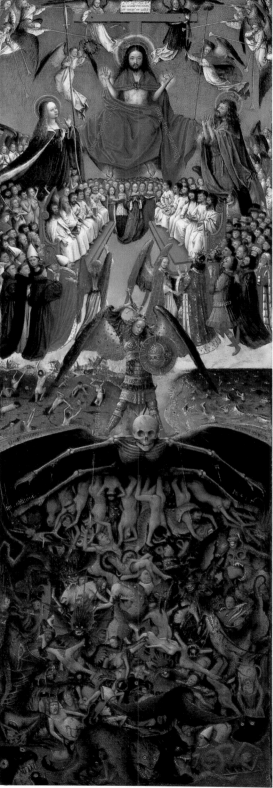

196. Hubert and/or
Jan van Eyck.
The Crucifixion and
The Last Judgment.
c. 1420–25. Tempera
and oil on canvas,
transferred from
wood, each panel
22¼ x 7¾"
(56.5 x 19.7 cm).
The Metropolitan
Museum of Art,
New York

Fletcher Fund, 1933

court painter, highly esteemed by Duke Philip the Good of Burgundy, who occasionally sent him on confidential diplomatic errands. We can follow Jan's career after 1432 through a number of signed and dated pictures.

Jan's earlier development, however, remains disputed. There are several "Eyckian" works that may have been painted by him, by his older brother, Hubert—a shadowy figure who died in 1426—or by both. The most fascinating of these is a pair of panels showing the Crucifixion and the Last Judgment (fig. 196), which date from between 1420 and 1425. The style of these paintings has many qualities in common with that of the *Mérode Altarpiece:* the all-embracing devotion to the visible world, the unlimited depth of space, and the angular drapery folds, less graceful but far more realistic than the unbroken loops of the International Style. At the same time, the individual forms are not starkly tangible, like those characteristic of the Master of Flémalle, and seem less isolated, less "sculptural." The sweeping sense of space is the result not so much of violent foreshortening as of subtle changes of light and color. If we inspect the *Crucifixion* panel closely, we see a gradual decrease in the intensity of local colors and in the contrast of light and dark from the foreground figures to the far-off city of Jerusalem and the snow-capped peaks beyond. Everything tends toward a uniform tint of light bluish gray, so that the farthest mountain range merges imperceptibly with the color of the sky.

This optical phenomenon is known as **atmospheric perspective**. The Limbourg brothers had already been aware of the effect (see fig. 193), but the van Eycks were the first to utilize it fully and systematically. The atmosphere is never wholly transparent. Even on the clearest day, the air between us and the things we are looking at acts as a hazy screen that interferes with our ability to see distant shapes clearly. As we approach the limit of visibility, it swallows them altogether. Atmospheric perspective is more fundamental to our perception of deep space than **linear perspective**, which records the diminution in the apparent size of objects as their distance from us increases. Atmo-

spheric perspective is effective not only in faraway vistas. In the *Crucifixion* panel, even the foreground seems enveloped in a delicate haze that softens contours, shadows, and colors. Thus, the entire scene has a continuity and harmony quite beyond the pictorial range of the Master of Flémalle.

How did the van Eycks achieve this effect? Their exact technical procedure is difficult to reconstruct, but there can be no question that they used the oil medium with extraordinary refinement. By alternating opaque and translucent layers of paint, they were able to impart to their pictures a soft, glowing radiance of tone that has never been equaled, probably because it depends fully as much on their individual sensibilities as it does on their technical skill.

Seen as a whole, *The Crucifixion* seems singularly devoid of drama, as if the scene had been gently becalmed by some magic spell. Only when we concentrate on the details do we become aware of the violent emotions in the faces of the crowd beneath the cross and the restrained but profoundly touching grief of the Virgin Mary and her companions in the foreground. In *The Last Judgment*, this dual quality of the Eyckian style takes the form of two extremes. Above the horizon, all is order, symmetry, and calm; below it, on earth and in the subterranean realm of Satan, violent chaos prevails. The two states thus correspond to heaven and hell, contemplative bliss in contrast to physical and emotional turbulence. The lower half, clearly, was the greater challenge to the artist's imaginative powers. The dead rising from their graves with frantic gestures of fear and hope, the damned being torn apart by devilish monsters more frightful than any we have seen before (compare fig. 147), all have the awesome reality of a nightmare, but a nightmare "observed" with the same infinite care as the natural world of the *Crucifixion* panel.

As observed before, donors' portraits, each of splendid individuality, occupy a conspicuous position in the *Mérode Altarpiece*. A renewed interest in realistic portraiture had developed in the North in the mid-fourteenth century, but until about 1420 its best achievements were in sculpture. The portrait did not play a major role

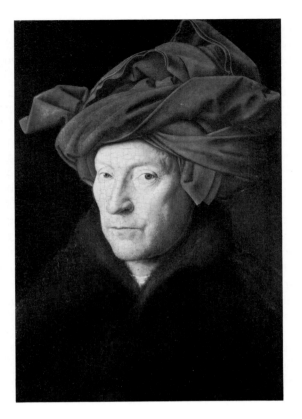

197. Jan van Eyck. *Man in a Red Turban (Self-Portrait?)*. 1433. Oil on panel, 10¼ x 7½" (26 x 19.1 cm). The National Gallery, London

in Northern painting until the Master of Flémalle, the first artist since antiquity to have real command of a close-range view of the human face from a three-quarter angle instead of in profile. In addition to donors' portraits, we now begin to encounter in growing numbers small, independent likenesses whose peculiar intimacy suggests that they were treasured keepsakes, pictorial substitutes for the real presence of the sitter. One of the most compelling is Jan van Eyck's *Man in a Red Turban* of 1433 (fig. 197), which may well be a self-portrait. (The slight strain about the eyes seems to come from gazing into a mirror.) The sitter is bathed in a gentle, clear light. Every detail of shape and texture has been recorded with almost microscopic precision. Jan does not suppress the sitter's personality, yet this face, like all of Jan's portraits, remains a psychological puzzle. It might be described as even-tempered in the most exact sense of the term: its character traits are balanced

against each other so perfectly that none can assert itself at the expense of the rest. Jan was fully capable of expressing emotion—we need only recall the faces of the crowd in *The Crucifixion*—so the stoic calm of his portraits surely reflects his conscious ideal of human character rather than indifference or lack of insight.

The Flemish cities of Tournai, Ghent, and Bruges, where the new style of painting flourished, were the rivals of Florence, Venice, and Rome as centers of international banking and trade. Their foreign residents included many Italians. For one of these, perhaps a member of the Arnolfini family, Jan van Eyck painted his remarkable double portrait to celebrate the alliance of two families active in Bruges and Paris (fig. 198, page 248). It probably represents the betrothal of Giovanni Arnolfini and Giovanna Cenami in the main room of the bride's house. The young couple touches hands in espousal as the groom raises his right hand in

solemn oath. They seem to be quite alone, but in the mirror conspicuously placed behind them is the reflection of two other people who have entered the room (fig. 199). One of them is presumably the bride's father, who by tradition presents her to the groom. The other must be the artist, since the words above the mirror, in florid legal lettering, tell us that *Johannes de eyck fuit hic* ("Jan van Eyck was here" in the year 1434.

Jan's role, then, is that of a witness to the event, which also entailed a legal and financial contract between the two families. The picture claims to show exactly what he saw. Given its secular nature, we may wonder whether the picture is filled with the same sort of disguised symbolism as the *Mérode Altarpiece,* or whether the pervasive realism serves simply as an accurate record of the domestic setting. The elaborate bed was the main piece of furniture in a well-appointed living room of the day. May it not also contain a discreet allusion to the physical consummation that validated marriage? Has the couple taken off their shoes merely as a matter of custom, or to remind us that they are standing on "holy ground"? By the same token, is the little dog no more than a beloved pet, or is it an emblem of fidelity? The other furnishings of the room pose similar problems of interpretation. What is the role of the single candle in the chandelier, burning in broad daylight (compare fig. 195)? And is the convex mirror, whose frame is decorated with scenes from the Passion of Christ, not a symbol of the vanity of earthly things (see fig. 199, page 248)? Clearly Jan was so intrigued by its unusual visual effects that he incorporated it into two other paintings as well.

Rogier van der Weyden In the work of Jan van Eyck, the exploration of the reality made visible by light and color reached a level that was not to be surpassed for another two centuries. Rogier van der Weyden (1399/1400–64), the third great master of early Flemish painting, set himself a different though equally important task: to recapture the emotional drama and the pathos of the Gothic past within the framework of the new style created by his predecessors. In *Descent from the Cross* (fig. 200), a splendid early work painted around the same time as Jan's *Arnolfini Portrait,* the modeling is sculpturally precise, with brittle, angular drapery folds recalling those of his teacher, the Master of Flémalle. The soft half shadows and rich, glowing colors show his knowledge of Jan van Eyck, with whom he may also have been in contact. However, Rogier is far more than a follower of the two older artists. Whatever he owes to them (and it is obviously a great deal) he uses for purposes that are not theirs but his. The external events (in this case, the lowering of Jesus' body from the cross) concern him less than the world of human feeling: "the inner desires and emotions . . . whether sorrow, anger, or gladness," in the words of an early account. The visible world, in turn, becomes a means toward that same end.

Rogier's art has been well described as "at once physically barer and spiritually richer than Jan van Eyck's." This Descent, judged for its expressive content, could well be called a Lamentation. The Virgin's swoon echoes the pose and expression of her son. So intense are her pain and grief that they inspire in the viewer the same compassion. Rogier has staged his scene in a shallow architectural niche or shrine, not against a landscape background. This bold device gives him a double advantage in heightening the effect of the tragic event. It focuses the viewer's entire attention on the foreground and allows the artist to mold the figures into a coherent, formal group. It seems uniquely fitting that Rogier treats his figures as if they were colored statues, for the artistic ancestry of these grief-stricken gestures and faces is in sculpture rather than painting. The panel descends from the Strasbourg *Death of the Virgin* (see fig. 173), to which it bears a strong similarity in both composition and mood.

Rogier's art is truly "Late Gothic," for it never departs from the spirit of the Middle Ages. Yet visually it belongs just as clearly to the new era, so that the past is inevitably restated in contemporary terms. It was thus accessible to people still imbued with a medieval outlook. No wonder he set an example for countless other artists. When he died in 1464, after thirty years as the foremost painter of Brussels, his

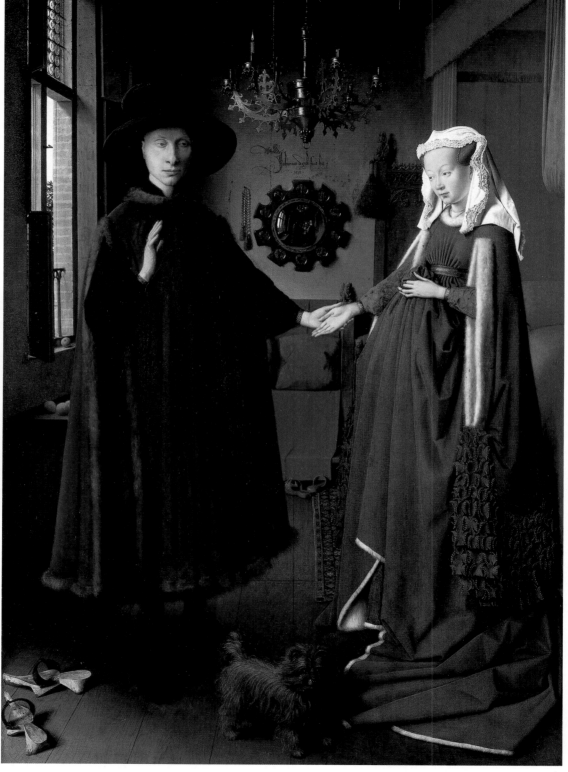

198. Jan van Eyck. *Portrait of Giovanni Arnolfini (?) and His Wife Giovanna Cenami (?)*. 1434. Oil on wood panel, 33 x 22¹/₂" (83.8 x 57.2 cm). The National Gallery, London

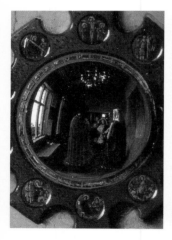

199. Detail of figure 198

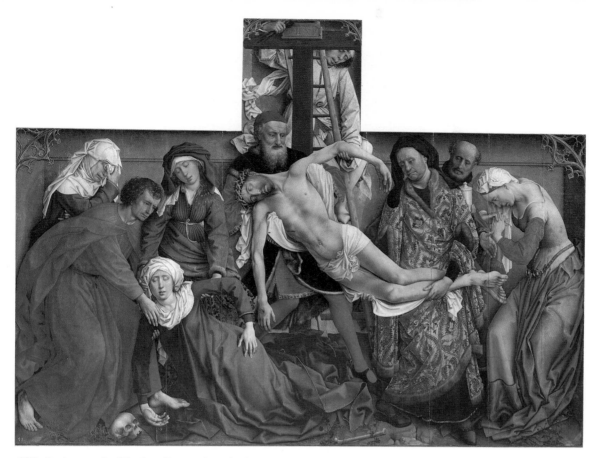

200. Rogier van der Weyden. *Descent from the Cross*. c. 1435. Oil on panel, 7'2⁵/8" x 8'7¹/8" (2.2 x 2.62 m). Museo del Prado, Madrid

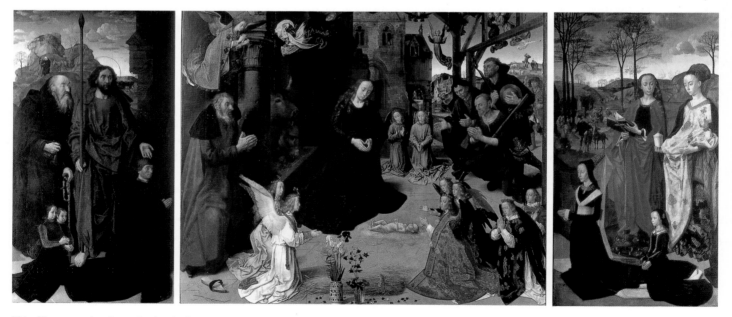

201. Hugo van der Goes. *Portinari Altarpiece* (open). c. 1476. Tempera and oil on panel, center 8'3¹/2" x 10' (2.53 x 3.05 m), wings each 8'3¹/2" x 4'7¹/2" (2.53 x 1.41 m). Galleria degli Uffizi, Florence

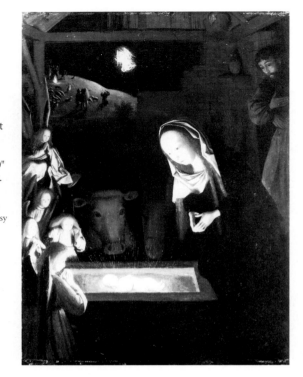

202. Geertgen tot Sint Jans. *Nativity*. c. 1490. Oil on panel, 13½ x 10" (34.3 x 25.4 cm). The National Gallery, London

▼ The OX and ASS in depictions of the Nativity of Jesus refer to the prophet Isaiah's words, "the ox knoweth its owner, and the ass its master's crib" (Isaiah I:3). Both humble creatures, the ox is associated with sacrifice and unquestioning labor and thus contrasts to the fertility bull images of earlier Near Eastern civilizations.

▼ A TRIPTYCH has three fields for images, a DIPTYCH two. They can be fixed panels or wings that fold together and may be of any size.

influence was supreme throughout Europe north of the Alps. Such was the authority of his style that its impact continued to be felt almost everywhere outside Italy, in painting as well as sculpture, until the end of the century.

Hugo van der Goes Few of the artists who came after Rogier van der Weyden succeeded in escaping from the great painter's shadow. To them his paintings offered a choice between intense drama on the one hand and delicate restraint on the other. Most opted for the latter, and their work is marked by a fragile charm. The most dynamic of Rogier's disciples was Hugo van der Goes (c. 1440–82). After a spectacular rise to fame in the cosmopolitan atmosphere of Bruges, he decided in 1478, when he was nearly forty years of age, to enter a monastery as a lay brother. He continued to paint for some time, but increasing fits of depression drove him to the verge of suicide, and four years later he was dead.

Van der Goes's most ambitious work, the huge altarpiece he completed about 1476 for Tommaso Portinari, is an awesome achievement (fig. 201). There is a tension between the artist's devotion to the natural world and his concern with the supernatural. Hugo has rendered a wonderfully spacious and atmospheric landscape setting, with a wealth of precise detail. Yet the disparity in the size of the figures seems to contradict this realism. In the wings, the kneeling members of the Portinari family are dwarfed by their patron saints, whose gigantic size characterizes them as being of a higher order. The latter figures are not meant to be "larger than life," however, for they share the same huge scale with Joseph, the Virgin Mary, and the shepherds of the Nativity in the center panel, whose height is normal in relation to the architecture and to the ▼OX and ASS. The angels are drawn to the same scale as the donors and thus appear abnormally small.

This variation of scale stands outside the logic of everyday experience affirmed in the environment the artist has provided for his figures. Although it originated with Rogier van der Weyden and has a clear symbolic purpose,

Hugo exploited the incongruity for expressive effect. There is another striking contrast between the hushed awe of the shepherds and the ritual solemnity of all the other figures. These field hands, gazing in breathless wonder at the newborn Child, react to the dramatic miracle of the Nativity with a wide-eyed directness new to Flemish art. They aroused particular admiration in the Italian painters who saw the work after it arrived in Florence in 1483.

Geertgen tot Sint Jans During the last quarter of the fifteenth century, there were no painters in Flanders comparable to Hugo van der Goes, and the most original artists appeared farther north, in Holland. To one of these, Geertgen tot Sint Jans of Haarlem, who died about 1495, we owe the enchanting *Nativity* reproduced in figure 202, a picture as daring in its quiet way as the center panel of the *Portinari Altarpiece*. The idea of a nocturnal Nativity, illuminated mainly by radiance from the Christ Child, goes back to the International Style (see fig. 194), but Geertgen, applying the pictorial discoveries of Jan van Eyck, gives new, intense reality to the theme. The magic effect of his little panel is greatly enhanced by the smooth, simplified shapes that record the play of light with striking clarity. The heads of the angels, the Infant, and the Virgin are all as round as objects turned on a lathe, while the manger is a rectangular trough.

Hieronymus Bosch If Geertgen's uncluttered forms seem surprisingly modern, another Dutch artist, Hieronymus Bosch, appeals to our interest in the world of dreams. Little is known about Bosch except that he came from a family of painters named van Aken, spent his life in the provincial town of 's Hertogenbosch, and died, an old man, in 1516. His work, full of weird and seemingly irrational imagery, has proved difficult to interpret.

We can readily see why when we study the ▼TRIPTYCH known as *The Garden of Delights* (fig. 203, page 252), the richest and most puzzling of Bosch's pictures. Its peculiar qualities may be owing in part to the fact that this is not a traditional altarpiece but a secular work: it was probably commissioned by Henry III of Nassau

for his palace in Brussels, where it was hanging immediately after Bosch's death. This German prince would have been familiar with Bosch's work in 's Hertogenbosch, site of the royal summer residence. Many ingenious proposals have been put forward by scholars to explicate the painting: for example, that it represents the days of Noah, or that it is a heretical allegory of redemption through the acceptance of humanity's natural state before ▼THE FALL. Much of the imagery in *The Garden of Delights* derives from treatises on ▼ASTROLOGY and ALCHEMY, which Bosch would have known through his father-in-law, a well-to-do pharmacist. These unite the HUMORS with the ZODIAC in a universal scheme of good and evil paralleling ▼NEOPLATONISM, which was itself interested in magic in this prescientific era. Yet, none of these explanations is wholly satisfactory in itself. In the end, we must take the character of the painting itself into account; moreover, any interpretation must be consistent with Bosch's work as a whole.

Of the three panels, only the left one has a clearly recognizable subject: the Garden of Eden, where the Lord introduces Adam to the newly created Eve. The landscape, almost Eyckian in its airy vastness, is filled with animals, among them such exotic creatures as an elephant and a giraffe, as well as hybrid monsters of odd and sinister kinds. The distant rock formations behind them are equally strange. They are perhaps a reference to the alchemical furnace, in which foul gases are purified. The right wing, a nightmarish scene of burning ruins and fantastic instruments of torture, surely represents hell. But what of the center, the Garden of Delights?

Here is a landscape much like that of the Garden of Eden, populated with countless nude men and women engaged in a variety of peculiar activities. In the center, they parade around a circular basin on the backs of all sorts of beasts. Many frolic in pools of water. Most of them are closely linked with enormous birds, fruit, flowers, or marine animals. Only a few are openly engaged in lovemaking, but there can be no doubt that the delights in this "garden" are those of carnal desire, however oddly disguised. The birds, fruit, and the like are symbols or metaphors

▼ Judeo-Christian belief holds that the original male and female, Adam and Eve, were originally immortal and lived in the Garden of Eden. When they consciously disobeyed one of the few rules God had laid down and ate a fruit from the Tree of the Knowledge of Good and Evil, they committed the original sin. For this, God forced them to leave the Garden, imbued them with the sense of shame, and took back the gift of eternal life. These events are known as THE FALL.

▼ ASTROLOGY is the art and science of foretelling events by observing and interpreting the movements of the sun, moon, planets, and stars. In the Middle Ages and until the sixteenth century, astrology was regarded very seriously. ALCHEMY is the supposed transformation of base metals into silver and gold; its practitioners, alchemists, relied on astrologists to advise them on the most propitious times to perform their mystical and secretive activities. The ZODIAC technically is a zone of the sky encompassing the major paths of the sun, moon, and planets. It is divided into twelve equal zones of 30 degrees, each named for a major constellations of stars; the interplay of the zodiacal sections are important to astrology. The four HUMORS— identified in ancient times as blood, phlegm, black bile, and yellow bile—were thought to determine health and temperament.

▼ NEOPLATONISM is a philosophy developed by Plotinus in the third century A.D. among Greeks living in Alexandria, based on Plato's hierarchy of forms, but with a strong metaphysical component that seems to derive in part from Oriental mysticism. The Neoplatonic system holds that all existence emanates from a single source, the One, to which the soul can be reunited, and that the One emanates the Divine Mind or Logos ("Word"), containing all intelligences of all individuals.

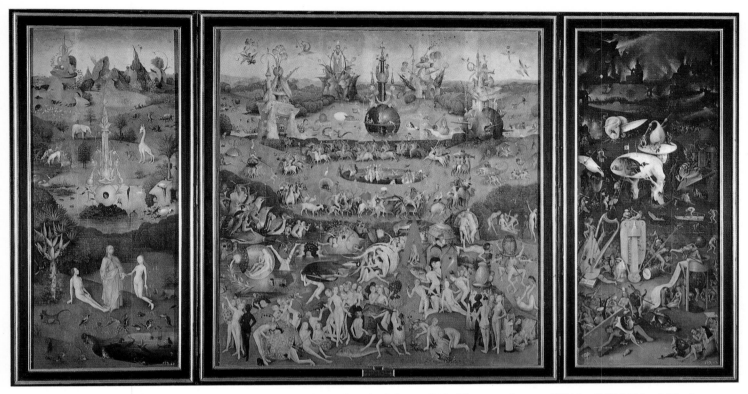

203. Hieronymus Bosch. *The Garden of Delights*. c. 1510. Oil on panel, center 7'2¹/₂" x 6'4³/₄" (2.2 x 1.95 m), wings each 7'2¹/₂" x 3'2" (2.2 x 0.97 m). Museo del Prado, Madrid

that Bosch uses to depict life on earth as an unending repetition of the Original Sin of Adam and Eve, which dooms us to be the prisoners of our appetites. Nowhere does he so much as hint at the possibility of salvation. Corruption, on the animal level at least, had already asserted itself in the Garden of Eden before the Fall, and we are all destined for hell, the Garden of Satan, with its grisly and refined tools of torture.

Bosch conveys a profoundly pessimistic attitude about humanity. We nevertheless sense a fundamental ambiguity in the central panel. There is an innocence, even a haunting poetic beauty, in this panorama of human sinfulness. Consciously, Bosch was a stern moralist who intended his pictures to be visual sermons, every detail packed with didactic meaning. Unconsciously, however, he must have been so enraptured by the sensuous appeal of the world of the flesh that the images he coined in such abundance tend to celebrate what they are meant to condemn. That, surely, is the reason why

The Garden of Delights still evokes so strong a response today, even though we no longer understand every word of the pictorial sermon.

Swiss and French Painting

The new realism of the great Flemish painters began to spread after about 1430 into France and Germany until, by the middle of the century, its influence prevailed everywhere from Spain to the Baltic. Among the countless artists (many of them still anonymous today) who turned out provincial adaptations of Netherlandish painting, only a few were gifted enough to impress us with a distinctive personality.

Conrad Witz One of the earliest and most original of the painters outside the Netherlands was Conrad Witz of Basel (1400/10–45/46), whose altarpiece for Geneva Cathedral, painted in 1444, includes the remarkable panel shown in figure 204. To judge from the drapery,

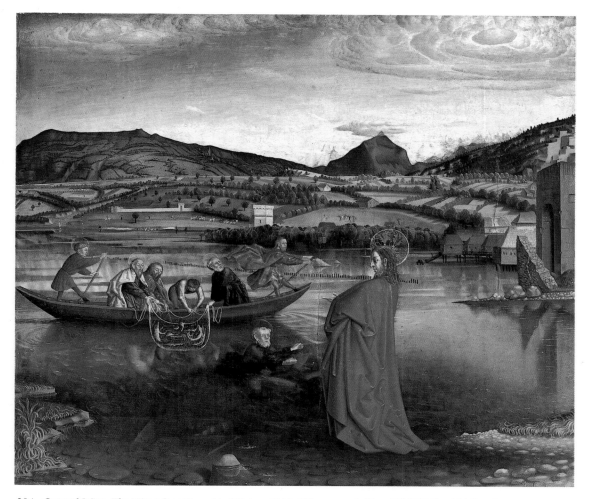

204. Conrad Witz. *The Miraculous Draught of Fishes*. 1444. Oil on panel, 51 x 61" (129.5 x 154.9 cm).
Musée d'Art et d'Histoire, Geneva

Music in Fifteenth-Century Flanders

The brilliance of the fifteenth-century Flemish painters had a close parallel in the field of music. After about 1420, the Netherlands produced a school of composers—Guillaume Dufay (c. 1400–74), Johannes Ockeghem (c. 1420–95), Josquin Des Prés (c. 1440–1521), and Adrian Willaert (c. 1490–1562)—so revolutionary as to dominate the development of music throughout Europe for the next 125 years. How much the new style was appreciated can be gathered from the words of the Flemish theorist Johannes Tinctoris (1446?–1511), writing of these composers in 1477: "although it seems beyond belief, nothing worth listening to had been composed before their time." Except for the absence of any reference to the revival of antiquity, this remark, with its sweeping rejection of medieval music, shows a Flemish "Renaissance consciousness" much like that of the Italian humanists of the same period. In fact, Des Prés and Willaert held important positions in Italy, and Dufay had spent nearly a decade there early in his career. In Italy they were revered as the greatest composers of their day, and we shall return to them in discussing Italian High Renaissance music. The greatest contribution of these Flemings was the invention of the FUGUE, the passing of a theme from one voice to another of equal weight (think of "Three Blind Mice"), a technique that was to become highly developed in the sixteenth century.

Tinctoris credited the English composer William Dunstable (c. 1370–1453), active in France between 1422 and 1435, with beginning a revolution that replaced the complexities of Gothic polyphony with a simpler style. Dufay carried Dunstable's innovations further by placing the main melody, which earlier had been sung by the tenor, in the soprano voice. This simple change gave greater prominence to the melodic line and emphasized its beauty. Dufay also led a movement to replace plainsong in sacred music with themes from secular songs, which were more flexible than chant and more appealing to contemporary taste. In the following century, these innovations evolved into a form called the PARODY MASS, in which most of the themes were taken from popular songs, freely modified, and connected with newly composed passages.

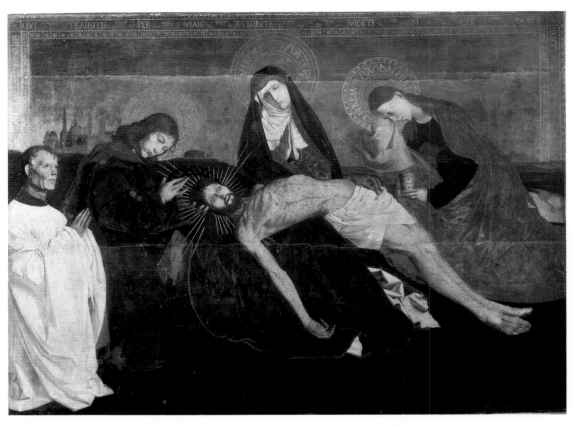

205. Enguerrand Quarton (?). *Avignon Pietà*. c. 1470. Oil on panel, 5'3 3/4" x 7'1 7/8" (1.62 x 2.18 m). Musée du Louvre, Paris

with its tubular folds and sharp, angular breaks, he must have had close contact with the Master of Flémalle. But the setting, rather than the figures, attracts our interest, and here the influence of the van Eycks seems dominant. Witz, however, did not simply follow these great pioneers. An explorer himself, he knew more about the optical appearances of water than any other painter of his time, as we can see from the reflections and especially the bottom of the lake in the foreground. The landscape, too, is an original contribution. Representing a specific part of the shore of Lake Geneva, it is among the earliest landscape "portraits" that have come down to us.

Avignon Pietà A Flemish style, influenced by Italian art, characterizes the most famous of all fifteenth-century French pictures, the *Avignon Pietà* (fig. 205). As its name indicates, the panel comes from the extreme south of France, and it is attributed to an artist of that region, Enguerrand Quarton. He must have been thoroughly familiar with the art of Rogier van der Weyden, for the figure types and the expressive content of the *Avignon Pietà* could be derived from no other source. At the same time, the magnificently simple and stable design is Italian rather than Northern. These are qualities we first saw in the art of Giotto. Southern, too, is the bleak, featureless landscape emphasizing the monu-

mental isolation of the figures. The distant buildings behind the donor on the left have an unmistakably Islamic flavor, suggesting that the artist meant to place the scene in an authentic Near Eastern setting. From these various features he has created an unforgettable image of heroic pathos.

"Late Gothic" Sculpture

If we had to describe fifteenth-century art north of the Alps in a single phrase, we might label it "the first century of panel painting," which so dominated the art of the period between 1420 and 1500 that its standards apply to manuscript illumination, painted glass, and even, to a large extent, sculpture. It was the influence of the Master of Flémalle and Rogier van der Weyden that ended the International Style in Northern European sculpture. The carvers, who quite often were also painters, began to reproduce in stone or wood the style of those two painters and continued to do so until about 1500.

Michael Pacher The most characteristic works of the "Late Gothic" carvers are wooden altar shrines, often large and incredibly intricate in detail. Such shrines were especially popular in the Germanic countries. One of the richest examples is the *St. Wolfgang Altarpiece* (fig. 206, page 256) by the Tyrolean sculptor and painter Michael Pacher (c. 1435–98). Its lavishly gilt and colored forms make a dazzling spectacle as they emerge from the shadowy depth of the shrine under spiky webs of intricate vaulting. We enjoy it, but in pictorial rather than plastic terms. We have no experience of volume, either positive or negative. The figures and setting in *The Coronation of the Virgin* (in the center panel) seem to melt into a single pattern of agitated, twisting lines that permits only the heads to stand out as separate entities. Surprisingly, when we turn to the paintings of scenes from the life of the Virgin on the interior of the wings, we enter a different realm, one that already commands the vocabulary of the Northern Renaissance. Here Pacher provides a deep space in scientific perspective that takes the viewer's

vantage point into account, so that the upper panels are represented slightly from below. Paradoxically, the figures, powerfully modeled by the clear light, seem far more "sculptural" than the carved ones, despite the fact that they are a good deal smaller. It is as if Pacher the "Late Gothic" sculptor felt unable to compete with Pacher the painter in the rendering of three-dimensional bodies and therefore choose to treat *The Coronation of the Virgin* in pictorial terms, by extracting the maximum of drama from contrasts of light and shade.

The Graphic Arts

Printing

The development of printing, for pictures as well as books, north of the Alps was an important event that had a profound effect on Western civilization. Our earliest printed books in the modern sense were produced in the Rhineland—generally defined as the area along the Rhine River in Germany between Karlsruhe and Essen—soon after 1450. (It is not certain whether Johannes Gutenberg deserves the priority long claimed for him.) The new technique quickly spread all over Europe and developed into an industry, ushering in the era of increased literacy. Printed pictures had hardly less importance, for without them the printed book could not have replaced the work of the medieval scribe and illuminator so quickly and completely. The pictorial and the literary aspects of printing were, indeed, closely linked from the start.

Woodcut

The idea of printing pictorial designs from blocks of wood onto paper seems to have originated in Northern Europe at the very end of the fourteenth century. Many of the oldest surviving examples of such prints, called **woodcuts**, are German, others are Flemish, and some may be French; all show the familiar qualities of the International Style. The designs were probably furnished by painters or sculptors. The actual carving of the woodblocks, however,

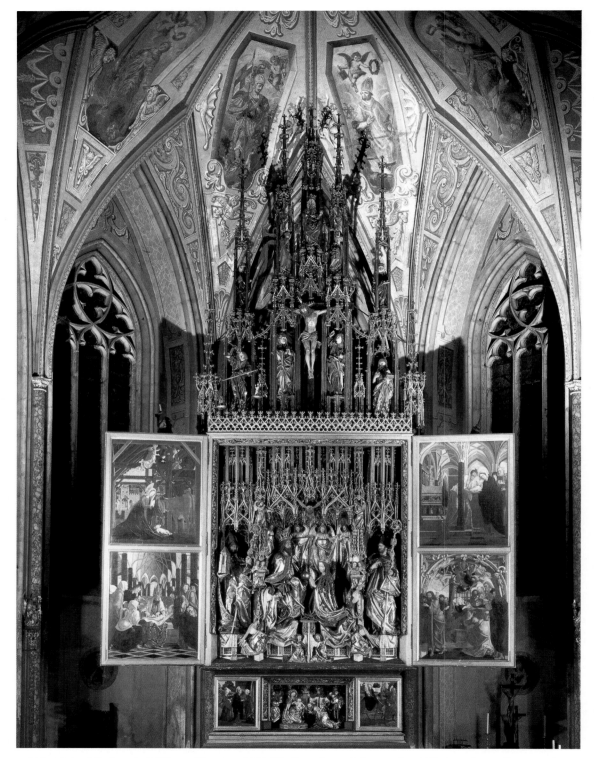

206. Michael Pacher. *St. Wolfgang Altarpiece*. 1471–81. Carved wood, figures about lifesize; wings, oil on panel. Church of St. Wolfgang, Austria

207. *Saint Dorothy*. c. 1420. Woodcut, 10⅝ x 7½"
(27 x 19.1 cm). Staatliche Graphische Sammlung,
Munich

was done by the specially trained artisans who also produced woodblocks for textile prints. As a result, early woodcuts, such as the *Saint Dorothy* in figure 207, have a flat, ornamental pattern. Forms are defined by simple, heavy lines with little concern for three-dimensional effects, as there is no ▼HATCHING or SHADING. Since the outlined shapes were meant to be filled in with color, these prints often recall **stained glass** (compare fig. 182) more than the **miniatures** they replaced. Despite their aesthetic appeal to modern eyes, we should remember that fifteenth-century woodcuts were popular art, on a level that did not attract artists of great ability until shortly before 1500. A single woodblock yielded thousands of copies, to be sold for a few pennies apiece, bringing the individual ownership of pictures within almost everyone's reach for the first time in our history.

Engraving

Whoever first thought of metal type for setting text probably had the aid of goldsmiths to work out the technical production problems. This is all the more likely since many goldsmiths had already entered the field of printmaking as engravers. The technique of **engraving**—of embellishing metal surfaces with **incised** pictures—was developed in classical antiquity and continued to be practiced throughout the Middle Ages (see fig. 153, where the engraved lines are filled in with enamel). Thus, no new skill was required to engrave a plate that was to serve as the printing surface for a paper print.

The idea of making an engraved print ▼(ENGRAVING) apparently came from the desire for an alternative to WOODCUTS. In a woodcut, lines left by gouging out the block are ridges; hence, the thinner they are, the more

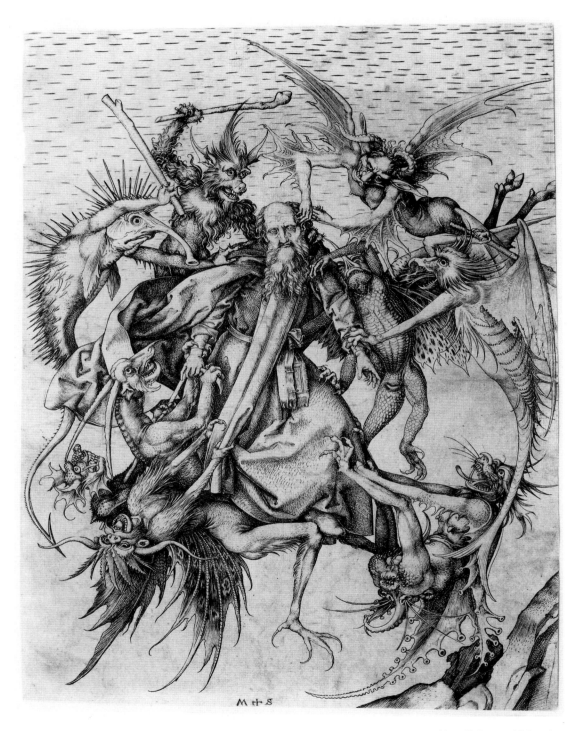

208. Martin Schongauer. *Saint Anthony Tormented by Demons*. c. 1480–90. Engraving, 12¹/₄ x 9" (31.1 x 22.9 cm).
The Metropolitan Museum of Art, New York

difficult to carve. In an engraving, lines are incised with a tool (called a **burin**) into a metal plate, usually copper, which is relatively soft and easy to work, so that they are much more refined and flexible. Engravings appealed from the first to a smaller and more sophisticated public. The oldest known examples, dating from about 1430, already show the influence of the great Flemish painters. Their forms are systematically modeled with hatching and often are convincingly foreshortened. Nor do engravings share the anonymity of early woodcuts. Individual hands can be distinguished almost from the beginning, dates and initials soon appear, and most of the important engravers of the last third of the fifteenth century are known to us by name. Even though the early engravers were usually goldsmiths by training, their prints are so closely linked to local painting styles th at their geographic origin can be far more easily determined than is true for woodcuts. Especially in the Upper Rhine region (centered near the German-Swiss border), we can trace a continuous tradition of fine engravers from the time of Conrad Witz to the end of the century.

Martin Schongauer The most accomplished of these Rhenish engravers is Martin Schongauer (c. 1430–91) of Colmar, the first printmaker whom we also know as a painter, and the first to gain international fame. Schongauer might be called the Rogier van der Weyden of engraving. After learning the goldsmith's craft in his father's shop, he must have spent considerable time in Flanders, for he shows a thorough knowledge of Rogier's art. His prints are filled with Rogierian motifs and expressive devices, and they reveal a deep temperamental affinity to the great Fleming. Yet Schongauer had his own impressive powers of invention. His finest engravings have a complexity of design, spatial depth, and richness of texture that make them fully equivalent to panel paintings. In fact, lesser artists often found inspiration in them for large-scale pictures.

Saint Anthony Tormented by Demons (fig. 208), one of Schongauer's most famous works, with remarkable skill combines savage expressiveness and formal precision, violent movement and ornamental stability. The longer we look at it, the more we marvel at its range of tonal values, the rhythmic beauty of the engraved line, and the artist's ability to render every conceivable surface—spiky, scaly, leathery, furry—by varying the burin's attack upon the plate. In this respect he was not to be surpassed by any later engraver. Although he remained "Late Gothic" in spirit, Schongauer paved the way for Albrecht Dürer, who was to become the greatest representative of the Renaissance in the North (see pages 327–9). Indeed, Dürer hoped to become a member of Schongauer's workshop but arrived in Colmar shortly after the older artist's death.

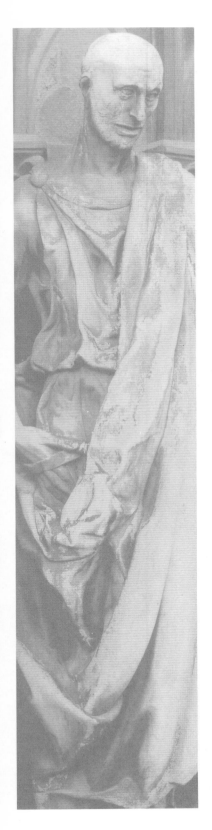

Chapter 13

The Early Renaissance in Italy

We do not yet understand the link between the great Flemish painters and the social, political, and cultural setting in which they worked well enough to explain why the new style of painting arose in Flanders about 1420. We have far more insight into the special circumstances that help explain why Early Renaissance art was born in Florence at the beginning of the fifteenth century rather than somewhere else or at some other time. In the years around 1400, Florence faced an acute threat to its independence from the powerful duke of Milan, who was trying to bring all of Italy under his rule. He had already subjugated the Lombard plain in the north of Italy and most of the central Italian city-states; only Florence remained a serious obstacle to his ambition. The city put up a vigorous and successful defense on the military, diplomatic, and intellectual fronts. Of these three, the intellectual was by no means the least important. The duke had eloquent support as a new Caesar, bringing peace and order to the country. Florence, in its turn, rallied public opinion by proclaiming itself as the champion of freedom against unchecked tyranny. The humanist Leonardo Bruni concluded in *Praise of the City of Florence* (written in 1402–3) that it had assumed the same role of political and intellectual leadership as Athens at the time of the Persian Wars. The patriotic pride, the call to greatness implicit in this image of Florence as the "new Athens" aroused a deep response throughout the city. Just when the forces of Milan threatened to engulf them, the Florentines embarked on an ambitious campaign to finish the great artistic enterprises begun a century before, at the time of Giotto. The huge investment was itself not a guarantee of artistic quality, but, stirred by such civic enthusiasm, it provided a splendid opportunity for the emergence of creative talent and the coining of a new style worthy of the new Athens.

Ascension of the Fine Arts

From the start, the visual, or fine, arts were considered essential to the resurgence of the Florentine spirit. Throughout antiquity and the Middle Ages, they had been classed with the crafts, or "mechanical arts." It cannot be by chance that the first explicit statement claiming a place for them among the liberal arts occurs about 1400 in the writings of the Florentine chronicler Filippo Villani. A century later, this claim was to win general acceptance throughout most of the Western world. What does it imply? The liberal arts were defined by a tradition going back to Plato and comprised the intellectual disciplines necessary for a "gentleman's" education: mathematics (including musical theory), dialectics (intellectual investigation by dialogue), grammar, rhetoric (study of principles and rules of written and spoken language), and philosophy. The fine arts were excluded because they were "handiwork" supposedly lacking a theoretical basis. Thus, when artists gained admission to this select group, the nature of their work had to be redefined. They were acknowledged as people of ideas rather than mere manipulators of materials, and works of art came to be viewed more and more as the visible records of their creative minds. This meant that works of art need not—indeed, should not—be judged by fixed standards of artisanship. Soon everything that bore the imprint of a great artist was eagerly collected, regardless of its incompleteness: drawings, sketches, fragments, unfinished pieces.

The outlook of artists underwent important changes as well. Now in the company of scholars and poets, they themselves often became learned and literary. They might write poems, autobiographies, or theoretical treatises. Perhaps as another consequence of this new social status, artists often tended to develop into one of two contrasting personality types: the person of the world, self-controlled, polished, at ease in aristocratic society; or the solitary genius, secretive, idiosyncratic, subject to fits of melancholy, and likely to be in conflict with patrons. This remarkably modern view soon became a living reality in the Flo-

rence of the Early Renaissance. From there it spread to other centers in Italy and throughout Europe. However, such an attitude did not take immediate hold everywhere, nor did it apply equally to all artists. England, for example, was slow to grant them special status, and women in general were denied the professional training and opportunities available to men.

In addition to humanism and historical forces, we must acknowledge the decisive importance of individual genius in the birth of Renaissance art. It originated with three men of exceptional ability—the architect Filippo Brunelleschi, the sculptor Donatello, and the painter Masaccio. It is hardly a coincidence that these founders knew each other. Moreover, they faced the same fundamental task: to reconcile classical form with Christian content in creating the new style. Yet each possessed a unique artistic personality that enabled him to solve this problem in a distinctive way. Thanks to them, Florentine art retained the undisputed leadership of the movement during the first half of the fifteenth century, which became the heroic age of the Early Renaissance. To trace its beginnings, we must discuss sculpture first, for although Brunelleschi was perhaps the central figure of the time, the sculptors had earlier and more plentiful opportunities than did the architects or the painters to meet the challenge of the new Athens.

Sculpture

Nanni di Banco The artistic campaign to become the new Athens had opened with the competition for the Baptistery doors, and for some time it consisted mainly of sculptural projects. Ghiberti's trial relief, we recall, does not differ significantly from the International Gothic (see fig. 181). His admiration for ancient art, evidenced by the torso of Isaac, merely recaptures what Nicola Pisano had done a century earlier (see fig. 179). A decade after the trial relief, we find that this limited medieval classicism has been surpassed by a somewhat younger artist, Nanni di Banco (c. 1384–1421). The four saints called the *Quattro Coronati*, which he made about 1410–14 for one of the

209. Nanni di Banco. *Quattro Coronati* (*Four Saints*). c. 1410–14. Marble, about lifesize. Orsanmichele, Florence

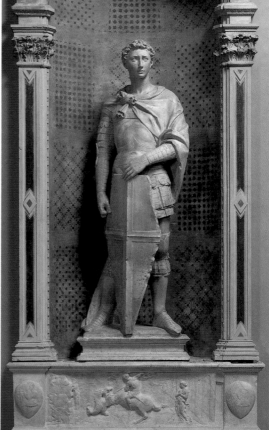

210. Donatello. *Saint George Tabernacle*, from Orsanmichele, Florence. c. 1415–17. Marble, height of statue 6'10 (2.08 m). Museo Nazionale del Bargello, Florence

niches on the exterior of the Church of Orsanmichele (fig. 209), demand to be compared not with the work of Nicola Pisano but with the Reims *Visitation* (see fig. 174). They represent four Christian sculptors who were executed for refusing to carve the statue of a pagan god ordered by Diocletian—a story later conflated with that of four martyrs who refused to worship in the pagan god's temple. The figures in both groups are approximately lifesize, yet Nanni's give the impression of being a good deal larger than those at Reims. Their quality of mass and monumentality was quite beyond the range of medieval sculpture. This is so, even though Nanni depended less directly on ancient models than had the sculptor of the *Vis-*

itation or Nicola Pisano. Although only the heads of the second and third of the *Coronati* directly recall examples of Roman sculpture, Nanni was obviously impressed by its realism and the agonized expression of its subjects (see fig. 96). His ability to retain the essence of both these qualities indicates a new attitude toward ancient art, which unites classical form and content, instead of separating them as medieval classicists had done.

Donatello Early Renaissance art, in contrast to "Late Gothic," sought an attitude toward the human body similar to that of classical antiquity. The artist who did most to reestablish this attitude was Donatello (Donato de Betto di

Bardi, 1386–1466), the greatest sculptor of his time. We have clearly entered a new epoch when we look at his *Saint George* (fig. 210), carved in marble for another niche of the Church of Orsanmichele around 1415. Here is the first statue we have seen since ancient times that can stand by itself—or, put another way, the first to recapture the full meaning of classical **contrapposto** (see page 86). The artist has mastered at one stroke the central achievement of ancient sculpture: he has treated the human body as an articulated *structure* capable of movement. The armor and drapery are a secondary structure that is determined by the body underneath. Unlike any Gothic statue, this *Saint George* can take off his clothes. Unlike any Gothic statue, he can be taken away from his architectural setting and lose none of his immense authority. His stance, with his weight placed on the forward leg, conveys the idea of readiness for combat. (The right hand originally held a weapon.) The controlled energy of his body is echoed in his eyes, which seem to scan the horizon for the approaching enemy. This *Saint George*, slayer of dragons, is a proud and heroic defender of the new Athens.

The unidentified prophet (fig. 211), nicknamed *Zuccone* ("Pumpkinhead") for obvious reason, was carved some eight years later for the bell tower of Florence Cathedral. It has long enjoyed special fame as a striking example of Donatello's realism. But, we may ask, what *kind* of realism have we here? Donatello has not followed the conventional image of a prophet (a bearded old man in Oriental-looking costume, holding a large scroll). Rather, he has invented an entirely new type, and it is difficult to account for his impulse in terms of realism. Why did he not simply reinterpret the old image from a realistic point of view, as Sluter had done (see fig. 178)? Donatello obviously felt that the established type was inadequate for his own conception of the subject. But how did he conceive it anew? Surely not by observing the people around him. More likely, he imagined the personalities of the prophets from what he had read about them in the Old Testament. He gained an impression, we may assume, of divinely inspired orators haranguing the multitude. This, in turn,

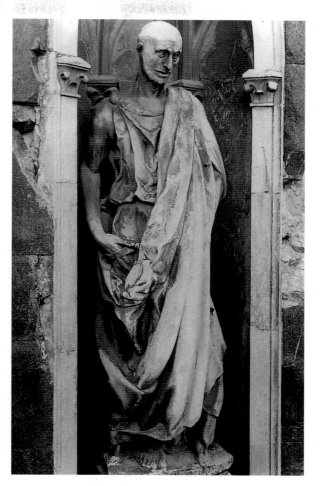

211. Donatello. *Prophet (Zuccone)*, from the Campanile of Florence Cathedral. 1423–25. Marble, height 6'5" (1.96 m). Museo dell'Opera del Duomo, Florence

reminded him of the Roman orators he had seen in ancient sculpture. Hence the classical costume of the *Zuccone*, whose mantle falls from one shoulder like those of the toga-clad patricians in figure 92. Hence, too, the fascinating head, ugly yet noble, like Roman portraits of the third century A.D. (compare fig. 95).

To shape all these elements into a coherent whole was a revolutionary feat that required an almost visible struggle. Donatello himself seems to have regarded the *Zuccone* as a particularly hard-won achievement. It is the first of his surviving works to carry his signature. He is said to have sworn "by the *Zuccone*" when he wanted to emphasize a statement and to have shouted at the statue while working on it, "Speak, speak, or the plague take you!"

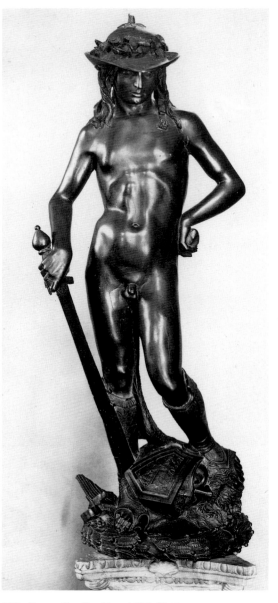

212. Donatello. *David*. c. 1425–30. Bronze, height 5'2¹/2" (1.59 m). Museo Nazionale del Bargello, Florence

Donatello had learned the technique of bronze sculpture as a youth working under Ghiberti on the first Baptistery doors. By the 1420s, he began to rival his former teacher in that medium, which he used to make *David* (fig. 212). This is the first **freestanding** lifesize nude statue since antiquity. *David*, moreover, is nude in the full classical sense. Donatello has clearly rediscovered the sensuous beauty of the unclothed body. Medieval nudes, even the most accomplished, are devoid of that appeal, which we take for granted in every nude of classical antiquity. It was purposely avoided rather than unattainable, for to the medieval mind the physical beauty of the ancient "idols," especially nude statues, embodied the insidious attraction of paganism. The Middle Ages would surely have condemned *David* as an idol, and Donatello's contemporaries, too, must have felt uneasy about it. For many years it remained the only work of its kind.

The statue must be understood as a civic-patriotic public monument identifying ▼DAVID—weak but favored by the Lord—with Florence, and GOLIATH with Milan. David's nudity is most readily explained as a reference to the classical origin of Florence, and his wreathed hat was the opposite of Goliath's elaborate helmet: peace versus war. Donatello chose to model an adolescent boy, not a full-grown youth like the athletes of Greece, so that the skeletal structure here is less fully enveloped in swelling muscles. Nor does he articulate the torso according to the classical pattern (compare fig. 75). In fact his *David* resembles an ancient statue only in its beautifully poised contrapposto. If the figure nevertheless conveys a profoundly classical air, the reason lies beyond its anatomical perfection. As in ancient statues, the body speaks to us more eloquently than the face, which by Donatello's standards is strangely devoid of individuality.

Donatello was invited in 1443 to Padua, where he produced the equestrian monument of *Gattamelata* (fig. 213), portraying the recently deceased commander of the Venetian armies. This statue, the artist's largest freestanding work in bronze, still occupies its original position on a tall pedestal near the facade of the church dedicated to Saint Anthony of Padua. Without directly imitating the mounted *Marcus Aurelius* in Rome (see fig. 94), the *Gattamelata* shares its material, its impressive scale, and its sense of balance and dignity. Donatello's horse, a heavy-set animal fit to carry a man in full armor, is so large that the rider must dominate it by his authority of command, rather than by physical force. The *Gattamelata*, in the new Renaissance

fashion, is not part of a tomb. It was designed solely to immortalize the fame of a great soldier. Nor is it the self-glorifying statue of a sovereign, but a monument authorized by the Republic of Venice in special honor of distinguished and faithful service. To this purpose, Donatello has coined an image that is a complete union of ideal and reality. The head is powerfully individual yet endowed with a truly Roman nobility of character. The general's armor likewise combines modern construction with classical detail.

Lorenzo Ghiberti Donatello's only serious rival in Florence was his former teacher, Lorenzo Ghiberti (c. 1378–1455). After the great success of his first Baptistery doors, Ghiberti was commissioned to do a second pair, which were to be dubbed the *"Gates of Paradise."* These reliefs, unlike those of the first doors (see fig. 181), were large and were set in simple square frames, which provided a more generous field (fig. 214). They mark the artist's successful conversion, under the influence of Donatello and the other pioneers of the new style, to the Early Renaissance point of view. The only lingering elements of the Gothic style are to be found in the figures, whose gentle and graceful classicism still remind us of the International Style. *The Story of Jacob and Esau* shows the new pictorialism that distinguishes Renaissance reliefs. The hint of spatial depth we saw in *The Sacrifice of Isaac* has grown into a complete setting for the figures that goes back as far as the eye can reach. We can imagine the figures leaving the scene, for the deep, continuous space of this "pictorial relief" in no way depends on their presence. How did Ghiberti achieve this effect? In part by varying the degree of relief, with the forms closest to us being modeled almost in the round, a method familiar from ancient art (see figs. 67, 97). Far more important is the carefully controlled recession of figures and architecture, which causes their apparent size to diminish systematically (rather than haphazardly, as before) as their distance from us increases. This system, known as **linear perspective**, was invented by Filippo Brunelleschi, whose architectural achievements will occupy us soon. It is a geometric procedure for projecting space onto a plane, analogous to the

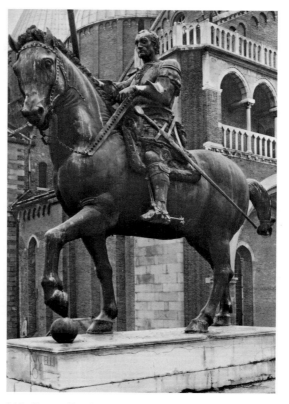

213. Donatello. *Gattamelata*. 1445–50. Bronze, approx. 11 x 13' (3.35 x 3.96 m). Piazza del Santo, Padua

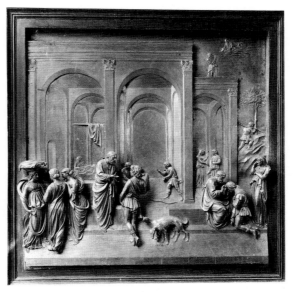

214. Lorenzo Ghiberti. *The Story of Jacob and Esau.* Panel of the *"Gates of Paradise."* c. 1435. Gilt bronze, 31¼" (79.4 cm) square. Museo dell'Opera del Duomo, Florence

The Early Renaissance in Italy *265*

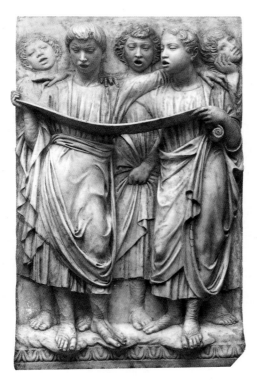

215. Luca della Robbia. *Singing Angels*, from the *Cantoria*, Florence Cathedral. c. 1435. Marble, approx. 38 x 24" (96.5 x 61 cm). Museo dell' Opera del Duomo, Florence

way the lens of a photographic camera projects a perspective image on the film. Its central feature is the vanishing point, toward which all parallel lines will seem to converge. If these lines are perpendicular to the picture plane, their vanishing point will be on the horizon, corresponding exactly to the position of the beholder's eye. Brunelleschi's discovery in itself was scientific rather than artistic, but it immediately became highly important to Early Renaissance artists because it enabled them to gain command over every aspect of composition. Unlike the more intuitive perspective practices of the past, it was objective, precise, and rational. In fact, it soon became an argument for upgrading the fine arts into the liberal arts.

Luca della Robbia Except for Ghiberti, the only significant sculptor in Florence after Donatello left was Luca della Robbia (1400–82). He had made his reputation in the 1430s with the marble reliefs of the *Cantoria* (singers' pulpit) in the Florence Cathedral. The *Singing Angels* panel

reproduced here (fig. 215) shows the beguiling mixture of sweetness and gravity characteristic of all of Luca's work. Its style, we realize, has very little to do with Donatello. Instead, it recalls the classicism of Nanni di Banco (see fig. 209), with whom Luca may have worked as a youth. We also sense a touch of Ghiberti here and there, as well as the powerful influence of Roman reliefs (see fig. 98). Apparently, Luca lacked a capacity for growth, despite his great gifts. So far as we know, he never did a freestanding statue, and the *Cantoria* remained his most ambitious achievement.

Because of Luca's almost complete withdrawal from the domain of carving, there was a real shortage of capable marble sculptors in the Florence of the 1440s. This gap was filled by a group of younger sculptors from the little hill towns to the north and east of Florence that had long supplied the city with stonemasons and carvers. Now, the most gifted of them developed into artists of considerable importance.

Bernardo Rossellino The oldest of the sculptors from the hill towns, Bernardo Rossellino (1409–64), seems to have begun as a sculptor and architect in Arezzo. He established himself in Florence about 1436 but received no commissions of consequence until some eight years later, when he was entrusted with the tomb of Leonardo Bruni (fig. 216). This great humanist and diplomat had played a vital part in the city's affairs ever since the beginning of the century (see page 260). When he died in 1444, he received a grand funeral *all'antica* ("in the manner of the ancients"). His monument was probably ordered by the city governments of both Florence and Arezzo, where he and Rosellino were born.

Although the Bruni monument is not the earliest Renaissance tomb, nor even the earliest large-scale tomb of a humanist, it can claim to be the first memorial that fully expresses the spirit of the new era. Echoes of Bruni's funeral *all'antica* are everywhere. The deceased reclines on a bier supported by Roman eagles, his head wreathed in laurel and his hands enfolding a volume (presumably his own *History of Florence*, rather than a prayer book). The monument is a

fitting tribute to the man who, more than any other, had helped to establish the new historical perspective of the Florentine Early Renaissance. On the classically severe sarcophagus, two winged **genii** (singular, *genius,* meaning guardian spirit) display an inscription very different from those on medieval tombs. Instead of recording the name, rank, age, and date of death of the deceased, it refers only to his timeless accomplishments: "At Leonardo's passing, history grieves, eloquence is mute, and it is said that the ▼MUSES, Greek and Latin alike, cannot hold back their tears." The religious aspect of the tomb is confined to the lunette, where the Madonna is adored by angels. The entire monument may thus be viewed as an attempt to reconcile two contrasting attitudes toward death: the retrospective, commemorative outlook of the ancients, and the Christian concern with afterlife and salvation. Bernardo's design is admirably suited to such a program, balancing architecture and sculpture within a compact, self-contained framework.

The sculptural style of the Bruni tomb is not easy to define, since its components vary a good deal in quality. Broadly speaking, it reflects the classicism of Ghiberti and Luca della Robbia; echoes of Donatello are few and indirect. During the later 1440s, Bernardo's workshop was the only training ground for ambitious young marble sculptors. Their share in the Bruni monument is hard to determine, but all the tombs, tabernacles, and reliefs of the Madonna produced by younger artists between 1450 and 1480 have a common ancestor in it, whatever other elements we may discern in them.

Antonio del Pollaiuolo By 1450, the great civic campaign of art patronage came to an end, and Florentine artists had to depend mainly on private commissions. This put the sculptors at a disadvantage because of the high costs involved in their work. Since the monumental tasks were few, they concentrated on works of moderate size and price for individual patrons, such as bronze statuettes. The collecting of sculpture, widely practiced in ancient times, had apparently ceased during the Middle Ages. The taste of kings, feudal aristocracy, and

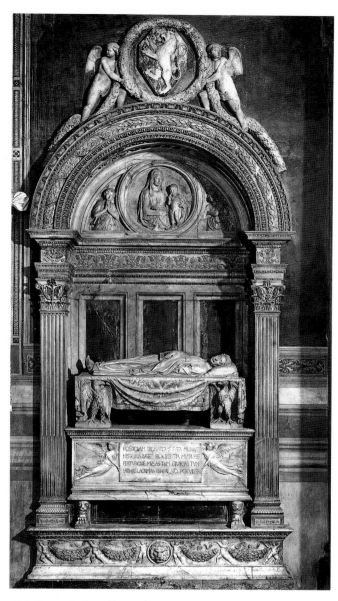

216. Bernardo Rossellino. Tomb of Leonardo Bruni. c. 1445–50. Marble, height to top of arch 20' (6.1 m). Sta. Croce, Florence

others who could afford to collect for personal pleasure ran to precious objects. The habit was reestablished in fifteenth-century Italy as part of the revival of antiquity. Humanists and artists first collected ancient sculpture, especially small bronzes, which were numerous and of convenient size. Before long, contemporary artists began to cater to the spreading vogue, with portrait busts and small bronzes of their own "in the manner of the ancients."

▼ Patron goddesses of intellectual and creative endeavors, the MUSES were nine mythical daughters of Zeus and the goddess of memory, Mnemosyne. They were Klio, history; Kalliope, epic poetry; Erato, love poetry; Euterpe, lyric poetry; Melpomene, tragedy; Polyhymnia, songs and poetry for the gods; Thalia, comedy; Terpsichore, choral songs and dance; and Urania, astronomy.

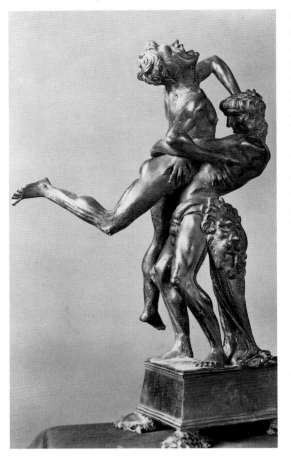

217. Antonio del Pollaiuolo. *Hercules and Antaeus*. c. 1475. Bronze, height with base 18" (45.7 cm). Museo Nazionale del Bargello, Florence

A particularly fine piece of this kind is *Hercules and Antaeus* (fig. 217) by Antonio del Pollaiuolo (1431–98), who represents a sculptural style very different from that of the marble carvers discussed above. Trained as a goldsmith and metalworker, probably in the Ghiberti workshop, he was deeply impressed by the late styles of Donatello and Andrea del Castagno (see fig. 227), as well as by ancient art. From these sources, he evolved the distinctive manner that appears in our statuette. To create a freestanding group of two figures in violent struggle, even on a small scale, was a daring idea in itself. Even more astonishing is the way Pollaiuolo has endowed his composition with a centrifugal impulse. Limbs seem to radiate in

every direction from a common center, and we see the full complexity of their movements only when we examine the statuette from all sides. Despite its strenuous action, the group is in perfect balance. To stress the central axis, Pollaiuolo in effect grafted the upper part of Antaeus onto the lower part of his adversary. There is no precedent for this design among earlier statuary groups of any size, ancient or Renaissance. The artist has simply given a third dimension to a composition from the field of drawing or painting. He himself was a painter and engraver as well as a bronze sculptor, and we know that about 1465 he did a large picture of ▼HERCULES and ANTAEUS, which is now lost but whose design is preserved in a smaller replica, for the ▼MEDICI family, who owned our statuette. For the first time since antiquity, a sculptural group has acquired the pictorial quality that had characterized reliefs since the early years of the Renaissance.

Andrea del Verrocchio Although Pollaiuolo did two monumental bronze tombs for St. Peter's in Rome during the late years of his career, he never had an opportunity to execute a large-scale freestanding statue. For such works we must turn to his slightly younger contemporary Andrea del Verrocchio (1435–88), the greatest sculptor of his day and the only one to share some of Donatello's range and ambition. A modeler as well as a carver—there are works of his in every medium—he combined elements from Bernardo Rossellino and Antonio del Pollaiuolo into a unique synthesis. He was also a respected painter and the teacher of Leonardo da Vinci, which is unfortunate, as he has been overshadowed ever since.

Like *Hercules and Antaeus* by Pollaiuolo, Verrocchio's *The Doubting of Saint Thomas* (fig. 218) is closely related to a painting: a Baptism of Jesus painted with the assistance of the young Leonardo. Here the tendency toward pictorialism in Early Renaissance sculpture reaches its climax in a monumental group of astonishing boldness. In contrast to the *Quattro Coronati* of Nanni di Banco (see fig. 209), the figures are not confined by their architectural niche. It thus acts as a foil rather than as a con-

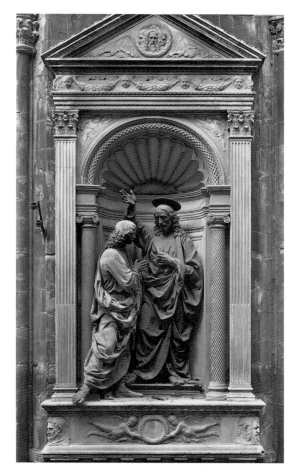

218. Andrea del Verrocchio. *The Doubting of Saint Thomas*. 1465–83. Bronze, lifesize. Orsanmichele, Florence

tainer for the statues, which have no backs in order to fit the shallow ledge. The drama conveyed by the exchange of gestures between Jesus and Thomas is heightened by the active drapery, with its deep folds. The graceful poses and contemplative faces show a high degree of idealization. The head of Jesus in particular was admired by contemporaries for its great beauty.

Architecture

Filippo Brunelleschi Although Donatello was its greatest and most daring master, he did not create the Early Renaissance style in sculpture all by himself. The new architecture, on the other hand, did owe its existence to one person, Filippo Brunelleschi (1377–1446). Nine years older than Donatello, he too had begun his career as a sculptor. After failing to win the competition of 1401–2 for the first Baptistery doors, Brunelleschi reportedly went to Rome with Donatello. He studied the architectural monuments of the ancients and seems to have been the first to take exact measurements of these structures. His discovery of linear perspective (see page 265–66) may well have grown out of his search for an accurate method of recording their appearance on paper. What else he did during this long gestation period we do not know, but in 1417–19 we again find him competing with Ghiberti, this time for the job of building the Florence Cathedral dome (see fig. 168). Its design had been established half a century earlier and could be altered only in details, but its vast size posed a difficult problem of construction. Brunelleschi's proposals, although contrary to all traditional practice, so impressed the authorities that this time he won out over his rival. Thus, the dome deserves to be called the first work of postmedieval architecture, as an engineering feat if not for style.

In 1419, while he was working out the final plans for the cathedral dome, Brunelleschi received his first opportunity to create buildings entirely of his own design. It came from the head of the Medici family, one of the leading merchants and bankers of Florence, who asked him to develop a new design for the Church of S. Lorenzo. The construction, begun in 1421, was often interrupted, so that the interior was not completed until 1469, more than twenty years after the architect's death. (The exterior remains unfinished to this day.) Nevertheless, the building in its present form is essentially what Brunelleschi had envisioned about 1420 and thus represents the first full statement of his architectural aims (figs. 219, 220 on page 270). The plan may not seem very novel, at first glance. The unvaulted nave and transept link it to Sta. Croce (see fig. 167). What distinguishes it is a new emphasis on symmetry and regularity. The entire design consists of square units. Four large squares form the **choir**, the **crossing**, and the arms of the **transept**. Four more are combined into the **nave**. Other

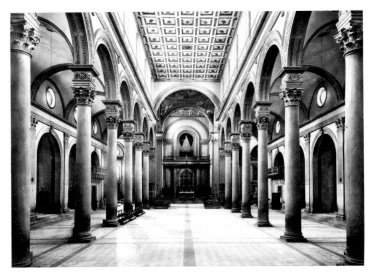

219. Filippo Brunelleschi. S. Lorenzo, Florence. 1469

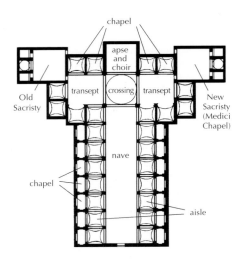

220. Plan of S. Lorenzo

squares, one-fourth the size of the large ones, make up the aisles and the **chapels** attached to the transept. (The oblong chapels outside the aisles were not part of the original design.) Brunelleschi was not concerned with the thickness of the walls, so that the transept arms are slightly longer than they are wide, and the length of the nave is not four but four and one-half times its width. In other words, he conceived S. Lorenzo as a grouping of abstract "space blocks," the larger ones being simple multiples of the standard unit. Once we understand this, we realize how revolutionary he was, for his clearly defined, separate space compartments represent a radical departure from the Gothic architect's way of thinking.

The interior bears out our expectations. Cool, static order has replaced the emotional warmth, the flowing spatial movement of Gothic church interiors. S. Lorenzo does not sweep us off our feet. It does not even draw us forward after we have entered it, and we are quite content to remain near the door. From that vantage point, our view seems to take in the entire structure, almost as if we were confronted with a particularly clear and convincing demonstration of linear perspective (compare fig. 214). The total effect recalls the "old-fashioned" Tuscan Romanesque, such as the Baptis-

tery of S. Giovanni in Florence (see fig. 143) and Early Christian basilicas (compare fig. 90). These monuments, to Brunelleschi, exemplified the church architecture of classical antiquity. They inspired his return to the use of the round **arch** and of **columns**, rather than **piers**, in the nave **arcade**. Yet these earlier buildings lack the transparent lightness, the wonderfully precise articulation of S. Lorenzo. Clearly, then, Brunelleschi did not revive the architectural vocabulary of the ancients out of mere antiquarian enthusiasm. The very quality that attracted him to the component parts of classical architecture must have seemed, from the medieval point of view, their chief drawback: inflexibility. Not that the classical vocabulary is completely rigid. But the disciplined spirit of the Greek orders, which can be felt even in the most original Roman buildings, demands regularity and consistency but discourages sudden, arbitrary departures from the norm.

Architectural Proportions If Renaissance architecture found a standard vocabulary in the revival of classical forms, the theory of harmonious proportions provided it with the kind of syntax that had been mostly absent from medieval architecture. This controlling principle is what makes the interior of S. Lorenzo

seem so beautifully integrated and accounts for the harmonious, balanced character of its design. The secret of good architecture, Brunelleschi was convinced, lay in giving the "right" proportions—that is, proportional ratios expressed in simple whole numbers—to all the significant measurements of a building. The ancients had possessed this secret, he believed, and he tried to rediscover it by painstakingly surveying the remains of their monuments. What he found, and how he applied his theory to his own designs, we do not know for sure. He may have been the first to think out what would be explicitly stated a few decades later in Leone Battista Alberti's *Treatise on Architecture*: that the mathematical ratios determining musical harmony must also govern architecture, for they recur throughout the universe and are thus divine in origin.

Even Brunelleschi's faith in the universal validity of harmonious proportions did not tell him how to allot these ratios to the parts of any given building. It left him many alternatives, and his choice among them was necessarily subjective. We may say, in fact, that the main reason S. Lorenzo strikes us as the product of a single great mind is the very individual sense of proportion permeating every detail.

Leone Battista Alberti The death of Brunelleschi in 1446 brought to the fore Leone Battista Alberti (1404–72), whose career as a practicing architect, like Brunelleschi's, had been long delayed. Until he was forty, Alberti seems to have been interested in the fine arts only as an ▼ANTIQUARIAN and theorist. He was close to the leading artists of his day: *On Painting*, one of three treatises he wrote, is dedicated to Brunelleschi and refers to "our dear friend" Donatello. Alberti began to practice art as a DILETTANTE, and eventually he became a professional architect of outstanding ability. Highly educated in classical literature and philosophy, he exemplifies both the humanist and the person of the world.

In the Church of S. Andrea in Mantua (fig. 221), his last work, Alberti accomplished the seemingly impossible feat of superimposing a classical temple front on the traditional **basilican** church **facade**. To harmonize this mar-

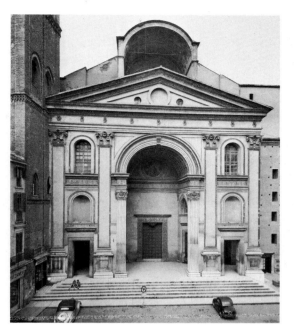

221. Leone Battista Alberti. S. Andrea, Mantua. Designed 1470

riage, he used **pilasters**, which are flat, instead of columns, thus emphasizing the continuity of the wall surface. They are of two sizes. The smaller ones sustain the arch over the huge center niche; the larger ones form what is known as a ▼COLOSSAL ORDER spanning all three stories of the facade wall, balancing exactly the horizontal and vertical impulses within the design. So intent was Alberti on stressing the inner cohesion of the facade that he inscribed the entire design within a square, even though it is appreciably lower in height than the nave of the church. (The effect of the west wall protruding above the **pediment** is more disturbing in photographs than at street level, where it is nearly invisible.) Although it is physically distinct from the main body of the structure, the facade offers an exact "preview" of the interior, where the same colossal order, the same proportions, and the same **triumphal-arch** motif reappear on the nave walls.

Alberti's facade design interprets his classical models freely. They no longer embody an absolute authority that must be quoted literally but serve as a valuable store of motifs to be utilized at will. With this sovereign attitude toward his sources, he was able to create a structure that

truly deserves to be called a Christian temple. Because S. Andrea occupies the site of an older basilican church, it does not conform to the ideal shape of sacred buildings as defined in Alberti's *Treatise on Architecture*. There he explains that the plan of such structures should be either circular or of a shape derived from the circle (square, hexagon, octagon, and so forth), because the circle is the perfect, as well as the most natural, figure and therefore a direct image of divine reason—an argument that rests on Alberti's faith in the God-given validity of mathematically determined proportions.

Alberti's ideal church demands a design so harmonious that it would be a revelation of divinity and would arouse pious contemplation in the worshiper. It should stand alone, elevated above the surrounding everyday life; and light should enter through openings placed high, for only the sky should be seen through them. A church, he believed, must be a visible embodiment of "divine proportion," which the central plan alone could attain. That such an isolated, **central-plan** structure was ill-adapted to the requirements of Catholic ritual made no difference to Alberti. But how could he reconcile his design with the historical evidence around him? Alberti arbitrarily disregarded the standard longitudinal form of both ancient temples and Christian churches, and he relied instead on the Pantheon and similar structures (see fig. 87).

Giuliano da Sangallo When Alberti formulated these ideas in his treatise, about 1450, he could not yet cite any modern example of them. Toward the end of the century, after his treatise became widely known, the central-plan church gained general acceptance, and between 1500 and 1525 it became a vogue reigning supreme in High Renaissance architecture. It is no coincidence that Sta. Maria delle Carceri in Prato (fig. 222), an early and distinguished example of this trend, was begun in 1485, the date of the first printed edition of Alberti's treatise. Its architect, Giuliano da Sangallo (c. 1443–1516), must have been an admirer of Brunelleschi, but the basic shape of his structure conforms closely to Alberti's ideal. Except

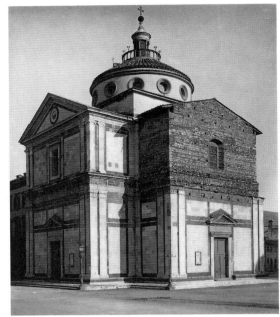

222. Giuliano da Sangallo. Sta. Maria delle Carceri, Prato. 1485

for the dome, the entire church would fit neatly inside a cube, since its height (up to the **drum**) equals its length and width. By cutting into the corners of this cube, as it were, Giuliano has formed a Greek cross (a plan he preferred for its symbolic value). The arms are **barrel-vaulted**, and the dome rests on these vaults, yet the dark ring of the drum does not quite touch the supporting arches, making the dome seem to hover weightlessly like the pendentive domes of Byzantine architecture (compare fig. 115). There can be no doubt that Giuliano wanted his dome to accord with the age-old tradition of the Dome of Heaven. The single round opening in the center and the twelve circular windows on the perimeter clearly refer to Christ and the apostles.

Painting

Florence

Masaccio Early Renaissance painting did not appear until the early 1420s, a decade later than Donatello's *Saint George* and some six years after Brunelleschi's first designs for S. Lorenzo.

Its inception was most extraordinary: this new style in painting was launched single-handedly by a young genius called Masaccio (Tommaso di Giovanni di Simone Guidi, 1401–28), who was only twenty-four years old at the time he painted *The Holy Trinity* fresco in Sta. Maria Novella (fig. 223). Because the Early Renaissance was already well established in sculpture and architecture, Masaccio's task was easier than it would have been otherwise, but his achievement is stupendous nevertheless.

Here, as in the case of the *Mérode Altarpiece*, we seem to plunge into a new environment. But Masaccio's world is a realm of monumental grandeur rather than the concrete, everyday reality of the Master of Flémalle. It seems hard to believe that only two years earlier, in Florence, Gentile da Fabriano had completed *The Adoration of the Magi* (see fig. 194), one of the greatest works of the International Gothic. What the *Trinity* fresco brings to mind is not the style of the immediate past but Giotto's art, with its sense of large scale, its compositional severity, and its sculptural volume. Masaccio's renewed allegiance to Giotto was only a starting point, however. For Giotto, body and drapery form a single unit, as if both had the same substance. In contrast, Masaccio's figures are "clothed nudes," like Donatello's, their drapery falling like real fabric. They indicate a thorough command of anatomy not seen since Roman art.

The setting, fully up-to-date, reveals an equally complete understanding of Brunelleschi's new architecture and of linear perspective. For the first time in history, we are given all the data needed to measure the depth of this painted interior, to draw its plan, and to duplicate the structure in three dimensions. It is, in short, the earliest example of a *rational* picture space. For Masaccio, like Brunelleschi, it must have also been a symbol of the universe ruled by divine reason. This barrel-vaulted chamber is no mere niche but a deep space in which the figures could move freely if they wished. As in Ghiberti's later relief panel *The Story of Jacob and Esau* (see fig. 214), the picture space is independent of the figures: they inhabit it but do not create it. Take away the architecture and

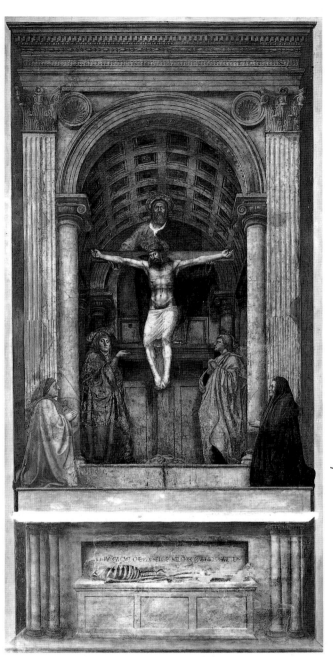

223. Masaccio. *The Holy Trinity with the Virgin, Saint John, and Two Donors.* Fresco in Sta. Maria Novella, Florence. 1425

plan of ceiling derived from the painting

Massacio's one-point linear perspective creates a rational picture space— the illusion that the figures are standing in a coffered, barrel-vaulted niche just above our eye

you take away the figures' space. We could go even further and say that linear perspective depends not just on architecture but on this particular kind of architecture, so different from Gothic.

224. Masaccio. Frescoes on left wall of Brancacci Chapel, Sta. Maria del Carmine, Florence. c. 1427

The largest group of Masaccio's works to come down to us are frescoes in the Brancacci Chapel in Sta. Maria del Carmine (fig. 224), devoted to the life of Saint Peter. *The Tribute Money*, in the upper tier, is the most renowned of these. It illustrates the story in the Gospel of Matthew (17:24–27) by the age-old method known as continuous narration. In the center, Jesus instructs Peter to catch a fish, whose mouth will contain the tribute money for the tax collector. On the far left, in the distance, Peter takes the coin from the fish's mouth, and on the right, he gives it to the tax collector. Since the lower edge of the fresco is almost 14 feet above the floor of the chapel, Masaccio expects us to imagine that we are looking directly at the central vanishing point, which is located behind the head of Jesus. Oddly

enough, this feat is remarkably easy. The illusion depends to only a minor degree on Brunelleschian perspective. Masaccio's means here are exactly those employed by the Master of Flémalle and the van Eycks. He controls the flow of light (which comes from the right, where the window of the chapel is actually located), and he uses **atmospheric perspective** in the subtly changing tones of the landscape.

The figures in *The Tribute Money*, even more than those in the *Trinity* fresco, display Masaccio's ability to merge the weight and volume of Giotto's figures with the new functional view of body and drapery. All stand in beautifully balanced contrapposto, and close inspection reveals fine vertical lines scratched in the plaster by the artist, establishing the gravitational axis of each figure from the head to the heel of

225. Domenico Veneziano. *Madonna and Child with Saints*. c. 1455. Oil on panel, 6'7¹/₂" x 6'11⁷/₈" (2.02 x 2.13 m). Galleria degli Uffizi, Florence

the engaged leg. In accord with Masaccio's dignified approach, the narrative is conveyed by intense glances and a few emphatic gestures rather than by physical movement. But in another fresco of the Brancacci Chapel, *The Expulsion from Paradise* (to the upper left in fig. 224), Masaccio proves decisively his ability to display the human body in motion. The tall, narrow format leaves little room for a spatial setting. The gate of Paradise is only indicated, and in the background are a few shadowy, barren slopes. Yet the soft, atmospheric modeling, and especially the forward-moving angel, boldly foreshortened, suffice to convey a free, unlimited space. Masaccio's grief-stricken Adam and Eve, though hardly dependent on ancient models, are equally striking exemplars of the beauty and power of the nude human form.

Domenico Veneziano Masaccio died too young (he was only twenty-seven) to be the founder

school, school of, follower of

Art historians use the word *school* in several ways. Some master artists developed a following of people who worked in their presence, consciously emulating the style of the master. Similarly, artists who worked in the same time, place, and style sometimes are considered to be a school, such as the nineteenth-century Barbizon school. *School of* is used to identify an unknown artist clearly working under the influence of a major figure, and *follower of* suggests a second-generation artist whose work continues the style of the named master.

of a school, and his style was too bold to be taken up immediately by his contemporaries. Their work, for the most part, combines his influence with lingering elements of the International Style. Then, in 1439 a gifted painter from Venice, Domenico Veneziano, settled in Florence. We can only guess at his age (he was probably born about 1410 and he died in 1461), training, and previous work. He must, however, have been in sympathy with the spirit of Early Renaissance art, for he quickly became a thoroughgoing Florentine-by-choice and an artist of great importance in his new home. His *Madonna and Child with Saints*, shown in figure 225, is one of the earliest examples of a new type of altar panel that was to prove popular from the mid-fifteenth century on, the so-called *sacra conversazione* (sacred conversation). The type includes an enthroned Madonna framed by architecture and flanked by saints, who may converse with her, with the beholder, or among themselves.

Looking at Domenico's panel, we can understand the wide appeal of the *sacra conversazione*. The architecture and the space it defines are supremely clear and tangible yet are elevated above the everyday world. The figures, while echoing the formal solemnity of their setting, are linked with each other and with us by a thoroughly human awareness. We are admitted to their presence, but they do not invite us to join them. Like spectators in a theater, we are not allowed on stage. In Flemish painting, by contrast, the picture space seems a direct extension of the viewer's everyday environment (compare fig. 195).

The basic elements of our panel were already present in Masaccio's *Trinity* fresco. Domenico must have studied it carefully, for his Saint John looks at us while pointing toward the Madonna, repeating the glance and gesture of Masaccio's Virgin. Domenico's perspective setting is worthy of the Masaccio, although the slender proportions and colored inlays of his architecture are less severely Brunelleschian. His figures, too, are balanced and dignified like Masaccio's, but without the same weight and bulk. The slim, sinewy bodies of the male saints, with their highly individualized, expressive faces, show

Donatello's influence (see fig. 211).

Unlike Masaccio, Domenico treats color as an integral part of his work, and the *sacra conversazione* is quite as remarkable for its color scheme as for its composition. The blond tonality—its harmony of pink, light green, and white set off by strategically placed spots of red, blue, and yellow—reconciles the decorative brightness of Gothic panel painting with the demands of perspective space and natural light. Ordinarily, a *sacra conversazione* is an indoor scene, but this one takes place in a kind of loggia (a covered open-air arcade) flooded with sunlight streaming in from the right, as we can tell from the cast shadow behind the Madonna. The surfaces of the architecture reflect the light so strongly that even the shadowed areas glow with color. Masaccio had achieved a similar quality of light in one of his paintings, which Domenico surely knew. In this *sacra conversazione*, the technique has been applied to a far more complex set of forms and integrated with Domenico's exquisite color sense. The influence of its distinctive tonality can be felt throughout Florentine painting of the second half of the century.

Piero della Francesca When Domenico Veneziano settled in Florence, he had a young assistant from southeastern Tuscany named Piero della Francesca (c. 1420–92), who became his most important disciple and one of the truly great artists of the Early Renaissance. Surprisingly, however, Piero left Florence after a few years, never to return. The Florentines seem to have regarded his work as somewhat provincial and old-fashioned, and from their point of view they were right. Piero's style, even more strongly than Domenico's, reflected the aims of Masaccio. He retained this allegiance to the founder of Italian Renaissance painting throughout his long career, whereas Florentine taste developed in a different direction after 1450.

Piero's most impressive achievement is the fresco cycle in the choir of S. Francesca in Arezzo, which he painted from about 1453 to 1458. Its many scenes represent the legend of the True Cross (that is, the story of the cross used for Jesus' crucifixion). The section in

226. Piero della Francesca. *The Discovery and Proving of the True Cross*. Fresco in S. Francesco, Arezzo. c. 1453–58

figure 226 shows the empress Helena, the mother of Constantine the Great, discovering the True Cross and the two crosses of the thieves who died beside Jesus (all three had been hidden by enemies of the Faith). On the left, the crosses are being lifted out of the ground, and on the right, the True Cross is identified by its power to bring a dead youth back to life.

Piero's link with Domenico Veneziano is readily apparent from his colors. The tonality of this fresco, although less luminous than in Domenico's *Madonna and Child with Saints*, is similarly blond, evoking early morning sunlight in much the same way. Since the light enters the scene at a low angle, in a direction almost parallel to the picture plane, it serves both to define the three-dimensional character of every shape and to lend drama to the narrative. But Piero's figures have a harsh grandeur that recalls Masaccio, or even Giotto, more than Domenico. These men and women seem to belong to a lost heroic race, beautiful and strong—and silent. Their inner life is conveyed by glances and gestures, not by facial expressions. They have a gravity, both physical and emotional, that makes them seem kin to Greek sculpture of the Severe style (see fig. 68).

How did Piero arrive at these memorable images? Using his own testimony, we may say that they were born of his passion for perspective. More than any artist of his day, Piero believed in linear perspective as the basis of painting. In a rigorous mathematical treatise, the first of its kind, he demonstrated how it applied to scientifically measured (stereometric) bodies, to architectural shapes, and to the human form. This mathematical outlook permeates all his work. When he drew a head, an arm, or a piece of drapery, he saw it as a variation or compound of spheres, cylinders, cones, cubes, and pyramids, thus endowing the visible world with some of the impersonal clarity and permanence of stereometric bodies. We may regard Piero as a precursor of the abstract artists of the twentieth century, for they, too, work with systematic simplifications of natural forms. It is hardly surprising that Piero's fame is greater today than ever before.

Andrea del Castagno The new direction in Florentine taste after 1450 can be seen in the

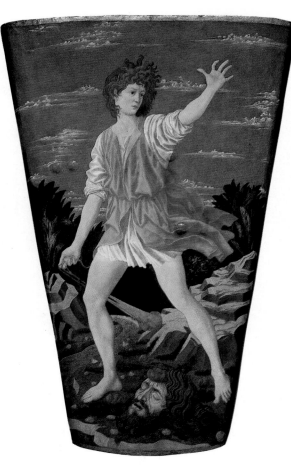

227. Andrea del Castagno. *David*. c. 1450–57.
Tempera on leather mounted on wood, height
45¹/₂" (115.6 cm). National Gallery of Art,
Washington, D.C.

remarkable *David* (fig. 227) by Andrea del Castagno (c. 1423–57), which was executed shortly before Piero's Arezzo frescoes. It is painted on a leather shield that was to be used for display, not protection. Its owner probably wanted to convey an analogy between himself and the biblical hero, since David is here defiant as well as victorious. Solid volume and statuesque immobility have given way to graceful movement, conveyed by both the pose and the windblown hair and drapery. The modeling of the figure has been minimized, and the forms are now defined mainly by their outlines, so that the David seems to be in relief rather than in the round.

Sandro Botticelli The dynamic linear style seen in *David* was to dominate the second half of the century. Its climax came in the final quarter of the century, in the art of Sandro Botticelli (1444/5–1510), who soon became the favorite painter of the patricians, literati, scholars, and poets surrounding Lorenzo the Magnificent, the head of the Medici family and, for all practical purposes, the real ruler of the city. For one member of this group, Botticelli painted *The Birth of Venus* (fig. 228), his most famous picture. The shallow modeling and the emphasis on outline produces an effect of low relief rather than of solid, three-dimensional shapes. We note, too, a lack of concern with deep space. The grove on the right-hand

Early Italian Renaissance Music and Theater

Medieval theater continued with little change until around 1500 (see "Medieval Music, Theater, and Art" on page 196). Unlike other literary forms, theater was slow to show the influence of humanism, which dominated so much of Italian Renaissance intellectual life. This seems surprising, since the earliest humanist tragedy and comedy date from about 1390. (Both of these were written in Latin, and neither was actually performed). Perhaps the main reason that new forms of drama were slow to develop in the Renaissance was that the works of the

Greek and Roman dramatists were only gradually rediscovered in the West. Although the plays of Seneca (see page 116) were known in the Middle Ages, Plautus's second-century B.C. comedies were not rediscovered until 1429. When Constantinople fell to the Turks in 1453, fleeing Greek scholars began to settle in Italy, many bringing classical manuscripts with them. Renaissance theater was revolutionized in 1465, when the printing press was introduced to Italy. One result was that between 1472 and 1518, all of the known Greek and Roman plays were published.

Italian humanists were always interested more in philosophy and theory than in actual practice. This emphasis may have

inhibited the development of music, for Italy was slow to produce a composer of stature. Until the middle of the sixteenth century, the popes and the rulers of the Italian cities imported French and Flemish musicians to occupy all the important positions for composers in churches and at ducal courts. Moreover, since the goal of the humanists was to revive Latin and Greek, few of them were interested in writing poetry in Italian for composers to work with. The first humanist to write extensively in Italian was Angelo Poliziano (1454–94), a member of the Medici circle in Florence, whose poetry inspired paintings by Botticelli and Raphael (see figs. 228, 247).

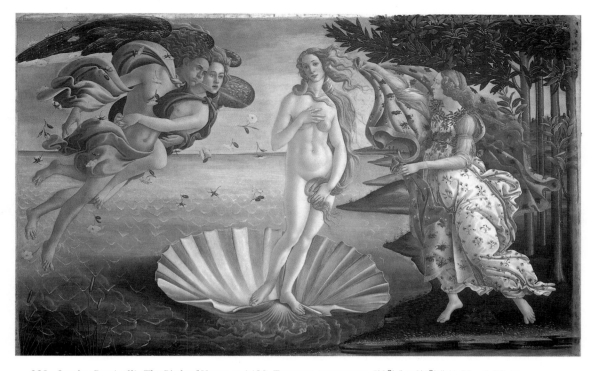

228. Sandro Botticelli. *The Birth of Venus*. c. 1480. Tempera on canvas, 5'8⅞" x 9'1⅞" (1.75 x 2.79 m). Galleria degli Uffizi, Florence

side of the Venus, for example, functions as an ornamental screen. Bodies are attenuated and drained of all weight and muscular power. Indeed, they seem to float even when they touch the ground. All this seems to deny the basic values of the founders of Early Renaissance art, yet the picture does not look medieval. The bodies, ethereal though they be, retain their voluptuousness. They are genuine nudes enjoying full freedom of movement.

The subject itself was inspired by the Homeric *Hymn to Aphrodite*, which begins: "I shall sing of beautiful Aphrodite . . . who is obeyed by the flowery sea-girt land of Cyprus, wither soft Zephyr and the breeze wafted her in soft foam over the waves. Gently the golden-filleted Horae received her, and clad her in divine garments." Yet no single literary source accounts for the pictorial conception, which owes something as well to the great Roman poet Ovid and the humanist poet Angelo Poliziano, who was, like Botticelli, a member of the Medici circle and may well have advised him

on the painting, as he undoubtedly did in other instances.

Neoplatonism *The Birth of Venus*, in fact, contains the first monumental image since Roman times of the nude goddess in a pose derived from classical statues of Venus. Moreover, the subject of the picture is clearly meant to be serious, even solemn. How could such images be justified in a Christian civilization, without subjecting both artist and patron to the accusation of neopaganism?

To understand how a cultivated fifteenth-century viewer would have seen this picture, we must consider its meaning and the general use of classical subjects in Early Renaissance art. During the Middle Ages, classical form had become divorced from classical subject matter. Artists could only draw upon the ancient repertory of poses, gestures, expressions, and types by changing the identity of their sources: philosophers became apostles, the Greek god Orpheus turned into Adam, the mythic Herakles was

▼ The Greek myth of EUROPA AND THE BULL recounts how the legendary daughter of the Phoenician king Agenor was gathering flowers at the sea's edge when the god Zeus saw and fell in love with her. Taking the form of a chestnut-colored bull, Zeus persuaded Europa to climb onto his back, whereupon he bore her across the ocean to the island of Crete.

▼ One of the most creative and influential philosophers of all time, PLATO (c. 428–c.347 B.C.) was an aristocratic Athenian, a pupil of Socrates, and founder of the Academy in the outskirts of Athens. (Aristotle was Plato's outstanding student.) Plato's writings are in the form of dialogues, and the ideas characterized as "Platonic thought" are those that rely on his theory of Forms, or Ideas. Expressed very simply, Plato distinguishes two levels of awareness: opinion—based on information received by the senses and experiences—and genuine knowledge, which is derived from reason and is universal and infallible. In Platonic thinking, the objects conceived by reason exist in a pure form in an idea realm.

now the Old Testament's Samson. When medieval artists had occasion to represent the pagan gods, they based their pictures on literary descriptions rather than visual models. In the Middle Ages, moreover, classical myths were at times interpreted didactically, however remote the analogy, as allegories of Christian precepts. The myth of ▼EUROPA AND THE BULL, for instance, could be declared to signify the soul redeemed by Christ. But such pallid constructions were hardly an adequate excuse for reinvesting the pagan gods with their ancient beauty and strength.

To fuse the Christian faith with ancient mythology, rather than merely relate them, required a more sophisticated argument. This was provided by the Neoplatonic philosophers, whose foremost representative, Marsilio Ficino, enjoyed tremendous prestige during the later years of the fifteenth century and after. Ficino's thought was based as much on the mysticism of the third century A.D. Neoplatonist Plotinus as on the authentic works of ▼PLATO. Ficino believed that the life of the universe, including human life, was linked to God by a spiritual circuit continuously ascending and descending, so that all revelation—whether from the Bible, Plato, or classical myths—was one. Similarly, he proclaimed that beauty, love, and beatitude, being phases of this same circuit, were one. Thus, Neoplatonists could invoke the "celestial Venus" (that is, the nude Venus born of the sea, as in our picture) interchangeably with the Virgin Mary as the source of "divine love" (meaning the cognition of divine beauty). This celestial Venus, according to Ficino, dwells purely in the sphere of Mind, while her twin, the terrestrial Venus, engenders "human love."

Once we understand that Botticelli's picture has this quasi-religious meaning, it seems less astonishing that the wind god Zephyr and breeze goddess Aura on the left look so much like angels and that the Greek goddess Hora personifying Spring on the right, who welcomes Venus ashore, recalls the traditional relation of John the Baptist to the Savior in the Baptism of Jesus (compare fig. 148). As baptism is a "rebirth in God," the birth of Venus evokes the hope for rebirth from which the Renais-

sance takes its name. Thanks to the fluidity of Neoplatonic doctrine, the number of possible associations to be linked with our painting is vast. All of them, however, like the celestial Venus herself, "dwell in the sphere of Mind," and Botticelli's deity would hardly be a fit vessel for them if she were less ethereal. Thus, rather than being merely decorative, the highly stylized treatment of the surface is what elevates the picture to allegory.

Neoplatonic philosophy and its expression in art were obviously too complex to become popular outside the select and highly educated circle of its devotees. In 1494, the suspicions of ordinary people were aroused by the friar Girolamo Savonarola, an ardent advocate of religious reform who gained a huge following with his sermons attacking the "cult of paganism" in the city's ruling circle. Botticelli himself was perhaps a follower of Savonarola and reportedly burned a number of his own "pagan" pictures. In his last works, Botticelli returned to traditional religious themes but with no essential change in style. He seems to have stopped painting entirely after 1500, even though the apocalyptic destruction of the world predicted by Savonarola at the millennium-and-a-half was not fulfilled.

Piero di Cosimo *The Discovery of Honey* (fig. 229) by Botticelli's younger contemporary Piero di Cosimo (1462–1521) illustrates a view of pagan mythology diametrically opposed to that of the Neoplatonists. Instead of "spiritualizing" the pagan gods, it brings them down to earth as beings of flesh and blood. In this alternate theory, humanity had slowly risen from a barbaric state through the discoveries and inventions of a few exceptionally gifted individuals. Gratefully remembered by posterity, they were finally accorded the status of gods. Augustine of Hippo subscribed to such a view (which can be traced back to Hellenistic times) without facing all of the implications expressed by ancient authors. The complete theory, which was not revived until the late fifteenth century, postulates a gradual evolution from the animal level and so conflicts with the scriptural account of Creation. This could be glossed

229. Piero di Cosimo. *The Discovery of Honey*. c. 1499. Tempera on wood panel, 31¼ x 50⅝" (79.4 x 128.6 cm). Worcester Museum of Art, Worcester, Massachusetts

over, however, by making a happy idyll out of the achievements of these pagan "culture heroes" to avoid the impression of complete seriousness, which is exactly what Piero di Cosimo has done in our picture.

Its title refers to the central episode, a group of ▼SATYRS busying themselves about an old willow tree. They have discovered a swarm of bees and are making as much noise as possible with their pots and pans to induce the bees to cluster on one of the branches. The satyrs will then collect the honey, from which they will produce mead, a fermented drink. Behind them, to the right, some of their companions are about to discover the source of another fermented beverage: they are climbing trees to collect wild grapes. Beyond is a barren rock, while on the left are gentle hills and a town. This contrast does not imply that the satyrs are city dwellers. It merely juxtaposes civilization, the goal of the future, with untamed nature. Here the culture hero is BACCHUS,

who appears in the lower right-hand corner with a tipsy grin on his face, next to his ladylove, Ariadne. Despite their classical appearance, Bacchus and his companions do not in the least resemble the frenzied revelers of ancient mythology. They have an oddly domestic air, suggesting a fun-loving family clan on a picnic. The brilliant sunlight, the rich colors, and the far-ranging landscape make the scene a still more plausible extension of everyday reality. We can well believe that Piero di Cosimo, in contrast to Botticelli, admired the great Flemish masters, for this landscape would be inconceivable without the strong influence of the *Portinari Altarpiece* (compare fig. 201).

Domenico Ghirlandaio Piero was not the only Florentine painter receptive to the realism of the Flemings. Domenico Ghirlandaio (1449–94), another contemporary of Botticelli, shared this inclination. His touching panel *An Old Man*

▼ In Greek mythology, SATYRS were goat-legged, horned, and tailed deities of the woods and hills, creatures who accompanied BACCHUS, a Greek god of wine, in revelry and orgies. Silenus was the father of the breed.

230. Domenico Ghirlandaio. *An Old Man and His Grandson*. c. 1480. Tempera and oil on wood panel, 24⅛ x 18" (61.3 x 45.7 cm). Musée du Louvre, Paris

and His Grandson (fig. 230), though lacking the pictorial delicacy of Flemish portraits (compare fig. 197), reflects their precise attention to surface texture and facial detail. But no Northern painter could have rendered the tender relationship between the little boy and his grandfather with Ghirlandaio's human understanding. Psychologically, our panel plainly bespeaks its Italian origin.

Northern Italy

Andrea Mantegna Florentine artists had been carrying the new style of Early Renaissance art to Venice and to the neighboring city of Padua in northern Italy since the 1420s. Their presence, however, evoked only rather timid local responses until, shortly before 1450, the young Andrea Mantegna (1431–1506) emerged as an independent master. He was first trained by a minor Paduan painter, but his early development was decisively shaped by the impressions he received from locally available Florentine works and, we may assume, by personal contact with Donatello. Next to Masaccio, Mantegna was the most important painter of the Early Renaissance. He, too, was a precocious genius, fully capable at seventeen of executing commissions of his own. Within the next decade, he reached artistic maturity. His greatest achievement, the frescoes in the Church of the Eremitani in Padua, was almost entirely destroyed by accidental bombing during World War II. The scene we reproduce in figure 231, *Saint James Led to His Execution*, is the most dramatic of the cycle because of its daring "worm's-eye view" perspective, which is based on the beholder's actual eye-level. (The central vanishing point is below the bottom of the picture, somewhat to the right of center.) The architectural setting consequently looms large, as in Masaccio's *Trinity* fresco (see fig. 223). Its main feature, a huge triumphal arch, although not a copy of any known Roman monument, looks so authentic in every detail that it might as well be.

231. Andrea Mantegna. *Saint James Led to His Execution.* Fresco in Ovetari Chapel, Church of the Eremitani, Padua. c. 1455. Destroyed 1944

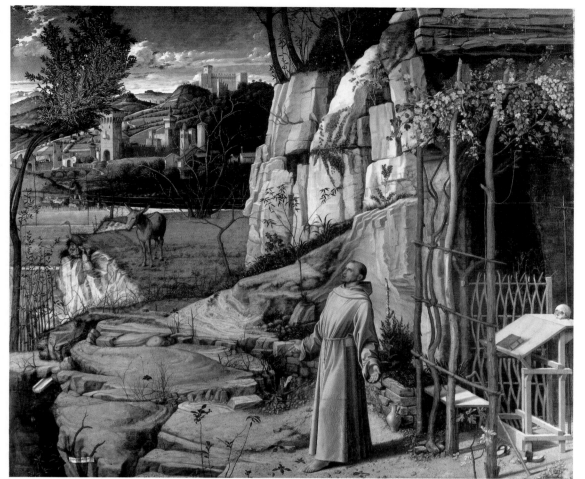

232. Giovanni Bellini.
Saint Francis in Ecstasy.
c. 1485. Oil and
tempera on panel,
49 x 55⅞"
(124.5 x 141.9 cm).
The Frick Collection,
New York

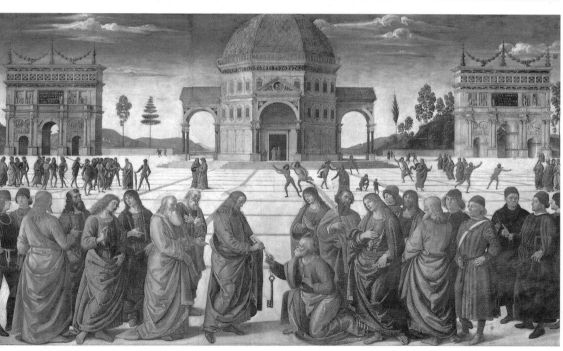

233. Pietro Perugino.
The Delivery of the Keys.
Fresco in the Sistine
Chapel, Vatican, Rome.
1482

Here Mantegna's devotion to the visible remains of antiquity, almost like an archeologist's, shows his close association with the learned humanists at the University of Padua, who had the same reverence for every word of ancient literature. No Florentine painter or sculptor of the time could have transmitted such an attitude to him. The same desire for authenticity can be seen in the costumes of the Roman soldiers (compare fig. 98). It even extends to the use of "wet" drapery patterns, inherited by the Romans from Classical Greek sculpture (see fig. 73). But the tense figures, lean and firmly constructed, and especially their dramatic interaction, clearly derive from Donatello. Mantegna's subject hardly demands this agitated staging. The saint, on the way to his execution, blesses a paralyzed man and commands him to walk. Many of the bystanders express by glance and gesture how deeply the miracle has stirred them. The large crowd generates an extraordinary emotional tension that erupts into real physical violence on the far right, as the great spiral curl of the banner echoes the turbulence below.

Giovanni Bellini If Mantegna was a master of powerful drama, his brother-in-law in Venice, Giovanni Bellini (c. 1431–1516), was a poet of light and color. Bellini was slow to mature. His finest pictures, such as _Saint Francis in Ecstasy_ (fig. 232), date from the final decades of the century and later. The subject is unique. The saint has left his wooden sandals behind and stands barefoot on holy ground (see page 247). The absence of the crucified seraph that appeared to him notwithstanding, the painting seemingly shows Francis receiving the stigmata (the wounds of Christ) on Mount Alverna during the Feast of the Holy Cross in 1224, although they are barely visible even in person. However, it must also allude to the "Hymn of the Sun," which he composed the following year after his annual fast at a hermitage near his hometown of Assisi. During that time, he could not bear the sight of light and was plagued as well by mice. The monk finally emerged from these torments after being assured by the Lord that he would enter the Kingdom of Heaven.

We see him looking ecstatically up at the sun (note the direction of the shadows). In the background is a magnificent expanse of Italian countryside. Yet this is no ordinary landscape. It represents the Heavenly Jerusalem, inspired by the Revelation of Saint John the Divine, which is always represented as unpopulated in the art of the period. Behind looms Mount Zion, where the Lord dwells. Despite the bridge to the left, we cannot enter the gate to Paradise, shown as a large tower. How, then, shall we attain salvation? For Francis, it lay in the ascetic life, signified by the cave, which also connects him symbolically to Saint Jerome, the first great hermit saint. The donkey is a symbol of Francis himself, who referred to his body as Brother Ass, which must disciplined. The other animals (difficult to discern in our illustration) are, like monks, solitary creatures in Christian lore: the heron, bittern, and rabbit.

The complex iconography is not sufficient in itself to explain the picture. Far more important is the treatment of the landscape. Francis is here so small in comparison to the setting that he seems almost incidental. Yet his mystic rapture before the beauty of the visible world sets our own response to the view that is spread out before us, ample and intimate at the same time. Francis revered nature as the Lord's handiwork, made for humanity's benefit. Our artist shares the saint's tender lyricism, expressed in his "Hymn of the Sun":

> Be praised, my Lord, with all Your
> creatures,
> Above all Brother Sun,
> Who gives the day and by whom You
> shed light on us.
> And he is beautiful and radiant with
> great splendor.
> Of Thee, Most High, he is a symbol.

Bellini's contours are less brittle than Mantegna's; the colors are softer and the light more glowing. Bellini's interest in light-filled landscape testifies to the impact of the great Flemish painters; they were much admired in Venice, which had strong trade links with the North. Bellini surely knew their work, and he shares

their concern for every detail of nature. Unlike the Northerners, however, he can define the beholder's spatial relationship to the landscape. The rock formations of the foreground are structurally clear and firm, like architecture rendered by the rules of linear perspective.

Rome

Pietro Perugino Rome, long neglected during the papal exile in Avignon (see page 188), once more became an important center of art patronage in the later fifteenth century. As the papacy regained its political power on Italian soil, the occupants of the Chair of Saint Peter began to beautify both the Vatican and the city, in the conviction that the monuments of Christian Rome must outshine those of the pagan past. The most ambitious pictorial project of those years was the decoration of the walls of the Sistine Chapel beginning around 1482. Among the artists who carried out this large cycle of Old and New Testament scenes we encounter most of the important painters of central Italy, including Botticelli and Ghirlandaio, although these frescoes do not, on the whole, represent their best work.

There is, however, one exception: *The De-livery of the Keys* (fig. 233) by Pietro Perugino (c. 1450–1523) must rank as his finest achievement. Born near Perugia in Umbria (the region southeast of Tuscany), he maintained close ties with Florence. His early development was decisively influenced by Verrocchio, as the statuesque balance and solidity of the figures in *The Delivery of the Keys* suggest. The grave, symmetrical design conveys the special importance of the subject in this particular setting: the authority of Peter as the first pope, and that of all his successors, rests on his having received the keys to the Kingdom of Heaven from Jesus himself. A number of contemporaries, with powerfully individualized features, witness the solemn event. Equally striking is the vast expanse of the background. Its two Roman triumphal arches flank a domed structure in which we recognize the ideal church of Alberti's *Treatise on Architecture*. The spatial clarity, achieved by the mathematically exact perspective of this view, is the heritage of Piero della Francesca, who spent much of his later life working for Umbrian clients, notably the duke of Urbino. Also from Urbino, shortly before 1500, Perugino received a pupil whose fame would soon outshine his own: Raphael, the most classic master of the High Renaissance.

Chapter 14

The High Renaissance in Italy

It used to be taken for granted that the High Renaissance followed upon the Early Renaissance as naturally and inevitably as night follows day. The great masters of the sixteenth century—Leonardo, Bramante, Michelangelo, Raphael, Giorgione, Titian—were thought to have shared the ideals of their predecessors but to have expressed them so completely that their names became synonyms for perfection. Their works brought Renaissance art to a climax, its classic phase, just as the Parthenon represented the art of ancient Greece at its highest point. Such a view could also explain why these two classic phases—though two millenniums apart—were so short: if art is assumed to develop along the pattern of a ballistic curve, its highest point cannot be expected to last more than a moment.

Since the 1920s, art historians have come to realize the limitations of this scheme. When we apply it literally, the High Renaissance becomes so absurdly brief that we wonder whether it happened at all. Moreover, we hardly increase our understanding of the Early Renaissance if we regard that period as a not-yet-perfect High Renaissance, any more than an Archaic Greek statue can be satisfactorily viewed from a Classical standpoint. Nor is it very useful to insist that the subsequent post-Classical phase, whether Hellenistic or "Late Renaissance," must be decadent. The image of the ballistic curve has now been abandoned, and we have gained a less assured, but also less arbitrary, estimate of what, for lack of another term, we still call the High Renaissance.

The Artist as Genius

In some fundamental respects, we shall find that the High Renaissance was indeed the culmination of the Early Renaissance, while in other respects it represented a significant departure. Certainly the tendency to view the artist as a sovereign genius, rather than as a devoted artisan, was never stronger than during the first half of the sixteenth century. Plato's concept of genius—the spirit that causes the poet to compose in a "divine frenzy"—had been broadened by Marsilio Ficino and his fellow Neoplatonists to include architects, sculptors, and painters.

What set these artists apart was the God-given inspiration guiding their efforts, which made them worthy of being called divine, immortal, and creative (before 1500, creating, as distinct from making, was the privilege of God alone). To ▼GIORGIO VASARI, the painters and sculptors of the Early Renaissance, like those of the "Late Gothic," had learned only to imitate coarse nature, whereas the geniuses of the High Renaissance had conquered nature by ennobling, transcending, or subjecting it to art. In fact, the High Renaissance remained thoroughly grounded in nature. Its achievement lay in the creation of a new classicism through abstraction—an act of the imagination, not the intellect, for the result was a poetic ideal informed by a spirit of ineffable harmony.

The faith in the divine origin of inspiration led artists to rely on subjective, rather than objective, standards of truth and beauty. If Early Renaissance artists felt bound by what they believed to be universally valid rules, such as the numerical ratios of musical harmony and the laws of linear perspective, their High Renaissance successors were less concerned with rational order than with visual effectiveness. They evolved a new drama and a new rhetoric to engage the emotions of the beholder, whether sanctioned or not by classical precedent. Indeed, the best works of the great High Renaissance artists immediately became classics in their own right, their authority equal to that of the most renowned monuments of antiquity. At the same time, the cult of genius had a profound effect on the artists of the High Renais-

sance. It spurred them to vast and ambitious goals, and it prompted their awed patrons to support such enterprises. In the case of Michelangelo, these ambitions often went beyond the humanly possible and were apt to be frustrated by external as well as internal difficulties, leaving the artist with a sense of having been defeated by a malevolent fate.

Here we encounter a paradox. If the creations of genius are viewed as unique by definition, they cannot be successfully imitated by lesser artists, however worthy they may seem of such imitation. Indeed, unlike the founders of the Early Renaissance, the leading artists of the High Renaissance did not set the pace for a broadly based "period style" that could be practiced on every level of quality. The High Renaissance produced astonishingly few minor artists. It died with those who had created it, or even before.

Leonardo da Vinci

The key monuments of the High Renaissance were all produced between 1495 and 1520, despite the great differences in age of the artists creating them. Bramante, the oldest, was born in 1444, and Titian, the youngest, about 1488–90. Of the six great personalities mentioned on page 286, only Michelangelo and Titian lived beyond 1520. Yet the distinction of being the earliest High Renaissance master belongs to Leonardo da Vinci (1452–1519), not to Bramante. Born in the little Tuscan town of Vinci, Leonardo was trained in Florence by Verrocchio. At the age of thirty he went to work for the duke of Milan as a military engineer and, only secondarily, as an architect, sculptor, and painter.

The Virgin of the Rocks Soon after arriving in Milan, Leonardo painted *The Virgin of the Rocks* (fig. 234, page 288). The figures emerge from the semidarkness of a grotto, enveloped in a moisture-laden atmosphere that delicately veils their forms. This fine haze, called **sfumato**, is more pronounced than similar effects in Flemish and Venetian painting. It lends a peculiar warmth and intimacy to the scene. It also creates a

▼ Painter, architect, and historiographer GIORGIO VASARI (1511–74) defined Italian Renaissance art in 1550 by publishing the history of Italian art from Cimabue (c. 1240–1302?) through Michelangelo. Vasari's *The Lives of the Most Excellent Italian Architects, Painters, and Sculptors,* known as the *Lives,* gives a mass of anecdotal biographical information about Florentine artists, which handed Florence most of the credit for the Renaissance. More significantly, Vasari's view that the goal of art should be the faithful imitation of nature expressed a value judgment favoring classical and Renaissance art which endured for centuries.

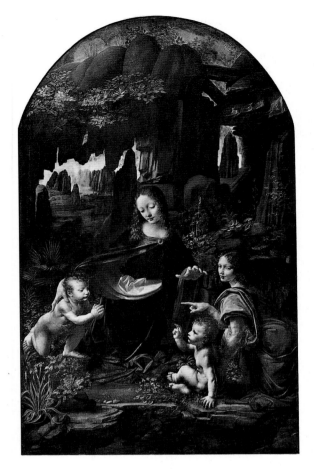

234. Leonardo da Vinci. *The Virgin of the Rocks.*
c. 1485. Oil on panel, 6'3" x 3'7¹/2"
(1.91 x 1.11 m). Musée du Louvre, Paris

remote, dreamlike quality and makes the picture seem a poetic vision rather than an image of reality. The subject, the infant John adoring the Infant Jesus in the presence of the Virgin and an angel, is without immediate precedent. The story of their meeting is one of the many legends that arose to satisfy the abiding curiosity about the "hidden" early life of Jesus, which is hardly mentioned in the Bible. (According to a similar legend, John, about whom equally little is known, spent his childhood in the wilderness; hence he is shown wearing a hair shirt.) Leonardo was the first to depict this subject, and his treatment is mysterious in many ways: the secluded, rocky setting, the pool in front, and the plant life, carefully chosen and exquis-

itely rendered, all hint at levels of meanings that are somehow hard to define. How are we to interpret the relationships among the four figures? Perhaps the key is the interplay of gestures. Protective, pointing, blessing, they convey the wonderment of John's recognition of Jesus as the Savior, but with a tenderness that carries the scene beyond the merely doctrinal. The gap between these hands and John makes the exchange all the more charged with meaning. Although present in germinal form in *The Doubting of Saint Thomas* by Leonardo's teacher, Verrocchio (see fig. 218), the elegant gestures and the refined features are the first fully mature statement of that High Renaissance "grace" signifying a spiritual state of being.

The Last Supper Despite its originality, *The Virgin of the Rocks* does not yet differ clearly in conception from the aims of the Early Renaissance. Leonardo's *The Last Supper*, later by a dozen years, has always been recognized as the first classic statement of the ideals of High Renaissance painting (fig. 235). Unfortunately, the famous mural began to deteriorate a few years after its completion. The artist was dissatisfied with the limitations of the traditional fresco technique and experimented in an oil-tempera medium that did not adhere well to the wall. We thus need some effort to imagine its original splendor, but what remains is sufficient to account for its tremendous impact. Viewing the composition as a whole, we are struck at once by its balanced stability. Only afterward do we discover that this balance has been achieved by the reconciliation of competing, even conflicting, claims that no previous artist had attempted.

Leonardo began with the figure composition, and the architecture had merely a supporting role from the start. Hence, it is the very opposite of the rational pictorial space of the Early Renaissance: his perspective is an ideal one. The painting, high up on the refectory (dining hall) wall, assumes a vantage point some 15 feet above the floor and 30 feet back—an obvious impossibility, yet we readily accept it nevertheless. The central vanishing point, which governs our view of the interior, is

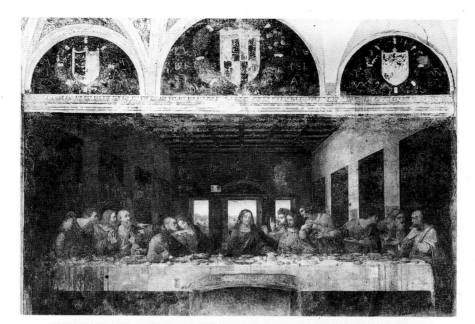

235. Leonardo da Vinci.
The Last Supper.
Mural in Sta. Maria
delle Grazie,
Milan. c. 1495–98.
Oil and tempera,
15'2" x 28'10"
(4.62 x 8.79 m)

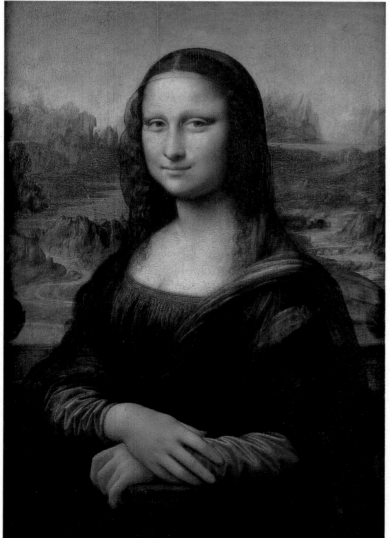

236. Leonardo da Vinci.
Mona Lisa. c. 1503–5.
Oil on panel, 30¹/₄ x 21"
(76.8 x 53.3 cm).
Musée du Louvre, Paris

located behind the head of Jesus in the exact middle of the picture and thus becomes charged with symbolic significance. Equally plain is the symbolic function of the main opening in the back wall: its projecting pediment acts as the architectural equivalent of a halo. We thus tend to see the perspective framework of the scene almost entirely in relation to the figures rather than as a preexisting entity. How vital this relationship is can be seen by covering the upper third of the picture. The composition then takes on the character of a **frieze**, and the grouping of the apostles is less clear. Above all, the calm, triangular shape of Jesus becomes merely passive, instead of acting as a physical and spiritual force. At the same time, the perspective system helps to lock the composition in place, lending the scene an eternal quality without making it appear static in any way.

The Savior, presumably, has just spoken the fateful words "One of you shall betray me," and the disciples are asking, "Lord, is it I?" We actually see nothing that contradicts this interpretation, but to view the scene as one particular moment in a psychological drama hardly does justice to Leonardo's intentions. These went well beyond a literal rendering of the biblical narrative, for he crowded together all the disciples on the far side of the table, in a space quite inadequate for so many people. He clearly wanted to condense his subject physically by the compact, monumental grouping of the figures and spiritually by presenting several levels of meaning at one time. The gesture of Jesus is one of submission to the divine will and of offering. It is a hint at Jesus' main act at the Last Supper, the institution of the Eucharist, in which bread and wine become his body and blood through transubstantiation. The apostles do not simply react to his words. Each of them reveals his own personality, his own relationship to the Savior. For example, although Judas is not segregated from the rest, his dark, defiant profile sets him apart well enough. Leonardo has carefully calculated each pose and expression so that the drama unfolds across the picture plane. The figures exemplify what the artist wrote in one of his notebooks, that the highest and most difficult aim of painting is to depict "the intention of man's soul" through gestures and movements of the limbs. This dictum is to be interpreted as referring not to momentary emotional states but to the inner life as a whole.

Mona Lisa In 1499, the duchy of Milan fell to the French, and Leonardo, after brief trips to Mantua and Venice, returned to Florence. He must have found the cultural climate very different from his recollections of it. The Medici had been expelled, and the city was briefly a republic again, until their return. There Leonardo painted his most famous portrait, the *Mona Lisa* (fig. 236). The delicate sfumato of *The Virgin of the Rocks* is here so perfected that it seemed miraculous to the artist's contemporaries. The forms are built from layers of glazes so gossamer-thin that the entire panel seems to glow with a gentle light from within. But the fame of the *Mona Lisa* comes not from this pictorial subtlety alone. Even more intriguing is the psychological fascination of the sitter's personality. Why, among all the smiling faces ever painted, has this particular one been singled out as mysterious? Perhaps the reason is that, as a portrait, the picture does not fit our expectations. The features are too individual for Leonardo to have simply depicted an ideal type, yet the element of idealization is so strong that it blurs the sitter's character. Once again, the artist has brought two opposites into harmonious balance. The smile, also, may be read in two ways: as the echo of a momentary mood, and as a timeless, symbolic expression, akin to the Archaic smile of the Greeks (see fig. 65). Who was the sitter for this, the most famous portrait in the world? Her identity remained a mystery until very recently. We now know that she was the wife of a Florentine merchant who was born in 1479 and died before 1556. This is not the only version of the *Mona Lisa*: Leonardo also painted a nude one that once belonged to the king of France. The *Mona Lisa* seemingly embodies a quality of maternal tenderness that was to Leonardo the essence of womanhood. Even the landscape in the background, composed mainly of rocks and water, suggests elemental generative forces.

Music and Theater during the High Renaissance

Although the term applies specifically to art, the High Renaissance was intimately connected to literature, theater, and music. Indeed, these arts created the cultural climate that made the High Renaissance possible in the first place. The early sixteenth century ushered in the first great age of Italian literature since Dante and Petrarch some 200 years earlier. It centers on the poet Lodovico Ariosto (1474–1533), whose masterpiece, *Orlando Furioso* (1532), used the story of the Crusade knight Roland to glorify his patron, the d'Este family of Ferrara. As early as 1508, Ariosto had written the first comedy along classical lines in Italian. Even Niccolò Machiavelli (1469–1527), who is best known for his manual of power and courtly life, *The Prince* (published posthumously in 1532), wrote a comedy. The first vernacular tragedy, *Sofonisba* (1515) by Giangiorgio Trissino (1478–1550), was written in the Greek style to combat the classical Roman influence of Seneca, thus setting off a debate that was effectively won by partisans of Latin drama in 1541, when *Orbecche* by Giambattista Cinthio (1504–74) became the first Italian tragedy actually to be produced.

The High Renaissance counterpart to Ariosto in music was Josquin Des Prés (c. 1440–1521), the Fleming who became the most celebrated composer of his time. Artistically he belonged to the same generation as Leonardo da Vinci, though he was even older. Despite his notorious artistic temperament, he was employed at one time or another by all the leading courts in Italy and France, and enjoyed the patronage of no less than three popes. (He was present at the Vatican when Perugino and Botticelli were decorating the walls of the Sistine Chapel.) Josquin was regarded with much the same awe as Michelangelo came to be by his peers. The first true musical genius we know of, Josquin was a virtuoso equally at ease in secular and religious music. His work represented the perfect marriage of Flemish composition and Italian humanism, which, inspired by Greek accounts, sought unity between text and music. He thus found his ideal outlet in song (*chanson*) and the MOTET, which made an entire realm of human action and feeling available to him that lay outside the scope of the traditional Mass. He cultivated a smooth, homogenous style that has aptly been compared to the art of Raphael as the embodiment of the classical ideal in its calm, balanced perfection. He was also important for beginning to lead music away from the system of modes used throughout the Middle Ages and Early Renaissance.

Josquin became famous throughout Europe, thanks not only to his travels but also to the invention of music publication using movable type by the Venetian Ottaviano Petrucci (1466–1539) in 1498, a development that proved as revolutionary as printing had been for books and printmaking. Petrucci enjoyed such success that during the 1520s and 1530s France, Germany, and the Netherlands also emerged as major centers of music publishing. The diffusion of music and ideas in print helped to elevate composers in humanist circles. Like artists, they now became "learned" and joined in debates over matters of theory with other intellectuals. Their status was further enhanced by the appearance of the first primers, which taught amateurs how to play instruments and set off a new wave of enthusiasm for music.

Architecture Contemporary sources attest that Leonardo was esteemed as an architect. Actual building seems to have concerned him less, however, than problems of structure and design. The numerous architectural projects in his drawings were intended, for the most part, to remain on paper. Nevertheless, these sketches, especially those of his Milanese period, have great historic importance, for only in them can we trace the transition from the Early to the High Renaissance in architecture.

The domed, centrally planned churches of the type illustrated in figure 237 hold particular interest for us. The plan recalls Early Renaissance structures, but the new relationship of the spatial units is more complex, while the exterior, with its cluster of domes, is more monumental than any earlier fifteenth-century building. In conception, this design stands halfway between the dome of Florence Cathedral

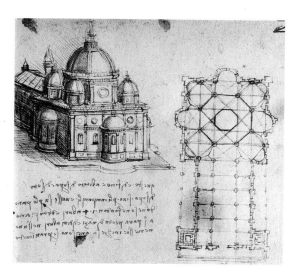

237. Leonardo da Vinci. Project for a church (Ms. B). c. 1490. Pen drawing, 9¹/₈ x 6³/₄" (23 x 17 cm). Library of the Institut de France, Paris

and the most ambitious structure of the six-
teenth century, the new basilica of St. Peter's in
Rome (compare figs. 168, 238, and 239). It gives
evidence, too, of Leonardo's close contact
during the 1490s with the architect Bramante,
who was then also working for the duke of
Milan. After Milan fell to the French, Bramante
went to Rome, where, during the last fifteen
years of his life, he became the creator of High
Renaissance architecture.

Donato Bramante

St. Peter's Most of the great achievements that
made Rome the center of Italian art during the
first quarter of the sixteenth century belong to
the decade 1503–13, which corresponded to
the papacy of Julius II. It was he who decided
to replace the old basilica of St. Peter's, which
had long been in precarious condition, with a
church so magnificent as to overshadow all the
monuments of imperial Rome. The task fell to
Donato Bramante (1444–1514), who had estab-
lished himself as the foremost architect in the
city. His original design of 1506 is known to us
only from a plan (fig. 238) and from the medal
commemorating the start of the building cam-
paign (fig. 239), which shows the exterior in
rather imprecise perspective. These, however,
bear out the words Bramante reportedly used to
define his aim: "I shall place the Pantheon on
top of the Basilica of Constantine."

The goal of surpassing the two most
famous structures of Roman antiquity with a
Christian edifice of unexampled grandeur tes-
tifies to the vast ambition of Julius II, who
wanted to unite all Italy under his command
and thus to gain temporal power matching the
spiritual authority of his office. Bramante's
design is indeed of truly imperial magnificence.
A huge, hemispherical dome crowns the cross-
ing of the barrel-vaulted arms of a Greek cross,
with four lesser domes and tall corner towers
filling the angles. This plan fulfills all the
demands laid down by Alberti for sacred archi-
tecture (see page 272). Based entirely on the
circle and the square, it is so rigidly symmet-
rical that we cannot tell which apse was to hold
the high altar. Bramante envisioned four iden-

238. Donato Bramante. Original plan for St. Peter's,
Rome. 1506 (after Geymuller)

tical facades like that on the medal of 1506,
dominated by severely classical forms—domes,
half-domes, colonnades, pediments.

These simple geometric shapes, however,
do not prevail inside the church. Here the
"sculptured wall" reigns supreme. The plan
shows no continuous surfaces, only great,
oddly shaped "islands" of masonry that have
been well described by one critic as giant pieces
of toast half-eaten by a voracious space. The
huge size of these islands can be visualized only
when we realize that each arm of the Greek
cross has about the dimensions of the Basilica
of Constantine (see fig. 90). Bramante's refer-
ence to the Pantheon and the Basilica of Con-
stantine was, then, no idle boast. His plan
dwarfs these monuments, as well as every Early
Renaissance church.

Michelangelo

The concept of genius as divine inspiration, a
superhuman power granted to a few rare indi-
viduals and acting through them, is nowhere
exemplified more fully than in the life and
work of Michelangelo (Michelangelo di Lodo-

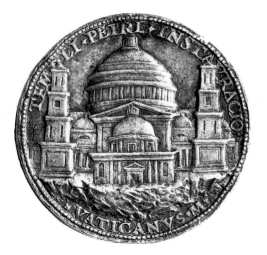

239. Christofor Foppa Caradosso. Bronze medal showing Bramante's design for St. Peter's. 1506. The British Museum, London

real, three-dimensional bodies from recalcitrant matter could satisfy his urge (for his procedure, see pages 13–14). Painting, for him, should imitate the roundness of sculptured forms, and architecture, too, must partake of the organic qualities of the human figure.

Michelangelo's faith in the human image as the supreme vehicle of expression gave him the strongest sense of kinship with Classical sculpture of any Renaissance artist. Among recent masters he admired Giotto, Masaccio, and Donatello more than the artists he knew as a youth in Florence. Nevertheless, his mind was decisively shaped by the cultural climate of Florence during the 1480s and 1490s. Both the Neoplatonism of Marsilio Ficino and the religious reforms of Savonarola affected him profoundly. These conflicting influences reinforced the tensions within Michelangelo's personality, his violent changes of mood, his sense of being at odds with himself and with the world. As he conceived his statues to be human bodies released from their marble prison, so the body was the earthly prison of the soul—noble, surely, but a prison nevertheless. This dualism of body and spirit endows his figures with their extraordinary pathos. Outwardly calm, they seem stirred by an overwhelming psychic energy that has no release in physical action.

vico Buonarroti Simoni, 1475–1564). This position was first voiced by the historiographer Giorgio Vasari in 1550. Not only his admirers viewed him in this light. He himself, steeped in the tradition of Neoplatonism (see page 251), accepted the idea of his genius as a living reality, although it seemed to him at times a curse rather than a blessing. The element that brings continuity to his long and stormy career is the sovereign power of his personality, his faith in the subjective rightness of everything he created. Conventions, standards, and traditions might be observed by lesser spirits, but he could acknowledge no authority higher than the dictates of his genius.

Unlike Leonardo, for whom painting was the noblest of the arts because it embraced every visible aspect of the world, Michelangelo was a sculptor to the core; more specifically, he was a carver of marble statues. Art, for him, was not a science but "the making of men," analogous (however imperfectly) to divine creation. Hence, the limitations of sculpture that Leonardo condemned were essential virtues in Michelangelo's eyes. Only the "liberation" of

David The unique qualities of Michelangelo's art are already fully present in his *David* (fig. 240, page 294), the earliest monumental statue of the High Renaissance. Commissioned in 1501 as the civic-patriotic symbol of the Florentine republic, the huge figure was designed to be placed high above the ground, on one of the buttresses of Florence Cathedral. The city authorities chose instead to put it in front of the Palazzo Vecchio, the fortresslike palace of the Medici near the center of town, where it has since been replaced by a modern copy.

We can well understand their decision. Because the head of Goliath has been omitted, Michelangelo transforms his *David* from a victorious hero into the champion of a just cause. To Michelangelo, David embodied the civic virtue of fortitude. Vibrant with pent-up energy,

240. Michelangelo. *David*. 1501–4. Marble, height of figure 13'5" (4.09 m). Galleria dell'Accademia, Florence

David faces the world like Donatello's *Saint George* (see fig. 210), although his nudity links him as well to the older sculptor's bronze *David* (see fig. 212). The style of the figure nevertheless proclaims an ideal very different from the wiry slenderness of Donatello's youths. Michelangelo had just spent several years in Rome, where he had been deeply impressed with the emotion-charged, muscular bodies of Hellenistic sculpture. Their heroic scale, their superhuman beauty and power, and the swelling volume of their forms became part of Michelangelo's own style and, through him, of Renaissance art in general. Whereas his earlier work could sometimes be taken for ancient statues, in the *David* he competes with antiquity on equal terms and replaces its authority with his own. This resolute individualism is partly indebted to Leonardo da Vinci, who had recently returned to Florence. (As with all of Michelangelo's great peers, they soon became arch rivals.) So is the expressive attitude, which conveys the "intention of man's soul." In Hellenistic statues (compare fig. 79), the body often acts out the spirit's agony, while the *David*, at once calm and tense, shows the action-in-repose so characteristic of Michelangelo.

The Sistine Ceiling Soon after completing *David*, Michelangelo was called to Rome by Pope Julius II, the greatest and most ambitious of Renaissance popes, for whom he designed an enormous tomb. After a few years, the pope changed his mind and set the reluctant artist to work instead on the ceiling fresco of the Sistine Chapel (fig. 241, page 296). Driven by his desire to resume work on the tomb, as well as by pressure from Julius II, Michelangelo completed the entire ceiling in four years, between 1508 and 1512. He produced a work of truly epochal importance. The ceiling is a huge organism with hundreds of figures rhythmically distributed within the painted architectural framework, dwarfing the earlier murals (see fig. 233) by its size and still more by its compelling inner unity. In the central area, subdivided by five pairs of girders, are nine scenes based on the Old Testament Book of Genesis—from the Creation of the World (at the far end of the chapel

in our illustration) to the Drunkenness of Noah.

The theological scheme of these scenes is accompanied by a complex array of nude youths, ▼PROPHETS, SIBYLS (see figs. 4, 5), medallions, and scenes in the **spandrels**. This rich program has not been fully explained, but we know that it links early history and the coming of Christ. What greater theme could Michelangelo wish than the creation, destruction, and salvation of humanity? We do not know how much responsibility Michelangelo had for the program, but he was not someone to submit easily to dictation. The subject matter of the ceiling, moreover, fits his cast of mind so perfectly that his own desires cannot have conflicted strongly with those of his patron.

The Creation of Adam (fig. 242, page 297) must have stirred Michelangelo's imagination most deeply. It shows not the physical molding of Adam's body but the passage of the divine spark—the soul—and thus achieves a dramatic juxtaposition unrivaled by any other artist. The dynamism of Michelangelo's design contrasts the earthbound Adam and the figure of God rushing through the sky. This relationship becomes even more meaningful when we realize that Adam strains not only toward his Creator but also toward Eve, whom he sees, yet unborn, in the shelter of the Lord's left arm. The recent cleaning of the frescoes has also revealed Michelangelo's extraordinary gifts as a colorist. *The Creation of Adam* shows the bold, intense hues typical of the whole ceiling. The range of Michelangelo's palette is astonishing. Contrary to what had been thought, the heroic figures have anything but the quality of painted sculpture. Full of life, they act out their epic roles in illusionistic "windows" in the architectural setting. Michelangelo does not simply color the areas within the contours but builds up his forms from broad and vigorous brushstrokes in the tradition of Giotto and Masaccio.

The Last Judgment When Michelangelo returned to the Sistine Chapel in 1534, more than twenty years after completing the ceiling fresco, the Western world was enduring the spiritual and political crisis of the Reformation (see page 307). We see with shocking directness how the mood has changed as we turn from the radiant vitality of Michelangelo's ceiling fresco to the somber vision of his *Last Judgment*. The Blessed and Damned alike huddle together in tight clumps, pleading for mercy before a wrathful God (fig. 243, page 297). All traces of classicism have disappeared, save for the Apollo-like figure of the Lord. Straddling a cloud just below the Lord is the apostle Bartholomew, holding a human skin to represent his martyrdom by flaying. The face on that skin, however, is not the saint's but Michelangelo's own. In this grimly sardonic self-portrait, so well hidden that it was recognized only in modern times, the artist has left his personal confession of guilt and unworthiness.

The Medici Chapel The interval between the Sistine Ceiling and *The Last Judgment* coincides with the papacies of Leo X (1513–21) and Clement VII (1523–34). Both were members of the Medici family and preferred to employ Michelangelo in Florence. His activities centered on S. Lorenzo, the Medici church, where Leo X decided to build a chapel to house four tombs. Michelangelo took early charge of this project and worked on it for fourteen years, completing the architecture and two of the tombs—those for the lesser Lorenzo and Giuliano. (*Lesser* means "younger." These two Medicis were namesakes of their great forebears). These tombs are nearly mirror images of each other. The New Sacristy was thus conceived as an architectural-sculptural ensemble. It is the only work of the artist where his statues remain in the setting planned specifically for them, although their exact placement is problematic. Michelangelo's plans for the Medici tombs underwent many changes of program and form while the work was under way. Other figures and reliefs were planned but never executed. The present state of the monuments can hardly be the final resolution of the changes, but the dynamic process of design was halted when the artist left permanently for Rome in 1534.

▼ The twelve Biblical PROPHETS include Elijah, Ezekiel, Isaiah, Jeremiah, and Anna, a prophetess. The four males are Old Testament prophets of Israel, whose actions and words are regarded as transmissions of the will of God. In disguised language, they foretold the coming of Jesus Christ. Anna recognized the Infant Jesus as the Lord at the Presentation in the Temple. SIBYLS, also numbering twelve, were the pagan female counterparts to the prophets. They were believed to have prophetic gifts and to have existed since ancient times. By the Middle Ages, Sibyls were credited with predicting the advent of Jesus Christ.

Speaking of

program

The word *program* is used in a specific way in the discipline of art history. It refers to the conceptual scheme of the subject matter and symbolism behind complex, many-scened works of painting or sculpture, such as those of the Sistine Ceiling or the sculpture of many Romanesque and Gothic church facades.

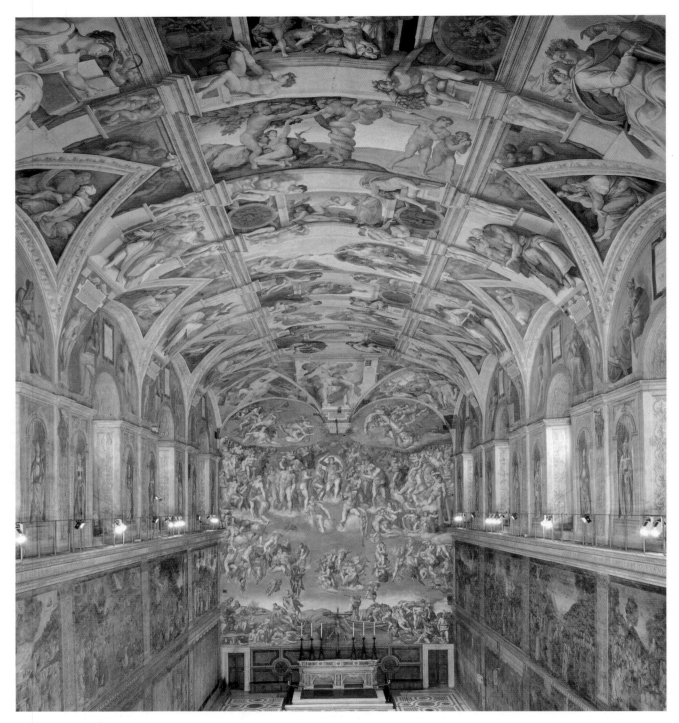

241. Interior, Sistine Chapel, Vatican, Rome. Ceiling frescoes by Michelangelo, 1508–12; scenes on the side walls by Perugino, Ghirlandaio, Botticelli, and others, 1481–82

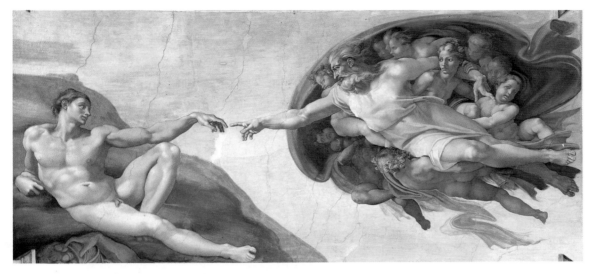

242. Michelangelo. *The Creation of Adam.* Detail of fresco on the ceiling of the Sistine Chapel

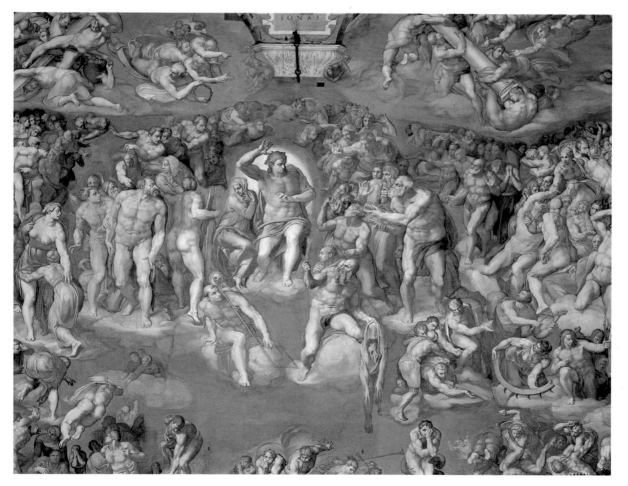

243. Michelangelo. *The Last Judgment.* Detail of fresco, Sistine Chapel. 1534–41

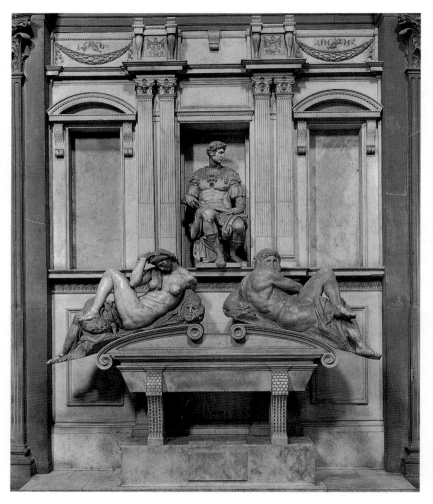

244. Michelangelo. Tomb of Giuliano de' Medici. 1524–34. Marble, height of central figure 5'11" (1.8 m). New Sacristy, S. Lorenzo, Florence

The tomb of Giuliano (fig. 244) remains a compelling visual unit, although the niche is too narrow and too shallow to accommodate his statue comfortably. The great triangle of the statues is held in place by a network of verticals and horizontals whose slender, sharp-edged forms heighten the roundness and weight of the sculpture. The design still shows some kinship with such Early Renaissance tombs as that of Leonardo Bruni (see fig. 216), but the differences weigh more heavily. There is no inscription, and the effigy—the image of the deceased—has been replaced by two allegorical figures—*Day* on the right, *Night* on the left in our illustration. What is the meaning of this triad? The question, put countless times, has never found a satisfactory answer. Some lines penned on one of Michelangelo's drawings suggest a possibility:

> Day and Night speak, and say: We with our swift course have brought the Duke Giuliano to death. . . . It is only just that the Duke takes revenge [for] he has taken the light from us; and with his closed eyes has locked ours shut, which no longer shine on earth.

Giuliano, the ideal image of the prince, is in classical military garb, and bears no resemblance to the deceased Medici. ("A thousand

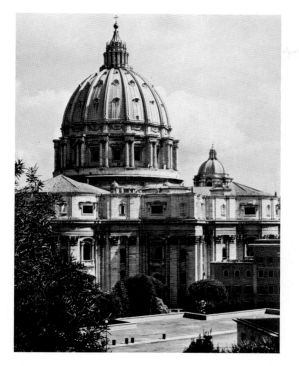

245. Michelangelo. St. Peter's (view from the west), Rome. 1546–64. Dome completed by Giacomo della Porta, 1590

years from now, nobody will know what he looked like," Michelangelo is said to have remarked.) Originally, the base of each tomb was to have included a pair of river gods. The reclining figures, derived from ancient river gods (compare fig. 393, page 459), embody the quality of action-in-repose more dramatically than any other works by Michelangelo. In the brooding menace of *Day*, whose face was left deliberately unfinished, and in the disturbed slumber of *Night*, the dualism of body and soul is expressed with unforgettable grandeur.

St. Peter's The construction of St. Peter's progressed at so slow a pace that in 1514, when Bramante died, only the four crossing piers had actually been built. For the next three decades the campaign was carried on hesitantly by architects trained under Bramante, who modified his design in a number of ways. A new and decisive phase in the history of St. Peter's began only in 1546, when Michelangelo took charge.

The present appearance of the church (fig. 245) is largely shaped by his ideas. Michelangelo simplified Bramante's complex plan without changing its centralized character. He also redesigned the exterior. Unlike Bramante's many-layered elevation (see fig. 239), Michelangelo's uses a colossal order of pilasters to emphasize the compact body of the structure, thereby setting off the dome more dramatically. We have encountered the colossal order before, on the facade of Alberti's S. Andrea (see fig. 221), but it was Michelangelo who welded it into a fully coherent system. The same desire for compactness and organic unity led Michelangelo to simplify the interior, again without changing its basic character. The dome reflects his ideas in every important respect, although it was built largely after his death.

Bramante had planned his dome as a stepped hemisphere above a narrow drum, which would have seemed to press down on the church below. Michelangelo's conveys the opposite sensation, a powerful thrust that draws energy upward from the main body of the structure. The high drum, the strongly projecting buttresses accented by double columns, the ribs, the raised curve of the cupola, the tall lantern—all contribute to the insistent verticality. Michelangelo borrowed both the double-shell construction and the Gothic profile from the Florence Cathedral dome (see fig. 168), but to immensely different effect. The smooth planes of Brunelleschi's dome give no hint of the internal stresses. Michelangelo, in contrast, finds a sculptured shape for these contending forces and relates it to the rest of the building. (The impulse of the paired colossal pilasters below is taken up by the double columns of the drum, continues in the ribs, and culminates in the lantern.) The logic of this design is so persuasive that few domes built between 1600 and 1900 fail to acknowledge it in some way.

Raphael

If Michelangelo exemplifies the solitary genius, Raphael (Raffaello Sanzio, 1483–1520) belongs just as surely to the opposite type: the artist as a

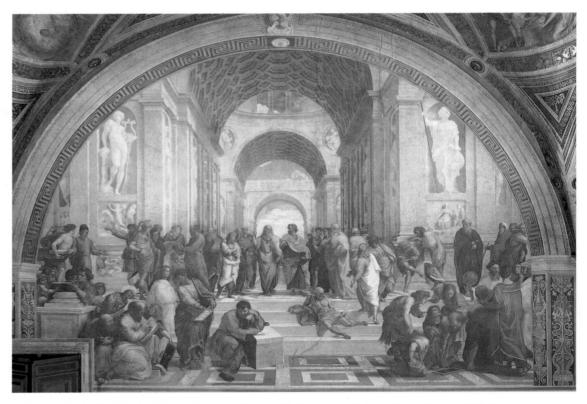

246. Raphael. *The School of Athens*. Fresco in Stanza della Segnatura, Vatican Palace, Rome. 1510–11

person of the world. In consequence, they were natural antagonists. The contrast between the two was as clear to their contemporaries as it is to us. Although each had his defenders, they enjoyed equal fame. Twentieth-century sympathies have been less evenly divided, thanks to Vasari, Michelangelo's chief partisan, as well as the authors of historical novels and fictionalized biographies. Michelangelo still fascinates people today, while Raphael is usually discussed only by historians of art. The younger artist's career seems too much a success story, his work too marked by effortless grace, to match the tragic heroism of Michelangelo. Raphael also appears to have been less of an innovator than Leonardo, Bramante, and Michelangelo, whose achievements were basic to his. Nevertheless, he is the central painter of the High Renaissance. Our conception of the entire style rests more on his work than on any other artist's.

The genius of Raphael was a unique power of synthesis that enabled him to merge the qualities of Leonardo and Michelangelo, creating an art at once lyric and dramatic, pictorially rich and sculpturally solid. The full force of Michelangelo's influence can be felt only in Raphael's Roman works, rather than the early ones from Perugia and Florence. At the time Michelangelo began to paint the Sistine Ceiling, Julius II summoned the younger artist to Rome and commissioned him to decorate a series of rooms in the Vatican Palace. The first room, the Stanza della Segnatura (Room of the Seal), may have housed the pope's library, but it was also where the tribunal of the seal (*segnatura*), presided over by the pope, dispensed canon and civil law. Raphael's cycle of frescoes on its walls and ceiling refers to the four domains of learning: theology, philosophy, law, and the arts. The program, derived from the sainted Franciscan theologian Bonaventure, had no doubt already been provided by a Franciscan at the papal court, but the realization is Raphael's alone.

The School of Athens Of the frescoes in the Vatican Palace, *The School of Athens* (fig. 246) has long been acknowledged as Raphael's greatest work and the perfect embodiment of the classical spirit of the High Renaissance. Its subject is "the Athenian school of thought," a group of famous Greek philosophers gathered around Plato and Aristotle, each in a characteristic pose or activity. Raphael must have already seen the Sistine Ceiling, then nearing completion. He evidently owes to Michelangelo the expressive energy, the physical power, and the dramatic grouping of his figures. Raphael has not simply borrowed Michelangelo's repertory of gestures and poses, however. He has absorbed it into his own style and thereby given it different meaning.

Body and spirit, action and emotion, are now balanced harmoniously, and all members of this great assembly play their roles with magnificent, purposeful clarity. The total conception of *The School of Athens* suggests the spirit of Leonardo's *The Last Supper* (see fig. 235) rather than the Sistine Ceiling. This holds true of the way Raphael makes each philosopher reveal "the intention of his soul," distinguishes the relations among individuals and groups, and links them in formal rhythm. The artist carefully worked out the poses in a series of drawings, many of them no doubt from life. Also Leonardesque is the centralized, symmetrical design, as well as the interdependence of the figures and their architectural setting. With its lofty dome, barrel vault, and colossal statuary, Raphael's classical edifice carries far more of the compositional burden than does the hall of *The Last Supper*. Inspired by Bramante, it seems like an advance view of the new St. Peter's. (Bramante was from the same town and even posed for the figure of ▼PYTHAGORAS, seen holding the book in the foreground to the lower left. Michelangelo is also present, just to the right, as HERAKLEITOS writing on the steps.) The structure's geometric precision and spatial grandeur bring to a climax the tradition begun by Masaccio and transmitted to Raphael by his teacher Perugino, who had inherited it from Piero della Francesca. What is new is the active role played by the architecture in creating narrative space.

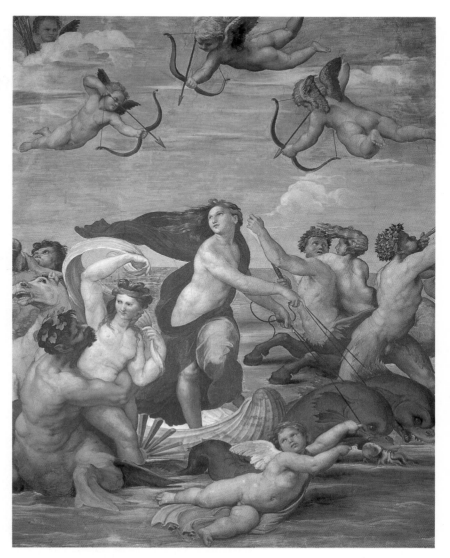

247. Raphael. *Galatea*. Fresco in Villa Farnesina, Rome. 1513

This innovation was of such fundamental importance that it had a profound impact on the course of painting far beyond the sixteenth century.

Galatea Raphael rarely again set so splendid an architectural stage as he did in *The School of Athens*. To create pictorial space, he relied increasingly on the movement of human figures rather than perspective vistas. In the *Galatea* of 1513 (fig. 247), the subject is again classical: the

▼ PYTHAGORAS (c. 580–c. 500 B.C.) was a Greek mathematician who attracted a following in southern Italy devoted to reforming political, moral, and social values. The Greek philosopher HERAKLEITOS (c. 540–c. 480 B.C.) developed a worldview characterized by the notion that all things are in a state of dynamic equilibrium and that the whole is a manifestation of logos, original wisdom.

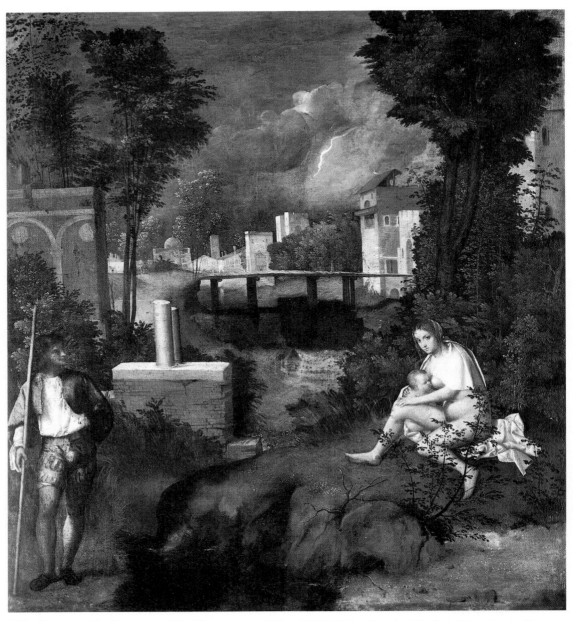

248. Giorgione. *The Tempest*. c. 1505. Oil on canvas, 31¼ x 28¾" (79.4 x 73 cm). Galleria dell'Accademia, Venice

▼ In Greek mythology, the sea nymph GALATEA was vainly pursued by the ugly, one-eyed giant (Cyclopean) shepherd, POLYPHEMOS. The Cyclops crushed Galatea's lover, Acis, by hurling stones, whereupon Galatea turned the blood into a river.

beautiful nymph ▼GALATEA, vainly pursued by the Cyclops POLYPHEMOS, belongs to Greek mythology. Like the verse by Angelo Poliziano that inspired it, the painting celebrates the exuberant and sensuous aspect of antiquity, in contrast to the austere idealism of *The School of Athens*. If the latter presents an ideal concept of the antique past, *Galatea* captures its pagan spirit as if it were still a living force. The composition recalls *The Birth of Venus* (see fig. 228) by Botticelli, a picture Raphael knew from his Florentine days that shares a debt to Poliziano (see page 279). Yet their very resemblance emphasizes their profound dissimilarity. Raphael's

full-bodied, dynamic figures take on their expansive spiral movement from the vigorous contrapposto of Galatea. In Botticelli's picture, the movement is not generated by the figures but imposed on them from without by the decorative, linear design, so that it never detaches itself from the surface of the canvas.

Giorgione

The distinction between Early and High Renaissance art, so marked in Florence and Rome, is far less sharp in Venice. Giorgione (Giorgione da Castelfranco, 1478–1510), the first Venetian painter to belong to the new era, left the orbit of Giovanni Bellini only during the final years of his short career. Among his very few mature works, *The Tempest* (fig. 248) is both the most singular and the most enigmatic. There have been many attempts to explain this peculiar image. Perhaps the most persuasive one proposed thus far is that the painting represents Adam and Eve after the Fall. Their fate as decreed by God, whose awesome voice is represented by the lightning bolt, is that man shall till the ground from which he was taken and that woman shall bring forth children in sorrow. Adam, dressed in contemporary Venetian costume, is seen resting from his labors, while Eve, whose draped nudity signifies shame and carnal knowledge, suckles Cain, her firstborn son. In the distance is a bridge over the river surrounding the city of the earthly Paradise, from which they have been expelled. Barely visible near the rock at river's edge is a snake, signifying the Temptation. The broken columns complete the tragic vision: they stand for death, the ultimate punishment of Original Sin.

As in Bellini's *Saint Francis in Ecstasy* (see fig. 232), however, the symbolism does not tell us the whole story. It is the landscape, rather than Giorgione's figures, that interprets the scene for us. Belonging themselves to nature, Adam and Eve are passive victims of the thunderstorm seemingly about to engulf them. The contrast is nevertheless striking. Bellini's landscape is meant to be seen through the eyes of Francis as a piece of God's creation. If its subject is biblical, the mood in *The Tempest* is never-theless that of an enchanted idyll, a dream of pastoral beauty soon to be swept away. Only poets had hitherto captured this air of nostalgic reverie. Now, it entered the repertory of the painter. Indeed, the painting is very similar in its mood to *Arcadia*, a pastoral poem about unrequited love that was popular in Giorgione's day. Thus, *The Tempest* initiates what was to become an important new tradition.

Titian

Giorgione died before he could explore in full the sensuous, lyrical world he had created in *The Tempest*. This task was taken up by Titian (Tiziano Vecellio, 1488/90–1576), who was decisively influenced by Giorgione and surely worked in his studio. An artist of extraordinary gifts, Titian dominated Venetian painting for the next half century.

Bacchanal Titian's ▼*BACCHANAL* of about 1518 (fig. 249, page 304) is openly pagan, inspired by an ancient author's description of such a revel. The landscape, rich in contrasts of cool and warm tones, has all the poetry of Giorgione's *The Tempest*, but the figures are of another breed. Active and muscular, they move with a joyous freedom that recalls Raphael's *Galatea*. By this time, many of Raphael's compositions had been engraved (see fig. 393), and from these reproductions Titian became familiar with the High Renaissance in Rome, which he was soon to absorb at first hand. A number of the celebrants in his *Bacchanal* also reflect the influence of classical art. Titian's approach to antiquity, however, is very different from Raphael's. He visualizes the realm of classical myths as part of the natural world, inhabited not by animated statues but by beings of flesh and blood. The figures of the *Bacchanal* are idealized just enough beyond everyday reality to persuade us that they belong to a long-lost golden age. They invite us to share their blissful state in a way that makes Raphael's *Galatea* seem cold and remote by comparison.

Portraits Titian's prodigious gifts made him the most sought-after portraitist of the age. The dreamy intimacy of *Man with a Glove* (fig. 250,

▼ A BACCHANAL is a feast and celebration in honor of the Greek god of wine, Bacchus (see page 304).

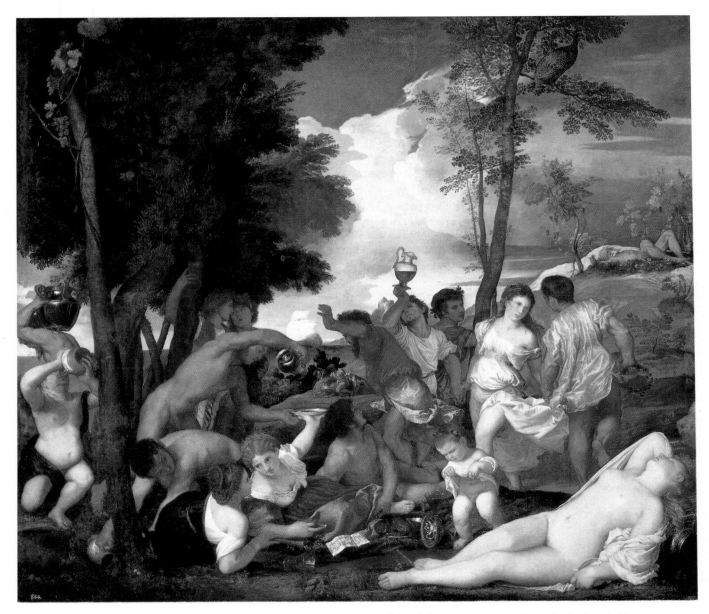

249. Titian. *Bacchanal*. c. 1518. Oil on canvas, 5'8 7/8" x 6'4" (1.75 x 1.93 m). Museo del Prado, Madrid

page 305), with its soft outline and deep shadows, still reflects the style of Giorgione. Lost in thought, the young man seems quite unaware of us. The slight melancholy in his features conjures up the poetic appeal of *The Tempest*. The breadth and power of form, however, go far beyond Giorgione. In Titian's hands, the possibilities of the oil technique now are fully realized: rich, creamy highlights and deep dark tones that are transparent and delicately modulated. The separate brushstrokes, hardly visible before, become increasingly free, so that the personal rhythms of the artist's "handwriting" are an essential element of the finished work. In this respect, Titian seems infinitely more modern than Leonardo, Michelangelo, or Raphael.

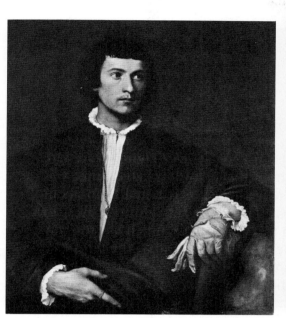

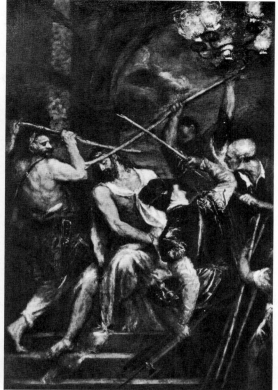

250. Titian. *Man with a Glove*. c. 1520. Oil on canvas, 39¹/₂ x 35" (100.3 x 88.9 cm). Musée du Louvre, Paris

251. Titian. *Christ Crowned with Thorns*. c. 1570. Oil on canvas, 9'2" x 6' (2.79 x 1.83 m). Alte Pinakothek, Munich

Late Works A change of pictorial technique is no mere surface phenomenon. It always reflects a change of the artist's aim. This correspondence of form and technique is especially clear in *Christ Crowned with Thorns* (fig. 251), a great work of Titian's old age. The shapes emerging from the semidarkness now consist wholly of light and color. Despite the heavy impasto, the shimmering surfaces have lost every trace of material solidity and seem translucent, as if aglow from within. In consequence, the violent physical action has been miraculously suspended. What lingers in our minds is not the drama but the strange mood of serenity engendered by deep religious feeling. The painting participates in a visionary tendency that was widely shared by other late-sixteenth-century Venetian artists. We shall meet it again in the work of Tintoretto and El Greco.

Chapter 15

Mannerism and Other Trends

What happened after the High Renaissance? Eighty years ago, the answer would have been that the High Renaissance was followed by the Late Renaissance, which lasted from about 1520 until the Baroque style emerged at the end of the century. This span was regarded as an interval between two high points, much like the way Renaissance intellectuals viewed the Middle Ages. Today, the term *Late Renaissance* has generally been discarded as misleading, but art historians have yet to agree on a name for the eighty years separating the High Renaissance from the Baroque. We have run into this difficulty before, in dealing with the problem of Late Classical versus Hellenistic art. The dilemma is that any label implies that the period has only a single style, but this period was a time of crisis that gave rise to several competing tendencies rather than one dominant ideal. And because it was full of inner contradictions, not unlike the present, it remains peculiarly fascinating to us.

Discoveries and Reform

Although they had taken place during the High Renaissance, the great voyages of discovery—Columbus's landing in the New World in 1492, followed by Amerigo Vespucci's exploration of South America seven years later and Magellan's voyage to circumnavigate the globe beginning in 1519—had far-reaching consequences that were to reverberate until the end of the sixteenth century. The most immediate consequence was the rise of the great European colonial powers, which vied with each other for commercial supremacy around the world. An unexpected effect was the explosion of knowledge as explorers brought back a host of natural and artistic wonders never before seen in Europe.

At almost the same time, the Protestant Reformation was launched by Martin Luther, a former Augustinian friar who had become professor of theology at the University of Wittenberg. At face value, the Ninety-five Theses he nailed to the Wittenberg Castle church door on All Saints' Eve (Halloween) in October 1517 were little more than a broadside protesting the sale of indulgences promising redemption of sins, but more fundamentally they constituted a wholesale attack against Catholic dogma, for he claimed that the Bible and natural reason were the sole bases of religious authority. Freed from traditional doctrine, the Protestant (protest) movement rapidly developed splinter groups. Within a few years, a Swiss pastor, Huldrych Zwingli, sought to reduce religion to its essentials by preaching an even more radical fundamentalism, renouncing the arts as distractions and denying the validity of even the Eucharist as a rite. This led to a split with Luther that was never healed. Even within Zwingli's camp there were rifts: the Anabaptists accepted only adult baptism. What divided the reformers were the twin issues of grace and free will in attaining faith and salvation. These had been spelled out with the aid of the humanists, who initially counted Luther and Zwingli among their number, although many of them eventually turned against the Reformation because of its extremism. By the time of Zwingli's death at the hands of the Catholic forces, the essential body of Protestant theology had been defined. It was codified around midcentury by John Calvin of Geneva, who tried to mediate between Luther and Zwingli while adopting the puritanical beliefs of the Anabaptists.

The Catholic Church soon inaugurated a reform movement of its own, generally known today as the Counter-Reformation. It was spearheaded following the Council of Trent in 1545–47 by the Society of Jesus, the Jesuit order representing the militant Church, which had been founded in 1534 by Ignatius of Loyola, a Spaniard. The internal reforms were carried out mainly by Pope Paul IV after he ascended the throne of Saint Peter in 1555 and by Carlo Borromeo, who initiated the model reform as bishop of Milan five years later. The Reformation and Counter-Reformation quickly became bound up in the political upheavals and social unrest sweeping Europe. Rulers allied themselves with one movement or the other, depending on dynastic and economic self-interest. Thus, Henry VIII of England established the Church of England in 1531 in order to make divorce easier so that he could produce a male heir. At about the same time, Charles I, king of Spain, made the Catholic cause part of the Hapsburg dynastic ambitions; with his new title of Holy Roman Emperor Charles V, he cloaked his motives in the mantle of a crusade for the True Faith.

Painting

Mannerism in Florence and Rome

Among the various trends in art in the wake of the High Renaissance, Mannerism is the most significant, as well as the most problematic. In scope, the original meaning of the term was narrow and derogatory, designating a group of mid-sixteenth-century painters in Rome and Florence whose self-consciously "artificial" style (*maniera*) was derived from certain aspects of the work of Raphael and Michelangelo. The style of these midcentury artists, sometimes called High Mannerism, has since been recognized as part of a wider movement that had begun earlier, around 1520.

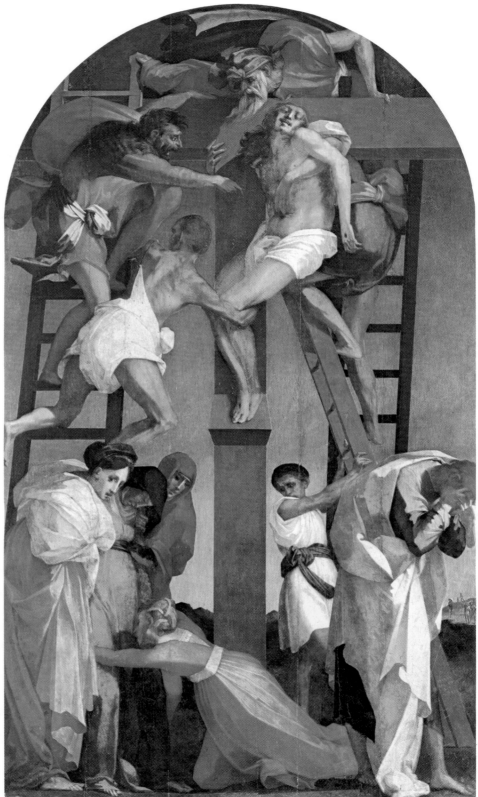

252. Rosso Fiorentino.
The Descent from the Cross.
1521. Oil on panel,
11' x 6'5½" (3.35 x 1.97 m).
Pinacoteca Communale,
Volterra, Italy

Keyed to a sophisticated, even rarefied taste, early Mannerism had appealed to a small circle around aristocratic patrons like Cosimo I, the grand duke of Tuscany. The style soon became international as a number of events—such as the plague of 1522 and, above all, the ▼SACK OF ROME in 1527—disrupted its development and displaced it abroad, where most of its next phase took place. This new phase, High Mannerism, was the assertion of a purely aesthetic ideal. Through formulaic abstraction, it translated expression into a style of the utmost refinement emphasizing grace, variety, and virtuoso display at the expense of content, clarity, and unity. This taste for mannered elegance and bizarre conceits appealed to a small but sophisticated audience, but in a larger sense Mannerism signified a major shift in Italian culture. In part, it resulted from the High Renaissance quest for originality as a projection of the individual's personality, which had given artists license to explore their imaginations freely. This investigation of new modes was ultimately healthy, but the Mannerist style itself came to be regarded by many as decadent, and no wonder: given such subjective freedom, it produced extreme personalities that today seem the most "modern" of all sixteenth-century painters.

The seemingly cold and barren formalism of High Mannerist work has been recognized as part of a wider movement that placed inner vision, however private or fantastic, above the twin standards of nature and the ancients. Hence, some scholars have broadened the definition of *Mannerism* to include the later style of Michelangelo, who could himself acknowledge no artistic authority higher than his own genius. Mannerism is often considered a reaction against the normative ideal created by the High Renaissance as well. Save for a brief initial phase, however, Mannerism did not consciously reject the tradition from which it stemmed. Although the subjectivity inherent in this aesthetic was necessarily unclassical, it was not deliberately anticlassical, except in its more extreme manifestations. Even more conspicuous than Mannerism's anticlassicism is its insistent antinaturalism. The relation of Mannerism to religious trends was equally paradox-

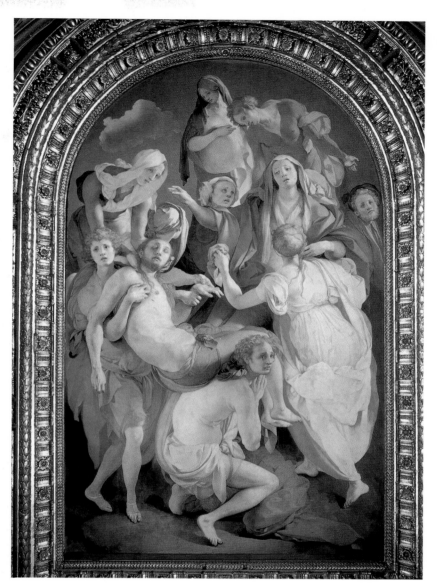

253. Jacopo da Pontormo. *Deposition*. c. 1526–28. Oil on panel, 10'3" x 6'4" (3.12 x 1.93 m). Sta. Felicità, Florence

ical. Notwithstanding the intense religious feeling that informs many works by the first generation, it has rightly been observed that Mannerism as a whole illustrates the spiritual bankruptcy of the age. In particular, the extreme worldliness of the next generation, the High Mannerists, was fundamentally antithetical to both the Reformation, with its stern morality, and the Counter-Reformation, which demanded a strict adherence to doctrine. However, after midcentury there was a Counter-

▼ Rome and the papacy were caught up in the imperial rivalries among Francis I of France, Henry VIII of England, and Holy Roman Emperor Charles V. In 1526, Henry and Charles both laid claim to Italy. In the following year, Francis, Henry, and Pope Clement VII invaded Italy. Charles's forces prevailed, however, and the pope was taken captive. The six-month siege, marked by burning and looting, is referred to as the SACK OF ROME.

Mannerist trend, which adapted the vocabulary of Mannerism for Counter-Reformation ends. At the same time, the subjective latitude of Mannerism became valued for its visionary power as part of a larger shift in religious sensibility.

Rosso Fiorentino The first indications of disquiet in the High Renaissance appear shortly before 1520 in Florence. Art had been left in the hands of a younger generation that could refine but not further develop the styles of the great innovators who had spent their early careers there before leaving the city. Having absorbed the lessons of the leading artists, the first generation of Mannerists was free to apply High Renaissance formulas to a new aesthetic divorced from its previous content. By 1521, Rosso Fiorentino (1495–1540), the most eccentric member of this group, expressed the new attitude with full conviction in *The Descent from the Cross* (fig. 252). Nothing has prepared us for the shocking impact of this latticework of spidery forms spread out against the dark sky. The figures are agitated yet rigid, as if congealed by a sudden, icy blast. Even the draperies have brittle, sharp-edged planes. The acid colors and the light—brilliant but unreal—reinforce the nightmarish effect of the scene. Here is clearly a full-scale revolt against the classical balance of High Renaissance art: a profoundly disquieting, willful, visionary style that suggests a deep inner anxiety.

Jacopo da Pontormo Jacopo da Pontormo (1494–1556/7), a friend of Rosso, had a similarly eccentric personality. Introspective, willful, and shy, he worked only when and for whom he pleased, and he would shut himself up in his quarters for weeks on end, remaining inaccessible even to his closest friends. Pontormo's *Deposition* (fig. 253) seems to reflect these facets of his character. The painting contrasts sharply with Rosso's *Descent from the Cross* but is no less disturbing. Unlike Rosso's attenuated forms, Pontormo's have a nearly classical beauty and sculptural solidity inspired by Michelangelo, who admired his art, yet the figures are confined to a stage so claustrophobic as to cause acute discomfort in the viewer. The very implausibility of

the image renders it convincing in spiritual terms. Indeed, this visionary quality is essential to its meaning, which is communicated by purely formal means. We have entered a world of innermost contemplation in which every pictorial element responds to a purely subjective impulse. Everything is subordinate to the play of graceful linear rhythms created by the tightly interlocking forms. These patterns unify the surface and impart a poignancy unlike any we have seen. Although they act in concert, the mourners are lost in a grief too personal to share with each other—or us. In this hushed atmosphere, anguish is transmuted into a lyrical expression of exquisite sensitivity. The entire scene is as haunted as Pontormo's self-portrait just to the right of the swooning Madonna. The artist, moodily gazing into space, seems to shrink from the outer world, as if scarred by the trauma of some half-remembered experience, and into one of his own invention.

Parmigianino The first phase of Mannerism, exemplified by Rosso and Pontormo, was soon replaced by one less overtly anticlassical, less laden with subjective emotion, but equally far removed from the confident, stable world of the High Renaissance. *The Madonna with the Long Neck* (fig. 254, page 312) was painted by Parmigianino (Girolamo Francesco Maria Mazzuoli, 1503–40) after he had returned to his native Parma from several years in Rome. He had been deeply impressed with the rhythmic grace of Raphael's art, but he has transformed the older artist's figures into a remarkable new breed. Their limbs, elongated and ivory-smooth, move with effortless languor, embodying an ideal of beauty as remote from nature as any Byzantine figure. The pose of the baby Jesus balanced precariously on the Madonna's lap echoes that of a Pietà. Although it has antecedents in Byzantine icons, this unusual device, essentially of Parmigianino's own invention, helps to explain the setting, which is not as arbitrary as it may seem. The gigantic column alludes to the Flagellation of the Lord during the Passion, reminding us of his sacrifice, which the tiny figure of a prophet foretells from his scroll. But it also serves to disrupt our perception of space, which is strangely

Music, Theater, and Poetry in the Age of Mannerism

The music and theater of Italy between 1530 and 1600 reflect the same rich variety found in art. The most characteristic musical form after about 1530 was the MADRIGAL, which was an outgrowth of French and Italian popular songs. It was similar to the motet in that all the voices were equally important, but it was livelier and more expressive. The madrigal was also closely connected to the resurgence of Italian poetry in the work of Ludovico Ariosto (see page 291) and Torquato Tasso (1544–95), Ariosto's successor as court poet to the ruling d'Este family of Ferrara. Although at first the best composers of madrigals were Flemish, after 1575 Italians dominated the form. Foremost among them was Carlo Gesualdo (c.1560–1613), an aristocrat whose music was as bold and flamboyant as his personality. His madrigals are full of complex verbal and musical conceits that make them counterparts to the paintings of the High Mannerists.

The church dignitaries at the Council of Trent (1545–63), which spearheaded the Counter-Reformation in the Catholic Church, objected to the growing use of secular melodies in sacred music, as well as to elaborate polyphony that obscured the words of the liturgy. In response, Giovanni Palestrina (c. 1525–94) based his masses on traditional Gregorian chants. In many respects, however, his works are the successors of Josquin's in their seamless texture and the perfect balance of melodic and harmonic values—that is, the beauty both of the principal melody and the other notes that accompany it, known as harmony. Palestrina held all the important musical posts in Rome during his lifetime, and his style became "classic": it was held up as a model for imitation into the twentieth century.

Venice, unlike Rome, was ruled by secular authorities, and Venetian music differed greatly from that composed for the pope. The vast spaces of St. Mark's church—which was the palace chapel of the doges—encouraged the colorful music of Palestrina's contemporary, Andrea Gabrieli (1510–86) and his nephew and pupil Giovanni Gabrieli (1557–86). The compositions of the Gabrielis emphasized sensuous effects of sound over COUNTERPOINT (different melodic lines moving independently, or "counter" to each other). Giovanni was also the first composer to specify which instruments should play which parts, to include dynamic markings in his music as indications of loudness and softness, and to make use of harmonies that sound "modern" to our ears. Much of Giovanni's music was purely INSTRUMENTAL. Instrument-only music in the late sixteenth century began to achieve its independence from vocal music by adapting popular dance tunes, often treated as a theme with variations. Such dances had been performed for centuries, although they were rarely written down. This development coincided with the creation of new families of instruments, such as viols and recorders, whose ranges—soprano, contralto, tenor, and bass—approximated those of human voices. These instruments lent late Renaissance music a wonderfully diverse and distinctive sound.

The principal theatrical performances in sixteenth-century Italy were public spectacles paid for by the aristocracy. Two Florentine examples were the *Masque of the Genealogy of the Gods* (Florence,1566), with sets and costumes designed by Giorgio Vasari, and *The Battle of the Argonauts*, mounted in 1608 on the Arno River. Both glorified the Medici family in allegorical terms. These displays spurred the development of more elaborate and sophisticated scenery design at the Medici court, as well as in a number of other Italian cities. SCENOGRAPHY initially relied on the accounts of Roman theater in the architectural treatise of Vitruvius published in 1486, the same year that the humanist antiquarian Pomponius Laetus (1424–98) began to produce ancient plays at the Roman Academy. Even more important was the influence of Leon Battista Alberti's linear perspective (see pages 271–72). Sebastiano Serlio (1474–1554) published an architectural treatise in 1545, which included a number of stage designs that made use of Alberti's perspective system to visualize Vitruvius's descriptions of Roman theaters. Serlio's designs proved so influential throughout Europe that they were often used to illustrate later editions of Vitruvius.

The occasional nature of dramatic presentations meant that few permanent theaters were built during the sixteenth century. The first court theater was erected by the Medici in Florence. More important was the first public theater, built in 1565 in Venice, which immediately established its leadership in theater writing and production. Twenty years later the architect Andrea Palladio (see page 321) designed a theater for the Olympic Academy in Vicenza, which opened with a performance of Sophocles' *Oedipus Rex*. Although the theater was soon abandoned, its construction is a measure of sixteenth-century interest in serious classical theater.

Before 1550, Renaissance theories of drama centered on Horace's *Art of Poetry* and Aristotle's *Poetics*, which had been published in a Latin translation in 1498. Drawing on these sources, a new body of theory evolved that promoted the concept of "verisimilitude," incorporating realism, morality, and universality. These ideas in turn led to an insistence on DECORUM, that is, strict adherence to whatsoever was considered appropriate to the age, sex, temperament, and social status of each character. Drama was further divided into tragedy and comedy along class lines. Tragedy involved the actions of noble, that is, aristocratic, characters; comedy was devoted to the buffooneries of the lower classes. Following classical example, tragedy and comedy alike were presented in five acts and had to obey the "unities" of time, space, and action: the events portrayed had to take place in roughly the same time as it took to present them (or at least within one day); in a space approximately the size of the actual stage; and with the story line revolving around a single incident or problem. However, the few plays written according to these rules met with a mixed reception in sixteenth-century Italy. Among the most popular forms of theater were pastoral plays, such as Torquato Tasso's *Aminta* (1573). Pastoral plays shared a common story line, in which a sophisticated young man or woman—in *Aminta* this was actually the god Cupid—is forced by circumstance to spend some time among simple rural folk. The healthy manner of living and innocent goodness of the country people teach an important moral lesson and send the protagonist back to normal life refreshed in spirit. Also popular were comic interludes (*intermezzi*) between the acts of dramas, which featured such sensational scenery, costumes, music, dance, and special effects that they eventually became more important than the plays themselves.

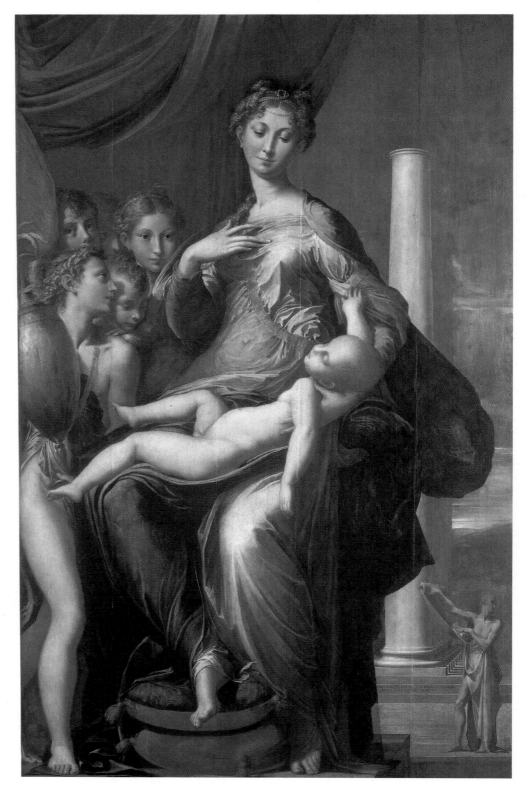

254. Parmigianino. *The Madonna with the Long Neck*. c. 1535. Oil on panel, 7'1" x 4'4" (2.16 x 1.32 m). Galleria degli Uffizi, Florence

disjointed. Parmigianino seems determined to prevent us from measuring anything in this picture by the standards of ordinary experience. Here we have approached that artificial style for which the term *Mannerism* was originally coined. *The Madonna with the Long Neck* is a vision of unearthly perfection, its cold elegance no less compelling than the violence in Rosso's *Descent*.

Agnolo Bronzino The second generation of Mannerists, with whom High Mannerism is identified, congealed the style they inherited from Rosso, Pontormo, and Parmigianino into a cool perfection that filtered out the last vestige of their intensely personal sensibility. As a consequence, they produced few masterpieces. The style nevertheless produced splendid portraits, like that of Eleanora of Toledo (fig. 255), the wife of Cosimo I de' Medici, by his court painter Agnolo Bronzino (1503–72). The sitter here appears as the member of an exalted social caste, not as an individual personality. Congealed into immobility behind the barrier of her lavishly ornate costume, Eleanora seems more akin to Parmigianino's *Madonna* (compare the hands) than to ordinary flesh and blood.

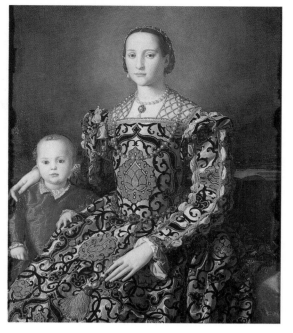

255. Agnolo Bronzino. *Eleanora of Toledo and Her Son Giovanni de' Medici.* c. 1550. Oil on panel, 45¼ x 37¾" (114.9 x 95.9 cm). Galleria degli Uffizi, Florence

Mannerism in Venice

Jacopo Tintoretto Mannerism did not appear in Venice until the middle of the sixteenth century. There it became allied with the visionary tendencies already manifest in Titian's late work (see fig. 251). Its leading exponent, Jacopo

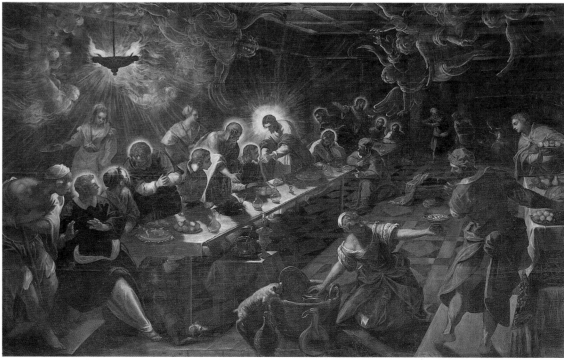

256. Jacopo Tintoretto. *The Last Supper.* 1592–94. Oil on canvas, 12' x 18'8" (3.66 x 5.69 m). S. Giorgio Maggiore, Venice

Tintoretto (1518–94) was an artist of prodigious energy and inventiveness who combined qualities of both its anticlassical and elegant phases in his work. He reportedly wanted "to paint like Titian and to design like Michelangelo," but his relationship to these two artists, though real enough, was as peculiar as Parmigianino's was to Raphael. Tintoretto's final major work, *The Last Supper* (fig. 256), is one of his most spectacular. At first, this canvas seems to deny in every possible way the classic values of Leonardo's version (see fig. 235), painted almost exactly a century earlier. Jesus, to be sure, still occupies the center of the composition, but his small figure in the middle distance is distinguishable mainly by the brilliant halo, while the table is placed at a sharp angle to the picture plane in exaggerated perspective. In fact, this arrangement is designed to relate the scene to the **chancel**, or choir, of the church—the space set off from the nave for the clergy and the choir— for which it was commissioned, intended to be seen by the faithful as they kneel at the altar rail to receive communion. Tintoretto has gone to great lengths to give the event an everyday setting, cluttering the scene with attendants, containers of food and drink, and domestic animals. There are also celestial attendants, who converge upon Jesus just as he offers his body and blood, in the form of bread and wine, to the disciples. The smoke from the blazing oil lamp miraculously turns into clouds of angels, blurring the distinction between the natural and the supernatural and turning the scene into a magnificently orchestrated vision. Tintoretto barely hints at the human drama of Judas's betrayal, so important to Leonardo: Judas can be seen isolated on the near side of the table, but his role is so insignificant that he could almost be mistaken for an attendant. The artist's main concern has been to make visible the miracle of the Eucharist—the transubstantiation of earthly food into the body and blood of Christ— central to Catholic doctrine, which was reasserted during the Counter-Reformation.

El Greco The last, and today most famous, Mannerist painter was also a member of the Venetian school for a while. Domenikos Theotocopoulos (1541–1614), nicknamed El Greco, came from Crete, which was then under Venetian rule. His earliest training must have been from a Cretan artist still working in the Byzantine tradition. Soon after 1560, El Greco arrived in Venice and quickly absorbed the lessons of Titian, Tintoretto, and other artists. A decade later, in Rome, he came to know the art of Raphael, Michelangelo, and the central Italian Mannerists. In 1576–77, he went to Spain, settling in Toledo for the rest of his life. There he became established in the leading intellectual circles of the city, then a major center of learning as well as the seat of Catholic reform in Spain. Although Counter-Reformation theology provides the content of his work, it does not account for the exalted emotionalism that informs his painting. The spiritual tenor of El Greco's mature work was primarily a response to mysticism, which was especially intense in Spain. Contemporary Spanish painting, however, was too provincial to affect him. His style had already been formed before he arrived in Toledo. Nor did he forget his Byzantine background. (Until the very end of his career, he signed his pictures in Greek.)

The largest, most resplendent of El Greco's major works, and the only one for a public chapel, is *The Burial of Count Orgaz* (fig. 257) in the Church of S. Tomé. The program, which was given at the time of the commission, emphasizes the traditional role of good works in salvation and of the saints as intercessors with heaven. This huge canvas honors a medieval benefactor so pious that ▼SAINT STEPHEN and Saint Augustine miraculously appeared at his funeral and themselves lowered the body into its grave. The burial took place in 1323, but El Greco presents it as a contemporary event, portraying among the attendants many of the local nobility and clergy. The dazzling display of color and texture in the armor and vestments could hardly have been surpassed by Titian himself. Directly above, the count's soul (a small, cloudlike figure akin to the angels in Tintoretto's *The Last Supper*) is carried to heaven by an angel. The celestial assembly filling the upper half of the picture is painted very differently from the lower half:

▼ SAINT STEPHEN is called the Protomartyr because, according to the New Testament, he was the first Christian martyr. Acts 6:8–15 recounts how he was accused of blasphemy for trying to win converts to the new religion. Stephen was condemned to death by stoning before he could finish his own defense speech.

257. El Greco. *The Burial of Count Orgaz.* 1586. Oil on canvas, 16' x 11'10" (4.88 x 3.61 m). Chapel in S. Tomé, Toledo, Spain

every form—clouds, limbs, draperies—takes part in the sweeping, flamelike movement toward the distant figure of Christ. Here, even more than in Tintoretto's art, the entire range of Mannerism fuses into a single ecstatic vision.

Because of its location within the original setting, the viewer must look sharply upward to see the upper half of the picture. El Greco's vio-

lent foreshortening is calculated to achieve an illusion of boundless space above, while the lower foreground figures appear as on a stage. (Their feet are cut off by the molding just below the picture.) A large stone plaque set into the wall also belongs to the ensemble, representing the front of the sarcophagus into which the two saints lower the body of the count; it thus

explains the action within the picture. The beholder, then, perceives three levels of reality: the grave itself, supposedly set into the wall at eye-level and closed by an actual stone slab; the contemporary reenactment of the miraculous burial; and the vision of celestial glory witnessed by some of the participants. El Greco's task here was analogous to Masaccio's in his *Trinity* mural (see fig. 223). But whereas the Renaissance painter creates the illusion of reality through his command of rational pictorial space that appears continuous with ours, El Greco summons an apparition that remains essentially separate from its architectural surroundings.

El Greco has created a spiritual counterpart to his imagination in contrast to Counter-Reformation images of saints, which were given a convincing physical presence to convey their doctrinal message as clearly as possible. Every passage is alive with his peculiar religiosity, which is felt as a nervous exaltation occurring as the dreamlike vision is conjured up. This kind of mysticism is very similar in character to the Spiritual Exercises of Ignatius of Loyola (see page 356). Ignatius sought to make visions so real that they would seem to appear before the very eyes of the faithful—mysticism that could be achieved only through strenuous devotion. Such effort is mirrored in the intensity of El Greco's work, which fully retains a feeling of spiritual struggle.

Realism

Although Mannerism affected the art of Venice and other cities, it failed to establish dominance outside Florence and Rome. Elsewhere, it competed with other tendencies. In towns along the northern edge of the Lombard plain, such as Brescia and Verona, we find a number of artists who worked in a style based on those of Giorgione and Titian, but with a stronger interest in everyday reality.

Girolamo Savoldo One of the earliest and most attractive of the north Italian realists was Girolamo Savoldo (c. 1480–1550) from Brescia. His greatest work, *Saint Matthew and the Angel* (fig. 258), must be contemporary with Parmi-

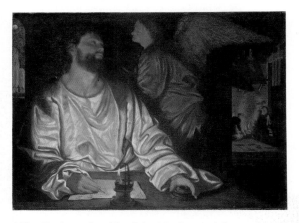

258. Girolamo Savoldo. *Saint Matthew and the Angel*. c. 1535. Oil on canvas, 36³⁄4 x 49" (93.3 x 124.5 cm). The Metropolitan Museum of Art, New York
Marquand Fund, 1912

gianino's *The Madonna with the Long Neck* (see fig. 254). The broad, fluid manner of painting reflects the dominant influence of Titian, but that great Venetian artist would never have placed the Evangelist in so thoroughly domestic an environment. The humble scene in the background shows the saint's milieu to be lowly indeed and makes the presence of the angel doubly miraculous. This tendency to visualize sacred events among ramshackle buildings and simple people had been characteristic of "Late Gothic" painting, and Savoldo must have acquired it from that source. The nocturnal lighting, too, recalls such Northern pictures as the *Nativity* by Geertgen tot Sint Jans (see fig. 202). But the main source of illumination in Geertgen's panel is the divine radiance of the Child, whereas Savoldo uses an ordinary oil lamp for his similarly magical and intimate effect.

Paolo Veronese In the work of Paolo Veronese (1528–88), north Italian realism attains the splendor of pageantry. Born and trained in Verona, Veronese became, after Tintoretto, the most important painter in Venice. Both found favor with the public, though they were utterly unlike each other in style. The contrast is strikingly evident if we compare Tintoretto's *The Last Supper* (see fig. 256) and Veronese's *Christ in the House of Levi* (fig. 259), which have similar subjects. Veronese avoids all reference to

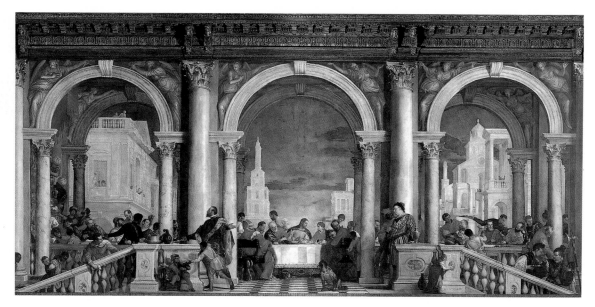

259. Paolo Veronese. *Christ in the House of Levi.*
1573. Oil on canvas, 18'2" x 42' (5.54 x 12.8 m).
Galleria dell'Accademia, Venice

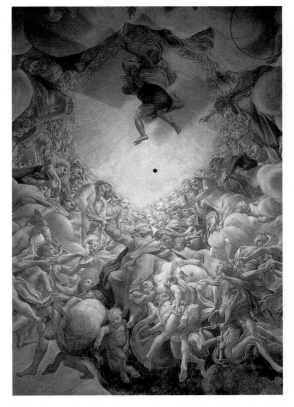

260. Correggio. *The Assumption of the Virgin.* Portion of
fresco in the dome, Parma Cathedral, Italy. c. 1525

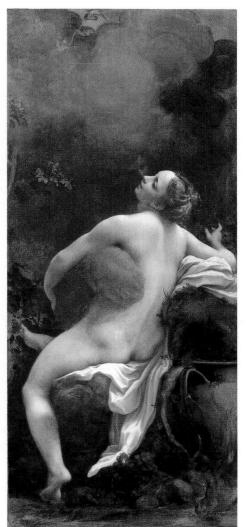

261. Correggio. *Jupiter and Io.*
c. 1532. Oil on canvas,
64 1/2 x 27 3/4" (163.8 x 70.5 cm).
Kunsthistorisches Museum,
Vienna

the supernatural. His symmetrical composition harks back to paintings of Leonardo and Raphael, while the festive mood of the sumptuous banquet reflects examples by Titian, so that at first glance the picture looks like a High Renaissance work born fifty years too late. Missing is the elevated, ideal conception of humanity underlying the High Renaissance. Veronese's ideal of humanity was one of cultivated urbanity, so that he paints a sumptuous banquet, a true feast for the eyes, but not "the intention of man's soul."

Significantly, we are not even sure which event from the life of Jesus he originally meant to depict, for he gave the canvas its present title only after he had been summoned by the religious tribunal of the ▼INQUISITION on the charge of filling his picture with "buffoons, drunkards, Germans, dwarfs, . . . and similar vulgarities" unsuited to its sacred character. The tribunal thought the painting represented the Last Supper, but Veronese's testimony never made clear whether it was the Last Supper or the Supper in the House of Simon. To him, apparently, this distinction made little difference. In the end, he settled on a convenient third title, *Christ in the House of Levi*, which permitted him to leave the offending incidents in place. He argued that they were no more objectionable than the nudity of Christ and the Heavenly Host in Michelangelo's *Last Judgment*, but the tribunal failed to see the analogy on the grounds that "in the *Last Judgment* it was not necessary to paint garments, and there is nothing in those figures that is not spiritual."

The Inquisition considered only the impropriety of Veronese's art, not its lack of concern with spiritual depth. His dogged refusal to admit the justice of the charge, his insistence on his right to introduce directly observed details, however "improper," and his indifference to the subject of the picture spring from an attitude so startlingly extroverted that it was not generally accepted until the nineteenth century. The painter's domain, Veronese seems to say, is the entire visible world, and here he acknowledges no authority other than his senses.

▼ The INQUISITION began as a papal judicial process in the twelfth century, was codified in 1231 with the institution of excommunication, and was formalized in 1542 by Pope Paul III as the Holy Office. In Spain in 1478, it independently became an instrument of the state that was not abolished until 1834. In all its forms, its purpose was to rid the Catholic Church of heresy. At its fairest, the process was just and merciful; at its worst, the Inquisition was pure political terrorism.

▼ JUPITER is a Roman counterpart to the Greek god Zeus, who fell in love with IO. To disguise Io so that his wife, Hera (Juno in Roman mythology), would not be jealous, Zeus turned Io into a white heifer. Jove suspected Io's real identity and demanded the heifer as a gift from Jupiter. Correggio's painting shows the moment before Io was transformed—when Jupiter made himself into a cloud for an amorous visit.

Proto-Baroque

A third trend that emerges about 1520 in northern Italy has been labeled Proto-Baroque, as much because it eludes convenient categories as because it embodies so many features that would later characterize the Baroque style. This tendency centers largely on Correggio, although later in the century it has a counterpart in architecture (see pages 322–23).

Correggio Correggio (Antonio Allegri da Correggio, 1489/94–1534), a phenomenally gifted painter, spent most of his brief career in Parma, located along the Lombard plain. There he absorbed a wide range of influences—of Leonardo and the Venetians as a youth, then of Michelangelo and Raphael—but their ideal of classical balance did not attract him. Correggio's work partakes of north Italian realism but applies it with the imaginative freedom of the Mannerists, though we do not find any hint of his fellow resident Parmigianino in his style. His largest commission, the fresco of *The Assumption of the Virgin* in the dome of Parma Cathedral (fig. 260), is a magnificent display of illusionistic perspective, a vast, luminous space filled with soaring figures. They move with such exhilarating ease that the force of gravity seems not to exist for them. They are healthy, energetic beings of flesh and blood, not the disembodied spirits of El Greco, and they frankly delight in their weightless condition.

There was little difference between spiritual and physical ecstasy for Correggio, who thereby established an important precedent for Baroque artists such as Gianlorenzo Bernini. We can see this by comparing *The Assumption of the Virgin* with his *Jupiter and Io* (fig. 261), one in a series of canvases illustrating the loves of the classical gods. The nymph ▼IO, swooning in the embrace of a cloudlike JUPITER, is the direct kin of the jubilant angels in the fresco. Leonardesque sfumato, combined with a Venetian sense of color and texture, produces an effect of exquisite voluptuousness that exceeds even Titian's in his *Bacchanal* (see fig. 249). Correggio had no immediate successors or any lasting influence on the art of his century, but

toward 1600 his work began to be widely appreciated. For the next century and a half, he was admired as the equal of Raphael and Michelangelo, while the Mannerists, so important before, were largely forgotten.

Sculpture

Italian sculptors of the later sixteenth century failed to match the achievements of the painters. Perhaps Michelangelo's overpowering personality discouraged new talent in this field, but the dearth of challenging new tasks is a more plausible reason. The "anticlassical" phase of Mannerism, represented by the style of Rosso, has no sculptural counterpart, but the second, elegant phase of Mannerism appears in countless sculptural examples in Italy and abroad.

Benvenuto Cellini The best-known representative of this elegant style in Mannerist sculpture is Benvenuto Cellini (1500–71), the Florentine goldsmith and sculptor who owes much of his fame to his picaresque ▼AUTOBIOGRAPHY. The gold saltcellar for Francis I, king of France (fig. 262), Cellini's only major work in precious metal to escape destruction, displays the virtues and limitations of his art. To hold condiments is obviously the lesser function of this lavish conversation piece. Because salt comes from the sea and pepper from the land, Cellini placed the boat-shaped salt container under the guardianship of Neptune, god of the sea, while the pepper, in a tiny triumphal arch, is watched over by a personification of Earth. On the base are figures representing the four seasons and the four parts of the day.

The entire object thus reflects the cosmic significance of the Medici tombs (compare fig. 244), but on this miniature scale Cellini's program turns into playful fancy. He wants to impress us with his ingenuity and skill. Earth, he wrote, is "fashioned like a woman with all the beauty of form, the grace and charm, of which my art was capable." The allegorical significance of the design is simply a pretext for this display of virtuosity. When he tells us, for instance, that Neptune and Earth each have a

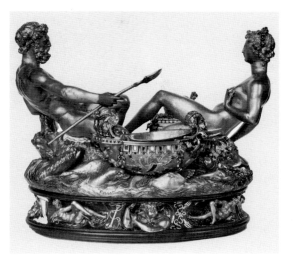

262. Benvenuto Cellini. *Saltcellar of Francis I.* 1539–43. Gold with enamel, 10 1/2 x 13 1/8" (26 x 33.3 cm). Kunsthistorisches Museum, Vienna

bent and a straight leg to signify mountains and plains, form is completely divorced from content. Despite his boundless admiration for Michelangelo, Cellini here has created elegant figures as elongated, smooth, and languid as Parmigianino's (see fig. 254).

Giovanni Bologna In 1530, Rosso was called to France by Francis I to decorate the palace at Fontainebleau. He was soon followed by Cellini and other leading Mannerists, who made Mannerism the dominant style in sixteenth-century France. Their influence went far beyond the royal court. It reached Jean de Bologne (1529–1608), a gifted young sculptor from Douai in northern France, who went to Italy about 1555 for further training. He stayed and became, under the Italianized name of Giovanni Bologna, the most important sculptor in Florence during the last third of the century. His over-lifesize marble group, *The Abduction of the Sabine Woman* (fig. 263, page 320), won particular acclaim and still has its place of honor near the Palazzo Vecchio.

Actually, the artist designed the group, with no specific subject in mind, to silence those critics who doubted his ability as a monumental sculptor in marble. He selected what seemed to him the most difficult feat, three

▼ Benvenuto Cellini's AUTOBIOGRAPHY, begun in 1538 while he was in the service of Francis I at Paris, is a valuable (if somewhat exaggerated) account of social, political, and ecclesiastical life, especially in sixteenth-century Florence, where Cellini lived from 1545 onward. It was first translated into English in 1960.

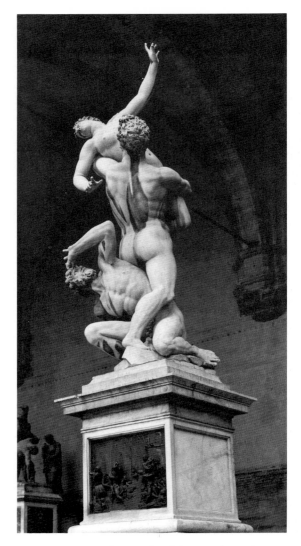

263. Giovanni Bologna. *The Abduction of the Sabine Woman*. Completed 1583. Marble, height 13'6" (4.11 m). Loggia dei Lanzi, Florence

figures of contrasting character united in a common action. Their identities were disputed among the learned connoisseurs of the day, who finally settled on *The Abduction of the Sabine Woman* as the most suitable title. Here, then, is another artist who is noncommittal about subject matter, although his unconcern had a different motive than Veronese's. Like Cellini's, Bologna's purpose was virtuoso display. His self-imposed task was to carve in marble, on a massive scale, a sculptural composition that was to be seen not from one but from all sides;

this had previously been attempted only in bronze and on a much smaller scale. He has solved this purely formal problem, but at the cost of insulating his group from the world of human experience. These figures, spiraling upward as if confined inside a tall, narrow cylinder, perform their well-rehearsed choreographic exercise with ease. Yet, like much Hellenistic sculpture (compare fig. 79), they are ultimately devoid of emotional meaning. We admire their discipline, but we find no trace of genuine feeling.

Architecture

Mannerism

The term *Mannerism* was first coined to describe painting of the period. We have not encountered any difficulty in applying it to sculpture. But can it usefully be extended to architecture as well? And if so, what qualities must we look for? These questions have proved surprisingly difficult to answer precisely. The reasons are all the more puzzling because the important Mannerist architects were leading painters and sculptors. Reflecting our dilemma, only a few structures are generally acknowledged today as Mannerist. Such a building is the Palazzo del Te in Mantua by Giulio Romano (c. 1499–1566), Raphael's chief assistant. The courtyard facade (fig. 264) features unusually squat proportions and coarse rustication. The massive, and utterly useless, **keystones** of the windows have been "squeezed" up by the force of the triangular lintels—an absurd impossibility, since there are no true arches except over the central doorway, which is surmounted by a pediment in violation of classical canon. Even more bizarre is how the **metope** midway between each pair of columns "slips" downward in defiance of all logic and accepted practice, creating the uneasy sense that the frieze might collapse before our eyes.

The reliance on idiosyncratic gestures that depart from Renaissance norms does not in itself provide a viable definition of Mannerism as an architectural period style. What, then, are the qualities we should look for? Above all, form must be divorced from content for the sake of

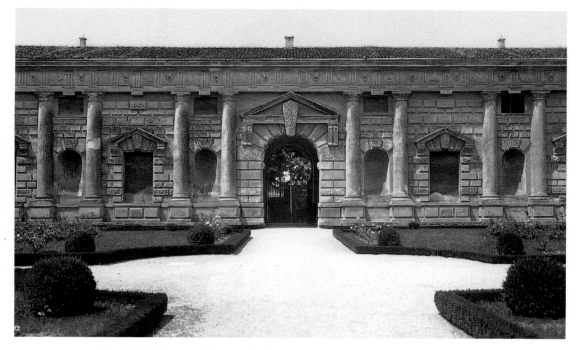

264. Giulio Romano. Courtyard, Palazzo del Te, Mantua. 1527–34

surface effect. The emphasis instead has to be on picturesque devices, especially encrusted decoration, with the occasional distortion of form and novel, even illogical rearrangement of space. Thus, Mannerist architecture lacks a consistent integration between elements.

Classicism

Andrea Palladio By the standards we have just outlined, most late-sixteenth-century architecture can hardly be called Mannerist at all. Indeed, the work of Andrea Palladio (1518–80), next to Michelangelo the most important architect of the century, stands more in the tradition of the humanist and theoretician Leone Battista Alberti (see page 271). Although his career centered on his native town of Vicenza, Palladio's buildings and theoretical writings soon brought him international status. Palladio insisted that architecture be governed both by reason and by certain universal rules that were perfectly exemplified by the buildings of the ancients. He thus shared Alberti's basic outlook and his firm faith in the cosmic significance of numerical ratios. The two differed in how each related theory and practice,

however. With Alberti, this relationship had been loose and flexible, whereas Palladio believed quite literally in practicing what he preached. His architectural treatise, *The Four Books of Architecture* (1570), is consequently more practical than Alberti's (this helps explain its huge success), whereas his buildings are linked more directly with his theories. It has even been said that Palladio designed only what was, in his view, sanctioned by ancient precedent. Thus, the usual term for both Palladio's work and his theoretical attitude is *classicistic*, to denote a conscious striving for classic qualities, though the results are not necessarily classical in style.

The Villa Rotonda (figs. 265, 266, page 322), one of Palladio's finest buildings, perfectly illustrates the meaning of his classicism. An aristocratic country residence near Vicenza, it consists of a square block surmounted by a dome and is faced on all four sides with identical porches in the shape of temple fronts. Alberti had defined the ideal church as such a completely symmetrical, centralized design, and it is evident that Palladio found in the same principles the ideal country house. How could he justify a context so purely secular for

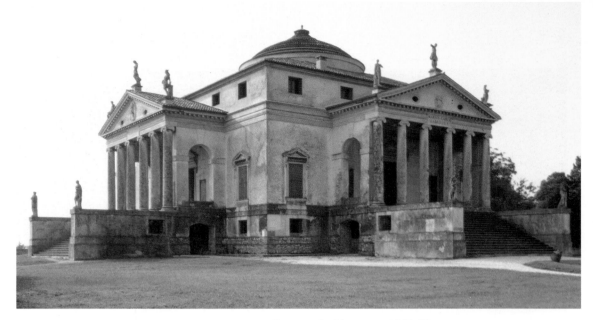

265. Andrea Palladio. Villa Rotonda, Vicenza. c. 1567–70

the solemn motif of the temple front? Like Alberti, he sought support in a selective interpretation of the historical evidence. He was convinced, on the basis of ancient literary sources, that Roman private houses had **porticoes** like these (excavations have since proved him wrong). But Palladio's use of the temple front here is not mere antiquarianism. He probably persuaded himself that it was legitimate because he regarded this feature as desirable for both beauty and utility. Beautifully correlated with the walls behind, the porches of the Villa Rotonda are an organic part of his design that lend the structure an air of serene dignity and festive grace.

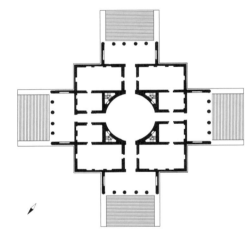

266. Plan of Villa Rotunda

Proto-Baroque

Because of his allegiance to the antique orders, Palladio had difficulty solving the problem of how to fit a classical facade onto a basilican church, although he was undoubtedly familiar with Alberti's compromise at S. Andrea (see fig. 221). The architects of the Church of Il Gesù (Jesus) in Rome, Giacomo Vignola (1507–73) and Giacomo della Porta (c. 1540–1602), had assisted Michelangelo at St. Peter's and had absorbed his architectural vocabulary. Building on this foundation, they offered a new solution to the problem. Il Gesù is a building whose importance for subsequent church architecture can hardly be exaggerated. Since it was the mother church of the Jesuits, its design must have been closely supervised so as to conform to the aims of the militant new order. We may thus view it as the architectural embodiment of the spirit of the Counter-Reformation. The planning stage of the structure began in 1550, only five years after the Council of Trent had begun. Michelangelo himself once promised a design but never furnished it. The present plan, by Vignola, was adopted in 1568.

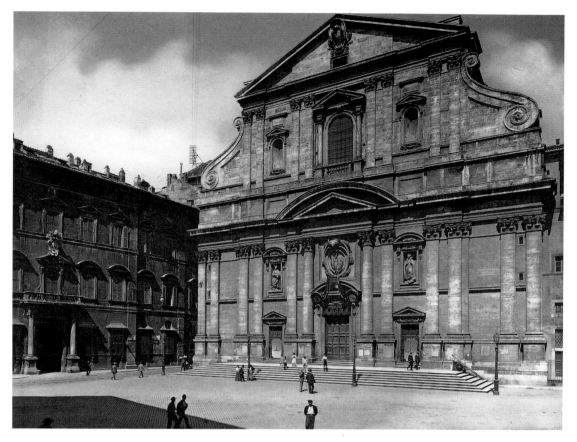

267. Giacomo della Porta. Facade of Il Gesù, Rome. c. 1575–84

Della Porta was responsible for the bold facade (fig. 267). The paired **pilasters** and broken **architrave** on the lower story are clearly derived from the colossal order on the exterior of St. Peter's (see fig. 245), and with good reason, for it was della Porta who completed Michelangelo's dome. In the upper story, the same pattern recurs on a somewhat smaller scale, with four instead of six pairs of supports. The difference in width is bridged by a pair of scroll-shaped **buttresses**. This novel device, taken from Michelangelo, forms a graceful transition to the large pediment crowning the facade, which retains the classic proportions of Renaissance architecture (the height equals the width).

What is fundamentally new here is the integration of all the parts into one whole. Della Porta, freed from classicistic scruples by his allegiance to Michelangelo, gave the same vertical rhythm to both stories of the facade. This rhythm is obeyed by all the horizontal members

(note the broken **entablature**), but the horizontal divisions in turn determine the size of the vertical members (hence no colossal order). Equally important is the emphasis on the main portal: its double frame—two pediments resting on coupled pilasters and columns—projects beyond the rest of the facade and gives strong focus to the entire design. Not since Gothic architecture has the entrance to a church received such a dramatic concentration of features, attracting the attention of the beholder outside the building much as the concentrated light beneath the dome channels that of the worshiper inside.

What are we to call the style of Il Gesù? Obviously, it has little in common with Palladio. The label *Mannerist* will not serve us either. As we shall see, the design of Il Gesù will become basic to Baroque architecture. By calling it Proto-Baroque, we suggest both its special place in relation to the past and its germinal importance for the future.

Chapter 16
The Renaissance in the North

North of the Alps, most fifteenth-century artists remained indifferent to Italian forms and ideas. Since the time of the Master of Flémalle and the van Eycks they had looked to Flanders, rather than to Tuscany, for leadership. This relative isolation ended suddenly toward the year 1500. As if a dam had burst, Italian influence flowed northward in an ever wider stream, and Northern Renaissance art began to replace "Late Gothic." The term *Northern Renaissance*, however, has a less well defined meaning than *"Late Gothic,"* which refers to a single, clearly recognizable stylistic tradition. The diversity of trends north of the Alps during the sixteenth century is even greater than in Italy. Nor does Italian influence provide a common denominator, for this influence is itself diverse: Early Renaissance, High Renaissance, and Mannerist—all are to be found in regional variants from Lombardy, Venice, Florence, and Rome. Its effects, too, vary greatly. They may be superficial or profound, direct or indirect, specific or general. Nevertheless, we may speak for the first time of a Renaissance proper in the North. Like its cousin in Italy, it is distinguished by an interest in humanism, albeit with equally inconsistent results.

The "Late Gothic" tradition remained very much alive, if no longer dominant, and its encounter with Italian art resulted in a kind of Hundred Years' War among styles that ended only when the Baroque emerged as an international movement in the early seventeenth century. Its course, moreover, was decisively affected by the Protestant Reformation, which had a far more immediate impact on art north of the Alps than in Italy. Our account necessarily emphasizes the heroic phases of the struggle at the expense of the lesser skirmishes.

Germany

Let us begin with Germany, the home of the ▼REFORMATION, where the main battles of the "war of styles" took place during the first quarter of the century. Between 1475 and 1500, Germany had produced such important artists as Michael Pacher and Martin Schongauer (see figs. 206, 208), but they hardly prepare us for the astonishing burst of creative energy that was to follow. The range of achievements of the Northern Renaissance, which was comparable in its brevity and brilliance to the Italian High Renaissance, is measured by the contrasting personalities of its greatest artists: Matthias Grünewald and Albrecht Dürer. Both died in 1528, probably at about the same age, although we know only Dürer's birth date (1471). Dürer quickly became internationally famous, while Grünewald, who was born about 1470–80, remained so obscure that his real name, Mathis Gothart Nithart, was discovered only at the end of the nineteenth century.

Matthias Grünewald Grünewald's fame, like that of El Greco, has developed almost entirely within our own century. His main work, the *Isenheim Altarpiece*, is unique in the Northern art of his time in its ability to overwhelm us with something like the power of the Sistine Chapel ceiling. Long believed to be by Dürer, it was painted between 1509/10 and 1515 for the monastery church of the Order of Saint Anthony at Isenheim, in Alsace, and is now in the museum of the nearby city of Colmar.

This extraordinary altarpiece is a carved shrine with two sets of movable wings, which give it three stages, or views; two of them are shown here. The first, formed when all the wings are closed, shows *The Crucifixion* (fig. 268, page 326)—the most impressive ever painted. In one respect, it is very medieval. Jesus' terrible agony and the desperate grief of the Virgin, John, and Mary Magdalen recall the older German *Andachtsbild* (see fig. 177). But the pitiful body on the cross, with its twisted limbs, its countless lacerations, its rivulets of blood, is on a heroic scale that raises it beyond the human and thus reveals the two natures of Jesus. The same mes-sage is conveyed by the flanking figures. The three historic witnesses on the left mourn Jesus' death as a man, while John the Baptist, on the right, points with calm emphasis to him as the Savior. Even the background suggests this duality. Golgotha here is not a hill outside Jerusalem but a mountain towering above lesser peaks. The Crucifixion, lifted from its familiar setting, thus becomes a lonely event silhouetted against a deserted, ghostly landscape and a blue-black sky. Darkness is over the land, in accordance with the Gospel, yet brilliant light bathes the foreground with the force of sudden revelation. This union of time and eternity, of reality and symbolism, gives Grünewald's *Crucifixion* its awesome grandeur.

When the outer wings are opened, which makes the altarpiece half closed, the mood of the *Isenheim Altarpiece* changes dramatically (fig. 269, page 327). All three scenes in this second view—*The Annunciation*, *The Angel Concert for the Madonna and Child*, and *The Resurrection*—celebrate events as jubilant in spirit as *The Crucifixion* is austere. Most striking in comparison with "Late Gothic" painting is the sense of movement pervading these panels. Everything twists and turns as though it had a life of its own. The angel of the Annunciation enters the room like a gust of wind that blows the Virgin backward; the canopy over the angel concert seems to writhe in response to the heavenly music; and the Risen Christ leaps from his grave with explosive force. This vibrant energy is matched by the ecstatic vision of heavenly glory in celebration of Jesus' birth, seen behind the Madonna and Child, who are surely among the most tender and lyrical in all of Northern art. In contrast to the brittle, spiky contours and angular drapery patterns of "Late Gothic" art, Grünewald's forms are soft, elastic, fleshy. His light and color show a corresponding change. Commanding all the resources of his great Flemish predecessors, he employs them with extraordinary boldness and flexibility. His color scale is richly iridescent, its range matched only by the Venetians. Indeed, his exploitation of colored light was altogether without parallel at that time. Grüne-wald's genius achieved miracles through light

▼ Most broadly defined, the REFORMATION was a European religious revolution that gave rise to religions founded on beliefs that proved irreconcilable with positions of the Roman Catholic Church. Opposition to Roman Catholic doctrine and practices was expressed as early as the fourteenth century, but it was Martin Luther's vehement objections in the first half of the sixteenth century that lead directly to the creation of Protestant religions, among them Lutheranism and Calvinism.

Isenheim Altarpiece fully open

half closed

fully closed

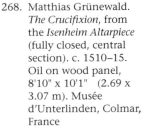

268. Matthias Grünewald. *The Crucifixion*, from the *Isenheim Altarpiece* (fully closed, central section). c. 1510–15. Oil on wood panel, 8'10" x 10'1" (2.69 x 3.07 m). Musée d'Unterlinden, Colmar, France

▼ GUILDS were associations of people with a common interest or enterprise, such as a business, a profession, or a craft. In the European Middle Ages, two types of guilds succeeded one another as powerful civic and economic forces: the merchant guild and the craft guild. Both were critical in the rise of a prosperous middle class. The merchant guild arose in the eleventh century and virtually regulated commerce and trade. By the fourteenth century, the craft guild had taken its place as the chief commercial institution. Painters belonged to guilds, as did sculptors (carvers) and smiths.

that to this day remain unsurpassed in the luminescent angels of the concert, the apparition of God the Father and the Heavenly Host above the Madonna, and, most spectacularly, the rainbow-hued radiance of the Risen Christ.

How much did Grünewald owe to Italian art? Nothing at all, we are first tempted to say. Yet he seems to have learned from the Italian Renaissance in more ways than one. His knowledge of perspective (note the low horizons) and the physical vigor of some of his figures cannot be explained by the "Late Gothic" tradition alone, and occasionally his pictures show architectural details of Southern origin. Perhaps the most important effect of the Renaissance on him, however, was psychological.

We know little about his career, but he apparently did not lead the settled life of an artisan-painter controlled by the rules of his ▼GUILD. He was also an architect, an engineer, something of a courtier, and an entrepreneur. Moreover, he worked for many different patrons and stayed nowhere for very long. He was in sympathy with Martin Luther, even though as a painter he depended on Catholic patronage. In a word, Grünewald seems to have shared the free, individualistic spirit of Italian Renaissance artists. The daring of his pictorial vision likewise suggests a reliance on his own resources. The Renaissance, then, had a liberating influence on him but did not change the basic cast of his imagination. Instead, it helped him epitomize the expressive aspects of the "Late Gothic" in a style of unique intensity and individuality.

269. Matthias Grünewald. *The Annunciation, The Angel Concert for the Madonna and Child,* and *The Resurrection,* from the *Isenheim Altarpiece* (half closed). c. 1510–15. Oil on wood panel, each wing 8'10" x 4'8" (2.69 x 1.42 m); center panel 8'10" x 11'2 1/2" (2.69 x 3.42 m)

Albrecht Dürer For Albrecht Dürer (1471–1528), the Renaissance held a richer meaning than it did for Grünewald. Attracted to Italian art while still young, he visited Venice in 1494/95 and returned to his native Nuremberg with a new conception of the world and the artist's place in it. The unbridled fantasy of Grünewald's art was to him "a wild, unpruned tree" (a phrase he used for painters who worked by rules of thumb, without theoretical foundations) that needed the discipline of the objective, rational standards of the Renaissance. Taking the Italian view that the fine arts belong among the liberal arts, he also adopted the ideal of the artist as a gentleman and humanistic scholar. By steadily cultivating his intellectual interests, he came to encompass in his lifetime an unprecedented variety of subjects and techniques. And since he was the greatest printmaker of the time, Dürer had a wide influence on sixteenth-century art through his **woodcuts** and **engravings**, which circulated throughout Europe.

The first artist that we know of to be so fascinated by his own image that he did self-portraits throughout his career, Dürer was in this respect more of a Renaissance personality than any Italian artist. His earliest known work, a drawing made at thirteen, is a self-portrait, and he continued to produce self-portraits thereafter. Most impressive, and uniquely revealing, is the panel of 1500 (fig. 270). Pictorially, it

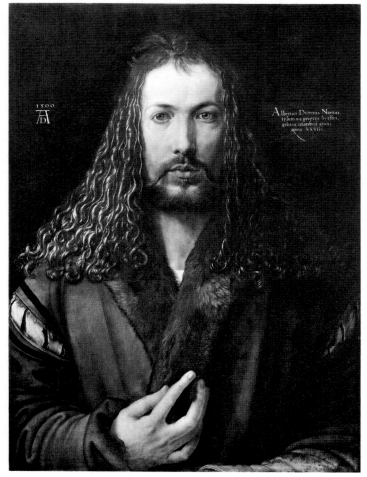

270. Albrecht Dürer. *Self-Portrait.* 1500. Oil on wood panel, 26 1/4 x 19 1/4" (66.7 x 48.9 cm). Alte Pinakothek, Munich

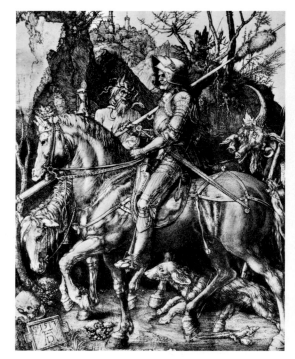

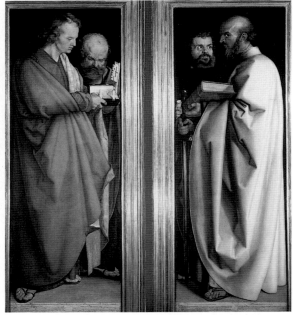

271. Albrecht Dürer. *Knight, Death, and Devil.*
1513. Engraving, 9⁷/₈ x 7¹/₂" (25.1 x 19.1 cm).
Museum of Fine Arts, Boston

272. Albrecht Dürer. *The Four Apostles.* 1523–26. Oil on
wood panel, each 7'11" x 2'6" (2.16 x 0.76 m).
Alte Pinakothek, Munich

▼ Dutch writer and scholar DESIDE-RIUS ERASMUS (1466?–1536) was northern Europe's leading humanist: he applied classical studies and scholarship to Christian learning. One of his most influential works was his 1503 *Manual of a Christian Knight,* which was a plea for and a guide to living according to simple Christian ethics. Regarded now as a precursor to the Protestant Reformation, Erasmus in fact remained a Catholic at the barricades in a humanistic war against ignorance and superstition.

belongs to the Flemish tradition (compare Jan van Eyck's *Man in a Red Turban,* fig. 197), but the solemn, frontal pose and the Christlike idealization of the features assert an authority quite beyond the range of ordinary portraits. The picture reflects not so much Dürer's vanity as the seriousness with which he regarded his mission as an artistic reformer. (It recalls Martin Luther's response to his challengers: "Here I stand; I cannot do otherwise.")

The didactic, or instructional, aspect of Dürer's art is clearest perhaps in the engraving *Knight, Death, and Devil* (fig. 271), one of his finest prints. The knight on his beautiful mount, poised and confident as an equestrian statue, embodies an ideal both aesthetic and moral. He is the Christian Soldier, steadfast on the road of faith toward the Heavenly Jerusalem, seen on the mountain in the background, and undeterred by the hideous rider threatening to cut him off or the grotesque devil behind him. The dog, symbol of fidelity, loyally

follows his owner despite the lizards and skulls in its path. Italian Renaissance form, united with the heritage of "Late Gothic" symbolism (whether open or disguised), here takes on a new, characteristically Northern significance.

The subject of *Knight, Death, and Devil* seems to have been derived from the *Manual of the Christian Knight* by ▼ERASMUS, the greatest of the Northern humanists. Dürer's own convictions were essentially those of Christian humanism. They made him an early and enthusiastic follower of Martin Luther, although, like Grünewald, he continued to work for Catholic patrons. Nevertheless, his new faith can be sensed in the growing austerity of style and subject in his religious works after 1520. The climax of this trend is represented by *The Four Apostles* (fig. 272), paired panels containing what has rightly been termed Dürer's artistic testament.

Dürer presented the panels in 1526 to the city of Nuremberg, which had joined the

Lutheran camp the year before. The chosen apostles are basic to Protestant doctrine: John and Paul face each other in the foreground, with Peter and Mark behind. Quotations from their writings, inscribed below in Luther's translation, warn the city government not to mistake human error and pretense for the will of God. They plead against Catholics and ultrazealous Protestant radicals alike. But in another, more universal sense, the figures represent the Four Temperaments—and, by implication, the other cosmic quartets: the seasons, the elements, the times of day, and the four stages (ages) of human life—encircling, like the cardinal points of the compass, the deity who is at the invisible center of this "triptych." In keeping with their role, the apostles have a cubic severity and grandeur such as we have not encountered since Masaccio and Piero della Francesca. That the style of *The Four Apostles* has evoked the names of these great Italians is no coincidence, for Dürer devoted a good part of his last years to the theory of art, including a treatise on geometry based on a thorough study of Piero della Francesca's discourse on perspective.

Lucas Cranach the Elder Dürer's hope for a monumental art embodying the Protestant faith remained unfulfilled. Other German painters, notably Lucas Cranach the Elder (1472–1553), also tried to cast Luther's doctrines into visual form but created no viable tradition. On his way to Vienna around 1500, Cranach had probably visited Dürer in Nuremberg. In any event, he fell early on under the influence of Dürer's work, which he turned to for inspiration throughout his career but invested with a highly individual expression. In 1504, Cranach left Vienna for Wittenberg, then a center of humanist learning. There he became court painter to Frederick the Wise of Saxony, as well as a close friend of Martin Luther, who even served as godfather to one of his children. Efforts to embody Protestant doctrine in art were doomed, since the spiritual leaders of the Reformation often looked upon religious art with outright hostility, even though Luther himself seems to have been relatively tolerant of

it. Like Grünewald and Dürer, Cranach continued to rely on Catholic patronage, although many of his altarpieces have a Protestant content; ironically, they lack the fervor of those he painted before converting to Protestantism. He is best remembered today for his portraits and his delightfully incongruous mythological scenes, which embody a peculiarly Northern adaptation of humanism. In *The Judgment of Paris* (fig. 273, page 330), nothing could be less classical than the wriggly nakedness of the three coquettish damsels. ▼PARIS is here a German knight clad in fashionable armor, indistinguishable from the nobles at the court of Saxony who were the artist's patrons. The playful eroticism, small size, and precise, miniature-like detail of the picture make it plainly a collector's item, attuned to the refined tastes of a provincial aristocracy.

Cranach's contribution also lies in the handling of the landscape, which lends Dürer's naturalism a lively fantasy through the ornate treatment of forms, such as the crinkly vegetation. Cranach had formulated this manner soon after arriving in Vienna. It played a critical role in the formation of the Danube School, which culminated in Altdorfer.

Albrecht Altdorfer Albrecht Altdorfer (c. 1480–1538), a somewhat younger artist than Cranach, spent most of his career in Bavaria. As remote as any of Cranach's works from the classic ideal, but far more impressive, is Altdorfer's *The Battle of Issus* (fig. 274, page 331). Without the text on the tablet suspended in the sky and the inscriptions on the banners, we could not possibly identify the subject—Alexander the Great's victory over Darius III (see page 75). The artist has tried to follow ancient descriptions of the actual number and kind of combatants in the battle, but this required him to adopt a bird's-eye view whereby the two kings are lost in the antlike mass of their own armies (contrast the Hellenistic representation of the same subject in fig. 58). Moreover, the soldiers' armor and the fortified town in the distance are unmistakably of the sixteenth century.

The picture might well show some contemporary battle, except for one feature: the

▼ The judgment of PARIS refers not to the mythical Greek hero's being judged, but to his being forced to name the most beautiful goddess among Hera, Athena, and Aphrodite, each of whom tried to bribe him. (He chose Aphrodite, which made Athena and Hera furious enemies of his country, Troy. Paris claimed Aphrodite's "prize," Helen, the most beautiful woman in the world and wife of Menelaus of Sparta, and took her home to Troy.) These events, according to myth, brought on the Trojan War.

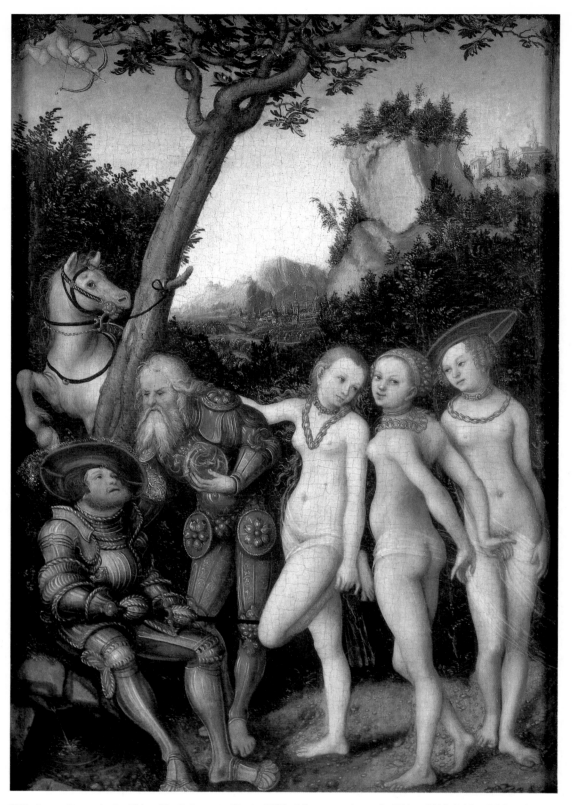

273. Lucas Cranach the Elder. *The Judgment of Paris*. 1530. Oil on wood panel, 13$^{1}/_{2}$ x 8$^{3}/_{4}$" (34.3 x 22.3 cm). Staatliche Kunsthalle, Karlsruhe, Germany

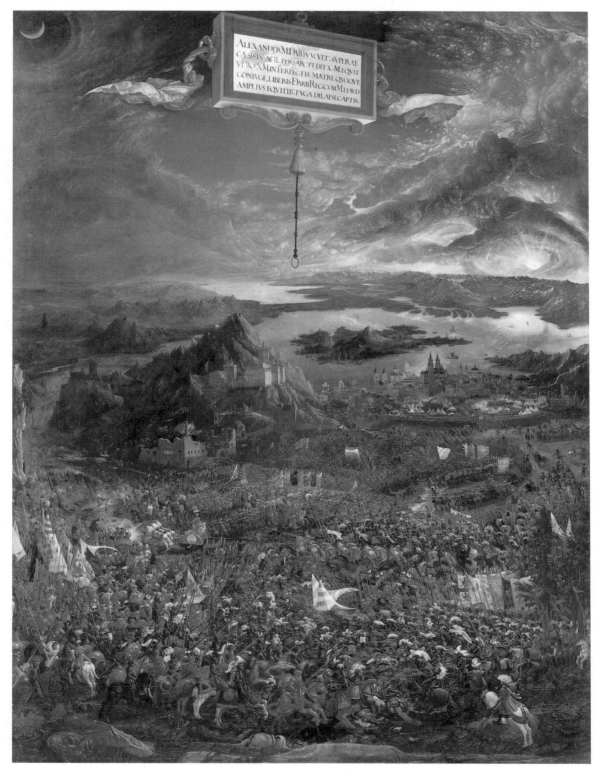

274. Albrecht Altdorfer. *The Battle of Issus*. 1529. Oil on wood panel, 5'2" x 3'11" (1.58 x 1.19 m). Alte Pinakothek, Munich

spectacular sky, with the sun triumphantly breaking through the clouds and "defeating" the moon. The celestial drama above a vast Alpine landscape, obviously correlated with the human contest below, raises the scene to the cosmic level. This is strikingly similar to the vision of heavenly glory above the Virgin and Child in the *Isenheim Altarpiece* (see fig. 269). Altdorfer may indeed be viewed as a later, albeit lesser, Grünewald. Although Altdorfer, too, was an architect, well acquainted with perspective and the Italian stylistic vocabulary, his paintings show the same unruly imagination as the older master's. But Altdorfer is also unlike Grünewald: he makes the human figure incidental to its spatial setting, whether natural or architectural. The tiny soldiers of *The Battle of Issus* have their counterpart in his other pictures, and he painted at least one landscape with no figures at all, the earliest known pure landscape.

Hans Holbein Gifted though they were, Cranach and Altdorfer both evaded the main challenge of the Renaissance so bravely faced, if not always conquered, by Dürer: the human image. Their style, antimonumental and miniaturelike, set the pace for dozens of lesser artists. Perhaps the rapid decline of German art after Dürer's death was due to a failure of ambition among artists and patrons alike. The painter Hans Holbein the Younger (1497–1543) was the exception that confirms this general rule. The son of an important artist, he was born and raised in Augsburg, a center of international commerce in southern Germany particularly open to Renaissance ideas, but he left at the age of eighteen with his brother to seek work in Switzerland. Thanks in large part to the help of humanist patrons, he was firmly established in Basel by 1520 as a designer of woodcuts, a splendid decorator, and an incisive portraitist. His likeness of Erasmus of Rotterdam (fig. 275), painted soon after the famous author had settled in Basel, gives us a truly memorable image of the Renaissance individual, at once intimate and monumental. The very ideal of the humanist scholar, this doctor of humane letters has a calm rationality that lends him an intellectual authority formerly reserved for the doctors of the Church.

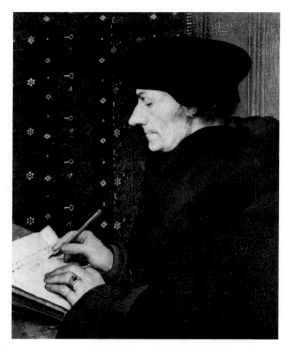

275. Hans Holbein the Younger. *Eramus of Rotterdam*. c. 1523. Oil on wood panel, 16¹/₂ x 12¹/₂" (41.9 x 31.8 cm). Musée du Louvre, Paris

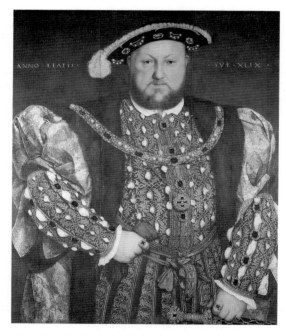

276. Hans Holbein the Younger. *Henry VIII*. 1540. Oil on wood panel, 32¹/₂ x 29" (82.6 x 73.7 cm). Galleria Nazionale d'Arte Antica, Rome

Music and Theater in the Northern Renaissance

The most significant musical development of the Reformation was the introduction of congregational singing in the services of the Protestant churches. The reformer Martin Luther, himself a singer and composer, admired the sophisticated polyphony of Josquin Des Prés, whose music he retained for use by choirs in the Latin Mass. Luther also believed strongly in the educational value of music, and he wanted every member of the church to participate in the service by singing. So in 1524 he wrote a German Mass with CHORALES—simple hymns to be sung by the congregation—based on traditional chants and secular songs for use especially in parishes without professional choirs. The Swiss reformer John Calvin, on the other hand, insisted that only the Word of God be sung in church. The result was the Calvinist PSALTER: Old Testament psalms set to traditional melodies, generally sung in unison. Another form of Protestant music was the English ANTHEM, a kind of motet that could be "full" (sung by the choir a capella, "without accompaniment") or "verse" (for soloists with chorus and instruments).

In secular music, the most popular form throughout Northern Europe was the MADRIGAL. Its chief exponent was Roland de Lassus (1532–94), a Fleming who had lived in Italy, but spent most of his career in Munich. Regarded as the leading composer of his day, he was the equal of Palestrina as a writer of religious music; but because his temperament was more secular, many of his religious compositions are parody masses (see box, page 253). In his later years he concentrated on madrigals and motets. In its impulsive leaps, irregular rhythms, and dramatic harmonies, his style anticipate's the bold brilliance of Gesualdo (see box, page 348). During the reign of Elizabeth I (1558–1603), the English developed a distinguished madrigal school under Thomas Morley (1557–c. 1602) and John Dowland (1563–1626), whose lute songs are sensitive settings of poems by Shakespeare and his contemporaries.

It is utterly remarkable that English theater developed into greatness during the late sixteenth century: its tradition was deeply rooted in medieval religious drama, and secular theater reached back only to about 1520. When Queen Elizabeth suppressed religious theater in the 1570s, secular theater came to the fore under humanist influence at schools, universities, and inns, colleges where young men completed their education. Yet neither the decline of religious theater nor the influence of the humanists can account satisfactorily for the enthusiastic support of theater throughout the realm (there were ten public outdoor theaters built in London between 1567 and 1642, in addition to numerous private indoor theaters) or for the sudden appearance of four very fine playwrights within just a few years: Thomas Kyd, Christopher Marlowe, John Lyly, and Robert Greene, and one great one, William Shakespeare (1564–1616). Shakespeare's plays featured bold plots (many of them drawn from English history and patterned after Roman dramas) and refrained from conventional moralizing and traditionally happy endings in favor of tragedy of unrelenting darkness. His greatness lies in his use of BLANK VERSE (unrhymed, although metrical, composition), which he perfected into a poetic language of infinite richness and subtlety capable of expressing any thought or mood on a transcendent, indeed universal, plane.

Holbein must have felt confined in Basel, for in 1523–24 he traveled to France, apparently with the intention of offering his services to Francis I. When he returned two years later, Basel was in the throes of the Reformation crisis, and he went to England, hoping for commissions at the court of Henry VIII. He bore with him the portrait of Erasmus in figure 275 as a gift to the humanist Thomas More, who became his first patron in London. (Erasmus, recommending him to More, wrote: "Here [in Basel] the arts are out in the cold.") On his return to Basel in 1528, Holbein saw fanatical Protestant mobs destroying religious images as "idols" and reluctantly abandoned Catholicism. Despite the entreaties of the city council, Holbein departed for London four years later. He went back to Basel only once, in 1538, while traveling on the Continent as court painter to Henry VIII, who had had More beheaded in 1525 for refusing to consent to the Act of Supremacy that made the king the head of the Church of England. The council made a last attempt to keep Holbein at home, but he had become an artist of international fame to whom Basel now seemed provincial indeed.

Holbein's style, too, had gained an international flavor. His portrait of Henry VIII (fig. 276) has the rigid frontality of Dürer's self-portrait (see fig. 270), but its purpose is to convey the almost divine authority of the absolute ruler. The monarch's physical bulk creates an overpowering sensation of his ruthless, commanding presence. The portrait of the king shares with Bronzino's *Eleanora of Toledo* (see fig. 255) the immobile pose, the air of unapproachability, and the precisely rendered costume and jewels. Holbein's picture, unlike Bronzino's, does not yet reflect the Mannerist ideal of elegance, but both clearly belong to the same species of court portrait.

Although Holbein's pictures molded British taste in aristocratic portraiture for decades, he had no English disciples of real talent. The Elizabethan genius was more literary and musical than visual, and the demand for portraits in the later sixteenth century continued to be filled largely by visiting foreign artists.

The Netherlands

The Netherlands in the sixteenth century had the most turbulent and painful history of any country north of the Alps. When the Reformation began, the region was part of the far-flung empire of the ▼HAPSBURGS under Charles V, who was also king of Spain. Protestantism quickly became powerful in the Netherlands, and the attempts of the crown to suppress it led to open revolt against foreign rule. After a bloody struggle, the northern provinces (today's Holland) emerged at the end of the century as an independent state, while the southern ones (roughly corresponding to modern Belgium) remained in Spanish hands.

The religious and political strife might have had catastrophic effects on the arts, yet this, astonishingly, did not happen. The art of the period, to be sure, does not equal that of the fifteenth century in brilliance, nor did it produce any pioneers of the Northern Renaissance comparable to Dürer and Holbein. This region absorbed Italian elements more slowly than did Germany—but also more steadily and systematically—so that instead of a few isolated peaks of achievement we find a continuous range. Between 1550 and 1600, their most troubled time, the Netherlands produced the major painters of Northern Europe; these artists in turn paved the way for the great Dutch and Flemish painters of the next century.

Two main concerns, sometimes separate, sometimes interwoven, characterized sixteenth-century Netherlandish painting. One was to assimilate Italian art from Raphael to Tintoretto (though this was often accomplished in a dry and didactic manner). The other was to develop a repertory that would supplement the traditional religious subjects.

Jan Gossaert Around 1507, a group of Netherlandish artists, the so-called Romanists, began to visit Italy in the wake of Albrecht Dürer, and they returned home having absorbed the latest tendencies of Renaissance art. The preceding generation of Flemish painters had already shown a growing interest in Renaissance art and humanism, but none ventured south of

the Alps, so that they assimilated both at second hand. The greatest of the Romanists, Jan Gossaert (c. 1478–1532; nicknamed Mabuse, for his hometown), was also the first of this group to travel south. In 1508, he accompanied Philip of Burgundy to Italy, where the Renaissance and antiquity made a deep impression on him. He nevertheless viewed this experience through characteristically Northern eyes. Except for their greater monumentality, his religious subjects were based on fifteenth-century Netherlandish art, and he often found it easier to assimilate Italian classicism through the intermediary of Dürer's prints. *Danaë* (fig. 277), painted toward the end of Gossaert's career, is his most thoroughly Italianate work. In true humanist fashion, the subject of Jupiter's seduction of the mortal is treated as a pagan equivalent of the Annunciation, so that the picture may be seen as a chaste counterpart to Correggio's *Io* (see fig. 261). The god, disguised as a shower of gold comparable to the miraculous stream of light in the *Mérode Altarpiece* (see fig. 195), enters Danaë's chambers, where she has been confined by her father against all suitors. Her partial nudity notwithstanding, she appears as modest as the Virgin in any Annunciation. Indeed, she hardly differs in type from Gossaert's paintings of the Madonna and Child, inspired equally by van Eyck and Raphael. She even wears the blue robe traditional to Mary. The linear perspective of the architectural fantasy, compiled largely from Italian treatises, marks a revolution. Never before have we encountered such a systematic treatment of space in the Netherlands.

Still Life, Landscape, and Genre After 1550, narrative painting was largely supplanted by the secular themes that would loom so large in Dutch and Flemish painting of the Baroque era: **still life**, landscape, and **genre** (scenes of everyday life). The process was gradual—it began around 1500 and was not complete until 1600—and was shaped less by the genius of individual artists than by the need to cater to popular taste as Church commissions became steadily scarcer. (Protestant iconoclastic zeal was particularly widespread in the Netherlands.)

▼ One of Europe's oldest, most powerful, and eminently prominent royal families, the HAPSBURGS, first became major players in 1273 with the election of count Rudolf as German king and Holy Roman Emperor. Through marriages and political alliances, the family produced dukes and archdukes of Austria from the late twelfth century; kings of Hungary and Bohemia from 1526 to 1918; kings of Spain from 1516 to 1700; and emperors of Austria through the nineteenth century until 1918. Their power peaked in the mid-sixteenth century with Holy Roman Emperor Charles V.

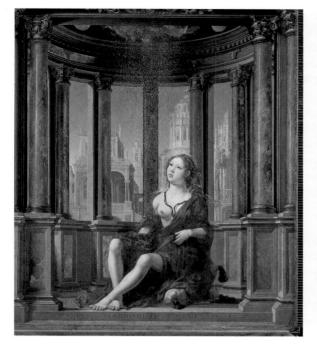

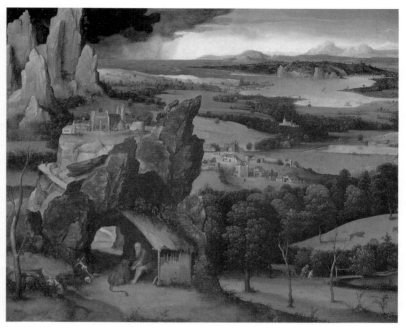

277. Jan Gossaert. *Danaë*, 1527. Oil on wood panel, 44 1/2 x 37 3/8" (113 x 94.9 cm). Alte Pinakothek, Munich

278. Joachim Patinir. *Landscape with Saint Jerome Removing the Thorn from the Lion's Paw*. c. 1520. Oil on wood panel, 29 1/8 x 35 7/8" (74 x 91 cm). Museo del Prado, Madrid

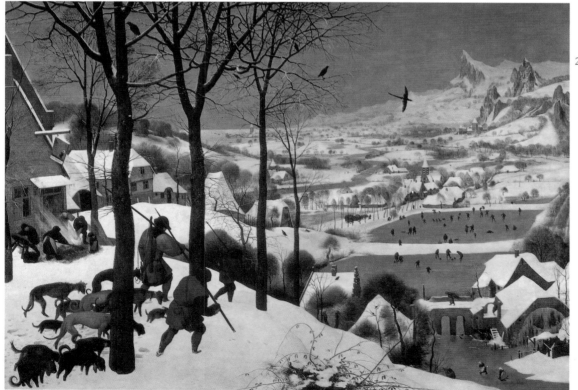

279. Pieter Bruegel the Elder. *The Return of the Hunters*. 1565. Oil on wood panel, 3'10 1/2" x 5'3 3/4" (1.18 x 1.62 m). Kunsthistorisches Museum, Vienna

Still life, landscape, and genre had been part of the Flemish tradition since the Master of Flémalle and the brothers van Eyck. We can recall the objects grouped on the Virgin's table and the scene of Joseph in his workshop in the *Mérode Altarpiece* or the setting of the van Eyck *Crucifixion* (see fig. 196). But these elements had remained ancillary, governed by the principle of disguised symbolism and subordinated to the devotional purpose of the whole. Now they acquired a new independence, until they became so dominant that the religious subject itself could be relegated to the background.

Joachim Patinir We see the beginnings of this approach in the paintings of Joachim Patinir (c. 1485–1524). *Landscape with Saint Jerome Removing the Thorn from the Lion's Paw* (fig. 278) reveals him as the heir of Hieronymus Bosch in both his treatment of nature and his choice of subject, but without the strange demonic overtones of *The Garden of Delights* (see fig. 203). Although the landscape dominates the scene, the figures, rather than being incidental, are central to it, both visually and iconographically. The landscape has been constructed around the hermit in his cave, which could exist happily in another setting, whereas this landscape would be incomplete without it. *Saint Jerome* is an allegory of the pilgrimage of life, contrasting the way of the world with the road to salvation through ascetic withdrawal. (Note the two pilgrims wending their up the hill to the right past the lion hunt, which takes place unnoticed by them.) The church on the mountain represents the ▼HEAVENLY JERUSALEM, which can be reached only by passing directly through the ascetic's cave. Like Bosch, Patinir reveals a fundamental ambivalence toward his subject, for the vista in the background, with its well-kept fields and tidy villages, is enchanting in its own right. Yet, he seems to tell us, we should not be distracted from the path of righteousness by these temptations.

Pieter Bruegel the Elder Pieter Bruegel the Elder (1525/30–69), the only genius among these Netherlandish painters, explored landscape, peasant life, and ▼MORAL ALLEGORY.

Although his career was spent in Antwerp and Brussels, he may have been born near 's Hertogenbosch, the home of Hieronymus Bosch. Certainly Bosch's work impressed him deeply, and he is in many ways as puzzling to us as the older painter. What were his religious convictions, his political sympathies? We know little about him, but his preoccupation with folk customs and the daily life of humble people seems to have sprung from a complex philosophical attitude. Bruegel was highly educated, the friend of humanists who, with wealthy merchants, were his main clients, though he was also patronized by the Hapsburg court. Yet he apparently never worked for the Church, and when he dealt with religious subjects he did so in a strangely ambiguous way.

A trip to the South in 1552–53 took Bruegel to Rome, Naples, and the Strait of Messina, but the famous monuments admired by other Northerners seem not to have interested him. He returned instead with a sheaf of magnificent landscape drawings, especially Alpine views. He was probably much impressed by landscape painting in Venice, particularly its integration of figures and scenery and the progression in space from foreground to background (see figs. 248, 249). Out of these memories came sweeping landscapes in Bruegel's mature style. *The Return of the Hunters* (fig. 279) is one of a set depicting the months. (He typically composed in series.) Such cycles, we recall, had begun with medieval calendar illustrations, and Bruegel's scene still shows its descent from the *Très Riches Heures du Duc de Berry* (see fig. 193). Now, however, nature is more than a setting for human activities: it is the main subject of the picture. Men and women in their seasonal occupations are incidental to the majestic annual cycle of death and rebirth that is the breathing rhythm of the cosmos.

The Blind Leading the Blind (fig. 280), one of Bruegel's last pictures, shows a philosophical detachment from religious and political fanaticism. Its source is the Gospels (Matthew 15:12–19): Jesus says of ▼PHARISEES, "And if the blind lead the blind, both shall fall into the ditch." This parable of human folly recurs in humanist as well as popular literature, and we

▼ As a metaphor for the Christian heaven, HEAVENLY JERUSALEM was seen as the counterpart to the earthly city of Jerusalem: the site where God dwelled and the place to which the Saved would ascend on Judgment Day.

▼ Allegory is used to convey symbolic meaning in literary and artistic mediums. Religious allegory uses extended metaphor, parable (a Biblical metaphor, usually in narrative form in the New Testament), or fable to teach a lesson. Thus, MORAL ALLEGORY delivers a moral lesson in disguised form, and Bruegel's illustration of the parable of the blind leading the blind is a moral allegory about the futility and folly of the ignorant preaching to the ignorant.

▼ PHARISEES were a Jewish school or party traceable as an independent group to the second century B.C. They promoted the notion of government by rules of Divine Law, which was not popular with the state, and opposed virtually all Greek or other influences that might contaminate or dilute the religion of their ancestors.

know it in at least one earlier representation, but the tragic depth of Bruegel's forceful image gives new urgency to the theme. He has used continuous narrative to ingenious effect. Each succeeding pose becomes progressively more unstable along the downward diagonal, leaving us in little doubt that everyone will end up in the ditch with the leader. (The gap behind him is especially telling.) Perhaps Bruegel found the biblical context of the parable specially relevant to his time, for Jesus continued: "out of the heart proceed evil thoughts, murders . . . blasphemies." Could Bruegel have thought that this verse applied to the controversies then raging over details of religious ritual?

France

It took the Northern countries longer to assimilate Italian forms in architecture and sculpture than in painting. France, more closely linked with Italy than the rest (France, we will recall, had conquered Milan in 1499), was the first to achieve an integrated Renaissance style. In 1546, King Francis I, who had shown his admiration for Italian art earlier by inviting first Leonardo in 1517 and then several Mannerist artists to France, including Francesco Primaticcio (see page 339) decided to replace the old Gothic royal castle, the Louvre (see fig. 193), with a new and much larger structure on the same site. The project, barely begun at the time of his death, was not completed until more than a century later. But its oldest portion, by Pierre Lescot, is the finest surviving example of Northern Renaissance architecture.

Pierre Lescot Pierre Lescot (c. 1515–78) drew on the work of Bramante and his successors. The details of Lescot's Louvre facade (fig. 281) have an astonishing classical purity, yet we would not mistake it for an Italian structure. Its distinctive quality comes not from Italian forms superficially applied but from a genuine synthesis of the traditional French ▼CHÂTEAU with the Renaissance palace. Italian are the superimposed classical orders, the pedimented window frames, and the arcade on the ground floor. But the continuity of the facade is interrupted by three projecting pavilions that have supplanted the château turrets, and the high-pitched roof is also traditionally French. The vertical accents thus overcome the horizontal ones, their effect reinforced by the tall, narrow windows.

Germain Pilon The greatest French sculptor of the later sixteenth century was Germain Pilon (c. 1535–90). In his early years, he learned a good deal from Francesco Primaticcio, Cellini's rival at the court of Francis I (see page 319), but he soon developed his own idiom by merging the Mannerism of Fontainebleau with elements taken from ancient sculpture, Michelangelo, and the Gothic tradition. His main works are monumental tombs, of which the earliest and largest was for Henry II and Catherine de' Medici (fig. 282, page 339). Primaticcio built the architectural framework, an oblong, free-standing chapel on a platform decorated with bronze and marble reliefs. Four large bronze statues of ▼VIRTUES, their style reminiscent of Fontainebleau, mark the corners. On the top of the tomb are bronze figures of the king and queen kneeling in prayer, while inside the chapel, the couple reappears recumbent as marble *gisants*, or nude corpses (fig. 283).

This contrast of such effigies had been a characteristic feature of fourteenth-century Gothic tombs. The *gisant* expressed the transient nature of the flesh, usually showing the body in an advanced stage of decomposition, with vermin sometimes crawling through its open cavities. How could this gruesome image take on Renaissance form without losing its emotional significance? Pilon's solution is brilliant: by idealizing the *gisants* he reverses their former meaning. The recumbent queen in the pose of a classical Venus and the king in that of the dead Jesus evoke neither horror nor pity but, rather, the pathos of a beauty that persists even in death. The shock effect of their predecessors has given way to a poignancy that is no less intense.

Remembering our earlier distinction between the classical and medieval attitudes toward death, this quality can be defined. The Gothic *gisant*, which emphasizes physical decay,

▼ Counterpart to the English fortified castle, the French CHÂTEAU (plural, châteaux) was a securely fortified residence and stronghold for French nobility and large landholders in the late Middle Ages and Renaissance. In the sixteenth century, châteaux were less heavily fortified—a moat was usually enough—and were outfitted with gardens and decorative secondary structures.

▼ In the Western world, there are two main types of VIRTUES: so-called natural virtues and Christian virtues. Both are regarded as qualities of good character and conduct that are more to be cultivated than innate. Going back to Plato's writings, the natural virtues are wisdom (or prudence), justice, temperance, and courage (or fortitude). The Christian virtues are faith, hope, and charity. The natural and Christian virtues together form the seven cardinal virtues of Christianity.

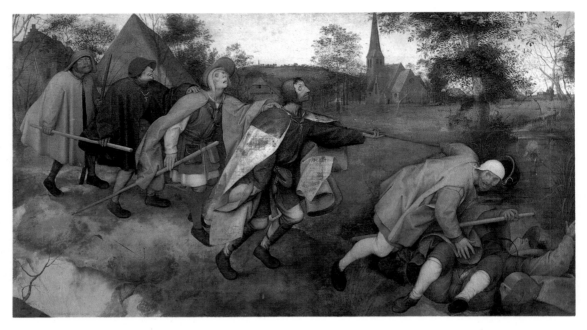

280. Pieter Bruegel the Elder. *The Blind Leading the Blind*. c. 1568. Oil on wood panel, 2'10½" x 5'¾" (0.88 x 1.54 m).
 Museo di Capodimonte, Naples

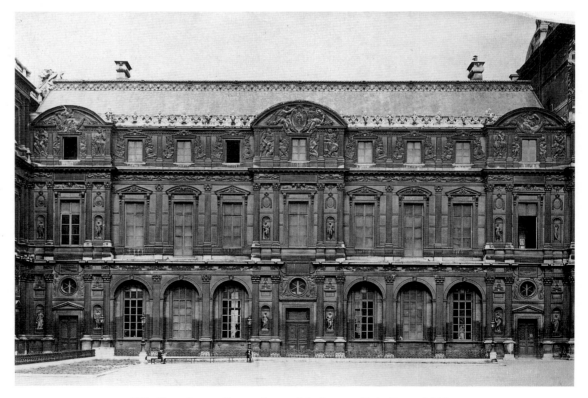

281. Pierre Lescot. Square Court of the Louvre, Paris. Begun 1546

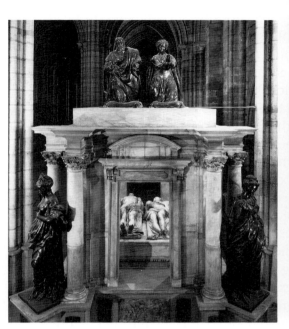

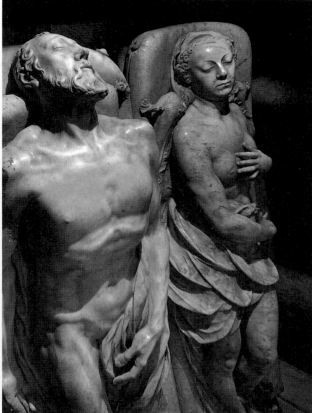

282. Francesco Primaticcio and Germain Pilon. Tomb of Henry II and Catherine de' Medici. 1563–70. Abbey Church of St-Denis, Île-de-France

283. Germain Pilon. *Gisants* of the king and queen. Detail of the Tomb of Henry II and Catherine de'Medici

represents the future state of the body, in keeping with the whole "prospective" character of the medieval tomb. Pilon's *gisants*, however, are "retrospective" yet do not deny the reality of death. In this union of opposites—never to be achieved again, even by Pilon himself—lies the greatness of these figures. The illusion is worthy of Gianlorenzo Bernini, the finest sculptor of the Italian Baroque, who must have appreciated the theatricality of the ensemble during his stay in Paris.

Chapter 17
The Baroque in Italy and Spain

What is Baroque art? Like Mannerism, the term *Baroque* was originally coined to disparage the very style it designates: it meant "irregular, contorted, grotesque." Art historians otherwise remain divided over its definition. Should *Baroque* be used only for the dominant style of the seventeenth century, or should it include other tendencies, such as classicism, to which it bears a problematic relationship? Should the time frame be extended to cover the period 1700–50, known as the Rococo? More important, is the Baroque an era distinct from both Renaissance and modern, or is it the final phase of the Renaissance? On this last question, we have chosen the first alternative as a matter of convenience, while admitting that a good case can be made for the second. Which of the alternatives is adopted on all these issues is perhaps less important than an understanding of the forces underlying the Baroque.

The fact is that the Baroque eludes simple classification. Rather, it incorporates an extreme range of contradictions. Hence, we run into a series of paradoxes typical of the conflicting nature of the Baroque. It has been claimed that the Baroque style expresses the spirit of the Counter-Reformation; yet the Counter-Reformation had already done its work by 1600. Catholicism had recaptured much of its former territory, Protestantism was on the defensive, and neither side had the power to upset the new balance. As if to signify the triumph of the old faith, the heroes of the Counter-Reformation—Ignatius of Loyola, Francis Xavier, Teresa of Ávila, Philip Neri, Carlo Borromeo, and Isidoro Agricola—were sainted in 1610 and 1622, beginning a wave of canonizations that lasted through the mid-eighteenth century. In contrast to the piety of these reformers, the new Church princes who supported the growth of Baroque art were known primarily for worldly splendor.

Other reasons we should guard against overemphasizing the Baroque's ties to the Counter-Reformation are that, unlike Mannerism, the new style was not specifically Italian (although historians generally agree that it was born in Rome during the final years of the sixteenth century), and it was not confined to religious art. Baroque elements quickly penetrated the Protestant North, where they were applied primarily to other subjects.

Equally problematic is the assertion that Baroque is "the style of absolutism," reflecting the centralized state ruled by an autocrat. Although absolutism climaxed in the reign of Louis XIV of France in the later seventeenth century, it had been developing since the 1520s, under Francis I in France and the Medici dukes in Tuscany. Moreover, Baroque art flourished in bourgeois Holland no less than in the absolutist monarchies.

Science, Faith, and Power in the Seventeenth Century

It is tempting to see the turbulent history of the era reflected in Baroque art. The seventeenth century was one of almost continuous warfare, which involved virtually every nation in a complex web of shifting alliances. The Thirty Years' War (1618–48) was fueled by the dynastic ambitions of the kings of France, who sought to exert their domination over Europe, and the Hapsburgs, who ruled Spain, the Netherlands, and Austria. Though fought largely in Germany, it eventually engulfed nearly all of Europe, even absorbing the Dutch struggle for independence from Spain, which had been waged since 1581. After the Peace of Westphalia formally ended the war and granted the Dutch their freedom, the United Provinces—as the independent Netherlands was known—entered into a series of battles with England and France for commercial and maritime supremacy that lasted until 1679. Yet, other than in Germany, which was left in ruins, there is little correlation between these rivalries and the art of the period. Given the turmoil that marked the seventeenth century, it is remarkable that this century has been called the golden age of painting in France, Holland, Flanders, and Spain. We look in vain, moreover, for the impact of these wars on Baroque imagery, though we occasionally catch an indirect glimpse of it in Dutch militia scenes, such as Rembrandt's *"Night Watch"* (see fig. 311).

We encounter similar difficulties when we try to relate Baroque art to the science and philosophy of the period. A direct link did exist in the Early and High Renaissance, when an artist could also be a humanist and a scientist. During the seventeenth century, however, scientific and philosophical thought became too complex, abstract, and systematic for most artists to share. Gravitation theory and calculus did not stir the artist's imagination any more than did Descartes's motto *Cogito, ergo sum* ("I think, therefore I am").

There is nevertheless a relationship between Baroque art and science that, though subtle, is essential to an understanding of the entire age. The medieval outlook, which had persisted through the Renaissance, was gradually overthrown by Baroque science. The complex metaphysics of the Neo-Platonists, which endowed everything with religious import, was replaced by a new cosmology, beginning with the work of astronomers Nicolas Copernicus and Galileo Galilei and culminating with that of philosopher-scientists René Descartes and Isaac Newton. In addition to placing the sun, not the earth (and humanity), at the center of the universe, these philosophers and scientists defined underlying relationships in mathematical and geometrical terms as part of the simple, orderly system of mechanics. The attacks on Renaissance science and philosophy, which could trace their origins (and authority) back to antiquity, also had the effect of supplanting natural magic, a precursor of modern science that included both astrology and alchemy. The difference was that natural magic sought to exercise practical control of the world through prediction and manipulation, by uncovering nature's "secrets" instead of its laws. To be sure, the magical worldview, linked as it was to traditional religion and morality, continued to live on in popular literature and folklore long afterward. We may nevertheless say that, thanks to advances in optical physics and physiology, the Baroque literally saw with new eyes, for its understanding of visual reality was forever altered by the new science.

In the end, Baroque art is not simply the result of religious, political, or intellectual developments. Let us therefore think of the art as one among other basic features that distinguish the period from what had gone before: the refortified Catholic faith of the ▼COUNTER-REFORMATION, the absolutist state, and the new role of science. These factors are combined in volatile mixtures that give the Baroque its fascinating variety. Such diversity was perfectly suited to express the expanding view of humanity. What ultimately unites this refractory era is a reevaluation of people and their relation to the universe. Central to this image is the new psychology reflected quite clearly in Baroque art, where the tensions of the era often erupted into open conflict. A prominent role was now assigned by

▼ The COUNTER-REFORMATION was a movement within Roman Catholicism in the sixteenth and seventeenth centuries that was intended to re-energize the Church, in part by opposing Protestantism. Pope Paul III (papacy 1534–49) was the prime catalyst of the movement, which was marked by the rapid growth of a number of teaching orders and new seminaries, the canonization of many saints, genuine spirituality among Counter-Reformation leaders, and repressive diplomatic and military measures against groups of Protestants.

284. Caravaggio. *The Calling of Saint Matthew*. c. 1599–1602. Oil on canvas, 11'1" x 11'5" (3.38 x 3.48 m). Contarelli Chapel, S. Luigi dei Francesi, Rome

philosophers to human passion, which encompasses a wider range of emotions and social levels than ever before. The scientific revolution culminating in Newton's unified mechanics responded to the same impulses, for it assumes a more active role in our ability to understand and in turn affect the world around us. Remarkably, the Baroque remained an age of great religious faith, however divided it may have been in its loyalties. The counterpoint among passions, intellect, and spirituality may be seen as forming a dialogue that has never been truly brought to a close.

Painting in Italy

Around 1600, Rome became the fountainhead of the Baroque, as it had of the High Renaissance a century before, by gathering artists from other regions to perform challenging new tasks. The papacy patronized art on a large scale with the aim of making Rome the most beautiful city of the Christian world "for the greater glory of God and the Church." This campaign had begun as early as 1585, but the artists then on hand were late Mannerists of feeble distinc-

285. Artemisia Gentileschi. *Judith and Her Maidservant with the Head of Holofernes*. c. 1625. Oil on canvas, 6'1/2" x 4'7³/4" (1.89 x 1.42 m). The Detroit Institute of Arts

tion. Soon, however, it attracted ambitious young artists, especially from northern Italy, who created the new style.

Caravaggio Foremost among the young artists who came to Rome was a painter of genius, Michelangelo Merisi (1571–1610), called Caravaggio after his birthplace near Milan. His first important religious commission was for a series of three monumental canvases devoted to Saint Matthew, which he painted for the Contarelli Chapel in S. Luigi dei Francesi, Rome, from about 1599 to 1602. *The Calling of Saint Matthew* (fig. 284), the most extraordinary picture of all, is remote from both Mannerism and the High Renaissance. Its only antecedent is the north Italian realism of artists like Savoldo (see fig. 258). According to a contemporary account, Caravaggio painted directly on the canvas from live models. But Caravaggio's realism is of a new and radical kind.

Never have we seen a sacred subject depicted so entirely in terms of contemporary low life. Matthew, the tax gatherer, sits with some

armed men (evidently his agents) in what is a common Roman tavern as two figures approach from the right. The arrivals are poor people, their bare feet and simple garments contrasting strongly with the colorful costumes of Matthew and his companions. Why do we sense a religious quality in this scene and not mistake it for an everyday event? The answer is that Caravaggio's north Italian realism is wedded to elements derived from his study of Renaissance art in Rome, which lend the scene its surprising dignity. His style, in other words, is classical in the largest sense, without looking classicistic. The composition, for example, is disposed across the picture surface, its forms sharply highlighted, much as in a relief (see fig. 97). For Caravaggio, moreover, naturalism is not an end in itself but a means of conveying profoundly religious content. What identifies one of the figures as Jesus? It is surely not the Savior's halo, the only supernatural feature in the picture, which is an inconspicuous gold band that we might well overlook. Our eyes fasten instead upon his commanding gesture, borrowed from Michelangelo's *The Creation of Adam* (see fig. 242), which bridges the gap between the two groups and is echoed by Matthew, who points questioningly at himself.

Most decisive is the strong beam of sunlight above Jesus that illuminates his face and hand in the gloomy interior, thus carrying his call across to Matthew. Without this light, so natural yet so charged with symbolic meaning, the picture would lose its magic, its power to make us aware of the divine presence. Caravaggio here gives moving, direct form to an attitude shared by certain great saints of the Counter-Reformation: that the mysteries of faith are revealed not by intellectual speculation but spontaneously, through an inward experience open to all people. What separates the Baroque from the later Counter-Reformation is the externalization of the mystic vision, which appears to us complete, without any signs of the spiritual struggle in El Greco's art.

Caravaggio's paintings have a "lay Christianity" that appealed to Protestants no less than Catholics. This quality made possible his strong, though indirect, influence on Rembrandt, the greatest religious artist of the Protestant North (Chapter 18). In Italy, Caravaggio fared less well than Rembrandt, however. His work was acclaimed by artists and connoisseurs, but the ordinary people for whom it was intended resented meeting their own kind in these paintings; they preferred religious imagery of a more idealized and remote sort. Conservative critics, moreover, regarded it as lacking the propriety and reverence demanded of religious subjects. For these reasons, Caravaggism largely ran its course by 1630, when it was assimilated into other Baroque tendencies.

Artemisia Gentileschi Although we have not yet discussed a woman artist, this does not mean that there were none. Pliny the Elder, for example, mentions in his *Natural History* (Book XXXV) the names and describes the work of women artists in Greece and Rome, and there are records of women manuscript illuminators during the Middle Ages and the Renaissance. We must remember that the vast majority of *all* artists remained anonymous until the "Late Gothic" period, so that all but a few works by women have proved impossible to identify. Women began to emerge as distinct artistic personalities about 1550. Until the middle of the nineteenth century, however, women artists were largely restricted to painting portraits, genre scenes, and still lifes. Many carved out successful careers, often emerging as the equals or superiors of the men in whose styles they were trained. The obstacles they met in getting instruction in figure drawing and anatomy effectively barred them from painting narrative subjects. The exceptions to this general rule were several Italian women born into artistic families who were encouraged to cultivate their talents, though they did not receive the same training as men. Their major role began in the seventeenth century with Artemisia Gentileschi (1593–c.1653).

The daughter of Caravaggio's follower Orazio Gentileschi, she was born in Rome and became one of the leading painters and personalities of her day. Her characteristic subjects are ▼BATHSHEBA, an object of King DAVID's obsessive passion, and JUDITH, who saved her

▼ The Old Testament tells that the innocent BATHSHEBA so inflamed King DAVID that he arranged to have her husband, Uriah, killed in battle (while he, David, seduced her) so that Bathsheba could be his wife. Their second son was Solomon, later King Solomon.

JUDITH is an Old Testament heroine who rallied her people to defend their city, Bethulia, against an attack by Assyrian troops under general HOLOFERNES. Judith visited the Assyrian camp on the pretext of being an informer; she charmed Holofernes and was invited into his tent. When the general was drunk, Judith beheaded him. Inspired by Judith's fearlessness, the Bethulians attacked the leaderless Assyrians, who fled in panic.

people by beheading the Assyrian general HOLOFERNES. Both subjects were popular during the Baroque era, which delighted in erotic and violent scenes. While Gentileschi's early paintings of Judith take her father's and Caravaggio's work as their points of departure, our example (fig. 285) is a fully mature, independent work. The inner drama is uniquely hers, and it is no less powerful for its restraint in immortalizing Judith's courage. Rather than the decapitation itself, the artist shows the instant after. Momentarily distracted, Judith gestures theatrically as her servant stuffs Holofernes' head into a sack. The object of their attention remains hidden from view, heightening the air of intrigue. The hushed, candlelit atmosphere in turn establishes a mood of exotic mystery that conveys Judith's complex emotions with unsurpassed understanding.

Annibale Carracci The conservative wishes of everyday people in Italy were met by artists less radical, and less talented, than Caravaggio. They took their lead instead from another recent arrival in Rome, Annibale Carracci (1560–1609). Annibale came from Bologna, where since the 1580s he and two other members of his family had evolved an anti-Mannerist style based on north Italian realism and Venetian art. He was a reformer rather than a revolutionary. Like Caravaggio, who apparently admired him, it was Annibale's experience of Roman classicism that transformed his art. He, too, felt that art must return to nature, but his approach was less single-minded: he balanced studies from life with a revival of the classics, which to him meant the art of antiquity and of Raphael, Michelangelo, Titian, and Correggio. At his best, he succeeded in fusing these diverse elements, although their union always remained somewhat precarious.

Between 1597 and 1604, Annibale produced the ceiling fresco in the ▼GALLERY of the Palazzo Farnese, his most ambitious and important work. Our illustration (fig. 286) shows Annibale's rich and intricate design: the narrative scenes, like those of the Sistine Ceiling, are surrounded by painted architecture, simulated sculpture, and nude youths holding garlands. The Farnese Gallery does not rely solely on Michelangelo's fresco, however. The style of the main subjects, the loves of the classical gods, is reminiscent of Raphael's *Galatea* (see fig. 247), and the whole is held together by an illusionistic scheme that reflects Annibale's knowledge of Correggio and the great Venetians. Carefully foreshortened and illuminated from below (as we can judge from the shadows), the nude youths and the simulated sculpture and architecture appear real. Against this background, the mythologies are presented as simulated easel pictures, a solution adapted from one of Raphael's late decorations. Each of these levels of reality is handled with consummate skill, and the entire ceiling has an exuberance that sets it apart from both Mannerism and High Renaissance art.

Guido Reni and Guercino To artists who were inspired by it, the Farnese Gallery seemed to offer two alternatives. Pursuing the Raphaelesque style of the mythological panels, they could arrive at a deliberate, "official" classicism, or they could take their cue from the sensuous illusionism present in the framework. Their approach varied according to personal style and the conditions imposed by the actual site. Among the earliest responses to the first alternative is the ceiling fresco *Aurora* (fig. 287, page 346) by Guido Reni (1575–1642), showing Apollo in his chariot (the Sun) led by Aurora (Dawn). Here grace becomes the pursuit of absolute beauty. Nevertheless, the relieflike design would seem like little more than a pallid reflection of High Renaissance art were it not for the glowing and dramatic light, which gives it an emotional force that the figures alone could never achieve. Hence, this style is called Baroque classicism to distinguish it from all earlier forms of classicism, no matter how much it may be indebted to them. The *Aurora* ceiling (fig. 288) painted less than ten years later by the artist known as Guercino (Giovanni Francesco Barbieri, 1591–1666) is the very opposite of Reni's. Here architectural perspective, combined with the pictorial illusionism of Correggio and the intense light and color of Titian, converts the entire surface into

▼ A GALLERY is a long, rectangular space that usually functions as a passageway or corridor. From the Renaissance onward, galleries in palaces, public buildings, and stately houses, would be heavily decorated, frequently with paintings and works of sculpture. From this practice, the word *gallery* came to mean an independent space devoted to the show of works of art.

In churches, a gallery is a low story above the nave, often arcaded.

286. Annibale Carracci. Ceiling fresco in the Gallery, Palazzo Farnese, Rome. 1597–1604

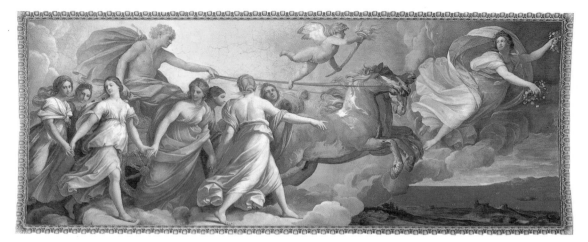

287. Guido Reni. *Aurora*. Ceiling fresco in the Casino Rospigliosi, Rome. 1613

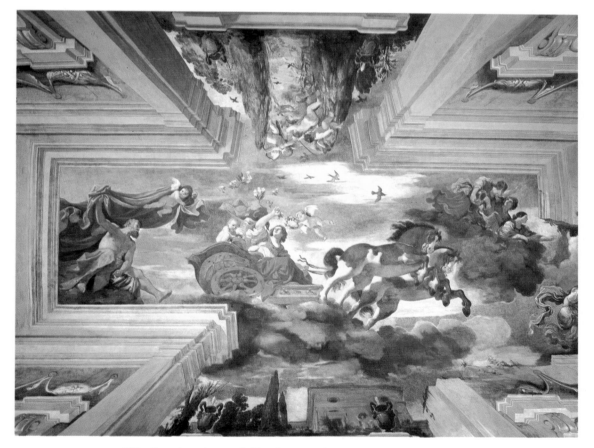

288. Guercino. *Aurora*. Ceiling fresco in the Villa Ludovisi, Rome. 1613

Baroque Music in Italy and Spain

The most important contribution of the Baroque to music and theater was the invention of OPERA, which united all the theatrical elements of the period into a spectacular whole. It began modestly enough as a humanist exercise in Florence. Following the suggestion of Girolamo Mei of Rome, members of the Camerata of Florence, so called because it met *in camera* (behind closed doors), set out to re-create ancient Greek drama, which they wrongly believed had been sung throughout. Around 1590, Vincenzo Galilei (c. 1520–91), the father of the astronomer Galileo, issued a polemic attacking the vocal counterpoint of madrigals as impersonal and artificial because it did not adhere to the Greek unity of text and music. Although Vincenzo experimented with MONODIES (short, dramatic monologues with continuo accompaniment), the first OPERA (short for *opera in musica*, "work in music") was *Dafne*, produced privately with a *libretto* (text) by Ottavio Rinuccini (1562–1621) and music mostly by Jacopo Peri (1561–1633). It was followed by *Euridice* from the same team with the assistance of Giulio Caccini (c. 1546–1618) and was performed in 1600 in honor of the marriage of Henry IV and Marie de' Medici. Despite its limitations, *Euridice's* new declamatory style, called representative or theatrical style, made an extraordinary impression on listeners.

Opera might have remained little more than an antiquarian phenomenon had it not been for Claudio Monteverdi (1567–1643). He has aptly been described as the "last great madrigalist and the first great opera composer." His *Orfeo*, produced in 1607 at Mantua, enlarged the story of *Euridice* into the standard five acts demanded by the Roman poet Horace while increasing the variety of vocal music and giving a greater role to the instrumental accompaniment. This expansion required all the skills he had gained composing madrigals—the very kind of music attacked by Vincenzo Galilei. Monteverdi was openly experimental. He was acutely aware of the conflict between the earlier style of the Netherlanders and the later Italian madrigalists such as Gesualdo (see page 333), and he fended off attacks by saying that he was working in an entirely new vein not subject to the old rules.

From then on, music took precedence over words in opera, which often emphasized extreme emotional states of mind through violent contrasts, as did Baroque art. The future of the new form lay in Rome and Venice, the latter of which opened the first public opera house in 1637. Operas soon became wildly popular, not only in Italy but throughout Europe: everyone vied for the services of the leading Italians. After 1650, the court in Vienna became *the* center of theater and opera—reaching its zenith with *The Golden Apple*, a huge spectacle staged in 1668 to celebrate the wedding of Emperor Leopold I and the infanta Margarita of Spain. The public wanted new operas as soon as they could be mounted, while star singers required virtuoso ARIAS, solos to which they often added florid ornamentation to showcase their talents.

Combined with an increasing emphasis on spectacle, these demands conspired to dilute opera as a dramatic form while the beauty of the music itself grew. The impact of opera was pervasive. Even church music became operatic in its CANTATAS and ORATORIOS. These three vocal forms reached maturity in the work of Alessandro Scarlatti (1659–1725), who worked in Naples and Rome.

The Baroque was the first period in which instrumental music equaled vocal music in stature. While continuing the practice of imitating different dance types, it also began to mimic vocal style. The two approaches are exemplified in the TRIO SONATAS of Arcangelo Corelli (1653–1717). His chamber sonatas use dance movements, while the church sonatas in principle do not. Both employ two violins and a continuo consisting of a lower viol and a keyboard instrument. When expanded to a full string orchestra, the trio sonata became the *CONCERTO GROSSO* (grand concerto), the most characteristic type of Baroque instrumental music, which began as OVERTURES to and during Mass. Corelli alternated sprightly, dancelike movements with slow ones that have a uniquely plaintive, bittersweet quality similar in character to the laments in Monteverdi's madrigals. Virtuoso touches of musical ornamentation are treated discretely so as not to disrupt the singing line, itself well within the range of the human voice. Each movement generally has an alternating melody (and at most two melodies) developed fully in clear progressions not using the modes of medieval and Renaissance music. These Baroque models became the basis for modern harmony.

one limitless space, in which the figures sweep past as if propelled by stratospheric winds. With this work, Guercino started what soon became a veritable flood of similar visions characteristic of the High Baroque after 1630.

Pietro da Cortona The most overpowering of the works following Guercino's *Aurora* is the ceiling fresco by Pietro da Cortona (1596–1669) in the great hall of the Palazzo Barberini in Rome, which presents a glorification of the reign of the Barberini pope Urban VIII (fig. 289). As in the Farnese Gallery, the ceiling area is subdivided by a painted framework simulating architecture and sculpture and filled with figural scenes, but beyond it we now see the unbounded sky, as in Guercino's *Aurora*. Clusters of figures, perched on clouds or soaring freely, swirl above as well as below this framework, creating a dual illusion: some figures appear to hover well inside the hall, perilously close to our heads, while others

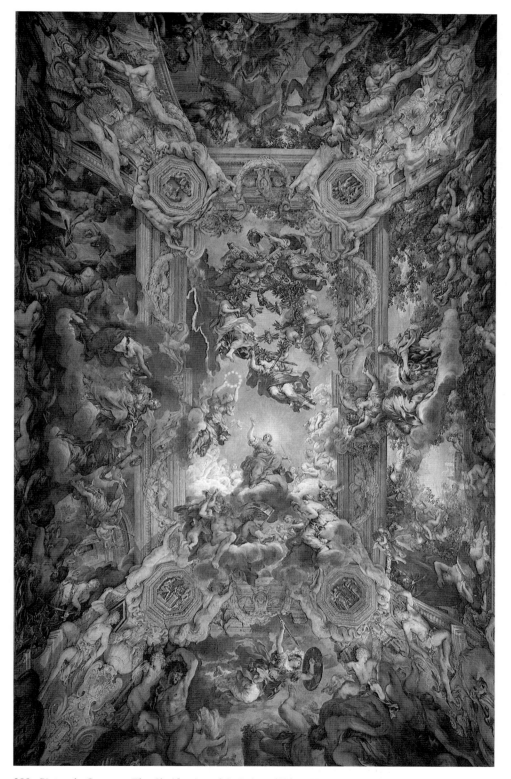

289. Pietro da Cortona. *The Glorification of the Reign of Urban VIII*. Portion of ceiling fresco in the Palazzo Barberini, Rome. 1633–39

recede into a light-filled, infinite distance. In the Barberini ceiling, the dynamism of the High Baroque style reaches a resounding climax. Cortona's source of inspiration was surely Correggio, who achieved a similar effect in *The Assumption of the Virgin* (see fig. 260).

Cortona's frescoes provided the focal point for the rift between the High Baroque and Baroque classicism that grew out of the Farnese ceiling. The classicists asserted that art serves a moral purpose and must observe the principles of clarity, unity, and decorum. And supported by a long tradition reaching back to Horace's famous dictum *ut pictura poesis* ("as is painting, so is poetry"), they further maintained that painting should follow the example of tragic poetry in conveying meaning through a minimum of figures whose movements, gestures, and expressions can be easily read. Cortona, though not anticlassical, presented the case for art as epic poetry, with many actors and episodes that elaborate on the central theme and create a magnificent effect. He was also the first to argue that art has a sensuous appeal that exists as an end in itself.

Although the debate over illusionistic ceiling painting took place on a largely theoretical level, it represented more than fundamentally divergent approaches to telling a story and expressing ideas in art. The issue lay at the very heart of the Baroque. Illusionism enabled artists to overcome the apparent contradictions of the era by fusing separate levels of reality into a pictorial unity of such overwhelming grandeur as to sweep aside any differences between them. The leader of the reaction against what were regarded as the excesses of the High Baroque was neither a fresco painter nor an Italian, but a French artist living in Rome who had shared the same antiquarian patron as Cortona: Nicolas Poussin (Chapter 19). Despite the intensity of the argument, in actual practice the two sides rarely came into conflict over easel paintings, where the differences between Cortona and Carracci's followers were not always so clear-cut. For that reason, late Baroque painting after 1650 was increasingly characterized by a conservative synthesis of the High Baroque and

Baroque classicism. This eventually yielded to an academic style that flourished in Rome and Naples around the turn of the eighteenth century.

Architecture in Italy

Carlo Maderno The beginnings of the Baroque style in architecture cannot be defined as precisely as in painting. As the vast ecclesiastical building program got under way in Rome toward the end of the sixteenth century, the most talented young architect to emerge was Carlo Maderno (1556–1629). In 1603, he was given the task of completing, at long last, the church of St. Peter's. The pope had decided to add a nave to Michelangelo's building (see fig. 245) in order to convert it into a basilica. The change of plan (which may have been prompted by the example of Il Gesù) made it possible to link St. Peter's with the Vatican Palace, to the right of the church (fig. 290).

Maderno's design for the facade follows the pattern established by Michelangelo for the exterior of the church. It consists of a **colossal order** supporting an attic, but with a dramatic emphasis on the portals. The effect can be described as a crescendo that builds from the corners toward the center. The spacing of the supports becomes closer, pilasters turn into columns, and the facade projects step by step. This quickened rhythm had been hinted at a generation earlier in Giacomo della Porta's facade of Il Gesù (see fig. 267). Maderno made it the dominant principle of his facade designs, not only for St. Peter's but for smaller churches as well. In the process, he replaced the traditional concept of the church facade as one continuous wall surface—which was not yet challenged by the facade of Il Gesù—with the "facade-in-depth," dynamically related to the open space before it. The possibilities implicit in this new concept were not to be exhausted until 150 years later.

Gianlorenzo Bernini Maderno's work at St. Peter's was completed by Gianlorenzo Bernini (1598–1680), the greatest sculptor-architect of the century. He molded the open space in front

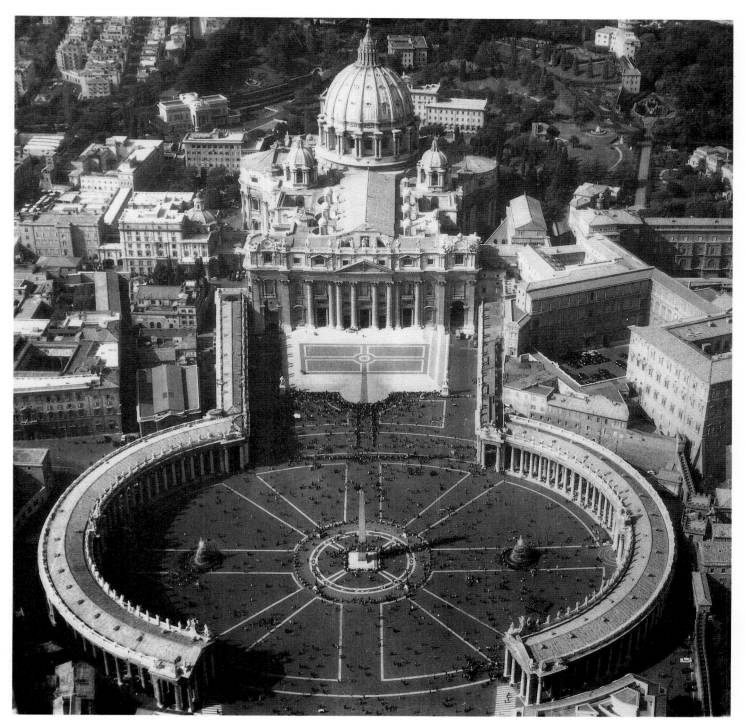

290. St. Peter's, Rome. Nave and facade by Carlo Maderno, 1607–15; colonnade by Gianlorenzo Bernini, designed 1657

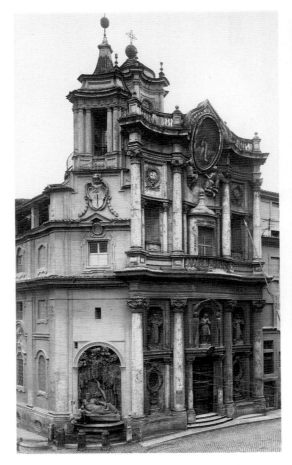

291. Francesco Borromini. Facade, S. Carlo alle Quattro Fontane, Rome. 1665–67

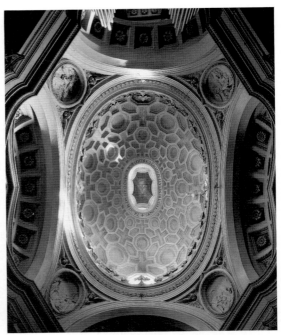

292. Dome, S. Carlo alle Quattro Fontane. 1635

of the facade into a magnificent oval forecourt framed by colonnades that Bernini himself likened to the motherly, all-embracing arms of the Church. For sheer impressiveness, this integration of the building with such a grandiose setting of "molded" open space can be compared only with the ancient Roman sanctuary at Palestrina (see fig. 85).

Francesco Borromini As a personality, Bernini represents a type we first met among the artists of the Early Renaissance: a self-assured, expansive person of the world. His great rival in architecture, Francesco Borromini (1599–1667), who started out as an assistant to Maderno, was the opposite type: a secretive and emotionally unstable genius who died by suicide. The works of

both exemplify the climax of Baroque architecture in Rome, but in equally different ways: Bernini's design for the colonnade of St. Peter's is dramatically simple and unified, while Borromini's structures are extravagantly complex. Not surprisingly, Bernini agreed with those who denounced Borromini for flagrantly disregarding the classical tradition, enshrined in Renaissance theory and practice, that architecture must reflect the proportions of the human body.

In Borromini's first major project, the Church of S. Carlo alle Quattro Fontane (fig. 291), the ceaseless play of concave and convex surfaces makes the entire structure seem elastic, as if pulled out of shape by pressures that no previous building could have withstood. The inside of the dome (fig. 292), like the plan that it echoes, looks as if it had been drawn on rubber and would snap back to normal if the tension were relaxed. The facade was designed almost thirty years later, and the pressures and counterpressures here reach their maximum intensity. Borromini merges architecture and sculpture in a way that must have shocked Bernini, as no such fusion had been ventured

since Gothic art. S. Carlo alle Quattro Fontane established Borromini's local and international fame. "Nothing similar," wrote the head of the religious order for which the church was built, "can be found anywhere in the world. This is attested by the foreigners who . . . try to procure copies of the plan. We have been asked for them by Germans, Flemings, Frenchmen, Italians, Spaniards, and even Indians. . . ."

A second project by Borromini is of special interest as a High Baroque critique of St. Peter's. Maderno had found one problem insoluble: although his new facade forms an impressive unit with Michelangelo's dome when seen from a distance, the dome is gradually hidden by the facade as we approach the church. Borromini designed the facade of Sta. Agnese in Piazza Navona (fig. 293) with this conflict in mind. Its lower part is adapted from the facade of St. Peter's but curves inward, so that the dome (a tall, slender version of Michelangelo's) functions as the upper part of the facade. The dramatic juxtaposition of concave and convex, always characteristic of Borromini, is further emphasized by the two towers, which form a monumental triad with the dome. (Such towers were also once planned for St. Peter's by Bernini, but they would have been freestanding.) Once again, Borromini joins Gothic and Renaissance features—the two-tower facade and the dome—into a remarkably elastic compound.

Guarino Guarini The wealth of new ideas that Borromini introduced was to be exploited not in Rome but in Turin, the capital of Savoy, which became the creative center of Baroque architecture in Italy toward the end of the seventeenth century. In 1666, that city attracted Borromini's most brilliant successor, Guarino Guarini (1624–83), a monk whose architectural genius was deeply grounded in philosophy and mathematics. His design for the facade of the Palazzo Carignano (fig. 294) repeats on a larger scale the undulating movement of S. Carlo alle Quattro Fontane (see fig. 291), using a highly individual vocabulary. Incredibly, the exterior of the building is entirely of brick, down to the last ornamental detail.

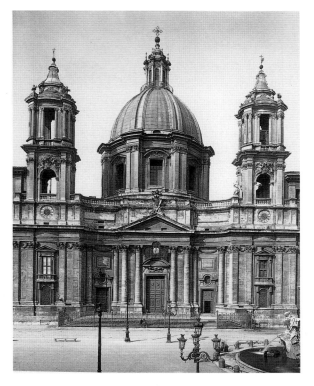

293. Francesco Borromini. Sta. Agnese in Piazza Navona, Rome. 1653–63

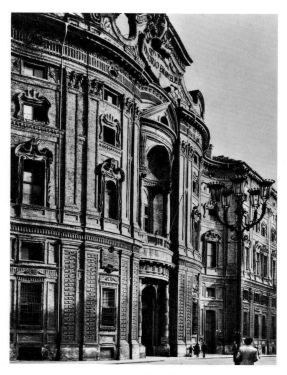

294. Guarino Guarini. Facade of Palazzo Carignano, Turin. Begun 1679

Sculpture in Italy

Gianlorenzo Bernini We have already encountered Gianlorenzo Bernini as an architect. It is now time to consider him as sculptor, although the two aspects are never far apart in his work. As in the colonnade for St. Peter's (see fig. 290), a strong relationship can often be discovered between Bernini's and Hellenistic sculpture. If we compare Bernini's *David* (fig. 295) with Michelangelo's (see fig. 240) and ask which is closer to the Pergamon frieze (see fig. 78), our vote must go to Bernini. His figure shares with Hellenistic works that unison of body and spirit, of motion and emotion, Michelangelo so conspicuously avoids. This does not mean Bernini is more classical than Michelangelo. It indicates, rather, that both the Baroque and the High Renaissance acknowledged the authority of ancient art, but each period drew inspiration from a different aspect of antiquity.

Bernini's *David*, obviously, is in no sense an echo of the Pergamon altar. What makes it Baroque is the *implied presence* of Goliath. Unlike earlier statues of David, including Donatello's (see fig. 212), Bernini's is conceived not as one self-contained figure but as half of a pair, his entire action focused on his adversary. Did Bernini, we wonder, plan a statue of Goliath to complete the group? He did not, for his *David* tells us clearly enough where *he* sees the enemy. Consequently, the space between David and his invisible opponent is charged with energy: it "belongs" to the statue.

Bernini's *David* shows us what distinguishes Baroque sculpture from the sculpture of the two preceding centuries: its new, active relationship with the space it inhabits. It rejects self-sufficiency for the illusion of presences or forces that are implied by the behavior of the statue. Because it so often presents an invisible complement (like the Goliath of Bernini's *David*), Baroque sculpture is a tour de force, attempting essentially pictorial effects that were traditionally outside its province. Such a charging of space with active energy is, in fact, a key feature of all Baroque art. Caravaggio had achieved it in his *Saint Matthew*, with the aid of a piercing beam of light. Indeed, Baroque art acknowl-

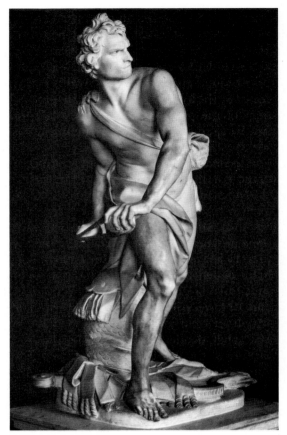

295. Gianlorenzo Bernini. *David*. 1623. Marble, lifesize. Galleria Borghese, Rome

edges no sharp distinction between sculpture and painting. The two may even be combined with architecture to form a compound illusion, like that of the stage.

In fact, Bernini, who had a passionate interest in the theater, was at his best when he could merge architecture, sculpture, and painting. His greatest work in this vein is the Cornaro Chapel, containing the famous group called *The Ecstasy of Saint Teresa* (fig. 296), in the Church of Sta. Maria della Vittoria. Teresa of Ávila, one of the great saints of the Counter-Reformation, had described how an angel pierced her heart with a flaming golden arrow: "The pain was so great that I screamed aloud; but at the same time I felt such infinite sweetness that I wished the pain to last forever. It was not physical but psychic pain, although it affected the body as well to some degree. It was

296. Gianlorenzo Bernini. *The Ecstasy of Saint Teresa.* 1645–52. Marble, lifesize. Cornaro Chapel, Sta. Maria della Vittoria, Rome

297. Anonymous. *The Cornaro Chapel.* Second half of the 17th century. Oil on canvas 5'6¹/₄" x 3'11¹/₄" (1.6 x 1.2 m). Staatliches Museum, Schwerin, Germany

the sweetest caressing of the soul by God."

Bernini has made this visionary experience as sensuously real as Correggio's *Jupiter and Io* (see fig. 261). In a different context, the angel would be indistinguishable from Cupid, and the saint's ecstasy is palpable. The two figures, on their floating cloud, are illuminated (from a hidden window above) in such a way as to seem almost dematerialized in their gleaming whiteness. The beholder experiences them as visionary.

The invisible complement here, less specific than David's but equally important, is the force that carries the figures heavenward, causing the turbulence of their drapery. Its divine nature is suggested by the golden rays, which come from a source high above the altar: in an illusionistic fresco by Guidobaldo Abbatini on the vault of the chapel—visible in a painting of

the interior (fig. 297)—the glory of the heavens is revealed as a dazzling burst of light from which tumble clouds of jubilant angels. This celestial explosion gives force to the thrusts of the angel's arrow and makes the ecstasy of the saint believable. To complete the illusion, Bernini even provides a built-in audience for his "stage": on the sides of the chapel are balconies resembling theater boxes, where we see marble figures, representing members of the Cornaro family, who also witness the ecstasy. Their space and ours are the same and thus are part of everyday reality, while the ecstasy, housed in a strongly framed niche, occupies a space that is real but beyond our reach. Finally, the ceiling fresco represents the infinite, unfathomable space of heaven.

We may recall that *The Burial of Count Orgaz* and its setting also form a whole embracing

three levels of reality (see fig. 257). There is nevertheless a profound difference between the two chapels. El Greco's Mannerism evokes an ethereal vision in which only the stone slab of the sarcophagus is "real," in contrast to Bernini's Baroque theatricality, where the distinction nearly breaks down altogether. Bernini was a devout Catholic who believed (as did Michelangelo) that he received his inspiration directly from God. Like the ▼SPIRITUAL EXERCISES OF IGNATIUS OF LOYOLA, which he practiced, his religious sculpture is intended to help the viewer achieve complete identification with miraculous events through a vivid appeal to the senses.

Bernini was steeped in Renaissance humanism and theory. Central to his sculpture is the role played by gesture and expression in arousing emotion. While no less important to the Renaissance (compare Leonardo), these devices have an apparent abandon that seems anticlassical in Bernini's hands. However, he essentially adhered to the Renaissance concept of decorum, and he calculated his effects very carefully, varying them in accordance with his subject. Unlike the French painter Nicolas Poussin (whom he admired), Bernini did this for the sake of expressive impact rather than conceptual clarity. The approaches of the two artists were diametrically opposed as well. For Bernini, antique art served as no more than a point of departure for his own fertile inventiveness, whereas for classicists like Poussin it provided a reference point that acted as a standard of comparison. It is nevertheless characteristic of the paradoxical Baroque that Bernini's theories should be far more orthodox than his art and that he sometimes sided with classicists against his fellow High Baroque artists, despite the fact that his sculpture has much in common with the paintings of Pietro da Cortona. He was perhaps motivated by professional jealousy: Cortona, like Raphael before him, also made an important contribution to architecture and was a rival in that sphere.

Alessandro Algardi It is ironic that Cortona, Bernini's competitor in architecture, was the closest friend of the sculptor Alessandro Algardi

(1596–1654), who is generally regarded as the leading classical sculptor of the Italian Baroque and the only serious rival to Bernini in sculptural ability. *The Meeting of Pope Leo I and Attila* (fig. 298), executed while he supplanted Bernini at the papal court, represents Algardi's main contribution, for it inaugurates a new kind of high relief that soon became widely popular. It depicts defeat of the ▼HUNS under ATTILA in 451, a fateful event in the early history of Christianity when its very survival was at stake. The subject revives one familiar to us from antiquity: the victory over barbarian forces (compare fig. 71), but now it is the Church, not civilization, that triumphs.

The commission was given in 1646 because moisture from condensation at its location in St. Peter's made a painting impossible. Never before had an Italian sculptor attempted such a large relief—it stands more than 28 feet high. The problems posed by translating a pictorial conception (the same subject had been treated by Raphael in one of the Vatican rooms) into a relief on this gigantic scale were formidable, and if Algardi has not succeeded in resolving every detail, his achievement is stupendous nevertheless. By varying the depth of the carving, he nearly convinces us that the scene takes place in the same space as ours. The foreground figures are in such high relief as to appear detached from the background. To accentuate the effect, the stage on which they are standing projects several feet beyond its surrounding niche. Thus, Attila seems to rush out toward us in fear and astonishment as he flees the heavenly vision of the two apostles defending the faith. The result is surprisingly persuasive, both visually and expressively. Such illusionism is quintessentially Baroque. Baroque, too, is the intense drama, worthy of Bernini himself, which is heightened by the twisting poses and theatrical gestures of the protagonists. Algardi was obviously touched by Bernini's towering genius. Only in Algardi's observance of the three traditional levels of relief carving (low, middle, and high, instead of continuously variable depth), his preference for frontal poses wherever possible, and his degree of restraint in dealing with the violent action

can he be called a classicist, and then purely in a relative sense. Clearly, then, we must not insist on drawing the distinction between the High Baroque and Baroque classicism too sharply in sculpture any more than in painting.

Painting in Spain

During the sixteenth century, at the height of its political and economic power, Spain had produced great saints and writers but no artists of the first rank. Nor did El Greco's presence prove a stimulus to native talent. The reason is that the Catholic Church, the main source of patronage, was extremely conservative and that the Spanish court and most of the aristocracy preferred to employ foreign painters, so native artists were held in low esteem. The main impetus came, rather, from Caravaggio. We do not know exactly how his style was transmitted, for his influence was felt in Spain by the second decade of the century, even before he fled Rome for Naples, then under Spanish rule, after slaying a man in a duel.

Francisco de Zurbarán Seville was the home of the leading Spanish Baroque painters before 1640. Francisco de Zurbarán (1598–1664) stands

298. Alessandro Algardi. *The Meeting of Pope Leo I and Attila.* 1646. Marble, 28'1³/4" x 16'2¹/2" (8.5 x 4.9 m). St. Peter's, Vatican, Rome

Baroque Theater in Italy and Spain

Besides the opera, the most popular form of Italian theater in the sixteenth and seventeenth centuries was the COMMEDIA DELL'ARTE ("comedy of skill"), which arose in the late sixteenth century and spread quickly throughout Europe, especially to France. The *commedia* actors improvised their dialogue on a rough plot outline, taking the roles of stock characters—the innocent young girl, the impoverished youth, the braggart captain, the pedantic doctor—in age-old scenarios of love and intrigue. The comedic characters were clever servants, often called *zanni* ("Johnny" in the Venetian dialect—from which the English word *zany* is derived), who delighted their audiences by outwitting their masters and other

figures of authority. The best known of these *zanni* were Harlequin, Mezzetin, and Pulcinella, whose name and huge nose survived into the twentieth century in the character of Punch of Punch-and-Judy puppet shows. The Italian *commedia* was also the source of modern slapstick and burlesque comedy. Its success depended on the close identification of the actors with their roles. Although the *commedia dell'arte* remained popular for 200 years, its heyday was over by 1650, when its creativity began to wane.

In Spain, the late sixteenth and early seventeenth century was a golden age of theater, as it was of art. It began around 1580, with the plays of Juan de la Cueva (1550–1610) and Miguel de Cervantes (1547–1616), the author of *Don Quixote*, but its greatest writer was Lope de Vega (1562–

1635), who claimed to have scripted more than 1,200 dramas and comedies. In its combination of worldliness and religion, Vega's work reflects the character and social order of Spain, which centered on the often-conflicting demands of love, honor, religion, and responsibility among the different social classes. The plots are lively and the writing fluid, but characters are rather conventional because they conform to established codes. Vega's successor, Pedro Calderón de la Barca (1600–81), wrote mainly cape-and-sword comedies for the court, which he served as Master of the Revels, as well as religious dramas (called *autos sacramentales*) after he was ordained a priest toward the end of his life. Throughout the century, both types were performed at court and in public theaters by professional actors employed by municipalities.

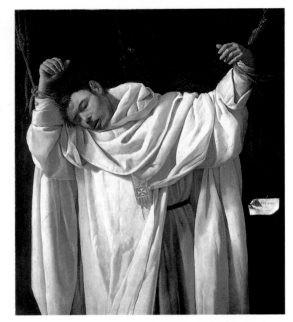

299. Francisco de Zurbarán.
Saint Serapion. 1628.
Oil on canvas, 47½ x 41"
(120.7 x 104.1 cm).
Wadsworth Atheneum,
Hartford, Connecticut

Ella Gallup Sumner and Mary
Catlin Sumner Collection

out among them for his quiet intensity. This artist's most important works were done for monastic orders and consequently are filled with an ascetic piety that is uniquely Spanish. *Saint Serapion* (fig. 299) shows an early member of the Mercedarians (Order of Mercy) who was brutally murdered by pirates in 1240 but canonized only a hundred years after this picture was painted. The canvas was appropriately placed as a devotional image in the funerary chapel of the order, which was originally dedicated to self-sacrifice.

The painting will remind us of Caravaggio's *David with the Head of Goliath* (see fig. 8). Each shows a single, three-quarter-length figure in

300. Diego Velázquez.
The Maids of Honor. 1656.
Oil on canvas,
10'5" x 9' (3.18 x 2.74 m).
Museo del Prado, Madrid

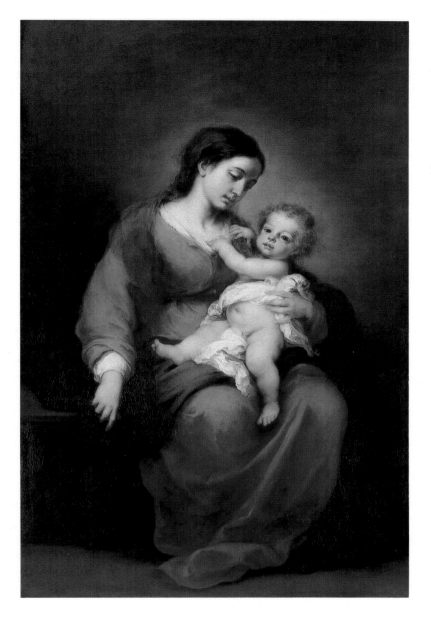

301. Bartolomé Esteban Murillo. *Virgin and Child.* c. 1675–80. Oil on canvas, 5'5 1/4" x 3'7" (1.66 x 1.09 m). The Metropolitan Museum of Art, New York

Rogers Fund, 1943

lifesize; but Zurbarán's saint is both hero and martyr, and it is the viewer who now contemplates the slain monk with a mixture of compassion and awe. The sharp contrast between the white robe and dark background lends the motionless figure a heightened visual and expressive presence. Here pictorial and spiritual purity become one. The hushed stillness creates a reverential mood that counteracts the stark realism, so that we identify with the strength of Saint Serapion's faith rather than his physical suffering. The very absence of rhetorical pathos makes this timeless image profoundly moving.

Diego Velázquez Diego Velázquez (1599–1660) painted in a Caravaggesque vein during his early years in Seville, but his interests centered on genre and still life rather than religious themes. In the late 1620s, Velázquez was appointed court painter to Philip IV, whose reign

from 1621 to 1665 represents the great age of painting in Spain. Much of the credit for the richness of this period must go to the duke of Olivares, who largely restored Spain's fortunes and supported an ambitious program of artistic patronage to proclaim the monarchy's greatness. Upon moving to Madrid, Velázquez quickly displaced the mediocre Florentines who had enjoyed the favor of Philip III and his minister, the duke of Lerma. He spent most of the rest of his life there, mainly doing portraits of the royal family. During one of his visits to the Spanish court, the Flemish painter Peter Paul Rubens helped Velázquez discover the beauty of the many Titians in the king's collection, from which Velázquez developed a new fluency and richness.

The Maids of Honor (fig. 300) displays Velázquez's mature style at its fullest. It is at once a group portrait and a genre scene. It might be subtitled "the artist in his studio," for Velázquez shows himself at work on a huge canvas. In the center is the little Princess Margarita, who has just posed for him, among her playmates and maids of honor. The faces of her parents, the king and queen, appear in the mirror on the back wall. Have they just stepped into the room, to see the scene exactly as we do, or does the mirror reflect part of the canvas (presumably a full-length portrait of the royal family) on which the artist has been working? This ambiguity shows Velázquez's fascination with light. The artist challenges us to find the varieties of direct and reflected light in The Maids of Honor. We are expected to match the mirror image against the paintings on the same wall and against the "picture" of the man in the open doorway.

Although the side lighting and strong contrasts of light and dark still suggest the influence of Caravaggio, Velázquez's technique is far more varied and subtle than Caravaggio's, with delicate glazes setting off the **impasto** of the highlights. The glowing colors have a Venetian richness, but the brushwork is even freer and sketchier than Titian's. Rather than concerning himself with metaphysical mysteries, Velázquez focused on the optical qualities of light, which he penetrated more completely than any painter of his time. His aim is to show the movement of light itself and the infinite range of its effects on form and color. For Velázquez, as for Jan Vermeer in Holland (see page 375), light *creates* the visible world.

Bartolomé Esteban Murillo The work of Bartolomé Esteban Murillo (1617–82), Zurbarán's successor as the leading painter in Seville, is the most cosmopolitan, as well as the most accessible, of any Spanish artist. For that reason, he exerted a vast influence on innumerable followers, whose pale imitations have obscured his considerable achievement. He learned as much from Northern artists, including Rubens and Rembrandt (Chapter 18), as he did from Italians like Reni and Guercino. The *Virgin and Child* in figure 301 unites these influences in an image that nevertheless retains an unmistakably Spanish character. The haunting expressiveness of the faces achieves a gentle pathos that lends a more overt appeal to Zurbarán's pietism. This must be seen as part of an attempt to inject new life into standard devotional images that had been reduced to formulaic repetition in the hands of lesser artists. The extraordinary sophistication of Murillo's brushwork and the subtlety of his color show that he must have been aware of Diego Velázquez.

Chapter 18
The Baroque in Flanders and Holland

I n 1581, the seven northern provinces of the Netherlands, led by William the Silent of Nassau, declared their independence from Spain, capping a rebellion that had begun fifteen years earlier against Catholicism and the attempt by Philip II of Spain to curtail local power. The southern Netherlands, then called Flanders, were soon recovered by Spain; but after a long struggle the United Provinces (today's Netherlands, commonly called Holland) gained autonomy, which was recognized by a truce declared in 1609. Although hostilities broke out again in 1621, the freedom of the Dutch was ratified by a treaty signed in Münster in 1648, which ended the Thirty Years' War and signified the Peace of Westphalia. The division of the Netherlands had very different consequences for the economy, social structure, culture, and religion of the north and the south.

Flanders and Holland in the Seventeenth Century

After being sacked by marauding Spanish troops in 1576, Antwerp lost half its population. The city gradually regained its position as Flanders's commercial and artistic capital, as well as its leading port, until the Scheldt River leading to its harbor was closed permanently to shipping as part of the Peace of Westphalia, thereby crippling trade for the next two centuries. (Only then did Brussels, the seat of the Spanish regent, come to play a major role in the country's cultural life.) Because Flanders continued to be ruled by the Spanish monarchy, which was staunchly Catholic and viewed itself as the defender of the true faith, its artists relied heavily on commissions from Church and State, although the patronage of the aristocracy and wealthy merchants was also of considerable importance.

Holland, meanwhile, was proud of its hard-won freedom. While the cultural links with Flanders remained strong, several factors encouraged the quick development of Dutch artistic traditions. Unlike Flanders, where all artistic activity radiated from Antwerp, Holland had a number of flourishing local schools. Besides Amsterdam, the commercial capital, we find important groups of painters in Haarlem, Utrecht, Leyden, Delft, and other towns. Thus, Holland produced an astonishing variety of outstanding artists and styles.

The new nation was one of merchants, farmers, and seafarers, and its religion was Reformed Protestant, which was ▼ICONOCLASTIC. Hence, Dutch artists did not have the large-scale commissions sponsored by State and Church that were available throughout the Catholic world. While municipal authorities and civic bodies provided a certain amount of art patronage, their demands were limited, so that the private collector now became the painters' chief source of support. This condition had already existed to some extent earlier, but its full effect can be seen only after 1600. There was no shrinkage of output; on the contrary, the general public developed such an appetite for pictures that the whole country became gripped by a kind of collector's mania. Pictures became a commodity, and their trade followed the law of supply and demand. Many artists produced "for the market" rather than for individual patrons. This enthusiasm for collecting paintings in seventeenth-century Holland caused an outpouring of artistic talent comparable only to Early Renaissance Florence. Many Dutch became painters, hoping for a success that failed to materialize, and even the greatest artists were sometimes financially hard-pressed. (It was not unusual for an artist to keep an inn or run a small business on the side.) Yet they survived—less secure, but freer than they had been under Spanish rule.

Flanders

Peter Paul Rubens In Flanders, all of art was overshadowed by the majestic personality of the great painter Peter Paul Rubens (1577–1640). It might be said that he finished what Dürer had started a hundred years earlier: the breakdown of the artistic barriers between North and South. Rubens's father was a prominent Antwerp Protestant who fled to Germany to escape Spanish persecution during the war of independence. The family returned to Antwerp after his death, when Peter Paul was ten years old, and the boy grew up a devout Catholic. Trained by local painters, Rubens became a master in 1598 but developed a personal style only when, two years later, he went to Italy.

During his eight years in the South, he absorbed the Italian tradition far more thoroughly than had any Northerner before him. He eagerly studied ancient sculpture, the great works of the High Renaissance, and the work of Caravaggio and Annibale Carracci. Rubens competed with the best Italians of his day on even terms and could well have made his career in Italy. When in 1608 his mother's illness brought him back to Flanders, he received a special appointment as court painter to the Spanish regent, which permitted him to establish a workshop in Antwerp, exempt from local taxes and guild regulations. Like Jan van Eyck before him, he was valued at court not only as

▼ The word *iconoclasm*, derived from Greek *eikon,* "image" and *kloein,* "to break," refers to a prohibition against the *religious* use of images—not all images per se. At the root of ICONOCLASTIC movements is the fear that images will be worshiped.

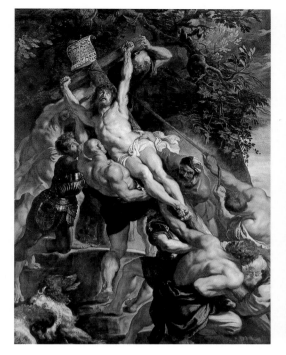

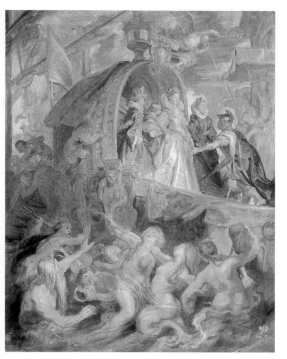

302. Peter Paul Rubens. *The Raising of the Cross.* Center panel of a triptych. 1609–10. Oil on panel, 15' x 11'2" (4.57 x 3.4 m). Antwerp Cathedral

303. Peter Paul Rubens. *Marie de' Medici, Queen of France, Landing in Marseilles.* 1622–23. Oil on panel, 25 x 19 3/4" (63.5 x 50.2 cm). Alte Pinakothek, Munich

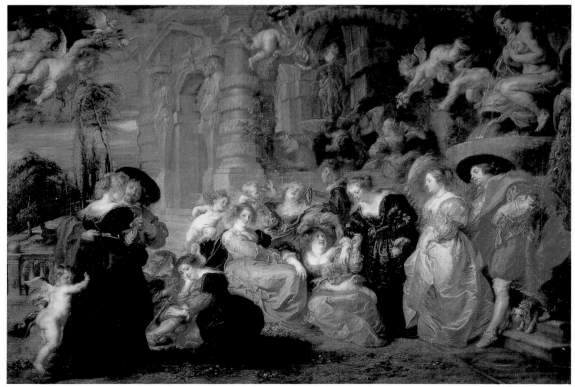

304. Peter Paul Rubens. *The Garden of Love.* c. 1638. Oil on canvas, 6'6" x 9'3 1/2" (1.98 x 2.83 m). Museo del Prado, Madrid

an artist but also as a confidential adviser and emissary. Diplomatic errands gave him entrée to the royal households of the major powers, where he procured sales and commissions. Aided by a small army of assistants, he also carried out a vast amount of work for the city of Antwerp, for the Church, and for private patrons. Thus, Rubens had the best of both worlds.

In his life, Rubens epitomized the extroverted Baroque ideal of the virtuoso for whom the entire universe is a stage. He was, on the one hand, a devoutly religious person and, on the other, a person of the world who succeeded in every arena by virtue of his character and ability. Rubens resolved the contradictions of the era through humanism, that union of faith and learning attacked by the Reformation and Counter-Reformation alike. In his paintings as well, Rubens reconciled seemingly incompatible opposites. His enormous intellect and vitality enabled him to synthesize his sources into a unique style that unites the natural and supernatural, reality and fantasy, learning and spirituality. Thus, his epic canvases defined the scope and the style of High Baroque painting. They possess a seemingly boundless energy and inventiveness, which, like his heroic nudes, express life at its fullest. The presentation of this heightened existence required the expanded arena that only Baroque theatricality, in the best sense of the term, could provide, and Rubens's sense of drama was as highly developed as Bernini's. At the same time, he could be the most intimate and accessible of artists.

The Raising of the Cross (fig. 302), the first major altarpiece Rubens produced after his return to Antwerp, shows just how much he was indebted to Italian art. The muscular figures, modeled to display their physical power and passionate feeling, recall those in Michelangelo's Sistine ceiling and Annibale Carracci's Farnese Gallery, while the lighting suggests Caravaggio's (see figs. 242, 286, and 284). The panel nevertheless owes much of its success to Rubens's remarkable ability to unite Italian influences with Netherlandish ideas, updating them in the process. The painting is more heroic in scale and conception than any previous Northern work, yet it is unthinkable without Rogier van der Weyden's *Descent from the Cross* (see fig. 200). Rubens is also a meticulous realist in such details as the foliage, the armor of the soldier, and the curly-haired dog in the foreground. These varied elements, integrated with greatest skill, form a composition of tremendous dramatic force. The unstable pyramid of bodies, swaying precariously, bursts the limits of the frame in a characteristically Baroque way, making the beholder feel like a participant in the action.

During the 1620s, Rubens's dynamic style reached its climax in his huge decorative schemes for churches and palaces. The most famous is the ▼CYCLE in the Luxembourg Palace in Paris, glorifying the career of Marie de' Medici, the widow of Henri IV and mother of Louis XIII. Our illustration shows the artist's oil sketch for one episode, the young queen landing in Marseilles (fig. 303). Rubens has turned what is hardly an exciting subject into a spectacle of unprecedented splendor. As Marie de' Medici walks down the gangplank, Fame flies overhead sounding a triumphant blast on two trumpets, and Neptune rises from the sea with his fish-tailed crew. Having guarded the queen's journey, they rejoice at her arrival. Everything flows together here in swirling movement: heaven and earth, history and allegory, even drawing and painting, for Rubens used oil sketches like this one to prepare his compositions. Unlike earlier artists, he preferred to design his pictures in terms of light and color from the very start. (Most of his drawings are figure studies or portrait sketches.) This unified vision, first explored by the great Venetians, was Rubens's most precious legacy to Northern painters.

Around 1630, the turbulent drama of Rubens's preceding work changes to a late style of lyrical tenderness inspired by Titian, whose work Rubens discovered anew in the royal palace when he visited Madrid (see page 303). *The Garden of Love* (fig. 304), one result of this encounter, is as glowing a tribute to life's pleasures as Titian's *Bacchanal* (see fig. 249). But these celebrants belong to the present, not to a golden age of the past, though they are playfully assaulted by swarms of ▼CUPIDS. The pic-

▼ CYCLE refers to a number of scenes, usually painted, that illustrate a story or a series of episodes or events.

▼ Shown as a naked and winged child (looking often like a chubby baby), CUPID is the Roman equivalent of the Greeks' Eros, child of Aphrodite and Ares, who is shown with a bow and sheaf of arrows. Cupid, also called Amor, and Eros are the personifications of love in all its many manifestations, from blissful to tormented and from erotic to platonic.

ture must have had special meaning for him, since he had just married a beautiful girl of sixteen (his first wife died in 1626). The Garden of Love had been a subject of Northern painting ever since the courtly style of the International Gothic. The early versions of the theme, however, were pure genre scenes showing groups of fashionable young lovers in a garden. By combining this tradition with Titian's classical mythologies, Rubens has created an enchanted realm where myth and reality become one.

Anthony Van Dyck Besides Rubens, only one Flemish Baroque artist won international stature. Anthony Van Dyck (1599–1641) was that rarity among painters, a child prodigy. Before he was twenty, he had become Rubens's most valued assistant. But like Rubens, he developed his mature style only after a formative stay in Italy. Although he lacked the older artist's vitality and inventiveness, his gifts were ideally suited to portraits. Those he painted in England as court painter to Charles I between 1632 and 1641 represent the crowning achievement of his career. *Portrait of Charles I Hunting* (fig. 305) shows the king standing near a horse and two grooms against a landscape backdrop. Representing the sovereign at ease, it might be called a dismounted-equestrian portrait, less rigid than a formal state portrait but hardly less grand, for the king remains fully in command of the State, symbolized by the horse. The fluid Baroque movement of the setting complements the self-conscious elegance of the king's pose. The painting continues the stylized grace of Mannerist portraits (compare fig. 255), which Van Dyck has brought up to date, rephrasing it in the pictorial language of Rubens and Titian. He created a new aristocratic portrait tradition that continued in England until the late eighteenth century and had considerable influence on the Continent as well.

Jacob Jordaens Jacob Jordaens (1593–1678) was the successor to Rubens and Van Dyck as the leading artist in Flanders. Although he never was Rubens's assistant, he turned to Rubens for inspiration throughout his career. His most characteristic subjects are mytholog-

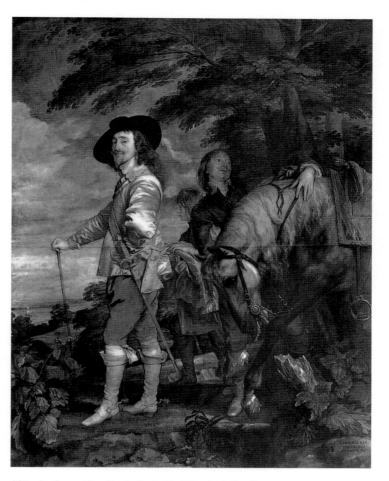

305. Anthony Van Dyck. *Portrait of Charles I Hunting*. c. 1635. Oil on canvas, 8'11" x 6'11½" (2.72 x 2.12 m). Musée du Louvre, Paris

ical themes depicting the revels of nymphs and satyrs. Throughout his career, Jordaens depicted the revels of ▼NYMPHS and satyrs that, like his eating and drinking scenes, epitomize a Flemish zest for life. Both his scenes of revelry and his eating and drinking scenes, which illustrate popular parables of an edifying and moralizing sort, reveal him to be a close observer of people. The denizens of the woods, however, inhabit an idyllic realm, untouched by the cares of human affairs. While the subject matter and painterly execution acknowledge a debt to Rubens, the generous figures in *Homage to Pomona* (*Allegory of Fruitfulness*) are Jordaens's

▼ NYMPHS were female divinities in Greek mythology who were identified with nature, natural objects, and sites. The Greeks had many classes of nymphs—most of them gentle and beautiful and some of them wild companions of satyrs—which numbered in the thousands.

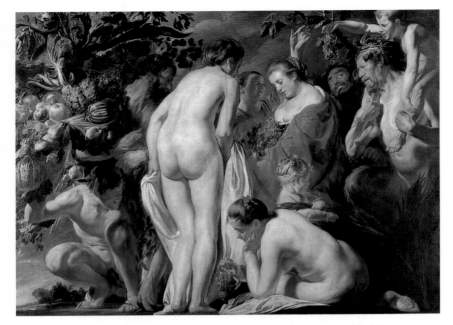

306. Jacob Jordaens. *Homage to Pomona* (*Allegory of Fruitfulness*). c. 1623. Oil on canvas, 5'10⁷/₈" x 7'10⁷/₈" (1.8 x 2.41 m). Royal Museum of Fine Arts, Brussels

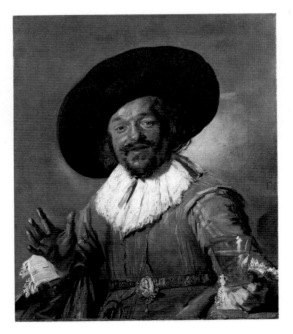

307. Frans Hals. *The Jolly Toper*. c. 1628–30. Oil on canvas, 31⁷/₈ x 26¹/₄" (81 x 66.7 cm). Rijksmuseum, Amsterdam

vaggio and his followers, some of whom were Dutch. One of the first artists to profit from this experience was Frans Hals (1580/85–1666), the great portrait painter of Haarlem. He was born in Antwerp, and what little is known of his early work suggests the influence of Rubens. However, his fully developed style, as seen in *The Jolly Toper* (fig. 307), combines Rubens's robustness and breadth with a concentration on the dramatic moment that must be derived from Caravaggio. Everything here conveys complete spontaneity: the twinkling eyes and half-open mouth, the raised hand, and the teetering wineglass. Most important of all is the quick way of setting down the forms. Hals works in dashing brushstrokes, each so clearly visible as a separate entity that we can almost count the total number of touches. With this open, split-second technique, the completed picture has the immediacy of a sketch by Rubens (compare fig. 303). The impression of a race against time is deceptive. Hals spent hours, not minutes, on this lifesize canvas, but he maintains the illusion of having done it all in the wink of an eye.

In the artist's last canvases, these pictorial fireworks are transformed into an austere style of great emotional depth. His group portrait *The Women Regents of the Old Men's Home at Haarlem* (fig. 308), the institution where he spent his final years, has an insight into human character matched only in Rembrandt's late style (compare fig. 312). The daily experience of suffering and death has so etched the faces of these women that they seem themselves to have become images of death—gentle, inexorable, and timeless.

Judith Leyster Hals's virtuosity was such that it could not be imitated readily, and his followers were necessarily few. The most important among them was Judith Leyster (1609–60). The enchanting *Boy Playing a Flute* (fig. 309) is her greatest work. The rapt musician is a memorable expression of a lyrical mood. To convey this spirit, Leyster investigated the poetic quality of light with a quiet intensity that anticipates the work of Jan Vermeer a generation later (see fig. 317).

Rembrandt van Rijn Like Hals, Rembrandt van Rijn (1606–69), the greatest genius of Dutch art,

creation (fig. 306). They dispense with Rubens's drama and possess a calm dignity all their own.

Holland

Frans Hals The Baroque style came to Holland from Antwerp through the work of Rubens and from Rome through direct contact with Cara-

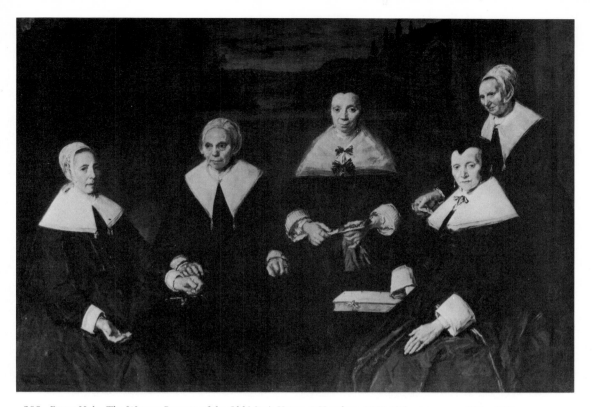

308. Frans Hals. *The Women Regents of the Old Men's Home at Haarlem*. 1664. Oil on canvas, 5'7" x 8'2" (1.7 x 2.49 m). Frans Halsmuseum, Haarlem, the Netherlands

was stimulated at the beginning of his career by indirect contact with Caravaggio. His earliest pictures are small, sharply lit, and intensely realistic. Many deal with Old Testament subjects, a lifelong preference. They show both his greater realism and his new emotional attitude as compared with the Italian's style. Rembrandt viewed the stories of the Old Testament in much the same "lay Christian" spirit that governed Caravaggio's approach to the New Testament: as direct accounts of God's ways with his human creations. How strongly these stories affected Rembrandt is evident from *The Triumph of Dalila* (fig. 310). Painted in the High Baroque style he developed in the 1630s, it shows us the Old Testament world in Oriental splendor and violence. The flood of brilliant light pouring into the dark tent is unabashedly theatrical, heightening the drama to the pitch of *The Raising of the Cross* (see fig. 302) by Rubens, whose work Rembrandt sought to rival.

Rembrandt was at this time an avid collector of Near Eastern paraphernalia, which serve as props in these pictures. He was now

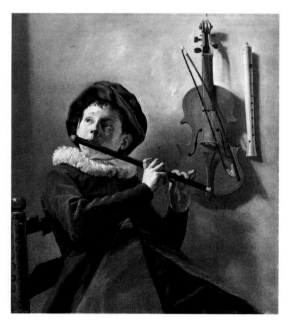

309. Judith Leyster. *Boy Playing a Flute*. 1630–35. Oil on canvas, 28 3/8 x 24 3/8" (72.1 x 61.9 cm). Nationalmuseum, Stockholm

310. Rembrandt van Rijn. *The Triumph of Dalila*. 1636. Oil on canvas, 7'9" x 9'11" (2.36 x 3.02 m). Städelsches Kunstinstitut, Frankfurt am Main, Germany

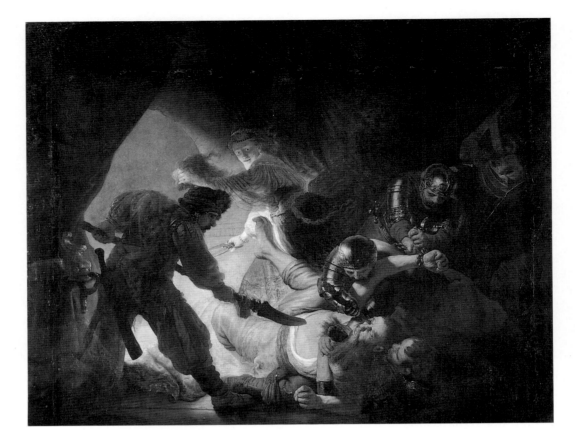

etching needle

drawing on a wax-coated etching plate

drypoint needles

Amsterdam's most-sought-after portrait painter, as well as a person of considerable wealth. His famous group portrait known as *"The Night Watch"* (fig. 311), painted in 1642, shows a military company assembling for the visit of Marie de' Medici to Amsterdam. Although its members had each contributed toward the cost of the huge canvas (originally it was even larger), Rembrandt did not give them equal weight. He was anxious to avoid the mechanically regular designs that afflicted earlier group portraits—a problem that only Frans Hals had overcome successfully. Instead, he made the picture a virtuoso performance of Baroque movement and lighting. Thus, some of the figures were plunged into shadow, while others were hidden by overlapping. Legend has it that the people whose portraits he had obscured were dissatisfied. There is no evidence that they were. On the contrary, we know that the painting was admired in its time.

Rembrandt's prosperity ran out in the 1640s, as he was replaced by other more fashionable artists, including some of his own pupils. Nevertheless, his fortunes declined less suddenly and completely than his romantic admirers would have us believe. Certain important people in Amsterdam continued to be his steadfast friends and supporters, and he received some major public commissions in the 1650s and 1660s. Actually, his financial difficulties resulted largely from poor management and his own stubbornness, which alienated his patrons. Still, the 1640s were a period of crisis, of inner uncertainty and external troubles. Rembrandt's outlook changed profoundly. After about 1650, his style forgoes the rhetoric of the High Baroque for lyric subtlety and pictorial breadth. Some exotic trappings from the earlier years remain, but they no longer create an alien, barbarous world.

We can trace this change in the many self-portraits Rembrandt painted over his long career. His view of himself reflects every stage of his inner development: experimental in the early Leyden years, theatrically disguised in the

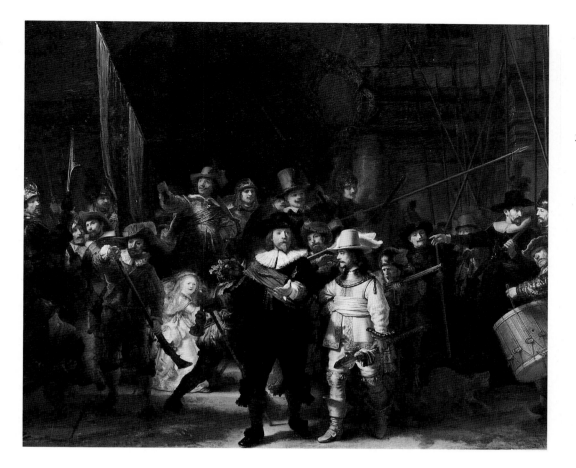

311. Rembrandt van Rijn.
"The Night Watch"
(*The Company of Captain
Frans Banning Cocq*). 1642.
Oil on canvas, 12'2" x 14'7"
(3.71 x 4.45 m). Rijks-
museum, Amsterdam

1630s, frank toward the end of his life. While our late example (fig. 312) is partially indebted to Titian's sumptuous portraits (compare fig. 250), Rembrandt scrutinizes himself with the same typically Northern candor found in Jan van Eyck's *Man in a Red Turban* (see fig. 197). This self-analytical approach helps account for the plain dignity we see in the religious scenes that play so large a part in Rembrandt's work in his later years.

Rembrandt's prints, such as *Christ Preaching* (fig. 313, page 371), show his depth of feeling. The sensuous beauty of *The Triumph of Dalila* has now yielded to a humble world of bare feet and ragged clothes. The scene is full of the artist's great compassion for the poor and outcast who make up Jesus' audience. Rembrandt may have had a special sympathy for Jews as the heirs of the biblical past and patient victims of persecution. Certainly he often drew and painted them. This print strongly suggests some corner in the Amsterdam Jewish ghetto and surely incorporates observations of life from the drawings he

habitually made throughout his career. Here it is the magic of light that endows *Christ Preaching* with spiritual significance.

Etching and Drypoint Rembrandt's importance as a ▼GRAPHIC ARTIST is second only to Dürer's, although we get no more than a hint of this from our single example. Like other creative printmakers of the day, he preferred **etching**, often combined with **drypoint**, to the techniques of **woodcut** and **engraving**, which were employed mainly to reproduce other works. An etching is made by coating a copper plate with resin to make an acid-resistant "ground," through which the design is scratched with a needle, laying bare the metal surface underneath. The plate is then bathed in an acid that etches (or "bites") the lines into the copper. To scratch a design with a needle into the resinous ground is an easier task than to gouge it with the burin used in engraving (see page 257). Hence, an etched line is smoother and more flexible

▼ A GRAPHIC ARTIST is one who makes prints by any of these printing methods: relief (woodcut, wood engraving), intaglio (engraving, etching, drypoint, aquatint, mezzotint), planographic (lithography), or monotype and stencil, or silkscreen, printing.

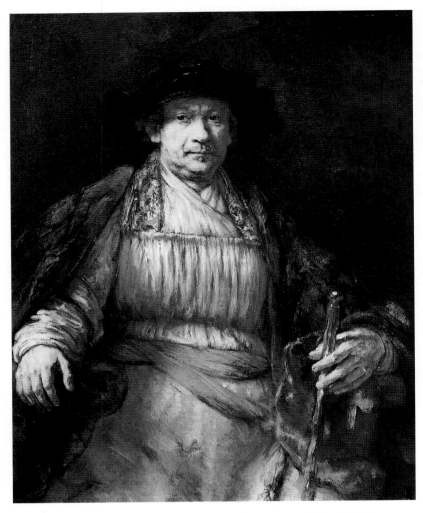

than an engraved line and preserves a sketchlike immediacy. As a result of its greater density of line, etching permits a wide tonal range, including velvety dark shades not possible in engraving or woodcut. Drypoint is made by scratching the design directly into the copper plate itself with a needle, which leaves a raised burr (the metal displaced by the needle) along the shallow line, which carries the ink. Since the burr quickly breaks down, a drypoint plate yields far fewer prints than an etched plate.

Landscape and Still Life Painters

Rembrandt's religious pictures demand an insight that was beyond the capacity of all but a few collectors. Most art buyers in Holland preferred subjects within their own experience: landscapes, architectural views, **still lifes**, everyday scenes. These various types, we recall, originated in the latter half of the sixteenth century. As they became fully defined, an unheard-of specialization began. The trend was not confined to Holland but is found throughout Europe to some degree. In both volume and variety, however, Dutch painters produced far more subtypes within each major division than anyone else.

Jacob van Ruisdael The richest of the newly developed "specialties" was landscape, both as a portrayal of familiar views and as an imaginative vision of nature. In *The Jewish Cemetery* (fig. 314) by Jacob van Ruisdael (1628/29–82),

312. Rembrandt van Rijn. *Self-Portrait*. 1658. Oil on canvas, 52 5/8 x 40 7/8" (133.7 x 103.8 cm). The Frick Collection, New York

Baroque Music, Theater, and Art in Holland

Dutch Protestant conservatism regarding music in the church inhibited the development of music in the Netherlands. Indeed, the only important Dutch composer in the seventeenth century was Jan Sweelinck (1562–1621). He was particularly noted for his psalm music, and he even enjoyed the protection of the town council from church authorities. Nevertheless, Sweelinck's strongest influence was felt not in Holland but in Germany, where his best

pupils were able to find employment and where a popular love of church music, fostered by Lutheranism, was widespread.

By contrast, Holland enjoyed a lively theatrical life, especially in Amsterdam. Dutch theater was partly an outgrowth of the societies of rhetoricians that had sprung up during the fifteenth century, and partly of the Dutch Academy, which was founded in 1617 as a "Netherlandish training school." The theater flourished also because the country was fortunate to produce a number of gifted playwrights at a time when rising nationalism placed new

emphasis on the Dutch language. The plots of many of the period's plays were Biblical stories, generally drawn from the Old Testament, and glorified the Dutch themselves as a new "chosen people." These dramas were an important inspiration to artists, particularly Rembrandt. Many of his paintings depict scenes drawn directly from these plays. Moreover, Rembrandt's use of exotic costumes and stage properties reveals a deep love of drama that helps account for the theatricality of his work.

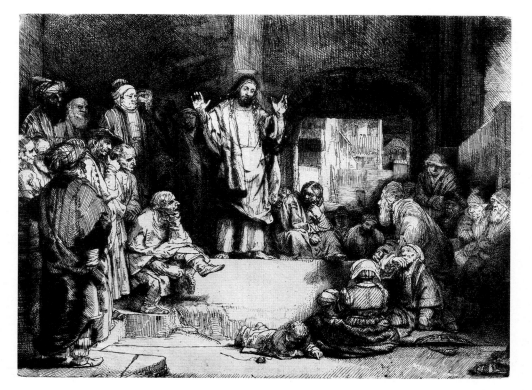

313. Rembrandt van Rijn.
Christ Preaching. c. 1652.
Etching, 6 1/8 x 8 1/8"
(15.6 x 20.6 cm).
The Metropolitan
Museum of Art, New York

Bequest of Mrs. H. O. Havemeyer,
1929. The H. O. Havemeyer
Collection

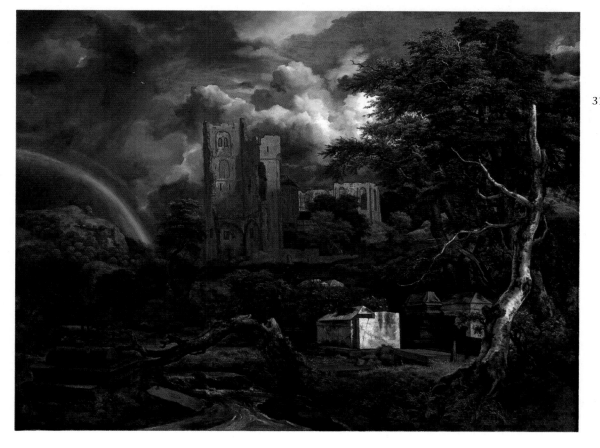

314. Jacob van Ruisdael.
The Jewish Cemetery.
1655–60. Oil on
canvas, 4'6" x 6'2 1/2"
(1.37 x 1.89 m).
The Detroit Institute
of Arts

Gift of Julius H. Haass
in memory of his brother
Dr. Ernest W. Haass

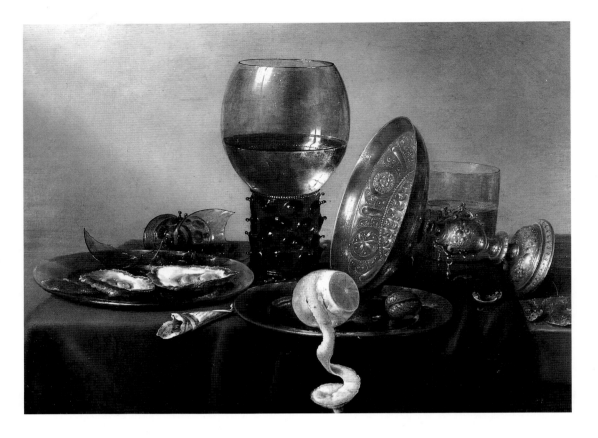

315. Willem Claesz Heda. *Still Life*. 1634. Oil on panel, 16⁷/₈ x 22⁷/₈" (42.9 x 58.1 cm). Boymans van Beuningen Museum, Rotterdam

▼ One of the sturdiest Protestant religions, CALVINISM arose in the mid-sixteenth century under the leadership of French reformer John Calvin (1509–64). While it shared most of its main tenets of belief with Lutheranism, Calvinism emphasized the doctrine of predestination, holding that believers were preselected by God, who likewise determined that others could not achieve salvation. Calvinism's belief that wordly success is a sign of God's grace encouraged thrift and hard work as moral virtues. Calvinism in Holland was received as Dutch orthodoxy; in France, Calvinism became the Huguenot movement; and in England, the response was the Puritan movement. Presbyterianism descends from Calvinism.

the greatest Dutch landscape painter, natural forces dominate the scene, which is frankly imaginary except for the tombs, depicting a Jewish cemetery near Amsterdam. The thunderclouds passing over a wild, deserted mountain valley, the medieval ruin, the torrent that has forced its way between ancient graves—all create a mood of deep melancholy. Nothing endures on this earth, the artist tells us: time, wind, and water grind all to dust, the feeble works of human hands as well as the trees and rocks. Even the elaborate tombs offer no protection from the same forces that destroy the church built in God's glory. Within the context of this extended allegory, the rainbow may nevertheless be understood as a sign of the promise of redemption through faith. Ruisdael's vision of nature harks back instead to Giorgione's tragic vision (see fig. 248). *The Jewish Cemetery* inspires that awe on which the Romantics (Chapter 22) later were to base their concept of the sublime. The difference is that,

for Ruisdael, nature ultimately remains apart from yet totally comprehensible to the viewer.

Willem Claesz Heda Still lifes are meant above all to delight the senses, but even they can be tinged with a melancholy air. Perhaps as a consequence of Holland's conversion to ▼CALVINISM, these visual feasts became vehicles for teaching moral lessons. In them, the disguised symbolism of "Late Gothic" painting lives on in a new form. Most Dutch Baroque still lifes treat the theme of *vanitas* (the transcience of all earthly things), either overtly or implicitly: they preach the virtues of temperance, frugality, and hard work by admonishing the viewer to contemplate the brevity of life, the inevitability of death, and the passing of all earthly pleasures. The imagery derives in part from emblem books, as well as other popular literature and prints, which encompass the prevailing ethic in words and pictures. The stern Calvinist sensibility is exemplified by homilies

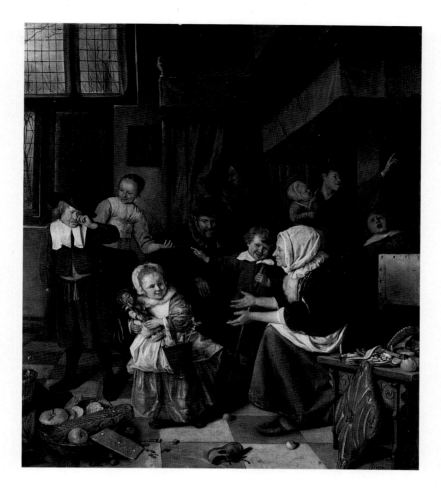

316. Jan Steen. *The Feast of Saint Nicholas.* c. 1660–65. Oil on canvas, 32¼ x 27¾" (81.9 x 70.5 cm). Rijksmuseum, Amsterdam

like "A fool and his money are soon parted" and is illustrated by flowers, shells, and other exotic luxuries. The presence in *vanitas* still lifes of precious goods, scholarly books, and objects appealing to the senses suggests an ambivalent attitude toward their subject. Such symbols, moreover, usually take on multiple meanings. In their most elaborate form, these moral allegories become visual riddles that rely on the very learning they sometimes condemn.

The **banquet** (or **breakfast**) **piece**, showing the remnants of a meal, had *vanitas* connotations almost from the beginning. The message may lie in such established symbols as death's-heads and extinguished candles or may be conveyed by less direct means. Willem Claesz Heda's *Still Life* (fig. 315) belongs to this widespread type. Food and drink are less emphasized here than luxury objects, such as crystal goblets and silver dishes, which are carefully

juxtaposed for their contrasting shape, color, and texture. Virtuosity was not Heda's only aim: he reminds us that all is vanity. Heda's "story," the human context of these grouped objects, is suggested by the broken glass, the half-peeled lemon, the overturned silver dish. The unstable composition, with its signs of a hasty departure, may be itself a reference to transience. Whoever sat at this table has been suddenly forced to abandon the meal. The curtain that time has lowered on the scene, as it were, invests the objects with a strange pathos.

Genre Painters

Jan Steen The large class of pictures termed **genre** is as varied as that of landscapes and still lifes. It ranges from tavern brawls to refined domestic interiors. *The Feast of Saint Nicholas* (fig. 316) by Jan Steen (1625/26–79) is midway

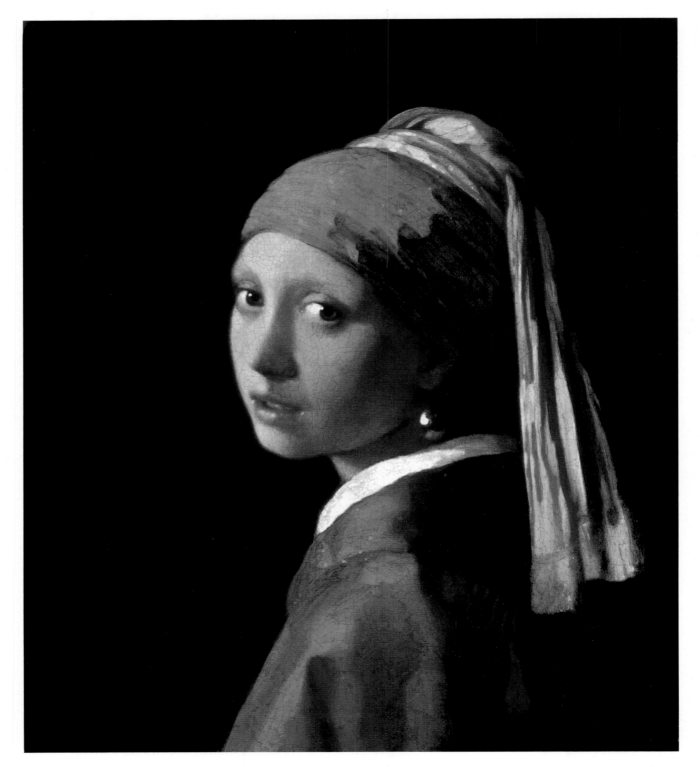

317. Jan Vermeer. *Girl with an Earring.* 1665–66. Oil on canvas, 18 1/4 x 15 3/8" (46.9 x 39 cm). Royal Cabinet of Paintings Mauritshuis, The Hague

between. Saint Nicholas has just paid his pre-Christmas visit to the household, leaving toys, candy, and cake for the children. Everybody is jolly except the bad boy on the left, who has received only a birch rod. Steen tells this story with relish, embroidering it with many delightful details. Of all the Dutch painters of daily life, he was the sharpest, and the most good-humored, observer. To supplement his earnings he kept an inn, which gave him ample opportunity to hone his keen insight into human behavior. His sense of timing and his characterization often remind us of Frans Hals (compare fig. 307), while his storytelling stems from the tradition of Pieter Bruegel the Elder (compare fig. 279).

Jan Vermeer In the genre scenes of Jan Vermeer (1632–75), by contrast, there is hardly any narrative. Single figures, usually women, engage in seemingly simple, everyday tasks; when there are two, they do no more than exchange glances. An especially beguiling example is *Girl with an Earring* (fig. 317). Though surely done from life, it is neither a portrait nor a genre scene, but a study in mood created through light alone. Vermeer was enchanted by the poetic possibilities of natural daylight, as was Judith Leyster before him (see fig. 309), but the idea of using an exotic costume and isolating the head against a dark background probably comes from Rembrandt, with whom Vermeer's teacher, Carel Fabritius (1622–54), had studied. Painted around the same time as *Woman Holding a Balance* (fig. 15), the canvas utilizes many of the same techniques. The young woman looks toward (but, typically for Vermeer, not at) the viewer. Everything is a harmony of contrasts, from the cool and warm tones of the turban and robe to the subtle gradations of light and shadow in the face. Colors are treated as broad areas of paint enlivened with beads of light, even in the corners of the lips. The effect serves to idealize the exquisite head through abstraction. With its white highlight, the large earring, probably glass, is of a size and shape to balance the girl's eyes and acts as a transition that carries light into the void behind her neck. (The painting would look surprisingly empty without it.) She exists in a timeless "still life" world, seemingly calmed by some magic spell. The cool, clear light that filters in from the left in our picture is the only active element, working upon all the objects in its path. As we look at *Girl with an Earring,* we feel as if a veil has been pulled from our eyes. The world shines with jewel-like freshness, beautiful as we have never seen it before. No painter since Jan Van Eyck *saw* as intensely as this. Nor shall we meet his equal again until the Rococo artist Chardin (see figs. 9, 335, 336).

Chapter 19

The Baroque in France and England

Under Henry IV, Louis XIII, and Louis XIV, France became the most powerful nation of Europe militarily and culturally. In this they were aided by a succession of extremely able ministers and advisers: the duc de Sully, Cardinal Richelieu, Cardinal Mazarin, and Jean-Baptiste Colbert. By the late seventeenth century, Paris was vying with Rome as the world capital of the major and minor arts, a position the Holy City had held for centuries.

We are tempted to think of French art in the age of Louis XIV as the expression of absolutism because of the Palace of Versailles and other vast projects glorifying the king of France. This is true of the climactic phase of Louis's reign, 1660–85, but by that time seventeenth-century French art had already attained its distinctive style.

The French are reluctant to call this style Baroque. To them, it is the Style of Louis XIV. They often describe the art and literature of the period as classic. In this context, the word *classic* has three meanings. It is first of all a synonym for *highest achievement*, which implies that the Style of Louis XIV corresponds to the High Renaissance in Italy or the age of Perikles in ancient Greece. The term also refers to the emulation of the forms and the subject matter of classical antiquity. Finally, *classic* suggests qualities of balance and restraint. The second and third of these meanings describe what could more accurately be called classicism. Since the Style of Louis XIV reflects Italian Baroque art, we may label it Baroque classicism.

The origin of this classicism was primarily artistic, not political. Sixteenth-century French architecture and, to a lesser extent, sculpture were more intimately linked with the Italian Renaissance than in any other Northern country. Classicism was also nourished by French humanism, with its intellectual heritage of reason and Stoic virtue, which reflected the values of the middle class, who dominated cultural and political life. These factors retarded the spread of the Baroque in France and modified its interpretation. Rubens's Medici cycle (see fig. 303), for example, had no effect on French art until the very end of the century. In the 1620s, when he painted it, the young artists in France were still assimilating early Baroque art.

Painting in France

Georges de La Tour Many of the early Baroque painters in France were influenced by Caravaggio, although how they absorbed his style is far from clear. They were for the most part minor artists toiling in the provinces, but a few developed highly original styles. The finest of them was Georges de La Tour (1593–1652), whose importance was not recognized until 200 years after his death. Although he spent his career in Lorraine in northeast France, he was by no means a simple provincial artist. In addition to being named a painter to the king, de La Tour regularly received important commissions for the governor of Lorraine. His mature religious pictures have great seriousness and grandeur. *Joseph the Carpenter* (fig. 318, page 378) might be mistaken for a genre scene were it not for its devotional spirit, which has the power of Caravaggio's *The Calling of Saint Matthew* (see fig. 284). The boy Jesus holds a candle, a favorite device with de La Tour, which lights the scene with an intimacy and tenderness reminiscent of Geertgen tot Sint Jans (compare fig. 202). de La Tour also shares Geertgen's tendency to reduce his forms to a geometric simplicity that elevates them above the everyday world, despite their apparent realism.

Nicolas Poussin Why was de La Tour so quickly forgotten? The reason is simply that after the 1640s, classicism was supreme in France. The clarity, balance, and restraint of de La Tour's art might be termed classical, especially when measured against other Caravaggesque painters, but he was certainly not a classicist. The artist who did the most to bring about the rise of classicism was Nicolas Poussin (1593/94–1665). The greatest French painter of the century and the first French painter in history to win international fame, Poussin nevertheless spent almost his entire career in Rome. There, under the inspiration of Raphael, he formulated the style that was to become the ideal model for French painters of the second half of the century.

The Abduction of the Sabine Women (fig. 319, page 378) shows his profound allegiance to antiquity. The painting epitomizes the severe discipline of Poussin's intellectual style, which developed in response to what he regarded as the excesses of the High Baroque. The strongly modeled figures are frozen in action like statues, and many are, in fact, derived from Hellenistic sculpture. Poussin has placed them before reconstructions of Roman architecture that he believed to be archeologically correct. The composition has an air of theatricality, and with good reason: it was worked out by moving clay figurines around a miniature stagelike setting until it looked right to the artist. Emotion is abundantly displayed, but it is so lacking in spontaneity that it fails to touch us. Clearly, the attitude reflected here is Raphael's. More precisely, it is Raphael as filtered through Annibale Carracci and his school (compare figs. 286, 287).

Poussin may strike us as a person who knew his own mind only too well, an impression confirmed by the numerous letters in which he expounded his views to friends and patrons. The highest aim of painting, he believed, is to represent noble and serious human actions. This is true even in *The Abduction of the Sabine Women*, which, ironically, was admired then as an act of patriotism that ensured the future of Rome. (According to the accounts of ▼LIVY and PLUTARCH, the ▼SABINE women abducted as wives by the Romans later became peacemakers between the two sides.) Be that as it may, such actions must be shown in a logical and orderly way—not as they really happened but as they would have happened if nature were perfect. To this end, the artist must strive for the general and typical. In appealing to the mind rather than the senses, he should suppress such incidentals as color and should stress form and composition. In a good picture, the beholder must be able to read the exact emotions of each figure and relate them to the story. These ideas were not new. We recall the ancient dictum *ut pictura poesis* ("as in painting, so in poetry") and Leonardo's statement that the highest aim of painting is to depict "the intention of man's soul." Before Poussin, however, no one made the analogy between painting and literature so closely, nor put it into practice so single-mindedly. His method accounts for the cold and

▼ Titus Livius, called LIVY (59 B.C.– A.D. 17), was a Roman historian whose *History of Rome* is a classic. He wrote forty-five books, publishing them five at a time. The first ten books are semilegendary accounts of Rome's founding and early history; the rest are more factual, although colored by Livy's intention to show, through its history, that Rome was destined for greatness.
 PLUTARCH (A.D. 46?–120)— Greek essayist, moral philosopher, and biographer—is especially appreciated for his *Parallel Lives*. Composed of biographies of illustrious Greeks and Romans, the *Lives* are regarded as historically valid and were, in fact, Shakespeare's source used for his Roman-history plays, among them *Anthony and Cleopatra* and *Julius Caesar*.

▼ Although the abduction of SABINE women by early Roman followers of Romulus is regarded as legendary, the Sabines were in fact an Italic people who moved from the mountains east of the Tiber River and settled on the hills that became the early city of Rome, as described in the margin of page 99.

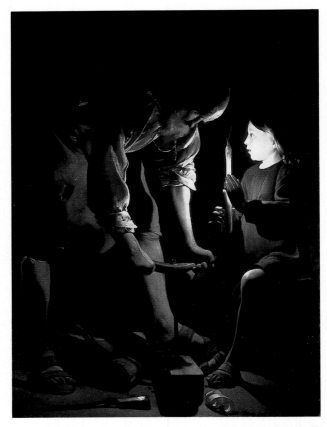

318. Georges de La Tour. *Joseph the Carpenter*. c. 1645. Oil on canvas, 51¹/₈ x 39³/₄" (129.9 x 101 cm). Musée du Louvre, Paris

overexplicit rhetoric in *The Abduction of the Sabine Women* that makes the picture seem so remote.

Poussin also painted "ideal landscapes" according to this theoretical view, with surprisingly impressive results, for they have an austere beauty and somber calm. This severe rationalism lasted until about 1650, when he began to paint a series of landscapes that return to the realm of mythology he had abandoned in middle age. These unite Titianesque light and color with the artist's Raphaelesque classicism to produce a new kind of mythological landscape, close in spirit to Claude Lorrain's (see fig. 321) but rich in personal associations that lend them multiple levels of meaning. Indeed, the artist's late ruminations have rightly been called transcendental meditations, for they contain archetypal imagery of universal significance. *The Birth of Bacchus* (fig.

319. Nicolas Poussin. *The Abduction of the Sabine Women.* c. 1636–37. Oil on canvas, 5'7/8" x 6'10⁵/8" (1.55 x 2.1 m). The Metropolitan Museum of Art, New York

Harris Brisbane Dick Fund, 1946

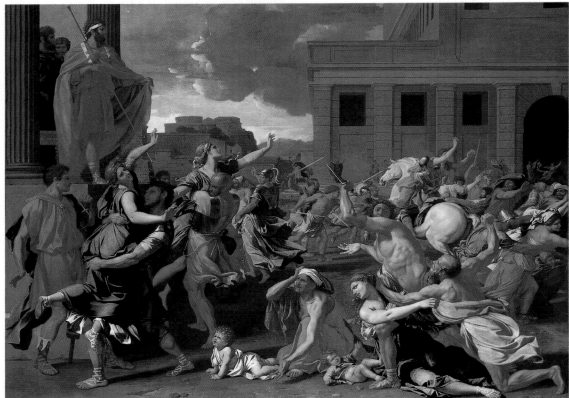

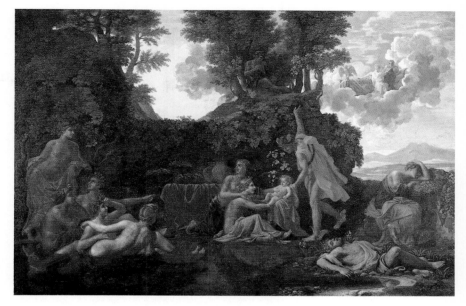

320. Nicolas Poussin. *The Birth of Bacchus*. c. 1657. Oil on canvas, 4'3/8" x 5'10 1/2" (1.23 x 1.79 m). Fogg Art Museum, Harvard University Art Museums, Cambridge, Massachusetts

320), among his most profound statements, takes up the great Stoic theme (which Poussin had treated twice already as a young man) that death is to be found even in the happiest realm. The painting shows the moment when the infant, created by Jupiter's union with the moon goddess Semele and born from his thigh, is delivered for safekeeping by Mercury to the river goddess Dirce, while the satyr Pan plays the flute in rapt inspiration. (Jupiter himself had been raised by sylvan deities.) The picture is not beautifully executed; the act of painting became difficult for the artist in old age, so that the brushwork is shaky. He nevertheless turned this liability to his advantage, and *The Birth of Bacchus* represents the purest realization of expressive intent in painted form. It is full of serene lyricism conveying the joy of life, on the one hand, and dark forebodings of death, on the other: to the right, the nymph Echo weeps over the dead Narcissus, the beautiful youth who spurned her love and instead drowned

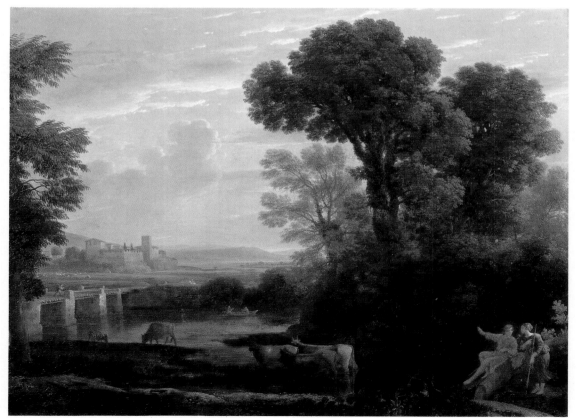

321. Claude Lorrain. *A Pastoral Landscape*. c. 1650. Oil on copper, 15 7/8 x 21 5/8" (40.3 x 54.9 cm). Yale University Art Gallery, New Haven, Connecticut

Leo C. Hanna, Jr., Fund

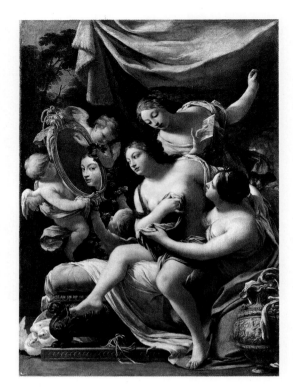

322. Simon Vouet. *The Toilet of Venus*. c. 1640.
Oil on canvas, 5'5¼" x 3'9" (1.66 x 1.14 m).
The Carnegie Museum of Art, Pittsburgh
Gift of Mrs. Horace Binney Hare, 52.7

▼ The Roman poet OVID (43 B.C.–
A.D. 17?) has been read, studied,
and admired for most of this mil-
lennium for his love poetry, his
METAMORPHOSES, and his
poetic letters. The *Metamorphoses*
are fifteen witty, playfully written
books of mythological transforma-
tions from the creation of the
world through the time of Julius
Caesar (whom Ovid changes
into a star). Ovid's influence can
be seen in the works of Ludovico
Ariosto and Giovanni Boccaccio,
Geoffrey Chaucer, William Shake-
speare, John Milton, and countless
other writers.

kissing his reflection. Poussin treats the story, taken from ▼OVID'S *METAMORPHOSES*, as part of the eternal cycle of nature, in which the gods embody natural forces and the myths contain fundamental truths. Although he certainly drew on the pantheistic writings of learned humanists, it is the artist's personal synthesis that brings these ideas to life.

Claude Lorrain If Poussin developed the heroic qualities of the ideal landscape, the great French landscapist Claude Lorrain (1600–82) brought out its idyllic aspects. He, too, spent almost his entire career in Rome. Like many Northerners, Claude explored the countryside outside that city (the Campagna) more thoroughly and affec-tionately than any Italian. Countless drawings made on the spot bear witness to his extraordi-nary powers of observation. He is also docu-

mented as having sketched in oils from nature, the first artist known to have done so. Sketches, however, were only the raw material for his paintings, which do not aim at topographic exactitude but evoke the poetic essence of a countryside filled with echoes of antiquity. Often, as in *A Pastoral Landscape* (fig. 321), the compositions are suffused with the hazy, lumi-nous atmosphere of early morning or late after-noon. The space expands serenely, rather than receding step by step as in Poussin's ideal land-scapes. An air of nostalgia hangs over such vistas, of past experience gilded by memory. Hence, they appealed especially to the English who had seen Italy only briefly or even not at all.

Simon Vouet At an early age, Simon Vouet (1590–1649), too, went to Rome, where he became the leader of the French Caravag-gesque painters; unlike Poussin and Claude, he returned to France. Upon settling in Paris, he quickly shed all vestiges of Caravaggio's manner and formulated a colorful style based on Carracci's, which won such acclaim that Vouet was named first painter to the king. He also brought with him memories of the great north Italian precursors of the Baroque. *The Toilet of Venus* (fig. 322) depicts a subject pop-ular in Venice from the time of Titian and Veronese. Vouet's figure looks back as well to Correggio's *Jupiter and Io* (see fig. 261), but without Io's frank eroticism. Instead, she has been given an elegant sensuousness that could hardly be further removed from Poussin's dis-ciplined art. Ironically, *The Toilet of Venus* was painted around 1640, toward the beginning of Poussin's ill-fated sojourn in Paris, where he had gone at the invitation of Louis XIII. Poussin met with no more success than Bernini was to have twenty-five years later (see page 382). After several years, Poussin left, deeply disillusioned by his experience at the court, whose taste and politics Vouet understood far better. In one sense, their rivalry was to continue long afterward. Vouet's decorative manner pro-vided the foundation for the Rococo (Chapter 20), but it was Poussin's classicism that soon dominated art in France. The two traditions vied with each other through the Romantic era,

Baroque Music and Theater in France

The central fact of French culture in the seventeenth century was the taste for classicism, already well established in the mid-sixteenth century. The Pléiade, a group of poets lead by Pierre de Ronsard, was founded in 1550 to develop French literature along the lines of Greek and Roman poetry and plays. Around the same time, court festivals became popular, as did INTER-MEZZI (also called BALLETS DE COUR), which combined song, dance, drama, and spectacle in the "antique" manner. French public theater was monopolized by the Confrérie de la Passion (Confraternity of the Passion), which was given total control over secular drama. (Religious plays were banned in 1548.) These three factors—classical taste, antiquarianism, and court patronage—decisively shaped French theater. The preference for classicism was reinforced by Henry II's Italian queen, Catherine de' Medici (reigned 1560–74). However, the development of the arts was disrupted by the Wars of Religion that broke out in 1562 between Catholics and Protestants. Hostilities continued until the Protestants were defeated in 1629 by the soldiers of Louis XIII under the direction of prime minister Cardinal Richelieu (1585–1642).

The end of the Wars of Religion placed Richelieu in a position of immense power. A highly cultivated man, he now turned his attention not only to governing France, but also to patronage of the arts. In 1628, the same year that the Protestants were defeated, the French Academy, a small group of intellectuals, began to meet informally to discuss literature. At Cardinal Richelieu's behest, it became a state institution based on Italian models in 1636. The Academy required that theater teach moral lessons and adhere to the Italian concept of verisimilitude (see page 311). This was the first of a number of French academies that would be founded during the course of the seventeenth century to foster painting and sculpture, music, architecture, and even dance. These state-controlled academies oversaw the training of young artists and were responsible for awarding royal commissions. As time went on, the academies became increasingly authoritarian, eventually exercising rigid control over all of the arts.

The foremost French dramatist was Alexandre Hardy (c. 1572–1632), a prolific playwright who wrote some 700 TRAGICOME-DIES (plays of serious subject that end happily) and PASTORAL PLAYS for the Hôtel de Bourgogne, the only permanent playhouse in Paris before the end of the wars in 1629. Otherwise, plays were performed on tennis courts (jeux de paume), with a platform erected as a stage. Cardinal Richelieu took a particular interest in drama and personally employed five playwrights to work under his supervision. The only one to achieve lasting fame was Pierre Corneille (1606–84), whose tragedies, drawn from ancient history and mythology, center on the hero who chooses death over dishonor. They are written in the ornate, emotional language that defined French classical drama before 1650. In 1640 Richelieu had a theater erected at his palace, the first in France to feature a proscenium (the arch separating the stage from the auditorium), an innovation from Italy that was soon to become standard throughout Europe.

French theatrical writing reached its zenith in the plays of Jean Racine (1639–99), whose tragedies in the Greek manner revolved around the conflict of desire and duty, expressed in direct, simple language that quickly replaced the elaborate language of Corneille. Early in his career Racine had been befriended by Molière (Jean-Baptiste Poquelin, 1622–73), whose plays marked the high tide of French comedy during the same decades. *The Misanthrope* (1666) and *Tartuffe* (1664) are masterpieces of cynical wit. In 1680 the Comédie Française was formed by royal decree, combining Molière's troupe with that of the rival Hôtel de Bourgogne. The Comédie Française was given a monopoly of all dramas in French, with the sole exception of the immensely popular Commedia dell'arte (see box, page 357), which was banned in 1697 for an imagined slight to the king's mistress.

The arts during the reign of Louis XIV were intended to glorify the king, and classicism had an essential role to play. Classicism was favored not only because of its learning and elevated moral tone, but also because it suggested that France was the successor to Greece and Rome. In the Academy debates of the later century known as the Battle of the Ancients and the Moderns, French academicians even sought to show the supremacy of French culture by using it to replace antiquity as the new standard.

When Louis XIV reached the age of legal majority and assumed full power as monarch, he began construction of a new palace at Versailles, outside Paris. Even before it was completed in 1685, he staged huge spectacles such as *The Pleasure of the Enchanted Land* (1664). The king also enjoyed operas and ballets by his court composer and dancing master, Jean-Baptiste Lully (1632–87). Lully had initially collaborated with the Molière on comic ballets for the court, but the two ceased to work together in 1672 because of Lully's unscrupulous practices. Lully then forged a close relationship with the playwright Philippe Quinault (1635–88). Their work was comparable in character to the tragedies of Corneille and Racine. Because he clung to the Florentine ideal of emphatic declamation, Lully composed music of measured and stately simplicity. He also introduced additional choruses and ballets to the opera, which lent the performances a greater pageantry that benefited greatly from the costumes designed by Jean Berain (1637–1711). The results were sober and pompous, but also colorful—perfectly suited to life at Versailles. Indeed, Lully occupied a position in French music comparable to that of Charles Le Brun in the arts (see page 382). In 1672 he merged the academies of music and dance to create the forerunner of the Opéra, the national opera company of France. His only rivals were the composers Marc-Antoine Charpentier (1634–1704), music director to the Jesuit order in Paris and the greatest French composer of religious music, and François Couperin (1668–1733), organist to the king at Versailles, whose harpsichord and orchestral suites are notable for their lively invention.

The political system that gives rise to an ABSOLUTE MONARCH is absolutism, in which full, unlimited, and unchecked power to rule a nation is in the hands of a single individual (an absolute monarch) or a group of rulers (oligarchs). Absolutism emerged in Europe near the end of the fifteenth century and is most clearly embodied by the reign Louis XIV of France.

alternating in succession without either gaining the upper hand for long.

The Royal Academy

When young Louis XIV took over the reins of government in 1661, Jean-Baptiste Colbert, his chief adviser, built the administrative apparatus to support the power of the ▼ABSOLUTE MONARCH. In this system, aimed at subjecting the thoughts and actions of the entire nation to strict control from above, the visual arts had the task of glorifying the king, and the official "royal style," in both theory and practice, was classicism. Centralized control over the visual arts was exerted by Colbert and the artist Charles Le Brun (1619–90), who became supervisor of all the king's artistic projects. As chief dispenser of royal art patronage, Le Brun commanded so much power that for all practical purposes he was the dictator of the arts in France. This authority extended beyond the power of the purse. It also included a new system of educating artists in the officially approved style.

Throughout antiquity and the Middle Ages, artists had been trained by apprenticeship, and this time-honored practice still prevailed during the Renaissance. As painting, sculpture, and architecture gained the status of liberal arts, artists wished to supplement their "mechanical" training with theoretical knowledge. For this purpose, art academies were founded, patterned on the academies of the humanists. (The name *academy* is derived from the term for the Athenian grove where Plato met with his disciples.) Art academies appeared first in Italy in the late sixteenth century. They seem to have been private associations of artists who met periodically to draw from the model and discuss questions of art theory. These academies later became formal institutions that took over some functions from the guilds, but their teaching was limited and far from systematic.

This was the case as well with the Royal Academy of Painting and Sculpture in Paris, founded in 1648. But when Le Brun became its director in 1663, he established a rigid curriculum of compulsory instruction in practice and theory, based on a system of rules. This set the pattern for all later academies, including their successors, the art schools of today. Much of this doctrine was derived from Poussin's views, but it was carried to rationalistic extremes. The Academy even devised a method for tabulating, in numerical grades, the merits of artists past and present in such categories as drawing, expression, and proportion. The ancients received the highest marks, needless to say, then came Raphael and his school, then Poussin. The Venetians, who "overemphasized" color, ranked low; the Flemish and Dutch, even lower. Subjects were similarly classified, from "history" (that is, narrative subjects, be they classical, biblical, or mythological) at the top to still life at the bottom.

Architecture in France

The Louvre Baroque classicism as the official royal style extended to architecture. The choice was deliberate, as can be seen from the history of the first great project Colbert directed, the completion of the Louvre. Work on the palace had proceeded intermittently for more than a century, along the lines of Lescot's design (see fig. 281). What remained to be done was to close the square court on the east side with an impressive facade. Colbert, dissatisfied with the proposals of French architects, invited Bernini to Paris in the hope that the most famous architect of the Roman Baroque would do for the French king what he had already done so magnificently for the Church. Bernini spent several months in Paris in 1665 and submitted three designs, all on a scale that would have completely engulfed the existing palace. After much argument and intrigue, Louis XIV rejected these plans and turned over the problem of a final design to a committee of three: Charles Le Brun, his court painter; Louis Le Vau, his court architect, who had worked on the project earlier; and Claude Perrault, who was a student of ancient architecture, not a professional architect. All three were responsible for the structure that was actually built (fig. 323), although Perrault is usually credited with the major share.

The design in some ways suggests the mind of an archeologist, but one who knew how to

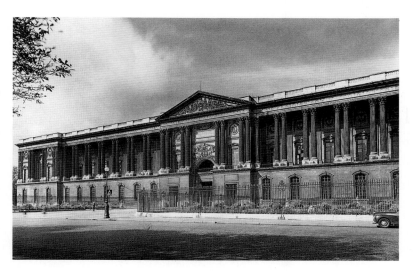

select those features of classical architecture that would link Louis XIV with the glory of the Caesars and still be compatible with the older parts of the palace. The center pavilion is based on a Roman temple front, and the wings look like the flanks of that temple folded outward. The temple theme demanded a single order of freestanding columns, but the Louvre had three stories. This difficulty was skillfully resolved by treating the ground story as the podium of the temple and recessing the upper two behind the screen of the colonnade. The combination of grandeur and elegance fully justifies the design's fame. The east front of the Louvre signaled the victory of French classicism over Italian Baroque as the royal style. Ironically, this great example proved too pure, and Perrault soon faded from favor.

Palace of Versailles The king's largest enterprise was the Palace of Versailles, just over eleven miles from the center of Paris. It was begun in 1669 by Le Vau, who died within a year, then was turned over to Jules Hardouin-Mansart (1646–1708), who expanded the entire project greatly to accommodate the ever-growing royal household. The garden front (fig. 324), intended by Le Vau to be the principal view of

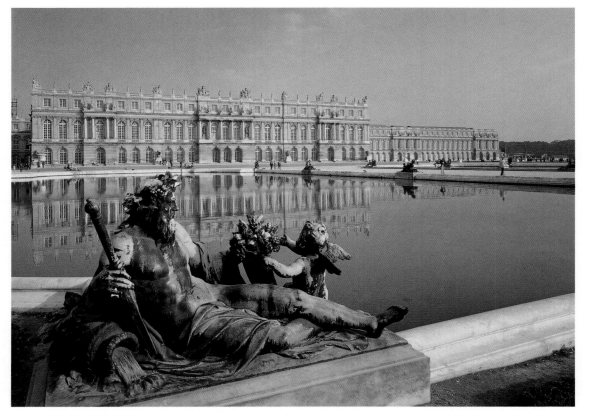

324. Louis Le Vau and Jules Hardouin-Mansart. Garden front, center block, Palace of Versailles. 1669–85

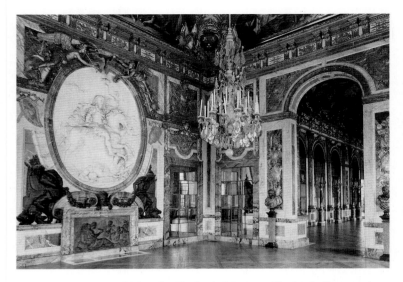

325. Jules Hardouin-Mansart, Charles Le Brun, and Antoine Coysevox. Salon de la Guerre, Palace of Versailles. Begun 1678

the palace, was stretched to an enormous length with no modification of the architectural membering, so that his original facade design, a less severe variant of the east front of the Louvre, now looks repetitious and out of scale. The whole center block contains a single room, the famous Galerie des Glaces (Hall of Mirrors), with the Salon de la Guerre (War) and its counterpart, the Salon de la Paix (Peace), at either end.

Baroque features, although not officially acknowledged, reappeared inside the palace. This difference corresponded to the king's own taste. Louis XIV was interested less in architectural theory and monumental exteriors than in the lavish interiors that would make suitable settings for himself and his court. Thus, the person to whom he really listened was not an architect but the painter Le Brun. Le Brun began as a pupil of Vouet and then spent several years studying under Poussin in Rome. The great decorative schemes of the Roman Baroque must also have impressed him, for they stood him in good stead twenty years later, both in the Louvre and at Versailles. He became a superb decorator, utilizing the combined labors of architects, sculptors, painters, and artisans for ensembles of unheard-of splendor. To

subordinate all the arts to the single goal of glorifying Louis XIV was in itself Baroque. Le Brun drew freely on his memories of Rome for the Salon de la Guerre (fig. 325), which seems close in many ways to the Cornaro Chapel (compare fig. 297), although Le Brun obviously emphasized surface decoration far more than did Bernini. As in so many Italian Baroque interiors, the separate ingredients here are less splendid than the effect of the whole.

Apart from the magnificent interior, the most impressive aspect of Versailles is the park extending west of the garden front for several miles. (The view in figure 326 shows only a part of it.) Its design, by André Le Nôtre (1613–1700), is so strictly correlated with the plan of the palace that it becomes a continuation of the architectural space. Like the interiors, these formal gardens, with their terraces, basins, clipped hedges, and statuary, were meant to provide an appropriate setting for the king's appearances in public. They form a series of "outdoor rooms" for the splendid fetes and spectacles that Louis XIV so enjoyed. The spirit of absolutism is even more striking in the geometric regularity imposed upon an entire countryside than it is in the palace itself.

Jules Hardouin-Mansart At Versailles, Jules Hardouin-Mansart worked as a member of a team, constrained by the design of Le Vau. His own architectural style can be better seen in the Church of the Invalides (figs. 327, 328), named after the institution for disabled soldiers of which it formed one part. The building presents a combination of Italian Renaissance and Baroque features, but reinterpreted in a distinctly French manner. The plan, consisting of a Greek cross with four corner chapels, is based ultimately (with various French intermediaries) on Michelangelo's plan for St. Peter's (see fig. 245); its only Baroque element is the oval choir. The dome, too, reflects the influence of Michelangelo, and the classicistic vocabulary of the facade is reminiscent of the east front of the Louvre, but the exterior as a whole is unmistakably Baroque. It breaks forward repeatedly in the crescendo effect introduced by Maderno (see fig. 290). And, as in Borromini's Sta. Agnese in Piazza Navona

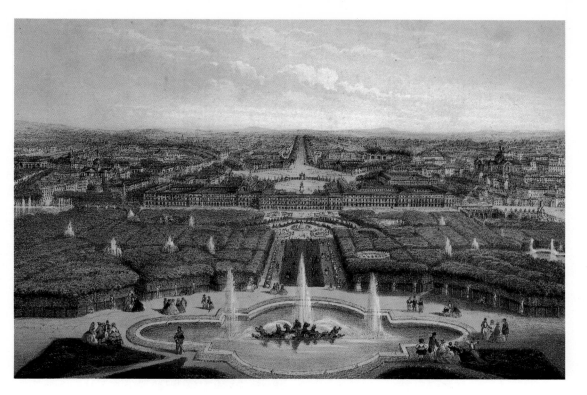

326. Palace and gardens of Versailles

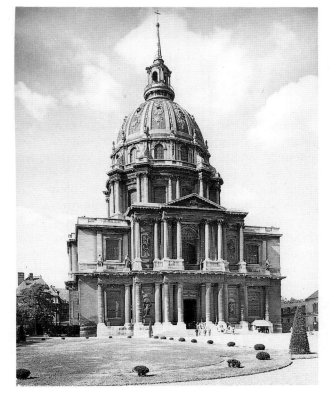

327. Jules Hardouin-Mansart. Church of the Invalides, Paris. 1680–91

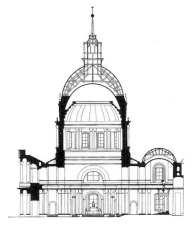

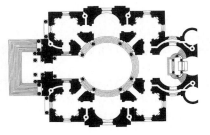

328. Section and plan of the Church of the Invalides

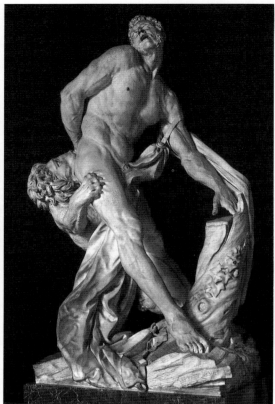

329. Antoine Coysevox. *Charles Le Brun*. 1676. Terracotta, height 26" (66 cm). Wallace Collection, London

330. Pierre-Paul Puget. *Milo of Crotona*. 1671–83. Marble, height 8'10¹⁄₂" (2.71 m). Musée du Louvre, Paris

(see fig. 293), the facade and dome are closely correlated. The dome itself is the most original, and the most Baroque, feature of Hardouin-Mansart's design. Tall and slender, it rises in one continuous curve from the base of the drum to the spire atop the lantern. On the first drum rests, surprisingly, a second, narrower drum. Its windows provide light for the painted vision of heavenly glory inside the dome, but they themselves are hidden behind a pseudo-shell with a large opening at the top, so that the heavenly glory seems mysteriously illuminated and suspended in space. Theatrical lighting so boldly directed would do honor to any Italian Baroque architect.

Sculpture in France

Sculpture arrived at the official royal style in much the same way as did architecture. While in Paris, Bernini carved a marble bust of Louis XIV and was commissioned to do an equestrian statue of him. The latter project shared the fate of Bernini's Louvre designs. Although he portrayed the king in classical military garb, the statue was rejected. Apparently it was too dynamic to safeguard the dignity of Louis XIV. This decision was far-reaching, for equestrian statues of the king were later erected throughout France as symbols of royal authority, and Bernini's design, had it succeeded, might have set the pattern for these monuments.

Antoine Coysevox Bernini's influence can be felt in the work of Antoine Coysevox (1640–1720), one of the sculptors Le Brun employed at Versailles. The victorious Louis XIV in Coysevox's large stucco relief for the Salon de la Guerre (see fig. 325) retains the pose of Bernini's rejected

Baroque Music, Theater, and Art in England

In England, court MASQUES adapted from Italian court pageants played a similar role to the French *ballets de cour* in that they promoted an idealized vision of monarchy presented through allegory and myth expressed in elegant speeches, music, and dance. Many of these masques were created for James I by the playwright Ben Jonson (1572–1637) and staged by the architect Inigo Jones (1573–1652), who became surveyor of the king's works in 1615. Upon the overthrow in 1642 of Charles I by the Puritans—whose religious views demanded the most austere social standards—all theaters were closed, and remained so during the Commonwealth, the Puritan period of rule led by Oliver Cromwell. Theaters were reopened only when the monarchy was restored in 1660. The Restoration, as the reign of the new king, Charles II, came to be known, was a great period of creativity for theater and music. There was an almost immediate demand for new plays, which were supplied by John Dryden (1631–1700), whose work was influenced by Shakespeare and the classical Roman authors. The later plays by Dryden are rather stilted, moralizing tragedies about people of noble birth. Comedy fared better, while adhering to the same goal of moral instruction. *The Rover: or the Banished Cavalier* (1677) by Mrs. Aphra Behn (1640–89) and *The Way of the World* (1700) by William Congreve (1670–1729) and John Vanbrugh (best known as a royal architect) are uproarious comedies of manners that reflect the cynicism—and what later critics would call the licentiousness—of the age. The Restoration marked a revolution in English theater: not only did women begin to write plays, they appeared on the legitimate stage for the first time. Some became sensationally successful: one, Nell Gwynn, soon retired from the stage to become Charles II's mistress.

Theater gave rise to a new class of stage music by the leading composer of the Restoration, Henry Purcell (1659–95). During the Commonwealth, English operas were plays set to music, which managed to avoid the ban against theater because they were considered concerts. This practice continued even during the Restoration. Thus, *Venus and Adonis*, by Henry Purcell's teacher John Blow (1649–1708), is essentially a masque in disguise. A large part of Purcell's output is theater music, such as *The Fairy Queen* (1692), which is a free adaptation of Shakespeare's *A Midsummer Night's Dream*. The closest Purcell came to opera was *Dido and Aeneas* (1689), which is basically a CONCERT OPERA reputedly composed for a girls' boarding school but perhaps given as a court entertainment instead. Blow and Purcell also wrote numerous odes for the royal family and to celebrate special occasions, as well as many church anthems and a considerable body of chamber music and keyboard works.

equestrian statue, albeit with a certain restraint. Coysevox is the first of a long line of distinguished French portrait sculptors. His bust of Le Brun (fig. 329) likewise repeats the general outlines of Bernini's bust of Louis XIV. The face, however, shows a realism and a subtlety of characterization that are Coysevox's own.

Pierre-Paul Puget Coysevox approached the Baroque in sculpture as closely as Le Brun would permit. Pierre-Paul Puget (1620–94), the most talented and most Baroque of seventeenth-century French sculptors, had no success at court until after Colbert's death, when the power of Le Brun was on the decline. *Milo of Crotona* (fig. 330), Puget's finest statue, bears comparison to Bernini's *David* (see fig. 295). Puget's composition is more contained than Bernini's, but the agony of the hero is such that its impact on the beholder is almost physical. The internal tension fills every particle of marble with an intense life that recalls Hellenistic sculpture. That, one suspects, is what made it acceptable to Louis XIV.

England

The English made no significant contribution to Baroque painting and sculpture. They were content instead with offshoots of Van Dyck's portraiture by imported artists like the Dutch-born Peter Lely (1618–80) and his German successor Godfrey Kneller (1646–1723). The English achievement in architecture, however, was of genuine importance. This is all the more surprising in light of the fact that the insular form of "Late Gothic" known as the Perpendicular style (see fig. 164) proved extraordinarily persistent. English architecture absorbed the stylistic vocabulary of the Italian Renaissance during the sixteenth century, but as late as 1600, English buildings still retained a "Perpendicular syntax." However, supported by Palladio's authority as a theorist, England stood as a beacon of classicist orthodoxy for 200 years.

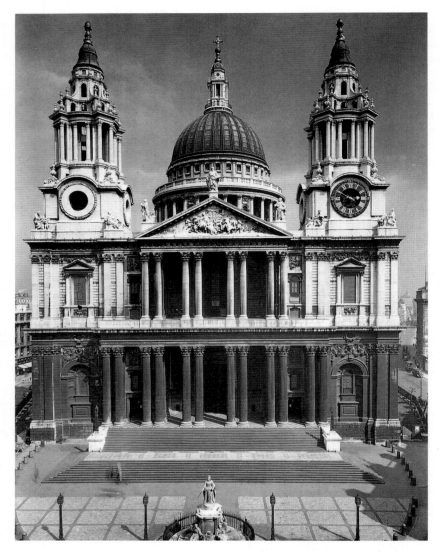

331. Christopher Wren. Facade of St. Paul's Cathedral, London. 1675–1710

part of the Renaissance artist-scientist. An intellectual prodigy, he first studied anatomy, then physics, mathematics, and astronomy, and he was highly esteemed by Isaac Newton. His serious interest in architecture did not begin until he was about thirty. However, it is characteristic of the Baroque as opposed to the Renaissance that there is apparently no direct link between his scientific and artistic ideas. It is hard to determine whether his technological knowledge significantly affected the shape of his buildings.

Had not the great London fire of 1666 destroyed the Gothic cathedral of St. Paul and many lesser churches, Wren might have remained an amateur architect. But following that catastrophe, he was named to the royal commission for rebuilding the city, and a few years later he began his designs for St. Paul's. The English tradition did not suffice for this task, beyond providing a starting point. On his only trip abroad, Wren had visited Paris at the time of the dispute over the completion of the Louvre, and he must have sided with Perrault, whose design for the east front is clearly reflected in the facade of St. Paul's. Yet, despite his belief that Paris provided "the best school of architecture in Europe," Wren was not indifferent to the achievements of the Roman Baroque. He must have wanted the new St. Paul's to be the St. Peter's of the Church of England: soberer and not so large, but equally impressive. His dome, like that of St. Peter's, has a diameter as wide as nave and aisles combined, but it rises high above the rest of the structure and dominates even our close view of the facade. The lantern and the upper part of the clock towers also suggest that he knew Borromini's Sta. Agnese in Piazza Navona (see fig. 293), probably from drawings or engravings. St. Paul's fittingly marks the end of an era. Its resolute classicism tames Borromini's Baroque exuberance, which was to provide the point of departure for St. Charles Borromaeus by Johann Fischer von Erlach, the first great church of the Rococo (see fig. 342).

Christopher Wren Classicism can be seen in some parts of St. Paul's Cathedral (fig. 331) by Christopher Wren (1632–1723), the great English architect of the late seventeenth century. The church is an up-to-date Baroque design reflecting a thorough acquaintance with contemporary architecture in Italy and France. Wren came close to being a Baroque counter-

Chapter 20
ROCOCO

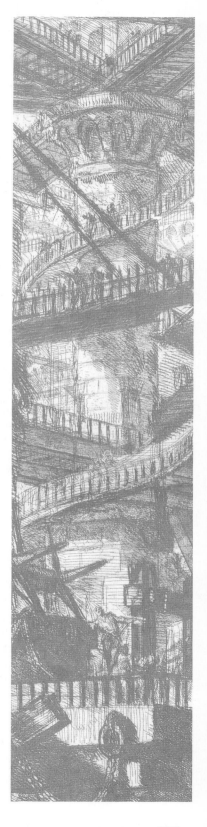

Much as the Baroque is often considered the final phase of the Renaissance, so the Rococo is generally thought of as the end of the Baroque—a long and delicious twilight, succeeded by the new day of Neoclassicism. In France, the Rococo is linked with the reign of Louis XV (reigned 1715–74), with which it corresponds roughly in date. However, it cannot be identified with the absolutist state or the Church any more than can the Baroque, even though they continued to provide its main patronage. Moreover, the essential characteristics of Rococo style were created before the king was born: its first signs appear as much as fifty years earlier, during the lengthy transition that constitutes the Late Baroque. Nevertheless, the view of the Rococo as the final phase of the Baroque is not without basis: as the writer François-Marie Arouet Voltaire acknowledged, the eighteenth century lived in the debt of the past. In art, Poussin and Rubens cast their long shadows over the Rococo. The controversy between their partisans, in turn, goes back much further to a debate between the supporters of Michelangelo and of Titian over the merits of design versus color. In this sense, the Rococo, like the Baroque, still belongs to the Renaissance world.

To overemphasize the similarities and stylistic debt of the Rococo to the Baroque, however, risks ignoring a fundamental difference between them. What is Rococo? In a word, it is fantasy. If the Baroque presents theater on a grand scale, the Rococo stage is smaller, more intimate. At the same time, the Rococo is both more lighthearted and more tender-minded, marked equally by playful whimsy and wistful nostalgia, evoking an enchanted realm that presents a temporary diversion from real life. To its considerable credit, the Rococo also discovered the world of love, and it broadened the range of human emotion in art to include, for the first time, the family as a major theme.

Throughout the history of most societies, aesthetic and practical intentions were not regarded as contradictory or incompatible. It was in the West in the late eighteenth century, led by the European academies and fueled by intellectual environment of the Enlightenment, that FINE ARTS (painting, sculpture, drawing, and architecture) were elevated at the expense of the so-called MINOR ARTS, which include ceramics, textiles and weaving, metalwork and gold- and silversmithery, furniture, glassware and stained glass, and enamel work. *DECORATIVE ARTS* and *APPLIED ARTS* have been used interchangeably with *minor arts* ever since.

Another term, *CRAFTS*, has been in and out of favor for a long time. Until the late Middle Ages in the West, crafts were art; they were art again in Rococo Europe and during the Arts and Crafts movement at the turn of this century.

France

The Rise of the Rococo After the death of Louis XIV, the centralized administrative machine that his chief adviser, Jean-Baptiste Colbert, had created ground to a stop. The nobility, formerly attached to the court at Versailles, was now freer of royal surveillance. Many of them chose not to return to their ancestral châteaux in the provinces but to live in Paris, where they built elegant town houses, known as *hôtels*. As state-sponsored building activity was declining, the field of "design for private living" took on new importance. These city sites were usually cramped and irregular, so that they offered scant opportunity for impressive exteriors. Hence, the layout and decor of the rooms became the architects' main concern. The *hôtels* demanded a style of interior decoration less grandiloquent and cumbersome than Le Brun's at Versailles. They required instead an intimate, flexible style that would give greater scope to individual fancy uninhibited by classicistic dogma. French designers created the Rococo (the Style of Louis XV, as it is often called in France) from Italian gardens and interiors to fulfill this need. The name fits well: it was coined as a caricature of *rocaille* (rock) and *coquillage* (shell), echoing the Italian *barocco*, which meant the playful decoration of grottoes with irregular stones and shells

The Decorative Arts

It was in the decorative arts that the Rococo flourished above all. We have not considered the decorative arts among the fine arts until now, because the conservative nature of the crafts encouraged only limited creativity for all but a few individuals of outstanding ability. But the latter half of the seventeenth century was a period of unprecedented change in French design. A central role was played by Colbert, who in the 1660s acquired the Gobelins manufactories (named after the brothers who founded the dye and tapestry works) for the crown and turned them into royal works supplying luxurious furnishings, including tapestries, to the court under the direction of the king's chief artistic adviser, Charles Le Brun.

After 1688, the War of the League of Augsburg forced major economies on the crown, including reductions at the Gobelins that gradually loosened central control of the decorative arts and opened the way to new stylistic developments. Thus, the situation paralleled the decline of the Academy's tyrannical influence over the fine arts, which gave rise to the Rococo in painting (see page 382).

This does not explain the excellence of French decor, however. Critical to its development was the importance assigned to designers: their engravings established new standards of design that were expected to be followed by artisans, who thereby lost much of their independence. Let us note, too, the collaboration of architects, who became increasingly involved in the decoration of the rooms they designed. Together with sculptors, who often designed the ornamentation, they helped to elevate the decorative arts virtually to the level of the fine arts, thus establishing a tradition that has continued into modern times.

During the Rococo, in fact, all the arts were considered to be on an equal footing, so that the finest designers and furniture makers were recognized as great artists in their own right. Thus, the decorative arts played a unique role during the Rococo. *Hôtel* interiors were more than assemblages of objects. They were total environments put together with fastidious care by discerning collectors and the talented architects, sculptors, decorators, and dealers who catered to their taste. A room, like a single item of furniture, could involve the services as well of a wide variety of artisans—cabinetmakers, wood carvers, goldsmiths and silversmiths, upholsterers, porcelain makers—all dedicated to producing the ensemble, even though each craft was, by tradition, a separate specialty subject to strict regulations. Together they fueled the insatiable hunger for novelty that swept Europe in the eighteenth century.

Nicolas Pineau Virtually none of the Rococo rooms has survived intact. Like the furniture they housed, most have been destroyed, heavily altered, or dispersed. We can nevertheless get a good idea of their appearance by the

reconstruction of one such room from the Hôtel de Varengeville, Paris, designed around 1735 by Nicolas Pineau (1684–1754) for the duchesse de Villars (fig. 332). The walls and ceiling are encrusted with ornamentation, and the elaborately carved furniture is adorned with gilt bronze. Everything swims in a sea of swirling patterns united by the most sophisticated sense of design and materials the world has ever known. There is no clear distinction between decoration and function—for example, in the clock on the mantel and the statuette in the corner of our illustration. Note, too, how the paintings have been integrated into the room.

Painting

"Poussinistes" versus "Rubénistes" It is hardly surprising that the straight-jacket system of the French Academy (see page 382) produced no significant artists. Even Le Brun, as we have seen, was far more Baroque in his practice than we would expect from his classicistic theory. The absurd rigidity of the official doctrine generated, moreover, a counterpressure that vented itself as soon as Le Brun's authority began to decline. Toward the end of the century, the members of the Academy formed two warring factions over the issue of drawing versus color: the *"Poussinistes"* (or conservatives) against the *"Rubénistes."* The conservatives defended Poussin's view that drawing, which appealed to the mind, was superior to color, which appealed to the senses. The *Rubénistes* advocated color, rather than drawing, as being more true to nature. They also pointed out that drawing, admittedly based on reason, appeals only to the expert few, whereas color appeals to everyone. This argument had revolutionary implications, for it proclaimed the layperson to be the ultimate judge of artistic values and challenged the Renaissance notion that painting, as a liberal art, could be appreciated only by the educated mind.

Antoine Watteau By the time Louis XIV died in 1715, the dictatorial powers of the Academy had long been overcome and the influence of Rubens and the great Venetians was every-

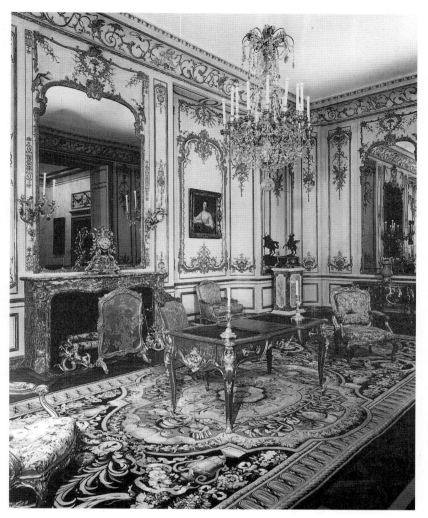

332. Nicolas Pineau. Room from the Hôtel de Varengeville, Paris. c. 1735. The Metropolitan Museum of Art, New York

Acquired with funds given by Mr. and Mrs. Charles Wrightsman, 1963

where. The greatest of the *Rubénistes* was the painter Jean-Antoine Watteau (1684–1721). Watteau's pictures violated all academic canons, and his subjects did not conform to any established category. To accommodate him, the Academy invented the new category of *fêtes galantes* (elegant fetes, or entertainments). The term refers to the fact that the artist's work mainly shows scenes of fashionable society or comedy actors in parklike settings. He characteristically interweaves theater and real life so that no clear distinction can be made between

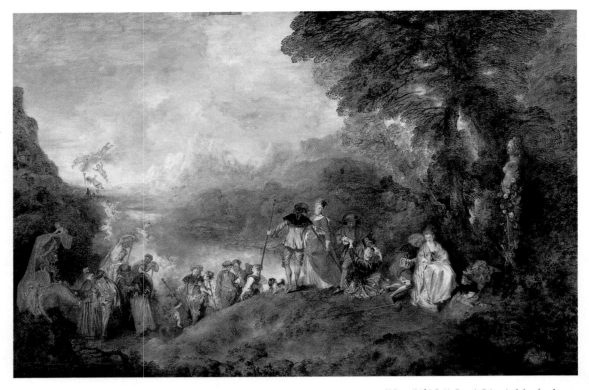

333. Jean-Antoine Watteau. *A Pilgrimage to Cythera*. 1717. Oil on canvas, 4'3" x 6'4¹/₂" (1.3 x 1.94 m). Musée du Louvre, Paris

the two. *A Pilgrimage to Cythera* (fig. 333), painted as his reception piece for the Academy, is an evocation of love that includes yet another element: classical mythology. These young couples have come to Cythera, the island of love, to pay homage to Venus, whose garlanded image appears on the far right. They are about to board the boat, accompanied by swarms of cupids. The action unfolds in the foreground, like a continuous narrative, from right to left: two lovers are still engaged in their amorous tryst; behind them, another couple rises to follow a third pair down the hill as the reluctant young woman casts a wistful look back at the goddess's sacred grove.

As a fashionable conversation piece, the scene at once recalls Rubens's *The Garden of Love* (see fig. 304), but Watteau has added a touch of poignancy, lending it a poetic subtlety reminiscent of Giorgione (see fig. 248). His figures, too, do not have the robust vitality of Rubens's. Slim and graceful, they move with

the studied assurance of actors who play their roles so superbly that they touch us more than reality ever could. They recapture an earlier ideal of mannered elegance.

François Boucher The work of Watteau signals a shift in French art as a whole to the Rococo. The term originally applied to the decorative arts, but it suits the playful character of French painting before 1774 equally well. By about 1720, even ▼HISTORY PAINTING becomes intimate in scale and delightfully ebullient in style and subject. The finest painter in this mode is François Boucher (1703–70), who epitomizes the age of ▼MADAME DE POMPADOUR, the mistress of Louis XV. *The Toilet of Venus* (fig. 334), painted for her private retreat, is full of silk and perfume. If Watteau elevated human love to the level of mythology, Boucher raised playful eroticism to the realm of the divine. What Boucher lacks in the emotional depth that distinguishes Watteau's art, he

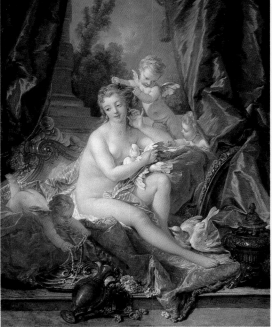

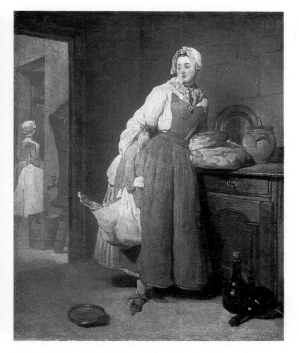

334. François Boucher. *The Toilet of Venus*. 1751.
Oil on canvas, 43 x 33¹/2" (109.2 x 85.1 cm).
The Metropolitan Museum of Art, New York
Bequest of William K. Vanderbilt, 1920

335. Jean-Baptiste-Siméon Chardin. *Back from the
Market*. 1739. Oil on canvas, 18¹/2 x 14³/4"
(47 x 37.5 cm). Musée du Louvre, Paris

makes up for in unsurpassed understanding of the world of fantasies that enrich people's lives.

Yet, compared with Vouet's sensuous goddess (see fig. 322), from which she is descended, Boucher's has been transformed into a coquette of enchanting beauty. In this cosmetic never-never land, she is an eternally youthful Venus, with the same soft, rosy skin as the cherubs who attend her.

Jean-Baptiste-Siméon Chardin The style of Jean-Baptiste-Siméon Chardin (1699–1779) can be called Rococo only with reservations. The *Rubénistes* had cleared the way for a renewed interest in still life and genre subjects by Dutch and Flemish artists as well. This revival was facilitated by the presence of numerous artists from the Netherlands, especially Flanders, who settled in France in growing numbers after about 1550 while maintaining artistic ties to their native lands. Chardin is the finest French painter in this vein. He is nevertheless far re-

moved in spirit and style, if not in subject matter, from any Dutch or Flemish painter. His paintings act as moral exemplars—not by conveying symbolic messages as Baroque still lifes often do, but by affirming the rightness of the existing social order and its values. To the rising middle class who were the artist's patrons, his genre scenes and kitchen still lifes proclaimed the virtues of hard work, frugality, honesty, and devotion to family.

Back from the Market (fig. 335) shows life in a Parisian middle-class household with such feeling for the beauty hidden in the commonplace, and so clear a sense of spatial order, that we can compare him only to Vermeer, but his remarkable technique is quite unlike any Dutch artist's. Devoid of bravura, his brushwork renders the light on colored surfaces with a creamy touch that is both analytical and subtly lyrical. To reveal the inner nature of things, he summarizes forms, subtly altering their appearance and texture rather than describing them in detail.

336. Jean-Baptiste-Siméon Chardin. *Kitchen Still Life*. c. 1731. Oil on canvas, 12¹/₂ x 15³/₈" (31.8 x 39.1 cm). Ashmolean Museum, Oxford, England

Bequeathed by Mrs. W. F. R. Weldon

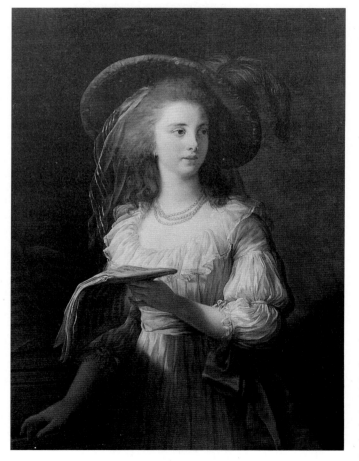

337. Marie-Louise-Élisabeth Vigée-Lebrun. *The Duchesse de Polignac*. 1783. Oil on canvas, 38³/₄ x 28" (98.4 x 71.1 cm). The National Trust Waddesdon Manor, Aylesbury, Buckinghamshire, England

Chardin discovered a hidden poetry in even the most humble objects and endowed them with timeless dignity. His still lifes usually depict the same modest environment, eschewing the "object appeal" of their Dutch predecessors. In *Kitchen Still Life* (fig. 336), we see only common objects that could belong in any kitchen: earth-enware jugs, a casserole, a copper pot, a piece of raw meat, smoked herring, two eggs. But how important they seem, each so firmly placed in re-lation to the rest, each so worthy of the artist's— and our—scrutiny. Despite his concern with formal problems, evident in the beautifully bal-anced design, Chardin treats these objects with a respect close to reverence. Beyond their shapes, colors, and textures, they are to him symbols of the life of common people.

Marie-Louise-Élisabeth Vigée-Lebrun It is from portraits that we can gain the clearest under-standing of the French Rococo, for the trans-formation of the human image lies at the heart of the age. In portraits of the aristocracy, men were endowed with the illusion of character as a natural attribute of their station in life, stemming from their noble birth. The finest achievements of Rococo portraiture were reser-ved for depictions of women, hardly a surpris-ing fact in a society that idolized love and feminine beauty. One of the best practitioners in this tradition was Marie-Louise-Élisabeth Vigée-Lebrun (1755–1842).

Throughout Vigée's long life, and partly because she was a very beautiful woman, she en-joyed great fame, which took her to every corner of Europe, including Russia, when she fled the French Revolution. *The Duchesse de Polignac* (fig. 337) was painted a few years after Vigée had become the portraitist for Queen ▼MARIE-ANTOINETTE, and it amply demonstrates her ability. The duchesse has the eternally youthful loveliness of Boucher's *Venus* (see fig. 334), made all the more persuasive by the artist's exquisite treatment of her clothing. At the same time, there is a sense of transience in the engaging mood that exemplifies the Rococo's whimsical theatricality. Interrupted in her singing, the lyrical duchesse becomes a real-life counterpart to the poetic creatures in Watteau's *A Pilgrimage*

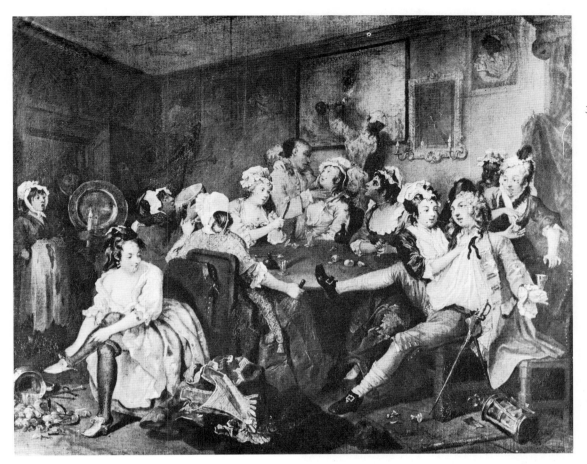

338. William Hogarth.
The Orgy, Scene III of *The Rake's Progress*. c. 1734.
Oil on canvas, 24½ x 29½"
(62.2 x 74.9 cm). Sir John Soane's Museum, London

to Cythera (see fig. 333) by way of the delicate sentiment she shares with the young woman in Chardin's *Back from the Market* (see fig. 335).

England

French Rococo painting from Watteau onward had a decisive, though unacknowledged, effect across the English Channel and, in fact, helped bring about the first school of English painting since the Middle Ages that had more than local importance.

William Hogarth The earliest of the English Rococo painters, William Hogarth (1697–1764), a natural-born satirist, began as an engraver and soon took up painting. Although he certainly learned something about color and brushwork from Venetian and French examples, as well as from Van Dyck, his work is of such originality as to be essentially without precedent. He made his mark in the 1730s with a new kind of picture, which he described as "modern moral subjects . . . similar to representations on the stage." He wished to be judged as a dramatist, he said, even though his "actors" could only "exhibit a dumb show." These pictures, and the prints he made from them for popular sale, came in sets, with details recurring in each scene to unify the sequence. Hogarth's "morality plays" teach, by horrid example, the solid middle-class virtues. They show a country girl who succumbs to the temptations of fashionable London; the evils of corrupt elections; and aristocratic rakes who live only for ruinous pleasure, marrying wealthy women of lower status for their fortunes, which they soon dissipate. He is probably the first artist in history to become a social critic in his own right. In *The Orgy* (fig. 338), from *The*

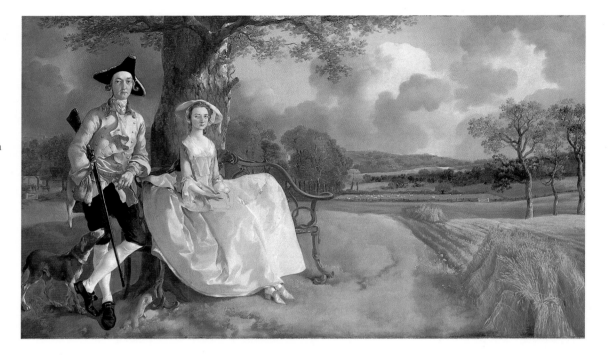

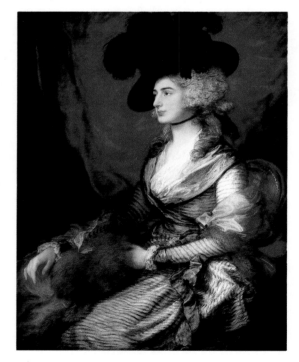

Rake's Progress, the young wastrel is overindulging in wine and women. The scene is so full of visual clues that a full account would take pages, plus constant references to the adjoining episodes. However literal-minded, the picture has great appeal. Hogarth combines some of Watteau's sparkle with Steen's narrative gusto (compare figs. 333 and 316), and he entertains us so well that we enjoy his sermon without being overwhelmed by its message.

Thomas Gainsborough Portraiture remained the only constant source of income for English painters. Here, too, eighteenth-century England produced a style that differed from the Continental traditions. Hogarth was a pioneer in this field as well. Its greatest artist, Thomas Gainsborough (1727–88), began by painting landscapes but ended as the favorite portraitist of British high society. His early portraits, such as *Robert Andrews and His Wife* (fig. 339), have a lyrical charm that is not always found in his later pictures. Compared to Van Dyck's artifice in *Portrait of Charles I Hunting* (see fig. 305), this country squire and his wife are unpretentiously at home in their setting. The landscape, although derived from Ruisdael and his school,

has a sunlit, hospitable air never achieved (or desired) by the Dutch painters, while the casual grace of the two figures, which affects an air of naturalness, indirectly recalls Watteau's style. The newlywed couple—she dressed in the fashionable attire of the day, he armed with a rifle to denote his status as a country squire (hunting was a privilege of wealthy landowners)—do not till the soil themselves. The painting nevertheless conveys the gentry's closeness to the land, from which the English derived much of their sense of national identity. Out of this attachment to place was to develop a feeling for nature that became the basis for English landscape painting, to which Gainsborough himself made an important early contribution.

Gainsborough spent most of his career working in the provinces, first in his native Suffolk, then in the fashionable resort town of Bath. Toward the end of his career, he moved to London, where his work underwent a pronounced change. The very fine portrait of the famous actress Sarah Kemble Siddons (fig. 340) has other virtues: a cool elegance that translates Van Dyck's aristocratic poses into late-eighteenth-century terms, as well as a fluid, translucent technique reminiscent of Rubens that renders the glamorous sitter, with her fashionable attire and coiffure, to ravishing effect.

Joshua Reynolds Gainsborough painted *Mrs. Siddons* in conscious opposition to his great rival on the London scene, Joshua Reynolds (1723–92), who had just portrayed the same sitter as the Tragic Muse (fig. 341). Reynolds, the president of the Royal Academy since its founding in 1768, was the champion of the academic approach to art, which he had acquired during two years in Rome. In his famous *Discourses*, he formulated what he felt were necessary rules and theories. His views were essentially those of Le Brun, tempered by British common sense. Like Le Brun, he found it difficult to live up to his theories in actual practice. Although he preferred history painting in the grand style, the vast majority of his works are portraits enriched, whenever possible, by allegorical additions or disguises like those in his picture of Mrs. Siddons. His style owed a good deal more to the

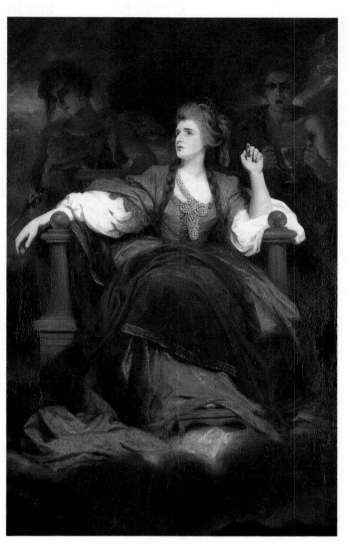

341. Joshua Reynolds. *Sarah Siddons as the Tragic Muse*. 1784. Oil on canvas, 7'9" x 4'9½" (2.36 x 1.46 m). Henry E. Huntington Library and Art Gallery, San Marino, California

Venetians, to the Flemish Baroque, and even to Rembrandt (note the lighting in *Sarah Siddons as the Tragic Muse*) than he conceded in theory, though he often recommended following the example of earlier artists.

Reynolds was generous enough to give praise to Gainsborough, whom he outlived by a few years and whose instinctive talent he must have envied. He eulogized him as one who saw with the eye of a painter rather than a poet. Yet,

Rococo Music

Although it was a direct outgrowth of seventeenth-century developments, music after 1700 not only sounded different, but was dominated by a handful of great composers. It should be remembered, however, that these composers were surrounded by many others of almost equal ability who began to form recognizable schools of composition and performance. This was made possible by the international circulation of printed scores and musical treatises and the codification of the modern major-minor harmonic system (see "Modern Harmony," page 399).

The earliest of these eighteenth-century giants was Antonio Vivaldi (c. 1678–1741), the son of a violinist at St. Mark's in Venice. His principal employment was as a music teacher at an orphanage for girls. Vivaldi's vast body of work shows enormous versatility, one of the chief characteristics of the Rococo; he composed in virtually every instrumental and vocal form.

Like the other great composers of the time, he was under constant pressure (in his case due to his teaching responsibilities and his great popularity) to write new music. He wrote operas (one of them in only five days)

and nearly 500 concertos, of which *The Four Seasons,* set to verses probably written by Vivaldi himself, is justly the most famous.

Johann Sebastian Bach (1685–1750), trained as an organist and violinist, spent part of his early career as a court composer. He then settled down as the music director of the Church of St. Thomas in largely Protestant Leipzig, a position that—like Vivaldi's—made enormous demands on him for new music. Bach assimilated the achievements of French and Italian composers, and the resulting music represents a remarkable balance of melody and polyphony, expressive power and supreme rationality. His instrumental works are largely built on FUGUES and VARIATIONS, which fully exploit his superb mastery of counterpoint.

As a young man, George Frideric Handel (1685–1759), a native of Halle, Germany, made an extended visit to Italy (1706–10), where he met the best Italian composers of the day. The stay in Italy was decisive for him, for it was there that he learned to compose operas and adopted the lyrical manner that distinguished his work. When he returned to Germany, he was appointed music director at the court of Hannover, but soon went to London on a leave of absence. As fate would have it, the

elector of Hannover became King George I of England and continued to support the composer in London. Handel made and lost fortunes there by producing Italian operas, until John Gay's *The Beggar's Opera* (1728) took the country by storm. This social satire in English used familiar songs culled from a variety of sources, including Henry Purcell's music (see page 387). Handel then also began to write in English, especially ORATORIOS, which were essentially CONCERT OPERAS with biblical subjects. Handel is best known today for his suites of "Water Music," originally written to be played on the royal barge, and his oratorio *The Messiah* (1742).

In Rococo France, after making his mark as a theorist (see page 399), Jean-Philippe Rameau (1683–1764) established his reputation as a composer of operas, which gained him the support of the court. His style has the clarity and grace of Watteau and the intelligence of Voltaire. Despite the fact that Rameau's operas are the direct descendents of Lully's, they were attacked at first by Lully's supporters. Eventually, however, they championed Rameau against Italian opera, and the Enlightenment philosopher Jean-Jacques Rousseau (1712–78) actually went so far as to promote Italian works on the grounds that French was not fit for singing.

for all of the differences between them, the two artists had more in common than they cared to admit, artistically and philosophically. Reynolds and Gainsborough looked back to Van Dyck, drawing different lessons from his example. Both emphasized, albeit in varying degrees, the visual appeal and technical proficiency of their paintings. Moreover, their portraits of Mrs. Siddons bear an unmistakable relationship to the Rococo style of France—note their resemblance to Vigée-Lebrun's *Duchesse* (fig. 337)—yet remain distinctly English in character.

Germany and Austria

The Rococo was a refinement in miniature of the curvilinear, "elastic" Baroque of Borromini and Guarini, and it thus could be happily united with architecture in Austria and Germany, where the Italian style had taken firm

root. It is not surprising that the Italian style received such a warm response there. In Austria and southern Germany, ravaged by the Thirty Years' War, the number of new buildings remained small until near the end of the seventeenth century. Baroque was an imported style, practiced mainly by visiting Italians. Not until the 1690s did native designers come to the fore. There followed a period of intense activity that lasted more than fifty years and gave rise to some of the most imaginative creations in the history of architecture. These monuments were erected for the glorification of princes and prelates who, generally speaking, deserve to be remembered only as lavish patrons of the arts. Rococo architecture in Central Europe is larger in scale and more exuberant than in France. Moreover, painting and sculpture are more closely linked with their settings. Palaces and churches are decorated with ceiling frescoes

Modern Harmony

The development of eighteenth-century music was made possible by the codification of the modern system of harmony, which, after a gradual development over approximately 300 years, was spelled out in its final form in the *Treatise on Harmony* (1722) by the French composer Jean-Philippe Rameau. This system was based on the "tempered" DIATONIC scale, a progression of notes derived by equally spacing ("tempering") twelve tones within an octave (in essence, the black and white keys of a piano). The tonal distance, or interval, between any two of these one-twelfth-octave tones is called a SEMITONE or "half step." Twice that interval is called a whole tone or "whole step." The diatonic system includes two principal scales, the MAJOR SCALE—the familiar "do-re-mi" that music students practice—and a modification of it called the MINOR SCALE. Both major and minor scales include a specific progression of five whole tones and two semitones, which start from the TONIC, the note on which the scale is based, to the same note an octave above it. Like Greek modes, the major and minor scales communicate emotional qualities. Generally, people experience the major scale as positive and optimistic and the minor scale as somber or plaintive.

The tempered scale allows a keyboard to include a number of octaves, which in turn increases the range of music that can be written for keyboard instruments. The forty-eight pieces that Johann Sebastian Bach wrote in his "Well-Tempered Clavier" (1722, 1744) were among the first series of compositions that exploited the possibilities of the newly expanded keyboard.

Another feature of the system as defined by Rameau were CHORDS, sets of notes based on specific tones of the scale, sounded together in accompaniment to the melody. The MAJOR CHORD, for example, is derived from the major scale. It is made up of the tonic, the third note of the scale, and the fifth note of the scale. The chords for each scale were intended to create a full multivoice sound that is pleasing to the ear. Rameau's rules defined which chords were to be used in which musical circumstances. However, it was also understood that a composer might "break" the rules to create a deliberate dissonance, or discordant sound, for expressive purposes. Such dissonances were almost always "resolved" back to the notes of the scale in which the work was being played.

We need not be schooled in music theory to appreciate the virtues of the new system, which are readily apparent to the ear: its orderliness and flexibility, which not only permitted the fullest development of counterpoint, but created new melodic possibilities as well. Modern harmony was an essential precondition for the work of the great composers of the eighteenth and nineteenth centuries, and it remained the basis of Western music composition until the end of World War I, when avant-garde composers began to seek other forms of musical expression.

and decorative sculpture unsuited to domestic interiors, however lavish, although they reflect the same taste that produced the Hôtel de Varengeville (see fig. 332).

Johann Fischer von Erlach Johann Fischer von Erlach (1656–1723), the first great architect of the Rococo in Central Europe, is a transitional figure linked most directly to the Italian tradition. His design for the Church of St. Charles Borromaeus (Carlo Borromeo) in Vienna (fig. 342) combines a thorough understanding of Borromini's Sta. Agnese (compare fig. 293) with reminiscences of St. Peter's and the Pantheon portico (see figs. 290, 87). Here a pair of huge columns derived from the Column of Trajan (see fig. 98) substitutes for facade towers, which have become corner pavilions, reminiscent of the Louvre court (compare fig. 281). With these inflexible elements of Roman imperial art embedded into the elastic curvatures of his church, Fischer von Erlach expresses, more boldly than any Italian Baroque architect, the power of the Christian faith to absorb and transfigure the splendors of antiquity.

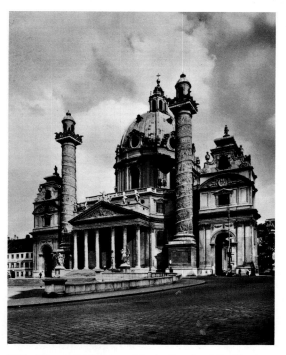

342. Johann Fischer von Erlach. Facade of St. Charles Borromaeus (Karlskirche), Vienna. 1716–37

343. Balthasar Neumann.
The Kaisersaal, Residenz,
Würzburg, Germany.
1719–44. Frescoes by
Giovanni Battista Tiepolo,
1751

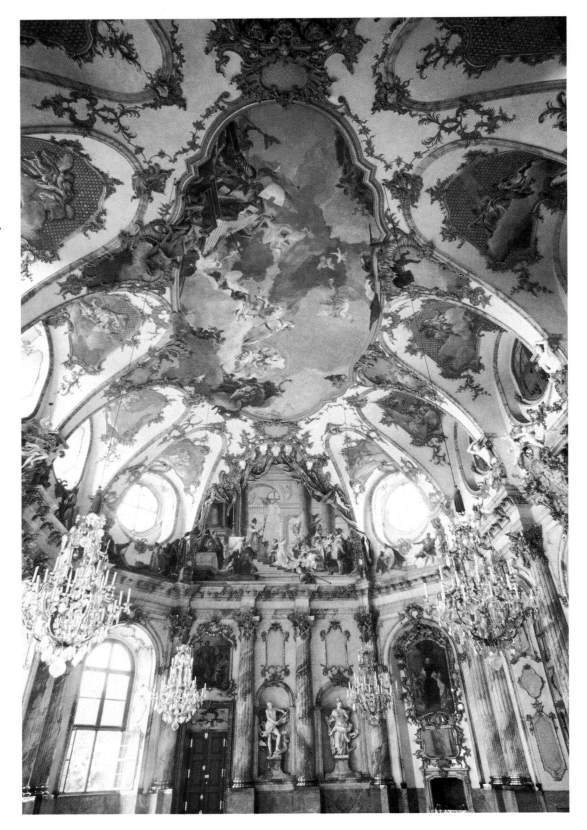

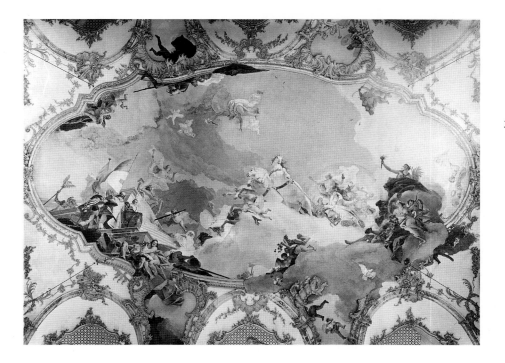

344. Giovanni Battista
Tiepolo. Detail of ceiling
fresco in the Kaisersaal.
1751

Balthasar Neumann The architects of the next generation favored a tendency toward lightness and elegance. The Residenz (Episcopal Palace) in Würzburg by Balthasar Neumann (1687–1753) includes the breathtaking Kaisersaal (Emperor's Hall, fig. 343), a great oval hall decorated in the favorite color scheme of the mid-eighteenth century: white, gold, and pastel shades. The number and aesthetic role of structural members such as columns, pilasters, and architraves are now minimized. Windows and vault segments are framed by continuous, ribbonlike moldings, and the white surfaces are spun over with irregular ornamental designs. This repertory of lacy, curling motifs, the hallmark of the French style, is happily combined with German Rococo architecture. The abundant illumination, the play of curves and countercurves, and the weightless grace of the stucco sculpture give the Kaisersaal an airy lightness far removed from the Roman Baroque. The vaults and walls seem thin and pliable, like membranes easily punctured by the expansive power of space.

Italy

Just as the style of architecture invented in Italy achieved its climax north of the Alps, much of the Italian Rococo took place in other countries.

The timid style of the Late Baroque in Italy had suddenly been transformed during the first decade of the eighteenth century by the rise of the Rococo in Venice, which had been relegated to a minor outpost for a hundred years. The Italian Rococo is distinguished from the Baroque by a renewed appreciation of Veronese's colorism and pageantry, but with a light and airy sensibility that is new. Rococo painters' skill at blending this painterly manner with High Baroque illusionism made the Venetians the leading decorative painters in Europe between 1710 and 1760, and they were active in every major center throughout Europe, particularly London and Madrid. They were not alone: artists from Rome and other parts of Italy also worked abroad in large numbers.

Giovanni Battista Tiepolo The last, and most refined, stage of Italian illusionistic ceiling decoration is represented in Würzburg by its greatest painter, Giovanni Battista Tiepolo (1696–1770). Venetian by birth and training, he blended that city's tradition of High Baroque illusionism with the pageantry of Veronese. His mastery of light and color, the grace and felicity of his touch, made him famous far beyond his home territory. When Tiepolo painted the Würzburg frescoes (fig. 344), his powers were at their height. The

The Rococo Theater

Theater throughout the Rococo period was marked by sentimentality and often by moralizing themes. In England this trend began in 1696 with *Love's Last Shift* by Colley Cibber (1671–1757), but the turning point came two years later when the theologian Jeremy Collier (1650–1726) published a treatise attacking the immorality of Restoration theater. Collier's denunciations led to a more conservative drama, exemplified by *The Conscious Lovers* (1712) by Richard Steele (1672–1729), in which erring people learn the folly of their ways and resolve to reform. POLITICAL SATIRES by dramatist Henry Fielding (1707–54), which offended prime minister Sir Robert Walpole, brought on further restraints. The Licensing Act of 1737 placed theater under strict censorship of subjects and scripts.

England, which had been influenced by Molière and Racine during the seventeenth century, now made an important contribution to French theater. In France, the counterpart to Steele's plays were the popular "tearful comedies," produced by a number of playwrights. Satire enjoyed a final resurgence in the plays of the writer and philosopher Voltaire (François-Marie Arouet, 1694–1778), who tried to liberalize the rigid conventions of classical drama after living in England, where he developed an admiration for Shakespeare. Voltaire's plays are no less sentimental than those of his contemporaries, but a growing emphasis on spectacle led him in 1759 to ban the audience from the stage, where it had sat since the seventeenth century. Comedy was left in the hands of the Comédie Italienne, created in 1716 after the death of Louis XIV, when the banished Commedia dell'arte was again allowed to perform in France. In Italy, by contrast, the energies of the playwrights were largely absorbed by the opera. The main exception was Carlo Goldoni (1707–93), a Venetian dramatist whose vivid comedies deliberately imitated those of Molière. Goldoni spent the last twenty years of his productive life in France, as the manager of the Comédie Italienne in Paris.

The major contributions of Rococo theater lay not in writing but in STAGECRAFT: scenic design and acting. With the increased demand for spectacle, many artists, including François Boucher, also worked as scenographers, with the result that the backgrounds of many paintings came to look increasingly like set designs. Boucher's pupil Philippe-Jacques de Loutherbourg (1740–1812), for example, also studied with the scene designer Louis-René Bosquet (1717–1814) and later brought the theatrical practices that he had learned to England, where many painters, including Hogarth's father-in-law James Thornhill (1675–1734), regularly worked for the theater.

De Loutherbourg had been invited to England by the actor David Garrick (1717–79) to superintend scene painting at his Drury Lane theater, and both men introduced a number of innovations, especially improved lighting. Garrick, like Voltaire, removed spectators from the stage. He also played a major role in theatrical reform on the Continent. Garrick and his contemporaries were the first stage managers to show an awareness of period dress, an innovation that was taken up by the French theater as well, especially in Voltaire's productions.

Women had been acting in the Comédie Française since the 1690s, but they never achieved the status of their English counterparts. Thus, Adrienne Lecouvreur (1692–1730), the first French actress to adopt formal court costumes for tragic heroines, was buried anonymously the same year that the English tragedienne Anne Oldfield (1683–1730) was honored by being buried in Westminster Abbey. After 1780, the reigning actress in England was Sarah Siddons (1755–1831). Like Garrick, she sat for portraits by both Gainsborough and Reynolds (see figs. 340 and 341). During the early years of the eighteenth century, a number of English women also became successful playwrights.

tissuelike ceiling so often gives way to illusionistic openings of every sort that we no longer feel it to be a spatial boundary. These openings do not reveal, however, avalanches of figures propelled by dramatic bursts of light, like those of Roman ceilings (compare fig. 289), but rather blue sky, sunlit clouds, and an occasional winged creature soaring in this limitless expanse. Only along the edges are there solid clusters of figures. Tiepolo proved himself a worthy successor to Pietro da Cortona and followed in his footsteps to Madrid, where he spent his later years decorating the Royal Palace. There he encountered the German painter Anton Raphael Mengs, a proponent of the classical revival whose presence signaled the effective end of the Rococo.

Giovanni Battista Piranesi During the eighteenth century, landscape in Italy evolved a new form in keeping with the character of the Rococo: *veduta* ("view") painting. Its beginnings can be traced back to the seventeenth century with the many foreigners, such as Claude Lorrain (see fig. 321), who specialized in depicting Rome's environs, but after 1720 it acquired a specifically urban identity. Moreover, its practitioners were often trained as stage designers. Thus the *Prison Caprices* (fig. 345) of Giovanni Battista Piranesi (1720–78) derive from his settings for operas. These impressive etchings were nevertheless intended as original works of art from the beginning, and they have a gripping power. In Piranesi's imagery, the play between reality and fantasy,

345. Giovanni Battista Piranesi. *Tower with Bridges*, from *Prison Caprices*. 1760–61. Etching, 21³/₄ x 16³/₈"
(55.2 x 41.6 cm). The Metropolitan Museum of Art, New York

Rogers Fund, 1941

so fundamental to the theatrical Rococo, has been transformed into a romanticized vision of despair as terrifying as any nightmare. His bold imagination appealed greatly to many Neoclassical artists of the next generation, on whom he exercised a decisive influence.

	Political History	Religion and Literature	Science and Technology
1400	Great Papal Schism (since 1378) settled 1417; pope returns to Rome Cosimo de'Medici leading citizen of Florence 1434–64	Leonardo Bruni (c. 1374–1444), *History of Florence* Leone Battista Alberti (1404–1472), *On Architecture; On Painting* Jan Hus, Czech reformer, burned at stake for heresy 1415; Joan of Arc burned at stake for heresy and sorcery 1431 Council of Florence attempts to reunite Catholic and Orthodox faiths 1439	Prince Henry the Navigator of Portugal (1394–1460) promotes geographic exploration Gutenberg credited with invention of printing with movable type 1446–50
1450	Hapsburg rule of Holy Roman Empire begins 1452 End of Hundred Years' War 1453 Constantinople falls to Turks 1453 Lorenzo de' Medici, "the Magnificent," virtual ruler of Florence 1469–92 Ferdinand and Isabella unite Spain 1469 Spain and Portugal divide southern New World 1493–94 Charles VIII of France invades Italy 1494–99 Henry VII (ruled 1485–1509), first Tudor king of England	Marsilio Ficino, Italian Neoplatonic philosopher (1433–1499) Pius II, humanist pope (ruled 1458–64) Sebastian Brant's *Ship of Fools* 1494 Savonarola virtual ruler of Florence 1494; burned at stake for heresy 1498	Bartholomeu Diaz rounds Cape of Good Hope 1488 Christopher Columbus discovers America 1492 Vasco da Gama reaches India, returns to Lisbon 1497–99
1500	Charles V elected Holy Roman Emperor 1519; Sack of Rome 1527 Hernando Cortés wins Aztec Empire in Mexico for Spain 1519; Francisco Pizarro conquers Peru 1532 Henry VIII of England (ruled 1509–47) founds Anglican Church 1534 Wars of Lutheran vs. Catholic princes in Germany; Peace of Augsburg (1555) lets each sovereign decide religion of his subjects	Erasmus of Rotterdam's *Manual of a Christian Knight* 1503 Thomas More's *Utopia* 1516 Martin Luther (1483–1546) posts 95 Theses 1517; excommunicated 1521 Castiglione's *Courtier* 1528 Machiavelli's *Prince* 1532 Ignatius of Loyola founds Jesuit order 1534 John Calvin's *Institutes of the Christian Religion* 1536	Vasco de Balboa sights Pacific Ocean 1513 First circumnavigation of the globe by Ferdinand Magellan and crew 1520–22 Copernicus refutes geocentric view of universe
1550	Ivan the Terrible of Russia (ruled 1547–84) Charles V retires 1556; son Philip II becomes king of Spain, Netherlands, New World Elizabeth I of England (ruled 1558–1603) Lutheranism becomes state religion in Denmark 1560, in Sweden 1593 Netherlands revolt against Sapin 1586 Spanish Armada defeated by English 1588 Henry IV of France (ruled 1589–1610); Edict of Nantes establishes religious toleration 1598	Montaigne, French essayist (1533–1592) Council of Trent for Catholic reform 1545–63 Teresa of Àvila, Spanish saint (1515–1582) Giorgio Vasari's *Lives* 1564 William Shakespeare, English dramatist (1564–1616)	
1600	Jamestown, Virginia, founded 1607; Plymouth, Massachusetts, 1620 Thirty Years' War 1618–48 Cardinal Richelieu, adviser to Louis XIII, consolidates power of king 1624–42 Cardinal Mazarin governs France during minority of Louis XIV 1643–61 (civil war 1648–53) Charles I of England beheaded 1649; Commonwealth under Cromwell 1649–53	Miguel de Cervantes' *Don Quixote* 1605–16 John Donne, English poet (1572–1631) King James Bible 1611 René Descartes, French mathematician and philosopher (1596–1650)	Johannes Kepler establishes planetary system 1609–19 Galileo (1564–1642) invents telescope 1609; establishes scientific method William Harvey describes circulation of the blood 1628
1650	Charles II restores English monarchy 1660 English Parliament passes Habeas Corpus Act 1679 Frederick William, the Great Elector (ruled 1640–88), founds power of Prussia Louis XIV absolute ruler of France (ruled 1661–1715); revokes Edict of Nantes 1685 Glorious Revolution against James II of England 1688; Bill of Rights	Molière, French dramatist (1622–1673) Blaise Pascal, French scientist and philosopher (1623–1662) Spinoza, Dutch philosopher 1632–1677 Racine, French dramatist (1639–1699) John Milton's *Paradise Lost* 1667 John Bunyan's *Pilgrim's Progress* 1678 John Locke's *Essay Concerning Human Understanding* 1690	Isaac Newton (1642–1727), theory of gravity 1687
1700	Peter the Great (ruled 1682–1725) westernizes Russia, defeats Sweden English defeat French at Blenheim 1704 Robert Walpole first prime minister 1721–42 Frederick the Great of Prussia defeats Austria 1740–45	Alexander Pope's *Rape of the Lock* 1714 Daniel Defoe's *Robinson Crusoe* 1719 Jonathan Swift's *Gulliver's Travels* 1726 Wesley brothers found Methodism 1738 Voltaire, French author (1698–1778)	Carolus Linnaeus, Swedish botanist (1707–1778)
1750	Seven Years' War (1756–63): England and Prussia vs. Austria and France, called French and Indian War in America; French defeated in Battle of Quebec 1759 Catherine the Great (ruled 1762–96) extends Russian power to Black Sea	Thomas Gray's *Elegy* 1750 Diderot's *Encyclopédie* 1751–72 Samuel Johnson's *Dictionary* 1755 Edmund Burke, English reformer (1729–1797) Jean-Jacques Rousseau, French philosopher and writer (1712–1778)	James Watt patents steam engine 1769 Priestley discovers oxygen 1774 Coke-fed blast furnaces for iron smelting perfected c. 1760–75 Benjamin Franklin's experiments with electricity c. 1750

Architecture	Sculpture	Painting	
Brunelleschi begins career as architect 1419; Florence Cathedral dome (168); S. Lorenzo, Florence (219, 220)	Donatello, St. George (210); Prophet (Zuccone) (211); David (212) Ghiberti, "Gates of Paradise," Baptistery, Florence (214) Donatello, Equestrian statue of Gattamelata, Padua (213)	St. Dorothy woodcut (207) Hubert and/or Jan van Eyck, Crucifixion and Last Judgment (196) Masaccio, Holy Trinity fresco, Sta. Maria Novella, Florence (223); Brancacci Chapel frescoes, Sta. Maria del Carmine, Florence (224)	Master of Flémalle, Mérode Altarpiece (195) Jan van Eyck, Man in a Red Turban (197); Wedding Portrait (198, 199) Rogier van der Weyden, Descent from the Cross (200) Conrad Witz, Geneva Cathedral altarpiece (204) Domenico Veneziano, Madonna and Child with Saints (225)
Alberti, S. Andrea, Mantua (221) Giuliano da Sangallo, Sta. Maria delle Carceri, Prato (222)	Verrocchio, Putto with Dolphin, Florence (218) Pollaiuolo, Hercules and Antaeus (217)	Castagno, David (227) Mantegna, Ovetari Chapel frescoes, Padua (231) Piero della Francesca, Arezzo frescoes (226) Hugo van der Goes, Portinari Atarpiece (201) Botticelli, Birth of Venus (228) Ghirlandaio, Old Man and His Grandson (230) Schongauer, Temptation of Saint Anthony engraving (208)	Perugino, Delivery of the Keys, Sistine Chapel, Rome (233) Leonardo, Virgin of the Rocks (234) Giovanni Bellini, Saint Francis in Ecstasy (232) Geertgen tot Sint Jans, Nativity (202) Leonardo, Last Supper, Sta. Maria delle Grazie, Milan (235) Piero di Cosimo, Discovery of Honey (229)
Bramante, design for St. Peter's, Rome (238) Michelangelo becomes architect of St. Peter's, Rome, 1546 (245) Lescot, Square Court of Louvre, Paris (281)	Michelangelo, David (240); Tomb of Giuliano de' Medici, Florence (244) Cellini, Saltcellar of Francis I (262)	Dürer, Self-Portrait (270) Bosch, Garden of Delights (203) Leonardo, Mona Lisa (236) Giorgione, The Tempest (248) Michelangelo, Sistine Chapel ceiling, Rome (5, 241, 242) Grünewald, Isenheim Altarpiece (268, 269) Raphael, School of Athens fresco, Stanza della Segnatura, Rome (246); Galatea fresco, Villa Farnesina, Rome (247) Dürer, Knight, Death, and Devil engraving (271)	Titian, Bacchanal (249); Man with a Glove (250) Rosso Fiorentino, Descent from the Cross (252) Holbein, Erasmus of Rotterdam (275) Pontormo, Deposition (253) Correggio, Assumption of the Virgin fresco, Parma Cathedral (260) Altdorfer, Battle of Issus (274) Cranach, Judgment of Paris (273) Michelangelo, Last Judgment fresco, Sistine Chapel, Rome (243) Parmigianino, Madonna with the Long Neck (254)
Palladio, Villa Rotonda, Vicenza (265) Della Porta, Facade of Il Gesù, Rome (267)	Giovanni Bologna, Rape of the Sabine Woman, Florence (263)	Bronzino, Eleanora of Toledo and Her Son Giovanni de' Medici (255) Bruegel, Return of the Hunters (279) Titian, Christ Crowned with Thorns (251) Veronese, Christ in the House of Levi (259) El Greco, Burial of Count Orgaz (257) Tintoretto, Last Supper (256) Caravaggio, Calling of Saint Matthew, Contarelli Chapel, Rome (284)	Annibale Carracci, Farnese Gallery ceiling, Rome (286)
Maderno, Nave and facade of St. Peter's, Rome; Bernini's colonnade (290) Borromini, S. Carlo alle Quattro Fontane, Rome (291, 292)	Bernini, David (295); Cornaro Chapel, Rome (296, 297)	Rubens, Raising of the Cross (302); Marie de' Medici, Queen of France, Landing in Marseilles (303) Artemisia Gentileschi, Judith and Her Maid-servant with the Head of Holofernes (285) Zurbarán, Saint Serapion (299) Hals, Jolly Toper (307) Leyster, Boy Playing a Flute (309)	Pietro da Cortona, Palazzo Barberini ceiling, Rome (289) Heda, Still Life (315) Van Dyck, Portrait of Charles I Hunting (305) Rembrandt, The Triumph of Dalila (310) Poussin, Abduction of the Sabine Women (319) Rubens, Garden of Love (304) De La Tour, Joseph the Carpenter (318)
Perrault, East front of Louvre, Paris (323) Hardouin-Mansart and Le Vau, Palace of Versailles, begun 1669 (324); with Coysevox, Salon de la Guerre (325) Guarini, Palazzo Carignano, Turin (294)	Puget, Milo of Crotona (330) Coysevox, Charles Lebrun (329)	Lorrain, Pastoral Landscape (321) Rembrandt, Christ Preaching (313) Ruisdael, Jewish Cemetery (314) Velázquez, Maids of Honor (300) Rembrandt, Self-Portrait (312) Steen, Feast of Saint Nicholas (316)	Hals, Women Regents of the Old Men's Home at Haarlem (308) Vermeer, Girl with an Earring (317)
Fischer von Erlach, St. Charles Borromaeus, Vienna (342) Neumann, Episcopal Palace, Würzburg (343) Burlington and Kent, Chiswick House, London (354)		Watteau, Pilgrimage to Cythera (333) Chardin, Kitchen Still Life (336) Hogarth, Rake's Progress (338) Gainsborough, Robert Andrews and His Wife (391)	
		Tiepolo, Würzburg ceiling fresco (344) Boucher, Toilet of Venus (334) Vigée-Lebrun, Duchesse de Polignac (337)	Reynolds, Sarah Siddons as the Tragic Muse (341)

NOTE: Figure numbers are in *italics*.

Part Four
The Modern World

Art history, according to the classical model of the eighteenth-century German archeologist and art historian Johann Joachim Winckelmann, unfolds in an orderly progression in which one phase follows another as inevitably as night follows day. In addition, the idea that a particular style is associated with a specific period implies that the arts march in lockstep, sharing the same characteristics and developing according to the same inner necessity. The thoughtful reader will already suspect, however, that any attempt to synthesize the history of art and place it into a broader context must inevitably mask a welter of facts that do not conform to such a systematic model and may actually call it into question. So far as the art of the distant past is concerned, we may indeed have little choice but to see it in larger terms, since so many facts have been lost that we cannot possibly hope to reconstruct a full and accurate historical record. Thus, it is arguably the case that any such reading of the past is an artificial construct inherently open to question. As we approach the art of our times, the issues involved in relating that art to its period become more than theoretical. They take on a new urgency as we try, perhaps vainly, to understand modern civilization and how it came to be.

It is suggestive of the difficulties facing the historian that the period that began 250 years ago has not acquired a name of its own. Perhaps this absence does not strike us as peculiar at first. We are, after all, still in its midst. Considering how promptly the Renaissance coined a name for itself, however, we may well wonder why no key concept comparable to the "rebirth of antiquity" has yet emerged. It is tempting to call this the age of revolution, for it has been characterized by rapid and violent change. It began with revolutions of two kinds: an industrial revolu-

tion, symbolized by the invention of the steam engine; and a political revolution, under the banner of democracy, in America and France.

Both of these revolutions are still going on. Industrialization and democracy are being sought over much of the world. Western science and Western political thought (and, in their wake, all the other products of modern civilization, such as food, dress, art, music, and literature) will belong to all peoples, although they have been challenged by other ideologies that command allegiance, particularly nationalism and religion. Industrialization and democracy are so closely linked today that we tend to think of them as different aspects of one process, with effects more far-reaching than any since the Neolithic Revolution 10,000 years ago. Still, the twin revolutions are not the same. Indeed, we cannot discern a common impulse behind these developments. The more we try to explain their relationship and trace their historic roots, the more paradoxical they seem. Both are founded on the idea of progress; but whereas progress in science and technology during the past two centuries has been more or less continuous and measurable, we can hardly make this claim for the "pursuit of happiness," however we choose to define it, that is a basic ingredient in the democratic revolution. Here, then, is a fundamental conflict that continues to this very day.

If we accept "the age of revolution" as a convenient name for the era as a whole, we must still isolate whatever it is that distinguishes our own period. For lack of a better word, we shall call it *modernity*, though the term is problematic. What is it? When did it begin? These questions are not unlike those posed by the Renaissance, and so perhaps is the answer. No matter how many different opinions there may be about the nature of the beast—and

scholars remain deeply divided over the issues—the modern era clearly began when people acquired "modern-consciousness." Around 1900, men and women in the Western world became aware intuitively as well as intellectually that they were living in a different age, one whose character was defined by the machine, which brought with it a different sense of time and space than before, as well as the promise of a new kind of humanity and society.

It is difficult for us to appreciate from our vantage point just how radical the technological revolution seemed to people in 1900, for rapid changes of technology have since become commonplace, with each one outstripped by even more far-reaching changes. The advances that took place in science, mathematics, engineering, and psychology during the 1880s and 1890s laid the foundation for the Machine Age. The diesel and turbine engines, electric motor, tire, automobile, lightbulb, phonograph, radio, box camera: all these were invented before 1900, and the airplane shortly thereafter. They forever transformed the quality of life—its very feel—but it was not until these new devices reached a "critical mass" in the opening years of this century that the sweeping magnitude of the change in that quality was fully realized. This was by no means the first time that people have felt modern, which simply means "contemporary." Yet modern-consciousness has been so fundamental to our identity that we can hardly hope to understand civilization for the better part of the past hundred years without it.

The word *modern* has its origins in the early medieval *modernus*, meaning "that which is present," "of our time," and, by extension, "new" or "novel." The language of antiquity, surprisingly, lacked a comparable expression, even though *modern* derives ultimately from the Latin *modo* ("just now"). The nineteenth century gave birth to two conflicting views of modernity that have continued to compete with each other to this day: first, modernism, based on scientific and material progress, arose out of the Enlightenment, with its belief in reason and freedom, and is identified with the middle class. The second view, the avant-garde (literally, "vanguard"), is a radical alternative that regards that same middle class as the enemy of culture—as philistines, in a word. The French writer Stendhal (Marie-Henri Beyle, 1783–1842) regarded the writer or artist as a warrior in the service of modernity—as a forerunner, in effect, of what would later be called the avant-garde. But why should modernity *need* such a warrior in the first place? Because the times were slow to accept the new, which could never be validated by the present but only by the future.

It was the French Symbolist poet and art critic Charles Baudelaire (1821–67) who gave *modernity* its current meaning. "Modernity," he wrote, "is the transitory, the fugitive, the contingent, the half of art, of which other half is the eternal and the immutable" Perceptively, he located the source of that beauty in urban existence. Baudelaire also had the distinction of being the first to use mechanical devices—the locomotive, for instance—as

metaphors for beauty in place of the organic ones then in favor. He further denounced the material progress of modern civilization, thereby helping to create the schism between modernity—modern-consciousness—and modernism, the faith in reason and progress derived from the Enlightenment. What is the difference between them? Paradoxically, modernism looks to the future, whereas modernity is concerned with the present, which can stand in the way of progress. To the artist, modernism is a trumpet call that both asserts the freedom to create in a new style and provides a mission to define the meaning of the times—and even to reshape society through art. To be sure, artists have always responded to the changing world around them, but rarely have they risen to the challenge as they have under the banner of modernism, or with so fervent a sense of personal cause.

Rising to this double challenge of creating new style and a new society is a role for which the avant-garde is hardly prepared. Although both modernism and the avant-garde arose toward the end of the nineteenth century, the term *avant-garde*, like *modernism*, has a long history reaching back to the Middle Ages. *Avant-garde* originated in French warfare and was first applied to the arts in the sixteenth century, but it began to acquire its modern definition only in the mid-eighteenth century. The avant-garde sometimes plays an active part in politics, but its scope normally has been limited to culture. Despite the fact that the concepts are closely linked, the avant-garde is by no means synonymous with—and can even be antithetical to—modernism. Both run counter to their times; but whereas modernism remains dedicated to a utopian vision of the future that stems from the Enlightenment, the avant-garde is bent solely on the destruction of "bourgeois modernity." Judged by this standard, few of the twentieth century's leading artists have been members of a true avant-garde.

Today, having cast off the framework of traditional authority which confined and sustained us before, we can act with a latitude both frightening and exhilarating. The consequences of this freedom to question all values are everywhere around us. Our knowledge about ourselves is now vastly greater, but this has not reassured us as we had hoped. In a world without fixed reference points, we search constantly for our own identity and for the meaning of human existence, individual and collective.

Because modern civilization lacks the cohesiveness of the past, it no longer proceeds by readily identifiable periods; nor are there clear period styles to be discerned in art or in any other form of culture. Instead, we find a continuity of another kind: movements and counter-movements. Spreading like waves, these "isms" defy national, ethnic, and chronological boundaries. Never dominant anywhere for long, they compete or merge with each other in endlessly shifting patterns. Hence our account of modern art is guided more by movements than by countries. Only in this way can we hope to do justice to the fact that modern art, all regional differences notwithstanding, is as international as modern science.

PACIFIC OCEAN

CANADA

UNITED STATES

NORTH AMERICA

Great Salt Lake

Missouri R.

OTTAWA QUEBEC

CHICAGO NEW YORK

ST. LOUIS WASHINGTON, D.C.

LOS ANGELES

DALLAS

HOUSTON

CENTRAL AMERICA

HAVANA CUBA

MARTINIQUE

ATLANTIC OCEAN

TAHITI

SOUTH AMERICA

BRAZIL

BRASILIA

NORTHEASTERN UNITED STATES

CANADA

ADIRONDACKS

Hudson R.

UNITED STATES

NEW YORK

BOSTON

PHILADELPHIA

WASHINGTON, D.C.

CHARLOTTESVILLE

ATLANTIC OCEAN

THE MODERN WORLD

NORWAY
FINLAND
●NOORMARKKU
RUSSIA
SIBERIA

NETHERLANDS
ENGLAND GERMANY
BELGIUM
FRANCE
ITALY
GEORGIA
BLACK SEA
CHINA

MADRID
● BARCELONA
SPAIN

MEDITERRANEAN SEA
● JERUSALEM
EGYPT

A F R I C A

AUSTRALIA

EUROPE

GLASGOW ●
SCOTLAND
ENGLAND
IRELAND
UTRECHT
AMSTERDAM
● WORPSWEDE
● BREMEN ● BERLIN
NORFOLK
HOLLAND GERMANY ● DESSAU
● BRESLAU
LONDON ●
● DRESDEN
ST. IVES ●
CORNWALL
● COLOGNE
WEIMAR
BRUSSELS
ENGLISH CHANNEL
● MALMAISON
AUGSBERG
POISSY-SUR-SEINE ● PARIS
PONT-AVEN ●
VERSAILLES
MUNICH
BRITTANY
ZURICH
VIENNA
FRANCE
ALPS ● LUCERNE
AUSTRIA
SWITZERLAND
VENICE
LOMBARDY
BORDEAUX ●
MILAN ● ARCOLE
AIX-EN-PROVENCE ●
MONT SAINTE VICTOIRE
● ARLES
● FLORENCE
ITALY
ROME ●
SPAIN
CATALONIA
NAPLES ──●
ISTANBUL
(CONSTANTINOPLE)
GREECE
SEVILLE ●
MEDITERRANEAN SEA
● ATHENS

ATLANTIC OCEAN

Elbe R.

Chapter 21
Neoclassicism

The history of Neoclassicism and Romanticism—the two movements to be dealt with in this and the next chapter—covers roughly a century, from about 1750 to 1850. Paradoxically, Neoclassicism has been seen as the opposite of Romanticism on the one hand and as no more than one aspect of it on the other. The difficulty is that the terms *Neoclassicism* and *Romanticism* are not evenly matched—any more than are *quadruped* and *carnivore*. Neoclassicism is a new revival of classical antiquity, more consistent than earlier classicisms, and one that was linked, at least initially, to Enlightenment thought. Romanticism, in contrast, refers not to a specific style but to an attitude of mind that may reveal itself in any number of ways, including classicism. Romanticism, therefore, is a far broader concept and is correspondingly harder to define. To compound the difficulty, the Neoclassicists and early Romantics were contemporaries, who in turn overlapped the preceding generation of Rococo artists. David and Goya, for example, were born within a few years of each other. And in England the leading representatives of the Rococo, Neoclassicism, and Romanticism—Reynolds, West, and Fuseli—shared many of the same ideas, although they were otherwise separated by clear differences in style and approach.

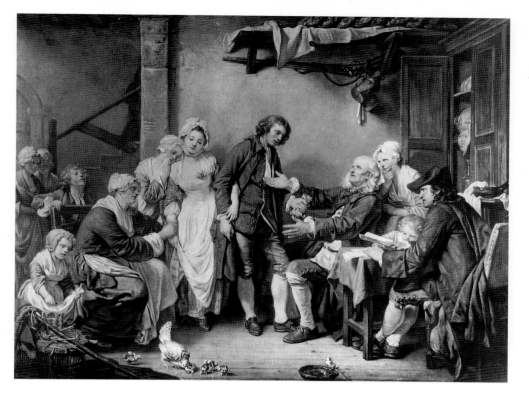

346. Jean-Baptiste Greuze.
The Village Bride. 1761.
Oil on canvas, 36 x 46¹/₂"
(91.4 x 118.1 cm).
Musée du Louvre, Paris

The Enlightenment

If the modern era was born during the American Revolution of 1776 and the French Revolution of 1789, these cataclysmic events were preceded by a revolution of the mind that had begun half a century earlier. Its standard-bearers were those thinkers of the Enlightenment in England, France, and Germany—David Hume, Voltaire, Denis Diderot, Jean-Jacques Rousseau, Heinrich Heine, and others—who proclaimed that all human affairs ought to be ruled by reason and the common good rather than by tradition and established authority. In the arts, as in economics, politics, and religion, this rationalist movement turned against the prevailing ornate and aristocratic Rococo. In the mid-eighteenth century, the call for a return to reason, nature, and morality in art meant a return to the ancients—after all, had not the classical philosophers been the original "apostles of reason"? The first to formulate this view was Johann Joachim Winckelmann (1717–68), the German art historian who popularized the phrase "noble simplicity and calm grandeur" for Greek art (in his *Thoughts on the Imitation of Greek Works . . .*, published in 1755). Because Classical art could offer little specific guidance, to most painters a return

to the classics meant the style and "academic" theory of Poussin, combined with a maximum of archeological detail newly gleaned from ancient sculpture and the excavations of Herculaneum and Pompeii, Italy, buried during the eruption of Mount Vesuvius in A.D. 79.

It is a measure of Italy's decline that leadership in art should pass to the Northerners who gathered in Rome, which remained a magnet for artists from all over Europe. The Italian school was eclipsed by the ▼FRENCH ACADEMY in Rome under Joseph-Marie Vien (1716–1809), its head from 1775 to 1781. Vien himself was a minor artist who transformed history painting into **genre** scenes of ancient life, but he was a gifted teacher, and it was his pupils who were to establish French painting as the inheritor and self-proclaimed guardian of the great tradition of Western art.

Painting

France

Jean-Baptiste Greuze In France, the anti-Rococo trend in painting was at first a matter of content rather than style, which accounts for the sudden fame around 1760 of Jean-Baptiste Greuze (1725–1805). *The Village Bride* (fig. 346),

▼ Strictly speaking, the FRENCH ACADEMY today is the Institut de France, a cluster of five learned societies brought together during the French Revolution. The original L'Académie Français began informally around 1630 and was made official in 1635 at the urging of Louis XIII's chief minister, the powerful Cardinal Richelieu (1585–1642). L'Académie Royale de Peinture et de Sculpture (later, L'Académie des Beaux-Arts), established in 1648 to encourage French fine artists and to mainta in the aesthetic standards favored by those in power, is sometimes referred to by art historians as the French Academy.

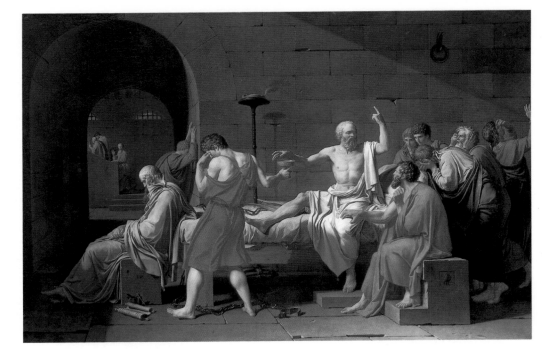

347. Jacques-Louis David.
The Death of Socrates. 1787.
Oil on canvas, 4'3" x 6'5¼"
(1.30 x 1.96 m).
The Metropolitan Museum
of Art, New York
Wolfe Fund, 1931. Catharine Lorillard
Wolfe Collection

▼ One of the leading minds of the Enlightenment was Swiss-born French Jean-Jacques ROUSSEAU (1712–78), a brilliant philosopher. (Enlightenment philosophers are called *philosophes*.) Rousseau's ideas about "natural man" were published in 1754 in his *Discourse on the Origin and Bases of Inequality among Men.* He wrote two immensely influential works, *The Social Contract* and *Émile,* the latter which provoked a long banishment from France.

▼ Denis DIDEROT (1713–84) was a genius in many fields, including natural science, and a novelist, dramatist, poet, and art critic. However, he is still best known as the compiler and editor of the great French *Encyclopédie* (1751–80), a staggering 28-volume compendium of the natural and physical sciences, law, and what would today be called political science. Fellow *philosophe* Jean-Jacque Rousseau was a contributor to the *Encyclopédie.*

like his other pictures of those years, is a scene of lower-class family life. What distinguishes it from earlier genre paintings (compare fig. 316) is its contrived, stagelike character, borrowed from Hogarth's "dumb show" narratives (see fig. 338). But Greuze had neither wit nor satire. His pictorial sermon illustrates the social gospel of Jean-Jacques ▼ROUSSEAU: that the poor, in contrast to the immoral aristocracy, are full of "natural" virtue and honest sentiment. Everything is intended to remind us of this, from the declamatory gestures and expressions of the actors to the smallest detail, such as the hen with her chicks in the foreground: one chick has left the brood and sits alone on a saucer, like the bride who is about to leave her "brood." *The Village Bride* was acclaimed a masterpiece, and the loudest praise came from Denis ▼DIDEROT, that apostle of reason and nature. Here at last was a painter with a social mission who appealed to the beholder's moral sense instead of merely giving pleasure like the frivolous artists of the Rococo. In his first flush of enthusiasm, Diderot accepted the narrative of Greuze's pictures as "noble and serious human action" in Poussin's sense. Diderot's extravagant praise of Greuze is understandable: *The Village Bride* is a pictorial counterpart to Diderot's melodramas.

Jacques-Louis David Diderot modified his views later, when a far more gifted and rigorous "Neo-*Poussiniste*" appeared on the scene: Jacques-Louis David (1748–1825). A disciple of Vien, David had developed his Neoclassical style in Rome during the years 1775–81. Upon his return to France, he quickly established himself as the leading Neoclassical painter, so that our conception of the movement is largely based on his accomplishments. In *The Death of Socrates* (fig. 347), David seems more *Poussiniste* than Poussin himself (see fig. 319). Like a relief, the composition unfolds parallel to the picture plane and the figures are as solid, and as immobile, as statues. David has added one unexpected element: the lighting, sharply focused and casting precise shadows. It is derived from Caravaggio, as is the firmly realistic detail. Consequently, the picture has a quality of life rather astonishing in so doctrinaire a statement. The very harshness of the design suggests that its creator was passionately engaged in the issues of his age, artistic as well as political. Socrates, refusing to compromise his principles, was convicted of a trumped-up charge and sentenced to death. About to drink the poison, he is shown not only as an example of Ancient Virtue, but also as the founder of the "religion of Reason." Here he is a Christ-like figure amid his twelve disciples.

David took an active part in the French Revolution, and for some years he had controlling power over the artistic affairs of the nation. During this time he painted his greatest picture, *The Death of Marat* (fig. 348). David's deep emotion has made a great work from a subject that would have embarrassed any lesser artist, for Marat, one of the political leaders of the revolution, had been murdered in his bathtub. A painful skin condition required immersion, and he did his work there, with a wooden board serving as his desk. One day a young woman named Charlotte Corday burst in with a personal petition, then plunged a knife into his chest while he read it. David has composed the scene with a stark directness that is awe-inspiring. In this canvas, which was planned as a public memorial to the martyred hero, classical art coincides with devotional image and historical account. However, classical art could offer little specific guidance here, even though the slain figure probably derives from an antique source, and the artist has drawn on the Caravaggesque tradition of religious art far more than in *The Death of Socrates*. It is no accident that his *Marat* reminds us so strongly of Zurbarán's *Saint Serapion* (see fig. 299).

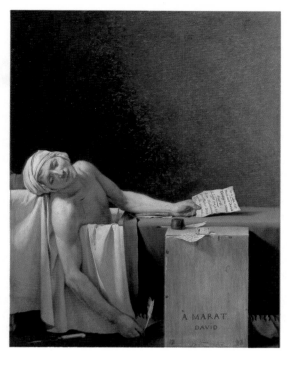

Royaux des Beaux-Arts de Belgique, Brussels

England

Benjamin West The martyrdom of a secular hero was first immortalized by Benjamin West (1738– 1820) in figure 349, *The Death of General Wolfe*. West traveled to Rome from Pennsylvania

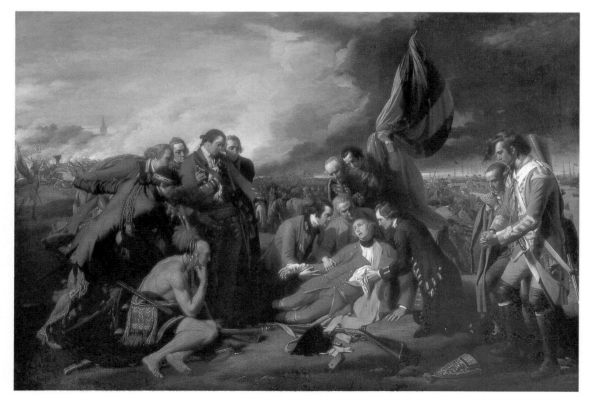

349. Benjamin West. *The Death of General Wolfe*. 1770. Oil on canvas, 4'11¹/₂" x 7' (1.51 x 2.13 m). The National Gallery of Canada, Ottawa

Gift of the Duke of Westminster

Classical Music

In common speech, *classical music* usually refers to "serious" rather than "popular" music. To a music historian, however, the term is primarily chronological: the Classical period follows the Rococo period, roughly encompassing the years between 1750 and 1820. Classical music in this sense is characterized by strict meter, general adherence to the rules of harmony, emotional restraint, and dignified simplicity. The composers of this period also, in the view of many, represent a high point of accomplishment that equals the achievements of other "classic" periods of Western art and culture.

Neoclassicism and *Sturm und Drang* (explained on page 423) had their counterparts in Classical music. The leading representative of the former was Christoph Willibald Gluck (1714–87). Gluck wrote two operas, *Orfeo ed Euridice* (1762) and *Alceste* (1767), that sought to correct the excesses of Italian opera through "a beautiful simplicity" and "to confine music to its proper function of serving the poetry for the expression and the situation of the plot." Though originally produced in Vienna, which had become the opera capital of Europe, the two operas enjoyed greater success in Paris, where classicism was an uninterrupted tradition. Gluck's operas have a nobility and depth of feeling that hark back to Monteverdi but with a classicism and pageantry worthy of Lully and Rameau. The subject of both works is the immortality of love, which conquers even death.

Carl Philipp Emanuel Bach (1714–88), a son of Johann Sebastian Bach, served for nearly thirty years at the Berlin court of Frederick the Great (1712–86), himself a very able composer. Unlike his illustrious father, C. P. E. Bach loathed counterpoint.

The widespread reaction against the complexities of counterpoint may be likened to the call for natural morality by Bach's contemporary, the philosopher Jean-Jacques Rousseau (1712–78). Bach nevertheless adopted a conservative style that suited his patron's taste. Upon being appointed to the most important post of music director at Hamburg, he felt free to pursue a direct, expressive style that sometimes shows a debt to his predecessor there, Georg Philipp Telemann. His first Hamburg SYMPHONIES exemplify *Sturm und Drang* in music: they are full of extremes, with brooding, sighing slow movements sandwiched between dynamic fast ones characterized by irregular rhythms and emotional outbursts that startle the listener. Their limitation, and it is a significant one, is the composer's disregard for form, which prevented him from developing them further.

Sturm und Drang influenced the middle symphonies written by Franz Joseph Haydn (1732–1809) in 1771–74. He spent almost his entire career at the estate of Esterházy south of Vienna, where he had a small but excellent ensemble of instrumentalists and singers in the service of his enlightened, if demanding, patron. Haydn became the most famous composer of his era and was called to Paris (1785–86) and London (1790, 1794), where he created symphonies of unrivaled sophistication and richness. He was no less a master of the string quartet, which he wrote in large numbers, all of them marked by unprecedented variety, formal mastery, and refined feeling. Haydn remained a person of his times: the late oratorios—*The Creation* (1798), based on Milton's *Paradise Lost,* and *The Seasons* (1801), adapted from James Thomson's poem (1726–30) of the same name—maintain the late-eighteenth-century view of an orderly cosmos created by a benevolent god.

Haydn became a close friend of Wolfgang Amadeus Mozart (1756–91), despite their great differences in age, temperament, and outlook. A child prodigy, Mozart received a rigorous training from his father, Leopold (1719–87), who paraded him around the great courts of Europe and exposed him to the full range of contemporary music. Mozart failed in his efforts to gain a major court appointment; deprived of this measure of security, he became a prolific composer for the open market and put the stamp of his individual genius on everything he wrote. His finest quartets are the six dedicated to Haydn, who declared him the greatest composer alive, while the late symphonies blaze new territory and foreshadow those of the young Beethoven. His numerous CONCERTOS for piano, of which he was a virtuoso, combine enchanting lyricism with brilliant technical display. Mozart was a supreme vocal composer, and it is the singing quality of the human voice that underlies his mature work, regardless of instrument. He was also a master of compositional technique, including counterpoint, and his compositions depend for much of their success on their formal perfection. Indeed, for Mozart form was the vehicle of expression, which it served to contain, so that there was an ideal, "classical" balance between the two. He was fully sympathetic to the Enlightenment. Its philosophy both informs and burdens his operas, including his acknowledged masterpieces *The Marriage of Figaro* (1786), based on the play by Beaumarchais, and *Don Giovanni* (1787). Both are a new type of comic opera, called *opera buffa* to distinguish it from traditional serious opera (*opera seria*), but unlike others of their genre, they have a wonderful humanity and substantial content, thanks in part to the librettos by Mozart's collaborator, Lorenzo Da Ponte (1749–1838).

in 1760 and caused something of a sensation, since no recognized American painter had appeared in Europe earlier. He relished his role of the New World frontiersman: on being shown a famous Greek statue he reportedly exclaimed, "How like a Mohawk warrior!" He also quickly assimilated the lessons of Neoclassicism, so that when he left Rome a few years later, he was in command of the most up-to-date style. West stopped in London for what was intended to be a brief stay on his way home but stayed on to become first a founding member of the

ROYAL ACADEMY, then, after the death of Reynolds, its president. His career was thus European rather than American, but he always took pride in his New World background.

We can sense this pride in *The Death of General Wolfe*, his most famous work. Wolfe's death in 1759, which occurred in the siege of Quebec during the ▼FRENCH AND INDIAN WAR, had aroused considerable feeling in London. When West, among others, decided to represent this event, two methods were open to him. He could give a factual account with the maximum of historic accuracy; or he could use "the grand manner," Poussin's ideal conception of history painting (see page 377), with figures in "timeless" classical costume. Although West had absorbed the influence of the *Neo-Poussinistes* in Rome, he did not follow them in this painting—he knew the American scene too well for that. Instead, he merged the two approaches. His figures wear contemporary dress, and the conspicuous figure of the Native American places the event in the New World for those unfamiliar with the subject; yet all the attitudes and expressions are "heroic." The composition, in fact, recalls an old and hallowed theme, the lamentation over the dead Christ (see fig. 200), dramatized by Baroque lighting (see fig. 302). West thus endowed the death of a modern military hero both with the rhetorical pathos of "noble and serious human actions," as defined by academic theory, and with the trappings of a real event. He created an image that expresses a phenomenon basic to modern times: the shift of emotional allegiance from religion to nationalism. No wonder his picture had countless successors during the nineteenth century.

John Singleton Copley West's gifted compatriot, John Singleton Copley of Boston (1738–1815), moved to London just two years before the American Revolution. Already an accomplished portraitist, Copley now turned to history painting in the manner of West. His most memorable work is *Watson and the Shark* (fig. 350, page 418). As a young man, Watson had been dramatically rescued from a shark attack while swimming in Havana harbor, but not until he met Copley did he decide to have this gruesome event memorialized. Perhaps he thought that only a painter newly arrived from America would do full justice to the exotic flavor of the incident. Copley, in turn, must have been fascinated by the task of translating the story into pictorial terms. Following West's example, he made every detail as authentic as possible (here the African American has the same purpose as the Native American in *The Death of General Wolfe*) and utilized all the expressive resources of Baroque painting to invite the beholder's participation. Copley may have remembered representations of Jonah and the Whale, which include the elements of his scene, except that the action is reversed: the prophet is thrown overboard into the jaws of the sea monster. The shark becomes a monstrous embodiment of evil; the man with the boat hook resembles Archangel Michael fighting Satan; and the nude youth, recalling a fallen gladiator, flounders helplessly between the forces of doom and salvation. This kind of moral allegory is typical of Neoclassicism as a whole, and despite its charged emotion, the picture has the same logic and clarity found in David's *The Death of Socrates*.

Angelica Kauffmann One of the leading Neoclassicists in England was the Swiss-born painter Angelica Kauffmann (1741–1807). A founding member of the Royal Academy, she spent fifteen years in London among the group that included Reynolds and West, whom she had met in Winckelmann's circle in Rome. From the antique she developed a delicate style admirably suited to the interiors of Robert Adam (see fig. 356), which she was often commissioned to adorn. Nevertheless, Kauffmann's most ambitious works are narrative paintings, of which the artist John Henry Fuseli observed, "Her heroines are herself." *The Artist in the Character of Design Listening to the Inspiration of Poetry* (fig. 351, page 419), one of her most appealing pictures, combines both aspects of her art. The subject must have held particular meaning for her, for it is eloquent testimony to women's struggle to gain recognition in the arts: the artist has assumed the guise of Design, who bears her

▼ The founding in 1748 of Britain's ROYAL ACADEMY of Arts was King George III's way of encouraging painting, sculpture, and architecture in Great Britain. (*RA* after an artist's name or signature indicates membership in the Academy.) Conservative by nature, the Academy is still under the direct patronage of the Crown, which sponsors a large annual show of works by members and nonmembers.

▼ France and England fought for possession of North America for 150 years. Tension culminated in a nine-year conflict called the FRENCH AND INDIAN WAR. Waged in New York state, New England, and Quebec, it ended in 1763 when Canada was ceded to England.

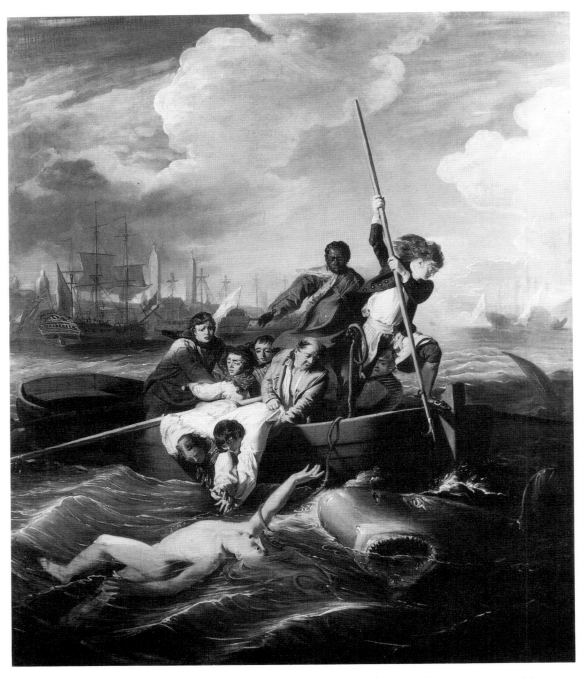

350. John Singleton Copley. *Watson and the Shark*. 1778. Oil on canvas, 7'6¹/4" x 6'¹/2" (2.29 x 1.84 m). Museum of Fine Arts, Boston

Gift of Mrs. George von Lengerke Meyer

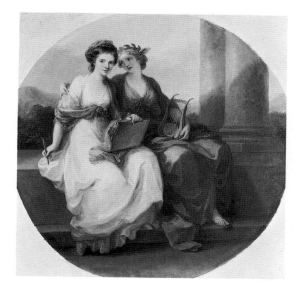

351. Angelica Kauffmann. *The Artist in the Character of Design Listening to the Inspiration of Poetry.* 1782. Oil on canvas, diameter 24" (61 cm). The Iveagh Bequest, Kenwood, London

features, attesting to her strong sense of identification with the muse.

Sculpture

The history of Neoclassical sculpture does not simply follow that of painting. Unlike painters, Neoclassical sculptors were almost overwhelmed by the authority accorded by Winckelmann and his circle to ancient statues. Although in fact most of them were mechanical Roman copies of no great distinction after Hellenistic pieces, they were praised as being supreme manifestations of the Greek genius and were venerated as embodiments of an aesthetic ideal undisturbed by the demands of time and place. To enter this world, modern sculptors set themselves the goal of creating "modern classics," that is, sculpture demanding to be judged on a basis of equality with its ancient predecessors. This was not merely a matter of style and subject matter. It meant that the sculptor had to find a way of creating monumental sculpture in the hope that critical acclaim would establish such works as "modern classics" and attract buyers. The solution to this problem was the ▼ORIGINAL PLASTER, which permitted major works to be presented to the public without a ruinous investment in expensive materials. We first encounter it at the ▼SALONS, the exhibi-

tions sponsored by the French Academy, where success was crucial for young artists. Without the original plaster, the Neoclassic revolution in sculpture would have been impossible to accomplish.

If Paris was the artistic capital of the Western world, Rome during the second half of the eighteenth century became the birthplace and spiritual home of Neoclassicism. However, the new style was pioneered by the resident foreigners from north of the Alps rather than by Italians. That Rome should have been an even stronger magnet for sculptors than for painters is hardly surprising. Rome offered an abundance of sculptural monuments but only a meager selection of ancient painting. In the shadow of these monuments, Northern sculptors trained in the Baroque tradition awakened to a new conception of what sculpture ought to be and thus paved the way for Antonio Canova, whose success as the creator of "modern classics" was the ultimate fulfillment of their aspirations (see pages 443–44).

England

Thomas Banks The leading role of Anglo-Roman artists prior to 1780 in the formulation of Neoclassicism was a result of England's enthusiasm for classical antiquity since the early

▼ One meaning of the word *original* is that an artist (or writer or musician) created the work in question. An ORIGINAL PLASTER is a three-dimensional work made by an artist from plaster of Paris, a hard-drying plaster traditionally modeled or cast as sculpture.

▼ The SALONS of France evolved over time from infrequent showings of L'Académie members' works in the seventeenth century to an annual event held in the Salon Carré of the Louvre in the early nineteenth century—hence the name Salon—and at other sites in Paris after 1850. Resentment over abuse of the selection process led Napoleon III to create an alternative exhibition, also "official," in 1863: the Salon des Refusés.

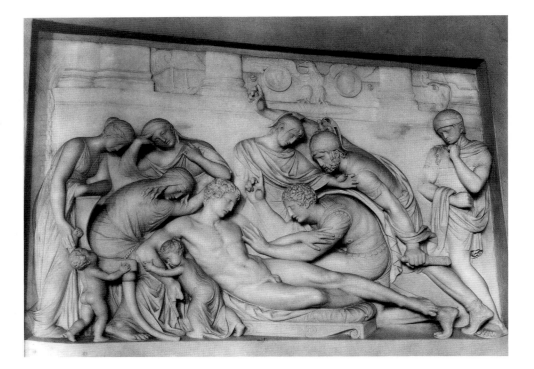

352. Thomas Banks. *The Death of Germanicus*. c. 1774. Marble, height 30" (76.2 cm). Holkham Hall, Norfolk, England

years of the century. Thomas Banks (1735–1805) came closest to establishing the creation of "modern classics" as the sculptor's true goal. Little is known of Banks's career before he went to Rome in 1772 for seven years on a traveling fellowship from the Royal Academy. *The Death of Germanicus* (fig. 352) of about 1774, a large relief, shows his close study of classical sources, yet it is not in the least archeological in flavor. While the facial types and drapery treatment derive from classical sources, the strained poses, the pronounced linear rhythms, and the emotional intensity of the scene have no counterpart in ancient sculpture. They reflect, rather, Banks's admiration for the two chief Anglo-Roman painters, Gavin Hamilton (1723–98), who had treated the same subject, and John Henry Fuseli (see pages 437–38).

On his return to England, Banks found little demand for his "new classics," although they were enthusiastically received by the recently established Royal Academy. Devoted to the nude and to heroic drama, he sought commissions for funerary monuments, which were the primary source of steady employment for sculptors in England.

353. Jean-Antoine Houdon. *Seated Voltaire*. 1781. Terra-cotta cast from marble original, height 47" (119.4 cm). Musée Fabre, Montpellier, France

France

Jean-Antoine Houdon Jean-Antoine Houdon (1741–1828), unlike most of his contemporaries, built his career on portraiture, which proved the most viable field for Neoclassic sculpture. How else could a modern artist rise

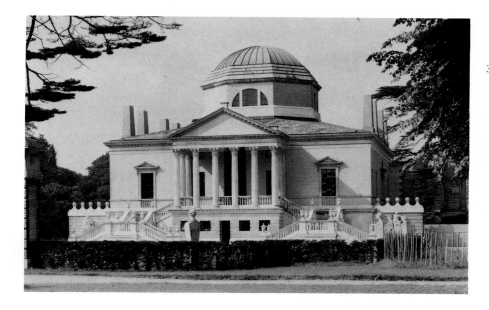

354. Lord Burlington and William Kent. Chiswick House, near London. Begun 1725

above the quality of the Greek and Roman classics, which were considered the acme of sculptural achievement by nearly everyone?

Houdon's portraits still retain the acute sense of individual character introduced by Coysevox (see fig. 329). Indeed, they established entirely new standards of physical and psychological verisimilitude. Houdon, more than any other artist of his time, knew how to give visible form to the ideals of the Enlightenment. His portraits have an apparent lack of style that is deceptive; they exhibit an uncanny ability to make all his sitters into Enlightenment personalities while remaining conscientiously faithful to their individual physiognomies.

Houdon modeled Voltaire from life a few weeks before the famous author's death in May 1778, then made a death mask as well. From these he created *Voltaire Seated* (fig. 353), which was immediately acclaimed as towering above all others of its kind. The original plaster has not survived, but a terra-cotta cast from it, retouched by Houdon, offers a close approximation. As contemporary critics quickly pointed out, the *Voltaire Seated* was a "heroicized" likeness, enveloping the frail old man in a Roman toga and even endowing him with some hair he no longer had so as to justify the classical headband. Yet the effect is not disturbing, for Voltaire wears the toga as casually as a dressing gown,

and his facial expression and the turn of his head suggest the atmosphere of an intimate conversation. Thus, Voltaire is not cast in the role of classical philosopher—he becomes the modern counterpart of one, a modern classic in his own right. In him, we recognize ourselves. Voltaire is the image of the modern person: unheroic, skeptical, with his own idiosyncratic mixture of rationality and emotion. That is surely why Voltaire strikes us as so "natural." We are, after all, the heirs of the Enlightenment, which coined this ideal type.

Architecture

The Palladian Revival

England was the birthplace of Neoclassicism in architecture, as it had been in the forefront of painting and sculpture. The earliest sign of this attitude was the Palladian revival in the 1720s, sponsored by the wealthy amateur architect Richard Boyle, Lord Burlington (1694–1753). Chiswick House (fig. 354), adapted from Palladio's Villa Rotonda (see fig. 265), is compact, simple, and geometric—the antithesis of Baroque pomp. What distinguishes this style from earlier classicisms is less its external appearance than its motivation. Instead of merely reasserting the superior authority of the ancients, it claimed to

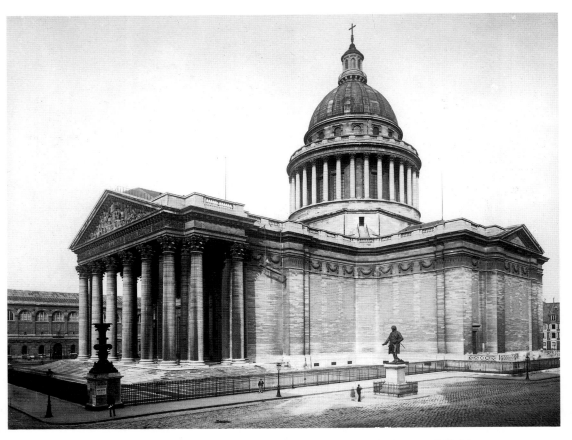

355. Jacques-Germain Soufflot. The Panthéon (Ste-Geneviève), Paris. 1755–92

▼ Since the seventeenth century, Britain's two chief political parties have been known as TORY and WHIG. Tory was originally a name for Irish outlaws. Later, it became associated with the political supporters of James II (1603–1701), the Roman Catholic Stuart king. The name Whig was used for those who opposed James II's succession to the Crown. Today's Conservative party members are called Tories; Liberal party followers are Whigs.

satisfy the demands of reason and thus to be more "natural" than the Baroque, which at the time was identified with ▼TORY policies by the WHIG opposition, thus beginning an association between Neoclassicism and liberal politics that was to continue through the French Revolution. This rationalism helps to explain the abstract, segmented look of Chiswick House. The surfaces are flat and unbroken, the ornament is meager, and the temple **portico** juts out abruptly from the blocklike body of the structure.

Jacques-Germain Soufflot The rationalist movement came somewhat later in France. Its first great monument, the Panthéon in Paris (fig. 355) by Jacques-Germain Soufflot (1713–80), was built as the Church of Ste-Geneviève but was secularized during the revolution. As with

so much else in eighteenth-century France, the building looks back to the preceding century, in this case Hardouin-Mansart's Church of the Invalides (see fig. 327). Its dome, interestingly enough, is derived from St. Paul's Cathedral in London (see fig. 331), indicating England's new importance for Continental architects. The smooth, sparsely decorated surfaces are abstractly severe, akin to those of Chiswick House (an effect further emphasized by later walling in the windows), while the huge portico is modeled directly on ancient Roman temples.

Neoclassicism and the Antique

Mid-eighteenth-century art was greatly stirred by two experiences: the rediscovery of Greek art as the original source of classic style, and the unearthing of Herculaneum and Pompeii. These

Neoclassical Theater

In France around the middle of the eighteenth century, the philosopher and encyclopedist Denis Diderot (1713–84) attempted to add DOMESTIC TRAGEDY and the COMEDY OF VIRTUE (the so-called middle genres) to the accepted classifications of theater. His sentimental plays, *The Illegitimate Son* (1757) and *The Father of a Family* (1758), were quickly forgotten. The only important French playwright of the later Enlightenment was Pierre-Augustin Caron de Beaumarchais (1732–99), whose comedies *The Barber of Seville* (1775) and *The Marriage of Figaro* (1783) became the basis for operas by Rossini and Mozart. While the *Barber* is a lighthearted farce about the triumph of young lovers over lecherous old men, *Figaro* was a critique of the aristocracy, whose ranks Beaumarchais joined, thanks to the wealth he amassed through his inventions and business ventures.

Neoclassicism in German theater was represented chiefly by the playwright, critic, and university professor Johann Christoph Gottsched (1700–66), whose plays followed French models. Critic and dramatist Gotthold Ephraim Lessing (1729–81), arguing against Gottsched's theories, proposed that the goal of drama is to arouse compassion, thereby fulfilling an important moral and social function. Although he belittled his own work, Lessing's plays, such as *Minna von Barnhelm* (1767), embody his principles very capably.

Lessing helped pave the way for the *Sturm und Drang* (Storm and Stress) period (1770–87), which was a virtual rebellion against the restrictions of Neoclassical drama and Enlightenment philosophy and was the first attempt to create a distinctive German form of theater. Although this literary movement took its name from a play of that title by F. M. Klingèr (1776), it centered on the young poet Johann Wolfgang von Goethe (1749–1832). Goethe's drama *Goetz von Berlichingen* (1773), inspired by the memoirs of a famous German knight, launched the *Sturm und Drang* movement in theater. (Its extreme subjectivity was epitomized by his novel *The Sorrows of Young Werther*, published the following year.) *Sturm und Drang* was poorly received but widely discussed; it was finally legitimized by August von Kotzebue (1761–1819), who became the most popular playwright in Europe. The late eighteenth century was also notable for the establishment of national theaters throughout Germany, as well as Austria: the Hamburg National Theater, which employed Lessing as its artistic adviser when it opened in 1767, and the Burgtheater in Vienna in 1776.

After the publication of *The Sorrows of Young Werther,* which established his reputation, Goethe was invited to the court in Weimar, where he spent the rest of his career and even served as minister of state for ten years. During a sojourn to Italy in 1786–88, he became a convert to classicism and rejected *Sturm und Drang*. In 1791, Goethe was appointed director of the theater at Weimar. There he and the poet and historian Friedrich von Schiller (1759–1805) formed a productive, lifelong friendship. From 1799 until his death, Schiller wrote great dramas, which were a direct outgrowth of his abiding interest in history. They center on the Thirty Years' War, about which he wrote the first major treatise, William Tell, Mary Stuart, and Joan of Arc. Under Goethe and Schiller, Weimar became home of the leading theater on the Continent. They argued that theater should transform experience through harmony and grace, rather than create an illusion of real life; hence, they instituted stylized conventions designed to lead the viewer to ideal truth. After Schiller's death Goethe lost interest in the theater.

excavations for the first time revealed the daily life of the ancients and the full range of their arts and crafts. Richly illustrated books about the Acropolis at Athens, the temples at Paestum, and the finds at Herculaneum and Pompeii were published in England and France. Archeology caught everyone's imagination. From this interest came a new style of interior decoration.

Robert Adam The Neoclassical style was epitomized by the work of the English designer Robert Adam (1728–92). His friendship with Piranesi in Rome reinforced Adam's goal of arriving at a personal style based on the antique without slavishly imitating it. His genius is seen most fully in the interiors he designed in the 1760s for palatial homes. Because he commanded an extraordinarily wide vocabulary, each room is different; yet the syntax remains distinctive to him. The library wing he added to Kenwood (fig. 356, page 424) shows Adam at his finest. Clearly Roman in inspiration, it is covered with a **barrel vault** connected at each end to an **apse** that is separated by a screen of **Corinthian columns**. Adam was concerned above all with movement, but this must be understood not in terms of Baroque dynamism or Rococo ornamentation but as the careful balance of varied shapes and proportions. The play of semicircles, half-domes, and arches lends an air of festive grace. The library thus provides an apt setting for "the parade, the convenience, and the social pleasures of life" since it was also a room "for receiving company." This intention was in keeping with Adam's personality, which was at ease with the aristocratic milieu in which he moved. The room owes much of its

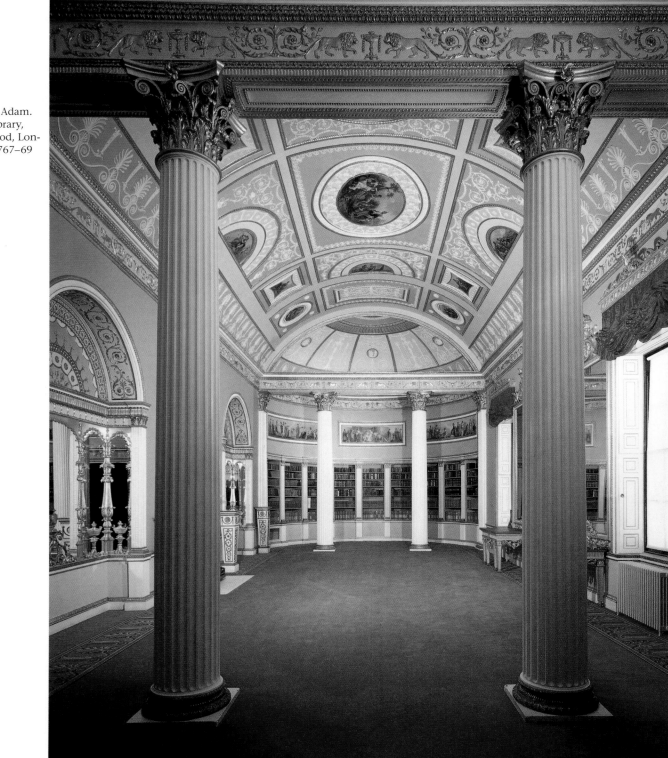

356. Robert Adam. The Library, Kenwood, London. 1767–69

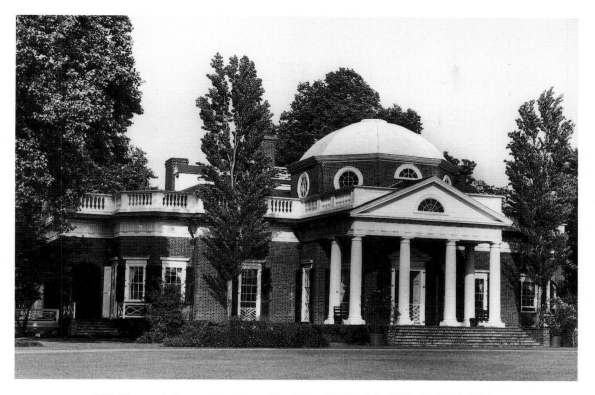

357. Thomas Jefferson. Monticello, Charlottesville, Virginia. 1770–84; 1796–1806

charm to the paintings by Antonio Zucchi (1762–95), later the husband of Angelica Kauffmann (who also worked for Adam), and the **stucco** ornament by Adam's plasterer Joseph Rose. The color, too, was in daring contrast to the stark white that was widely preferred for interiors at the time. The effect, stately yet intimate, echoes the delicacy of Rococo interiors (Adam had stayed in Paris in 1754 before going to Rome) but with a characteristically Neoclassic insistence on planar surfaces, symmetry, and geometric precision.

Thomas Jefferson Meanwhile, the Palladianism launched by Lord Burlington had spread overseas to the American colonies, where it became known as the Georgian style, after England's King Georges. An example of great distinction is Thomas Jefferson's house, Monticello (fig. 357). Built of brick with wood trim, in design it is not so doctrinaire as Chiswick House (note the less-compact plan and the numerous windows). Instead of using the Corinthian order, Jefferson (1743–1826) chose the Roman Doric order—a variation of Greek Doric in which the slenderer column rests on a base—which Adam had helped to legitimize as an alternative to the stark simplicity favored by Lord Burlington, although the late eighteenth century came to favor the heavier and more austere Greek Doric.

The "Greek revival" phase of Neoclassicism was quickly taken up everywhere, since it was believed to embody more of the "noble simplicity and calm grandeur" of classical Greece than did the later, less "masculine" orders. Because it was also the least flexible order, however, Greek Doric was particularly difficult to adapt to modern tasks, even when combined with Roman or Renaissance elements. Only rarely could it furnish a direct model for Neoclassical structures. For that reason, it fell out of favor during the Romantic era.

Chapter 22
The Romantic Movement

O f all the "isms" that populate Western art of the past two centuries, Romanticism has always been the most difficult to define. It deserves to be termed an ism only because its practitioners (or at least some of them) thought of themselves as being part of a movement. But none has left us anything approaching a definition of it. Perhaps the closest we can come to one of our own is to say that Romanticism was a certain state of mind rather than the conscious pursuit of a goal. If we try to analyze this state of mind, it breaks down into a series of attitudes, none of which, considered individually, is unique to Romanticism. It is only their peculiar combination that seems characteristic of the Romantic movement.

How did Romanticism come about? The Enlightenment, paradoxically, not only exalted reason but also liberated its opposite: a wave of emotionalism that was to last for the better part of a half-century and that came to be known as Romanticism. The word derives from tales of medieval adventure (such as the legends of King Arthur or the Holy Grail), which were called romances because they were written in a Romance language such as French or Italian, not in Latin. This vogue for the long-neglected "Gothick" past was symptomatic of a general trend. Those who, in the mid-eighteenth century, felt a revulsion against the prevailing social order and religion—against established values of any sort—either could try to found a new order based on reason or could seek satisfaction in emotional experience. The common denominator of these two choices was a desire to "return to Nature." The rationalists revered nature as the ultimate source of reason, while the Romantics worshiped it as unbounded, wild, and ever-changing. Both philosophies believed that evil would disappear if people were only to behave "naturally," giving their impulses free rein. In the name of this ideal, the Romantics acclaimed liberty, power, love, violence, Greek civilization, the Middle Ages, and anything else that aroused them. In fact, they exalted emotion as an end in itself. In its most extreme form, Romanticism could be expressed only through direct action, not through works of art. Thus, no *artist* can be a wholehearted Romantic, for the creation of a work of art demands detachment, self-awareness, and discipline. What William Wordsworth, the great Romantic poet, said of poetry in 1798—that it is "emotion recollected in tranquillity"—applies also to the visual arts.

Romanticism versus Neoclassicism

To cast fleeting experience into permanent form, the Romantic artists needed a style. Because they were in revolt against the old order, this style could not be the Rococo, which was the established style of the time. It had instead to come from some phase of the past to which the artists felt linked by "elective affinity" (another Romantic concept). Romanticism thus favored the revival not of one style but of a potentially unlimited number of them. In fact, the rediscovery and embracing of previously neglected or even scorned forms evolved into a principle in itself, so that revivals became the "style" of Romanticism in art, as they did, to a degree, in literature and music.

In this context, Neoclassicism may be seen as the first phase of Romanticism. Unlike most other Romantic revivals, however, Neoclassicism continued all the way through the nineteenth century and ultimately came to represent conservative taste. Perhaps it is best, therefore, to think of Romanticism and Neoclassicism as two sides of the same coin. If we maintain the distinction between them, it is because, until about 1800, Neoclassicism loomed larger than the other Romantic revivals and because of the Enlightenment's dedication to the cause of liberty over the cult of the individual represented by the Romantic hero.

Painting

It is one of the many apparent contradictions of Romanticism that it became, despite its desire for untrammeled freedom of individual creativity, art for the rising professional and commercial class, which effectively dominated nineteenth-century society and which replaced state commissions and aristocratic patronage as the most important source of support for artists. Painting remains the greatest creative achievement of Romanticism in the visual arts precisely because, being less expensive, it was less dependent than architecture or sculpture on public approval. It held a correspondingly greater appeal for the individualism of the Romantic artist. Moreover, it could better accommodate the themes and ideas of Romantic literature. Romantic painting was not essentially illustrative. But literature, past and present, now became a more important source of inspiration for painters than ever before and provided them with a new range of subjects, emotions, and attitudes. Romantic poets, in turn, often saw nature with a painter's eye. Many had a strong interest in art criticism and theory. Some, notably the German poet Johann Wolfgang von Goethe and the French novelist Victor Hugo, were capable illustrators; and the English poet William Blake cast his visions in pictorial as well as literary form (see fig. 371). Art and literature thus have a complex, subtle, and by no means one-sided relationship within the Romantic movement.

Spain

Francisco Goya We must begin our account of the Romantic movement with the great Spanish painter Francisco Goya (1746–1828), David's contemporary and the only artist of the age who may unreservedly be called a genius. His early works, in a delightful late Rococo vein, reflect the influence both of Tiepolo and the greatest of the French painters. (Spain had produced no painters of significance for over a century.) During the 1780s, Goya became more of a libertarian. He surely sympathized with the French Revolution—not with the king of Spain, who had joined other monarchs in war against the young French Republic. Yet Goya was much esteemed at the Spanish court, where he was appointed painter to the king in 1799. Goya now abandoned the Rococo for a Neo-Baroque style based on Velázquez and Rembrandt, the artists he had come to admire most. It is this Neo-Baroque style that announces the arrival of Romanticism.

The Family of Charles IV (fig. 358, page 428), Goya's largest royal portrait, deliberately echoes Velázquez's *The Maids of Honor* (see fig. 300). The entire royal family has come to visit the artist, who is painting in one of the picture galleries of the palace. As in Velázquez's painting, shadowy canvases hang behind the group and

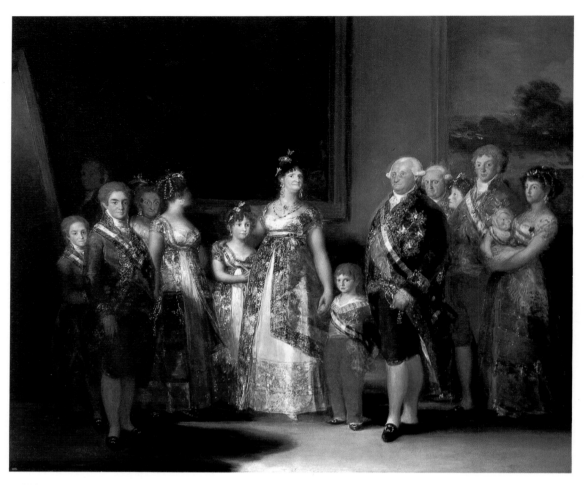

358. Francisco Goya. *The Family of Charles IV*. 1800. Oil on canvas, 9'2" x 11' (2.79 x 3.35 m). Museo del Prado, Madrid

▼ A brilliant military strategist with an insatiable appetite for glory, grandeur, and empire, NAPOLEON Bonaparte (1769–1821) dominated the European scene between about 1802 and 1815. After a decade of astonishing military successes, he came to power in 1799 as first consul of France. By 1804, he had himself crowned Emperor Napoleon I of France, the title he held until his 1815 military defeat at Waterloo (in Belgium) at the hands of allied British, Dutch, and German forces and the Prussian army. Napoleon and his first wife, Joséphine de Beauharnais (1763–1814), were ardent supporters of the Neoclassical style, which under their influence came to include Egyptian motifs. Napoleon was, in fact, the first European to direct an archeological exploration, in Eygpt.

the light pours in from the side, although its subtle gradations owe as much to Rembrandt as to Velázquez. The brushwork, too, has an incandescent sparkle rivaling that of *The Maids of Honor*. Although Goya's style is utterly unlike the Caravaggesque Neoclassicism of David, his painting has more in common with David's work than we might at first think. Like David, Goya practiced a revival style and, in his way, was equally devoted to the unvarnished truth: he used the Neo-Baroque strain of Romanticism to unmask the royal family.

Psychologically, *The Family of Charles IV* is almost shockingly modern. No longer shielded by the polite conventions of Baroque court portraiture, the inner lives of these individuals have been laid bare with pitiless candor. They

seem like a collection of ghosts: the frightened children, the bloated king, and—in a deft stroke of sardonic humor—the grotesquely vulgar queen, posed like Velázquez's Princess Margarita. How could Goya get away with this? Was the royal family so dazzled by the splendid painting of their costumes that they failed to realize what he had done to them? Goya must have succeeded in presenting them as they saw themselves, even as he unveiled a deeper truth to the rest of the world.

When ▼NAPOLEON's armies occupied Spain in 1808, Goya and many other citizens hoped that they would bring the liberal reforms so badly needed. The barbaric behavior of the French troops soon crushed these hopes and generated a popular resistance of equal sav-

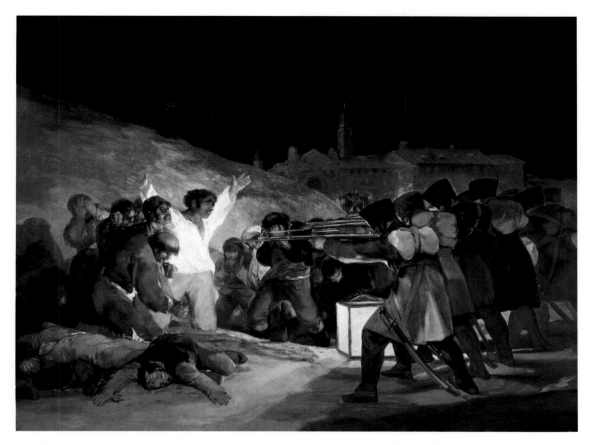

359. Francisco Goya. *The Third of May, 1808*. 1814–15. Oil on canvas, 8'9" x 13'4" (2.67 x 4.06 m). Museo del Prado, Madrid

agery. Many of Goya's works from 1810–15 reflect this bitter experience. The greatest is *The Third of May, 1808* (fig. 359), commemorating the execution of a group of Madrid citizens. Here the blazing color, the broad, fluid brushwork, and the dramatic nocturnal light are more emphatically Neo-Baroque than ever. The picture has all the emotional intensity of religious art, but these martyrs are dying for Liberty, not the Kingdom of Heaven. Nor are their executioners the agents of Satan, but of political tyranny: a formation of faceless automatons, impervious to their victims' despair and defiance. The same scene was to be reenacted countless times in modern history. With the clairvoyance of genius, Goya created an image that has become a terrifying symbol of our era.

Finally, in 1824, Goya went into voluntary exile. After a brief stay in Paris, he settled in Bordeaux, where he died. His importance for the Neo-Baroque Romantic painters of France is well attested by the greatest of them, Eugène Delacroix (see pages 432–34), who said that the ideal style would be a combination of Michelangelo's and Goya's art.

France

Antoine-Jean Gros With its glamour and its adventurous conquests in remote parts of the world, the reign of Napoleon (which lasted from 1799 to 1815, with one interruption) gave rise to French Romanticism. It emerged from the studio of Jacques-Louis David, who became

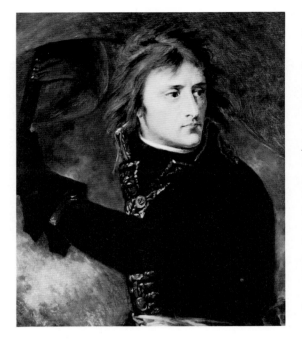

360. Antoine-Jean Gros. *Napoleon at Arcole*. 1796. Oil on canvas, 29¹/₂ x 23" (74.9 x 58.4 cm). Musée du Louvre, Paris

an ardent admirer of Napoleon and executed several large pictures glorifying the emperor. As a portrayer of the Napoleonic myth, however, he was partially eclipsed by artists who had been his students. They felt the style of David too confining and fostered a Baroque revival to capture the excitement of the age. Antoine-Jean Gros (1771–1835), David's favorite pupil, shows us Napoleon as a twenty-seven-year-old general leading his troops at the Battle of Arcole in northern Italy (fig. 360). Painted in Milan soon after a series of victories that gave the French the north Italian province of Lombardy, it conveys Napoleon's magic as an irresistible "man of destiny" with a Romantic enthusiasm David could never match.

After Napoleon's empire collapsed, David spent his last years in exile in Brussels, where his major works were playfully amorous subjects drawn from ancient myths or legends and were painted in a coolly sensuous Neo-Mannerist style he had initiated in Paris. He turned his

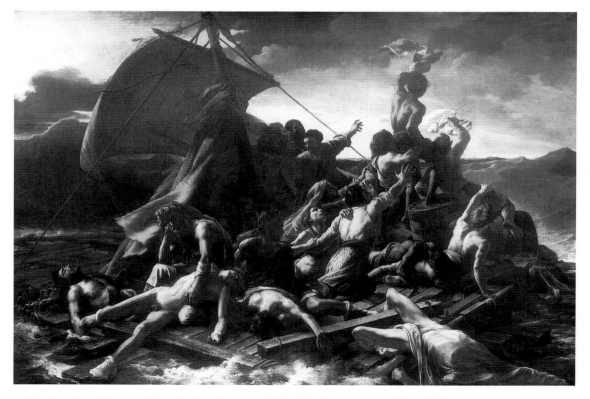

361. Théodore Géricault. *The Raft of the "Medusa."* 1818–19. Oil on canvas, 16'1" x 23'6" (4.9 x 7.16 m). Musée du Louvre, Paris

pupils in France over to Gros, urging him to return to Neoclassical orthodoxy. Much as Gros respected his teacher's doctrines, his emotional nature impelled him toward the color and drama of the Baroque. He remained torn between his pictorial instincts and these academic principles. Consequently, he never achieved David's authority and ended his life by suicide.

Théodore Géricault The Neo-Baroque trend initiated in France by Gros aroused the imagination of many talented younger artists. For them, politics no longer had the force of a faith. The chief heroes of Théodore Géricault (1791–1824), apart from Gros, were Michelangelo and the great Baroque artists. Géricault painted his most ambitious work, *The Raft of the "Medusa"* (fig. 361), in response to a political scandal and a modern tragedy of epic proportions. The *Medusa*, a government vessel, had foundered off the West African coast with hundreds on board. Only a handful were rescued, after many days on a makeshift raft that had been set adrift by the ship's heartless captain and officers. The event attracted Géricault's attention because, like many French liberals, he opposed the monarchy that was restored after Napoleon. He went to extraordinary lengths in trying to achieve a maximum of authenticity. He interviewed survivors, had a model of the raft built, even studied corpses in the morgue. This search for uncompromising truth is like David's, and *The Raft of the "Medusa"* is indeed remarkable for its powerfully realistic detail. Yet these preparations were subordinate in the end to the spirit of heroic drama that dominates the work. Géricault depicts the exciting moment when the rescue ship is first sighted. From the prostrate bodies of the dead and dying in the foreground, the composition is built up to a climax in the group that supports the frantically waving man, so that the forward surge of the survivors parallels the movement of the raft itself. Sensing, perhaps, that this theme of "man against the elements" would have strong appeal across the English Channel, where Copley had painted *Watson and the Shark* forty years earlier (see fig. 350), Géricault took the monumental canvas to England on a traveling exhibit in 1820.

Jean-Auguste-Dominique Ingres The mantle of David finally descended upon his pupil Jean-Auguste-Dominique Ingres (1780–1867). Too young to share in the political passions of the French Revolution, Ingres never was an enthusiastic Bonapartist, although he painted two portraits of Napoleon. In 1806, he went to Italy and remained for eighteen years, so he largely missed out on the formation of Romantic painting in France. Thus, after his return, he became the high priest of the Davidian tradition, defending it from the onslaughts of younger artists. What had been a revolutionary style only half a century earlier now congealed into rigid dogma, endorsed by the government and backed by the weight of conservative opinion.

Ingres is usually called a Neoclassicist, and his opponents, Romantics. Actually, both factions stood for aspects of Romanticism after 1800: the Neoclassical phase, with Ingres as the last important survivor, and the Neo-Baroque, first announced in France by Gros's *Napoleon at Arcole*. Indeed, the two seem so interdependent that we should prefer a single name for both if we could find a suitable one. (*Romantic Classicism*, which is appropriate only to the classical camp, has not won wide acceptance.) The two sides seemed to revive the old quarrel between *Poussinistes* and *Rubénistes* (see page 391). The original *Poussinistes* had never quite practiced what they preached, and Ingres's views, too, were far more doctrinaire than his pictures. He always held that drawing was superior to painting, yet a canvas such as his *Odalisque* (fig. 362, page 432) reveals an exquisite sense of color. Instead of merely tinting his design, he sets off the petal-smooth limbs of this Oriental Venus (*odalisque* derives from a Turkish word for "harem woman") with a dazzling array of rich tones and textures. The exotic subject, redolent with the enchantment of the *Thousand and One Nights*, is itself characteristic of the Romantic movement. Despite Ingres's professed worship of Raphael, this nude embodies no classical ideal of beauty. Her proportions, languid grace, and strange mixture of coolness and voluptuousness remind us, rather, of Parmigianino (compare fig. 254).

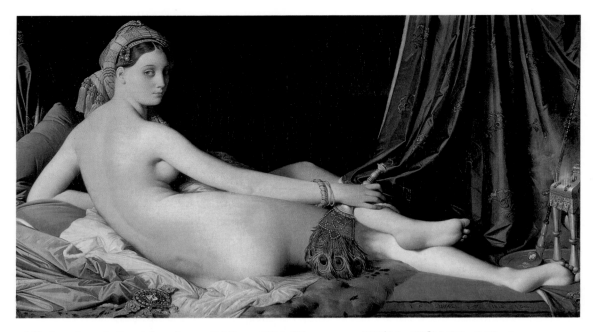

362. Jean-Auguste-Dominique Ingres. *Odalisque*. 1814. Oil on canvas, 2'11¼" x 5'3¾" (0.9 x 1.62 m). Musée du Louvre, Paris

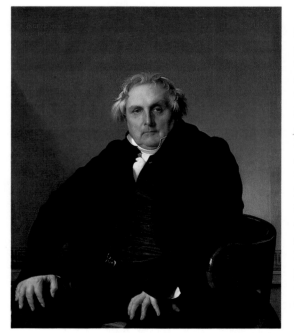

363. Jean-Auguste-Dominique Ingres. *Louis Bertin*. 1832. Oil on canvas, 46 x 37½" (116.8 x 95.3 cm). Musée du Louvre, Paris

History painting as defined by Poussin remained Ingres's lifelong ambition, but he had great difficulty with it—while portraiture, which he pretended to dislike, was his strongest gift and his steadiest source of income. He was, in fact, the last great professional in a field soon to be dominated by photography. Ingres's *Louis Bertin* (fig. 363) at first glance looks like a kind of "superphotograph," but this impression is deceptive. The artist applies the Caravaggesque Neoclassicism he had inherited from David to introduce slight changes of light and emphasis in the face, subtly altering its expression, which manifests an almost frightening intensity. Among the Romantics, only Ingres could so unify psychological depth and physical accuracy, while his followers concentrated on physical accuracy alone, competing vainly with the camera.

Eugène Delacroix The year 1824 was crucial for French painting. Géricault died after a riding accident. Ingres returned to France from Italy and had his first public success. The first showing in Paris of works by the English Romantic painter John Constable was a revelation to

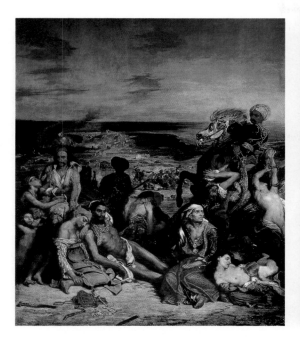

364. Eugène Delacroix. *The Massacre at Chios*. 1822–24. Oil on canvas, 13'10" x 11'7" (4.22 x 3.53 m). Musée du Louvre, Paris

365. Eugène Delacroix. *The Entombment of Christ*. 1848. Oil on canvas, 5'4" x 4'4" (1.62 x 1.32 m). Museum of Fine Arts, Boston

Gift by contribution in memory of Martin Brimmer

many French artists (see pages 438–39). And *The Massacre at Chios* (fig. 364) established Eugène Delacroix as the foremost Neo-Baroque Romantic painter. An admirer of both Gros and Géricault, Delacroix (1798–1863) had been exhibiting for some years, but *The Massacre at Chios* made his reputation. Conservatives called it "the massacre of painting," but others acclaimed it enthusiastically.

Like *The Raft of the "Medusa," The Massacre at Chios* was inspired by a contemporary event: the Greek war of independence against the Turks, which stirred a wave of sympathy throughout western Europe. (The full title of the painting is *Scenes of the Massacre at Chios: Greek Families Awaiting Death or Slavery*.) Delacroix, however, aimed at poetic truth rather than at recapturing a specific, actual event. In this, he relied on tradition to a surprising degree, for he has conjured up a scene as brutal as *The Rape of the Sabine Women* by Nicolas Poussin (compare fig. 319). The picture is treated as the kind of secular martyrdom already familiar to us from Benjamin West's *The Death of General Wolfe* (see fig. 349). Now, however, the victims are as nameless as those in *The Raft of the "Medusa."*

Such sources have been combined into an intoxicating mixture of sensuousness and cruelty. Delacroix does not entirely succeed, however, in forcing us to suspend our disbelief. While we revel in the sheer splendor of the painting, we do not quite accept the human experience as authentic. One reason may be the discontinuity of the foreground, with its dramatic contrasts of light and shade, as well as the luminous sweep of the landscape behind. (Delacroix is said to have hastily repainted part of the background after viewing Constable's *The Haywain*; see fig. 372.)

Sonorous color and the energetically fluid brushwork show Delacroix to be a *Rubéniste* of the first order. Ingres's *Odalisque* (see fig. 362) had also celebrated the exotic world of the Near East—alien, seductive, and color-filled—but the result was vastly different. No wonder that for the next quarter-century, he and Delacroix were acknowledged rivals, and their polarity, fostered by partisan critics, dominated the artistic scene in Paris.

The Deposition (fig. 365), painted in 1848, marks a shift in Delacroix's art. The painting has a new grandeur and an air of almost classical

366. Honoré Daumier. *The Third-Class Carriage*. c. 1862. Oil on canvas, 25 3/4 x 35 1/2" (65.4 x 90.2 cm). The Metropolitan Museum of Art, New York

Bequest of Mrs. H. O. Havemeyer, 1929. The H. O. Havemeyer Collection

▼ French poet, critic, and translator Charles-Pierre BAUDELAIRE (1821–67) was among the most astute of nineteenth-century observers. Well ahead of his time, he was writing symbolist poetry before Symbolism (Chapter 25) was a recognized movement. His best-known work and only published book of poetry, *Les Fleurs du mal* (Flowers of Evil, 1857), is modern in looking for goodness in the morbid and perverse.

▼ The changeover from a small-scale, agriculturally-based economy to one based on the large-scale, mechanized production and sale of manufactured goods is the INDUSTRIAL REVOLUTION. This great shift began in England in the late eighteenth century, was taken up by most of Western Europe and the United States in the middle of the nineteenth century, and continues to spread around the globe. The most profound effects have been urbanization, the rise of capitalism, the creation of new social classes, and the need for specialization.

restraint. This change was perhaps an outgrowth of a decorative cycle Delacroix had painted over the previous several years in the Bourbon Palace, which brought him into renewed contact with the tradition of Western art. His work now shows a preference for literary and biblical themes, without abandoning his earlier subjects. This interest may be seen as part of a larger crisis of tradition that gripped French art beginning in 1848, when revolution was in the air everywhere. Delacroix was now seen, with Ingres, as the last great representative of the mainstream of European painting. As the critic Charles ▼BAUDELAIRE wrote in his *Salon of 1846*: "Delacroix is . . . heir to the great tradition. . . . But take away Delacroix, and the great chain of history is broken and slips to the ground. It is true that the great tradition has been lost, and that the new one is not yet established." *The Deposition* suggests

that Delacroix was aware of his new status. The painting combines the color and sensuous brushwork of Titian and Rubens with the nobility of Poussin to make it that rarity in nineteenth-century art—a truly moving religious image.

Honoré Daumier The work of Delacroix reflects the attitude that eventually doomed the Romantic movement: its growing detachment from contemporary life. History, literature, the Bible, the Near East—these were the domains of the imagination where Delacroix sought refuge from the turmoil of the ▼INDUSTRIAL REVOLUTION. It is ironic that Honoré Daumier (1808–79), the one Romantic artist who did not shrink from everyday reality, remained practically unknown as a painter in his own time. A biting political cartoonist, he contributed satirical drawings to various Paris weeklies

for most of his life. He turned to painting in the 1840s but found no public for his work. Only a few friends encouraged him and, a year before his death, arranged his first one-person show.

Daumier's mature paintings have the full pictorial range of the Neo-Baroque, but the subjects of many of them are scenes of daily life like those he treated in his cartoons, now viewed with a painter's eye rather than from a satirist's angle. In *The Third-Class Carriage* (fig. 366), Daumier's forms reflect the compactness of François Millet's (see fig. 368) but are painted so freely that they must have seemed raw and "unfinished" even by Delacroix's standards. Yet Daumier's power derives from this very freedom. His concern is not for the tangible surface of reality but for the emotional meaning behind it. In this picture, he has captured a peculiarly modern human condition: the "lonely crowd." These people have in common only that they are traveling together in a railway car. Though they are physically crowded, they take no notice of one another—each is alone with his or her own thoughts. Daumier explores this state with an insight into character and a breadth of human sympathy worthy of Rembrandt, whose work he revered.

Camille Corot and French Landscape Painting Thanks to the cult of nature, landscape painting became the most characteristic expression of Romantic art. The Romantics believed that God's laws could be seen written in nature. While their faith, known as pantheism, arose from the Enlightenment, it was based not on rational thought but on subjective experience, and its appeal to the emotions rather than to the intellect made those lessons all the more compelling. In order to express the feelings inspired by nature, the Romantics sought to transcribe it as faithfully as possible, in contrast to the Neoclassicists, who had subjected the landscape to prescribed ideas of beauty and linked it to historical subjects. At the same time, the Romantics felt free to modify the appearance of the natural world in order to evoke heightened states of mind dictated by the imagination, the only standard they ulti-

mately recognized. Landscape inspired the Romantics with passions so exalted that only in the hands of the greatest history painters could human action equal nature in power. Hence, the Romantic landscape lies outside the descriptive and emotional range of the eighteenth century.

The first and undeniably greatest French Romantic landscape painter was Camille Corot (1796–1875). In 1825, he went to Italy for two years and explored the countryside around Rome, like a latter-day Claude Lorrain. What Claude recorded only in his drawings—the quality of a particular place at a particular time—Corot made into paintings, small canvases done on the spot in an hour or two (fig. 367, page 436). The immediacy of these quickly executed pictures is combined with a structural clarity and stability that recall Claude. Corot, however, insists on "the truth of the moment." His exact observation and his readiness to seize upon any view that attracted him during his excursions show a commitment to direct visual experience that we will see again in the work of John Constable. The Neoclassicists had also painted oil sketches outdoors. Unlike them, Corot did not transform his sketches into idealized pastoral visions. His willingness to accept them as independent works of art marks him unmistakably as a Romantic.

François Millet and the Barbizon School Corot's fidelity to nature was an important model for a group of younger painters known as the Barbizon School. Beginning in the 1830s, these artists settled in the village of Barbizon on the edge of the forest of Fontainebleau near Paris to paint landscapes and scenes of rural life. Seeking an alternative to the Neoclassical tradition and enthusiastic about John Constable, whose work had been exhibited in Paris in 1824, they turned to the Northern Baroque landscapes for inspiration. Their pastoral idylls are filled with a simple veneration of nature that admirably reflects the rallying cry of the French Romantics: sincerity. François Millet (1814–75) became a member of the Barbizon School in 1848, the year revolution swept France and the rest of Europe. Although Millet

was no radical, *The Sower* (fig. 368) was championed by liberal critics because it was the very opposite of the classical history paintings sanctioned by the establishment. Millet's archetypal image nevertheless has a self-consciously classical flavor that reflects his admiration for Poussin. Blurred in the hazy atmosphere, this "hero of the soil" is a timeless symbol of the ceaseless labor that the artist viewed as the peasant's inexorable fate. Ironically, the painting monumentalizes a rural way of life that was rapidly disappearing under the pressure of the Industrial Revolution. For that very reason, however, the peasant was seen as the quintessential victim of the evils arising from the age of mechanization.

Rosa Bonheur The Barbizon School generally advocated a return to nature as a way of fleeing the ills arising from industrialization and urbanization. Despite their members of conservative outlook, the popular revolution of 1848 elevated these artists to a new prominence in French art. That same year, Rosa Bonheur (1822–99), also an artist who worked outdoors, received a French government commission that led to her first great success and helped establish her as a leading painter of animals—and eventually as the most famous woman artist of

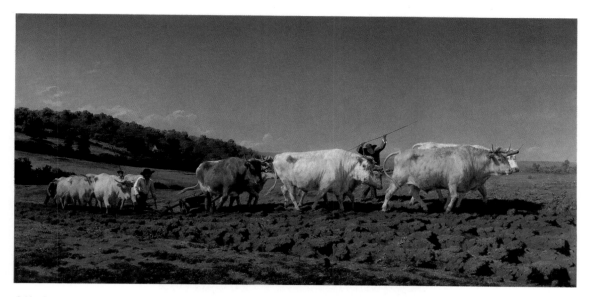

369. Rosa Bonheur. *Plowing in the Nivernais*. 1849. Oil on canvas, 5'9" x 8'8" (1.75 x 2.64 m). Musée d'Orsay, Paris

her time and one of the most acclaimed of all artists then working. Her painting *Plowing in the Nivernais* (fig. 369) was exhibited the following year, after a winter spent making studies from life. The theme of humanity's union with nature had already been popularized in the country romances of French writer George Sand, among others. Bonheur's picture shares Millet's reverence for peasant life, but the real subject here, as in all her paintings, is the animals within the landscape. These she depicts with a convincing naturalism that later placed her among the most influential Realists.

England

John Henry Fuseli England was as precocious in nurturing Romanticism as it had been in promoting Neoclassicism. In fact, one of its first representatives, John Henry Fuseli (1741–1825), was a contemporary of West and Copley. This Swiss-born painter (originally named Füssli) had an extraordinary impact on his time, more perhaps because of his adventurous and forceful personality than because of the merits of his work. Fuseli based his style on Michelangelo and the Mannerists, not on Poussin and the antique. A German acquaintance of those years described him as "extreme in everything,

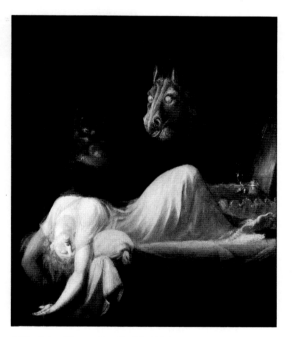

370. John Henry Fuseli. *The Nightmare*. c. 1790. Oil on canvas, 29¹/₂ x 25¹/₄" (74.9 x 64.1 cm). Freies Deutsches Hochstift-Frankfurter Goethe Museum, Frankfurt, Germany

Shakespeare's painter." Fuseli was a transitional figure. He espoused many of the same Neoclassical theories as Reynolds, West, and Kauffmann but bent their rules virtually to the breaking point. We see this in *The Nightmare* (fig. 370).

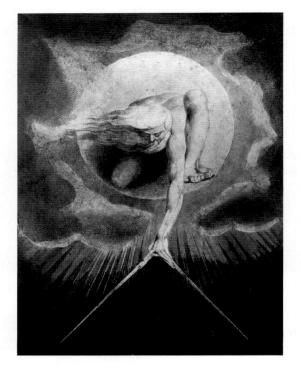

371. William Blake.
The Ancient of Days,
frontispiece of *Europe,
a Prophesy.* 1794.
Metal relief etching,
hand-colored, page
14^5/$_8$ x 10"
(37.2 x 25.4 cm),
illustration 9^1/$_8$ x 6^5/$_8$"
(23.2 x 16.8 cm).
Library of Congress,
Washington, D.C.

Lessing J. Rosenwald
Collection

The sleeping woman, more Mannerist than Michelangelesque, is Neoclassical. The grinning devil and the luminescent horse, however, come from the demon-ridden world of medieval folklore, while the Rembrandtesque lighting reminds us of Reynolds (compare fig. 341). Here the Romantic quest for terrifying experiences leads not to physical violence but to the dark recesses of the mind.

William Blake Later, in London, Fuseli befriended the poet-painter William Blake (1757–1827), who possessed an even greater creativity and stranger personality than his own. A recluse and visionary, Blake conceived a tremendous admiration for the Middle Ages, and he came closer than any other Romantic artist to reviving pre-Renaissance forms. He even produced and published his own books of poems with engraved text and hand-colored illustrations, which were meant to be the successors of illuminated manuscripts. Though he never left England, he acquired a large repertory of Michelangelesque and Mannerist motifs from engravings, as well as through the influence of Fuseli.

These elements are all present in Blake's memorable image *The Ancient of Days* (fig. 371). The muscular figure, radically **foreshortened** and fitted into a circle of light, is derived from Mannerism, while the symbolic compasses come from medieval representations of the Lord as Architect of the Universe. With these precedents, we would expect the Ancient of Days to signify Almighty God, but in Blake's esoteric mythology, he stands rather for the power of reason, which the poet regarded as ultimately destructive, since it stifles vision and inspiration. To Blake, the "inner eye" was all-important; he felt no need to observe the visible world around him.

John Constable It was in landscape rather than in narrative scenes that English painting reached its fullest expression. During the eighteenth century, the two main landscape modes had been the picturesque and the sublime. As the term implies, *picturesque* was a way of looking at nature through the eyes of landscape painters. The scenery of Italy and the idyllic landscapes of Claude had at first taught the English

to appreciate nature. In articulating sentiments inspired by these examples, eighteenth-century Scottish nature poet James Thomson (1700–48) further validated the aesthetic response to nature, often through reference to mythology. The picturesque was soon joined by wilder scenes reflecting a taste for the sublime—that delicious sense of awe experienced before grandiose nature, as defined by Irish statesman and writer Edmund Burke in his book *Inquiry into the Origin of Our Ideas of the Sublime and the Beautiful* of 1756. After touring the rugged Lake District of England in 1780, writer William Gilpin (1724–1804) claimed, however, that the picturesque lay somewhere between Burke's extremes, since it is neither vast nor smooth but finite and rough. The picturesque later came to include a topographical mode and a rustic mode based on Northern Baroque landscapes but remained fundamentally a way of manipulating nature to conform to artistic examples. John Constable (1776–1837) admired both Ruisdael and Claude, yet he strenuously opposed all flights of fancy. Landscape painting, he believed, must be based on observable facts; it should aim at "embodying a pure apprehension of natural effect." All of Constable's pictures show familiar views of the English countryside. It was, he later claimed, the scenery around his native Stour Valley that made him a painter. Although he painted the final versions in his studio, he prepared them by making oil sketches from nature. The sky, to him, remained "the key note, standard scale, and the chief organ of sentiment," a mirror of those sweeping forces so dear to the Romantic view of nature. In *The Haywain* (fig. 372, page 440) of 1821, he has caught a particularly splendid moment: a great expanse of wind, sunlight, and clouds playing over the spacious landscape. The earth and sky have both become "organs of sentiment" informed with the artist's poetic sensibility. At the same time, there is an intimacy in this monumental composition that reveals Constable's deep love of the countryside. This new, personal note is characteristically Romantic. Since Constable has painted the landscape with such conviction, we see the scene through his eyes and believe him, even though it perhaps did not look quite this way in reality.

Joseph Mallord William Turner Joseph Mallord William Turner (1775–1851) arrived at a style that Constable deprecatingly but acutely described as "airy visions, painted with tinted steam." Turner began as a watercolorist, and the use of translucent tints on white paper may help explain his preoccupation with colored light. Like Constable, he made copious studies from nature (though not in oils), but the scenery he selected satisfied the Romantic taste for the picturesque and the sublime: mountains, the sea, or sites linked with historic events. In his full-scale pictures he often changed these views so freely that they became quite unrecognizable. Many of Turner's landscapes are related to literary themes. When they were exhibited, he would add appropriate quotations from ancient or modern authors to the catalog, or he would make up some lines himself and claim to be citing his own unpublished poem "Fallacies of Hope." These canvases are nevertheless the opposite of history painting as defined by Poussin. The titles indeed indicate "noble and serious human actions," but the tiny figures, lost in the seething violence of nature, suggest the ultimate defeat of all endeavor—the "fallacies of hope."

The Slave Ship (fig. 373, page 440), one of Turner's most spectacular visions, illustrates how he translated his literary sources into "tinted steam." First entitled *Slavers Throwing Overboard the Dead and Dying—Typhoon Coming On*, the painting contains several levels of meaning. Like Géricault's *The Raft of the "Medusa"* (see fig. 361), which had been exhibited in England in 1820, it has to do, in part, with a specific incident about which Turner had recently read. When an epidemic broke out on a slave ship, the captain jettisoned his human cargo because he was insured against the loss of slaves at sea, but not by disease. Turner also thought of a relevant passage from *The Seasons*, by poet James Thomson, that describes how sharks follow a slave ship during a typhoon, "lured by the scent of steaming crowds, or rank disease, and death." But what

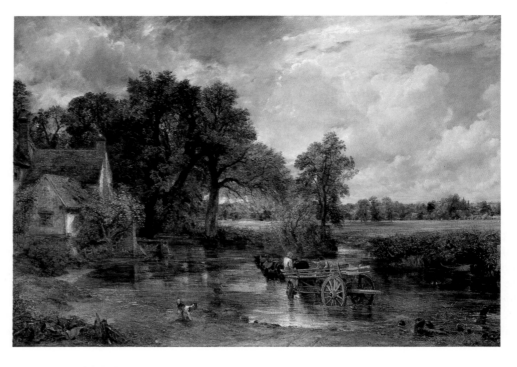

372. John Constable.
*The Haywain.*1821.
Oil on canvas,
4'3¹/4" x 6'1"
(1.3 x 1.85 m).
The National
Gallery, London

373. Joseph Mallord
William Turner.
The Slave Ship. 1840.
Oil on canvas,
35³/4 x 48"
(90.8 x 121.9 cm).
Museum of Fine
Arts, Boston

374. Caspar David Friedrich. *The Polar Sea*. 1824. Oil on canvas, 38 1/2 x 50 1/2" (97.8 x 128.3 cm). Kunsthalle, Hamburg, Germany

is the relation between the slaver's action and the typhoon? Are the dead and dying slaves being cast into the sea against the threat of the storm, perhaps to lighten the ship? Is the typhoon Nature's retribution for the captain's greed and cruelty? Of the many storms at sea that Turner painted, none has quite this apocalyptic quality. A cosmic catastrophe seems about to engulf everything, not merely the guilty slaver but the sea itself, with its crowds of fantastic and oddly harmless-looking fish.

While we still feel the force of Turner's imagination, most of us enjoy, perhaps with a twinge of guilt, the tinted steam for its own sake rather than as a vehicle of the awesome emotions the artist meant to evoke. Even in terms of the values he himself acknowledged, Turner strikes us as "a virtuoso of the Sublime" led astray by his very exuberance. He must have been pleased by praise from the theorist John ▼RUSKIN, that protagonist of the moral superiority of Gothic style, who saw in *The Slave Ship*, which he owned, "the true, the beautiful, and the intellectual"—all qualities that raised Turner above older landscape painters. Still, Turner may have come to wonder if his tinted

steam had its intended effect on all beholders. Soon after finishing *The Slave Ship*, he read in Goethe's *Color Theory*, recently translated into English, that yellow has a "gay, softly exciting character," while orange red suggests "warmth and gladness." Surely these would not be the emotions aroused by *The Slave Ship* in a viewer, even one who did not know its title. Later, Turner even painted a pair of canvases about the Biblical Flood that were meant to illustrate Goethe's theory of positive (light and warm) and negative (dark and cold) colors; yet they hardly differ in appearance from the rest of his work.

Germany

Caspar David Friedrich In Germany, as in England, landscape was the finest achievement of Romantic painting, and the underlying ideas, too, were often strikingly similar. When Caspar David Friedrich (1774–1840), the most important German Romantic artist, painted *The Polar Sea* (fig. 374) in 1824, he may have known of Turner's "Fallacies of Hope," for in an earlier picture on the same theme (now lost) he

▼ John RUSKIN (1819–1900) dominated English Victorian aesthetics through the power of his writings and lectures. His career as a writer, critic, and professor of art history at Oxford University was devoted to showing the affective relationship between morality and art. He favored an essentially religious aesthetic, believing it to be nobler and more significant than the sensory and sensual perception of works of art. Among Ruskin's reasons for opposing the Industrial Revolution was his belief that art is essentially spiritual and had reached its greatest heights in Gothic art and architecture. Hence, any mechanization of artmaking would defile the whole art enterprise.

The Romantic Movement in Literature and the Theater

Romanticism in art had an exact counterpart in literature and the theater, which was strongly influenced by the work of the German writer Johann Wolfgang von Goethe (1749–1832). Besides music, poetry, and plays, Goethe wrote on a wide range of other topics, including botany, architecture, and color theory. His novel *The Sorrows of Young Werther* (1774; final version 1787) had an immense impact on early Romanticism, and his long dramatic poem *Faust* (Part 1, 1808; Part 2, 1832) remains the movement's greatest monument.

German Romanticism centered on August Wilhelm von Schlegel (1767–1845), editor of a literary journal and a translator of Shakespeare, and his brother, Friedrich von Schlegel (1772–1829), a noted philosopher. Together they promoted Romanticism as an all-embracing vision. In literature, the Schlegels emphasized mood and character over plot and championed the revival of such medieval works as the twelfth-century German epic the *Nibelungenlied (Song of the Nibelungs)*. One of the finest playwrights to translate their sensibility was Heinrich von Kleist (1777–1811), whose tragedies and comedies are filled with the conflicts and extremes of emotion that characterize Romanticism. The writings of the Schlegels and their circle influenced a number of artists, including the landscape painter Caspar David Friedrich (see pages 441–42).

Romanticism was introduced to France by Anne-Louise-Germaine de Staël, whose book *Of Germany* (1810) presented many of the Schlegels' theories. Even more important for French Romanticism was enthusiasm for all things English. In 1823 the novelist Marie-Henri Beyle, known as Stendhal (1783–1842), declared Shakespeare's plays superior to Racine's, and four years later an English troupe caused a sensation by performing them in Paris. By then the historical novels of Sir Walter Scott (1771–1832) had already sparked a taste for medieval legends.

The central figure among the French Romantics was the novelist Victor Hugo (1802–85), who in 1830 wrote the play *Hernani* that announced the triumph of Romanticism. *Hernani* not only reversed the shopworn triumph of young lovers (so dear to classical French theater by ending in tragedy), it also broke from the stilted conventions of French dramatic poetry by altering the length of the poetic line. The other leading French Romantic dramatist was Alexandre Dumas the Elder (1802–70), who wrote a number of successful historical plays before turning to the novels for which he is best known today: *The Three Musketeers* (1844) and *The Count of Monte Cristo* (1845).

In England, all the important Romantic poets tried their hand at writing plays. The most successful of them was Lord Byron (George Gordon, 1788–1824), the very prototype of the Romantic figure. Byron's impact was immediate—Delacroix painted canvases inspired by Lord Byron's dramas *Marino Faliero* and *Sardanapalus*—and also lasted far beyond his brief lifetime. Later, the novelist George Bulwer-Lytton (1803–73) invented a form of "gentlemanly" MELODRAMA that gave an air of Victorian respectability to the theater.

had inscribed the name *Hope* on the crushed vessel. In any case, he shared Turner's attitude toward human fate. The painting, as so often before, was inspired by a specific event that the artist endowed with symbolic significance: a dangerous moment in explorer William Parry's Arctic expedition of 1819–20.

One wonders how Turner might have depicted this scene. Perhaps it would have been too static for him. Friedrich, however, was attracted by this very immobility. He has visualized the piled-up slabs of ice as a kind of **megalithic** monument to human defeat built by nature itself. Infinitely lonely, it is a haunting reflection of the artist's own melancholy. There is no hint of tinted steam—the very air seems frozen—nor any subjective handwriting. We look right through the paint-covered surface at a reality that seems created without Friedrich's intervention. This technique, impersonal and meticulous, is peculiar to German Romantic painting. It stems from the early Neoclassicists, but the Germans, whose tradition of Baroque painting was weak, adopted it more wholeheartedly than the English or the French.

United States

The New World, too, had its Romantic landscape artists. At first, Americans were far too busy carving out homesteads to pay much attention to the poetry of nature's moods. Their attitude toward landscape began to change only as the surrounding wilderness was gradually tamed, allowing them for the first time to see nature as the escape from civilization that inspired European painters. Pantheism virtually became a national religion during the Romantic era. Poets by 1825 were calling on American painters to depict the wilderness as the most conspicuous feature of the New World and its emerging civilization. While it could be frightening, nature was everywhere and was believed to play a special role in determining the American character. Led by Thomas Cole (1801–48), the founder of

the Hudson River School, which flourished from 1825 until the centennial celebration in 1876, American painters invested forests and mountains with the power to be symbolic of the United States.

Thomas Cole Like many early American landscapists, Cole came from England, where he was trained as an engraver, but he learned the rudiments of painting from an itinerant artist in the Midwest. Following a summer sketching tour up the Hudson River, he invented the means of expressing the elemental power of the country's primitive landscape by transforming the formulas of the English picturesque into Romantic hymns based on the direct observation of nature. Because he also wrote poetry, Cole was able to create a visual counterpart to the literary rhetoric of the day. *View of Schroon Mountain* (fig. 375, page 444), of 1838, shows the peak rising majestically, like a pyramid, from the forest below. It is treated as a symbol of permanence surrounded by death and decay, signified by the autumnal foliage, passing storm, and lightning-blasted trees. Stirred by sublime emotion, the artist has heightened the dramatic lighting so that the broad landscape becomes a revelation of God's eternal laws.

George Caleb Bingham *Fur Traders Descending the Missouri* (fig. 376, page 444) by George Caleb Bingham (1811–79) shows this close identification with the land. The picture, which is both a landscape and a **genre** scene, is full of the vastness and silence of the wide-open spaces. The two trappers in their dugout canoe, gliding downstream in the misty sunlight, are entirely at home in this idyllic setting. The assertion of a human presence portrays the United States as a benevolent Garden of Eden in which settlers assume their rightful place. Rather than being dwarfed by a vast and often hostile continent, these hardy pioneers live in an ideal state of harmony with nature, symbolized by the waning daylight. The picture carries us back to innocent era of Mark Twain's *Tom Sawyer* and *Huckleberry Finn*. At the same time, it reminds us of how much Romantic adventurousness went into the westward expansion

of the United States. The scene owes a good deal of its haunting charm to the silhouette of the black cub chained to the prow and its reflection in the water. This deft stroke adds a note of primitive mystery that we shall not meet again until the work of Henri Rousseau (Chapter 24).

Sculpture

The development of Romantic sculpture follows the pattern of painting. However, we shall find it much less venturesome than other forms of expression, including architecture, literature, music, and even cultural heroes such as Napoleon. The unique virtue of sculpture—its solid, space-filling reality (its "idol" quality)—was not congenial to the Romantic temperament. The rebellious and individualistic urges of Romanticism could find expression in rough, small-scale sketches but rarely survived the laborious process of translating them into permanent, finished monuments.

Italy

Antonio Canova Antonio Canova (1757–1822), who enjoyed unparalleled success as a creator of "modern classics," was not only the greatest sculptor of his generation but also the most famous artist of the Western world from the 1790s until long after his death. Both his work and his personality became a model for sculptors during those years. Canova's meteoric rise is well attested by his numerous commissions. Canova's friends included Jacques-Louis David, who helped to spread his fame in France. In 1802, Canova was invited to Paris by Napoleon, who wanted his portrait done by the greatest sculptor of the age. With Napoleon's approval, Canova made a colossal nude statue inspired by portraits of ancient rulers whose nudity signifies their status as divinities. The elevation of the emperor to a god marks a shift away from the lofty ideals of the Enlightenment that had given rise to Neoclassicism. Neoclassic glorification of the hero as an example of virtue, exemplified by Houdon's statue of Voltaire (see fig. 353), has been abandoned in favor of the

375. Thomas Cole. *View of Schroon Mountain, Essex County, New York, After a Storm.* 1838. Oil on canvas, 3'3" x 5'3" (1 x 1.6 m). The Cleveland Museum of Art

Hinman B. Hurlbut Collection

376. George Caleb Bingham. *Fur Traders Descending the Missouri.* c. 1845. Oil on canvas, 29 x 36¹/₂" (73.7 x 92.7 cm). The Metropolitan Museum of Art, New York

Morris K. Jesup Fund, 1933

Romantic cult of the individual. Romanticism recognized neither religion nor reason as a higher authority. For Canova, the imperative of Greek art remained unquestioned, but only as a style, divorced from content.

Not to be outdone, Napoleon's sister Pauline Borghese commissioned Canova to sculpt her as a reclining Venus (fig. 377). We recognize this work as a precursor, more classically proportioned, of Ingres's *Odalisque* (see fig. 362). Canova's style is typical of early Romanticism, which incorporated the erotic impulses of the Rococo, although in a less sensuous form. Strangely enough, *Pauline Borghese as Venus*

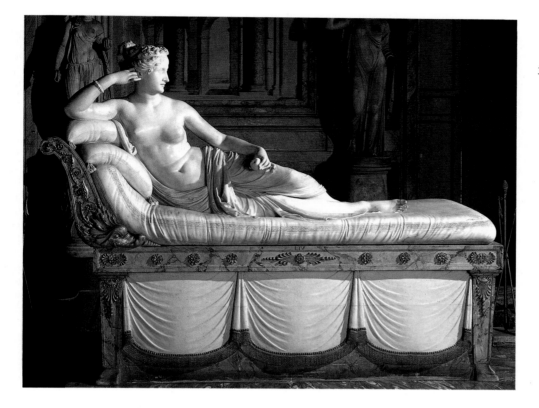

377. Antonio Canova. *Pauline Borghese as Venus*. 1808. Marble, lifesize. Galleria Borghese, Rome

seems less three-dimensional than Ingres's painting: it is designed for front and back view only, like a "relief in the round," and its considerable charm radiates almost entirely from the fluid grace of the contours.

France

The Romantic reaction against the ideal of the "modern classic" asserted itself in the sculpture sections of the French Salons only after the Revolution of 1830, which brought about the final fall of the Bourbon dynasty. However, the anticlassical impulse did not become dominant until the last two decades of the century, when Michelangelo at last won out over Canova. What ultimately destroyed classicism in sculpture was the Romantic idealization of the fragmentary and the unfinished.

That the Romantic "rebellion" started so much later in sculpture than in painting attests to how closely sculpture and politics were linked in nineteenth-century France. Artists were often passionately involved in politics during an era when political feelings were especially intense, but because the state remained the largest single source of commissions, the fortunes of the sculptors were more directly affected than those of the painters by changes in regime. This is not meant to suggest that French sculpture was dominated by its social and political environment. Yet, to the extent that it was a public art, sculpture responded to the pressure of these forces, directly or indirectly, far more than did painting, and sculpture was shaped by them in varying degrees, depending on local circumstances. Thus, we cannot understand its development without reference to the changing politics around it.

François Rude François Rude (1784–1855), who enthusiastically took Napoleon's side after the emperor's return from exile in Elba, sought refuge in Brussels from Bourbon rule, as had Jacques-Louis David, whom he knew and revered. Following his return to Paris, Rude must have felt that artistically he had reached a dead end and decided to strike out in new

Romanticism in Music

Music became the ideal Romantic art form because it was widely believed to allow the fullest expression of pure feeling, without the hindrance of literal meanings or appearances. The archetype of the early Romantic composer was Ludwig van Beethoven (1770–1827), who was in many ways a counterpart to Goethe, although Goethe really belonged to the previous generation. Beethoven's early works properly belong to the Classical period of music (see box on page 416). However, he greatly expanded the expressive range of the forms he inherited. He sympathized strongly with the American and French Revolutions, and in his personal relations he bowed to no one, least of all to his aristocratic patrons. Beethoven pushed the boundaries of Classical music to their limits, and sometimes beyond. His works are explosive and dynamic, loud as well as grand, and they fully exploit the resources of a large orchestra. Mercilessly self-critical, he composed far fewer works than either Haydn or Mozart. With rare exceptions, however, his are substantial contributions to musical literature that emphasize content over form—which Beethoven was increasingly willing to bend for expressive ends. Beethoven's work was the essential point of departure for the next generation of Romantic composers.

Franz Schubert (1797–1828), in contrast to Beethoven, was a man of quiet temperament, who made his greatest contribution as a composer of German ART SONGS (*Lieder;* singular, *Lied*), which he wrote in great quantity and variety. Their intimacy was well suited to his poetic sensibility. Although his symphonies show that he had some difficulty handling an extended form, Schubert's piano sonatas present an ideal combination of lyricism and large scale.

Orchestral writing presented no difficulties to Felix Mendelssohn-Bartholdy (1809–47). Like Mozart, he was a child prodigy who was writing significant music by late adolescence. His five symphonies and numerous overtures are notable for their vitality and colorism, which strive to "paint" vivid images in sound. Mendelssohn was stirred by literature, especially by the plays of Shakespeare. For an 1843 production of *A Midsummer Night's Dream,* he set the play to music that perfectly captures its impish spirit. Another important young composer and a friend of Mendelssohn, Robert Schumann (1810–56), was primarily a pianist, and his most characteristic works were for piano and voice. However, he also wrote four important symphonies, which strongly influenced the next generation of German composers.

The only composer to equal Beethoven's heroic stature was Hector Berlioz (1803–69). Despite being largely self-taught, this French musician had a masterly command of ORCHESTRATION—the technique of specifying which instruments in a full orchestra should play which parts of a musical composition. Berlioz's music is PROGRAMMATIC, that is, it tells a story, or at least suggests a sequence of incidents, and this emphasis on story line over pure form is one of his most Romantic qualities. Berlioz's *Symphonie fantastique* (*Fantastic Symphony,* 1830) tells a story of unrequited love, while his most successful work, *Romeo and Juliet* (1839), is virtually a dramatic realization of the play.

One of the most unusual personalities of the Romantic movement in music was the Polish composer Frédéric Chopin (1810–49). A virtuoso performer on the piano, Chopin introduced a wide range of new types of composition for the keyboard, most of them—the *polonaise* and the *mazurka,* for example—based on the national music of Poland. These compositions are so free and inventive that they seem to be new forms entirely, spun as if by magic from Chopin's endlessly fertile imagination. They can be poetic and intimate at one point and then heroic and grand. Chopin and his companion, the Romantic French novelist George Sand (Amandine-Aurore-Dupin Dudevant), sat for a famous portrait by Delacroix.

The opera, where stirring plots could be supported by vivid, emotional music, attracted the interest of many Romantic composers. While an opera might have a ridiculous plot, superb music and a good libretto could make it a masterpiece. The finest operas have worthy plots. Thus operas such as *The Barber of Seville* (1816) and *William Tell* (1829), both by Giaocchino Rossini (1792–1868); *Lucia di Lammermoor* (1835, based on a novel by Sir Walter Scott) by Gaetano Donizetti (1797–1848); and *La forza del destino* (1862) and *Aida* (1871) by Giuseppe Verdi (1813–1901) rank among the finest creations of Western music.

directions. He conceived a new interest in the French Renaissance tradition of the school of Fontainebleau and the sculptor Giovanni Bologna (see pages 319–20), which would eventually lead him back to Claus Sluter (see page 210). This rediscovery of national sculptural traditions, so characteristic of Romantic revivalism, was part of a new nationalism, which was also exemplified by a passion for historic portraits as "morally elevating for the public."

These concerns are manifest in Rude's greatest work, *The Departure of the Volunteers of 1792,* commonly called *"La Marseillaise"* (fig. 378), for Napoleon's unfinished triumphal arch on the Place de l'Étoile in Paris. King Louis-Philippe and his energetic minister of the interior, Adolphe Thiers, saw its completion as an opportunity to demonstrate that the new government was one of national reconciliation. Hence, the sculptural program had to offer something for every segment of the French political spectrum. Rude was fortunate in getting a commission for one of the four groups that flank the opening. He raised his subject—the French people rallying to defend the republic against attack from abroad—to the level of mythic splendor. The volunteers surge forth, some nude, others in classic armor,

378. François Rude. *"La Marseillaise."* 1833–36. Stone, approx. 42 x 26' (12.8 x 7.93 m). Arc de Triomphe, Paris

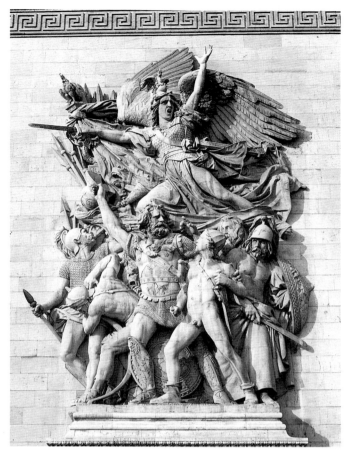

inspired by the great forward movement of the winged genius of Liberty above them. No wonder the work engendered an emotional response that made people identify the group with the national anthem itself. For Rude, the group had a deeply felt personal meaning: his father had been among those volunteers. When the arch was officially unveiled in 1836, there was almost unanimous agreement that Rude's group made the other three pale into insignificance. Despite its great public acclaim, *The Departure* failed to gain Rude the official honors he so clearly deserved. He found himself more and more in opposition to the regime, and his most important works between 1836 and 1848 were direct expressions of his Bonapartist political beliefs.

Jean-Baptiste Carpeaux The early 1830s, besides bringing Rude into prominence, also saw the rise of sculptors then still in their twenties. What separated them from the generation of their teachers was that none was old enough to have experienced the Napoleonic era. As it happened, there was not a single first-rate artist in this group. The French sculptors born during the second decade of the century may, with some hesitation, be designated late (or belated) Romantics, but we again look in vain for a major talent among them. The third decade, in contrast, saw the birth of several important sculptors. Of these, the greatest and best known was Jean-Baptiste Carpeaux (1827–75). Carpeaux's greatest work came at the end of the ▼SECOND EMPIRE, which succeeded the short-lived SECOND REPUBLIC in 1852. In 1861, his old friend the architect Charles Garnier began building the Paris Opéra and entrusted him with one of the four sculptural groups across the facade. *The Dance* (fig. 379) perfectly matches Garnier's Neo-Baroque architecture. (The plaster

379. Jean-Baptiste Carpeaux. *The Dance.* 1867–69. Plaster model, approx. 15' x 8'6" (4.57 x 2.64 m). Musée de l'Opéra, Paris

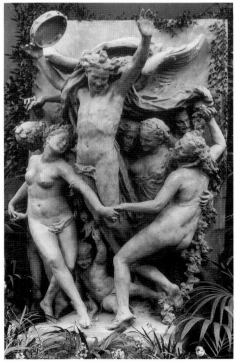

▼ Charles-Louis Napoleon Bonaparte (1808–73), nephew of Napoleon I, came to power after King Louis Philippe was ousted in the Revolution of 1848. Napoleon ran for election as president of the republic, the SECOND REPUBLIC, and he won on a relatively liberal platform. In 1851, he assumed dictatorial powers; by 1852 he converted the Second Republic to the SECOND EMPIRE, taking the title Napoleon III, emperor of France. An effective champion of domestic reform and liberalization, he failed to prepare France against military threats. The Prussians crushed France in the Franco-Prussian war of 1870. Napoleon III was captured and removed from office.

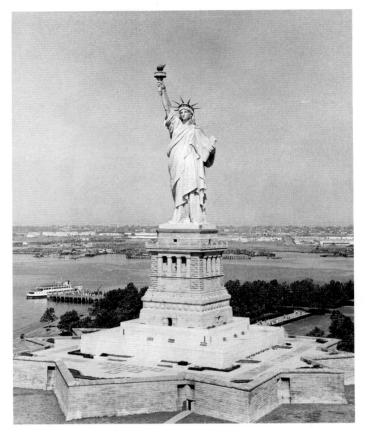

380. Auguste Bartholdi. *Statue of Liberty (Liberty Enlightening the World)*. 1875–84. Copper sheeting over metal armature, height of figure 151'6" (46.2 m). Bedloe's Island, New York Harbor

model in our illustration is both livelier and more precise than the final stone group, visible in fig. 384, lower right.) The coquettish gaiety derives from the Rococo. But Carpeaux's enormous figures (they are 15 feet tall) look undressed rather than nude, so that we do not accept them as legitimate denizens of the realm of mythology. Small wonder, then, that the group created a scandal after the unveiling in 1869. The nude dancing bacchantes around the winged male genius in the center were denounced as drunk, vulgar, and indecent. At first, public opinion insisted that it be replaced, but after the war with Germany in 1870 these complaints were forgotten and *The Dance* was greatly acclaimed. It is as obviously superior to the other three Opéra groups by more conserva-

tive sculptors as Rude's *Marseillaise* is to its neighbors on the Arc de Triomphe.

Auguste Bartholdi The late nineteenth century offered vast opportunities for official commissions. The most ambitious of these was the *Statue of Liberty* (or, to use its official title, *Liberty Enlightening the World*) by Auguste Bartholdi (1834–1904). This monument (fig. 380) in memory of French assistance to the United States during the War of Independence was a gift from the French people, not from the government. Hence, its enormous cost was raised by public subscription, which took ten years. Bartholdi based the *Statue of Liberty* on a figure he had conceived earlier, a gigantic lighthouse in the form of a woman holding a lamp to be erected at the northern entry to the Suez Canal. He exchanged the Egyptian headdress for a radiant crown and the lantern for a torch. The final model shows an austere, classically draped young woman holding the torch in her raised right hand and a tablet in her left. With her left foot, on which her weight rests, she steps out of the broken shackles of tyranny. The right leg (the free one, in accordance with the rules of classical **contrapposto**) is set back, so that the figure seems to be advancing when viewed from the side but looks stationary in the frontal view. As a piece of sculpture, the *Statue of Liberty* is less original than one might think. Formally and iconographically, it derives from a well-established ancestry reaching back to Canova and beyond. Its conservatism is, however, Bartholdi's conscious choice. He sensed that only a timeless statue could embody the ideal he wanted to glorify.

The figure, standing more than 150 feet tall, presented severe structural problems, which called for the skills of an architectural engineer. Bartholdi found the ideal collaborator in Gustave Eiffel, who was later to build the Eiffel Tower (see page 477). The project took more than a decade to complete. The *Statue of Liberty* was inaugurated at last in the fall of 1886, on a tall pedestal built with funds raised by the American public. Its fame as the symbol—one is tempted to say trademark—of the United States has reached across the world ever since.

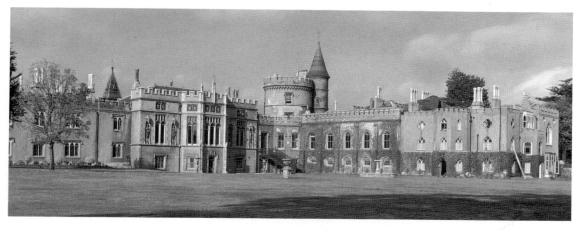

381. Horace Walpole, with William Robinson and others. Strawberry Hill, Twickenham, England. 1749–77

Architecture

Given the individualistic nature of Romanticism, we might expect the range of revival styles to be widest in painting, the most personal and private of the visual arts, and narrowest in architecture, the most communal and public. In fact, the opposite is true. Painters and sculptors were unable to abandon Renaissance habits of representation, and they never really revived medieval art or ancient art before the Classical Greek era. Architects were not subject to this limitation, however, and the revival styles persisted longer in architecture than in the other arts.

It is characteristic of Romanticism that at the time architects launched the classical revival, they also started a Gothic revival. England was far in advance here, as it was in the development of Romantic literature and painting, perhaps because Gothic forms had never wholly disappeared in England. They continued to be used on occasion for special purposes, but these were survivals of an authentic, if outmoded, tradition. The conscious revival, by contrast, was linked with the cult of the picturesque and with the vogue for medieval (and pseudomedieval) romances.

Horace Walpole In the spirit of medieval romances, Horace Walpole (1717–97), midway in the eighteenth century, enlarged and "gothicized" his country house, Strawberry Hill (figs. 381, 382), a process that took some two decades

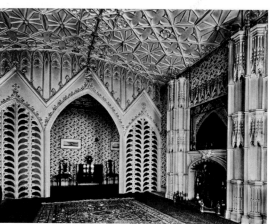

382. Interior, Strawberry Hill

and involved his circle of friends, including Robert Adam, who designed the round tower. On the exterior, the rambling structure has a studied irregularity that is decidedly picturesque. Inside, most of the elements were copied or faithfully adapted from authentic Gothic sources. Figure 382 shows a splendid imitation of the English Perpendicular style. Although Walpole associated the Gothic with the sublime, he acknowledged that the house was "pretty and gay." Despite its irregularity, the structure has dainty, flat surfaces that remind us strongly of Robert Adam (compare fig. 356): the interior looks almost as if it were decorated with lace-paper doilies. This playfulness, so free of dogma, gives Strawberry Hill its special charm. Gothic here is still an exotic style. It appeals because it is strange, but for that very reason it must be "translated," like a medieval romance or the Chinese motifs that crop up in Rococo decoration.

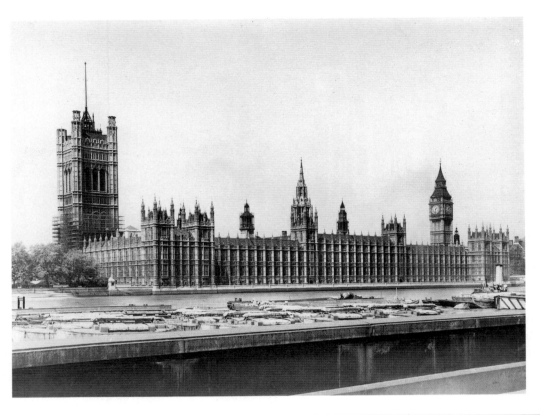

383. Charles Barry and
A. N. Welby Pugin.
The Houses of
Parliament, London.
Begun 1836

Charles Barry and A. N. Welby Pugin After 1800, the choice between the classical and Gothic modes was more often resolved in favor of Gothic. Nationalist sentiments, strengthened in the Napoleonic Wars, were probably an important factor in this preference. Indeed, England, France, and Germany each tended to think that the Gothic style expressed its particular national genius. Certain theorists (notably the English critic John Ruskin) also regarded Gothic as superior for ethical or religious reasons on the grounds that it was "honest" and "Christian." All these considerations lie behind the design, by Charles Barry (1785–1860) and A. N. Welby Pugin (1812–52), for the Houses of Parliament in London, the largest monument of the Gothic revival (fig. 383). As the seat of a vast and complex governmental apparatus, but at the same time as a focus of patriotic feeling, it presents a curious mixture: repetitious symmetry governs the main body of the structure and picturesque irregularity its silhouette. The building is indeed a contradiction in terms, for it imposes Pugin's Gothic vocabulary, inspired by the later English Perpendicular (compare

384. Charles Garnier. The Opéra, Paris. 1861–74

fig. 164), onto the classically conceived structure by Barry, with results that satisfied neither. Nevertheless, the Houses of Parliament admirably convey the grandeur of Victorian England at the height of its power.

Charles Garnier During this time, the stylistic alternatives for architects were continually increased by other revivals. When the Renaissance, and then the Baroque, returned to favor,

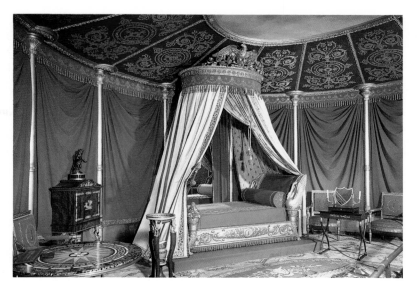

385. François-Honoré Jacob-Desmalter (after a design by Charles Percier and Pierre-François Fontaine). The bed of Empress Joséphine Bonaparte. c. 1810. Château de Malmaison, Rueil-Malmaison, France

the revival movement had come full circle: Neo-Renaissance and Neo-Baroque replaced the Neoclassical. This final phase of Romantic architecture, which dominated the years 1850–75 and lingered through 1900, is epitomized in the Paris Opéra (fig. 384), designed by Charles Garnier (1825–98). The Opéra was the culmination of Baron Georges-Eugène ▼HAUSSMANN's plan to modernize Paris under Napoleon III, for it is the focal point for a series of broad avenues that converge on it from all directions. Although the building was not completed until after the fall of the Second Empire, the opulence of its style epitomizes the new Paris. The building is a remarkable work of eclecticism. The massing of the main entrance is reminiscent of Lescot's Square Court of the Louvre (see fig. 281), but the paired columns of the facade are "quoted" from Perrault's east front of the Louvre (see fig. 323). The other entrance consists of a temple front. The totality consciously suggests a palace of the arts combined with a temple of the arts. The theatrical effect projects the festive air of a crowd gathering before the opening curtain. Its Neo-Baroque quality derives more from the profusion of sculpture—including Carpeaux's *The Dance* (see fig. 379)—and ornament than from its eclectic architectural vocabulary. The whole building looks "overdressed," its luxurious extravagance so naive as to be disarming. It reflects the taste of the beneficiaries of the Industrial Revolution, newly rich and powerful, who saw themselves as the heirs of the old aristocracy and thus found the styles predating the French Revolution more appealing than the classical or the Gothic.

Decorative Arts

The Empire Style The decorative arts followed much the same course as architecture during the Romantic era, but they were, if anything, more eclectic still. The revival sparked by the

discoveries at Pompeii and Herculaneum reached its climax during the early nineteenth century with the Empire style, a late form of Neoclassicism that spread throughout Europe in the wake of Napoleon's conquests. As the term suggests, the style drew heavily on Roman art, in order to associate Napoleon with the Caesars by borrowing imperial attributes. Initially, Roman prototypes had been copied more or less faithfully, but such imitations are among the least interesting products of Neoclassicism. Far more significant are the free adaptations of these sources to glorify the Bonapartes. These often incorporate Egyptian motifs to commemorate Napoleon's invasion in 1798, which opened up the Middle East.

Charles Percier and Pierre-François Fontaine
We have already caught a glimpse of the Empire style in the couch of Canova's *Pauline Borghese as Venus* (see fig. 377). We see it at its fullest in the Château de Malmaison, Napoleon's private residence near Paris, which was remodeled after 1798 by the architects Charles Percier (1764–1838) and Pierre-François Fontaine (1762–1853), who were also entrusted with its furnishings. The bedroom of Napoleon's wife, Empress Joséphine, reveals her taste for the ostentatious, which was so characteristic of the Empire style as a whole (fig. 385). Thus, its lavish splendor tells us a great deal about the First Empire—the regime of Napoleon—and its ambitions. The decor here serves

▼ Baron Georges-Eugène HAUSSMANN (1809–91) was an urban planner appointed by Napoleon III (ruled 1852–70) to reconceive the French capital in the mid-nineteenth century. In addition to widening boulevards, Haussmann created a number of starlike focal points at which major streets converge, moved the railroad stations to points outside the central city, and designated sites for several large parks in central Paris.

the same propagandistic purpose as at Versailles, for this is a state bedroom. (The empress usually slept in a more modest one nearby.) Although ordered previously, the remarkable bed—made by François-Honoré Jacob-Desmalter (1770–1841), the preeminent furniture manufacturer under Napoleon, after a design by Percier and Fontaine—became the centerpiece of a total redecoration in 1810 that continued to proclaim Joséphine as empress even though her marriage to Napoleon had been annulled earlier that year. The bed incorporates swans and cornucopias, standard Napoleonic devices, with a traditional canopy that subtly evokes a military tent surmounted by an imperial eagle. Nearby is a tripod washstand, with basin and jug, based on Pompeian examples. Like everything else about the bedroom, it is archeologically accurate in details. Yet nothing in antiquity looked like this, and the effect is surprisingly close to the Style of Louis XVI on the eve of the French Revolution.

Photography

Is photography art? The fact that we still pose the question testifies to the continuing debate. The answers have varied with the changing definition and understanding of art. In itself, photography is simply a medium, like oil paint or pastel, used to make art but having no inherent claim to being art. After all, what distinguishes an art from a craft is *why*, not *how*, it is done. But photography shares creativity with art because, by its very nature, its performance necessarily involves the imagination. Any photograph, even a casual snapshot, represents both an organization of experience and the record of a mental image. The subject and style of a photograph thus tell us about the photographer's inner and outer worlds. Furthermore, like painting and sculpture, photography participates in aspects of the same process of seek-and-find. Photographers may not realize what they respond to until after they see the image that has been printed.

Like woodcut, etching, engraving, and **lithography**, photography is a form of printmaking that is dependent on mechanical processes. But in contrast to the other graphic mediums, photography has always been tainted as the product of a new technology. For this reason, the camera has usually been considered little more than a recording device. Photography, however, is by no means neutral, and its reproduction of reality is never completely faithful. Whether we realize it or not, the camera alters appearances. Photographs reinterpret the world around us, making us literally see it in new terms.

Photography and painting represent parallel responses to their times and have generally expressed the same worldview. Sometimes the camera's power to extend our way of seeing has been realized first by the painter's creative vision. The two mediums nevertheless differ fundamentally in their approach and temperament: painters communicate their understanding through techniques that represent their cumulative response over time; photographers recognize the moment when the subject before them corresponds to the mental image they have formed of it. Not surprisingly, photography and painting have enjoyed an uneasy relationship from the start. Artists have generally treated the photograph as something like a preliminary sketch. Photography has in turn been heavily influenced throughout its history by the painter's mediums, and photographs may still be judged according to how well they imitate paintings and drawings. To understand photography's place in the history of art, we must learn to recognize its particular strengths and inherent limitations.

The Founders of Photography

In 1822, a French inventor named Joseph-Nicéphore Niépce (1765–1833) succeeded, at the age of fifty-seven, in making the first permanent photographic image, although his earliest surviving example (fig. 386) dates from four years later. He then joined forces with a younger man, Louis-Jacques-Mandé Daguerre (1789–1851), who had devised an improved camera. After ten more years of chemical and mechanical research, the **daguerreotype**, using positive exposures, was unveiled publicly in 1839, and the age of photography was born. The announcement spurred the Englishman William Henry Fox Talbot (1800–77) to com-

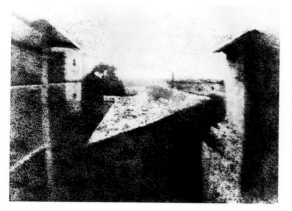

386. Joseph-Nicéphore Niépce. *View from His Window at Le Gras*. 1826. Heliograph, 6¹/₂ x 7⁷/₈" (16.5 x 20 cm). Gernsheim Collection, Harry Ranson Research Center, The University of Texas at Austin

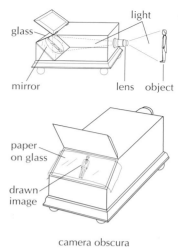

camera obscura

plete his own photographic process, involving a paper negative from which positives could be made, which he had been pursuing independently since 1833.

What motivated the earliest photographers? They were searching for an artistic medium, not for a device of practical utility. Though Niépce was a research chemist rather than an artist, his achievement was an outgrowth of his efforts to improve the lithographic process. Daguerre was a skilled painter, and he probably turned to the camera to heighten the illusionism in his huge painted **dioramas**, which were the sensation of Paris during the 1820s and 1830s. Fox Talbot saw in photography a substitute for drawing, as well as a means of reproduction, after using an ancient device called a camera obscura as a tool to sketch landscapes while on a vacation. The camera obscura ("dark chamber") is a box with a small hole in one end that casts a small image on the opposite interior wall.

That the new medium should have a mechanical aspect was particularly appropriate in the nineteenth century. It was as if the Industrial Revolution, having forever altered civilization's way of life, had now to invent its own method for recording itself, although the transience of modern existence was not captured by "stopping the action" until the 1870s. Photography underwent a rapid series of improvements, including inventions for better lenses, glass plate negatives, and new chemical processes, which provided faster emulsions and more stable images. Because many of the initial limitations of photography were overcome around midcentury, it would be misleading to tell the early history of the medium in terms of technological developments, important though they were.

The basic mechanics and chemistry of photography, moreover, had been known for a long time. In the sixteenth century, the camera obscura was widely used for visual demonstrations. In the seventeenth century, which saw major advances in optical science culminating in ▼NEWTONIAN PHYSICS, the camera was fitted with a mirror, and later, with a lens. By the 1720s the device had become an aid in drawing architectural scenes; at the same time, silver salts were discovered to be light-sensitive.

Why, then, did it take another hundred years for someone to put this knowledge together? Much of the answer lies in the nature of scientific revolutions. As a rule, they involve combining old technologies and concepts with new ones in response to changing world views that they, in turn, influence. Photography was neither inevitable in the history of technology nor necessary to the history of art; yet it was an idea whose time had clearly come. If we try for a moment to imagine that photography was invented a hundred years earlier, we find this idea to be impossible simply on artistic, apart from technological, grounds: the eighteenth century was too devoted to fantasy to be interested in the literalness of photography. Rococo portraiture, for example, was more concerned with providing a flattering image than an accurate likeness, and the camera's straightforward record would have been totally out of place. Even in architectural painting, extreme liberties were willingly taken with topographical truth.

The invention of photography was a response to the artistic urges and historical forces that underlie Romanticism. Much of the impulse came from a quest for the True and the Natural. The desire for "images made by Nature" can already be seen in the late-eighteenth-century vogue for silhouette portraits (traced

▼ Sir Isaac NEWTON (1642–1727), English mathematician and scientist, made outstanding contributions to the study of matter and energy (physics), including his three laws of motion, his observations on gravitation, and his studies of optics. His scientific work is so great that it came to be called NEWTONIAN PHYSICS. It represented the culmination of Baroque mechanics and was part of a comprehensive philosophy that reconciled science and religion. Among his inventions was the first reflecting-mirror telescope (1668). His theory of light, articulated in his 1704 *Optiks*, was studied by pioneers of photography.

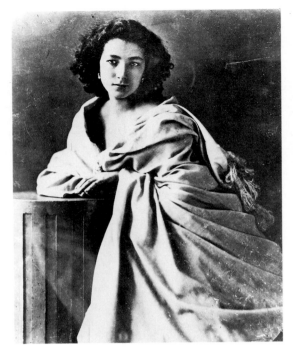

387. Nadar. *Sarah Bernhardt.* 1859. Bibliothèque Nationale, Paris

also keen competition among photographers to get the famous to pose for portraits.

Gaspard-Félix Tournachon (1820–1910), better known as Nadar, managed to attract most of France's leading personalities to his studio. Like many early photographers, he started out as an artist but came to prefer the lens to the brush. He initially used the camera to capture the likenesses of the 280 sitters whom he caricatured in an enormous lithograph, *Le Panthéon Nadar.* The actress Sarah Bernhardt posed for him several times, and his photographs of her (fig. 387) are the direct ancestors of modern glamour photography. With her romantic pose and expression, she is a counterpart to the soulful maidens who inhabit much of nineteenth-century painting. Nadar has treated her in remarkably sculptural terms: indeed, the play of light and sweep of drapery are reminiscent of the sculptured portrait busts that were so popular with collectors at the time.

The Restless Spirit and Stereophotography

Early photography reflected the outlook and temperament of Romanticism, and indeed the entire nineteenth century had a pervasive curiosity and an abiding belief that everything could be discovered. While this fascination sometimes manifested a serious interest in science—witness Charles ▼DARWIN's voyage on the *Beagle* from 1831 to 1836—it more typically took the form of a restless quest for new experiences and places. Photography had a remarkable impact on the imagination of the period by making the rest of the world widely available, or by simply revealing it in a new way.

A love of the exotic was fundamental to Romantic escapism, and by 1850 photographers had begun to cart their equipment to faraway places. The unquenchable thirst for vicarious experiences accounts for the expanding popularity of stereoscopic daguerreotypes. Invented in 1849, the two-lens camera produced two photographs that correspond to the slightly different images perceived by our two eyes; when seen through a special viewer called a stereoscope, the stereoptic photographs fuse to create

from the shadow of the sitter's profile), which led to attempts to record such shadows on light-sensitive materials. David's harsh realism in *The Death of Marat* (see fig. 348) had already proclaimed the cause of unvarnished truth. So did Ingres's *Louis Bertin* (see fig. 363), which established the standards of physical reality and character portrayal that photographers would follow.

Portraiture

Like lithography, which was invented only in 1797, photography met the growing middle-class demand for images of all kinds. By 1850, large numbers of the bourgeoisie were having their likenesses painted, and it was in portraiture that photography found its readiest acceptance. Soon after the daguerreotype was introduced, photographic studios sprang up everywhere, especially in the United States. Anyone could have a portrait taken cheaply and easily. In the process, the average person became memorable. Photography thus became an outgrowth of the democratic values fostered by the American and French revolutions. There was

▼ English scientist Charles Robert DARWIN (1809–82) shook the world in 1859 when he published *On the Origin of Species,* in which he theorized that evolution proceeds by natural selection, that the fittest specimans of life survive and reproduce, and that the human species arose from less evolved forms of life in this way. His research was based on observations gathered during a five-year voyage around the world aboard the *Beagle.*

a remarkable illusion of three-dimensional depth. Two years later, stereoscopes became the rage at the Crystal Palace exposition in London. Countless thousands of double views were taken, such as that in figure 388. Virtually every corner of the earth became accessible to practically any household, with a vividness second only to being there.

Stereophotography was an important breakthrough, for its binocular vision marked a distinct departure from linear perspective in the pictorial tradition and demonstrated for the first time photography's potential to enlarge vision. Curiously enough, this success waned, except for special uses. People were simply too habituated to viewing pictures as if with one eye. When the halftone plate was invented in the 1880s for reproducing pictures on a printed page, stereophotographs revealed another drawback: as our illustration shows, they were unsuitable for this process of reproduction. From then on, single-lens photography was inextricably linked with the mass media of the day.

Photojournalism

Fundamental to the rise of photography was the pervasive nineteenth-century sense that the present was already history in the making. Only with the advent of the Romantic hero did great acts other than martyrdom become popular subjects for contemporary painters and sculptors, and it is not surprising that photography was invented a year after the death of Napoleon, who had been the subject of more paintings than any secular leader before him. At about the same time, Géricault's *The Raft of the "Medusa"* and Delacroix's *The Massacre at Chios* (see figs. 361, 364) signaled a decisive shift in the Romantic attitude, toward representing contemporary events. This outlook brought with it a new kind of photography: photojournalism.

Its first great representative was Mathew Brady (1823–96), who covered the American Civil War (1861–65). Other wars had already been photographed, but Brady and his twenty assistants, using cameras too slow and cumbersome to show actual combat, managed to bring

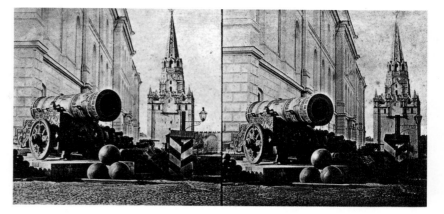

388. *Czar Cannon outside the Spassky Gate, Moscow.* (World's largest-caliber cannon, 890 mm, cast 1586; at present inside the Kremlin.) Second half 19th century. Stereophotograph. Courtesy Culver Pictures

389. Alexander Gardner. *Home of a Rebel Sharpshooter, Gettysburg.* July 1863. Wet-plate photograph. Chicago Historical Society

home its horrors with unprecedented directness. *Home of a Rebel Sharpshooter* (fig. 389) by Alexander Gardner (1821–82), who left Brady to form his own company, is a landmark in the history of art. Never before had both the grim reality and, above all, the significance of death on the battlefield been conveyed so inexorably in a single image. Compared with the heroic act celebrated by Benjamin West (see fig. 349), this tragedy is as anonymous as the slain soldier himself. The photograph is all the more persuasive for having the same harsh realism of David's *The Death of Marat* (see fig. 348), and the limp figure, hardly visible between the rocks framing the scene, is no less poignant.

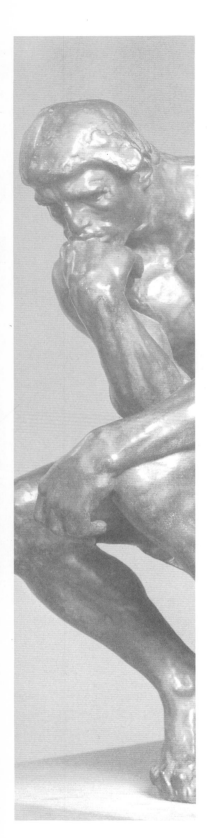

Chapter 23
Realism and Impressionism

"Can Jupiter survive the lightning rod?" asked the economist-philosopher Karl Marx, not long after the middle of the nineteenth century. The question implies that the ancient god of thunder and lightning was now in jeopardy through science. We experienced a similar dilemma between art and life in the controversy surrounding *The Dance* by the sculptor Carpeaux (see fig. 379). The French poet and art critic Charles Baudelaire was addressing himself to the same problem when, in 1846, he called for paintings that expressed "the heroism of modern life."

The Realism introduced by French painter Gustave Courbet in the mid-nineteenth century, then, was a revolution of subject matter more than of style. The conservatives' rage at him as a dangerous radical is understandable even so. He treated everyday life with the gravity and monumentality traditionally reserved for narrative painting. Courbet's sweeping condemnation of all traditional subjects drawn from religion, mythology, and history spelled out what many others had begun to feel but had not dared to put into words or pictures.

Impressionism, which followed close on the heels of Realism, was initially driven by some of the same antiestablishment impulses and values.

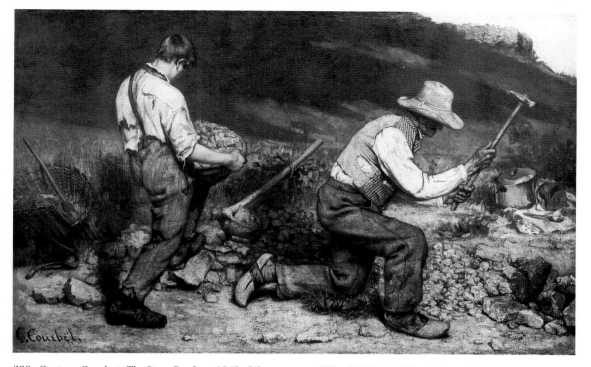

390. Gustave Courbet. *The Stone Breakers*. 1849. Oil on canvas, 5'3" x 8'6" (1.6 x 2.6 m). Formerly Gemäldegalerie, Dresden, Germany. Destroyed 1945

Painting

France

Gustave Courbet and Realism At the time Baudelaire called for heroism, only one painter was willing to make an artistic creed of this demand: Baudelaire's friend Gustave Courbet (1819–77). Born in Ornans, a village near the French-Swiss border, Courbet remained proud of his rural background. A ▼SOCIALIST in politics, he had begun painting as a Neo-Baroque Romantic in the early 1840s. By 1848, under the impact of the revolutionary upheavals then sweeping over Europe, he came to believe that the Romantic emphasis on feeling and imagination was merely an escape from the realities of the time. The modern artist must rely on direct experience and be a Realist. "I cannot paint an angel," he said, "because I have never seen one." As a descriptive term, *Realism* is not very precise. For Courbet, it meant something akin to the realism of Caravaggio (see page

344). As an admirer of Rembrandt he had, in fact, strong links with the Caravaggesque tradition, and his work, like Caravaggio's, was denounced for its supposed vulgarity and lack of spiritual content. What ultimately defines Courbet's Realism, however, and distinguishes it from Romanticism is his allegiance to radical politics. His socialist viewpoint colored his entire outlook, and although it did not determine the specific content or appearance of his pictures, it does help to account for his choice of subject matter and style, which went against the grain of tradition.

The storm broke at the Salon of 1850–51 when he exhibited *The Stone Breakers* (fig. 390), the first canvas fully embodying his programmatic Realism. Here, for the first time, was a picture that treated a genre scene with the same seriousness and the same monumentality as a history painting, in disregard of the academic hierarchy, and with a heavy **impasto**—a thick, rough application of paint—that violated accepted standards of finish. Courbet had seen

▼ Socialism is an economic and social doctrine that advocates state ownership and control of the basic means of production together with the egalitarian distribution of wealth. A *SOCIALIST,* therefore, is one who believes in socialism. In France in the mid-nineteenth century, socialism enjoyed wide support as an alternative to monarchy, empire, and unstable republics. The goal of ending economic and social oppression by one class or group over another helped to fuel the Revolution of 1848.

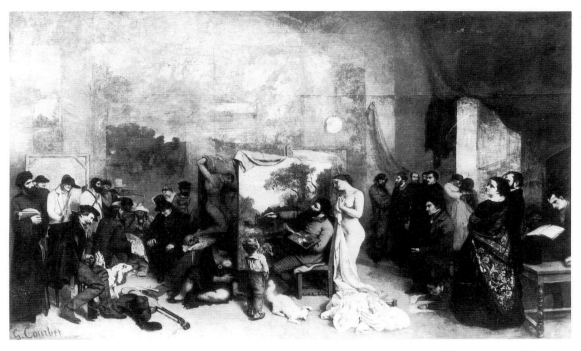

391. Gustave Courbet. *Studio of a Painter: A Real Allegory Summarizing My Seven Years of Life as an Artist.* 1854–55. Oil on canvas, 11'10" x 19'7" (3.6 x 5.97 m). Musée d'Orsay, Paris

▼ The Exposition Universelle (PARIS EXPOSITION) of 1855 was the first of a long series of French international expositions, but not the first such world's fair. In 1851, Queen Victoria and Prince Albert of England had inaugurated the very first international exhibition in the newly built Crystal Palace in London (see fig. 415, page 476). The Paris expositions were showcases for the work of officially favored French painters and sculptors.

two men working on a road and had asked them to pose for him in his studio. He painted them lifesize, solidly and matter-of-factly. The picture is very much larger than anything by Millet and has none of his overt sentiment (compare fig. 368). The young man's face is averted, the old one's is half hidden by a hat. Courbet cannot have picked them casually, however; their contrast in age is significant: one is too old for such heavy work, the other too young. Endowed with the dignity of their symbolic status, they do not turn to us for sympathy. One of Courbet's friends, the socialist journalist Pierre-Joseph Proudhon, likened them to a parable from the Gospels.

During the ▼PARIS EXPOSITION of 1855, where works by Ingres and Delacroix were prominently displayed, Courbet brought his pictures to public attention by organizing a private exhibition in a large wooden shed and by distributing a "manifesto of Realism." The show centered on a huge canvas, the most ambitious of his career, entitled *Studio of a Painter: A Real Allegory Summarizing My Seven Years of Life as an*

Artist (fig. 391). The term *real allegory* is something of a teaser; allegories, after all, are unreal by definition. Courbet meant either an allegory couched in the terms of his particular Realism or one that did not conflict with the "real" identity of the figures or objects embodying it. The framework is familiar. Courbet's composition clearly belongs to the type of Velázquez's *The Maids of Honor* and Goya's *The Family of Charles IV* (see figs. 300, 358). Now the artist has moved to the center, and the visitors are here as his guests, not royal patrons who enter whenever they wish. He has invited them specially, for a purpose that becomes evident only upon thoughtful reflection. The picture does not yield its full meaning unless we take the title seriously and inquire into Courbet's relation to this assembly.

There are two main groups. On the left are "the people." They are types rather than individuals, drawn largely from the artist's home environment at Ornans: hunters, peasants, workers, a Jew, a priest, a young mother with her baby. On the right, in contrast, we see

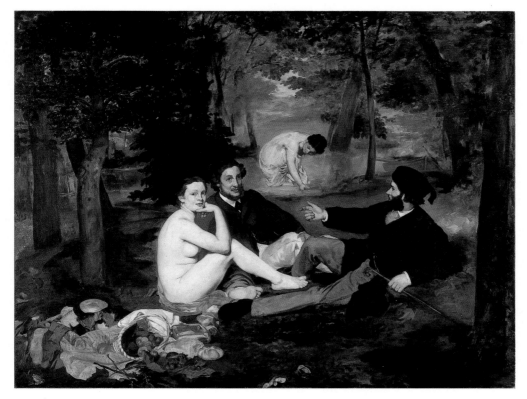

392. Édouard Manet. *Luncheon on the Grass (Le Déjeuner sur l'Herbe).* 1863. Oil on canvas, 7' x 8'10"
(2.13 x 2.64 m). Musée d'Orsay, Paris

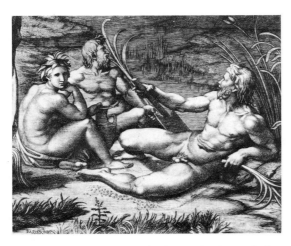

393. Marcantonio Raimondi, after Raphael. Detail of
The Judgment of Paris. c. 1520. Engraving,
11⁵/₈ x 17¹/₄" (29.5 x 43.8 cm). The Metropolitan
Museum of Art, New York

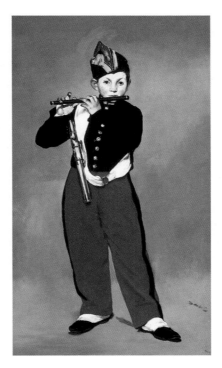

394. Édouard Manet. *The Fifer.* 1866. Oil on canvas,
5'3" x 3'2¹/₄" (1.6 x 0.97 m). Musée d'Orsay, Paris

Realism and Impressionism *459*

groups of portraits representing the Parisian side of Courbet's life: clients, critics, intellectuals. (The man reading is Baudelaire.) All of these people are strangely passive, as if they are waiting for we know not what. Some are quietly conversing among themselves; others seem immersed in thought. Yet hardly anyone looks at Courbet. They are not his audience but rather a representative sampling of his social environment. Only two people watch the artist at work: a small boy, intended to suggest "the innocent eye," and a nude model. What is her role? In a more conventional picture, we would identify her as Inspiration, or Courbet's muse, but she is no less "real" than the others here. Courbet probably meant her to be Nature: the undisguised Truth that he proclaimed to be the guiding principle of his art. (Note the emphasis on the clothing she has just taken off.) Significantly enough, the center group is illuminated by clear, sharp daylight, but the background and the lateral figures are veiled in semidarkness to underline the contrast between the artist—the active creator—and the world around him, which waits to be brought to life.

Édouard Manet and the "Revolution of the Color Patch" Courbet's *Studio* helps us understand a picture that shocked the public even more: *Luncheon on the Grass* (fig. 392, page 459), showing a nude model accompanied by two gentlemen in frock coats, by Édouard Manet (1832–83). Manet was the first artist to grasp Courbet's full importance; his *Luncheon*, among other things, is a tribute to the older artist. Manet particularly offended contemporary morality by juxtaposing the nude and nattily attired figures in an outdoor setting, the more so since the noncommittal title offered no "higher" significance. The group has so formal a pose, however, that Manet certainly did not intend to depict an actual event. In fact, the main figures were borrowed from a print after Raphael (fig. 393, page 459). Perhaps the meaning of the canvas lies in this denial of plausibility, for the scene fits neither the plane of everyday experience nor that of allegory.

The *Luncheon* is a visual manifesto of artistic freedom far more revolutionary than Courbet's.

It asserts the painter's privilege to combine elements for aesthetic effect alone. The nudity of the model is "explained" by the contrast between her warm, creamy flesh tones and the cool black and gray of the men's attire. Or, to put it another way, the world of painting has "natural laws" that are distinct from those of familiar reality, and the painter's first loyalty is to the canvas, not to the outside world. Here begins an attitude that was later summed up in the doctrine of "art for art's sake" and became a bone of contention between progressives and conservatives for the rest of the century (see page 494). Manet himself disdained such controversies, but his work attests to his lifelong devotion to "pure painting": to the belief that brushstrokes and color patches themselves—not what they stand for—are the artist's primary reality. Among painters of the past, he found that Hals, Velázquez, and Goya had come closest to this ideal. He admired their broad, open technique, their preoccupation with light and color values. Many of his canvases are, in fact, "pictures of pictures": they translate into modern terms older works that particularly challenged him. Manet always took care to filter out the expressive or symbolic content of his models, lest the beholder's attention be distracted from the pictorial structure itself. His paintings, whatever their subject, have an emotional reticence that can easily be mistaken for emptiness unless we understand its purpose.

Courbet is said to have remarked that Manet's pictures were as flat as playing cards. Looking at *The Fifer* (fig. 394, page 459), we can see what he meant. Done three years after the *Luncheon*, it is a painting with very little modeling, no depth, and hardly any shadows. The figure looks three-dimensional only because its contour renders the forms in realistic foreshortening. Otherwise, Manet neglects all the methods devised since Giotto's time for transforming a flat surface into pictorial space. The undifferentiated light gray background seems as near to us as the figure, and just as solid. If the fifer stepped out of the picture, he would leave a hole, like the cutout shape of a stencil.

Here, then, the canvas itself has been redefined. It is no longer a "window" but rather a

screen made up of flat patches of color. How radical a step this was can be readily seen if we match *The Fifer* against Delacroix's *The Massacre at Chios* or even Courbet's *The Stone Breakers* (see figs. 364, 390), which still follow the "window" tradition of the Renaissance. We realize in retrospect that the revolutionary qualities of Manet's art were already to be seen in the *Luncheon*, even if they were not yet so obvious. The three figures lifted from Raphael's group of river gods form a unit nearly as shadowless and stencil-like as in *The Fifer.* They would be more at home on a flat screen, for the **chiaroscuro** of their present setting, which is inspired by the landscapes of Courbet, no longer fits them.

What brought about this "revolution of the color patch"? We do not know, and Manet himself surely did not reason it out beforehand. It is tempting to think that he was impelled to create the new style by the challenge of photography. The "pencil of nature," then known for a quarter century, had demonstrated the objective truth of Renaissance perspective, but it established a standard of representational accuracy that no handmade image could hope to rival. Painting needed to be rescued from competition with the camera. This Manet accomplished by insisting that a painted canvas is, above all, a material surface covered with pigments—that we must look *at* it, not *through* it. Unlike Courbet, he gave no name to the style he had created. When his followers began calling themselves Impressionists, he refused to adopt the term for his own work. His aim was to be accepted as a Salon painter, a goal that eluded him until late in life.

Claude Monet and Impressionism The term *Impressionism* was coined in 1874, after a hostile critic had looked at a picture entitled *Impression: Sunrise* by Claude Monet (1840–1926), and it certainly fits Monet better than it does Manet. Monet had adopted Manet's concept of painting and applied it to landscapes done outdoors. Monet's *On the Bank of the Seine, Bennecourt* of 1868 (fig. 395, page 462) is flooded with sunlight so bright that conservative critics claimed it made their eyes smart. In this flickering network of color patches, shaped like mosaic **tesserae**, the reflections on the water are as "real" as the banks of the Seine. Even more than *The Fifer*, Monet's painting is a "playing card." Were it not for the woman and the boat in the foreground, the picture would be almost as effective upside down. The mirror image here serves a purpose contrary to that of earlier mirror images (compare fig. 204): instead of adding to the illusion of real space, it strengthens the unity of the actual painted surface. This inner coherence sets *On the Bank of the Seine* apart from Romantic "impressions" such as Corot's *Papigno* (see fig. 367), even though both have the same on-the-spot immediacy and fresh perception.

In the late 1860s and early 1870s, Monet and his friend Auguste Renoir worked closely together to develop Impressionism into a fully mature style, one that proved ideally suited to painting outdoors. Monet's *Red Boats, Argenteuil* (fig. 396, page 462) captures to perfection the intense sunlight along the Seine near Paris, where the artist was spending his summers. Now the flat brushstrokes have become flecks of paint, which convey an extraordinary range of visual effects. The amazingly free brush weaves a tapestry of rich color inspired by the late paintings of Delacroix. Despite its spontaneity, Monet's technique retains an underlying logic in which each color and brushstroke has its place. As an aesthetic, then, Impressionism was hardly the straightforward realism it first seems. It nevertheless remained an intuitive approach, even in its color, although the Impressionists were familiar with many of the optical theories that were to provide the basis for Seurat's Divisionism (see page 481).

Auguste Renoir The Impressionist painters answered Baudelaire's call to artists to capture the "heroism of modern life" by depicting its dress and its pastimes. Scenes from the world of entertainment—dance halls, cafés, concerts, the theater—were favorite subjects for them. These vignettes of bourgeois pleasure are flights from the cares of daily life. Auguste Renoir (1841–1919) filled his work with the *joie de vivre* of a singularly happy temperament. The flirting couples in *Le Moulin de la Galette* (fig. 397, page 463), dappled with sunlight and shadow,

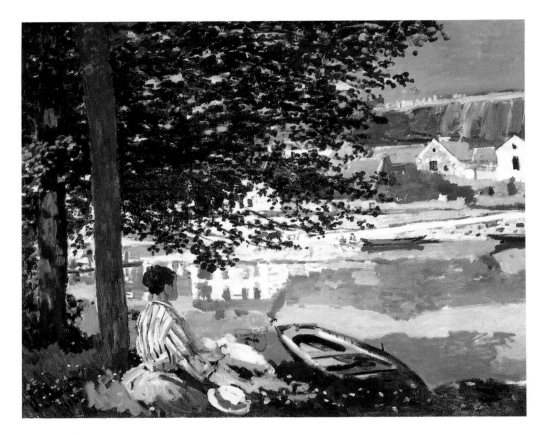

395. Claude Monet.
On the Bank of the Seine, Bennecourt.
1868. Oil on canvas,
$32^{1}/_{8}$ x $39^{5}/_{8}$"
(81.5 x 100.7 cm).
The Art Institute of Chicago
Mr. and Mrs. Potter Palmer Collection

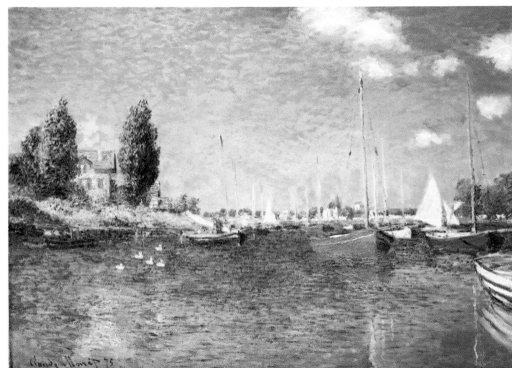

396. Claude Monet.
Red Boats, Argenteuil.
1875. Oil on canvas,
$23^{1}/_{2}$ x $31^{5}/_{8}$"
(59.7 x 80.3 cm).
Fogg Art Museum,
Harvard University
Art Museums,
Cambridge,
Massachusetts
Bequest of Collection of Maurice Wertheim, Class of 1906

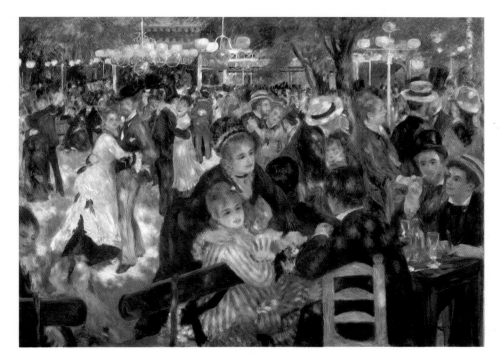

397. Auguste Renoir.
Le Moulin de la Galette.
1876. Oil on canvas,
4'3$^{1/2}$" x 5'9"
(1.31 x 1.75 m).
Musée d'Orsay, Paris

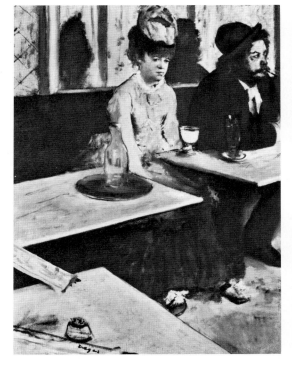

398. Edgar Degas. *The Glass of Absinthe.* 1876. Oil on
canvas, 36 x 27" (91.4 x 68.6 cm). Musée d'Orsay,
Paris

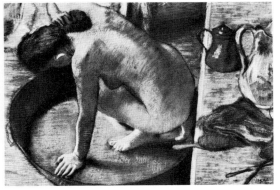

399. Edgar Degas. *The Tub.*
1886. Pastel, 23$^{1/2}$ x 32$^{1/2}$"
(59.7 x 82.6 cm). Musée
d'Orsay, Paris

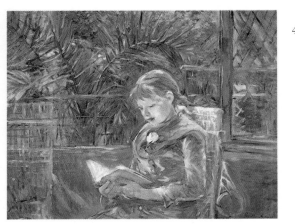

400. Berthe Morisot. *La Lecture
(Reading).* 1888. Oil on
canvas, 29$^{1/4}$ x 36$^{1/2}$"
(74.3 x 92.7 cm). Museum
of Fine Arts, St. Petersburg,
Florida
Gift of Friends of Art in Memory of
Margaret Acheson Stuart

radiate a human warmth that is utterly entrancing, even though the artist permits us no more than a fleeting glance at any of them. Our role is that of the casual stroller who takes in this slice of life in passing.

Edgar Degas In contrast to Renoir, Edgar Degas (1834–1917) makes us look steadily at the disenchanted pair in his café scene *The Glass of Absinthe* (fig. 398, page 463), but out of the corner of our eye, so to speak. The design of this picture at first seems as unstudied as a snapshot—Degas himself practiced photography—yet a longer look shows us that everything dovetails precisely. The zigzag of empty tables between us and the luckless couple reinforces their brooding loneliness, for example. Compositions as boldly calculated as this set Degas apart from other Impressionists. A wealthy aristocrat by birth, he had been trained in the tradition of Ingres, whom he greatly admired. Like Ingres, he despised portraiture as a trade, but, unlike him, he acted on his conviction and portrayed only friends and relatives, people with whom he had emotional ties. His profound sense of human character lends weight even to seemingly casual scenes such as that in *The Glass of Absinthe*.

The Tub (fig. 399, page 463), of a decade later, is again an oblique view, but now severe, almost geometric in design. The tub and the crouching woman, both vigorously outlined, form a circle within a square. The rest of the rectangular format is filled by a shelf so sharply tilted that it almost shares the plane of the picture. Yet on this shelf Degas has placed two pitchers that are hardly foreshortened at all. (Note, too, how the curve of the small one fits the handle of the other.) Here the tension between two-dimensional surface and three-dimensional depth comes close to the breaking point. *The Tub* is Impressionist only in its shimmering, luminous colors. Its other qualities are more characteristic of the 1880s, the first Post-Impressionist decade, when many artists showed a renewed concern with problems of form (Chapter 24).

Berthe Morisot The Impressionists' ranks included several women of great ability. The subject matter of Berthe Morisot (1841–95), a member of the group from its inception, was the world she knew: the domestic life of the French upper middle class, which she depicted with sympathetic understanding. Morisot's early paintings, centering on her mother and her sister Edma, were influenced at first by Manet, whose brother she later married, but they have a subtle sense of alienation distinctive to her. Her mature work is altogether different in character. The birth of her daughter Julie in 1878 signaled a change in Morisot's art, which reached its height during the following decade. Her painting of a little girl reading in a room overlooking the artist's garden (fig. 400, page 464) shows a light-filled style of her own making. Morisot applied her virtuoso brushwork with a sketchlike brevity that omits nonessential details yet conveys a complete impression of the scene. The figure is fully integrated within the formal design, whose appeal is enhanced by the pastel hues she favored. Morisot's painting radiates an air of contentment free of the sentimentality that often affects genre paintings of the period.

Mary Cassatt In 1877, the American painter Mary Cassatt (1845–1926) joined the Impressionists after receiving standard academic training in her native Philadelphia. Like Morisot, she was able to pursue her career as an artist, an occupation regarded as unsuitable for women, only because she was independently wealthy. A tireless champion of the Impressionists, Cassatt was instrumental in gaining early acceptance of their paintings in the United States through her social contacts with wealthy private collectors. Maternity provided the thematic and formal focus of most of her work. Cassatt developed a highly accomplished individual style, seen at its best in *The Bath* (fig. 401), which is characteristic of her mature work around 1890. The oblique view, simplified color forms, and flat composition show the impact of her mentor Degas, as well as her study of Japanese prints. Despite the complexity of its design, the painting has a directness that acknowledges the simple dignity of motherhood.

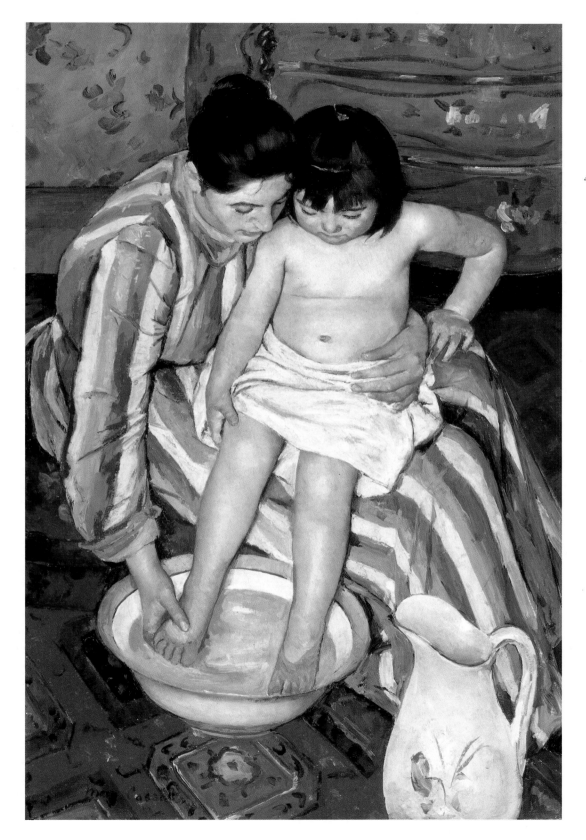

401. Mary Cassatt. *The Bath.*
1891-92. Oil on canvas,
39¹/₂ x 26" (100.3 x 66 cm).
The Art Institute of
Chicago

Robert A. Waller Fund

Monet's Later Works By the mid-1880s, Impressionism became widely accepted, its technique imitated by conservative painters and practiced as a fusion style by a growing number of artists around the world. Ironically, the movement now underwent a deep crisis. Manet died in 1883. Renoir, already beset by doubts, moved toward a more classical style. Racked by internal dissension, the group held its last show in 1886. Among the major figures of the movement, Monet alone remained faithful to the Impressionist view of nature. Nevertheless, his work became more subjective over time, although he never ventured into fantasy, nor did he forsake the basic approach of his earlier landscapes. About 1890, Monet began to paint pictures in series, showing the same subject under various conditions of light and atmosphere. These tended increasingly to resemble Turner's "airy visions, painted with tinted steam" as Monet concentrated on effects of colored light. (He had visited London and knew Turner's work). *Water Lilies* (fig. 402, page 468), of 1907, is a fascinating sequel to *On the Bank of the Seine, Bennecourt* (see fig. 395) across a span of almost forty years. The surface of the water now takes up the entire canvas, so that the effect of a weightless screen is stronger than ever. The artist's brushwork, too, has greater variety and a more individual rhythm. While the scene is still based on nature, this is no ordinary landscape but one entirely of the painter's making. On the estate at Giverny given to him late in life by the French government, Monet created a self-contained world for purely personal and artistic purposes. The subjects he painted there are as much reflections of his imagination as they are of reality. They convey a different sense of time as well. Instead of the single moment captured in *On the Bank of the Seine*, his *Water Lilies* summarizes a shifting impression of the pond in response to the changing water as the breezes play across it.

England

The Pre-Raphaelites By the time Monet came to admire his work, Turner's reputation was at a low in his own country. In 1848, the painter and poet Dante Gabriel Rossetti (1828–82) helped found an artists' society called the Pre-Raphaelite Brotherhood. The Pre-Raphaelites' basic aim was to do battle against the frivolous art of the day by producing "pure transcripts . . . from nature" and by having "genuine ideas to express." As the name of the society proclaims, its members took their inspiration from the "primitive" artists of the fifteenth century. To that extent, they belong to the Gothic revival, which had long been an important aspect of the Romantic movement. What set the Pre-Raphaelites apart from the Romantics was an urge to reform the ills of modern civilization through their art. In this they were aroused by Chartism, a democratic working-class movement that reached its peak in the revolutionary year 1848. Rossetti himself was not concerned with social problems, however; he thought of himself as a reformer of aesthetic sensibility. His great early work, *Ecce Ancilla Domini (The Annunciation),* though naturalistic in detail, is full of self-conscious archaisms such as the pale tonality, the limited range of colors, the awkward perspective, and the stress on the verticals, not to mention the title in Latin (fig. 403, page 469). At the same time, this Annunciation radiates an aura of repressed eroticism that became the hallmark of Rossetti's work and exerted a powerful influence on other Pre-Raphaelites.

William Morris William Morris (1834–96) started out as a Pre-Raphaelite painter but soon shifted his interest to "art for use": domestic architecture and interior decoration such as furniture, tapestries, and wallpapers. He wanted to displace the shoddy products of the Machine Age by reviving the handicrafts of the preindustrial past, an art "made by the people, and for the people, as a happiness to the maker and the user."

Morris was an apostle of simplicity. Architecture and furniture ought to be designed in accordance with the nature of their materials and working processes. Surface decoration likewise must be flat rather than illusionistic. His interiors (fig. 404, page 469) are total environments that create an effect of quiet intimacy.

Music in the Mid-Nineteenth Century

Although it flourished at the same time as the Realist movement in art, the music of the third quarter of the nineteenth century represented the high tide of Romanticism. One of its chief characteristics was nationalism (an essential element of Romanticism), which after 1850 took the form of keen interest in national and regional folklore and folk music.

Richard Wagner (1813–83) wrote operas—such as *Tristan and Isolde* (1859), *Parsifal* (1882), and the immense four-part *Ring of the Nibelungs* (1853–74)—based on the legends of medieval Germany. Wagner's ideal was a complete fusion of music, literature, and theater. The style of his texts, which he wrote himself, reflects the influence of Goethe, while his music is dense, complex, and highly demanding of both singers and orchestra. One of Wagner's characteristic devices is the LEITMOTIF (pronounced as if spelled "light moteef," from German, "leading motif"), a melodic line that represents a person, idea, or situation. If, for example, the music brings together the leitmotif for Tristan with one that signifies Fate, the informed listener understands that Tristan is being drawn toward his destiny. Add the motif for Isolde, and we know that his fate is intertwined with hers. Music of this level of sophistication of course demanded a highly educated audience, which the prosperous cities of nineteenth-century Europe could supply.

Johannes Brahms (1833–97), regarded as Wagner's antithesis, is considered the successor to Beethoven. A student of Robert Schumann (see box on page 446), Brahms's development was slow; his first symphony was not finished until 1876, and it is cast in Beethoven's heroic mold. Brahms's symphonies and chamber works are intense, alternately brooding and rapturous, with dense textures and much of the writing in the upper register, but his slow movements are astonishingly lyrical. Despite their highly emotional character, all Brahms's works are held together by his thorough command of composition and classical structure.

Brahms was fascinated by folk music, and he was among the first to appreciate the Czech composer Antonin Dvorak (1841–1904), whose career he encouraged. Dvorak's music is almost uniformly sunny. Like Brahms, he was affected by the music of his native country, but he was also influenced by the music of other countries, most notably by American folk music during his sojourn in New York City as head of the National Conservatory (1892–95). In those years he produced the work for which he is best known today, the *"New World" Symphony*.

Despite its physical isolation, Russia in the nineteenth century was closely linked culturally to the capitals of western Europe and produced some composers of great stature. The most famous of these was Peter Ilyich Tchaikovsky (1840–93). Tchaikovsky's TONE POEMS—free-form compositions expressing a literary or descriptive idea—pulsate with Romantic yearning and a sense of adventure. His six symphonies are programmatic, especially the last three, which are widely thought to be autobiographical. Indeed, one of these (his sixth, the so-called *Pathétique*) is a statement surveying the composer's life, with all its struggles and triumphs. Tchaikovsky also wrote operas and ballets, of which *The Nutcracker* is the best known.

Despite Morris's self-proclaimed championship of the medieval tradition, he never imitated its forms directly but instead sought to capture its spirit. His achievement was to invent the first original system of ornament since the Rococo.

Through the many enterprises he sponsored, as well as his skill as a writer and publicist, Morris became a tastemaker without peer in his day. Toward the end of the century, his influence had spread throughout Europe and the United States. What is more he was not content to reform the arts of design in isolation. He saw them, rather, as powerful instruments by which to reform modern society as a whole. Not surprisingly, he played an important part in the early history of Fabianism, a gradualist variety of socialism invented in England as an alternative to the revolutionary socialism of the Continent.

United States

James Abbott McNeill Whistler American painters were among the earliest followers of Manet and his circle. James Abbott McNeill Whistler (1834–1903) went to Paris in 1855 to study painting. Four years later, he moved to London, where he spent the rest of his life, but he visited France during the 1860s and was in close touch with the rising Impressionist movement. *Arrangement in Black and Gray: The Artist's Mother* (fig. 405, page 469), his best-known picture, reflects the influence of Manet in its emphasis on flat areas, and the likeness has the austere precision of Degas's portraits. Its fame as a symbol of motherhood is a paradox of popular psychology that would have dismayed Whistler: he wanted the canvas to be appreciated for its formal qualities alone.

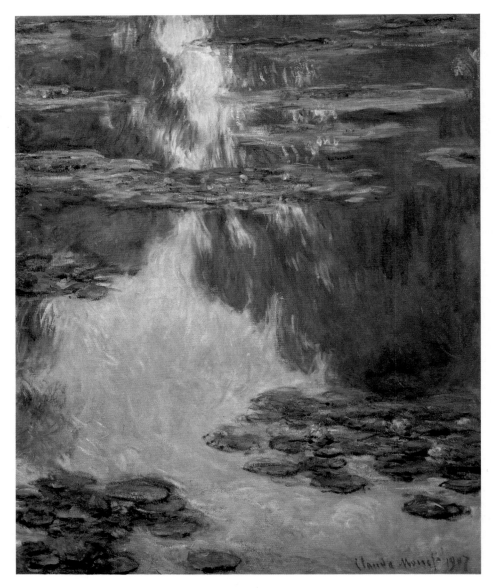

402. Claude Monet. *Water Lilies.*
1907. Oil on canvas,
36½ x 29" (92.5 x 73.5 cm).
Kawamura Memorial
Museum of Art, Sakura City,
Chiba Prefecture, Japan

A witty, sharp-tongued advocate of "art for art's sake," he thought of his pictures as analogous to pieces of music and called some of them symphonies or nocturnes. The boldest example, painted about 1874, is *Nocturne in Black and Gold: The Falling Rocket* (fig. 406). Without an explanatory subtitle, we would have real difficulty making it out. No French painter had yet dared to produce a picture so nonrepresentational, so reminiscent of Turner's "tinted steam" (see fig. 373). It was this canvas, more than any other, that prompted John Ruskin to accuse Whistler of "flinging a pot of paint in the public's face." (Since the same critic had highly praised Turner's *The Slave Ship*, what Ruskin really liked was not the tinted steam itself but the Romantic sentiment behind it.)

During Whistler's successful libel suit against Ruskin, the artist defined his aims in terms that apply well to *The Falling Rocket*: "I have perhaps meant rather to indicate an artistic interest alone in my work, divesting the picture from any outside sort of interest. . . . It

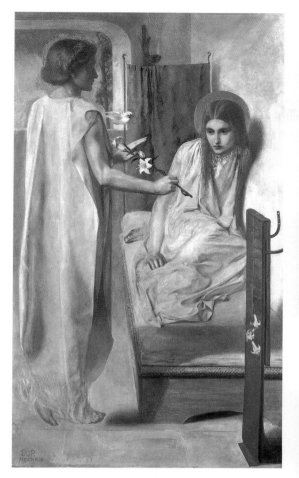

403. Dante Gabriel Rossetti. *Ecce Ancilla Domini
(The Annunciation).* 1849–50. Oil on canvas,
28¹/₂ x 16¹/₂" (72.4 x 41.9 cm). Tate Gallery,
London

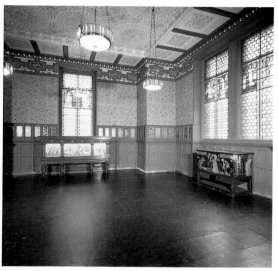

404. William Morris (Morris & Co.). Green Dining
Room. 1867. Victoria and Albert Museum,
London. Crown copyright reserved

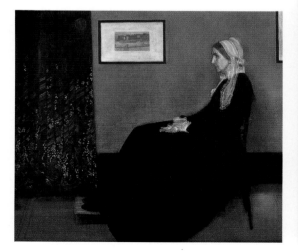

405. James Abbott McNeill Whistler. *Arrangement in
Black and Gray: The Artist's Mother.* 1871. Oil on
canvas, 4'9" x 5'4¹/₂" (1.45 x 1.64 m). Musée
d'Orsay, Paris

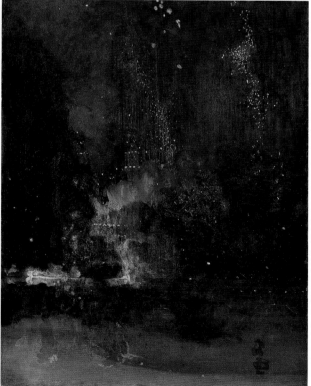

406. James Abbott McNeill Whistler. *Nocturne in Black and Gold:
The Falling Rocket.* c. 1874. Oil on wood panel, 23³/₄ x 18³/₈"
(60.3 x 46.7 cm). The Detroit Institute of Arts
Gift of Dexter M. Ferry, Jr.

▼ PYGMALION was a Greek
sculptor and king of Crete, and
misogynist in Greek mythology.
The exception to his despise of
women was a sculpture he carved
of the goddess Aphrodite; he fell in
love with it, and married the god-
dess after Aphrodite endowed the
sculpture with life. The Pygmalion
story involving GALATEA (see
page 302) was a comedy pub-
lished in 1871 by W. S. Gilbert,
later the librettist of the Gilbert and
Sullivan comic operas popular
since the late nineteenth century.

is an arrangement of line, form, and color, first, and I make use of any incident of it which shall bring about a symmetrical result." The last phrase has special significance, since Whistler acknowledges that, in utilizing chance effects, he does not look for resemblances but for a purely formal harmony. While he rarely practiced what he preached to quite the same extent as he did in *The Falling Rocket*, his statement reads like a prophecy of American abstract painting (see fig. 478).

Winslow Homer Whistler's gifted contemporary in the United States, Winslow Homer (1836–1910), went to Paris in 1866. Though he left too soon to receive the full impact of French art, it did have an important effect on his work. He was a pictorial reporter throughout the Civil War and continued as a magazine illustrator until 1875. Yet he was also a remarkable painter. *Snap the Whip* (fig. 407, page 472) conveys a nostalgia for the simpler era of the United States before the Civil War (see fig. 376). The sunlit scene might be called pre-Impressionist. Its fresh delicacy lies halfway between Corot and Monet (compare figs. 367, 395). The air of youthful innocence relies equally on the composition, which was undoubtedly inspired by the bacchanals then popular in French art (compare fig. 379, Carpeaux's *The Dance*). The sophisticated design shows the same subtle understanding of motion as Bruegel's *The Blind Leading the Blind* (see fig. 280), which likewise terminates in a fallen figure.

Thomas Eakins Thomas Eakins (1844–1916) arrived in Paris from Philadelphia about the same time as Homer. He went home four years later, after receiving conventional academic training, with decisive impressions of Courbet and Velázquez. Elements of both these artists' styles are combined in *William Rush Carving His Allegorical Figure of the Schuylkill River* (fig. 408, page 472; compare figs. 391, 300). Eakins had encountered stiff opposition for advocating traditional life studies at the Pennsylvania Academy of the Fine Arts. To him, Rush was a hero for basing his 1809 statue for the Philadelphia Water Works on the nude model. Eakins no doubt knew contemporary European paint-

ings of sculptors carving from the nude; these were related to the theme of ▼PYGMALION and GALATEA, popular at the time among academic artists. Conservative critics denounced *William Rush Carving His Allegorical Figure of the Schuylkill River* for its nudity, despite the presence of the chaperon knitting quietly to the right. To us, the painting's declaration of honest truth seems a courageous fulfillment of Baudelaire's demand for pictures that express the heroism of modern life.

Henry O. Tanner Thanks to a long tradition of liberalism in Philadelphia and also to Eakins's enlightened attitude, the city became the leading center of minority artists in the United States. Eakins encouraged women and African Americans to study art seriously at a time when professional careers were closed to them. African Americans had no chance to enter the arts before Emancipation, and after the Civil War the situation improved only gradually. Henry O. Tanner (1859–1937), the first important African American painter, studied with Eakins in the early 1880s. Tanner's greatest work, *The Banjo Lesson* (fig. 409, page 473), painted after he moved permanently to Paris, bears Eakins's unmistakable influence. Avoiding the mawkishness of similar subjects by other American painters, Tanner rendered the scene with the same direct realism as Eakins's *William Rush Carving His Allegorical Figure of the Schuylkill River*.

Sculpture

Impressionism, it is often said, revitalized sculpture no less than painting. The statement is at once true and misleading. Auguste Rodin, arguably the first Western sculptor of genius since Bernini, redefined sculpture during the same years that Manet and Monet redefined painting. In so doing, however, he did not follow these artists' lead. How, indeed, could the effect of such pictures as *The Fifer* or *On the Bank of the Seine* be reproduced in three dimensions and without color?

Auguste Rodin What Auguste Rodin (1840–1917) accomplished is strikingly visible in *The*

Thinker (fig. 410, page 473), originally conceived as part of a large unfinished project called *The Gates of Hell*. The welts and wrinkles of the vigorously creased surface produce, in polished bronze, an ever-changing pattern of reflections. But is this effect borrowed from Impressionist painting? Does Rodin actually dissolve three-dimensional form into flickering patches of light and dark? The fiercely exaggerated shapes pulsate with sculptural energy, and they retain this quality under whatever conditions the piece is viewed. Like all sculptors in bronze, Rodin modeled his figures in wax or clay, which was then cast in metal. How, then, could he calculate in advance the reflections on the bronze surfaces of the casts that would ultimately be made from these models?

He worked as he did, we must assume, for an altogether different reason: not to capture elusive optical effects but to emphasize the process of "growth"—the miracle of inert matter coming to life in the artist's hands. As the color patch for Manet and Monet is the primary reality, so are the malleable lumps from which Rodin builds his forms. By insisting on this "unfinishedness," he rescued sculpture from mechanical reproduction just as Manet rescued painting from photographic realism.

Who is *The Thinker*? In the context of *The Gates of Hell*, he was originally conceived as a generalized image of ▼DANTE, the poet who in his mind's eye sees what goes on all around him. Once Rodin decided to detach him from *The Gates*, he became *The Poet-Thinker*, and finally just *The Thinker*. But what kind of thinker? Partly Adam, no doubt, partly the mythological Prometheus, who gave fire to humanity, and partly the brute imprisoned by the passions of the flesh. Rodin wisely refrained from giving him a specific name, for the statue fits no preconceived identity. In this new image of a man, form and meaning are one, instead of cleaving apart as in Carpeaux's *The Dance* (see fig. 379). Carpeaux's naked figures "pretend" to be nude in the antique sense, while *The Thinker*—like the nudes of Michelangelo, in whose action-in-repose he shares—presents a heroic ideal independent of the undressed model.

Rodin, however, was by instinct a modeler, not a carver like Michelangelo. His greatest works were intended to be cast in bronze. Yet even they reveal their full strength only when we see them in plaster casts made directly from Rodin's clay originals. The *Monument to Balzac*, his last creation, as well as most daring and controversial one (fig. 411, page 473), remained in plaster for many years, rejected by the writers' association that had commissioned it. He declared it to be "the sum of my whole life. . . . From the day of its conception, I was a changed man." The sculpture shows the writer clothed in a long dressing gown—described by his contemporaries as a monk's robe—which he liked to wear while working at night. Here was a timeless costume that permitted Rodin to conceal and simplify the contours of the body. Balzac awakens in the middle of the night, seized by a sudden creative impulse, and hastily throws the robe over his shoulders without putting his arms through the sleeves before he settles down to put his thoughts on paper. But Balzac is not about to write. He looms before us with the frightening insistence of a specter, utterly unaware of his surroundings. The entire figure leans backward to stress its isolation from the beholder.

The figure is larger than life, physically and spiritually. Like a huge monolith, this genius towers above the crowd. He shares "the sublime egotism of the gods" (as the Romantics put it). From a distance we see only the great bulk of the figure. From the mass formed by the shroudlike cloak, the head thrusts upward—one is tempted to say erupts—with elemental force. When we are close enough to make out the features clearly, we sense beneath the disdain an inner agony that stamps *Balzac* as the kin of *The Thinker*.

Edgar Degas It is revealing of the fundamental difference between painting and modeling that among the Impressionists only Degas tried his hand at sculpture, producing dozens of small-scale wax figurines that explore the same themes as his paintings and drawings. These are private works made for his own interest. Few were exhibited during the artist's lifetime, and none was cast until after his death early in

▼ DANTE (Dante Alighieri, 1265–1321) was one of the greatest poets of all time and the first major literary figure to write in the Italian language. His epic poem *Commedia,* known in English as *The Divine Comedy* (the word *divine* was added in the sixteenth century), was written after he was exiled from Florence for political reasons in 1302. Dante's life and work were much favored in the nineteenth century, especially by Romantic artists and writers.

407. Winslow Homer.
Snap the Whip.
1872. Oil on canvas,
22¹/4 x 36¹/2"
(56.5 x 92.7 cm).
The Butler Institute
of American Art,
Youngstown, Ohio

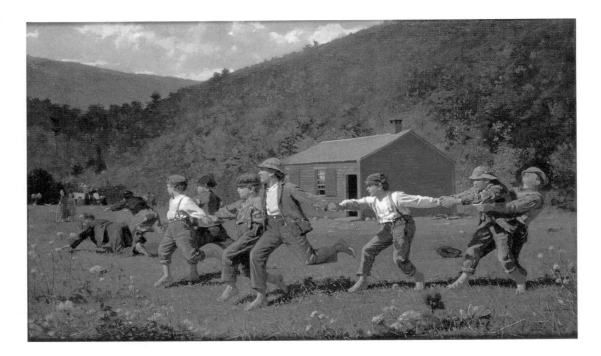

408. Thomas Eakins.
*William Rush Carving
His Allegorical Figure
of the Schuylkill River.*
1877. Oil on canvas,
20¹/8 x 26¹/2"
(51.1 x 67.3 cm).
Philadelphia Museum
of Art

Given by Mrs. Thomas Eakins
and Miss Mary A. Williams

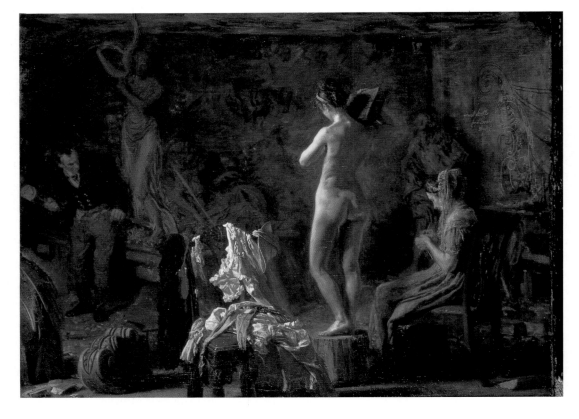

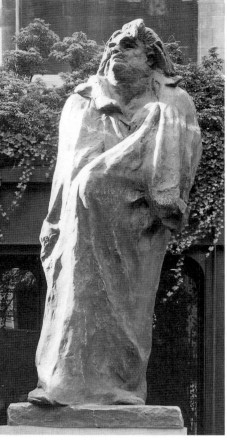

411. Auguste Rodin.
Monument to Balzac.
1897–98. Bronze
(cast 1954),
9'3" x 4'1/4" x 3'5"
(2.82 x 1.23 x 1.04 m).
The Museum of
Modern Art, New York
Presented in memory of Curt
Valentin by his friends

409. Henry O. Tanner. *The Banjo Lesson.* c. 1893.
Oil on canvas, 48 x 35" (121.9 x 88.9 cm).
Hampton University Museum, Hampton, Virginia

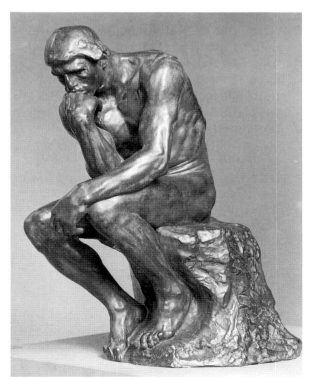

this century. During the 1870s, there was a growing taste for casts made from artists' working models, reflecting the same appreciation for the qualities of spontaneity and inspiration found in drawings and oil sketches, which had long appealed to collectors. For the first time, sculptors felt emboldened to violate time-honored standards of naturalism and skill for statuettes and to leave the impression of their fingers on the soft material as they molded it. Nevertheless, when Degas showed the wax original of *The Little Fourteen-Year-Old*

410. Auguste Rodin. *The Thinker.* First modeled c. 1880,
executed c. 1910. Bronze, height 27½" (69.9 cm).
The Metropolitan Museum of Art, New York
Gift of Thomas F. Ryan, 1910

Realism and Impressionism *473*

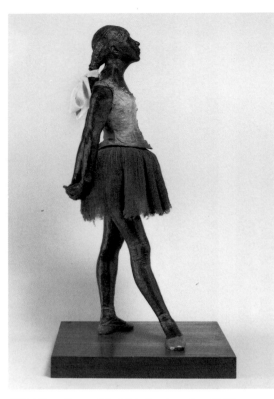

412. Edgar Degas. *The Little Fourteen-Year-Old Dancer*. 1878–81. Bronze with gauze tutu and satin hair ribbon, height 38" (96.5 cm). Norton Simon Art Foundation, Pasadena, California

Dancer (fig. 412) at the Impressionist exhibitions of 1880 and 1881, the public was scandalized by both its lack of traditional finish and its uncompromising adherence to unvarnished truth, although the response from critics was less harsh. The sculpture is nearly as rough in texture as the slightly smaller nude study from life on which it is based. Instead of sculpting her costume, Degas used real cotton and silk, a revolutionary idea for the time but something the Romantics, with their emphatic naturalism, must often have felt tempted to do. The ungainliness of the young adolescent's body is subtly emphasized by her pose, a standard ballet position that is nevertheless difficult to assume. Yet rather than awkwardness, the statuette conveys a simple dignity and grace that are irresistible. The openness of the stance, with hands clasped behind the back and legs pointing in opposite directions, demands that we walk around the dancer to arrive at a com-

plete image of her. As we view the sculpture from different angles, the surface provides a constantly shifting impression of light comparable to that in Degas's numerous paintings and pastels of the ballet.

Architecture

For more than a hundred years, from the mid-eighteenth to the late nineteenth century, architecture was dominated by a succession of revival styles. The term *revival*, we will recall, does not imply that earlier buildings were slavish copies, however. On the contrary, the best work of the time had both individuality and high distinction. Nevertheless, the architectural wisdom of the past, no matter how freely interpreted, proved in the long run to be inadequate for the practical demands of the Industrial Age: the factories, warehouses, stores, and city apartments that formed the bulk of building construction. After about 1800, in the world of commercial architecture we find the gradual introduction of new materials and techniques that were to have a profound effect on architectural style by the end of the century. The most important of these was iron, never before used as a structural member. Within a few decades of their first appearance, cast-iron columns and arches became the standard means of supporting roofs over the large spaces required by railroad stations, exhibition halls, and public libraries.

Henri Labrouste A famous early example of the new spaces supported by cast iron is the Bibliothèque Ste-Geneviève in Paris by Henri Labrouste (1801–75). The exterior (fig. 413) represents the revivalism still prevailing at mid-century: its appearance is drawn chiefly from Italian Renaissance–style banks, libraries, and churches. To identify the building as a library, Labrouste used the simple but ingenious device of inscribing the names of great writers around the facade. The Reading Room (fig. 414), on the other hand, recalls the nave of a French Gothic cathedral (compare fig. 160). Why did Labrouste choose cast-iron columns and arches, hitherto used exclusively for railroad

Realism in Mid-Nineteenth-Century Theater

Realism was the dominant style in mid-nineteenth-century theater, as it was in painting. In part, theatrical Realism was a reflection of the pragmatic character of the Industrial Revolution. Its principal theorist was the French philosopher Auguste Comte (1798–1857), the founder of a system of thought known as Positivism, which called for a material explanation of truth based on objective observation and scientific analysis. As in art, Realism in drama covered a wide range of tendencies, from simple adherence to historic fact, social reality, or physical appearance to highly emotional treatments that have much in common with Romanticism.

The Realist playwright best known today is Alexandre Dumas the Younger (1824–95), whose drama *Camille* (1852) was the first to treat the now-familiar theme of the prostitute with a heart of gold. While a modern audience might find *Camille* somewhat emotionally melodramatic, in its own time the play was considered an unflinching depiction of life at the fringes of Parisian society. The most popular playwright of the period was Victorien Sardou (1831–1908), whose drama *La Tosca* (1887) gave an important starring role to the great British tragic actress Sarah Bernhardt (1844–1923). *La Tosca*, a melodrama of love, treachery, and revenge during the Italian struggle for independence, was later turned into a well-known opera by the Italian composer Giacomo Puccini (see box on page 486).

Russian authors of the time had a particular affinity for psychological Realism. Ivan Turgenev (1818–83) wrote a number of dramas that are remarkable for their portrayal of their characters' inner lives and complex relationships. The novelist and social critic Leo Tolstoy (1828–1910) also wrote plays, notably *The Power of Darkness* (produced in 1895, although written nearly thirty years earlier), as did a distant relation, Aleksi Tolstoy (1817–75), the leading Russian realist whose major works are *The Death of Ivan the Terrible* (1870) and *Tsar Boris* (1870).

In the United States, Realism was expressed primarily as an interest in local color. Especially popular in the years just before the American Civil War (1861–65) were various stage adaptations of the 1852 novel *Uncle Tom's Cabin* by Harriet Beecher Stowe (1811–96). Stowe's portrayal of the life of slaves on Southern plantations greatly helped the cause of abolitionism.

stations? Cast iron was necessary not to provide structural support for the two barrel-vaulted roofs—this could have been done using other materials—but to complete the building's symbolic program. The library, Labrouste suggests to us, is a storehouse of something even more valuable and sacred than material wealth: the world's literature, which takes us on journeys not to faraway places but of the mind.

Labrouste chose to leave the interior iron skeleton uncovered and to face the difficulty of relating it to the massive Renaissance revival style of the exterior of his building. If his solution does not fully integrate the two systems, it at least lets them coexist. The iron supports, shaped like **Corinthian columns**, are as slender as the new material permits. Their collective effect is that of a space-dividing screen, belying their structural importance. To make them weightier, Labrouste has placed them on tall pedestals of solid masonry instead of directly on the floor. Aesthetically, the arches presented greater difficulty, since there was no way to make them look as powerful as their masonry ancestors. Here Labrouste has gone to the other extreme, perforating them with lacy scrolls as if they were pure ornament. This architectural (as

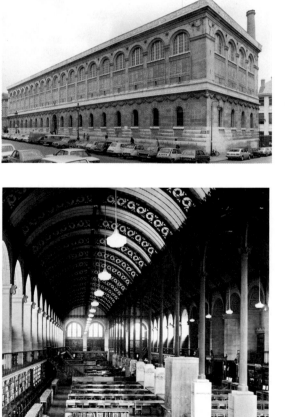

413. Henri Labrouste. Bibliothèque Ste-Geneviève, Paris. 1843–50

414. Reading Room, Bibliothèque Ste-Geneviève

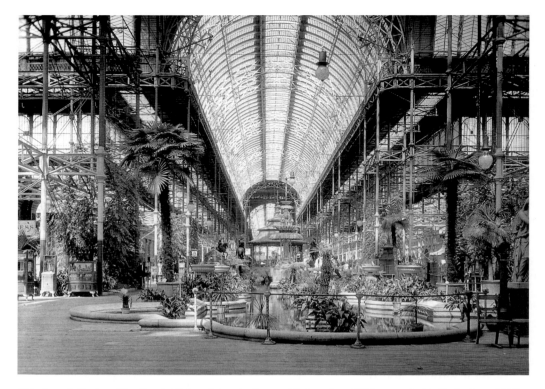

415. Joseph Paxton. The Crystal Palace (view to the north), London. 1851; reerected in Sydenham 1852; destroyed 1936. Lithograph by Joseph Nash. Victoria and Albert Museum, London. Crown copyright reserved

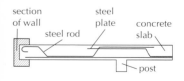

ferroconcrete slab

against merely technical) use of exposed iron members has a fanciful and delicate quality that links it, indirectly, to the Gothic revival. Cast iron was later superseded by ▼STRUCTURAL STEEL and FERROCONCRETE. Its use here is a peculiarly appealing final chapter in the history of Romantic architecture.

The authority of historic modes had to be broken if the industrial era was to produce a truly contemporary style. It nevertheless proved extraordinarily persistent. The "architecture of conspicuous display" espoused by Garnier (see pages 450–51) was divorced, even more than previous revival styles, from the needs of the present. And Labrouste, pioneer though he was of cast-iron construction, could not think of architectural supports as anything but columns having proper capitals and bases, rather than as metal rods or pipes (see fig. 415). It was only in structures that were not considered architecture at all that new building materials and techniques could be explored without these inhibitions.

Joseph Paxton Within a year of the completion of the Bibliothèque Ste-Geneviève, the Crystal Palace (fig. 415) was built in London. A pioneering achievement far bolder in conception than Labrouste's library, the Crystal Palace was designed to house the first of the great international expositions that continue today. Its designer, Joseph Paxton (1801–65), was an engineer and builder of greenhouses. The Crystal Palace was, in fact, a gigantic greenhouse—so large that it enclosed some old trees growing on the site—with its iron skeleton freely displayed. Paxton's design was such a success that it set off a wave of similar buildings for commercial purposes, such as public markets. Still, the notion that there might be beauty, and not merely utility, in the products of engineering made headway very slowly, even though the doctrine—later articulated by the Chicago architect Louis Sullivan—"form follows function" had already found advocates in the mid-nineteenth century. Hence, most

such edifices were adorned with decorations that follow the eclectic taste of the period.

Gustave Eiffel Only rarely could an engineering feat express the spirit of the times, however. What was needed for products of engineering to be accepted as architecture was a structure that would capture the world's imagination through its bold conception. The breakthrough came with the Eiffel Tower (fig. 416), named after its designer, Gustave Eiffel (1832–1923). The Eiffel Tower was erected at the entrance to the Paris World's Fair of 1889, where it served as a triumphal arch of science and industry. It has become such a visual cliché beloved of tourists—much like the *Statue of Liberty,* which also involved Eiffel (see fig. 380)—that we can hardly realize what a revolutionary impact it had at the time. The tower, with its frankly technological aesthetic, so dominated the city's skyline then—as now—that it provoked a storm of protest by the leading intellectuals of the day. Eiffel used the same principles of structural engineering that he had already applied successfully to bridges. Yet the tower is so novel in appearance and so daring in construction that nothing else like it has ever been built, before or since.

The Eiffel Tower owed a good measure of its success to the fact that for a small sum anyone could ascend its elevators to see a view of Paris previously reserved for the privileged few able to afford hot-air balloon rides. It thus helped to define a distinctive feature of modern architecture, one that it shares with modern technology as a whole: it acts on large masses of people without regard to social or economic class. Although this capacity, shared only by the largest churches and public buildings of the past, has also served the aims of political extremists

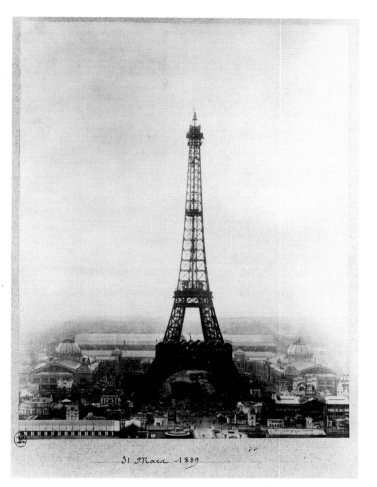

416. Gustave Eiffel. The Eiffel Tower. 1887–89. Paris

at both ends of the spectrum, modern architecture has tended by its very nature to function as a vehicle of democracy. We can readily understand, then, why the Eiffel Tower quickly became a popular symbol of Paris itself. It could do so, however, precisely because it serves no practical purpose whatsoever.

Post-Impressionism, Symbolism, Art Nouveau

The three movements that came to the fore after 1884—Post-Impressionism, Symbolism, and Art Nouveau—bore a complex, shifting relationship to one another. At face value, they had little in common other than the time span they shared: the mid-1880s to about 1910. Post-Impressionism encompassed a wide range of styles, from the cerebrally analytical to the highly expressive. As such, it could be readily adapted to different outlooks. Symbolism was not a style at all but an intensely private worldview based on the literary movement of the same name. Symbolists were free to adopt any style that suited their purposes, including Post-Impressionism. Art Nouveau, by contrast, was both a style and an attitude toward life and art intimately link to aestheticism and the Arts and Crafts movement. What united Post-Impressionism, Symbolism, and Art Nouveau, no matter how diverse their responses, were the desire to be new and the profound social and economic changes brought on by the Industrial Revolution.

Painting

Post-Impressionism

In 1882, just before his death, Manet was made a chevalier (knight) of the Legion of Honor by the French government. This event marks the turn of the tide: Impressionism had gained wide acceptance among artists and the public—but, by the same token, it was no longer a pioneering movement. When the Impressionists held their last group show four years later, the future already belonged to the "Post-Impressionists." This colorless label designates a group of artists who passed through an Impressionist phase in the 1880s but became dissatisfied with the style and pursued a variety of directions. Because they did not have a common goal, it is difficult to find a more descriptive term for them than *Post-Impressionists*. They certainly were not "anti-Impressionists." Far from trying to undo the effects of the "Manet revolution," they wanted to carry it further. Thus Post-Impressionism is in essence just a later stage, though a very important one, of the development that had begun in the 1860s with such pictures as Manet's *Luncheon on the Grass*.

Paul Cézanne Paul Cézanne (1839–1906), the oldest of the Post-Impressionists, was born in Aix-en-Provence, near the Mediterranean coast, where he formed a close friendship with the writer Émile ▼ZOLA, later a champion of the Impressionists. A man of intensely emotional temperament, Cézanne went to Paris in 1861 imbued with enthusiasm for the Romantics. Delacroix was his first love among painters, and he never lost his admiration for him. Cézanne quickly grasped the nature of the Manet revolution as well. After passing through a Neo-Baroque phase, he began to paint bright outdoor scenes, but he did not share his fellow Impressionists' interest in "slice-of-life" subjects, in movement, and in change. Instead, his goal was "to make of Impressionism something solid and durable, like the art of the museums." This quest for the "solid and durable" can be seen in Cézanne's **still lifes**, such as *Still Life with Apples* (fig. 417, page 480). Not since Chardin have simple everyday objects assumed such importance in a painter's eye. The ornamental backdrop is integrated with the three-dimensional shapes, and the brushstrokes have a rhythmic pattern that gives the canvas its shimmering texture. We also notice another aspect of Cézanne's style that may puzzle us at first. The forms are deliberately simplified and outlined with dark colors, and the perspective is incorrect for both the fruit bowl and the horizontal surfaces, which seem to tilt upward. Yet the longer we study the picture, the more we realize the rightness of these apparently arbitrary distortions. When Cézanne took these liberties with reality, his purpose was to uncover the permanent qualities beneath the accidents of appearance. All forms in nature, he believed, are based on abstractions such as the cone, the sphere, and the cylinder. This order underlying the external world was the true subject of his pictures, but he had to interpret it to fit the separate, closed world of the canvas.

To apply this method to landscape became the greatest challenge of Cézanne's career. From 1882 on, he lived in isolation near his hometown of Aix-en-Provence, exploring its environs in much the same way that Claude Lorrain and Corot had explored the Roman countryside. One motif seemed almost to obsess him: the distinctive shape of the mountain called Mont Sainte-Victoire. Its craggy profile looming against the blue Mediterranean sky appears in a long series of paintings, sketches, and drawings culminating in the monumental late works such as that in figure 418. There are no hints of human presence here; houses and roads would only disturb the lonely grandeur of the view. Above the wall of rocky cliffs that bar our way like a chain of fortifications, the mountain rises in triumphant clarity, infinitely remote, yet as solid and palpable as the shapes in the foreground. For all its architectural stability, the scene is alive with movement; but the forces at work here have been brought into equilibrium, subdued by the greater power of the artist's will. This disciplined energy, distilled from the trials of a stormy youth, gives the mature style of Cézanne its enduring strength.

▼ After establishing himself as a journalist in Paris, Émile-Édouard-Charles-Antoine ZOLA (1840–1902) turned to writing what he called naturalist fiction. In most of his novels, he explored the harsh realities of people's lives, especially the social ills afflicting the lower classes. Zola was an outspoken critic on issues ranging from art to politics. In one famous published letter addressed to the president of France, known as *J'accuse (I accuse,* 1898), Zola defended Alfred Dreyfus, a captain in the French army who had been falsely accused and convicted of divulging military secrets.

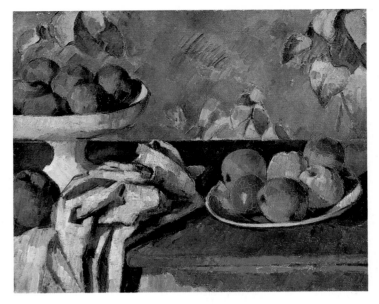

417. Paul Cézanne. *Still Life with Apples*. 1879–82.
Oil on canvas, 17¹⁄₈ x 21¹⁄₄" (43.5 x 54 cm).
Ny Carlsberg Glyptotek, Copenhagen

Georges Seurat Georges Seurat (1859–91) shared Cézanne's aim to make Impressionism "solid and durable," but he went about it very differently. His goal, he once stated, was to make "modern people, in their essential traits,

move about as if on friezes, and place them on canvases organized by harmonies of color, by directions of the tones in harmony with the lines, and by the directions of the lines." Seurat's career was as brief as those of Masaccio, Giorgione, and Géricault, and his achievement just as astonishing. Although he participated in the last Impressionist show, it is an indication of the Post-Impressionist revolution that there-after he exhibited with an entirely new group, the ▼SOCIETY OF INDEPENDENTS.

Seurat devoted his main efforts to a few very large paintings, spending a year or more on each of them and making endless series of preliminary studies before he felt sure enough to tackle the definitive version.

A Sunday Afternoon on the Island of La Grande Jatte of 1884–86 (fig. 419) had its gen-esis in this painstaking method. The subject is the sort that had long been popular among Impressionist painters. Impressionist, too, are the brilliant colors and the effect of intense sunlight. Otherwise, the picture is the very opposite of a quick "impression." The firm, simple contours and the relaxed, immobile fig-ures give the scene a timeless stability that

418. Paul Cézanne. *Mont
Sainte-Victoire Seen
from Bibémus Quarry*.
c.1897–1900. Oil on
canvas, 25¹⁄₂ x 31¹⁄₂"
(65.1 x 80 cm). The
Baltimore Museum
of Art
The Cone Collection, formed
by Dr. Claribel Cone and
Miss Etta Cone of Baltimore,
Maryland

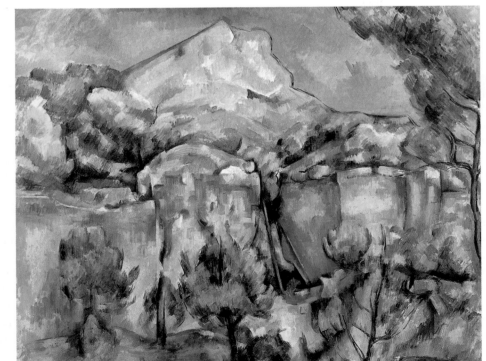

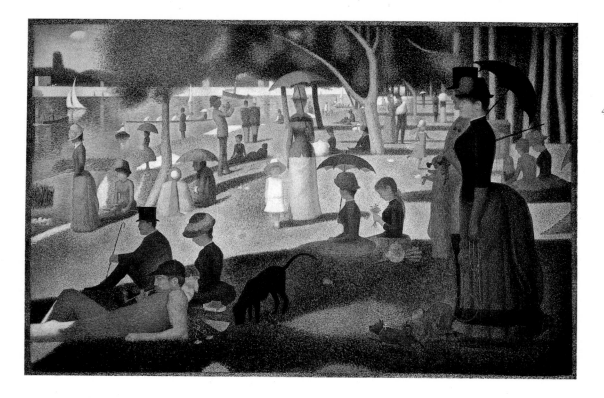

419. Georges Seurat.
*A Sunday Afternoon
on the Island of La
Grande Jatte.* 1884–86.
Oil on canvas,
6'10" x 10'1¹/₄"
(2.08 x 3.08 m).
The Art Institute of
Chicago

Helen Birch Bartlett Memorial Collection

recalls Piero della Francesca (see fig. 226). Even the brushwork demonstrates Seurat's passion for order and permanence: the canvas surface is covered with systematic, impersonal dots of brilliant color that were supposed to merge in the beholder's eye and produce intermediary tints more luminous than anything obtainable from pigments mixed on the palette. This procedure was variously known as Neo-Impressionism, Pointillism, or Divisionism (the term preferred by Seurat). The actual result, however, did not conform to the theory. Looking at *A Sunday Afternoon on the Island of La Grande Jatte* from a comfortable distance (7 to 10 feet for the original), we find that the mixing of colors in the eye remains incomplete. The dots do not disappear but are as clearly visible as the **tesserae** of a mosaic (compare fig. 113). Seurat himself must have liked this unexpected effect, which gives the canvas the quality of a shimmering, translucent screen. Otherwise, he would have reduced the size of the dots.

The painting has a dignity and simplicity suggesting a new classicism, but it is a distinctly modern classicism based on scientific theory.

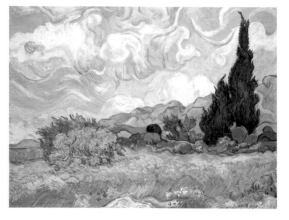

420. Vincent van Gogh. *Wheat Field and Cypress Trees.*
1889. Oil on canvas, 28¹/₂ x 36" (72.4 x 91.4 cm).
The National Gallery, London

Reproduced by courtesy of the Trustees

Seurat adapted the laws of color then recently published by Eugène Chevreul, O. N. Rood, and David Sutter, as part of a comprehensive approach to art. Like Degas, he had studied with a follower of Ingres, and his theoretical interests grew out of this experience. He came to believe that art must be based on a system. With the help of his friend Charles Henry (who was, like

Rood and Sutter, an American), he formulated a series of artistic "laws" based on early experiments in the psychology of visual perception. These principles helped him to control every aesthetic and expressive aspect of his paintings. But, as with all artists of genius, Seurat's theories do not really explain his pictures. It is the pictures, rather, that explain the theories.

Strange as it may seem, color was an adjunct to form in Seurat's work—the very opposite of the Impressionists' technique. The bodies have little weight or bulk. Modeling and foreshortening are reduced to a minimum, and the figures appear mostly in either strict profile or frontal views, as if Seurat had adopted the rules of ancient Egyptian art. Moreover, he has fitted them together within the composition as tightly as the pieces of a jigsaw puzzle. So exactly are they fixed in relation to each other that not a single one could be moved by even a millimeter. Frozen in time and space, they act out their roles with ritualized gravity, in contrast to the joyous abandon of the relaxed crowd in Renoir's *Le Moulin de la Galette* (see fig. 397), who are free to move about in the open air. Thus, despite the period costumes, we read this cross section of Parisian society as timeless. Small wonder the picture remains so spellbinding more than a century after it was painted.

Seurat's forms achieve a machinelike quality through rigorous abstraction. This is the first expression of a peculiarly modern outlook that would lead to Futurism. Seurat's systematic approach to art has the internal logic of modern engineering, which he and his followers hoped would transform society for the better. This social consciousness was allied to a form of anarchism descended from the thinking of Courbet's friend Pierre-Joseph Proudhon and contrasts with the general political indifference of the Impressionists. The fact that Seurat shares the same subject matter as the Impressionists serves only to emphasize further the fundamental difference in attitude.

Vincent van Gogh While Cézanne and Seurat were converting Impressionism into a more severe, classical style, Vincent van Gogh (1853–90) moved in the opposite direction. He believed that Impressionism did not provide artists with enough freedom to express their emotions. Since this was his main concern, he is sometimes called an Expressionist, although that term ought to be reserved for certain twentieth-century painters (Chapter 25). Van Gogh, the first great Dutch painter since the seventeenth century, did not become an artist until 1880; he died only ten years later, so his career was even briefer than Seurat's. His early interests were in literature and religion. Profoundly dissatisfied with the values of industrial society and imbued with a strong sense of mission, he worked for a while as a lay preacher among poverty-stricken coal miners in Belgium. This intense feeling for the poor dominates the paintings of his pre-Impressionist period, 1880–85. In 1886, he went to Paris, where his brother Theo, who owned a gallery devoted to modern art, introduced him to Degas, Seurat, and other leading French artists. Their effect on him was electrifying: his pictures now blazed with color, and he even experimented briefly with the Divisionist technique of Seurat. This Impressionist phase, however, lasted less than two years. Although it was vitally important for his development, he had to integrate it with the style of his earlier years before his genius could fully unfold. Paris had opened his eyes to the sensuous beauty of the visible world and had taught him the pictorial language of the color patch, but painting continued to be nevertheless a vessel for his personal emotions. To investigate this spiritual reality with the new means at his command, he went to Arles and then Saint-Rémy, in the south of France. There, between 1888 and 1890, he produced his greatest pictures.

Like Cézanne, van Gogh now devoted his main energies to landscape painting, but the sun-drenched Mediterranean countryside evoked a very different response in him. He saw it filled with ecstatic movement, not architectural stability and permanence. In *Wheat Field and Cypress Trees* (fig. 420, page 481), both earth and sky pulsate with an overpowering turbulence. The wheat field resembles a stormy sea, the trees spring flamelike from the ground, and the hills and clouds heave with the same undulant motion. The dynamism contained in every

brushstroke makes of each one not merely a deposit of color but an incisive graphic gesture. The artist's personal "handwriting" is here—an even more dominant factor than in the canvases of Daumier (compare fig. 366). To van Gogh himself, it was the color, not the form, that determined the expressive content of his pictures. The letters he wrote to his brother include many eloquent descriptions of his choice of hues and the emotional meanings he attached to them. He had learned about Impressionist color, but his personal color symbolism probably stemmed from discussions with Paul Gauguin (see later on this page), who stayed with van Gogh at Arles for several months. (Yellow, for example, meant faith or triumph or love to van Gogh, while carmine was a spiritual color, cobalt a divine one; red and green, on the other hand, stood for the terrible human passions.) Although he acknowledged that his desire "to exaggerate the essential and to leave the obvious vague" made his colors look arbitrary by Impressionist standards, he nevertheless remained deeply committed to the visible world.

Compared with Monet's *On the Bank of the Seine* (see fig. 395), the colors of *Wheat Field and Cypress Trees* are stronger, simpler, and more vibrant, but in no sense "unnatural." They speak to us of that "kingdom of light" van Gogh had found in the South and of his mystic faith in a creative force animating all forms of life—a faith no less ardent than the sectarian Christianity of his early years. His *Self-Portrait* (fig. 421, page 484) will remind us of Dürer's (see fig. 270), and with good reason: the missionary had now become a prophet. His luminous head, with its emaciated features and burning eyes, is set off against a whirlpool of darkness. "I want to paint men and women with that something of the eternal which the halo used to symbolize," van Gogh had written, groping to define for his brother the human essence that was his aim in pictures such as this. At the time of the *Self-Portrait*, he had already begun to suffer fits of a mental illness that made painting increasingly difficult for him. Despairing of a cure, he committed suicide a year later, for he felt very deeply that art alone made his life worth living.

Paul Gauguin and Symbolism The quest for religious experience also played an important part in the work, if not in the life, of another great Post-Impressionist, Paul Gauguin (1848–1903). He began as a prosperous stockbroker in Paris and an amateur painter and collector of modern pictures. At the age of thirty-five, he became convinced that he must devote himself entirely to art. He abandoned his business career, separated from his family, and by 1889 was the central figure of a new movement called Synthetism or Symbolism.

Gauguin began as a follower of Cézanne and once owned one of his still lifes. He then developed a style that, though less intensely personal than van Gogh's, was in some ways an even bolder advance beyond Impressionism. Gauguin believed that Western civilization was spiritually bankrupt because industrial society had forced people into an incomplete life dedicated to material gain while their emotions lay neglected. To rediscover for himself this hidden world of feeling, Gauguin left Paris in 1886 to live among the peasants of Brittany at Pont-Aven in western France. There, two years later, he met the young painters Émile Bernard (1868–1941) and Louis Anquetin (1861–1932), who had rejected Impressionism and began to evolve a new style, which they called Cloisonism because its strong outlines and brilliant color resembled an enamel technique called cloisonné. Gauguin incorporated their approach into his own and emerged as the most forceful member of the Pont-Aven group, which quickly came to center on him.

The Pont-Aven style was first developed fully in the works Gauguin and Bernard painted at Pont-Aven during the summer of 1888. Gauguin noticed particularly that religion was still part of the everyday life of the country people, and in pictures such as *The Vision after the Sermon (Jacob Wrestling with the Angel)* (fig. 422, page 484) he tried to depict their simple, direct faith. Here at last is what no Romantic artist had achieved: a style based on pre-Renaissance sources. Modeling and perspective have given way to flat, simplified shapes outlined heavily in black, and the brilliant colors are equally unnatural. This style, inspired by folk art and medieval

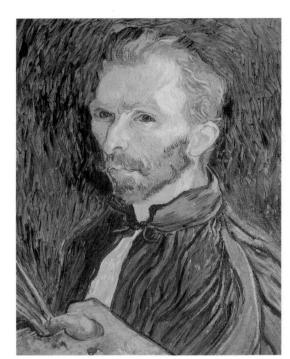

421. Vincent van Gogh. *Self-Portrait*. 1889. Oil on canvas, 22¹/₂ x 17" (57.2 x 43.2 cm). Collection Mrs. John Hay Whitney, New York

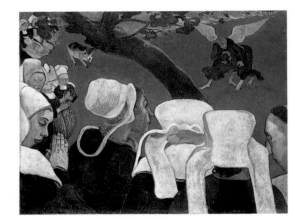

422. Paul Gauguin. *The Vision after the Sermon (Jacob Wrestling with the Angel)*. 1888. Oil on canvas, 28³/₄ x 36¹/₂" (73 x 92.7 cm). The National Galleries of Scotland, Edinburgh

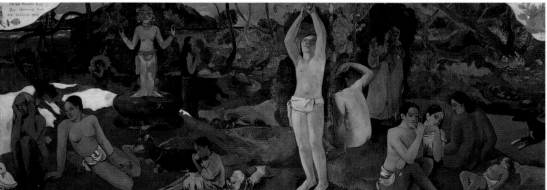

423. Paul Gauguin. *Where Do We Come From? What Are We? Where Are We Going?* 1897. Oil on canvas, 4'6³/₄" x 12'3¹/₂" (1.39 x 3.75 m). Museum of Fine Arts, Boston

Arthur Gordon Tompkins Residuary Fund

stained glass, is meant to re-create both the imagined reality of the vision and the trancelike rapture of the peasant women. The painting fulfills the goal of Synthetism: by treating the canvas in this decorative manner, the artist has turned it from a straightforward representation of the external world into a projection of an internal idea without using narrative or literal symbols. Yet we sense that although he tried to share this experience, Gauguin remained an outsider. He could paint pictures *about* faith but not *from* faith.

Two years later, Gauguin's search for the unspoiled life led him even farther afield. He went to Tahiti—he had already visited Martinique in 1887—as a sort of missionary in reverse, to learn from the natives instead of teaching them. Although he spent most of the rest of his life in the South Pacific, he never found the unspoiled Eden he was seeking. Indeed, he often had to rely on the writings and photographs of those who had recorded its culture before him. Nevertheless, his Tahitian canvases conjure up an ideal world filled with the beauty and meaning he sought so futilely in real life.

His greatest work in this vein is *Where Do We Come From? What Are We? Where Are We Going?* (fig. 423), painted as a summation of his art shortly before he was driven by despair to attempt suicide. Even without the suggestive title, we would recognize the painting's allegorical purpose from its monumental scale, the carefully thought-out poses and placement of the figures within the tapestry-like landscape, and their pensive air. Although Gauguin intended the surface to be the sole conveyer of

meaning, we know from his letters that the huge canvas represents an epic cycle of life. The scene unfolds from right to left, beginning with the sleeping girl, continuing with the beautiful young woman (a Tahitian Eve) in the center picking fruit, and ending with "an old woman approaching death who seems reconciled and resigned to her thoughts." In effect, the picture constitutes a variation on the Three Ages of Life. The enigmatic Maori god overseeing everything acts as a figure of death. The real secret to the central mystery of life, Gauguin tell us, lies in this primitive Eden, not in some mythical past.

The renewal of Western art and Western civilization as a whole, Gauguin believed, must come from outside its traditions. He advised other Symbolists to shun Graeco-Roman forms and to turn instead to Persia, the Far East, and ancient Egypt for inspiration. This idea itself was not new. It stems from the Romantic myth of the Noble Savage, propagated by the thinkers of the Enlightenment more than a century earlier, and its ultimate source is the age-old belief in an earthly paradise where people once lived, and might one day live again, in a state of nature and innocence. No artist before Gauguin had gone as far to put this doctrine of "primitivism"—as it was called—into practice. His pilgrimage to the South Pacific had more than a purely private meaning: it symbolized the end of the 400 years of expansion that had brought most of the globe under Western domination. Colonialism, once so cheerfully—and ruthlessly—pursued by the empire builders, was becoming unbearable.

Henri de Toulouse-Lautrec The decadent world Gauguin sought to escape provided the subject matter for Henri de Toulouse-Lautrec (1864–1901), an artist of superb talent who led a dissolute life in the night spots and brothels of Paris and died of alcoholism. He was a great admirer of Degas, and indeed his painting *At the Moulin Rouge* (fig. 424) recalls the zigzag pattern of Degas's *The Glass of Absinthe* (see fig. 398); yet this view of the well-known nightclub is no Impressionist "slice of life." Toulouse-Lautrec sees through the cheerful surface of the scene, viewing performers and customers with a pitilessly sharp eye for their character—including

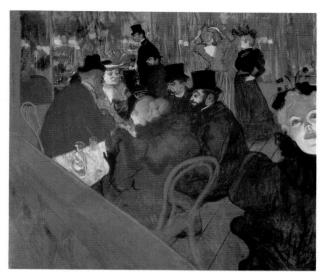

424. Henri de Toulouse-Lautrec. *At the Moulin Rouge.* 1893–95. Oil on canvas, 48³/₈ x 55¹/₂" (123 x 141 cm). The Art Institute of Chicago

Helen Birch Bartlett Memorial Collection

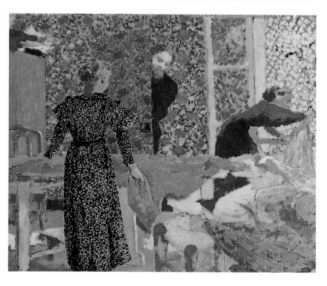

425. Édouard Vuillard. *The Suitor.* 1893. Oil on millboard panel, 12¹/₂ x 14" (31.8 x 35.6 cm). Smith College Museum of Art, Northampton, Massachusetts

Purchased, Drayton Hillyer Fund, 1938

his own: he is the tiny bearded man next to the very tall one in the back of the room. The large areas of flat color, however, and the emphatic, smoothly curving outlines, reflect the influence of Gauguin. The Moulin Rouge that Toulouse-Lautrec shows here has an atmosphere so joyless and oppressive that we may wonder if the artist did not regard it as a place of evil.

Symbolism

Van Gogh's and Gauguin's discontent with Western civilization was part of a sentiment widely shared at the end of the nineteenth century. It reflected an intellectual and moral

Music in the Post-Impressionist Era

Music in the late nineteenth century is as diverse as the painting styles of Post-Impressionism, with stylistic tendencies corresponding to Realism, Impressionism, and Symbolism. Many operas of the period, for example, reflected a general interest in social realism. These include *Carmen* (1875), the tragic love story of a Spanish soldier and a gypsy written by the French composer Georges Bizet (1838–75); and a number of works by the Italian Giacomo Puccini (1858–1924), including *Tosca* (1900), a highly successful adaptation of Sardou's famous play (see box on 475), and *La Bohème* (1896), about the lives of struggling artists in Paris. Puccini's later operas, such as *Madama Butterfly* (1904), *The Girl of the Golden West* (1910), and *Turandot* (1926), set respectively in Japan, North America, and China, appealed to a widespread taste for the exotic.

Impressionism cannot truly exist in music, because music by its very nature cannot describe; it can only evoke. The term nevertheless has been applied to the works of Claude Debussy (1862–1918) because of such works as *La Mer* (1905). Sonorous harmonies and fragments of melody that wander through the composition of *La Mer,* without apparent structure, convey the contrasting moods of the sea. In many respects, the spirit of Debussy's compositions have more in common with the inner vision of Symbolism. This is especially evident in his opera. *Pelléas et Mélisande* (1893–1902), derived from a play by the Belgian Symbolist poet and dramatist Maurice Maeterlinck (1862–1949). In its emphasis on mood and its use of recurring leitmotif-like themes, *Pelléas* reveals a debt to the music of Richard Wagner (see box on page 467). Debussy was also interested in the medieval modes and in Eastern music, an enthusiasm reinforced by hearing Javanese music at the Universal Exposition in Paris in 1889; as a consequence, he began to compose in a PENTATONIC (five-tone) scale corresponding to the five black keys in each octave on the piano keyboard. These compositions pushed the antistructural tendencies of "Impressionist" music to its limits.

Symbolism also touched Debussy's fellow "Impressionist," Maurice Ravel (1875–1937), particularly in early works such as the piano work *Gaspard de la nuit* (1908), which was inspired by a Symbolist poem. Ravel's choice of stories and their musical treatment seem to reach toward the realm of dreams and other emanations of the subconscious, despite their air of childlike innocence.

Almost in opposition to musical "Impressionism," which was essentially a French movement, was a group of German and Austrian composers who wrote in a late Romantic manner known as Neo-Romanticism. Foremost of this group were Gustav Mahler (1860–1911) and Richard Strauss (1864–1949). Strauss, a disciple of Wagner, first gained fame for his somewhat somber TONE POEMS, such as *Death and Transfiguration* (1889), but after 1905 he devoted himself primarily to operas, notably *Der Rosenkavalier* (*The Cavalier of the Rose*, 1911). Mahler, who worked in Vienna, wrote symphonies and song cycles that carry the traditions of Romantic music to their ultimate conclusion. The enormous scale of Mahler's works makes huge demands on both orchestra and chorus, while his extremes of emotion go beyond the expressive limits even of Romanticism. Mahler's more austere late works were a point of departure for the next generation of Viennese composers—Arnold Schoenberg, Anton Webern, and Alban Berg (see box on page 510).

A number of later Romantics lived well into the twentieth century. The Finnish composer Jean Sibelius (1865–1957) continued the nationalist tradition of the mid-nineteenth century; his early works are brooding, melancholic tone poems, often based on Nordic and Finnish legends. The other great nationalist composer of the early twentieth century, the Russian Sergei Rachmaninov (1873–1943), wrote passionate piano concertos and symphonies that mark him as a descendent of Tchaikovsky.

upheaval that rejected the modern world and its rational materialism in favor of irrational states of mind. A self-conscious preoccupation with decadence, evil, and darkness pervaded the artistic and literary climate. Even those who saw no escape from the problems of modern life analyzed their predicament in fascinated horror. Yet, somewhat paradoxically, this very awareness proved to be a source of strength, for it gave rise to the remarkable movement known as Symbolism.

Symbolism in art was at first an outgrowth of a literary movement that arose in 1885–86, with Jean Moréas and Gustave Kahn at its helm. Reacting against the naturalism (the matter-of-fact observation of life) of the novelist Émile Zola, they reasserted the primacy of subjective ideas and championed the so-called *poètes maudits* (doomed poets) Stéphane Mallarmé and Paul Verlaine. There was a natural sympathy between the Pont-Aven painters and the Symbolist poets, and in a long article defining Symbolism published in 1892, the writer G. Albert Aurier insisted on Gauguin's leadership. Nevertheless, unlike Post-Impressionism, which embodies several stylistic tendencies, Symbolism was a general outlook, one that allowed for a wide variety of styles—whatever would embody its peculiar frame of mind.

The Nabis Gauguin's Symbolist followers called themselves Nabis, from the Hebrew word for "prophet". They were less remarkable for their creative talent than for their ability to spell out and justify the aims of Post-Impressionism in theoretical form. One of them, Maurice Denis, made the statement that was to become the first article of faith for modernist painters of the

Theater in the Late Nineteenth Century

The major competing tendencies in the late nineteenth century were Realism and Symbolism, which were sometimes found in the work of the same writer. The most important Realist novelist was Émile Zola (1840–1902). Inspired in part by Charles Darwin's theory of evolution and the Positivism of Auguste Comte (see box on page 475), Zola argued that the dramatist should observe the human condition with the detachment of the scientist and illustrate the "inevitable laws of heredity and environment." However, Zola's plays were more important in theory than in production, and Realism found its main expression in the work of other authors. An important force in French drama in the later years of the nineteenth century was the director André Antoine (1858–1943), who established two theaters for Realist drama and experimental staging techniques.

Antoine also produced the work of foreign playwrights, such as the Norwegian Henrik Ibsen (1828–1906), whose VERSE DRAMA of the legendary past, *Peer Gynt* (1867), is still considered the national epic of Norway. In the 1870s, however, Ibsen turned to Realism in such plays as *Doll's House* (1879), and to Symbolism with *The Wild Duck* (1884). Ibsen's constant theme was the conflict between the self and duty, and the unforeseen consequences of human action.

The most important Realist playwright in Germany was Gerhart Hauptmann (1862–1946), whose drama *The Weavers* (1892) explores the lives of the urban working class with a social conscience reminiscent of the early work of Vincent van Gogh. Another Realist, Arnold Schnitzler (1862–1931), was interested in psychological, rather than social, realism. Schnitzler's play *Anatol* (1893) expresses the ideas of his friend Sigmund Freud, the founder of modern psychiatry, in dramatizing a series of love affairs that inevitably give way to boredom because ego gratification cannot give rise to enduring love. Germany was also a center for many technical innovations in stagecraft, including the revolving stage, the elevator stage, the rolling platform, and the sliding platform.

In England, the counterpart of the French and German Realists was George Bernard Shaw (1856–1950), who used sharp wit to illustrate philosophical propositions in the guise of social issues. His belief in human progress through moral persuasion and the exercise of free choice found its highest expression in *Man and Superman* (1905), the story of a socialist intellectual—representing spiritual creation—who outwits his rivals and, in turn, is outwitted by a woman who represents the life force. The leading Realist in Russia at the turn of the century was Anton Chekhov (1860–1904), whose fame rests on four plays, especially *The Three Sisters* (1901), about the stultifying lives of the Russian upper class, which was written for the Moscow Art Theater (see box on page 575) during the last five years of his life.

The antithesis of theatrical Realism was the Symbolism of such French playwrights as Aurélian-Marie Lugné-Poë (1869–1940). Lugné-Poë drew many of his ideas about scenery from his painter friends Édouard Vuillard, Maurice Denis, and Pierre Bonnard, whom he also employed to create sets, along with Odilon Redon and Henri de Toulouse-Lautrec. Lugné-Poë staged the play *Uburoi* by Alfred Jarry (1873–1907), which caused a riot on its opening night in 1896. Originally written as a schoolboy satire of one of his schoolteachers, Jarry's story about a repulsive and depraved bourgeois and his wife later exercised great influence on the absurdist theater of the Surrealists.

Swedish playwright August Strindberg (1849–1912) first established his reputation as a Realist in the late 1880s with *Miss Julie,* the story of a willful, aristocratic young woman and her tragic conflicts with men and people of a lower social class. Strindberg's later plays, in which he tried to imitate the disconnected sequences of dreams, were greatly influenced by Symbolism.

twentieth century: "A picture—before being a war horse, a female nude, or some anecdote—is essentially a flat surface covered with colors in a particular order." He added that "every work of art is a transposition, a caricature, the passionate equivalent of a received sensation." The theory of equivalents gave the Nabis their independence from Gauguin. "We supplemented the rudimentary teaching of Gauguin by substituting for his oversimplified idea of pure colors the idea of beautiful harmonies, infinitely varied like nature; we adapted all the resources of the palette to all the states of our sensibility; and the sights which caused them became to us so many signs of our own subjectivity. We sought equivalents, but equivalents in beauty!"

Édouard Vuillard We can now understand why paintings by the Nabis soon came to look so different from Gauguin's. These artists became involved with decorative projects that participate in the late nineteenth century's retreat into a world of beauty. The pictures of the 1890s by Édouard Vuillard (1868–1940), the most gifted member of the Nabis, combine the flat planes and emphatic contours of Gauguin (see fig. 422) with the shimmering Divisionist "color mosaic" and the geometric surface organization of Seurat (see fig. 419). Most of them are domestic scenes, small in scale and intimate in effect, like *The Suitor* (fig. 425, page 485). This seemingly casual view of Vuillard's mother's corset-shop workroom has a delicate balance of two-dimensional and three dimensional effects, probably derived from the flat patterns of the fabrics themselves. The picture's quiet magic makes us think of Vermeer and Chardin (compare figs. 317 and 335), whose subject matter, too, was the snug life of the

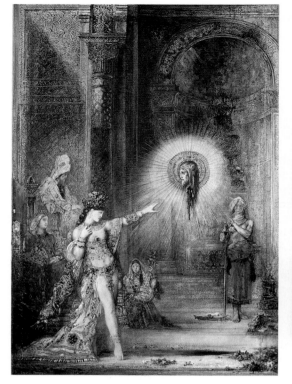

426. Gustave Moreau.
*The Apparition
(Dance of Salome).*
c. 1876. Watercolor,
41³/₄ x 28³/₈"
(106 x 72 cm).
Musée du Louvre,
Paris

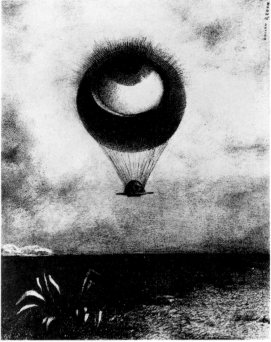

428. Odilon Redon. *The Eye Like a Strange Balloon
Mounts toward Infinity,* from the series *Edgar A. Poe.*
1882. Lithograph, 10¹/₄ x 7¹¹/₁₆" (25.9 x 19.6 cm).
The Museum of Modern Art, New York
Gift of Peter H. Deitsch

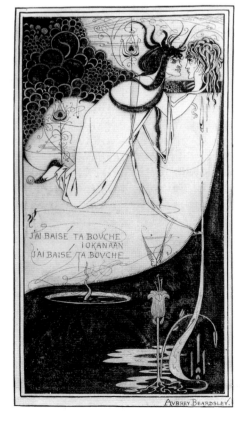

427. Aubrey Beardsley.
Salome. 1892.
Pen drawing,
10¹⁵/₁₆ x 5¹³/₁₆"
(27.8 x 14.8 cm).
Aubrey Beardsley
Collection. Manu-
scripts Division,
Department of Rare
Books and Special
Collections,
Princeton University
Library, New Jersey

middle class. In both subject and treatment, the painting has counterparts as well in Symbolist literature and theater: the poetry of Paul Verlaine and Stéphane Mallarmé and the theatrical productions of Aurélian-Marie Lugné-Poë, for whom Vuillard designed stage sets. The painting evokes a host of feelings through purely formal means that could never be conveyed by naturalism alone. The Nabis established an important precedent for the works painted by Matisse a decade later (see fig. 445). By then, however, the movement had disintegrated as its members became more conservative. Vuillard himself turned more to naturalism, and he never recaptured the delicacy and daring of his early canvases.

Gustave Moreau The Symbolists discovered that there were some older artists, descendants of the Romantics, whose work, like their own, placed inner vision above the observation of nature. One of these was Gustave Moreau (1826–98), a recluse who admired Delacroix. Moreau created a world of personal fantasy that

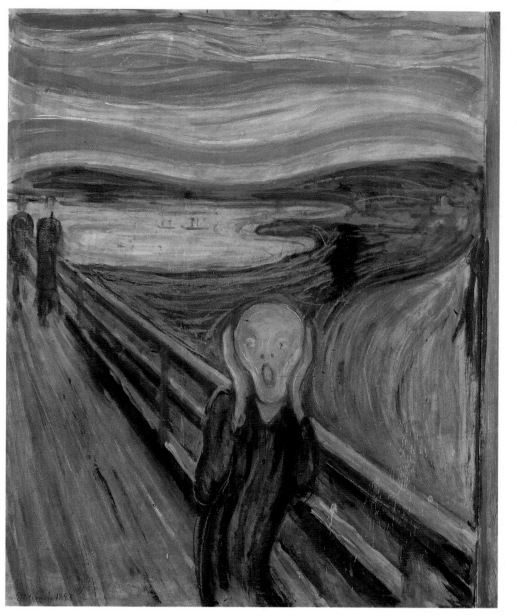

has much in common with the medieval reveries of some of the English Pre-Raphaelites. *The Apparition (Dance of Salome)* (fig. 426) shows one of his favorite themes: the head of John the Baptist, in a blinding radiance of light, appears to Salome, whose seductive dance has brought about his death. Her odalisque-like sensuousness, the stream of blood pouring from the severed head, the mysterious space of the setting, suggestive of an exotic temple rather than of the palace where the murder took place, all summon up the dreams of Oriental splendor

and cruelty so dear to the Romantic imagination, combined with an insistence on the reality of the supernatural.

Only late in life did Moreau achieve a measure of recognition. Suddenly, his art was in tune with the times. During his last six years, he even held a professorship at the conservative École des Beaux-Arts, the successor of the official art academy founded under Louis XIV (see box on page 417). There he attracted the most gifted students, among them such future modernists as Henri Matisse and Georges Rouault.

Aubrey Beardsley How prophetic Moreau's work was of the taste prevailing at the end of the century is evident from a comparison with Aubrey Beardsley (1872–98), a gifted young English artist whose black-and-white drawings were the very epitome of that elegantly "decadent" taste. They include an illustration for Oscar Wilde's *Salome* (fig. 427, page 488) that might well be the final scene of the drama depicted by Moreau: Salome has taken up John's severed head and triumphantly kissed it. Beardsley's erotic meaning is plain: Salome is passionately in love with John and has asked for his head because she could not have him in any other way. Although Moreau's intent remains ambiguous, the thematic parallel between the two works is striking, and there are formal similarities as well, such as the "stem" of trickling blood from which John's head rises like a flower. But Beardsley's *Salome* cannot be said to derive from Moreau's. The sources of his style are English—specifically, the art of the Pre-Raphaelites (see fig. 403)—with a strong element of Japanese influence.

Odilon Redon Another solitary artist whom the Symbolists discovered and claimed as one of their own was Odilon Redon (1840–1916). Like Moreau, he had a haunted imagination, but his imagery was even more personal and disturbing. Outstanding at etching and lithography, he drew inspiration from Goya as well as Romantic literature. The lithograph shown in figure 428 on page 488 is one of a set he issued in 1882 and dedicated to Edgar Allan Poe. The American poet had been dead for thirty-three years, but his tormented life and his equally tortured imagination made him the very model of the *poète maudit*, and his works, excellently translated by Charles Baudelaire and Stéphane Mallarmé, were greatly admired in France. Redon's lithographs do not illustrate Poe. They are, rather, "visual poems" in their own right, evoking the macabre, hallucinatory world of Poe's imagination. In our example, the artist has revived an ancient device, the single eye representing the all-seeing mind of God. But, in contrast to the traditional form of the symbol, Redon shows the whole eyeball removed from its socket and con-

verted into a balloon that drifts aimlessly in the sky. Disquieting visual paradoxes of this kind were to be exploited on a large scale by the Dadaists and Surrealists in our own century (see figs. 460, 468).

Edvard Munch A macabre quality pervades the early work of Edvard Munch (1863–1944), a gifted artist who came to Paris from Norway in 1889 and based his starkly expressive style on those of Toulouse-Lautrec, van Gogh, and Gauguin. He then settled in Berlin, where his works generated such controversy when they were exhibited in 1892 that a number of young radicals broke from the artists' association and formed the Berlin Secession. The group took its name from a similar one that had been founded in Munich earlier that year. The Secession quickly became a loosely allied international movement that spread to Austria and Belgium, where it had close ties to Art Nouveau (see page 494). *The Scream* (fig. 429, page 489) is an image of fear, the terrifying, unreasoned fear we feel in a nightmare. Unlike Fuseli (see fig. 370), Munch visualizes this experience without the aid of frightening apparitions, and his achievement is the more persuasive for that very reason. The rhythm of the long, wavy lines seems to carry the echo of the scream into every corner of the picture, making of earth and sky one great sounding board of fear.

Pablo Picasso's Blue Period When he arrived in Paris from his native Spain in 1900, Pablo Picasso (1881–1973) felt the spell of the same artistic atmosphere that had generated the style of Munch. His so-called Blue Period (the term refers to the prevailing color of his canvases as well as to their mood) consists almost exclusively of pictures of beggars, derelicts, and other outcasts or victims of society whose pathos reflects the artist's own sense of isolation. Yet these figures, such as that in *The Old Guitarist* (fig. 430) of 1903, convey poetic melancholy more than outright despair. The aged musician accepts his fate with a resignation that seems almost saintly, and the attenuated grace of his limbs reminds us of El Greco (compare fig. 257). *The Old Guitarist* is a strange

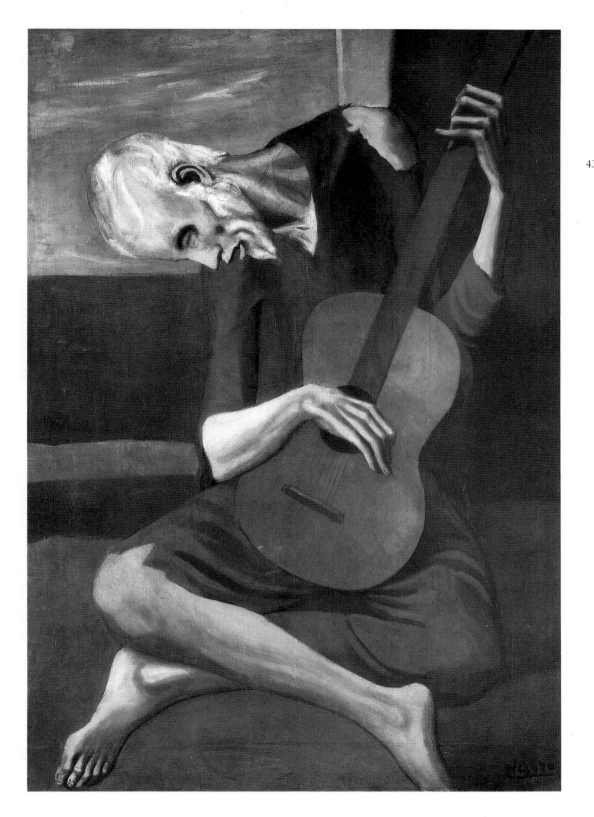

430. Pablo Picasso. *The Old Guitarist*. 1903. Oil on panel, 48³/₈ x 32¹/₂" (122.9 x 82.6 cm). The Art Institute of Chicago

Helen Birch Bartlett Memorial Collection

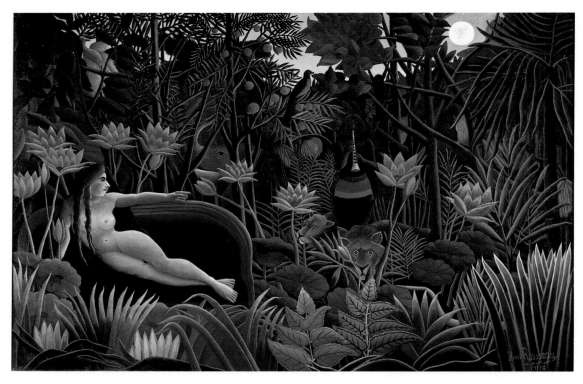

431. Henri Rousseau. *The Dream*. 1910. Oil on canvas, 6'8¹/2" x 9'9¹/2" (2.05 x 2.96 m). The Museum of Modern Art, New York

Gift of Nelson A. Rockefeller

amalgam of Mannerism and the art of Gauguin and Toulouse-Lautrec, imbued with an aura of gloom characteristic of the artist's work at this time.

Henri Rousseau A few years later, Picasso and his friends discovered a painter who until then had attracted no attention, although he had been exhibiting his work since 1886. He was Henri Rousseau (1844–1910), a retired customs collector who had started to paint in his middle age without training of any sort. His ideal—which, fortunately, he never achieved—was the arid academic style of Ingres's followers. Rousseau is that rarity, a folk artist of genius. His painting *The Dream* (fig. 431) depicts an enchanted world that needs no explanation, and indeed none is possible. Perhaps for that very reason its magic becomes believably real to us. Rousseau himself described the scene in a little poem:

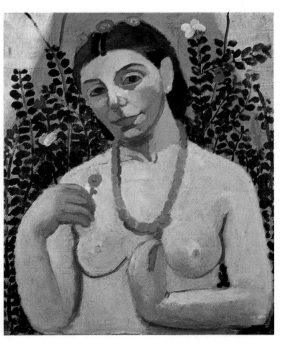

432. Paula Modersohn-Becker. *Self-Portrait*. 1906. Oil on canvas, 24 x 19³/4" (61 x 50.2 cm). Öffentliche Kunstsammlung Basel, Kunstmuseum, Switzerland

Yadwigha, peacefully asleep
Enjoys a lovely dream:
She hears a kind snake charmer
Playing upon his reed.
On stream and foliage glisten
The silvery beams of the moon.
And savage serpents listen
To the gay, entrancing tune.

Here at last was the innocent directness of feeling that Gauguin thought was so necessary for the age. Picasso and his friends were the first to recognize this quality in Rousseau's work. They revered him as the godfather of twentieth-century painting.

Paula Modersohn-Becker The inspiration that Gauguin had traveled so far to find was discovered by Paula Modersohn-Becker (1876–1907) in the small village of Worpswede, near her family home in Bremen, Germany. Among the artists and writers who congregated there was the Symbolist lyric poet Rainer Maria ▼RILKE, Rodin's friend and briefly his personal secretary. Rilke had visited Russia and had been deeply impressed with what he viewed as the purity of Russian peasant life. His influence on the colony at Worpswede certainly affected Modersohn-Becker, whose last works are direct precursors of modern art. Her gentle but powerful *Self-Portrait* (fig. 432), painted in 1906, the year before her early death, presents a transition from the Symbolism of Gauguin and his followers, which she absorbed during several stays in Paris, to Expressionism (Chapter 25). The color has the intensity of Matisse and the Fauves, but at the same time, Modersohn-Becker's deliberately simplified treatment of forms parallels the experiments of Picasso, which were to culminate in his first Cubist works (see page 511).

Sculpture

Aristide Maillol No tendencies equal to Post-Impressionism appear in sculpture until about 1900. Sculptors in France of a younger generation had by then been trained under the dominant influence of Rodin and were ready to go their own ways. The finest of these, Aristide

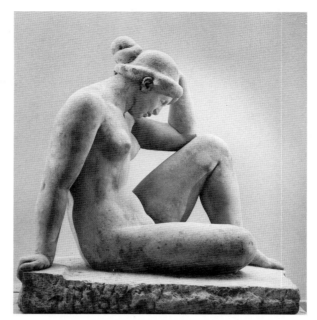

433. Aristide Maillol. *Seated Woman (La Méditerranée).* c. 1901. Stone, height 41" (104.1 cm). Collection Oskar Reinhart, Winterthur, Switzerland

Maillol (1861–1944), began as a Symbolist painter, although he did not share Gauguin's anti-Greek attitude. Maillol might be called a classical primitivist. Admiring the simplified strength of early Greek sculpture, he rejected its later phases. The *Seated Woman* (fig. 433) evokes memories of the Archaic and Severe styles (compare figs. 64, 68) rather than of Praxiteles. The solid forms and clearly defined volumes also recall Cézanne's statement that all natural forms are based on abstractions such as the cone, the sphere, and the cylinder. But the most notable quality of the figure is its harmonious, self-sufficient repose, which the outside world cannot disturb. A statue, Maillol thought, must above all be "static," structurally balanced like a piece of architecture. It must further represent a state of being that is detached from the stress of circumstance, with none of the restless, thrusting energy of Rodin's work. In this respect, the *Seated Woman* is the exact opposite of *The Thinker* (see fig. 410). Maillol later gave it the title *La Méditerranée (The Mediterranean)* to suggest the source from which he drew the timeless serenity of his figure.

▼ The German poet Rainer Maria RILKE (1875–1926) produced a body of introspective, often rapturous poetry and prose that pushed the German language beyond its earlier limits of nuance and has influenced poets and writers ever since. His two most famous works of poety are *The Duino Elegies* and *The Sonnets to Orpheus* (both 1923, after he had met and worked with Rodin). His much-studied novel *The Notebooks of Malte Laurids Brigge* (1910) is a symbolic recasting of the Old Testament story of the Prodigal Son.

Architecture

Art Nouveau

During the 1890s and early 1900s, a movement now usually known as Art Nouveau (New Art) arose throughout Europe and the United States. It takes its name from the shop opened in Paris in 1895 by the entrepreneur Siegfried Bing, who employed most of the leading designers of the day and helped to spread their work everywhere. By that time, however, the movement had already been in full force for several years. Art Nouveau has various other names as well: it is called Jugendstil (literally "Youth Style") in Germany and Austria, Stile Liberty (after the well-known London store that helped to launch it) in Italy, and Modernista in Spain. Like Post-Impressionism and Symbolism, Art Nouveau is not easy to characterize. It was primarily a new style of decoration based on sinuous curves, nominally inspired by Rococo forms, that often suggest organic shapes. Its favorite pattern was the whiplash line, its typical shape the lily. Yet there was a severely geometric side as well that in the long run proved of even greater significance. The ancestor of Art Nouveau was the ornament of William Morris, but Art Nouveau was also related to the styles of Whistler, Gauguin, Beardsley, and Munch, among others. In turn, it was allied to such diverse outlooks as ▼AESTHETICISM, ART FOR ART'S SAKE, socialism, and Symbolism.

The avowed goal of Art Nouveau was to raise the crafts to the level of the fine arts, thereby abolishing the distinction between them. In this respect, it was meant to be a "popular" art, available to everyone. Yet it often became so extravagant as to be affordable only by the wealthy. Art Nouveau had a profound impact on public taste, and its influence on the applied arts can be seen in wrought-iron work, furniture, jewelry, glass, typography, and even women's fashions. Historically, Art Nouveau may be regarded as a prelude to modernism, but its excessive refinement was perhaps a symptom of the malaise that afflicted the Western world at the end of the nineteenth century. Hence it is

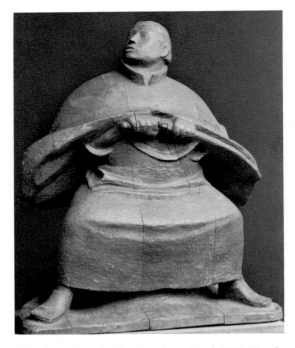

434. Ernst Barlach. *Man Drawing a Sword*. 1911. Wood, height 31" (78.7 cm). Cranbrook Academy of Art Museum, Bloomfield Hills, Michigan

Ernst Barlach Ernst Barlach (1870–1938), an important German sculptor who reached maturity in the years before World War I, seems the very opposite of Maillol: he is a "Gothic primitivist." What Gauguin had experienced in Brittany and the tropics—the simple humanity of a preindustrial age—Barlach found by going to Russia. His figures, such as *Man Drawing a Sword* (fig. 434), embody elementary emotions—wrath, fear, grief—that seem imposed upon them by invisible presences. When they act, they seem like sleepwalkers, unaware of their own impulses. Human beings, Barlach seems to say, are humble creatures whose fates are at the mercy of forces beyond their control. Characteristically, these figures do not fully emerge from the material substance (often, as here, a massive block of wood) of which they are made. Their clothing is like a hard chrysalis that hides the body, as in medieval sculpture. Barlach's figures nevertheless communicate an unforgettable mute intensity.

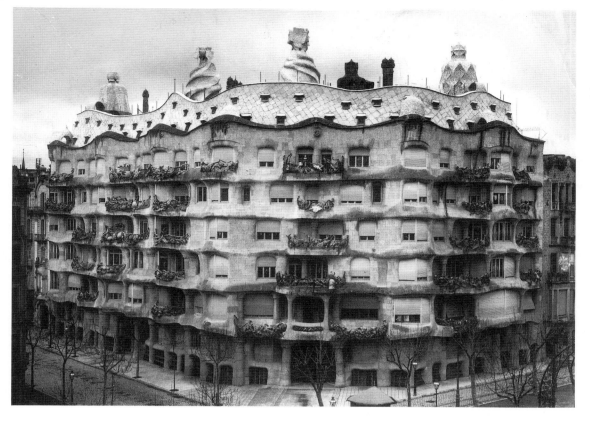

uniquely worthy of our attention as Western culture passes through the similar transition of Postmodernism.

As a style of decoration, Art Nouveau did not lend itself easily to architectural designs on a large scale. Indeed, it was aptly called book-decoration architecture by wags, for the origin of its designs, which were best suited to two-dimensional surface effects. But in the hands of architects of greatness, Art Nouveau undermined the authority of the revival styles once and for all.

Antoní Gaudí The most remarkable instance of Art Nouveau in architecture is the Casa Milá in Barcelona (fig. 435), a large apartment house by Antoní Gaudí (1852–1926). It shows an almost maniacal avoidance of all flat surfaces, straight lines, and symmetry of any kind, so that the building looks as if it had been freely modeled of some malleable substance, although it is in fact made of cut stone. The roof and softly rounded openings have the rhythmic motion of a wave, and the chimneys seem to have been squeezed from a pastry tube. The Casa Milá ex-

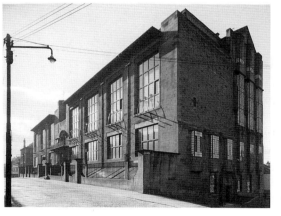

436. Charles Rennie Mackintosh. North facade, Glasgow School of Art, Glasgow, Scotland. 1896–1910

presses one person's fanatical devotion to the ideal of "natural" form, one that scarcely could be developed further. It is a tour de force of old-fashioned artisanship, an attempt at architectural reform through aesthetic rather than engineering.

Charles Rennie Mackintosh Gaudí represents one extreme of Art Nouveau architecture. The Scot Charles Rennie Mackintosh (1868–1928) represents another. Although they stood at opposite poles, both strove for the same goal—a

Post-Impressionism, Symbolism, Art Nouveau *495*

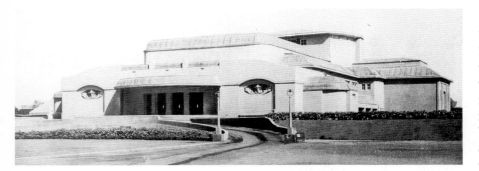

437. Henri van de Velde. Theater, Werkbund Exhibition, Cologne, Germany. 1914. Destroyed

438. Louis Sullivan. Wainwright Building, St. Louis, Missouri. 1890–91. Destroyed

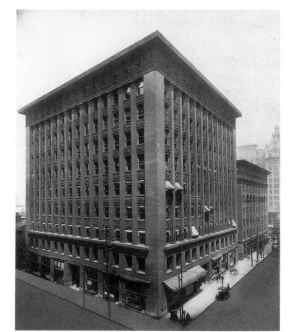

Velde fell under the influence of William Morris. He became a designer of posters, furniture, silverware, and glass, then after 1900 worked mainly as an architect. It was he who founded the Weimar School of Arts and Crafts in Germany, which became famous after World War I as the Bauhaus (see page 575). His most ambitious building, the theater he designed in Cologne for an exhibition sponsored by the Werkbund (arts and crafts association) in 1914 (fig. 437), makes a telling contrast to the Paris Opéra (see fig. 384), completed only forty years earlier. Whereas the older building tries to evoke the splendors of the Louvre Palace, van de Velde's exterior is a tautly stretched "skin" that both covers and reveals the individual units of which the internal space is composed. The Werkbund Exhibition was a watershed in the development of modern architecture. It provided a showcase for a whole generation of young German architects who were to achieve prominence after World War I (Chapter 27). Many of the buildings they designed for the fairgrounds anticipate ideas of the 1920s.

The United States

The search for a modern architecture in the United States began in earnest around 1880. It required wedding the ideas of William Morris and a new machine aesthetic, tentatively explored some fifteen years earlier in the decorative arts, to new construction materials and techniques. The process itself took several decades, during which architects experimented with a variety of styles. It is significant that the symbol of their quest was the skyscraper and that it first arose in Chicago, then a burgeoning metropolis not yet encumbered by allegiance to the styles of the past. The Chicago fire of 1871 had also opened enormous opportunities to architects from older cities such as Boston and New York.

Louis Sullivan Chicago was home to Louis Sullivan (1856–1924), although his first skyscraper, the Wainwright Building, was erected in St. Louis (fig. 438) in 1890–91. The building is **monumental**, but in a very untraditional

contemporary style independent of the past. Mackintosh's basic outlook is so pragmatic that at first glance his work hardly seems to belong to Art Nouveau at all. The north facade of the Glasgow School of Art (fig. 436) was designed as early as 1896 but might be mistaken for a building done thirty years later. Huge, deeply recessed studio windows have replaced the walls, leaving only a framework of massive, unadorned cut-stone surfaces, except in the center bay. This bay, however, is "sculptured" in a style not unrelated to Gaudí's, despite its preference for angles over curves. Another Art Nouveau feature is the spare wrought-iron grillwork.

Henri van de Velde One of the founders of Art Nouveau was the Belgian Henri van de Velde (1863–1957). Trained as a painter, van de

way. Its exterior—in the slender, continuous brick **piers** that rise between the windows from the base to the attic—both reflects and expresses the internal steel skeleton. The collective effect is that of a vertical grating encased by the corner piers and by the emphatic horizontals of attic and mezzanine. Although many possible "skins" could be stretched over the structural frame, what is important aesthetically is that we immediately feel that this wall is derived from the skeleton underneath and that it is not self-sustaining. *Skin* is perhaps too weak a term to describe this brick sheathing. To Sullivan, who often thought of buildings as analogous to the human body, it was more like the "flesh" and "muscle" that are attached to the "bone," and like them is capable of a variety of expressive effects. When he insisted that "form follows function," he understood the relationship as flexible rather than rigid.

Paradoxically, Sullivan's buildings are based on a lofty idealism and are adorned with a type of ornamentation that remain firmly rooted in the nineteenth century, even as they point the way toward twentieth-century architecture. From the beginning, Sullivan's geometry carried a spiritual meaning that centered on birth, flowering, decay, and regeneration. It was tied to a highly original style of decoration in accordance with his theory that ornament must give expression to structure—not by reflecting it literally but by interpreting the same concepts through organic abstraction. The soaring verticality of the Wainwright Building, for example, stands for growth, which is elaborated by the vegetative motifs of the moldings along the cornice and between the windows.

Photography

Documentary Photography

During the second half of the nineteenth century, the press played a leading role in the social movement that brought the harsh realities of poverty to the public's attention. The camera became an important instrument of reform through the photodocumentary, which tells the story of people's lives in a pictorial

439. Jacob Riis. *Bandits' Roost*. c. 1888. Gelatin-silver print. Museum of the City of New York

essay. The press reacted to the same conditions that had stirred Courbet, and its factual reportage likewise fell within the Realist tradition—only its response came a quarter century later. Hitherto, photographers had been content to present a romanticized image of the poor like that in genre paintings of the day. The first photodocumentary was John Thomson's illustrated sociological study *Street Life in London*, published in 1877. To take his pictures, however, Thomson had to pose his figures.

Jacob Riis The invention of gunpowder flash ten years later allowed Jacob Riis (1849–1914) to rely for the most part on the element of surprise. Riis was a police reporter in New York City, where he learned at first hand about the crime-infested slums and their appalling living conditions. He kept up a steady campaign of illustrated newspaper exposés, books, and lectures that in some cases led to major revisions of the city's housing codes and labor laws. The unflinching realism of his photographs has lost none of its force. Certainly it would be difficult to imagine a more nightmarish scene than *Bandits' Roost* (fig. 439).

440. Oscar Rejlander. *The Two Paths of Life*. 1857. Combination albumen print, 16 x 31" (40.6 x 78.7 cm). George Eastman House, Rochester, New York

With good reason, we sense a pervasive air of danger in the eerie light, for the notorious gangs of New York City's Lower East Side sought their victims by night, killing them without hesitation. The motionless figures seem to look us over with the practiced casualness of hunters coldly sizing up potential prey.

Pictorialism

The raw subject matter and realism of documentary photography had little impact on art and were shunned by most other photographers as well. England, through such organizations as the Photographic Society of London, founded in 1853, became the leader of the movement to convince doubting critics that photography, by imitating painting and printmaking, could indeed be art. To Victorian England, art above all had to have a high moral purpose or noble sentiment, preferably expressed in a classical style.

Oscar Rejlander *The Two Paths of Life* (fig. 440) by Oscar Rejlander (1818–75) fulfills these ends by presenting an allegory clearly descended from Hogarth's *The Rake's Progress* (see fig. 338). This tour de force, almost 3 feet wide, combines thirty negatives through composite printing. A young man (in two images) is choosing between the paths of virtue or of vice, the latter represented by a half-dozen nudes. The picture created a sensation in 1857, and Queen Victoria herself purchased a print. Rejlander, however, never enjoyed the same success again. The most adventurous photographer of his time, he soon turned to other subjects less in keeping with prevailing taste.

Julia Margaret Cameron The photographer who pursued ideal beauty with the greatest passion was Julia Margaret Cameron (1815–79). An intimate of leading poets, scientists, and artists, she took up photography at age forty-eight, when given a camera, and went on to create a remarkable body of work. Although in her own day Cameron was known for her allegorical and narrative pictures, she is now remembered primarily for her portraits of the men who shaped Victorian England. Many

441. Julia Margaret Cameron. *Ellen Terry, at the Age of Sixteen.* c. 1863. Carbon print, diameter 9 1/2" (24 cm). The Metropolitan Museum of Art, New York

Alfred Stieglitz Collection, 1949

442. Gertrude Käsebier. *The Magic Crystal.* c. 1904 Platinum print. Royal Photographic Society, Bath, England

of her finest photographs, however, are of the women who were married to her closest friends. An early study of the actress Ellen Terry (fig. 441) has the lyricism and grace of the Pre-Raphaelite aesthetic that shaped Cameron's style (compare fig. 403).

Photo-Secession

The issue of whether photography could be art came to a head in the early 1890s with the Secession movement (see page 490), which was spearheaded in 1893 by the founding in London of the Linked Ring, a rival group to the Royal Photographic Society of Great Britain. In seeking a pictorialism independent of science and technology, the Secessionists steered a course between idealism and naturalism by imitating every form of late Romantic art that did not involve narrative. Equally antithetical to their aims were Realist and Post-Impressionist painting, then at their zenith. In the group's art-for-art's-sake approach to photography, the Secession had much in common with Whistler's aestheticism.

To resolve the dilemma between art and mechanics, the Secessionists tried to make their photographs look as much like paintings as possible. Rather than resorting to composite or multiple images, however, they exercised total control over the printing process, chiefly by adding special materials to their printing paper to create different effects. Pigmented gum brushed on coarse drawing paper yielded a warm-toned, highly textured print that in its way approximated Impressionist painting. Paper impregnated with platinum salts was especially popular among the Secessionists for the clear grays it produced. The subtlety and depth of the platinum print lend a remarkable ethereality to *The Magic Crystal* (fig. 442) by the American photographer Gertrude Käsebier (1854–1934), in which spiritual forces almost visibly sweep across the photograph.

Edward Steichen Through Käsebier and another American photographer, Alfred Stieglitz, the Linked Ring had close ties with the United States, where Stieglitz opened his Photo-Secession gallery in New York in 1905. Among his

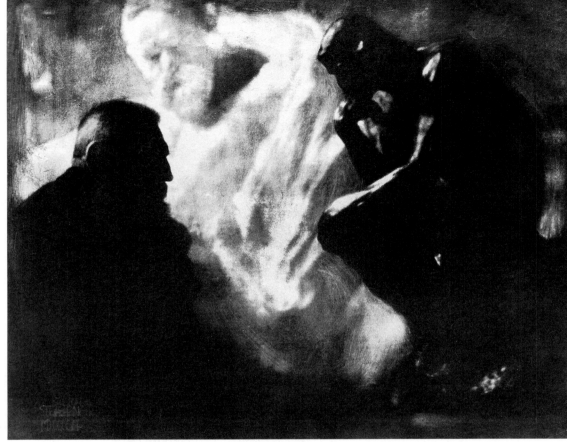

443. Edward Steichen. *Rodin with His Sculptures "Victor Hugo" and "The Thinker."* 1902. Gum print (single printing technique), 14¼ x 12¾" (36.3 x 32.4 cm). The Art Institute of Chicago

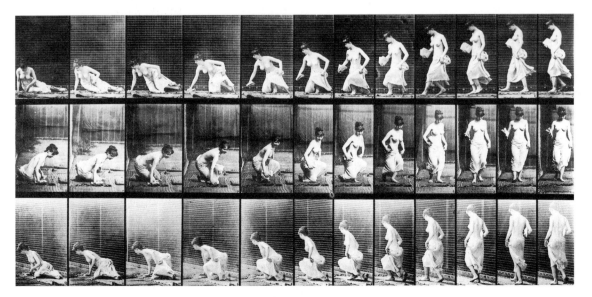

444. Eadweard Muybridge. *Female Semi-Nude in Motion*, from *Human and Animal Locomotion*, vol. 2, pl. 271. 1887. George Eastman House, Rochester, New York

protégés was the young Edward Steichen (1879–1973), whose photograph of Rodin in his sculpture studio (fig. 443) is without doubt the finest achievement of the entire Photo-Secession movement. The head in profile contemplating *The Thinker* expresses the essence of the confrontation between the sculptor and his work of art. His brooding introspection hides the inner turmoil evoked by the ghost-like monument to Victor Hugo, which rises dramatically like a genius in the background. Not since *The Creation of Adam* by Michelangelo (see fig. 242), who was Rodin's ideal artist, have we seen a more telling use of space or an image that penetrates the mystery of creativity so deeply.

Motion Photography

An entirely new direction was charted by Eadweard Muybridge (1830–1904), the father of motion photography. He wedded two different technologies, devising a set of cameras capable of photographing action at successive points. Photography had grown from such marriages; another instance had occurred earlier when Nadar used a hot-air balloon to take aerial shots of Paris. After some trial efforts, Muybridge managed in 1877 to produce a set of pictures of a trotting horse that forever changed artistic depictions of the horse in movement. Of the 100,000 photographs he devoted to the study of animal and human locomotion, the most remarkable were those taken from several vantage points at once (fig. 444). The idea was surely in the air, for the art of the period occasionally shows similar experiments, but Muybridge's photographs must nevertheless have come as a revelation to artists. The simultaneous views present an entirely new treatment of motion across time and space that challenges the imagination. Like a complex visual puzzle, they can be combined in any number of ways that are endlessly fascinating. Muybridge's photographs convey a peculiarly modern sense of dynamics, reflecting the new tempo of life in the machine age. However, because the gap was then so great between scientific fact on the one hand and visual perception and artistic representation on the other, their far-reaching aesthetic implications were to be realized only later.

Chapter 25
Twentieth-Century Painting

In our account of art in the modern era, we have already discussed a succession of "isms": Neoclassicism, Romanticism, Realism, Impressionism, Post-Impressionism, Divisionism, Symbolism. There are many more to be found in twentieth-century art. These isms can form a serious obstacle to understanding: they may make us feel that we cannot hope to comprehend the art of our time unless we immerse ourselves in a welter of esoteric doctrines. Actually, we can disregard all but the most important isms. Like the terms we have used for the styles of earlier periods, they are merely labels to help us sort things out. If an ism fails the test of usefulness, we need not retain it. And many isms in contemporary art do fail that test. The movements they designate either cannot be seen very clearly as separate entities or have so little importance that they can interest only the specialist. It has always been easier to invent new labels for art than to create a movement that truly deserves a new name.

Still, we cannot do without isms altogether. Since the start of the modern era, the Western world (and, increasingly, the rest of the world) has faced the same basic circumstances everywhere, and local artistic traditions have steadily given way to international trends. Among them we can distinguish three main currents, each comprising a number of isms that began among the Post-Impressionists and have developed greatly in our own century: Expressionism, abstraction, and fantasy. Expressionism stresses the artist's emotional attitude toward himself or herself and the world. Abstraction concerns itself primarily with the formal structure of the work of art. Fantasy explores the realm of the imagination, especially its spontaneous and irrational qualities. We must not forget, however, that feeling, order, and imagination are all present in every work of art. Without feeling, art would leave us unmoved; without some degree of order, it would be chaotic; without imagination, art would be deadly dull.

These currents, then, are not by any means mutually exclusive. We shall find them interrelated in many ways. The work of an artist often falls into more than one category and may embrace a wide range of approaches, from the realistic to the completely nonrepresentational (or nonobjective). Thus, these three currents correspond to general attitudes rather than to specific styles. The primary concern of Expressionism is the human community; of abstractionism, the structure of reality; and of fantasy, the labyrinth of the individual human mind. And we shall find that Realism, which is concerned with the appearance of reality, has continued to exist independently of the other three, especially in the United States, where art has often pursued a separate course from Europe's. These currents bear a shifting relation to each other that reflects the complexity of modern life. To be understood, they must be seen in their proper historical context. Beginning in the mid-1930s, however, the distinctions among them begin to break down, so that after 1945 it is no longer meaningful to trace them separately.

In examining the art of the twentieth century, we shall find it anything but tidy. On the contrary, we quickly discover that the visual arts are like soldiers marching to different drummers. A purely chronological approach would reveal just how out of step they have generally been with each other—but at the cost of losing sight of their internal development. Does this mean that the various visual arts have shared none of the same concerns? No, that is not the case either. The three main currents we will outline in painting—Expressionism, abstraction, and fantasy—may be found as well in sculpture, architecture, and photography before 1945. But they are present in different measure and do not always carry the same meaning. For that reason, the parallels among them should not be emphasized.

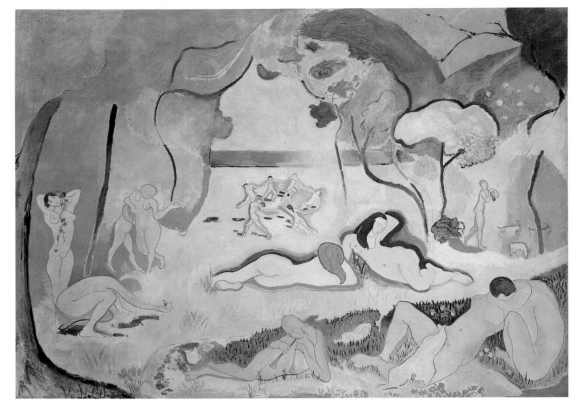

445. Henri Matisse.
The Joy of Life.1905–6.
Oil on canvas,
5'8$^{1}/_{2}$" x 7'9$^{3}/_{4}$"
(1.74 x 2.38 m). The
Barnes Foundation,
Merion, Pennsylvania

Painting before World War I

Expressionism and the Fauves

▼ The idea of the NOBLE SAVAGE goes back to the seventeenth century, but came into its own in the Romantic era, especially in the philosophical writings of Jean-Jacques Rousseau (1712–78). Essentially an expression of longing for simpler times, the concept of the noble savage refers to peoples uncorrupted by civilization whose outlook was simple, pure, and emotionally direct and who chose to live under just and reasonable laws.

The twentieth century may be said to have begun five years late, so far as painting is concerned. Between 1901 and 1906, several comprehensive exhibitions of the work of van Gogh, Gauguin, and Cézanne were held in Paris, as well as in Germany. For the first time, the achievements of these great artists were seen by a broad public. The young painters who had grown up in the "decadent," morbid mood of the 1890s were profoundly impressed by what they saw. Several of them developed a radical new style, full of the violent color of van Gogh and the bold distortions of Gauguin, which they manipulated freely for pictorial and expressive effects. When their work first appeared in 1905, it so shocked critical opinion that they were dubbed *les fauves* ("the wild beasts"), a label they wore with pride. Actually, it was not a common program that brought them together but their shared sense of liberation and experiment. As a movement, Fauvism comprised a number of loosely related individual styles, and the group dissolved after a few years, most of its members unable to sustain their inspiration or adapt successfully to the challenges posed by Cubism (see page 511). It was nevertheless a decisive breakthrough, for it constituted the first unequivocally modern movement of the twentieth century in both style and attitude, one to which every important painter before World War I acknowledged a debt.

Henri Matisse The leader of the Fauves was Henri Matisse (1869–1954), the oldest of the founders of twentieth-century painting. *The Joy of Life* (fig. 445) sums up the spirit of Fauvism perhaps better than any other single work. It derives its flat planes of color, heavy undulating outlines, and the "primitive" flavor of its forms from Gauguin (see fig. 423). Even its subject suggests the vision of humanity in a state of nature that Gauguin had pursued in Tahiti. But we soon realize that Matisse's figures are not ▼"NOBLE SAVAGES" under the spell of a native god. The subject is a pagan scene in the classical sense: a

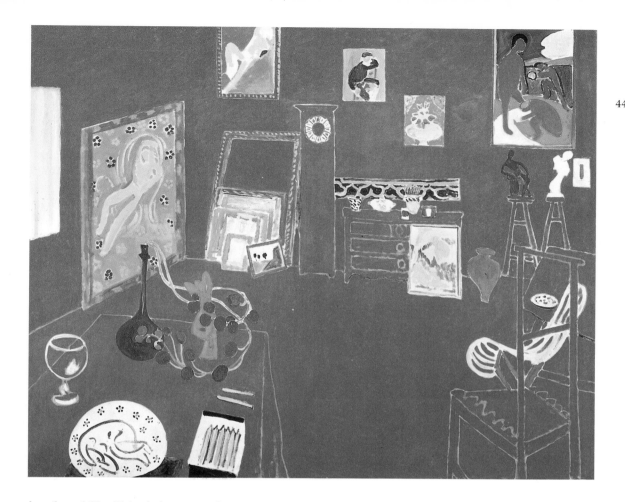

446. Henri Matisse. *The Red Studio*. 1911. Oil on canvas, 5'11¼" x 7'2¼" (1.81 x 2.19 m). The Museum of Modern Art, New York

Mrs. Simon Guggenheim Fund

bacchanal like Titian's (compare fig. 249). Even the poses of the figures have for the most part a classical origin, and in the apparently careless drafting resides a profound knowledge of the human body, betraying Matisse's academic training. What makes the picture so revolutionary is its radical simplicity, its "genius of omission." Everything that possibly can be has been left out or stated by implication only, yet the scene retains the essentials of plastic (three-dimensional) form and spatial depth. What holds the painting together is its firm underlying structure, reminiscent of the work of Cézanne, whom Matisse venerated, and one of whose paintings he owned.

Painting, Matisse seems to say, is not a representation of observed reality but the rhythmic arrangement of line and color on a flat plane. In the process emerges a problem basic to twentieth-century painting: how far can the image of nature be pared down without destroying its basic properties and thus reducing it to mere surface ornament? "What I am after, above all," Matisse once explained, "is expression. . . . [But] . . . expression does not consist of the passion mirrored upon a human face. . . . The whole arrangement of my picture is expressive. The placement of figures or objects, the empty spaces around them, the proportions, everything plays a part." What does *The Joy of Life* express? Exactly what its title says. Whatever his debt to Gauguin, Matisse was never stirred by the same agonized discontent with the decadence of Western civilization. He instead shared the untroubled outlook of the Nabis, with whom he had previously associated, and the canvas derives its decorative quality from their work (compare fig. 425). Matisse was concerned, above all, with the act of painting. This to him was an experience so profoundly joyous that he wanted to transmit it to the beholder.

Matisse's "genius of omission" is again at work in *The Red Studio* (fig. 446). By reducing

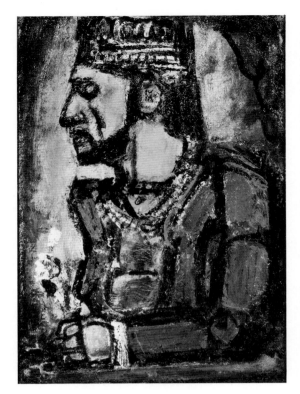

447. Georges Rouault. *The Old King*. 1916–37. Oil on canvas, 30¼ x 21¼" (76.8 x 54 cm). The Carnegie Museum of Art, Pittsburgh

Patrons Art Fund

the number of tints to a minimum, he makes color an independent structural element. The result is to emphasize the radical new balance he struck between the two-dimensional and three-dimensional aspects of painting. Matisse spreads the same flat red color on the tablecloth and wall as on the floor, yet he distinguishes the horizontal from the vertical planes with complete assurance, using only a few lines. Equally bold is Matisse's use of pattern. By repeating a few basic shapes, hues, and decorative motifs in seemingly casual, but perfectly calculated, array around the edges of the canvas, he harmonizes the relation of each element with the rest of the picture. Cézanne had pioneered this integration of surface ornament into the design of a picture (see fig. 417), but Matisse here makes it a mainstay of his composition.

Georges Rouault Another important member of the Fauves, Georges Rouault (1871–1958), would hardly have agreed with Matisse's defini-

tion of *expression*. For him this term still had to include, as it had in the past, "the passion mirrored upon a human face." Rouault was the true heir of van Gogh's and Gauguin's concern for the corrupt state of the world. However, he hoped for spiritual renewal through a revitalized Catholic faith, and his pictures are personal statements of that ardent hope. Trained in his youth as a stained-glass worker, he was better prepared than the other Fauves to share Gauguin's enthusiasm for medieval art. Rouault's mature work, such as *The Old King* (fig. 447), exhibits glowing colors and compartmented, black-bordered shapes built up in thick layers of richly textured paint inspired by Gothic stained-glass windows (compare fig. 182). Within this framework he retained a surprising pictorial freedom, with which he expressed his profound understanding of the human condition. Here the old king's face conveys a mood of resignation and inner suffering that reminds us of Rembrandt and Daumier (see figs. 312, 366).

German Expressionism

Fauvism exerted a decisive influence on the Expressionist movement that arose at the same time in Germany. Because Expressionism had deep historical roots that made it especially appealing to the Northern mind, it lasted far longer in Germany, where it proved correspondingly broader and more diverse than in France. For these reasons, the term *Expressionism* is sometimes applied to German art alone, but such a limit ignores the close ties and numerous similarities between German Expressionism and Fauvism. To be sure, Fauvism was generally less neurotic and morbid, and German Expressionism was characterized by greater emotional extremes and a more spontaneous approach, but the two were not separated by any fundamental difference in style or content.

Emil Nolde and Die Brücke Expressionism in Germany began with Die Brücke (The Bridge), a group of like-minded painters who lived in Dresden in the early years of the twentieth century. Through its totally bohemian lifestyle,

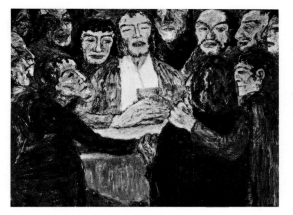

448. Emil Nolde. *The Last Supper*. 1909. Oil on canvas, 32½ x 41¾" (82.6 x 106.1 cm). Stiftung Seebüll Ada und Emil Nolde, Neukirchen, Schleswig, Germany

Die Brücke cultivated a sense of imminent disaster that is one of the hallmarks of the modern avant-garde. Its members were nevertheless idealists who sought to revive German art. Their early works not only reflect Matisse's simplified, rhythmic line and bright color but also clearly reveal the direct influence of van Gogh and Gauguin. They also show elements derived from Munch, who was living then in Berlin and deeply impressed the German Expressionists. The greatest Brücke artist, Emil Nolde (1867–1956), stands somewhat apart. Older than the rest, he was already working in an Expressionist style when he was invited to join the movement in 1906. Nolde shared Rouault's preference for religious themes, and his figures show a like sympathy for the suffering of humanity. The deliberately clumsy drafting of *The Last Supper* (fig. 448) shows that Nolde, too, rejected pictorial refinement in favor of a primeval, direct expression inspired by Gauguin. The thickly encrusted surfaces of Rouault's canvases also come to mind, as does the blocklike **monumentality** of Ernst Barlach's peasants (see fig. 434).

Oskar Kokoschka Another artist of highly individual talent was the Austrian painter Oskar Kokoschka (1886–1980). In 1910, he was invited to Berlin by the publisher of *Der Sturm (The Storm),* an art journal that soon attracted members of Die Brücke and Der Blaue Reiter (see below). His main contribution are the portraits

he painted before World War I, such as the moving *Self-Portrait* in figure 449, page 508. Like van Gogh, Kokoschka saw himself as a visionary, a witness to the truth and reality of his inner experiences (compare fig. 421). The hypersensitive features seem lacerated by an ordeal of the imagination. We may find in this tortured psyche an echo of the cultural climate that also produced Sigmund Freud.

Wassily Kandinsky The most daring and original step beyond Fauvism was taken in Germany by a Russian, Wassily Kandinsky (1866–1944), the leading member of a group of Munich artists called Der Blaue Reiter (The Blue Rider) after one of Kandinsky's early paintings. Formed in 1911, it was a loose alliance united only by its mystical tendencies. Kandinsky began to forsake representation as early as 1910 and abandoned it altogether several years later. Using the rainbow colors and the free, dynamic brushwork of the Paris Fauves, he created a completely nonobjective style. These works have titles as abstract as their forms: our example, one of the most striking, is called *Sketch I for "Composition VII"* (fig. 450, page 508).

Perhaps we should avoid the term *abstract*, because it is often taken to mean that the artist has analyzed and simplified visible reality into geometric forms according to Cézanne's dictum. Kandinsky did indeed derive his shapes from the world around him—in landscapes that he freely invented—but by transforming rather than reducing them to geometric shapes. Kandinsky's antinaturalism was inherent in Expressionist theory from the very beginning. Whistler, too, had spoken of "divesting the picture from any outside sort of interest"; he even anticipated Kandinsky's "musical" titles (see fig. 406). But it was the liberating influence of the Fauves that permitted Kandinsky to put this approach into practice.

As the first part of his book *Concerning the Spiritual in Art*, published in 1912, makes clear, Kandinsky's aim was to charge form and color with a "purely spiritual meaning" (as he put it) that expressed his deepest feelings by eliminating all resemblance to the physical world. To him, the only reality that mattered was the artist's inner

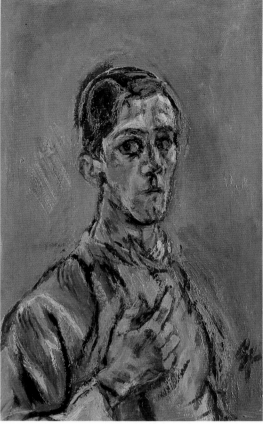

449. Oskar Kokoschka. *Self-Portrait*. 1913. Oil on canvas, 32 x 19¹/₂" (81.7 x 49.7 cm). The Museum of Modern Art, New York

Purchase

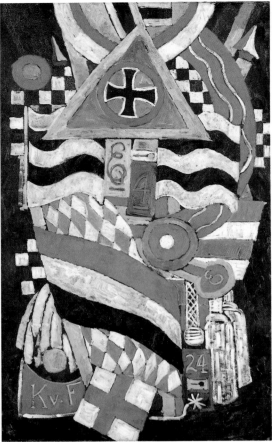

451. Marsden Hartley. *Portrait of a German Officer*. 1914. Oil on canvas, 5'8¹/₄ x 3'5³/₈" (1.73 x 1.05 m). The Metropolitan Museum of Art, New York

The Alfred Stieglitz Collection, 1949

450. Wassily Kandinsky. *Sketch I for "Composition VII."* 1913. India ink, 30³/₄ x 39³/₈" (78.1 x 100 cm). Kunstmuseum, Bern, Switzerland

Collection Felix Klee

reality. Thus, Kandinsky acknowledged the Symbolists as his ancestors. Like Gauguin, he wanted to create an art of spiritual renewal. But in contrast to Rouault or Nolde, his was an art without a specific spiritual program, though its theoretical underpinning has close affinities with the ideas of the Austrian-born social philosopher Rudolf Steiner, whose theosophy influenced many early modern artists in Germany. Kandinsky believed, as did Steiner, that humanity had lost touch with its spiritual center through attachment to material things, and he sought to rekindle that dreamlike consciousness through his art.

What does all this have to do with Kandinsky's paintings themselves? The character of his art is best summed up by his later statement: "Painting is the vast, thunderous clash of many worlds, destined, through a mighty struggle, to

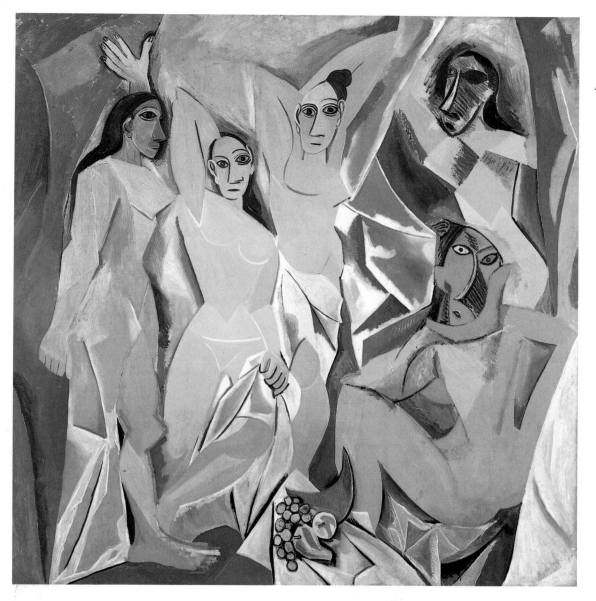

erupt into a totally new world, which is creation. And the birth of a creation is much akin to that of the Cosmos. There is the same vast and cataclysmic quality belonging to that mighty symphony—the Music of the Spheres."

How valid is the analogy between painting and music? The case is difficult to argue, and it does not matter whether this theory is right or wrong; the proof of the pudding is in the eating, not in the recipe. No artist's ideas are important to us unless we are convinced of the significance of the work itself. Kandinsky undoubtedly created a viable style, though his work admittedly demands an intuitive response that may be

hard for some. The painting reproduced here has density, vitality, and a radiant freshness of feeling that impresses us even though we may be uncertain of the artist's intent.

Marsden Hartley Americans became familiar with the Fauves through exhibitions from 1908 on. After a pivotal exhibition, the Armory Show of 1913, which introduced the latest European art to New York, there was a growing interest in the German Expressionists in the United States as well. The driving force behind the modernist movement in the United States was the photographer Alfred Stieglitz (see pages

Music before World War I

If any one event announced the arrival of twentieth-century music, it was the ballet *The Rite of Spring* by the Russian composer Igor Stravinsky (1882–1971). In 1910–13 Sergei Diaghilev of the Ballets Russes in Paris commissioned three ballets from the young composer: *The Firebird, Petrushka,* and *The Rite of Spring.* The first two revealed Stravinsky's striking gift for melody and his unusual sense of rhythm, which emerged fully in *Rite.* Its premier in 1913 is remembered for a riot, although there is evidence that this was staged. Stravinsky's work was a musical counterpart to Picasso's Cubism; indeed, the *Rite* may be compared to Picasso's *Les Demoiselles d'Avignon* (see fig. 452) in its use of "primitivism," eroticism, and dissonance to dismantle the established conventions of Western music. Like Picasso, Stravinsky also would turn to classicism after 1920.

Just as the art of the twentieth century was distinguished by abstraction from an early date, so its music has often been marked by ATONALITY, a rejection of the major and minor diatonic scales, the rules of harmony in general, and especially, the impor-tance of the TONIC (the first tone of the scale in which a given piece was written; see box on page 399). From about 1550, most European music had centered around the tonic note, in effect a musical "home base" to which the melody tended to return. However, a frequent return to the tonic note is not actually required by the rules of harmony or the tempered scale (see box on page 399)—a fact that had already been exploited by a number of German composers, starting with Wagner. It was almost inevitable that the final break with TONALITY—the importance of the tonic—would be made by a Post-Romantic. The final step was taken by Arnold Schoenberg (1874–1951), whose early work *Transfigured Night* (1899) has the sensuality of the famous *"Liebestod"* duet in Wagner's opera *Tristan and Isolde.* Schoenberg, an Expressionist by inclination, later became a friend of Kandinsky and a capable artist in his own right. Schoenberg, however, moved almost immediately into complete atonality. In 1912 he took the further step of abandoning the pitches used in normal singing for "speech-song" (German, *Sprechstimme*). Schoenberg nevertheless continued to make use of other traditional techniques of composition, which he built into pieces of extraordinary complexity. Finally, in 1923, he produced his first SERIAL works based on the so-called TWELVE-TONE ROW (or SERIES). Each row uses all the notes of the tempered scale just once, except for a few "free" notes that do not conform to the sequence. It thus constitutes a self-contained musical realm. By subjecting the series to a number of modifications and extensions, the row can be built into a large-scale composition without repeating any sequence.

Schoenberg's music makes extraordinary demands on both musicians and listeners, and its dissonances still are distasteful to many people. Yet he was able to attract talented disciples almost as soon as he settled in Vienna in 1903. Chief among them was Anton von Webern (1883–1945), whose compositions, all small in scale, are miracles of rigor, conciseness, and purity. Much of Webern's mature work consists of vocal music that has never been surpassed in difficulty. No less individual are the Expressionist operas of Alban Berg (1885–1935): *Wozzeck* (1923) and the unfinished *Lulu* (1935), both emotionally harrowing explorations of the dark side of human existence.

584–86), who almost single-handedly supported many of its early members. To him, modernism meant abstraction and its related concepts. Among the most significant achievements of the Stieglitz group are the canvases painted by Marsden Hartley (1887–1943) in Munich during the early years of World War I under the direct influence of Kandinsky. *Portrait of a German Officer* (fig. 451) is an extraordinary work of design from 1914, the year Hartley was invited to exhibit with Der Blaue Reiter. He had already been introduced to Futurism and several offshoots of Cubism, which he used to discipline Kandinsky's supercharged surface. The emblematic portrait is testimony to the militarism Hartley encountered everywhere in Germany. It incorporates the insignia, epaulets, Maltese cross, and other details from an officer's uniform of the time.

Abstraction before World War I

The second of our main currents is abstraction. When discussing Kandinsky, we said that the term *abstraction* is usually taken to mean the process (or the result) of analyzing and simplifying observed reality into geometric shapes. Literally, it means "to draw away from, to separate." Actually, abstraction goes into the making of any work of art, whether the artist knows it or not, since even the most painstakingly realistic portrayal can never be an entirely faithful replica. As far as we know, the process was not conscious and controlled, however, until the Early Renaissance, when artists began to analyze the shapes of nature in terms of solid geometric forms. Cézanne and Seurat revitalized this approach and explored it further, thus becoming the direct ancestors of the abstract movement in twentieth-century art. The difference, as one critic has noted, is that for the latter abstraction has been both a premise and a goal, not simply a reductive refinement. Abstraction has been the most distinctive and consistent feature of modern painting, to which even its most vocal opponents have responded.

Cubism

Picasso's Demoiselles d'Avignon It is difficult to imagine the birth of modern abstraction without Pablo Picasso. About 1905, stimulated as much by the Fauves as by the retrospective exhibitions of the great Post-Impressionists, he gradually abandoned the melancholy lyricism of his Blue Period (see pages 490–92) for a more robust style. He shared Matisse's enthusiasm for the work of Gauguin and Cézanne, but he viewed these great artists very differently. In 1907, he produced his own counterpart to *The Joy of Life*, a monumental canvas so challenging that it outraged even Matisse (fig. 452; see fig. 445). The title, *Les Demoiselles d'Avignon (The Young Ladies of Avignon)*, does not refer to the town of that name, but to Avignon Street in a notorious section of Barcelona. When Picasso started the picture, it was to be a temptation scene in a brothel, but he ended up with a composition of five nudes and a still life. But what nudes! Matisse's generalized figures in *The Joy of Life* seem utterly innocuous compared with this abandoned aggressiveness.

The three on the left are angular distortions of classical figures, but the violently dislocated features and bodies of the other two have many qualities in common with African sculpture. Following Gauguin's lead, the Fauves had discovered the aesthetic appeal of African and Oceanic forms and had introduced Picasso to them as well. Nevertheless, it was Picasso, not the Fauves, who used such "primitive" art as a battering ram against the classical conception of beauty. Not only the proportions but also the organic integrity and continuity of the human body are denied here, so that the canvas (in the apt description of one critic) "resembles a field of broken glass."

Picasso, then, has destroyed a great deal. What has he gained in the process? Once we recover from the initial shock, we begin to see that the destruction is quite methodical. Everything—the figures as well as their setting—is broken up into angular wedges or facets. These are not flat but are shaded in a way that gives them a certain three-dimensionality. We cannot always be sure whether they are concave or convex. Some look like chunks of solidified space, others like fragments of translucent bodies. They constitute a unique kind of matter, which imposes a new integrity and continuity on the entire canvas. The *Demoiselles*, unlike *The Joy of Life*, can no longer be read as an image of the external world. Its world is its own, analogous to nature but constructed along different principles. Picasso's revolutionary "building material," compounded of voids and solids, is hard to describe with any precision. The early critics, who saw only the prevalence of sharp edges and angles, dubbed the new style Cubism.

Analytic Cubism That the *Demoiselles* owes anything to Cézanne may at first seem incredible. However, Picasso had studied Cézanne's late work (see fig. 418) with great care, finding in Cézanne's abstract treatment of volume and space the translucent structural units from which to derive the faceted shapes of what is called Analytic (or Facet) Cubism. The link is clearer in Picasso's *Portrait of Ambroise Vollard* (fig. 453), painted three years later. The facets are now small and precise, more like prisms, and the canvas has the balance and refinement of a fully mature style.

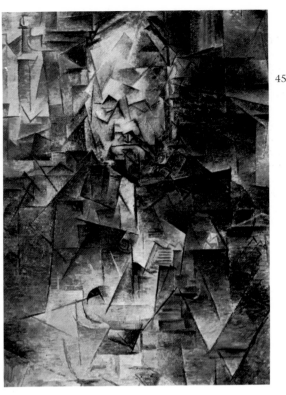

453. Pablo Picasso. *Portrait of Ambroise Vollard*. 1910. Oil on canvas, 36 1/4 x 25 5/8" (92.1 x 65.1 cm). The Pushkin State Museum of Fine Arts, Moscow

Speaking of

primitive

This is an especially "vexed term" in the sense that today the word carries negative connotations from the past, when it was used with some disdain to refer to peoples and cultures that had developed differently from Anglo-American culture. The term actually means "early," but has been used to describe the violent, crude, ignorant, and naive, especially about cultures that are unfamiliar to the person who uses the word. Paradoxically, *primitivism* is the name of the tendency to elevate, even idealize, some of these traits.

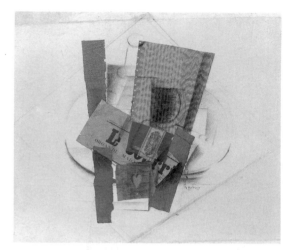

454. Georges Braque. *Newspaper, Bottle, Packet of Tobacco (Le Courrier)*. 1914. Collage of charcoal, gouache, pencil, ink, and pasted paper on cardboard, 20⅝ x 25" (52.4 x 63.5 cm). Philadelphia Museum of Art

A. E. Gallatin Collection

Contrasts of color and texture, so pronounced in the *Demoiselles*, are now reduced to a minimum; the subdued tonality of the picture approaches monochrome, so as not to compete with the design. The structure has become so complex and systematic that it would seem wholly cerebral if the "imprismed" sitter's face did not emerge with such dramatic force. There is no trace of the "barbaric" distortions in the *Demoiselles*; they had served their purpose. Cubism has become an abstract style in the Western sense, but its distance from observed reality has not significantly increased. Picasso may be playing an elaborate game of hide-and-seek with nature, but he still needs the visible world to challenge his creative powers. The nonobjective realm held no appeal for him, then or later.

Synthetic Cubism By 1910, Cubism was well established as an alternative to Fauvism, and Picasso had been joined by a number of other artists, notably Georges Braque (1882–1963), with whom he collaborated so intimately that their work from this period is difficult to distinguish. Both of them (it is not clear to whom the chief credit belongs) initiated the next

phase of Cubism, which was even bolder than the first. Usually called Synthetic Cubism because it puts forms back together, it is also known as Collage Cubism, after the French word for "paste-up," the technique that started it all. By 1911, Picasso and Braque were producing still lifes composed almost entirely of cut-and-pasted scraps of chair caning, newsprint, and other material, with only a few lines added to complete the design. In *Newspaper, Bottle, Packet of Tobacco (Le Courrier)* by Braque (fig. 454), we recognize strips of imitation wood graining, part of a tobacco wrapper with a contrasting stamp, half the masthead of a newspaper, and a bit of newsprint made into a playing card (the ace of hearts). Why did Picasso and Braque suddenly prefer the contents of the wastepaper basket to brush and paint? In wanting to explore their new concept of the picture as a sort of tray on which to "serve" the still life to the beholder, they found the best way was to put real things on the tray. The ingredients of a collage actually play a double role. They have been shaped and combined, then drawn or painted upon to give them a representational meaning, but they do not lose their original identity as scraps of material, "outsiders" in the world of art. Their function is both to represent (to be a part of an image) and to present (to be themselves). In this latter capacity, they endow the collage with a self-sufficiency that no Analytic Cubist picture can have. A tray, after all, is a self-contained area, detached from the rest of the physical world. Unlike a painting, it cannot show more than is actually on it.

The difference between the two phases of Cubism may also be defined in terms of picture space. Analytic Cubism retains a certain kind of depth, so that the painted surface acts as a window through which we still perceive the remnants of the familiar perspective space of the Renaissance. Though fragmented and redefined, this space lies behind the picture plane and has no visible limits. Potentially, it may contain objects that are hidden from our view. In Synthetic Cubism, on the contrary, the picture space lies in front of the plane of the "tray." Space is not created by illusionistic

devices, such as **modeling** and **foreshortening**, but by the actual overlapping of layers of pasted materials. The integrity of the non-perspective space is not affected when, as in *Le Courrier*, the apparent thickness of these materials and their distance from each other is increased by a bit of shading here and there. Synthetic Cubism, then, offers a basically new space concept, the first since Masaccio. It is a true landmark in the history of painting.

Before long, Picasso and Braque discovered that they could retain this new pictorial space without the use of pasted materials. They only had to paint as if they were making collages. World War I, however, put an end to their collaboration and disrupted the further development of Synthetic Cubism, which reached its height in the following decade.

Futurism As originally conceived by Picasso and Braque, Cubism was a formal discipline of subtle balance applied to traditional subjects: still life, portraiture, the nude. Other painters, however, saw in the new style a special affinity with the geometric precision of engineering that made it uniquely attuned to the dynamism of modern life. The short-lived Futurist movement in Italy exemplifies this attitude. In 1909–10 its disciples, led by the poet Filippo Tommaso Marinetti, issued a series of manifestos violently rejecting the past and exalting the beauty of the machine.

At first they used techniques developed from Post-Impressionism to convey the surge of industrial society, but these were otherwise static compositions, still dependent upon representational images. By adopting the simultaneous views of Analytic Cubism in *Dynamism of a Cyclist* (fig. 455), Umberto Boccioni (1882–1916), the most original of the Futurists, was able to communicate the look of furious pedaling across time and space far more tellingly than if he had actually depicted the human figure, which could be seen in only one time and place in traditional art. In the flexible vocabulary provided by Cubism, Boccioni found the means of expressing the twentieth century's new sense of time, space, and energy that Albert Einstein had defined in 1905 in his

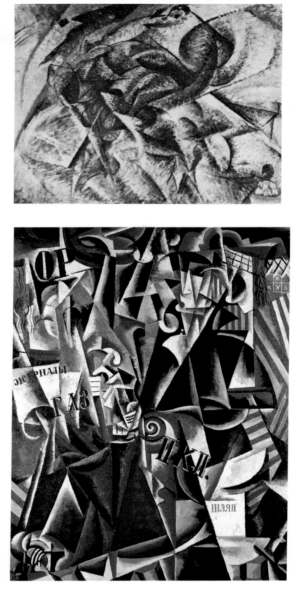

455. Umberto Boccioni. *Dynamism of a Cyclist.* 1913. Oil on canvas, 27⅝ x 37⅜" (70.2 x 94.9 cm). Collection Gianni Mattioli, Milan

456. Liubov Popova. *The Traveler.* 1915. Oil on canvas, 56 x 41½" (142.2 x 105.4 cm). Norton Simon Art Foundation, Pasadena, California

▼SPECIAL THEORY OF RELATIVITY. Moreover, Boccioni suggests the unique quality of the modern experience. With his pulsating movement, the cyclist has become an extension of his environment, from which he is now indistinguishable.

Futurism literally died out in World War I. Its leading artists were killed by the same vehicles of destruction they had glorified only a few years earlier in their manifestos, but their legacy soon passed on to artists in France, the United States, and, above all, Russia.

▼ In his SPECIAL THEORY OF RELATIVITY (originally published while he was a doctoral candidate in Zurich, Switzerland, as "On the Electrodynamics of Moving Bodies,") the brilliant physicist Albert Einstein (1879–1955) put forth his theory for understanding the nature of measurement and interaction of space and time. To the end of his days, Einstein sought a unified field theory that would explain all major phenomena encompassed by the field of physics.

Cubo-Futurism Cubo-Futurism arose in Russia a few years before World War I as the result of close contacts with the leading European art centers. Its style was drawn from Picasso's and its theories were based on Futurist tracts. The Russian Futurists were, above all, modernists. They welcomed industry, which was spreading rapidly throughout Russia, as the foundation of a new society and the means for conquering that old Russian enemy, nature. Unlike the Italian Futurists, however, the Russians rarely glorified the machine, least of all as an instrument of war.

Central to Cubo-Futurist thinking was the concept of *zaum*, a term that has no counterpart in the West. Invented by Russian poets, *zaum* was a "trans-sense" (as opposed to the Dadaists' nonsense; see page 523) language based on new word forms and syntax. In theory, *zaum* could be understood universally, since it was thought that meaning was implicit in the basic sounds and patterns of speech. When applied to painting, *zaum* provided the artist with complete freedom to redefine the style and content of art. The picture surface was now seen as the sole conveyer of meaning through its appearance. Hence, the "subject" of a work of art became the visual elements and their formal arrangement. However, because Cubo-Futurism was concerned with means, not ends, it failed to provide the actual content that is found in other modernist works. Historically, the Cubo-Futurists were more important as theorists than as artists, for they provided the springboard for several later Russian movements.

The new world envisioned by the Russian modernists foretold a broad redefinition of the roles of man and woman. It was therefore in Russia that women achieved an artistic stature not equaled in Europe or the United States until considerably later. The finest painter of the group was Liubov Popova (1889–1924). She studied in Paris in 1912 and visited Italy in 1914. The combination of Cubism and Futurism that she absorbed abroad is seen in *The Traveler* (fig. 456). The treatment of forms remains essentially Cubist, but the painting shares the Futurist obsession with representing dynamic motion in time and space. The jumble of image fragments creates the impression of

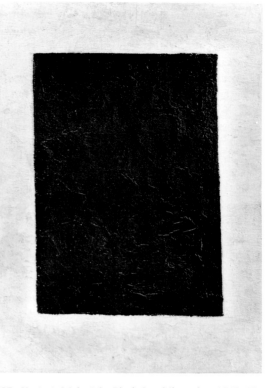

457. Kazimir Malevich. *Black Quadrilateral*. c. 1913–15. Oil on canvas, 24 x 17" (61 x 43.2 cm). Copyright the George Costakis Collection, Athens

objects seen in rapid succession. Across the plane, the furious interaction of forms with their environment threatens to extend the painting into the surrounding space. At the same time, the strong modeling draws attention to the surface, lending it a relieflike quality that is enhanced by the vigorous texture.

Suprematism

The first purely Russian art of the twentieth century was that of Suprematism. In one of the greatest leaps of the symbolic and spatial imagination in the history of art, Kazimir Malevich (1878–1935) invented the *Black Quadrilateral* seen in figure 457. How is it that such a disarmingly simple image should be so important? By limiting art to a few elements—a single shape repeated in two tones and fixed firmly to the picture plane—he emphasized the painting as a painting even more radically than had his

Theater before World War I

By far the most adventurous theater before World War I was to be found in Russia, and the experiments of this period prepared the way for even more radical innovations after the Revolution of 1917. The most important of the Russian reformers was Konstantin Stanislavsky (1863–1938), a cofounder of the Moscow Art Theater. Stanislavsky emphasized the actor, insisting on rigorous training of body and voice and a thorough understanding of the play itself, so that the action would unfold naturally and convincingly. Stanislavaky's theories were later practiced in America as "method acting" (see box on page 535). Vsevolod Meyerhold (1874–1940) held the almost opposite point of view, that the director was the main creative force in the theater. Meyerhold dispensed with the theatrical curtain and set his productions in symbolic scenery or even on a bare stage. Alexander Tairov (1885–1950) adopted a centrist position, considering the actor important (like Stanislavsky), but also, like Meyerhold, treating the play as a point of departure for the director's creativity. He also maintained that theater performances should be like the sacred dances at ancient temples. His productions, which stressed the unity of word, music, and dance, were similar in intent to Classical Greek plays.

The ballet director Sergei Diaghilev (1872–1929), whose journal *The World of Art* promoted Symbolist art, literature, and theater, took a dance company to Paris in 1909 with such success that he formed the Ballets Russes there, featuring the great dancer Vaslav Nijinsky (1890–1950) and the music of Igor Stravinsky. With the onset of the Russian Revolution, the company remained in Paris, and later employed Picasso, Braque, and de Chirico as set and costume designers.

For all of its innovations, the early-twentieth-century theater in Russia contributed little in the way of new dramas. Instead, the creative impetus in dramatic writing came from Ireland, where plays with an Irish focus were produced by the Irish National Theatre Society, better known as the Abbey Theatre, where the company was housed after 1904. The most important playwrights were the poet William Butler Yeats (1865–1939), Lady Isabella Augusta Gregory (1863–1935), and John Millington Synge (1871–1909). Yeats's early work was closely related to that of the French Symbolists, while Lady Gregory's was Realistic. Synge successfully synthesized the best features of both their work in the two finest dramas staged by the Abbey, *The Playboy of the Western World* (1907) and *Riders to the Sea* (1904). Synge was fearless in tackling controversial subjects—*Playboy* caused riots wherever it played—but the real secret of his success was his extraordinary, poetic prose.

In England, the most important theorist of the late-nineteenth-century theater was the director and designer Gordon Craig (1872–1966), whose thinking laid the ground for many of the key concepts of modern directing. Like Meyerhold, Craig conceived of himself as an artist whose creative work was independent of the drama itself, using lights and painted screens for expressive theatrical effect. No one, however, had more impact on modern theater than Max Reinhardt (1873–1943), director of the Deutsches Theater in Berlin. He realized that each play demanded a different approach, and insisted that the director rethink and control every detail of the production, which was prepared in close collaboration with his actors and designers.

predecessors. At the same time, he transformed it into a concentrated symbol having multiple layers of meaning, thereby providing the content missing from Cubo-Futurism. The inspiration for *Black Quadrilateral* came in 1913 while Malevich was working on designs for the opera *Victory over the Sun*, a production that was one of the important artistic collaborations in the modern era. In the context of the opera, the black quadrilateral represents the eclipse of the sun of Western painting and of everything based on it. Further, the work can be seen as the triumph of the new order over the old, the East over the West, humanity over nature, and idea over matter. The black quadrilateral (which is not even a true rectangle) was intended to stand as a modern icon. It supersedes the traditional Christian trinity and symbolizes a "supreme" reality, because geometry is an independent abstraction in itself; hence the movement's name, Suprematism.

According to Malevich, Suprematism was also a philosophical color system constructed in time and space. His space was an intuitive one, with both scientific and mystical overtones. The flat plane replaces volume, depth, and perspective—the traditional means of defining space. Each side or point represents one of the three dimensions, with the fourth side standing for the fourth dimension, time. Like the universe itself, the black surface would be infinite were it not delimited by an outer boundary, which is the white border and shape of the canvas. *Black Quadrilateral* thus constitutes the first satisfactory redefinition, visually and conceptually, of time and space in modern art. Like Einstein's formula $E=mc^2$ for the theory of relativity, it has an elegant simplicity that belies the intense effort required to synthesize a complex set of ideas and reduce them to a fundamental "law." When it first appeared, Suprematism had much the same impact on

Russian artists that Einstein's theory had on scientists. It unveiled a world never seen before, one that was unequivocally "modern." The heyday of Suprematism was over by the early 1920s. Reflecting the growing diversity and fragmentation of Russian art, its followers defected to other movements, above all to the Constructivism led by Vladimir Tatlin (see pages 553–54).

Fantasy before World War I

The third current, which we term fantasy, follows a less clear-cut course than the other two, since it depends on a state of mind more than on any particular style. The one thing all painters of fantasy have in common is the belief that imagination, "the inner eye," is more important than the outside world. We must be careful how we use the term *fantasy*. It originated in psychoanalytic theory and meant something very different in the early twentieth century than it does now. It was thought of as mysterious and profound, anything but the lighthearted and superficial view we take of it today.

Why did private fantasy come to loom so large in twentieth-century art? There seem to be several interlocking causes. First, the gulf that developed between reason and imagination in the wake of the rationalism of the Enlightenment tended to dissolve the heritage of myth and legend that had been the common channel of private fantasy in earlier times. Second, the artist's greater freedom—and insecurity—within the social fabric gave rise to a sense of isolation and favored an introspective attitude. Finally, the Romantic cult of emotion prompted the artist to seek out subjective experience and to accept its validity. We saw the trend beginning at the end of the eighteenth century in the art of Fuseli (see fig. 370), although in nineteenth-century painting, private fantasy remained a minor current. After 1900, it became a major one, thanks to Symbolism on the one hand and the naive vision of artists like Henri Rousseau on the other.

Giorgio de Chirico The heritage of Romanticism can be seen most clearly in the aston-

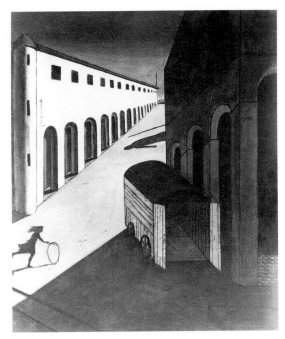

458. Giorgio de Chirico. *Mystery and Melancholy of a Street*. 1914. Oil on canvas, 34¼ x 28½" (87 x 72.4 cm). Private collection

ishing pictures painted in Paris just before World War I by Giorgio de Chirico (1888–1978), such as *Mystery and Melancholy of a Street* (fig. 458). This deserted square with endless diminishing arcades, nocturnally illuminated by the cold full moon, has all the poetry of Romantic reverie. It has also a strangely sinister air. This is an ominous scene in the full sense of the term. Everything here suggests an omen, a portent of unknown and disquieting significance. The artist could not fully explain the incongruities in this painting—the empty furniture van or the girl with the hoop—that trouble and fascinate us. De Chirico called this metaphysical painting: "We who know the signs of the metaphysical alphabet are aware of the joy and the solitude which are enclosed by a portico, by the corner of a street, or even in a room, on the surface of a table, or between the sides of a box. . . . The minutely accurate and prudently weighed use of surfaces and volumes constitutes the canon of the metaphysical aesthetic." Later, after he returned to Italy, he adopted a conservative style and repudiated his early work, as if he were embarrassed at having put his dream world on public display.

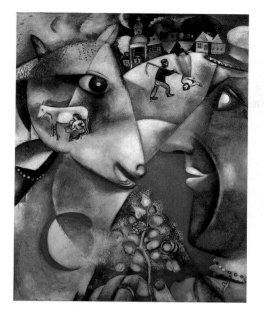

459. Marc Chagall. *I and the Village*. 1911.
Oil on canvas, 6'3⁵/8" x 4'11¹/2" (1.92 x 1.51 m).
The Museum of Modern Art, New York

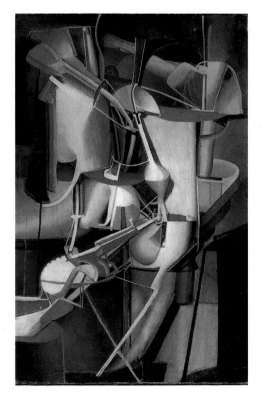

460. Marcel Duchamp. *The Bride*. 1912. Oil on canvas,
35¹/8 x 21³/4" (89.2 x 55.3 cm). Philadelphia
Museum of Art

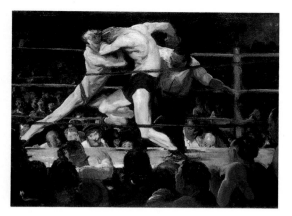

461. George Bellows. *Stag at Sharkey's*. 1909.
Oil on canvas, 36¹/4 x 48¹/4" (92.1 x 122.6 cm).
The Cleveland Museum of Art

Marc Chagall The power of nostalgia, so evident in *Mystery and Melancholy of a Street*, also dominates the fantasies of Marc Chagall (1887–1985), a Russian Jew who went to Paris in 1910. *I and the Village* (fig. 459) is a Cubist fairy tale, weaving dreamlike memories of Russian folktales, Jewish proverbs, and the look of Russia into one glowing vision. Here, as in many later works, Chagall relives the experiences of his childhood. These were so important to him that his imagination shaped and reshaped them for years without their vividness being diminished.

Marcel Duchamp In Paris on the eve of World War I, we encounter yet another artist of fantasy, the French painter Marcel Duchamp (1887–1968). After basing his early style on Cézanne, he initiated a dynamic version of Analytic Cubism, similar to Futurism, by superimposing successive phases of movement on each other, much as in multiple-exposure photography. Soon, however, Duchamp's development took a far more disturbing turn. In *The Bride* (fig. 460), we look in vain for any resemblance, however remote, to the human form. What we see is a mechanism that seems part motor, part distilling apparatus. It is beautifully engineered to serve no purpose whatever. The title cannot be irrelevant: by lettering it right onto the canvas, Duchamp has emphasized its importance. Yet it causes perplexity. Evidently the artist intended the machine as a kind of modern fetish that acts

as a metaphor of human sexuality. By "analyzing" the bride until she is reduced to a complicated piece of plumbing that seems utterly dysfunctional, physically and psychologically, he satirized the scientific outlook on humanity. Thus, the picture represents the negative counterpart of the glorification of the machine, so stridently proclaimed by the Futurists. We may further see in Duchamp's pessimistic outlook a response to the gathering forces that were soon to be unleashed in World War I and topple the political order that had been created a hundred years earlier at the Congress of Vienna.

Realism before World War I

The Ashcan School In the United States, the first wave of change was initiated not by the Stieglitz circle but by the Ashcan School, which flourished in New York just before World War I. Centering on the painter Robert Henri, who had studied with a pupil of Thomas Eakins at the Pennsylvania Academy, this group of artists consisted mainly of former illustrators for Philadelphia and New York newspapers. They were fascinated with the teeming life of the city and found an endless source of subjects in the everyday urban scene, to which they brought the reporter's eye for color and drama. Despite the socialist philosophy that many of them shared, theirs was not an art of social commentary but one that felt the pulse of city life, discovering in it vitality and richness while ignoring poverty and squalor. To capture these qualities they relied on rapid execution, inspired by Baroque and Post-Impressionist painting, which lends their canvases the immediacy of spontaneous observation.

George Bellows Although not a founding member of the Ashcan School, George Bellows (1882–1925) became a leading representative of the group in its heyday. His greatest work, *Stag at Sharkey's* (fig. 461), shows why: no other painter in the United States before Jackson Pollock (see pages 532–34) expressed such heroic energy. *Stag at Sharkey's* still reminds us of Eakins's *William Rush Carving His Allegorical Figure of the Schuylkill River* (see fig. 408), for it

▼ THE EIGHT were American painters who showed together in a 1908 exhibition that proved to be crucial in establishing American Realism and Post-Impressionism as popular and authentic alternatives to the academic aestheticism that held sway. The artists were founder Robert Henri, George Luks, William J. Glackens, John Sloan, Everett Shinn, Ernest Lawson, Arthur B. Davies, and Maurice Prendergast.

continues the same Realist tradition. Both place us in the scene as if we were present, and both use the play of light to pick out the figures against a dark background. Bellows's paintings were fully as shocking as Eakins's had been. Most late-nineteenth-century American artists had all but ignored urban life in favor of landscapes, and compared with these, the subjects and surfaces of the Ashcan pictures had a disturbing rawness.

The Armory Show

The Ashcan School was quickly eclipsed by the rush toward a more radical modernism set off by the Armory Show held in New York in 1913. It was an outgrowth of another exhibition, the Independents Show of three years earlier, which showcased the talents of a group of rising young artists known as ▼THE EIGHT. The Armory Show was intended to foster a "new spirit in art" by introducing Americans to the latest trends in Europe and the United States. The modern section was heavily French, with a major emphasis on Matisse and Picasso, while German Expressionism was poorly represented and Futurism was omitted completely. American art, which made up the largest part of the exhibition, included works by members of the Ashcan School, the Stieglitz group, and the Eight. While it failed to promote the interests of its organizers, the Armory Show did succeed in its goal of introducing a new cosmopolitanism into the American art scene. Despite the outraged criticism of some of the press, it proved surprisingly successful with the public, who bought an astonishing number of works from the exhibition.

Painting between the Wars

The Founders: Picasso and Matisse

As we examine painting between the wars, we shall find anything but an orderly progression. World War I had totally disrupted the further evolution of modernism, and the war's end unleashed an unprecedented outpouring of art after a four-year creative lull. The responses were cor-

respondingly diverse. Because they were already fully formed artists, Picasso and Matisse followed very different paths from those of younger painters who had not yet emerged into maturity by 1914. They broke the very "rules" they themselves had established earlier, responding only to the dictates of their sovereign imaginations; hence, their work of this period transcends ready categorization. Rather than a simple linear development, we must therefore think in terms of multiple layers of varying depth that bear a shifting relation to each other.

Pablo Picasso We continue with Picasso, whose extraordinary genius towers over the period. As a Spanish national living in Paris, he was not involved in the war, unlike many French and German artists who served in the military and even sacrificed their lives. This was a time of quiet experimentation that laid the foundation for Picasso's art of the next several decades. The results did not become fully apparent, however, until the early 1920s, following a period of intensive cultivation. *Three Musicians* (fig. 462, page 520) shows the fruit of that labor. It utilizes the "cut-paper style" of Synthetic Cubism so consistently that we cannot tell from the reproduction whether it is painted or pasted.

By now, Picasso was internationally famous. Cubism had spread throughout the Western world, influencing not only other painters but also sculptors and even architects. Yet Picasso himself was already striking out in a new direction. Soon after the invention of Synthetic Cubism, he had begun to make drawings in a meticulous realistic manner reminiscent of Ingres, and by 1920 he was working simultaneously in two quite separate styles: the Synthetic Cubism of the *Three Musicians* and a "neoclassical" style of strongly modeled, heavy-bodied figures. To many of his admirers, this seemed a kind of betrayal, but in retrospect the reason for Picasso's double-track performance is clear. Chafing under the limitations of Synthetic Cubism, he wanted to resume contact with the classical tradition, the "art of the museums."

A few years later, the two tracks of Picasso's style began to converge into an extraordinary synthesis that was to become the basis of his art.

The *Three Dancers* of 1925 (fig. 463, page 521) shows how he accomplished this seemingly impossible feat. Structurally, the picture is pure Synthetic Cubism. It even includes painted imitations of specific materials, such as patterned wallpaper and samples of various fabrics cut out with pinking shears. The figures are a wildly fantastic version of a classical scheme (compare the dancers in Matisse's *The Joy of Life*, fig. 445). They are an even more violent assault on convention than the figures in *Les Demoiselles d'Avignon* (see fig. 452). Human anatomy is here simply the raw material for Picasso's incredible inventiveness. Limbs, breasts, and faces are handled with the same sovereign freedom as the fragments of external reality in Braque's *Le Courrier* (see fig. 454). Their original identity no longer matters. Breasts may turn into eyes, profiles merge with frontal views, shadows become substance, and vice versa, in an endless flow of metamorphoses. They are "visual puns," offering wholly unexpected possibilities of expression: humorous, grotesque, macabre, tragic.

Henri Matisse From 1911 on, Matisse had been influenced increasingly by Cubism. After the war he, like Picasso, abandoned it and returned to the classical tradition, but the lessons he had absorbed had far-reaching consequences for his style. We see this in *Decorative Figure against an Ornamental Background* (fig. 464, page 521) of 1927, which has a new luxuriance. At the same time, there is an underlying discipline resulting from his study of Cubism. The carpet provides a firm geometric structure for organizing the composition, so that everything has its place, although the system itself is entirely intuitive. Only in this way could Matisse control all the elements of his elaborate picture. It is among the finest in a long series of odalisques that Matisse painted during the 1920s and 1930s. In them, the artist emerges as the heir of the French tradition, which he had absorbed through his teacher Moreau (see page 489). The visual splendor would be worthy of Delacroix himself. Yet in the calm pose and strong contours of the figure, Matisse reveals himself to be a classicist at heart, more akin to Ingres' than to the Romantics. The picture has overtones of Degas, who

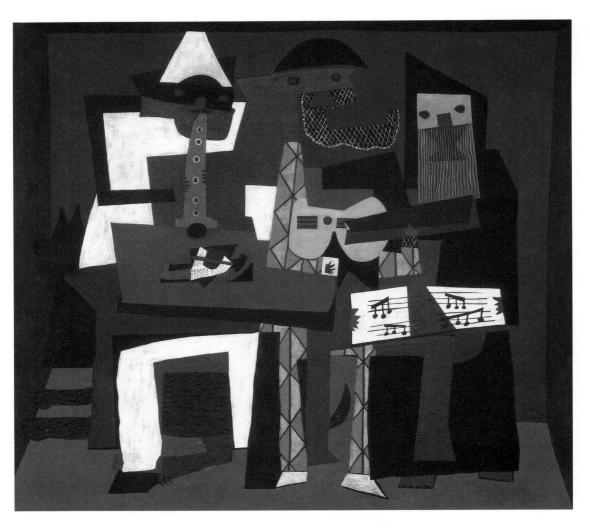

had been trained by a disciple of Ingres' and thus formed an important link in the chain of tradition. It also breathes the classical serenity of *Seated Woman* by Matisse's friend Maillol (see fig. 433), who early in his career had likewise been inspired by Gauguin. However, Matisse's remains a distinctly modern classicism.

Abstraction between the Wars

Picasso's abandonment of strict Cubism signaled the broad retreat from abstraction after 1920. The utopian ideals associated with modernism, which it embodied, had been largely dashed by "the war to end all wars." In retrospect, abstraction can be seen as a necessary phase through which modern painting had to pass, but it was not essential to modernism as such, even though it has been perhaps the dominant tendency of the twentieth century.

Fernand Léger The Futurist spirit continued to find adherents on both sides of the Atlantic. Buoyant with optimism and pleasurable excitement, *The City* (fig. 465) by the French painter Fernand Léger (1881–1955) conjures up a mechanized utopia. This beautifully controlled industrial landscape is stable without being static and reflects the clean geometric shapes of modern machinery. In this instance, the term *abstraction* applies more to the choice of design elements and their manner of combination than to the shapes themselves, since these are "prefabricated" entities, except for the two figures on the staircase.

Charles Demuth The modern movement in the United States proved short-lived. One of the few

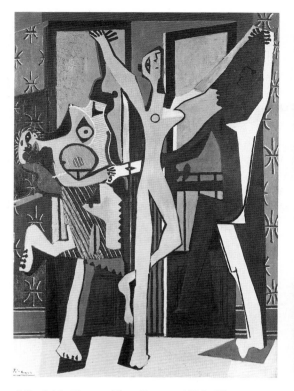

463. Pablo Picasso. *Three Dancers*. 1925. Oil on canvas, 7'1½" x 4'8¼" (2.15 x 1.43 m). Tate Gallery, London

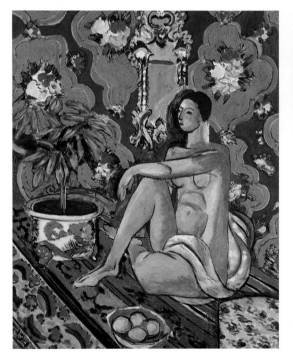

464. Henri Matisse. *Decorative Figure against an Ornamental Background*. 1927. Oil on canvas, 51⅛ x 38½" (129.9 x 97.8 cm). Musée National d'Art Moderne, Paris

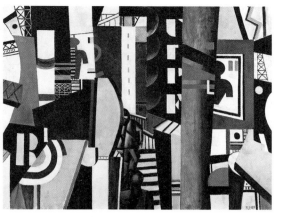

465. Fernand Léger. *The City*. 1919. Oil on canvas, 7'7" x 9'9" (2.31 x 2.97 m). Philadelphia Museum of Art

A. E. Gallatin Collection

466. Charles Demuth. *I Saw the Figure 5 in Gold*. 1928. Oil on composition board, 36 x 29¾" (91.4 x 75.6 cm). The Metropolitan Museum of Art, New York

The Alfred Stieglitz Collection, 1949

artists to continue working in this vein after World War I was Charles Demuth (1883–1935). A member of the Stieglitz group, he had been friendly with Duchamp and exiled Cubists in New York during World War I. A few years later, under the impact of Futurism, he developed a style known as Precisionism to depict urban and industrial architecture. We can detect influences from all these movements in *I Saw the Figure 5 in Gold* (fig. 466). The title is taken from the poem "The Great Figure" by Demuth's friend William Carlos Williams, whose name also forms part of the design, as *Bill*, *Carlo*[s], and *W.C.W.* In the poem, the figure 5 appears on a red fire truck,

while in the painting it has become the dominant feature, thrice repeated to reinforce its echo in our memory as the fire truck rushes on through the night:

> Among the rain
> and lights
> I saw the figure 5 in gold
> on a red
> firetruck
> moving
> tense
> unheeded
> to gong clangs
> siren howls
> and wheels rumbling
> through the dark city

Piet Mondrian The most radical abstractionist of our time was a Dutch painter nine years older than Picasso, Piet Mondrian (1872–1944). He arrived in Paris in 1912 as a mature Expressionist in the tradition of van Gogh and the Fauves. Under the impact of Analytic Cubism, his work soon underwent a complete change, and within the next decade Mondrian developed an entirely nonrepresentational style that he called Neo-Plasticism. The short-lived design movement based on his thinking is known as de Stijl, after the Dutch magazine advocating his ideas, which were formulated with Theo van Doesburg (1883–1931) and Bart van der Leck (1876–1958). Mondrian became the center of the abstract movement in Paris, where he returned in 1919 and remained until the onset of World War II. Indeed, the School of Paris in the 1930s was made up largely of foreigners like him—especially the Abstraction-Création group, which included artists of every persuasion. As a result, the differences between the various movements soon became blurred, although Mondrian himself consistently adhered to his principles.

Composition with Red, Blue, and Yellow (fig. 467, page 524) shows Mondrian's style at its most severe. He restricts his design to horizontals and verticals and his colors to the three primary hues, plus black and white. Every possibility of representation is thereby eliminated,

▼ THEOSOPHY (from Greek *theos,* "divine" and *sophos,* "wisdom") is any religious and philosophical system that seeks knowledge of God and the universe in relation to God. In Mondrian's time, the most influential theosophist was Madame (Helena Petrovna) Blavatsky (1831–91), a Russian-born spiritualist medium, mystic, and occultist who founded the Theosophical Society in New York in 1875. Its worldwide program included the study of all Eastern religions and a keen interest in latent mental and intuitional faculties, as well as a search for a universal and unifying spiritual principle.

although Mondrian sometimes gave his works such titles as *Trafalgar Square* or *Broadway Boogie Woogie* that hint at some degree of relationship, however indirect, with observed reality. Like Kandinsky, Mondrian was affected by ▼THEOSOPHY, albeit the distinctive Dutch branch founded by M. H. J. Schoenmaekers, a mystic and mathematician who believed it was possible to arrive at a mathematical understanding of the universe that would enable people to live in a state of harmony. Unlike Kandinsky, however, Mondrian did not strive for pure, lyrical emotion. His goal, he asserted, was "pure reality," and he defined this as equilibrium "through the balance of unequal but equivalent oppositions." For all of their analytic calm, Mondrian's paintings are highly idealistic, in accordance with Schoenmaekers's views. In Mondrian's words: "When we realize that equilibrated relationships in society signify what is just, then we shall realize that in art, likewise, the demands of life press forward when the spirit of the age is ready."

Perhaps we can best understand what he meant by equilibrium if we think of his work as "abstract collage" that uses black bands and colored rectangles instead of recognizable fragments of chair caning and newsprint. He was interested solely in visual relationships and wanted no distracting elements or fortuitous associations. By establishing the "right" relationships among his bands and rectangles, he transforms them as thoroughly as Braque transformed the snippets of pasted paper in *Le Courrier* (see fig. 454). How did he discover the "right" relationship? And how did he determine the shape and number for the bands and rectangles? In Braque's *Le Courrier,* the ingredients are to some extent "given" by chance. Mondrian, apart from his self-imposed rules, constantly faced the dilemma of unlimited possibilities. He could not change the relationship of the bands to the rectangles without changing the bands and rectangles themselves. When we consider his task, we begin to realize its infinite complexity.

Looking again at *Composition with Red, Blue, and Yellow,* we find that when we measure the various units, only the proportions of the canvas itself are truly rational, an exact square. Mon-

drian has arrived at all the rest "by feel" and must have undergone agonies of trial and error. How often, we wonder, did he change the dimensions of the red rectangle to bring it and the other elements into self-contained equilibrium? Strange as it may seem, Mondrian's exquisite sense for nonsymmetrical balance is so specific that critics well acquainted with his work have no difficulty in distinguishing forgeries from genuine pictures. Designers who work with nonfigurative shapes, such as architects and typographers, are likely to be most sensitive to this quality, and Mondrian has had a greater influence on them than on painters (see page 574).

Fantasy between the Wars

Dada Out of despair over the mechanized mass killing of World War I, a number of artists in Zurich and New York, including Marcel Duchamp, simultaneously launched in protest a movement called Dada (or Dadaism), which then spread to other cities in Germany and France. The term *dada*, which means "hobby-horse" in French, was reportedly picked at random from a dictionary, and as an infantile, all-purpose word, it perfectly fit the spirit of the movement. Dada has often been called nihilistic, and its declared purpose was indeed to make clear to the public at large that all established values, moral or aesthetic, had been rendered meaningless by the catastrophe of the Great War. During its short life (c. 1915–22) Dada preached nonsense and anti-art with a vengeance. As artist and poet Hans Arp wrote, "Dadaism carried assent and dissent ad absurdum. In order to achieve indifference, it was destructive." Yet Dada was not a completely negative movement. In its calculated irrationality there was also liberation, a voyage into unknown provinces of the creative mind. The only law respected by the Dadaists was that of chance, and the only reality, that of their own imaginations.

Max Ernst Although their most characteristic art form was the ready-made (see page 555), the Dadaists adopted the collage technique of Synthetic Cubism for their purposes: figure 468 on page 524 by the German Dadaist Max Ernst

(1891–1976), an associate of Duchamp, is largely composed of snippets from illustrations of machinery. The caption pretends to enumerate these mechanical ingredients, which include (or add up to) "1 Piping Man." Actually, there is also a "piping woman." These offspring of Duchamp's prewar *Bride* stare at us blindly through their goggles.

Surrealism In 1924, after Duchamp's retirement from Dada, a group led by the French poet André Breton founded Dada's successor, Surrealism. The Surrealists defined their aim as "pure psychic automatism . . . intended to express . . . the true process of thought . . . free from the exercise of reason and from any aesthetic or moral purpose." Surrealist theory was heavily larded with concepts borrowed from psychoanalysis, and its overwrought rhetoric is not always to be taken seriously. The notion that a dream can be transposed by "automatic handwriting" directly from the unconscious mind to the canvas, bypassing the conscious awareness of the artist, did not work in practice; some degree of control was simply unavoidable. Nevertheless, Surrealism stimulated several novel techniques for soliciting and exploiting chance effects.

Ernst's Decalcomania Max Ernst, the most inventive member of the group, often combined collage with "frottage" (rubbings from pieces of wood, pressed flowers, and other relief surfaces—the process we all know from the children's pastime of rubbing with a pencil on a piece of paper covering, say, a coin). He also obtained fascinating shapes and textures by "decalcomania" (the transfer, by pressure, of oil paint to the canvas from some other surface). In *The Attirement of the Bride* (fig. 469, page 524), Ernst certainly found an extraordinary wealth of images to elaborate on. The end result has some of the qualities of a dream, but it is a dream born of a strikingly romantic imagination.

Joan Miró Surrealism had an even more boldly imaginative branch. Some works by Picasso, such as *Three Dancers* (see fig. 463), have affinities with it, and its greatest exponent was also

467. Piet Mondrian. *Composition with Red, Blue, and Yellow.* 1930. Oil on canvas, 20" (50.8 cm) square. Private collection

Courtesy of the Mondrian Estate/Holtzman Trust/MBI NY

468. Max Ernst. *1 Copper Plate 1 Zinc Plate 1 Rubber Cloth 2 Calipers 1 Drainpipe Telescope 1 Piping Man.* 1920. Collage, 12 x 9" (30.5 x 22.9 cm). Estate of Hans Arp

469. Max Ernst. *The Attirement of the Bride.* 1940. Oil on canvas, 51 x 37⁷/₈" (129.5 x 96.2 cm). Peggy Guggenheim Collection, Venice

Spanish: Joan Miró (1893–1983), who painted the striking *Composition* of 1933 (fig. 470). His style has been labeled biomorphic abstraction, since his designs are fluid and curvilinear, like organic forms, rather than geometric. Actually, *biomorphic concretion* might be a more suitable name, for the shapes in Miró's pictures have their own vigorous life. They seem to change before our eyes, expanding and contracting like amoebas until they approach human individuality closely enough to have pleased the artist. Their spontaneous "becoming" is the very opposite of abstraction as we defined it (see page 502), though Miró, who was originally a Cubist, worked with a formal discipline no less rigorous than that of Mondrian.

Paul Klee The German-Swiss painter Paul Klee (1879–1940) was decisively influenced early in his career by Der Blaue Reiter and shared many ideas with his friend Kandinsky. Like Kandinsky, Klee was fascinated with music and was himself a talented violinist. His theories of art

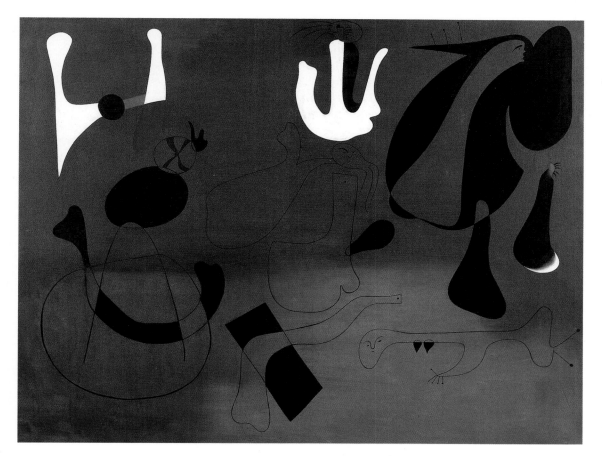

470. Joan Miró. *Composition*. 1933. Oil on canvas, 4'3¹/₄" x 5'3¹/₂" (1.3 x 1.61 m). Wadsworth Atheneum, Hartford, Connecticut

Ella Gallup Sumner and Mary Catlin Sumner Collection

also have much in common with those of Kandinsky. (They were colleagues at the Bauhaus during the 1920s; see pages 574–76.) Klee nevertheless went in a direction different from Kandinsky's. Instead of a higher reality, Klee wanted to illuminate a deeper one from within the imagination that parallels nature but is independent of it. Thus, natural forms are essential to his work, but as pictorial metaphors filled with hidden meaning rather than as representations of nature. He was affected, too, by Cubism, but Egyptian and black African art and the drawings of small children held an equally vital interest for him. During World War I, he molded these disparate elements into a pictorial language of his own, marvelously economical and precise. *Twittering Machine* (fig. 471), a delicate pen drawing tinted with watercolor, demonstrates the unique flavor of Klee's art. With a few simple lines, he created a ghostly mechanism that imitates the sound of birds, simultaneously mocking our faith in the miracles of the machine age and our sentimental

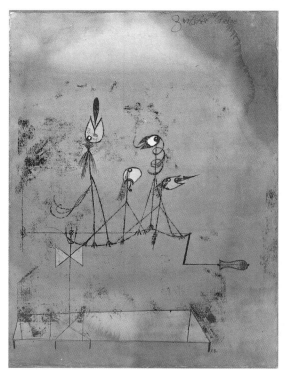

471. Paul Klee. *Twittering Machine (Zwitscher-Maschine)*. 1922. Watercolor and pen and ink on oil transfer drawing on paper, mounted on cardboard, 25¹/₄ x 19" (64.1 x 48.3 cm). The Museum of Modern Art, New York

Purchase

appreciation of bird song. The little contraption is not without its sinister aspect: the heads of the four sham birds look like fishing lures, as if they might entrap real birds. It thus condenses into one striking invention a complex of ideas about present-day civilization.

The title has an indispensable role. It is characteristic of the way Klee worked that the picture itself, however visually appealing, does not reveal its full evocative quality unless the artist tells us what it means. The title, in turn, needs the picture: the witty concept of a twittering machine does not kindle our imagination until we are shown such a thing. This interdependence is familiar to us from cartoons. Klee lifts it to the level of high art without relinquishing the playful character of these verbal-visual puns. To him art was a language of signs, of shapes that are images of ideas as the shape of a letter is the image of a specific sound, or an arrow the image of the command "This way only." He also realized that in any conventional system the sign is no more than a "trigger." The instant we perceive it, we automatically invest it with meaning, without stopping to ponder its shape. Klee wanted his signs to impinge upon our awareness as visual facts, yet also to share the quality of "triggers."

Expressionism between the Wars

Käthe Kollwitz The experience of World War I filled German artists with a deep anguish at the state of modern civilization, which found its principal outlet in Expressionism. The work of Käthe Kollwitz (1867–1945) consists almost exclusively of prints and drawings that parallel those of Kokoschka, whose work she admired. Her graphics had their sources in the nineteenth century. Munch was an early inspiration, as was her friend Ernst Barlach. Yet Kollwitz pursued a resolutely independent course, devoting her art to themes of inhumanity and injustice. To articulate her social and ethical concerns, she adopted an intensely expressive, naturalistic style that is as unrelenting in its bleakness as her choice of subjects. Gaunt mothers and exploited workers provided much of Kollwitz's thematic focus, but her most eloquent statements were

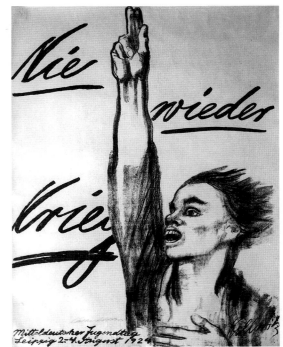

472. Käthe Kollwitz. *Never Again War!* 1924. Lithograph, 37 x 27 1/2" (94 x 70 cm). Courtesy Gallerie St. Étienne, New York

reserved for war. World War I, which cost her oldest son his life, made her an ardent pacifist. Her 1924 lithograph *Never Again War!* (fig. 472) is an unforgettable image of protest.

George Grosz George Grosz (1893–1959), a painter and graphic artist who had studied in Paris in 1913, joined the Dada movement in Berlin after the end of the war. Inspired by the Futurists, he developed a dynamic form of Cubism for his bitter and often savage satires, which expressed the disillusionment of his generation. In *Germany, a Winter's Tale* (fig. 473), the city of Berlin forms the kaleidoscopic and chaotic background for several large figures, which are superimposed on it as in a collage: the marionette-like "good citizen" at his table and the sinister forces that have molded him: a hypocritical cleric, a general, and a schoolteacher.

Max Beckmann Max Beckmann (1884–1950), a robust descendant of the Brücke artists, did not become an Expressionist until after he had lived through World War I, which filled him with such despair at the state of modern civilization

Theater between the Wars

Under the Weimar Republic (1919–33), Germany was the most vibrant center of theater in all of Europe. German Expressionism in art had its counterpart in EXPRESSIONIST DRAMA, which sought to compress as much emotion as possible into a play, eliminating anything not needed to convey the central message of the piece. The most important Expressionist drama was *Man and the Masses* (1921) by Ernst Toller (1893–1939), a play that exemplifies the pessimism that was to lead to the decline of Expressionism a few years later. In its place rose EPIC THEATER, a deliberately episodic style of drama that, in contrast to Expressionism, encouraged psychological distance in the viewer through such devices as divided stages and the use of film clips, as well as having characters speak to the audience directly, thus breaking the traditional theatrical illusion that the audience is watching actual events as they are taking place.

The main exponent of epic theater was Bertolt Brecht (1898–1956), whose *Three Penny Opera* (1928), with cabaret-style music by Kurt Weill (1900–50), is even more cynical than the original opera by John Gay on which it is based. Brecht's best play, however, is *Mother Courage and Her Children* (1938–39), the story of the destruction of a family during the Thirty Years' War; it sought to provoke viewers to think about its meaning by setting contemporary events in the past and presenting them as a series of disjointed episodes, with strange stage effects that seem to be a commentary on the action.

The 1920s were also a time of technical innovation. Walter Gropius, the long-time director of the Bauhaus school (pages 574–75), designed a stage that could be reconfigured in numerous ways so as to place the audience in the center of the action, while Oskar Schlemmer (1888–1943), head of the school's theater workshop, designed abstract costumes that treated actors as architectural units to be placed at will within the stage space by rigorously controlling their every movement.

In France, the major contribution was Surrealist theater. In addition to Jarry's *Ubu roi* (see box on page 487), *The Breasts of Tiresias* (1903–17) by Guillaume Apollinaire (1880–1918) was the early prototype of Surrealist drama, mingling popular theater with music and dance in an illogical free form. The poet Jean Cocteau (1892–1963) used many of these devices in *Parade* (1917), a ballet presented by Diaghilev's Ballets Russes, with costumes by Picasso and music by Eric Satie—one of the great collaborations of this century.

Although the Surrealists mounted numerous ABSURDIST events in the 1920s and 1930s, perhaps the most interesting drama influenced by the Surrealists was *No Exit* (1944), written during World War II by the philosopher Jean-Paul Sartre (1905–80). *No Exit* is a play of interpersonal relations in which a man and two women vainly pursue each other as they seek self-validation in other people's eyes. This was Sartre's attempt to "explore the state of man in its entirety, and to present to modern man a portrait of himself through his choices and actions."

Other approaches were developed as well. The playwright Antonin Artaud (1896–1948), whose *The Theater of Cruelty* (1935) rejected language as impotent and mounted a concerted assault on all the senses, attempted to drain the "abscesses" of civilization by "providing the spectator with the true sources of his dreams, in which his taste for crime, his erotic obsessions, his savagery. . . would surge forth." In Italy the psychological dramatist Luigi Pirandello (1867–1936) wrote *Six Characters in Search of an Author* (1921), a play that mixes fantasy and reality so completely that truth becomes subjective and unknowable, varying according to the perspective of each character.

Russia after the Revolution was a hotbed of theatrical experimentation. The director Vsevolod Meyerhold (see box on page 515) now emphasized BIOMECHANICS (machine-like movement as a means of expression), and his sets, designed by the Constructivists, are the most boldly imaginative the world has ever seen. Meyerhold also collaborated with the poet Vladimir Mayakovsky (1894–1930), a true literary genius produced by the Communist Revolution. Despite Mayakovsky's wholehearted belief in the Revolution, his later plays were satires of Soviet bureaucracy; they were badly received, and Mayakovsky committed suicide.

Theater thrived in England after World War I. Not since the Elizabethan era were there so many great directors and actors, or so many major theaters. English playwriting of the time is remembered now chiefly for comedies by the novelist W. Somerset Maugham (1874–1965) and Noël Coward (1899–1973), but there was considerable dramatic writing by serious authors as well. A notable example is *I Have Been Here Before* (1937) by the novelist J. B. Priestley (1894–1984), which deals with the effect of previous incarnations on the present. The poet W. H. Auden (1907–73) and the novelist Christopher Isherwood (1904–86) collaborated on several plays in expressionistic verse, including *The Dog Beneath the Skin* (1935), which was presented at the Group Theatre. The American-born poet T. S. Eliot (1888–1965), a founder of the Group Theatre, wrote *Sweeney Agonistes* (1932), an "Aristophanic melodrama," and *Murder in the Cathedral* (1935), about the murder of the medieval archbishop of Canterbury, Thomas à Becket. Both plays were attempts to restore verse to theater using popular forms and music-hall techniques. In Ireland, the early dramas written for the Abbey Theatre in the mid-1920s by Sean O'Casey (1884–1964), dealt with the impact of the Irish Easter Rebellion on people's lives, although O'Casey's style later veered toward Expressionism in the pacifist play *The Silver Tassie* (1928).

In the United States, new theatrical groups sprang up everywhere, many of them later subsidized during the Depression by the government under the Federal Theater Project. The Group Theater, begun in 1931 by Lee Strasberg (1901–82) and others along the lines of the Moscow Art Theater, included such stars as Stella Adler (1904–92) and Elia Kazan (b. 1909). For the first time in its history, America had writers who were the equal of Europeans, and many Americans wrote for the stage. The finest was unquestionably Eugene O'Neill (1888–1953), whose powerful dramas *Desire under the Elms* (1925), *Mourning Becomes Electra* (1931) and *The Iceman Cometh* (1940–46) remain the great American classics of the era. Their only rivals are the plays written by Clifford Odets (1906–63) in 1935 for the Group Theater—*Waiting for Lefty, Awake and Sing!* and *Paradise Lost*—all scripted in intense, graphic language. Odets's most popular work remains *Golden Boy* (1937), about a young violinist who becomes a boxer to earn money—a thinly veiled reference to his own decision to move to Hollywood. The 1930s was also a golden age of Hollywood films.

473. George Grosz. *Germany, a Winter's Tale*. 1918. Oil on canvas, 7'5/8" x 4'4" (215 x 132 cm). Formerly Collection Garvens, Hanover, Germany

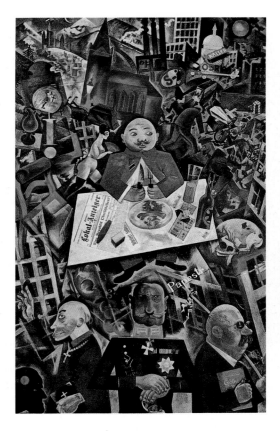

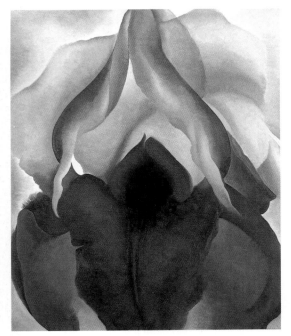

475. Georgia O'Keeffe. *Black Iris III*. 1926. Oil on canvas, 36 x 29 7/8" (91.4 x 75.9 cm). The Metropolitan Museum of Art, New York

The Alfred Stieglitz Collection, 1949

474. Max Beckmann. *Departure*. 1932–33. Oil on canvas triptych, center panel 7'3/4" x 3'9 3/8" (2.15 x 1.15 m), side panels each 7'3/4" x 3'3 1/4" (2.15 x 1 m). The Museum of Modern Art, New York

Given anonymously by exchange

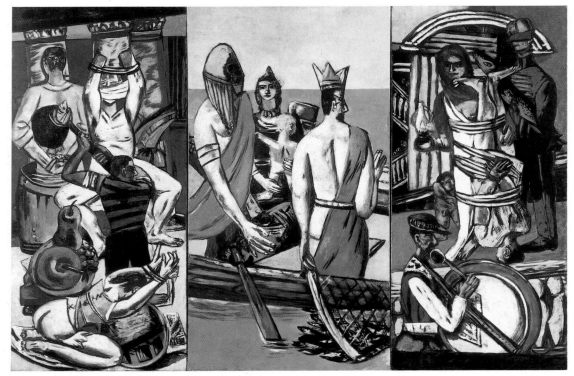

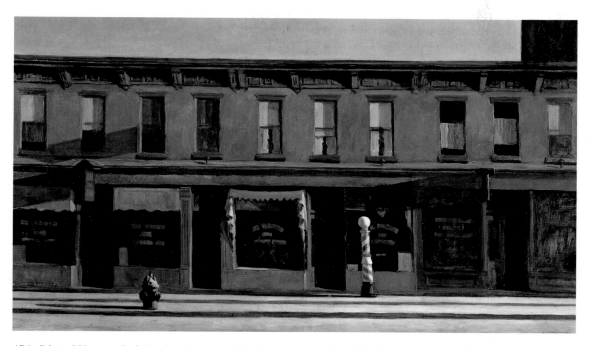

476. Edward Hopper. *Early Sunday Morning*. 1930. Oil on canvas, 35 x 60" (88.9 x 152.4 cm). Whitney Museum of American Art, New York

that he took up painting to "reproach God for his errors." In his **triptych** *Departure* (fig. 474), the two wings show a nightmarish world crammed with puppetlike figures, as disquieting as those in Bosch's version of hell (see fig. 203). The right panel incorporates a blind man holding the fish, a lantern, and a mad musician. The left shows a scene of almost unimaginable torture. What are we to make of these brutal images? We know from letters written by the artist and a close friend that they represent life itself as endless misery filled with all manner of physical and spiritual pain. The woman trying to make her way in the dark with the aid of the lamp is carrying the corpse of her memories, evil deeds, and failures, from which no one can ever be free so long as life beats its drum. The center panel signifies the departure from life's illusions to the reality behind appearances. The crowned figure seen from behind perhaps represents the mythical Fisher King from the legend of the Holy Grail, whose health and that of his land are restored by the virtuous knight Parsifal. In the hindsight of today, *Departure* has acquired the force of prophecy. It was completed when,

under Nazi pressure, the artist was on the verge of leaving his homeland. The topsy-turvy quality of the two wing scenes, full of mutilations and meaningless rituals, well captures the flavor of Hitler's Germany. The stable design of the center panel, in contrast, with its expanse of blue sea and its sunlit brightness, conveys the hopeful spirit of an embarkation for distant shores. After spending World War II in occupied Holland, Beckmann lived the final three years of his life in the United States.

Realism between the Wars

Georgia O'Keeffe After 1920 in the United States, most of the original members of the Stieglitz group concentrated on landscapes, which they treated in representational styles derived loosely from Expressionism. The naturalism that characterized American art as a whole during the 1920s found its most important representative in Georgia O'Keeffe (1887–1986). Throughout her long career, she covered a wide range of subjects and styles. O'Keeffe practiced a form of organic abstraction indebted to Expressionism;

Music between the Wars

The most important composer to emerge between the world wars was Bela Bartok (1881–1945). In 1905, Bartok met the composer Zoltan Kodaly (1882–1967), and together they began to collect the folk music of Hungary. Bartok from then on based his work on ethnic melodies, and he also incorporated Stravinsky's complex rhythms and percussive treatments and Schoenberg's dissonances and atonality. Bartok's music is intensely personal; his searing emotionalism is apparent in the opera *Bluebeard's Castle* (1918), the ballet *The Mandarin Prince* (1926), and especially his six string quartets (1908–39). Bartok was also a famous piano virtuoso, writing a number of concertos for that instrument. His lyrical final piano concerto and his *Concerto for Orchestra* (1943) are deliberately more melodic than his earlier work, appealing to a wide audience.

Sergei Prokofiev (1891–1953), another piano virtuoso, began his career as an avant-garde composer in Russia after the Revolution of 1917, with two very dissonant piano concertos. Nevertheless, the heart of his music remained melody. When he returned to Russia in 1936, he composed his ballet *Romeo and Juliet* and an orchestral piece with narration for children, *Peter and the Wolf*. Although Prokofiev tried to meet the demands of Soviet authorities for propaganda music, he suffered terrible privation and repression, as did his younger contemporary Dmitri Shostakovich (1906–75). Ironically enough, no one today listens to the composers who were approved by Russian officials.

The United States produced two important composers during the first years of the twentieth century: Charles Ives (1874–1954) and Henry Cowell (1897–1965). Ives received a conventional music education at Yale University, but even before he attended the school, he had begun to experiment with effects that were to become the hallmarks of his music. They reach their height in *Symphony No. 4* (1916), which employs several themes played simultaneously in different keys by different groups under separate conductors that create a clashing, kaleidoscopic effect, and in the *Concord Sonata* for piano (1920), for which the performer uses elbows and wood blocks to play the notes. Ives was nevertheless a gifted melodist. His *Three Places in New England* (1914) is a self-consciously American piece in its choice of themes and its alternately festive and haunting atmosphere. Henry Cowell, like Ives, was a pioneer in experimental music for the piano. He wrote several pieces for "prepared piano," an instrument made ready for performance by having objects attached to or placed on its strings, some of which might also be tuned unconventionally. Cowell was also the first American composer to show a consistent interest in the music of other cultures, which he successfully incorporated into his numerous symphonies.

Aaron Copland (1900–90), who studied in Paris during the early 1920s, was influenced greatly by the music of Stravinsky. (When he returned to the United States, he adopted the themes and rhythms of jazz.) Copland sought to create music that would speak to all Americans, not simply those of one region. As a result of his self-conscious nationalism, Copland more than any composer defined the concept of "American" music across a wide spectrum, including Latin, Appalachian, Western, and Midwestern strains. His three ballets—*Billy the Kid* (1938), *Rodeo* (1942), and *Appalachian Spring* (1944)—are his most popular works, for they bring together touching lyricism with rhythmic vivacity in an almost irresistible combination. Copland's work also includes a number of atonal pieces in the manner of Stravinsky that are more appreciated by other composers than the public.

England also had an important school of composers before 1945, starting with the Victorian Romantic Edward Elgar (1857–1934). Elgar's cantata *A Dream of Gerontius* (1900), based on a poem about a soul's journey to heaven by the theologian John Henry Newman, conveys the idealism that was to characterize the English school well into the twentieth century. Perhaps the finest English composer was Ralph Vaughan Williams (1872–1958). His best works, such as the *Serenade to Music* (1938), set to a text from Shakespeare's *Othello*, exemplify the lyricism of late English Romantic music.

she also adopted the Precisionism of Charles Demuth (see page 521), so that she is sometimes considered an abstract artist. Her work often combines aspects of both approaches. As she assimilated a subject into her imagination, she would alter and simplify it to convey a personal meaning. Nevertheless, O'Keeffe remained a realist at heart. *Black Iris III* (fig. 475) is the kind of painting for which she is best known. The image is marked by a strong sense of decorative design uniquely her own. The flower, however, is deceptive in its treatment. Observed close up and magnified to large scale, it is transformed into a thinly disguised symbol of female sexuality.

American Scene Painting The 1930s witnessed an even stronger artistic conservatism than the previous decade's, in reaction to the economic depression and social turmoil that gripped both Europe and the United States. The dominance of realism signaled the retreat of modernist movements everywhere. In Germany, where realism was known as the New Objectivity, it was linked to the reassertion of traditional values. In the United States, there was renewed interest in painting the American scene, with artists split into two camps: the Regionalists and the Social Realists. The Regionalists sought to revive idealism by updating the American myth, defined, however, largely in

midwestern terms. In their pictures, the Social Realists captured the dislocation and despair of the Great Depression era and were often concerned with social reform. Both movements, although bitterly opposed, drew freely on the Ashcan School.

Edward Hopper The one artist who appealed to all factions, including that of the few remaining modernists, was a former pupil of Robert Henri, Edward Hopper (1882–1967). He focused on what has since become known as the "vernacular architecture" of American cities—storefronts, movie houses, all-night diners—which no one else had thought worthy of an artist's attention. *Early Sunday Morning* (fig. 476) distills a haunting sense of loneliness from the all-too-familiar elements of an ordinary street. Its quietness, we realize, is temporary. There is hidden life behind these facades. We almost expect to see one of the window shades raised as we look at them. Apart from its poetic appeal, the picture also shows an impressive formal discipline. We note the strategy in placing the fireplug and barber pole, the subtle variations in the treatment of the row of windows, the precisely calculated slant of sunlight, the delicate balance of verticals and horizontals. Obviously, Hopper was not unaware of Mondrian.

Painting since World War II

Abstract Expressionism: Action Painting

The world, having survived the most serious economic calamity and the greatest threat to civilization in all of history, now faced a potentially even greater danger: nuclear holocaust. This central fact conditioned the entire Cold War era, which has only recently come to an end. Ironically, it was also a period of unprecedented prosperity in much of the West, but not in the rest of the world, which, with the notable exception of Japan, struggled to compete successfully.

The painting that prevailed for about fifteen years following the end of World War II

arose in direct response to the anxiety brought on by these historical circumstances. The term *Abstract Expressionism* is often applied to this style, which was initiated by artists living in New York City and includes Action painting and Color Field painting, discussed in this chapter. Under the influence of existentialist philosophy, Action painters, the first of the Abstract Expressionists, developed from Surrealism a new approach to art. Painting became a counterpart to life itself, an ongoing process in which artists face comparable risks and overcome the dilemmas confronting them through a series of conscious and unconscious decisions in response to both inner and external demands. The Color Field painters in turn coalesced the frenetic gestures and violent hues of the Action painters into broad forms of poetic color that partly reflect the spirituality of Eastern mysticism. In a sense, Color Field painting resolved the conflicts expressed by Action painting. The two are, however, different sides of the same coin, separated by the thinnest differences of approach.

Arshile Gorky Arshile Gorky (1904–48), an Armenian who came to the United States at age sixteen, was the pioneer of the Abstract Expressionist movement and the single most important influence on its other members. After twenty years of experimentation, first with the manner of Cézanne, then in the vein of Picasso, Gorky arrived at his mature style, superbly exemplified by *The Liver Is the Cock's Comb* (fig. 477, page 532), his greatest work. The enigmatic title suggests Gorky's close contact with the poet André Breton and other Surrealists who found refuge in New York during the war. Distraught by the war's carnage, which threatened the very existence of Western civilization, the early Abstract Expressionists were mythmakers who sought to evoke archetypal images that expressed their sense of impending disaster. Gorky developed a personal mythology that underlies his work; each form represents a private symbol within this hermetic realm. Everything here is in the process of turning into something else. The treatment reflects his own experience in camouflage, gained from a

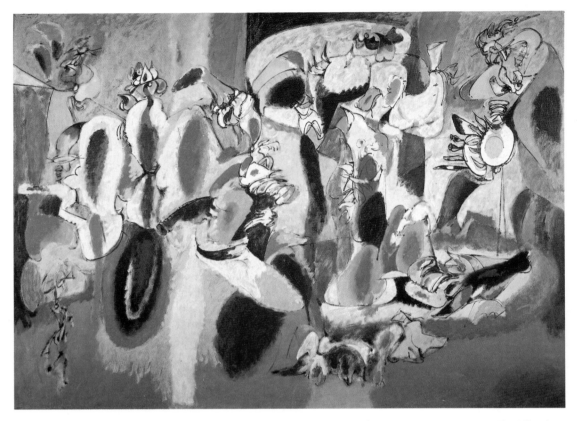

477. Arshile Gorky. *The Liver Is the Cock's Comb.* 1944. Oil on canvas, 6'1¼" x 8'2" (1.86 x 2.49 m). The Albright-Knox Art Gallery, Buffalo, New York
Gift of Seymour H. Knox, 1956

class he had conducted earlier. The biomorphic shapes clearly owe much to Miró, while their spontaneous handling and the glowing color reflect Gorky's enthusiasm for Kandinsky (see figs. 470, 450). Yet the dynamic interlocking of the forms and their aggressive power of attraction and repulsion are uniquely his own.

Jackson Pollock The most important of the Action painters proved to be Jackson Pollock (1912–56). His huge canvas entitled *Autumnal Rhythm: Number 30, 1950* (fig. 478) was executed mainly by pouring and spattering the colors, instead of applying them with a brush. The result, especially when viewed at close range, suggests both Kandinsky and Max Ernst (compare figs. 450, 469). Kandinsky's nonrepresentational Expressionism and the Surrealists' exploitation of chance effects are indeed

the main sources of Pollock's work, but they do not sufficiently account for his revolutionary technique and the emotional appeal of his art. Why did Pollock "fling a pot of paint in the public's face," as Ruskin had accused Whistler of doing? It was surely not to be more abstract than his predecessors, for the strict control implied by abstraction is exactly what Pollock relinquished when he began to dribble and spatter. Rather, he came to regard paint itself not as a passive substance to be manipulated at will but as a storehouse of pent-up forces for him to release.

The actual shapes visible in our illustration are largely determined by the internal dynamics of his material and his process: the viscosity of the paint, the speed and direction of its impact upon the canvas, its interaction with other layers of pigment. The result is a surface

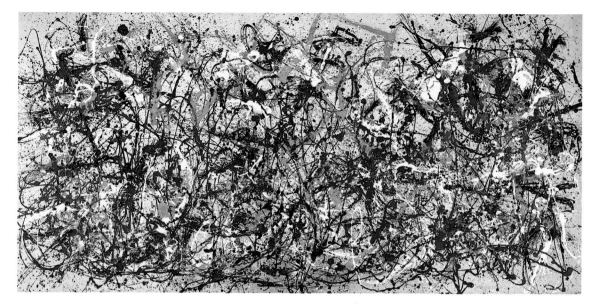

478. Jackson Pollock. *Autumnal Rhythm: Number 30, 1950*. 1950. Oil on canvas, 8'8" x 17'3" (2.64 x 5.26 m). The Metropolitan Museum of Art, New York

George A. Hearn Fund, 1957

479. Lee Krasner. *Celebration*. 1959–60. Oil on canvas, 7'8¹/4" x 16'4¹/2" (2.34 x 4.99 m). Private collection

Courtesy Robert Miller Gallery, New York

so alive, so sensuously rich, that all earlier painting looks static in comparison. When he "aims" the paint at the canvas instead of "carrying" it on the tip of his brush—or, if you will, releases the forces within the paint by giving it a momentum of its own—Pollock does not simply "let go" and leave the rest to chance. He is himself the ultimate source of energy for these forces, and he "rides" them as a cowboy might ride a wild horse, in a frenzy of psychophysical action. He does not always stay in the saddle; yet the strenuous exhilaration of

this contest is well worth the risk. The main difference between Pollock and his predecessors is his total—physical as well as personal—commitment to the act of painting. Thus, he preferred to work on huge canvases that provided a "field of combat" large enough for him to paint not merely with his arms, but with the motion of his whole body.

The term *Action painting* conveys the essence of this approach far better than does *Abstract Expressionism*. Although Pollock relinquished some control of his medium, this loss was more than offset by a gain—the new continuity and expansiveness of the creative process that gave his work its distinctive mid-twentieth-century stamp. Pollock's drip technique, however, was not in itself essential to Action painting, and he stopped using it in 1953.

Lee Krasner Lee Krasner (1908–84), who was married to Pollock, never abandoned the brush. She struggled to establish her artistic identity and emerged from Pollock's long shadow of fame after undergoing several changes in direction and destroying much of her early work. After Pollock's death, she succeeded in doing what he had been attempting to do for the last three years of his life: she reintroduced the figure into Abstract Expressionism while retaining its automatic handwriting, derived from Surrealism (see page 523). The potential had always been there in Pollock's work: in *Autumnal Rhythm*, we can easily imagine that we see wildly dancing people. In *Celebration* (fig. 479), Krasner defines these nascent shapes from within the tangled network of lines by using the broad gestures of Action painting to suggest human forms without actually depicting them.

Willem de Kooning The work of Willem de Kooning (b. 1904), another prominent member of the Abstract Expressionist group and a close friend of Gorky, always retains a link with the world of images, whether or not it has a recognizable subject. In some paintings, such as *Woman II* (fig. 480, page 536), the image emerges from the jagged welter of brushstrokes. De Kooning has in common with Pollock the furious energy of the process of painting, the sense of risk, of a challenge successfully—but barely—met. What are we to make of his wildly distorted *Woman II*? It is as if the flow of psychic impulses in the process of painting has unleashed this nightmarish specter from deep within the artist's subconscious. For that reason, he has sometimes been accused of being a woman hater, a charge he denies. Rather, de Kooning's woman is like a primordial goddess, cruel yet seductive, who represents the dark side of our makeup. At the same time, she is intended as a humorous caricature of modern movie stars such as Marilyn Monroe. He shared with Max Beckmann an Old World horror of empty space, which to him signified the existential void. Ironically, only after he moved to Long Island from New York City was he able to overcome this deep-seated anxiety.

Expressionism in Europe since World War II

Action painting marked the international coming of age for American art. The movement had a powerful impact on European art, which in those years had nothing to show of comparable force and conviction. One French artist, however, was of such prodigal originality as to constitute a movement all by himself: Jean Dubuffet, whose first exhibition soon after the end of World War II electrified and antagonized the art world of Paris.

Jean Dubuffet As a young man, Jean Dubuffet (1901–85) had formal instruction in painting, but he responded to none of the various trends he saw around him nor to the art of the museums. All struck him as divorced from real life, and he turned to other pursuits. Only in middle age did he experience the breakthrough that permitted him to discover his creative gifts. Dubuffet suddenly realized that for him true art had to come from outside the ideas and traditions of the artistic elite, and he found inspiration in the art of children and the insane. The distinction between "normal" and "abnormal" struck him as no more tenable than established notions of "beauty" and "ugliness."

Theater since World War II

The end of World War II brought an explosion of theater throughout Europe and the United States. In Europe especially, government subsidies restored national theaters and established new ones. Most new dramas in France initially were by established writers such as Jean Anouilh (1910–87), whose work centers on the dilemma of maintaining youthful integrity in an adult world based on compromise. But the essential contribution of postwar France was the THEATER OF THE ABSURD, which was not an organized movement and was only given that name by a critic in 1961. The term derives from the essay "The Myth of Sisyphus" written in 1943 by existential philosopher Albert Camus (1913–60), who considered the universe so irrational that the search for meaning was as "absurd" as the futile task of the mythological king Sisyphus, who was condemned in Hades to push the same boulder up a hill forever. Camus's outlook was closely related to the EXISTENTIALISM of Jean-Paul Sartre, which held that truth in any absolute sense is unknowable and that meaning must be self-created by each individual. This attitude was strongly conditioned by the horrors of the war and the anxiety of the ensuing Cold War, with its omnipresent threat of nuclear holocaust. In fact, *End Game* (1957) by Samuel Beckett (1906–89), the greatest of the absurdists, takes place at the end of the world, using the metaphor of chess to represent the human condition as four characters alternately torment and console each other in their incomprehensible predicament, over which they have no control. Although he was Irish, Beckett spent much of his career in Paris, and *End Game* was originally written in French. Paris was also home to the Romanian-born Eugène Ionesco (1912–94), whose early one-act dramas, such as *The Bald Soprano* (1949) which was inspired by an English phrase-book, were "anti-plays" using the conventions of language to convey irrational, anguished states of mind. His later works, notably *Rhinoceros* (1960), are more conventional in form and character delineation, but they are no less hallucinatory in their effect. Of all the absurdists, the most disturbing was Jean Genet (1910–86). His masterpiece, *The Balcony* (1956), like many of his plays, deals with outcasts—Genet himself was a homosexual and a criminal—caught in a web of destructive relationships, but nevertheless reveals his compassionate, if pessimistic, view of humanity.

England rebuilt its fabled theater system, including the Old Vic and the Stratford Festival Company, and reestablished the important festivals. Experimental theater, however, came only in the mid-1950s, when the English Stage Company, under George Devine (1910–66), was established and produced two epoch-making plays by John Osborne (1929–94): *Look Back in Anger* (1956), an attack on the inherited class system and its injustices, and *The Entertainer* (1957), starring Laurence Olivier as the fading music-hall actor Archie Rice, who symbolizes the decline of England. At about the same time, the Theatre Workshop began to reach its height under the director Joan Littlewood (b. 1914), who wanted to create a working-class theatre. She featured the work of two playwrights, the Irish poet and novelist Brendan Behan (1923–64) with her production of *The Quare Fellow* (actually written in 1945) about the impending execution of an Irish Republican Army sympathizer; and Shelagh Delaney (b. 1939), whose *A Taste of Honey* (1958), about a teenaged mother who rears her child with the help of a gay man. Under Peter Hall (b. 1930) and Peter Brook (b. 1925), the most experimental of all English directors, the newly chartered Royal Shakespeare Company became the leading venue for avant-garde theater in the 1960s. By far the most significant English playwright of the post-war era has been Harold Pinter (b. 1930), whose enigmatic "comedies of menace," such as *The Caretaker* (1960), have much in common with Beckett's dramas but are filled with a sense of mystery and fear that makes them psychologically gripping.

Although the United States government gave little support to theater after the war, experimental theater thrived in off-Broadway theaters and in a number of new regional companies. The most prominent organization was the Actors Studio, which was cofounded in 1947 by the director Elia Kazan, although drama teacher Lee Strasberg soon became its key figure. It was the first theater to promote the "method" acting of Stanislavski (see box on page 515), which dominated the American stage into the 1960s. More important, it staged the first classics of American post-war drama: *A Streetcar Named Desire* (1947) by Tennessee Williams (1911–83), and *Death of a Salesman* (1949) by Arthur Miller (b. 1916). The former, featuring the actor Marlon Brando in his first important role as the brutish Stanley Kowalski, is an unforgettable play about sex, madness, and violence in the South, while the latter, which focuses on the American dream of success, was written as a classical tragedy about the common man. As in the other arts, the period since 1945 has witnessed the high tide of writing for the American stage. The most important playwright of the 1960s was Edward Albee (b. 1928), who began as an absurdist, then turned to dramas *(Who's Afraid of Virginia Woolf,* 1962) about how people deal psychologically with inner and external reality, before finally becoming an iconoclast whose meanings are ambiguous *(The Marriage Play,* 1987). In 1964, Sam Shepard (b. 1943) won an Obie award for his first play, *Cowboy,* centering on his favorite theme, the American West, which is treated in archetypal fashion.

The late 1960s and early 1970s was a time of turmoil everywhere. In addition to student riots in France and the United States in 1968, there were protests against the Vietnam War, which found an outlet in such plays as *America Hurrah!* (1967) by Jean-Claude van Itallie (b. 1936) and *Sticks and Bones* (1971) by David Rabe (b. 1940).

Theater since 1965 has increasingly reflected the rich diversity of American life. Feminists, African Americans, Asian Americans, Hispanic Americans, Native Americans, gays and lesbians, the visually and hearing impaired: all have found their voice in contemporary theater. This inclusiveness does more than address perceived injustices; it is part of the larger trend toward multiculturalism that has stimulated interest in theater outside the West, particularly in Africa, South America, and Asia, each of which has a vibrant tradition of its own. In the 1980s and 1990s this cosmopolitan outlook came under siege. The political backlash has threatened to do away with the national endowments for the arts and humanities, as well as public radio and television, which would once again leave the United States as the only major country in the world without significant government funding for culture. No less serious are the economic difficulties confronting cultural organizations, many of which have traded artistic leadership for popular efforts to attract a wider audience and greater funding.

480. Willem de Kooning. *Woman II.* 1952. Oil on canvas, 59 x 43" (149.9 x 109.2 cm). The Museum of Modern Art, New York

Gift of Mrs. John D. Rockefeller 3rd

481. Jean Dubuffet. *Le Métafisyx*, from the *Corps de Dames* series. 1950. 45 3/4 x 35 1/4" (116.2 x 89.5 cm). Private collection

Perhaps not since Marcel Duchamp (see pages 517–18) had anyone ventured so radical a critique of the nature of art.

Dubuffet made himself the champion of what he called *l'art brut* ("art in the raw"), but he created something of a paradox besides. While extolling the directness and spontaneity of the amateur as against the refinement of professional artists, he became a professional artist himself. Whereas Duchamp's questioning of established values had led him to cease artistic activity altogether, Dubuffet became incredibly prolific, second only to Picasso in output. Compared with Paul Klee, who had first imitated the style of children's drawings (see pages 524–26), Dubuffet's art is "raw" indeed. Its stark immediacy, its explosive, defiant presence, are the opposite of Klee's formal discipline and economy of means. Did Dubuffet perhaps fall into a trap of his own making? If his work merely imitated the *art brut* of children and the insane, would not these self-chosen conventions limit him as much as those of the artistic elite?

We may be tempted to think so at our first sight of *Le Métafisyx* (fig. 481) from his *Corps de Dame* series—even de Kooning's wildly distorted *Woman II* seems gentle when matched against this shocking assault on our cultural sensibilities. The paint is as heavy and opaque as a rough coating of plaster, and the lines articulating the blocklike body are scratched into the surface like graffiti made by an untrained hand. Appearances are deceiving, however. The fury and concentration of Dubuffet's attack should convince us that his demonic female is not "something any child can do." In an eloquent statement, the artist has explained the purpose of images such as this: "The female body . . . has long . . . been associated with a very specious notion of beauty which I find miserable and most depressing. Surely I am for beauty, but not that one. . . . I intend to sweep away everything we have been taught to consider—without question—as grace and beauty [and to] substitute another and vaster beauty, touching all objects and beings, not excluding the most despised."

Francis Bacon The English artist Francis Bacon (1909–92) was allied not with Abstract Expres-

sionism, though he was clearly related to it, but with the Expressionist tradition. For his power to transmute sheer anguish into visual form he had no equal among twentieth-century artists unless it be Rouault. Bacon often derived his imagery from other artists, freely combining several sources while transforming them so as to infuse them with new meaning. *Head Surrounded by Sides of Beef* (fig. 482) reflects Bacon's obsession with Velázquez's portrait of pope Innocent X, a picture that haunted him for some years. It is no longer the pope we see here but a screaming ghost, inspired by the scene on the Odessa steps in Sergei Eisenstein's film *The Battleship Potemkin*, that is materializing out of a black void in the company of two luminescent sides of beef taken from a painting by Rembrandt. Knowing the origin of the canvas does not help us to understand it, however. Nor does comparison with earlier works such as Grünewald's *The Crucifixion*, Fuseli's *The Nightmare*, or Munch's *The Scream* (see figs. 268, 370, and 429), which are its antecedents. Bacon was a gambler, a taker of risks, in real life as well as in the way he worked. What he sought were images that, in his words, "unlock the deeper possibilities of sensation." Here he competes with Velázquez, but on his own terms, which are to set up an almost unbearable tension between the shocking violence of his vision and the luminous beauty of his brushwork.

Abstract Expressionism: Color Field Painting

By the late 1940s, a number of artists began to transform Action painting into the style called Color Field painting, in which the canvas is often stained (rather than painted) with thin, translucent color washes. These may be oil or even ink, but the favored material quickly became acrylic, a plastic suspended in a polymer resin, which can be thinned with water so that it flows freely.

Mark Rothko In the mid-1940s, Mark Rothko (1903–70) worked in a style derived from Gorky, but within less than a decade he subdued the aggressiveness of Action painting so completely

482. Francis Bacon. *Head Surrounded by Sides of Beef.* 1954. Oil on canvas, 50³/₄ x 48" (129 x 122 cm). The Art Institute of Chicago
Harriott A. Fox Fund

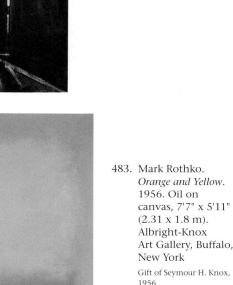

483. Mark Rothko. *Orange and Yellow.* 1956. Oil on canvas, 7'7" x 5'11" (2.31 x 1.8 m). Albright-Knox Art Gallery, Buffalo, New York
Gift of Seymour H. Knox, 1956

that his pictures breathe the purest contemplative stillness. *Orange and Yellow* (fig. 483) consists of two rectangles with blurred edges on a dark red ground. The lower rectangle seems immersed in the red ground, while the upper one stands out more assertively in front of the

Music since World War II

Music after 1945, like postwar art, has so vastly extended the experiments of the early-twentieth-century composers that its diversity can seem almost chaotic. Nevertheless, certain sounds, textures, intervals, and rhythms are so widely used that they have become virtual signatures of later twentieth-century music. Many composers have incorporated extremes of dissonance, extensive repetition of motifs, and even chance events into their works. Others have continued to look to world music for inspiration, have abandoned traditional notation, or have written for newly invented electronic instruments. While these innovations have widened the scope of contemporary music, they often, like Abstract Expressionist painting, place extreme demands on the audience, requiring that it abandon traditional standards to judge each work on its own terms.

The most important composer of the postwar era was the Frenchman Olivier Messiaen (1908–92). Despite his position as a leader of the avant-garde, his music often has a haunting beauty that makes it remarkably accessible. Messiaen was a devout Catholic whose music was primarily religious. Nowhere is his cosmic vision more apparent than in *Colors of the Heavenly City* (1963) for piano and ensemble, a kaleidoscopic yet ethereal evocation of the Apocalypse that makes use of exotic instruments and compositional modes from India and Asia to suggest a universal spirituality. His music radiates an enchantment with divine creation that led him to incorporate transcriptions of bird songs in the delightful *Exotic Birds* (1955–56). There is an intimate connection between these works: Messian associated the colors of his heavenly vision with the brilliant plumage of birds, whose songs in turn provided the thematic basis for his music. Messiaen had a decisive influence on his pupils Pierre Boulez (b. 1925) and Karlheinz Stockhausen (b. 1928).

The most intellectual composer writing today, Boulez is a master of serialism (see box on page 510). He has greatly extended Schoenberg's conception, rejecting the twelve-tone row for an ATHEMATIC (themeless) style that permits the incorporation of calculated ALEATORY (chance) effects and "concrete" (prerecorded) music. Stockhausen also experimented with "concrete" music early in his career but after the electronic synthesizer was invented in 1950, he began to compose for the new instrument. In the mid-1950s, he wrote compositions for multiple orchestras and choruses under different conductors, using a succession of musical moments instead of a traditional structure, an idea that he abandoned in the following decade for free-form performances in which the musicians improvised on brief texts.

The French-born American composer Edgar Varèse (1883–1965) was fascinated by sounds of all sorts. With the invention of the tape recorder in 1948 and the synthesizer soon thereafter, he found his medium. Electronics allowed him to create and mix sounds of every conceivable sort into a new kind of total sound experience. His *poème électronique (electronic poem)*, written for the Brussel's World's Fair of 1958, is considered the first masterpiece of American electronic music.

During World War II Europe's leading composers—Stravinsky, Bartok, and Schoenberg among them—came to the United States, where they exercised considerable influence. Thus, the most important American postwar composer, John Cage (1912–92), studied with such varied mentors as Cowell, Varèse, and Schoenberg. Cage nevertheless owed his unique approach to music primarily to his own wide range of interests, including printmaking, dance—he worked closely with the avant-garde choreographer Merce Cunningham (b. 1919)—and light shows. During the 1940s Cage, like Cowell, experimented with the "prepared" piano (see box on page 530); then in the 1950s he became interested in Zen Buddhism, which stimulated his fascination with aleatory events. "Chance" for Cage, however, must be understood not as total randomness but as improvisation within a defined context, for Cage considered music a kind of organized noise within the stream of life itself. He invented new notational systems which could record any sound as "music." For example, *Imaginary Landscape #4* (1951) features twelve radios tuned to different frequencies established by the score, though the final result was unpredictable because what each radio would play could not be predetermined. Such an approach comes very close to that of the Abstract Expressionists, particularly Jackson Pollock, who also relied on chance as part of his painting technique. Like Messiaen, Cage sought a spiritual experience in music; toward that end, silence—what is not there—is often just as important as the sounds themselves.

Roger Sessions (1896–1985), an early pioneer of modernism with Copland in the 1920s, continued to work in that vein until the end of his career. The symphonies and chamber music Sessions composed following his adoption of the twelve-tone system in 1953 established him as one of America's leading composers. His masterpiece is the cantata *When Lilacs Last in the Dooryard Bloom'd* (1970), a haunting evocation of verses by the poet Walt Whitman (1819–92), dedicated to John F. Kennedy and Martin Luther King, Jr.

Samuel Barber (1910–81) is the best known of a group of twentieth-century Romantic composers whose work emphasizes melody. Although Barber felt the influence of Stravinsky, his compositions for voice use dissonance discreetly to emphasize the text, to which he had a unique sensitivity. *Knoxville: Summer of 1915* (1947), set to a poem by James Agee, is surely the most purely beautiful vocal work by any American composer.

The main tendency to emerge in recent years has been dubbed Minimalism, which uses many of the same devices as the art movement of the same name. Identified most closely with Steve Reich (b. 1936), Philip Glass (b. 1937), and Laurie Anderson (b.1950), it relies on the repetition of simple motifs that are gradually varied over time to create a hypnotic, almost mystical effect, often inspired by Eastern religions.

red. The thin washes of paint permit the texture of the cloth to be seen through the very large canvas. This description hardly begins to touch the essence of the work or the reasons for its mysterious power to move us. These are to be found in the delicate equilibrium of the shapes, their strange interdependence, the subtle variations of hue. Not every beholder responds to the works of this withdrawn, introspective artist. For those who do, the experience is akin to a trancelike rapture.

Morris Louis Among the most gifted of the Color Field painters was Morris Louis (1912–62). The successive layers of color in *Blue Veil* (fig. 484, page 540) appear to have been "floated on" without visible marks of the brush. Their harmonious interaction creates a delicately shifting balance, like the aurora borealis, that gives the picture its mysterious beauty. How did Louis achieve this mesmerizing effect, so akin to late paintings by Monet (see fig. 402)? We do not know for certain, but he seems to have poured his gossamer-thin paints down the canvas, which he tilted and turned to give direction to their flow. Needless to say, it took a great deal of experimentation to arrive at the seemingly effortless perfection seen in our example.

Minimalism and Other Trends

Ellsworth Kelly Many artists who came to maturity in the 1950s turned away from Action painting altogether in favor of "hard-edge" painting. *Red Blue Green* (fig. 485, page 540) by Ellsworth Kelly (b. 1923), an early leader of this tendency, abandons Rothko's impressionistic softness. Instead, flat areas of color are circumscribed within carefully delineated (hard-edge) forms as part of a formal investigation of color and design problems.

This radical abstraction of form is known as Minimalism, a term which implies an equal reduction of content. Minimalism was a quest for basic elements representing the fundamental aesthetic values of art, without regard to issues of content. Minimalism was a necessary, even valuable, phase of modern art. At its most extreme, it reduced art not to an eternal essence but to an arid simplicity. In the hands of a few artists of genius like Kelly, however, it yielded works of unprecedented formal perfection.

Frank Stella The brilliant and precocious Frank Stella (b. 1936) began as an admirer of Mondrian's work, then soon evolved an even more self-contained nonfigurative style. Unlike Mondrian, Stella did not concern himself with the vertical-horizontal balance that relates the older artist's work to the world of nature. Logically enough, he also abandoned the traditional rectangular format, to make quite sure that his pictures bore no resemblance to windows. The shape of the canvas had now become an integral part of the design. In one of his largest works, the majestic *Empress of India* (fig. 486), this configuration is determined by the thrust and counterthrust of four huge chevrons, identical in size and form but sharply differentiated in color and in their relationship to the whole. The paint, moreover, contains powdered metal, which gives it an iridescent sheen. This is yet another way to stress the impersonal precision of the surfaces and to remove the work from any comparison with the "handmade" look of easel pictures. In fact, to speak of *Empress of India* as a picture seems decidedly awkward. It demands to be called an object, sufficient unto itself.

Romare Bearden Romare Bearden (1912–88), too, was affected by Abstract Expressionism but, dissatisfied with the approach, abandoned it in favor of a collage technique, although abstraction remained the underpinning of his art. He got his start in the 1930s, but not until the mid-1950s did he decided to devote his career entirely to art. Over the course of his long life, he pursued interests in mathematics, philosophy, and music that enriched his work. He emerged into his own during the mid-1960s, when he achieved widespread recognition for his photomontages, such as *The Prevalence of Ritual: Baptism* (fig. 487, page 541). Bearden's aim, as he put it, was to depict "the life of my [African American] people as I know it, passionately and dispassionately as Brueghel. My intention is to reveal through pictorial

484. Morris Louis. *Blue Veil.* 1958–59. Acrylic resin paint on canvas, 7'7 3/4" x 13' (2.3 x 4 m). Fogg Art Museum, Harvard University Art Museums, Cambridge, Massachusetts
Gift of Lois Orswell and Purchase from the Gifts for Special Uses Fund

485. Ellsworth Kelly. *Red Blue Green.* 1963. Oil on canvas, 7'8" x 11'4" (2.34 x 3.45 m). Museum of Contemporary Art, San Diego, La Jolla, California
Gift of Jack and Carolyn Farris

complexities the life I know." He had a full command of the resources of Western and African art. Our example is as intricate in its composition as Caravaggio's *The Calling of Saint Matthew* (fig. 284), but it is couched in the familiar forms of African masks. The picture admirably fulfills Bearden's goals and exercises an immediate and universal appeal to people of all races. Small wonder that he is revered as the first great black painter.

Op Art

A trend that gathered force in the mid-1950s was known as Op art because of its concern with optics, the physical and psychological process of vision. Op art has been devoted primarily to optical illusions. Needless to say, all representational art from the Old Stone Age onward has been involved with optical illusion in one sense or another. What is new about Op art is that it is rigorously nonrepresentational. It evolved partly from hard-edge abstraction, although its ancestry can be traced back still further to Mondrian. At the same time, it seeks to extend the realm of optical illusion in every possible way by taking advantage of the new materials and processes constantly supplied by science, including laser technology. Much Op art consists of constructions or "environments"

486. Frank Stella. *Empress of India*. 1965. Metallic powder in polymer emulsion paint on canvas, 6'5" x 18'8"
(1.96 x 5.69 m). The Museum of Modern Art, New York
Gift of S. I. Newhouse, Jr.

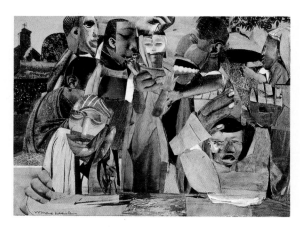

487. Romare Bearden. *The Prevalence of Ritual: Baptism*.
1964. Collage of photochemical reproduction,
synthetic polymer, and pencil on paperboard,
9$^1/8$ x 12" (23.2 x 30.5 cm). Hirshhorn Museum
and Sculpture Garden, Smithsonian Institution,
Washington, D. C.

Gift of Joseph H. Hirshhorn, 1966

488. Josef Albers. *Apparition,* from *Homage to the Square*
series. 1959. Oil on masonite, 47$^1/2$" (120.7 cm
square). Solomon R. Guggenheim Museum,
New York

(see page 566) that are dependent for their
effect on light and motion and cannot be
reproduced satisfactorily in a book.

Because of its reliance on science and tech-
nology, Op art's possibilities appear to be un-
limited. The movement nevertheless matured
within a decade of its inception and developed
little thereafter. The difficulty lies primarily with
its subject. Op art seems overly cerebral and sys-
tematic, more akin to the sciences than to the
humanities. And although its effects are unde-
niably fascinating, they encompass a relatively
narrow range of concerns that lie, for the most
part, outside the mainstream of modern art.
Only a handful of artists have enriched it with
the variety and expressiveness necessary to
make it a viable tradition.

Josef Albers Op art involves the beholder with
the work of art in a truly novel, dynamic way.

Josef Albers (1888–1976), who came to the United States after 1933, when Hitler closed the Bauhaus school at Dessau (see pages 574–76), became the founder of another, more austere kind of Op art. He preferred to work in series that allowed him to explore each theme fully before moving on to a new subject. Albers devoted the latter part of his career to color theory. *Homage to the Square* (fig. 488), his final series, is concerned with subtle color relations among simple geometric shapes, which he reduced to a few basic types. Within these confines, he was able to invent almost endless combinations based on rules he devised through ceaseless experimentation. Basically, Albers relied on color scales in which primary hues are desaturated in perceptually even gradations by giving them higher values (that is, by diluting them with white or gray). A step from one color scale can be substituted for the same step in another; these in turn can be combined by following the laws of color mixing, complementary colors, and so forth. This approach requires the utmost sensitivity to color, and even though the paint is taken directly from commercially available tubes, the colors bear a complex relation to each other. In our example, the artist creates a strong optical push-pull through the play of closely related colors of contrasting value. The exact spatial effect is determined not only by the hue and intensity of the pigments but by their sequence and the relative size of the squares.

Richard Anuszkiewicz Albers was an important teacher as well as theorist. His gifted pupil Richard Anuszkiewicz (b. 1930) developed his art by relaxing Albers's self-imposed restrictions. In *Entrance to Green* (fig. 489, page 544), the ever-decreasing series of rectangles creates a sense of infinite recession toward the center. This is counterbalanced by the color pattern, which brings the center close to us by the gradual shift from cool to warm tones as we move inward from the periphery. Surprising for such an avowedly theoretical work is its expressive intensity. The resonance of the colors within the strict geometry heightens the optical push-pull, producing an almost mystical power. The painting can be likened to a modern icon,

capable of providing a deeply moving experience to those attuned to its vision.

Pop Art

Other artists who made a name for themselves in the mid-1950s rediscovered what the public continued to take for granted despite all efforts to persuade it otherwise: that a picture is not "essentially a flat surface covered with colors," as Maurice Denis had insisted, but an image wanting to be recognized. If art was by its very nature representational, then the modernist movement, from Manet to Pollock, was based on a fallacy, no matter how impressive its achievements. Painting, it seemed, had been on a kind of voluntary starvation diet for the previous hundred years, feeding on itself rather than on the world around it. It seemed time for artists to give in to "image hunger"—a hunger from which the public at large had never suffered, since its demand for images had been abundantly supplied by photography, advertising, magazine illustrations, and comic strips.

Artists now seized on these products of commercial art catering to popular taste. Here, they realized, was an essential aspect of our century's visual environment that had been entirely disregarded as vulgar and antiaesthetic by the representatives of "highbrow" culture, a presence that cried out to be examined. Only Marcel Duchamp and some of the Dadaists, with their contempt for all orthodox opinion, had dared to penetrate this realm. It was they who now became the patron saints of Pop art, as the new movement came to be called.

Pop art actually began in London in the mid-1950s with the Independent Group of artists and intellectuals. They were fascinated by the impact on British life of the American mass media, which had been flooding England ever since the end of World War II. It is not surprising that the new art had a special appeal in the United States and that it reached its fullest development there during the following decade. In retrospect, Pop art in the United States was an expression of the optimistic spirit of the 1960s that began with the election of John F. Kennedy and ended at the height of the

Vietnam War. Unlike Dada, Pop art was not motivated by despair or disgust at contemporary civilization. It viewed commercial culture as its raw material, an endless source of pictorial subject matter, rather than as an evil to be attacked. Nor did Pop art share Dada's aggressive attitude toward the established values of modern art.

Jasper Johns Jasper Johns (b. 1930), who helped pave the way for Pop art in the United States, began by painting, meticulously and with great precision, such familiar objects as flags, targets, numerals, and maps. His *Three Flags* (fig. 490) presents an intriguing problem: just what is the difference between image and reality? We instantly recognize the Stars and Stripes, but if we try to define what we actually see here, we find that the answer eludes us. These flags behave "unnaturally." Instead of waving or flapping, they stand at attention, as it were, rigidly aligned in a kind of reverse perspective. There is movement of another sort as well: the reds, whites, and blues are not areas of solid color but are subtly modulated. Can we really say, then, that this is an image of three flags? Clearly, no such flags can exist anywhere except in the artist's head. The more we think about it, the more we recognize the picture as a feat of the imagination, which is probably the last thing we expected to do when we first looked at it.

Roy Lichtenstein Roy Lichtenstein (b. 1923) has seized on comic strips—or, more precisely, on the standardized imagery of the traditional strips devoted to violent action and sentimental love rather than those bearing the stamp of an individual creator. His paintings, such as *Drowning Girl* (fig. 491, page 545), resemble greatly enlarged copies of single frames, including the text balloons, the impersonal, simplified black outlines, and the dots used for printing colors on cheap paper.

Lichtenstein's pictures are perhaps the most paradoxical in the entire field of Pop art. (Unlike any other paintings past or present, they cannot be accurately reproduced in this book, for they then become almost indistinguishable from the comic strip on which they are based.) Enlarging a design meant for an area of about 6 square inches to one of no less than 4,514 square inches must have given rise to a host of formal problems that could be solved only by the most intense scrutiny: how, for example, to draw the girl's nose so it would look "right" in comic-strip terms, or how to space the colored dots so they would have the proper weight in relation to the outlines?

Clearly, our picture is not a mechanical copy but an interpretation that remains faithful to the spirit of the original only because of the countless changes and adjustments of detail that the artist has introduced. How is it possible for images of this sort to be so instantly recognizable? Why are they so "real" to millions of people? What fascinates Lichtenstein about comic strips, and what he makes us see for the first time, are the rigid conventions of their style, as firmly set and as remote from life as those of Byzantine art.

Andy Warhol Andy Warhol (1928–87) used the very qualities of comic strips in his ironic commentaries on modern society. A former commercial artist, he made the viewer consider the aesthetic qualities of such everyday images as soup cans, which we readily overlook. He did much the same thing with the subject of death, an obsession of his, in ▼SILK-SCREENED pictures of electric chairs and gruesome traffic accidents, which suggest that the mass media have reduced dying to a banality. Warhol had an uncanny understanding of how the media shape our view of people and events, creating their own reality and larger-than-life figures. He became an expert at manipulating the media to project a public persona that disguised his true character. These themes come together in his *Gold Marilyn Monroe* (fig. 492, page 545). Set against a gold background, like a Byzantine icon, she becomes a modern-day Madonna. (It is no coincidence that the 1980s pop singer Madonna deliberately cultivated a Marilyn look-alike image.) Yet Warhol conveys a sense of the tragic personality that lay behind the famous movie star's glamorous facade. The color, lurid and off-register like reproduction in a sleazy

▼ SILK SCREEN, also called serigraph and screenprint, is a stencil print-making technique. In the most direct method, the artist paints an image on the surface of a tightly stretched, very fine-meshed framed screen of silk. Next, the top surface of the screen is sealed with lacquer and allowed to dry. This is followed by rubbing water on the underside of the screen, which dissolves the glue and leaves the drawn areas unplugged by lacquer. Paint is forced through the screen with a squeegee onto a sheet of paper, creating the image which becomes the silk-screen print.

489. Richard Anuszkiewicz. *Entrance to Green.* 1970. Acrylic on canvas, 9 x 6' (2.74 x 1.83 m). Collection the artist

magazine, makes us realize that Marilyn has been reduced to a cheap commodity. Through mechanical means, she is rendered as impersonal as the Virgin that stares out from the thousands of icons produced by hack artists through the ages.

Photorealism

Although Pop art was sometimes referred to as "the new realism," the term hardly seems to fit the painters we have discussed. They are, to be sure, sharply observant of their sources. However, their chosen material is itself rather abstract: flags, numerals, lettering, signs, badges, comic strips. A more recent offshoot of Pop art is the trend called Photorealism because of its fascination with camera images. Nineteenth-century painters had utilized photographs soon after the camera was invented (one of the earliest to do so, surprisingly, was Delacroix), but as no more than a convenient substitute for reality. For the Photorealists, in contrast, the photograph itself is the reality on which they build their pictures.

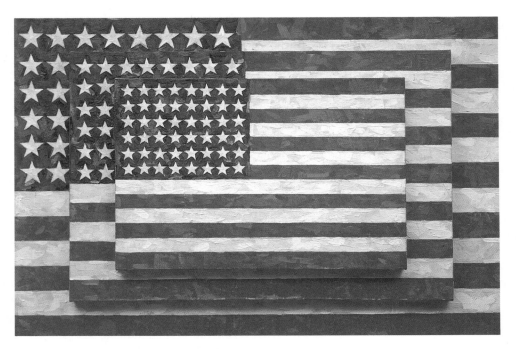

490. Jasper Johns. *Three Flags.* 1958. Encaustic on canvas, 30⅞ x 45½ x 5" (78.4 x 115.6 x 12.7 cm). Whitney Museum of American Art, New York

493. Don Eddy. *New Shoes for H.* 1973–74. Acrylic on canvas, 44 x 48" (111.8 x 121.9 cm). The Cleveland Museum of Art

Purchased with a grant from the National Endowment for the Arts and matched by gifts from members of The Cleveland Society for Contemporary Art

494. Don Eddy. Photograph for *New Shoes for H.* 1973–74. The Cleveland Museum of Art.

Gift of the artist

491. Roy Lichtenstein. *Drowning Girl.* 1963. Oil with synthetic polymer paint on canvas, 5'7⁵⁄8" x 5'6³⁄4" (1.72 x 1.7 m). The Museum of Modern Art, New York

Philip Johnson Fund and Gift of Mr. and Mrs. Bagley Wright

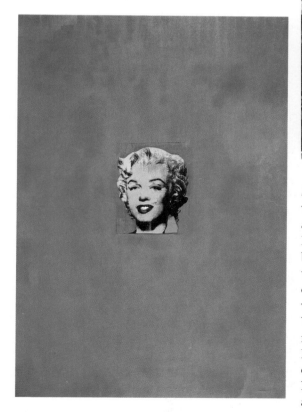

492. Andy Warhol. *Gold Marilyn Monroe.* 1962. Synthetic polymer paint, silkscreened, and oil on canvas, 6'11¹⁄4" x 4'7" (2.12 x 1.4 m). The Museum of Modern Art, New York

Gift of Philip Johnson

Don Eddy The Photorealists' work often has a visual complexity that challenges the most acute observer. *New Shoes for H* (fig. 493) by Don Eddy (b. 1944) shows Photorealism at its best. Eddy grew up in southern California. As a teenager he learned to do fancy paint jobs on cars and surfboards with an airbrush, then he worked as a photographer for several years. When he became a painter, he used both commercial skills. In preparing *New Shoes for H*, Eddy took a series of pictures of the window display of a shoe store on Union Square in Manhattan. One photograph (fig. 494) served as the basis for the painting. What intrigued him, clearly, was the way glass filters and alters everyday reality. Only a narrow strip along the left-hand edge offers an unobstructed view.

Everything else is seen through one or more layers of glass, all of them at oblique angles to the picture surface. The familiar scene is transformed into a dazzlingly rich and novel visual experience by the combined displacement, distortion, and reflection of these panes.

When we compare the painting with its preliminary photograph, we realize that they are related in much the same way as Lichtenstein's *Drowning Girl* is to the original comic-strip frame from which it derives. Eddy's canvas shows everything in uniformly sharp focus, articulating details lost in the shadows in the photograph. Most important, he gives pictorial coherence to the scene through a brilliant color scheme whose pulsating rhythm plays over the entire surface. At the time he painted *New Shoes for H*, color had become newly important in Eddy's thinking. The *H* of the title pays homage to Henri Matisse and to Hans Hofmann, an Abstract Expressionist whom Eddy had come to admire.

Audrey Flack Photorealism was part of a general tendency that marked American painting in the 1970s: the resurgence of realism. This impulse took on a wide range of themes and techniques, from the most personal to the most detached, depending on the artist's vision of objective reality and its subjective significance. Photorealism's flexibility made realism a sensitive vehicle for the feminist movement that came to the fore in the same decade. Women artists such as Audrey Flack (b. 1931) have used realism to explore the world around them and their relation to it from a personal as well as a feminist viewpoint. Like most of Flack's paintings, *Queen* (fig. 495, page 548) is an extended allegory. The queen is the most powerful figure on the chessboard, yet she remains expendable in defense of the king. Equally apparent is the meaning inherent to the queen of hearts, but here the card also refers to the passion for gambling in members of Flack's family, which is represented by the locket with photos of the artist and her mother. The contrast of youth and age is central to *Queen*: the watch is a traditional emblem of life's brevity, and the dewy rose stands for the transience of beauty, which is further conveyed by the makeup on the dressing table. The suggestive shapes of the bud and fruits can also be taken as symbols of feminine sexuality.

Queen is successful not so much for its statement, however, as for its compelling imagery. Flack creates a purely artistic reality by superimposing two separate photographs. Critical to the illusion is the gray border, which acts as a framing device and also establishes the central space and color of the painting. The objects that seem to project from the picture plane are shown in a perspective different from those on the tilted tabletop behind. The picture space is made all the more active by the play of its colors within the neutral gray.

Late Modernism

Neo-Expressionism and Neo-Abstraction

The art we have looked at since 1945, although distinctive to the postwar era, is so closely related to what came before it that it was clearly cut from the same cloth, and we do not hesitate to call it modernist. At long last, however, twentieth-century painting, to which everything from Abstract Expressionism to Photorealism made such a vital contribution, began to lose vigor. The first sign of decline came in the early 1970s with the widespread use of "Neo-" to describe the latest tendencies, which came and went in rapid succession and are all but forgotten today. Only one of these movements has made a lasting contribution: Neo-Expressionism, which arose toward the end of the 1970s and became the dominant current of the 1980s. Indeed, imagery of all kinds completely overshadowed Neo-Abstraction (also known as Neo-Geo), to the point that abstraction itself was declared all but dead by the critics. The few abstract works produced were feeble imitations of earlier achievements and seemed to signify that art had turned its back on mainstream modernism. And despite the fact that Neo-Expressionism is deeply rooted in that heritage, there can be little question that it represents the end of the tradition we have traced throughout this chapter.

Francesco Clemente The Italian Francesco Clemente (b. 1952) is representative in many respects of his artistic generation. His association with the Arte Povera ("Poor Art") movement in Italy, which relied on inexpensive materials to ally itself with ordinary people, led him to develop a potent Neo-Expressionist style. His career took a decisive turn in 1982, when he decided to move to New York in order "to be where the great painters have been," but he also spends much of his time in India, where he has been inspired by Hinduism. His canvases and wall paintings sometimes have an ambitiousness that can assume the form of allegorical cycles addressed directly to the Italian painters who have worked on a grand scale, starting with Giotto. His most compelling works, however, are those having as their subject matter the artist's moods, fantasies, and appetites. Clemente is fearless in recording urges and memories that the rest of us repress. Art becomes for him an act of cathartic necessity that releases, but never resolves, the impulses that assault his acute self-awareness. His self-portraits (fig. 496, page 548) suggest a soul bombarded by drives and sensations that can never be truly enjoyed. Alternately fascinating and repellent, his pictures remain curiously unsensual, yet their expressiveness is riveting. Since his work responds to fleeting states of mind, Clemente utilizes whatever style or medium seems appropriate to capturing the transient phenomena of his inner world. He is unusual among Italians in being influenced heavily by Northern European Symbolism and Expressionism, with an occasional reminiscence of Surrealism. Here indeed is his vivid nightmare, having the psychological terror of Munch and the haunted vision of de Chirico.

Anselm Kiefer The German artist Anselm Kiefer (b. 1945) is the direct heir to Northern Expressionism, but rather than investigating personal moods he confronts moral issues posed by Nazism that have been evaded by other postwar artists in his country. By exploring the major themes of German Romanticism from a modern perspective, he has attempted to reweave the threads broken by history. That tradition, which began as a noble ideal based on a similar longing for the mythical past, ended as a perversion at the hands of Hitler and his followers because it lent itself readily to abuse.

To the Unknown Painter (fig. 497, page 549) is a powerful statement of the human and cultural catastrophe presented by World War II. Conceptually as well as compositionally it was inspired by the paintings of Caspar David Friedrich, of which it is a worthy successor. To express the tragic proportions of the Holocaust, Kiefer works on an appropriately epic scale. Painted in jagged strokes of predominantly earth and black tones, the charred landscape is made tangible by the inclusion of pieces of straw. Amid this destruction stands a somber ruin; it is shown in woodcut to proclaim Kiefer's allegiance to the German Renaissance and to Expressionism. The fortresslike structure is a suitable monument for heroes in recalling the tombs and temples of ancient civilizations. But instead of being dedicated to soldiers who died in combat, it is a memorial to the painters whose art was equally a casualty of fascism.

Elizabeth Murray Neo-Expressionism has a counterpart in Neo-Abstraction, which has yielded less impressive results thus far. The greatest success in the Neo-Abstractionist vein has been achieved by those artists seeking to infuse their formal concerns with the personal meaning of Neo-Expressionism. Elizabeth Murray (b. 1940) has emerged since 1980 as the leader of this crossover style in the United States. *More Than You Know* (fig. 498) makes a fascinating comparison with Audrey Flack's *Queen* (see fig. 495), for both are filled with autobiographical references. While it is at once simpler and more abstract than Flack's, Murray's composition seems about to fly apart under the pressure of barely contained emotions. The table will remind us of the one in Picasso's *Three Musicians* (see fig. 462), a painting she has referred to in other works from the same time. The contradiction between the flattened collage perspective of the table and chair and the allusions to the distorted three-dimensionality of the surrounding room establishes a disquieting pictorial space. The more we look at the painting, the more we

495. Audrey Flack. *Queen.*
1975–76. Acrylic on
canvas, 6'8" (2.03 m)
square. Private col-
lection

Courtesy Louis K. Meisel
Gallery, New York

496. Francesco Clemente.
Untitled. 1983. Oil and
wax on canvas, 6'6" x 7'9"
(1.98 x 2.36 m). Courtesy
Thomas Ammann,
Zurich, Switzerland

497. Anselm Kiefer. *To the Unknown Painter.* 1983.
Oil, emulsion, woodcut, shellac, latex, and straw
on canvas, 9'2" (2.79 m) square. The Carnegie
Museum of Art, Pittsburgh

Richard M. Scaife Fund; A. W. Mellon Acquisition Endowment
Fund

begin to realize how eerie it is. Indeed, it seems
to radiate an almost unbearable tension. The
table threatens to turn into a figure surmounted
by a skull-like head that moves with the same
explosive force of Picasso's *Three Dancers* (see fig.
463). What was Murray thinking of? She has said
that the room reminds her of a place where she
sat with her ill mother. At the same time, the
demonic face was inspired by Munch's *The
Scream* (see fig. 429). *More than You Know* is the
culmination of twentieth-century modernist
painting. Beyond it lies only Postmodernism,
which seeks to reject that tradition altogether.

498. Elizabeth Murray. *More Than You Know.* 1983. Oil
on ten canvases, 9'3" x 9' x 8" (2.82 m x 2.74 m
x 20.3 cm). The Edward R. Broida Trust

Courtesy Paula Cooper Gallery, New York
Thomas Segal Gallery, Boston

Chapter 26
Twentieth-Century Sculpture

Sculpture, the most conservative of the arts throughout most of the nineteenth century, found it difficult to cast off the burden of tradition. It has remained far less adventurous on the whole than painting, which often influenced it. Indeed, the American sculptor David Smith claimed that modern sculpture was created by the painters, and to a remarkable degree he was right. Sculpture has successfully challenged the leadership of painting in our time only by following a separate path.

Sculpture before 1945

France

Henri Matisse Some of the most important experiments in sculpture were conducted by Matisse in the years 1907–14, when he was inspired by African sculpture, although there had been a growing interest in "primitive" art on the part of painters like Gauguin before the first major public collections began to be formed in 1890. At first glance, *Reclining Nude I* (fig. 499) seems utterly removed from Matisse's paintings. Yet sculpture was a natural complement to his pictures, which allowed him to investigate problems of form that later provided important lessons for painting. Despite the bulging distortions in the anatomy, which create an astonishing muscular tension, the artist was concerned above all with **arabesque**: the rhythmic contours that define the nude. We will recognize the statuette's kinship with the recumbent figures in *The Joy of Life* (see fig. 445), which were likewise conceived in outline. But now these rhythms are explored plastically and are manipulated for expressive effect. Remarkably, Matisse accomplishes this without diminishing the fundamentally classical character of the nude.

Constantin Brancusi Sculpture remained only a sideline for Matisse. At that time, Expressionism was a much less important current in sculpture than in painting. This may seem rather surprising, since the rediscovery of African sculpture by the Fauves might have been expected to evoke a strong response among sculptors. Yet only one important sculptor shared in this rediscovery: Constantin Brancusi (1876–1957), a Romanian who went to Paris in 1904. He was more interested in the formal simplicity and coherence of African carvings than in their expressiveness. This is evident in *The Kiss* (fig. 500), executed in 1909 and now placed over a tomb in a Parisian cemetery. The compactness and self-sufficiency of this group is a radical step beyond Maillol's *Seated Woman* (see fig. 433), to which it is related, much as the Fauves are to Post-Impressionism. Brancusi has

499. Henri Matisse. *Reclining Nude I.* 1907. Bronze, 13⁹⁄₁₆ x 19⁵⁄₈ x 11" (34.5 x 49.9 x 28 cm). The Baltimore Museum of Art

Cone Collection, formed by Dr. Claribel Cone and Ms. Etta Cone of Baltimore, Maryland

500. Constantin Brancusi. *The Kiss.* 1909. Stone, height 35¹⁄₄" (89.5 cm). Tomb of T. Rachevskaia, Montparnasse Cemetery, Paris

501. Constantin Brancusi. *Bird in Space* (unique cast). 1928. Bronze 54 x 8¹/₂ x 6¹/₂" (137.2 x 21.6 x 16.5 cm). The Museum of Modern Art, New York
Given anonymously

him, a monument is an upright slab, symmetrical and immobile—a permanent marker, like the stelae of the ancients—and he disturbs this basic shape as little as possible. The embracing lovers are differentiated just enough to be separately identifiable. They seem primeval, a timeless symbol of generation, innocent and anonymous. Herein lies the genius of Brancusi: he posed the first successful alternative to Rodin. In the process, he gave modern sculpture its independence.

Brancusi's work took another daring step about 1910, when he began to produce nonrepresentational pieces in marble or metal. These fall into two groups: variations on the egg shape and soaring, vertical "bird" motifs. In concentrating on two basic forms of such uncompromising simplicity, Brancusi strove for essences, not for Rodin's illusion of growth. He was fascinated by the antithesis of life as potential and as kinetic energy: the self-contained perfection of the egg, which hides the mystery of all creation, and the pure dynamics of the creature released from this shell.

Bird in Space (fig. 501) is the culmination of Brancusi's art. It began as the figure of a mythical bird that talks, which he gradually simplified until it is no longer the abstract image of a bird. Rather, it is flight itself, made visible and concrete: "All my life I have sought the essence of flight," Brancusi stated, and he repeated the motif in variants of ever greater refinement. Its disembodied quality is emphasized by the high polish that gives the surface the reflectivity of a mirror and thus establishes a new continuity between the molded space within and the free space without.

Raymond Duchamp-Villon In the second decade of the century, a number of artists tackled the problem of body-space relationships with the formal tools of Cubism—no simple task, since Cubism was a painter's approach more suited to shallow relief and not easily adapted to objects in the round. Most of the Cubist painters tried at least a few sculpture, but the results were generally timid. The boldest solution to the problems posed by Analytic Cubism in sculpture was achieved by the sculptor Ray-

a "genius of omission" not unlike Matisse's. And his attitude toward art expresses the same optimistic faith of early modernism: "Don't look for mysteries," he said. "I give you pure joy." To

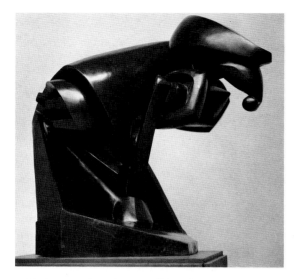

502. Raymond Duchamp-Villon. *The Great Horse*. 1914 (cast 1957). Bronze, 39¹/₄ x 24 x 36" (99.7 x 60.9 x 91.4 cm). The Art Institute of Chicago

Gift of Miss Margaret Fisher in memory of her parents, Mr. and Mrs. Walter L. Fisher

mond Duchamp-Villon (1876–1916), an elder brother of Marcel Duchamp, in *The Great Horse* (fig. 502). He began with abstract studies of the animal, but his final version is an image of "horsepower," wherein the body has become a coiled spring and the legs resemble piston rods. Because of this very remoteness from their anatomical model, these quasi-mechanical shapes have a dynamism that is altogether persuasive.

Italy

Umberto Boccioni In 1912, the Futurists suddenly became absorbed with making sculpture, which they sought to redefine as radically as painting. They used "force-lines" to create an "arabesque of directional curves" as part of a "systematization of the interpenetration of planes." Hence, the Futurist painter and sculptor Umberto Boccioni declared, "We break open the figure and enclose it in environment." His running figure entitled *Unique Forms of Continuity in Space* (fig. 503) is as breathtaking in its complexity as Brancusi's *Bird in Space* is simple. Boccioni has attempted to represent not the human form but the imprint of its motion upon the medium in which it moves. The figure itself remains concealed behind its "garment" of aerial turbulence. The picturesque statue recalls

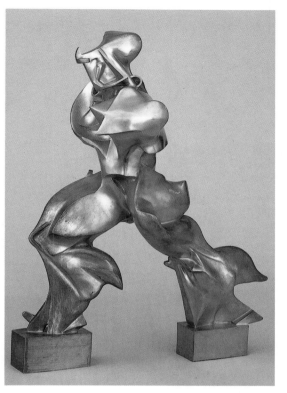

503. Umberto Boccioni. *Unique Forms of Continuity in Space*. 1913. Bronze (cast 1931), 43⁷/₈ x 34⁷/₈ x 15³/₄" (111.4 x 88.6 x 40 cm). The Museum of Modern Art, New York

Acquired through the Lillie P. Bliss Bequest

the famous Futurist statement that "the roaring automobile is more beautiful than the *Winged Victory*," although it obviously owes more to the *Winged Victory* (the *Nike of Samothrace*, see fig. 79) than to the design of motorcars, whose fins and streamlining, in 1913, were still to come.

Sculpture between the Wars

Russia

Vladimir Tatlin In Analytic Cubism, we recall, concave and convex were postulated as equivalents. All volumes, whether positive or negative, were "pockets of space." The Constructivists, a group of Russian artists led by Vladimir Tatlin (1895–1956), applied this principle to relief sculpture and arrived at what might be called three-dimensional collage. Eventually the final step was taken of making the works freestanding. According to Tatlin and his followers,

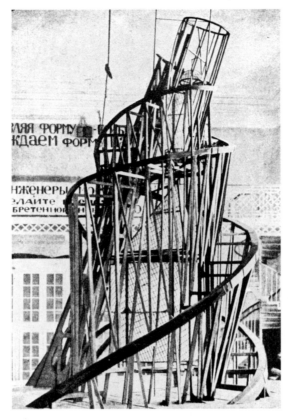

504. Vladimir Tatlin. Project for *Monument to the Third International*. 1919–20. Wood, iron, and glass, height 20' (6.09 m). Destroyed; contemporary photograph

these "constructions" were actually four-dimensional: since they implied motion, they also implied time. Suprematism (see pages 514–16) and Constructivism were therefore closely related and in fact overlapped, for both had their origins in Cubo-Futurism. They were nevertheless separated by a fundamental difference in approach. For Tatlin, art was not the Suprematists' spiritual contemplation but an active process of formation that was based on material and technique. He believed that each material dictates specific forms that are inherent in it and that these must be followed if the work of art is to be valid according to the laws of life itself. In the end, Constructivism won out over Suprematism because it was better suited to the post-Revolution temperament of Russia, when great deeds, not great thoughts, were needed.

Cut off from artistic contact with Europe during World War I, Constructivism developed into a uniquely Russian art that was little affected by the return of some of the country's most important artists, such as Kandinsky and Chagall. The Russian Revolution of 1917 galvanized the modernists, who celebrated the overthrow of the old regime with a creative outpouring throughout Russia. Tatlin's model for a *Monument to the Third International* (fig. 504) captures the dynamism of the technological utopia envisioned under communism. Pure energy is expressed as lines of force that establish new time-space relationships as well. The work also implies a new social structure, for the Constructivists believed in the power of art literally to reshape society. This extraordinary tower revolving at three speeds was conceived on a monumental scale, complete with Communist party offices. Like other such projects, it was wildly impractical in a society still recovering from the ravages of war and revolution and was never built.

Constructivism subsequently proceeded to a "Productivist" phase, which denied any contradiction between artistic creativity and the making of utilitarian objects. After the movement had been suppressed as "bourgeois formalism," some of its members emigrated to the West and joined forces with the Dutch design group de Stijl (see page 522).

France

Jacques Lipchitz After World War I, sculptors in France largely forsook abstraction and abandoned Expressionism altogether. Only Jacques Lipchitz (1891–1973) continued to explore the possibilities offered by Cubism. He also shared in Brancusi's primevalism, and in the mid-1920s he achieved a remarkable synthesis of these two tendencies. With its intently staring eyes, *Figure* (fig. 505) is a haunting evocation in Cubist terms of guardian figures from Africa, but with a complex design and monumental scale reserved only for the largest wood carvings there. Consisting of two interlocking figures, it creates a play of open and closed forms that relieves Brancusi's austere simplicity

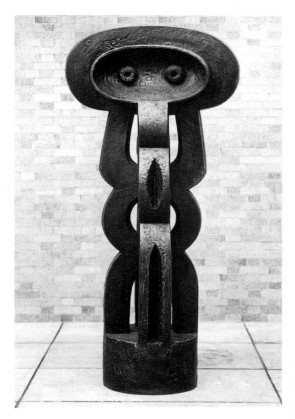

505. Jacques Lipchitz. *Figure*. 1926–30 (cast 1937). Bronze, 7'1¹/₄" x 3'2⁵/₈" (2.17 m x 0.98 m). The Museum of Modern Art, New York

Van Gogh Purchase Fund

through arabesque rhythms akin to those of Matisse. Not surprisingly, the patron who commissioned *Figure* as a garden sculpture found it difficult to live with. No other sculptor at the time was able to rival Lipchitz for sheer power, and he set an important example for the generation of sculptors that reached maturity a decade later.

Marcel Duchamp Lipchitz's disciplined abstraction was the very antithesis of Dada, which fostered nontraditional approaches that have both enriched and confounded sculpture ever since. As it did in the other arts—perhaps even more so—Dada uncompromisingly rejected formal discipline in sculpture. Playfulness and spontaneity are the impulses behind the "ready-mades" of Marcel Duchamp, which the artist created by shifting the context of everyday

506. Marcel Duchamp. *In Advance of the Broken Arm*. 1945, after the original of 1915. Snow shovel, length 46³/₄" (118.7 cm). Yale University Art Gallery, New Haven, Connecticut

Gift of Katherine S. Dreier for the Collection Société Anonyme

objects from the utilitarian to the aesthetic. He would put his signature and a provocative title on ready-made objects such as bottle racks and snow shovels and exhibit them as works of art. *In Advance of the Broken Arm* (fig. 506) pushed the spirit of ready-mades to a new height. (Duchamp re-created the lost original version of 1915.) Some of Duchamp's examples consist of combinations of found objects. These "assisted" ready-mades approach the status of constructions or of three-dimensional collage. This technique, later baptized assemblage (see page 564),

507. Méret Oppenheim. *Object (Le Déjeuner en fourrure)*. 1936. Fur-covered cup, saucer, and spoon, overall height 2⁷/₈" (7.3 cm); diameter of cup 4³/₄" (12.1 cm); diameter of saucer 9³/₈" (23.8 cm); length of spoon 8" (20.3 cm). The Museum of Modern Art, New York

Purchase

proved to have unlimited possibilities, and numerous younger artists have explored it since, especially in junk-ridden America.

Surrealism

Ready-mades are certainly extreme demonstrations of a principle: that artistic creation depends neither on established rules nor on manual craft. The principle itself was an important discovery, although Duchamp abandoned ready-mades after only a few years. The Surrealist contribution to sculpture is harder to define. It was difficult to apply the theory of "pure psychic automatism" to painting, but still harder to live up to it in sculpture. How indeed could solid, durable materials be given shape without the sculptor being consciously aware of the process?

Méret Oppenheim A breakthrough in sculpture came in 1930, when the Surrealists met in response to a growing crisis within the movement. They issued a new manifesto drafted by André Breton, which called for the "profound and veritable occultation of Surrealism." It further required "uncovering the strange symbolic life of the most ordinary and clearly defined objects." The result was a new class of Surrealist

object: neither ready-made nor sculpture, it constituted a kind of three-dimensional collage assembled not out of aesthetic concerns using traditional techniques but according to "poetic affinity" following dictates of the subconscious. Like *Object* (fig. 507) by Méret Oppenheim (1913–85), which created a sensation when it was exhibited in 1936, many were intended to be unsettling in the extreme, or even repulsive, and proved all the more fascinating for that reason.

Pablo Picasso As in painting, Picasso's genius provided much of the impetus for sculpture during the 1930s. In 1928, sculpture emerged as a serious interest for him, and for the next five years he concentrated intensively on making sculpture of all sorts. A glance at *Girl before a Mirror* of about the same time (see fig. 7) suggests why the artist turned to sculpture in the first place. On the one hand, his shapes have a solidity that practically demands to be translated into three-dimensional form. On the other, his work is so replete with startling transformations that the process of metamorphosis involved in sculpture became highly intriguing. Here there can be little doubt that Picasso's involvement with Surrealism stimulated his imagination and allowed him to approach sculpture without preconception. As he put it, "One should be able to take a bit of wood and find it's a bird." That is what allowed him to see the possibilities in the debris of modern civilization—an attitude that culminates in *Bull's Head* (see fig. 2).

Julio González Picasso contributed to the astonishing sculptural imagination of Julio González (1876–1942). Trained as a wrought-iron worker in his native Catalonia, in Spain, González had gone to Paris in 1900. Although he was a friend of both Brancusi and Picasso, he produced little of consequence until the 1930s, when his creative energies suddenly came into focus after Picasso called him for technical advice in working with wrought iron. It was González who established this medium as an important one for sculpture, taking advantage of the very difficulties that had discouraged its

508. Julio González. *Head*. c. 1935. Wrought iron, 17³/4 x 15¹/4" (45.1 x 38.7 cm). The Museum of Modern Art, New York
Purchase

use earlier. *Head* (fig. 508) combines extreme economy of form with an aggressive reinterpretation of anatomy that is derived from Picasso's work after the mid-1920s. As in the head of the figure on the left in Picasso's *Three Dancers* (see fig. 463), the mouth is an oval cavity with spikelike teeth, the eyes two rods that converge upon an "optic nerve" linking them to the tangled mass of the "brain." González has produced a gruesomely expressive metaphor; the violence of his working process seems to mirror the violence of modern life.

Alexander Calder Surrealism in the early 1930s led to still another important development, the mobile sculpture of the American Alexander Calder (1898–1976). Called mobiles for short, they are delicately balanced constructions of metal wire, hinged together and weighted so as to move with the slightest breath of air. They may be of any size, from tiny tabletop models to the huge *Lobster Trap and Fish Tail* (fig. 509).

509. Alexander Calder. *Lobster Trap and Fish Tail*. 1939. Painted steel wire and sheet aluminum, approx. 8'6" x 9'6" (2.59 x 2.9 m). The Museum of Modern Art, New York
Commissioned by the Advisory Committee for the stairwell of the Museum

▼KINETIC SCULPTURE had been conceived by the Constructivists. Their influence is evident in Calder's earliest mobiles, which were motor-driven and tended toward abstract geometric configurations. Calder was also affected early on by Mondrian, but it was his contact with Surrealism that made him realize the poetic possibilities of "natural" rather than fully controlled movement. He borrowed biomorphic shapes from Miró and began to think of mobiles as similes of organic structures: flowers on flexible stems, foliage quivering in the breeze, marine animals floating in the sea. Such mobiles are infinitely responsive to their environment so that they seem more truly alive than any other fabricated thing. Unpredictable and ever-changing, they incorporate the fourth dimension as an essential element of their structure.

England

The effects produced by Calder can be compared directly with those of Surrealist painting. The same cannot be said of two English sculptors who represent the culmination of the modern sculptural tradition before 1945: Henry Moore (1898–1986) and Barbara Hepworth (1903–75). The presence of Kokoschka, Mondrian, Gropius, and other emigrés contributed greatly to the rise of modern art in England during the mid-1930s, when Moore and Hepworth were emerging as mature artists. In consequence, they absorbed the full spectrum of earlier twentieth-century art, but in different measure, reflecting their contrasting personalities. Moore was the more boldly inventive artist, but Hepworth may well have been the better sculptor. However, the two were closely associated as leaders of the modern movement in England, and they influenced one another.

Henry Moore The majestic *Two Forms* (fig. 510), an early work by Moore, may be regarded as the second-generation offspring of Brancusi's *The Kiss* done a quarter century earlier (see fig. 500), although there is no direct connection between them. Abstract and subtle in shape, they are nevertheless "persons" in much the same vein as Lipchitz's *Figure* (see fig. 505), even though

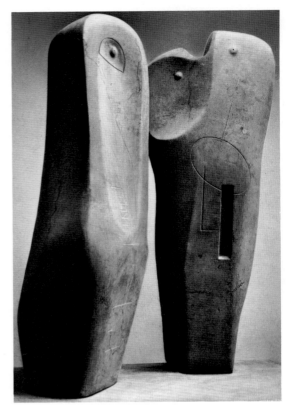

510. Henry Moore. *Two Forms*. 1936. Stone, height approx. 42" (106.7 cm). Collection Mrs. H. Gates Lloyd, Haverford, Pennsylvania

they can be called "images" only in the metaphoric sense. This family group—the forked slab evolved from the artist's studies of the mother-and-child theme—is mysterious and remote, like the monoliths of Stonehenge, which greatly impressed the sculptor (see fig. 22). And like Stonehenge, Moore's figures are meant to be placed in a landscape, so architectural are they in character.

Barbara Hepworth Hepworth's sculpture became more abstract after her marriage to the painter Ben Nicholson, her association with the Constructivist Naum Gabo, and her contact in Paris with Brancusi and Hans Arp. For a time she was practicing several modes at once under these influences. With the onset of World War II, she moved to St. Ives in Cornwall, where she initiated an individual style that emerged fully in

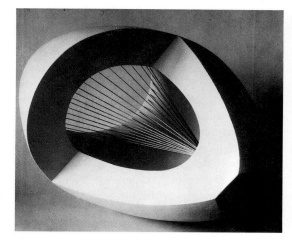

511. Barbara Hepworth. *Sculpture with Color (Oval Form), Pale Blue and Red*. 1943. Wood with strings, length 18" (45.7 cm). Private collection

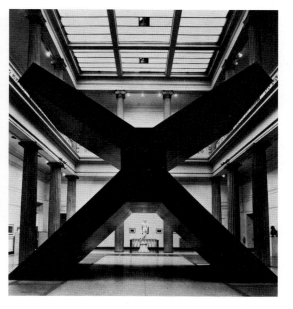

1943. *Sculpture with Color (Oval Form)* flawlessly synthesizes painting and sculpture, Surrealist biomorphism and organic abstraction, and the molding of space and shaping of mass (fig. 511). Carved from wood and immaculately finished, it reduces the natural shape of an egg to a timeless ideal that has the lucid perfection of a classical head, yet the elemental expressiveness of an African mask. Hepworth's egg undoubtedly owes something to Brancusi's, although their work is very different. The colors accentuate the play between the interior and exterior of the hollowed-out form, while the strings, a device first used by Moore, seem to suggest a life force within. As a result of its open forms, *Sculpture with Color* enters into an active relationship with its surroundings. Like Moore, Hepworth was concerned with the relationship of the human figure in a landscape, but in a uniquely personal way. From her house overlooking St. Ives Bay, she wrote: "I was the figure in the landscape and every sculpture contained to a greater or lesser degree the ever-changing forms and contours embodying my own response to a given position in that landscape. I used colour and strings in many of the carvings of this time. The colour in the concavities plunged me into the depth of water, caves, or shadows deeper than the carved concavities themselves. The strings were the tension I felt between myself and the sea, the wind or the hills."

Sculpture since 1945

Monumental Sculpture

Like painting, sculpture since 1945 has been notable for its epic proportions. Indeed, scale assumed fundamental significance for a sculptural movement that extended the scope—indeed, the very concept—of sculpture in an entirely new direction. *Primary Structure*, the most suitable name suggested for this type, conveys its two salient characteristics: extreme simplicity of shapes and a kinship with architecture. Another term, *environmental sculpture* (not to be confused with mixed-medium "environments"), refers to the fact that many Primary Structures are designed to envelop the beholder, who is invited to enter or walk through them. It is this space-articulating function that distinguishes Primary Structures from all previous sculpture and relates them to architecture. They are the modern successors, in structural steel and concrete, to such prehistoric monuments as Stonehenge (see figs. 21, 22).

Ronald Bladen Often, the sculptors of Primary Structures limit themselves to the role of designer and leave the execution to others, to emphasize the impersonality and duplicability of their invention. If no patron is found to foot the bill for carrying out these costly structures,

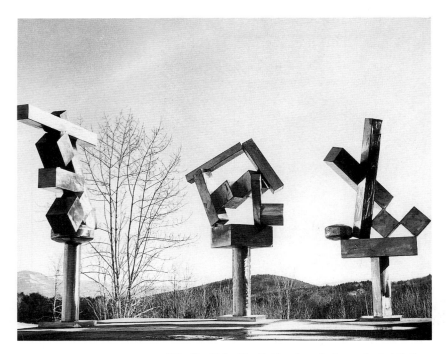

513. David Smith. *Cubi* series, photographed at Bolton Landing, New York. Stainless steel. From left to right: *Cubi XVIII*. 1964. Height 9'8" (2.95 m). Museum of Fine Arts, Boston; *Cubi XVII*. 1963. Height 9' (2.74 m). Dallas Museum of Fine Arts; *Cubi XIX*. 1964. 9'5" (2.87 m). Tate Gallery, London

structions of Julio González (see fig. 508), but during the last years of his life he evolved a singularly impressive form of Primary Structure in his *Cubi* series. Figure 513 shows three of these against the open sky and rolling hills of the artist's farm at Bolton Landing, New York. (All are now in major museums.) Smith has created a seemingly endless variety of configurations using few basic components, chiefly cubes and cylinders. The units that make up the structures are poised one upon the other as if they were held in place by magnetic force, so that each represents a fresh triumph over gravity. Unlike many members of the Primary Structures movement, Smith executed these pieces himself, welding them of sheets of stainless steel whose shiny surfaces he finished and controlled with exquisite care. As a result, his work displays an "old-fashioned" subtlety of touch that reminds us of the polished bronzes of Brancusi.

Minimalism and Post-Minimalism A younger generation of Minimalists, Bladen among them, carried the implications of Primary Structures to their logical conclusion. In search of the ultimate unity, they reduced their geometry to the fewest possible components and used mathematical formulas to establish precise relationships. They further eliminated any hint of personal expression by contracting out the work to industrial fabricators. Minimalism was a quest for basic elements representing the fundamental aesthetic values of art, without regard to issues of content. It made an important contribution by enabling the sculptor to achieve an elusive perfection through total control over every element. At its most extreme, however, Minimalism reduced art not to an eternal essence but to a barren simplicity.

they remain on paper, like unbuilt architecture. Sometimes such works reach the mock-up stage. *The X* (fig. 512), by the Canadian Ronald Bladen (1918–88), was originally built with painted wood substituting for metal for an exhibition inside the two-story hall of the Corcoran Gallery in Washington, D.C. Its commanding presence, dwarfing the Neoclassical colonnade of the hall, seems doubly awesome in such a setting.

David Smith Not all Primary Structures are environmental sculpture. Most are freestanding works independent of the sites that contain them. Bladen's *The X*, for example, was later constructed of painted steel as an outdoor sculpture. Primary Structures nevertheless have in common a monumental scale and economy of form. The artist who played the most influential role in defining their character was David Smith (1906–65). His earlier work had been strongly influenced by the wrought-iron con-

Claes Oldenburg Executed on a large scale, sculpture by Pop artists can also be monuments. But they celebrate not historical events but their designer's imagination. Monuments in the traditional sense virtually died out when contemporary society lost its consensus of what ought to be publicly remembered. Yet the belief in the possibility of such monuments has not been abandoned altogether. The Pop artist

514. Claes Oldenburg. *Giant Ice Bag.* 1969–70. Plastic with metal, with interior motor, extended height 15'6" (4.72 m), diameter 18' (5.49 m)

Thomas Segal Gallery, Boston

Claes Oldenburg (b. 1929) has proposed a number of unexpected and imaginative solutions to the problem of the monument. He is, moreover, an exceptionally persuasive commentator on his ideas. All his monuments are heroic in size, though not in subject matter. And all share one feature: their origin in humble objects of everyday use.

In 1969, Oldenburg conceived his most unusual project. For a piece of outdoor sculpture he wanted a form that combined hard and soft and did not need a base. An ice bag met these demands, so he bought one and started playing with it. As he manipulated the object, he realized "that movement was part of its identity and should be used." He then executed a work shaped like a huge ice bag (fig. 514) with a mechanism inside to produce "movements caused by an invisible hand," as the artist described them. He sent the *Giant Ice Bag* to the U.S. Pavilion at Expo 70 in Osaka, Japan, where crowds were endlessly fascinated to watch it heave, rise, and twist like a living thing, then relax with an almost audible sigh.

What do such monuments celebrate? Part of their charm, which they share with ready-mades and Pop art, is that they reveal the aesthetic potential of the ordinary and all-too- familiar. But they also have an undeniable grandeur. There is one dimension, however, that is missing in Oldenburg's monuments. They delight, astonish, and amuse—but they do not move us. Wholly secular, wedded to the here and now, they fail to touch our deepest emotions.

Robert Smithson The ultimate medium for environmental sculpture is the earth itself, since it provides complete freedom from the limitations of the human scale. Some designers of Primary Structures have, logically enough, turned to earth art, inventing projects that stretch over many miles. These latter-day successors to the mound-building Native Americans of Neolithic times have the advantage of modern earth-moving machinery, but this is more than outweighed by the problem of cost and the difficulty of finding suitable sites on our crowded planet.

The few projects of theirs that have actually been carried out are mostly found in remote regions of the western United States, so that the finding is itself often difficult. *Spiral Jetty*, the work of Robert Smithson (1938–73), jutted out into the Great Salt Lake in Utah (fig. 515, page 562) and is now partly submerged. Its appeal rests in part on the Surrealist irony of the concept: a spiral jetty is as self-contradictory as a straight corkscrew. But it can hardly be said to have grown out of the natural formation of the terrain. No wonder it has not endured long, nor was it intended to. The process by which nature is reclaiming *Spiral Jetty*, already twice submerged, was integral to Smithson's design from the start. The project nevertheless lives on in photographs.

Joel Shapiro Confronted by what they perceived as an artistic dead end, a number of artists began to move away from Minimalism without entirely renouncing it. This trend, called Post-Minimalism to denote its continuing debt to the earlier style, has as its leading exponent Joel Shapiro (b. 1941). After fully exploring the possibilities of small pieces

515. Robert Smithson. *Spiral Jetty.* As built in 1970. Total length 1,500' (457.2 m), width of jetty 15' (4.57 m). Great Salt Lake, Utah

516. Joel Shapiro. *Untitled.* 1989–90. Bronze, 8'5 1/2" x 3'6" x 6'8" (2.58 x 1.1 x 1.98 m). North Carolina Museum of Art, Raleigh

517. Martin Puryear. *The Spell.* 1985. Pine, cedar, and steel, 4'8" x 7' x 5'5" (1.42 x 2.13 x 1.65 m). Collection the artist

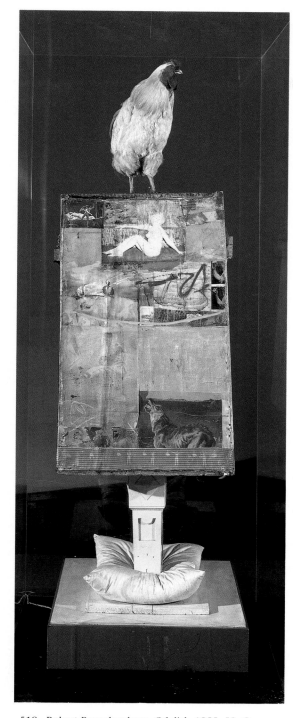

518. Robert Rauschenberg. *Odalisk*. 1955–58. Construction, 6'9" x 2'1" x 2'1" (2.06 x 0.64 x 0.64 m). Museum Ludwig, Cologne

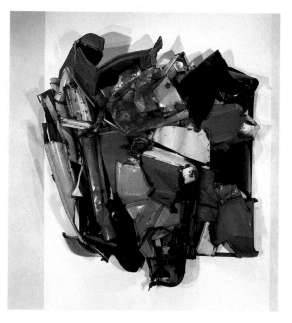

519. John Chamberlain. *Essex*. 1960. Automobile body parts and other metal, 9' x 6'8" x 3'7" (2.74 x 2.03 x 1.09 m). The Museum of Modern Art, New York

Gift of Mr. and Mrs. Robert C. Scull and purchase

having great conceptual intensity and aesthetic power, he suddenly began to produce sculpture of simple wood beams that refer to the human figure but do not directly represent it. They assume active "poses," some standing awkwardly off-balance, others dancing or tumbling, so that they charge the space around them with energy. Shapiro soon began casting them in bronze, which retains the impression of the rough wood grain (fig. 516). These are hand-finished with a beautiful patina by fine artisans, reasserting the skill traditional to sculpture. By freely rearranging the vocabulary of David Smith, who actually experimented with a similar figure before his death, Shapiro has given Minimalist sculpture a new lease on life. Nevertheless, his work remains one of the few successful attempts to revive contemporary sculpture, which on the whole has found it especially difficult to seek a new direction.

Martin Puryear Minimalism was a decisive influence on a group of talented African Americans who came to maturity as sculptors in the

1960s, although their contribution has only recently begun to receive critical attention. Their work has helped to make the late twentieth century the first great age of African American art. While the artists themselves show a variety of style, subject matter, and approach, all address the black experience in the United States within a contemporary abstract aesthetic. In this they have the advantage over African American painters, who have often been burdened by representationalism and traditional styles.

Martin Puryear (b. 1941), a leading sculptor on the American scene today, draws on his experience with the woodworkers of both Sierra Leone in western Africa, where he spent several years in the Peace Corps, and Sweden, where he attended the Royal Academy. Puryear manages to weld these disparate sources into a seamless unity. He adapts African motifs and materials to the modern Western tradition, relying on meticulous skill to bridge the gap. His forms, at once bold and refined, have an elegant simplicity that contrasts the natural and the handmade, the finished and the unfinished. They may evoke a saw, bow, fishnet, anthill, or, in this case, a basket (fig. 517)—whatever his memory suggests—each restated in whimsical fashion.

Constructions and Assemblage

Constructions present a difficult problem. If we agree to restrict the term *sculpture* to objects made largely or entirely of a single substance, then we must put assemblages (that is, constructions using mixed mediums) in a class of their own. This is probably a useful distinction because of their kinship with ready-mades. But what of Picasso's *Bull's Head* (see fig. 2)? Is it not an instance of assemblage, and have we not called it a piece of sculpture? Actually, there is no inconsistency here. The *Bull's Head* is a bronze cast, even though we cannot tell this by looking at a photograph of it. Had Picasso wished to display the actual handlebars and bicycle seat, he would surely have done so. Since he chose to have them cast in bronze, this must have been because he wanted to "dematerialize" the ingredients of the work by having them reproduced in a single material. Appar-

ently he felt it necessary to clarify the relation of image to reality in this way—the sculptor's way—and he used the same procedure whenever he worked with ready-made objects.

Some sculpture combine metal, string, wood, and other elements. Yet they do not strike us as being assemblages because these materials are not made to assert their separate identities. Conversely, an object may deserve to be called an assemblage even though composed of essentially homogeneous material. Such is often true of works known as junk sculpture, made of fragments of old machinery, parts of wrecked automobiles, and similar discards, which constitute a broad class that can be called sculpture, assemblage, or environment, depending on the work itself.

Robert Rauschenberg Painter Robert Rauschenberg (b. 1925) pioneered assemblage as early as the mid-1950s. Like a composer making music out of the noises of everyday life, he constructed works of art from the trash of urban civilization. *Odalisk* (fig. 518) is a box covered with a miscellany of pasted images—comic strips, photos, clippings from picture magazines—held together only by the skein of brushstrokes the artist has superimposed on them. The box perches on a foot improbably anchored to a pillow on a wooden platform and is surmounted by a stuffed chicken.

The title, a witty blend of *odalisque* and *obelisk*, refers both to the nude girls among the collage of clippings as modern "harem girls" and to the shape of the construction as a whole, for the box shares its verticality and slightly tapering sides with real obelisks. Rauschenberg's unlikely "monument" has at least some qualities in common with its predecessors: compactness and self-sufficiency. We will recognize in this improbable juxtaposition the same ironic intent as in the ready-mades of Duchamp, whom Rauschenberg had come to know well in New York.

John Chamberlain A most successful example of junk sculpture, and a puzzling borderline case of assemblage and sculpture, is *Essex* (fig. 519) by John Chamberlain (b. 1927). The

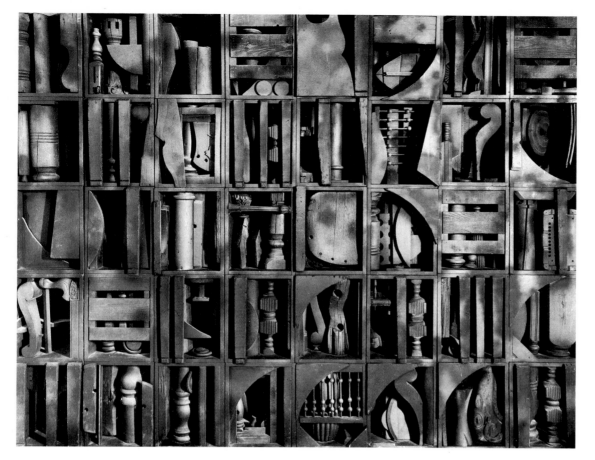

520. Louise Nevelson. *Black Cord*. 1964. Painted wood, 8' x 10' x 11¹/₂" (2.44 x 3.05 x 0.29 m). Collection Joel Ehrenkranz

title refers to a make of car that has not been on the market for many decades, suggesting that the object is a kind of homage to a vanished species. But we may well doubt that these pieces of enameled tin ever had so specific an origin. They have been carefully selected for their shape and color and have been composed in such a way that they form a new entity, evoking Duchamp-Villon's *The Great Horse* (see fig. 502) rather than the crumpled automobiles to which they once belonged.

Louise Nevelson Although it is almost always made entirely of wood, the work of Louise Nevelson (1900–88) must be classified as assemblage, and when extended to a monumental scale, it acquires the status of an environmental sculpture. Before Nevelson, no women had been recognized as important sculptors in twentieth-century America. Before the mid-nineteenth

century, women had been excluded from this medium as a rule in America. In the second half of the nineteenth century, the American Neoclassical sculptor Harriet Hosmer (1830–1908), among others, succeeded in legitimizing sculpture as a medium for women. This school of sculpture lapsed, however, when the sentimental, idealizing Neoclassical style fell out of favor around 1880.

In the 1950s, Nevelson rejected representation and began to construct a private reality, using her collection of found pieces of wood. At first these self-contained realms were miniature cityscapes. They soon grew into large environments of freestanding "buildings," encrusted with decorations that were inspired by the sculpture on Mayan ruins. Nevelson's work generally took the form of large wall units that flatten her structures into reliefs (fig. 520). Assembled from individual compartments, the

whole is always painted a single color, usually a matte black to suggest the shadowy world of dreams. Each compartment is elegantly designed and is itself a metaphor of thought or experience. While the organization of the ensemble is governed by an inner logic, the entire statement remains an enigmatic monument to the artist's fertile imagination.

Environments and Installations

Some artists associated with Pop art have turned to assemblage because they find the flat surface of the canvas too confining. In order to bridge the gap between image and reality, they often introduce three-dimensional objects into their pictures. Some even construct full-scale models of everyday things and real-life situations, utilizing every conceivable kind of material in order to embrace the entire range of their physical environment, including the people, in their work. These "environments" combine the qualities of painting, sculpture, collage, and stagecraft. Being three-dimensional, they can claim to be considered sculpture, but the claim rests on a convention that Pop art itself has helped make obsolete. According to this convention, a flat or smoothly curved work of art covered with pigments is a painting (or, if the surface consists mainly of lines, a print or drawing). Everything else is sculpture, regardless of medium or size—unless we can enter it, in which case we call it architecture.

Our habit of using the term *sculpture* in this sense is only a few hundred years old. Antiquity and the Middle Ages had different words to denote various kinds of sculpture according to the materials and working processes involved, but no single term covered them all. Perhaps it is time to revive such distinctions and to modify the all-inclusive definition of sculpture by acknowledging "environments" as a separate category, distinct from both painting and sculpture in their use of heterogeneous materials ("mixed mediums") and blurring of the borderline between image and reality. The differences are underscored by **installations**, which are expansions of environments into room-size settings.

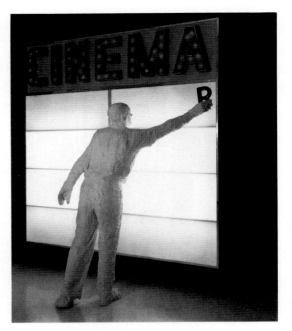

521. George Segal. *Cinema*. 1963. Plaster, metal, Plexiglas, and fluorescent light, 9'10" x 8' x 3'3" (3 x 2.44 x 0.99 m). The Albright-Knox Art Gallery, Buffalo, New York

Gift of Seymour H. Knox

George Segal George Segal (b. 1924) creates life-size three-dimensional pictures showing people and objects in everyday situations. The subject of *Cinema* (fig. 521) is ordinary enough to be instantly recognizable: a man changing the letters on a movie theater marquee. Yet the relation of image and reality is far more subtle and complex than the obvious authenticity of the scene suggests. The man's figure is cast from a live model by a technique of Segal's invention and retains its ghostly white plaster surface. Thus it is one crucial step removed from our world of daily experience, and the illuminated sign has been carefully designed to complement and set off the shadowed figure. Moreover, the scene is brought down from its natural context, high above the entrance to the theater where we might have glimpsed it in passing, and is presented at eye level, in isolation, so that we grasp it completely for the first time.

Edward Kienholz Some environments can have a shattering impact on the viewer. This is cer-

522. Edward Kienholz. *The State Hospital*. 1966. Mixed mediums, 8 x 12 x 10' (2.44 x 3.66 x 3.05 m). Moderna Museet, Stockholm

523. Judy Pfaff. *Dragons*. Installation at the Whitney Biennial, February–April 1981. Mixed mediums. Whitney Museum of American Art, New York
Courtesy Holly Solomon Gallery, New York

tainly true of *The State Hospital* (fig. 522) by the West Coast artist Edward Kienholz (b. 1927), which shows a cell in a ward for senile patients, with a naked old man strapped to the lower bunk. He is the victim of physical cruelty, which has reduced what little mental life he had almost to the vanishing point. His body is little more than a skeleton covered with leathery, discolored skin, and his head is a glass bowl with live goldfish, of which we catch an occasional glimpse. The horrifying realism of the scene even has an olfactory dimension. When the work was displayed at the Los Angeles County Museum of Art, it exuded a sickly hospital smell. But what of the figure in the upper bunk? It almost duplicates the one below, with one important difference: it is a mental image, since it is enclosed in the outline of a comic-strip balloon rising from the goldfish bowl. It represents, then, the patient's awareness of himself. The abstract devices of the balloon and the metaphoric goldfish bowl are both alien to the realism of the scene as a whole, but

they play an essential part in it: they make us think as well as feel. Kienholz's means may be Pop, but his aim is that of Greek tragedy. As a witness to the unseen miseries beneath the surface of modern life, he has no equal.

Judy Pfaff The installations of Judy Pfaff (b. 1946) can be likened to exotic indoor landscapes. The inspiration of nature is apparent in the junglelike density of *Dragons* (fig. 523), aptly named for its fiery forms and colors. Pfaff uses painting together with sculpture and various materials to activate architectural space. The treatment of the wall surface will remind us of the collage in *Odalisk* (see fig. 518), but Pfaff's playfulness is closer to Calder's whimsy (see fig. 509) than to Rauschenberg's ironic wit. The nearest equivalent to Pfaff's spontaneous energy is the Action painting of Pollock. It is as if the poured paint had been released from the canvas and left free to roam in space. The swirling profusion around the viewer makes for an experience that is at once pleasurable and vertiginous.

524. Joseph Kosuth. *One and Three Chairs*. 1965. Wooden folding chair, photographic copy of chair, and photographic enlargement of dictionary definition of chair; chair 32³/8 x 14⁷/8 x 20⁷/8" (82.2 x 37.8 x 53 cm); photo panel 36 x 24¹/8" (91.5 x 61.1 cm); text panel 24 x 24¹/8" (61 x 61.3 cm). The Museum of Modern Art, New York

Larry Aldrich Foundation Fund

Conceptual Art

Conceptual art has the same "patron saint" as Pop art: Marcel Duchamp. It arose during the 1960s out of the Happenings staged by Alan Kaprow, in which the event itself became the art. Conceptual art challenges our definition of art more radically than Pop, insisting that the leap of the imagination, not the execution, is art. According to this view, since the works of art are incidental by-products of the imaginative leap, they can be dispensed with altogether; so too can galleries and, by extension, even the artist's public. The creative process need only be documented in some way. Sometimes this is in verbal form, but more often it is by still photography, video, or film shown in an installation.

Conceptual art, we will recognize, is akin to Minimalism as a phenomenon of the 1960s, but instead of abolishing content, it eliminates aesthetics from art. This deliberately anti-art approach, stemming from Dada (see page 523), poses a number of stimulating paradoxes. As soon as the documentation takes on visible form, it begins to come perilously close to more traditional forms of art (especially if it is placed in a gallery where it can be seen by an audience), since it is impossible fully to divorce the imagination from aesthetic matters.

Joseph Kosuth *One and Three Chairs* (fig. 524) by Joseph Kosuth (b. 1945), which is clearly indebted to Duchamp's ready-mades (see fig. 506), "describes" a chair by combining in one installation an actual chair, a full-scale photograph of that chair, and a printed dictionary definition of a chair. Whatever the Conceptual artist's intention, this making of the work of art, no matter how minimal the process, is as essential as it was for Michelangelo. In the end, all art is the final document of the creative process, because without execution, no idea can ever be fully realized. Without such "proof of performance," the Conceptual artist becomes like the emperor wearing new clothes that no one else can see. And, in fact, Conceptual art has embraced all of the mediums in one form or another.

Performance Art

Performance art, which originated in the early decades of this century, belongs to the history of theater, but the form that arose in the 1970s combines aspects of Happenings and Conceptual art with installations. In reaction to Minimalism, the artist now sought to assert his or her presence once again by becoming, in effect, a living work of art. The results, however, have relied mainly on the shock value of irreverent humor or explicit sexuality. Nevertheless, performance art emerged as perhaps the most characteristic art form of the 1980s.

Joseph Beuys The German artist Joseph Beuys (1921–86) managed to overcome these limitations, though he, too, was a controversial figure who incorporated an element of parody into his work. Life for Beuys was a creative process in which everyone is an artist. He assumed the guise of a modern-day shaman intent on heal-

525. Joseph Beuys. *Coyote*. Photo of performance at Rene Block Gallery, New York, 1974.

ing the spiritual crisis of contemporary life caused, he believed, by the rift between the arts and sciences. To find the common denominator behind such polarities, he created objects and scenarios that, though often baffling at face value, were meant to be accessible to the intuition. In 1974, Beuys spent one week caged up in a New York gallery with a coyote (fig. 525), an animal sacred to Native Americans but persecuted by others. His objective in this "dialogue" was to lift the trauma caused to an entire nation by the schism between the two opposing worldviews. That the attempt was inherently doomed to failure does not in any way reduce the sincerity of this act of conscience.

Nam June Paik The notes and photographs that document Beuys's performances hardly do them justice. His chief legacy today lies perhaps in the stimulation he provided his many students, including Anselm Kiefer (see page 547), and collaborators, among them Nam June Paik (b. 1932). The sophisticated video displays of the Korean-born Paik fall outside the scope of this book, but his installation with a Buddha

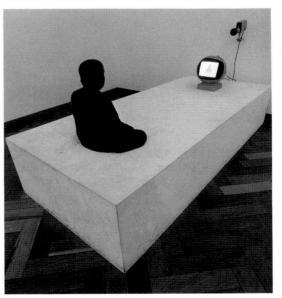

526. Nam June Paik. *TV Buddha*. 1974. Video installation with statue. Stedelijk Museum, Amsterdam

contemplating himself on a television monitor (fig. 526) is a memorable image uniquely appropriate to our age, in which the fascination with electronic mediums often seems to have replaced transcendent spirituality as the focus of modern life.

Chapter 27
Twentieth-Century Architecture

Modernism in twentieth-century architecture has meant first and foremost an aversion to decoration for its own sake, without a trace of historicism. Instead, modernism favors a clean functionalism, stripped of all adornment, that expresses the machine age and its insistent rationalism. Yet modern architecture demanded far more than a reform of architectural grammar and vocabulary. To take advantage of the expressive qualities of the new building techniques and materials that the engineer had placed at the architect's disposal, a new philosophy was needed. The leaders of modern architecture have characteristically been vigorous and articulate thinkers, in whose minds architectural theory is closely linked with ideas of social reform to meet the challenges posed by industrial civilization. To them, architecture's ability to shape human experience brings with it the responsibility to play an active role in molding modern society for the better.

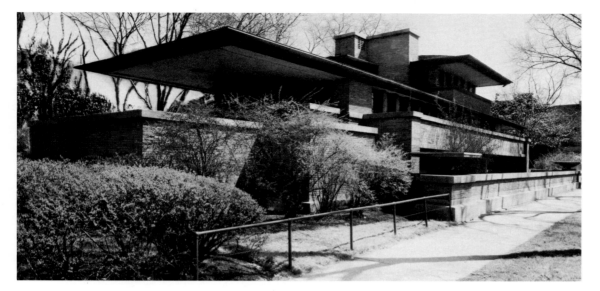

527. Frank Lloyd Wright. Robie House, Chicago. 1909

Architecture before World War I

Early Modernism

Frank Lloyd Wright The first indisputably modern architect was Frank Lloyd Wright (1867–1959), Louis Sullivan's great disciple. If Sullivan and van de Velde could be called the Post-Impressionists of architecture (Chapter 25), Wright took architecture to its Cubist phase. This is certainly true of his brilliant early style, which he developed between 1900 and 1909 and which had broad international influence. In the beginning, Wright's main activity was the design of suburban houses in the upper Midwest. These were known as Prairie houses because their low, horizontal lines were meant to blend with the flat landscape around them. His last, and his most accomplished, example in this series is the Robie House of 1909 (figs. 527, 528). The exterior, so unlike anything seen before, instantly proclaims the building's modernity. However, its "Cubism" is not merely a matter of the clean-cut rectangular elements composing the structure but of Wright's handling of space. It is designed as a number of "space blocks" around a central core, the chimney. Some of the blocks are closed and others are open, yet all are defined with equal precision. Thus, the space that has

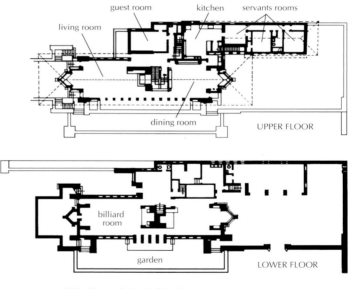

528. Plan of the Robie House

been architecturally shaped includes the balconies, terrace, court, and garden, as well as the house itself. Voids and solids are regarded as equivalents, analogous in their way to Analytic Cubism in painting, and the entire complex enters into an active and dramatic relationship with its surroundings. Wright did not aim simply to design a house but also to create a complete environment. He even took command of the details of the interior. Wright acted

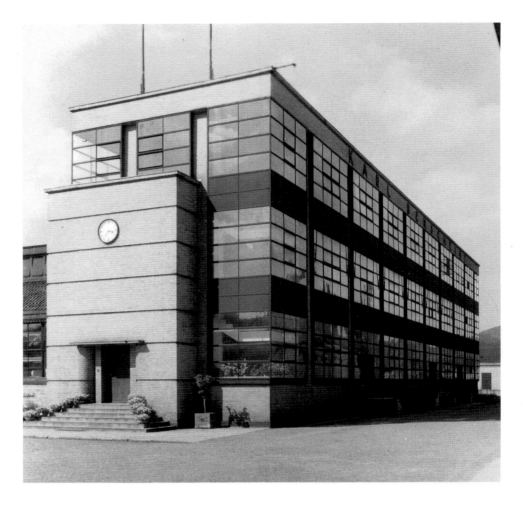

529. Walter Gropius and Adolf Meyer. Fagus Shoe Factory, Alfeld, Germany. 1911–14

out of a conviction that buildings have a profound influence on the people who live, work, or worship in them, making the architect, consciously or unconsciously, a molder of people.

Deutscher Werkbund In Europe, modern architecture developed more slowly and unevenly than in the States, and it came to maturity only on the eve of World War I. Central to the early development of modernism in Germany was the Deutscher Werkbund (artisans community), founded in 1907 by Hermann Muthesius (1861–1927) as an alliance of "the best representatives of art, industry, crafts and trades." Its mission under him became to translate the Arts and Crafts movement into a machine style using the most advanced techniques of industrial design and manufacturing. The way was led by Peter Behrens (1869–1940), the chief architect and designer for the electrical firm A.E.G., whose three disciples became the founders of modern architecture: Walter Gropius, Ludwig Mies van der Rohe, and Le Corbusier.

Walter Gropius The first to cross the threshold of modern architecture fully was Gropius (1883–1969). The Fagus Shoe Factory (fig. 529), designed with Adolph Meyer (1881–1929), represents the critical step toward modernism in European architecture. Only in the classically conceived entrance did the architects pay homage to the past. The most dramatic feature is the walls, which are a nearly continuous surface of glass. This radical innovation had been possible ever since the introduction several decades before of the structural steel skeleton,

which relieved the wall of any load-bearing function. Sullivan had approached it, but he could not yet free himself from the traditional notion of the window as a "hole in the wall." Far more radically than Sullivan or Behrens, Gropius frankly acknowledged, at last, that in modern architecture the wall is no more than a curtain or climate barrier, which may consist entirely of glass if maximum daylight is desirable. The result is rather surprising: since such walls reflect as well as transmit light, their appearance depends on the interplay of these two effects. They respond, as it were, to any change of conditions without and within, and they thus introduce a strange quality of life into the structure. (The mirrorlike finish of Brancusi's *Bird in Space* serves a similar purpose.) The same principles have been used on a much larger scale for skyscrapers ever since.

Max Berg Modern architecture incorporates Expressionism, which stresses artists' emotional attitude toward themselves and the world (see page 502). The spontaneous and irrational qualities of fantasy are not lacking either, but because the modern architect shares the Expressionist's primary concern with the human community, rather than the labyrinth of the imagination, fantasy plays a far lesser role than Expressionism, which has subsumed it.

The visionary side that distinguishes Expressionist architecture is well represented by the Centennial Hall in Breslau (fig. 530), designed in 1912 by Max Berg (1870–1948) to celebrate Germany's liberation from Napoleon a hundred years earlier. Berg, for the first time, has taken full advantage of reinforced concrete's incredible flexibility and strength, explained on page 476. The vast scale is not simply an engineering marvel but a visionary space. Ultimately the interior looks back to the Pantheon (see fig. 88), but with the solids and voids in reverse, so that we are reminded of nothing so much as the interior of Hagia Sophia (see fig. 115). Centennial Hall further recalls the soaring spirituality of a Gothic cathedral (such as our fig. 156)—not by coincidence, for Berg shared with Rouault and Nolde an intense religiosity, which later led him to abandon his profession.

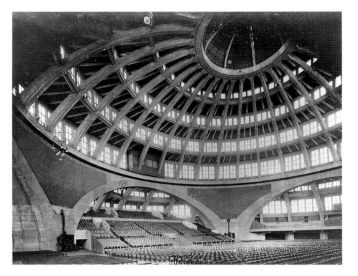

530. Max Berg. Interior of the Centennial Hall, Breslau, Germany. 1912–13

531. Antonio Sant'Elia. Central Station project for Città Nova (after Banham). 1914

Antonio Sant'Elia The final component of modernist architecture—its utopian side—was added by the Futurist Antonio Sant'Elia (1888–1916), who declared that "we must invent and reconstruct the Futurist city as an immense, tumultuous yard and the Futurist house as a gigantic machine." The Central Station project for his Città Nova (New City; fig. 531) is

planned in terms of circulation patterns that determine the relationships between buildings. This treatment establishes a restless motion that fulfills the Futurist vision announced in Boccioni's work (see figs. 455, 503). But it is the enormous scale, dwarfing even the most grandiose complexes of the past, that makes this a uniquely modern conception. It even includes a runway for airplanes, impractical as that may seem.

Architecture between the Wars

By the onset of World War I, the stage was set for a modern architecture. But which path would it follow—the impersonal standard of the machine aesthetic advocated by Muthesius or the individual creativity espoused by van de Velde. Ironically, the issue was decided by van de Velde's choice of Behrens's disciple Walter Gropius as his successor at the Weimar School of Arts and Crafts in Germany. Yet the onset of the war effectively postponed the further development of modern architecture for nearly a decade. When it resumed in the 1920s, the outcome of the issues posed at the Cologne Werkbund exhibition in 1914 was by no means clear. Rather than a simple linear progression, we find a complex give and take between modernism and competing tendencies representing traditional voices and alternative visions. This varied response has its parallel in the art of the period, which largely rejected abstraction in favor of fantasy, Expressionism, and Realism.

Gerrit Rietveld The work of Frank Lloyd Wright attracted much attention in Europe by 1914. Among the first to recognize its importance were some young Dutch architects who, a few years later, joined forces with Mondrian in the de Stijl movement (see page 522). Among their most important experiments is the Schröder House, designed by Gerrit Rietveld (1888–1964) in 1924 for Truus Schröder, an artist. The facade looks like a Mondrian painting transposed into three dimensions, for it utilizes the same rigorous abstraction and refined geometry (fig. 532). The lively arrangement of floating panels and intersecting planes is based on Mon-

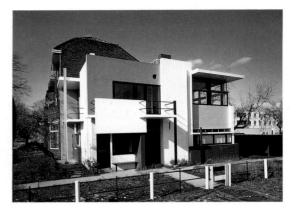

532. Gerrit Rietveld. Schröder House, Utrecht, the Netherlands. 1924

drian's principle of dynamic equilibrium: the balance of unequal but equivalent oppositions, which expresses the mystical harmony of humanity with the universe. Steel beams, rails, and other elements are painted in bright, primary colors to articulate the composition. Unlike the elements of a painting by Mondrian, the exterior parts of the Schröder House look as if they can be shifted at will, though in fact they fit as tightly as interlocking pieces of a jigsaw puzzle. Not a single element could be moved without destroying the delicate balance of the whole. Inside, the living quarters can be reconfigured through a system of sliding partitions to suit the lifestyle of the owner.

The Schröder House proclaims a utopian ideal widely held in the early twentieth century. The machine would hasten our spiritual development by liberating us from nature, with its conflict and imperfection, and by leading us to the higher order of beauty reflected in the architect's clean, abstract forms. The harmonious design of the Schröder House owes its success to the insistent logic of this aesthetic, which we respond to intuitively even without being aware of its ideology. Yet the design, far from being impersonal, is remarkably intimate.

The International Style

The Bauhaus The Schröder House was recognized immediately as one of the classic statements of modern architecture. The de Stijl

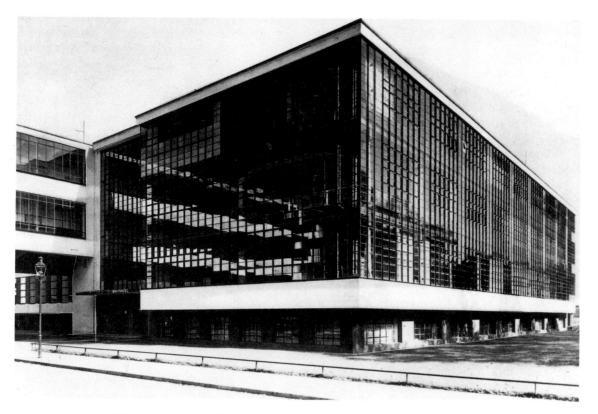

533. Walter Gropius. Shop Block, the Bauhaus, Dessau, Germany. 1925–26

architects represented the most advanced ideas in European architecture in the early 1920s. They had a decisive influence on so many architects abroad that the movement soon became international. The largest and most complete example of this International Style of the 1920s is the group of buildings created in 1925–26 by Walter Gropius for the Bauhaus in Dessau, the famous German art school, of which he was the director. The most dramatic building is the Shop Block, a four-story box with walls that are a continuous surface of glass (fig. 533). It is a fully mature statement of the principles announced ten years earlier in Gropius's Fagus Shoe Factory (see fig. 529). More important than this individual structure, however, is the complex as a whole and what it stood for (fig. 534).

During its Weimar phase, the Bauhaus (which was the result of merging two separate schools) tried to fulfill the goals of the Arts and Crafts movement, but the traditional attitudes

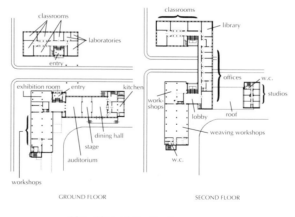

534. Plan of the Bauhaus.

toward the arts and crafts were too different for this romantic dream to succeed. In consequence, a deep split quickly developed between the "workshop masters," who were responsible for practical crafts, and the "masters of form," whom Gropius invited to teach theory, such as Kandinsky and Klee. The arrival of Laszlo

Moholy-Nagy, a Hungarian follower of the Constructivists (see pages 553–54), and then Josef Albers gave the curriculum a far more rational basis. But it was the move to the city of Dessau, which invited the school to transfer there when it was closed down for a while by the government of Weimar, that proved decisive. The character of the Bauhaus is reflected in Gropius's design. The curriculum embraced all the visual arts, linked by the root concept of "structure" (*Bau*). It included, in addition to an art school, departments of industrial design under Marcel Breuer, graphic art under Herbert Bayer, and architecture, whose chief representative was Ludwig Mies van der Rohe (see page 579), the Bauhaus's last director. Gropius's buildings at Dessau incorporate elements of de Stijl and Constructivism, just as the school accommodated a range of temperaments and approaches. The Shop Block proclaims the Bauhaus's frankly practical approach. Yet the complex promoted a remarkable community spirit, which was entirely different from the factionalism Gropius had inherited from van de Velde at Weimar. The Bauhaus thus embodied Gropius's tolerant but unified vision. Not surprisingly, the school did not long outlast his departure in 1929 to pursue architecture full-time. After his handpicked successor, Hannes Meyer (1889–1954), was forced to resign because of his ▼MARXIST leanings, Mies van der Rohe tried vainly to revive the school's fortunes, but it was closed by the Dessau parliament. By then, most of its leaders had left, and after a final attempt to reopen it as a private school in Berlin, the Bauhaus was shut down by the Nazis in 1933.

Le Corbusier In France, the most distinguished representative of the International Style during the 1920s was the Swiss-born architect Le Corbusier (Charles-Édouard Jeanneret, 1887–1965). At that time, he built only private homes (from necessity, not choice), but they are worthy successors to Wright's Prairie houses and Rietveld's Schröder House. Le Corbusier called them *machines à habiter* ("machines to live in"), a term intended to suggest his admiration for the clean, precise shapes of machinery, not the Futurist

desire for "mechanized living." (The paintings of his friend Fernand Léger during those years reflect the same attitude; see fig. 465.) Perhaps he also wanted to imply that his houses were so different from conventional homes as to constitute a new species.

The most famous of them, the Villa Savoye at Poissy-sur-Seine (fig. 535), resembles a low, square box resting on stilts—pillars of reinforced concrete that form part of the structural skeleton and reappear to divide the "ribbon windows" running along each side of the box. The flat, smooth surfaces, denying all sense of weight, stress Le Corbusier's preoccupation with abstract "space blocks." The functionalism of the Villa Savoye is governed by a "design for living," not by mechanical efficiency. Within the house, we are still in communication with the outdoors, but we enjoy complete privacy, since an observer on the ground cannot see us unless we stand next to a window.

Alvar Aalto Although the style and philosophy of the International Style were codified around 1930 by an international committee of Le Corbusier and his followers, soon all but the most purist among them began to depart from this standard. One of the first to break ranks was the Finnish architect Alvar Aalto (1898–1976), whose Villa Mairea (fig. 536) reads at first glance like a critique of Le Corbusier's Villa Savoye of a decade earlier. Like Rietveld's Schröder House, Villa Mairea was designed for a woman who was an artist. This time, however, the architect was given a free hand by his patron, and the building is a summation of ideas Aalto had been developing for nearly ten years. He adapted the International Style to the traditional architecture, materials, lifestyle, and landscape of Finland. Aalto's primary concern was human needs, both physical and psychological, which he sought to harmonize with functionalism. The modernist heritage, extending back to Wright, is unmistakable in his vocabulary of forms and massing of elements; yet everywhere there are romantic touches—such as the use of wood, brick, and stone—that add a warmth absent from Le

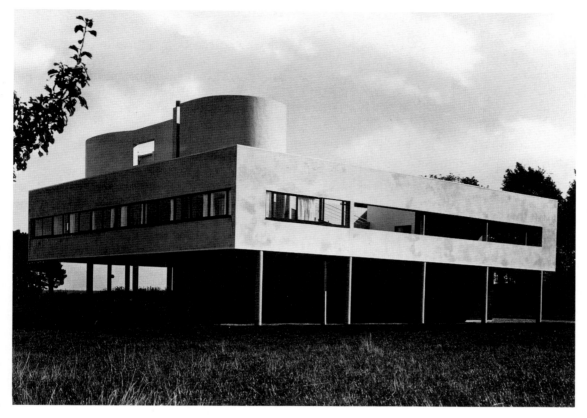

535. Le Corbusier. Villa Savoye, Poissy-sur-Seine, France. 1929–30

Corbusier's pristine classicism. Free forms are employed to break up the cubic geometry and smooth surfaces favored by the International Style. Aalto's importance is undeniable, but his place in twentieth-century architecture remains unclear. His infusion of nationalist elements in the Villa Mairea has been interpreted both as a rejection of modernism and as a fruitful regional variation on the International Style. Today his work can be seen as a direct forerunner of Postmodern architecture (see pages 599–600).

The Skyscraper in the United States The United States, despite its early position of leadership, did not share the exciting growth that took place in European architecture during the 1920s. The impact of the International Style did not begin to be felt on its side of the Atlantic until the very end of the decade. A

536. Alvar Aalto. Villa Mairea, Noormarkku, Finland. 1937–38

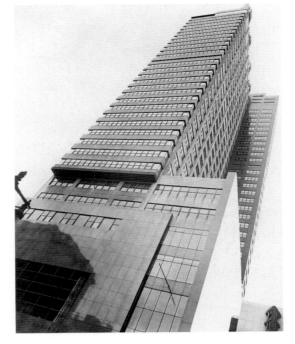

537. George Howe and William E. Lescaze. Philadelphia Savings Fund Society Building, Philadelphia. 1931–32

pioneer example of its arrival is the Philadelphia Savings Fund Society Building of 1931–32 (fig. 537) by George Howe (1886–1954) and William E. Lescaze (1896–1969). It is the first skyscraper built anywhere to incorporate many features that evolved in Europe after the end of World War I. The skyscraper was of compelling attraction to modernist architects in Europe as the embodiment of the *idea* of the United States, and during the 1920s Gropius and Mies designed several prototypes that were remarkably advanced for their time. Yet none was erected, while those constructed in the United States were sheathed in a variety of mostly revival styles, especially the Gothic. Although they quickly became the most characteristic form of American architecture, even the skyscrapers of the 1930s—when many of the most famous ones, such as the Empire State Building, were erected—are in the tradition of Sullivan and do little to expand on the Wainwright Building (see fig. 438) except to make it bigger. Despite the fact that it does not adhere rigorously enough to the International Style to satisfy purists, the skyscraper of Howe and Lescaze is a landmark in the history of architecture that, remarkably enough, was not to be surpassed for another twenty years (compare fig. 539).

Design

Like their predecessors in the Rococo, many of the great architects since Gaudí and Mackintosh have also been important designers who exercised an incalculable influence on others. The reason is not hard to find: they have had a unique, even privileged, understanding of modernism, its meaning, materials, and techniques. Their designs, like their buildings, have generally expressed the machine age through clean lines and cubic shapes bereft of unnecessary decoration. This was particularly true of the Bauhaus, where architecture and design were closely linked. The Bauhaus nevertheless failed in its goal of unifying the arts and putting the decorative arts on the same level as the fine arts. The main reason was that its members were far more gifted in architecture and painting than in design, despite the considerable emphasis placed on this area.

Gropius himself considered Bauhaus designs as models for the future that would fulfill his goal of providing high-quality wares to everyone through mass manufacturing techniques, although only under Hannes Meyer's directorship was design placed at the service of people's practical needs. The interiors of the "masters' houses" designed by Marcel Breuer (1902–81) reflect the school's outlook (fig. 538). They have an almost monastic asceticism that is further emphasized by the stark simplicity of the furnishings. Breuer's famous chair, in the foreground, is a marvel of elegant geometry for its own sake—without regard to comfort, as anyone who has ever sat in one can attest. Here, then, is the chief limitation of so much of twentieth-century design: the tyranny of form over human considerations.

Architecture since 1945

High Modernism

Following the rise of the Nazis, the best German architects, whose work Hitler condemned as "un-German," emigrated to the United States and greatly stimulated the development of American architecture. Gropius, who was appointed chair of the architecture department at Harvard Uni-

versity, had an important educational influence. Ludwig Mies van der Rohe (1886–1969), his former colleague at Dessau, settled in Chicago as a practicing architect. After the war, they were to realize the dream of modern architecture, contained in germinal form in their buildings of the 1930s but never fully implemented. We may call the style that dominated architecture for twenty-five years after World War II High Modernism, for it was indeed the culmination of the developments that had taken place during the first half of the twentieth century.

Ludwig Mies van der Rohe The crowning achievement of American architecture in the postwar era was the modern skyscraper, defined largely by Mies van der Rohe. The Seagram Building in New York, designed with his disciple Philip Johnson (fig. 539), carries the principles announced in Gropius's architectural design for the Bauhaus to their ultimate conclusion: the Seagram Building, by applying the principles developed by Louis Sullivan and Frank Lloyd Wright—Mies van der Rohe's great predecessors in Chicago—extends the structure to a vast height. Yet the building looks like nothing before it. Though not quite a pure box, it exemplifies Mies's famous dictum that "less is more." This alone does not explain the difference, however. Mies discovered the perfect means to articulate the skyscraper in the I beam, its basic structural member, which rises continuously along nearly the entire height of the facade. (The actual skeleton of the structure remains completely hidden from view.) The effect is as soaring as the **responds** inside a Gothic cathedral (compare fig. 160)—and with good reason, for Mies believed that "structure is spiritual." He achieved the effect through the lithe proportions, which create a perfect balance between the play of horizontal and vertical forces. This harmony expresses the idealism, social as well as aesthetic, that underlies High Modernism in architecture.

Urban Planning

Mies van der Rohe belongs to the same heroic generation as Gropius and Le Corbusier; all were born in the 1880s. In the course of their long,

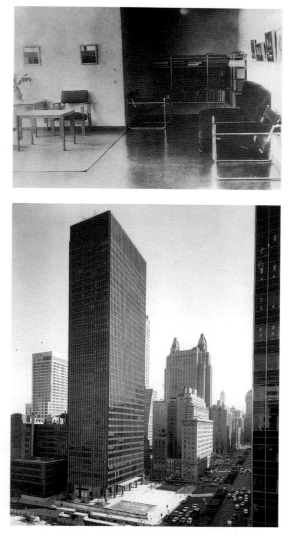

538. Marcel Breuer. The living room of Josef and Anni Albers, Master's House, Bauhaus, Dessau, Germany. c. 1929

539. Ludwig Mies van der Rohe and Philip Johnson. Seagram Building, New York. 1954–58

fruitful careers, these geniuses coined the language of twentieth-century architecture. Their successors continue to use many elements of its vocabulary in new building types and materials without forgetting the fundamental logic of the system. To some younger architects, the greatest challenge is not the individual structure but urban design, which involves marshaling the political, social, and economic resources of an entire society. Urban planning is probably as old as civilization itself (the term *civilization* in fact means "city life"). Its history is difficult to trace by direct visual evidence. Cities, like living organisms, are ever-changing, and to reconstruct their pasts from their present appearances is not an easy task. With the advent of the industrial era two centuries ago, cities began to grow explo-

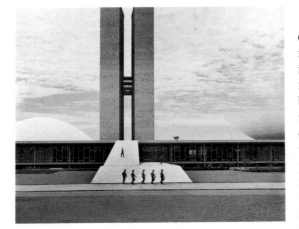

540. Oscar Niemeyer. Brasília, Brazil. Completed 1960

sively. Much of this growth was uncontrolled. The unfortunate result can be seen in the overcrowded, crumbling apartment blocks that are the blight of vast urban areas. Architects, however, have generally failed in their social mandate to replace the slums of our decaying cities with housing that will provide a socially healthful environment for very large numbers of people.

Oscar Niemeyer Nowhere are the issues facing modern civilization put into sharper relief than in the grandiose urban projects conceived by modern architects. These utopian visions may be regarded as laboratory experiments that seek to redefine the role of architecture in shaping our lives and to pose new solutions. Limited by their very scope, few of these ambitious proposals make it off the drawing board. Among the rare exceptions is Brasília, the inland capital of Brazil, built entirely since 1960. Presented with an unparalleled opportunity to design a major city from the ground up and with vast resources at its disposal, the design team, headed by the Brazilian Oscar Niemeyer (b. 1907), achieved undeniably spectacular results (fig. 540). Like most projects of this sort, Brasília's massive scale and insistent logic make it overwhelming and oppressive, so that, despite the lavish display, the city provides a chilling glimpse of the future.

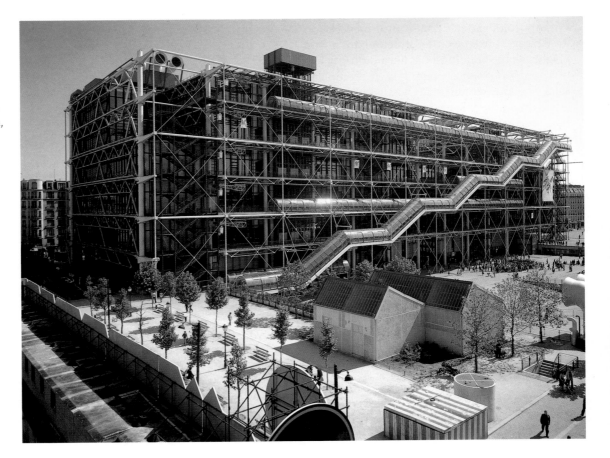

541. Richard Rogers and Renzo Piano. Centre National d'Art et de Culture Georges Pompidou, Paris. 1971–77

Late Modernism

Since 1970, architecture has been obsessed with breaking the tyranny of the cube—and the High Modernism it stands for. In consequence, a wide range of tendencies has arisen, representing almost every conceivable point of view. This variety has made architecture perhaps the most vital of the arts in the last quarter of the twentieth century. Like so much else in contemporary art, architecture has become theory-bound. Yet once the dust settles, we may simplify these bewildering categories, with their equally confusing terminology, into Late Modernism, Postmodernism, and Deconstructivism (see Chapter 29). These classifications are separated only by the degree to which they challenge the basic principles of High Modernism.

Richard Rogers and Renzo Piano Late Modernism began innocuously enough as an attempt to introduce greater variety of form and material but ended in the segmentation of space and use of high-tech finishes that are the hallmarks of late-twentieth-century buildings. Among the freshest, as well as most controversial, results of Late Modernism is the Centre Georges Pompidou, the national arts and cultural center in Paris, which rejects the formal beauty of the International Style without abandoning its functionalism (fig. 541). Selected in an international competition, the design by the Anglo-Italian team of Richard Rogers (b. 1933) and Renzo Piano (b. 1937) looks like the Bauhaus (see fig. 533) turned inside out. The architects have eliminated any trace of Van der Rohe's elegant facades (see fig. 539), exposing the building's inner mechanics while disguising the underlying structure. The interior itself has no fixed walls, so that temporary dividers can be arranged to meet any need. This stark utilitarianism expresses a populist sentiment current in France. Yet it is enlivened by eye-catching colors, each keyed to a different function. The festive display is as vivacious and imaginative as Léger's *The City* (see fig. 465), which, with Paris's Eiffel Tower, can be regarded as the Pompidou Center's true ancestor.

542. Foster Associates. Hongkong Bank, Hong Kong. 1979–86

Norman Foster Rogers helped to bring Late Modernism to maturity in a series of buildings that inspired the wrath of conservative Prince Charles of England. We can see why in the Hongkong Bank, designed by Norman Foster, one of Rogers's former associates (fig. 542). It testifies to the company's desire to have the most beautiful building in the world. (It is certainly the most expensive that money can buy.) Everything about the structure is extreme. The huge scale represents the megalomania of some modern corporations and the architects who work for them. The edifice was intended quite consciously as a cathedral of banking. Like a Gothic cathedral, the reinforcing members of this capitalist "church" are located on the exterior in the form of bizarre struts (compare fig. 157). The Hongkong Bank has been hailed as a brilliant architectural feat and has been condemned as a monstrosity that offers a nightmarish vision of the future. In any event, there can be little doubt that both the principles and the vocabulary of the International Style have been abandoned. One may consider the building to be an example of Late Modernism or of Postmodernism (Chapter 29) with equal justification. Whatever we choose to call it, we have clearly reached the end of High Modernist architecture.

Chapter 28
Twentieth-Century Photography

During the nineteenth century, photography struggled to establish itself as art but failed to find an identity. Only under extraordinary conditions of political upheaval and social reform did it address the most basic subject of art, which is life itself. In forming an independent vision, photography would combine the aesthetic principles of the Secession and the documentary approach of photojournalism with lessons learned from motion photography. At the same time, modern painting, with which it soon became allied, forced a decisive change in photography by undermining its aesthetic assumptions and posing a new challenge to its credentials as one of the arts. Like the other arts, photography responded to the three principal currents of our time: Expressionism, abstraction, and fantasy. But because it has continued to be devoted for the most part to the world around us, modern photography has adhered largely to realism and, hence, has followed a separate evolution. We must therefore discuss twentieth-century photography primarily in terms of different schools and how they have dealt with those often-conflicting currents.

The course pursued by modern photography was facilitated by technological advances. It must be emphasized, however, that these advances have increased but not dictated the photographer's options. George Eastman's invention of the hand-held camera in 1888 and the advent of 35mm photography with the Leica camera in 1924 made it easier to take pictures that had been difficult but by no means impossible to take with the traditional view camera. Surprisingly, even color photography did not have such revolutionary importance as might be expected. Color, in fact, has had a relatively modest impact on the content, outlook, and aesthetic of photography, even though it removed the last barrier cited by nineteenth-century critics of photography as an art.

543. Eugène Atget. *Pool, Versailles*. 1924. Albumen-silver print, 7 x 9³/₈" (17.8 x 23.9 cm).
The Museum of Modern Art, New York

Abbott-Levy Collection. Partial gift of Shirley C. Burden

The First Half Century

The Paris School

Eugène Atget Modern photography began quietly in Paris with Eugène Atget (1856–1927), who turned to the camera only in 1898, at the age of forty-two. From then until his death, he toted his heavy equipment around Paris, recording the city in all its variety. Atget was all but ignored by the art photographers, for whom his commonplace subjects had little interest. He himself was a humble person whose studio sign read simply, Atget—Documents for Artists, and, indeed, he was patronized by the founders of modern art: Braque, Picasso, Duchamp, and Man Ray (see page 591), to name only the best known. It is no accident that these artists were also admirers of Henri Rousseau, for Rousseau and Atget had in common a naive vision, though Atget found inspiration in unexpected corners of his environment rather than in magical realms of his imagination.

Atget's pictures are marked by a subtle intensity and technical perfection that heighten the reality and hence the significance of even the most mundane subject. Few photographers have equaled his ability to compose simultaneously in two- and three-dimensional space. Like *Pool, Versailles* (fig. 543), of 1924, his scenes are often desolate, bespeaking a strange and individual outlook. The viewer has the haunting sensation that time has been transfixed by the stately composition and the photographer's obsession with textures. Atget's photographs are directly related to a strain of magic realism that was a forerunner of Surrealism, and it is easy to see why he was rediscovered by Man Ray, the Dadaist and Surrealist artist-photographer.

Henri Cartier-Bresson The culmination of the Paris school of photography is no doubt Henri Cartier-Bresson (b. 1908), the son of a wealthy thread manufacturer. He studied under a Cubist painter in the late 1920s before taking up photography in 1932. Strongly affected at

544. Henri Cartier-Bresson. *Mexico, 1934*. 1934. Gelatin-silver print

first by Atget, Man Ray (see page 591), and even motion pictures, he soon developed into the most influential photojournalist of his time. His purpose and technique are nevertheless those of an artist.

Cartier-Bresson is the supreme practitioner of capturing what he has termed "the decisive moment." This phrase to him means the instant recognition and visual organization of an event at the most intense moment of action and emotion in order to reveal its inner meaning, not simply to record its occurrence. Unlike other members of the Paris school, he seems to feel at home anywhere in the world and always to be in sympathy with his subjects, so that his photographs have a nearly universal appeal. His photographs are distinguished by an interest in composition for its own sake, derived from modern abstract art. He also has a particular fascination with motion, which he invests with all the dynamism of Futurism and the irony of Dada. The key to his work is his use of

space to establish relations that are suggestive and often astonishing. Indeed, although he deals with reality, Cartier-Bresson is a Surrealist at heart. The results can be disturbing, as in *Mexico, 1934* (fig. 544). By omitting the man's face, Cartier-Bresson prevents us from identifying the meaning of the gesture, yet we respond to its tension no less powerfully.

The United States

Alfred Stieglitz The founder of modern photography in the United States was Alfred Stieglitz, whose influence remained dominant throughout his life (1864–1946). From his involvement with the Photo-Secession onward (see page 499), he was a tireless spokesperson for photography-as-art, although he defined this role more broadly than did other members of the movement. He backed his words by publishing the magazine *Camera Work* and supporting other pioneers of American photog-

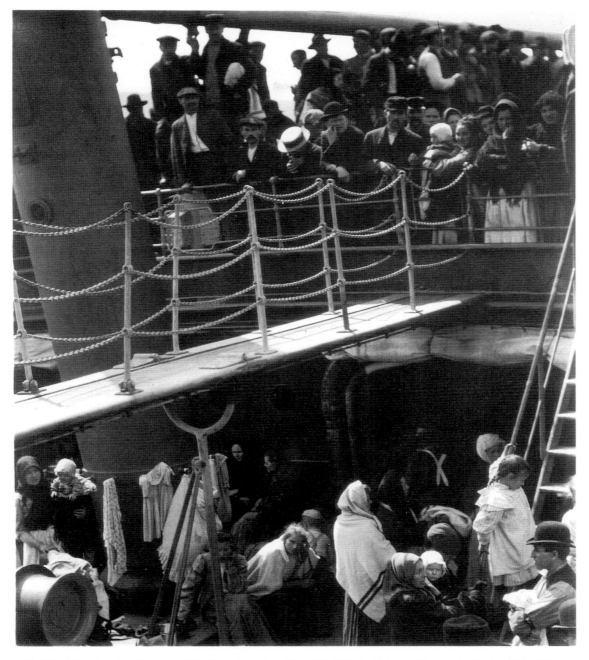

545. Alfred Stieglitz. *The Steerage*. 1907. Chloride print, 4³/₈ x 3⁵/₈" (11.1 x 9.2 cm). The Art Institute of Chicago

Alfred Stieglitz Collection

raphy through exhibiting their work in his New York galleries, especially the first one, known as 291. The bulk of his early work adheres to Secessionist conventions, treating photography as a pictorial equivalent to painting. During the mid-1890s, however, he took

some pictures of street scenes that foretell his mature photographs.

His classic statement, and the one he regarded as his finest photograph, is *The Steerage* (fig. 545). Taken in 1907 on a trip to Europe, it captures the feeling of a voyage by letting the

546. Alfred Stieglitz. *Equivalent*. 1930. Chloride print. The Art Institute of Chicago

Alfred Stieglitz Collection

shapes and composition tell the story. The gangway bridge divides the scene visually, emphasizing the contrasting activities of the people below in the steerage, which was reserved for the cheapest fares, and the observers on the upper deck. What it lacks in obvious sentiment it makes up for by remaining true to life.

This kind of "straight" photography is deceptive in its simplicity, for the image mirrors the feelings that stirred Stieglitz. For that reason, it marks an important step in his evolution and a turning point in the history of photography. Its importance emerges only in comparison with earlier photographs such as Steichen's *Rodin* and Riis's *Bandits' Roost* (see figs. 443, 439). *The Steerage* is a pictorial statement independent of painting on the one hand and free from social commentary on the other. It represents the first time that documentary photography achieved the level of art in the United States.

Stieglitz's straight photography formed the basis of the American school. It is therefore ironic that it was Stieglitz, with Steichen's encouragement, who became the champion of abstract art against the urban realism of the Ashcan School (see page 518), whose paintings were at face value often similar in content and appearance to his photographs. The resemblance is misleading. For Stieglitz, photography was less a means of recording things than of expressing his experience and philosophy of life, much as a painter does.

This attitude culminated in his "Equivalents." In 1922, Stieglitz began to photograph clouds to "show that his work was independent of subject and personality." A remarkably lyrical cloud photograph from 1930 (fig. 546) corresponds to a state of mind waiting to find full expression rather than merely responding to the moonlit scene. The study of clouds is as old as Romanticism itself, but no one before Stieglitz had made them a major theme in photography. As in Käsebier's *The Magic Crystal* (see fig. 442), unseen forces are evoked that make *Equivalent* a counterpart to Kandinsky's *Sketch I for "Composition VII"* (see fig. 450).

Edward Weston Stieglitz's concept of Equivalents opened the way to "pure" photography as an alternative to straight photography. The leader of this new approach was Edward Weston (1886–1958), who, although not Stieglitz's protégé, was decisively influenced by him. During the 1920s, Weston pursued abstraction and realism as separate paths, but by 1930 he fused them in images that are wonderful in their design and miraculous for their detail. *Pepper* (fig. 547) is a splendid example that is anything but a straightforward record of this familiar fruit. Like Stieglitz's Equivalents, Weston's photography makes us see the mundane with new eyes. The pepper is shown with preternatural sharpness and so close up that it seems larger than life. Thanks to the tightly cropped composition, we are forced to contemplate the form, whose every undulation is revealed by the dramatic lighting. *Pepper* has the sensuousness of O'Keeffe's *Black Iris III* (see fig. 475) that lends the Equivalent a new meaning. Here the shapes are intentionally suggestive of the photographs of the female nude that Weston also pioneered.

Ansel Adams To achieve uniform detail and depth, Weston worked with the smallest possible camera lens openings, and his success led to the formation, in 1932, of the West Coast society known as Group f/64, for the smallest lens opening. Among the founding members was Ansel Adams (1902–84), who soon became

the foremost nature photographer in the United States.

Adams was a meticulous technician, beginning with the composition and exposure and continuing through the final printing. His justifiably famous work *Moonrise, Hernandez, New Mexico* (fig. 548) came from pure serendipity that could never be repeated, a perfect marriage of straight and Equivalent photography. As in all of Adams's pictures, there is a full range of tonal nuances, from clear whites to inky blacks. The key to the photograph lies in the low cloud that divides the scene into three zones, so that the moon appears to hover effortlessly in the early evening sky.

Margaret Bourke-White Stieglitz was among the first to photograph skyscrapers, the new architecture that came to dominate the horizon of America's growing cities. In turn, he championed the Precisionist painters (see page

547. Edward Weston. *Pepper*. 1930. Center for Creative Photography, Tucson, Arizona

548. Ansel Adams. *Moonrise, Hernandez, New Mexico*. 1941. Gelatin-silver print, 15 x 18$^{1/2}$" (38.1 x 47 cm). The Museum of Modern Art, New York
Gift of the photographer

549. Margaret Bourke-White. *Fort Peck Dam, Montana, 1936*
Time-Life Inc.

550. James Van Der Zee. *At Home*. 1934. James Van Der Zee Estate

▼ Precipitated by a massive crash of the stock market in 1929, America and eventually most of the world experienced the twelve-year-long GREAT DEPRESSION. No other modern economic crisis has been as long-lasting or as severe. At the nadir in 1933, one-third of the available American workforce was unemployed. Many in the middle class lost all their savings and property, and personal misery was very widespread. Only when the United States began shifting to a military economy in 1941 did the Great Depression begin to retreat.

521), who began to depict urban and industrial architecture around 1925 under the inspiration of Futurism. Several of them soon took up the camera as well. Thus, painting and photography once again became closely linked. Both were responding to the revitalized economy after World War I, which led to an unprecedented industrial expansion on both sides of the Atlantic. During the subsequent ▼GREAT DEPRESSION of 1929 to about 1941, industrial photography continued surprisingly to grow with the new mass-circulation magazines that ushered in the great age of photojournalism and, with it, of commercial photography. In the United States, most of the important photographers were employed by the leading journals and corporations.

Margaret Bourke-White (1906–71) was the first staff photographer hired by *Fortune* magazine and then by *Life* magazine. Her cover photograph of Fort Peck Dam in Montana for the inaugural November 23, 1936, issue of *Life* remains a classic example of the new photojournalism (fig. 549). The decade witnessed enormous building campaigns, and with her keen

eye for composition, Bourke-White drew a visual parallel between the dam and the massive constructions of ancient Egypt (compare fig. 31). In addition to their architectural power, Bourke-White's columnar forms have a remarkable sculptural quality and an almost human presence, looming like colossal statues at the entrance to a temple. But unlike the pharaohs' passive timelessness, these "guardian figures" have the spectral alertness of Henry Moore's abstract monoliths (see fig. 510). Bourke-White's rare ability to suggest multiple levels of meaning made this cover and her accompanying photo essay a landmark in photojournalism.

James Van Der Zee The nature of the Harlem Renaissance, which flourished in New York in the 1920s, was hotly debated by African American critics even in its own day. While its achievement in literature is beyond dispute, the photography of James Van Der Zee (1886–1983) is often regarded today as its chief contribution to the visual arts. Much of Van Der Zee's work is commercial and variable in quality, yet it remains of great documentary value and, at its

best, provides a compelling portrait of an era. Van Der Zee had an acute understanding of settings as reflections of people's sense of place in the world, which he used to bring out a sitter's character and dreams. Though posed in obvious imitation of fashionable photographs of white society, his picture of the wife of the Reverend George Wilson Becton (fig. 550), taken two years after the popular pastor of the Salem Methodist Church in Harlem was murdered, shows Van Der Zee's unique ability to capture the pride of African Americans whose dreams seemed on the verge of being realized.

Germany

With the New Objectivity movement in Germany during the late 1920s and early 1930s (see page 530), photography achieved a degree of excellence that has not been surpassed. Fostered by the invention of superior German cameras and the boom in publishing everywhere, this German version of straight photography emphasized materiality at a time when many other photographers were turning away from the real world. New Objectivity photographs brought out the intrinsic beauty of things through their clarity of form and structure. Their approach accorded with Bauhaus principles except with regard to function (see pages 575–76).

August Sander When applied to people rather than things, the New Objectivity could have deceptive results. August Sander (1876–1964), whose book *Face of Our Time* was published in 1929, concealed its intentions behind a disarmingly straightforward surface. The sixty portraits provide a devastating survey of Germany during the rise of the Nazis, who later suppressed the book. Clearly proud of his position, the man in Sander's *Pastry Cook, Cologne* (fig. 551) is the very opposite of the timid figure in George Grosz's *Germany, a Winter's Tale* (see fig. 473). Despite their curious resemblance, this "good citizen" seems oblivious to the evil that Grosz has depicted so vividly. While the photograph passes no individual judgment, in the context of the book the sitter's unconcern stands as a strong indictment of the era as a whole.

551. August Sander. *Pastry Cook, Cologne*. 1928. August Sander Archiv/SK-Stiftung Kultur, Cologne, Germany

The Heroic Age of Photography

The period from 1930 to 1945 can be called the heroic age of photography for its photographers' notable response to the challenges of their times. Photographers in those difficult years demonstrated moral courage as well as physical bravery. Under Roy Stryker, staff photographers of the Farm Security Administration (FSA) compiled a comprehensive photodocumentary archive of rural America during the Depression. While the FSA photographers presented a balanced and objective view, most of them were also reformers whose work responded to the social problems they confronted daily in the field.

Dorothea Lange The concern of Dorothea Lange (1895–1965) for people and her sensitivity to their dignity made her the finest documentary photographer of the time in the United States. At a pea pickers' camp in Nipomo,

552. Dorothea Lange. *Migrant Mother, California.* February 1936. Gelatin-silver print. Library of Congress, Washington, D.C.

California, Lange discovered 2,500 virtually starving migrant workers and took several pictures of a young widow with her children, much later identified as Florence Thompson; when *Migrant Mother, California* (fig. 552) was published in a news story on their plight, the government rushed in food, and eventually migrant relief camps were opened. More than any Social Realist or Regionalist painting (see pages 530–31), *Migrant Mother, California* has come to stand for that entire era. Unposed and uncropped, this photograph has an unforgettable immediacy no other medium can match.

Fantasy and Abstraction

"Impersonality," the very liability that had precluded the acceptance of photography in the eyes of many critics, became a virtue in the 1920s. Precisely because photographs are produced by mechanical devices, the camera's images now seemed to some artists the perfect means for expressing the modern era. This change in attitude did not stem from the Futur-

ists, who, contrary to what might be expected, never fully grasped the camera's importance for modernism. The new view of photography arose as part of the Berlin Dadaists' assault on traditional art.

Toward the end of World War I, the Dadaists "invented" the **photomontage** and the **photogram**, although these completely different processes had been practiced early in the history of photography. In the service of anti-art they lent themselves equally well to fantasy and to abstraction, despite the apparent opposition of the two modes.

Photomontages Photomontages are simply parts of photographs cut out and recombined into new images. Composite negatives originated with the art photography of Rejlander (see page 498), but by the 1870s they were already being used in France to create witty impossibilities that are the ancestors of Dada photomontages. Like *1 Copper Plate . . . 1 Piping Man* (see fig. 468) by Max Ernst (who, not surprisingly, became an expert at the genre), Dadaist photomontages utilize the techniques of Synthetic Cubism to ridicule social and aesthetic conventions.

These imaginative parodies destroy all pictorial illusionism and therefore stand in direct opposition to straight photographs, which use the camera to record and probe the meaning of reality. Dada photomontages might be called ready-images, after Duchamp's ready-mades. Like other collages, they are literally torn from popular culture and given new meaning. Although the photomontage relies more on the laws of chance (see page 523), the Surrealists later claimed it to be a form of automatic handwriting on the grounds that it responds to a stream of consciousness.

Posters Photomontages were soon incorporated into carefully designed posters. In Germany, posters became a double-edged sword of political propaganda, used by Hitler's sympathizers and enemies alike. The most acerbic anti-Nazi commentaries were provided by John Heartfield (1891–1968), who changed his name from the German Herzfeld as a sign of protest.

553. John Heartfield. *As in the Middle Ages, So in the Third Reich*. 1934. Poster, photomontage. Akademie der Künste, John Heartfield Archiv, Berlin

554. Man Ray. Untitled (Rayograph). 1928. Gelatin-silver print, $15^{1}/_{2}$ x $11^{5}/_{8}$" (39.4 x 29.5 cm). The Museum of Modern Art, New York
Gift of James Thrall Soby

His horrific poster of a Nazi victim crucified on a swastika (fig. 553) appropriates a Gothic image of humanity punished for its sins on the wheel of divine judgment. Obviously, Heartfield was not concerned about misinterpreting the original meaning in his montage, which communicates its new message to powerful effect.

Photograms The photogram does not take pictures but makes them: objects are placed directly onto photographic paper and exposed to light. This technique was not new. The Dadaists' photograms, however, like their photomontages, were intended to alter nature's forms, not to record them, and to substitute impersonal technology for the work of the individual. Since the results in the photogram are so unpredictable, making one involves even greater risks than does a photomontage.

Man Ray Man Ray (1890–1976), an American working in Paris, was not the first to make photograms, but his name is the most closely linked to them through his "Rayographs." Fittingly enough, he discovered the process by accident. The amusing face in figure 554 was made according to the laws of chance by dropping a string, two strips of paper, and a few pieces of cotton onto the photographic paper, then coaxing them here and there before exposure. The resulting image is a witty creation that shows the playful, spontaneous side of Dada and Surrealism as against Heartfield's grim satire.

Photography since 1945

Minor White Photography after World War II was marked by abstraction for nearly two decades, particularly in the United States. Minor

555. Minor White. *Ritual Branch*. 1958. Gelatin-silver print, 10³/₈ x 10⁵/₈" (26.4 x 27 cm). The International Museum of Photography at George Eastman House, Rochester, New York

White (1908–76) closely approached the spirit of Abstract Expressionism. He was decisively influenced by Stieglitz's concept of the Equivalent. During his most productive period, from the mid-1950s to the mid-1960s, White evolved a highly individual style, using the alchemy of the darkroom to transform reality into a mystical metaphor. His *Ritual Branch* (fig. 555) evokes a primordial image: what it shows is not as important as what it stands for, but the meaning we sense is there remains elusive.

Robert Frank The birth of a new form of straight photography in the United States was largely the responsibility of one man, Robert Frank (b. 1924). His book *The Americans*, compiled from a cross-country odyssey made in 1955–56, created a sensation upon its publication in 1959, for it expressed the same restlessness and alienation as *On the Road*, published in 1957, by Frank's traveling companion, the Beat poet Jack Kerouac. As this friendship suggests, words have an important role in Frank's photographs, which are as loaded in their meaning as Demuth's paintings (see fig. 466); yet Frank's social point of view is often hidden behind a facade of disarming neutrality. It is with shock that we finally recognize the ironic intent of *Santa Fe, New Mexico* (fig. 556):

556. Robert Frank. *Santa Fe, New Mexico*. 1955–56. Gelatin-silver print. Collection Pace-MacGill Gallery, New York

557. Bill Brandt. *London Child.* 1955.
Copyright Mrs. Noya Brandt

558. Joanne Leonard. *Romanticism Is Ultimately Fatal*, from *Dreams and Nightmares.* 1982. Positive transparency selectively opaqued with collage, $9^3/_4$ x $9^1/_4$" (24.8 x 23.5 cm). Collection M. Neri, Benicia, California

the gas pumps face the sign SAVE in the barren landscape like members of a religious cult vainly seeking salvation at a revival meeting. Frank, who subsequently turned to film, holds up an image of American culture that is as sterile as it is joyless. Even spiritual values, he tells us, become meaningless in the face of vulgar materialism.

Bill Brandt Fantasy gradually reasserted itself on both sides of the Atlantic in the mid-1950s. Photographers first manipulated the camera for the sake of extreme visual effects by using special lenses and filters to alter appearances, sometimes virtually beyond recognition. Since about 1970, however, they have employed mainly printing techniques, with results that are frequently even more startling.

The manipulation of photographs was pioneered by Bill Brandt (1904–83). Though regarded as the quintessential English photographer, he was born in Germany and did not settle in London until 1931. He decided on a career in photography during psychoanalysis and was apprenticed briefly to Man Ray. Consequently, Brandt remained a Surrealist who

manipulated visual reality in search of a deeper one, charged with mystery. His work was marked consistently by a literary, even theatrical, cast of mind that drew on the motion picture for some of its effects. His early photo-documentaries were often staged as re-creations of personal experience for the purpose of social commentary based on Victorian models. Brandt's fantasy images manifest a strikingly romantic imagination. Yet there is an oppressive anxiety implicit in his landscapes, portraits, and nudes. *London Child* (fig. 557) has the haunting mood of the Victorian Gothic novels by the sisters Charlotte, Emily, and Anne Brontë. At the same time, Brandt's photograph is a classic dream image fraught with troubling psychological overtones. The spatial dislocation, worthy of de Chirico, expresses the malaise of a person who is alienated from both himself and the world.

Joanne Leonard Contemporary photographers have often turned to fantasy as autobiographical expression. Both the image and the title of *Romanticism Is Ultimately Fatal* (fig. 558) by Joanne Leonard (b. 1940) suggest a meaning

559. David Hockney.
*Gregory Watching
the Snow Fall,
Kyoto, Feb. 21, 1983.*
Photographic collage,
43¹/₂ x 46¹/₂"
(110.5 x 118.1 cm).
Collection the artist

that is personal in its reference; it was made during the breakup of her marriage. We will recognize in this disturbing vision something of the tortured eroticism of Fuseli's *The Nightmare* (see fig. 370). The clarity of the presentation turns the apparition at the window into a real and terrifying personification of despair: this is no romantic knight in shining armor but a grim reaper.

David Hockney The most recent demonstrations of photography's power to extend our vision have come, fittingly enough, from artists. The photographic collages that the English painter David Hockney (b. 1937) has been making since 1982 are like revelations that overcome the traditional limitations of a unified image, fixed in time and place, by closely approximating how we actually see. In *Gregory Watching the Snow Fall, Kyoto, Feb. 21, 1983* (fig. 559), each frame is analogous to a discrete eye movement containing a piece of visual data that must be stored in our memory and synthesized by the brain. Just as we process only essential information, so there are gaps in the matrix of the image, which becomes more fragmentary toward its edges, though without the loss of acuity experienced in vision itself. The resulting shape of the collage is an extraordinary piece of design. The scene appears to bow curiously as it comes toward us. This ebb and flow is more than simply the result of optical physics. In the perceptual process, space and its corollary, time, are not linear but fluid. Moreover, by including his own feet as reference points to establish our position clearly, Hockney helps us realize that vision is less a matter of looking outward than an egocentric act that defines the viewer's visual and psychological relationship to the surrounding world. The picture is as expressive as it is opulent. Hockney has recorded his friend several times to suggest his reactions to the serene landscape outside the door. His approach is embedded in the history of modern painting, for it shows a self-conscious awareness of earlier art. It combines the faceted views of Picasso and the dynamic energy of Popova (see figs. 453, 456). *Gregory Watching the Snow Fall* is nevertheless a distinctly contemporary work, for it incorporates the fascinating effects of Photorealism and the illusionistic potential of Op art.

Chapter 29
Postmodernism

W e began Part Four with a discussion of modernism. It is appropriate that we end, for now, with its antithesis: Postmodernism. We live in the Postmodern era. How can that be, if *modern* is what is today? The term *Postmodern* itself suggests the quizzical nature of the trend, which seeks out incongruity. To resolve this paradox, we must understand *modern* in a dual sense: modernity and modernism. Postmodernism as a trend not only supersedes modernism but, as we shall see, is opposed to the world order as it exists today and to the values that created it.

The Paradox of Postmodernism

What is Postmodernism and when did it begin? Critics are in little agreement on these questions, which is hardly surprising, given how recent the phenomenon is. Generally speaking, Postmodernism is marked by an abiding skepticism that rejects modernism as an ideal defining twentieth-century culture as we have known it. In challenging tradition, however, Postmodernism resolutely refuses to define a new meaning or impose an alternative order in its place. It represents a generation consciously *not* in search of its identity. Hence, it is not a coherent movement at all but a loose collection of tendencies that, all told, reflect a new sensibility. Each country has a somewhat different outlook and terminology; nevertheless, all may be grouped under the rubric of Postmodernism. We must therefore resort to a composite picture. Though broadly painted as a matter of necessity, it will provide us with a general idea of Postmodernism's peculiar character. Our treatment of Postmodern art is likewise intended to be suggestive.

As the term *post-* suggests, our world is in a state of transition—without telling us where we will land. Postmodernism springs from post-industrial society, which is passing rapidly deep into the Information Age (the so-called Third Wave). According to this view, the political, economic, and social structures that have governed the Western world since the end of World War II are changing, undergoing attack from within, or breaking down altogether, ironically at the same time as the collapse of communism in Eastern Europe. This institutional erosion has resulted in a corresponding spiritual crisis that reflects the disarray of people's lives. Postmodernism is a product of the disillusion and alienation afflicting the middle class. At the same time, bourgeois culture has exhausted its possibilities by absorbing its old enemy, the avant-garde. Strangely enough, the avant-garde's mission was ended by its very success. During the 1950s, the media made the avant-garde so popular that the middle class accepted it and began to hunger for ceaseless change for its own sake. By the following decade, modernism was reduced to a capitalist mode of expression by large corporations, which adopted it not just in architecture but also in painting and sculpture.

Postmodernism celebrates the death of modernism, which it regards as not only arrogant in its claim to universality but also responsible for the evils of contemporary civilization. Democracy, based on Enlightenment values, is seen in turn as a force of oppression to spread the West's hegemony throughout the world. In common with most earlier avant-garde movements (including ▼EXISTENTIALISM) Postmodernism is antagonistic to humanism as it has evolved since the Renaissance, which it dismisses as bourgeois. Reason, with its hierarchies of thought, is abandoned in order to liberate people from the established order. This rejection opens the way for nontraditional approaches, especially those from the Third World, emphasizing emotion, intuition, fantasy, contemplation, mysticism, and even magic. In this view, Western science is no better than any other system of thought, since it has failed to solve today's problems. And because scientific reality does not conform to human experience, it is useless in daily life.

Truth is rejected as neither possible nor desirable on the grounds that it can be used by its creators for their own power and ends. Subjective and conflicting interpretations are all that can be offered, and these may vary freely according to the context. Since no set of values can have more validity than any other, everything becomes relative. Bereft of all traditional guidelines, the Postmodernist drifts aimlessly in a sea without meaning or reality. To the extent that the world makes any sense, it is at the local level, where the limited scale makes understanding possible in human terms.

The only escape from an existence in which nothing has intrinsic worth is inaction or hedonism on the one hand and spirituality on the other. The latter is rarely an option, however, since religions impose their own authority and self-discipline; hence, only the most extreme forms of mysticism, lacking all rational control, are acceptable. Postmodernists are thus fated to become pleasure-

▼ Although its roots reach back to the nineteenth century, EXISTENTIALISM is regarded as a characteristically mid-twentieth-century response to modern life. An existentialist believes that human beings are not born with an essential nature or a God-within who determines the choices people make; rather, all are painfully free to choose and each person becomes the sum of his or her choices. Surrounding this existential condition is the inevitability of death, or not-being. Having life at all is a random, absurd fact, and making decisions is all there is to life.

seeking narcissists lacking any strong identity, purpose, or attachments. Avowedly cynical and amoral, they live for the moment, unburdened by any concern for larger issues, which are imponderables in the first place. Rather than vices, however, these traits are considered virtues, for they grant Postmodernists a flexible approach to life that allows them to pursue new modes of existence, free from all restraints or authority.

In the brave new world of Postmodernism, the individual is no longer anchored in time or space. Both have been rendered obsolete in life as they have in science, because they are beyond normal human comprehension and are based on assumptions that are subject to doubt. Traditional definitions of time and space, moreover, were based on hierarchies of thought that served the purposes of colonialism, and the new "hyperspace" created by global communication makes it impossible to position oneself within customary boundaries.

Just as time and space have lost all meaning, so has history. In the end, however, Postmodernism cannot escape the very laws of history it claims to deny. As a parody of modernity, it has its parallels—indeed, its origins—in the avant-garde of a hundred years ago. The same "decadence" and nihilism can be found toward the end of the nineteenth century in the Symbolist movement, with its apocalyptic vision of despair.

Postmodernism makes no attempt to provide new answers to replace the old certitudes it destroys. It instead substitutes pluralism in the name of multicultural diversity, since no one aesthetic is better than any other. Pluralism leads inevitably to eclecticism, with which it is virtually interchangeable. Not only are the two functions of each other, they become ends in themselves.

By the same token, Postmodernism does not try to make the world a better place. In its resolute antimodernism, it is socially and politically ambivalent at best, self-contradictory at worst. Its operating principle is anarchism, but to the extent that it does offer an alternative, Postmodernism espouses any new doctrine as superior to the one it seeks to displace. In the end, Postmodernism remains essentially a form of cultural activism motivated by intellectual theory, not political causes, to which it is ill-suited.

Postmodernism has all the classic earmarks of a self-appointed avant-garde, despite the fact that it vigorously disavows any such connection. The relativism and anarchism of Postmodernism are patently subversive in their intent. This nihilism reflects the prevailing skepticism of the late twentieth century, when very little is deemed to have any significance or worth.

Because it has so many meanings, *Postmodernism* itself is a meaningless term, posing the kind of hopeless double bind that it delights in. In fact, Postmodernism as a whole is riddled with contradictions. But if nothing is valid, then the values it often espouses—feminism, pluralism, and the like—could be fallacious as well.

Semiotics and Deconstruction

The information age is obsessed with meaning—and the lack thereof. Like the intellectual disciplines, nearly all branches of culture have come under the spell of semiotics—the study of signs, also known as semiology (though a distinction is sometimes made between the two). And with good reason, for semiotics is part of philosophy, linguistics, science, sociology, anthropology, communications, psychology, art, literature, cinema: any sphere of human endeavor that involves symbols. (There are other classes of signs that are the subject of semiotic inquiry as well.) Semiotics in turn has been attacked from within by deconstruction, which constitutes undoubtedly the most potent critique mounted to date by Postmodernism. As the term suggests, deconstruction is destructive, not constructive. It tears a text apart by using the text against itself, until the text finally "deconstructs" itself. What is important for our discussion is not the theories, interesting though they may be, but their effect on art.

Postmodern Art

We are, in a sense, the new Victorians. A century ago, Impressionism underwent a similar crisis,

from which Post-Impressionism emerged as the direction for the next twenty years. Behind its elaborate rhetoric, Postmodernism can be seen as a stratagem for sorting through the past while making a decisive break with it that will allow new possibilities to emerge. Having received a rich heritage, artists are faced with a wide variety of alternatives. The principal features of the new art are a ubiquitous eclecticism and a bewildering array of styles. Taken together, these pieces provide a jigsaw puzzle of our times. Another indication of the state of flux is the reemergence of many traditional European and regional American art centers.

Art since 1980 has been called Postmodern, but not all of it fits under this umbrella. We shall find that the participation of the visual arts in the Postmodern adventure has varied greatly and has taken some surprising turns. In particular, the traditional mediums of painting and sculpture have played a secondary role. Much of the reason is that painting and sculpture are closely identified with the modernist tradition; by extension, they are tainted as tools of the ruling class. Meanwhile, nontraditional forms, such as installations and photography, have come to the forefront and have become highly politicized in the process.

Much of the basis for Postmodern art can be traced back to Conceptual art (see page 568), which led the initial assault on modernism. Indeed, it has been argued that the beginnings of Postmodernism can be dated to the rise of Conceptualism in the mid-1960s. The two, however, are products of two distinctly different generations. Furthermore, Conceptualism itself derived from Dada, which has provided an antimodern alternative since early in the twentieth century. In the context of the 1960s, it was simply part of that ongoing dialogue, in which Pop art also participated. Such a date, moreover, seems decidedly too early for the onset of what is fundamentally a late-twentieth-century phenomenon.

Installations and performance art have been around that long as well. What has clearly changed is the *content* of these art forms as part of a larger shift in viewpoint. Focused as it was on matters of art, early Conceptualism seems almost innocent in retrospect. Postmodernists, in contrast, attack modern art as part of a larger offensive against contemporary society. They are far more issue-oriented than their predecessors, and their work cuts across a much wider spectrum of concerns than ever before.

From all the recent ferment a new direction in art has begun to appear, at least for the time being. The principal manifestation of Postmodernism is ▼APPROPRIATION, which like Dada looks back self-consciously to earlier art, both by imitating previous styles and by taking over specific motifs or even entire images. Artists have always borrowed from tradition, but rarely so systematically as now. Such plundering is nearly always a symptom of deepening cultural crisis, suggesting bankruptcy. (The same thing is going on in popular culture, with its perpetual "retro" revivals.) Unbound as it is to any system, postmodernism is free not only to adopt earlier imagery but also to alter its meaning radically by placing it in a new context. The traditional importance assigned to the artist and object is furthermore de-emphasized in this approach, which stresses content and process over aesthetics. The other main characteristic of postmodernism is the merging of art forms. Thus, there is no longer a clear difference between painting, sculpture, and photography, and we maintain the distinction primarily as a matter of convenience.

Postmodernism is undeniably a fascinating phenomenon. Yet it has an Achilles' heel: it has produced little art that is memorable—it is merely "symptomatic" of our age. But for that very reason it is worthy of our interest. Although it has an antiintellectual side, Postmodernism is preoccupied with theory. In consequence, art (and, along with it, art history) has become theory-bound. Yet despite a growing body of writing and criticism, art lags far behind literature and poetry in developing a postmodern approach. Compared to language, the visual arts are traditionally poor vehicles for theory. Perhaps they have become so word-oriented of late in an attempt to keep pace with other disciplines.

▼ In contrast to copying or imitation, APPROPRIATION is the deliberate inclusion of "borrowed" images by other artists in a new work of art, some of it electronic. Appropriation raises all kinds of questions about intellectual property rights and originality and has been an area of heated debate since the mid-1980s.

Architecture

We begin with architecture, which not only initiated the Postmodern dialogue in the arts but also puts the issues literally in concrete form.

Postmodernism

In art, the term *Postmodernism* was first used to denote an eclectic mode of architecture that arose around 1980. Because it is a style, we shall capitalize it to distinguish it from the larger phenomenon of Postmodernism, to which it is intimately related. As the term implies, Postmodernism constitutes a broad repudiation of the mainstream of twentieth-century architecture. Although it uses the same construction techniques, Postmodernism rejects not only the vocabulary of Gropius and followers like Mies van der Rohe but also the social and ethical ideals implicit in their lucid proportions. Looking at the Seagram Building (see fig. 539), we can well understand why: as a statement, the building is overwhelming in its authority, which is so immense as to preclude deviation and so cold as to be lacking in appeal. The Postmodernist critique of the International Style was, then, essentially correct: in its search for universal ideals, the International Style failed to communicate with people, who neither understood nor liked it. Postmodernism represents an attempt to reinvest architecture with the human meaning so conspicuously absent from the self-contained designs of High Modernism. It does so by reverting to what can only be called premodernist architecture.

The chief means of introducing greater expressiveness has been to adopt elements from historical styles rich with association. All traditions in theory have equal validity, so that they can be combined at will, but in the process, the

561. James Stirling, Michael Wilford, and Associates. Neue Staatsgalerie, Stuttgart, Germany. Completed 1984

compilation itself becomes a conscious parody characterized by ironic wit. This eclectic historicism is nevertheless highly selective in its sources; they are restricted mainly to various forms of classicism (notably Palladianism) and some of the more exotic strains of Art Deco, which, as we have seen, provided a viable alternative to modernism during the 1920s and 1930s. Architects have repeatedly plundered the past in search of fresh ideas. What matters is the originality of the final result.

Michael Graves The Public Services Building in Portland, Oregon (fig. 560), by Michael Graves (b. 1934) is exemplary of Postmodernism. Elevated on a pedestal, it mixes classical, Egyptian, and assorted other motifs in a whimsical building-block paraphrase of Art Deco, which shared an equal disregard for historical propriety. In this way, Graves relieves the building of the monotony imposed by the tyranny of the cube that afflicts so much modern architecture. Although the lavish sculptural decoration was never added, the exterior has a surprising warmth that continues inside. The Public Services Building represents more than mere historicism, however; no earlier structure looks at all like it. What holds this historical mix together is the architect's personal style. It is based on a mastery of abstraction that is as systematic and inimitable as Mondrian's. Indeed, Graves was a skilled Late Modernist who first earned recognition in 1969 at the same exhibition held by the Museum of Modern Art in New York that showcased another Postmodernist, Richard Meiers.

Today Postmodern buildings are being erected everywhere. They are often recognizable by their reliance on keyhole arches, round "Palladian" windows, and other vestiges of the architectural past. Most Postmodern architecture is commercial in character, although often conjuring an aura of luxury in keeping with the 1980s, one of the most prosperous and extravagant decades in recent history. Nevertheless, the retrospective eclecticism of Postmodernism soon became dated through the repetitious quotation of standard devices. In a larger sense, this quick passage reflects the restless quest for novelty and, more important, a new modernism that has yet to emerge to replace the old.

James Stirling The Postmodernists criticize Late Modernism for its commitment to the "tradition of the new" and its consequent paucity of integrity of invention and usage. Moreover, they maintain, Late Modernism lacks both pluralism and a complex relation to the past. We may test this proposition for ourselves by comparing the Pompidou Center (see fig. 541) with the Neue Staatsgalerie in Stuttgart (fig. 561), which was immediately recognized as a classic of Postmodernism. The latter has the grandiose scale befitting a "palace" of the arts, but instead of the monolithic cube of the Pompidou Center, English architect James Stirling (b. 1926) incorporates a greater variety of shapes within more complex spatial relationships. There is, too, an overtly decorative quality that reminds some of Garnier's Paris Opéra (see fig. 384), albeit indirectly. The similarity does not stop there. Stirling has also invoked a form of historicism through paraphrase that is far more subtle than Garnier's opulent revivalism but is no less self-conscious. The primly Neoclassical masonry facade, for example, is punctured by a narrow arched window recalling Italian Renaissance forms (compare fig. 221) and by a rusticated portal that has a distinctly Mannerist look. At the same time, there is an exaggerated quoting of modernism through the use of such high-tech materials as painted metal. This eclecticism is more than a veneer—it lies at the heart of the building's success. The site, centering on a circular sculpture court, is designed along the lines of ancient temple complexes from Egyptian through Roman times, complete with a monumental entrance stairway. This plan enables Stirling to solve a wide range of practical problems with ingenuity and to provide a stream of changing vistas that fascinate and delight the visitor. By comparison, the Pompidou Center is arguably a far more radical building.

Deconstructivism

Although it claims to deal with the substance as well, in the end Postmodernist historicism

addresses only the decorative veneer of the International Style. Spurred by more radical theories, Deconstructivism, another tendency that has been gathering momentum since 1980, goes much further in challenging its substance. It, too, does so by engaging in appropriation. Oddly enough, Deconstructivism returns to one of the earliest sources of modernism: the Russian avant-garde. The Russian experiment in architecture proved short-lived, and few of its ideas ever made it beyond the laboratory stage. Recent architects, inspired by the bold sculpture of the Constructivists and the graphic designs of the Suprematists, seek to violate the integrity of modern architecture by subverting its internal logic, which the Russians themselves did little to undermine. Nevertheless, Deconstructivism does not abandon modern architecture and its principles altogether but remains an architecture of the possible based on structural engineering.

Deconstructivism is a new term that combines *Constructivism* and *deconstruction*. Strictly speaking, there can be no architecture of deconstruction, because building puts things together instead of taking them apart. Deconstructivism nevertheless follows similar principles and is symptomatic of Postmodernism as a whole. It does so by dismembering modern architecture, then reassembling it again in new ways. Although it claims Michelangelo, Bernini, and Guarini as its ancestors, Deconstructivism goes far beyond anything that can be found in earlier architecture. We will find little common ground among its practitioners. The main devices they have in common are superimpositions of clashing systems or layers of space and distortions from within that subvert the normal vocabulary and purposes of modernist architecture.

Bernard Tschumi One of the few architects who was avowedly influenced by deconstruction is Bernard Tschumi (b. 1944). The most complete embodiment of his Deconstructivism is the Parc de la Villette in Paris, for which the founder of deconstruction, Jacques Derrida, later wrote an essay in the brochure explaining the project. The park's program was set by the fact that it had to include a variety of functions (workshop, baths, gymnasium, playground, concert facilities) and other parks and buildings already on site. Tschumi presents an intelligent solution to what could have been a hopelessly complex problem that would have overwhelmed any traditional approach.

To describe the Parc de la Villette, we must resort to the coded terminology of Deconstructivism itself. The architect began by laying out the grounds in a simple abstract grid to provide a strong yet flexible conceptual framework for change, improvisation, and substitution; he then subverted it by superimposing two other grid systems on it, so as to prevent any dominant hierarchy or clear relation between the program and the solution (fig. 562, page 602). This multiple grid is deliberately antifunctional, anticontextual, and infinite. (In principle, it could be extended in any direction indefinitely.) Tschumi creates highly unorthodox relationships through decentralization, fragmentation, combination, and superimposition of elements, so that the architecture appears to serve no purpose. He further supplants form, function, and structure with contiguity, substitution, and permutation. To undermine the traditional rules of composition, hierarchy, and order, he uses cross-programming (using space for a different purpose than intended), transprogramming (combining two incompatible programs and spaces), and disprogramming (combining two programs to create a new one from their contradictions). The programmatic functions are dispersed through a series of buildings (called *folies*) whose components, appearance, and uses are interchangeable. The play between free and rigid form within this multiplicity leads to ambiguity, disorder, impurity, imperfection. The result denies any inherent meaning to the forms, structure, or organization.

What does all this theory have to do with the actual experience? Surprisingly little. The ensemble is meant to induce a sense of disassociation, both within and between its elements, that conveys an unstable programmatic madness *(folie)* through a form of cinematic montage inspired by the films

562. Bernard Tschumi Architects. Folie P6, Parc de la Villette, Paris. 1983

of the Russian Sergei Eisenstein and others. However, the visitor is hardly aware of this effect. On the contrary, the system creates an order and rhythm of its own, whether Tschumi intended it or not. We are left only with a feeling of enchantment, which suggests the more playful meaning of *folie*, not just madness. The *folies* themselves resemble large-scale sculpture extended almost to the breaking point. Yet the tension between the reality of the built structures and their "impossibility" results in an architecture of rare vitality. It is especially fitting that two of the most captivating *folies* are for use by children. Although the architect insists that he was not expressing himself, this effect is perhaps the ultimate test of the park's success. Tschumi himself acknowledges the fact indirectly by speaking of "affirmative deconstruction"—a self-contradiction if ever there was one.

Postmodernism vs. Deconstructivism Try as their adherents might to deny it, Postmodernism and Deconstructivism are really two sides of the same Postmodernist coin, which has

pushed modern architecture to its limits. As a style Postmodernism challenges modernism from the outside, while Deconstructivism as an approach corrupts it from within. This sort of questioning has gone on before. Postmodernism is a transition much like Art Nouveau had been at the turn of the century, when it provided part of the foundation for modern architecture. It is a necessary part of the process that will redefine architecture as we have come to know it.

Sculpture

Installations

Sculpture today descends mainly from the work of Joseph Beuys, who, with Andy Warhol and John Baldessari, may be regarded as the patron saint of Postmodern art. Traditional sculpture has such a small role in Postmodernism that it seems almost out of place when it does make an appearance. Instead, installations have become the focal point of the movement. They may be regarded as the ideal manifestations of the deconstructionist idea of the world as "text," whose intent can never be fully known, even by its author, so that "readers" are free to interpret it in light of their own understanding. The installation artist creates a separate world that is a self-contained universe, at once alien and familiar. Left to their own devices to wander this microcosm, viewers bring their own understanding to bear on the experience in the form of memories that are elicited by the novel environment. In effect, then, they help to write the "text." In themselves, installations are empty vessels: they may contain anything that "author" and "reader" wish to put into them. Hence, they serve as ready vehicles for expressing social, political, or personal concerns, especially those that satisfy the postmodern agenda. The installation as text can become deliberately literal: it is often linked to an actual text that makes the program explicit.

Ilya Kabakov Russian artists have a special genius for installations. Cut off for decades from contemporary art in the West, they developed

provincial styles of painting and sculpture. Yet that very isolation allowed them to cultivate a unique brand of Conceptual art that provided the foundation for their installations. The first to gain international acclaim was Ilya Kabakov (b. 1933), who now keeps his studio in New York. *Ten Characters* was a suite of rooms like those of a seedy communal apartment, each inhabited by an imaginary person possessed of an "unusual idea, one all-absorbing passion belonging to him alone." The most spectacular was *The Man Who Flew into Space from His Apartment* (fig. 563): he achieves his dream of flying into space by being hurled from a catapult suspended by springs while the ceiling and roof are blown off at the precise moment of launching. Like the other rooms, it was accompanied by a text of ▼DOSTOYEVSKIAN darkness written by the artist, reflecting the traditional Russian talent for storytelling. The installation was more than an elaborate realization of this bizarre fantasy, however. The extravagant clutter was a sardonic commentary encapsulating a wealth of observations that reflect the peculiar dilemmas of life in the former Soviet Union—its tawdry reality, its broken dreams, the pervasive role of central authority.

Ann Hamilton Kabakov was inspired in part by the example of Beuys, who was also an influence on the young American installation artist Ann Hamilton (b. 1956). Her work is about loss, be it from personal tragedy or

563. Ilya Kabakov. *The Man Who Flew into Space from His Apartment*, from *Ten Characters*. 1981–88. Mixed-media installation at Ronald Feldman Fine Arts, New York, 1988.

Courtesy Ronald Feldman Fine Arts

Postmodernism in Music and Theater

It is hardly possible to discuss Postmodernism in music, for although contemporary composers have used the Postmodern devices of appropriation and deconstruction, they have not yet produced significant results. Perhaps the closest Postmodernism has come to forming an identifiable style is the MINIMALISM of Steve Reich, Philip Glass, and Laurie Anderson (see box on page 538). Theater, by contrast, is ideally suited to both appropriation and—especially—deconstruction, since it readily permits viewers to participate in creating the text as they perceive it. The main tendency has been to reinterpret existing works, both classics and those of recent vintage, in untraditional ways that challenge conventional ideas about their content and meaning. This is the direction followed by Peter Sellars (b. 1957), former director of the American National Theater at the Kennedy Center in Washington; Les Breuer (b. 1937), director of the Mabou Mines Company in New York City, who was influenced by both Beckett and Brecht; and Robert Wilson (b. 1942), who worked with Philip Glass on the opera *Einstein on the Beach* (1976). Wilson has also written his own works, in collaboration with the autistic teenager Christopher Knowles, that juxtapose elements of different cultures and media in seemingly arbitrary fashion. A particularly important contribution has been made by the Environmental Theater of Richard Schechner (b. 1934), who conceives of theater as an event that can take place in any environment, and assigns an active role to the audience. In Schechner's drama, every element is independent of the text. Indeed, there need not be any text. Although none of these ideas is new in itself, their unique combination is characteristic of the late twentieth century.

distortion of a natural relationship. Unlike Beuys, she seeks only to raise issues, not to resolve them; resolution is left to the visitor. Yet she uses many of the same means: her installations involve all of the senses through the manipulation of unusual materials, often in disturbing ways, in order to present a paradox that lies at the center of each work. She exercises these choices through a train of free association until the idea crystallizes. Her installations are labor-intensive—obsessively, even ritualistically, so. Thus *parallel lines* for the 1991 São Paolo Bienal (fig. 564, page 606) began with assistants coating the walls of one gallery with soot from burning candles, then attaching sequentially numbered copper tags to the floor (demonstrating an interest in seriality that is basic to Conceptual art). Finally, a huge bundle of candles was placed in the room, so as to dominate it. A second room, covered entirely in the same copper tags, held nothing but two glass library cases containing turkey carcasses that were slowly devoured by beetles. This assault on the viewer's senses—and sensibilities—was intended to pose a number of questions. What is collected, why, and by whom? What is the moral difference between showing candles made by people from the fat of dead animals and exhibiting a dead bird with beetles carrying out their natural role as scavengers? Although death is treated matter-of-factly, there is a strangely mournful air to the entire installation, which invites us to ponder these matters and to arrive at our own conclusions.

Painting

Painting, like sculpture, is a traditional medium that does not lend itself well to Postmodernism. Indeed, it is arguable that most of what passes as Postmodern painting is really Late Modernism in disguise. In any event, there is no fixed boundary between the two. To the extent that it can be said to exist at all, however, Postmodern painting is an outgrowth of Conceptualism, Pop art, and Neo-Expressionism. Yet it differs from them in a fundamental respect: now painting acts like a deconstructed text gutted of all significance,

except for whatever we choose to add by way of free association from the reservoir of our own experience.

How did painting come to be so barren of content? Traditional vehicles such as allegory require a shared culture; yet such a thing is hardly possible in the Postmodern age, despite the concept of the "global village," for our civilization is more fractured than ever. Deconstruction, moreover, proclaims the death of the author and subject matter as unnecessary vestiges of humanism, thus rendering meaning null and void. It argues instead that representation in its broadest sense is both unnecessary and undesirable on the grounds that it strives to re-create a fraudulent reality, and therefore it can never provide an authentic experience. Such an attitude is not confined to deconstruction, however. It is inherent in Postmodernism as a whole.

Mark Tansey There is one artist who has successfully used deconstruction to construct representational images that are literally made up of texts. *Derrida Queries de Man* (fig. 565) by Mark Tansey (b. 1949) shows the founder of deconstruction, Paul de Man, with his chief American disciple. If we look closely, we see that the landscape consists of typeset lines that merge to form the steep cliffs. Here the texture of the paint serves to bridge the gap between text and illustration by embedding the idea within the image. In this sense, the painting functions as an illustration of a metaphor—but what is it saying? Certainly it makes a serious point about the relations among content, picture, and reality. Yet it does so with surprising wit, beginning with the very idea of building a painting out of words. And, in a gesture of supreme irony, Tansey has appropriated the image from a famous illustration showing the death of Sherlock Holmes at the hands of his archenemy, Professor Moriarty. By precluding a literal reading of the painting, this astonishing juxtaposition opens up new lines of questioning for the viewer that never fully resolve themselves.

A. R. Penck Instead of using the Roman alphabet, A. R. Penck (b. 1939) follows in the foot-

steps of artists such as Paul Klee by inventing a personal vocabulary of pictographs. Penck is the pseudonym adopted by Ralf Winkler from a famous geologist whose specialty was the Ice Age. In fact, the artist lived in East Germany throughout most of the Cold War, a political ice age of its own, before emigrating to the West in 1980. He is one of several artists from the former German Democratic Republic who have helped to make Germany the leading school of painting in the West today. The "childish" quality in *The Demon of Curiosity* (fig. 566, page 607), with its colorful directness, is deceptive. Although Penck is largely self-taught, his fluid technique is, in fact, very sophisticated, making it a wonderfully sensitive vehicle for expressing every possible meaning. But what are we to make of the picture's content? At first glance, it seems as bewildering as a rock engraving in a prehistoric cave. Upon closer inspection we realize that the artist's "code" can be broken, at least enough for us to understand the basic intent. The demon, as fierce as anything conjured up by Gauguin (compare fig. 423), is surmounted by a bird looking both ways that signifies inquisitiveness, to which the small crucified figure at the left has been sacrificed. The figures swim in a sea of hex-like signs, letters, and numbers, symbolizing knowledge, which fills up the man to the point that he seems literally "pregnant (or at least bloated) with meaning." The painting reflects the artist's fascination with cybernetics, the science of information systems.

Photography

Photography, too, has taken up the theme of image as "text." Given the close association of words and photographs in Conceptual art, such a move was perhaps inevitable. It was abetted, however, by the new importance attached to semiotics, which has opened up fruitful new avenues of investigation for the artist. How do signs acquire public meaning? What is the message? Who originates it? What (and whose) purpose does it serve? Who is the audience? What are the means of spreading the idea? Who controls the mediums?

Photographers, especially some in the United States, raise these questions in order to challenge our received notions of the world and the social order it imposes. Unlike Joanne Leonard or David Hockney, postmodern photographers are "rephotographers" who for the most part do not take their own pictures but appropriate them from other mediums. To convey their message, these new Conceptualists often follow the formula of placing image and text side by side. Sometimes their pictures are intended as counterparts to paintings and are enlarged on an unprecedented scale, using commercial processes developed for advertisements, which may also serve as sources. Here it is the choice of image that matters, since the act of singling it out and changing its context from billboard to gallery wall itself constitutes the comment. In both cases, however, we are asked to base our judgment on the message; the means of delivery deliberately shows so little individuality that it is often impossible to tell the work of one artist from another. In the process, however, the message often becomes equally forgettable.

Barbara Kruger Lack of individuality is not a problem with Barbara Kruger (b. 1945), whose pictures are instantly recognizable for their confrontational approach. *You Are a Captive Audience* (fig. 567, page 607) exemplifies her style. It nearly always involves a tightly cropped close-up photograph in black and white, taken from a magazine or newspaper and blown up as crudely as possible to monumental proportions, so that the viewer cannot escape its presence or the message, which is stenciled in white letters against a red background. The conjoining of unrelated text and image marks this as a form of deconstruction intended for radical ends. The challenging statement is intended to provoke acute anxiety by playing on people's latent fears of being controlled by nameless forces, especially such large, impersonal power centers as the government, the military, or corporations.

Annette Lemieux Kruger's work is like a sharp blow to the solar plexus: the message is direct, the response immediate, especially the first time around. The themes of Annette Lemieux

564. Ann Hamilton. *parallel lines*. Two parts of an installation in two rooms, São Paolo Bienal, September–December 1991. Mixed media.
Courtesy Richard Ross

565. Mark Tansey. *Derrida Queries de Man*. 1990. Oil on canvas, 6'11" x 4'7" (2.13 x 1.4 m). Collection of Michael and Judy Ovitz, Los Angeles
Courtesy Curt Marcus Gallery, New York

(b. 1957) are quieter but correspondingly more thought-provoking. Centering on social issues, they address the human condition without engaging in polemic. Lemieux has a particular gift for perceiving new possibilities of meaning in old photographs and illustrations. *Truth* (fig. 568), of 1989, is an image about sound—or, rather, the lack of it. The photograph, derived from a book on the history of radio, is a visual counterpart to the saying, Hear no evil, speak no evil, see no evil. Transferred to canvas, it acquires a very different meaning in its new context, a classic example of deconstruction.

Stenciled in bold letters is the Russian proverb, Eat bread and salt but speak the truth, which means, roughly, "Be frank when accepting someone's hospitality." The lettering transforms the image from an amusing publicity photograph into an ominous-looking propaganda poster. Contrary to initial impressions, the issue is neither Russia nor communism—the photograph features the famous American entertainer Jack Benny—but the role of the media in modern life. The media enter our homes as guests without being candid: here the performer covers his mouth in order to speak no evil. Shielded by the medium of radio itself, he distorts truth by selectively concealing information, not by telling a deliberate falsehood. Truth emerges as a matter of relative perspective, determined both by who controls it and by who hears it.

566. A. R. Penck. *The Demon of Curiosity.* 1982. Acrylic on canvas, 9'2¹/₃" (2.8 m square). Rivendell Collection, New York

Courtesy Michael Werner Gallery, New York and Cologne

567. Barbara Kruger. *You Are a Captive Audience.* 1983. Gelatin-silver print, 48 x 37³/₄" (122 x 96 cm)

Courtesy the artist and Annina Nosei Gallery, New York

568. Annette Lemieux. *Truth.* 1989. Latex and acrylic on canvas, 7' x 11'1" x 1¹/₂" (2.13 m x 3.3 m x 3.8 cm)

Courtesy Josh Baer Gallery, New York

CHRONOLOGICAL CHART 4

	Political History	Religion and Literature	Science and Technology
1750	Seven Years' War (1756–63); French and Indian War, French defeated in Battle of Quebec 1769 Catherine the Great (ruled 1762–96) extends Russian power to Black Sea	Thomas Gray's *Elegy* 1750 Denis Diderot's *Encyclopédie* 1751–72 Samuel Johnson's *Dictionary* 1755 Edmund Burke, English reformer (1729–1797) Jean-Jacques Rousseau, French philosopher and writer (1712–1778)	James Watt patents steam engine 1769 Joseph Priestley discovers oxygen 1774 Coke-fed blast furnaces for iron smelting perfected c. 1760–75 Benjamin Franklin's experiments with electricity c. 1750
1775	American Revolution 1775–85; Constitution adopted 1789 French Revolution 1789–97; Reign of Terror under Maximilien Robespierre 1793 Consulate of Napoleon 1799	Edward Gibbon's *Decline and Fall of the Roman Empire* 1776–87 Thomas Paine's *The Rights of Man* 1790 William Wordsworth and Samuel Taylor Coleridge, *Lyrical Ballads*, 1798	Power loom 1785; cotton gin 1792 Edward Jenner's smallpox vaccine c. 1798
1800	Louisiana Purchase 1803 Napoleon crowns himself emperor 1804; exiled to St. Helena 1815 War of 1812 Greeks declare independence 1822 Monroe Doctrine proclaimed by U.S. 1823	Johann Wolfgang von Goethe's *Faust* (part I) 1808 George Gordon Byron's *Childe Harold's Pilgrimage* 1812–18 John Keats, English poet (1795–1821) Percy Bysshe Shelley, English poet (1792–1822) Jane Austen, English novelist (1775–1817) Walter Scott's Waverly novels (1814–25)	Lewis and Clark expedition to Pacific 1803–06 First voyage of Fulton's steamship 1807; first Atlantic crossing 1819 George Stephenson's first locomotive 1814 Michael Faraday discovers principle of electric dynamo 1821
1825	Revolution of 1830 in France Queen Victoria crowned 1837 U.S. treaty with China opens ports 1844 Famine in Ireland, mass emigration 1845 U.S. annexes western land areas 1845–60 Revolution of 1848; fails in Germany, Hungary, Austria, Italy; France sets up Second Republic (Louis Napoleon) Gold discovered in California 1848	Aleksandr Pushkin, Russian writer (1799–1837) Victor Hugo, French writer (1802–1885) Stendahl's *The Red and the Black* 1831 Ralph Waldo Emerson, American essayist (1803–1882) Margaret Fuller, American reformer (1810–1850) Charles Dickens's *Oliver Twist* 1838 George Eliot, English novelist (1819–1880) William Thackeray's *Vanity Fair* 1847 Karl Marx's *Communist Manifesto* 1848 Edgar Allan Poe, American poet (1809–1849)	Erie Canal opened 1825 First railway completed (England) 1825 Cyrus Hall McCormick invents reaper 1831 Daguerreotype process of photography introduced 1839 Samuel F. B. Morse perfects telegraph 1844
1850	Louis Napoleon takes title of emperor 1852 Matthew Calbraith Perry's visit ends Japan's isolation 1854 Frederick Douglass (c. 1817–1895) becomes American abolitionist leader Russia abolishes serfdom 1861 U.S. Civil War (1861–65) ends slavery; Abraham Lincoln assassinated 1865 Susan B. Anthony (with Elizabeth Cady Stanton) organizes National Woman Suffrage Association 1869 Franco-Prussian War 1870–71 Benjamin Disraeli British prime minister 1874–80	Herman Melville's *Moby-Dick* 1851 Harriet Beecher Stowe's *Uncle Tom's Cabin* 1851 Henry David Thoreau's *Walden* 1854 Walt Whitman's *Leaves of Grass* 1855 Gustave Flaubert's *Madame Bovary* 1856 Charles Baudelaire, French poet (1821–1867) Leo Tolstoy's *War and Peace* 1864–69 Fyodor Dostoyevsky's *Crime and Punishment* 1866 Karl Marx's *Das Kapital* 1867–94	Charles Darwin publishes *On the Origin of Species* 1859 Henry Bessemer patents tilting converter for turning iron into steel 1860 Louis Pasteur develops germ theory 1864 Gregor Mendel publishes first experiments in genetics 1865 Nobel invents dynamite 1867 First transcontinental railroad completed in America 1869 Suez Canal opened 1869

Architecture	Sculpture	Painting	Photography
Walpole, Strawberry Hill, Twickenham *(381)* Soufflot, The Panthéon, Paris *(355)*		Greuze, *The Village Bride (346)* West, *The Death of General Wolfe (349)*	
Jefferson, Monticello, Charlottesville *(357)*	Houdon, *Voltaire (353)*	Copley, *Watson and the Shark (350)* David, *The Death of Socrates (347); The Death of Marat (348)* Gros, *Napoleon at Arcole (360)*	
	Canova, *Pauline Borghese as Venus (377)*	Goya, *The Family of Charles IV (358)* Ingres, *Odalisque (362)* Goya, *The Third of May, 1808 (359)* Géricault, *The Raft of the "Medusa" (361)* Constable, *The Haywain (372)* Friedrich, *The Polar Sea (374)*	
Barry and Pugin, The Houses of Parliament, London *(383)* Labrouste, Bibliothèque Ste-Geneviève, Paris *(413, 414)*	Rude, *"La Marseillaise,"* Arc de Triomphe, Paris *(378)*	Delacroix, *The Massacre at Chios (364)* Corot, *View of Rome: The Bridge and Castel Sant' Angelo with the Cupola of St. Peter's (367)* Ingres, *Louis Bertin (363)* Turner, *Slave Ship (373)* Bingham, *Fur Traders Descending the Missouri (376)* Bonheur, *Plowing in the Nivernais (369)* Courbet, *Stone Breakers (390)*	Niépce, *View from His Window at Le Gras (386)*
Paxton, The Crystal Palace *(415)* Garnier, The Opéra, Paris *(384)*	Carpeaux, *The Dance (379)*	Rossetti, *Ecce Ancilla Domini (403)* Millet, *The Sower (368)* Daumier, *The Third-Class Carriage (366)* Manet, *Luncheon on the Grass (392); The Fifer (394)* Homer, *Snap the Whip (407)* Monet, *On the Bank of the Seine, Bennecourt (395)* Whistler, *Arrangement in Black and Gray: The Artist's Mother (405); Nocturne in Black and Gold: The Falling Rocket (406)*	Rejlander, *The Two Paths of Life (440)* Nadar, *Sarah Bernhardt (387)* Gardner, *Home of a Rebel Sharpshooter, Gettysburg (389)* Cameron, *Ellen Terry, at the Age of Sixteen (441)* *Czar Cannon Outside the Spassky Gate, Moscow (388)*

NOTE: Figure numbers are in *italics*.

Political History	Religion and Literature	Science and Technology
1875 Peak of colonialism worldwide 1876–1914 First pogroms in Russia 1881–82 First Zionist Congress called by Theodor Hertzl 1897 Spanish-American War 1898; U.S. gains Philippines, Guam, Puerto Rico, annexes Hawaii	Mark Twain's *Tom Sawyer* 1876 Henrik Ibsen, Norwegian dramatist (1828–1906) Émile Zola, French novelist (1840–1902) Oscar Wilde, Irish writer (1854–1900) Henry James, American novelist (1843–1916) G. B. Shaw, British writer (1856–1950) Emily Dickinson (1830–1886), poetry published 1890, 1891	Alexander Graham Bell patents telephone 1876 Thomas Alva Edison invents phonograph 1877; invents electric light bulb 1879 First internal combustion engines for gasoline 1885 Wilhelm Konrad Roentgen discovers X-rays 1895 Guglielmo Marconi invents wireless telegraphy 1895 Edison invents motion picture 1896
1900 President Theodore Roosevelt (1901–09) proclaims Open Door policy; Panama Canal opened 1914 8,800,000 immigrate to U.S. 1901–10 Internal strife, reforms in Russia 1905 Revolution in China, republic established 1911 First World War 1914–18; U.S. enters 1917 Bolshevik Revolution 1917; Russia signs separate peace with Germany 1918 Mahatma Gandhi agitates for Indian independence, starting in 1919 Woman Suffrage enacted in U.S. 1920; in England 1928; in France 1945 Irish Free State established 1921 Benito Mussolini's Fascists seize Italian government 1922 Turkey becomes republic 1923	Marcel Proust, French novelist (1871–1922) W. B. Yeats, Irish poet (1865–1939) André Gide, French novelist (1869–1951) Gertrude Stein, American writer (1874–1946) T. S. Eliot, British poet (1888–1964) James Joyce, Irish writer (1882–1941) Eugene O'Neill, American dramatist (1888–1953) D. H. Lawrence, English novelist (1885–1930)	Marie and Pierre Curie discover radium 1898 Max Planck formulates quantum theory 1900 Sigmund Freud's *Interpretation of Dreams* 1900 Ivan Pavlov's first experiments with conditioned reflexes 1900 Wright brothers' first flight with power-driven airplane 1903 Albert Einstein's Special Theory of Relativity 1905 Victor Victrola available 1906 Henry Ford begins assembly-line automobile production 1909 First radio station begins regularly scheduled broadcasts 1920
1925 Joseph Stalin starts first Five-Year Plan 1928 Adolf Hitler seizes power in Germany 1933 Franklin Delano Roosevelt proclaims New Deal 1933 Spanish Civil War 1936–39; won by Franco Hitler annexes Austria 1938; invades Poland 1939 Second World War 1939–45 Atomic bomb dropped on Hiroshima 1945 United Nations Charter signed 1945 Israel gains independence 1948 Apartheid becomes government policy in South Africa 1948 NATO founded 1949 Communists under Mao win in China 1949 India gains independence 1949	Virginia Woolf, English author (1882–1941) William Faulkner, American novelist (1897–1962) Ernest Hemingway, American writer (1898–1961) Thomas Wolfe, American novelist (1900–1938) Bertolt Brecht, German dramatist (1898–1956) Jean-Paul Sartre, French philosopher (1905–1980) Simone de Beauvoir, French author (1908–1986) Albert Camus, French novelist (1913–1960)	First regularly scheduled TV broadcasts in U.S. 1928, in England 1936 Motion pictures with sound appear in theaters 1928 Margaret Mead's *Coming of Age in Samoa* 1928 Atomic fission demonstrated on laboratory scale 1942 Penicillin discovered 1943 Computer technology developed 1944

Architecture	Sculpture	Painting	Photography
Sullivan, Wainwright Building, St. Louis *(437)*	Degas, *The Little Fourteen-Year-Old Dancer (412)* Rodin, *The Thinker (410); Monument to Balzac (411)*	Moreau, *The Apparition (Dance of Salome) (426)* Renoir, *Le Moulin de la Galette (397)* Degas, *The Glass of Absinthe (398)* Eakins, *William Rush Carving His Allegorical Figure of the Schuylkill River (408)* Cézanne, *Still Life with Apples (417)* Redon, *Edgar A. Poe (428)* Seurat, *Sunday Afternoon on the Island of La Grande Jatte (419)* Degas, *The Tub (399)* Morisot, *La Lecture (Reading) (400)* Gauguin, *Vision After the Sermon (Jacob Wrestling with the Angel) (422)* Van Gogh, *Self-Portrait (421); Wheat Field and Cypress Trees (420)* Cassatt, *The Bath (401)* Toulouse-Lautrec, *At the Moulin Rouge (424)* Beardsley, *Salome (427)* Munch, *The Scream (429)* Tanner, *The Banjo Lesson (409)* Cézanne, *Mont Sainte-Victoire Seen from Bibémus Quarry (418)*	Käsebier, *The Magic Crystal (442)* Muybridge, *Female Semi-Nude in Motion (444)* Riis, *Bandits' Roost (439)*
Gaudí, Casa Milá, Barcelona *(435)* Wright, Robie House, Chicago *(527, 528)* Van de Velde, Theater, Werkbund Exhibition, Cologne *(438)* Rietveld, Schröder House, Utrecht *(532)*	Maillol, *Seated Woman (La Méditerranée) (433)* Brancusi, *The Kiss (500)* Barlach, *Man Drawing a Sword (434)* Boccioni, *Unique Forms of Continuity in Space (503)* Duchamp-Villon, *The Great Horse (502)* Duchamp, *In Advance of the Broken Arm (506)* Tatlin, Project for *Monument to the Third International (504)* Brancusi, *Bird in Space (501)*	Matisse, *The Joy of Life (445)* Picasso, *Les Demoiselles d'Avignon (452)* Monet, *Water Lilies (402)* Matisse, *The Red Studio (446)* Nolde, *The Last Supper (448)* Picasso, *Portrait of Ambroise Vollard (453)* Rousseau, *The Dream (431)* Chagall, *I and the Village (459)* Duchamp, *The Bride (460)* Braque, *Le Courrier (454)* Boccioni, *Dynamism of a Cyclist (455)* Kandinsky, *Sketch I for "Composition VII" (450)* Malevich, *Black Quadrilateral (457)* De Chirico, *Mystery and Melancholy of a Street (458)* Popova, *The Traveler (456)* Rouault, *The Old King (447)* Léger, *The City (465)* Ernst, *1 Copper Plate . . . (468)* Picasso, *Three Musicians (462)* Klee, *Twittering Machine (Zwitscher-Maschine) (471)* O'Keeffe, *Black Iris III (475)*	Steichen, *Rodin with His Sculptures "Victor Hugo" and "The Thinker" (443)* Stieglitz, *The Steerage (545)* Atget, *Pool, Versailles (543)* Man Ray, Untitled *(Rayograph) (554)*
Gropius, The Bauhaus, Dessau *(533)* Le Corbusier, Villa Savoye, Poissy-sur-Seine *(535)* Aalto, Villa Mairea, Noormarkku *(536)*	González, *Head (508)* Moore, *Two Forms (510)* Calder, *Lobster Trap and Fish Tail (509)* Picasso, *Bull's Head (2)* Hepworth, *Sculpture with Color (Oval Form), Pale Blue and Red (511)*	Picasso, *Three Dancers (463)* Demuth, *I Saw the Figure 5 in Gold (466)* Hopper, *Early Sunday Morning (476)* Mondrian, *Composition with Red, Blue, and Yellow (467)* Beckmann, *Departure (474)* Miró, *Composition (470)* Ernst, *Attirement of the Bride (469)* Gorky, *The Liver Is the Cock's Comb (477)*	Sander, *Pastry Cook, Cologne (551)* Stieglitz, *Equivalent (546)* Weston, *Pepper (547)* Heartfield, *As in the Middle Ages, So in the Third Reich (553)* Van Der Zee, *At Home (550)* Cartier-Bresson, *Mexico, 1934 (544)* Bourke-White, *Fort Peck Dam, Montana (549)* Lange, *Migrant Mother, California (552)*

NOTE: Figure numbers are in *italics*.

Political History	Religion and Literature	Science and Technology
1950 Korean War 1950–53 U.S. Supreme Court outlaws racial segregation in public schools 1954 Common Market established in Europe 1957 African colonies gain independence after 1957 Fidel Castro takes over Cuba 1959	Wallace Stevens, American poet (1879–1955) Samuel Beckett, Irish author (1906–1989) Jean Genet, French dramatist (1910–1986) Eugène Ionesco, French dramatist (1912–1994) Lawrence Durrell, English novelist (1912–1990) Jack Kerouac's *On the Road* 1957	Genetic code cracked 1953 First hydrogen bomb (atomic fusion) exploded 1954 Sputnik, first satellite, launched 1957
1960 Sit-ins protest racial discrimination in U.S. 1960 Berlin Wall built 1961 John F. Kennedy assassinated 1963 Lyndon Johnson begins massive U.S. intervention in Vietnam 1965 Great Proletarian Cultural Revolution in China 1965–68 Martin Luther King, Jr., assassinated 1968 Russia invades Czechoslovakia 1968	Jorge Luis Borges, Argentinian author (1899–1986) John Steinbeck awarded Nobel Prize 1962 Betty Friedan's *The Feminine Mystique* 1963	First manned space flight 1961 First manned landing on the moon 1969
1970 Massacre of student demonstrators at Kent State University, Ohio, 1970 Civil war in Pakistan gains independence for People's Republic of Bangladesh 1972–73 Vietnam War ends 1973 Richard Nixon resigns presidency 1974 Iranian Revolution 1979	Gabriel García Márquez' *One Hundred Years of Solitude* 1970 First non-Italian pope elected since Adrian VI in 1522—Pope John Paul II (from Poland) 1978	First orbiting laboratory (Skylab) 1973 Viking I and II space probes land on Mars 1976 Personal computers available 1978 Voyager I space probe orbits Jupiter 1979
1980 Lech Walesa, Polish Solidarity leader, wins Nobel Peace Prize 1983 Mikhail Gorbachev begins implementing reform policy of *perestroika* (restructuring) and *glasnost* (openness) in U.S.S.R. 1985 Tiananmen Square massacre 1989 Reform movements develop throughout Eastern Europe; Berlin Wall demolished; Vaclav Havel elected president of Czechoslovakia; Romanians overthrow Nicolae Ceausescu 1989 Breakup of Soviet Union into independent states 1989–90	Alice Walker's *The Color Purple* 1982 Salman Rushdie's *The Satanic Verses* 1989; death threats by outraged Islamic fundamentalist force him into hiding	AIDS virus recognized 1981 Space shuttle initiated by U.S. 1981 First artificial heart implanted 1982 Compact discs available 1983 Explosion of space shuttle Challenger 1986
1990 Walesa elected president of Poland 1990 Reunification of Germany 1990 Persian Gulf War 1991 Aung Sang Suu Kyi awarded Nobel Peace Prize 1991 Borris Yelsten elected president of Russia 1991 Civil war erupts in the states of the former Yugoslavia 1991–92 South Africa holds first multiracial elections: Nelson Mandela elected president 1994 Palestinians gain self-rule from Israel in Jericho and Gaza 1994	Popular acceptance of CD-ROM encyclopedias and reference works	New office technology: facsimile machine, modem, rapid development of software programs, fiber-optic technology 1990s Hubble space telescope launched 1990 Chicken pox vaccine developed 1994 Human origins pushed back to 4 million years ago, tool-making to 2 1/2 million years ago 1996 Thirty billion new galaxies discovered 1996

Architecture	Sculpture	Painting	Phoptography
Mies van der Rohe, Seagram Building, New York *(539)* Wright, Solomon R. Guggenheim Museum, New York *(13, 14)*	Rauschenberg, *Odalisk (518)*	Pollock, *Autumnal Rhythm: Number 30, 1950 (478)* Dubuffet, *Le Métafisyx (481)* De Kooning, *Woman, II (480)* Rothko, *Orange and Yellow (483)* Albers, *Apparition (488)* Johns, *Three Flags (490)* Louis, *Blue Veil (484)* Krasner, *Celebration (479)*	Brandt, *London Child (557)* Frank, *Santa Fe, New Mexico (556)* White, *Ritual Branch (555)*
Niemeyer, Brasília *(540)*	Segal, *Cinema (521)* Smith, *Cubi* series *(513)* Nevelson, *Black Cord (520)* Kosuth, *One and Three Chairs (524)* Kienholz, *The State Hospital (522)* Bladen, *The X (512)* Oldenburg, *Giant Ice Bag (514)*	Warhol, *Gold Marilyn Monroe (492)* Lichtenstein, *Drowning Girl (491)* Kelly, *Red Blue Green (485)* Stella, *Empress of India (486)*	
Rogers and Piano, Centre National d'Art et de Culture Georges Pompidou, Paris *(541)* Graves, Public Service Building, Portland *(560)*	Smithson, *Spiral Jetty*, Great Salt Lake, Utah *(515)*	Anuszkiewicz, *Entrance to Green (489)* Eddy, *New Shoes for H. (493)* Flack, *Queen (495)* Penck, *The Demon of Curiousity (566)*	
Tschumi, Folie P6, Parc de la Villette, Paris *(562)* Stirling, Neue Staatsgalerie, Stuttgart *(561)*	Shapiro, *Untitled (516)* Kabakov, *The Man Who Flew Into Space from His Apartment (563)*	Clemente, *Untitled (496)* Kiefer, *To the Unknown Painter (497)* Murray, *More Than You Know (498)*	Leonard, *Romanticism Is Ultimately Fatal (558)* Hockney, *Gregory Watching the Snow Fall, Kyoto, Feb. 21, 1983 (559)* Kruger, *You Are a Captive Audience (567)* Lemieux, *Truth (568)*
Venturi and Brown, Seattle Art Museum, 1992	Restored Sistine Ceiling unveiled, 1992 Hamilton, *parallel lines (564)*	Tansey, *Derrida Queries de Man (565)*	Mapplethorpe exhibit, Cincinnati, 1992

NOTE: Figure numbers are in *italics*.

Glossary

Cross-references are indicated by words in SMALL CAPITALS.

ABACUS. The uppermost element of a CAPITAL, often a flat, square slab.

ABSTRACT. Having little or no reference to the appearance of natural objects; pertaining to the nonrepresentational art styles of the twentieth century; also the reduction of figures and objects to geometric shapes.

ACRYLIC. Plastic binder MEDIUM for PIGMENTS that is soluble in water, developed about 1960.

AISLE. A side passageway of a BASILICA or church, separated from the central NAVE by a row of COLUMNS or PIERS.

ALTARPIECE. A painted or carved work of art placed behind and above the altar of a Christian church. It may be a single panel, a DIPTYCH, TRIPTYCH, or polyptych having hinged wings.

AMBULATORY. A passageway to the outside of the NAVE that forms a walkway around the APSE of a church.

AMPHORA. Greek vase having an egg-shaped body, a narrow cylindrical neck, and two curving handles joined to the body at the shoulder and neck.

ANIMAL STYLE. A type of artistic design, popular in west Asia and Europe in the ancient and medieval periods, characterized by animal-like forms in intricate, linear patterns.

APSE. A large architectural niche facing the NAVE of a BASILICA or church, usually at the east end. In a church with a TRANSEPT, the apse begins beyond the CROSSING.

ARABESQUE. A type of linear ornamentation characterized by flowing, organic shapes, often in the form of interlaced vegetal, floral, and animal MOTIFS.

ARCADE. A series of ARCHES and their supports.

ARCH. A structural member, often semicircular, used to span an opening; it requires support from walls, PIERS, or COLUMNS, and sometimes BUTTRESSING.

ARCHAIC. A relatively early style, such as Greek sculpture of the seventh and sixth centuries B.C.; or any style

adopting characteristics of an earlier period.

ARCHITRAVE. The main horizontal beam, and the lowest part of an ENTABLATURE.

ARCHIVOLT. The molding framing the face of an ARCH, often highly decorated.

ARTS AND CRAFTS MOVEMENT. A late-nineteenth-century design movement centered in England that developed in reaction to the influence of industrialization. Its supporters promoted the return to handcraftsmanship.

ASSEMBLAGE. Two or more "found" objects put together as a construction. See READY-MADE.

ATMOSPHERIC PERSPECTIVE. Means of showing distance or depth in a painting by lightening the tones of objects that are far away from the PICTURE PLANE and by reducing in gradual stages the contrast between lights and darks.

ATRIUM. In ancient architecture, a room or courtyard with an open roof; or the vestibule, usually roofed, in an Early Christian church.

BANQUET PIECE. See BREAKFAST PIECE.

BAPTISTERY. A building or part of a church, often round or octagonal, in which the sacrament of baptism is administered. It contains a baptismal font, a receptacle of stone or metal for water used in the rite.

BARREL VAULT. A semicylindrical VAULT.

BASE. The lowest element of a COLUMN, PIER, wall, or DOME.

BASILICA. During the Roman period, a large meeting hall with its exact form varying according to the building's specific use as an official public building. The term was used by the Early Christians to refer to their churches. An Early Christian basilica had an oblong PLAN, flat timber ceiling, trussed roof, a NAVE, and an APSE. The entrance was on one short side and the

apse projected from the opposite side, at the far end of the building.

BAY (pl. bays). Compartments into which a building may be subdivided, usually formed by the space between consecutive architectural supports.

BLACK-FIGURE. A type of Greek vase painting, practiced in the seventh and sixth centuries B.C., in which the design was painted mainly in black against a lighter-colored background, usually the natural clay.

BLIND ARCADE. An arcade in which the ARCHES and supports are attached to a wall and have only a decorative purpose.

BOOK OF HOURS. A book for individual private devotions with prayers for different hours of the days; often elaborately ILLUMINATED.

BREAKFAST PIECE. A STILL LIFE depicting food, drink, and table settings in disorder, as after a meal. This was a popular subject among seventeenth-century Dutch painters and may have been related to the VANITAS tradition.

BURIN. An ENGRAVING tool made of a pointed steel rod and a wooden handle.

BUTTRESS. A masonry support that counteracts the THRUST exerted by an ARCH or a VAULT. See FLYING BUTTRESS, PIER BUTTRESS.

CAMERA OBSCURA. Latin for "dark room." A darkened enclosure or box with a small opening or lens on one wall through which light enters to form an inverted image on the opposite wall. The principle had long been known but was not used as an aid in picture making until the sixteenth century.

CAMPANILE. Italian for "bell tower." A FREESTANDING tower erected adjacent to a church; a common element in late medieval and Renaissance church building.

CAPITAL. The crowning member of a COLUMN, PIER, or PILASTER on which the

lowest element of the ENTABLATURE rests.

CARTOON. Derived from the Italian *cartone*, meaning "heavy paper." A preliminary SKETCH or DRAWING made to be transferred to a wall, panel, or canvas as a guide in painting a finished work.

CASTING. A method of reproducing a three-dimensional object or RELIEF. Casting in bronze or other metal is often the final stage in the creation of a piece of SCULPTURE; casting in plaster is a convenient and inexpensive way of making a copy of an original.

CATACOMB. An underground place of burial consisting of tunnels and niches for tombs; most common during Early Christian times.

CELLA. The main chamber of a temple that housed the cult image in Near Eastern, Greek, and Roman temples.

CENTRAL-PLAN CHURCH. The standard design used for churches in Eastern Orthodox Christianity, in which symmetrical chambers radiate from a central primary space.

CHANCEL. See CHOIR.

CHAPEL. A compartment in a church containing an altar dedicated to a saint.

CHIAROSCURO. Italian for "light and dark." In painting, a method of MODELING form primarily by the use of light and shade.

CHOIR. In a church, the space reserved for the clergy and singers, set off from the NAVE by steps, and occasionally by a screen.

CHOIR SCREEN. An element of church architecture, often decorated with sculpture, that is used to separate the CHOIR from the NAVE or TRANSEPT.

CLASSICAL. Used generally to refer to the art of the Greeks and the Romans.

CLASSICAL ORDERS. The three most common Greek and Roman ORDERS are the DORIC, IONIC, and CORINTHIAN.

CLERESTORY. A row of windows piercing the NAVE walls of a BASILICA or church above the level of the side AISLES.

CLOISTER. An open courtyard surrounded by a covered ARCADE. Cloisters are usually associated with spiritual or scholarly reflection and are often attached to monasteries, churches, or universities.

COLLAGE. A composition made by pasting cut-up textured materials, such as newsprint, wallpaper, etc., to form all or part of a work of art; may be combined with painting or drawing or with three-dimensional objects.

COLONNADE. A series of COLUMNS placed at regular intervals.

COLOR. The choice and treatment of the HUES in a painting.

COLOSSAL ORDER. An ORDER built on a large scale, extending over two or more stories.

COLUMN. A vertical architectural support, usually consisting of a BASE, a rounded SHAFT, and a CAPITAL.

COMPOSITION. The arrangement of FORM, COLOR, LINE, space, and mass in a work of art.

COMPOUND PIER. A PIER with COLUMNS, PILASTERS, or SHAFTS attached.

CONTRAPPOSTO. Italian for "set against." The disposition of the parts of the body so that the weight-bearing leg, or engaged leg, is distinguished from the raised leg, or free leg, resulting in a shift in the axis between the hips and shoulders. Used first by the Greek sculptors as a means of showing movement in a figure.

CORBELING. A space-spanning technique in which each layer of stone increasingly tapers inward to form an ARCH or a VAULT.

CORINTHIAN COLUMN. First appeared in fifth-century-B.C. Greece, apparently as a variation of the IONIC COLUMN. The CAPITAL differentiates the two: the Corinthian capital has an inverted bell shape, decorated with acanthus leaves, stalks, and VOLUTE scrolls.

CORINTHIAN ORDER. The most ornate CLASSICAL ORDER, distinguished by a fluted COLUMN, a bell-shaped CAPITAL decorated with acanthus-leaf carvings, and a decorated ENTABLATURE. Widely used by the Romans.

CORNICE. A crowning, projecting architectural feature, especially the uppermost part of an ENTABLATURE.

CROSSING. In a cross-shaped church, the area where the NAVE and TRANSEPT intersect.

CRYPT. A VAULTED space beneath the main floor of a church, usually below the CHOIR, used as a burial or relic chamber.

CUPOLA. A rounded, domed roof or ceiling.

DAGUERREOTYPE. Originally, a photograph on a silver-plated sheet of copper that had been treated with fumes of iodine to form silver iodide on its surface and, after exposure, was developed by fumes of mercury. The process, invented by L. J. M. Daguerre and made public in 1839, was modified and accelerated as daguerreotypes gained worldwide popularity.

DIPTYCH. A painting or RELIEF executed on two panels joined by a hinge.

DOME. A large, curved roof element supported by a circular wall (DRUM) or square BASE.

DORIC COLUMN. The Doric column stands without a BASE directly on top of the stepped platform of a temple. Its SHAFT has shallow FLUTES.

DORIC ORDER. The CLASSICAL ORDER characterized by a fluted COLUMN without a BASE, and with an undecorated CAPITAL and a plain ENTABLATURE.

DRAWING. SKETCH, design, or representation by LINES. Drawings are usually made on paper with pen, pencil, charcoal, pastel, chalk, and the like.

DRESSED STONE. Stone that is evenly cut and laid and is smoothly finished; generally used for architectural exteriors.

DRUM. Cylindrical wall supporting a DOME; one of several sections composing the SHAFT of a COLUMN.

DRYPOINT. A graphic-arts process in which a pointed drypoint needle is used to directly inscribe the design into a copper or zinc plate. The INCISING creates a ragged edge that produces a soft line in the print, the distinguishing quality of a drypoint. Also, a print made by this process.

ECHINUS. The cushionlike slab below the ABACUS of a Doric CAPITAL; also, the molding below the VOLUTES on an Ionic CAPITAL.

ELEVATION. Architectural drawing of a face of a building.

EMBOSSING. A technique in metalwork used to make designs stand out in RELIEF.

ENAMELING. The process of fusing colored glass to metal by firing in a kiln.

ENCAUSTIC. Method of painting in colors mixed with wax and applied with a brush, usually while the mixture is hot. The technique was practiced in ancient times and in the Early Christian period, and has been revived by some modern painters.

ENGAGED COLUMN. A COLUMN that is part of a wall or projects from it only slightly; such columns often have only decorative purposes.

ENGRAVING. A graphic-arts process in which a design is INCISED in reverse on a copper plate; this is coated with printer's ink, which remains in the incised lines when the plate is wiped off. Damp paper is placed on the plate, and both are put into a press; the paper soaks up the ink and produces a print of the original. Also, a print made by this process.

ENTABLATURE. The upper part of an architectural ORDER consisting of ARCHITRAVE, FRIEZE, and CORNICE.

ENTASIS. The slight swelling of the SHAFT of a COLUMN. Entasis creates an optical illusion that makes the column appear consistent and straight from bottom to top when viewed from ground level.

ETCHING. Like ENGRAVING, etching is an INCISING graphic-arts process. However, the design is drawn in reverse with a needle on a plate thinly coated with wax or resin. The plate is placed in a bath of nitric acid, which etches the lines to receive ink. The coating is then removed, and the prints are made as in engraving. Also, a print made by this process.

FACADE. The front face of a building.

FLUTE. Vertical channel on a column SHAFT.

FLYING BUTTRESS. An ARCH that springs from the upper part of the PIER BUTTRESS of a Gothic church, spans the AISLE roof, and abuts the upper NAVE wall to receive the THRUST from the nave VAULTS; it transmits this thrust to the solid pier buttresses.

FORESHORTENING. Method of representing objects as if seen at an angle and receding or projecting into space.

FORM. The external shape or appearance of a representation, considered apart from its COLOR or material.

FREESTANDING. Used to refer to a work of SCULPTURE IN THE ROUND, that is, in full three-dimensionality; also, not attached to architecture and not sculptured in RELIEF.

FREESTANDING COLUMN. A COLUMN that is detached from a wall, usually having a structural purpose.

FRESCO. A technique of wall painting known since antiquity. PIGMENT is mixed with water and applied to a freshly plastered area of a wall. The result is a particularly long-lasting form of painted decoration.

FRIEZE. In CLASSICAL ORDERS, the element of the ENTABLATURE that rests on the ARCHITRAVE and is immediately below the CORNICE. Also, any decorated horizontal band.

GABLE. Triangular part of a wall, enclosed by the lines of a sloping roof.

GALLERY. In church architecture, an elevated story above the NAVE and usually open to it.

GENIUS (pl. genii). Latin for "guardian spirit."

GENRE. French for "kind" or "sort." A work of art, usually a painting, showing a scene from everyday life that is represented for its own sake.

GISANT. A sculptured, recumbent image of a deceased person lying on the lid of his or her tomb.

GLAZE. In ceramics, a thin coating of glass fused to a ceramic surface by firing in a kiln. The result is a decorative and waterproof surface. In oil painting, a thin translucent layer of paint applied over a dry underlayer, which produces a luminous effect.

GOSPELS, GOSPEL BOOK. Contains the four books of the New Testament that tell the life of Christ, attributed to the Evangelists Matthew, Mark, Luke, and John. Often elaborately illustrated.

GROIN. The sharp edge formed by the intersection of two VAULTS.

GROIN VAULT. VAULT formed by the intersection at right angles of two BARREL VAULTS of equal height and diameter so that the GROINS form a diagonal cross.

GROUND PLAN. An architectural drawing that shows the outline shape of a building just above ground level, together with its space-defining interior parts.

GROUND PLANE. In pictures or RELIEFS, the surface upon which figures and objects appear to stand.

GROUNDLINE. In pictures or RELIEFS, a LINE that indicates the field of ground upon which objects are placed (GROUND PLANE). Multiple groundlines may be used in a single work of art to indicate spatial depth.

GUILD. An association of artisans or craftspeople organized to educate its members and promote their products. Guilds were most common and powerful during the Middle Ages and Early Renaissance. Its members were ranked according to experience, from lowest to highest: apprentice, journeyman, and master.

GUTTAE. Small, peglike projections below the FRIEZE in the ENTABLATURE of the DORIC ORDER.

HALO. The projection of light surrounding the head or body of a figure, indicating divinity, holiness, or spiritual eminence.

HERALDIC. Relating to a system of elaborate symbols used to designate family membership. Heraldic symbols were often used to decorate the homes and armor of noble families.

HIEROGLYPHICS. Meaning "sacred writing." The characters and picture-writing used by the ancient Egyptians.

HIGH RELIEF. See RELIEF.

HUE. The particular shade of a COLOR.

ICON. A panel painting of Christ, the Virgin, or saints; regarded as sacred, especially by Eastern Christians.

ILLUMINATION. A painting technique combining rich PIGMENTS, gold, and other precious metals to produce dazzling color effects. A term used generally for describing painting in manuscripts. Illuminated manuscripts may

contain separate ornamental pages, marginal illustrations, ornament within the text, entire MINIATURE paintings, or any combination of these.

ILLUSIONISM, ILLUSIONISTIC. The effort of an artist to represent the visual world.

ILLUSTRATION. The representation of an idea, scene, or text by visual means.

IMPASTO. From the Italian, meaning "in paste." Paint, usually OIL PAINT, applied thickly and showing the marks of the brush or other application tool.

INCISING. Technique of cutting into a hard surface with a sharp instrument to create a linear image.

IONIC COLUMN. The Ionic column stands on a molded BASE. The SHAFT normally has FLUTES more deeply cut than DORIC flutes. The Ionic CAPITAL is identified by its pair of spiral, scroll-like ornaments.

IONIC ORDER. The CLASSICAL ORDER distinguished by its fluted COLUMN, volute CAPITAL, molded ARCHITRAVE, and ENTABLATURE.

JAMB. Side of a doorway or window frame.

KEYSTONE. The stone at the center of an ARCH that locks the other stones in place.

KORE. ARCHAIC-period Greek statue of a draped maiden.

KOUROS. ARCHAIC-period Greek statue of a standing nude youth.

KRATER. An ancient Greek vessel used to hold a mixture of wine and water. A large body and wide mouth were standard features; but within these parameters, kraters were produced in many different styles.

LANTERN. Small structure above a roof or DOME with open or windowed walls to allow in light and air; also the tower above the CROSSING of a church.

LATIN CROSS. Cross with three arms of equal length and one longer arm. Beginning with Romanesque architecture, the standard plan in Christian church building.

LINE. Mark made by a moving tool, such as a pen or pencil; more generally, an outline, contour, or silhouette.

LINEAR PERSPECTIVE. A mathematical system for representing three-dimensional objects and space on a two-dimensional surface. All objects are represented as seen from a single viewpoint.

LINTEL. A horizontal architectural element upheld by upright posts or COLUMNS to form an opening.

LITHOGRAPHY. A graphic-arts process in which a design is drawn with a grease pencil on a limestone or zinc surface, which is then wetted and inked. A damp paper is pressed against this surface, transferring the final image.

LOW RELIEF. See RELIEF.

LUNETTE. A semicircular zone, either painted or sculptured, usually above a window or doorway.

MANDORLA. Italian for "almond." An almond-shaped radiance of light surrounding a holy figure.

MASS. The expanse of COLOR that defines a painted shape; the three-dimensional volume of a sculptured or architectural form.

MASTABA. Aboveground tomb building with a flat roof and inward-sloping walls, linked by a deep shaft to an underground burial chamber. A tomb form popular in ancient Egypt.

MEDIUM. The material with which an artist works, such as marble, OIL PAINT, TERRA-COTTA, and WATERCOLOR.

METOPE. An oblong or square panel found as an element of the ENTABLATURE of the DORIC ORDER. It is located specifically on the FRIEZE between the TRIGLYPHS.

MINIATURE. A painting or drawing in an ILLUMINATED manuscript; also a very small portrait, sometimes painted on ivory.

MOBILE. A type of sculpture made of parts that can be set in motion by the movement of air currents.

MODELING. An additive sculptural process in which a malleable material is molded into a three-dimensional form. In painting or DRAWING, the means by which the three-dimensionality of a form is suggested on a two-dimensional surface, usually through variations of COLOR and the play of lights and darks.

MONUMENTAL. Frequently used to describe works that are larger than lifesize; also used to describe works giving the impression of great size, whatever their actual dimensions.

MOSAIC. A design formed by embedding small pieces of colored stone or glass in cement. In antiquity, large mosaics were used chiefly on floors; from the Early Christian period on, mosaic decoration was increasingly used on walls and vaulted surfaces.

MOTIF. A distinctive and recurrent feature or theme, shape, or figure in a work of art.

MURAL. A wall painting. See FRESCO.

MUTULE. In the DORIC ORDER, the projecting flat block above the TRIGLYPH.

NARTHEX. The vestibule at the main entrance of a BASILICA or church.

NAVE. The central aisle of a BASILICA or church; also, the section of a church between the main entrance and the CHOIR.

OIL PAINTING. Though known to the Romans, it was not systematically used until the fifteenth century. In the oil technique of early Flemish painters, PIGMENTS were mixed with drying oils and fused while hot with hard resins; the mixture was then diluted with other oils.

ORDER. In architecture, a CLASSICAL system of proportion and interrelated parts. These include a COLUMN, usually with a BASE, SHAFT, and CAPITAL, and an ENTABLATURE with ARCHITRAVE, FRIEZE, and CORNICE.

PAINTING MEDIUMS. See ACRYLIC, ENCAUSTIC, FRESCO, OIL PAINTING, TEMPERA, and WATERCOLOR.

PALETTE. The range of COLORS chosen by an artist for use in a particular painting.

PANTHEON. A temple dedicated to all the gods, or housing tombs of the illustrious dead of a nation, or memorials to them.

PASSION. Events surrounding Jesus Christ's death, resurrection, and ascension to heaven.

PASTEL. Powdered PIGMENTS mixed with

gum and molded into sticks for drawing; also a picture or SKETCH made with this type of crayon.

PEDIMENT. Triangular section above the ENTABLATURE on the face of a building. The pediments at either end of a temple often contained HIGH RELIEF or FREESTANDING SCULPTURE.

PENDENTIVES. Among the supports for a DOME, the triangular segments of a wall leading from the square BASE to the circular DRUM.

PERISTYLE. COLONNADE (or ARCADE) around a building or open court.

PERSPECTIVE. See ATMOSPHERIC PERSPECTIVE, LINEAR PERSPECTIVE.

PHOTOGRAM. A shadowlike picture made by placing opaque, translucent, or transparent objects between light-sensitive paper and a light source and developing the latent photographic image.

PHOTOMONTAGE. A photograph in which prints in whole or in part are combined to form a new image. A technique much practiced by the Dada group in the 1920s.

PICTORIAL SPACE. In pictures or RELIEFS, the ILLUSION of depth created by devices such as multiple GROUNDLINES and PERSPECTIVE.

PICTURE PLANE. The imaginary plane suggested by the actual surface of a painting, drawing, or relief.

PIER. A vertical architectural element, usually rectangular in section; if used with an ORDER, often has a BASE and CAPITAL of the same design.

PIER BUTTRESS. An exterior PIER in Romanesque and Gothic architecture, buttressing the THRUST of the VAULTS within.

PIETÀ. In painting or SCULPTURE, a representation of the Virgin Mary mourning the dead Jesus, whom she holds.

PIGMENT. A dry, powdered substance that, when mixed with a suitable liquid, or vehicle, gives COLOR to paint. See ACRYLIC, ENCAUSTIC, FRESCO, OIL PAINTING, TEMPERA, WATERCOLOR.

PILASTER. A flat, vertical, attached element having a CAPITAL and BASE, projecting slightly from a wall. Has a decorative rather than a structural purpose.

PLAN. The schematic representation of a three-dimensional structure, such as a building or monument, on a two-dimensional plane.

PLASTIC. Describes a form that is molded or MODELED.

POLYCHROMY. The decoration of architecture or sculpture in multiple colors.

PORTAL. A doorway, gate, or entrance of imposing size. In Romanesque and Gothic churches, portals may be elaborately decorated.

PORTICO. A roofed porch supported by COLUMNS.

POST AND BEAM. A system or unit of construction consisting solely of vertical and horizontal elements. See LINTEL.

POST-AND-LINTEL CONSTRUCTION. A space-spanning technique in which two or more vertical beams (posts) support a horizontal beam (LINTEL).

PREDELLA. The long and narrow horizontal panel beneath the main scene on an ALTARPIECE. The panel is often painted or sculptured to correspond with the altarpiece's overall theme.

PROPORTION. The relation of the size of any part of a figure or object to the size of the whole. For architecture, see ORDER.

PYLON. In Egyptian architecture, the entranceway set between two broad, oblong towers with sloping sides.

QUATREFOIL. A decorative MOTIF composed of four lobes; often used in Gothic art and architecture.

READY-MADE. A manufactured object exhibited as being aesthetically pleasing. When two or more accidentally "found" objects are place together as a construction, the piece is called an ASSEMBLAGE.

RED-FIGURE. A type of Greek vase painting in which the design is outlined in black and the background painted in black, leaving the figures and the reddish color of the baked clay after firing. This style replaced the BLACK-FIGURE style toward the end of the sixth century B.C.

RELIEF. Forms in SCULPTURE that are carved from a background block, to which they remain attached. Relief may be hollowed to create sunken relief, modeled shallowly to produce low relief, or modeled deeply to produce high relief; in very high relief, the sculpture will project almost entirely from its background.

REPRESENTATIONAL. As opposed to ABSTRACT, a portrayal of an object in recognizable form.

RESPOND. A projecting and supporting architectural element, often a PIER, that is bonded with another support, usually a wall, to carry one end of an ARCH.

RHYTHM. The regular repetition of a particular form: also, the suggestion of motion by recurrent forms.

RIB. A projecting arched member of a VAULT.

RIBBED VAULT. A compound masonry vault, the GROINS of which are marked by projecting stone RIBS.

ROSE WINDOW. Round windows decorated with STAINED GLASS and TRACERY, frequently incorporated into FACADES and TRANSEPTS of Gothic churches.

SARCOPHAGUS (pl. sarcophagi). A coffin made of stone, marble, TERRA-COTTA (less frequently, of metal). Sarcophagi are often decorated with paintings or RELIEFS.

SCALE. Generally, the relative size of any object in a work of art, often used with reference to human scale.

SCULPTURE. A three-dimensional form, usually in a solid material. Traditionally, two basic techniques have been used: subtractive—carving in a hard material such as marble; and additive—modeling in a soft material such as clay or wax. See FREESTANDING and RELIEF.

SCULPTURE IN THE ROUND. See FREESTANDING.

SECTION. Architectural drawing representing the vertical arrangement of a building's interior.

SFUMATO. The gentle gradation from light to dark TONES, which softens the appearance of painted images.

SHAFT. A cylindrical form; in architecture, the part of a COLUMN or PIER intervening between the BASE and the CAPITAL. Also, a vertical enclosed space.

SKETCH. A rough DRAWING representing the main features of a composition; often used as a preliminary study.

SPANDREL. The triangular surface formed by the outer curve of an arch and its rectangular frame.

STAINED GLASS. The technique of filling architectural openings with glass colored by fused metallic oxides; pieces of this glass are held in a design by strips of lead.

STELA. A vertical stone slab decorated with a combination of images in RELIEF and inscriptions; often used as a grave marker.

STILL LIFE. A painting or drawing of an arrangement of inanimate objects.

STUCCO. A mixture of lime, sand, and other materials that can be used as a general ground in FRESCO painting, or as a final covering for a wall surface. The mixture can also be manipulated for use as decorative MOLDING.

SUNKEN RELIEF. See RELIEF.

TEMPERA. A painting process in which PIGMENT is mixed with an emulsion of egg yolk and water or egg and oil. Tempera, the basic technique of medieval and Early Renaissance painters, dries quickly, permitting almost immediate application of the next layer of paint.

TERRA-COTTA. Clay, MODELED or molded and baked until very hard. Used in architecture for functional and decorative reasons, as well as in pottery and SCULPTURE. Terra-cotta may have a painted or glazed surface.

TESSERA (pl. tesserae). A small piece of colored glass or stone used to create a MOSAIC.

THRUST. The downward and outward pressure exerted by an ARCH or VAULT and requiring BUTTRESSING.

TONALITY. The soft or garish impression given by a COLOR or range of colors.

TONE. A reference to the COLOR, darkness, depth, or brightness of a PIGMENT.

TRACERY. Ornamental stonework in elaborate intersecting patterns, used either in windows or on wall surfaces.

TRANSEPT. In a cross-shaped church, the arm forming a right angle with the NAVE, usually inserted between the latter and the CHOIR or APSE.

TRIFORIUM. An ARCADE running along the walls above the NAVE, and usually pierced by three openings per BAY.

TRIGLYPH. A vertical block with **V**-cut channels. It is located specifically on the FRIEZE between the METOPES.

TRIPTYCH. A painting or RELIEF executed on three panels that are often hinged so that the two outer panels fold like doors in front of the central panel.

TRIUMPHAL ARCH. A massive, FREE-STANDING ornamental gateway; originally developed by the ancient Romans to honor a military victory. Also, a MONUMENTAL arch inside a structure.

TRUMEAU. A central post supporting the LINTEL of a large doorway, as in a Romanesque or Gothic PORTAL, where it was frequently decorated with sculpture.

TYMPANUM. The semicircular panel between the LINTEL and ARCH of a medieval PORTAL or doorway; a church tympanum frequently contains RELIEF sculpture.

VANISHING POINT. In PERSPECTIVE, the point at which parallel lines seem to meet and disappear.

VANITAS. A STILL LIFE in which the objects represent the transience of life. A popular subject in seventeenth-century Dutch painting.

VAULT. An arched architectural covering made of brick, stone, or concrete.

VEDUTA. A painting, drawing, or print of an actual city.

VELLUM. Thin, bleached calfskin that can be written, printed, or painted upon.

VOLUTE. A decorative spiral scroll, seen most commonly in IONIC CAPITALS.

VOTIVE. An object created as an offering to a god or spirit.

VOUSSOIRS. Wedge-shaped stones forming an ARCH.

WATERCOLOR. PIGMENTS mixed with water instead of oil or other medium; also, a picture painted with watercolor, often on paper.

WESTWORK. The elaborate west entrance of Carolingian, Ottonian, and Romanesque churches, composed of exteriors with towers and multiple stories, and an interior with an entrance vestibule, a CHAPEL, and GALLERIES overlooking a NAVE.

WOODCUT. A printing process in which a design or lettering is carved in RELIEF on a wooden block; the areas intended not to print are hollowed out.

ZIGGURAT. An elevated platform, varying in height from several feet to the size of an artificial mountain, built by the Sumerians to support their shrines.

Books for Further Reading

This list includes standard works and the most recent and comprehensive books in English. Books with material relevant to several chapters are cited only under the first heading. Asterisks (*) indicate titles available in paperback; for publishers, distributors, and the like, see *Paperbound Books in Print* (R.R. Bowker, annual).

INTRODUCTION
*Broude, Norma, and Mary D. Garrard, eds. *Feminism and Art History: Questioning the Litany*. Harper & Row, New York, 1982
*Holt, Elizabeth Gilmore, ed. *A Documentary History of Art*. 3 vols. Vols. 1–2, Princeton University Press, Princeton, 1981–86; vol. 3, Yale University Press, New Haven, 1986
Kostof, Spiro. *A History of Architecture: Settings and Rituals*. 2nd ed. Oxford University Press, New York, 1995
*Panofsky, Erwin. *Meaning in the Visual Arts*. Reprint of 1955 ed. University of Chicago Press, Chicago, 1982
*Taylor, Joshua C. *Learning to Look: A Handbook for the Visual Arts*. 2nd ed. University of Chicago Press, Chicago, 1981
Trachtenberg, Marvin, and Isabelle Hyman. *Architecture: From Prehistory to Post-Modernism*. Harry N. Abrams, New York, 1986

Part One THE ANCIENT WORLD
1 PREHISTORIC AND ETHNOGRAPHIC ART
Sandars, Nancy K. *Prehistoric Art in Europe*. Reprint of 1985 2nd integrated ed. Pelican History of Art. Yale University Press, New Haven, 1992

2 EGYPTIAN ART
Panofsky, Erwin. *Tomb Sculpture: Four Lectures on Its Changing Aspects from Ancient Egypt to Bernini*. Reprint of 1969 ed. Harry N. Abrams, New York, 1992
*Smith, William S., and William K. Simpson. *The Art and Architecture of Ancient Egypt*. Reprint of 1981 2nd ed. Pelican History of Art. Yale University Press, New Haven, 1993

3 ANCIENT NEAR EASTERN ART
*Frankfort, Henri. *The Art and Architecture of the Ancient Orient*. Pelican History of Art. Yale University Press, New Haven, 1995

4 AEGEAN ART
Graham, James. *The Palaces of Crete*. Rev. ed. Princeton University Press, Princeton, 1986
Hampe, Ronald, and Erika Simon. *The Birth of Greek Art from the Mycenaean to the Archaic Period*. Oxford University Press, New York, 1981

5 GREEK ART
Boardman, John. *The Oxford Illustrated History of Classical Art*. Oxford University Press, New York, 1993
*Lawrence, Arnold W. *Greek Architecture*. Pelican History of Art. Yale University Press, New Haven, 1992
*Pollitt, Jerome. *Art and Experience in Classical Greece*. Cambridge University Press, New York, 1989
*———. *Art in the Hellenistic Age*. Cambridge University Press, New York, 1986
*———. *Art of Ancient Greece: Sources and Documents*. Rev. ed. Cambridge University Press, New York, 1990
Richter, Gisela M. A. *A Handbook of Greek Art*. 9th ed. Da Capo, New York, 1987

*Stewart, Andrew F. *Greek Sculpture: An Exploration*. 2 vols. Yale University Press, New Haven, 1990

6 ETRUSCAN ART
*Brendel, Otto J. *Etruscan Art*. 2nd ed. Pelican History of Art. Yale University Press, New Haven, 1995

7 ROMAN ART
Brilliant, Richard. *Roman Art from the Republic to Constantine*. Phaidon, London, 1974
Kleiner, Diana. *Roman Sculpture*. Yale University Press, New Haven, 1992
Ling, R. *Roman Painting*. Cambridge University Press, New York, 1991
MacDonald, William L. *The Architecture of the Roman Empire*. Rev. ed. 2 vols. Yale University Press, New Haven, vol. 1, 1982; vol. 2, 1987
Pollitt, Jerome. *The Art of Rome, c. 753 B.C.–A.D. 337: Sources and Documents*. Cambridge University Press, New York, 1983
*Strong, Donald E. *Roman Art*. 2nd rev. ed. Pelican History of Art. Penguin, Harmondsworth, England, 1990

Part Two THE MIDDLE AGES
*Calkins, Robert G. *Monuments of Medieval Art*. Reprint of 1979 ed. Cornell University Press, Ithaca, 1985

8 EARLY CHRISTIAN AND BYZANTINE ART
*Beckwith, John. *Early Christian and Byzantine Art*. 2nd integrated ed. Pelican History of Art. Penguin, Harmondsworth, England, 1979
Demus, Otto. *Byzantine Art and the West*. New York University Press, New York, 1970
Kitzinger, Ernst. *Byzantine Art in the Making: Main Lines of Stylistic Development in Mediterranean Art, 3rd–7th Century*. Harvard University Press, Cambridge, 1977
*Krautheimer, Richard. *Early Christian and Byzantine Architecture*. 4th ed. Pelican History of Art. Yale University Press, New Haven, 1986
*MacDonald, William L. *Early Christian and Byzantine Architecture*. The Great Ages of World Architecture. Braziller, New York, 1965
*Mango, Cyril. *The Art of the Byzantine Empire, 312–1453: Sources and Documents*. Reprint of 1972 ed. University of Toronto Press in association with the Medieval Academy of America, Toronto, 1986
Snyder, James. *Medieval Art: Painting, Sculpture, Architecture, 4th–14th Century*. Harry N. Abrams, New York, 1989

9 EARLY MEDIEVAL ART
*Conant, Kenneth J. *Carolingian and Romanesque Architecture, 800–1200*. 4th ed. Pelican History of Art. Yale University Press, New Haven, 1993
Davis-Weyer, Caecilia, ed. *Early Medieval Art, 300–1150: Sources and Documents*. Reprint of 1971 ed. University of Toronto Press in association with the Medieval Academy of America, Toronto, 1986
Dodwell, C. R. *The Pictorial Arts of the West, 800–1200*. New ed. Pelican History of Art. Yale University Press, New Haven, 1993
Mayr-Harting, M. *Ottonian Book Illumination: An Historical Study*. 2 vols. Oxford University Press, New York, 1991–93
*Pevsner, Nikolaus. *An Outline of European Architecture*. Reprint of 1972 ed. Penguin, London, 1990

10 ROMANESQUE ART
Bowie, Fiona, and Oliver Davies, eds. *Hildegard of Bingen: Mystical Writings*. Crossroad, New York, 1990

Focillon, Henri. *The Art of the West in the Middle Ages*. Ed. Jean Bony. 2 vols. Reprint of 1963 ed. Cornell University Press, Ithaca, 1980

*Hearn, M. F. *Romanesque Sculpture: The Revival of Monumental Stone Sculpture in the Eleventh and Twelfth Centuries*. Cornell University Press, Ithaca, 1981

*Schapiro, Meyer. *Romanesque Art*. Braziller, New York, 1993

Stoddard, Whitney S. *Art and Architecture in Medieval France: Medieval Architecture, Sculpture, Stained Glass, Manuscripts, the Art of the Church Treasuries*. Harper & Row, New York, 1972

11 GOTHIC ART

Bony, Jean. *French Gothic Architecture of the Twelfth and Thirteenth Centuries*. California Studies in the History of Art. University of California Press, Berkeley, 1983

Frisch, Teresa G. *Gothic Art, 1140–c. 1450: Sources and Documents*. Reprint of 1971 ed. University of Toronto Press in association with the Medieval Academy of America, Toronto, 1987

Krautheimer, Richard, and Trude Krautheimer-Hess. *Lorenzo Ghiberti*. Princeton University Press, Princeton, 1982

Meiss, Millard. *Painting in Florence and Siena After the Black Death: the Arts, Religion, and Society in the Mid-Fourteenth Century*. Princeton University Press, Princeton, 1978

Pope-Hennessy, John. *Italian Gothic Sculpture*. 3rd ed. Oxford University Press, New York, 1986

*Simson, O. von. *The Gothic Cathedral: Origins of Gothic Architecture and the Medieval Concept of Order*. 3rd ed. Bollingen Series. Princeton University Press, Princeton, 1988

*White, John. *Art and Architecture in Italy, 1250–1400*. 3rd ed. Pelican History of Art. Yale University Press, New Haven, 1993

Part Three THE RENAISSANCE, MANNERISM, AND THE BAROQUE

12 "LATE GOTHIC" PAINTING, SCULPTURE, AND THE GRAPHIC ARTS

*Cuttler, Charles D. *Northern Painting: From Pucelle to Bruegel: Fourteenth, Fifteenth, and Sixteenth Centuries*. Rev. and updated printing. Holt, Rinehart, and Winston, New York, 1972

*Hind, Arthur M. *A History of Engraving and Etching from the Fifteenth Century to the Year 1914*. Reprint of 3rd rev. ed. Dover, New York, 1963

*———. *An Introduction to a History of Woodcut*. 2 vols. Houghton Mifflin, Boston, 1935

Ivins, W. M., Jr. *How Prints Look: Photographs with a Commentary*. Rev. and exp. ed. Beacon Press, Boston, 1987

Panofsky, Erwin. *Early Netherlandish Painting*. 2 vols. Harvard University Press, Cambridge, 1971

Snyder, James. *Northern Renaissance Art: Painting, Sculpture, the Graphic Arts, from 1350–1575*. Harry N. Abrams, New York, 1985

13 THE EARLY RENAISSANCE IN ITALY

Borsook, Eve. *The Mural Painters of Tuscany: From Cimabue to Andrea del Sarto*. 2nd ed. Oxford University Press, New York, 1981

*Burckhardt, Jacob C. *The Civilization of the Renaissance in Italy*. Penguin Classics. Penguin, Harmondsworth, England, 1990

Gilbert, Creighton E. *Italian Art, 1400–1500: Sources and Documents*. Reprint of 1980 ed. Northwestern University Press, Evanston, Illinois, 1992

*Gombrich, E. H. *Norm and Form*. 4th ed. Studies in the Art of the Renaissance. University of Chicago Press, Chicago, 1985

Hartt, Frederick. *History of Italian Renaissance Art*. 4th ed. Harry N. Abrams, New York, 1994

*Heydenreich, Ludwig Heinrich. *Architecture in Italy, 1400–1500*. Pelican History of Art. Yale University Press, New Haven, 1996

Huse, Norbert, and W. Wolters. *The Art of Renaissance Venice: Architecture, Sculpture, and Painting, 1460–1590*. University of Chicago Press, Chicago, 1990

*Janson, H. W. *The Sculpture of Donatello*. Combined 1 vol. ed. Princeton University Press, Princeton, 1963

Pope-Hennessy, John. *Donatello: Sculptor*. Abbeville, New York, 1993

———. *Italian Renaissance Sculpture*. 3rd ed. Oxford University Press, New York, 1986

Seymour, Charles, Jr. *Sculpture in Italy, 1400–1500*. Pelican History of Art. Penguin, Harmondsworth, England, 1966

Wilde, Johannes. *Venetian Art from Bellini to Titian*. Clarendon Press, Oxford, 1981

14 THE HIGH RENAISSANCE IN ITALY

Clark, Kenneth. *Leonardo da Vinci*. Rev. and introduced by M. Kemp. Penguin, New York, 1993

Freedberg, Sydney J. *Painting in Italy, 1500–1600*. 3rd ed. Pelican History of Art. Yale University Press, New Haven, 1993

———. *Painting of the High Renaissance in Rome and Florence*. New rev. ed. 2 vols. Hacker Art Books, New York, 1985

Hibbard, Howard. *Michelangelo*. 2nd ed. Harper & Row, New York, 1985

*Klein, R., and H. Zerner. *Italian Art, 1500–1600: Sources and Documents*. Reprint of 1966 ed. Northwestern University Press, Evanston, Illinois, 1989

Pope-Hennessy, John. *Italian High Renaissance and Baroque Sculpture*. 3rd ed. 3 vols. Oxford University Press, New York, 1986

———. *Raphael*. New York University Press, New York, 1970

Rosand, David. *Painting in Cinquecento Venice: Titian, Veronese, Tintoretto*. Yale University Press, New Haven, 1986

15 MANNERISM AND OTHER TRENDS

Shearman, John K. G. *Mannerism*. Penguin, Harmondsworth, England, 1973

16 THE RENAISSANCE IN THE NORTH

*Blunt, Anthony. *Art and Architecture in France, 1500–1700*. 4th ed. Pelican History of Art. Penguin, Harmondsworth, England, 1980

Osten, Gert. von der, and Horst Vey. *Painting and Sculpture in Germany and the Netherlands, 1500–1600*. Pelican History of Art. Penguin, Harmondsworth, England, 1969

Panofsky, Erwin. *The Life and Art of Albrecht Dürer*. 4th ed. Princeton University Press, Princeton, 1971

*Stechow, W. *Northern Renaissance Art, 1400–1600: Sources and Documents*. Northwestern University Press, Evanston, Illinois, 1989

17 THE BAROQUE IN ITALY AND SPAIN

Brown, Jonathan. *The Golden Age of Painting in Spain*. Yale University Press, New Haven, 1991

Enggass, Robert, and Jonathan Brown. *Italy and Spain, 1600–1750: Sources and Documents*. Reprint of 1970 ed. Northwestern University Press, Evanston, Illinois, 1992

Held, Julius, and Donald Posner. *Seventeenth and Eighteenth Century: Baroque Painting, Sculpture, Architecture*. Harry N. Abrams, New York, 1971

Hibbard, Howard. *Bernini*. Reprint of 1965 ed. Penguin, Harmondsworth, England, 1982

Wittkower, Rudolf. *Art and Architecture in Italy, 1600–1750*. 3rd rev. ed. Pelican History of Art. Penguin, Harmondsworth, England, 1982

18 THE BAROQUE IN FLANDERS AND HOLLAND

Brown, Christopher. *Van Dyck*. Cornell University Press, Ithaca, 1983

Haak, B. *The Golden Age: Dutch Painters of the Seventeenth Century*. Harry N. Abrams, New York, 1984

Hulst, Roger-Adolf d'. *Jacob Jordaens*. Cornell University Press, Ithaca, 1982

Rosenberg, Jakob, Seymour Slive, and E. H. Ter Kuile. *Dutch Art and Architecture, 1600–1800.* 3rd ed. Pelican History of Art. Penguin, Harmondsworth, England, 1977

Schama, Simon. *The Embarrassment of Riches: An Interpretation of Dutch Culture in the Golden Age.* University of California Press, Berkeley, 1988

Schwartz, Gary. *Rembrandt: His Life, His Paintings.* Penguin, New York, 1991

Scribner, Charles, III. *Rubens.* Masters of Art. Harry N. Abrams, New York, 1989

Stechow, Wolfgang. *Dutch Landscape Painting of the Seventeenth Century.* Reprint of 1966 ed. Cornell University Press, Ithaca, 1991

White, Christopher. *Peter Paul Rubens: Man and Artist.* Yale University Press, New Haven, 1987

19 THE BAROQUE IN FRANCE AND ENGLAND

Blunt, Anthony. *Art and Architecture in France, 1500–1700.* 4th ed. Pelican History of Art. Penguin, Harmondsworth, England, 1980

*———. *Nicolas Poussin.* 2 vols. Princeton University Press, Princeton, 1967

*Waterhouse, Ellis Kirkham. *Painting in Britain, 1530–1790.* 5th ed. Pelican History of Art. Penguin, Harmondsworth, England, 1994

20 ROCOCO

Conisbee, Philip. *Chardin.* Bucknell University Press, Lewisburg, Pennsylvania, 1986

———. *Painting in Eighteenth-Century France.* Cornell University Press, Ithaca, 1981

*Levey, Michael. *Painting and Sculpture in France, 1700–1789.* New ed. Pelican History of Art. Yale University Press, New Haven, 1993

———. *Rococo to Revolution: Major Trends in Eighteenth-Century Painting.* The World of Art. Reprint of 1966 ed. Thames and Hudson, New York, 1985

Part Four THE MODERN WORLD

Arnason, H. H., and Marla Prather. *History of Modern Art.* 4th ed., rev. and enl. Harry N. Abrams, New York, 1997

Brown, Milton W., et al. *American Art: Painting, Sculpture, Architecture, Decorative Arts, Photography.* Harry N. Abrams, New York, 1979

Chipp, Herschel B. *Theories of Modern Art: A Source Book by Artists and Critics.* University of California Press, Berkeley, 1968

Fineberg, Jonathan. *Art since 1940: Strategies of Being.* Harry N. Abrams, New York, 1995

Janson, H. W. *Nineteenth-Century Sculpture.* Harry N. Abrams, New York, 1985

*Rosenblum, Naomi. *A World History of Photography.* Rev. ed. Abbeville, New York, 1989

*Taylor, Joshua. *The Fine Arts in America.* University of Chicago Press, Chicago, 1979

21 NEOCLASSICISM

*Boime, Albert. *The Academy and French Painting in the Nineteenth Century.* New ed. Yale University Press, New Haven, 1986

*Honour, Hugh. *Neoclassicism.* Reprint of 1968 ed. Penguin, London, 1991

*———. *Romanticism.* Harper & Row, New York, 1979

*Rosenblum, Robert. *Transformations in Late Eighteenth Century Art.* Princeton University Press, Princeton, 1967

*Vaughan, William. *German Romantic Painting.* 2nd ed. Yale University Press, New Haven, 1994

22 THE ROMANTIC MOVEMENT

Clark, Kenneth. *The Romantic Rebellion: Romantic versus Classical Art.* Harper & Row, New York, 1973

Daval, Jean-Luc. *Photography: History of an Art.* Skira and Rizzoli, New York, 1982

Licht, Fred. *Goya: The Origins of the Modern Temper in Art.* Harper & Row, New York, 1983

23 REALISM AND IMPRESSIONISM

*Clark, T. J. *The Painting of Modern Life: Paris in the Art of Manet and His Followers.* Reprint of 1984 ed. Princeton University Press, Princeton, 1989

*Fried, Michael. *Courbet's Realism.* University of Chicago Press, Chicago, 1990

Herbert, Robert L. *Impressionism: Art, Leisure, and Parisian Society.* Reprint of 1988 ed. Yale University Press, New Haven, 1995

Nochlin, Linda. *Impressionism and Post-Impressionism, 1874–1904: Sources and Documents.* Prentice Hall, Englewood Cliffs, New Jersey, 1966

———. *Realism and Tradition in Art, 1848–1900: Sources and Documents.* Prentice Hall, Englewood Cliffs, New Jersey, 1966

*Pool, Phoebe. *Impressionism.* World of Art. Thames and Hudson, London, 1985

*Rewald, John. *The History of Impressionism.* 4th rev. ed. New York Graphic Society, Greenwich, Connecticut, 1973

24 POST-IMPRESSIONISM

*Hamilton, George Heard. *Painting and Sculpture in Europe, 1880–1940.* 6th ed. Pelican History of Art. Yale University Press, New Haven, 1993

Rewald, John. *Post-Impressionism: From Van Gogh to Gauguin.* 3rd ed. Museum of Modern Art, New York, 1978

Sutter, Jean, ed. *The Neo-Impressionists.* New York Graphic Society, Greenwich, Connecticut, 1970

25 TWENTIETH-CENTURY PAINTING

*Gray, Camilla. *The Russian Experiment in Art, 1863–1922.* Rev. and enl. by Marian Burleigh-Motley. World of Art. Thames and Hudson, New York, 1986

Livingstone, Marco. *Pop Art: A Continuing History.* Harry N. Abrams, New York, 1990

*Rosenblum, Robert. *Cubism and Twentieth-Century Art.* Rev. ed. Harry N. Abrams, New York, 1976

Sandler, Irving. *The Triumph of American Painting: A History of Abstract Expressionism.* Harper & Row, New York, 1979

26 TWENTIETH-CENTURY SCULPTURE

Elsen, A. *Origins of Modern Sculpture.* Braziller, New York, 1974

Lucie-Smith, E. *Sculpture since 1945.* Universe Books, New York, 1987

Read, Herbert. *Modern Sculpture: A Concise History.* The World of Art. Reprint of 1964 ed. Thames and Hudson, London, 1987

27 TWENTIETH-CENTURY ARCHITECTURE

Curtis, William J. R. *Modern Architecture since 1900.* 2nd ed. Prentice Hall, Englewood Cliffs, New Jersey, 1987

Kultermann, Udo. *Architecture in the Twentieth Century.* Van Nostrand Reinhold, New York, 1993

29 POSTMODERNISM

Jencks, Charles. *Architecture Today.* 2nd ed. Academy Editions, London, 1993

———. *Post-Modernism: The New Classicism in Art and Architecture.* Rizzoli, New York, 1987

———. *What Is Post-Modernism?* 3rd ed. St. Martin's Press, New York, 1989

Norris, Christopher, and Andrew Benjamin. *What Is Deconstruction?* St. Martin's Press, New York, 1988

Rosenau, Pauline Marie. *Post-Modernism and the Social Sciences: Insights, Inroads, and Intrusians.* Princeton University Press, Princeton, 1992

Index

List of Credits

The author and the publisher wish to thank the libraries, museums, galleries, and private collectors for permitting the reproduction of works of art in their collections and for supplying the necessary photographs. Photographs from other sources are gratefully acknowledged below. All numbers refer to figure numbers unless otherwise noted.

PHOTOGRAPH CREDITS

Adros Studio, Rome: 152; H.N.A. Archive, N.Y.: 19, 39, 132, 135, 146, 220; Alinari, Florence: 8, 12, 70, 77, page 98, figs. 81, 84, 92–95, 97, 106, 166, 167, 179–81, 185, 190, page 260, figs. 209, 211–17, 219, 222, 223, 231, page 286, figs. 240, 250, page 306, figs. 264, 267, page 340, figs. 291, 293, 298, 330; Wayne Andrews: 357; © 1996 The Art Institute of Chicago, All Rights Reserved: 395, 401, 419, 424, 430, 443, 482, 502 (Robert Hashimoto), 545, 546; Artothek/Joachim Blauel, Peissenberg: 251, 270, 272, 274, 277, 303, 310; James Austin, Cambridge, U.K.: 139, 159; Josh Baer Gallery, N.Y.: 568; © 1996 The Barnes Foundation, Merion, All Rights Reserved: 445; Jean Bernard, Aix-en-Provence: page 188, fig. 172; © 1996 Bibliothèque Nationale, Paris: 183, 387; Bildarchiv Preussischer Kulturbesitz/Jörg Anders, Berlin: 34, 35, 45, 78; Paul Bitjebier, Brussels: 453; Alan Bowness, London: 511; Boyan & Spear, Glasgow: 436; The Edward Broida Trust, N.Y.: 498; F. Bruckmann Verlag, Munich: 390; © 1996 Jutta Brüdern, Braunschweig: 131, 149; Martin Bühler, Basel: 432; Bulloz, Paris: 147; C.N.M.H.S./ARS, N.Y.: 19, page 170, figs. 137, 138, 145, 178, page 324, figs. 282, 283, 305, 325, 346, 379; Cameraphoto-Arte, Venice: 259; Canali Photobank/Bertoni: 194, 210, 225; Canali Photobank, Capriolo, Italy: 6, 58, 61, 80, 99, 100, 101, 107, 111–13, 143, page 184, figs. 188, 189, page 240, figs. 201, 233, 247, 252, 253, 255, 256, 260, 273, 275, 276, 280, 284, 286–89, 296, 377; Canali Photobank/Rapuzzi: 56; Eugenio Cassin, Florence: 218; Center for Creative Photography, Arizona Board of Regents: 547; Chicago Historical Society: 389; Peter Clayton: 37; © 1996 The Cleveland Museum of Art, All Rights Reserved: 375, 461, 493, 494; Comstock, Inc. © Georg Gerster, N.Y.: pages 32, 38, fig. 31; The Conway Library/Courtauld Institute of Art, University of London: 171, 337, page 412, fig. 352; © *Country Life*, London: 382; Culver Pictures, N.Y.: 388; © 1995 The Detroit Institute of Arts, All Rights Reserved: 285, 314, 406; Deutsches Archäologisches Institut, Baghdad: 38; Jean Dieuzaide [Photo YAN], Toulouse: 136, 144; Bill Engdahl/ Hedrich-Blessing, Chicago: 527; English Heritage Photography Library, London: 351, 356; ESTO, Mamaroneck: © Peter Aaron 560/ © Peter Mauss 562/ © Ezra Stoller 539; Ronald Feldman Fine Arts, N.Y.: 563; Foto Marburg/Art Resource, N.Y. 160, 161, 169, 173, 175, 344, pages 406–9, figs. 413–15, figs. 529, 530; Foto Mayer, Vienna: 206; Foto Vitullo, Rome: 104; Fotocielo, Rome: 290; Fototeca Unione, American Academy, Rome: 85, 86, 90, 245; Alison Frantz Collection, American School of Classical Studies, Athens: pages 62, 69, figs. 53, 63; French National Tourist Board, Paris: page 426, fig. 378; G.E. Kidder-Smith, N.Y.: 13, 14, 98, 114, 294, 536; © 1996 George Eastman House, Rochester: 440, 444, 555; G.F.N., Rome: 295; © Gianfranco Gorgoni, N.Y.: 515; Giraudon, Paris: 128, 170, 193, 268, 269, 281, 353, 355, 385; Glyptothek (Fotomuseum), Munich: 67; Dr. Reha Günay, Istanbul: 120; © Ole Haupt/NY Carlsberg Glyptothek, Copenhagen: 417; © 1996 David Heald/Solomon R. Guggenheim Museum, N.Y.: 469, 488; Lucien Hervé, Paris: 535; Hirmer Fotoarchiv, Munich: 20, 25, 27–29, 51, 52, 65, 66, 69, 71–74, 76, 79, 96, page 130, fig. 109; © 1996 David Hockney, Los Angeles: page 582, fig. 559; Timothy Hursley, Little Rock: 561; Istituto Centrale del Restauro, Rome: 184; *Jahrbuch des Deutschen Werkbundes* (1915): 438; A.F. Kersting, London: 140, 323, 381; Nikos Kontos, Athens: 1, 49, 50, 55, 68, 75; Ian Lambot, London: 542; Kurt Lange, Obersdorf/Allgäu: 24; Jacques Lathion, Oslo: 429; Lauros/Giraudon, Paris: 416; By kind permission of the Earl of Leicester and the Trustees of the Holkham Estate: page 412, fig. 352; William Lescaze, N.Y.: page 570, fig. 537; Lichtbildwerkstätte Alpenland, Vienna: 108, 127, 261, 262, 279; *Life* Magazine © Time Inc.: 549; © Lilienthal, Bonn: 177; © Tony Linck, Fort Lee, N.J.: 23; James Linders, Rotterdam: 532; Magnum, N.Y.: 544; Curt Marcus Gallery, N.Y. © 1990 Mark Tansey: 565; Photo M.A.S. (Arxiu MAS), Barcelona © 1996 Museo del Prado: 200, 203, 300, 304, 358, 359; Leonard von Matt Archiv, Stansstad, Switzerland: 244; Mauritshuis, The Hague: 317; Rollie McKenna, Stonington, Conn.: 221; Louis Meisel Gallery, N.Y.: 495; © 1996 The Metropolitan Museum of Art, N.Y., All Rights Reserved: 4, 54, 64, 102, 195, 196, 208, 258, 301, 313, 319, page 389, figs. 332, 334, 345, 347, 366, 376, page 456, figs. 393, 410, 441, 451, 466, 475, 478; Robert Miller Gallery, N.Y.: 479; Ministry of Works, London: 21, 22, 354; Missouri Historical Society, St. Louis: 437; Ann Münchow, Aachen: page 154, fig. 125; © 1996 The Museum of Modern Art, N.Y., All Rights Reserved: 7, 16, 411, 428, 431, 446, 449, 452, 459, 462, 471, 474, 480, 486, 491, 492, page 550, figs. 501, 503, 505, 507–9, 519, 524, 533, 534, 543, 548, 554; © 1996 Board of Trustees, National Gallery of Art, Washington, D.C.: 9, 15, 88, 119, 227; National Monuments Record Center, Swindon, England: page 376, fig. 383; N.T.V. Corp., Tokyo: 5, 241–43; Takashi Okamura, Shizuoka City, Japan: 182; The Oriental Institute of the University of Chicago: page 40, fig. 32, pages 52–53, figs. 40, 47; Oronoz, Madrid © 1996 Museo del Prado: 249, 278; © Pedicini/Editoriale Museum, Rome: page 104, fig. 87; The Pierpont Morgan Library/Art Resource, N.Y.: 129; Pinacoteca di Brera, Milan: 235; Eric Pollitzer, N.Y.: 421; Pontificia Commissione di Archeologia Sacra, Rome: 103; Port Authority of New York: 380; Josephine Powell, Rome: 117; Antonio Quattrone, courtesy Olivetti, Florence: 224; Mario Quattrone, Florence: 228, 254; RBA, Cologne: 130, 518; © 1996 R.M.N., Paris: 43, 57, 151, 187, 230, 236, 318, 333, 335, 362–64, 369, 392, 394, 397, 398, 405, 426, 464; R. Rémy, Dijon: 192; Ekkehard Ritter, Vienna: 153; Roger-Viollet, Paris: 326, 384; Richard Ross: 564; Jean Roubier, Paris: 156, 174, 327, 360–64, 369; Routhier, Studio Lourmel, Paris: 399; Royal Commission on Historical Monuments, London: 164, 331; Royal Photographic Society, Bath, U.K.: 442; Sächsische Landesbibliothek, Deutsche Fotothek, Dresden: 176; Scala/Art Resource, N.Y.: 186, 246, 248; Helga Schmidt-Glassner Archiv, Stuttgart: 342; Ronald Sheridan's Ancient Art and Architecture Collection, Harrow-on-the-Hill, Middlesex, U.K.: 118; Edwin Smith, Saffron Waldon, U.K.: 163; Haldor Sochner, Munich: 257; Soprintendenza alle Gallerie, Florence: 226; Soprintendenza Archeologica all' Etruria Meridionale, Tarquinia, Italy: 82, 83; © Lee Stalsworth/Hirshhorn Museum and Sculpture Garden, Washington, D.C.: 487; Wim Swaan Archive, N.Y.: 3, 33, 36, 142, 157, 158, 165, 168, 263, 292, 324; © Jean Clottes/SYGMA, N.Y.: 17; The Tate Gallery/Art Resource, N.Y.: 403, 463; © 1996 Caroline Tisdall, Ronald Feldman Fine Arts, N.Y.: 525; Marvin Trachtenberg, Institute of Fine Arts, New York University, N.Y.: 62, pages 124–27, figs. 115, 154, 265, 343; © 1996 University Museum of National Antiquities, Oslo: 122; Robert Villani: 528; Elke Walford, Hamburg: 374; Clarence Ward, Oberlin: 155; Hermann Wehmeyer, Hildesheim: 133; Etienne Weill, Jerusalem: 500, 541; Michael Werner Gallery, N.Y.: page 595, fig. 566.

ILLUSTRATION COPYRIGHTS

Copyright © Blaser, Hannaford & Stucky, *Drawings of Great Buildings*, Basel, Birkhäuser Verlag AG © 1983: 266 (p. 119 Christopher Lue), 328 (p. 148 Sarah Lavica); copyright © Magdalena Droste, *Bauhaus 1919–1933*, Cologne, Benedikt Taschen Verlag © 1990: 538.

ARTIST COPYRIGHTS

Rights Agencies: © 1996 ARS, N.Y.: 484, 486, 519, 524; © 1996 ARS, N.Y./ADAGP: 447, 454, 459, 460, 470, 481, 500, 501, 506, 508, 509; © 1996 ARS, N.Y./ADAGP/ Man Ray Trust: 554; © ARS, N.Y./Pro Litteris: 449, 450, 507; © 1996 ARS, N.Y./SPADEM: 395, 396, 402, 433, 465, 468, 469; © 1996 ARS, N.Y./VG-Bildkunst: 471, 472, 474, 488, 525, 551, 553; The following artists copyrights are represented by ARS, N.Y.: © 1996 Estate of Mary Cassatt: 401; © 1996 The Conservators of Willem de Kooning: 480; © 1996 Estate of Arshile Gorky: 477; © 1996 Succession H. Matisse: figs. 445, 446, 464, 499; © 1996 Georgia O'Keeffe Foundation: 475, 545, 546; © 1996 Succession P. Picasso: 2, 7, 430, 452, 453, 462, 463; © 1996 Pollock-Krasner Foundation: 478, 479; © 1996 Kate Rothko-Prizel and Christopher Rothko: 483; © 1996 Andy Warhol Foundation for the Visual Arts: 492; The following artists copyrights are represented by VAGA, N.Y.: © 1996 Richard Anuszkiewicz: 489; © Estate of Giorgio de Chirico: 458; © 1996 Estate of George Grosz: 473, page 502; © 1996 Jasper Johns: 16, 490; © 1996 Estate of Jacques Lipchitz: page 550, fig. 505; © 1996 Robert Rauschenberg: 518; © 1996 Estate of Gerrit Rietveld: 532; © 1996 George Segal: 521; © 1996 Estate of David Smith: 513; © 1996 Estate of Vladimir Tatlin: 504; Tate Gallery/Art Resource, N.Y.: 403, 463. *Individuals*: © Ansel Adams Publishing Rights Trust, Carmel, Calif.: 548; © 1996 Francis Bacon Estate, Marlborough Fine Art, London: 482; © 1996 Ernst und Hans Barlach Lizenzverwaltung, Ratzeburg: 434; © 1996 Estate of Romare Bearden and Nannette Rohan Bearden, N.Y.: 487; Nachlass Max Beckmann, Berlin: 474; © 1996 Ronald Bladen, Washburn Galleries, N.Y.: 512; Margaret Bourke-White, *Life* Magazine © 1996 Times Inc., N.Y.: 549; © 1996 Noya Brandt, London: 557; © 1996 Francesco Clemente: 496; © 1996 Audrey Flack, Louis K. Meisel Gallery, N.Y.: 495; © 1996 Ann Hamilton: 564; © 1996 David Hockney, Los Angeles: 559; © 1996 Ilya Kabakov, N.Y.: 563; © Ellsworth Kelly, Spencertown, N.Y.: 485; © 1996 Anselm Kiefer, Domaine de la Sérénité, Barjac, France: 497; © 1996 Edward and Nancy Kienholz, Hope, Idaho: 522; © Barbara Kruger, Annina Nosei Gallery, N.Y.: 567; © 1996 The Dorothea Lange Collection, The Oakland Museum of California: 552; © 1996 Annette Lemieux, N.Y.: 568; © 1996 Joanne Leonard, Ann Arbor, Mich.: 558; © 1996 Roy Lichtenstein, N.Y.: 491; © 1996 The Mondrian Estate/Holtzman Trust/Licensed by ILP, Amsterdam: 467; © The Henry Moore Foundation, Much Hadham, Hertfordshire, U.K.: 510; © The Munch Museum/The Munch-Ellingsen Group/BONO, Oslo: 429; © 1996 Elizabeth Murray, Paula Cooper Gallery, N.Y.: 498; © 1996 Stiftung Ada und Emil Nolde, Seebüll, Germany: 448; © 1996 Claes Oldenburg, N.Y.: 514; © 1996 A.R. Penck, Michael Werner Gallery, Cologne/New York: page 595, fig. 566; © 1996 Judy Pfaff, André Emmerich Gallery, N.Y.: 523; © 1996 Martin Puryear, Donald Young Gallery, Seattle: 517; © Joel Shapiro, Paula Cooper Gallery, N.Y.: 516; The Estate of Edward Steichen, N.Y.: 443; © 1990 Mark Tansey, Curt Marcus Gallery, N.Y.: 565; © 1974 Caroline Tisdall: 525; © 1996 Estate of James VanDerZee, N.Y.: 550; © 1981 Edward Weston/Center for Creative Photography, Arizona Board of Regents, Tucson: 547; © 1996 The Minor White Archive, Princeton University: 555.

ELIZABETH TAYLOR

ELIZABETH TAYLOR:
MY LOVE AFFAIR WITH JEWELRY/

BY ELIZABETH TAYLOR;

EDITED BY RUTH A. PELTASON.

CONCEPT BY TIMOTHY R. MENDELSON

PHOTOGRAPHS BY JOHN BIGELOW TAYLOR

DESIGN BY TAKAAKI MATSUMOTO

Q739.27
T213m

SIMON & SCHUSTER
NEW YORK LONDON TORONTO SYDNEY SINGAPORE

C O N T E N T S

With great-grandson, Finn (Photo, Bruce Weber)

To my beloved Mike and Richard, the two greatest loves of my life.
And to my children, without whom there would have been no life.

Introduction

In September 1998, I had the privilege of being invited to Elizabeth Taylor's home in California to appraise her legendary jewels. This was a rare occasion. Although many of us have seen or heard about the Taylor-Burton diamond, La Peregrina pearl, or her Bulgari emerald and diamond parure, very few people (including specialists) have seen Miss Taylor's collection in its entirety. I was aware that Elizabeth Taylor's name was synonymous with jewels and that she had a particularly keen eye for gems, but I did not know what to expect, and the excitement, more than the jet lag, kept me awake most of the night before the visit.

At the said time, my colleagues and I arrived at her home and commenced our work (if you can call it work). I shall never forget the trays and trays of jewelry that were presented to us over the next two days. At first, it was the sheer volume that struck me, but gradually as I examined each piece, I was impressed by the quality and variety in the collection. And quality was the common denominator for every piece, regardless of stone or size.

We had been working for several hours in a room on the ground floor when there was a buzz overhead. Miss Taylor's assistant, who had been in and out of the room throughout the morning, approached me and said, "Miss Taylor would like to know what you think of her jewels." I was stumped, and as I was thinking of a clever response, Elizabeth Taylor entered the room.

As she talked to us about the pieces, I quickly realized that Elizabeth Taylor had a vast knowledge of jewelry. We discussed many of her jewels in detail. Whether she was explaining the geographical origin of her colored stones, the history of her famous Shah Jahan diamond necklace, the color and clarity of her 33-carat Krupp diamond, or the freshwater pearls used by Ruser (a famous Beverly Hills jeweler who retired in the 1960s), she demonstrated a full understanding of her pieces and the field of fine jewelry.

At Princess Grace's fortieth-birthday party. (Photo, Gianni Bozzacchi)

Over the years, pieces were chosen more for the quality of a particular object rather than because of a specific theme. Moreover, many of her jewels carry great sentimental value and are emblematic of special occasions or are gifts from family and friends. In this regard, deserving special mention is the jewelry from Mike Todd and Richard Burton, which is noteworthy for its special significance and exceptional quality.

In addition to the "star" or great historical pieces that you are about to discover, there are also exquisite examples from famous jewelry houses. They include works by Boucheron, Bulgari, Cartier, Chopard, Gerard, Ruser, Schlumberger, Tiffany, Van Cleef & Arpels, and David Webb. The collection ranges from an antique diamond tiara and an Art Deco Egyptian revival bracelet to more contemporary creations, such as the multicolored sapphire and diamond earrings by JAR, a famous, though very discreet, American jeweler who works from a tiny shop in the Place Vendôme, Paris. I suppose I should have guessed, but I never expected Elizabeth Taylor to know of him. She has also designed some jewelry to reflect her personality and taste. By the end of my conversation with Elizabeth Taylor, it was clear that she knew each piece intimately—its style, its history, its evolution . . . it was fascinating.

It is the intensely personal quality of the Elizabeth Taylor collection that sets it apart from all others. Not only does it include the very best in gemstones and jewelry but each piece has a reason for being in her collection, paying tribute to a particular person or moment in her life. Furthermore, Elizabeth Taylor did not assemble her collection to be kept in a vault. Rather, it is to be worn, to be enjoyed, and, fortunately for you and me, to be seen.

François Curiel
Head of Christie's Jewelry Department Worldwide

"The stories that accompany these pieces of jewelry have sort of tumbled out, some of them 'old friends' by now, others I hadn't recalled for years until I really began thinking about this book. Looking at these beautiful pieces of jewelry has invariably stirred up many moving memories and reminded me of some truly outrageous times. So here, in my own words and as I remember them, are my cherished stories about a lifetime of fun and love and laughter. I mean, how many young women get a set of rubies just for doing something wholesome like swimming laps? Or win a diamond ring at Ping-Pong with their husband, or find a perfect pearl in the soft little mouth of their sweetest puppy? Well, I did, and for all of these memories and the people in my life I feel blessed.

"Some of the pieces are newer than others, yet each one has profound meaning for me. Above all, the importance of the jewelry is emotional and psychological, and I knew that I wanted to share my collection with others so that they could get a glimpse of the joys, the thrills, and the pure happiness that these beautiful creations have given me. I hope their presence and their magic will be passed on to others, loved but not possessed, for we are all temporary custodians of beauty. And I hope that in the future others will take care of this jewelry in a sharing way—but not too soon!"

Elizabeth Taylor
Bel-Air, California
March 13, 2002

Who needs jewelry when you've got Sugar? (Photo, Herb Ritts)

"Dad had an art gallery in the Beverly Hills Hotel on the arcade level. Whenever I came through the front door, the doormen would greet me with, 'Hi, baby,' 'Hi, Elizabeth,' which always made me feel safe, and at home. Right off the entrance was a boutique filled with beautiful clothes and accessories, and I'd look in there and just sort of dream. What I most wanted was to buy my mother something on my own from that little shop, so I started saving my allowance. I was only twelve or thirteen, and I probably got something like 50 cents a week. One day I went into the boutique and told the

nice lady who worked there that I wanted to purchase a pin for my mother, but that as I didn't yet have enough money, would she hold it for me. Even at that age, I asked her if she could 'give me a good price.' (I guess I was a 'natural' at negotiating!) So she promised not to sell the pin to anyone else, especially as I had already been saving for many months. 'I'll even take it out of the window,' she said. I was so excited, I remember practically dancing to my father's art gallery. But I wanted this to be my secret, so at the time I didn't even tell Dad.

"The day came when I had enough money. I bought the pin, and it was wrapped with a pretty ribbon, the whole works. I went screaming into Dad's

gallery, waving the box, and telling him that I had a secret present for my mother. It was such a big secret, I told him, that I couldn't even undo the wrapping and show him. 'I'll leave work early,' Dad said, and he took me home. This was around the time I had done *National Velvet*, and I remember it was close to Mother's Day, which made the present an early Mother's Day gift. When my mother opened the box, she really was surprised, and very proud of me. Dad admired the pin and said, 'You have such good taste, Elizabeth,' which coming from an art dealer was the best praise. I was blissfully happy.

"When I think of that little story and now hold that box of jewelry in my hand—for it came back to me when my mother died—the memories are so vivid. It was the first piece of jewelry I ever bought, and the first time I'd saved up my allowance to do something special, instead of buying the usual candies or whatever. I'll never forget saying, 'I did it! I did it all on my own!' The independence of that act has stayed with me all these years."

Mrs. Taylor's recollection of the pin, as described in a letter from mother to daughter.
Opposite: The gold plate and colored stone brooch that Elizabeth Taylor bought for her mother, circa 1945.

A CHARMED LIFE

"I never cared whether or not I was an actress, especially when I was a very little girl. I was born in England, and we had a lodge on my godfather's estate. And I had my horse, which I had to leave behind when we came to America. The happiest days of my childhood were in England because I rode—that's where I learned to ride bareback—and took ballet lessons. I wanted to be a ballerina, so I was enrolled in the same school that the young princesses attended. At the age of three I was picked out to be in a performance for the Royal family. Every year there was a command performance. The child with the highest marks from each class was chosen to do a solo. And guess what? That year I was it! I was so enthralled by the applause that I couldn't stop doing my butterfly curtsy and taking a peek through my hair at the Royal box. They were all laughing and smiling. I would not get off the stage. After many whispered hisses of 'Elizabeth, get off,' from the wings, I eventually relinquished my place at the center of the stage and the warmth and glow of the audience that started me off I guess has never left me.

"Years later, after we had moved to America and settled in Beverly Hills, my father got me an audition for *Lassie Come Home* because of my English accent. So I just talked to the dog—'Poor Lassie. Poor girl.' And I got the part. Then MGM signed me up for eighteen years. I had a great imagination, and I just slid into being an actress. It was a piece of cake. But mostly, when I was first acting, I just liked playing with the dogs and the horses. Riding a horse gave me a sense of freedom and *abandon*, because I was so controlled by my parents and the studio when I was a child that when I was on a horse *we* could do whatever *we* wanted. Riding a horse was my way of getting away from people telling me what to do and when to do it and how to do it. And if I was a good little girl I would be rewarded . . . by receiving another script. On the other hand, by the age of fifteen—or whenever this picture was taken—I really did have a new love in my life: jewelry. And I've been loyal to that love ever since."

The fifteen-year-old ingénue returns to her homeland after having been in California for eight years (and having starred in six films). The five-week publicity tour included the usual sightseeing stops and autograph seekers.
True to character, though, a dog is always close at hand.
Opposite: At home, Beverly Hills, circa 1946

"Can you believe it? A child author! Even though the studio had this ridiculous way of schooling us when we were shooting—between takes you had to 'study' for a minimum of ten minutes—I must have learned something. *Nibbles and Me* sprang from a school assignment. Each week we had to do an essay on any subject we chose, and Nibbles was my favorite subject. I kept a diary of our experiences together. I think it was the teacher's suggestion that I write it with a sense of continuity, as if it were a book.

"I wanted to be an artist, but I became so busy with film work that all of my concentration went into acting. My dreams of forests and wild animals had to take a backseat. I drew for a few more years, but only as a private thing."

A promotional shot for the book, left, and the book cover of *Nibbles and Me*, center, published in 1946. At right, hard to say who's happier—the smiling actress or the two bounding pups?

Gold charm bracelet with 30 charms
Gold charm bracelet with 12 charms
Pages 18–21: Gold charm bracelet with 20 charms. The small gold sphere, left of center, is actually a locket with engraved medallions for each of Elizabeth Taylor's children.

... CLUB OF GREAT BRIT...
...TY RACE MEETIN...
...s MAID STAKE...
...RESENTED TO
...ELIZABETH TAYLO...
...THE DIRECTORS O...
...YONS & COMPANY L...
...ANDOWN PARK...
AUGUST 31st
1963

ELIZABETH
TAYLOR
BURTON
—
27·2·1932
—
CHALET ARIE
GSTAAD
—

Elizabeth

Above left: Eldest son, Michael Wilding, gives a kiss to a portrait nearly as pretty as his own adoring flesh-and-blood mother.

Above right: And Christopher makes two for Elizabeth and English actor Michael Wilding.

Opposite: The Wildings with their first-born, photographed by Cecil Beaton.

Above left: The luxury liner *Liberté* may have just pulled into the New York harbor, but Elizabeth Taylor was still a month away from giving birth. Mike Todd proudly referred to his wife in her "glamorous pregnancy"—sweetly covered in a two-piece pink silk maternity dress. Note the heavy charm bracelets.

Above right: Outside the entrance to Villa Fiorentina in St.-Jean-Cap-Ferrat, where Elizabeth Taylor, her two sons, and Mike Todd stayed for several weeks. She is wearing the 29.4-carat diamond ring and carnation diamond brooch, both gifts from her husband. (Photo, Edward Quinn)

Gold charm bracelet with 19 antique seals, detail

Sixteen gold bangle bracelets, each suspending an antique coin

Group of gem-set, gold and silver cruciform, and Star of David pendants on chains (enlarged)

THE LEGACY OF LOVE

"I've been astonishingly lucky with love—I've had two great loves in my life. Mike Todd and I only had thirteen months together, but I now see that Mike's love was a legacy to me. Mike was amazing: so loving and so unbelievably larger than life.

"When Mike gave me the rubies I was pregnant with Liza. We had rented a villa, La Fiorentina, just outside Monte Carlo near St.-Jean-Cap-Ferrat, about three months into our marriage. The most beautiful house you've ever seen. Actually, I rented it twice—once with Mike and once with Richard. I was in the pool, swimming laps at our home, and Mike came outside to keep me company. I got out of the pool and put my arms around him, and he said, 'Wait a minute, don't joggle

your tiara.' Because I was wearing my tiara in the pool! He was holding a red leather box, and inside was a ruby necklace, which glittered in the warm light. It was like the sun, lit up and made of red fire. First, Mike put it around my neck and smiled. Then he bent down and put matching earrings on me. Next came the bracelet. Since there was no mirror around, I had to look into the water. The jewelry was so glorious, rippling red on blue like a painting. I just shrieked with joy, put my arms around Mike's neck, and pulled him into the pool after me.

"It was a perfect summer day and a day of perfect love."

Ruby and diamond necklace, by Cartier (enlarged)

Above and preceding page: Never-before-published footage of a jubilant Elizabeth Taylor trying on the ruby-and-diamond jewelry from her husband at Villa Fiorentina. The home-movie shutterbug was Eve Johnson, wife of actor Van Johnson. Moments after this scene was taken, the camera followed a very pregnant Elizabeth Taylor romping in a lawn sprinkler with her sons—and happily wearing her new jewelry.

Opposite: At the Tropicana Hotel in Las Vegas, June 1958, where Eddie Fisher was performing.

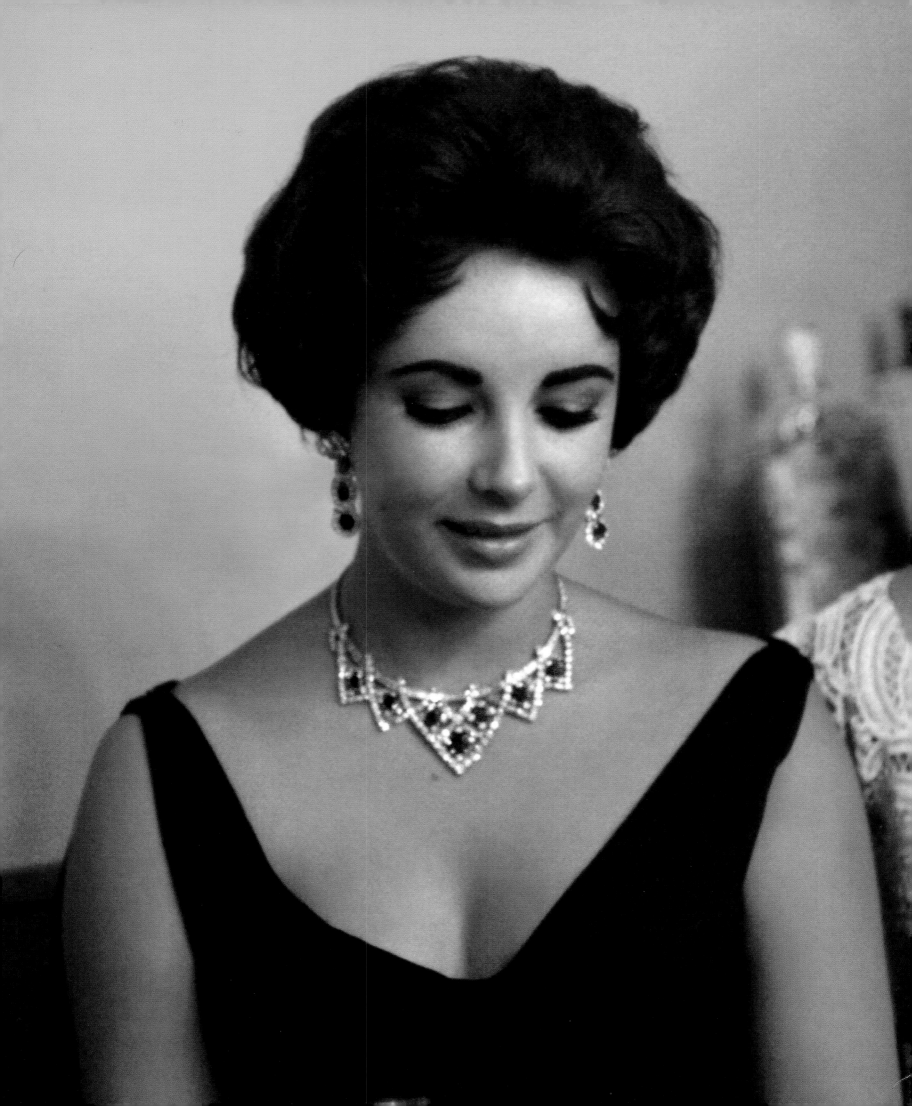

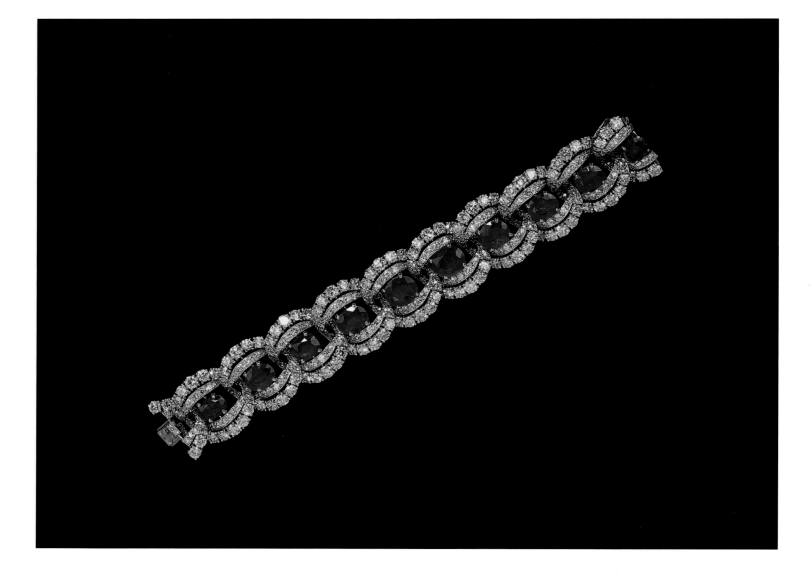

Ruby and diamond bracelet, by Cartier

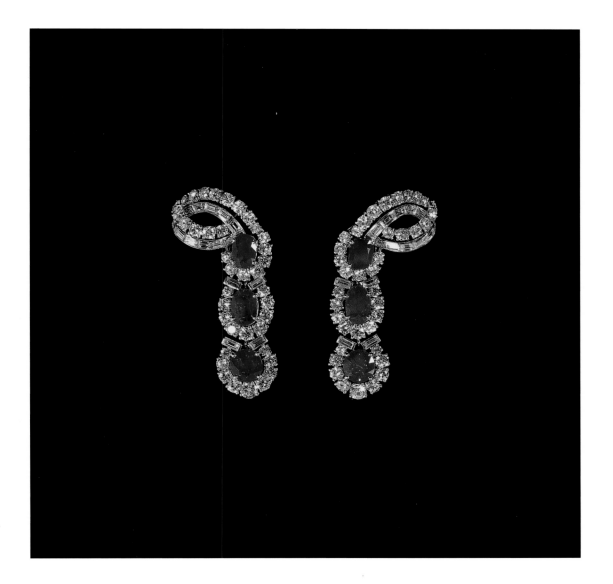

Pair of ruby and diamond ear pendants, by Cartier

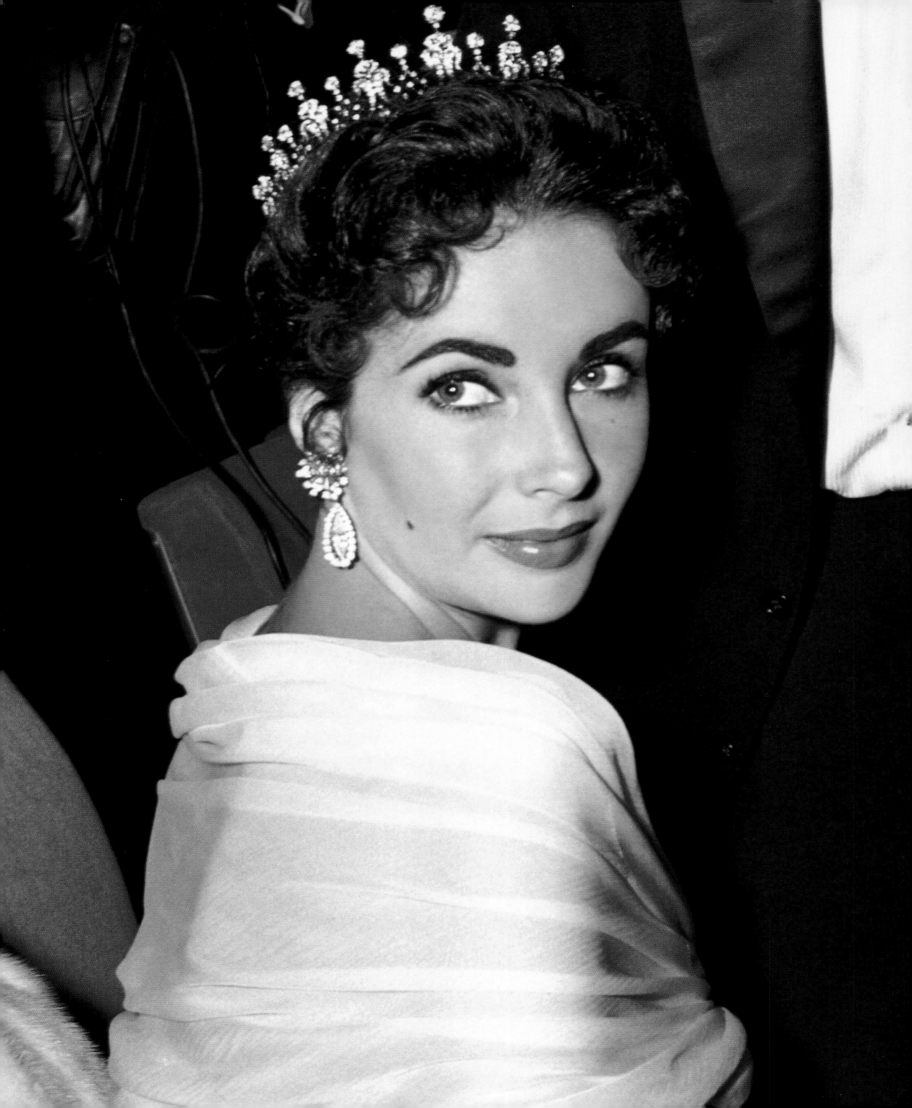

Above left: Just one day after being made Mrs. Mike Todd, husband and wife are toasted with champagne by their hosts in Acapulco. (February 3, 1957)

Above right: Wearing the full Cartier suite, including the bracelet, and her 29.4-carat diamond engagement ring.

Opposite: Both the tiara and the earrings were gifts from Mike Todd, which the young beauty wore at the screening of Todd's *Around the World in 80 Days* at the Cannes Film Festival, May 1957. The tiara was first seen in America two months earlier, at the Academy Awards in Los Angeles. (Photo, Edward Quinn)

My Ice Skating Rink

"By now people know about the Krupp diamond that Richard bought for me, but my darling Mike gave me a magnificent 29.4-carat ring when we got engaged. I used to call it my 'ice skating rink.' Even then, back in the late 1950s, people would stop me and ask me about my jewelry—they still do, as a matter of fact—and sometimes they've even asked to try it on, which I love.

"Toward the end of 1957, Mike and I had been on this crazy junket promoting *Around the World in 80 Days*, and our last stop was in Russia. We were on a tour in one of the great museums and we had this darling Russian guide with beautiful gray hair, and he was dressed in a perfectly matching gray suit. He was showing us the painting and sculpture galleries, and the jewelry, which was my main interest. When we came out of the museum, my diamond ring (which I had to sell years later) was sparkling away in the sunshine, and this dear man couldn't take his eyes off it. He looked at me and said, 'I mean no offense, madam, but a stone of that beauty should be in a museum, where everyone can see it.' 'You know,' I answered, 'I disagree with you. When I wear it, anyone can look at it, and I'll let anybody try it on. So more people have probably touched this stone, seen the beauty in the pure sunshine or when it sparkles at night. Anyone who is around me can see it up close. Isn't that better than putting it in a museum? How many people in a museum can actually take a rock of this size out of a case and put it on their finger? Besides, I take care of it. It's a part of me while I have it, and I'm there to protect it and insure it.' At that moment he finally understood what I meant. Then I asked whether he wanted to try it on."

The glow isn't just from the diamond, but from motherhood itself: Michael and Christopher Wilding cuddle around their mother and new baby sister, Liza Todd. (Photo, Toni Frissell)

Magazines about Hollywood celebrities were big business, and nothing fanned the flames of love (or stoked the cash register) better than tragedy, as seen in this magazine devoted exclusively to the happy but brief marriage of Elizabeth Taylor and Mike Todd. The cover shows the actress wearing jewelry from her husband: the diamond earrings (page 42) and Belle Époque diamond necklace (page 45).

Todd's larger-than-life personality was suited to the producer's highfalutin promotion on behalf of his blockbuster *Around the World in 80 Days*, which included, at left, a brief stopover in New York en route to London, with connection to Moscow; and center, a wildly extravagant birthday party that Todd threw at Madison Square Garden in New York. The occasion was the one-year anniversary of his film, which had just grossed $17 million. The party statistics tell a bigger story: The birthday cake for Todd's "baby" was 14 feet high and 30 feet in diameter, and was enjoyed by 18,000 invitation-only guests. Todd had even persuaded CBS to carry the party live on television. Elizabeth Taylor wears the Cartier suite, and in her hair a diamond carnation brooch, also a gift from Mike Todd. Some years later, the brooch was stolen in a hotel where the actress was staying. Above right: Signing the guest board at the premiere of *Raintree Country,* 1957, which starred Elizabeth Taylor and Montgomery Clift.
Opposite: Listening to Eddie Fisher perform at the Tropicana in Las Vegas, April 1959, but in full Mike Todd jewelry.

The Mike Todd diamond ear pendants

"These earrings have been among my favorites for years. Mike and I were staying at the Ritz in Paris. We were walking under the arcade, the Place Vendôme, where all the jewelry shops were. There were windows displaying hand-beaded handbags, and other just incredibly Parisian things that you couldn't get anyplace else in the world. I've always loved dangling earrings and at the time I wanted a pair of what I call 'chandelier' earrings. We were just sort of window-shopping, when I found the perfect window—and I said, 'Mike! Oh God, oh Mike, couldn't I please please please? I can't go home without them! Couldn't we at least go in and look at them?' In we went and I tried on these long earrings. The more I swished my head back and forth, the more they twinkled, and Mike was just smiling at me. 'Of course you can have them,' he said. They were beautifully done. I was smitten with them and wore them whenever I could. And these were paste—not even real diamonds!

"A couple of months later we were back in New York, and I went to put on those earrings. They were in a different box, but I didn't give it much thought. I opened the box, and the earrings looked all polished up, and I put them on. But there was something different about how they fit. And I said, 'Mike, there's something wrong with my earrings. They're not quite the same.' Well, he just chuckled, and told me he had taken the paste ones and had them made up with real diamonds! Mike was so incredibly inventive and loved to surprise me in so many different ways. We were a bit late for the party. . . ."

Left: Getting ready backstage before taking her seat at Fisher's Las Vegas show. Looking splendid and wearing the diamond girandole earrings, in the early 1960s, center, and at right, when arriving at the premiere for *Suddenly Last Summer*, 1959.

Belle Époque diamond necklace, circa 1900
"Another surprise present from Mike. I still wear it when the occasion calls for it."

"When Mike gave me this tiara, he said, 'You're my queen, and I think you should have a tiara.'

"I wore the tiara for the first time when we went to the Academy Awards. It was the most perfect night because Mike's film *Around the World in 80 Days* won for Best Picture. It wasn't fashionable to wear tiaras then, but I wore it anyway, because he was my king."

The Mike Todd diamond tiara, circa 1880

My Baby: 33 Carats and Growing

"This remarkable stone is called the Krupp diamond because it had been owned by Vera Krupp, of the famous munitions family which helped knock off millions of Jews. When it came up for auction in the late 1960s, I thought how perfect it would be if a nice Jewish girl like me were to own it.

"In truth, though, there's nothing funny about the Krupp. When I look into it, the deep Asscher cuts—which are so complete and so ravishing—are like steps that lead into eternity and beyond. My ring gives me the strangest feeling for beauty. With its sparks of red and white and blue and purple, and on and on, really, it sort of hums with its own beatific life. To me, the Krupp says, 'I want to share my chemistry—my magic—with you.' "

The Krupp diamond
Weighing 33.19 carats

Quoting the Burtons

Her: "Richard and I were two very volatile people. We were like two atom bombs, and when we'd go off together, there would be this tremendous explosion. But we always came down together, and we didn't sulk and we didn't pout. We had a ball fighting."

Him: "I fell in love with her at once. She was like a mirage of beauty of the ages, irresistible, like the pull of gravity. She has everything I want in a woman."

Her: "His relish, his energy—it's like knowing a whirlwind that sparkles and shoots off and people catch the sparkle. He has this mercurial, retentive, darting brain—there's something wild, rather like a running deer, about his thinking."

Him: "I cannot see life without Elizabeth. She is my everything—my breath, my blood, my mind, and my imagination."

Her: "So we are only apart when it is a matter of life and death. It's certainly nothing I planned. It's something we can't help—a marvelous accident of the heart to feel this way."

Her: "He called me Mabel, and I called him Charlie."

Budapest at night, where Richard Burton threw a lavish party to celebrate his wife's fortieth birthday, 1972. (Photo, Norman Parkinson)

"I don't want to be a sex symbol. I would rather be a symbol of a woman, a woman who makes mistakes, perhaps, but a woman who loves."

Photograph in *Vogue* magazine, 1991 (Photo, Herb Ritts)

"I can't deny that Richard gave me some spectacular gifts on birthdays and Christmas, but in truth he was so romantic that he'd use any excuse to give me a piece of jewelry. He'd give me 'It's Tuesday, I love you' presents. 'It's a beautiful day' presents. 'Let's go for a walk, I want to buy you something' presents. Over the years I've come to think of these as my 'It's Tuesday, I love you' jewelry. And I never knew when he would come up with the most extraordinary ring or something very sweet and simple."

Emerald and diamond brooch, by Bulgari

March 15, 1964, was a turning point for both stars: the filming of *Cleopatra* was well behind them and their happiness was legally sanctioned in this exchange of marital vows at the Ritz-Carlton in Montreal. Elizabeth Taylor's golden-yellow chiffon dress was made by Irene Sharaff, the costumer who also designed the actress's flowing gowns in *Cleopatra*. Burton had given his wife the Bulgari emerald and diamond brooch as an engagement present.

When in Rome . . . Go Shopping!

"Undeniably, one of the biggest advantages to working on *Cleopatra* in Rome was Bulgari's nice little shop. I used to visit Gianni Bulgari in the afternoons and we'd sit in what he called the 'money room' and swap stories. He had a whole section of antique silver and gold samovars and huge tea sets and other bits for fine homes. And the jewelry? The exclusive crème de la crème pieces were tucked away in a small room.

Blame it on *Cleopatra!*

"One day Richard said, 'I want to buy you a present. I feel like buying you a present.' And I said, 'Wow! What did we do today that you . . . that's amazing! Where? Where shall we go?' 'Bulgari, of course,' he said. 'Now Elizabeth, I am handling this and I would prefer if you would control yourself,' because I tend to get a little high-strung. 'My love,' I cooed, 'I promise whatever you give me will go straight to my heart like an arrow. Whatever you pick out for me.' Again, the Welsh baritone: 'Just be in a good mood.'

"So we went to Bulgari's back room, and Richard said to Gianni, who's now properly seated behind this rather formal desk, 'I want to buy Elizabeth a present but it cannot exceed $100,000.' Gianni smiled, went over to the safe, and brought out a pair of rather small—I mean very small—earrings. Richard and I looked at each other and sort of chuckled, 'You've got to be joking.' Gianni replied modestly, 'I thought you said $100,000.' Well, we did! 'So,' he said, with this little flourish of his hands and a shrug of his shoulders, 'that's $100,000.'

" 'Try again,' Richard suggested. Gianni opened another drawer in the safe and a little chunk of green flame came out. He opened another drawer

Clockwise, from top right: Two performers, two performances—the Burtons clown around backstage in Richard Burton's dressing room in Montreal, where he was starring in *Hamlet*. As they were getting ready for a wedding reception that evening, the new Mrs. Burton was showing off some of the more domestic gifts the couple received. By this time, matching earrings were part of the Bulgari ensemble, in this case as a thirty-second birthday present. A few weeks later, bottom left, the actress wears the emerald brooch at the opening of the Copacabana in New York, which offsets a pair of yellow diamond earrings (page 112), also a birthday gift, but from former husband Eddie Fisher.

and this time a giant green flame leapt out! Then a third drawer. This time we were blinded by a blaze of white. And it was diamonds. 'Gianni,' Richard said, 'what kind of game are you playing with us?' Gianni became very apologetic: 'You are right. These are way too expensive. I am so sorry. These are over your budget and I can't let you see them.' 'Oh come on, Gianni. Be a sport.'

"Of course Gianni was playing with us. He brought out a ruby and diamond necklace. I had never seen anything like it in my life, and by that time I already had the beautiful Cartier rubies from Mike. But this necklace was huge, with the most enormous stones. 'How much?' Richard asked. I didn't even dare put it on. Again Richard asked the price. 'Over a million dollars.' Richard sort of looked down, and mumbled 'No, no, no.' 'OK, I have a lesser piece,' and this time he brought out emeralds. We simply gasped, and I thought, 'Oh my God! I've got to have the emeralds.' Gianni was so smart, because he didn't just show us one piece, he showed us two different sets to choose from. The smaller of the two necklaces had a pendant that could also be worn as a brooch. So I tried them on, the huge one, then the smaller one, then the huge one, then the smaller one—the $100,000 limit was out the window. But I reasoned with Richard, 'You see, love, you can detach the pendant and wear it as a pin, so it's really like getting two pieces for the price of one!' We saw how beautiful it was both ways. The big diamonds around the brooch were 10 carats each.

"By this time we had been joined by Bob, who was one of Richard's and my dearest friends and who had been Richard's dresser for I don't know how

Emerald and diamond ring, by Bulgari

The look of love: In Puerto Vallarta, 1963, where Burton was making Tennessee Williams's *The Night of the Iguana*.

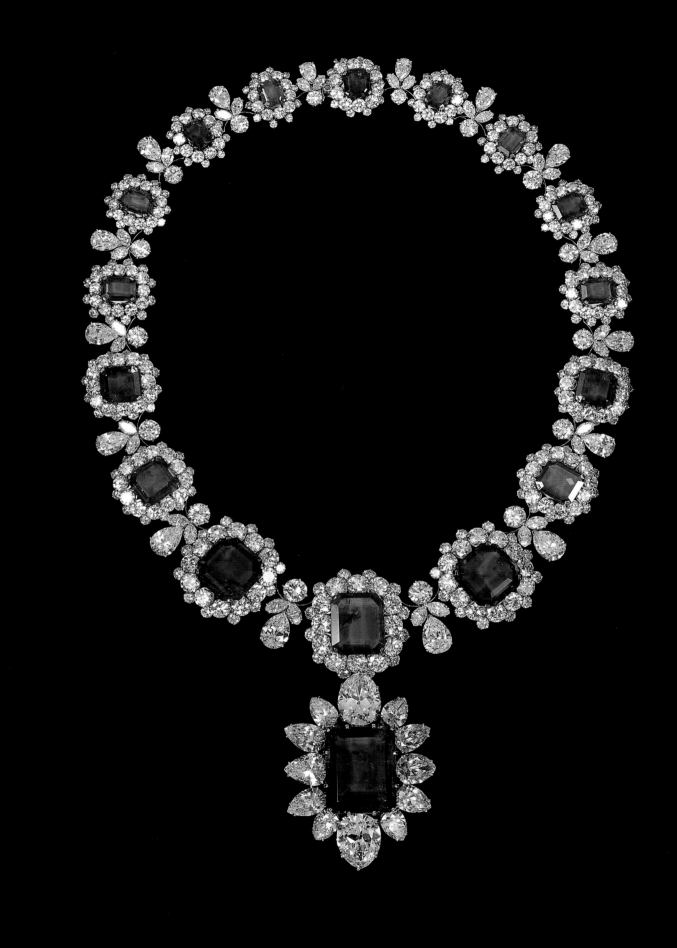

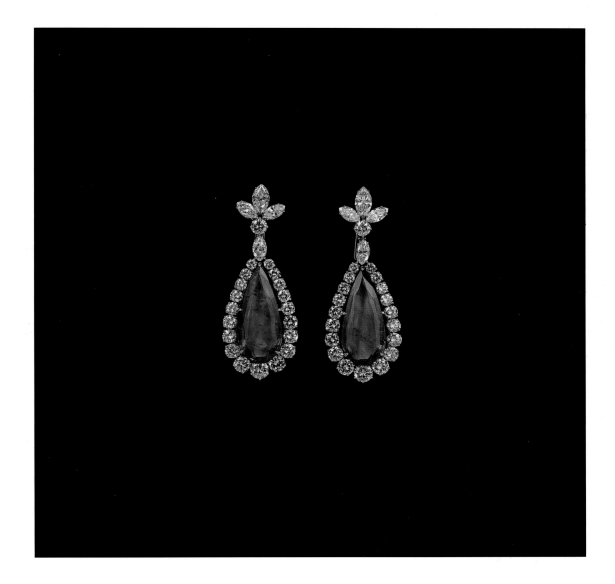

Pair of emerald and diamond ear pendants, by Bulgari

Opposite: Emerald and diamond necklace, by Bulgari

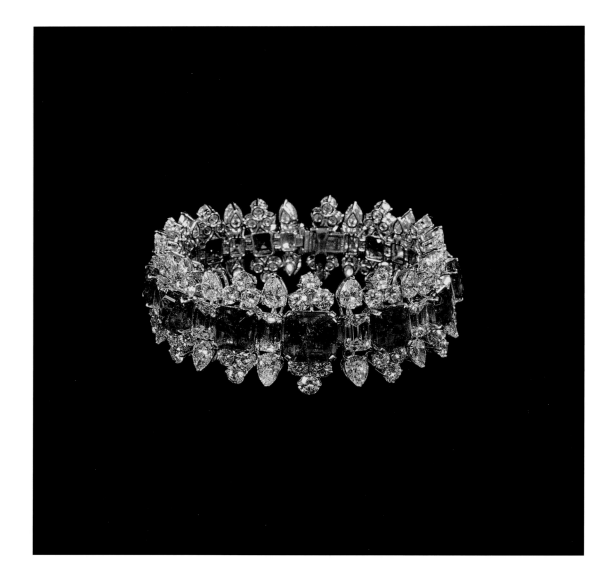

Emerald and diamond bracelet, by Bulgari

long. Bob was a very elegant, tall, Savile Row–dressed black man, who held himself with such perfect dignity. Richard turned to him and asked, 'Bob, what do you think?' because by now Richard was in a 'whatever you want' mood. We'd gone too far to turn back. I remember Bob looked at both necklaces and said he couldn't decide, either. Finally, I tried them each on one more time, and I said, 'Richard, you know, I think I like the smaller one.' With that, Bob turned to Richard, shot him this look of, oh boy! and said, 'Mr. B., you can't hardly get girls like that no more!' "

Emerald and diamond ring, by Bulgari

Overleaf: From the time Elizabeth Taylor first received the emerald and diamond jewelry—sometimes referred to as the Grand Duchess Vladimir Suite—she was seen wearing the gems literally all over the world. Clockwise, from top left: at dinner on the luxury liner *Queen Elizabeth*, 1964, with Richard Burton, Harry Karl, and Debbie Reynolds; at a benefit premiere of *Lawrence of Arabia* in Paris at the British Embassy; dancing at a ball given by Countess Marina Cicogna in the Vendramin Palace, Venice, 1967. Miss Taylor is also wearing the 29.4-carat diamond ring, given to her by Mike Todd; greeting Queen Elizabeth II at a dinner given in Washington, D.C., July 8, 1976, in honor of the Bicentennial; with an award for her role in *Suddenly Last Summer*, 1959, complementing the Bulgari emeralds with an emerald and diamond tremblant brooch; prior to the gala for *Lawrence of Arabia*, wearing the Mike Todd diamond tiara with her emeralds; at a party in 1970; at a Save Venice costume ball, 1967. The elaborate headdress of pearls and fake flowers was crafted by the famous hairdresser Alexandre of Paris.

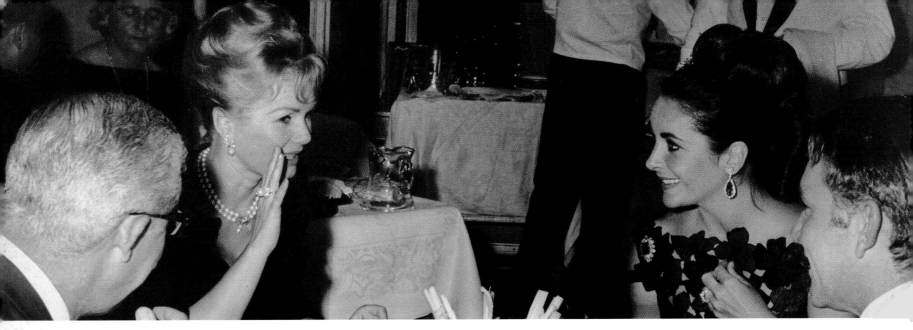

"By the time I got this bracelet from Richard, I already had a pretty good collection of emeralds and diamonds from Bulgari, but this bracelet was just so unusual. It was another one of those 'It's Tuesday, I love you' presents. I like to wear it with my emerald brooch."

Emerald and diamond "zigzag" bracelet

The occasion for this photograph by Cecil Beaton was the elegant Proust Ball, given by Baron and Baroness Guy de Rothschild at the Château de Ferrières, Seine-et-Marne, in 1972. The engraved invitation stipulated costumes appropriate to Proust's *A la recherche du temps perdu*. In particular, the women were asked to coif their hair in jewels. In addition to her own Bulgari emeralds and diamonds, Van Cleef & Arpels loaned Elizabeth Taylor some jewelry, which hairdresser Alexandre wove in and around her hair.

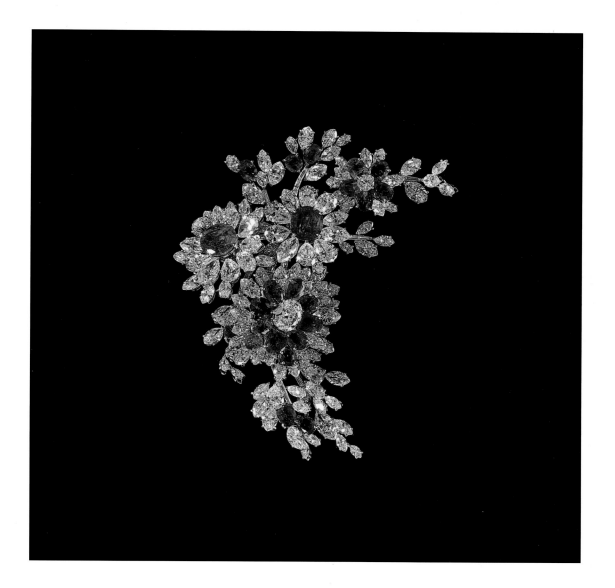

Emerald and diamond flower brooch, by Bulgari, detail opposite

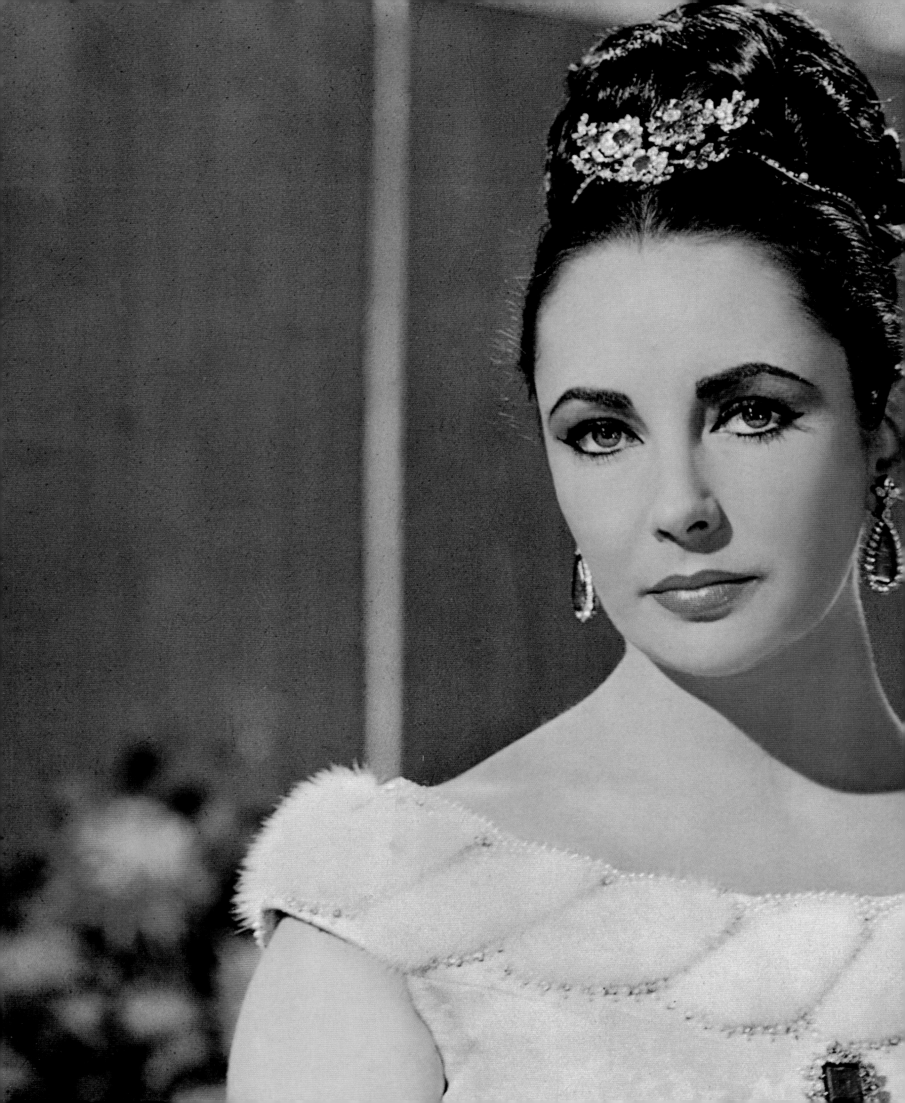

The emerald and diamond brooch (page 69), now used as an especially fine hair ornament in this promotional still for *The V.I.P.s*, 1963.

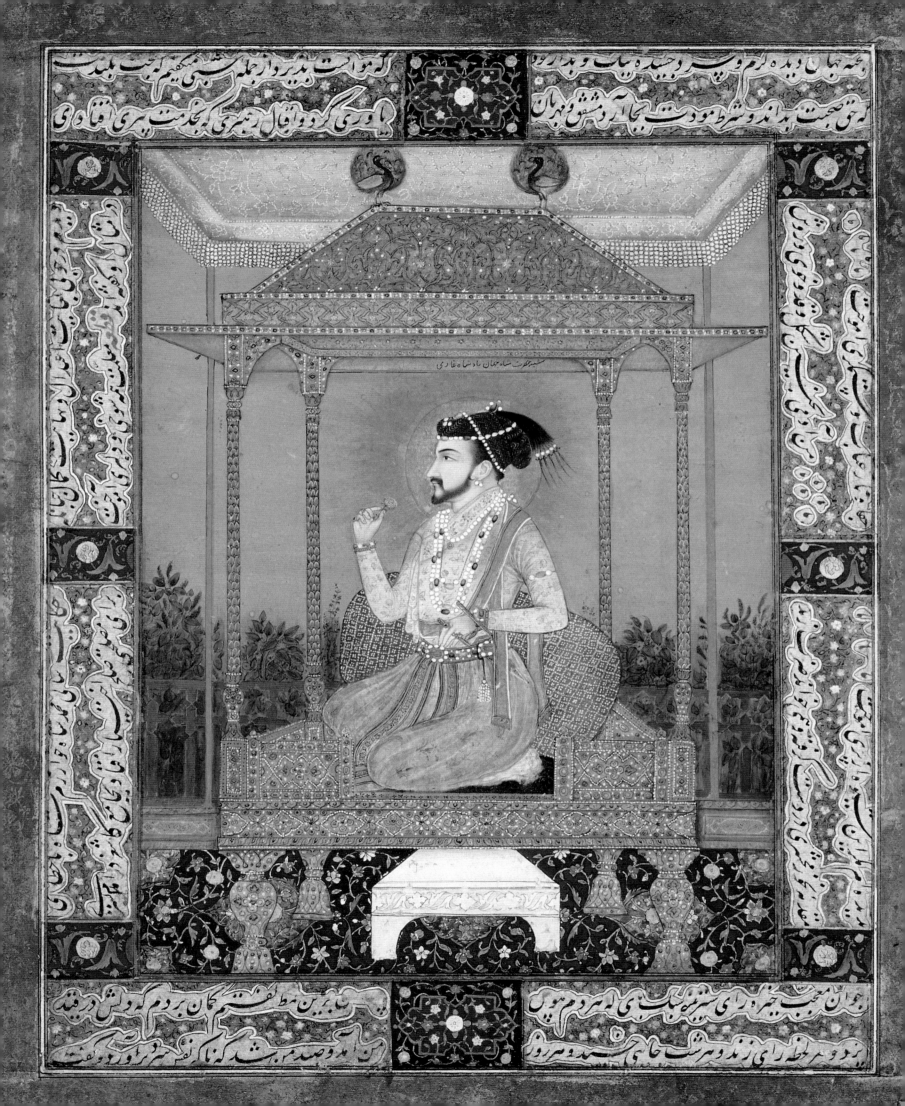

I Feel as Though I'm Only the Custodian of My Jewelry

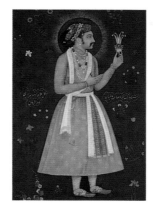

"I'm fortunate to have some very important pieces of jewelry. I don't believe I own any of the pieces. I believe that I am their custodian, here to enjoy them, to give them the best treatment in the world, to watch after their safety, and to love them. And they give their love back to me. We enjoy each other. I think it's because each piece has meaning for me and the memory of a piece of jewelry always brings back a stab of joy and love.

"One day somebody else will have them. Maybe not all the same bunch, but this piece or that piece or maybe a lot of pieces will be together, and I hope that new person will love the jewelry and respect it as much as I do, because this kind of beauty is so rare and should be treated with such care and admiration. When I die and they go off to auction I hope whoever buys them gives them a really good home.

"I've never, never thought of my jewelry as trophies. I'm here to take care of them and to love them."

Above: Shah Jahan holding a turban jewel, by Abul Hassan, 1617. Moghul miniature, inscribed in the margin by Shah Jahan, "a good portrait of me in my twenty-fifth year." Collection Victoria & Albert Museum, London
Opposite: Shah Jahan seated on the Peacock Throne. Mughal-style copy. Collection Victoria & Albert Museum, London

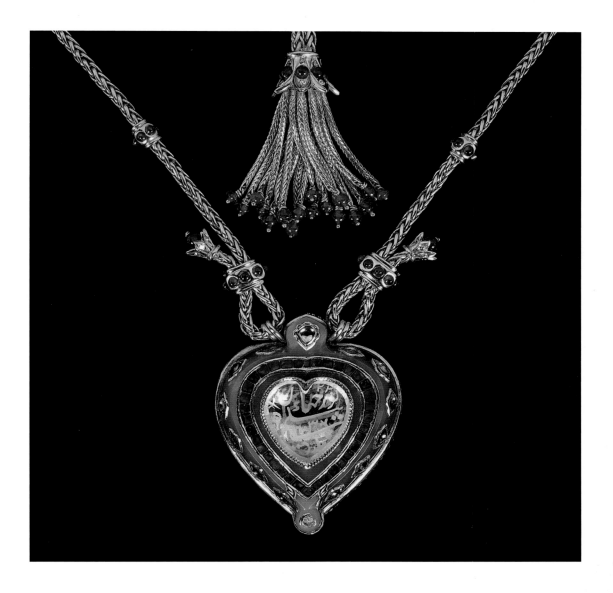

The Taj Mahal diamond, detail opposite

Gold and ruby chain by Cartier

"This piece grabbed both of us—it's incredibly beautiful, but the story behind the necklace is what gives it romantic value. According to the Persian inscription, it had first been made in 1627 for Nur Jahan, wife of the emperor Jahangir, who was the father of Shah Jahan. This Shah later received this stone from his father, and he in turn gave it to his favorite wife, Queen Mumtāz. Richard would joke that he had intended to buy me the Taj Mahal, but it was too big to move to our home in Switzerland. Some consolation prize!

"Although we bought the necklace during a stopover at Kennedy Airport—Cartier kindly managed to bring some jewelry out to the airport to show us while we waited for our connection—Richard officially gave it to me for my fortieth birthday at a sort of family-and-close-friends-only party in Budapest, which lasted two days. Originally, the pendant had been on a long white silken cord, which had worn out over the many years and had been replaced with an exact replica in gold and rubies."

Although Elizabeth Taylor had on some of her finest jewelry at her fortieth-birthday party, including her Krupp diamond, it was the Taj Mahal necklace, worn for a dinner-dance on the second night of festivities, which attracted the most notice. She is seen with guests Princess Grace and fellow actor and friend Michael Caine. At right, nearly thirty years later, the distinguished AIDS activist appears wearing the Taj Mahal necklace at a party sponsored by AmfAR in New York, March 1999. This was just days prior to the AmfAR fundraiser, "Fashions of the Oscars," held at Christie's.

"Look at the workmanship and the detail. It's just stunning. I mean, it takes my breath away. Everyone who sees the bracelet is awestruck by the hieroglyphics and the way it shines.

"When it came up for auction, Richard and I were fascinated by the provenance because it came from the collection of King Farouk. We both fell in love with it on the spot."

The King Farouk bracelet, circa 1925, detail

"If you're a collector, I think you've got to be willing to share. Some people lock their passions up in vaults, behind dark doors, so it's only theirs. Some people have their paintings put into storage so nobody else can look at them. I don't understand that mentality at all.

"Each piece is different, each piece is unique. And they each call out, 'Look at me, look at me.' I do, however, have a safe!!!"

Belle Époque diamond bow brooch, circa 1905, by Gillot

Antique ruby and diamond locket, circa 1880

LA PEREGRINA

"I was doing a film in Las Vegas, and when Richard wasn't working he was always in a black, grouchy mood. He had just bought the Peregrina at auction, and Ward Landrigan of Sotheby's had it flown out to us from New York. It was hanging from a very beautiful, little tiny pearl-and-platinum-chain necklace. I loved putting it around my neck and feeling it dangle. The pearl was so tactile, I couldn't stop rubbing it.

"The history of this totally natural, totally real pearl is unbelievable. When we got the Peregrina we also received a booklet with the story of the pearl and its family tree and a list of all the people who had owned it. It was just incredible. It had been discovered by a slave sometime in the 1500s. He got his freedom because of it and his owner made out pretty well, too. It ended up as part of the Spanish royal jewels, and along the way Prince Philip II of Spain gave it to Mary Tudor of England as an engagement present.

"Not long after I received the pearl, we saw a portrait of Mary Queen of Scots and that's when I decided how I wanted it set. So we took pictures of the painting to Cartier to have them design a setting. The choker part was in the painting, so we took that aspect of it. Both the larger and the smaller oriental pearls came from the painting, as well as the idea for the diamond and ruby ornaments between the pearls. It was the most incredibly beautiful choker. But the little diamond bail, suspending the pearl, is original to the piece."

Receiving an award in Italy for her film work, January 1973. For this occasion, the actress is wearing the Peregrina choker, natural pearl pendant earrings, and a ruby and diamond ring.

La Peregrina pearl, early 16th century
Suspended from a natural pearl, ruby, and diamond necklace by Cartier

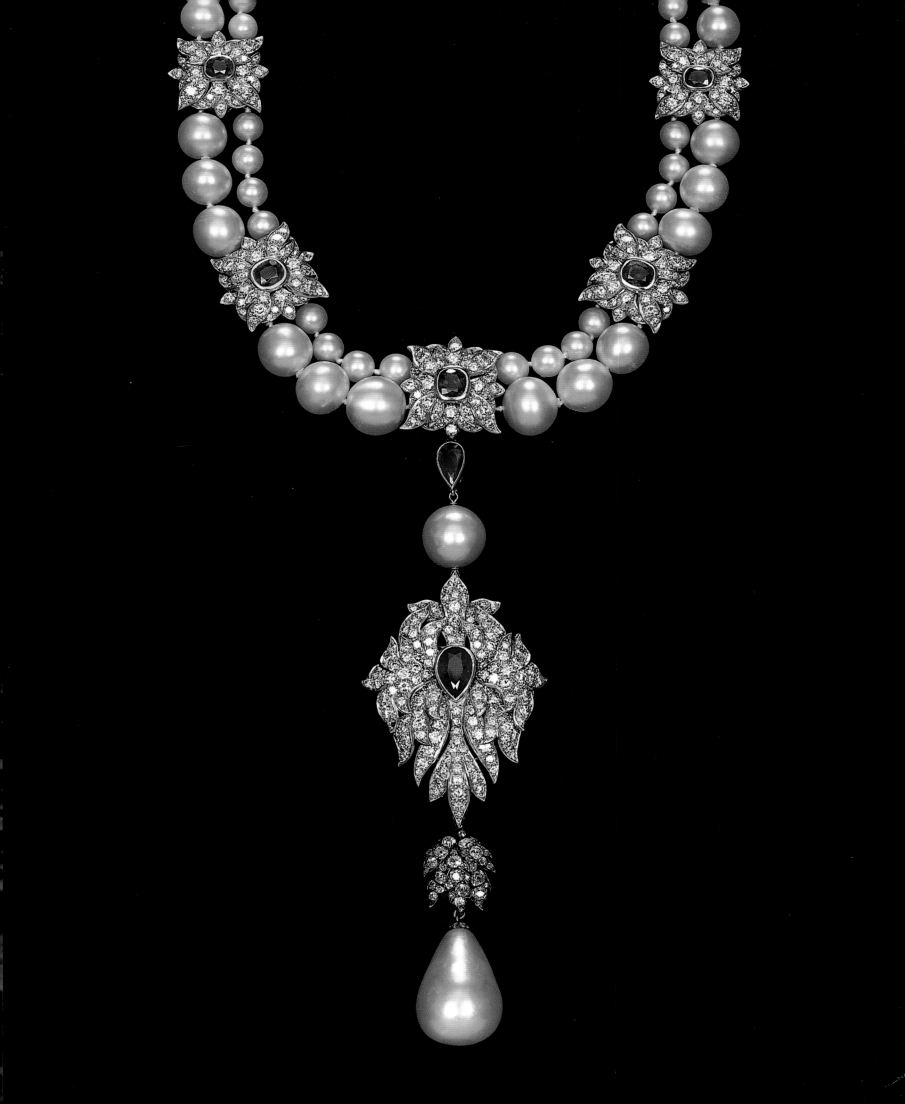

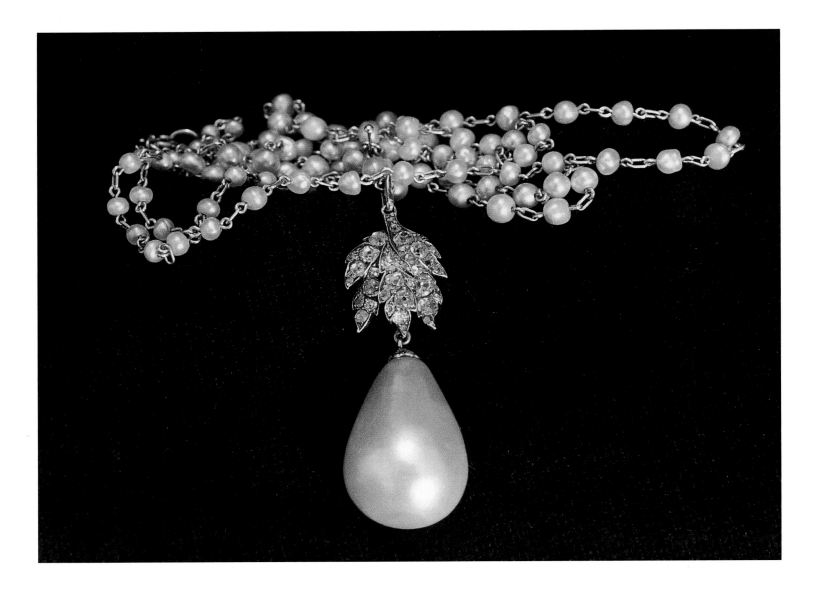

The actual Peregrina pearl, as purchased by Richard Burton for his wife. At this time, the necklace consisted of intermittently spaced small pearls along a slender chain. (Photo, Gianni Bozzacchi)

Indisputably one of the world's finest examples of a pear-shaped pearl, La Peregrina's origins are less certain, or less fully agreed upon by scholars worldwide. Even the meaning of the word "Peregrina"—wanderer—suggests the pearl's quixotic trail over some four hundred years, beginning in the early 1500s, when a slave discovered it in the Gulf of Panama. The slave won his freedom for his find and soon thereafter the Spanish crown received the bauble. Prince Philip II of Spain gave it to his wife, Mary Tudor of England, as a wedding gift, and over the succeeding generations the necklace was given to Spanish queens Margarita and Isabel. The next major holder of the pearl was the Bonaparte family, in the early 1800s. At this point, different versions circulate about the pearl's provenance, and *which* pearl in fact was in *whose* hands. Is it La Peregrina? Is it the Abercorn? About one point there is no confusion: Richard Burton bought the pearl for his wife at auction for $37,000 in January 1969. (The unhappy second-place bidder, Prince Alfonso de Bourbon Asturias, is testament to the ongoing controversy surrounding the pearl's "rightful" home.)

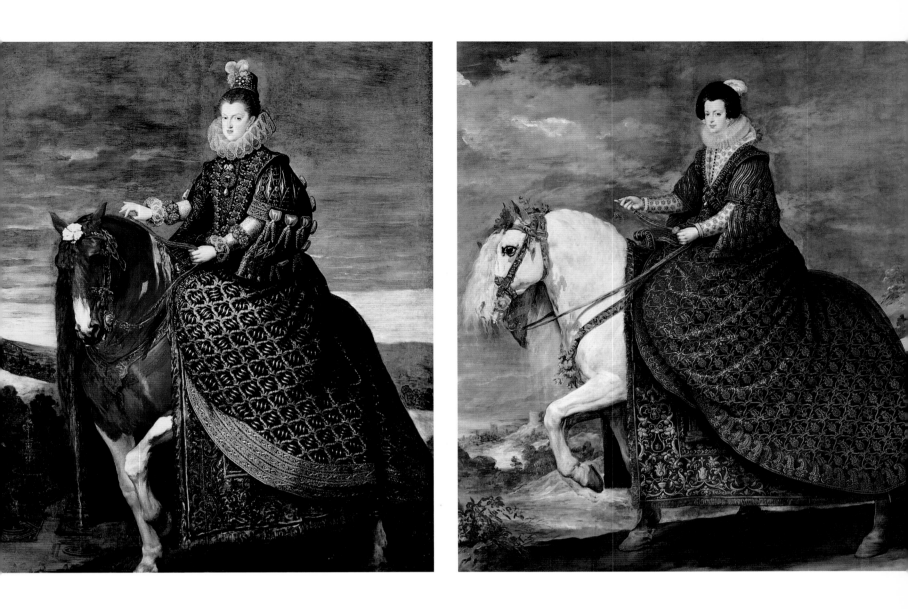

Left: Velásquez. *Queen Margarita on Horseback*. 1634–35. Collection Prado Museum

Right: Velásquez. *Queen Isabel on Horseback*. 1634–35. Collection Prado Museum

Art historical documentation of La Peregrina's ownership in the mid-1600s is provided in these two portraits made by Velásquez, the great Spanish court painter. At left, Queen Margarita, wife of Philip III, wears the pearl as a brooch fastened to her bodice, whereas her daughter-in-law, Queen Isabel, at right, wears it suspended from a long necklace.

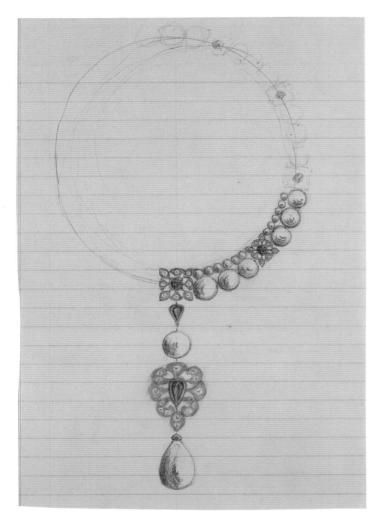

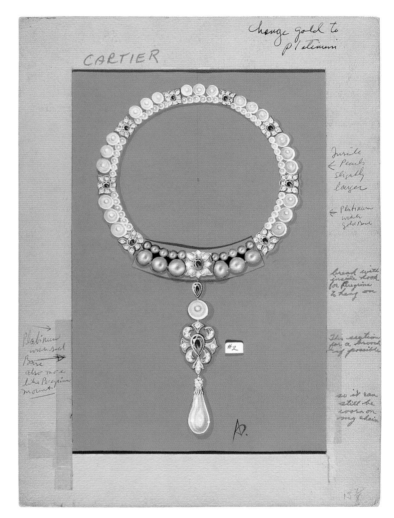

Three years after owning La Peregrina, the Burtons commissioned Cartier to design a new mount. Elizabeth Taylor, working with Cartier designer Al Durante (who shuttled between the New York offices and the Burtons' yacht in London), wanted the new necklace based on a necklace worn in a sixteenth-century portrait of Mary Queen of Scots that she and her husband had loved. The sketch at left, published for the first time, shows the earliest workings of the double-strand pearl and ruby choker. At right, the considerably evolved design with notes made by Elizabeth Taylor, in red pen, and by Cartier. Opposite, an alternate design for the flame motif, which the actress selected. In all, the new necklace, with its fifty-six exquisitely matched oriental pearls, took several months to complete.

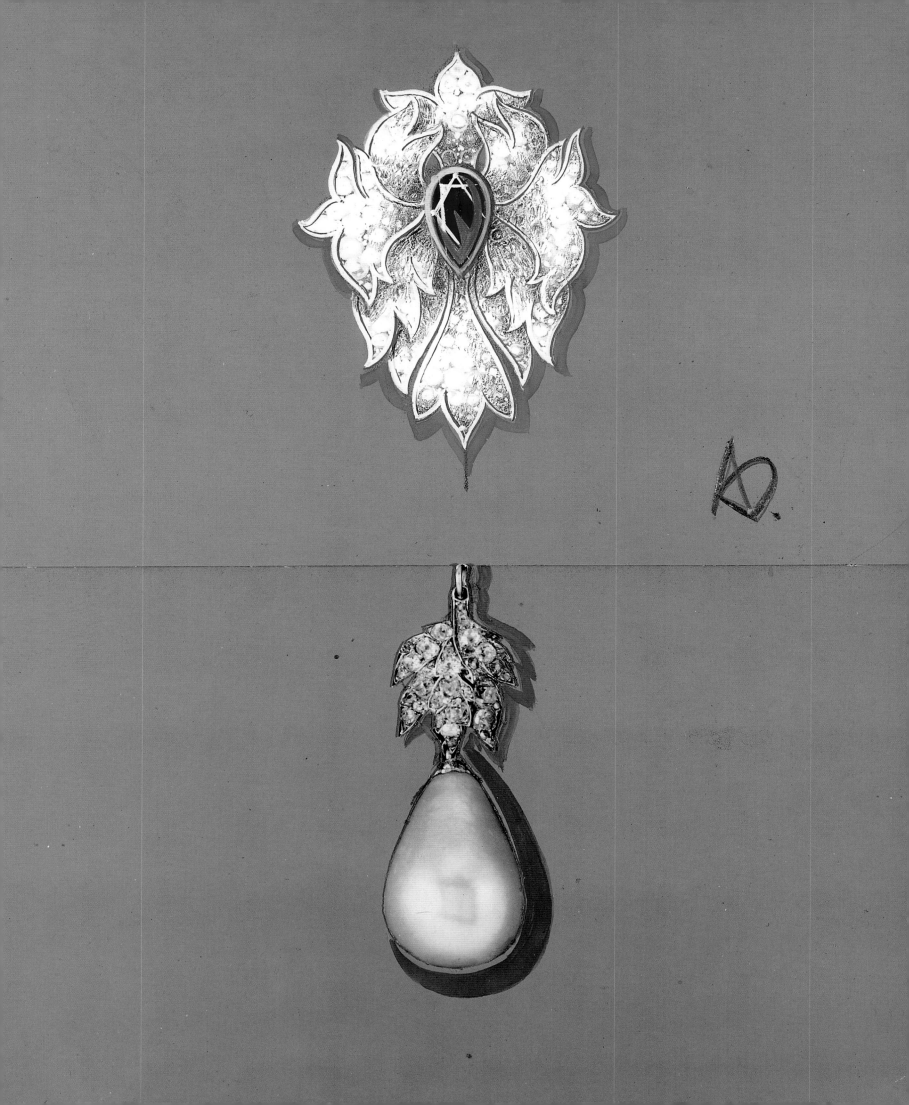

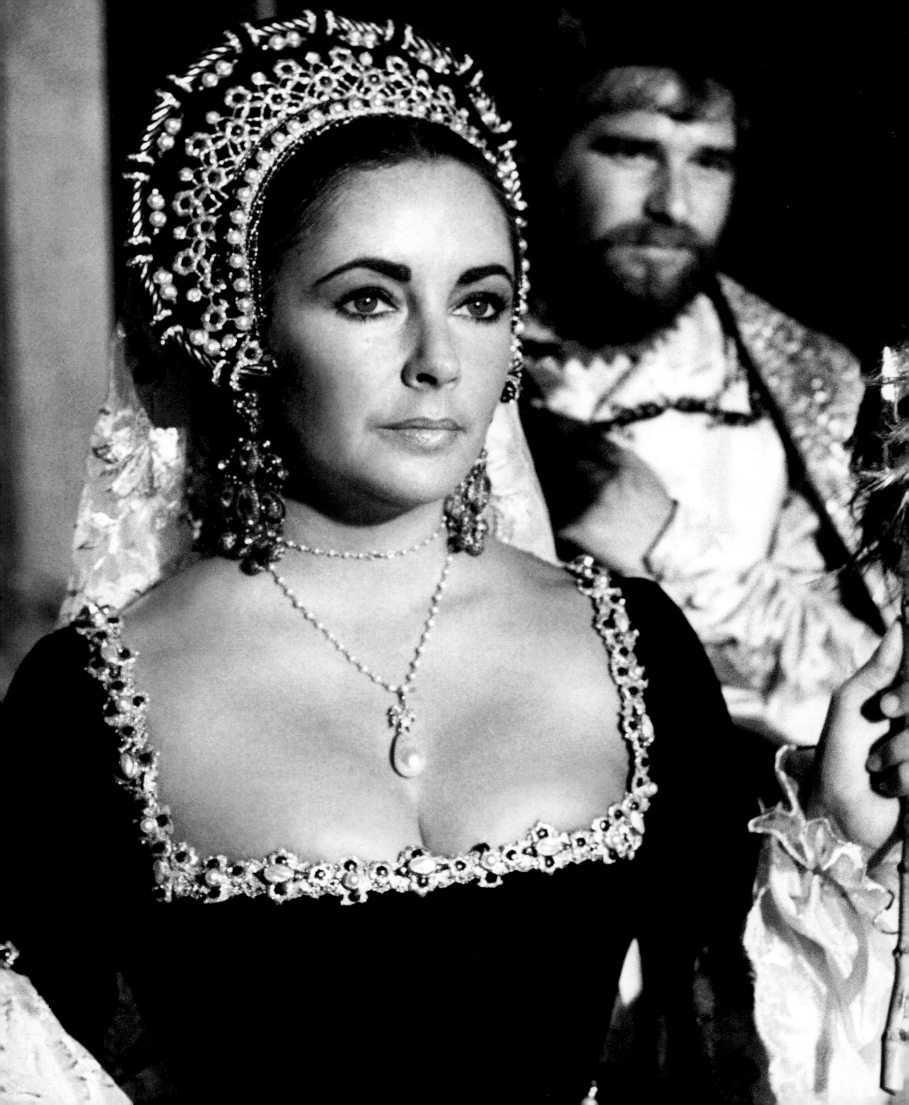

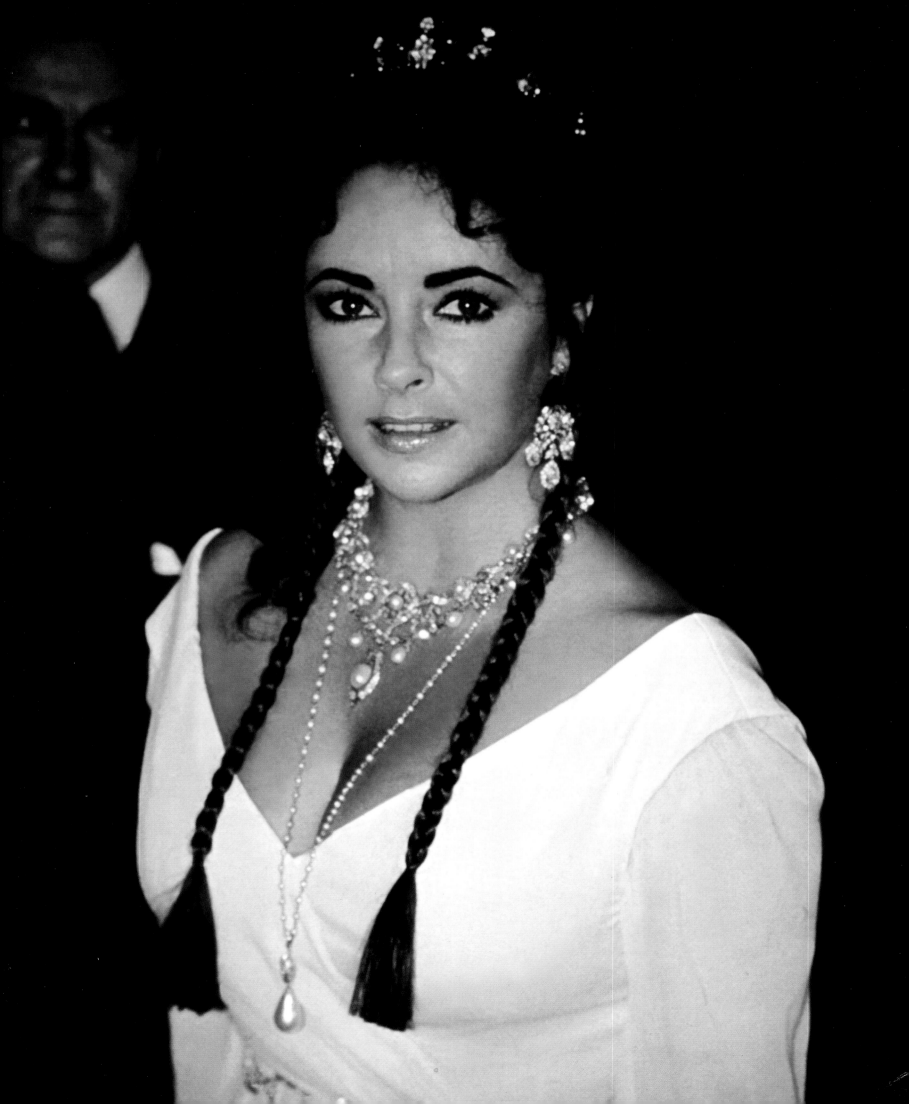

The Case of the Missing Pearl

"I had recently received the Peregrina from New York and it was on a delicate little chain, and I was touching it like a talisman and sort of walking back and forth through our room at Caesar's Palace—we had the whole top floor and the crew had about half of it. So I was dreaming and glowing and wanting to scream with joy, but Richard was in one of his Welsh moods, and his joy . . . well, he was a Welshman, so sometimes his joy was perverse and he would become dark. But when I'm happy I show it and scream it and yell it, and I wanted to throw myself at him and kiss him all over. But because I knew Richard very well, I had to play it by ear, and I knew that this was not the moment to become too demonstrative. Just the same, there was no one to talk to and no one to show the jewel to, and I was going out of my mind! At one point I reached down to touch the pearl—and it wasn't there! I glanced over at Richard, and thank God he wasn't looking at me, and I went into the bedroom and threw myself onto the bed, buried my head into the pillow, and screamed.

"Very slowly and very carefully, I retraced all my steps in the bedroom. I took my slippers off, took my socks off, and got down on my hands and knees, looking everywhere for the pearl. Nothing. I thought, 'It's got to be in the living room in front of Richard. What am I going to do? He'll kill me!'

A la mode 1960s, in a portrait by Firooz Zahedi, wearing La Peregrina on its original chain, in her hair. Pages 88–89: In an unbilled walk-on in her husband's film, *Anne of the Thousand Days,* 1969, Elizabeth Taylor wears her newly acquired pearl necklace. In the facing image, and well off-camera but not out of the camera's eye at the premiere of *Staircase* in 1969, she antes up the flash factor in a blaze of diamonds and pearls: the Mike Todd diamond tiara and earrings, a 19th-century natural pearl and diamond garland necklace (a gift from Richard Burton in 1968), and La Peregrina.

Because he loved that piece. Anything historic was important to him. This pearl is unique in the world of gems. It's one of the most extraordinary pieces there is. And I knew that he was proud inside, which was why he was being like this cartoon with a black cloud over his head and raindrops falling.

"So I went out and sort of started humming la la la, and I was walking back and forth in my bare feet, seeing if I could feel anything in the carpet. I was trying to be composed and look as if I had a purpose, because inside I was practically heaving I was so sick. I looked over and saw the white Pekingese, which was mine, and the orangey-brown Pekingese, which was Richard's. God, that dog worshiped him. All the puppies—it was their feeding time—were around the bowls munching. So I looked at the dogs, saying, 'Hi babies, such sweet little babies . . .' and I saw one chewing on a bone. And I did the longest, slowest double take in my head. I thought, 'Wait a minute. We don't give our dogs, especially the puppies, bones! What *is* he chewing on?' And I just wanted to put my hand over my mouth and scream again. But no, I just casually opened the puppy's mouth, and inside its mouth was the most perfect pearl in the world. And it was—thank you, God—not scratched.

"I did finally tell Richard. But I had to wait at least a week!"

In 1992, wearing La Peregrina and the natural pearl pendant earrings.

MAGNIFICENT JEWELRY

PARKE - BERNET GALLERIES · INC

"LIZ GETS THAT PEACHY PEAR"

—New York Daily News

"Richard was absolutely determined to have this diamond. He was still on a high from having bought me the Peregrina only a few months before, so when this huge diamond came up at auction Richard made up his mind he had to have it. Well, he and a few others (one rumored to be the Sultan of Brunei). Walter Annenberg's sister, Mrs. Paul Ames, had decided to put the diamond up for auction and we all went crazy. Richard had the diamond sent to us in Gstaad, where we lived. When it was time for the auction, Richard instructed our good friend and lawyer Aaron Frosch that he could bid as high as $1 million, still a lot of money today and God knows how much more in 1969. To Richard's amazement, he was outbid. Cartier bought the diamond with an offer of an additional $50,000, the most ever paid at auction for a diamond at the time. Richard was absolutely beside himself. I remember we were in our favorite pub and he got on the phone to Cartier, and practically before the first papers in New York hit the streets boasting about the purchase by Cartier, we were the new owners—for another $50,000, which was a pretty fast profit for them. And just as fast, the stone went from being called the Cartier diamond to the Taylor-Burton diamond.

"Originally, I wore the diamond as a ring, but even for me it was too big, so we had Cartier design a necklace. I'm still sick that I sold it some years later."

The Taylor-Burton diamond, by Cartier
Weighing 69.42 carats

Once the gavel hit, the regal diamond was newly owned, and thus newly named the Cartier diamond, featured here in the company's distinctive red leather box. Within forty-eight hours, the diamond had switched hands and names.
Opposite: There was nothing misleading about the title of Sotheby's auction, "Magnificent Jewelry," featuring the 69.42-carat diamond.

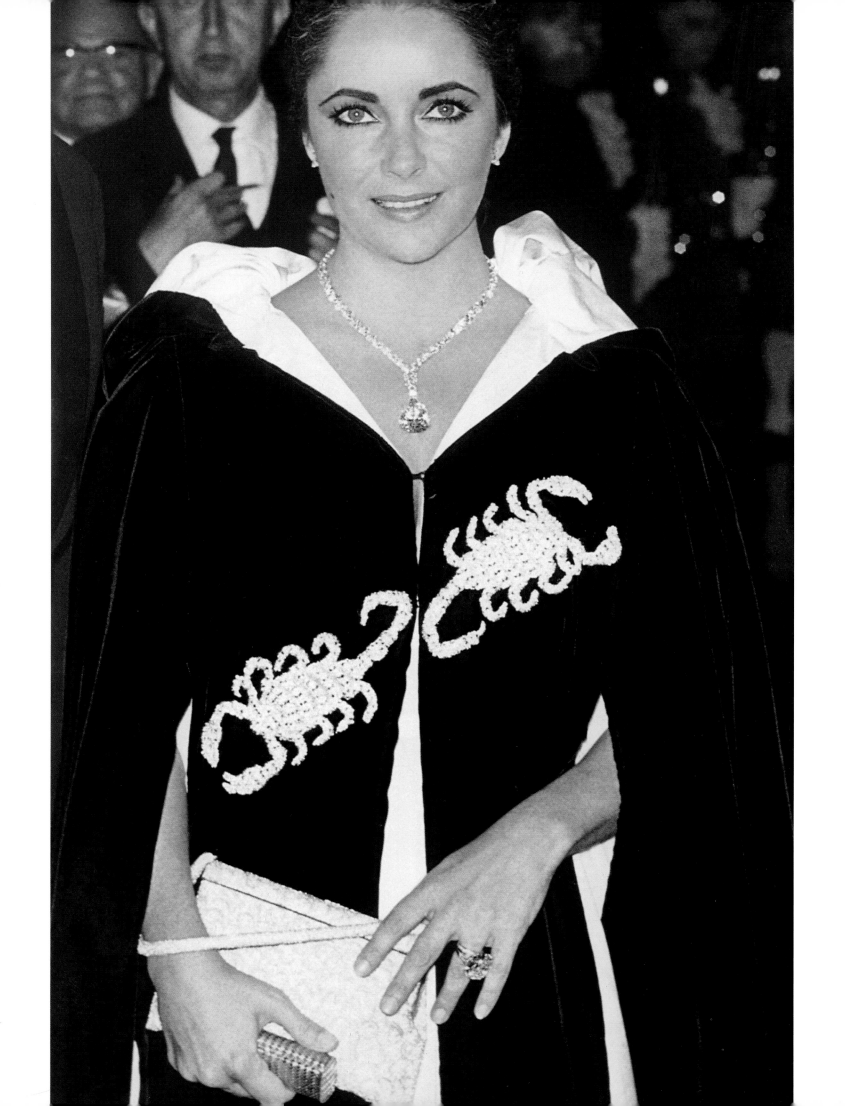

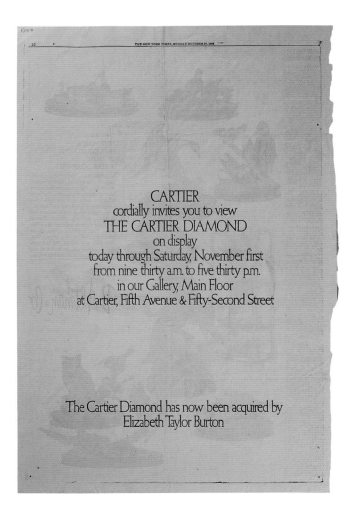

CARTIER
cordially invites you to view
THE CARTIER DIAMOND
on display
today through Saturday, November first
from nine thirty a.m. to five thirty p.m.
in our Gallery, Main Floor
at Cartier, Fifth Avenue & Fifty-Second Street

The Cartier Diamond has now been acquired by
Elizabeth Taylor Burton

When Richard Burton bought the diamond from Cartier subsequent to the auction, he agreed to allow the jeweler to display the large stone for a limited period of time in New York, as advertised in this announcement that ran in the *New York Times*. Crowds circled the corner of the Fifth Avenue store just to have a look.

Opposite: Grace Kelly's fortieth birthday in Monte Carlo was a lavish affair, by any standard. The stylish event was based on a scorpion theme, which was the princess's astrological sign. Elizabeth Taylor chose the party as the debut of the Taylor-Burton diamond, which required more than the usual insurance. First, the diamond was flown from New York to Nice in the company of two security guards, who delivered it to Elizabeth Taylor and her husband aboard their yacht, *Kalizma*. The Burtons were then escorted to the party with their security guards, who were armed with machine guns as added protection.

Left: At the Academy Awards, 1970. At Princess Grace's party, the Burtons had an inside joke that Elizabeth Taylor would wear both her largest diamonds (the Taylor-Burton and the Krupp) as well as one of her smallest diamonds (the Ping-Pong ring, page 172), seen center. (Photo, Gianni Bozzacchi) Right: Chatting with David Niven. Opposite: With Princess Grace.

A TOUCH OF CLASS

"I first met the Duke and Duchess of Windsor when I was eighteen and married to Nicky Hilton. I got to know them only slightly, and being so shy didn't make it any easier. But they always smiled at me and were sweet to me. Years later, Richard was doing a film in Paris, and whenever he worked I didn't, and when I worked he didn't so that we could always be together. That's when we got to know the Duke and Duchess much better. The Duke's respect for her was so beautiful. He called her Duchess. Besides, if you didn't call her Duchess I think you would have been on your way out. I never called her Wallis. I always called her Duchess.

"Around that time we were really being hatcheted to death by the press and dogged wherever we went, even though we were married by then. The Duke and Duchess must have seen the headlines and stuff and had a bit of déjà vu themselves. The beating *they* took by the press made us look like chopped chicken liver. They asked us to lunch with them at their house in Paris, which was exceptionally beautiful and quiet. The Duke had done the garden completely himself. He designed it, he dug it, he planted every flower and shrub. It was his jewel.

"Years later, I read in a book written by the Duchess's lady-in-waiting that when the Duchess was trying to decide what jewelry to wear to our lunch, she started to put on a diamond ring and then exclaimed, 'Oh no, I can't wear that! Elizabeth's diamond is much bigger. Give me the sapphire.' I thought this was very amusing.

At *Forbes* magazine's seventieth-birthday party in 1987, with Malcolm Forbes. Elizabeth Taylor wears gold and round diamond Creole-style earrings.

Opposite: The Duchess of Windsor, wearing the diamond clip in a photograph by Cecil Beaton, courtesy Sotheby's.

On one of our visits she came down wearing a pin that was the insignia of Wales, which I loved especially because Richard was so Welsh all the way through, and I was becoming Welsh myself by osmosis. I exclaimed over the pin and asked, 'Isn't that the royal insignia for the Prince of Wales, with the three feathers in the crown?' 'Indeed,' she said, 'and when Lord Mountbatten came to take back all the royal pieces he missed this one!' I thought it was a great story and also so romantic that the Duke had the brooch made up for the Duchess. She even offered to let me copy it. 'Oh my God,' I said, 'I simply couldn't do that! What you have is a unique piece.' 'Very well,' she agreed, 'but every time I see you I'll wear it in your honor.' I don't know how many times we went to their country house, but we always had a wonderful time. I could tell how much the Duchess loved him, and she must have been so lonely when he died. Poor thing, she got Alzheimer's, and that is such a slow and terrible death.

"There came a point when I stopped hearing from her, and whenever I tried to get in touch with her I was always politely shuffled aside. I never had the opportunity to say good-bye to her. Then the auction of her estate came up in 1987 and that's when I saw the pin. I had an immediate sense that she wanted me to have it. And it was important to me because the money was going to AIDS research. Even though I had never bought myself any important jewelry before—in a shop, much less at auction—I told myself that I was going to bid on that pin and that I was going to get it.

Diamond "Prince of Wales" brooch, circa 1935

"It was a warm day and my kids—just family—were around the pool in their bathing suits, and Ward Landrigan, of Sotheby's, and I were talking constantly on the phone. It seems I was bidding against somebody who wanted it as much as I did, but not for the same reason. I wanted it because I knew the Duchess had wanted me to have it. It was a spooky, eerie thing. I was also motivated because the money was going to a cause I was deeply committed to. So I kept on saying, 'More, more, yes, more, more. Yes! Yes!' And I started laughing, because the price was over $600,000. The kids were all looking at me, and my son Michael was staring at me as if I'd flipped my wig. And they didn't even know what the price was, they only heard me repeating 'More, more, more, more, more.' Then there was a silence. And I could hear the auctioneer: 'For $623,000 to the caller on the telephone. Do I hear more? Do I hear more? Going. Going. Gone!' I let out the biggest scream and so did the kids, especially when I told them the price . . . some of them threw themselves in the swimming pool.

"All along I knew my friend the Duchess wanted me to have it. And I still know that. It's a royal piece that I save for very special occasions because it means so much to me."

Diamond "Prince of Wales" brooch, detail

First a Broad, Now a Dame— The Most Exciting Day of My Life

"I've been a broad all my life, so a dame seemed a natural extension. You can be 'Damed' if you've been totally outstanding or, as in my case, for what they call 'services to acting and charity.' Honestly, I had no inkling I was receiving this honor. It came as a total surprise to me. I do not exaggerate: this was the most exciting day of my life.

"The protocol is that when the Queen pins you with your medals, you are allowed to wear them to your seat, but then you are supposed to remove them and return them to their very nice little case. So I returned to my seat, where all of my family was assembled from the four corners, feeling quite carried away by the spirit and pomp of the day. But as I was listening to the music, which really did give me goose bumps, I kept fingering my medal. By the time the ceremony was over and we were leaving, I was still wearing my medal and I thought to myself, 'This day will never happen again, so I am going to wear my new pins—forget protocol!' I simply held my head high and left Buckingham Palace, with the proof of my investiture for all to see.

"There is a nice little behind-the-scenes footnote to this day, which is that my old friend Julie Andrews was also among those being recognized by the Queen. Julie and I were glued to the hip out of pure nervousness and excitement. Julie is a lady and I'm not—I'm more of a broad, more gutsy and outgoing. As I recall, at one point while we were being 'briefed' on the ceremony, our patient instructor turned to Julie and advised her 'to look after me.' As though I would possibly misbehave! But Julie has a grand sense of humor, and I was so grateful to share that special day with her."

Opposite and right: Being made Dame Elizabeth, Commander of the Order of the British Empire, by Her Majesty, Queen Elizabeth II. Elizabeth Taylor wears the Van Cleef & Arpels earrings she designed for the occasion.

"Most people don't know that occasionally I like to design jewelry, too! These earrings, which I ended up wearing for one of the most significant events in my life, had such a humble beginning. Originally, they were part of a gift I gave to a friend. But she didn't really wear earrings, so she gave them back to me and kept the pin I had given her. I put the earrings in my drawer, but in truth they were much too small for me—I like long, dangly earrings. When I started to plan what I'd wear for my Dameship, I wanted something new and that's when I got the idea of using these little flowers and making them much bigger. So I took them to Van Cleef & Arpels—that's where they came from in the first place—and I saw these little butterfly pieces, and the rest of the design came together on the spot."

A sketch of two versions of the pendant earrings. The actual earrings, however, follow version A, but Elizabeth Taylor decided to adapt the intermittently spaced diamond stone of version B as a single flourish at the end of each earring.

A

B

"These chandeliers are so long they hit my shoulders. I was in London on the occasion of being made a Dame of the British Empire and I had seen these earrings in a display window at the Dorchester Hotel, where I always stay. While the rest of my group was going over to check in at the concierge, these things were like flashing laser lights out of one of the display windows. I could see the earrings just as clearly as could be. I walked as though in a trance toward them, chanting, 'You're mine! You're mine! You're mine!'

After I got a better look at them, I got ahold of the people at Kutchinsky, where they were made, and haggled with them over the price, because I don't buy anything for myself without haggling. I cut a pretty good deal. I'm a pretty good con lady!"

Pair of emerald and diamond ear pendants, by Kutchinsky
Opposite: Pair of coral, diamond, yellow sapphire, and cultured pearl ear pendants, by Van Cleef & Arpels

A PASSION FOR DIAMONDS

" Richard and I had sworn not to see each other—not because of the press but because of Sybil, his wife. My marriage to Eddie Fisher was already over. On this 'occasion' I had just turned thirty, and it was the most miserable day of my life. The earrings, the ring, and the brooch came as a total surprise from Eddie on my birthday. The whole set. I thanked him, but really I was just looking for some sign of something, *anything,* from Richard. There wasn't even a bouquet of flowers from him. 'Well,' I thought, 'we promised.' But I had to go to work with him, and we both tried not to look at each other during rehearsals. As for Eddie, in a couple of months he was out of the house, and a couple of months after that I received a bill for the jewelry. Did I end up paying the bill?—mmmm, probably."

With Aristotle Onassis at the Lido restaurant, in Paris, February 1964. In this photograph and the one with her husband, Elizabeth Taylor is wearing her yellow diamond pendant earrings and yellow diamond ring.

Diamond and colored diamond flower brooch, by Bulgari, detail

Pair of diamond and yellow diamond ear pendants, by Bulgari
Diamond and yellow diamond ring, by Bulgari (enlarged)

Diamond and colored diamond flower brooch, by Bulgari

Sapphire and diamond camellia brooch

Perfect Manners

"Dennis Stein and I had become engaged. Dennis loved giving me watches—actually, I kind of collected watches—and he loved giving me presents. As far as I'm concerned, a present doesn't have to be diamond earrings; it can be a sweater or sunglasses. With any kind of present I just go ballistic. As an engagement present, his boss, Ron Perelman, gave me some earrings—not chandelier style, but sweet. I was very touched that Ron was so thoughtful.

"But when Dennis and I broke off our engagement, I didn't return the earrings. Naturally, I returned the engagement ring to my fiancé. In time, I got an irate letter from Ron, which showed no manners. I felt it was my choice whether to return the earrings or not; I mean, I wasn't engaged to *Ron*. But I sent a note to Ron, together with the earrings, telling him how amazed I was by his request. The next thing I knew, Ron sent over an 'apology' for his boo-boo, and it was ten times prettier. I'm sure it cost him ten times more. So I hope I taught him a lesson in etiquette."

The Perelman bracelet, by Van Cleef & Arpels, detail

Let's Kiss and Make Up

"This is a diamond choker made completely of pavé diamonds all the way around with a beautiful pavé diamond heart. It's so thick with pavé diamonds that there isn't an inch which doesn't sparkle. There's a nice little story about this necklace, or at least a story with a nice ending.

"Richard and I had a fight, a serious fight. He was filming *The Voyage* with Sophia Loren and I thought they were just a little too friendly. I knew he was flirting his head off, and she was flirting right back, both of them speaking in Italian, which made me feel ridiculously left out. I thought, I'm not going to sit here and watch this. Screw them both. I was also doing a film in Rome, *The Driver's Seat*, but I was staying at the Grand, and Richard was in Sophia's guesthouse because he had been ill and she was trying to dry him out. I decided it was time for a little separation so that we could sit back and evaluate things.

"I wished Sophia good luck and came back to California to have exploratory tests at Scripps, because I was having horrible pains in my stomach. I was moved to one of the big UCLA hospitals, where they took out my appendix. I didn't call Richard and he didn't call me, but it wasn't long before he heard about my operation. The next thing I knew he was by my bedside and we were squeezing the air out of each other and kissing each other and crying. 'Please come back with me,' he asked.

"You've never seen anybody heal so fast. It was as if the Grand Maestro had placed a hand over my incision and healed me up. Richard went to Van Cleef & Arpels and came back with this extraordinary heart and choker. The necklace tends to 'roll,' so you don't see me wearing it much in photographs, but it's one of my favorite pieces of jewelry because it was given with such love. That man knew how to make up!"

Diamond heart-shaped pendant necklace, by Van Cleef & Arpels (enlarged)

Suite of diamond and pink diamond double heart jewelry, by Chopard

Diamond and multicolored sapphire butterfly brooch, by Chopard

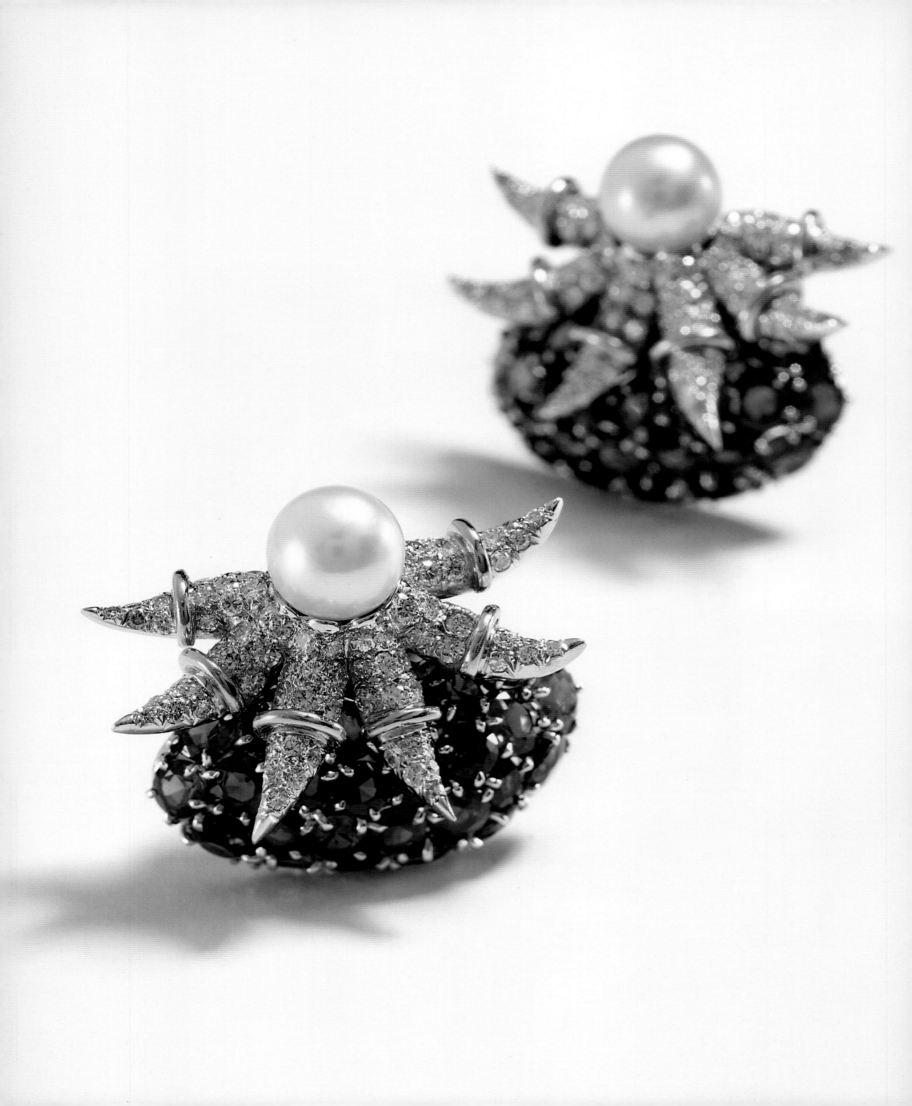

A rose is a rose is a rose, but the same can't be said of Elizabeth Taylor's concept of a brooch, which she sometimes wears in her hair, as seen at left, or even pinned to a sash at her waist for an especially elegant look. At right, for an outing at Ascot with Richard Burton and playwright Noel Coward, the actress's brooch anchors a scarf at her shoulder.

Pair of sapphire, diamond, and cultured pearl ear clips, circa 1964, by Jean Schlumberger, Tiffany & Co. (enlarged)

"Richard and I had a sentimental attachment to the Schlumberger iguana brooch because it symbolized when we were so madly, happily in love. Richard gave me this orchid brooch and the starfish and pearl earrings because he wanted me to have another memento from Schlumberger."

Sapphire and diamond orchid brooch, by Jean Schlumberger, Tiffany & Co. (enlarged)

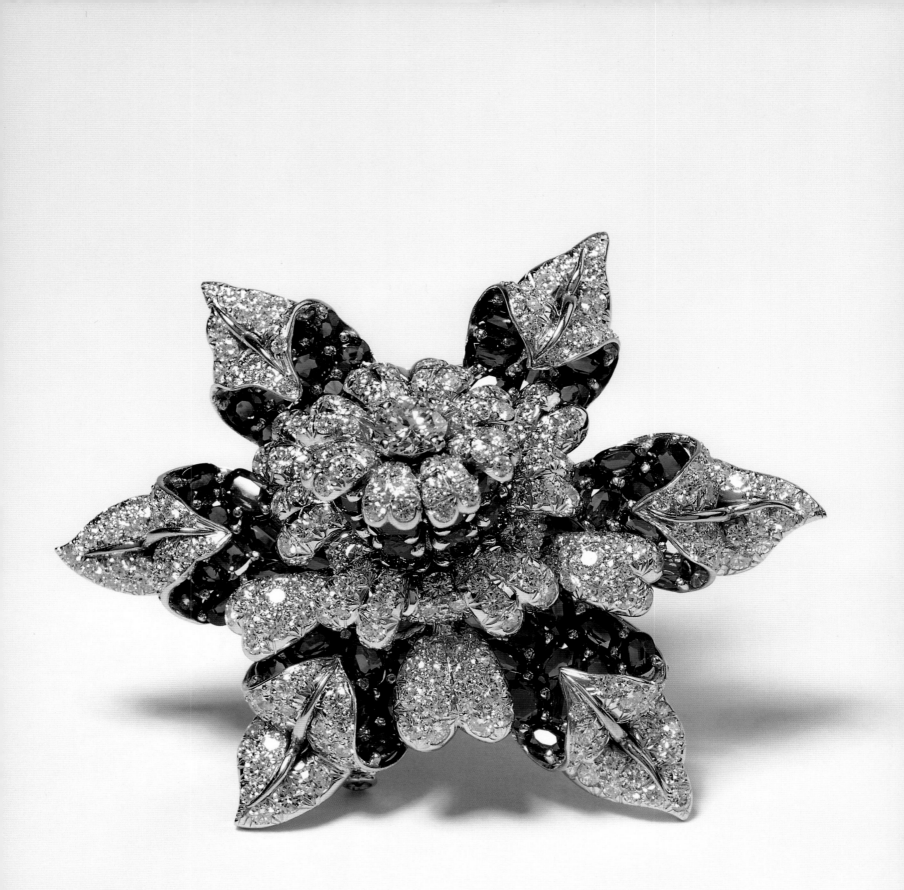

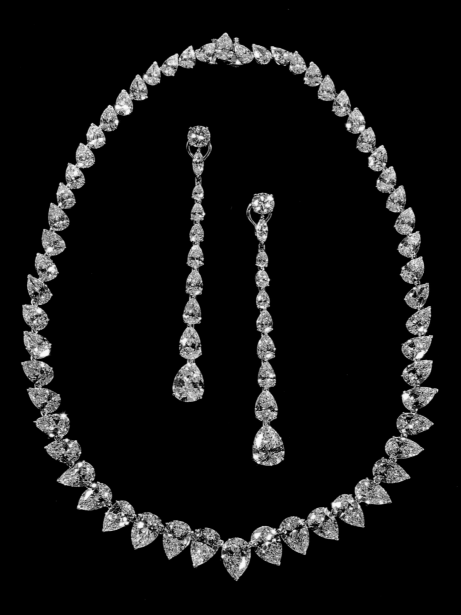

A marriage in Neverland—wearing the long diamond earrings of her own design. (Photo, Herb Ritts)

Diamond line necklace, by Cartier
The wedding diamond ear pendants, by Cartier

I L O V E A R T D E C O

"In 1977, I received the Hasty Pudding Award from Harvard and I wore this wonderful hunk of emerald on a pearl necklace with onyx and coral. I had it on with a very simple suit. The necklace hits just below the navel. I was in a room and there was a bunch of young guys below, on the sidewalk. When I leaned out of the window to say hi, my necklace leaned out with me. I waved to them, kind of chatting with them, and before long I was getting pretty cold. Just as I was saying good-bye a part of the necklace caught on the windowsill, the string broke, and pearls showered through the air, spiraling down below. I could practically see them spinning in the air. All at once there was a twinkle of coral, another twinkle of onyx, and more twinkles of pearls landing on the snow. Luckily, the big piece of emerald was in my hand. Otherwise, that would have been history.

" 'Oh my God,' I said, 'Hey guys—look!' And I showed them the torn string. 'Do you think you could do me a massive favor, please? Could you possibly help find some of my pearls? I see some of them on the red tile, there's some over on the snow. I think I saw some of them bounce down the stairs.' I sort of directed them which way to go. Well, these guys were on their hands and knees, scrambling around in the freezing weather. And one of them yelled up that they thought they'd found everything and could they bring it up. 'My God, yes,' I said. So they came up to the room, and you know, they had found every single pearl, every single piece of jet, every piece of coral—everything. I had the necklace restrung and I didn't have to have anything replaced. It's in perfect shape."

Art Deco emerald, coral, onyx, natural pearl, and diamond sautoir, circa 1925, by Cartier (enlarged)

Art Deco rock crystal, diamond, and enamel pendant watch, circa 1915, by Cartier, detail opposite

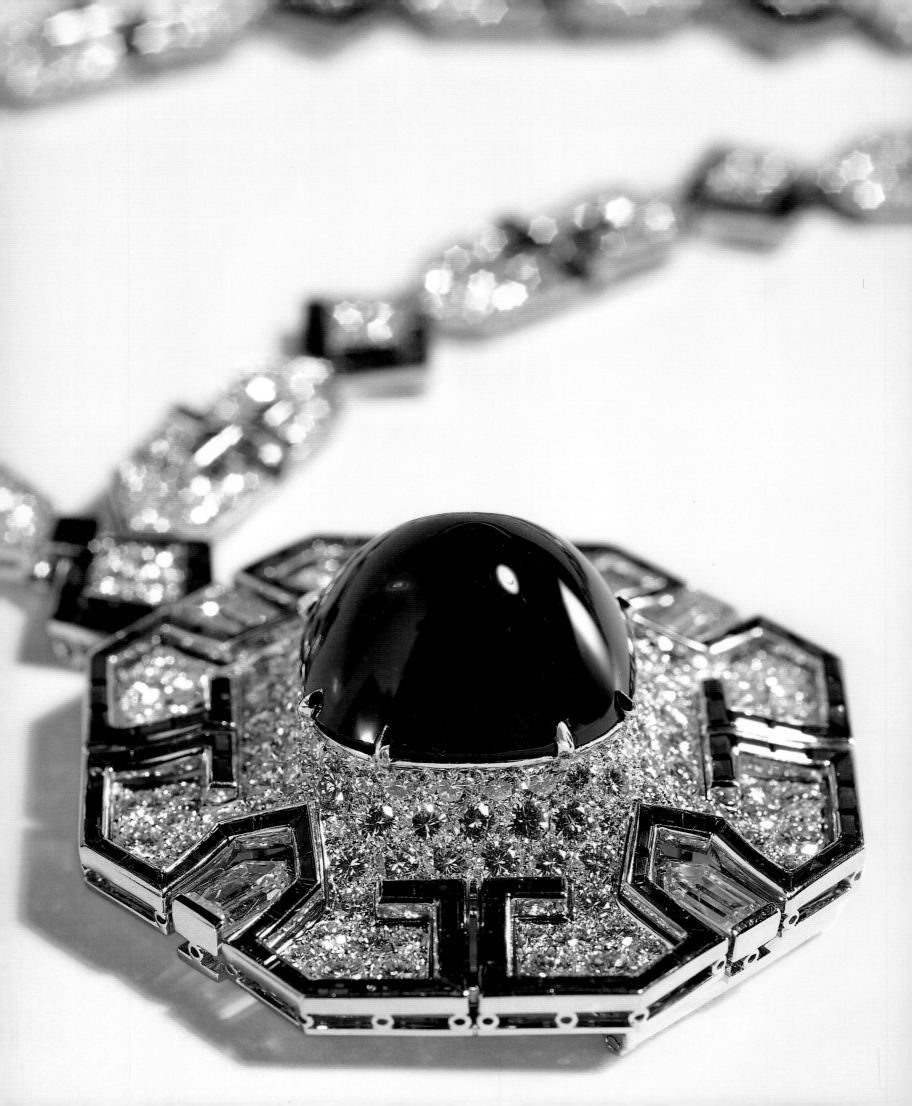

"Richard learned so much about jewelry, and his taste in jewelry became so refined. I think the more history there was to a piece, the more interested in it he became—there wasn't anything that interested him that he didn't do research on. And he loved to watch my reaction to any piece he was considering buying for me."

Here, Elizabeth Taylor wears the long Bulgari sapphire and diamond necklace doubled so that the handsome Art Deco–style pendant is more pronounced, circa 1972. (Photo, Gianni Bozzacchi)

Sapphire and diamond sautoir, by Bulgari, detail

With Deborah Kerr and Roddy McDowall, perhaps Elizabeth Taylor's oldest Hollywood friend, from the early 1940s when they filmed *Lassie Come Home* and *The White Cliffs of Dover* together. Kerr and McDowall were about to receive Lifetime Achievement awards from the American Cinema Institute, November 1985.

Sapphire and diamond sautoir, circa 1971, by Bulgari

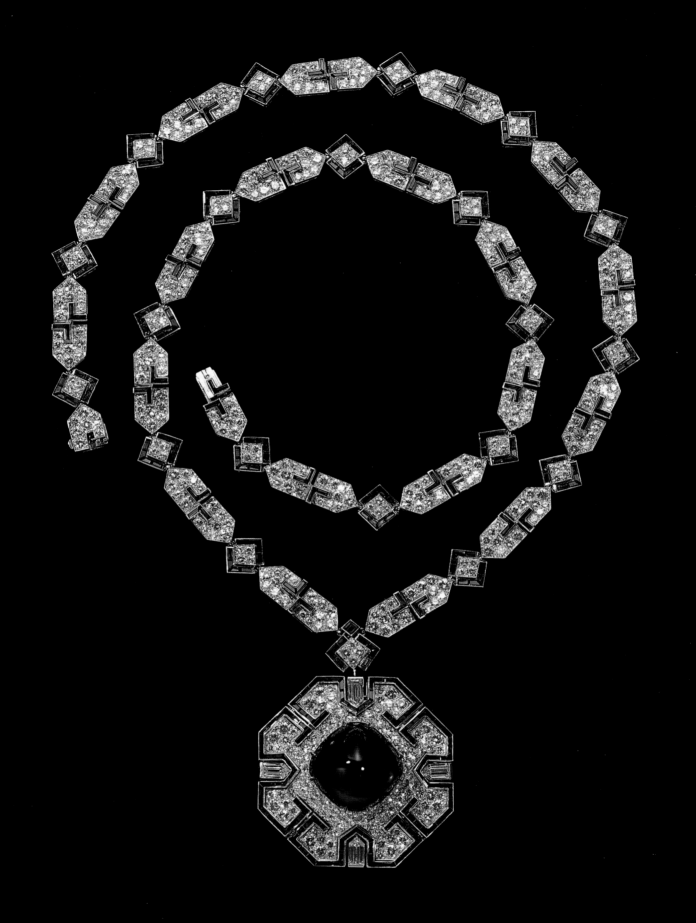

"A lot of my jewelry finds itself, sometimes separated by years. For instance, in 1971, Richard gave me a Bulgari sapphire and diamond necklace, which has an enormous sugarloaf cabochon. Several years later, I came across this ring and I just knew it was the perfect mate to the necklace. It's even by the same jeweler."

Pair of diamond and invisibly set sapphire ear pendants, by Van Cleef & Arpels
Opposite: Sugarloaf cabochon sapphire and diamond "trombino" ring, by Bulgari (enlarged)

"This was in Van Cleef & Arpels's private vault in Paris, and the shop knew I was a sucker for diamonds, especially when set in period pieces. Of course, when I saw it . . . well, it seemed to fit right in. And I just happen to have a pair of circular pavé diamond earrings that go beautifully with it."

Art Deco diamond bow brooch, circa 1926, by Van Cleef & Arpels

Sapphire and diamond bracelet watch, by Fred

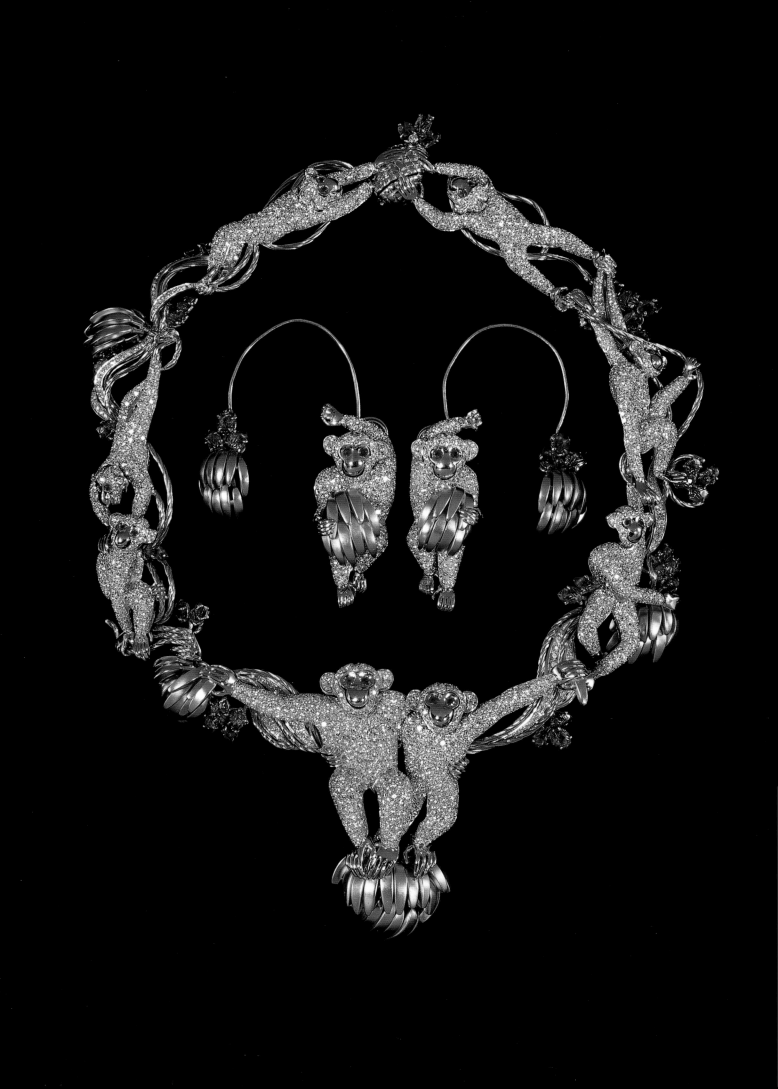

MICHAEL JACKSON, A PRECIOUS FRIEND

"Over the years Michael has given me some truly incredible jewelry. Once he gave me a huge diamond ring and he kept saying, 'Put it on, put it on. Look at the way it sparkles. I bet it's bigger than the Krupp.' So I asked innocently, 'Really? How many carats is it, Michael?' 'Seventeen,' he answered. I embraced him and whispered in his ear, 'My honey darling, you missed.'

"Another time we were at an auction together and I was getting excited about bidding on a pair of long shaggy Marina B diamond earrings, so I told him that he had to buy something, too. I showed him this delightful monkey necklace made up of diamonds, emeralds, and rubies with matching earrings. He probably thought I had something like 'auction fever' when I pointed out that the two monkeys symbolized us, bonded in friendship. In hindsight, I must have made some sense, because these little monkeys are perfectly at home with all my other beloved jewelry."

Diamond and sapphire ring
Opposite: Suite of diamond, emerald, and ruby "monkey" jewelry, by Massoni

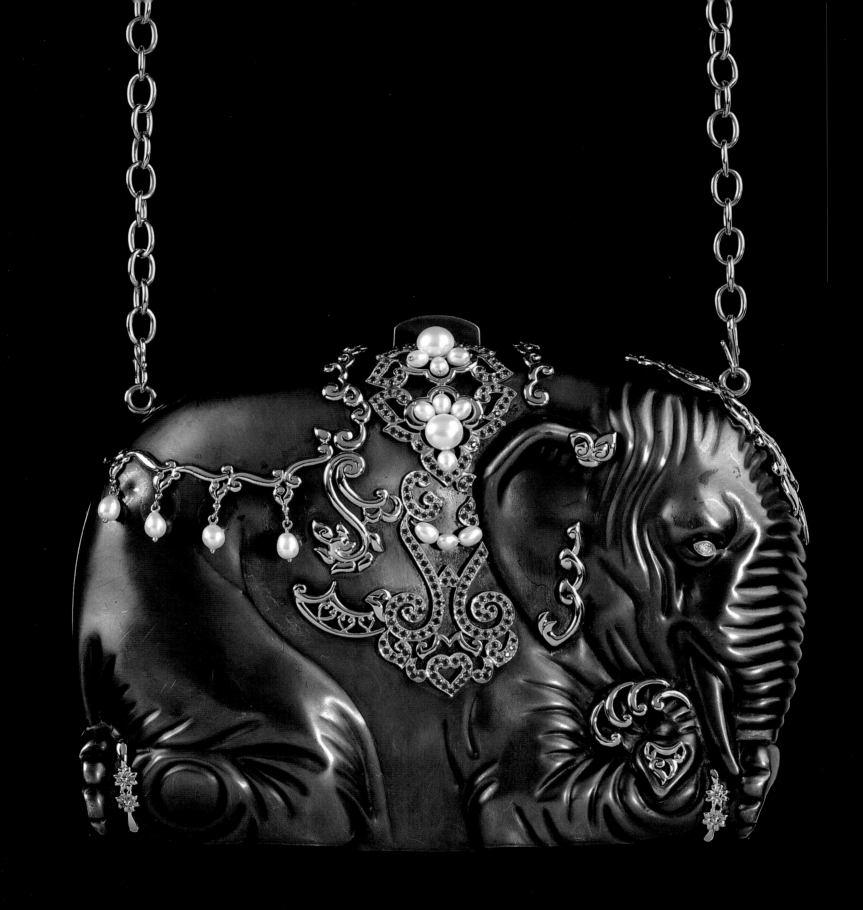

"A year or two ago, Michael and I and a couple other friends decided to go to Las Vegas for my birthday. We stayed at the incredibly beautiful Bellagio, where we had dinner and watched the fountains. The whole thing was just perfect for me because I've grown tired of big-deal birthdays. At one point, I turned to Michael and said, 'All right, where's my present?' Well, he looked at the ground, he looked around the room, he looked at our friend Arnie Klein, but he didn't really say anything. So I said, 'Michael, I know they have great jewelry shops in the lobby, I can't believe you haven't noticed.' Michael and Arnie start giggling. I continued, 'This is really breaking my heart, Michael, I'm not sure I can go on.' You know, I was really hamming it up. Finally, Michael and Arnie excused themselves and returned to the table some time later with a perfectly interesting-sized box. Any box can be interesting to me! I opened it and inside was some weird padded black wrapping, protecting the most exquisite titanium elephant evening bag. A saddle of rubies and pearls was dangling from its backside, and the dear little creature had huge diamond eyes.

"'Michael! Michael! I was just kidding around!' I mean, this was the most unusual thing I'd ever seen. I was playing with the long dangling pearls, in part because I was so happy and because I was also a little embarrassed that he had actually gone and gotten me something this amazing. But Michael and I do kid around a lot, and I knew I hadn't really overstepped my place in our relationship.

"When I got home, there in my front hall was a huge box, tied with a red ribbon. It was my *real* birthday present from Michael, the one he had planned to give me all along—one of those superflat TV sets. Truly, the biggest one I've ever seen. I was the innocent in all this, the most happy innocent. And Michael played it totally straight.

"Years before, soon after Larry Fortensky and I got married at Michael's

Titanium, diamond, cultured pearl, and ruby evening bag, by Fred

Neverland Valley Ranch, I couldn't think of what to give Michael to show my undying thanks. He rarely invites anyone to Neverland, and this was the first time, which was so generous, such a glamorous compliment to our friendship. I had been trying to think of a truly meaningful way to thank him. Then I got an idea: Michael has a zoo. I'll get him an elephant! That clinched it. I got him a great big Asian elephant named Gypsy. I guess you could say we exchanged elephants."

Elizabeth Taylor wears the heart-shaped emerald and diamond necklace from Michael Jackson for the first time at an American Film Institute tribute in 1993, along with her cognac diamond pendant earrings (page 185). With close friend Michael Jackson, n.d. She is wearing some of her gold coin bracelets (page 26) and a cruciform pendant (page 27).

Emerald and diamond necklace
Diamond bow brooch, by Van Cleef & Arpels
This was the first gift Michael Jackson gave Elizabeth Taylor. By this time, he had become famous and was known for his little black bow tie. The diamond pin was his version of that tie.

The Michael Jackson diamond bracelet

Diamond bracelet watch, by Vacheron Constantin

MY OWN PRIVATE ZOO

"When Richard and I married for the second time, we spent three months in Africa, in Botswana. The animals would come into our camp, which enchanted me. I even trained a group of monkeys to come into our bungalow by bribing them with bowls of fruit. I fell in love with this place. When we got back to Johannesburg, there was a beautiful jewelry shop in our hotel. I've always yearned for a pink diamond—I think they are the most exquisite stones in the world—and the one we saw was around 10 carats, which for a pink diamond is simply incredible. Richard bought it for me. But after a bit I told Richard that I'd prefer to sell the pink diamond and use the money instead to build three small hospitals in Botswana. I didn't have to bat my eyelashes or ask for it. I just said that I would be thrilled if we could do this. That pink diamond was the biggest one I'd ever seen in my life—I mean, it was a perfect pink—so for me to give it up was 'quite a statement.' Alas, months after we built our hospitals, the jungles reclaimed them, and that still breaks my heart."

Elizabeth Taylor described this long-ago event, above: "The owner of this little cub gave him to me as a present. And I got to take him home with his bottle and formula. He was just adorable. One time he started chewing on my dress, so my mother made me change and she sent the dress to the dry cleaner. Well, they tried to clean it, but they said there was a stain that just wouldn't come out. What was the stain, they asked my mother. 'Lion drool,' she said. Soon thereafter my father made me give the cub back, explaining that we had no business raising a lion!"

Cultured pearl, diamond, and emerald lion bracelet, by David Webb, detail

Opal clamshell and diamond starfish pendant, by David Webb, designed by Elizabeth Taylor; gold necklace, by Ilias Lalaounis
Opposite: Cultured pearl, diamond, and emerald lion bracelet, by David Webb
Opposite: Cultured pearl, diamond, and emerald lion necklace, by David Webb

Overleaf: Since she was a little girl in England, Elizabeth Taylor has always had a soft spot for animals—chipmunks, lions, dogs and cats, and certainly horses have all been part of her beloved menagerie, and the Hollywood press mill knew how to capitalize on their animal-friendly star. Clockwise, from top left: This oversized lion cub was just one of the "guests" at a dinner Mike Todd gave in Cannes when celebrating *Around the World in 80 Days*. (Photo, Edward Quinn) The precocious thirteen-year-old gets her three dogs—Twinkle, Monty, and Spot—to croon for their crackers. On the set of *Becket*, at Shepperton Studios, Middlesex, 1963. For their second honeymoon, 1974, the Burtons traveled to Botswana, where the actress enchanted this cheetah.

Home Notes

3d.
ON SALE SATURDAY,
JUNE 23rd, 1945

Elizabeth Taylor

PICTURE POST

A LESSON IN LONDON
(see inside)

cinema

Elizabeth Taylor
y LASSIE
EL PERRO PRODIGIO
EL VALOR DE

Country Gentlewoman

SEPTEMBER, 1946

"Richard gave me this pin to wear for the opening of *The Night of the Iguana*, which forever symbolized the early days of our marriage when we lived in Puerto Vallarta, while Richard was working on the Tennessee Williams film. To me, this is one of the most extravagant pieces that Schlumberger ever designed. The timing was fortuitous."

The Night of the Iguana brooch, circa 1962, by Jean Schlumberger, Tiffany & Co.

Opposite: Wearing the fantastic Schlumberger brooch that Burton nicknamed "The Iguana" in honor of the film he had recently completed. The Burtons had just flown in their private plane from their home in Sardinia to attend a film premiere in London, October 1967.

"I've been fascinated by these insects for a long time."

Art Nouveau plique-à-jour enamel and gem-set butterfly brooch, by Boucheron
Plique-à-jour enamel and diamond butterfly brooch, by Cartier
Overleaf: Four plique-à-jour enamel and gem-set dragonfly brooches

Enamel, diamond, and ruby serpent bangle bracelet
The enamel serpent bracelet was a gift to the actress from Franco Zeffirelli, who directed her in The Taming
of the Shrew *(1967).*

This image, taken on the set of *Cleopatra* in Rome, shows Elizabeth Taylor wearing her diamond ring from the late
Mike Todd and the remarkable diamond and gold serpentine bangle watch (see overleaf).

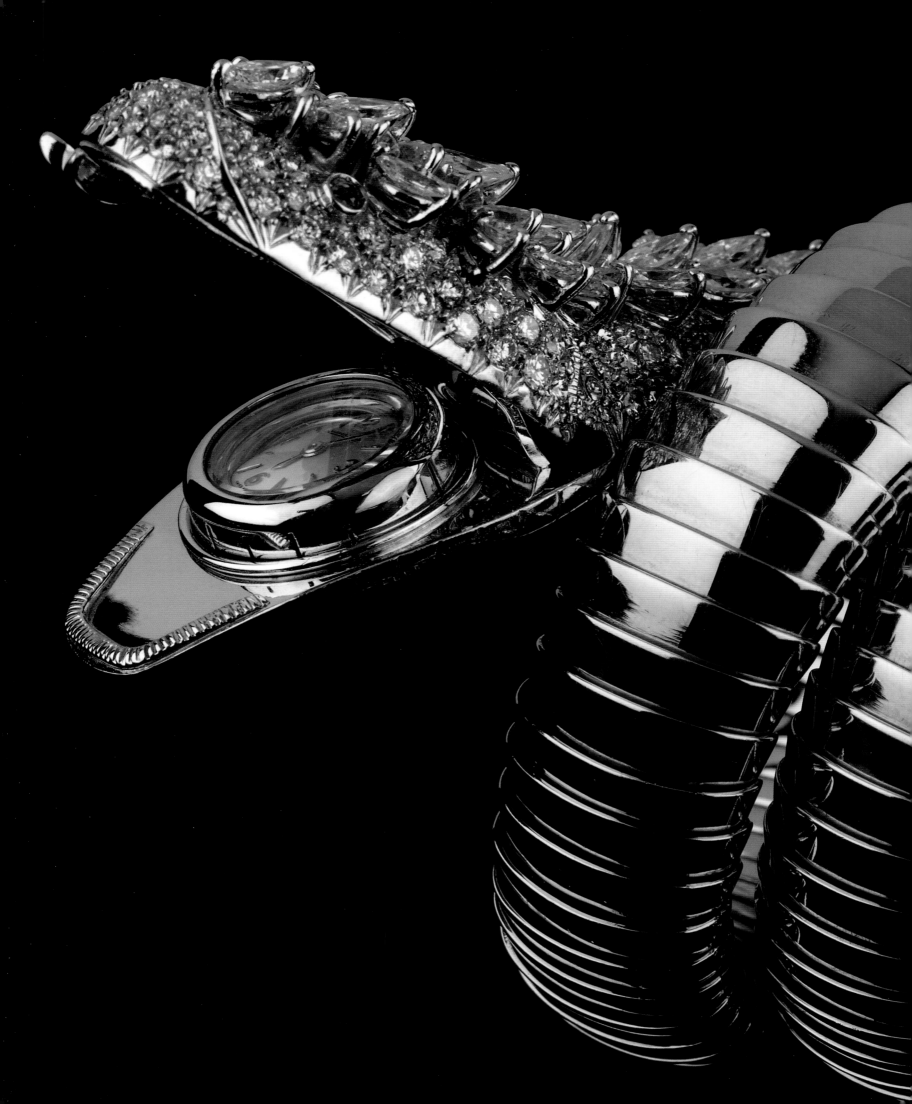

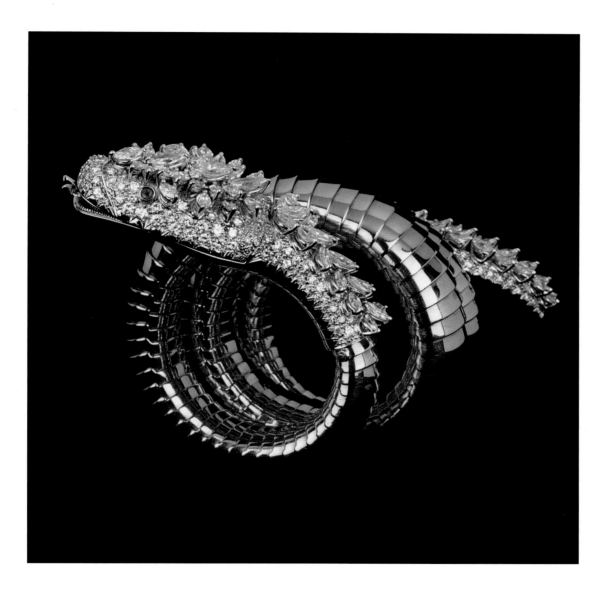

Diamond, emerald, and gold serpent bangle watch, by Bulgari, Jaeger-LeCoultre, detail opposite

Overleaf: Enamel, diamond, and ruby horse bangle bracelet; Enamel, diamond, and ruby serpent bangle bracelet;
Coral, diamond, and emerald lion bangle bracelet; Gold, emerald, and diamond chimera bangle bracelet,
all by David Webb

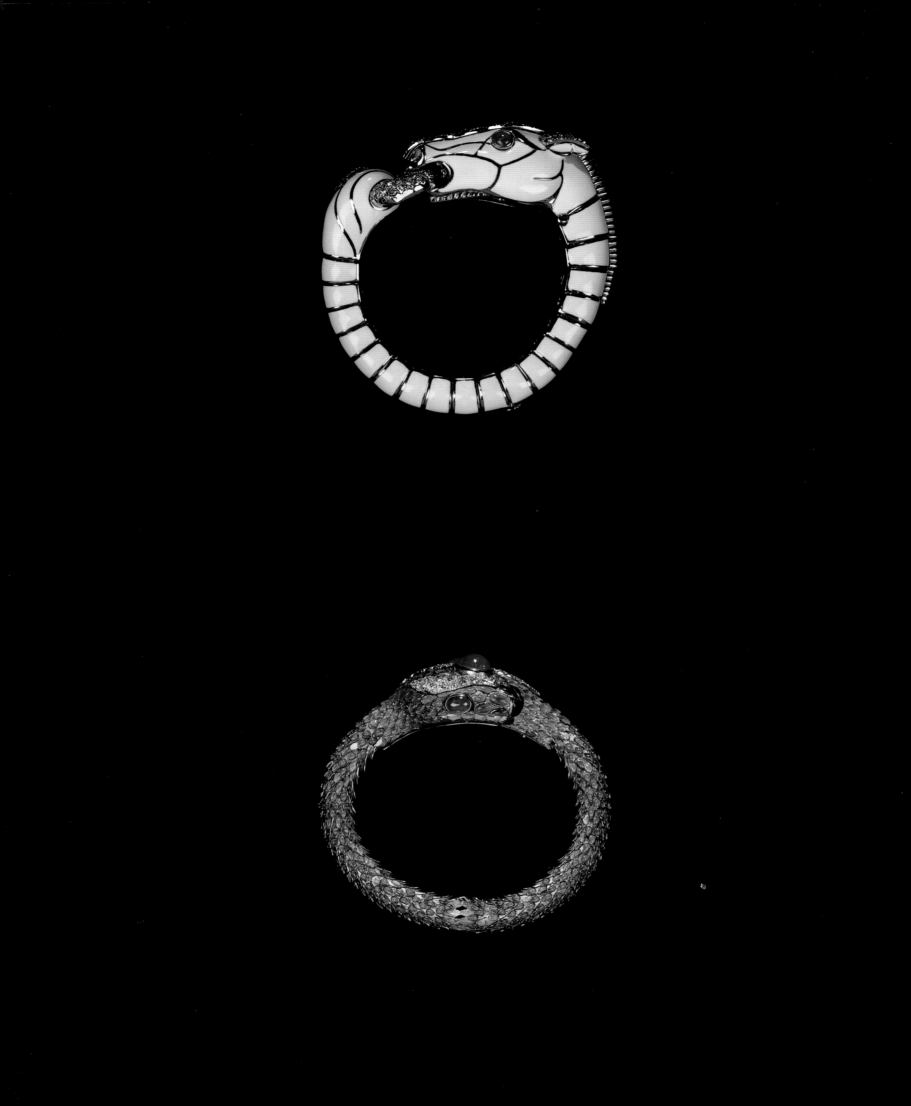

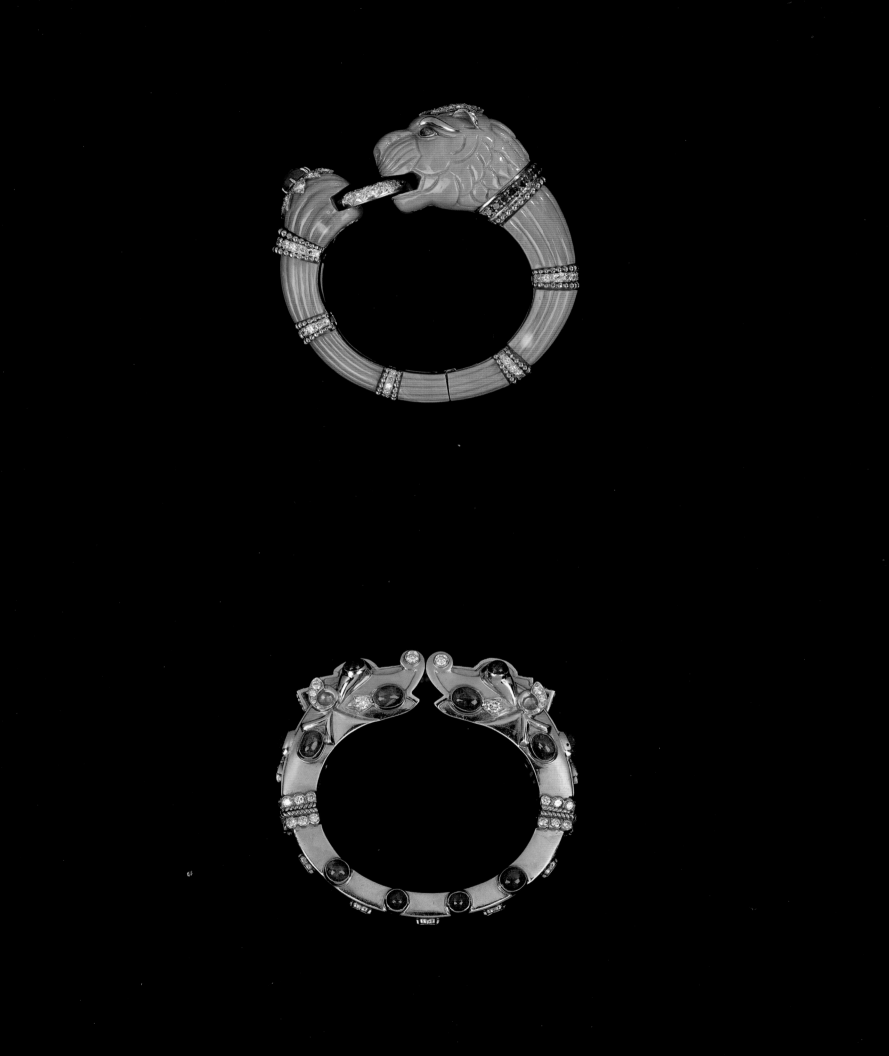

RED IS FOR WALES—AND RICHARD BURTON

"I call this my Christmas stocking story. Richard and I had been married for I don't know how many years, and we'd had Christmas, and all the gifts and the food and wrappings had been through the cleanup. I was just about to take a shower and get ready for friends coming over when my little girl Liza came into my dressing room with her hands behind her back, clutching something, and she said, 'Mommy, Mommy!' 'What is it?' I asked. 'Daddy said to tell you that you left something important in the bottom of your Christmas stocking.' We'd stuffed the stockings with nice things, like apples and oranges and walnuts all mixed together. Cute things—Christmasy stuffing things. 'Oh my goodness,' I exclaimed, 'What is it?' 'Which hand?' she asked. I pretended to ponder very hard, and then said, 'That one!' Her face split into a smile and her eyes danced. In her hand was the smallest box I'd ever seen. By now my heart was beating and bouncing and I opened the box very, very slowly. Inside it glowed with the fire of the most perfect colored stone I'd ever seen. With the most perfect cut. I'm sure I almost fainted. I screamed, which probably echoed over the mountains, and I couldn't stop screaming. I knew I was staring at the most exquisite ruby anyone had ever seen.

"I went running to the living room where Richard was sitting in a chair reading a book—probably waiting for me to appear. I threw myself at him and covered him in kisses and hugs. I just couldn't get over it. I almost smothered him to death! He enjoyed it immensely, with a shit-eating grin on his face. Four years before, when he bought me the emeralds, he had said, 'One day I'm going to find you the most perfect ruby in the world. It's my favorite stone—red for Wales. But it has to be perfect.' It took him four years to find this. I still treasure that Christmas stocking."

With daughter Liza Todd. Elizabeth Taylor is wearing the ruby and diamond ring from Richard Burton. (Photo, Eve Arnold)

Ruby and diamond ring, by Van Cleef & Arpels (enlarged)

"I've been astonishingly lucky. I've had two great loves in my life. Richard was a terrible flirt, and when I met him on the set of *Cleopatra* I thought, 'I'm not going to be a scalp on his belt.' Then I looked into those green eyes, and well. . . . It was so intense. All Welsh people are intense and mystical. That sense of poetry and wildness in Richard was where I wanted to be, and he and I went that route together. Neither of us held the other back.

"Hotels are forever putting glossy magazines in your room, and when I first saw this sapphire brooch it was on the cover of one of those magazines. I think it was from Asprey's. Of course I drooled over it, and the next thing I knew, Richard had bought it for me. It's an amazing piece. Recently I bought myself some antique earrings to wear with it."

The place: Paris. The event: Unicef fund-raiser. The time: 1967. The next act: Richard Burton.
Preceding pages: In Paris, 1965 (Photo, Douglas Kirkland)

Antique sapphire and diamond brooch, late 19th century
Sapphire and diamond blackamoor brooch, by Nardi

The Ping-Pong Diamond

"From time to time Richard and I would get into a wicked game of Ping-Pong at our home in Gstaad. I know that on more occasions than one, being the actor he was, he would fake letting me win. But in all fairness, I was good at Ping-Pong, so some of my wins were legit. On this particular occasion, he said to me, 'If you can get 10 points off me, I'll give you a perfect diamond.' Well, that's not the sort of thing a woman walks away from. So I not only got those 10 points, I also beat him. He lost. I won. Time to go shopping!

"Gstaad had all the necessary creature comforts, in my case a nice little jewelry shop just down the hill from us in the village. So we took a little stroll. Richard was determined to find the smallest diamond ring in Gstaad and he did. It was something like one-eighth of a carat.

"This was around the time that Richard had bought me the huge 69-carat diamond ring, which I was intending to wear for the first time at Princess Grace's fortieth-birthday party in Monte Carlo. Richard and I had a private joke between us that when someone's mouth would drop and they'd say, 'Oh my God, what a magnificent diamond!' I would raise my right hand and wiggle my little finger which was wearing the Ping-Pong diamond, and say, 'Isn't it beautiful! The setting is lovely and the diamond is absolutely perfect.' Then we would break into a giggle."

The Ping-Pong diamond ring (enlarged)
In their quest for the smallest possible ring in Gstaad, the Burtons ended up with three very small rings. The smallest—and most perfect—was thereafter dubbed "the Ping-Pong" diamond ring.

"I've felt that ever since Richard started giving me jewelry, there was some meaning in it for him, too. He would do it with such a twinkle and with such glee. He'd say, 'I know I could give you a $10 ornament for your hair or a $10,000 Van Cleef & Arpels necklace to wear around your neck, and in your eyes I'd see the same appreciation. I just love to watch your response, and that's why I love giving you jewelry.' "

Page 174: The amethyst and kunzite stones were specially selected by Richard Burton to match his wife's legendary violet eyes. (Photo, Scavullo)

Page 175: Suite of amethyst, kunzite, and diamond jewelry, by Van Cleef & Arpels
Above and opposite: Suite of coral, amethyst, and diamond jewelry, by Van Cleef & Arpels

Coral, amethyst, and diamond bracelet, by Van Cleef & Arpels

Pair of coral, amethyst, and diamond ear pendants, by Van Cleef & Arpels

Set of coral and diamond jewelry, by Van Cleef & Arpels

Opposite: Coral, amethyst, and diamond Maltese Cross pendant necklace, by Van Cleef & Arpels

Opposite: Coral, amethyst, and diamond tassel necklace, by Van Cleef & Arpels

"Of all the jewelry he gave me, this little antique diamond-and-ruby bracelet was Richard's favorite piece. He loved the delicacy of it. After all the huge stuff he had given me, I think he liked the fairylike smallness of it. Rubies were his favorite stone."

Belle Époque ruby and diamond bracelet, circa 1895

Top row, left to right: At the 1960 Academy Awards, wearing a sumptuous coral and diamond floral brooch; in Venice, 2001, for an AIDS benefit, splendid in angel skin coral pendant earrings and Chopard diamond butterfly brooch; with the Burton brooch affixed as a pendant. Center row: with Halston and then-husband Senator John Warner at a luncheon. Bottom row, left to right: showing off her cognac diamond earrings and cognac diamond ring, n.d.; in the early 1970s, wearing the amethyst and kunzite suite with her cognac diamond ring; on the set of *Anne of the Thousand Days*, in which her husband was starring. The actress is wearing two rings from Richard Burton: the Krupp diamond and the ruby and diamond ring. What appears to be a gold cuff is actually a double-faced wide texture gold watch made by Milner. One face is tiger's eye and the other is malachite; both watch faces are surrounded by small diamonds. (Photo, Eve Arnold)

"I usually wear this on a diamond necklace. Richard gave me this brooch early on in our relationship. A girl needs simple things, too—like a cluster of diamonds!"

The Burton diamond brooch, by Van Cleef & Arpels

The Burton cognac diamond ear pendants, by Van Cleef & Arpels
The Burton cognac diamond ring, by Van Cleef & Arpels

"Richard loved this because it is a rare antique and has a hypnotic quality. It's an amazingly magical piece."

Art Nouveau enamel, glass, and pearl brooch, circa 1910, by Lalique
Antique natural pearl and diamond necklace, circa 1860

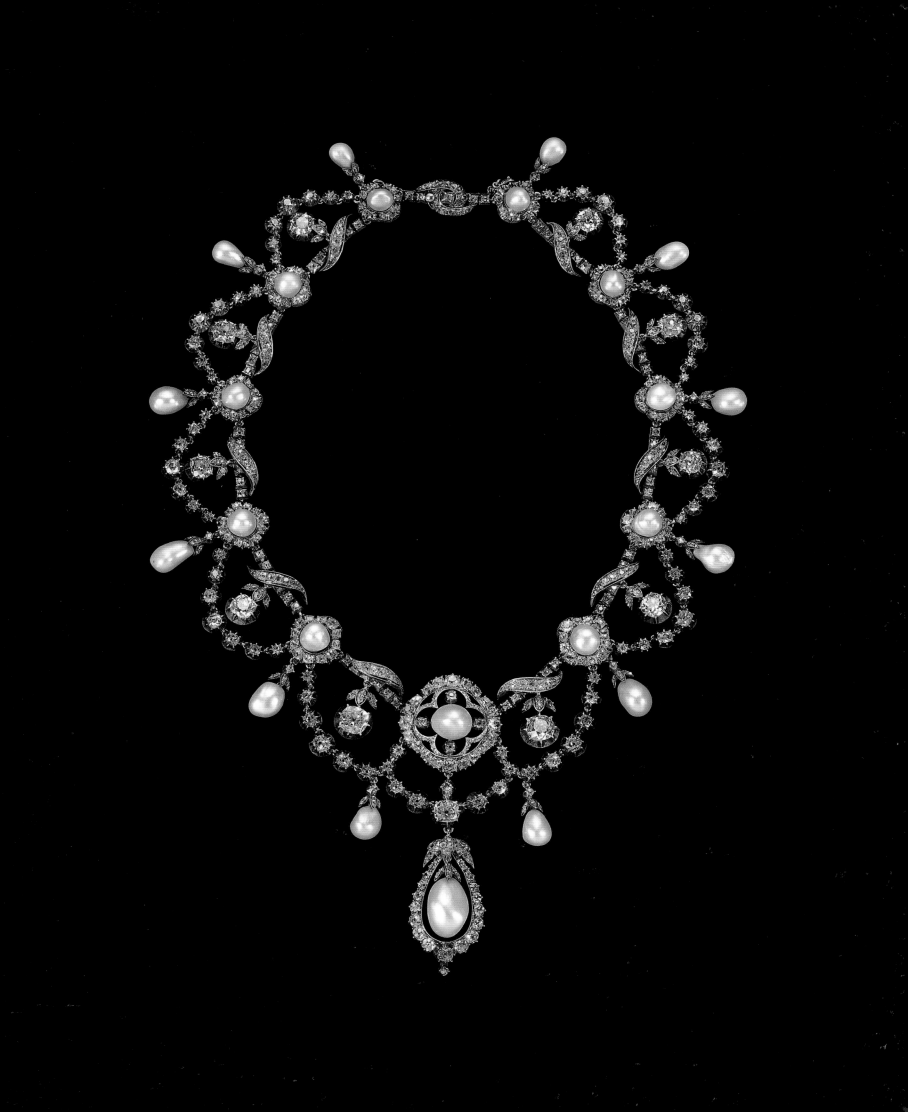

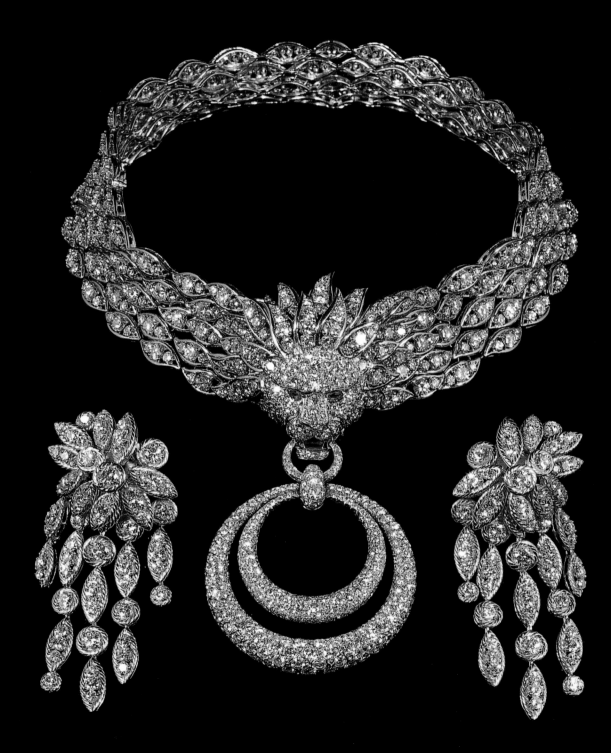

" My oldest child, Michael, became a parent when he was only eighteen. That made me a grandmother at the age of thirty-eight. After I cried with joy at the news, Richard and I embraced each other. He took me by the hand and we started a well-trodden walk up the hill from our yacht to Van Cleef & Arpels, because he wanted to buy me a 'granny present.' We perused the shop for a few minutes, and I always know when something is right because my heart goes 'click,' and my heart was clicking like a castanet when I saw this set with long, drippy, swingy diamond earrings set in gold, and a choker that fit perfectly around my throat. In the center was a lion magnificently sculpted out of diamonds and gold, and in his snarling mouth hung two golden rings. Richard loved it on me and he said, 'Wow! You are so beautiful, nobody is going to believe you're a grandmother.' "

Among the scores of magazines that have pictured Elizabeth Taylor on their covers during her many years as a star, *Life*'s treatments are particularly noteworthy. She—and her jewelry—have graced over a dozen *Life* covers, going back to 1947. In a 1961 cover, she was shown at the Academy Awards the night she was named Best Actress for *Butterfield 8*, wearing South Sea pearl and diamond earrings. In 1972, on the occasion of her fortieth birthday, she wore the 'granny earrings.' Ten years later, in 1982, she wore the Burton brooch as a pendant. Elizabeth Taylor's last *Life* cover was taken on February 27, 1997, the date of her sixty-fifth birthday. *Life* pictured her wearing a pair of antique diamond ear pendants and an antique diamond flower necklace dating from 1830. This cover photograph was taken only a few days before her brain surgery.

The granny necklace and ear pendants, by Van Cleef & Arpels

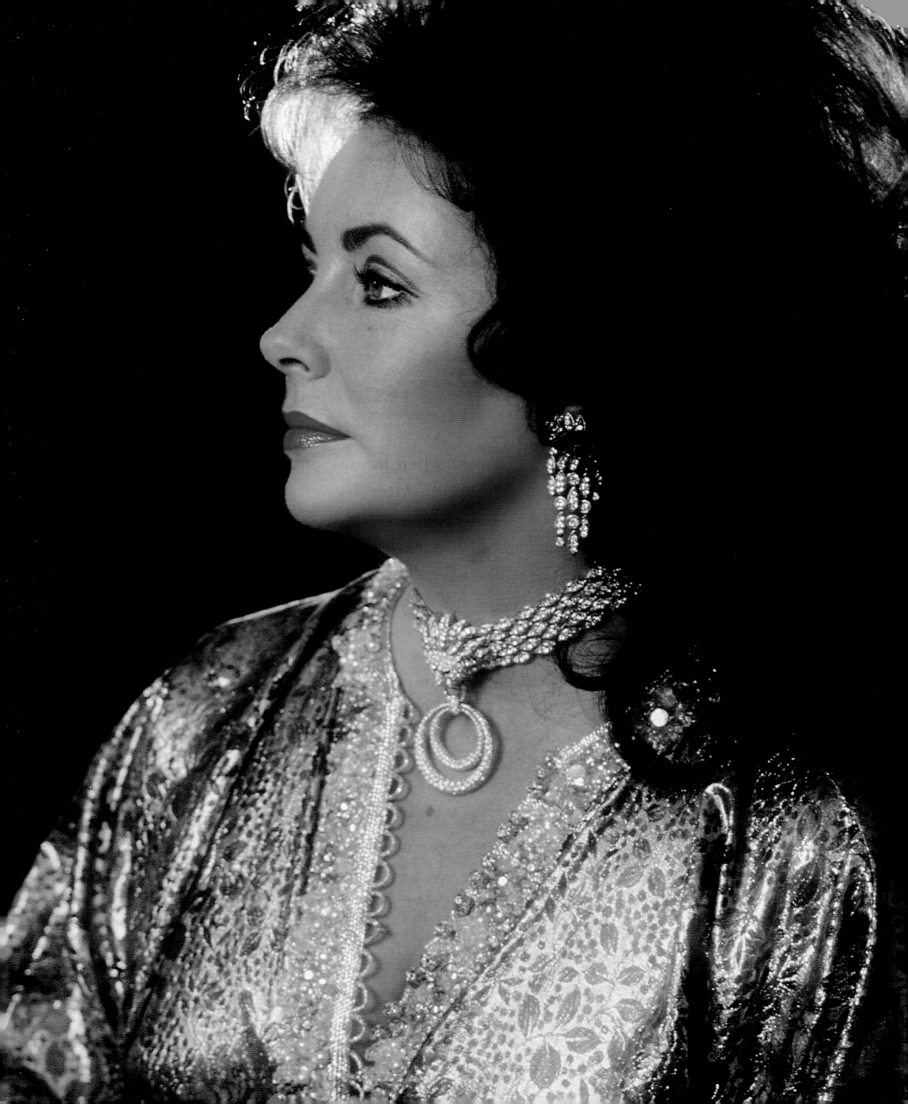

"Speaking of offspring, some years later my granny earrings gave birth to these little gems, designed by Costantino Bulgari's daughter, Marina B. Now these earrings swing!"

Pair of diamond tassel ear pendants, by Marina B.
These earrings were formerly owned by the Baroness di Portanova. She had commissioned Marina Bulgari to make them based on a chandelier in her Acapulco home.

Hard to believe this is the face of a grandmother. (Photo, Norman Parkinson)

"This bracelet belonged to my mother, which she gave me when she was in her seventies."

Perhaps it goes with the territory, but child stars and their parents have always had a special closeness, which was certainly true for the teenage beauty, shown left, at the Stork Club with her parents, Francis and Sara Taylor, 1947. The sapphire bracelet, center, was a gift from her mother. At right, three generations of women, Sara Taylor, Elizabeth Taylor, and Liza Todd, circa mid-1970s. Opposite: One of Elizabeth Taylor's favorite pictures with her mother, mid-1960s.

Art Deco sapphire and diamond bracelet, circa 1920, by Boucheron

" After my dear friend Malcolm Forbes died, his family gave me one of his small enamel eggs with a moonstone on a gold chain. It came from his impressive Fabergé egg collection. The blue egg is so delicate that I don't wear it out much, but I look at it often, for it reminds me of my beloved Malcolm, whom I miss very much."

A champagne (and rose) send-off in Far Hills, New Jersey, moments before Malcolm Forbes and his motorcycle club, the Capitalist Tools, head off to a charity motorcycle event in Elysburg, Pennsylvania, May 1988. Elizabeth Taylor's "casual" jewelry includes the Krupp diamond (always), diamond straight-line bracelet, and David Webb bracelet.

Enamel, colored gold, and moonstone egg pendant, circa 1905, by Fabergé (enlarged)

"Here was the most perfect perforated jewelry a girl could ever want. Malcolm gave me a beautifully wrapped leather jewelry box. Inside was this remarkable cutout paper jewelry of pearls and diamonds."

Motorcycle mama—greeting Malcolm Forbes at a motorcycle rally, 1987, and, right, in more formal attire, wearing ruby and diamond girandole earrings, with Forbes, turned out in full Scots regalia, and King Mohammed VI of Morocco, then Crown Prince, 1989.

Paper jewelry pearl and gold suite

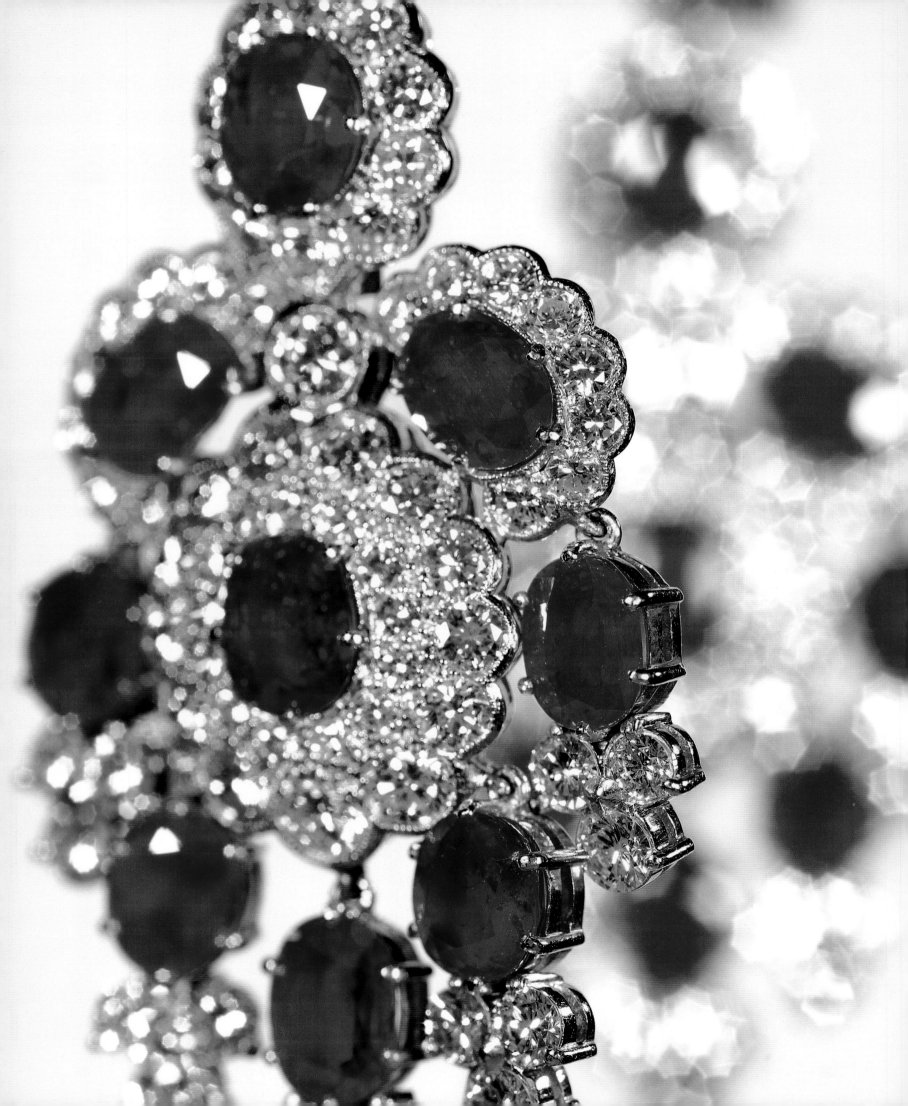

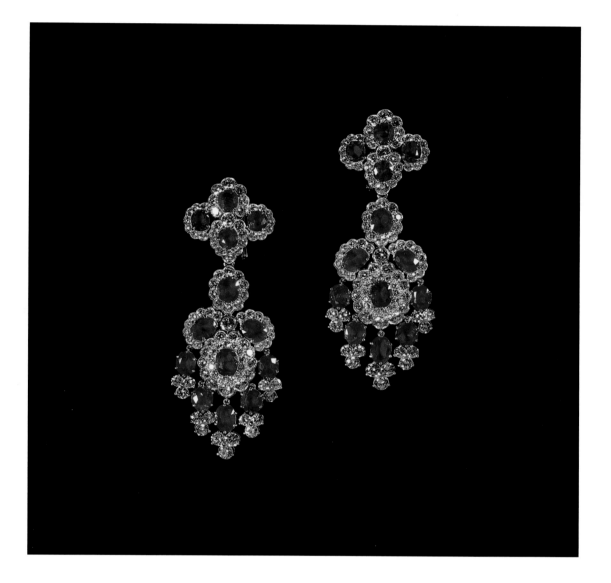

Pair of ruby and diamond ear pendants and detail, opposite

Malcolm's Generosity, My Cunning

"Malcolm and I were in Bangkok and had gone into their best jewelry shop where I saw these wonderfully long ruby earrings. Malcolm casually offered that I should look around and see what I liked. 'Maybe a pair of chandelier earrings,' he mused. That was easy: 'Yes, love. How about those nice dangly earrings?' said I, pointing to the rubies I had just fixed on. Malcolm, no slouch as a negotiator, bargained the price down and was quite proud of how much he got taken off the asking price. I said, 'I know . . . with the money you just saved, you can buy me another present!' He got the giggles and was so sweet. 'I absolutely agree. Go ahead and pick out something else.' Well, that's how I got the ruby and diamond bracelet."

Ruby and diamond horse brooch
Ruby and diamond bracelet

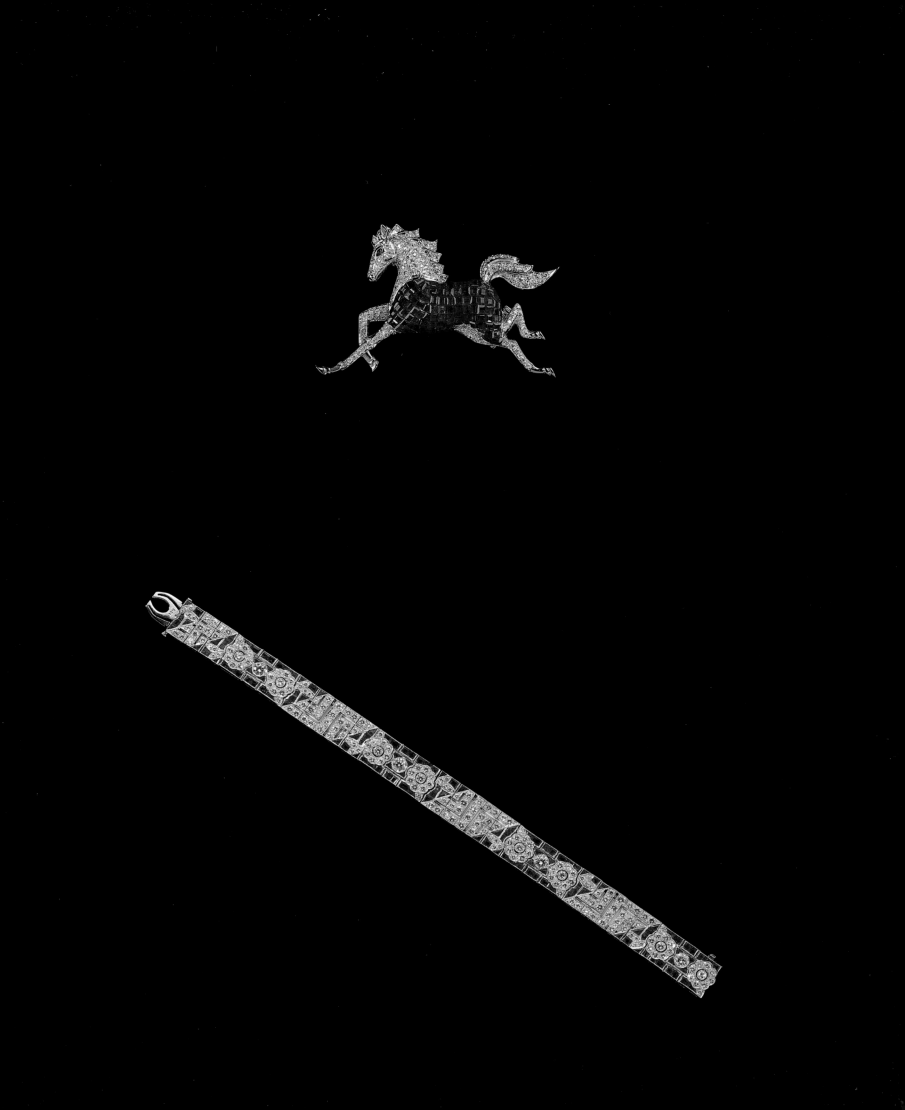

A GALLERY OF GOOD TIMES

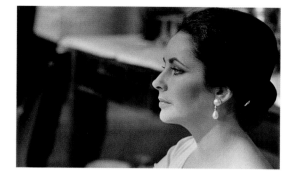

" As I look at some of my jewels I realize what a very lucky girl I am. Sometimes I wonder what will become of everything, because just like the Duchess of Windsor's collection, they will all be up for auction one day. They will be scattered to the four corners of the world, and I hope that whoever buys each piece loves it as much as I do and takes care of it and realizes that having jewelry is a temporary gift. In truth, we 'owners' are just the caretakers. Nobody owns beautiful paintings. Nobody ever owns anything this beautiful. We are only the guardians."

Elizabeth Taylor's collection includes some remarkable pearls, from the historic La Peregrina (page 83) to a pitch-perfect strand of cultivated pearls in hues that range from the cleanest whites to hints of pale pink and cream (page 210). The ring seen opposite is exceptional for its shape, its size, and its floral-like setting of eight diamond "leaves." (Photo, Douglas Kirkland) From time to time, the actress has worn her own jewelry in films, such as the natural pearl pendant earrings in *Ash Wednesday* (1973), above. Their simplicity belies their staggering beauty.

"I met Aaron Frosch through Richard, and they were like brothers. Aaron was the most honest, dearest man in the world, and I worshiped him. He was our lawyer forever and took such good care of Richard and me. He gave me the Cartier Art Deco elephant necklace for my fortieth birthday, and years later gave me these pearl earrings to go with the Peregrina."

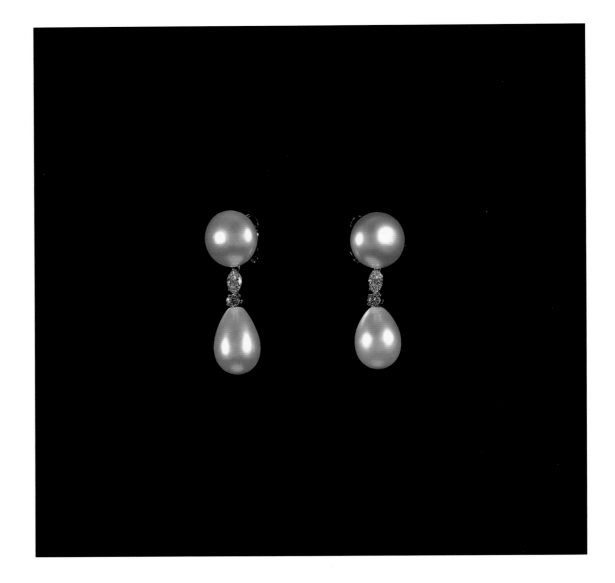

Pair of natural pearl and diamond ear pendants, by Bulgari
South Sea pearl and diamond ring, by Ruser (enlarged)
"This pearl was a gift from my uncle, Howard Young. I had the setting changed because it was in a sort of
platinum shell, which made the pearl 'sit up' too much. I think the diamonds softened it."

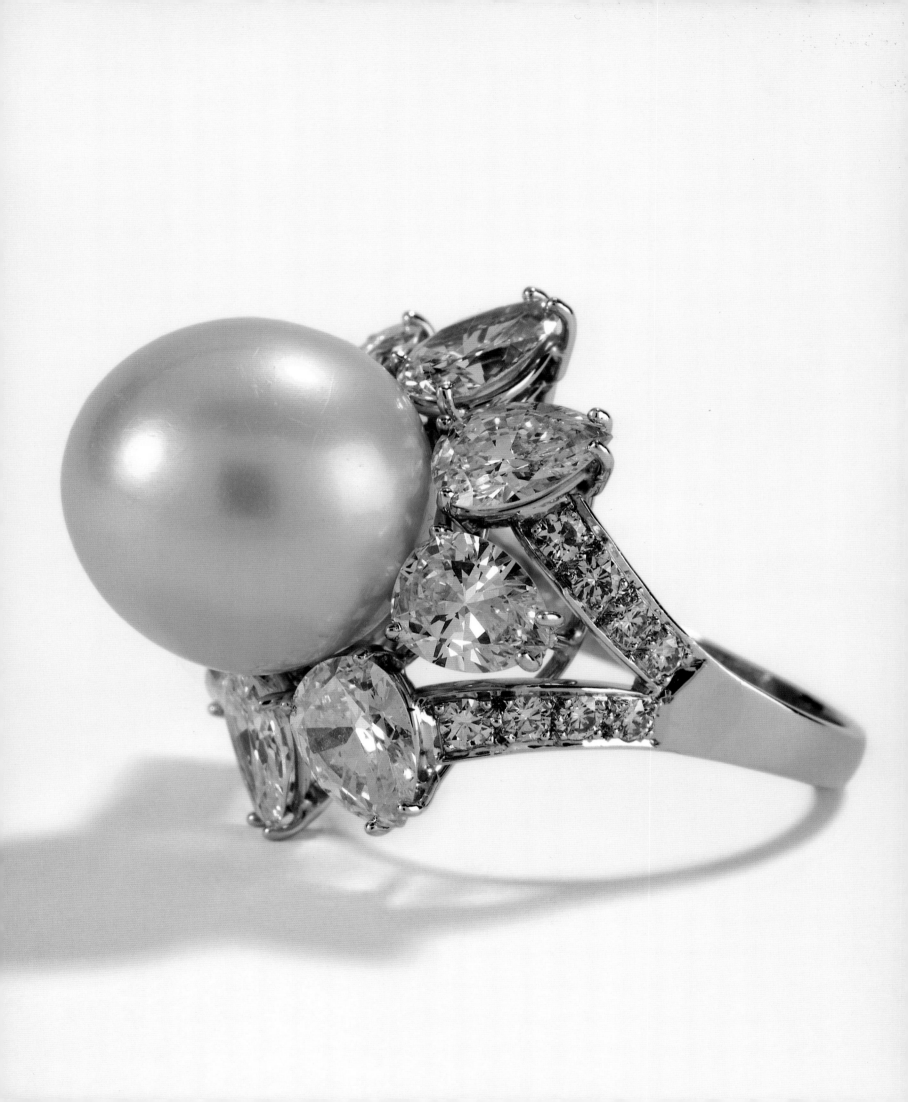

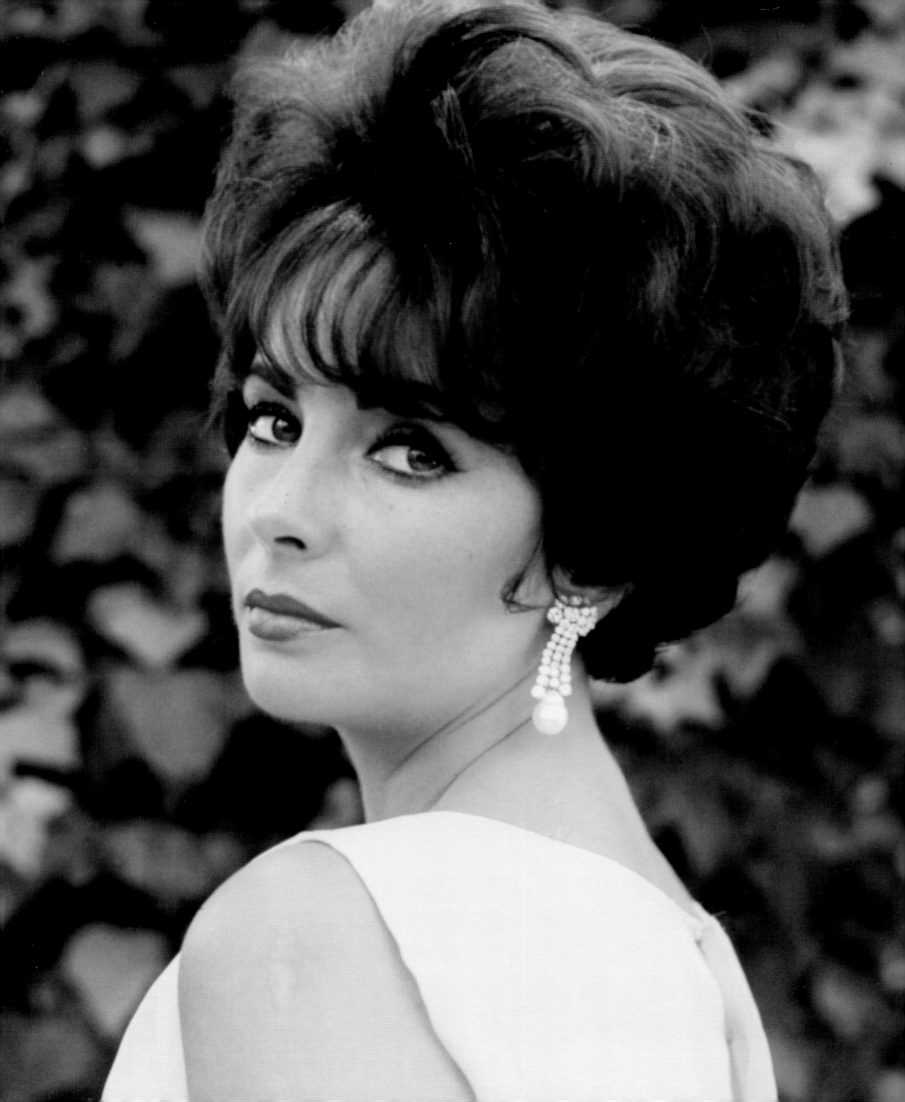

"These earrings started me on my love of long, drippy earrings. I can't remember how long I've had them, but it's been years and years and years."

Pair of South Sea cultured pearl and diamond ear pendants

These South Sea pearl and diamond earrings received a lot of publicity when Elizabeth Taylor wore them to the Academy Awards in 1960 and received the Oscar for her performance in *Butterfield 8.* As a consequence, these earrings even made the cover of *Life* magazine (see page 189).

Pair of black cultured pearl and diamond ear pendants, by David Webb

Gray baroque cultured pearl and diamond necklace, by Ruser, detail

Pair of cultured pearl and diamond ear pendants

Opposite: South Sea cultured pearl necklace, by Lynn Nakamura

"Edith Head, the great costume designer, was like my surrogate mother. Whenever I was in trouble, whenever I wanted a place to hide out and avoid socializing, I would go to Edith Head's house. She and her husband, Bill, who never had children, considered me like their daughter. They had a wonderful Spanish-style adobe house with a tennis court and swimming pool. For me, it was a haven where I could get away from everyone and work out my problems on my own. Edith and I both loved Jack Daniel's, so when she came home we would have a nice big glass of Jack Daniel's together. We both had a slightly perverse, offbeat sense of humor. (Years later, Edith sent me over a perfectly nice Jack Daniel's T-shirt in black—framed.) I think she really loved me, and I truly loved her.

"Edith had cultivated a certain look, which was part of her persona—the dark glasses, the black hair pulled back into a bun, and a necklace made of ivory turn-of-the-century Victorian theatre tickets. She collected these ivory charms, and I loved them. They were always jingling, so stylish and so Edith, with her tiny upright body and her little strut. She used to say that she was going to leave the necklace to me in her will. I remember saying to her, 'Edith, don't be so silly, I like seeing it on you. I don't like to hear you talk about dying.'

"When she died in 1981, I mourned very deeply. She was like a second mother to me and I could talk to her so easily. After all her years working for the studios, Edith had become pretty savvy about the business, and she had no personal interest whatsoever in pushing me in any one direction. I knew I could count on her for *real* advice that was neither altruistic nor had a hidden agenda.

"True to her word, in her will she left me one thing—that necklace, which I cherish. It's still hard for me to wear, because I feel it's sacred. But I love to look at it and know the love we shared.

"Years ago when I visited with Edith and Bill, I saw that she had put a little plaque on the stairs going up to my room: *Elizabeth Taylor Sleeps Here.* I wish I knew what became of that plaque."

Gold and ivory necklace, detail

With George Hamilton in Paris, 1987.

Gold and ivory necklace

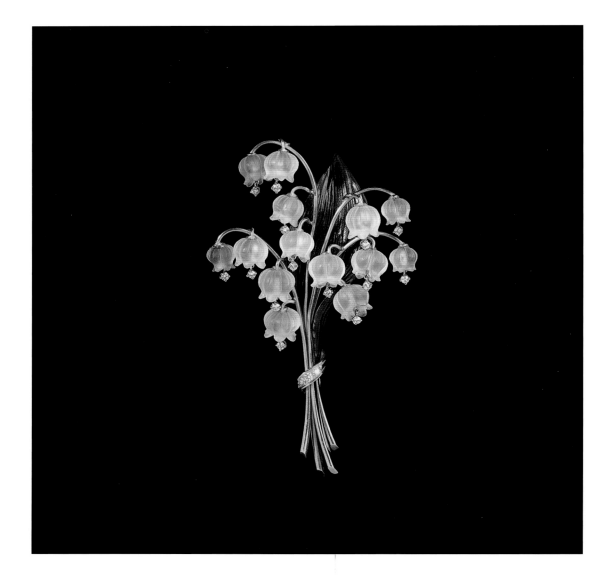

Nephrite, rock crystal, and diamond lily of the valley brooch

"Rex Harrison was the stingiest man alive. He and I had been through the most grueling eleven months of film in the history of films. A little ditty called *Cleopatra,* which affected everyone who worked on it.

"Years later, in Vienna, I was shooting *A Little Night Music,* and Rex was working on some other film. We were both staying at the Imperial Hotel. It was a joy to see my friend Rex, the bitter old tart with the wonderful sense of humor. We kissed and laughed and reminisced. I was engaged to John Warner, who was visiting me in Vienna on his senatorial spring break. We were planning on getting married as soon as my work on the film was over. John started teasing Rex about what he was going to get me as a wedding present.

"In one of the shop windows of the Imperial Hotel (those shop windows have always been my downfall!) there was a gorgeous pin designed as a simple bouquet of my favorite flowers, lilies of the valley. I would tease Rex terribly and say, 'Come on, you know you're dying to buy this for me. Deep down inside of that stingy heart beats a sentimental one.' He was an easy tease—in part because he truly hated spending money—so I would keep at him: 'Now, Rex, you know I'm going to be married on a big old Virginia farm in the dead of winter, and it would be so nice to wear this little pin on my coat. I'd like to think of it as my wedding bouquet.'

In 1960, when she was Cleopatra to his Julius Caesar.

"He sort of sputtered and his eyes darted everywhere but to mine: 'Oh, Elizabeth, you really are too much. You know I don't spend MONEY.' 'That's just the point,' I said, 'You're the stingiest man alive. That way, your giving me this pin would be doubly important because it would signify a personal triumph over your naturally stingy nature. I know you deeply, deeply love me. This would make you feel good about yourself, and prove that you can actually write out a check. This will be a monumental day in your life.'

"Poor Rex. I was enjoying all of this immensely. I went on like that for three months. Finally, I wore him down, and when I finished work on my film he gave me the pin. I wore it on my coat at my wedding to John, while standing on top of a beautiful mound overlooking the Blue Ridge Mountains. It's a memento I shall always cherish . . . as I will Rex."

Pages 218–19: The many faces, events, and jewelry of Elizabeth Taylor, from top left clockwise: with Madonna at her nationally televised sixty-fifth birthday party, in antique diamond necklace and earrings, 1997; at an AIDS event, Elizabeth Taylor has on her diamond girandole earrings, when receiving a check of $1 million from Mrs. Joan Kroc, for AmfAR, 1987, and also, below, at the Academy Awards with *Cat on a Hot Tin Roof* costar Paul Newman; in Tahitian beads, addressing the National Press Club about AIDS in Washington, D.C., 1996; when she received the Jean Hersholt Award at the 65th Annual Academy Awards, Elizabeth Taylor had borrowed this daisy parure from Van Cleef & Arpels, which she subsequently purchased; in rock crystal and diamond earrings, 1982, and again when visiting with Rudolf Nureyev, 1981; appearing at a press conference in New York, 1971, wearing the David Webb coral Maltese Cross; and in 1970 with her husband at the 7th Annual Press Awards at the Century Plaza Hotel, in Los Angeles. Her "swinging" diamond and turquoise earrings are in keeping with the times. (Photo, Bernard Godfryd)

Set of rock crystal and diamond jewelry (bracelet and ring), by Gérard
Suite of rock crystal and diamond jewelry, by Gérard, detail

Pair of turquoise and diamond ear pendants

Opposite: Diamond and gold pendant necklace, by Van Cleef & Arpels

Turquoise, diamond, and gold bracelet, by Jean Schlumberger, Tiffany & Co.
Suite of sapphire and diamond jewelry

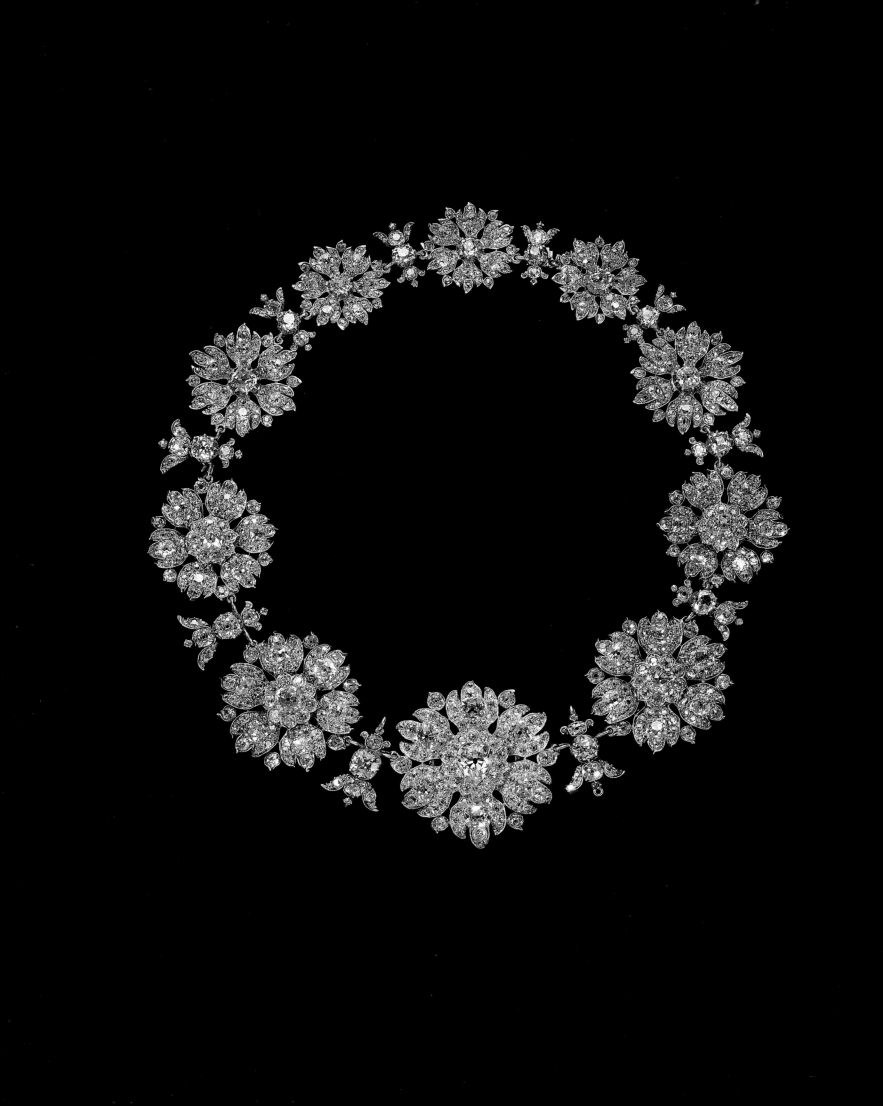

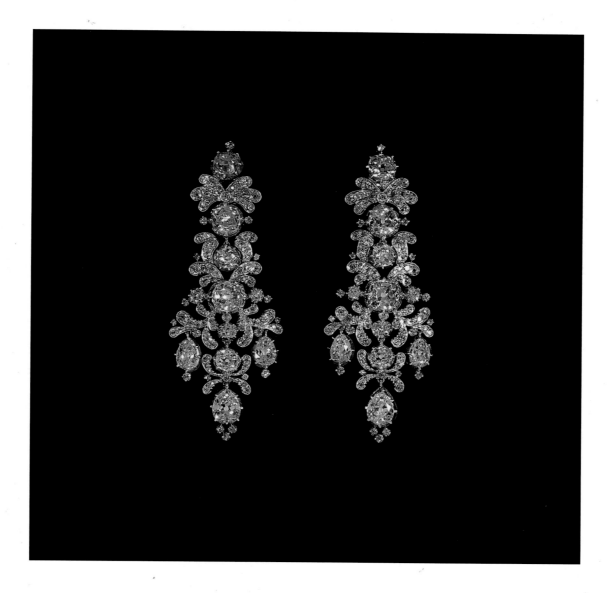

Pair of antique diamond ear pendants, circa 1830

Opposite: Antique diamond flower necklace, circa 1830

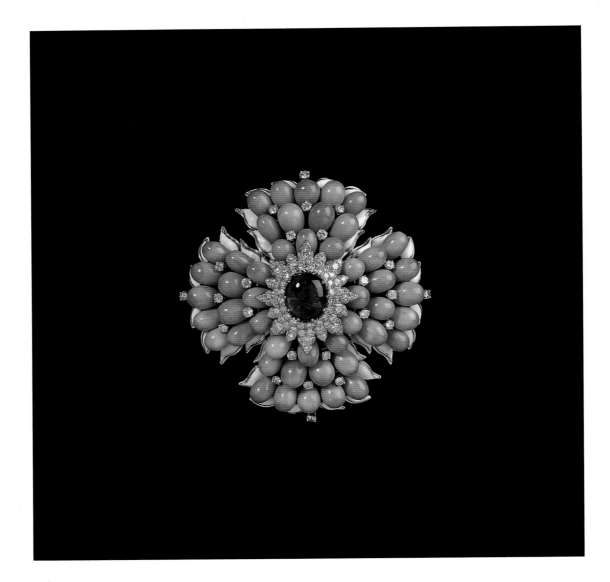

Coral, sapphire, diamond, and enamel brooch, by David Webb
The daisy parure, by Van Cleef & Arpels

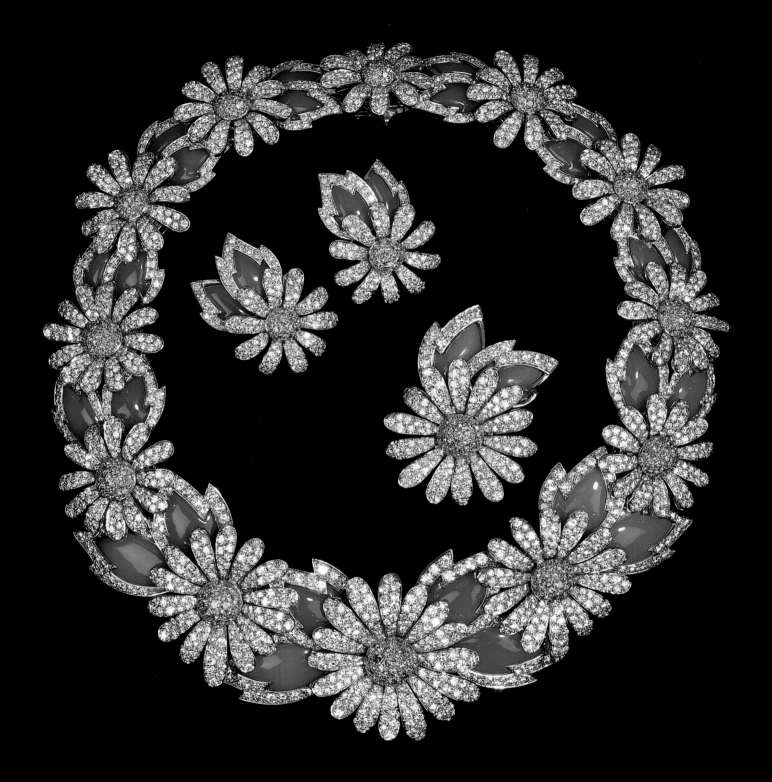

Page 55

Emerald and diamond brooch
By Bulgari
Set with a rectangular-cut emerald, weighing approximately 18.00 carats, surrounded by twelve pear-shaped diamonds, mounted in platinum. May be worn as a pendant with the emerald and diamond necklace (page 60).

Gift from Richard Burton upon their engagement, 1962

Page 59

Emerald and diamond ring
By Bulgari
Set with a cut-cornered rectangular-cut emerald, weighing approximately 18.61 carats, surrounded by circular-cut diamonds with modified triangular-cut diamond shoulders, mounted in platinum.

Gift from Richard Burton

Page 60

Emerald and diamond necklace
By Bulgari
Of sixteen graduated rectangular-cut emerald and circular-cut diamond clusters, each spaced by graduated pear-shaped and circular-cut diamond quatrefoil motifs, mounted in platinum. For pendant brooch, see entry above, Emerald and diamond brooch (page 55).

Gift from Richard Burton

Page 61

Pair of emerald and diamond ear pendants
By Bulgari
Each set with a pear-shaped emerald, weighing approximately 9.50 and 8.44 carats, within a circular-cut diamond mount, suspended from a marquise- and circular-cut diamond quatrefoil motif, mounted in platinum.

Gift from Richard Burton

Page 62

Emerald and diamond bracelet
By Bulgari
Designed as a line of thirteen graduated rectangular-cut emeralds, alternately set with thirteen rectangular-cut diamonds, bordered by circular-cut diamond trefoil motifs and pear-shaped diamonds, mounted in platinum.

Gift from Richard Burton

Page 63

Emerald and diamond ring
By Bulgari
Set with a rectangular-cut emerald, weighing approximately 7.60 carats, surrounded by pear-shaped diamonds, mounted in platinum.

Gift from Richard Burton

Page 66

Emerald and diamond "zigzag" bracelet
Set with rectangular-cut emeralds and marquise-cut diamonds in an undulating pattern, mounted in platinum.

Gift from Richard Burton

Page 69

Emerald and diamond flower brooch
By Bulgari
The *en tremblant* floral spray, set with three vari-shaped diamond flower heads enhanced by oval-cut emeralds and extending baguette-cut diamond stems, mounted in platinum.

Gift from Richard Burton

Page 75

The Taj Mahal diamond, circa 1627–28
Gold and ruby chain by Cartier, no. 55559
Set with an engraved heart-shaped diamond, within a red stone and jade mount, suspended from a long woven gold chain enhanced by cabochon rubies.

The literal translation of the Persian inscription on the stone has three entries: *Nur Jahan Baygum-e Padshah*; *23*; and *1037*. This means that Nur Jahan was a lady of the Padshah, while the number 23 refers to the regnal year of Shah Jahangir, which was indeed 1037, equivalent to 1627–28 A.D. Research indicates that Shah Jahangir had the stone engraved with his wife's name, Nur Jahan, although it is not known whether in fact Nur Jahan ever owned or wore the jewelry. At some point Shah Jahangir gave the jewel to his son, Mughal Emperor Shah Jahan or "King of the World" (1592–1666). Shah Jahan presented the diamond to Mumtāz-I-Mahal, his favorite and most beloved wife. In 1627, at the age of thirty-five, Prince Khurram, as he was then known, ascended the throne and although he had several wives, Mumtāz-I-Mahal was said to have been his most trusted advisor and friend. After bearing him fourteen children, she died in childbirth in 1631, at which point the emperor, overcome by grief, locked himself in his room, refusing food for eight days. In memory of his wife, the emperor commissioned a grand mausoleum in her honor that took 20,000 laborers twenty years to complete and utilized only the finest materials available. Initially referred to as the *rauza*, or tomb, it was later named the Taj Mahal and stands as one of the greatest testaments of architectural elegance in the world today. It is thought that this pendant hung from a similar engraved diamond and was worn at the top of the arm as a bracelet.

Gift from Richard Burton, for Elizabeth Taylor's 40th birthday, 1972

Pages 78–79

The King Farouk bracelet, circa 1925

Of Art Deco Egyptian revival design, composed of five pierced pavé-set diamond plaques, three depicting a buff-top calibré-cut ruby, emerald, and sapphire falcon, the other three similarly set with an ox, a seated figure, and a sphinx, enhanced by calibré-cut sapphire trim and baguette and bullet-cut diamond accents, mounted in platinum.

This bracelet was originally in the collection of King Farouk (1920–1965), who officially became ruler of Egypt in 1937, at the age of seventeen. Egypt, a newly independent state, was in a state of turmoil and was the victim of corruption. Unable to unify the country and bring an end to the chaos, King Farouk, in July of 1952, was forced to abdicate the throne in favor of his son, Ahmed Fouad II, and fled to Italy, where he lived in exile until his death.

Gift from Richard Burton

Page 80

Belle Époque diamond bow brooch, circa 1905
By Gillot
The pierced openwork flexible bow, set with old European-cut diamonds and three-stone marquise-cut diamond accents, suspending two pear-shaped diamond drops, mounted in platinum.

Page 81

Antique ruby and diamond locket, circa 1880
Of oval outline, designed as four sections of old mine-cut diamonds, intersected by a cushion-cut ruby cross, two sections set with enamel, gem-set, and gold coat-of-arms, and the other two set with ruby and diamond coat-of-arms, with old mine-cut diamond bail, opening to reveal a locket compartment, mounted in silver and gold, inscribed "1856 4th June 1881," and a fancy gold link chain.

Page 83

La Peregrina pearl, early 16th century
Natural pearl, ruby, and diamond necklace
by Cartier, designed by Elizabeth Taylor with
Al Durante of Cartier
Centering upon a drop-shaped natural pearl detachable pendant, with an old mine- and rose-cut diamond and silver foliate bail, suspended from a large circular-cut diamond flame motif, enhanced by a pear-shaped ruby and a large single natural pearl, joined to a two-row necklace, of twenty-three and thirty-four natural pearls, intersected by eight smaller circular-cut diamond and cushion-cut ruby flame motif plaques, mounted in platinum and 18k gold. The pendant may also be worn as a brooch.

Discovered by a slave in the Gulf of Panama in the early 1500s, La Peregrina was presented to Spain's Prince Philip II, who offered it as a wedding present to Queen Mary Tudor of England. Upon her death in November 1558, the pearl returned to Spain and was worn by a succession of Spanish queens, including Margarita and her

daughter-in-law, Isabel, and is featured in each of their portraits by Velásquez. During the 19th century, it was in the possession of the Bonaparte family, but it is after this time that the history becomes questionable. Discussion has arisen over the years as to whether this is in fact La Peregrina or perhaps another famous pearl, the Abercorn.

Gift from Richard Burton, purchased from Parke-Bernet Galleries, New York, January 23, 1969, for $37,000

Page 93
The Taylor-Burton diamond
By Cartier
Originally designed as a ring, set with a single stone pear-shaped diamond, weighing approximately 69.42 carats, later remounted by Cartier as a pendant suspended from a V-shaped necklace of graduated pear-shaped diamonds, mounted in platinum. For the diamond necklace, see entry below, Diamond line necklace (page 126).

This stone was originally fashioned from a piece of rough diamond, weighing approximately 240.80 carats, which was discovered in the South African Premier mine in 1966. The rough was later purchased by Harry Winston, who cut and sold the diamond, mounted as a ring, to Mrs. Paul (Harriet) Ames, sister of Walter Annenberg, in 1967. Two years later, Mrs. Ames auctioned the ring at Parke-Bernet Galleries in New York on October 23, 1969, as lot 133; Cartier purchased the stone for the then-record price of $1,050,000, after which they named it "The Cartier Diamond." Less than 48 hours later, Richard Burton (the underbidder at the auction) purchased the stone from Cartier and subsequently renamed it "The Taylor-Burton Diamond." Elizabeth Taylor first wore the diamond publicly at The Scorpio Ball, a party held in Monaco on the occasion of Princess Grace's fortieth birthday. In 1978, Elizabeth Taylor sold the diamond to New York jeweler Henry Lambert, who in turn sold it to Mr. Robert Mouawad, the internationally renowned diamond merchant, in December 1979.

Gift from Richard Burton, purchased from Cartier, October 25, 1969, for $1,100,000

Page 101
Diamond "Prince of Wales" brooch, circa 1935
Designed as a plume of three pavé-set diamond feathers signifying the Prince of Wales, with baguette-cut diamond spines, gathered by a crown, mounted in platinum and 18k gold.

From the collection of the Duchess of Windsor
Purchased by Elizabeth Taylor, from Sotheby's, Geneva, April 2, 1987, lot 27, for $623,333

Page 108
Pair of coral, diamond, yellow sapphire, and cultured pearl ear pendants

By Van Cleef & Arpels, designed by Elizabeth Taylor upon the occasion of being made a Dame of the British Empire
Each of a carved coral flower with circular-cut diamond center cluster, suspending a graduated line of circular-cut diamond and yellow sapphire butterflies, spaced by cultured pearls and enhanced by circular-cut diamond collets, mounted in gold.

Page 109
Pair of emerald and diamond ear pendants
By Kutchinsky
Each pavé-set diamond trefoil cluster set with a circular cabochon emerald, suspending three articulated rows of circular-cut diamond foliate motif links spaced by oval cabochon emerald accents, mounted in gold.

Elizabeth Taylor purchase, London, 2001

Page 112
Pair of diamond and yellow diamond ear pendants, circa 1962
By Bulgari
Each detachable pendant set with a pear-shaped yellow diamond, weighing approximately 15.68 and 16.20 carats, suspended from a circular- and marquise-cut and pear-shaped diamond cluster, mounted in platinum.

Gift from Eddie Fisher, for Elizabeth Taylor's 30th birthday, February 27, 1962

Page 113
Diamond and yellow diamond ring, circa 1962
By Bulgari
Set with a marquise-cut yellow diamond, weighing approximately 2.25 carats, surrounded by marquise- and circular-cut and pear-shaped diamonds, mounted in platinum.

Gift from Eddie Fisher, for Elizabeth Taylor's 30th birthday, February 27, 1962

Page 114
Diamond and colored diamond flower brooch
By Bulgari
The *en tremblant* floral spray, set with three vari-shaped diamond flower heads enhanced by a circular-cut fancy vivid yellow diamond, weighing approximately 3.00 carats, a circular-cut fancy intense yellow diamond, weighing approximately 1.50 carats and a circular-cut fancy intense brown diamond, weighing approximately 1.50 carats, enhanced by numerous circular-cut brown diamonds, with pavé-set diamond leaves and extending baguette-cut diamond stems, mounted in platinum.

Gift from Eddie Fisher, for Elizabeth Taylor's 30th birthday, February 27, 1962

Page 115
Sapphire and diamond camellia brooch

With pavé-set diamond petals, extending three calibré-cut sapphire leaves with gold wirework detail.

Page 116
The Perelman bracelet
By Van Cleef & Arpels
Of intertwined lines of circular-cut diamonds, mounted in 18k gold.

Gift from Ron Perelman

Page 119
Diamond heart-shaped pendant necklace
By Van Cleef & Arpels, no. 32526
The double-sided pavé-set diamond bombé heart pendant, suspended from a circular-cut diamond necklace.

Gift from Richard Burton, 1974

Page 120
Suite of diamond and pink diamond double heart jewelry
By Chopard
Comprising a necklace, designed as two pavé-set diamond hearts, one of diamonds suspended from a line of circular-cut pink diamonds and the other of pink diamonds, suspended from a line of circular-cut diamonds; and a pair of ear clips en suite.

Page 121
Diamond and multicolored sapphire butterfly brooch
By Chopard
The old mine-cut diamond body extending rose-cut diamond wings, enhanced by small circular-cut blue, pink, and yellow sapphires and a diamond antennae.

Page 122
Pair of sapphire, diamond, and cultured pearl ear clips, circa 1964
By Jean Schlumberger, Tiffany & Co.
Of starfish design, each set with a cultured pearl, extending pavé-set diamond tendrils, enhanced by gold bands, to the circular-cut sapphire bombé shell, mounted in platinum and 18k gold.

Gift from Richard Burton

Page 125
Sapphire and diamond orchid brooch
By Jean Schlumberger, Tiffany & Co.
Designed as an orchid, with a circular-cut diamond center and petals, extending six leaves of oval-cut sapphires and circular-cut diamonds, enhanced by gold wirework detail, mounted in platinum and 18k gold.

Gift from Richard Burton, 1964–65

Page 126
Diamond line necklace

By Cartier, no. 11039
Of fifty-three graduated pear-shaped diamonds, mounted in platinum. Refashioned from the necklace that suspended the Taylor-Burton diamond.

Page 126
The wedding diamond ear pendants
By Cartier, designed by Elizabeth Taylor
Each set with a line of eight graduated pear-shaped diamonds, suspended from a circular- and marquise-cut diamond, mounted in platinum. Refashioned from the necklace that suspended the Taylor-Burton diamond.
 Worn on the occasion of Elizabeth Taylor's wedding to Larry Fortensky, October 6, 1991

Page 128
Art Deco emerald, coral, onyx, natural pearl, and diamond sautoir, circa 1925
By Cartier
Centering upon a V-shaped diamond and onyx link joined to a coral disk suspending an onyx, emerald, and coral bead pendant from a natural pearl, coral, and onyx necklace, mounted in platinum.
 Purchased in Paris, 1971

Page 130
Art Deco rock crystal, diamond, and enamel pendant watch, circa 1915
By Cartier
Centering upon a detachable pendant, set with a carved rock crystal elephant, with a circular- and marquise-cut diamond howdah upon a circular-cut diamond and white enamel base, revealing a watch, the oval white dial with black enamel Arabic chapters, blued steel hands and diamond wind stem, suspended from a platinum chain of rectangular links spaced by circular-cut diamonds, mounted in platinum.

Page 135
Sapphire and diamond sautoir, circa 1971
By Bulgari
The detachable pavé-set diamond octagonal pendant, centering upon a sugarloaf cabochon sapphire, weighing approximately 50.00 carats, with calibré-cut sapphire trim and bullet-cut diamond accents, suspended from a chain of pavé-set diamond and calibré-cut sapphire geometric links, mounted in platinum. The pendant may also be worn as a clip brooch.
 Gift from Richard Burton, for Elizabeth Taylor's 40th birthday, February 27, 1972

Page 136
Sugarloaf cabochon sapphire and diamond "trombino" ring
By Bulgari
Set with a sugarloaf cabochon sapphire, weighing

approximately 22.00 carats, within a graduated baguette and pavé-set diamond and platinum mount.

Page 137
Pair of diamond and invisibly set sapphire ear pendants
By Van Cleef & Arpels, no. 53971
Each detachable drop-shaped pendant with invisibly set sapphires and circular-cut diamond cap, suspended from a paisley motif plaque, centering upon a pear-shaped sapphire, within a circular-cut diamond and calibré-cut sapphire three-tiered frame, mounted in platinum.

Page 138
Art Deco diamond bow brooch, circa 1926
By Van Cleef & Arpels
Designed as a pavé-set diamond circle and bow, suspending articulated old European and baguette-cut diamond fringe, mounted in platinum.

Page 139
Sapphire and diamond bracelet watch
By Fred
The modified square dial of pavé-set diamonds and calibré-cut buff-top sapphires, with black enamel hands, joined to a band of similarly designed geometric links.

Page 140
Suite of diamond, emerald, and ruby "monkey" jewelry
By Massoni
Comprising a necklace, centering upon a pair of pavé-set diamond yellow and white gold monkeys, enhanced by circular-cut ruby eyes, perched atop a bunch of bananas, joined to a series of similarly set frolicking monkeys, enhanced by circular-cut diamond and gold stylized foliate motifs, accented by carved emerald leaves and twisted gold rope, joined to a gold pineapple clasp; and a pair of ear pendants en suite, mounted in yellow and white gold.
 From the collection of the Baron and Baroness di Portanova
 Gift from Michael Jackson, purchased from Christie's, New York, October 25, 2000, lot 416

Page 141
Diamond and sapphire ring
Set with a pear-shaped diamond, weighing approximately 17.00 carats, within a pear-shaped diamond and calibré-cut sapphire frame, mounted in white gold.
 Gift from Michael Jackson

Page 142
Titanium, diamond, cultured pearl, and ruby evening bag
The sculpted titanium seated elephant, with mar-

quise-cut diamond eyes, with applied gold wirework accents set with circular-cut rubies and cultured pearls, joined to a polished gold oval link chain.
 Gift from Michael Jackson, for Elizabeth Taylor's birthday, purchased from Fred Leighton at the Bellagio Hotel, Las Vegas

Page 145
Diamond bow brooch
By Van Cleef & Arpels
Of pavé-set diamond design, mounted in 18k gold.
 Gift from Michael Jackson

Page 145
Emerald and diamond necklace
Set with a heart-shaped emerald, within an undulating circular- and baguette-cut diamond three-tiered mount, joined to a polished gold fancy link chain, mounted in gold.
 Gift from Michael Jackson

Page 146
The Michael Jackson diamond bracelet
Centering upon a rectangular-cut diamond, flanked on either side by a square- and baguette-cut diamond, within an arched baguette and circular-cut diamond oval-shaped frame, joined to three rows of graduated circular-cut diamonds and a clasp of similar design.
 Gift from Michael Jackson

Page 147
Diamond bracelet watch
By Vacheron Constantin
The dial set with rectangular-cut diamonds, case integral bracelet, and clasp set with rectangular-cut diamonds, mounted in 18k gold.
 Gift from Michael Jackson

Page 150
Cultured pearl, diamond, and emerald lion bracelet
By David Webb
Designed as a pavé-set diamond lion's head, enhanced by circular-cut emerald eyes, holding a similarly set ring and tail, joined to multistrands of cultured pearls, mounted in platinum and 18k gold.

Page 150
Cultured pearl, diamond, and emerald lion necklace
By David Webb
Designed as twin pavé-set diamond lion heads, with circular-cut emerald eyes and accents, holding a pavé-set diamond ring, joined to two rows of cultured pearls, mounted in platinum and 18k gold.

Page 151
Opal clamshell and diamond starfish pendant

By David Webb, designed by Elizabeth Taylor,
gold necklace by Ilias Lalaounis
The pavé-set diamond starfish, enhanced by
an opal clamshell, suspended from a fancy link
gold chain.

Page 155
The Night of the Iguana brooch, circa 1962
By Jean Schlumberger, Tiffany & Co.
Designed as a fantastical dolphin, with circular-cut
diamond and polished gold scales, the head
enhanced by cabochon sapphire eyes and calibré-
cut emerald lips, mounted in platinum and 18k gold.
 Gift from Richard Burton for the premiere of the
film *The Night of the Iguana*, August 11, 1964

Page 157
Art Nouveau plique-à-jour enamel and gem-set
butterfly brooch, circa 1905
By Boucheron
The opal and aquamarine butterfly extending blue
and green plique-à-jour enamel wings, enhanced by
rubies and emeralds, with gold wirework detail,
mounted in 18k gold.

Page 157
Plique-à-jour enamel and diamond butterfly
brooch
By Cartier
The diamond-set butterfly, with ruby eyes, extend-
ing diamond and plique-à-jour enamel wings,
mounted in 18k gold.

Pages 158–59
Four plique-à-jour enamel and gem-set dragonfly
brooches
Each gem-set dragonfly, extending multicolor
plique-à-jour enamel wings, enhanced by gold
veining and various gemstones.

Page 160
Enamel, diamond, and ruby serpent
bangle bracelet
The rigid band, designed as an entwined dark
green enamel serpent, enhanced by ruby eyes and
diamond accents.
 Gift from Franco Zeffirelli, director of *Taming of*
the Shrew

Pages 162 and 163
Diamond, emerald, and gold serpent
bangle watch
By Bulgari, Jaeger-LeCoultre
Of flexible design, the serpent composed of pol-
ished gold overlapping links, enhanced by a vari-
cut diamond head and tail, and accented by cabo-
chon emerald eyes, the head opening to reveal a
hidden watch, mounted in 18k gold.

Page 164
Enamel, diamond, and ruby horse bangle bracelet
By David Webb
Designed as a white enamel horse, with polished
gold mane and cabochon ruby eyes, clenching a
pavé-set diamond link in its mouth, the white
enamel body forming the hinged hoop, mounted in
platinum and 18k gold.

Page 164
Enamel, diamond, and ruby serpent
bangle bracelet
By David Webb
Designed as a textured gold and green enamel
serpent, with cabochon ruby eyes and detail,
enhanced by a pavé-set diamond head, the green
enamel body forming the hinged hoop, mounted in
platinum and 18k gold.

Page 165
Coral, diamond, and emerald lion bangle bracelet
By David Webb
Designed as a diamond, emerald, and carved coral
lion, with cabochon emerald eyes, wearing a circu-
lar-cut emerald collar, and clenching a pavé-set
diamond link in its mouth, the carved coral body
forming the hinged hoop, enhanced by circular-cut
diamond and polished gold intersections, mounted
in platinum and 18k gold.

Page 165
Gold, emerald, and diamond chimera
bangle bracelet
By David Webb
Designed as two circular-cut diamond, cabochon
emerald, and polished gold facing chimeras, the
hinged polished gold hoop enhanced with similarly
set emeralds and diamonds and polished gold geo-
metric motifs, mounted in platinum and 18k gold.

Page 166
Ruby and diamond ring
By Van Cleef & Arpels
Set with an oval-cut ruby, weighing 8.90 carats,
within a circular-cut diamond surround, to the
circular-cut diamond shoulders and polished
18k gold hoop.
 Gift from Richard Burton, Christmas, 1968

Page 171
Antique sapphire and diamond brooch,
late 19th century
Centering upon an elongated oval-cut sapphire,
weighing approximately 40.00 carats, within an old
mine-cut diamond surround, mounted in silver and
gold.
 Gift from Richard Burton

Page 171
Sapphire and diamond blackamoor brooch
By Nardi
The carved hardstone blackamoor wearing a
textured gold, circular-cut diamond, and oval-cut
sapphire turban, with diamond ear pendants, and
a tunic of similar design, mounted in gold.
 Gift from Richard Burton

Page 172
The Ping-Pong diamond ring
Set with a circular-cut diamond, mounted in
18k white gold
 Gift from Richard Burton, for winning a game
of Ping-Pong, circa 1970

Page 175
Suite of amethyst, kunzite, and diamond jewelry
By Van Cleef & Arpels, nos. 23536, 23534, 23659
Comprising a necklace, composed of a series of
oval-cut kunzite and circular-cut diamond links,
joined by circular-cut diamond bar links to the
amethyst bead hoops; a bracelet and a pair of ear
pendants en suite, mounted in 18k gold.
 Gift from Richard Burton

Pages 176 and 177
Suite of coral, amethyst, and diamond jewelry
By Van Cleef & Arpels, nos. 21413, 131125A
Comprising a choker, composed of six cabochon
coral, oval-cut amethyst, and circular-cut diamond
links, alternately set with smaller cabochon coral,
oval-cut amethyst, and circular-cut diamond spac-
ers; a ring and a pair of ear clips en suite, mounted
in 18k gold. Choker may be modified to be worn
as a bracelet.
 Gift from Richard Burton, Geneva, 1970

Page 178
Coral, amethyst, and diamond bracelet
By Van Cleef & Arpels, no. 21770
Composed of five cabochon amethyst, cabochon
coral, and circular-cut diamond links, alternately
set with circular-cut diamond and cabochon coral
spacers, mounted in platinum and 18k gold.
 Gift from Richard Burton

Page 179
Pair of coral, amethyst, and diamond
ear pendants
By Van Cleef & Arpels, no. 13.307 SA
Each with a cabochon coral and circular-cut
amethyst and diamond trefoil motif, to a cabochon
coral, suspending a cascade of similarly set coral
and diamonds, enhanced by articulated pear-
shaped amethyst fringe, mounted in 18k gold.
 Gift from Richard Burton

Page 180
Coral, amethyst, and diamond tassel necklace
By Van Cleef & Arpels, no. 13147
The amethyst bead tassel enhanced by circular-cut diamond rondelles, suspended from a cabochon coral, circular-cut diamond, and textured gold surmount, to the fancy link gold chain, with coral and amethyst beads and circular-cut diamond spacers, mounted in 18k gold.
 Gift from Richard Burton

Page 180
Coral, amethyst, and diamond Maltese Cross pendant necklace
By Van Cleef & Arpels, no. 21835
The circular-cut diamond, vari-shaped amethyst, and cabochon coral Maltese Cross pendant, suspended from a fancy link gold chain enhanced by coral and amethyst beads and circular-cut diamond spacers, mounted in 18k gold. The pendant may also be worn as a brooch.
 Gift from Richard Burton

Page 181
Set of coral and diamond jewelry
By Van Cleef & Arpels, no. 19644
Comprising a ring, centering upon a cabochon coral, within a circular-cut diamond surround; and a pair of ear pendants en suite, mounted in 18k gold.
 Gift from Richard Burton

Page 182
Belle Époque ruby and diamond bracelet, circa 1895
Designed as a series of three oval-cut ruby links, each within a rose- and old mine-cut diamond surround, enhanced by similarly set diamond foliate spacers, mounted in platinum and gold.
 Of all the jewelry given by Richard Burton to his wife, this piece was his favorite.
 Gift from Richard Burton

Page 184
The Burton diamond brooch
By Van Cleef & Arpels, no. 18828
Centering upon a circular-cut diamond flower motif, within an openwork circular, marquise- and baguette-cut diamond surround, mounted in platinum.
 Gift from Richard Burton, Christmas, 1967

Page 185
The Burton cognac diamond ear pendants
By Van Cleef & Arpels, no. 44251
Each baguette and circular-cut diamond shield-shaped surmount, suspending a circular- and marquise-cut diamond cluster, to the pear-shaped light brown diamond, weighing approximately 7.25 and

7.74 carats, within an independent circular- and baguette-cut diamond frame, mounted in 18k gold.
 Gift from Richard Burton

Page 185
The Burton cognac diamond ring
By Van Cleef & Arpels
Set with a pear-shaped light brown diamond, weighing approximately 29.00 carats, within a circular-cut diamond surround.
 Gift from Richard Burton

Page 186
Art Nouveau enamel, glass, and pearl brooch, circa 1910
By Lalique
The sculpted blue-green glass face, within a textured and polished gold serpent surround, enhanced by blue and green enamel, and suspending a baroque pearl.
 Gift from Richard Burton

Page 187
Antique natural pearl and diamond necklace, circa 1860
Of garland design, the flexible old mine-cut diamond line suspending similarly set diamond swags, gathered by old mine-cut diamond and natural pearl intersections, suspending natural pearl terminals from old mine-cut diamond lines.
 Gift from Richard Burton, London, 1968

Page 188
The granny necklace and ear pendants
By Van Cleef & Arpels, ear pendants no. 21276
The wide flexible choker composed of overlapping circular-cut diamond and polished gold links, centering upon a circular-cut diamond lion face, with cabochon emerald eyes, holding in its mouth a circular-cut diamond link, suspending larger similarly set double hoops; and a pair of ear pendants en suite, mounted in 18k gold.
 Given to Elizabeth Taylor when she became a grandmother
 Gift from Richard Burton, 1972

Page 191
Pair of diamond tassel ear pendants
By Marina B.
Each pendant suspending a series of graduated rose-cut diamond spectacle-link tassels, with a pavé-set diamond foliate motif cap, suspended by a pavé-set diamond openwork shield-shaped motif and arched link, mounted in 18k gold.
 From the collection of the Baron and Baroness di Portanova, modeled after the chandeliers in the dining room of the di Portanova's Acapulco home, "Arabesque."

Purchased from Christie's, New York, October 25, 2000, lot 416

Page 192
Art Deco sapphire and diamond bracelet, circa 1920
By Boucheron, Paris
Centering upon a cushion-cut sapphire, enhanced on either side by calibré-cut sapphires, within an old mine-cut diamond surround, to the similarly set sapphire and diamond shoulders and tapering diamond flexible line band, mounted in platinum.
 Gift from Sara Taylor, Elizabeth Taylor's mother, Los Angeles, August 1972

Page 194
Enamel, colored gold, and moonstone egg pendant, circa 1905
By Fabergé, stamped H. W. for workmaster Henrik Wigström
Designed as a blue guilloché enameled scent bottle egg pendant, enhanced by sculpted rose and yellow gold garland, swag and palmette detail, the swags set with rose-cut diamonds, the base, which acts as a stopper and can be removed, accented by a cabochon moonstone terminal, suspended from a fine link gold chain.
 Gift from the Estate of Malcolm Forbes

Page 199
Pair of ruby and diamond ear pendants
Each designed as an oval-cut ruby and circular-cut diamond quatrefoil motif, suspending an oval-cut ruby and circular-cut diamond pendant of similar design, enhanced by similarly set ruby and diamond articulated terminals, mounted in white and yellow gold.
 Gift from Malcolm Forbes

Page 201
Ruby and diamond horse brooch
Designed as a galloping pavé-set diamond horse, with cabochon ruby eyes, the body enhanced by calibré-cut rubies and polished gold trim, mounted in 18k gold.
 Gift from Malcolm Forbes

Page 201
Ruby and diamond bracelet
The flexible band, alternately set with circular-cut diamond and calibré-cut ruby segments, decorated with circular-cut diamond flower motifs, mounted in white gold.
 Gift from Malcolm Forbes

Page 204
Pair of natural pearl and diamond ear pendants
By Bulgari
Each natural button pearl, suspending a drop-

shaped natural pearl, from a circular- and mar-quise-cut diamond line, mounted in platinum.

Page 205
South Sea pearl and diamond ring
By Ruser
Centering upon a cultured pearl, within a pear-shaped diamond surround, to the circular-cut diamond shoulders, mounted in platinum, inscribed "something old, something new."

Gift from Howard Young, Elizabeth Taylor's uncle

Page 207
Pair of South Sea cultured pearl and diamond ear pendants
By Ruser
Each circular-cut diamond cluster, suspending three slightly graduated circular-cut diamond lines, the center line terminating in a baroque cultured pearl.

Elizabeth Taylor wore these ear pendants to the Academy Awards in 1960, where she won the Oscar for Best Actress for her performance in *Butterfield 8*.

Page 208
Pair of black cultured pearl and diamond ear pendants
By David Webb
Each pavé-set diamond hoop, suspending a similarly set diamond arched link and cap, to a black cultured pearl terminal, mounted in platinum.

Page 209
Gray Baroque cultured pearl and diamond necklace
By Ruser
Of seventy-six gray baroque cultured pearls, joined by a bombé pavé-set diamond clasp, mounted in platinum.

Page 210
South Sea cultured pearl necklace
By Lynn Nakamura
Of twenty-nine cultured pearls, joined by a pavé-set diamond sphere clasp.

Page 211
Pair of cultured pearl and diamond ear pendants
Each set with a cultured pearl, and enhanced by two circular-cut diamond lines, terminating in pear-shape and briolette-cut diamonds.

Page 215
Gold and ivory necklace
Ivory pendants, circa 18th and 19th centuries
Designed as a series of polished gold links, suspending thirteen circular antique ivory opera passes.

These pendants served as opera tickets in the 18th and 19th centuries and are engraved with the name of the opera house, the seat allocation, and name of the ticket holder.

Gift from the Estate of Edith Head

Page 216
Nephrite, rock crystal, and diamond lily of the valley brooch
Designed as a polished gold bouquet, each carved and frosted rock crystal flower enhanced by a circular-cut diamond terminal, with a carved nephrite leaf, and gathered by a circular-cut diamond ribbon, mounted in gold.

Gift from Rex Harrison

Page 220
Set of rock crystal and diamond jewelry
By Gérard
Comprising a bracelet, composed of two circular-cut diamond and textured gold rigid bands, enhanced at the front by a cushion-shaped carved rock crystal link, the inside edge trimmed by circular-cut diamonds; and a ring en suite, mounted in 18k gold.

Page 221
Suite of rock crystal and diamond jewelry
By Gérard
Comprising a sautoir, designed as a series of fluted rock crystal links, joined by circular-cut diamond arched links, the front suspending a pavé-set diamond navette motif, to a similarly set diamond hoop, within an independent fluted rock crystal hoop; and a pair of ear pendants en suite, mounted in 18k gold.

Page 222
Diamond and gold pendant necklace
By Van Cleef & Arpels, no. 21907
Composed of a series of rectangular and circular textured gold and circular-cut diamond links, joined by polished gold bar links, the front suspending a similarly set openwork circular pendant of oriental motif, mounted in 18k gold.

Page 223
Pair of turquoise and diamond ear pendants
Each suspending a circular-cut diamond openwork pendant of circular outline, by a circular-cut diamond line, from a cabochon turquoise and circular-cut diamond openwork surmount.

Gift from Marvin Hime, circa 1970

Page 224
Turquoise, diamond, and gold bracelet
By Jean Schlumberger, Tiffany & Co.
Composed of a series of ten cabochon turquoise, each within a polished gold gadrooned and matte gold surround, joined by polished gold X-motif links and enhanced by circular-cut diamonds, mounted in platinum and 18k gold.

Page 225
Suite of sapphire and diamond jewelry
Comprising a necklace of openwork design, the front set with four slightly graduated oval-cut sapphires, with circular-cut diamond flower spacers, enhanced by circular-cut diamond trim, to the similarly set diamond shoulders and polished gold link back chain; a bracelet and a pair of ear pendants en suite, mounted in gold.

Page 226
Antique diamond flower necklace, circa 1830
Composed of ten graduated old mine-cut diamond flower head links, joined by similarly set diamond foliate spacers, mounted in silver and gold, in a Rundell, Bridge & Rundell fitted case.

Page 227
Pair of antique diamond ear pendants, circa 1830
Each pendant composed of old mine-cut diamond scroll and foliate links, enhanced by diamond collet spacers and pear-shaped old mine-cut diamond terminals, mounted in silver and gold.

Page 228
Coral, sapphire, diamond, and enamel brooch
By David Webb
Designed as a cabochon coral and circular-cut diamond Maltese Cross, set in the center with a cabochon sapphire within a circular-cut diamond surround, enhanced by white enamel and polished gold trim, mounted in 18k gold.

Page 229
The daisy parure
By Van Cleef & Arpels, nos. 575951-2, 5871-3
Comprising a necklace, designed as a series of graduated pavé-set diamond daisies, each enhanced by circular-cut yellow diamond pistils, joined by calibré-cut chrysoprase leaves, and enhanced by circular-cut diamond trim; a brooch and a pair of ear clips en suite, mounted in 18k gold.

Acknowledgments

As with so many projects, my thanks for their help on my book begins with those closest to "home"—my personal team, led by Tim Mendelson, Marion Rosenberg, Tom Hoberman, Jess Morgan, Barbara Berkowitz, Warren Cowan, Richard Hoffman, Derrick Lee, and Pam Turski. Each of these people has been in my life for years, and I am eternally grateful for their help, their kindness, and their support.

In New York, my creative team worked to shape my stories and display my jewelry so beautifully, and I thank each of them for their vision and their dedication: Ruth Peltason, Takaaki Matsumoto, John Bigelow Taylor, Dianne Dubler, and Kevin Kwan. My publisher, Simon & Schuster, has been a dream partner in this venture, and in particular my warmest appreciation goes to Walter L. Weintz, Michael Korda, and Chuck Adams.

At Christie's, I'd like to acknowledge Nancy Valentino for her tremendous efforts; François Curiel, for his generous introduction; and Simon Teakle, Daphne Lingon, and Elizabeth Irvine in the jewelry department for compiling the impressive catalogue of my jewelry! Martha Nelson and Charla Lawhon at *InStyle* have been longtime fans and I thank them. For their research and help, my thanks to Miryam Shehatelian and Bonnie Selfe at Cartier; and Aleida Keevil and Chapin Carson at Sotheby's.

Over the years, I have been blessed to know and work with so many great photographers. First, a special mention goes to my old friends Herb Ritts, Bruce Weber, Francesco Scavullo, and Gianni Bozzacchi. And to the many other photographers and agencies whose images are reproduced here, I thank you.

In closing, I hope that all of my family and dear friends who have been a part of my life know that I cherish their love more than anything. You can't cry on a diamond's shoulder, and diamonds won't keep you warm at night. But they're sure fun when the sun shines.

Elizabeth Taylor

Edited by Ruth A. Peltason, Bespoke Books
Art direction and design by Takaaki Matsumoto, Matsumoto Incorporated
Photo editor, Kevin Kwan

Editorial note:
Elizabeth Taylor's jewelry is shown actual size, unless otherwise stated.

Photograph Credits
The author and publisher gratefully acknowledge the photographers, companies, publications, museums, and individuals listed below for supplying their images and necessary permissions. References are to page numbers.

AP/Wide World Photos: 35 left, 40 center, 77 left & center, 183 bottom left, 192 left, 195, 218 top left & right, 219 top left & right, bottom left; Eve Arnold/ Magnum Photos: 167, 183 bottom right; Cecil Beaton photographs courtesy of Sotheby's, London: 23, 67, 98; ©Bettmann/CORBIS: 25 left, 134; ©Gianni Bozzacchi: Cover, 8, 84, 96 center, 133; John Bryson/Timepix: 41, 44 left; Courtesy of Cartier: 86 both, 87; Culver Pictures: 149, 161, 203; Frank D. Dandridge/Timepix: 57 bottom left; Frank Edwards/Getty Images: 218 bottom left; ©Rufus F. Folkks/CORBIS: 183 top center; ©Toni Frissell/Library of Congress, Prints & Photographs Division, Toni Frissell Collection/Courtesy of Timepix: 41; M. Garrett/Getty Images: 40 right; Getty Images: 35 right, 44 center & right, 57 bottom right, 64 top, center left, bottom left, 65 top left & right, bottom left, 82, 93, 111 left, 123 left; Bernard Godfryd/Getty Images: 218 bottom right; Henry Grossman/Timepix: 54, 57 top left & right, center left & right, bottom center; Arron Hess/All Action/Retna: 104; ©Hulton-Deutsch Collection/CORBIS: 89; Eve Johnson/Getty Images: 29–30; ©Douglas Kirkland/CORBIS: 2, 168–69, 202; William Lovelace/Getty Images: 154; ©MacFadden Publishing/CORBIS: 111 right; ©Wayne Maser/A+C Anthology: back endpaper; David McGough/Timepix: 99, 219 bottom right; Truman Moore/Timepix: 58; Alex Oliveira/Timepix: 91; Norman Parkinson Limited/ Fiona Cowan: 190; ©Norman Parkinson Limited/Fiona Cowan/CORBIS: 51; M. Payer/Camera Press/Retna: 183 bottom center; Bob Penn/Camera Press/Retna: 153 bottom right; ©Photo B.D.V./CORBIS: 214; Photofest: 31, 40 left, 56, 64 bottom right, 70, 88, 90, 170, 183 top left & right, 206, 217; Edward Quinn, The Edward Quinn Archive, Scalo Publishers, Zurich-Berlin-New York: 25, 34, 152 top left, 230, 240; ©Herb Ritts: front endpaper, 10, 52, 127; Tony Rizzo/Getty Images: 96 left; Scala/Art Resource, NY: 85 both; ©Francesco Scavullo: 174; John Spellman/Retna Ltd USA: 77 right; Peter Stackpole/ Timepix: 153 top left; Frank Teti/Getty Images: 192 right; Collection of Elizabeth Taylor: 13, 14, 15, 16, 22, 65 bottom right, 92, 94, 95; John Gilbert Fox, 183 center, 193, 218 center right; Rene Maestri, 96 right & 97, 105, 123 right, 144 right, 152 bottom right; Timepix: 144 left, 189, 197 left & right; Courtesy of Van Cleef & Arpels: 107; Victoria & Albert Museum/Art Resource, N.Y.: 72, 73; ©Bruce Weber: 6.

Page 1: Pair of diamond and multicolored sapphire "ball" ear clips, by JAR
Page 2: In Paris, 1963 (Photo, Douglas Kirkland)
Page 230: A window-shopping expedition with Mike Todd in Monte Carlo led to a jewelry stop at Cartier, circa 1957. (Photo, Edward Quinn)
Page 240: When once asked why she has so many diamonds, Elizabeth Taylor's reply was deceptively simple: "Because they're my passion." For this outing, diamond earrings were the happy choice. (Photo, Edward Quinn)

Front endpaper: Herb Ritts
Back endpaper: Wayne Maser

Simon & Schuster
Rockefeller Center
1230 Avenue of the Americas
New York, NY 10020

For information about special discounts for bulk purchases, please contact Simon & Schuster Special Sales:
1-800-456-6798 or business@simonandschuster.com

Manufactured in Italy

10 9 8 7 6 5 4 3 2 1

Library of Congress Cataloging-in-Publication Data
Taylor, Elizabeth
 Elizabeth Taylor: my love affair with jewelry/by Elizabeth Taylor;
 edited by Ruth Peltason; photographs by John Bigelow Taylor;
 design by Takaaki Matsumoto.
 p. cm.
 Includes index.
 1. Taylor, Elizabeth, 1932—Art collections. 2. Jewelry—Private
collections—United States. 3. Elizabeth, Taylor—Relations with men.
I. Peltason, Ruth A. II. Taylor, John Bigelow. III. Title.
NK7303.T39 T39 2002
739.27'074'73—dc21 2002066862
ISBN 0-7432-3664-5